A HISTORY OF

ART

PAINTING·SCULPTURE·ARCHITECTURE

MAGIC, FORM, AND FANTASY · ANCIENT WORLD · MIDDLE

ART

FREDERICK HARTT
Paul Goodloe McIntire Professor Emeritus of the History of Art, University of Virginia

AGES · RENAISSANCE · BAROQUE · MODERN WORLD

A HISTORY OF
PAINTING · SCULPTURE
ARCHITECTURE

SECOND EDITION

HARRY N. ABRAMS, INC.
New York

TO
MEYER SCHAPIRO

Scholar, teacher, counselor, friend

Second Edition 1985
Project Director: MARGARET L. KAPLAN
Editors: MARGARET DONOVAN, ELLYN CHILDS ALLISON
Director, Rights and Reproductions: BARBARA LYONS

Library of Congress Cataloging in Publication Data
Hartt, Frederick.
 Art: a history of painting, sculpture, architecture.
 Bibliography: p.
 Includes index.
 1. Art—History. I. Title.
N5300.H283 1985c 709 84-24445
ISBN 0-8109-1824-2

Printed and bound in Japan

CONTENTS

PREFACE

Art is the only thing that can go on
mattering once it has stopped hurting.

Elizabeth Bowen

The purpose of this book is to give students of all ages something that really will go on mattering, once the bluebooks have been handed in and the painfully memorized names and dates have receded into dimmer levels of consciousness. To this end I have tried to put together a usable account of the whole history of artistic production in the Western world—an activity that ranks as the highest of all human achievements (so I maintain), surpassing even the most startling cures of modern medicine and the little machine hurtling past the last planets and out into interstellar space. Obviously no teacher can use all the material in these two volumes. But I respect teachers enough to give them their choice of what to include and what to leave out, and students enough to want them to have a book that they can keep and continue to explore on their own, whether or not they ever take another course in the history of art. General readers, equally deserving of respect, will surely not object to as full a picture as possible.

The revised edition is the product of many months of thought and labor. Much has had to be changed through experience, mine and that of other teachers. The format is different, with colorplates mixed in with black-and-white illustrations in closer proximity to the relevant text. The order of several chapters has been changed, in order to produce a more continuous flow of barbarian, Byzantine, and Renaissance art. The Introduction and time lines have been totally recast and illustrated. The Introduction may seem a little less "scholarly" than the original version, but it now includes guidelines on how to approach, look at, and think about works of art. Books have been written on this subject, many of them, and I have deliberately restricted my account to what can fit into an introduction. Also, the defeating columns of continuous print in the Introduction have been broken up by illustrations, chosen so as to provide immediate examples of the principles under discussion (figure numbers are supplied to refer to still more examples in later chapters).

Finally, a long-overdue attempt has been made to give women something approaching their just treatment in the history of art. But the reader should understand that the task is not as easy as it might seem. What can one say about women artists in periods when women were systematically excluded from all forms of artistic production except, let us say, embroidery? And what can one write about women as artistic leaders in later periods when they were still permitted only marginal participation? In those chapters in which women either do not appear at all or turn up in minor roles, an attempt is made to explain why. I hope the reader will also understand that what I say in the Introduction about Women in Art, and what I undertake in other chapters, has been carried out with goodwill and conviction. Time alone will tell whether it is sufficient.

The teacher-student relationship is one of the deepest and most productive of all human bonds. How can I forget what my own long career has owed to the teachers, graduate and undergraduate, who gave me my start? Fifty years ago, as a college sophomore, I registered for a class with Meyer Schapiro, and the whole course of my life was transformed. Not only did he introduce me to the fields of medieval and modern art, in which his knowledge is vast, but he opened my eyes to the meaning of art-historical studies and to methods of art-historical thought and investigation. I am grateful to other magnificent teachers, now no longer living, especially to Walter W. S. Cook, Walter Friedlaender, Karl Lehmann, Millard Meiss, Richard Offner, Erwin Panofsky, George Rowley, and Rudolf Wittkower, and to Richard Krautheimer. The faith, advice, and inspiration of Bernard Berenson stood me in good stead in many a difficult moment. I owe much to the generosity of Katherine S. Dreier who in 1935 opened to me her pioneer collection of modern art and to the rigorous discipline of the sculptor Robert Aitken who taught me what a line means.

At this moment I think also with warmth and happiness of all my students since I began teaching in 1939—of those seas of faces in the big survey courses at Smith College, Washington University, the University of Pennsylvania, and the University of Virginia, as well as of the advanced and graduate groups, many of whose members have themselves been teaching for a quarter of a century and are now in a position to give me valued criticism and advice.

My colleagues at the University of Virginia—Malcolm Bell III for ancient art, John J. Yiannias for Byzantine and early medieval, Marion Roberts for late medieval and Northern Renaissance, Keith P. F. Moxey for Baroque, and David Winter for the eighteenth and nineteenth centuries—read the sections of the manuscript that pertain to their special fields, gave me the benefit of their learning and insight, and made many crucial suggestions. Once the first edition was in print, Kenneth J. Conant, Miles Chappell, and Martin S. Stanford made important corrections. My former colleague Fred S. Kleiner and my present colleague John Dobbins provided many valuable corrections and suggestions for the chapters on Greek and Roman art. Helpful suggestions were also made by Karl Kilinski II. The reviewers invited by Prentice-Hall made many comments for the revision, some mutually contradictory, others extremely useful. Marvin Eisenberg in particular gave me more and better advice for the reorganization of the book than I can ever hope to acknowledge.

I deeply appreciate the confidence of the late Harry N. Abrams for having entrusted me with the task of writing this book and am grateful to the unforgettable Milton S. Fox for starting me off on it. My thanks also go to Margaret L. Kaplan for invaluable supervisory and editorial work on both editions and for valiant assistance in the crises that inevitably beset any ambitious undertaking; to John P. O'Neill for his sensitive and careful editorship of the first edition; to Margaret Donovan who with insight and patience has edited the second, collaborating with me in the innumerable problems of revision; and to Barbara Lyons and her staff who—with infinite labor—assembled all the illustrative material. The fresh new design is the work of several talented people, and the beautiful new maps and time lines were devised by Robert Gray. Jeryldene Wood has helped me on many matters, especially the search for new material in libraries, and the revision of the text for the time lines.

<div align="right">

Frederick Hartt
Belvoir, Charlottesville, Virginia
Advent, 1983

</div>

THE NATURE OF ART

What is art? That question would have been answered differently in almost every epoch of history. Our word *art* comes from a Latin term meaning "skill, way, or method." In ancient times and during the Middle Ages all kinds of trades and professions were known as arts. The liberal arts of the medieval curriculum included music but neither painting, sculpture, nor architecture, which were numbered among the mechanical arts, since they involved making objects by hand. At least since the fifteenth century, the term *art* has taken on as its principal characteristic in most societies the requirement of aesthetic appreciation as distinguished from utility. Even if its primary purpose is shelter, a great building, for example, is surely a work of art.

The word *aesthetic* derives from a Greek term for "perceive," and perception will occupy us a little farther on. What is perceived aesthetically is "beauty," according to the Oxford Dictionary, and beauty is defined as the quality of giving pleasure to the senses. Yet there are paintings, sculptures, plays, novels intended to produce terror or revulsion by the vivid representation of tragic or painful subjects. The same goes for certain moments in music, when loud or dissonant sounds, hardly distinguishable from noise, are essential for the full realization of the composer's purpose. These are undeniably works of art in the modern meaning of the term, even though beauty conceived as pleasure is largely excluded—that is, unless we are willing to count the pleasure we feel in admiring the author's ability to present reality or the not especially admirable pleasure a horror film gives to an audience seated in perfect safety.

Clearly something essential has been overlooked in the Oxford definition of beauty. To be sure, throughout history beauty has been analyzed on a far loftier plane than mere sensory pleasure, beginning in Greek philosophy with treatments of a divine order of which the beauty we perceive is a dim earthly reflection. And later writers on the philosophy of art—especially in the eighteenth century and since, culminating in the self-proclaimed "science" of aesthetics—have considered beauty from many different standpoints, constructing elaborate philosophical systems, often on the basis of limited knowledge of art and its history. Is there not some distinguishing quality in the very nature of a work of visual, literary, or musical art that can embrace both the beautiful and the repellent, so often equally important to the greatest works of art? The question may perhaps be answered in the light of a concept developed by the early twentieth-century American philosopher of education John Dewey in his book *Art as Experience*. Without necessarily subscribing to all of Dewey's doctrines, one can assent to his basic belief that all of human experience, beautiful and ugly, pleasurable and painful, even humorous and absurd, can be distilled by the artist, crystallized in a work of art, and preserved to be experienced by the observer as long as that work lasts. It is this ability to embrace human experience of all sorts and transmit it to the observer that distinguishes the work of art.

Purpose If all of human experience can be embodied in works of art, we have then to ask, "Whose experience?" Obviously the artist's first of all. The work inevitably includes some reference to the artist's existence, but often even more to the time in which he or she lived. It may have been ordered by a patron for a specific purpose. If a building or part of a building, the work undoubtedly had a role to play in the social or religious life of the artist's time. Can we appreciate such works without knowing anything of their purpose, standing as we do at a totally different moment in history?

Perhaps we can. There are many works of prehistoric art—like the animals on cave walls and ceilings (see figs. 20, 21, and 22)—that we cannot interpret accurately in the complete absence of reliable knowledge, but to our eyes they remain beautiful and convincing. This may be because we can easily relate them to our own experience of animals. And there are others, such as the temples on the island of Malta (see fig. 35) or the colossal Easter Island sculptures (see fig. 50), that are impressive to us even if foreign to every kind of experience we can possibly know. Simply as forms, masses, lines, we find them interesting. Yet how much more articulate and intelligent our response to works of art can be if we know their purpose in the individual or corporate experience of their makers. We can take a part of a building that strikes us as beautiful, study how it was originally devised to fit a specific practical use, then watch it develop under changing pressures, sometimes to the point of total transformation. Or we can watch a type of religious image arise, change, become transfigured, or disappear, according to demands wholly outside the artist's control. Such knowledge can generate in us a deeper understanding and eventually an enriched appreciation of the works of art we study. If we learn to share the artist's experience, insofar as the historical records and the works of art themselves make it accessible to us, then our own life experience can expand and grow. We may end up appreciating the beauty and meaning of a work of art we did not even like at first.

Today people make works of art because they want to. They enjoy the excitement of creation and the feeling of achievement, not to speak of the triumph of translating their sensory impressions of the visible world into a personal language of lines, surfaces, forms, and colors. This was not always so. Throughout most of history artists worked characteristically on commission. No matter how much they enjoyed their work, and how much of themselves they poured into it, they never thought of undertaking a major work without the support of a patron and the security of a contract. In most periods of history artists in any field had a clear and definable place in society—sometimes modest, sometimes very important—and their creations thus tended to reflect the desires of their patrons and the forces in their human environment.

Today the desires that prompt patrons to buy works of art are partly aesthetic. Collectors and buyers for museums and business corporations do really experience a deep pleasure in surrounding themselves with beautiful things. But there are other purposes in collecting. Patrons want to have the best or the latest (often equated with the best) in order to acquire or retain social status. Inevitably, the thought of eventual salability to collectors can, and often does, play a formative role in determining aspects of an artist's style. It takes a courageous artist to go on turning out works of art that will not sell.

In earlier periods in history factors of aesthetic enjoyment and social prestige were also important. Great monarchs or popes enjoyed hiring talented artists not only to build palaces or cathedrals, but also to paint pictures, to carve statues, to illustrate manuscripts, or to make jewels—

partly because they enjoyed the beautiful forms and colors, but partly also to increase their apparent power and prestige.

If our appreciation of art is subject to alterations brought about by time and experience, what then is quality? What makes a work of art good? Are there standards of artistic value? These essential questions, perpetually asked anew, elude satisfactory answer on a verbal plane. One can only give examples, and even these are sure to be contradictory. The nineteenth-century American poet Emily Dickinson was once asked how she knew when a piece of verse was really poetry. "When it takes the top of your head off," she replied. But what if a work of art that ought to take the top of your head off refuses to do so? Demonstrably, the same work that moves some viewers is unrewarding to others. Moreover, time and repeated viewing can change the attitude of even an experienced person.

Often a dynamic new period in the history of art will find the works of the preceding period distasteful. Countless works of art, many doubtless of very high quality, have either perished because the next generation did not like them or have been substantially altered to fit changes in taste. (As we shall see, there are other motives for destruction as well.) And even observers of long experience can disagree in matters of quality.

The twentieth century, blessed by unprecedented methods of reproduction of works of art, has given readers a new access to the widest variety of styles and periods. Incidentally, André Malraux in his book *The Museum Without Walls* has pointed out the dangers of this very opportunity in reducing works of art of every size and character to approximately the same dimensions and texture. There is, of course, no substitute for the direct experience of the real work of art, sometimes overwhelming in its intensity no matter how many times the student has seen reproductions.

The ideal of the twentieth century is to like every "good" work of art. There is an obvious advantage in such an attitude—one gains that many more wonderful experiences. Yet there are inborn differences between people that no amount of experience can ever change. If after reading many books and seeing many works of art, ineradicable personal preferences and even blind spots still remain, the student should by no means be ashamed of them. Barriers of temperament are natural and should be expected. But—and this is all-important—such admissions should come *after*, not before, a wholehearted attempt to accept the most disparate works of art on their own grounds; one must not merely condemn them because they are unfamiliar. The world of art is wide and rich; there is room in it for everyone who wants to learn, to experience, above all to *see*.

Women in Art Part of the explanation of women's exclusion from artistic endeavors, as well as from others, is doubtless to be sought in their physical status in times before modern medicine. What men have historically demanded of women was a home and children. Until quite recently it took a steady round of childbearing to produce a few living heirs. Most women were married in their teens, and most married women were pregnant most of the time. Many died in or as a result of endless childbirths, and relatively few survived the childbearing age for long. Men also wanted to make sure that the children were their own. In their eyes, the hurly-burly of a studio full of apprentices and assistants was no place to maintain "chastity." In fact, the pioneer woman painter Artemisia Gentileschi was actually raped in her father's studio by one of his assistants. Nor could women be permitted to study the nude figure, in periods when such study was the

foundation of all art involving human representation. As recently as 1931–34, when I attended drawing and sculpture classes at the Art School of the National Academy of Design in New York City, women and men were required to work in separate life classes, and no male model could be shown entirely nude to women. A glance at even the bathing suits of the 1920s and 1930s (not to speak of those of the 1890s) in old photographs will show how far we have come since. Modern medicine has insured that most babies will survive, and contraception can limit the number of births to those desired. Women, in the Western world at least, now outlive men. We are still trying to cope with the moral implications of the revolution in sexual attitudes, but one by-product has surely been that women can now study the human body and engage in studio life without disapproval.

Furthermore, a woman tied to domesticity and constant pregnancy could scarcely participate in any other very arduous physical activities. In the days when architects got their start as carpenters or stonemasons, and sculptors as stonecutters, it is not hard to see why women could not join in. Even painting, in the Renaissance, involved strenuous activity high on scaffolding, carrying sacks of sand and lime and pots of water. The only women artists recorded in antiquity painted portraits, which could be done in comfortable surroundings. Alas, their work is all lost. But in the Middle Ages nuns in convents, remote from male company, were considered expert painters of illuminated manuscripts. Five splendid examples known to have been painted by women are included in this revision, for the first time in any general textbook. Then, in the sixteenth and seventeenth centuries, painters' daughters (like Artemisia Gentileschi) began to participate, and the occasional woman painter appeared on her own. Some achieved excellence, and several are included here. But even as late as the eighteenth century women were still mostly limited to portrait painting (often with spectacular results).

In sculpture the widespread use of the pointing machine eventually relegated stonecutting to expert workmen, and once the procedure became less physically demanding women sculptors appeared—in the late nineteenth and twentieth centuries. And when architecture began to be taught in schools rather than springing spontaneously from woodworking or stoneworking shops women students began to attend, although they are still relatively rare.

In periods when women artists are infrequent or entirely absent I have done my best to explain why. When they begin to turn up in numbers, they take their place with the men in these pages. Since the final work of art often owes a great deal to the desires of the patron who commissioned it, consideration has also been given to women patrons, who were many times extremely imaginative and original.

PERCEPTION AND REPRESENTATION How has the artist perceived and recorded the visible world—trees, let us say—in widely separated periods in the history of art? The earliest known European landscape, a wall painting from the Greek island of Thera (fig. 1), dates from about 1500 B.C. and shows natural forms reduced to what look like flat cutouts. The contours and a few inner shapes of rocks, plants, and birds are drawn in outline (as in most very early art, or indeed the art of children or of present-day untrained adults) and simply colored in, accurately enough, however, for identification. Doubtless the occupants of the room felt they were in the midst of a "real" landscape, wrapped around

Style

1. Room with landscape frescoes from the Cycladic island of Thera, including areas of modern reconstruction. Before 1500 B.C. National Archaeological Museum, Athens

2. GIOTTO. *Joachim Takes Refuge in the Wilderness,* fresco, Arena Chapel, Padua, Italy. 1305–6

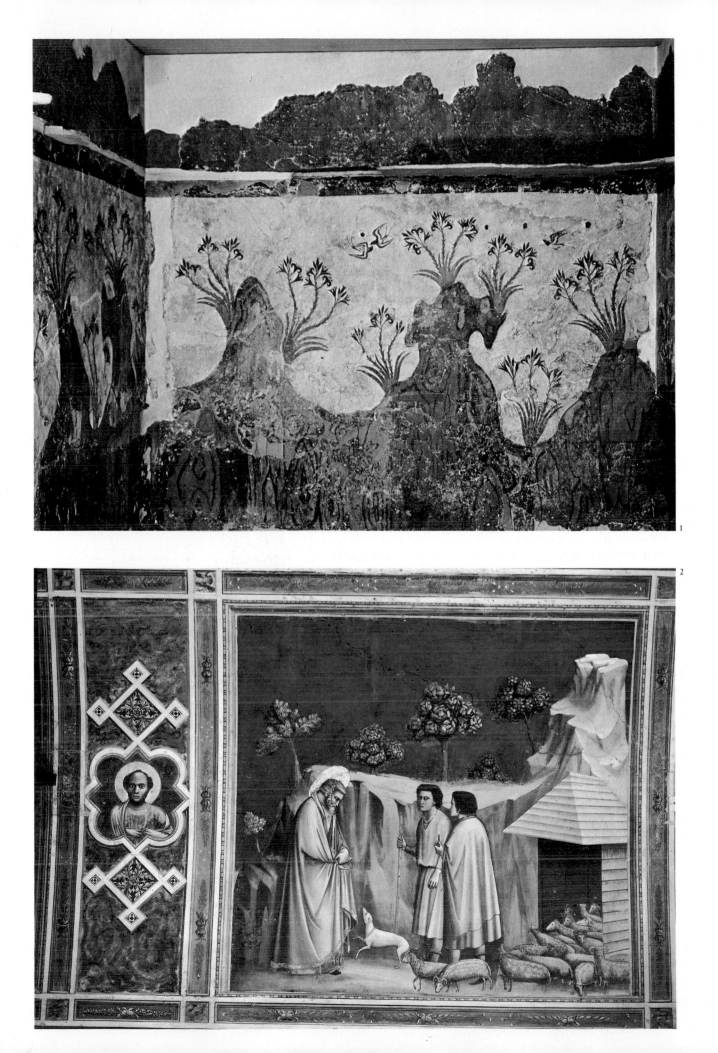

them on three walls, but few today would agree, despite the charm of the murals as decoration and the bouncing vitality of the outlines.

In a work (fig. 2) painted shortly after A.D. 1300 by the Italian artist Giotto, rocks and plants are beautifully modeled in light and shade and do seem to exist in three dimensions, yet they are anything but real to our eyes compared to the figures who stand in front of them. Accounts written by one of Giotto's followers indicate that he advised painting one rock accurately and letting that stand for a mountain or one branch for a tree. Nonetheless we know that Giotto's contemporaries thought that his paintings looked very real.

A little over a hundred years later the Netherlandish painter Jan van Eyck presents in a panel from the *Ghent Altarpiece* (fig. 3) a view of rocky outcroppings and vegetation similar in structure to that of Giotto's fresco, but in a manner anyone today would easily call realistic. Van Eyck's amazingly sharp perception has enabled him to render every object, from the smallest pebble in the foreground to the loftiest cloud in the sky, with an accuracy few photographs can rival. Every tree appears entire and in natural scale, down to the last leaf, and in believable light and shade. Yet is the picture as real as it seems at first sight? Do we encounter in real experience figures looking like this, all turned toward us and lined up on a rocky ledge that is sharply tilted so we can see every object clearly?

A radically different and very modern form of perception is seen in such Impressionist paintings of the late nineteenth century as Renoir's *Les Grands Boulevards* (fig. 4), in which all contours and indeed all details disappear, being blurred or lost as the artist seeks to seize with rapid brushstrokes a fleeting view of city life in bright sunlight and in constant motion. Trees and their component branches and foliage are now mere touches of the brush. This was the uncalculated, accidental way in which Renoir and his fellow Impressionists viewed the world, striving in their pictures for the speed and immediacy no snapshot photograph could then achieve and at the same time for a brilliance of color inaccessible to photography until many decades later. Today most viewers accept this image quite happily, but not in Renoir's day, when the Impressionists were violently attacked in print for being so *un*real!

Finally, in the twentieth century, painters fully trained in both realist and Impressionist methods transformed the image of trees into a pattern almost as unreal to our eyes as that of the Thera murals, even though it is often rendered with a freedom of brushwork that owes much to the Impressionists. To the Dutch painter Mondrian, his *Red Tree* (fig. 5), overpowering in its fiery red against a blue sky, translates what may have been the color of sunset light into an expression of the ultimate reality of inner individual experience.

Optically, there can have been very little difference in the images of trees transmitted to the retinas of Mondrian, Renoir, van Eyck, Giotto, and the unknown painter of Thera. The startling difference in the results is due to the differing sets of conventions, inherited or self-imposed, according to which each artist selected, reinforced, and recombined those aspects of the visual image which seemed important. Reality, in the long run, is as elusive and subjective a concept as beauty, yet just as compelling for the artist and for us.

THE VOCABULARY OF ART

Form. The *form* of an object is its shape, usually considered in three dimensions. (The word *form* is also used in music and literature, and in the visual arts as well, to mean the interrelationship of all the parts of a

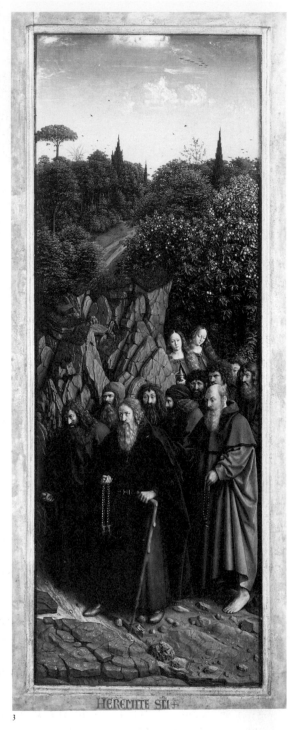

3

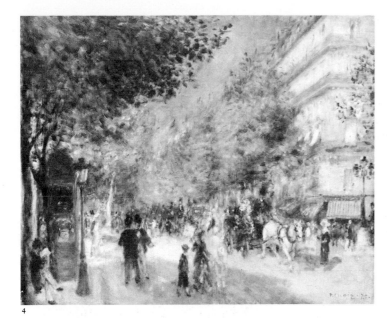

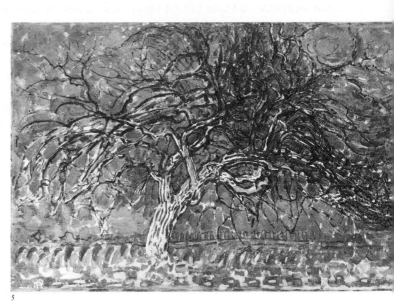

4 5

work.) Visual form is perceived first of all through binocular vision, by
means of which each eye sees the object from a slightly different point of
view, enabling the mind to create a three-dimensional image. The reader
has only to test this proposition by closing one eye and noting the diffi-
culty in perceiving accurately the shapes of objects and their positions in
space. Form can also be perceived manually, through the sense of touch,
which sends messages to the brain; by its very nature sculpture appeals
to this sense. Painting, generally on flat or nearly flat surfaces, can only
suggest the "3-D" effect that is the birthright of sculpture. The elements
used by painting to indicate form are line, light and shade, and color,
each of which as we will see can also play other important parts in the
effect of the work of art.

The words *volume* and *mass* are also used almost interchangeably to
indicate three-dimensionality, but without the connotation of shape, which
is essential to the word *form*. *Volume* can even indicate the spatial content
of an interior. The impact of mass on the observer is greatly enhanced by
scale, which is an absolute quality in works of art, hence the difficulty in
experiencing from small illustrations the breathtaking effect of colossal
buildings like Egyptian temples or Gothic cathedrals.

Line. Line can be seen as an edge or contour, of one shape against an-
other or against distance, by means of which form can be deduced. A
line can also be drawn, like the lines of a diagram or those which make
up a printed letter of the alphabet. This kind of line can not only convey
a great deal of factual information but can also clearly delineate form, as
in Greek vase paintings (fig. 6; see also figs. 207, 1161). Lines can be in-
dependent, or several lines can cooperate in the formation of a pattern
(see page 23). Generally in ancient and medieval art, lines are drawn
firmly and appear unbroken, but sometimes a very lively effect is ob-
tained by preserving in a sketchy line the actual motion of the artist's
hand carrying the drawing instrument (as in some medieval manuscripts;
see fig. 505, for example). Finally, line can suggest the direction of motion
("line of fire," for example), seen typically in such instances as the "sweep"
or "fall" of folds of cloth (*drapery* is the technical term; see figs. 232 and
576, for sharply different examples).

3. HUBERT(?) and JAN VAN EYCK. *Hermit Saints*,
 detail of the *Ghent Altarpiece* (open). Completed
 1432. Oil on panel, 11' 5¾ × 15' 1½" (entire
 altarpiece). Cathedral of St. Bavo, Ghent, Bel-
 gium.

4. PIERRE AUGUSTE RENOIR. *Les Grands Boulevards*.
 1875. Oil on canvas, 20½ × 25". Collection
 Henry P. McIlhenny, Philadelphia

5. PIET MONDRIAN. *The Red Tree*. 1908. Oil on
 canvas, 27½ × 39". Gemeentemuseum, The
 Hague

Light and shade. Light falling on an object leaves a *shade* on the side opposite to the source of light; this shade is distinct from the *shadow* cast by the object on other objects or surfaces. The shade may be hard and clearcut or soft and indistinct, according to the degree of diffusion of the light that causes it. The relationship of light and shade suggests form, but can be deceptive, since shade varies not only according to projections but to the position of the source of light. The same work of sculpture can look entirely different in photographs taken in different lights. Light and shade are also often used very effectively in strong contrast to produce effects of emotion (see figs. 396, 906, 995, 1075).

Color. Color is subject to more precise and complex scientific analysis than any of the other elements that make up the visual experience of art. For this book the most useful terms are those describing the effects of the various ways the artist employs *hue* (red, blue, yellow, etc.), *saturation* (intensity of a single color), and *value* (proportion of color to black and white). Colors can be described in terms such as brilliant, soft, harmonious, dissonant, harsh, delicate, strident, dull, and in a host of other ways. Blue and its adjacent colors in the familiar color circle, green and violet, are generally felt as cool, and through association with the sky and distant landscape appear to recede from us. Yellow and red, with their intermediate neighbor orange, are warm and seem nearer. In most early painting color is applied as a flat tone from outline to outline (see, for instance, figs. 93, 114). Broken color, in contrast, utilizes brushwork to produce rich effects of light (see figs. 290, 325). Modeling in variations of warm and cool colors suggests form, but color, modeled or not, evokes by itself more immediate emotion than any element available to the artist, to such a degree that extremely saturated color, like bright red or yellow, would be felt as unbearable if applied to all four walls and the ceiling of a room.

Space. *Space* may be defined as extent, either between points or limits, or without known limits, as in outer or interplanetary space. Since space encourages, limits, or directs human existence and motion, it constitutes one of the most powerful elements in art just as it does in life. An architect can set boundaries for space in actuality, as a painter or sculptor can through representation. The space of the Pantheon (fig. 7)—a Roman temple consisting of a hemispherical dome on a circular interior whose height is equal to its radius and therefore to that of the dome—has a liberating effect the minute one steps inside, almost like a view into the

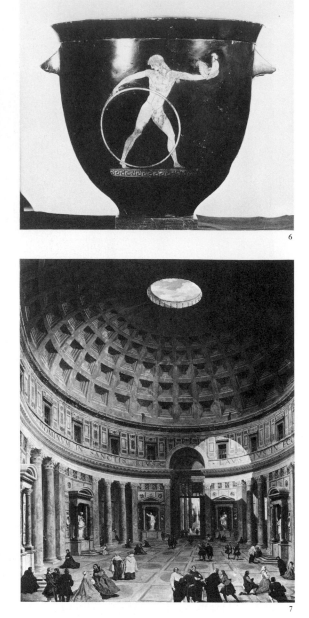

6

7

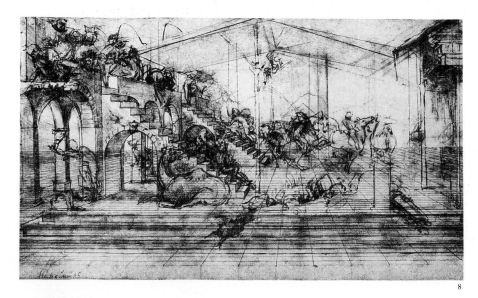

8

6. THE BERLIN PAINTER. *Ganymede* (portion of a bell-shaped krater found in Etruria, Italy). Early 5th century B.C. Height c. 13″. The Louvre, Paris

7. GIOVANNI PAOLO PANNINI. *Interior of the Pantheon.* c. 1750. Oil on canvas, 50½ × 39″. National Gallery of Art, Washington, D.C. Samuel H. Kress Collection

8. LEONARDO DA VINCI. *Architectural Perspective and Background Figures,* for the *Adoration of the Magi.* c. 1481. Pen and ink, wash, and white, 6½ × 11½″. Gabinetto dei Disegni e Stampe, Galleria degli Uffizi, Florence

9. *King Chephren,* from Giza, Egypt. c. 2530 B.C. Diorite, height 66⅛″. Egyptian Museum, Cairo

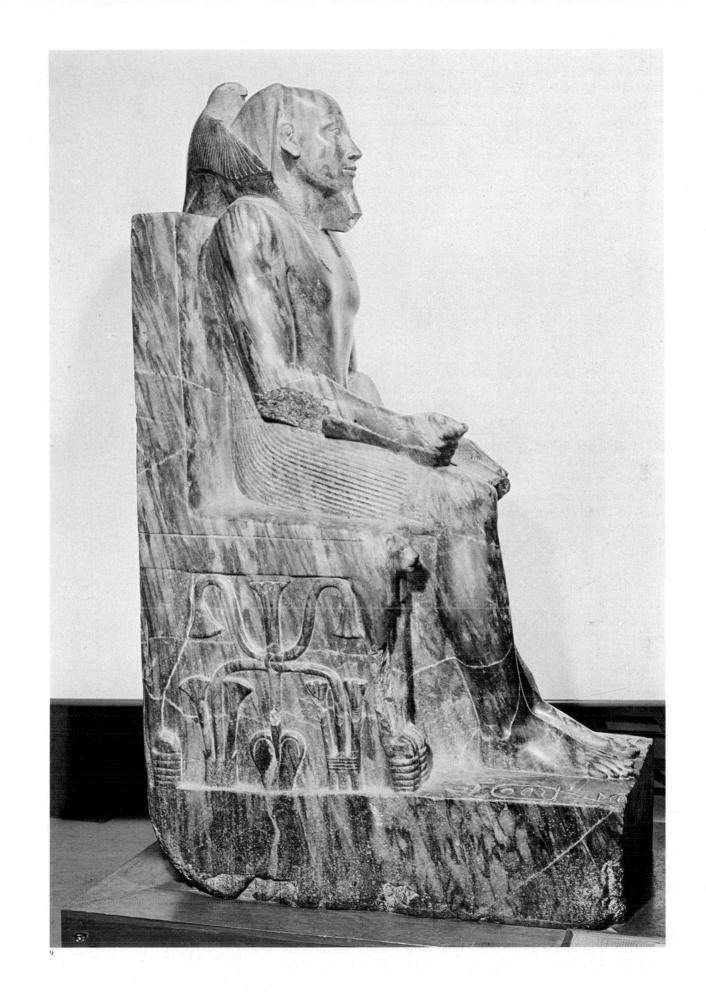

9

sky (itself often called a dome). The space would seem to rotate constantly if it were not held fast by a single niche opposite the entrance. In sharp contrast the interior of the French abbey church of Vézelay (see fig. 530)—long, relatively low, and cut into segments by heavy, striped arches—seems to constrict and gradually drive the observer inward.

A painter or sculptor can represent space by means of *linear perspective*. This is a system in which spatial depth is indicated by means of receding parallel lines that meet at a vanishing point on the horizon and cross all lines parallel to the surface of the image, as seen in Leonardo da Vinci's preparatory drawing for a painting of the *Adoration of the Magi* (fig. 8). The grid thus formed controls the size of all represented objects according to their positions in its diminishing squares, so that they too diminish in an orderly fashion as they recede from the eye. Although diminution takes place just the same indoors and outdoors, a consistent system of linear perspective obviously demands a man-made enclosing structure, composed of regularly recurring elements, like a colonnade or a checkered floor. Perspective can also be *atmospheric*, that is, objects can lose their clarity according to their distance from us, because of the always increasing amount of moisture-laden atmosphere that intervenes (see figs. 322, 755). In early art space is generally represented diagrammatically, by superimposing distant objects above those nearby (see figs. 92, 645). Space can even be suggested, though not represented, by means of flat, continuous backgrounds without defined limits (see figs. 225, 657).

Surface. The physical surface of any work of art is potentially eloquent. A painted surface has a *texture* (from the Latin word for weave), which can sometimes be consistent and unaltered; such is the case with Egyptian, Greek, and Etruscan murals (see figs. 93, 225, 305), where the surface declares the clean white plaster of the wall, or with Greek vases (see figs. 207, 208), where red clay slip is set against glossy black. Or it can be enriched as we have seen, in the rendering of light and shade and color, by countless brushstrokes so as to form a vibrant web of tone, as in Roman painting (see fig. 321). In mosaic—the art of producing an image by means of cubes of colored stone or glass—the handling of the surface is especially important. In the Middle Ages these facets were set at constantly changing angles to the light so as to sparkle (see, for instance, figs. 413, 431, 465).

Depending on the inherent properties of the material, sculpture in stone can sometimes be smooth and polished to reflect light, as in fig. 9, in green diorite (see also, for example, fig. 331 in black and white onyx; fig. 382 in red porphyry; and fig. 190 in white marble). Or the crisp details of a marble surface can be filed away so that the crystalline structure of the stone can retain light and blur shadow (see fig. 281). Or it can be left somewhat rough, showing even the tool marks, so as to give an impression of density and strength in keeping with the architecture of which it is a part (see figs. 601, 602). Sculpture cast in bronze has generally been smoothed by tools after casting to produce a polished surface reflecting light. The tool marks scratched in the original clay model from which the molds were made can be left unaltered (see fig. 265) or reinforced by cutting with a sharp metal tool into the final bronze surface (see fig. 307). Closer to our own time, the French sculptor Rodin in the late nineteenth century allowed the bronze to preserve all the freshness of the soft clay without any attempt to smooth away the marks of the fingers (see figs. 1136, 1137). Such surfaces may be compared with the free brushwork of the Impressionists, Rodin's contemporaries.

Opposites in architectural surface are the inert, quiet stone of the

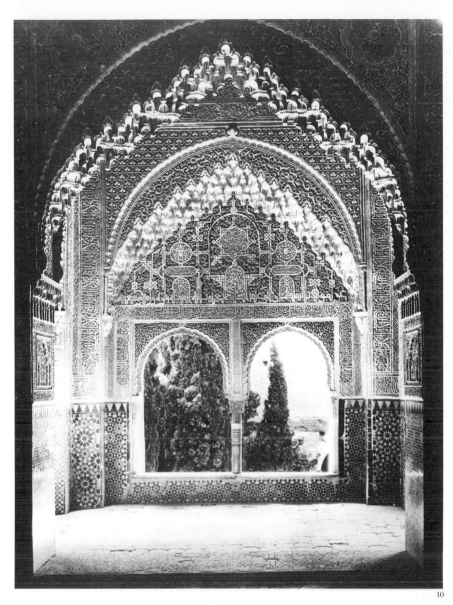

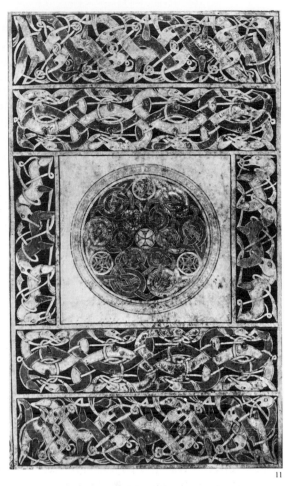

11

10. The Queen's Chamber, the Alhambra, Granada, Spain. c. 1354–91

11. Decorative page from the *Book of Durrow.* Northumbria. 2nd half of 7th century A.D. Illumination. Trinity College, Dublin

oldest Egyptian monuments (see fig. 201) or early Romanesque churches of the eleventh century (see fig. 523), left untreated to bring out the essential inner power of the stone, and the bewildering shimmer of later Islamic (fig. 10) and Flamboyant Gothic (see fig. 605) buildings, carved into a lacework that seems to defy the very nature of stone, dissolving it in countless sparkles of light and shade.

Pattern. Most of the previous elements—line, light and shade, color, surface—can be combined to form a *pattern* if the individual sections (known as *motives*) recur with some regularity, either exactly or in recognizable variations. Brilliant examples of pattern raised to a high pitch of complexity are the Islamic buildings we have just seen and the Hiberno-Saxon illuminated manuscripts of the early Middle Ages (fig. 11). Generally pattern is considered to operate only in two dimensions, so form and space have been excluded.

Composition. All of the elements we have been discussing, or any selection from them, can be combined to form a *composition*, understood as a general embracing order, if the artist has determined their coherence consistently. The artist may have made a preliminary sketch showing where the various sections would go, or they may have fallen into place as the artist worked. Types of composition can be enumerated almost indefi-

nitely, according to the artist's decision to emphasize one element or another or to the kind of system the artist devises to bring all the motives together. A great many different types will appear in the following pages.

Style. Finally, in any work of art, visual, musical, or literary, the total aesthetic character, as distinguished from the *content* or meaning (see pp. 27–28), is known as *style*. In other words, style is the way in which the artist has treated the visual elements we have been considering (or such corresponding elements as words, phrases, sentences in literature; tones, melodies, harmonies in music). Names, such as primitive, archaic, classic, realistic, abstract, have been developed for styles and are capitalized if they correspond to specific countries, historical periods (Middle Ages, Renaissance), or movements (Impressionism, Cubism). Such names are useful as hooks on which to hang works of art in our minds so that we can find them again. But they can be dangerous if we consider them as entities in themselves. Indeed, if we try to force our observations of works of art into grooves predetermined by names of styles, we may find ourselves shaping various elements in order to make them fit the names, or even ignoring incongruous elements altogether. In many periods, such as Egyptian, a common style was indeed imposed on all works of art with only occasional exceptions. Nonetheless quite different styles, sometimes a surprising number of them, can exist at the same time and place, and even make war upon each other. Throughout this book an effort has been made to bring out the special style of each individual work of art and to place it in relation to the complex and perhaps even contradictory tendencies of the period in which it was produced.

Iconography

In almost every society, up to and probably including the present, what we call today *iconography* (from two Greek words meaning "image" and "write"), that is, the subject matter of art, is of primary importance.

In the past iconography was generally related predominantly to religion or politics or both and was therefore likely to be systematic. In a religious building the subjects of wall paintings, stained-glass windows, or sculpture were usually worked out by the patron, often with the help of a learned adviser, so as to narrate in the proper sequence scenes from the lives of sacred beings or to present important doctrines in visible form through an array of images with a properly determined order and placing, and even with the proper colors. The artist was usually presented with such a program and required to execute it. Sometimes, as in the wall paintings in the interior of Byzantine churches, the subjects, the ways of representing them, and the places in which they could be painted were codified down to the smallest detail and keyed delicately to the Liturgy. Even in those periods in history when powerful artistic personalities worked in close relationship with patrons and advisers, artists were still not free to choose their subjects at will.

In regard to secular subjects as well, when patrons wished to commemorate their historic deeds they were certain to direct the artist as to how these should be represented. Only extremely learned artists, in certain relatively late periods of historic development, might be in a position to make crucial decisions regarding secular iconography on their own, and even then only with the general approval of the patron. Often in regard to both religious and secular subjects artists worked with the aid of iconographic handbooks compiled for the purpose.

Also, although we have little documentary evidence, the desires of the secular or religious patron for an effect—aiming at such qualities as

12. *God as Architect*, from the *Bible Moralisée*. Reims, France. Middle 13th century. Illumination. Österreichische Nationalbibliothek, Vienna

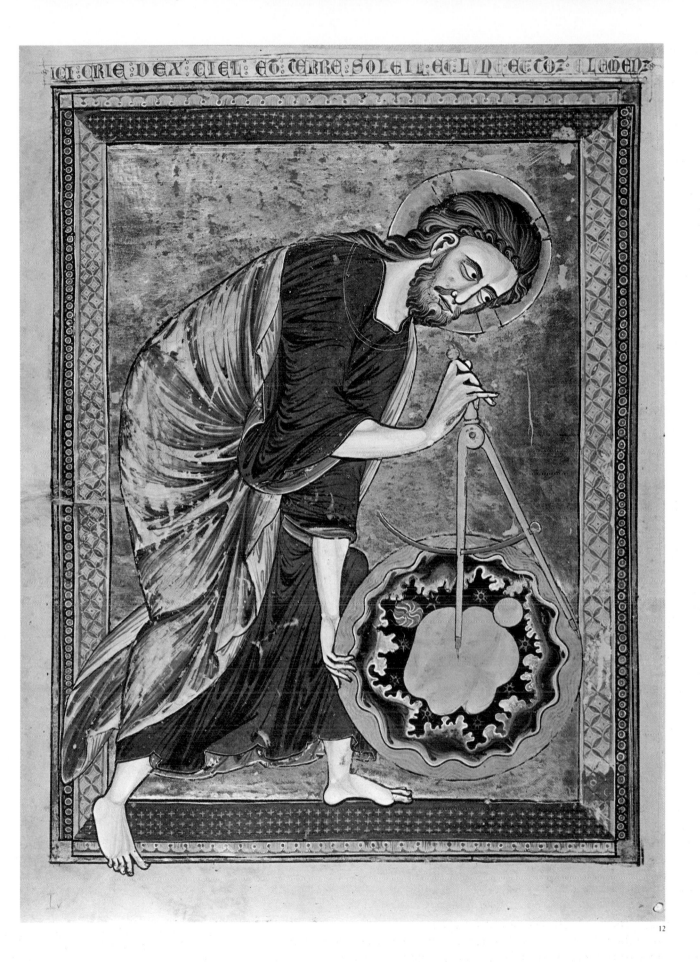

grandeur, magnificence, austerity, or delicacy—were necessarily taken into consideration by the artist, and therefore determined the prevailing mood of a work of art. Both religious and secular works of art were sometimes refused as unsuitable to the purpose for which they had been commissioned; often the artist was required to change certain crucial aspects that offended the patron. A study of the subjects of contemporary art—in those cases in which subjects are still recognizable—might well suggest patterns of social preference that have influenced artists without their being fully aware of them.

Patronage, in exercising an influence on iconography, may also affect style. For example, Christianity held the representation of the nude human body in horror, save when the soul appears naked before God for judgment or when a saint is stripped (shamed) before martyrdom. It is not likely, therefore, that an art thoroughly dominated by the more rigorous forms of Christianity, as in certain periods during the Middle Ages, could show much comprehension of or interest in the movement of the clothed figure, which can only be understood through study of the nude body. Similarly, a culture such as ancient Greece that placed a high valuation on the total human being, including physical enjoyment and athletic prowess, and displayed nude images in places of great prominence was likely to reject instinctively those colors and ornaments which might eclipse the beauty of the body.

The study of iconography can also assist us in understanding what one might call the magical aspects of works of art, for the process of representation has always seemed to be somewhat magical. Totems and symbols in early societies (see figs. 44–47) warded off evil spirits and propitiated favorable ones. Even today certain peoples defend themselves by force against the taking of photographs, which might drain off some of their strength. In many societies the injury of an image of a hated person is deemed to aid in bringing about that person's illness or death. Enemies are still burned in effigy, and a national flag is so potent a symbol that laws are made to protect it from disrespect.

When ancient city-states were defeated in battle the conquerors often destroyed or carried off the statues from the enemies' temples in order to deprive them of their gods and therefore their power. The instances of miracle-working images in the history of Christianity are innumerable and still occur. Many today feel a power emanating from a great work of art. A picture may be said to "fill a room," though it occupies only a small space on the wall, or a building to "dominate a town" when it is only one of many on the skyline, because of the supernatural power we still instinctively attribute to images.

Finally, the very existence or nonexistence of works of art has been until relatively recent times due first of all to their subjects. The patron wanted a statue or a picture of a god, a saint, an event, or a person, not primarily because of its beauty but for a specific iconographic purpose. Even in seventeenth-century Holland, in the early days of the open art market, artists often chose certain subjects for their easy salability.

The converse is often true. Taken literally, the Second Commandment severely limited if it did not indeed rule out entirely the creation of religious images by the Hebrews, the Muslims, and the Calvinists. Even more unhappily, strict interpretation of this and other religious prohibitions has resulted in the mutilation or total destruction of countless works of art. Many of the tragic losses of Greek, Roman, early Byzantine, medieval English, and Netherlandish art have resulted from what we might term destruction for anti-iconographic purposes, even when the

very groups carrying out the destruction nonetheless encouraged the production of secular art, such as plant and animal ornament, portraiture, landscapes, or still lifes.

The iconographic purpose of art, especially in the representation of events or ideas but also in the depiction of people and nature, has given the work of art its occasionally strong affinity with religion. Artists can be so moved by religious meditation, or by the contemplation of human beauty or human suffering, or by communion with nature, that they can create compelling works of art offering a strong parallel to religious experience. The religious art of the past generally offers us the most persuasive access to religious ideas. So effective can be religious art that many agnostic scholars find themselves unconsciously dealing with religious images as reverently as if they were believers.

The links between art and religion are observed at their strongest in the creative act itself, which mystifies even the artist. However carefully the process of creation can be documented in preparatory sketches and models for the finished work of art, it still eludes our understanding. In the Judeo-Christian-Islamic tradition, and in many other religions as well, God (or the gods) plays the role of an artist. God is the creator of the universe and of all living beings. Even those who profess no belief in a personal god nonetheless often speak of creative power or creative energy as inherent in the natural world. In medieval art God is often represented as an artist, sometimes specifically as an architect (fig. 12), tracing with a gigantic compass a system and an order upon the earth, which was previously "without form, and void." Conversely, in certain periods artists themselves have been considered to be endowed with divine or quasi-divine powers. Certain artists have been considered saints: soon after his death Raphael was called "divine"; Michelangelo was often so addressed during his lifetime. The emotion art lovers sometimes feel in the presence of works of art is clearly akin to religious experience. An individual can become carried away and unable to move while standing before the stained-glass windows of Chartres Cathedral or the *David* by Michelangelo.

Of course, many works of art in the past, and many more today, were made for purposes that have a merely peripheral iconographic intent. We enjoy a well-painted realistic picture of a pleasant landscape partly because it *is* a pleasant landscape, with no iconographic purpose, and partly because it possesses in itself agreeable shapes and colors. Furthermore, a jewel, an arch or columns, or a passage of nonrepresentational ornament may be felt as beautiful entirely in and of itself. In most societies, however, such works have been limited to decoration or personal embellishment. Only when nonrepresentational images have been endowed with strong symbolic significance, as those in Christian art (the Cross, the initial letters in illuminated manuscripts; see figs. 426, 496), have they been raised to a considerably higher level and permitted to assume prominent positions (except, of course, in architecture, where certain basic forms exist primarily of constructional necessity and often symbolize nothing). Only in the twentieth century have people created works of art with no immediately recognizable subjects, the so-called abstractions.

Above, beyond, within iconography lies the sphere of *content*. While content is not so easy to define as iconography, which can almost always be set down in neat verbal equivalents, it relies on iconography as the blood relies on the veins through which it flows. Like all supremely important matters, content is elusive. Better to try an illustration. Let us imagine two equally competent representations (from a technical point of view that is), both depicting the same religious subject, such as the Na-

tivity or the Crucifixion. Each one shows all the prescribed figures, each personage dressed according to expectations and performing just the right actions, the settings and props fitting the narrative exactly. Iconographically, both images could be described in the selfsame words. Yet one leaves us cold despite its proficiency while the other moves us to tears. The difference is one of content, which we might try to express as the psychological message or effect of a work of art. It is the content of works of art, almost as much as their style, and in certain cases even more, that affects the observer and relates the painter, the sculptor, the architect (for buildings can excite deep emotions) to the poet, the dramatist, the novelist, the composer—indeed to the actor, the musician, the dancer. In a mysterious and still inexplicable fusion, content is at times hardly separable from style, giving it life and meaning. Iconography can be dictated to the artist; content must be really inspiring to enlist the artist's full allegiance. Like style, content is miraculously implicit in the very act of creation.

The History of Art

Any form of human activity has its history. The history of art, like the purpose of art, is inevitably bound up with many other aspects of history, and it is therefore generally organized according to the broad cultural divisions of history as a whole. But individual styles have their own inner cycles of change, not only from one period to the next but within any given period, or even within the work of a single artist. Iconography and purpose can be studied with little reference to the appearance of the work of art, but stylistic change, like style itself, is the special province of the study of art history. The individual work of art can and must be considered in relation to its position in a pattern of historical development if we wish to understand it fully. Long ago it occurred to people to wonder whether there might be laws governing stylistic change which, if discovered, could render more intelligible the transformations we see taking place as time is unrolled before us.

The earliest explanations of stylistic development can be classified as *evolutionary in a technical sense*. We possess no complete ancient account of the theory of artistic development, but the Greeks appear to have assumed a steady progression from easy to constantly more difficult stages of technical achievement. This kind of thinking, which parallels progress in representation with that in the acquisition of any other kind of technical skill, is easy enough to understand, but tends to downgrade early stages in any evolutionary sequence. Implicit also in such thinking is the idea of a summit of perfection beyond which no artist can ascend, and from which the way leads only downward, unless every now and then a later artist can recapture the lost glories of a Golden Age.

Artistic evolution is not always orderly. In ancient Egypt, for example, after an initial phase lasting for about two centuries, a complete system of conventions for representing the human figure was devised shortly after the beginning of the third millennium B.C. and changed very little for nearly three thousand years thereafter. Certainly, one cannot speak of evolution from simple to complex, or indeed of any evolution at all. Even more difficult to explain in evolutionary terms is the sudden decline in interest in the naturalistic representation of the human figure and the surrounding world in late Roman art as compared to the subtle, complex, and complete Greek and early Roman systems of representation, which had just preceded this period. It looks as if the evolutionary clock had been turned backward from the complex to the simple.

A new pattern of art-historical thinking, which can be characterized as *evolutionary in a biographical sense*, is stated in the writings of the sixteenth-century Italian architect, painter, and decorator Giorgio Vasari, who has often been called the first art historian. He compared the development of art to the life of a human being, saying that the arts, "like human bodies, have their birth, their growing up, their growing old and their dying." Vasari made no uncomfortable predictions about the death of art after his time, but his successors were not so wise. Much of the theoretical and historical writing on art during the seventeenth century looks backward nostalgically to the perfection of the High Renaissance.

Imperceptibly, the ideas of Charles Darwin in the nineteenth century began to affect the thought of art historians, and a third tendency, seldom clearly expressed but often implicit in the methods and evaluations of late-nineteenth- and early-twentieth-century writers, began to make itself felt. This theory explained stylistic change according to an inherent process that we might call *evolutionary in a biological sense*. Ambitious histories were written setting forth the art of entire nations or civilizations, as were monographs analyzing the careers of individual artists, in an orderly manner proceeding from early to late works as if from elementary to more advanced stages. The biological-evolutionary tendency underlies much art-historical writing and thinking even today and is evident in the frequent use of the word *evolution*, generally in a Darwinian spirit.

A fourth major tendency of art-historical interpretation, which might be described as *evolutionary in a sociological sense*, has emerged during the twentieth century. Many historians have written about separate periods or events in the history of art along sociological lines, demonstrating what appear to be strong interconnections between forms and methods of representation in art and the demands of the societies for which these works were produced. Often, however, sociological explanations fail to hold up under close examination. How does one explain, for example, the simultaneous existence of two or more quite different—even mutually antagonistic—styles, representative examples of which were bought or commissioned by persons of the same social class or even by the same person?

Stylistic tendencies or preferences are, in fact, often explicable by widely differing interpretations (the notion of cause and effect in the history of art is always dangerous), sometimes not responsive to any clear-cut explanation. Three of the four theories discussed above—the technical, biological, and sociological—are still useful in different ways and at different moments in the history of art. But Vasari's biographical premise is generally renounced as a fallacious kind of reasoning by analogy.

There is something especially persuasive about the Greek theory of technical evolution. This can be shown to correspond, for example, to the learning history of a given individual, who builds new experiences into patterns created by earlier ones, and may be said to evolve from stage to stage of always greater relative difficulty. The stopping point in such a cycle might correspond to the gradual weakening of the ability to learn, and it varies widely among individuals. Certain artists never cease developing, others reach their peak at a certain moment and repeat themselves endlessly thereafter. From the achievements of one artist, the next takes over, and the developmental process continues. The element of competition also plays its part, as in the Gothic period when cathedral builders were trying to outdo each other in height and lightness of structure, or the Impressionist period, when painters worked side by side attempting to seize the most fugitive aspects of sunlight and color. Such an orderly development of refinements on the original idea motivating a school of

artists can also be made to correspond to the biological-evolutionary theory, showing (as it seems) a certain inherent momentum.

In art as in any other aspect of human life, changes of style may even result from sheer boredom. When a given style has been around to the point of saturation, artists and public alike thirst for something new. Or mutations may also occur from time to time through purely accidental discoveries, a factor that has yet to be thoroughly explored. On investigation, apparent artistic accidents may turn out to be in reality the result of subconscious tendencies that had long been brewing in an artist's mind, and that almost any striking external event could bring into full play.

The Total Work of Art

The four major factors we have been considering—purpose, style, iconography, and historical position—are involved in the formation of any work of art, and all four should be taken into consideration in our study. The total work of art consists of the sum, or more exactly the product, of these four factors. At the risk of oversimplification, we may represent the total work of art as a series of circles, one for each element, arranged around a larger circle (fig. 13), all contributing to the work of art at the center, and all related to each other. In the effort to interpret any given work of art we can start anywhere in the larger circle and move in any direction, including across it, as long as we realize that those elements which are separated for the purpose of diagrammatic clarity are in reality fused into a transcendent whole, with blurred and shifting boundaries.

The only certainty in art-historical studies is that as we try to penetrate deeply into the work of art, to understand it fully, and to conjecture why and how it came to be as it is we must examine carefully in each individual instance all the factors that might have been brought to bear on the act of creation, and regard with healthy skepticism any theory that might tend to place a limitation on the still largely mysterious and totally unpredictable forces of human creativity.

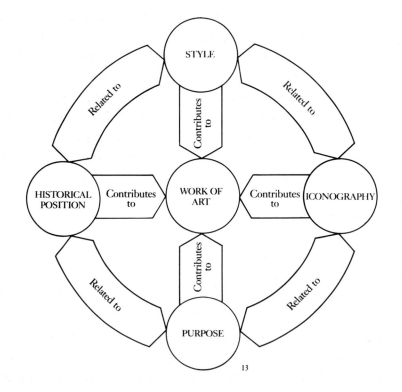

13. The Total Work of Art

PART

MAGIC, FORM, AND FANTASY

ONE

The words *primitive* and *prehistoric* are often used to denote early phases in the artistic production of humanity. Both adjectives can be misleading. *Primitive* suggests crudeness and lack of knowledge, yet some of the oldest works of art we know, such as the ivory carvings and cave paintings of the first true humans in western Europe, show great refinement in their treatment of polished surfaces and considerable knowledge of methods of representation, while much later works, presumably by their descendants, sometimes betray loss of skill in both respects. The highly formalized objects made by African and North American Indian cultures close to our own time have been valued by some twentieth-century European artists because of their supposed primitivism; nonetheless, the few really ancient works as yet discovered from these same cultures are strikingly naturalistic. *Prehistoric* implies the absence of both a feeling for the past and a desire to record it, but we know from African societies that history was carefully preserved in an oral tradition whose accuracy can at times be corroborated when checked against the written records of invading cultures. The unwritten legends of the Eskimo and North American Indians may well have had a basis in historic fact.

The first section of this book brings together the arts of certain societies that flourished in a wide variety of geographic and climatic environments. Except for the Pre-Columbian societies, these cultures all lacked the ability to compile permanent records. But their arts have other important characteristics in common. One extremely important trait is the identification of representation with magical or religious power, so that the object of art itself comes into existence as the embodiment of an attempt to control or to propitiate, through ritual, natural beings or natural forces. Fantasy and magic generally operate outside the control of reason. Measure, the basis of order in art as in life, can exist only with writing, and measure is conspicuously absent from all preliterate art forms except only those which, like weaving, are by their very nature dependent on a considerable number of material elements of approximately identical size, subject to distribution and repetition. Without the rational overlay governing the art of most subsequent periods, basic human impulses find expression in rhythmic form. In a magical art the motion of the hand holding the tool takes on the quality of a dance, and visual patterns that of choreography. No wonder that works of art produced for magical purposes and based on antirational principles should have been considered "barbaric" by historic societies whose culture was based on writing or that such works should have been codified as evolutionary stages in human development by the encyclopedic science of the later nineteenth century.

A second universal trait of these arts is the total lack of concern for the representation of the space in which we all must move, or even the ground on which we stand. The surface the artist works on is the only space and the only ground (see fig. 20). Animals, birds, fish, and to a lesser extent human beings,

are widely represented, usually in conformity with transmitted stereotypes; plants appear only quite late, and then are ornamentalized. Landscape elements (save for the volcano of Çatal Hüyük, see fig. 33) never demand representation, and the immense spaces surrounding mankind, which must have appeared mysterious and challenging, are not even suggested.

Some of the arts described in this section precede chronologically the more developed phases of civilization; others persist side by side with them right up to the present time. Interestingly enough, the twentieth century, which has conquered physical space to such an extraordinary degree, and which has transcended representation by photography, the cinema, and television and even writing by means of electronic communication and records, is the first to find the art of early people artistically exciting. This may be in part because the twentieth century has also discovered the irrational basis of much of humanity's inner life through the researches of psychology and thus has found preliterate art emotionally accessible. But as we continue our study of art through later periods, even in the most highly literate cultures, it will become apparent that the irrational and impulsive nature of humanity lies fairly close to the surface and, at moments of intense individual or collective experience, can again determine essential aspects of the work of art.

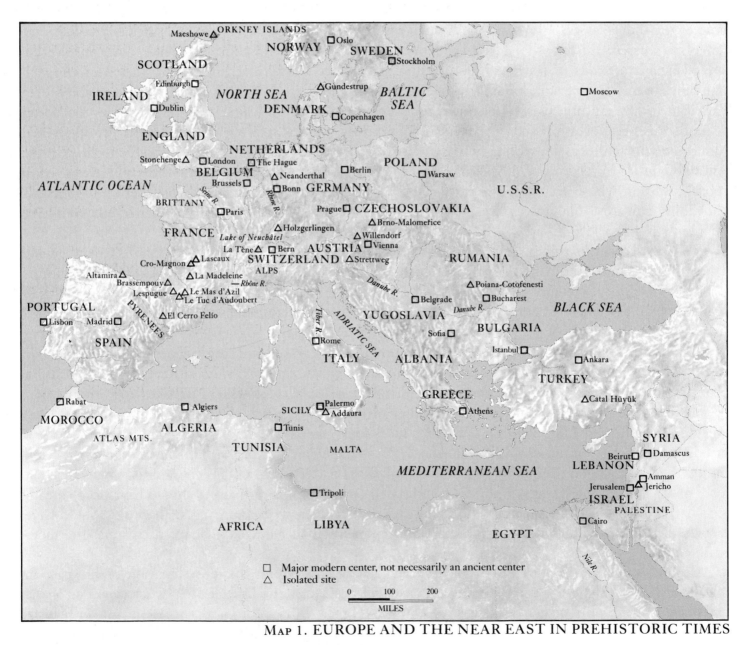

MAP 1. EUROPE AND THE NEAR EAST IN PREHISTORIC TIMES

CHAPTER

ART BEFORE WRITING

ONE

We do not know when or how human beings took the significant step of making objects for their own interest and enjoyment rather than for pure utility; probably, we shall never know. But we do have extensive evidence, almost all of it discovered within the past hundred years, regarding human artistic production at a very early stage. Such subhuman groups as the Neanderthal did not make works of art. The first artists were the ancestors of modern Europeans, the Cro-Magnon people, who roamed over Europe, equipped with stone tools and weapons, during the last glacial period, when the Alpine region, northeastern Europe, and most of the British Isles were covered deep in glacial ice. So much of the world's water was frozen in polar ice caps and continental glaciers that coastlines were very different from their present shape, and the southern portions of the British Isles were connected with each other and the Continent. Vegetation was subarctic; most of western Europe was a tundra, and forests were limited to the Mediterranean region. In this inhospitable environment early humans, vastly outnumbered by the animals on which they depended for food, lived in caves or in temporary settlements of shelters made from mud and branches.

There seem to be no early stages in the evolution of Paleolithic art; the earliest examples are of an astonishingly high quality. This fact, coupled with the great period of time covered by the finds, suggests the existence of a strong tradition in the hands of trained artists, transmitting their knowledge and skill from generation to generation. While these early works of art have been found all the way from southern Spain and Sicily to southern Siberia, most of the discoveries have come to light in south-central France, northern Spain, and the Danube region. The approximate dates given here are based on analysis of organic material at the sites, according to the known rate of disintegration of radioactive carbon 14, absorbed by all living organisms, into nonradioactive nitrogen 14 after death. Even more surprising than the immense age of the earliest finds is the extraordinary duration of the cave culture, some twenty thousand years, or nearly twice as long as the entire period that has elapsed since.

SCULPTURE The tiny female statuette jocularly known as Venus (fig. 14), found near Willendorf in Lower Austria, is datable between 30,000 and 25,000 B.C. It is one of the earliest known representations. Grotesque as it may at first appear, the *"Venus" of Willendorf* is, on careful analysis, a superb work of art. The lack of any delineation of the face, the rudimentary arms crossed on the enormous bosom, and the almost equally enlarged belly and genitals indicate that the statuette was not intended as a naturalistic representation but as a fertility symbol; as such, it is compelling. From the modern point of view, the statue harmonizes spherical and spheroid volumes with such power and poise that it has influenced twentieth-century abstract sculpture. A similar but larger statuette, from Lespugue in southwestern France, is tentatively dated much later, about 20,000–18,000 B.C. In this work, carved in ivory, the swelling, organic forms of the *"Venus" of Willendorf* are conventionalized and become almost ornamental. Across the back of the statuette (fig. 15) runs a sort of skirt, imitating cloth, which dates weaving back to a remarkably early moment. One of the finest of these tiny sculptures is the delicate ivory head of a woman from the cave called Grotte du Pape at Brassempouy in southwestern France (fig. 16). As in the *"Venus" of Willendorf*, the hair is carved into a grid suggesting an elaborate hairdo, which hangs down on the sides to flank a slender neck. The pointed face is divided only by nose and eyebrows; the mouth and eyes may originally have been painted on.

As compared to these stylized images of human beings, the earliest represented animals are strikingly naturalistic. A little bison (fig. 17) carved about 12,000 B.C. from a piece of antler was found at La Madeleine in south-central France. The legs are only partially preserved, but the head, turned to look backward, is convincingly alive, with its open mouth, wide eye, mane, and furry ruff indicated by firm, sure incisions. The projections are so slight that the relief approaches the nature of drawing. Another brilliant example of animal art is the little spear-thrower (fig. 18), from Le Mas d'Azil in southwestern France, representing a chamois in a similar pose of alarm, its head turned backward and its feet brought almost together in a precarious perch on the end of the implement.

CAVE ART The most impressive creations of Paleolithic humans are the large-scale paintings, almost exclusively representing animals, which decorate the walls and ceilings of limestone caves in southwestern France and northern Spain (see figs. 20–22). Their purpose is still obscure. By analogy with the experience of surviving tribal cultures, it has been suggested that these paintings are an attempt to gain magical control, by means of representation, of the animals early humans hunted for food. Recent investigation has shown this explanation to be untenable. Judging from the bones found in the inhabited caves, the principal food of the cave dwellers was reindeer meat. But the chief animals represented, in order of frequency, were the horse, the bison, the mammoth, the ibex, the aurochs, and at long last several species of deer. Most of the paintings are found at a distance from the portions of the caves, near the entrances, where early humanity lived, worked, cooked, and ate (as at Lascaux, fig. 19). Often, the painted chambers are accessible only by crawling through long, tortuous passages or by crossing underground streams. This placing, together with the enormous size and compelling grandeur of some of these paintings, suggests that the remote chambers were sanctuaries for magical or religious rituals to which we have as yet no clue. Evidence indicates that the chambers were used continuously for thousands of years,

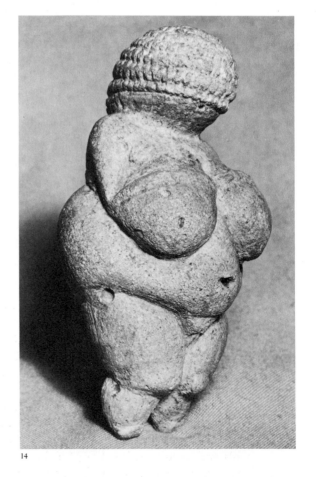

14

14. *"Venus" of Willendorf.* c. 30,000–25,000 B.C. Limestone, height 4⅜". Naturhistorisches Museum, Vienna

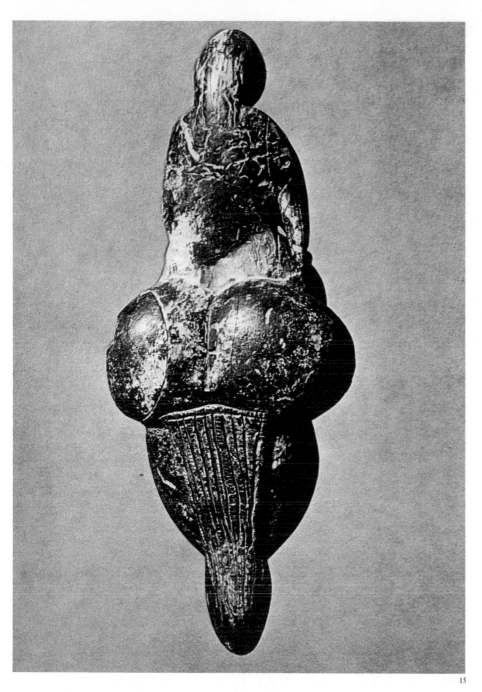

15. *"Venus" of Lespugue.* c. 20,000–18,000 B.C.
Ivory, height 5¾". Musée de l'Homme, Paris

and microscopic analysis by the American scholar Alexander Marshack
has shown that the paintings were repainted periodically, many times in
fact, in layer after layer. Abstract signs and symbols, which may be the
ancestors of writing, appear consistently throughout all the painted caves
and also on many of the bone implements found in them. One day these
symbols may yield to interpretation; possibly, they will provide the an-
swer to the mysterious questions of the meaning and purpose of these
magnificent paintings.

In the absence of natural light, the paintings could only have been
done with the aid of stone lamps filled with animal fat and burning wicks
of woven moss fibers or hair. The colors were derived from easily found
minerals and include red, yellow, black, brown, and violet, but no green
or blue. The vehicle could not have been fat, which would not penetrate
into the chronically damp, porous walls; a water vehicle could amalga-
mate with the moisture and carry the color into the structure of the lime-
stone. No brushes have been found, so in all probability the broad black

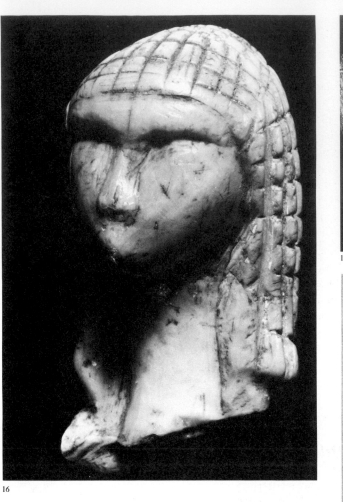

16

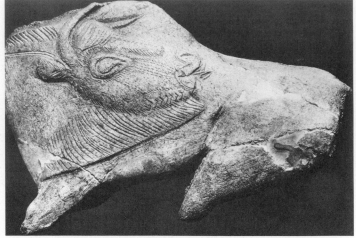

17

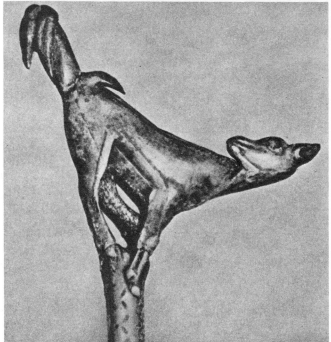

18

16. *Woman's Head*, from Grotte du Pape, Bras-sempouy (Landes), France. c. 22,000 B.C. Ivory, height 1¼". Musée des Antiquités Nationales, St.-Germain-en-Laye, France

17. *Bison*, from La Madeleine (Tarn), France. c. 12,000 B.C. Antler, length 4". Musée des Antiquités Nationales, St.-Germain-en-Laye

18. *Chamois*, from Le Mas d'Azil (Ariège), France. Antler, length 11⅝". Collection Pé-quart, St.-Brieuc, France

19. Diagrammatic plan showing the layout of caves at Lascaux (Dordogne), France (Based on a diagram by the Service de l'Architecture)

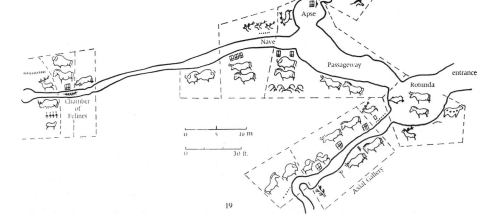

19

outlines were applied by means of mats of moss or hair. The surfaces appear to have been covered by paint blown from a tube; color-stained tubes of bone have been found in the caves.

The paintings have always been described as "lifelike," and so they are, but they are also in some respects standardized. The animals were invariably represented from the side, and generally as standing in an alert position, the legs tense and apart, the off legs convincingly more distant from the observer, the tail partially extended. Rarer running poses show front and rear legs extended in pairs, like the legs of rocking horses. No vegetation appears, nor even a groundline. The animals float as if by magic on the rock surface. Their liveliness is achieved by the energy of the broad, rhythmic outline, set down with full arm movements so that it pulsates around the sprayed areas of soft color.

The cave of Altamira in Spain was the first to be discovered, a century ago, but was not at once accepted as authentic. Today it is considered the finest. The famous bison on the ceiling of Altamira (fig. 20), vividly alert, are as powerful as representations of animals can be. Although artists of periods later in human history analyzed both surface and anatomical structure more extensively, the majesty of the Altamira animals has never been surpassed. The cave of Lascaux in France, dating from about 15,000 B.C. and discovered in 1940, is a close competitor to Altamira. It is one of a large number of painted caves in the Dordogne region. The low ceiling of the so-called Hall of Bulls at Lascaux (fig. 21) is covered with bulls and horses, often partly superimposed, painted with such vitality that they fairly thunder off the rock surfaces at us. In another chamber is the tragic painting of a bison pierced by a spear (fig. 22), dragging his intestines as he turns to gore a man who is represented schematically as compared to the naturalistic treatment of the animals.

Some images are in low relief, such as the tense, still throbbing bison modeled in clay (fig. 23) about 15,000 B.C. on the sloping ground of a cave at Le Tuc d'Audoubert in France; some have been carved into the rock, as are the far-from-schematic, half-reclining nude women occasionally found, always without heads. The easy pose of the relief at La Madeleine (fig. 24) contrasts sharply with the stylization of the *"Venus" of Willendorf*. Both reliefs are filled with the same organic power as the paintings.

Our understanding of cave paintings cannot help being different from that of the people who painted them so many thousands of years ago. Until we learn to decipher the signs and symbols appearing in the caves we have no real clue as to what may have been going through the minds of the painters, or for that matter even whether they were men or women. But we can perhaps reach them across the intervening millennia through our common humanity. To our eyes the attitudes and sometimes even the expressions of the painted animals are so intense, and the outlines painted with such force and freedom, that it would be amazing if these early artists did not experience deep creative pleasure in what they were doing, regardless of any purpose the pictures might have been intended to serve. In fact Louis-René Nougier has suggested that to the cave artists *artistic* creation may have seemed identical with *actual* creation, and that by their activity in paint they were somehow making these animals who moved through their forest world. "Prehistoric art," Nougier wrote, "is essentially action." This concept of action identifies, then, the artist's movements of arm and hand with those of the animals the artist reproduces. The fact that the individual images were so often painted right over one another would in itself show that the moment of creation, whether religious, magical, or some mysterious combination of both, was more important than the final image and its survival.

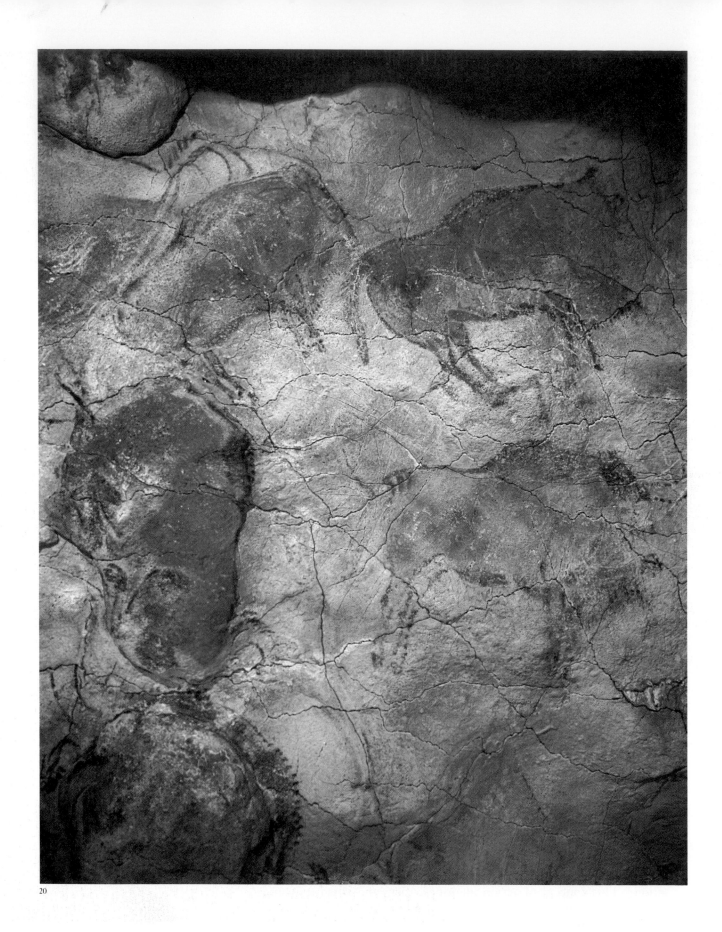

20

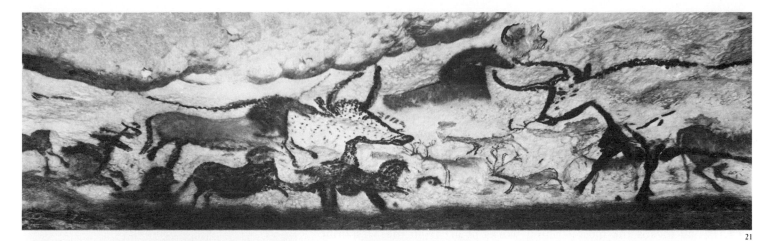

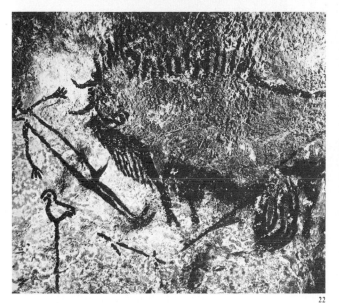

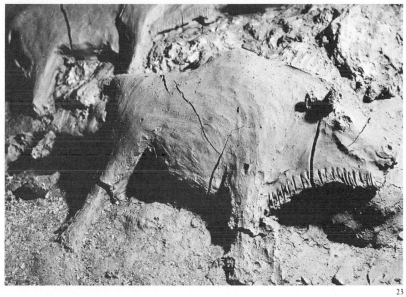

20. *Bison.* c. 15,000–10,000 B.C. Cave painting. Altamira, Spain

21. Cave painting in the Hall of Bulls, Lascaux. c. 15,000–10,000 B.C.

22. *Wounded Bison Attacking a Man.* c. 15,000–10,000 B.C. Cave painting, length of bison 43″. Lascaux

23. *Two Bison,* from the cave at Le Tuc d'Audoubert (Ariège), France. c. 15,000 B.C. Clay low relief, length 24″ each

24. *Reclining Woman,* from the cave at La Madeleine. Low relief

The disappearance of the great glaciers and the consequent rise in temperature brought early humanity out of the caves and fostered a gradual transition to the farming society of the Neolithic period (New Stone Age). This intermediate stage, known as the Mesolithic (Middle Stone Age), is far less rewarding artistically than the Paleolithic. Paintings were made on the walls of open shelters on rocky cliff faces. More than sixty sites have been located in eastern Spain, but the small-scale paintings of animals lack not only the size but also the vigor of the cave paintings, and were usually done in a single tone of red. An example from El Cerro Felío (fig. 25) shows a group of male and female hunters, greatly schematized but nonetheless pursuing at remarkable speed an antelope that seems to have eluded their spears and arrows. Mesolithic rock paintings of a somewhat similar style are scattered from Scandinavia to South Africa. By all means the most striking works of art from the Mesolithic period are the brilliant series of outline drawings of human figures and animals discovered in 1952 on the walls of a small cave at Addaura, just outside Palermo, Sicily (fig. 26). The figures, depicted in a variety of attitudes, may be engaged in a ritual dance, perhaps including acts of torture; the vigor and freedom of their movements remind one of certain twentieth-century works, notably those of Henri Matisse.

Mesolithic Art (Middle Stone Age), c. 10,000–8000 B.C.

25. *Hunting Scene*. Watercolor copy of a cave painting at El Cerro Felío (near Alacón), Spain

26. *Ritual Dance*. Drawing in the cave at Addaura, Sicily. c. 15,000–10,000 B.C. Height of figures 10″

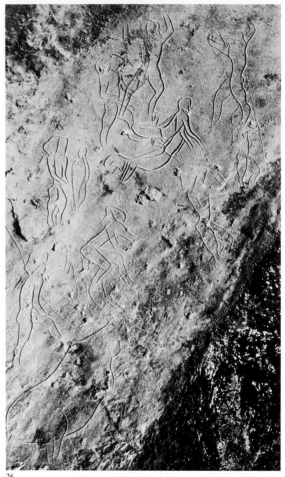

26

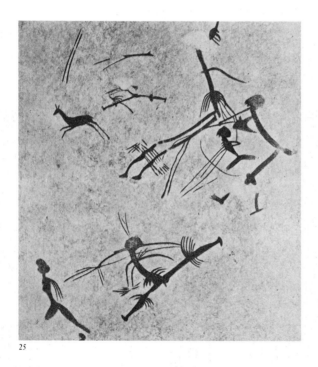

25

With the recession of the last glaciers, the climate grew irregularly but inexorably warmer, and humanity, all the way from the British Isles to the Indus Valley, was able to set up a new existence free from the limitations of the caves. Wild grains and legumes now flourished throughout a wide area and were eventually domesticated; so, one by one, were various species of animals. Although stone remained the principal material for weapons and tools, here and there humans discovered how to smelt certain metals. Pottery, often richly decorated, began to replace utensils of wood or stone, and weaving became highly developed. Objects made of nonindigenous materials indicate the existence of travel and commerce. Although they were still hunters, people were no longer utterly dependent on wild animals, and representations of animals consequently lost

Neolithic Art (New Stone Age), 8000–3000 B.C.

the intimate naturalism so impressive in Paleolithic art. More lasting settlements grew up, some of a considerable size, and the beginnings of architecture made their appearance, these early examples being generally constructed of perishable materials such as timber, wicker, and thatch. The many Neolithic town sites excavated throughout central Europe and northern Italy have yielded much information about a wide variety of early cultures; only in the Middle East, however, have there appeared ruins of masonry structures, which can be considered the ancestors of architecture as we know it. From the evidence available, what may have been Paleolithic religious life is scarcely distinguishable from magic, but in the Neolithic period structures appear that can only be described as sanctuaries, implying the existence of an organized religion, with a priestly class making new demands on art.

JERICHO The earliest masonry town we know is the still only partially excavated city of Jericho in southern Palestine (now Jordan). Around 8000 B.C. the settlement was composed of oval mud-brick houses on stone foundations. By about 7500 B.C. it was surrounded by a rough stone wall whose preserved portions reach a height of twelve feet and was further defended by a moat cut in the rock and by at least one stone tower thirty feet high (fig. 27), the earliest known fortifications in stone. Even more impressive are the human skulls found here (fig. 28). Their features had been reconstructed in modeled plaster, with shells inserted for eyes. These skulls originally belonged to bodies buried beneath the plaster floors of

27. Fortifications, Jericho, Jordan. c. 7500 B.C.

28. *Plastered Skull*. c. 7000–6000 B.C. Jericho

27

28

the houses and were doubtless intended to serve as homes for ancestral spirits, to be propitiated by the living. The soft modeling is delicately observed; when painted, these heads must have been alarmingly vivid.

ÇATAL HÜYÜK From 1961 to 1963, excavations in the mound of Çatal Hüyük on the plain of Anatolia, in central Turkey, disclosed a small portion of a city that, according to carbon 14 dating, enjoyed a life of some eight hundred years, from 6500 to 5700 B.C. The city was destroyed and rebuilt twelve times, the successive layers of mud brick revealing a high level of Neolithic culture, whose artifacts included woven rugs with bold decorative patterns (not preserved, but simulated in wall paintings) and polished mirrors made from obsidian, a hard volcanic stone. Oddly enough, the inhabitants had not yet discovered pottery and made their receptacles from stone or wood and from wicker. The houses (fig. 29) were clustered together without streets in a manner not unlike that of the pueblos of the American Southwest (see fig. 54), with a common outer wall for defense, and they could be entered only by means of ladders. The furniture was built in; it consisted of low plastered couches under which the bones of the dead were buried after having been exposed to vultures to remove the flesh. A remarkable series of religious artifacts has been found, including statues of a mother goddess (fig. 30) whose immense breasts and belly recall the *"Venus" of Willendorf*. The head appearing between her knees clearly symbolizes childbirth.

Alongside the rooms intended for lay habitation, shrines are occasionally found with couches doubtless meant for the priesthood. These shrines enclose symbols of magical potency and—even in reconstruction—of awesome grandeur. Some shrines were adorned by rows of paired wild-bull horns mounted on the floor, facing entire bull skulls fixed to the wall above (fig. 31). These were probably male symbols. A stylized but very aggressive silhouette painting of a bull appears on a flanking wall. Other shrines (fig. 32) were apparently dedicated to death, symbolized by wall paintings of huge vultures devouring tiny, headless humans depicted in the poses in which corpses were buried. Schematized and flattened though they are, these birds, whose wings spread diagonally across whole walls as if wheeling through the air, must have struck terror into the hearts of the inhabitants. On one wall was found the earliest known landscape painting (fig. 33), showing Çatal Hüyük itself, represented as a series of rough squares surmounted by an erupting volcano.

All excavations bring up surprises of some kind, but the urban civilization of Çatal Hüyük, with its farflung connections, was totally unexpected at so early a date. Yet after the abandonment of the town it seems to have had little or no influence on later civilizations. Only the bull deities, if that is what they were, may have been picked up in Egypt, Mesopotamia, and Crete. But after all, the bull is a natural symbol of magical strength and potency. Everything that could be salvaged from the excavations was removed to the National Archaeological Museum at Ankara, but it is especially sad to relate that the only partially uncovered ruins have now been destroyed a thirteenth time—and for good. The sun and wind have reduced them to dust, and winds and rain have carried the dust away. At least three quarters of Çatal Hüyük is still underground. Who knows what later excavations may yield?

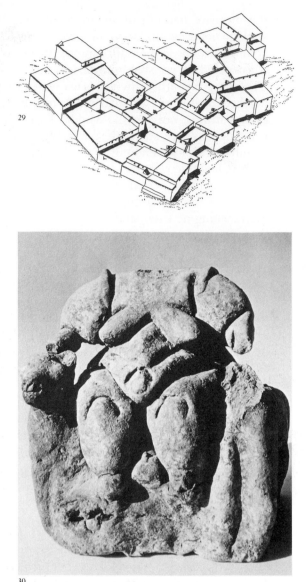

29. Houses, Çatal Hüyük, Turkey. 6500–5700 B.C. (Architectural reconstruction after J. Mellaart)

30. *Goddess Giving Birth*, from Çatal Hüyük. c. 6500–5700 B.C. Baked clay, height 8″. Archaeological Museum, Ankara, Turkey

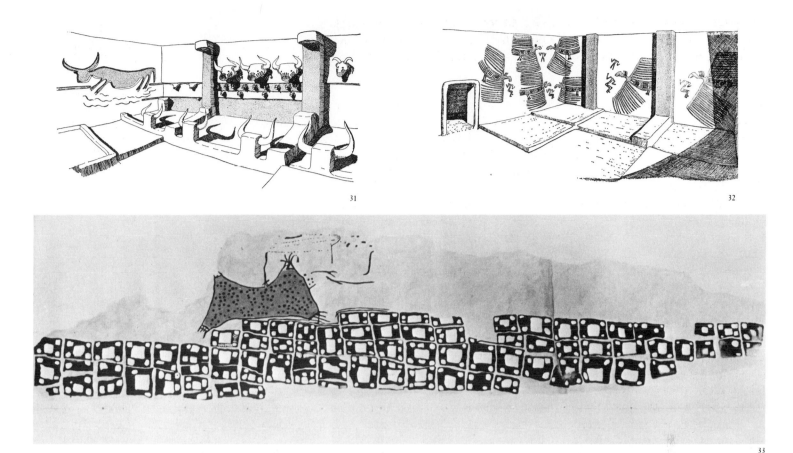

MEGALITHIC ARCHITECTURE

MEGALITHIC ARCHITECTURE A number of sites, generally on islands or near the seacoast, preserve impressive remains of monuments made partially or wholly of giant stones (megaliths). The accepted dating of these buildings has been revised in the light of the discovery that the carbon 14 method consistently underestimated by as much as eight hundred years the age of California bristlecone pine trees, in some of whose cross sections more than eight thousand rings have been counted, one for each year of life. The ancient civilization on the Mediterranean island of Malta, for example, which lasted about eight hundred years, has now been dated before 3000 B.C. A hard limestone was used for the exterior walls of the temples and for the trilithon (three-stone) portals (fig. 34). A double vinescroll ornament of unexpected rhythmic grace, the earliest known appearance of a motive that later became universal in Classical decoration, is carved in low relief on the entrance slab of one of the temples at Tarxien (fig. 35). The interiors of tombs and temples generally follow a trefoil plan; the stones are corbeled (projected one beyond the other) to form a sloping wall that probably supported a wooden roof. At the other extreme of European culture, almost as far as possible from Malta, an actual corbel vault, the earliest known, roofs a tomb chamber (fig. 36) in the center of a mound at Maeshowe, on a remote island of the Orkneys, north of Scotland. It is datable about 2800 B.C.

Long famous are the megaliths of Brittany, giant single stones known as *menhirs*, which march across the countryside for miles, and the dolmens or trilithons, probably intended as graves to be surrounded by mounds. A number of *cromlechs*, ritual stone circles, are preserved in England, the grandest of which is Stonehenge on the Salisbury Plain (figs. 37, 38). Now datable about 2000 B.C., this is the third and most ambitious circle built on the site. Claims of extraordinary astronomical com-

31. Shrine with bull horn and skull decoration, Çatal Hüyük. 6500–5700 B.C. (Architectural reconstruction after J. Mellaart)

32. Shrine with wall paintings of vultures, Çatal Hüyük. 6500–5700 B.C. (Architectural reconstruction after J. Mellaart)

33. Landscape painting (copy), from Çatal Hüyük. c. 6150 B.C.

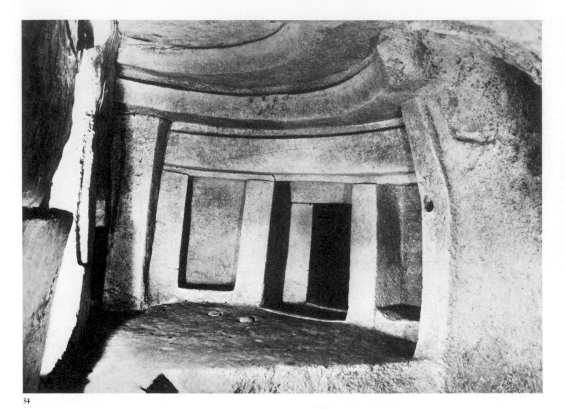

34

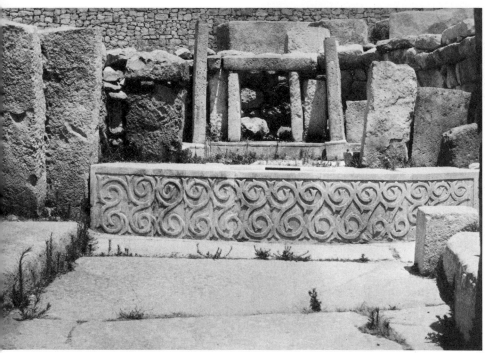

35

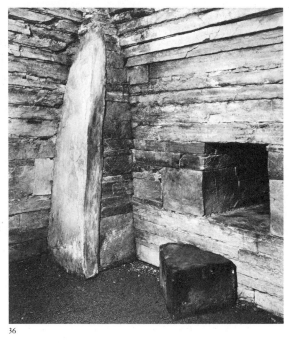

36

petence on behalf of these Stone Age builders, surpassing even that of the later Greeks, have been strongly challenged, but it is clear that the stones were arranged to coincide at least roughly with sunrise at the summer solstice. The impression of rude majesty they impart is tempered somewhat by the observation of considerable subtleties: these stones, weighing as much as fifty tons, were dragged for twenty-four miles by hundreds of men; they were dressed (trimmed) to taper upward and even endowed with a slight swelling known later to the Greeks as *entasis*; and their lintels were curved according to their places in the circle.

34. Trilithon portals, Hal Saflieni, Malta. Before 3000 B.C. Limestone

35. Entrance slab of Temple, Tarxien, Malta. Late 3rd millennium B.C. Limestone low relief

36. Tomb chamber, Maeshowe, Orkney Islands, Scotland. c. 2800 B.C.

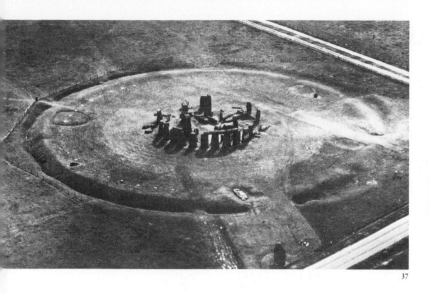

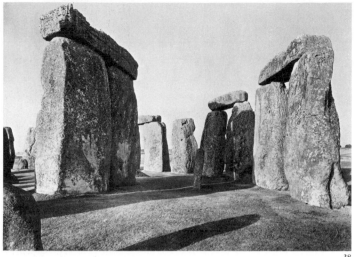

37

38

Megalithic monuments such as Stonehenge remained above ground in several countries to incite speculation from awestruck people during the rest of human history. But the very existence of Stone Age painting and sculpture was unsuspected until the first chance discoveries about a hundred years ago were followed by systematic excavations in ever-increasing numbers up to our own time. We now possess a vast body of knowledge about early humanity and early societies, derived in great part from artifacts of all sorts unearthed in these excavations. We have also made another discovery of the greatest intellectual, even spiritual importance: that the species to which we belong—*homo sapiens*—was from its very beginnings endowed with a high degree of artistic talent and that this talent was exercised over a period lasting at least five times as long as all of recorded history. On the basis of the works rediscovered by chance or by plan, we can safely say that artistic ability is not, like science or any form of learning, something achieved through millennia of struggle, but is an inborn essential of human nature. Prehistoric art, therefore, has now told us much, not only about early humanity but about ourselves. And with a force utterly unpredictable before the first objects were found, prehistoric art has inspired important aspects of the art of the twentieth century.

37. Aerial view of Stonehenge, Salisbury Plain, England. c. 2000 B.C.

38. Stonehenge. Salisbury Plain. Height 13′6″

THE ART OF LATER ETHNIC GROUPS

Of necessity this book is chiefly concerned with the artistic traditions of European societies and of their descendants in North America. The preliterate arts introduced in Chapter One were produced by the direct ancestors of modern Europeans and thus, to a great extent, of modern North Americans. But an increasingly large proportion of North Americans are descended only in part, or not at all, from Europeans. It is therefore especially important in this introductory section to look at some characteristic works of high quality produced either by the ethnic groups who inhabited the American continent when the Europeans arrived or by those whose numbers were brought to America by Europeans against their will, as well as at the strikingly similar arts created by the peoples of the complex island chains that jewel the immensity of the Pacific Ocean.

In these cases there is obviously no direct development from preliterate to literate art, rather the sudden overlay of a comparatively late phase of the art of white people imposed, along with the other values of a white society, upon red, brown, or black preliterate groups, often by force. Much the same process took place much earlier, as we will see, when the Celtic and Germanic societies of northern Europe were conquered by the Romans. Yet the artistic traditions of these subject or displaced ethnic groups have continued to flourish up to our own time, even when adulterated by an almost inevitable admixture of values from the dominant European culture. The same basic principles of magical imagery and essential spacelessness unite these arts with those of early humanity. There is also the same tendency toward eventual abstraction, through the constant repetition of traditional ideas and forms which began as naturalistic. Mysteriously, the more recent ethnic arts have added a special invention, common to all across many thousands of miles of land and ocean—the mask. In ritual or in death, confronting the forces of the supernatural or personifying them, individuals must conceal their identity behind artificial faces, sometimes serene, more often terrifying. On these masks enormous skill and every resource of the artist are lavished for overwhelming effect.

The arts of early humanity had been dormant and forgotten for thousands of years and were rediscovered only within the past century, even the past few decades, while those of later ethnic groups were still being produced in quantity when Europeans arrived on the scene. By a fascinating historical irony, these tradition-bound arts were found by the more sophisticated European observers to be fresh and *free* from tradition, meaning of course from the customs and conventions of European society. Thus the arts of "primitive" peoples have had an enormous influence on those of Europe and of Europeanized American societies. Primitive became fashionable, and the forms and colors of the black African, the "South Sea" islander, and the North and South American Indian remain essential ingredients in today's culture.

Below the Sahara Desert stretches a vast region of Africa, including uplands, open steppes, and tropical rain forests, the home of an incredible number and variety of artistically productive black cultures. European contacts with the arts of black Africa have undergone at least five distinct phases. At first, artifacts were brought home as curiosities by early explorers, traders, and colonists. To this activity we often owe the continued existence of wooden objects, doomed to a short life in central African heat and humidity. Then, with the growth of anthropological studies in the nineteenth century, the objects were exhibited as specimens in museums of natural history. Next, in the opening years of the twentieth century, the aesthetic properties of African art were discovered as a powerful source of inspiration by adventurous European artists. Since then, archaeological investigation, still all too rare and limited, has discovered works of courtly art of astonishing beauty and great antiquity, antedating any contacts with Europeans. Finally, in our own time, quantities of cheaply produced imitations of tribal artifacts—so-called airport art—have flooded the market.

The discovery in 1938 of a superb series of naturalistic heads and busts in clay and in bronze at Ife in Nigeria in central West Africa came as a total surprise. Ife artists had been thoroughly familiar with the lost-wax process of casting, in which a work is built up on a fireproof core with a thin layer of wax and then covered with a fireproof mold usually based on clay. When the mold has hardened, it is heated, the wax runs out, and molten metal, which assumes the shape of the original wax layer, is poured in. Invented by Bronze Age peoples, this method was known throughout the Mediterranean world in antiquity. No contacts have been traced between the Ife civilization, which flourished between the eleventh and fifteenth centuries A.D., and the Mediterranean; it is quite possible that the Ife artists discovered the lost-wax method independently. The royal heads, such as the one believed to represent the early queen Olokun (fig. 39), are of striking nobility and beauty. The broad, smooth surfaces of the skin are striated with parallel grooves representing ritual scars and are perforated around the mouth with holes possibly intended for jewels. Probably, these heads were made to surmount wooden bodies.

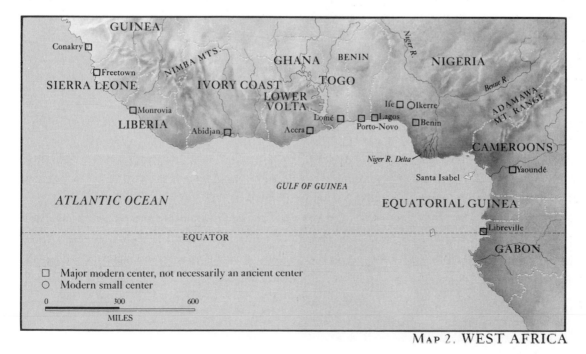

MAP 2. WEST AFRICA

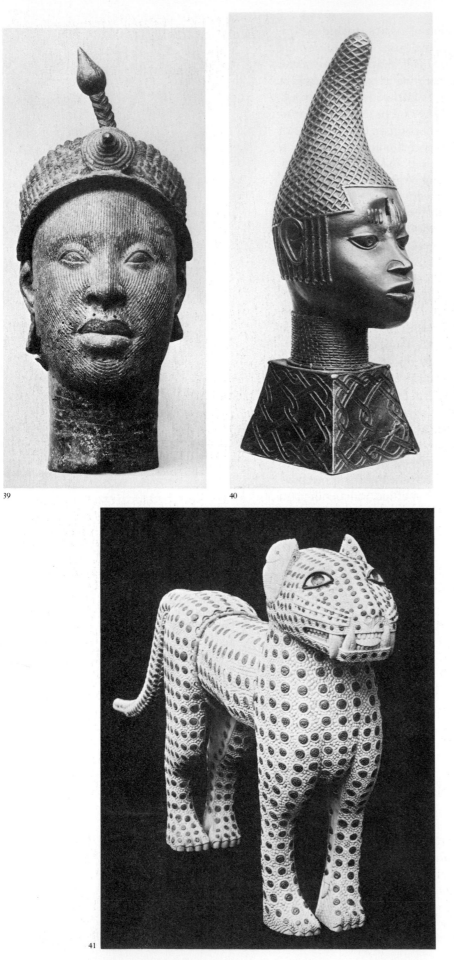

39. *Head of Queen Olokun*, from Ife, Nigeria.
c. 11th–15th century A.D. Clay and bronze,
height to top of ornament c. 36″. British Mu-
seum, London

40. *"Princess,"* from Benin, Nigeria. c. 14th–16th
century A.D. Bronze, lifesize. British Mu-
seum, London

41. *Leopard*, from Benin. c. 16th–17th century
A.D. Ivory with brass inlay, length 32⅝″.
British Museum, London

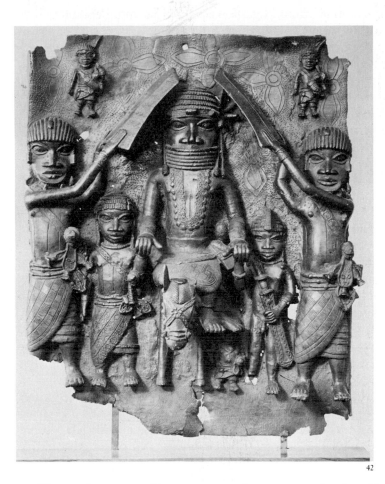

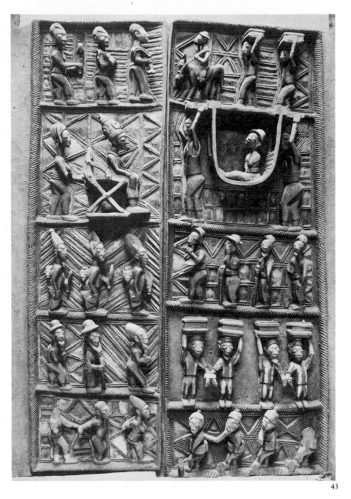

Sixteenth-century Portuguese explorers were the first Europeans to visit the nearby Nigerian kingdom of Benin. Its art, however, was not widely known until the city of Benin was destroyed in 1897 and a large number of splendid bronze objects from the palace were taken to England. Among them was the elegant and serene head of a girl, dating from the fourteenth, fifteenth, or sixteenth century, known as the *"Princess"* (fig. 40). She wears a high, beaded collar and a beautiful horn-shaped woven headdress. The refined workmanship of the very thin bronze casting is derived, according to oral tradition, from the older Ife culture, but a certain stylization has softened the overwhelming sense of reality of the Ife heads. Handsome leopards of ivory studded with brass disks (fig. 41), symbols of royal power, and many grand bronze reliefs from the palace, like the one representing a king symmetrically enthroned between smaller attendants (fig. 42), show other possibilities of the Benin style, which is very dense in its opposition of cylindrical volumes to surfaces enriched by parallel grooves, striations, and incised ornament.

A very few examples must suffice to indicate some of the superb artistic and expressive qualities of the vast quantities of more recent tribal art, which doubtless perpetuate the forms of older and now-lost works. Rich figural reliefs, such as the carved-wood doors from the Yoruba culture at Ikerre in Nigeria (fig. 43), which illustrate scenes from tribal life and ritual, continue some aspects of the ornamentalized Benin tradition. Much more familiar are the guardian figures of wood covered with sheet brass (fig. 44) from the Bakota tribe of Gabon in West Africa. These figures were originally set over urns containing ancestral skulls to ward off evil spirits. Their clear-cut, tense geometric forms and strong magical content aided greatly in the development of abstract art in Europe. Yo-

42. *Mounted King with Attendants*, from Benin. c. A.D. 1550–1680. Bronze relief plaque, height 19½". Museum of Primitive Art, New York

43. Yoruba door, from Ikerre, Nigeria. Wood. British Museum, London

ruba ceremonial masks from Nigeria were often far more complex. The one in fig. 45, for instance, culminates in a veritable explosion of cactus forms, flanked by crouching birds at either side and crowned by an animal head. Such masks, sometimes weighing as much as a hundred pounds, are used for the *epa* cult, held every two years to evoke fertility for the land and for the humans who till it.

In fact these majestic masks should always be imagined as being actually worn by participants in complex rituals of fertility or death, rituals accompanied by dances and by music of astonishing rhythmic intricacy. The *kanaga* masks (fig. 46), used in the *dama* feasts of a secret religious society of the Dogon people in the Republic of Mali, are considered so sacred and so charged with magical powers that between feasts they are kept hidden. Women and children, not yet initiated, may not go near them for fear of being harmed. The masks embody a complete world system, expressed in the outstretched wings of the cosmic bird (accidentally resembling a so-called Cross of Lorraine) and its sharp beak above the wearer's face. Even the motion of the raffia skirts and arm-fringes should be pictured as part of the total experience when one sees such works of art in glass cases or hung on walls today.

A deliberately terrifying group of masks are those of the powerful goddess Nimba (fig. 47), worshiped by the Baga people of Guinea. The wearer's head fits in the hollow of the torso, his eyes looking out between the flat and pendulous breasts, and the whole structure is supported on four leglike struts going over his shoulders and chest. Little of the wearer save his arms appears above the raffia skirt. The head, with its staring eyes and monstrous nose outlined by raised dots like nailheads, would bob and sway with the dancer's ritual motions. No twentieth-century

44. Bakota guardian figure, from Gabon, West Africa. Wood covered with sheet brass, height 21¼". L. van Bussel Collection, The Hague

45. Yoruba helmet mask, from Nigeria. Height 30¾". Koninklijk Museum voor Midden-Afrika, Tervuren, Belgium

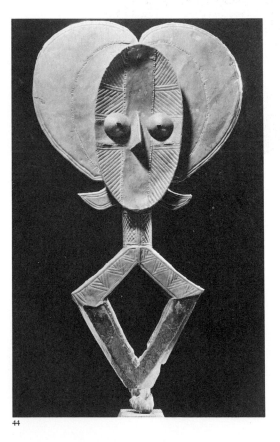

44

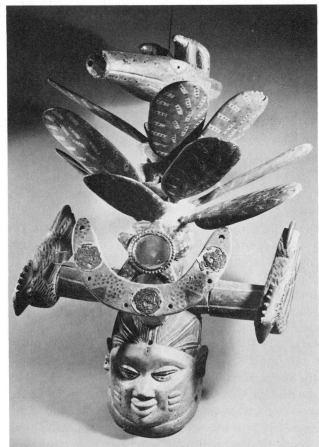

45

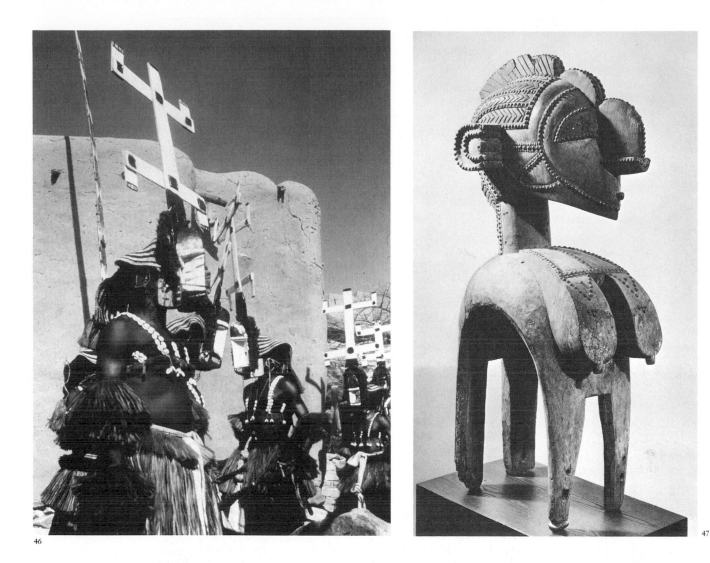

white sculpture has ever surpassed the grandeur and severity of these almost architectural forms.

Blacks who survived the horrors of the slave ships could bring no ritual objects with them, but they did not leave their creativity behind in Africa. Black folk arts of great interest grew up in areas of the American South and continue to flourish. And black artists in the twentieth century have taken their rightful place among the communities of painters, sculptors, and architects of American metropolitan centers.

A strikingly different but equally wide range of aesthetic and emotional value was exploited by the mixed Mongoloid and melanotic (dark-skinned) peoples from Asia, who as early as the second millennium B.C. settled the innumerable islands that dot the western Pacific Ocean, at a time when the lower water level in the area, as in Europe, left much of the continental shelf uncovered. The separate tribes that flourished in the rain forests of the coastal areas, the river valleys, and the mountainous uplands were often headhunters, sometimes ritual cannibals. Their surviving artifacts, usually carved in wood and painted, and therefore of quite recent date, were designed to satisfy practical and ceremonial necessities. Human and animal figures of compelling physical presence coexist with shapes that, at first sight, appear entirely abstract. But the dizzying effect on the modern observer, and presumably on the enemy, of the swirling curves and floating ovoids that decorate a war shield from the Sepik River region of

46. Dogon dancers wearing *kanaga* masks during a *dama*, Diamini-na, Mali

47. Simo mask of the goddess Nimba with carrying yoke, from the Guinea Coast. Wood, height 52″. Private collection, New York

Oceanic Art

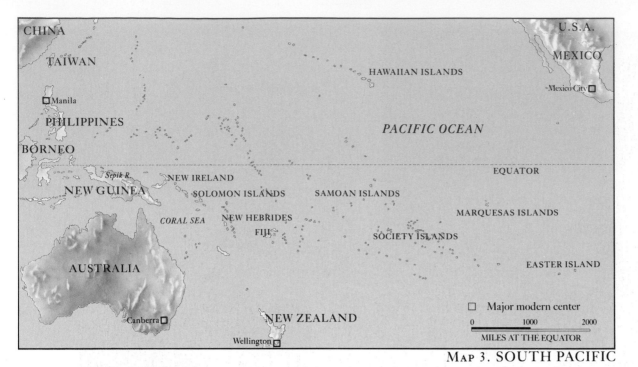

MAP 3. SOUTH PACIFIC

48

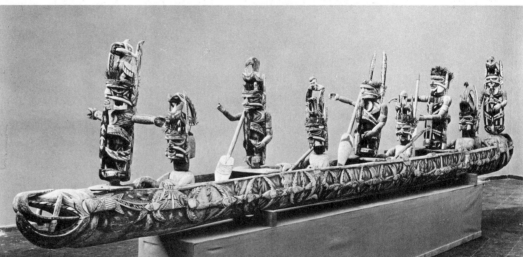

49

northern New Guinea (fig. 48) is stabilized by the realization that the shield is in fact a gigantic mask, with nose, eyes, and ornamentalized teeth, bearing on its brow a smaller and even more frightening face. Such objects were, of course, never intended to be seen apart from the context of tribal life, some of the intensity of which engulfs us in the huge "soul boat" from New Ireland (fig. 49) containing wooden sculptures of a dead chieftain, his relatives, and several of the enemies he has slain. The work, discovered in 1903, is unique, probably because all the other "soul boats" were actually sent to sea, perpetuating an earlier rite in which the bodies themselves were also thus treated. The fierce and jagged shapes of the stylized figures, the bird heads that crown them, and the great boat itself with its fins and its open, toothy mouth and lashing tongue compete in power and drama with the finest Northwest American Indian works.

Still unexplained are the colossal stone figures on Easter Island (fig. 50) that stand in long rows, suggesting the menhirs of Brittany, and lead along avenues to the volcanic craters from whose soft lava they were carved. As early as the seventeenth century the first European explorers noted that the inhabitants had lost track of the meaning of the statues and had pushed many of them into the sea. The backs of the heads are entirely

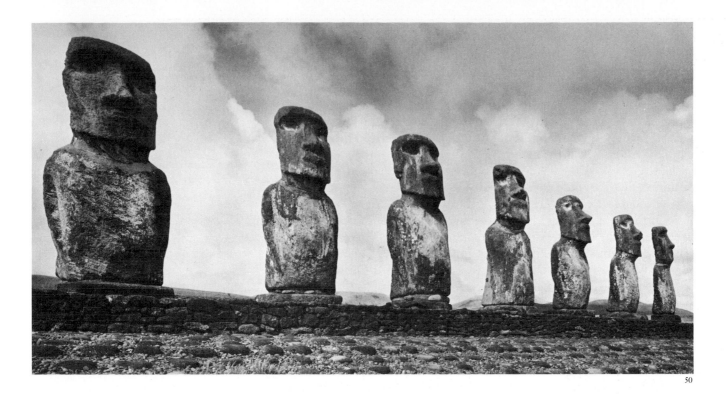

absent, the bodies barely suggested, so that the images are really a succession of staring masks, overpowering largely because of their gigantic scale, which unites them with the desolate landscape.

The first Europeans in North America may have been closer to the truth than we recognize when they called the inhabitants "Indians"; these peoples had in fact wandered from Asia, by way of a land bridge formed about 20,000 B.C. by what are now the Aleutian Islands, and they may even have brought Asiatic traditions with them. Many of these nomadic tribes of hunters were still in the Old or the Middle Stone Age, and some remained so, in spite of enforced mass migrations, until the present century.

Our conception of the American Indians is founded on an old and fallacious image of the "naked savage," nomadic and living in tepees. While the Indians of the Great Plains were indeed constrained by their environment to hunt buffalo and move constantly from place to place, this was not at all true of the tribal groups of the Southwest or the nations that once populated the central heartland of what is now the United States. These last were ethnically complex, and the tribes were strikingly different physically. They spoke scores of languages, often totally unrelated to each other. During the glacial era they hunted and gathered food, like Paleolithic humanity in Europe. But from about 7000 B.C. they lived in villages, and from about 1000 B.C. to A.D. 700 they existed by farming and inhabited groups of villages composing considerable towns along the great rivers in the center of the North American continent. Excavations have shown that these Indians maintained a widespread commerce, for materials from thousands of miles away have turned up at their burial sites. Their buildings were constructed of vertical logs, plastered with mud, like those of northern Europe.

The principal Indian architectural monuments were the famous mounds, found all the way from Florida to Wisconsin. There were once over 10,000 mounds in the Ohio Valley alone, some as much as one hundred feet high. Depending on the particular culture, these mounds

North American Indian Art

48. War shield, from the Sepik River region, New Guinea. Late 19th–early 20th century A.D. Wood, height 61⅜″. University Museum of Archaeology and Ethnology, Cambridge, England

49. "Soul boat," from New Ireland, New Guinea. c. A.D. 1903. Wood, length 19′. Linden-Museum, Stuttgart, Germany

50. Stone images. 17th century A.D. or earlier. Height 30′; weight c. 16 tons each. Easter Island, South Pacific

were employed for religious purposes, for burials, for the residences of rulers and nobles, or for temples. Some were built in the shapes of gigantic animals or birds, with wings spread (reminding us of Çatal Hüyük!), others were cones or domes, and the latest built were formed like truncated pyramids. The largest of these, at Cahokia just outside East St. Louis, Illinois, has a greater volume than the greatest of the Egyptian pyramids. Astonishingly, these millions of tons of earth were all brought up by hand, in baskets or cloths, then tamped down. Most of the mounds have perished, victims of the spade, the bulldozer, the reservoir, or the highway, but many thousands have been preserved. They are almost impossible to photograph effectively, and their full majesty can be appreciated only on the spot. But fig. 51 gives a faint idea of one of the most impressive, the Great Serpent Mound, in Adams County, Ohio, 1,247 feet in uncoiling length and holding what is apparently an egg in its open jaws. Not until the twentieth century, in works of so-called Earth Art, has anything like these great projects been attempted.

Many mounds have been excavated and approximately dated by means of carbon 14. Their inner burial chambers built of logs (or sometimes the earth itself) have yielded spectacular treasures. Aristocrats of the Hopewell culture, named after the family on whose Ohio farm the first and greatest finds were made, have been found entirely clothed in pearls and accompanied by objects of brilliant naturalistic observation and beauty of workmanship. Chief among these objects are pipes, with hollows for tobacco and a hole drilled through one end, intended to be held in the hand while smoking. The pipe representing a hawk (fig. 52), dating between 200 B.C. and A.D. 300, shows a degree of formal mastery and technical finish suggesting the art of the Old Kingdom in Egypt (see Part Two, Chapter One). The culture of the mound builders totally disappeared, no one knows why—perhaps epidemics, perhaps invasions—so that the first Europeans found the area largely deserted, except for Indians who had no memory of the mound builders, who may or may not have been their ancestors. The Indians of the lower Mississippi Valley, still utilizing their temple and palace mounds, were massacred by the thousands at the hands of De Soto and his men, but their culture had already started to decline.

The Indians of the Southwest built stupendous masonry villages in the broad cave mouths of cliffs, the grandest of which is the famous Cliff

51. The Great Serpent Mound, Adams County, Ohio. Adena culture, 1000 B.C.–A.D. 400. Length 1,247'

52. Hopewell pipe in the form of a hawk, from Tremper Mound, Scioto County, Ohio. c. 200 B.C.–A.D. 300. Gray pipestone, height 3"; length 3½". Ohio Historical Society, Columbus

53. Cliff Palace, Mesa Verde, Colorado. c. A.D. 1150

54. Adobe pueblos, Taos, New Mexico

52

51

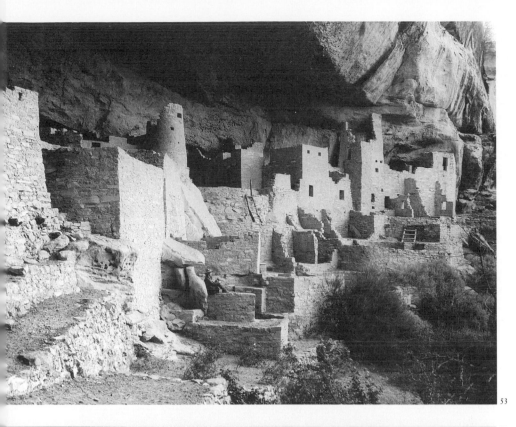

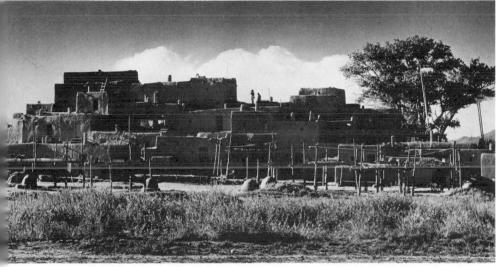

Palace at Mesa Verde in Colorado (fig. 53), dating from about 1150. Again we are reminded, perhaps accidentally, of Çatal Hüyük, because there are no streets and the houses are entered from each other, in tiers, by means of ladders. Descendants of the same Indians live today in adobe pueblos, like those in Taos, New Mexico (fig. 54), constructed on exactly the same principle. Sand paintings, intended to have a magical effect, are still produced today in the Southwest, but do not outlive the moment of their creation. Such sand paintings have been of great importance to the "Action Painters" of the 1950s in New York. Similarly, the lively, flickering designs of Indian blankets, produced by the complex interactions of basic geometric shapes (fig. 55), have much in common with the abstract paintings of the 1960s and 1970s and are often exhibited as wall hangings and appreciated as paintings. So indeed are the painted tepees and shields, the carved figures, the pottery, baskets, and beaded clothing, blazing with color and bursting with vitality of conception and design.

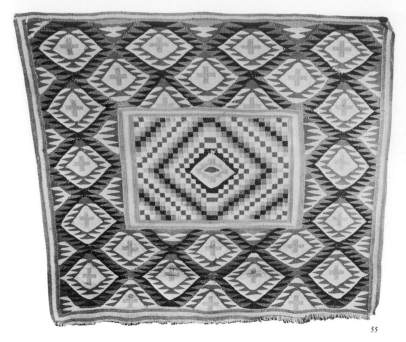

55

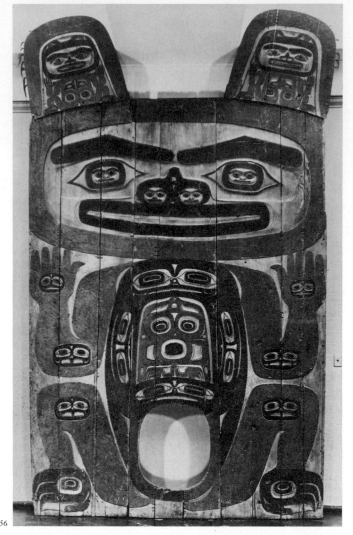

56

Perhaps the most powerful of more recent Indian works are the ceremonial animal sculptures of the Pacific Northwest. An effect of great mass is obtained by surrounding broad areas with incised rectangular contours having slightly rounded corners. The larger animals surprisingly disclose smaller ones—in their ears, their body joints, or even in their eyes and mouths—like the Scythian panther from southern Russia (see fig. 489). A Haida bear mask (fig. 57) of painted wood is provided with eyes and teeth of brilliant, veined blue abalone shell, suggesting that we are looking past and through the staring animal into distant sky. Even more majestic are the towering wood sculptures of the Tlingit—doorjambs, totem poles, gables, house partitions—of which one of the grandest is a colossal bear screen (fig. 56).

Few white Americans realize that some descendants of the builders of the Midwestern mounds and the Far Western cliff dwellings work in the construction of the steel frames of present-day American skyscrapers, where their immense skill, courage, and self-control are invaluable in building the most characteristic structures of the modern world. In general, while commercialized versions of the great Indian objects are being made in ever-growing numbers for the tourist trade, talented Indian artists are becoming increasingly assimilated into the currents of the dominant white culture.

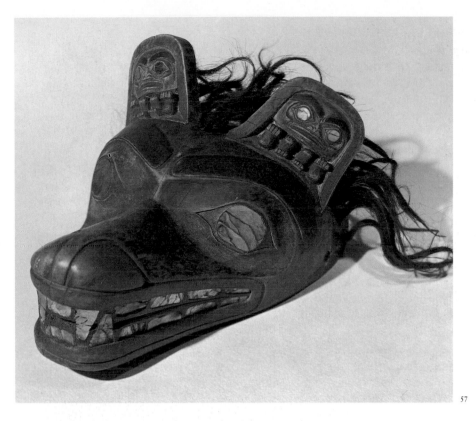

55. Nobility blanket. Thompson Indians (Northwest Coast). Before A.D. 1860. Peabody Museum, Harvard University, Cambridge, Massachusetts

56. Bear screen. Tlingit Indians (Northwest Coast). 1840. Carved and painted wood, 15 × 9′. The Denver Art Museum, Colorado

57. Bear mask. Haida Indians (Northwest Coast). Painted wood with abalone-shell inlay. Carnegie Museum, Anthropological Center, Meridian, Pennsylvania

Certainly to be counted among great ancient civilizations, and in part classifiable as Neolithic, are those cultures that flourished in Central America and northern South America before the arrival of the Europeans in the sixteenth century. Pre-Columbian art is indeed sometimes discussed along with ancient art, but has been placed here partly because it is an American art made by people related to the North American Indians, partly so as not to interrupt later the natural sequence from Roman to Early Christian and Byzantine art.

Pre-Columbian Art

CENTRAL AMERICAN ART The small bands of Spanish adventurers, who with the aid of gunpowder defeated and subjugated with ease the Aztec and Inca empires and the Mayan states, were astonished at the high level of urban culture they found. Where not precluded by mountainous terrain, cities had been laid out on a grid plan with wide, straight streets. Before the Spaniards tore it down, house by house, in the protracted battle of 1520–21, Montezuma's capital, the lake city of Tenochtitlán, boasted a luxurious palace and fine residences united by a network of canals. Both the Maya and the later Aztecs possessed complex systems of hieroglyphic writing, as yet only partially deciphered, and each had a calendar so precise that both Mayan and Aztec inscriptions can be dated down to the day according to our system. While their massive temples were intended mostly for exterior use, the Maya and the Aztecs knew and employed the post-and-lintel system, the corbel arch, and the corbel vault. The Spaniards admired the craftsmanship of Aztec sculpture and minor arts, but they saw in them little artistic merit and melted down most of the gold and silver objects. They also systematically destroyed almost all Aztec manuscripts, which were written on a kind of paper made from the bark of the fig tree; only a very few illuminated examples survive. Montezuma showed the Spaniards with pride his botanical garden, which had a specimen of every identifiable plant that grew in his empire. Arithmetic and astronomy were among the great interests of both

Aztecs and Maya. The Aztecs had even developed a system of universal education. Astonishingly enough, none of these original Americans knew the use of the wheel, and they had no draft animals. In most respects it can be said that the Maya and the Aztecs, at least, had reached a stage of development analogous to that of the ancient Sumerians, and that the Incas, at the very least, had arrived at about the level of predynastic Egypt.

A prominent feature of Central American life was the institution of human sacrifice, and wars were systematically conducted to obtain victims for that purpose. Human sacrifice was rationalized as essential for the propitiation of the gods of heaven and the continuance of their light and heat, but in fact it provided a staple source of protein for the conquerors in the absence of domestic animals. European hands, of course, were far from clean in respect to mass slaughter, as witness the bloody spectacles of the Roman arenas or the Christian executions of heretics by sword and fire. On their arrival the Spaniards were shocked at the endless lines of battle prisoners awaiting sacrifice, although it is debatable whether in their occupation even more human lives might not have been taken in the name of the most Christian king of Spain.

One of the most remarkable aspects of these vanished cultures to us is the lack of any certain evidence of contact between them and the rest of the world; the Incas and their predecessors in the Andes even developed in total isolation from the Aztecs in Mexico and the Maya in Yucatán. We can speculate that all the early Americans arrived from Asia by way of a land bridge formed by the Aleutian chain during the last glacial period and cut off when the glaciers receded and the water level rose. After settling in Central and South America, these peoples must have independently recapitulated much of what Asiatic, North African, and European peoples were inventing. Until about 3000 B.C. the early Americans remained in the Old Stone Age. The first mature pottery and clay statuettes can be dated about 1500 B.C. Metals and the techniques of working them were discovered fairly late, around A.D. 1000; many of the finest works of architecture and sculpture were executed with tools made of stone or bone.

Interestingly enough, nowhere in Pre-Columbian sculpture does any conception of the essential dignity of humanity require either freely walking or even freestanding human figures. Carved human images are invariably restricted in projection by the surfaces of the architecture into whose blocks they are carved. Their cramped poses are in sharp contradistinction to the sensitive observation of their faces and hands. Free from this kind of patterning, painting nonetheless conforms to the flatness of the wall. Even in painting, female figures are rare; from sculpture women (as distinguished from female deities) are entirely absent.

Teotihuacán. The Aztecs were aware that they were latecomers to the Mexican highland and that they had had predecessors there in a happier era before human sacrifice became "necessary." These earlier peoples built cities, the most impressive of which was Teotihuacán, whose main avenue of temples, dating from well before A.D. 600, has been excavated (fig. 58). The rites of early American nature worship required hilltops, and when these were unavailable, mounds were built. By the beginning of the Christian era, the mounds had reached the form of carefully constructed step-pyramids, ascended by a central flight of stairs. The parallel in form and purpose with Mesopotamian ziggurats (see figs. 123, 125) is compelling. The American structures were, however, not built of mud brick but according to an elaborate system of inner stone piers and fin

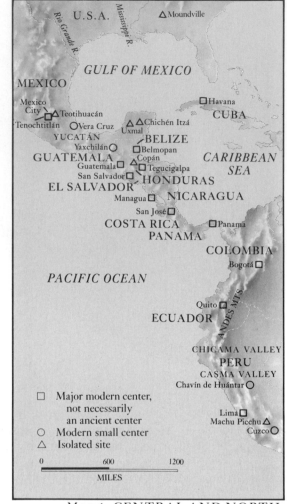

MAP 4. CENTRAL AND NORTH-
WESTERN SOUTH AMERICA

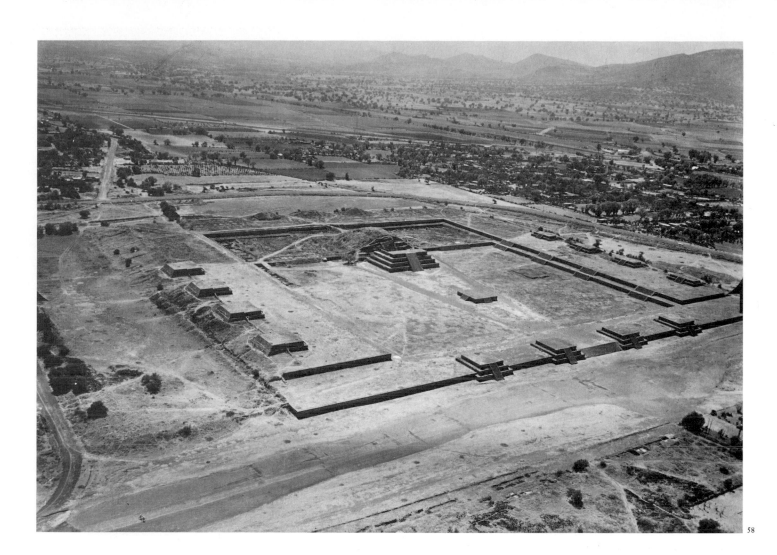

58

walls, filled in with earth and rubble, and faced with well-cut stone masonry. Not only in sheer craftsmanship but also in the feeling for mass and proportion, and in the disposition of spaces, these pyramids of Teotihuacán are majestic works of architecture. With a single exception, the various levels are ornamented only with simple paneling, which accentuates their cubic grandeur.

The Olmec. The mysterious Olmec culture, which flourished on the Gulf Coast of Mexico from about 800 B.C. to about A.D. 600, produced a surprisingly naturalistic sculpture in the round, including a series of colossal heads of unknown purpose. An example from San Lorenzo Tenochtitlán (fig. 59) has been provided with a closefitting helmet, under which the brows are knitted in a frown; the prominent lips are partly open, and the large eyes stare. The mass of basalt has thus been transformed into the appearance of living flesh with astonishing power and intensity.

The Maya. The pyramid with central staircase, established at Teotihuacán, was recapitulated in countless variations of size, shape, and proportion throughout central Mexico and Yucatán; its form became sharply steeper and higher in the Mayan civilization. The Maya had their own religious rites, one of which was a ball game in which the rubber ball passing back and forth overhead symbolized the course of the sun through the heavens. The reconstruction of a ball court at Copán (fig. 60), as it appeared about A.D. 600, shows the Mayan genius for the deployment of architectural masses, often unrelieved, crowned here with a windowless

58. Ciudadela court, Teotihuacán, Mexico (view from the west). Before A.D. 600

story richly ornamented with the relief sculpture at which the Maya excelled. In the so-called Nunnery of the tenth century at Uxmal (fig. 61; its actual purpose is unknown), the customary cubic masonry of the lower story is contrasted with an upper zone of ornament in which lattice shapes alternate with carved masks. The horizontality of accent produces an effect unlike that of any Old World architecture. Even when the Maya were under the domination of the Toltec, who seem to have introduced human sacrifice, the originality of Mayan architecture was maintained. The Mayan-Toltecan center of Chichén Itza is filled with structures whose massive grandeur and delicate relief carving create an impression of the greatest variety and richness. The Caracol (observatory) is one of the most impressive—a cylindrical building on a lofty platform (fig. 62). Over the doorway grins a fierce mask strikingly suggestive of the Haida bear masks (see fig. 57) of the Pacific Northwest. The interior is formed by two concentric circular corridors, roofed by pointed corbel vaults.

During the "classic" Mayan period (to use the designation employed by archaeologists), which corresponds to about the first millennium of our era, sculpture in the round was rare and generally limited to ceramics and stucco. Painting, while extensive and of high quality, was executed on walls in narrow spaces, and is extremely difficult to reproduce today except in copies. Sculpture in low relief was abundant, and beautiful both in its characteristic contrast of blank and enriched areas and its spontaneous transformation of inert blocks and cubes into live masses.

A rare example of sculpture in the round is the colossal *Water Goddess*, dating before 700, from Teotihuacán (fig. 63). The immense size (10½ feet high) and blocky appearance of the image may be explained by its probable function as a caryatid figure upholding a central wooden roofbeam. Its identification as a water goddess depends only on the wave motif running along the hem of the skirt, an obvious symbol omnipresent in early art all the way from Ireland to China. Not only in execution but

59. Colossal head, from San Lorenzo Tenochtitlán (Veracruz), Mexico. Olmec, c. 800 B.C.–c. A.D. 600. Basalt, height 70⅞". Museo de Antropología, Jalapa, Mexico

60. Main ball court, Copán, Honduras. Maya culture, c. A.D. 600 (Architectural reconstruction)

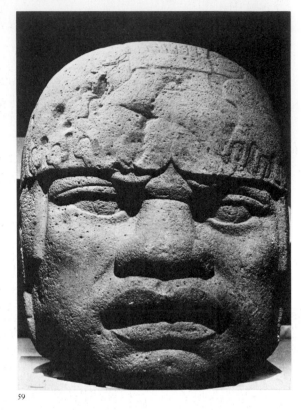

59

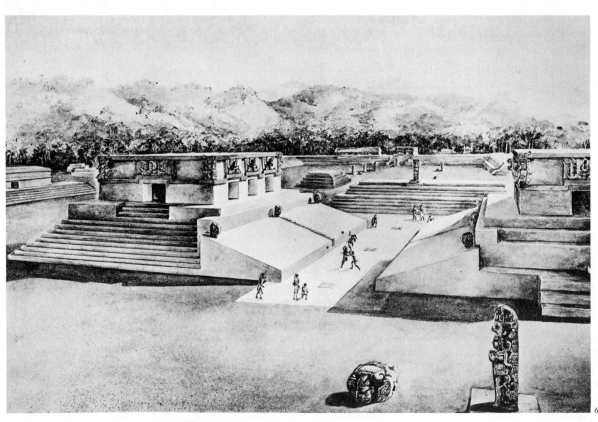

60

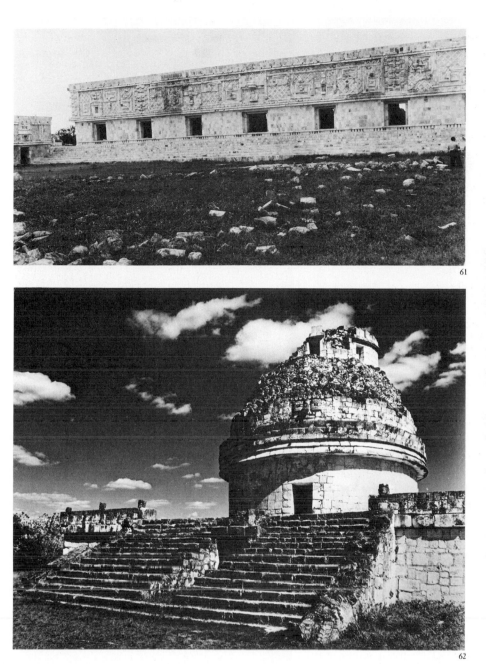

61

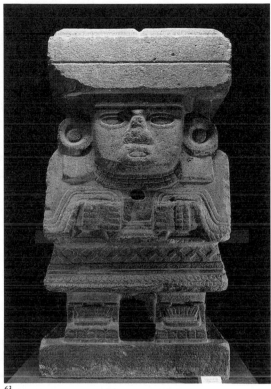

63

62

in basic conception the work is a relief. Ears, limbs, and extremities are drawn upon and carved into the flat surfaces of the block and shown frontally so that fingers and toes may be counted. The rectilinearity of the block mass controls every aspect of the representation. The eyes stare blankly forward and in the open mouth may be seen a protruding tongue. The chest contains a cavity in which, apparently, was placed a stone heart. In the dimness of an ancient interior the total effect of the towering yet squat deity must have been awesome.

Although still limited by the surface of the stone slabs into which they are lightly carved—even by the angles of the corners—the numerous stone lintels in low relief are far more flexible. A very fine relief, datable to 692–726, from the lintel of a house at Yaxchilán (fig. 64) shows a possibly ceremonial, possibly visionary subject, difficult to interpret exactly in the present state of our knowledge of Mayan hieroglyphs. These appear in the upper corners of the relief and in an upside-down, L-shaped area in the center. On the left a strange design of scrolls and scales resolves itself into a fantastic serpent or dragon, above a delicately drawn

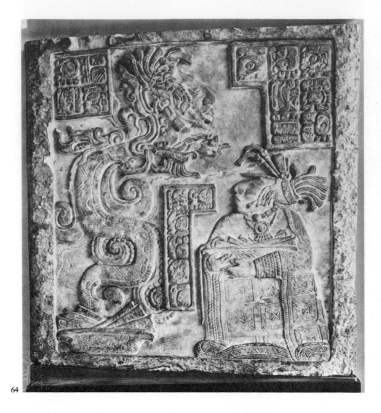

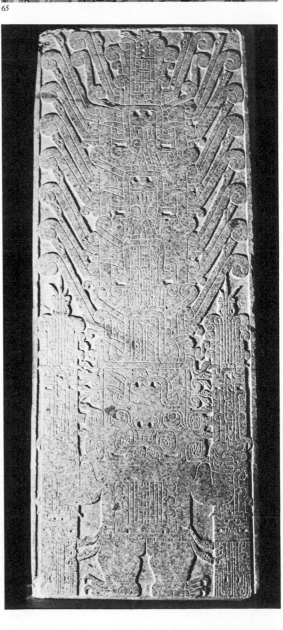

bowl, seen slightly from below, containing instruments of a possibly sacrificial purpose. On the right kneels a richly robed and crowned figure, apparently a priest, whose sensitively observed features have the typical Mayan cast. He holds a basket of instruments and looks up in wonder at the apparition of a crowned head and hand from the serpent's mouth. The extreme delicacy and suppleness of the draftsmanship, and the manner in which ornament suddenly comes to life, make this and other Mayan reliefs works of art of fascinating and compelling beauty.

Many surviving early Mayan wall paintings cover large areas with ritual compositions either arranged in registers in a manner comparable to the tomb paintings of ancient Egypt or forming intricate patterns made up of deities, humans, animals, and plants. Dominated as in sculpture by the flatness of the wall on which they are projected, these paintings contain many surprises for a viewer accustomed to European art. Some of the later paintings abandon their rigor of planar design for a seemingly spontaneous picture of action in open space. A painting of siege operations from the thirteenth century in the Temple of the Jaguars at Chichén Itza (fig. 65) presents an astonishing panoramic view of the chaos of a battle. Yet European perspective is never suggested. The ground is synonymous with the wall surface, into which the figures are splattered as if by an explosion, attacking, resisting, counterattacking, armed with spears and defended with shields. They conform to no all-over pattern, but their poses are predetermined by convention, and they never overlap. Outlines are firm and concise, and between them the color is flatly applied. In the midst of the confusion rise two siege towers populated with attackers, themselves menaced by the enveloping folds of dragon-like creatures slithering around the beams. Once the spatial conventions of such views are accepted, the free ferocity of a battle situation is convincing.

ANDEAN ART The Andean region formed a totally distinct area of pre-Columbian culture, whose origins cannot be traced. The Spaniards arriving in Peru in 1536 found an even more recent empire than that of

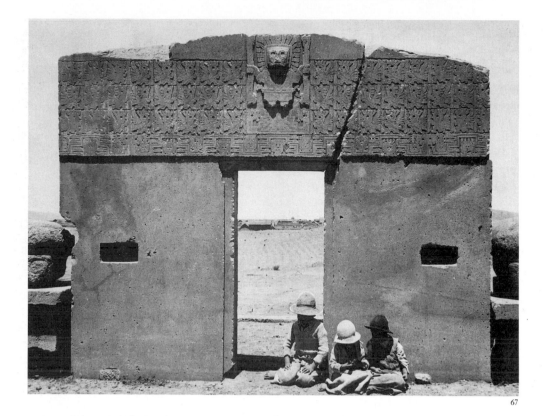

67

the Aztecs of Tenochtitlán. The Incas had no writing, and their vast empire was held together by an extraordinary system of oral communication, messages being delivered by runners in short and frequent relays, making it possible for a message to travel one hundred and fifty miles in a day—as compared to the twelve to fifteen days required by the later Spanish system of post-horses. The Spaniards were astonished to find themselves everywhere expected. In the absence of writing, the Incas made relief models of areas of their mountainous empire to aid them in moving subject peoples from one region to another in order to forestall revolt. In Andean architecture we find many of the familiar features we have encountered in Mexico—platforms, step-pyramids, gridiron cities. Mining was extensively practiced, and the smelting, casting, beating, and chasing of metals done with the utmost skill. It cannot be claimed, however, that Andean art often reached the level of Mayan art at its best.

Andean carvings were generally incised on stone in patterns of great complexity, but not further carved save for reduction of the background. One of the most fascinating Andean reliefs is the *Raimondi Monolith* (fig. 66), datable about 500, from Chavín de Huántar in northern Peru. This was probably a ceiling decoration, intended to be read in either direction. At first sight one distinguishes a chunky personage, with claws on his feet, in the lower third of the relief; his short arms and massive hands extend to hold two richly carved scepters. His face is a mask, displaying a grinning mouth, full of square teeth, and saucer-shaped depressions for nostrils and eyes. The upper two thirds of the relief appears to be filled with a towering headdress from which feathers sprout on either side; when one turns the picture around, the upper sections become a series of masks, each hanging from the jaws of the one above. The magical intensity of the complex pattern renders it extremely attractive to modern eyes.

Few remains of Andean buildings can compete in splendor with those of the Central American cultures. Yet the so-called Gateway of the Sun (fig. 67) at Tiahuanaco is a majestic creation in its own right; located in the lofty plateau region surrounding Lake Titicaca, a site now in northern

64. Lintel relief, from a Maya house, Yaxchilán, Mexico. c. A.D. 692–726. British Museum, London. Maudslay Collection

65. *Siege Operations During a Battle*, painting from the south wall, inner room, upper Temple of the Jaguars, Chichén Itzá. Maya Toltec culture, 13th century A.D. Peabody Museum, Harvard University, Cambridge, Massachusetts

66. *Raimondi Monolith*, from Chavín de Huántar (Ancash), Peru. c. A.D. 500. Stone, height 72″. Museo Nacional de Antropología y Arqueología, Lima

67. Gateway of the Sun, Tiahuanaco, Bolivia. Tiahuanacan culture, shortly after A.D. 300. Height 9′

Bolivia, it dates shortly after A.D. 300. Two monolithic jambs, each nine feet high, support a huge lintel that at first appears to be decorated with three superimposed strips of floral or foliate ornament above a lower border of a meander pattern suggesting those common in ancient Greece and throughout the decorative art of China. In the center, over the doorway, is a sharply stylized frontal relief showing the sun god holding a bow in his right hand and two arrows in his left. From his masklike countenance emerge gigantic rays. On closer analysis the strips of ornaments resolve themselves into registers of eight running figures, thus forty-eight in all, each holding two arrows and wearing a feather crown. Those in the upper and lower rows have human heads in profile directed straight forward, while the upturned heads of those in the central row display open bird beaks. All have staring eyes, some round, some square, and all these minions of the sun god are propelled by wings lifted behind them. Into the openings in the meander pattern are inserted other sun-masks in wigwag style, now up, now down. As in the Raimondi relief the combination of powerful vertical and horizontal rhythms with an elusive balance between apparently floral but actually animal representations produces an almost dizzying effect.

At the opposite pole from this very nearly abstract art, with its probable religious significance and ritual purpose, the same region of northern Peru in which the Raimondi relief was carved, at roughly the same period, produced strikingly naturalistic pottery intended for daily use, in which the entire pot was turned into an image of a human head. The Mochica potters experimented with different types of facial expressions until they were able to produce natural, spontaneous, and infectious ones, an example of which is shown in the *Laughing Man* (fig. 68), whose features are irradiated with a wide and happy grin and whose eyes are almost closed in laughter.

The grandest productions of the short-lived Inca Empire, which governed an enormous Andean area from its capital at Cuzco in southern Peru, are its cities, built of masonry that has been sculptured to fit, stone against stone, so that literally (as is almost too widely known) the blade of a knife cannot be inserted between them. The city of Machu Picchu, most of whose buildings are datable about 1500, is probably the most fantastic of all early American cities known to us (fig. 69). Its extensive ruins stand on a crag that towers among other crags about two thousand feet above a misty valley.

The culture of the Spanish Renaissance, however, ended the indigenous art of the ancient American civilizations in the sixteenth century and imposed its own European styles on the conquered inhabitants, along with its languages and religion.

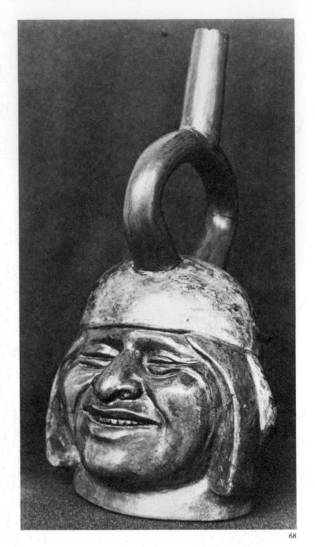

68

68. Vessel representing a laughing man. Mochica culture, c. A.D. 500. Museo Nacional de Antropología y Arqueología, Lima

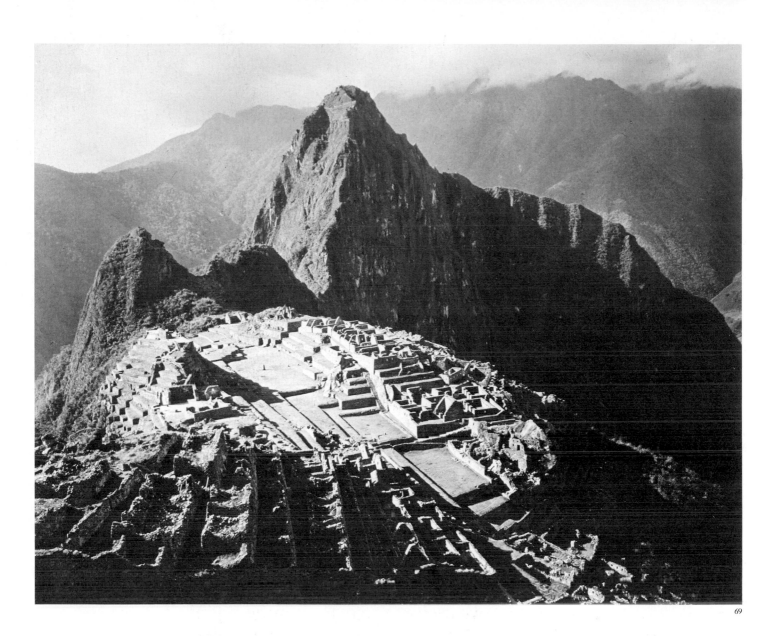

69. Aerial view of Machu Picchu, Peru. Inca culture, c. A.D. 1500

These few objects we have seen represent only a small selection from the immense riches of ethnic art, which has at once perpetuated many of the modes of creation found in the earliest arts of humanity and brought the raw power of preliterate art closer to our own times, often under a high degree of intellectual control. For twentieth-century artists, ethnic art has served as a reservoir of emotional energy as well as of forms and designs and a reminder that magic and unreason are far from dead. They live deep in the subconscious of all "civilized" peoples and provide more strength in our lives than we will perhaps admit.

TIME LINE I

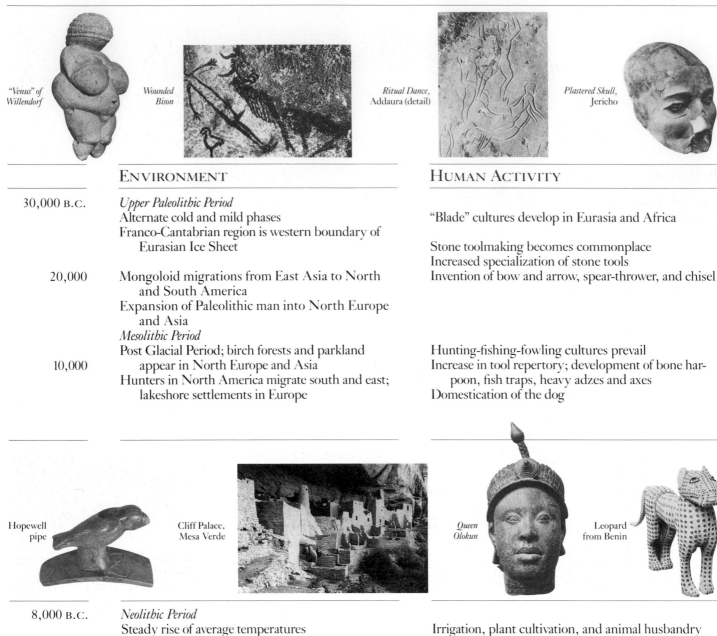

"*Venus*" *of Willendorf*

Wounded Bison

Ritual Dance, Addaura (detail)

Plastered Skull, Jericho

ENVIRONMENT		HUMAN ACTIVITY
30,000 B.C.	*Upper Paleolithic Period* Alternate cold and mild phases Franco-Cantabrian region is western boundary of Eurasian Ice Sheet	"Blade" cultures develop in Eurasia and Africa Stone toolmaking becomes commonplace Increased specialization of stone tools
20,000	Mongoloid migrations from East Asia to North and South America Expansion of Paleolithic man into North Europe and Asia	Invention of bow and arrow, spear-thrower, and chisel
	Mesolithic Period Post Glacial Period; birch forests and parkland appear in North Europe and Asia	Hunting-fishing-fowling cultures prevail
10,000	Hunters in North America migrate south and east; lakeshore settlements in Europe	Increase in tool repertory; development of bone har- poon, fish traps, heavy adzes and axes Domestication of the dog

Hopewell pipe

Cliff Palace, Mesa Verde

Queen Olokun

Leopard from Benin

8,000 B.C.	*Neolithic Period* Steady rise of average temperatures Rise in sea levels Increased foresting of land	Irrigation, plant cultivation, and animal husbandry gain sophistication Pottery; ground and polished tools Start of mining and quarrying Jericho develops farming and hunting
4,000	Climatic optimum: worldwide warm spell	Diffusion of farming to Crete, Sicily, South Italy
2,000	Stabilization of climatic conditions Mongoloid and Melanotic settlements in Oceania	Bronze Age; Tigris-Euphrates civilizations flourish
1,000		Metallurgy spreads from Near East to Egypt, Mediterranean; Iron Age
A.D. 1100		
1800		

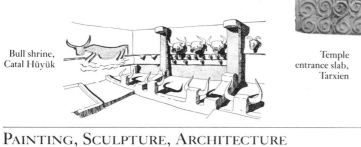

Bull shrine,
Catal Hüyük

Temple
entrance slab,
Tarxien

Stonehenge

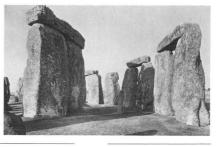

PAINTING, SCULPTURE, ARCHITECTURE

"Venus" of Willendorf
Woman's Head from Grotte du Pape

"Venus" of Lespugue
Painted caves at Lascaux; *Bison* and *Reclining Woman*, La Madeleine
Bison, Altamira; *Two Bison*, relief at Le Tuc d'Audoubert
Chamois from Le Mas d'Azil
Ritual Dance, Addaura

Hunting Scene (copy), El Cerro Felío

CHAPTERS

Art Before Writing Paleolithic	30,000 B.C.
	20,000
Mesolithic	10,000

Easter Island
figures

Colossal Olmec
head

Machu Picchu

Stone fortifications, Jericho; *Plastered Skull*, Jericho
Çatal Hüyük: houses, Bull Sanctuary, Shrine with wall paintings
Goddess Giving Birth from Çatal Hüyük

Temple, Tarxien; trilithon portals, Malta

Corbel vault from tomb chamber, Maeshowe
Stonehenge
Hopewell pipe; Great Serpent Mound
Easter Island figures; *Raimondi Monolith;* Olmec head
Cliff Palace, Mesa Verde; The Caracol, Chichén Itzá
Queen Olokun; "Princess," Leopard, and bronze reliefs from Benin
Adobe pueblos, Taos; Tlingit screen; Haida mask; nobility blanket
Yoruba door from Ikerre; Bakota guardian figure; Yoruba mask; Simo
 mask of Nimba
War shield from Sepik River; "soul boat" from New Ireland

Neolithic	8,000 B.C.
Later Ethnic Groups	4,000
	2,000
	1,000
	A.D. 1100
	1800

THE ANCIENT WORLD

TWO

For many thousands of years, Neolithic humans were able to produce and preserve food and thus develop permanent settlements, yet they depended entirely on memory for records, communications, and the preservation of history, religion, and literature. No matter how highly developed, memory is notoriously fickle. No large-scale systematic enterprise, whether political, economic, or religious, was possible in the absence of reliable and enduring records. How humans first hit on the idea of setting down information in visible form, thus arriving at a system of writing, we do not know, but this essential change seems to have taken place a little more than five thousand years ago, in Mesopotamia and Egypt, on both sides of the land bridge connecting Asia and Africa. In both of these civilizations the earliest writing was pictographic, but soon the little images became codified and developed connections with syllables and words independent of their original derivation. Egypt, which possessed both quantities of hard stone and swamps from whose reeds a paper-like material called papyrus was fabricated, long retained the pictorial shapes the Greeks named *hieroglyphs* ("sacred writing," because its use was a prerogative of the priesthood). Mesopotamia, however, relied on soft clay as a writing surface, and there the pictographs were rapidly codified into groups of impressions made with the wedge-shaped end of a reed stylus—a form of writing we call *cuneiform* (from the Latin word for "wedge").

Records and communications facilitated commerce and systematic agriculture as well as the development of governmental authority. Cities grew to considerable size. Monarchies arose and extended their sway to ever wider regions by the subjugation of neighboring states. By the middle of the second millennium B.C., three powerful and prosperous empires had developed: in Egypt, in Mesopotamia, and in the islands of the Aegean Sea. The end of the second millennium, however, was a time of great upheaval for the ancient world, and none of the major powers escaped unscathed. From the ensuing chaos arose the glorious, if partial and short-lived, democratic experiment of the Greek city-states. But despite the enormous influence of Greek culture on the future, the separate Greek political systems could not resist the march to power of Rome. By the end of the first millennium B.C., all the states of the Mediterranean world and many of the still tribal polities of northern, central, and eastern Europe were either absorbed or on the road to absorption by the Roman Empire. Political unification prepared the ancient world for religious unification as well, and the religions surviving from the ancient states proved no match for the universal claims of Christianity or, a few centuries later, of Islam.

Along with writing and the new attitudes and systems it made possible, there arose entirely new modes of intellectual activity based on writing and aimed at the intellectual and physical control of the environment and of humanity itself. History and epic and religious poetry were put in writing in Egypt and Mesopotamia. The sciences of zoology, botany, anatomy, and medicine made remarkable progress.

Numbers, considered apart from enumerated objects, became transferable to any object, or became subject to abstract analysis. Arithmetic and geometry, including principles still valid and methods still taught, were discovered. Optics, perspective, and astronomy made remarkable beginnings, and scientific calendars were devised. Speculation and abstract reasoning followed observation, and under the Greeks and Romans the major branches of philosophy were established. New scientific attitudes began to replace mythological systems with a cosmology based on scientific method.

The adoption by the Greeks of the Phoenician alphabet about 750 B.C. facilitated the codification of language and the establishment of regular grammar and syntax. Recorded literature included not only the preliterate oral poetry of the Greeks, which could at last be set down, but newly composed dramas and lyrics and a systematic attempt at accurate history. Fortunately enough, in one way or another Greek and Latin have remained accessible, but in the case of the twin colossi of the pre-Greek world, Egypt and Mesopotamia, not only their languages but even their systems of writing had seemed hopelessly lost. Only a combination of lucky accident and tireless investigation in the nineteenth century has enabled us at last to read the writing in which their civilizations were crystallized, and thus to reconstruct a remarkable proportion of their history and religion. These writings have also helped us to understand the purpose and meaning of thousands of works of art.

Ancient music, now almost entirely lost, was based on scales and mathematical principles still in use today; it apparently reached great heights. But along with the earliest steps in the evolution of science, and before any presently known achievements of philosophy, literature, and music, the mental attitudes born of writing made possible entirely new purposes, standards, and practices for the visual arts. For the first time, in Egypt and Mesopotamia, emphasis in figural art was transferred from animals to humans, individually or in groups, described with accuracy and analyzed with understanding, and set upon a continuous groundline or within an increasingly complex spatial environment. Compositions could be measured and controlled. Empirical Neolithic building methods gave way to a rational architecture composed of regular and regularly recurring modular units and spaces, often mathematically interrelated, and constructed with so accurate an understanding of physical stresses that, if they had been kept in repair, most ancient masonry structures would be standing today. Not only buildings but whole cities were laid out according to regular plans and provided with systematic water supply and drainage.

In all fields of human endeavor, reason is the triumphant discovery of the ancient world. The best works of ancient art, founded upon reason, are of a quality that has seldom since been equaled and never surpassed. Indeed, none of the other great conquests of the ancient world in any field—practical, intellectual, or spiritual—could have been achieved without reason. Professionals in all fields, whose activities were based on systematic exploitation of every facet and consequence of the reasoning process, were highly regarded in all ancient civilizations, and as we shall see, especially in Egypt and Greece, they sometimes attained high positions. As far as we can tell, from pictures and from literary evidence, these professionals were always male, except for an occasional woman poet (such as the matchless Sappho, in Greece in the sixth century B.C.) and a handful of later Greek portrait painters. This situation was entirely due to the social restrictions placed on women. In Egypt women could become dancers, but this was not a highly regarded profession. In recompense, however, powerful female patrons, like the Egyptian queen Hatshepsut or the Roman empress Livia, must have imposed their own ideas of style on some of the greatest monuments of the ancient world.

Ancient humanity was still haunted from every side by the irrational, embodied and given legal force in the form of state religions, the violation of whose codes could bring death, as it did to even a figure as universally admired as the philosopher Socrates in Athens in the fifth century B.C. The hidden purposes of ancient deities could be divined only by specially gifted persons (priests or oracles), and their favor was won by sacrifices. Dangerous as these irrational forces might become if not propitiated, it was still to

them that some of the most impressive structures of antiquity, with all their works of art, were conse-crated. We might even say that in the ancient world *irrational* content (devotion to unpredictable and vengeful divinities, sometimes part animal and often free from any commitment to morality in their own behavior) provided the animating spirit within the *rationally* organized works we now respect. At some moment, especially in conventions imposed by religious purposes but systematically carried out, rational and irrational can be said to coalesce. It is from this very equipoise between reason and unreason that ancient art derives much of its excitement.

The social upheavals following the dissolution of the ancient empires were responsible for the destruc-tion of much of humanity's early artistic achievements. Tragic as are our losses—most of the productions of ancient visual art and literature and all of ancient music but for a few tantalizing fragments—archae-ology has won back countless works of art from what had seemed impenetrable darkness. To the High Renaissance of the sixteenth century in Italy, archaeology was a humanist scholar's impracticable dream, but in the eighteenth century it became a reality, and whole buried cities were dug up. Since then archae-ology has developed a scientific theory and a rigorous methodology. In most countries this science has also inspired a determined and often successful attempt at legal control of excavation, whose validity has been recognized internationally by resolutions of the United Nations. The majority of the works of art illustrated in this section, "The Ancient World," were either once buried under the continually rising level of the earth or sunk in the sea. They owe their resurrection to archaeology. The discoveries continue. In recent years, many splendid works of art have come to light, including the two powerful bronze statues illustrated in figs. 217 and 218.

Alas, not all excavation has been disinterested. Temples and tombs have been robbed of their treasures for private gain, and many of the results of such depredations, often involving the ruin of what was left in place or underground, fill museums in every country. It is an experience of unforgettable sadness to visit, for example, the majestic rock-cut temples at Lungmen in Northern China and witness the pitiful remnants of beheaded figures, or the scars left by statues clumsily hacked from their bases. But in spite of violence and cupidity, what is left of ancient art, no matter how scarred or brutally torn from its original setting, remains a supreme intellectual and spiritual heritage—and inspiration—for us today.

CHAPTER

EGYPTIAN ART

ONE

The antiquity and continuity of Egyptian civilization were legendary, even to the Greeks and Romans. In fact, the period of roughly three thousand years during which Egyptian culture and Egyptian art persisted, unchanged in many essential respects, is longer by half than the entire time that has elapsed since the identity of Egypt was submerged in the larger unity of the Roman Empire. Although the rival cultures of the Near East, especially Mesopotamia, had a somewhat earlier start, and even influenced to a limited extent some of the early manifestations of Egyptian art, the Mesopotamian region did not enjoy natural barriers like those that protected Egypt. Consequently, group after group of invaders overwhelmed, destroyed, or absorbed preceding invaders throughout Mesopotamia's stormy history. Moreover, with few observable outside influences, the Egyptians rapidly developed their own highly original forms of architecture, sculpture, and painting earlier than any comparable arts in Mesopotamia, and it is Egyptian rather than Mesopotamian art that provided norms for the entire ancient world. It seems preferable, therefore, to commence our story of the ancient world with Egypt.

The dominating reality of Egyptian life has always been the gigantic vitality of the Nile River. For nearly a quarter of its four thousand miles, it flows through Egyptian territory. The Nile Valley, nowhere more than twelve and a half miles wide, forms a winding green ribbon between the barren rocky or sandy wastes of the Libyan Desert to the west and the Arabian Desert to the east. During the fourth millennium B.C., the valley was inhabited by a long-headed, brown-skinned ethnic group, apparently of African origin, while the Nile delta to the north was the home of a round-skulled people originally from Asia. Remains of Neolithic cultures, including a rich variety of decorated ceramics, abound in both regions.

The chronology of Egyptian history is still far from clear, and most dates are approximate and disputed. But, according to an account set down by a Hellenized Egyptian called Manetho in the second century B.C., the separate kingdoms of Upper (southern) and Lower (northern) Egypt were united by a powerful Upper Egyptian monarch called Menes, founder of the first of those dynasties into which Manetho divided Egyptian history. Menes has been identified by modern scholars as Narmer, the king depicted on the slate tablet in fig. 71. His tremendous achievement—establishing the first large-scale, unified state known to history—took place either shortly before or shortly after 3000 B.C.

The inscriptions that abound on all Egyptian monuments were written in a form of picture writing known as hieroglyphic (examples appear in many illustrations; see figs. 81, 94, 100, 110). Although, for millennia afterward, hieroglyphic was known in Europe and admired for its beauty, it was never understood. In fact, it became the subject for the most fantastic theorizing. Then, in one of the most important discoveries in the history of archaeology, the Rosetta Stone, a fragmentary inscribed slab, was found near the town of Rosetta in the Nile Delta by French scholars who accompanied the armies of General Na-

poleon Bonaparte in his invasion of Egypt in 1799. The slab contained texts in three scripts, Greek (which everyone knew), *demotic* (a late, popular form of Egyptian writing), and hieroglyphic. Although it was immediately guessed that the text was the same in all three scripts, not until 1821 did the young French scholar Jean-François Champollion (1790–1832) succeed in deciphering the other two. Ancient Egyptian turned out to be the direct ancestor of Coptic, a now-extinct language spoken by the Egyptians in Early Christian times and thus known to scholars. Champollion, and his many successors, thus had the key for the deciphering of countless inscriptions and manuscripts, a practice that continues to the present day. Egyptian history, economics, social structure, literature, and religion were open to study, and much can be read in translation.

The Egyptian king, or *pharaoh* as he is known in the Old Testament (from an Egyptian word originally meaning "great house"), was considered divine. He participated, therefore, in the rule of universal law that governed the natural life of the entire valley. The sun rose over the eastern cliffs in the morning and set over the western cliffs in the evening. All day the sun sent down its vivifying rays until it was devoured by the night, but one could be perfectly sure that next morning it would be resurrected. In the same way the Egyptians faced death with the certainty that, like the sun, they would live again. Every autumn the river overflowed, spreading over the land the fertile silt brought from central Africa. Even in the almost total absence of rainfall, abundant crops could be produced. The unchanging order of the natural world was personified by a complex and often changing pantheon of nature deities engaged in a continuous mythological drama rhythmically repeated according to the cycles of nature. By these deities the pharaoh was believed to have been generated, and to them he would return after a life spent maintaining in the state an order similar to that which they had ordained for the Nile Valley—beyond which, at the start of Egyptian civilization at least, little was known and nothing mattered.

The Egyptians built their houses, their cities, and even their palaces of simple materials such as palm trunks, papyrus bundles, Nile mud, and sun-dried bricks. Little is left of the palaces beyond an occasional foundation or fragments of a floor or painted ceiling, and almost nothing of the dwellings of ordinary people. But tombs and temples were soon to be constructed of stone, of which there was an abundance in the desert—sandstone, limestone, granite, conglomerate, and diorite, to name only a few. The Egyptians devoted their major artistic efforts to the gods and to the afterlife, not only in architecture but also in sculpture—both of which were often of colossal dimensions, meant to rival the immensity of the landscape and the sky—and in those delightful decorative reliefs and paintings from which we derive most of our knowledge of Egyptian life. As we will see throughout our survey of their art, with rare exceptions the Egyptians' desire for permanence, stability, and order runs through every aspect of their temples, their tombs, their sculpture, and their painting, determining down to the last detail how every structure should be organized and carried out and even how the human figure should be posed and proportioned.

The Archaic Period and the Old Kingdom, c. 3200–2185 B.C.

A striking illustration of the difference between preliterate, predynastic Egypt and the subsequent tightly organized civilization that was to prove so amazingly durable can be seen by comparing the earliest known example of an Egyptian mural painting (fig. 70), made shortly before 3000 B.C., with almost any subsequent works of Egyptian figurative art. The painting comes from the plaster wall of a tomb chamber at Hierakonpolis, a city in Upper Egypt about fifty miles south of Thebes. Not essentially different from Neolithic rock paintings found in the Spanish Levant, the random composition shows three Nile boats, possibly carrying coffins, attended by tiny figures with raised arms who may represent mourning women. Antelope and other animals are scattered about, and men fight animals and each other.

THE STONE PALETTES Within a relatively short time after this improvised mural with its diagrammatic figures—perhaps as little as a century or two—Egyptian art had changed totally, reflecting the character of the monarchy, which had impressed itself on all aspects of Egyptian life. The most striking examples of this newborn Egyptian art are the stone "palettes" carved on both sides with images in low relief and on one side hollowed into a slight depression. The exact purpose of these palettes is unknown, but since they were found in the lowest levels of religious buildings excavated at Abydos and Hierakonpolis, it is doubtful that they had a purely practical purpose. It has been surmised that they

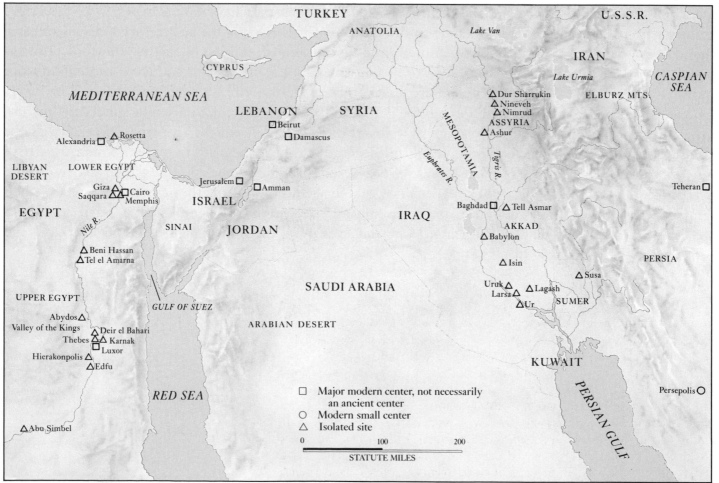

MAP 5. EGYPT AND THE NEAR EAST IN ANCIENT TIMES

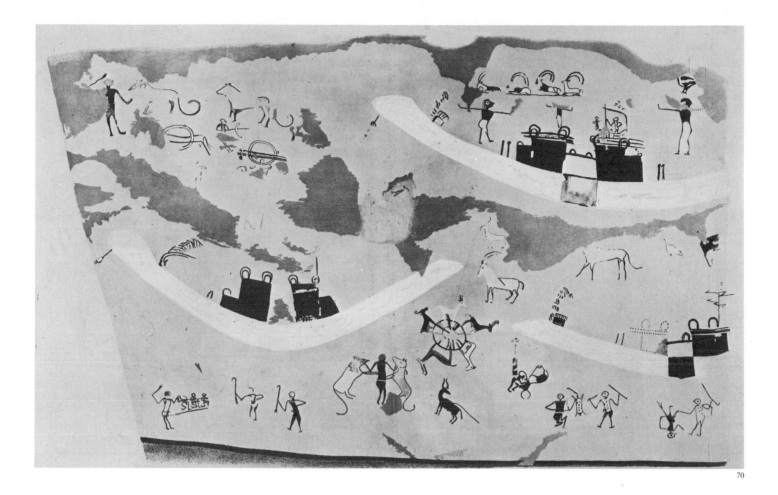

were used to mix the paint applied to the eyes of divine images in order to provide the gods with sight. The finest of these palettes is that of King Narmer (fig. 71), whose capital was at Thinis in Upper Egypt. In this work a sense of total order prevails. The king appears in his own right, standing firmly on a definite groundline; adorned with a bull's tail and wearing the crown of Upper Egypt, he grasps his enemy by the forelock with his left hand while his uplifted right hand brandishes a mace. Cow heads (sign of the goddess Hathor) representing the four corners of the heavens flank an abbreviated symbol of a palace bearing the king's name. Behind the king walks a servant with his sandals; the king is unshod as if to indicate the sanctity of the moment (as later with Moses on Mount Sinai). A hawk, symbol of the sky god Horus, protector of the pharaohs, holds a rope attached to a head growing from the same soil as the papyrus plants of Lower Egypt. Below the king's feet his foes flee in terror.

The other side of the palette (fig. 72) is divided into three registers beneath the cow heads at the top. The king, now wearing the crown of Lower Egypt, strides forth, followed by the sandal bearer and preceded by warriors carrying standards, in order to inspect ten decapitated bodies, their heads placed between their legs. As if to emphasize the king's immense strength, his leg and arm muscles are sharply demarcated. In the central register two felines resembling panthers, perhaps representing the eastern and western heavens, led by divinities from barbaric regions to the east and west of Egypt, entwine their fantastically prolonged necks to embrace the sun disk, hollowed out to form a cup for the paint. (The meanings of these early images are often far from certain; the animals can also be interpreted as symbols of Upper and Lower Egypt.) Below, a bull

70. Tomb painting, from Hierakonpolis, Egypt. Before 3000 B.C. Egyptian Museum, Cairo

symbolizing the king gores a prostrate enemy before his captured citadel, its walls and towers represented in plan—the earliest architectural plan known. The naturalism and sense of order that appear for the first time in these reliefs are no more striking than their introduction of a set of conventions that controlled Egyptian representations of the figure for the next three thousand years. Apparently in order to provide the observer with complete information, the eyes and shoulders are shown frontally while the head, legs, and hips are represented in profile. The weight is evenly divided between both legs, with the far leg advanced. Exceptions are made only when both hands are engaged in the same action, as in the agricultural occupations depicted in wall paintings; then the near shoulder is folded around so that it, too, appears in profile.

THE TOMB AND THE AFTERLIFE The Old Kingdom began in earnest with the Third Dynasty and the removal of the capital to Memphis, in Lower Egypt. Now appear for the first time in monumental form those amazing manifestations of the belief in existence beyond death that dominated Egyptian life and thought. Each human had a mysterious double, the *ka* or life force, that survived his or her death but still required a body; hence the development of the art of mummification. In case the mummy were to disintegrate, the *ka* could still find a home in the statue of the deceased, which sat or stood within the tomb in a special chamber provided with a false door to the other world and with a peephole through which incense from the funeral rites could penetrate to its nostrils. The deceased was surrounded with the delights of this world to ensure enjoyment of them in the next: the tomb was filled with food, furniture, household implements, a considerable treasure, and sometimes even with mummified dogs and cats. The coffin, in the shape of the mummy, could be made of wood and merely painted with ornamental inscriptions and with the face of the deceased, or, in the case of the pharaoh, made of solid gold. The walls of the tomb were adorned with paintings or painted reliefs depicting in exhaustive detail the deceased's life on earth as well as the funeral banquet at which the deceased was represented alive and enjoying the viands. Once the ceremonies were over and the tomb sealed, all this beauty was, of course, doomed to eternal darkness and oblivion. But not quite all, because the royal tombs were systematically plundered even during the Old Kingdom, perhaps by the very hands that had placed the precious objects in their chambers—an odd commentary on the discrepancy between belief and practice.

The characteristic external form of the Egyptian tomb, doubtless descended from the burial mounds common to many early cultures, is called by the name *mastaba* (Arabic for "bench"), a solid, rectangular mass of masonry and mud brick with sloping sides, on one of which was the entrance to a shaft leading diagonally to interconnected tomb chambers excavated from the rocky ground of the western desert (fig. 73). The location was important: the tombs had to be placed out of reach of the annual floods that inundated the entire Nile Valley and to the west of the city, where the sun sank nightly into the desert, for that was the direction from which the deceased began their journies into the other world.

The Step Pyramid at Saqqara. The earliest colossal stone structure we know, the step pyramid of King Zoser at Saqqara (figs. 74, 75), to the west of Memphis, was originally planned about 2750 B.C. as such a mastaba. However, it occurred to the royal architect Imhotep, the first artist whose name has come down to us, to set six mastabas of constant height

71

72

71. *Palette of King Narmer* (front view). c. 3200–2980 B.C. Stone, height 25″. Egyptian Museum, Cairo

72. *Palette of King Narmer* (back view)

but diminishing area one upon the other to form a majestic staircase ascending to the heavens. His creation, rising from the desert, is still a work of overwhelming grandeur, and Imhotep was revered by posterity as a god. The funerary temple was far more impressive when its complex series of surrounding courtyards and temples, whose outer walls measure approximately 1,800 by 900 feet, was intact (fig. 76). All of Imhotep's forms were derived from wooden palace architecture, which he imitated

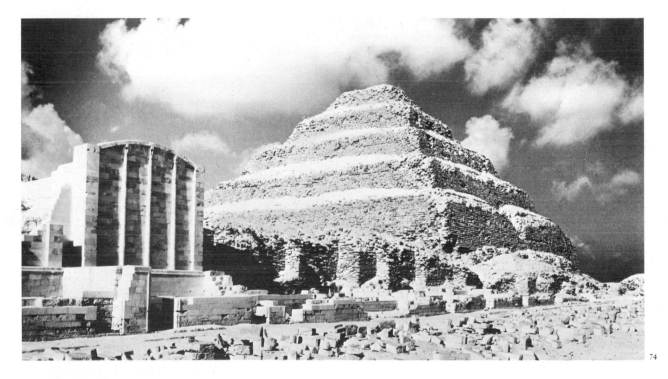

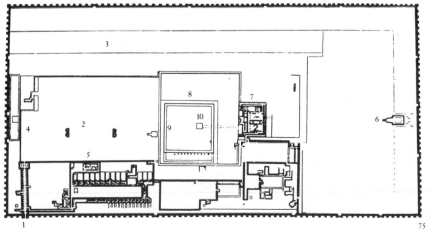

73. Group of mastabas (Architectural reconstruction after A. Badawy) 1. Chapel 2. *Serdab* (statue chamber) 3. Shaft to burial chamber 4. Burial chamber

74. Imhotep. Funerary Complex of King Zoser with step pyramid, Saqqara. c. 2750 B.C. Limestone

75. Plan of the Funerary Complex of King Zoser, Saqqara 1. Entrance Hall 2. Courtyard with two stones for king's ritual race (*heb sed*) 3. Storeroom galleries 4. Secondary tomb 5. King's robing room for *heb sed* 6. *Serdab* (statue chamber) 7. Funerary temple 8. Pyramid 9. Mastaba 10. Shaft to burial chamber

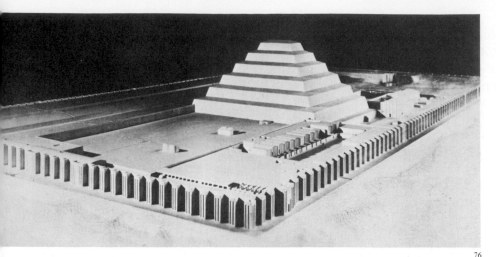

with the utmost elegance in clear golden-white limestone. The surrounding walls, now partly reconstructed, were divided into projecting and recessed members, each paneled. The processional entrance hall, recently partly rebuilt largely from its original stones (fig. 77), had a ceiling made of cylindrical stones in imitation of palm logs, supported by slender columns reflecting in their channeled surfaces the forms of plants, probably palm branches lashed together since the capitals appear to be formalized palm leaves (fig. 78). These are the earliest known columns, and apparently Imhotep did not entirely trust them to bear so great a weight, because he attached them to projecting walls that do most of the work. But the essentials of the Classical column—shaft, capital, and base—are already here.

Similar plant forms of the greatest elegance appear throughout the architecture of the courtyards, in which stood statues of the king and his family, including a colossus, the earliest known, of whom only fragments survive. But one splendid seated lifesize statue of Zoser in limestone, still another first (the earliest known royal portrait) among the achievements of this extraordinary reign, has survived relatively intact. In its majestic pose (fig. 79) we have the prototype of all subsequent seated statues for the rest of Egyptian history. It bears the name of Imhotep on its base. The statue was originally placed in the *serdab*, or sealed statue chamber, built against the center of the north wall of the step pyramid, with two peepholes through which the king could look forth to the sky. The statue's appearance must have been less solemn when the rock crystal eyes, gouged out long ago by tomb robbers, and the original surface paint were intact. The king wears the "divine" false beard, and his massive wig is partly concealed by the royal linen covering. He is swathed in a long mantle descending almost to his feet. The statue is absolutely frontal, utterly immobile, and perfectly calm. Obviously, it was drawn upon three faces of the block of stone and carved inward till the three sides of the figure merged into one another; its nobility of form arises from the perfect discipline of this procedure, recommended for sculptors as late as the Italian Renaissance.

Later stages of the carving process are illustrated in a Sixth Dynasty relief from Saqqara (fig. 80) in which we see two sculptors finishing a statue with mallet and bronze chisel, then polishing it with stone tools. Interestingly enough, while the sculptors are represented with shoulders frontal or folded round according to the necessities of the action, the statue does not conform to the conventions governing living figures, and remains in profile throughout. Immense dignity, if not the majesty of the

76. Model of the Funerary Complex of King Zoser, Saqqara

77. Entrance Hall, Funerary Complex of King Zoser, Saqqara (partly rebuilt)

78. Entrance Hall and colonnade, Funerary Complex of King Zoser, Saqqara (Reconstruction drawing by Jean Philippe Lauer)

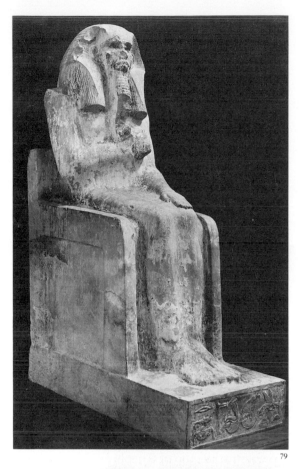

divine monarch, is shared by court officials such as Hesira (fig. 81), holding symbols of his authority as well as writing instruments, in a wooden relief from his tomb at Saqqara. Although slenderer than King Narmer, he stands before us in the same manner, with weight evenly distributed on both feet. Convention also invariably and inexplicably gives relief figures two left hands, except when the right hand is holding something, and two left feet (or two right, in the rare instances when they move from right to left). This convention continues in force except for a brief period in the Eighteenth Dynasty when the feet, but not the hands, are shown as in nature (see fig. 94); immediately thereafter the old convention returns. The present impression of beautifully controlled surfaces of wood given by the Hesira relief would be sharply different if it still retained its original bright paint, but it must always have shown the grace, authority, and firm handling of muscular shapes characteristic of Old Kingdom art.

The Pyramids of Giza. The grandest monuments of the Old Kingdom, and the universal wonder of mankind ever since, are the great pyramids of Giza (fig. 82), a few miles to the north of Saqqara. They were built by three kings of the Fourth Dynasty who are generally known by their Greek names: Cheops, Chephren, and Mycerinus (Egyptian: Khufu, Khafre, and Menkure). It is still unclear whether the perfect shape, with its four isosceles-triangular sides (fig. 83), evolved from the step pyramids at Saqqara and elsewhere, or whether it had special religious significance. The earliest of the Giza pyramids, that of Cheops, is also the largest, originally 480 feet high, more than twice the height of the step pyramid

79. *King Zoser.* c. 2750 B.C. Limestone with traces of paint, height 55″. Egyptian Museum, Cairo

80. *Sculptors at Work*, from Saqqara. c. 2340–2170 B.C. Painted stone relief. Egyptian Museum, Cairo

81. *Hesira*, from Saqqara. c. 2750 B.C. Wood relief, height 45″. Egyptian Museum, Cairo

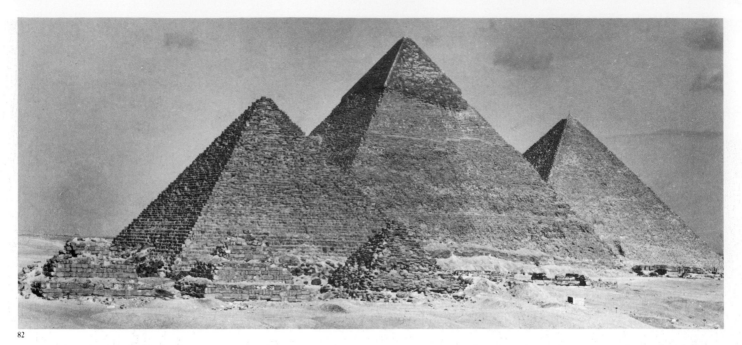

82

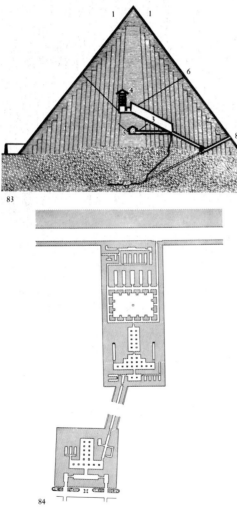

83

84

of Zoser. Whether seen from modern Cairo some eight miles distant or across the rocky ledges and sands of the desert or towering close at hand, these amazing structures convey an impression of unimaginable size and mass. Originally, they also had the characteristic Old Kingdom perfection of form, but this, alas, has vanished since the smooth, finely dressed limestone surface was stripped from the underlying blocks for use in the buildings of Cairo. Only a small portion at the top of Chephren's pyramid remains. No elaborate courtyards were ever contemplated. Each pyramid had a small temple directly before it, united by a causeway with a second or valley temple at the edge of cultivation (fig. 84); the valley temple was accessible from the Nile by canal or, during the floods, directly by boat. Flanking the great pyramids were extensive and carefully planned groups of smaller pyramids for members of the royal family and mastabas for court officials. The great pyramids were oriented directly north and south, and the pyramids of Cheops and Chephren were constructed along a common diagonal axis.

The accounts by Greek and Roman writers of forced labor used to build the pyramids are probably legendary. The concept of large firms of contractors and paid labor is more consistent with what we know of Egyptian society, and remains have been found of a considerable settlement that grew up at the edge of the valley to house workers, supervisors, and planners. Brick ramps were built up; on these the limestone blocks, transported by boat from quarries on the other side of the Nile, could be dragged, probably on timber rollers (the wheel was as yet unknown).

Only the valley temple of Chephren can now be seen (fig. 85); in contrast to Imhotep's architecture at Saqqara, all its forms derive their beauty from the very nature of stone. The walls are built of pink granite blocks, the shafts and lintels are granite monoliths, and the floor is paved with irregularly shaped slabs of alabaster. All the masonry is fitted together without mortar and with perfect accuracy, creating an impression of austere harmony. Alongside the valley temple rises the Great Sphinx (fig. 86), carved from the living sandstone; it is not only the earliest colossus to be preserved but also by far the largest to survive. In spite of later damage by Muslims which has almost destroyed the face, this immense lion with the head of Chephren is possibly the most imposing symbol of royal power ever created.

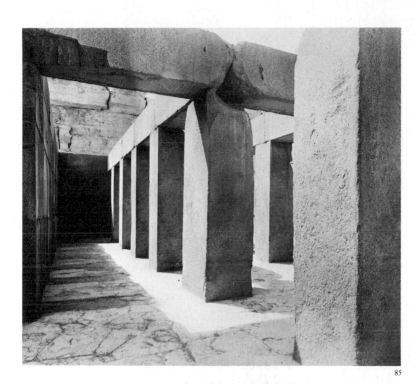

85

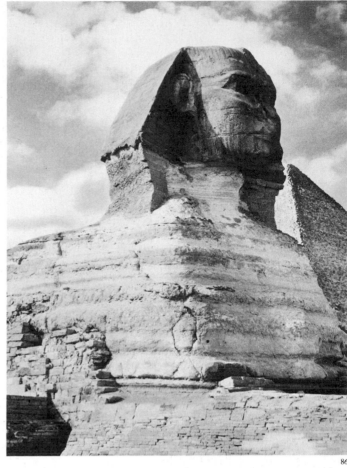

86

OLD KINGDOM STATUES

A statue of Chephren (see fig. 9), which once stood in his valley temple, is luckily almost undamaged. Immobile, grand, unchanging, the pose of the figure derives from that of Zoser (see fig. 79). Seated on a lion throne, the king is clad only in a richly pleated kilt and a linen head covering, horizontally pleated over the shoulders, that completely conceals the customary wig. The lines of this massive headdress are perfectly aligned with the wings of the hawk-god Horus, spread in protection behind the king's head. The broad, simple treatment of the shapes, the grand proportioning of the elements, and the smooth movement of the unbroken surfaces of diorite all culminate in the noble features of the king, whose serene expression bespeaks calm, total, unchallengeable control. In lesser works the systematic method of the Egyptian artists sometimes results in uniformity and mediocrity, but in the hands of the finest Old Kingdom sculptors the method itself exemplifies Egyptian beliefs regarding the divinity of the king and is the visual counterpart of the unalterable law governing earth and sky, life and death. By common consent, the *Chephren* is both one of the supreme examples of ancient sculpture and one of the great works of art of all time.

Somewhat less impersonal than the *Chephren* is the superb group statue showing King Mycerinus, wearing a kilt and the crown of Upper Egypt, flanked by the cow-goddess Hathor and a local deity (fig. 87). Each of the goddesses has an arm around Mycerinus as if to demonstrate his habitual intimacy with divinities. The work is carved from gray-green schist, and although the sculptor has not maintained quite the exalted dignity so impressive in the *Chephren*, he has delightfully contrasted the broad-shouldered, athletic figure of the king with the trim, youthful, sensuously beautiful forms of the female divinities, fully revealed by their clinging

82. Pyramids of Mycerinus (c. 2500 B.C.), Chephren (c. 2530 B.C.), and Cheops (c. 2570 B.C.), Giza, Egypt. Limestone, height of Cheops pyramid c. 480'

83. North-south section of the Pyramid of Cheops, Giza (Drawing after L. Borchardt) 1. Original fine limestone facing 2. Entrance 3. Large gallery 4. King's burial chamber 5. So-called queen's chamber 6. Possible air-shafts 7. False tomb chamber 8. Tunnels dug by thieves

84. Plan of the Pyramid of Chephren and Valley Temples, Giza

85. Valley Temple of Chephren, Giza. c. 2530 B.C.

86. The Great Sphinx, Giza. c. 2530 B.C. Sandstone, 65 × c. 240'

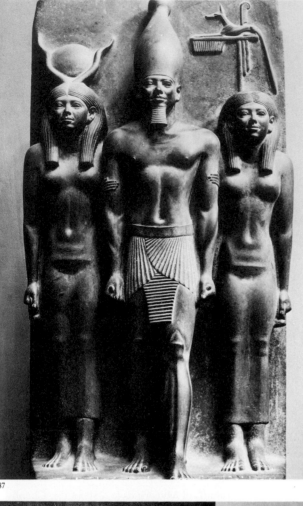

87

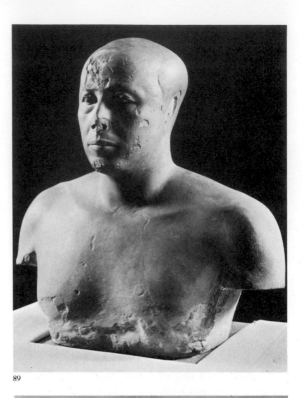

89

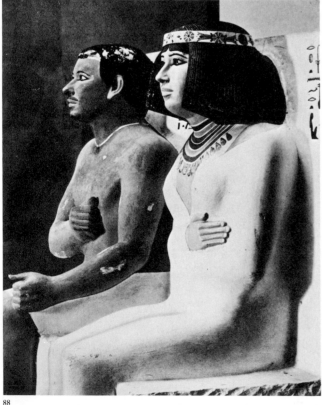

88

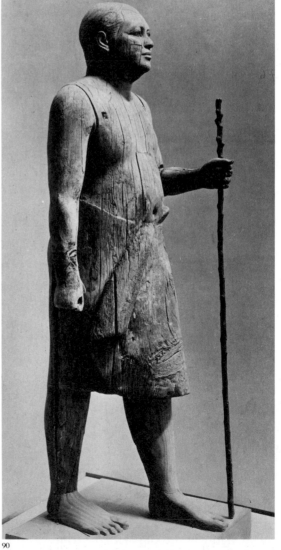

90

garments. Interestingly enough, while the king stands with legs apart, weight evenly distributed on both feet as in the *Hesira* relief, Hathor takes only a timid step forward and the local goddess keeps her feet together as if rooted to the spot.

While the royal statues are obviously individualized portraits, Old Kingdom naturalism is held in check by the need to emphasize the majesty and divinity of the pharaoh. But even in the more vividly lifelike statues of princes and officials, the dignity, simplicity, and balance characteristic of the Old Kingdom are consistently maintained. *Prince Rahotep and His Wife Nofret* (fig. 88) is carved from limestone, softer and easier to work than diorite or schist. The pair retain most of their original coating of paint. Rahotep is brown, his wife yellow ocher—the colors used by the Egyptians to distinguish male from female, probably to show that men braved the fierce sun from which delicate female skin was protected. The coloring, combined with the inlaid eyes of rock crystal, Rahotep's little mustache, and Nofret's plump cheeks, gives the pair an uncanny air of actuality that, to modern eyes, contrasts strangely with their ceremonial poses. On a far higher plane is the painted limestone bust of *Prince Ankhhaf* (fig. 89), son-in-law of Cheops. The aging forms of body and face are clearly indicated, but the whole is pervaded with a mood of pensive melancholy that makes the observer wonder about its origin. This beautiful psychological portrait is unique in its subtlety among the more forthright Old Kingdom figures.

The Fifth Dynasty wooden statue of Kaaper (fig. 90), originally painted, betrays a lower-class allegiance; its uncompromising realism, not sparing the fat belly and smug expression of the subject, has earned the statue the modern nickname of *Sheikh el Beled* (Arabic for "headman of the village"), but the artist has not sacrificed any of the firmness and control typical of the best Old Kingdom work. Another brilliant Fifth Dynasty portrait is the painted limestone *Seated Scribe* (fig. 91), doubtless portraying a bureaucrat, alert and ready to write on his papyrus scroll. The engaging figure is just as intensely real and just as rigid as *Kaaper*.

RELIEF SCULPTURE AND PAINTING Our understanding of life in Old Kingdom Egypt is illustrated with a completeness beyond any expectations by the innumerable scenes—carved in low relief on the limestone blocks of tomb chambers and then painted, or painted directly without underlying relief—that describe in exhaustive detail the existence the deceased enjoyed in this world and hoped would be perpetuated in the next. Only such scenes are represented; the paintings do not tell stories. Within the conventional structure of Egyptian style, these scenes describe in rich detail all the elements of what we know to be taking place, not just the incident as we might see it from one vantage point. Usually the walls are divided into registers, each with a firm and continuous groundline and no indication of distant space. For example, in a relief representing a high official, *Ti Watching a Hippopotamus Hunt* (fig. 92), the owner of the tomb is represented at least twice the size of the lesser figures, and he merely contemplates, but does not participate in, the events of daily existence. Yet, since the scenes line the walls of the tomb chambers on all sides, they surround us with the illusion of an enveloping space in which we walk among the humans, animals, birds, and plants of 4,500 years ago. In this case the background consists of vertical grooves to indicate the stems of a papyrus swamp. Ti stands in his boat, posed according to the principles of relief representation we have already seen, holding his staff of office, while men in a neighboring

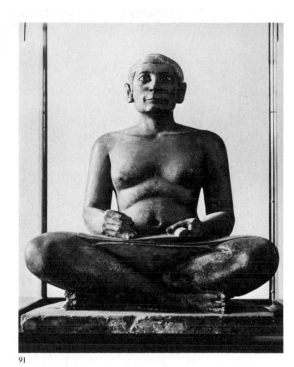

91

87. *King Mycerinus Between Two Goddesses*, from the Valley Temple of Mycerinus, Giza. c. 2570 B.C. Gray-green schist, height 37⅜". Egyptian Museum, Cairo

88. *Prince Rahotep and His Wife Nofret*. c. 2610 B.C. Painted limestone, height 47¼". Egyptian Museum, Cairo

89. *Bust of Prince Ankhhaf*, from Giza. c. 2550 B.C. Painted limestone, height 22½". Museum of Fine Arts, Boston

90. *Kaaper (Sheikh el Beled)*, from Saqqara. c. 2400 B.C. Wood, height 43". Egyptian Museum, Cairo

91. *Seated Scribe*, from Saqqara. c. 2400 B.C. Painted limestone, height 21". The Louvre, Paris

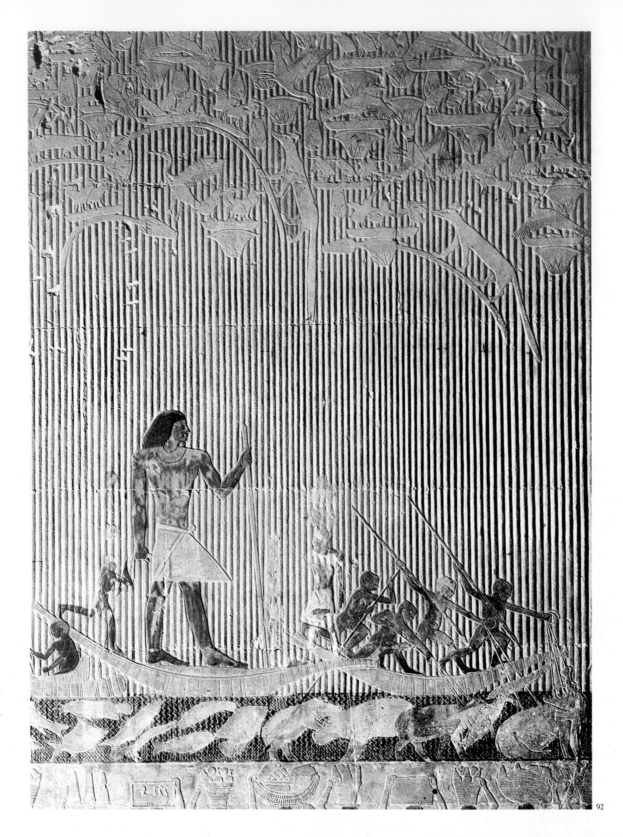

92

boat spear the hippopotamuses. Toward the top of the relief are scattered papyrus flowers, among which wild animals lurk and birds fly or nest in an amazing variety of beautifully rendered poses. There is none of the random waywardness of the Hierakonpolis mural (see fig. 70). An exact sense of order prevails—even the spears of the huntsmen are drawn parallel to one line of the triangle formed by Ti's kilt. Among the innumerable incidents that line the tomb is a touching scene (fig. 95) in which cattle are being led across a river and a terrified calf, too small to ford the

92. *Ti Watching a Hippopotamus Hunt*, from the Tomb of Ti, Saqqara. c. 2400 B.C. Painted limestone relief, height c. 45″

93. *Geese of Medum* (detail of a fresco). c. 2600 B.C. Egyptian Museum, Cairo

94. Preparatory drawing and relief from the Tomb of Horemheb, Valley of the Kings (west of Thebes, Egypt). c. 1334–1306 B.C.

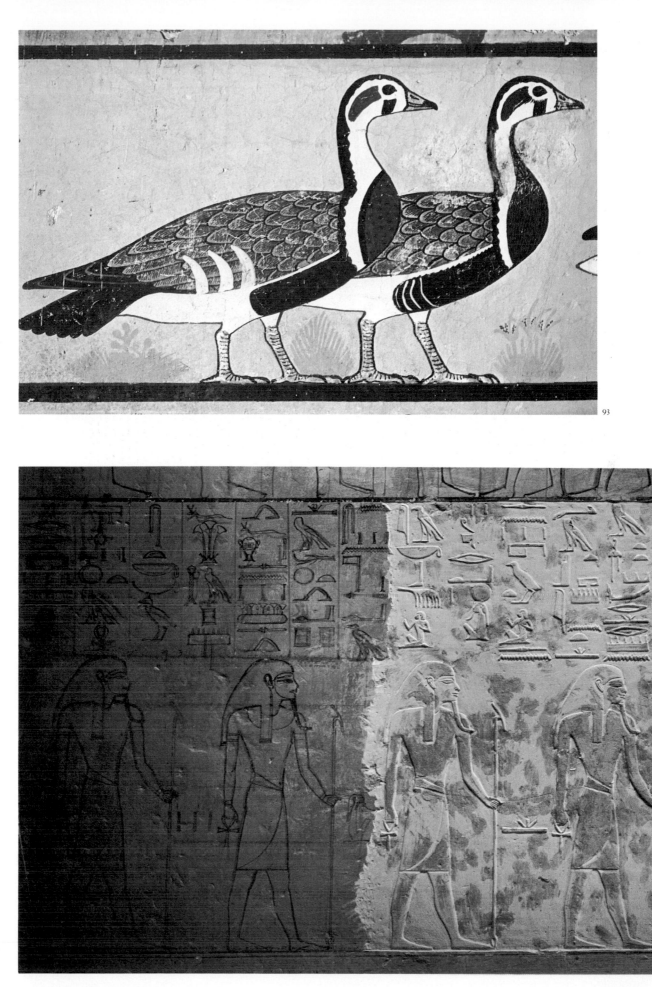

93

94

stream, turns its head as it is carried over and cries to its anxious mother. The water is convincingly suggested by parallel vertical zigzags, over which the legs of humans and animals are painted, not carved.

The celebrated *Geese of Medum* (fig. 93), actually a strip from a continuous series of wall paintings, shows the extent to which the Old Kingdom could carry both its naturalism and its strong sense of form, so fused that the formalization characteristic of almost all Egyptian art seems to be derived effortlessly from the motion of these delightful birds, rather than from outside, as is so often the case with representations of human beings.

Luckily, a few unfinished tomb designs are preserved, left in that state because the deceased, for some unknown reason, had to be buried in haste. An unfinished passage from the later tomb of the pharaoh Horemheb (fig. 94), in the Eighteenth Dynasty, shows us how the reliefs were made. First, as we see in the left-hand figure, the painter did his preparatory drawing on the stone, according to a fixed system of proportions represented by ruled lines. But the artist was clearly very sensitive to nuances of contour and changed his outline two or three times before he was satisfied. Then, either he or a specialized stone carver cut out the shallow relief according to the drawing, down to a uniform background level. Finally, the painter returned to color the figures and objects. Even more revealing is a scene from the tomb of Neferirkara (fig. 96), from the Fifth Dynasty, in which only the preliminary drawing was ever done. Presumably the finished birds would have been drawn and painted with the same precision as the *Geese of Medum*, but the present airy grace of the descending pigeons comes not only from the astonishing variety of their poses but from the lightness of the brush drawing as well.

Although it was in Old Kingdom Egypt that people first learned to be fully human, our ideas of Old Kingdom art and life are entirely formed on the funerary art through which the Egyptians faced eternity. Their

95. *Cattle Fording a River* (detail of a relief from the Tomb of Ti, Saqqara). c. 2400 B.C. Painted limestone

96. *Birds in Flight*, preparatory drawing from the Tomb of Neferirkara, Saqqara. c. 2480–2340 B.C. Limestone

97. Model of a troop of Nubian mercenaries, from a tomb at Asyūt, Egypt. 2181–2133 B.C. Painted wood, height 15¾". Egyptian Museum, Cairo

98. Funerary Temple of Mentuhotep III, Deir el Bahari, Egypt. After 1990 B.C. (Architectural reconstruction after Dieter Arnold)

houses, palaces, and temples have mostly vanished, leaving hardly a clue. In the very nature of things, the beautiful system that sustained and gave meaning to the life of the Old Kingdom could not last forever. Perhaps the cost of the great funerary temples and pyramids was too heavy to bear. A king who is also a god must be able to act the part. At any rate, the weak kings of the Seventh and Eighth dynasties could not meet these demands, and their reigns were followed by a period of great social disorder during which the real power passed into the hands of provincial rulers and little art worthy of notice was created.

MIDDLE KINGDOM ARCHITECTURE In a prolonged struggle, the kings of the Eleventh Dynasty regained power from provincial rulers and reunited the country, whose capital oscillated between Memphis in Lower Egypt and Thebes in Upper Egypt. Power no longer depended upon the divine authority of the pharaoh but on military force. Tombs often contained remarkable miniature groups in wood, representing every kind of daily activity, including the all-important military ones. A company of forty Nubian mercenaries (fig. 97) advancing toward us is a brutal indication of the changed conditions of the Middle Kingdom. Some small stone-faced brick pyramids were built, and numerous tombs whose

The Middle Kingdom, c. 2040–1650 B.C., and the Empire, c. 1550–1070 B.C.

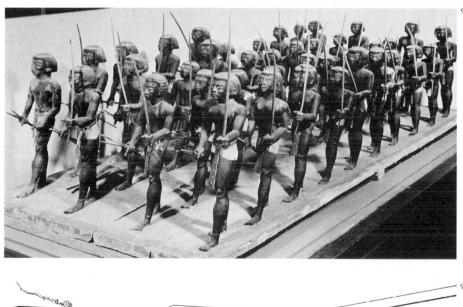

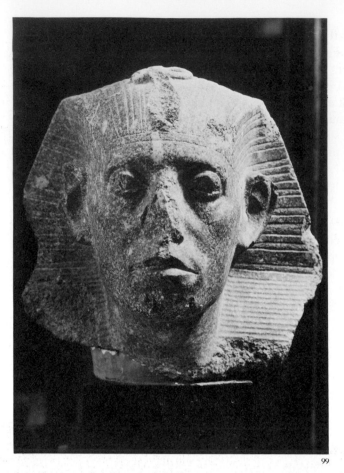

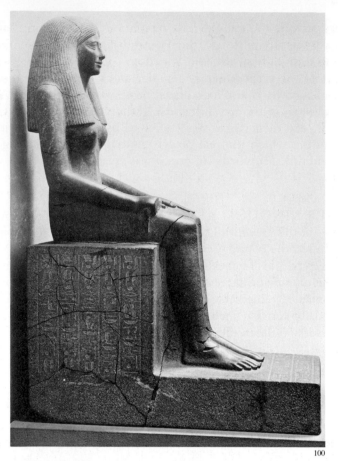

chambers and columned halls were cut directly into the rock, but the most impressive architectural work we know from this period is the funerary temple of Mentuhotep III at Deir el Bahari, across the Nile from Thebes. From what remains of the building, alongside which Queen Hatshepsut was later to build her even more ambitious temple (see fig. 102), we can reconstruct its original appearance (fig. 98). From a grove of geometrically aligned trees a long ramp led to a terrace supported by a row of square piers; from there one entered a second colonnade through a canted doorway and moved into a courtyard from the center of which rose a massive block with canted sides like a huge mastaba outlined against the immense cliffs of the western mountain. According to some reconstructions, the tomb may have been topped with a small pyramid. The scale, as compared to Old Kingdom tombs, is almost human.

99. *King Sesostris III*, from Medamud, Egypt. c. 1878–1843 B.C. Granite. Egyptian Museum, Cairo

100. *Princess Sennuwy*, from Kerma, Sudan. c. 1950 B.C. Granite, height 67½″. Museum of Fine Arts, Boston

101. *Queen Hatshepsut*. c. 1495 B.C. Limestone, height c. 77″. The Metropolitan Museum of Art, New York. Rogers Fund and contribution from Edward S. Harkness, 1929

MIDDLE KINGDOM SCULPTURE Some royal portraits reveal with devastating frankness the chronic anxiety in which, according to literary accounts, Middle Kingdom monarchs lived, tormented by the military struggles needed to maintain their rule. Especially intense are the brooding portraits of Sesostris III (fig. 99), whose careworn face shows none of the serene confidence of the Old Kingdom. Against such a background, the exquisite seated statue of Princess Sennuwy, posed like a pharaoh (fig. 100), comes as a delightful surprise. This masterpiece in polished granite shows in its slender forms and softly flowing surfaces a style as sensuous as that of the best Old Kingdom female figures but endowed with a wholly new elegance and grace.

At the close of the Twelfth Dynasty ensued a new period of political chaos, during which Lower Egypt was invaded by Asiatic rulers known as the Hyksos, or shepherd kings. These conquerors imported two com-

modities soon to be triumphantly adopted by the Egyptians—the horse and the wheel. After a century of foreign rule, pharaohs from Upper Egypt for the third time regained power, and the Eighteenth Dynasty saw not only the expulsion of the Hyksos and the reunification of the country, with its capital at Thebes, but also the extension of Egyptian power over neighboring lands as well—Syria, Palestine, Libya, Nubia, an area more than 2,000 miles in length.

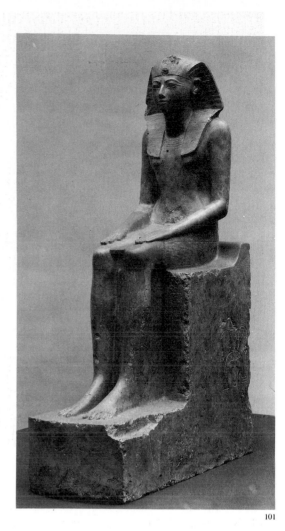

101

ARCHITECTURE OF THE EMPIRE The next five centuries, variously known as the Empire or the New Kingdom, constitute a period of unprecedented imperial power and wealth, celebrated by enormous architectural projects, largely in the surroundings of the Theban metropolis—at modern Karnak and Luxor on the east bank of the Nile and Deir el Bahari on the west. Amon, the local deity of Thebes, was promoted to the ruling position among the gods in recognition of his services to the Empire and was identified with Ra, the sun god, thus becoming Amon-Ra. The new temples were often decorated with statues, reliefs, and paintings representing the power and historic exploits of the pharaohs.

The Mortuary Temple of Queen Hatshepsut. Among the earliest of these ambitious builders of the Empire was Queen Hatshepsut, the first great female ruler of whom we have any record. Daughter of Tuthmosis I, half-sister and wife of his weak successor, Tuthmosis II, she ruled first as queen consort, then after her husband's death, supposedly as regent for her stepson Tuthmosis III. In fact, she assumed power as pharaoh and governed peacefully for twenty years (c. 1501–1481 B.C.). A limestone statue of this brilliant monarch (fig. 101), clad in her kingly headcloth and kilt, reminds us of the slenderness and delicacy of the statue of Sennuwy more than four hundred years earlier, yet radiates an air of majesty and quiet power.

Hatshepsut's immense mortuary temple (figs. 102, 103), alongside and to the north of that of Mentuhotep III (see fig. 98) at Deir el Bahri, directly across the Nile from the capital at Thebes, consists of three ascending colonnaded terraces, connected by ramps, and a final colonnaded court, now largely destroyed. The outer colonnades employ simple, square pillars, but the columns of the sanctuary of Anubis (fig. 104), at the right of the second terrace, and also the inner columns of the sanctuaries, are delicately faceted into sixteen slightly concave sides, a form invented during the Middle Kingdom that deceptively suggests the fluted columns of later Greek temples. In the blinding glare of Egyptian sunlight the present effect looks a bit bleak, but was surely sumptuous when the queen's full array of brightly painted statues, not to speak of the rich plantings, were all in place. Alas, her successor, the mighty conqueror Tuthmosis III, obtained his revenge for his long wait by having them all smashed, but many have been put together from the fragments. Hatshepsut was represented as a divine king, with red or yellow skin, blue eyebrows, and false beard. Colossal painted statues of the queen in dark granite knelt at either side of the entrance to the sanctuary, and a row of huge standing statues in limestone, blazing with color, stood before the pillars of the upper terrace, crowning the entire complex and doubtless visible for miles. All in all the queen was shown more than seventy times in superhuman scale; in addition, her head appeared on more than a hundred painted sandstone sphinxes and on twenty-two more in red granite facing each other in a double rank up the center of the lower terrace.

All that is still left in place of this brilliant display of color are the

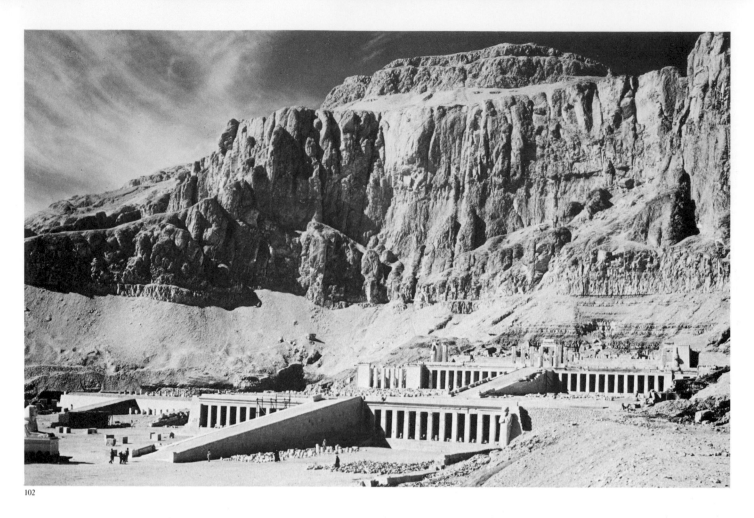

102

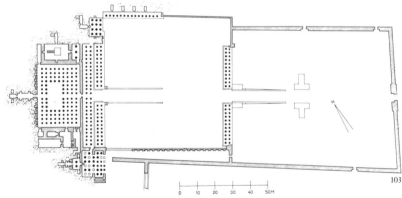

103

104

open halls on the right side of the middle terrace (see fig. 104), which contain generally well-preserved reliefs narrating in great detail scenes from Hatshepsut's life, beginning with her supposed divine origin as a daughter of Amon. The terraces were filled with fragrant myrrh trees, highly prized as a source of incense, and the reliefs include representations of the expedition dispatched by Hatshepsut to the distant land of Punt, in modern Somalia near the coast of the Red Sea, to acquire these precious trees. People, dwellings, plants, animals, and birds all appear, and the ruler of Punt is shown next to his magnificently corpulent queen (fig. 105), whose fat piles up in rolls on her swaybacked body, long arms, and stubby legs. There are also a number of tiny portraits of Hatshepsut's architect and chief minister, Senmut, usually shown kneeling at the entrances to various sanctuaries. Senmut may also have been the queen's lover; his tomb, left unfinished at her death, was carved from solid rock

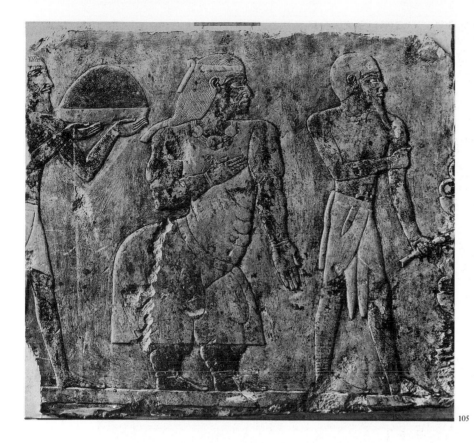

105

underneath the temple. A worthy successor to Imhotep of the Old Kingdom, Senmut planned the uppermost courtyard to abut the mass of the cliff into which the sanctuary chamber of Amon is cut, since the sun bark disappeared over the mountain daily. Thus the thousand-foot mass of the living rock of the western mountain substitutes for a man-made pyramid.

The Temples of Luxor and Karnak. A powerful priesthood in Thebes administered the royal temples of Amon, his wife Mut, and their son Khonsu at Luxor and at Karnak. These were originally connected by an avenue of sphinxes more than a mile in length, of which hundreds are still in place. Egyptian temples, unlike those of the later Greeks, offered no unified outer view. They were built along a central axis to enclose a succession of spaces of increasing sanctity and exclusiveness, starting with the entrance gateway, which was flanked by slanting stone masses called pylons. Our illustration (fig. 106) is drawn from the much later Temple of

106

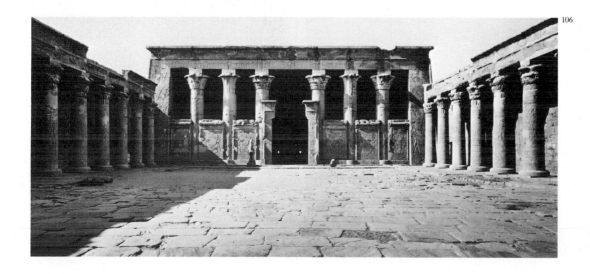

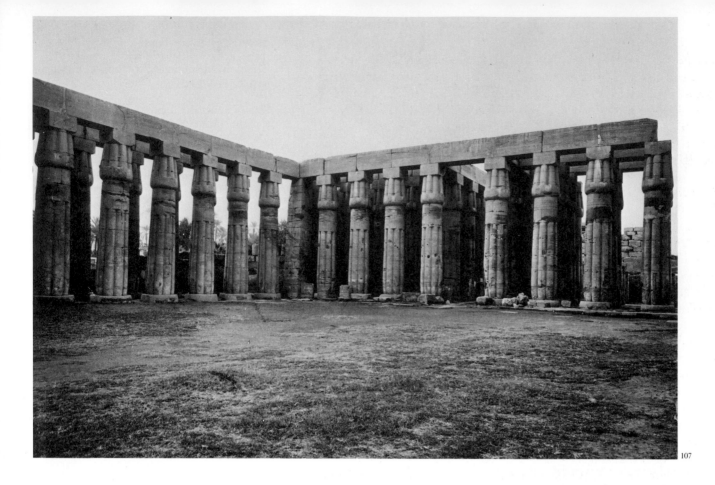

107

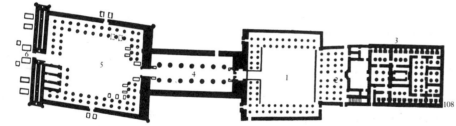

108

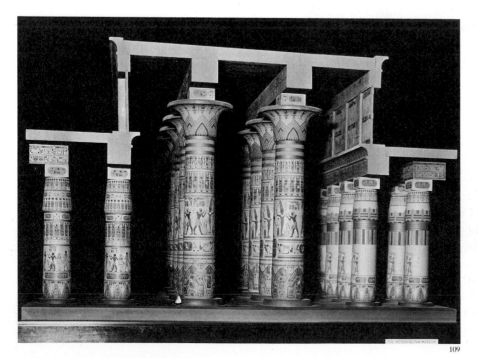

109

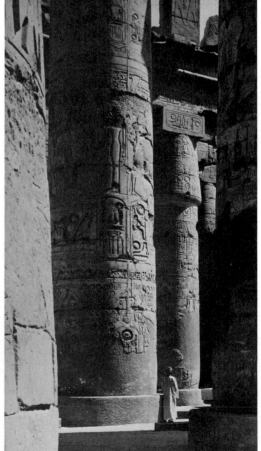

110

Horus at Edfu, which closely followed the principles and shapes established in the Empire. Through the gateway the worshiper was admitted to a spacious colonnaded court. Then came one of the most characteristic features of Egyptian imperial temples, the hypostyle hall, a lofty room whose stone roof was supported by immense columns. The central section of this structure (see fig. 109) was usually elevated above the sides and was lighted and ventilated by a row of upper windows known as a clerestory. This feature was adopted in Roman architecture as well and was then used constantly throughout the Middle Ages in Europe and the Near East. The strong Egyptian sunlight and great heat were controlled by stone grilles in the clerestory windows. Clerestory, grilles, and all were derived from wooden counterparts in Egyptian houses. After the hypostyle hall came the smaller, more secret, and much darker sanctuaries containing cult statues and the "bark of Amon" (sacred boat), reserved for the priesthood and their rituals.

The Temple of Amon-Mut-Khonsu at Luxor was built by Amenhotep III on this standard principle in the late fourteenth century B.C., but he soon added an impressive entrance hall (fig. 108). Later Ramses II added a second courtyard and a new set of entrance pylons in front, deflecting the axis on account of the curve of the nearby Nile. The immensity of Amenhotep's thirty-foot columns (fig. 107) is far removed from the elegance and purity of Imhotep's forms, but the problems themselves required new solutions. The unknown architect at Luxor built massive freestanding columns of local sandstone rather than of the fine limestone available at Saqqara, and he shaped them according to the conventionalized forms of bundles of papyrus reeds, traditional supports for the more ephemeral architecture of the vanished Egyptian houses and palaces. The columns sustain huge undecorated sandstone lintels that surround the courtyard and continue in the hypostyle hall, where they supported a now-fallen roof of stone slabs. Light came from the clerestory over low walls, so that the center of the hall remained mysteriously dim. The grand proportions of the columns, which seem to continue in all directions, always blocking any clear view, create an effect of majestic solemnity.

The even larger and far more complex temple at Karnak was one of the most extensive sanctuaries of the ancient world, with a perimeter wall about a mile and a half in circumference. The partially ruined temple was constructed piecemeal by so many pharaohs that the overall effect is confusing, yet many of the surviving portions are very beautiful. The hypostyle hall (figs. 109, 110) built by Seti I and Ramses II in the Nineteenth Dynasty was filled with columns so massive that diagonal views are impossible from the central axis. Wherever one looks, the vista is blocked by these immense shapes, decorated by bands of incised hieroglyphics and painted reliefs.

TOMB DECORATIONS Scores of tombs survive from the period of the Empire. Pharaohs and aristocracy alike gave up building monumental tombs, which could not be defended against robbers. The dead were buried deep in rock-cut chambers in mountain valleys, and the entrances carefully hidden. Even the royal tombs in the Valley of the Kings, west of Thebes, were invariably discovered and plundered, but the wall decorations remain. In the splendid Eighteenth Dynasty painted tomb of Nebamun at Thebes (fig. 114), the deceased is shown fowling. Accompanied by his hunting cat, he plays havoc among the brilliantly drawn and painted birds of a papyrus swamp. A fragment from this same tomb

107. Court of Amenhotep III, Temple of Amon-Mut-Khonsu, Luxor (view into hypostyle hall)

108. Plan of the Temple of Amon-Mut-Khonsu, Luxor, Egypt. c. 1375 B.C. (After N. de Garis Davies) 1. Colonnaded court 2. Hypostyle hall 3. Sanctuaries 4. Entrance hall (addition by Amenhotep III) 5. Colonnaded court (addition by Ramses II) 6. Pylons (addition by Ramses II)

109. Model of hypostyle hall, Temple of Amon-Ra, Karnak, Egypt. c. 1290 B.C. The Metropolitan Museum of Art, New York. Bequest of Levi Hale Willard, 1890

110. Portion of hypostyle hall, Temple of Amon-Ra, Karnak. c. 1290 B.C. (begun by Seti I and completed by Ramses II)

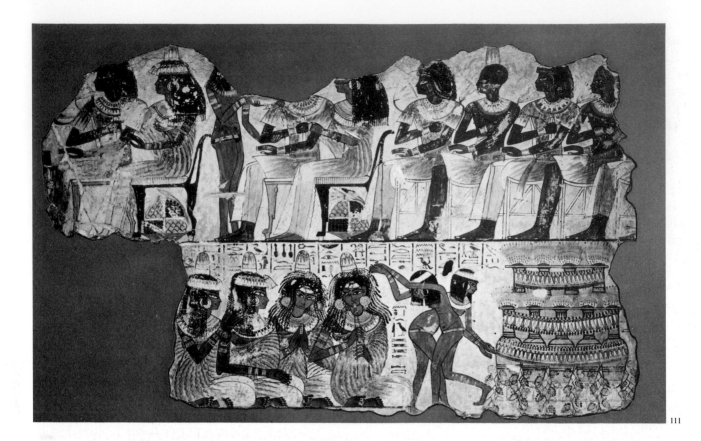

111

(fig. 111) shows an entrancing banquet scene, at which both the revelers and the musicians wear cones of perfumed unguents on their heads. Delightful female dancers, clad only in jeweled collars and tiny golden belts, clap their hands as they move with exquisite lightness and grace. While most of the figures are shown from the side, two of the crouching musicians unexpectedly face directly outward, and all the crouching figures point the soles of their feet toward us. In such poses, apparently, Egyptian conventions were useless and therefore thrown aside. In the subtle, delicate style of the Eighteenth Dynasty there can also be great pathos, as in the relief of the *Blind Harper* (fig. 112) from the tomb of Patenemhab at Saqqara, in which the harper gently strums his octave of strings. His song is inscribed on the wall beside him:

Pass the day happily, O priest.
. . . have music and singing before you,
Cast all ill behind you and think only of joy,
Until the day comes when you moor your boat in the land that
loves silence.

Characteristic of the arrangement of scenes in superimposed strips is the tomb of Sen-nedjem at Deir el Medineh, from the Nineteenth Dynasty (fig. 113). At the end of the chamber the deceased crosses to the other world in the boat of the dead to be received by the gods, and below are shown the harvest of his grainfields and the rows of his fruit trees. On the right the gods themselves are aligned above his funeral feast. As in the tomb of Ti, scenes like these in registers continuing around the chamber create a special kind of space that, once one accepts the conventions of Egyptian art, becomes surprisingly real and convincing when one actually stands in the chamber, surrounded by the paintings on all sides.

111. *Banquet Scene*, fragment of a wall painting from the Tomb of Nebamun, Thebes. c. 1400 B.C. British Museum, London

112. *Blind Harper*, relief from the Tomb of Patenemhab, Saqqara. c. 1552–1306 B.C. Rijksmuseum van Oudheden, Leiden, the Netherlands

113. Wall paintings from the Tomb of Sennedjem, Deir el Medineh (Thebes). c. 1150 B.C.

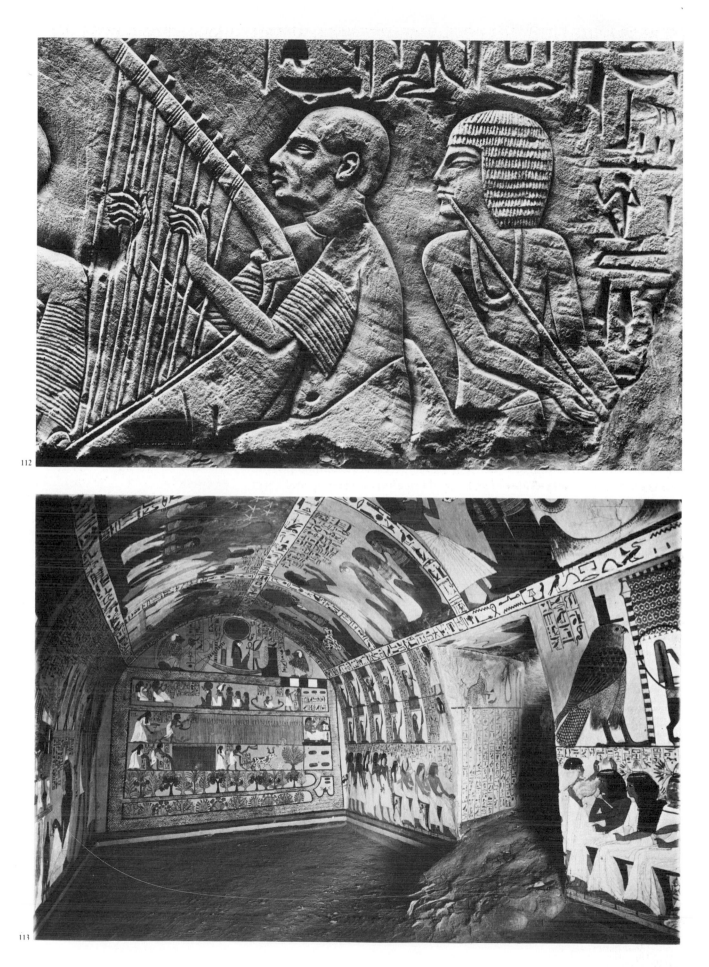

112

113

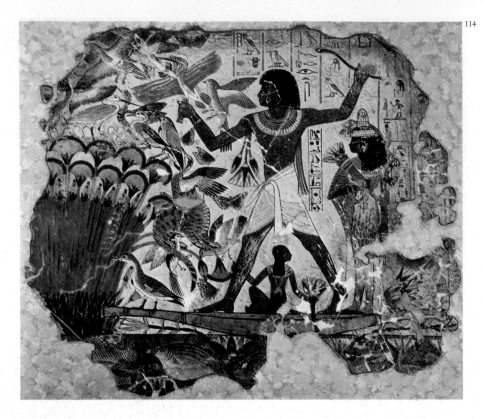

114. *Nebamun Hunting Birds*, fragment of a wall painting from the Tomb of Nebamun, Thebes. c. 1400 B.C. British Museum, London

115. *King Akhenaten*, from the Temple of Aten, Karnak (fragment). c. 1360 B.C. Sandstone, height 60¼". Egyptian Museum, Cairo

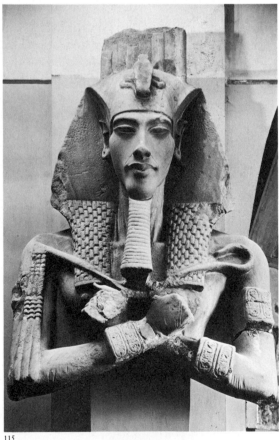

115

AKHENATEN Just when everything about Egyptian life and art seemed to be safely settled for an indefinite period, an unexpected reformer appeared who tried his best to unravel the entire fabric, and indeed succeeded for a limited time. During the reign of Amenhotep III in the Eighteenth Dynasty (1567–1320 B.C.), there arose at the imperial court a new cult that worshiped the disk of the sun, called the Aten. Amenhotep's son, first his co-ruler and then his successor, changed his name from Amenhotep IV to Akhenaten in honor of the new solar god, of whom he declared himself to be the sole earthly representative. This extraordinary religion, a kind of early monotheism, required the closing of the temples of Amon-Ra and the disinheriting of the priesthood, which had become the true ruling class of Egyptian society. Although Akhenaten built a new Temple of Aten at Karnak, he moved the capital from Thebes to an entirely new site, dedicated to Aten, at a spot now called Tell el Amarna. The insubstantial secular buildings of the Egyptians usually vanished, like those of Çatal Hüyük, under new structures, leaving few traces, but when Akhenaten died his successors were so anxious to wipe out the memory of the heretic that they destroyed the new city of Akhenaten immediately. The plans and even painted floors from the palace and from the houses of state officials have, however, been excavated, and the entire contents of a sculptor's studio were discovered, including casts from life, models for sculpture, and unfinished works.

Something of the character of this royal visionary who neglected the military necessities of empire to promulgate his new religion can be seen from strange statues and reliefs of him and others, which have been found in considerable numbers because they were used as building blocks by later pharaohs. One colossal pillar statue from the Temple of Aten at Karnak (fig. 115) shows his slack-jawed, heavy-lipped features and dreamy gaze and, instead of the athletic male ideal of the earlier pharaohs, an exaggeratedly feminine body with swelling breasts—as if the king in his new messianic role were to embody both paternal and maternal principles. An incised relief (this method, which freed the sculptor from the

necessity of reducing the entire background, was characteristic of large-scale Empire reliefs) shows the king sacrificing to Aten (fig. 116), whose rays terminate in hands that bestow life to the earth, represented by papyrus plants. He is followed by the queen, Nefertiti, whose figure is shaped just like his, though in smaller scale, and by a still smaller daughter.

The famous painted limestone bust of Nefertiti (fig. 117), a work of consummate elegance and grace, shows the queen at the height of her beauty, wearing the crown of Upper and Lower Egypt and decked with the usual ceremonial necklaces. Every plane of her strong cheekbones, perfect nose, firm chin, and full lips, and every line of the heavy makeup applied to her eyebrows, eyes, and mouth, moves with an arresting combination of smoothness and tension. The slender, long-necked ideal is irresistible to twentieth-century eyes, attuned to contemporary fashion. But entranced viewers of this masterpiece, less often of the original than the countless reproductions on sale everywhere, seldom realize that this bust was never intended for public view. It is a model for official portraits of the queen and was found in the studio of the sculptor who made it. It comes as a shock to note that he never finished the left eye (the eye is completed in all the copies)! If we were to see this same lovely head poised above the flat-chested, full-bellied figure visible in all representations of Akhenaten's surprising family, we might be less charmed. Nonetheless, there is something undeniably personal about this astonishing model. We would perhaps be justified in considering it a testament of admiration on the part of a great if unknown artist to the beauty but also to the intelligence and supreme calm of an extraordinary woman.

TUTANKHAMEN Through a happy accident of history, even more is preserved to show the brief life and activities of Akhenaten's successor, known to us by the name Tutankhamen, who died between eighteen and twenty years of age. The young king may have been Akhenaten's younger half brother; his name was forced upon him by the revived priesthood of Amon. His is the only royal tomb that has been found intact; it had been obscured and protected by debris from a later tomb. When discovered in 1922, the chambers contained a dazzling array of beautiful objects, displaying the taste of the imperial court for delicacy and grace. The king's many coffins, one inside the other, were found intact. The innermost, of solid gold, weighs 222 pounds! The cover of the coffin has a breathtaking portrait of the boy king in solid gold, with the ceremonial beard, the eyebrows, and lashes all inlaid in lapis lazuli. But even more beautiful, if possible, is the gold mask that covered the face of the actual mummy (fig. 118). The dead king wears the usual divine beard, and over his forehead appear the heads of the vulture-goddess of Upper Egypt and the serpent-goddess of Lower Egypt. While the brilliant blue stripes on the headdress are glass paste, the other inlays come from semiprecious stones, such as lapis lazuli, turquoise, carnelian, and feldspar. To the effect of splendor produced by the intrinsic value of the materials is added an impression of the greatest poetic sensitivity and gentleness. The wide eyes of the young king seem to be looking through and beyond us; no other work of art from antiquity brings us so close to the personality of a deceased monarch. Among the thousands of objects from the tomb, one of the most beautiful is the carved wood throne, covered with gold and inlaid with faience, glass paste, semiprecious stones, and silver. The charming relief on the back (fig. 119) shows the disk of Aten shining on the young king, who is seated on a delicately carved chair while his queen, Ankhesenamen, lightly touches his shoulder as she presents him with a beautiful bowl.

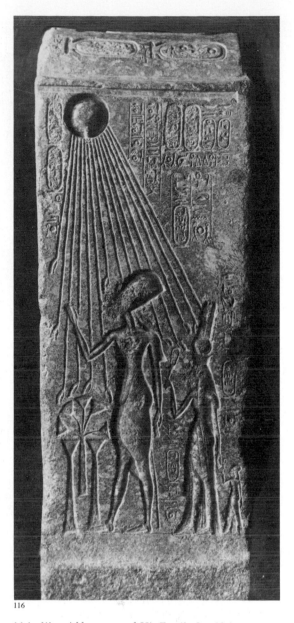

116

116. *King Akhenaten and His Family Sacrificing to Aten*, from Tell el Amarna, Egypt. c. 1360 B.C. Limestone relief. Egyptian Museum, Cairo

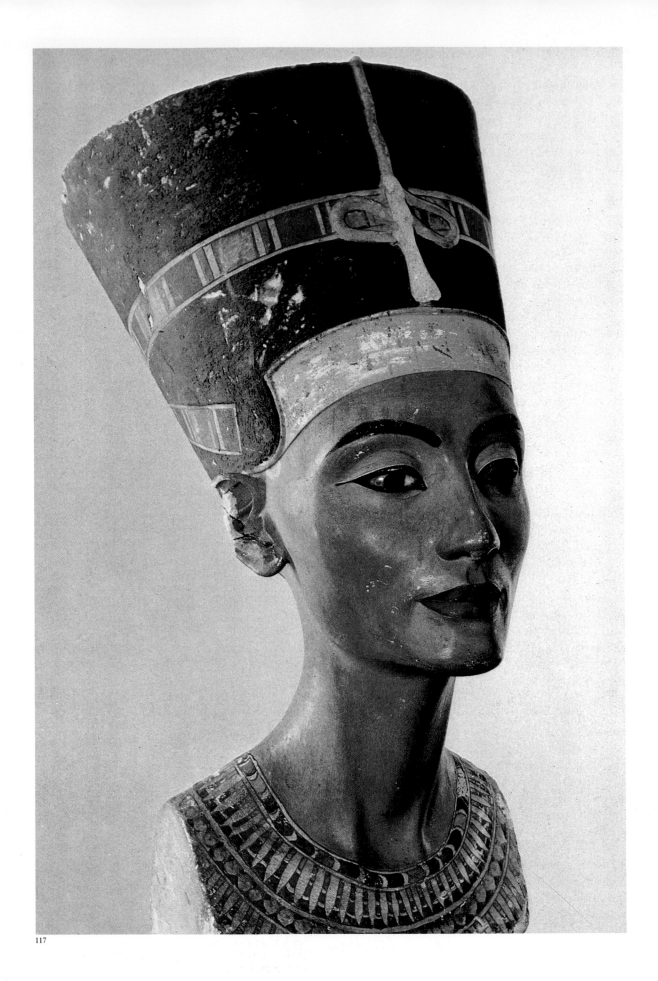

117

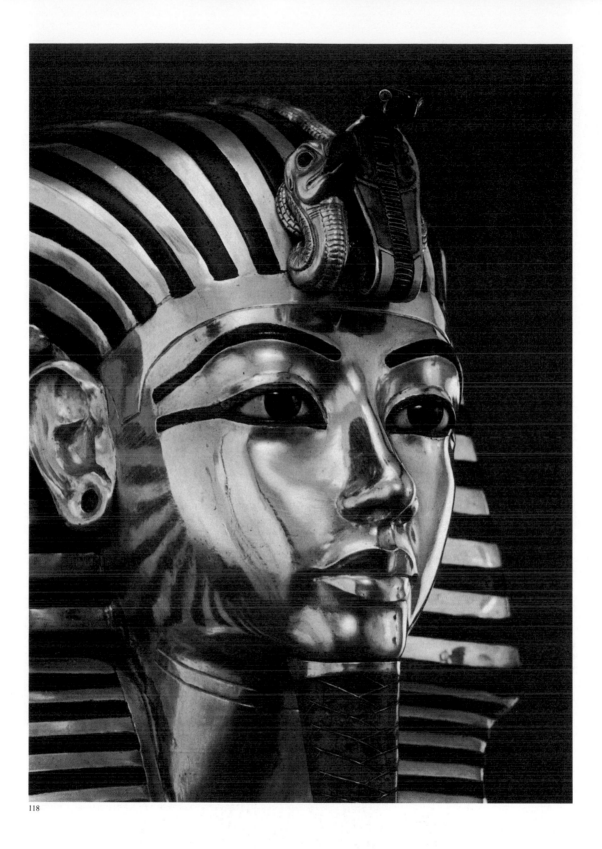

118

117. *Nefertiti*. c. 1365 B.C. Painted limestone,
height 19⅝″. Staatliche Museen, Berlin

118. Mask of King Tutankhamen, from the Tomb
of Tutankhamen, Valley of the Kings (west
of Thebes). c. 1355–1342 B.C. Gold inlaid
with blue glass, lapis lazuli, turquoise, car-
nelian, and feldspar, height 21¼″. Egyptian
Museum, Cairo

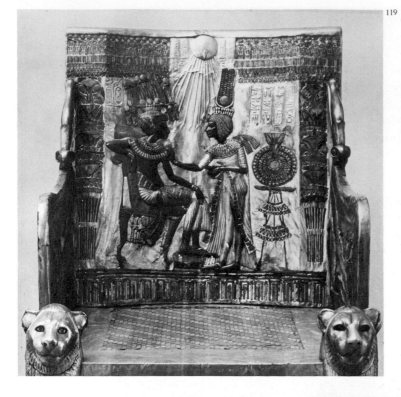

119

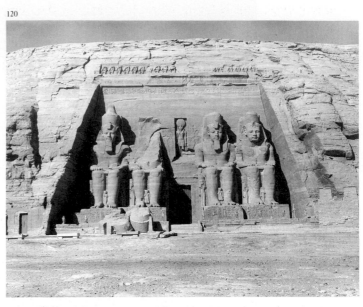

120

119. Throne (rear view) of King Tutankhamen
and his queen Ankhesenamen, from the
Tomb of Tutankhamen, Valley of the Kings
(west of Thebes). c. 1355–1342 B.C. Carved
wood covered with gold and inlaid with fai-
ence, glass paste, semiprecious stones, and
silver; height of throne 41″. Egyptian Mu-
seum, Cairo

120. Entrance façade, rock temple of Abu Sim-
bel, Nubia. c. 1290–1225 B.C.

121. Entrance pylons, Temple of Horus, Edfu.
3rd–1st century B.C.

122. *Last Judgment Before Osiris*, from the Books of
the Dead, found at the Theban Necropolis.
Painted papyrus. British Museum, London

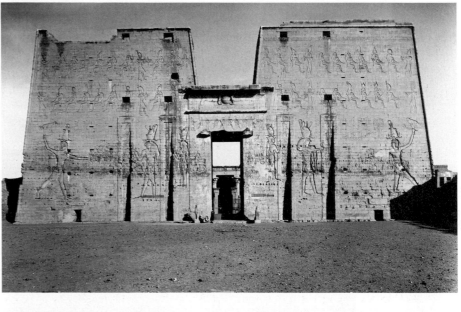

121

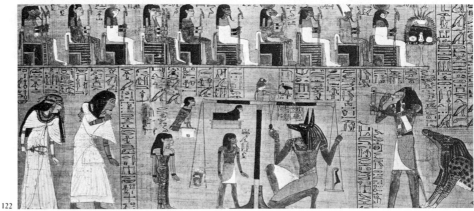

122

LATER PHARAOHS Succeeding monarchs, particularly the Ramesside pharaohs, were anxious to reestablish symbols of imperial might along with the neglected cult of Amon. Ramses II had himself portrayed in immense statues characteristic of the megalomania of his dynasty, not only between the columns of his forecourt for the Temple at Luxor, but in the four colossal seated figures that flank the entrance to his majestic tomb at Abu Simbel (fig. 120). These have become universally known in recent years through the successful campaign to cut the entire tomb from the rock, statues and all, and raise it to a new position above the rising waters dammed at Aswan.

Even under the Greek rulers of Egypt in the last centuries B.C., the principles of Egyptian architecture, sculpture, and painting continued virtually unchanged. If some of the conviction may have gone out of Egyptian art, the late works, such as the Temple of Horus at Edfu, south of Luxor (see fig. 106), are often impressive. This is the best preserved of all major Egyptian temples, still retaining the stone roof over its great hall. Its traditional pylons (fig. 121), terminated by simple, crisp moldings, are punctuated by recessed shafts for flagpoles and decorated with beautifully incised reliefs showing the (Greek!) pharaoh before Horus.

We cannot leave the Egyptians without a word about another of their inventions, the illuminated manuscript. These illustrated books were written and painted on rolls of papyrus, a surface made from the thin-shaved pith of the papyrus plant, glued together to form a continuous sheet. The most important of these are the so-called Books of the Dead, collections of prayers for the protection of the deceased during their perilous adventures in the other world. The best-known scene in every Book of the Dead is the dramatic moment (fig. 122) when, below a lineup of enthroned gods, the heart of the dead person (who is the little human-headed hawk just above the heart toward the left) is weighed against a feather. Luckily, it has just balanced, or the deceased would have been thrown to the crocodile-hyena-hippopotamus hungrily waiting at the right.

While the great architectural and figurative achievements of the Egyptians are often considered preparations for those of the Greeks, the Books of the Dead prefigure the illuminated manuscripts that form such an important part of medieval culture, and the weighing of the deceased's heart is a forerunner of the Christian Last Judgment. But we would do better to enjoy the beauties of Egyptian art for themselves. This, indeed, is just what the peoples of other ancient cultures did, for the road that Egyptian artists, despite the severe conventions within which they were obliged to work, opened up for the understanding of nature and its re-creation in visible form was the one soon to be followed by every ancient civilization. Often, as we will see in studying Minoan and early Greek art, the debt is obvious. And at times, as in the early years of the Roman Empire, Egyptian art was nostalgically imitated. It was also revived, almost as a fashion, in the eighteenth and early nineteenth centuries when the first excavations took place. Today's readers will recall the tremendous success of the touring Tutankhamen exhibition; for modern students the excitement of Egypt is inexhaustible.

CHAPTER

MESOPOTAMIAN ART

TWO

Roughly parallel with the civilization of Egypt, another, in some ways equally great, historic culture was developing in the region of the Near East known as Mesopotamia, from the Greek word meaning "land between the rivers." Traversed by the almost parallel courses of the Tigris to the northeast and the Euphrates to the southwest, this fertile valley was as attractive to ancient peoples as that of the Nile. But unity, stability, and permanence, the three foundation stones of Egyptian culture, were denied by nature to Mesopotamia. The narrow ribbon of the Nile Valley was protected from all but the best-organized invaders by the natural barriers of the Libyan and Arabian deserts, and the placid Nile itself formed a splendid means of communication between all parts of the realm, facilitating unified control. The broad valley of the two turbulent rivers, on the contrary, was open to invasion from all directions and had no easy means of internal communication. Consequently, the natural shape for human communities to assume was that of a city-state in the middle of supporting territory rather than a unified nation. Mesopotamian cities were under frequent and repeated siege from their neighbors or from foreign invaders and thus had to be heavily fortified. Nevertheless, Mesopotamian texts tell us of the continual destruction of these cities and of the removal of their power to other centers.

The climate itself, as compared to the rainless warmth that favored Egypt, watered only by its friendly river, was often hostile. Mesopotamia is subject to sharp contrasts of heat and cold, flood and drought, as well as to violent storms that parallel in the realm of nature the endemic conflicts between human communities. Not surprisingly, little attention seems to have been paid by Mesopotamian cultures to the afterlife, so important to the Egyptians. Security in *this* life, which except for intermediate periods of disorder was taken for granted throughout Egypt's long history, could be achieved in Mesopotamia only by strenuous and concerted efforts and was at best unpredictable. Propitiation of the deities who personified the mysterious and often menacing forces of nature was essential. At the opening of recorded history, the city-state was organized around the service of a local deity, who could intervene for its protection in the councils of heaven. The central temple controlled much economic activity, and shops and offices were grouped around it. Writing, laboriously taught in the earliest recorded schools, was accomplished by means of pressing the sharpened end of a reed into clay tablets to make *cuneiform* ("wedge-shaped") marks. Originally pictographs, these soon became ideographs, paralleling the hieroglyphs of Egypt. The tablets, which have been found by the thousands in Mesopotamian excavations, permit the economic and social life in the early theocracies to be reconstructed down to the minutest details.

Elected rulers rapidly assumed authority in their own right as kings and aspired to the control of neighboring states and eventually of the entire region, even of those outlying areas that produced the raw materials required by the economy of the state. Mesopotamian history is, in consequence, a bewilderingly

complex succession of conquests and defeats, of rises and falls, of city-states and eventually of hastily conquered empires with universal pretensions that melted away after a century or so of power, sometimes after only a few decades. Any attempt, therefore, to give an orderly account of the welter of conflicting societies in the Mesopotamian world is sure to be an oversimplification. As in Egypt, the basic ethnic structure of Mesopotamian civilization was not unified. One people, the Sumerians, apparently entered the region from the mountains to the north, but their exact origin is as mysterious as their language, which is not inflected and bears no relation to any other. The Sumerians in turn were conquered by the Akkadians, Semitic invaders from the west, but eventually Sumerian culture was adopted by the conquerors. Regardless of the ethnic origin of any Mesopotamian peoples, however, certain essentials characterize Mesopotamian cities for about three thousand years.

First, the central temple was invariably raised on a platform above the level of the surrounding town. Generally, the temple consisted of a series of superimposed solid structures forming a broadly based tower or artificial mountain known as a ziggurat, on the summit of which propitiatory ceremonies to the gods of nature took place. These ziggurats, the one best known to us being, of course, the Tower of Babel (Babylon), represented an immense communal effort and were visible for great distances across the Mesopotamian plain. They clearly symbolized humanity's attempt to reach the celestial deities and, during heavy weather with low-hanging clouds, may often have appeared to succeed. One should recall that according to the Greeks the gods dwelt on Mount Olympus, and that Moses went to the top of Mount Sinai for his conversations with the Almighty. Even in the later period of empires, the royal palace in Mesopotamia always contained a ziggurat.

Second, there were no local supplies of stone, so architecture in the manner of the Egyptian pyramids, tombs, and temples was out of the question. Mud brick, sometimes reinforced by timber, was the basic material for all Mesopotamian buildings, as it had been for the ephemeral dwellings of the Egyptians. Although Mesopotamian structures were sometimes faced with fired brick, most of them survive only in ground plan or in foundations, when these could be built of imported stone. Even sculpture, forced to rely on materials brought from a distance, was limited to modest dimensions, save for the ambitious palace decorations of the Assyrians, who lived in a northern region closer to a supply of stone. Under such circumstances neither architecture nor sculpture could be expected to function on the exalted level that it did in Egyptian art, with its endless sources of material and its continuous artistic tradition—but Mesopotamia did achieve some brilliant creations of its own.

Third, probably because of the extremes of Mesopotamian climate and the violence of Mesopotamian history, no wall paintings survive in condition remotely comparable to those of Egypt.

The earliest of the ziggurats to survive was built in the land of Sumer at Uruk (biblical Erech, modern Warka) on the banks of the Euphrates in southern Mesopotamia between 3500 and 3000 B.C. and was dedicated to the sky god Anu (figs. 123, 124). It is older than any known Egyptian monument. The building owes its partial preservation to having been enclosed in a far later Hellenistic sanctuary. The mound was so oriented as to direct its corners toward the four points of the compass and was sheathed by sloping brick walls so as to form a gigantic oblong platform, standing some forty feet above the level of the surrounding plain. On this terrace stood a small whitewashed brick temple (nicknamed the White Temple), only the lower portions of which remain. Curiously enough, the entrances do not face the steep stairway ascending the mound, and the altar is tucked into a corner of the interior, possibly for protection from wind. The buttressed walls were reinforced by timber, but it is not known just how the building was roofed. Since the Sumerian name for such

Sumer

123. The White Temple on its Ziggurat, Uruk (present-day Warka), Iraq. c. 3500–3000 B.C.

124. Plan of the White Temple on its Ziggurat, Uruk (After H. Frankfort)

125. Ziggurat, Ur (present-day El Muqeiyar), Iraq. c. 2100 B.C.

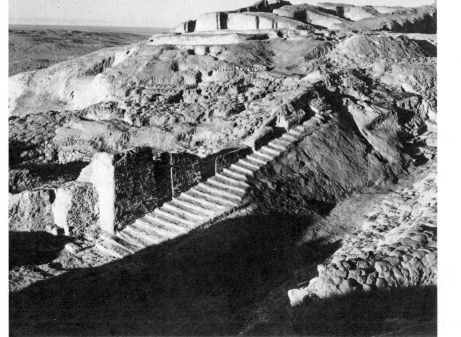
123

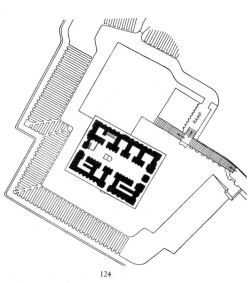
124

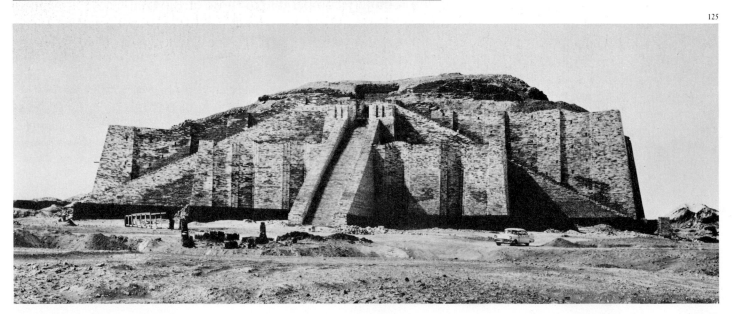
125

temples means "waiting room," the enclosure may well have provided a setting in which the worshipers could await the descent of the deity.

The better preserved and considerably larger ziggurat at Ur (fig. 125), near the confluence of the Tigris and the Euphrates, was built much later, during the so-called Neo-Sumerian period, when the Sumerians temporarily regained power after the collapse of the Akkadian Empire, about 2100 B.C. Three stairways, each of a hundred steps, converge at the top of the first platform; others ascended a second and then a third level, on which stood the temple. The remaining masses of brickwork, recently somewhat restored, dominate the plain for many miles. The original monument, perhaps planted with trees and other vegetation, must have made a majestic setting for religious ceremonials.

Two pieces of sculpture from Uruk, dating from the period of the White Temple, give us some insight into the character of these ceremonies. A superb alabaster vase (fig. 126) some three feet in height was probably intended to hold libations in honor of E-anna, the goddess of fertility and love. The cylindrical surface of the vase, only slightly swelling toward the top, is divided into four bands of low relief celebrating her cult. In the lowest, date palms alternate with stalks of barley, in the next ewes with rams. The third tier shows naked worshipers bringing baskets of fruit and other offerings, and the fourth the crowned goddess receiving a worshiper whose basket is brimming with fruit. (Nakedness survives in the Christian tradition that all will be naked before God at the Last Judgment; see fig. 532.) Some of the strength of the composition derives from the alternation, from one level to the next, of the directions in which the bands of figures are moving; some derives from the sturdy proportions and simple carving of the stocky figures. Their representation is governed by conventions not unlike those of Egyptian art: the torso seen in three-quarter view, the legs and heads in profile.

E-anna herself may be the subject of the beautiful *Female Head* (fig.

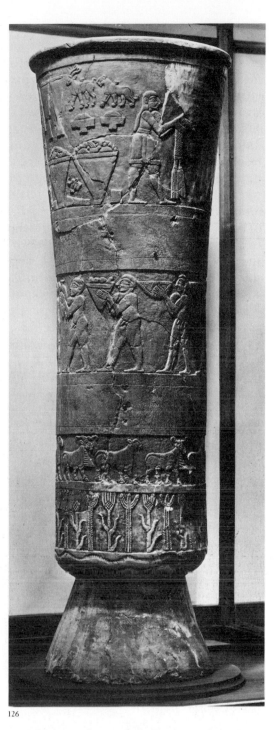

126

126. Sculptured vase, from Uruk, c. 3500–3000 B.C. Alabaster, height 36″. Iraq Museum, Baghdad

127. *Female Head*, from Uruk. c. 3500–3000 B.C. White marble, height c. 8″. Iraq Museum, Baghdad

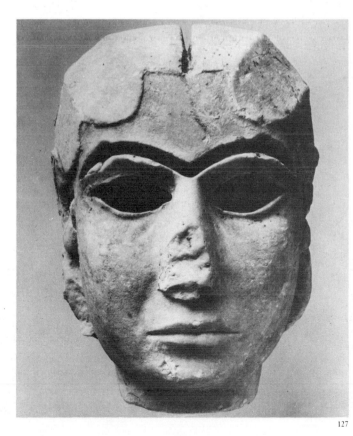

127

127) carved from white marble. It was probably intended to surmount a wooden statue. Originally, the eyes were filled with colored material, most likely shell and lapis lazuli held in by bitumen, which would have made the magical stare even more intense. The eyebrows were probably inlaid with bitumen and the hair plated with gold. Even in its present stripped condition, the contrast between the enormous eyes and the sensitively modeled surfaces of the delicate mouth and chin renders the head unforgettable. A much later assemblage of small marble statues (fig. 128) from the sanctuary of Abu, god of vegetation, at Tell Asmar shows the hypnotic effect of these great, staring eyes in Sumerian religious sculpture when the shell and lapis lazuli inlays (in this case, shell and black limestone) are still preserved. Grouped before the altar, the statues seem to be solemnly awaiting the divine presence. It is thought that the largest figures represent the god, whose emblem is inscribed on its base, and his spouse, but more probably they are meant to be the king and queen, since their hands are folded in prayer like those of the smaller figures. Their cylindrical shape, characteristic of Mesopotamian figures, is far removed from the cubic mass of Egyptian statues, which preserve the shape of the original block of stone.

Some of the splendor of a Sumerian court can be imagined from the gorgeous harp found in the tomb of Puabi, queen of Ur (fig. 129). The strings and wooden portions have been restored, but the gold-covered posts and the bull's head, with its human beard of lapis lazuli, are original; so are the four narrative scenes on the sound box, inlaid in gold, lapis lazuli, and shell. The bearded bull is a royal symbol throughout Mesopotamian art. Intensely real, the animal with its wide-open eyes and alert ears seems to be listening to the music. The uppermost scene on the sound box, showing a naked man wrestling two bearded bulls, all of whom stare out at us vacantly, and the lowest, a scorpion-man attended by a goat bearing libation cups, come from the epic of Gilgamesh, the half-historical, half-legendary hero. But the two incidents between are, alas, not so easy to trace. In one a table heaped with a boar's head and a sheep's head and leg is carried by a solicitous wolf with a carving knife tucked

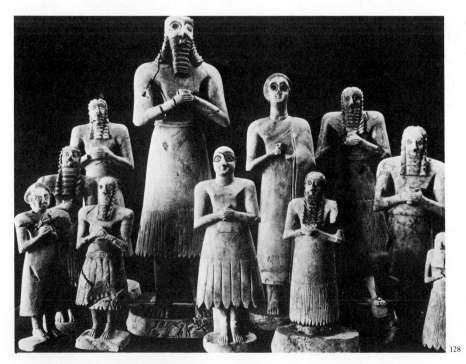

128

128. Statues from the Abu Temple, Eshnunna (present-day Tell Asmar), Iraq. c. 2700–2500 B.C. Marble with shell and black limestone inlay, height of tallest figure c. 30″. Iraq Museum, Baghdad, and The Oriental Institute, University of Chicago

129. Royal harp, from the Tomb of Queen Puabi, Ur. c. 2685 B.C. Wood with inlaid gold, lapis lazuli, and shell, height c. 13″. University Museum, University of Pennsylvania, Philadelphia

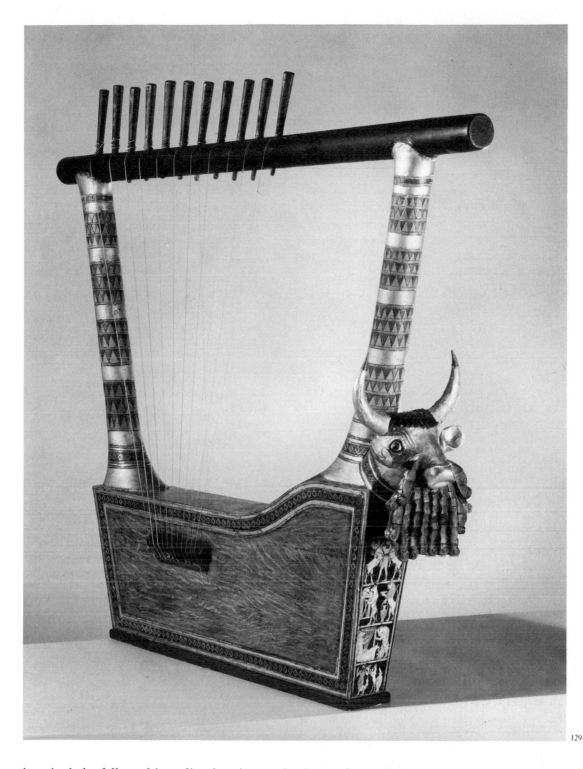

129

into its belt, followed by a lion bearing a wine jug and cup; in the other a donkey plays a bull-harp while a bear beats time and a jackal brandishes a rattle and beats a drum. Possibly these human-handed beasts come from some Sumerian legend yet unknown, but they suggest with perhaps illusory ease the tradition of animal fables known to us in every era from the days of Aesop to those of *Peter Rabbit*.

That such representations may contain a far deeper meaning than we tend to give them is suggested by the splendid goat, made of wood overlaid with gold and lapis lazuli, also found in the royal graves at Ur (fig. 130). We know from contemporary representations on the stone seals used to imprint clay tablets that this is the kind of offering stand customarily

set before the male fertility god Tammuz. The he-goat, proverbial symbol of masculinity, stands proudly erect before a gold tree, forelegs bent, eyes glaring outward with great intensity. The artist has executed every lock and every leaf with crispness and elegance. Descendants of such symbolic animals persist in heraldry even into modern times and are still endowed with allegorical significance.

A grim reminder of the impermanence of Mesopotamian society is given by the *Stele of King Eannatum* (fig. 131), found at Lagash, the modern Tello. This boundary stone is also called the *Stele of the Vultures*. In the upper register the king, conqueror of both Ur and Uruk, leads a phalanx into battle. He is clad in goatskins and carries a mace. The battalion is represented symbolically by a solid block of four shields originally surmounted by nine identical helmeted heads. From each shield protrude six spears, one above the other, each held by a pair of hands; below the shields a steady row of feet tramples a shapeless mass of prone naked bodies. In the broken lower register the king in his chariot, his quiver bristling with arrows, leads light infantry into battle. To modern eyes accustomed to mechanized warfare, this relentless and inhuman attack is all too familiar.

Such endemic warfare was to be followed by something far worse, the virtual collapse of the Sumerian social order under the weight of entirely new conceptions of divine monarchy, like that of Old Kingdom Egypt but maintained wholly by force of arms. A Semitic ruler, Sargon I, usurped the throne of Kish and then ruled for fifty-six years from neighboring Akkad, whose site has not yet been discovered. Sargon founded a dynasty of five kings who aspired to world conquest and in fact controlled the Middle East from the Mediterranean Sea to the Persian Gulf. The

130. *He-Goat*, from Ur. c. 2600 B.C. Wood overlaid with gold and lapis lazuli, height 20″. University Museum, University of Pennsylvania, Philadelphia

131. *Stele of King Eannatum* (*Stele of the Vultures*), from Lagash (present-day Tello), Iraq. c. 2560 B.C. Limestone, height 71″. The Louvre, Paris

Akkad (c. 2340–2180 B.C.)

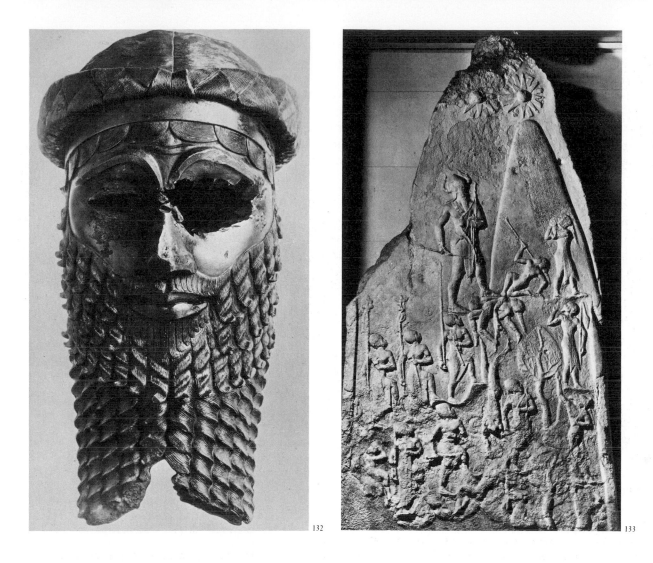

132.

133.

magnificent bronze *Head of an Akkadian Ruler* (fig. 132) is so great a work of art that it makes us regret that so little survives from the days of these Akkadian monarchs except for the literary texts in which their power and majesty were extolled. Even in the absence of the eyes, gouged out long ago, the head is overwhelming. The hair, braided and bound to form a kind of diadem, is gathered in a chignon on the neck. The face is half hidden in a beard whose two superimposed tiers of curls, each made up of spirals moving in the opposite direction to those in the tier below, exert an almost dizzying effect on the beholder by their blend of formal grandeur and linear delicacy. The great, flaring eyebrows plunge in convergence upon an aquiline nose below which the sensual lips are held quietly in a superb double curve of arrogant power not to be approached again until Greek and Roman sculpture. The identity of this monarch is unknown, but it is hard to believe that the great Sargon looked much different.

The only other work of art of first importance remaining from Akkadian rule also exudes an emotional violence that makes Sumerian art look bland in contrast. The sandstone *Stele of King Naram Sin* (fig. 133), Sargon's grandson, shows him protected by the luminaries of heaven and about to dispatch the last of his enemies. The king stands proudly beside the sacred mountain, mace in hand. One crumpled enemy attempts in agony to pluck the spear from his throat, another pleads for his life, two others hang over the edge of a cliff down which still another falls headlong. Meanwhile, up the ascending levels of the landscape stride the victorious soldiers of the king. The tremendous drama of this relief, the

132. *Head of an Akkadian Ruler*, from Nineveh (present-day Kuyunjik), Iraq. c. 2300–2200 B.C. Bronze, height 14⅜". Iraq Museum, Baghdad

133. *Stele of King Naram Sin*, from Susa (present-day Sush), Iran. c. 2300–2200 B.C. Sandstone, height 78". The Louvre, Paris

strength of the projection of the sculptural figures, and the freedom with which they move at various heights within the landscape space give the stele a unique position in Mesopotamian art.

Akkad, which lived by the sword, perished by it as well. A powerful people called the Guti invaded Mesopotamia from the mountainous regions to the northeast, conquered the Akkadian Empire, and destroyed its capital, only to vanish into history without positive achievements. Ironically, the proud *Stele of King Naram Sin* was carried off as booty.

Only the city-state of Lagash mysteriously escaped the general devastation wrought by the Guti, and its ruler, Gudea, interpreted this deliverance as a sign of divine favor. In gratitude he dedicated a number of votive statues of himself, all carved either from diorite or from dolerite, imported stones of great hardness, as gifts to temples in his small realm. All the Gudea statues radiate a sense of calm, even of wisdom. Holding a plan of a building on his lap, Gudea sits quietly with hands folded (fig. 134). Only the tension of the toes and the arm muscles betrays his inner feelings kept in check by control of the will. The surviving heads (fig. 135), often crowned with what appears to be a lambskin cap, show this same beautiful composure, expressed artistically in the broad curves of the brows and the smooth volumes of the cheeks and chin, handled with firmness and accuracy. While less dramatic than the *Akkadian Ruler*, the modest Gudea portraits achieve real nobility of form and content.

Remarkably enough, Gudea was able to win control by peaceful means over a considerable region of the former Akkadian Empire. In 2111, Urnammu, governor of Ur, usurped the monarchy of Sumer and Akkad and built the great ziggurat at Ur (see fig. 125). Little else of artistic merit survives from his reign, after which Mesopotamia reverted to its former chaotic pattern of conflicting city-states. From the brief Isin-Larsa period (2025–1763 B.C.), so called from the ascendancy of the cities bearing these names, dates a terra-cotta relief of extraordinary power and beauty, the first voluptuous female nude known from antiquity (fig. 136). This creature, at once alluring and frightening, represents the goddess of death, the baleful Lilith, possibly the screech owl of Isa. 34:14. Adorned only with gigantic earrings and the characteristic four-tiered headdress of a deity, she smilingly upholds, behind her head, a looped cord—either the symbol of human life or the instrument with which she brings it to an end. Her great wings are partially spread behind her full-breasted, round-hipped body. Instead of feet she has terrible feathered talons; flanked by staring owls, she perches upon the rumps of two lions back to back. Originally, her body was painted red, one owl black and the other red, and the manes of the lions black. The setting is established by the pattern of scales along the base, a conventionalization of the sacred mountain.

The great king Hammurabi (1792–1750 B.C.) briefly brought all of Mesopotamia under the rule of Babylon and reduced its various and often conflicting legal systems to a unified code; this code is inscribed on a tall stele of black basalt at whose summit Hammurabi, in a simple and noble relief (fig. 137), stands before the throne of the god Shamash, again on a sacred mountain indicated by the customary scale pattern. Wearing the same four-tiered headdress as Lilith and with triple flames emerging from his shoulders, this magnificent being extends his symbols of power, a rod and a ring. At first sight prosaic, this elemental colloquy between man and god becomes grander as one watches; like Moses on Mount Sinai, the king talks familiarly with the deity who sanctifies his laws. The cylindrical figures typical of early Mesopotamian art are conventionalized in pose,

Neo-Sumer and Babylon (c. 2125–1750 B.C.)

134

134. Seated statue of Gudea with architectural plan, from Lagash. c. 2150 B.C. Diorite, height 29″. The Louvre, Paris

135. *Head of Gudea*, from Lagash. c. 2150 B.C. Diorite, height 9″. Museum of Fine Arts, Boston

136. *The Goddess Lilith*. c. 2025–1763 B.C. Terra-cotta relief, height 19⅝″. Collection Colonel Norman Colville, United Kingdom

137. Stele with the Code of Hammurabi (upper portion). c. 1792–1750 B.C. Basalt, height of relief 28″; height of stele 84″. The Louvre, Paris

138. *The Lion Gate*, Boğazköy, Turkey. Hittite, c. 1400 B.C. Stone

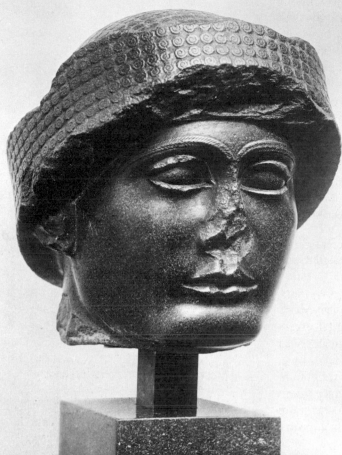

135

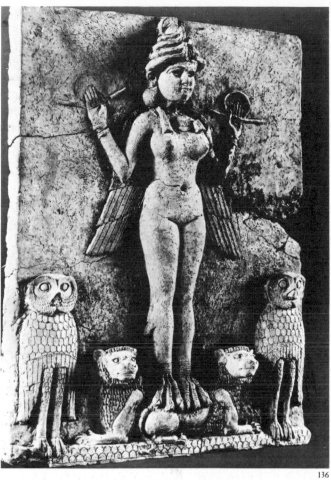

136

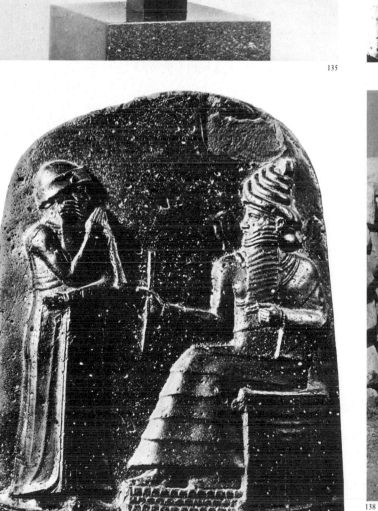

137

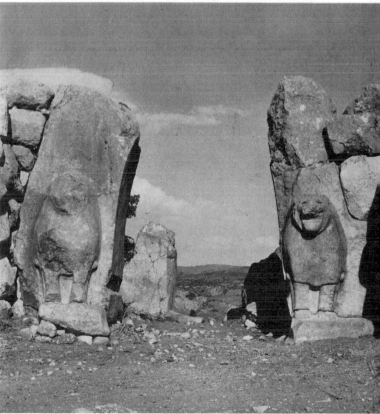

138

as indeed they are throughout pre-Greek art, so that the torso is shown frontally while the hips and legs, insofar as they can be seen within the enveloping drapery, are depicted in profile. For the first time, however, the eyes are not frontal; the gaze between man and god is unswerving.

About 1595 B.C., the Babylonian kingdom was conquered by the Hittites, a people from Anatolia. The sturdy, virile art of the Hittites is seldom of a quality to compete with the best of Mesopotamian art, but the rude and massive lions (c. 1400 B.C.) that flank the entrance to the gigantic stone walls of the Hittite citadel near modern Boğazköy (fig. 138) are the ancestors of the winged beasts that guard the portals of the palaces of the Assyrian kings. It is interesting that after the death of Tutankhamen, the Hittites were so powerful in the Middle East that Ankhesenamen, the distraught widow of the young pharaoh, besought the Hittite king Suppiluliuma I for the hand of one of his sons in marriage as protection.

In the welter of warring peoples—including the Elamites, Kassites, and Mitannians—who disputed with each other for the succession to Babylonian and Hittite power, a single warlike nation called the Assyrians, after their original home at Ashur on the Tigris River in northern Mesopotamia, was both skillful and ruthless enough to gain eventual ascendancy over the entire region. In fact, for a considerable period their power extended to the west over Syria, the Sinai Peninsula, and into Lower Egypt, where they destroyed Memphis, and to the north into the mountains of Armenia. The Assyrians gloried in what from their voluminous historical records and their art seems to have been very nearly continuous warfare, mercilessly destroying populations and cities before they in turn were vanquished and their own cities razed to the ground.

The Palace of Sargon II. Only one of the great Assyrian royal residences is known in some detail, the eighth-century palace of King Sargon II at Dur Sharrukin, the modern Khorsabad, which has been systematically excavated (fig. 139). This massive structure was built into the perimeter of a citadel some five hundred feet square, which was in turn incorporated into the city wall. The entire complex was laid out as symmetrically as possible (fig. 140). Above a network of courtyards on either side sur-

Assyria (c. 1000–612 B.C.)

139. Citadel of King Sargon II, Dur Sharrukin (present-day Khorsabad), Iraq. c. 742–706 B.C. (Architectural reconstruction by Charles Altman)

140. Plan of the Palace in the Citadel of King Sargon II, Dur Sharrukin 1. Central courtyard, accessible from Citadel 2. Courtyard of the Ambassadors, lined with relief sculpture 3. Gate shown in fig. 141 4. Throne Room, lined with mural paintings 5. Royal apartments 6. Ziggurat

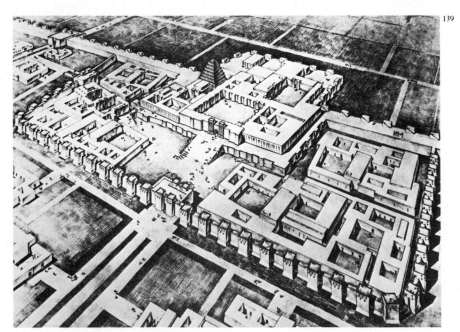

139

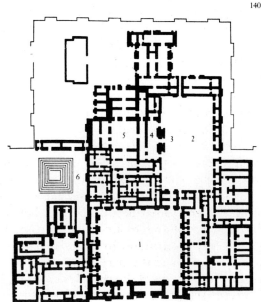

140

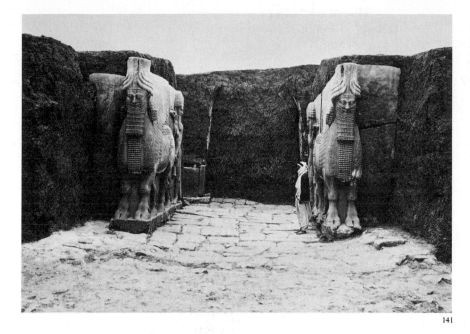

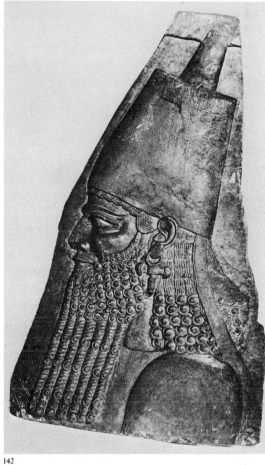

rounded by administrative buildings, barracks, and warehouses rose a platform the height of the city wall. On this eminence stood the palace proper, protruding from the wall into the surrounding plain, so that the king and the court could survey the countryside from its ramparts. It was defended by its own towers. The entire complex was dominated by a lofty ziggurat, descendant of those at Uruk and at Ur (see figs. 124, 125) and doubtless intended for a similar purpose. It was, however, much more carefully formalized. Its successive stages—there may have been seven of these, each painted a different color—were not separate platforms; the structure was ascended counterclockwise by a continuous ramp, a square spiral as it were, so that worshipers always had the paneled wall on their left while on their right they looked out over ever-widening views of the plain.

Like all Mesopotamian buildings, the palace of Sargon II was mostly built of mud brick (although certain crucial portions were faced by baked and glazed brick), which accounts for the ease of its demolition by the next wave of invaders. Considerable use seems to have been made of arches and barrel vaults. Luckily, the Assyrians had access to stone for sculpture, and they were able to flank the entrances to the brightly painted throne room with colossal limestone guardians, in the tradition of the Hittite lions (see fig. 138). Two of these majestic creatures are shown still in place in fig. 141. They were monstrous beings with the bodies of bulls (one recalls the royal bulls of archaic Egyptian palettes, fig. 72), grand, diagonally elevated wings, and human heads with long curly beards and many-tiered divine headdresses (compare figs. 132, 142), doubtless symbols of the supernatural powers of the king. Built into the gates and visible only from two sides, they were really a kind of relief sculpture rather than statues in the round. So that the viewer might see four legs from any point of view, the sculptors generously gave these creatures five.

Sargon II himself can be seen in a superb limestone relief (fig. 142) from the Dur Sharrukin palace, a relief possibly intended to recall the bronze *Head of an Akkadian Ruler* (see fig. 132) but lacking its calm majesty. There is an almost hysterical intensity about the flare of the eyelids and eyebrows and the cruel set of the narrow lips that is increased by the ornamental curves of the sharply separated forms characteristic of Assyrian relief sculpture throughout its brief history.

141. Gate, Palace of King Sargon II, Dur Sharrukin (during excavation)

142. *Portrait of King Sargon II*, from Dur Sharrukin. Limestone relief, height 35". Museo Egizio, Turin

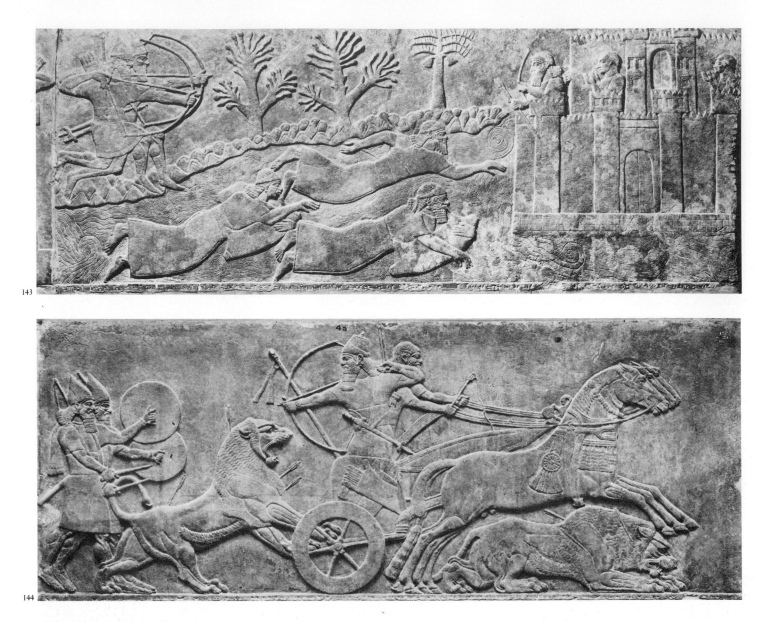

The Palaces of Nimrud and Nineveh. Emissaries of friendly rulers could approach the monarch only through a succession of halls lined with continuous wall reliefs intended to overawe the visitors not only with the king's intimacy with the gods but also with his military exploits and personal courage. These historical reliefs are ancestors of the lengthy political narratives of Roman imperial sculpture (see figs. 352, 353). In strips often superimposed in the manner of Egyptian tomb reliefs, the Assyrians can be seen fighting battles that they always win and cheerfully burning cities, dismantling the fortifications, and massacring the inhabitants. The reliefs were drawn on the surface of alabaster slabs and the background was then cut away to give just a slight projection, as in Egyptian relief. Yet the contours are so bold and so strongly ornamentalized and the proportions are so chunky that they convey an impression of massive volume instead of Egyptian delicacy and elegance. The innumerable scenes of unrelieved mayhem can become monotonous, especially because the quality of the reliefs, which were apparently turned out at some speed, is not uniformly high. But there were great sculptors in the group who could find in their narrative subjects inspiration for an epic breadth of vision entirely new in art. Sometimes the scenes have an unconscious humor, as in *Elamite Fugitives Crossing a River* (fig. 143), from the palace

143. *Elamite Fugitives Crossing a River*, from the Palace of King Ashurnasirpal II, Kalhu (present-day Nimrud), Iraq. c. 883–859 B.C. Alabaster relief, height c. 39″. British Museum, London

144. *King Ashurnasirpal II Killing Lions*, from the Palace of King Ashurnasirpal II, Nimrud. c. 883–859 B.C. Alabaster relief, 39 × 100″. British Museum, London

145. *Dying Lioness* (detail of *The Great Lion Hunt*), from the Palace of King Ashurbanipal, Nineveh. c. 668–627 B.C. Alabaster relief, height 13¾″. British Museum, London

of Ashurnasirpal II at Nimrud. Two Assyrian bowmen shoot from the bank at two fully clothed Elamites who cling to inflated goatskins and at a third who has to rely entirely on his own strength to stay afloat as they swim toward the walls of their little city, defended by Elamite warriors on the tops of the towers. In the manner of Egyptian reliefs and paintings, the swimmers have two left hands. The undulating shapes of the swimmers and the ornamentalized trees on the bank create the strong and effective pattern characteristic of the best Assyrian reliefs.

Strangely enough, while human expressions remain impassive under any conditions, those of animals are represented with a depth of understanding that turns the conflicts between men and beasts into the grandest action scenes in Mesopotamian art—in fact, into some of the most powerful in the entire history of art. Lions were released from their cages, after having been goaded into fury, so that the king could display his strength and courage by shooting down the maddened beasts from his chariot. The best sculptors seem to have been employed for these heroic reliefs, which unleash an astonishing explosion of forces—the swift flight of the horses, the resolute power of the monarch, the snarling rage of the tormented beasts. Not since archaic Egypt have the muscles of humans and animals been shown swelling with such tremendous tension as in the relief depicting Ashurnasirpal engaged in his cruel sport (fig. 144). Almost unbearable in its tragic intensity is the detail of the *Dying Lioness* from the palace of Ashurbanipal at Nineveh (fig. 145). Pierced by three arrows, bleeding profusely, and howling in impotent defeat, the poor beast drags her paralyzed hindquarters desperately along. After these horrors the relief of a flock of gazelles from the same palace (fig. 146) is totally unexpected in its airy grace. One turns his head in fear, the others plod along, the little ones struggling to keep up, as they flee their archenemy, man. Equally surprising is the device of scattering the animals lightly about the surface of the slab to suggest open space.

145

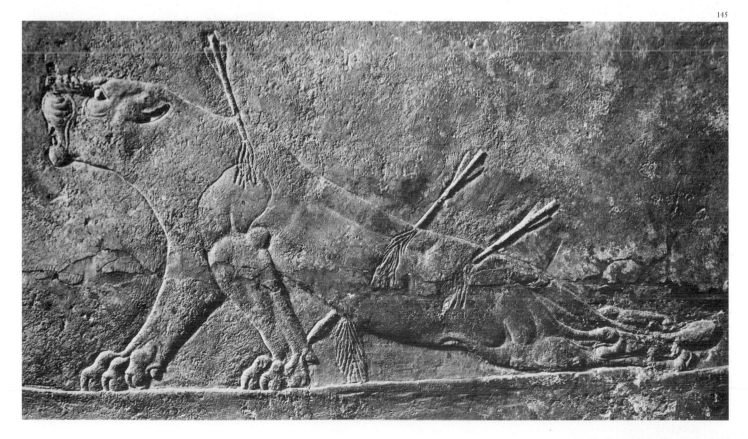

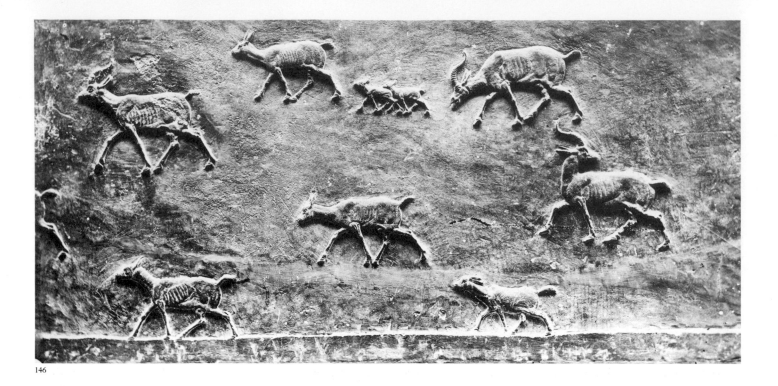

146

The collapse of Assyria in 612 B.C. was brought about by invasions of Scythians from the east and Medes from the north. Order was restored by Nebuchadnezzar II, ruling from Babylon in the south, which had never lost its cultural importance even under Assyrian domination. In the scanty remains of Neo-Babylonian stone sculpture an attempt can be discerned to emulate the style of Sargon I, some eleven hundred years earlier, but the brief revival of Babylonian glory is best known for its architectural remains. For two hundred years or so Babylon had possessed the Hanging Gardens, one of the wonders of the ancient world, a series of four brick terraces rising above the Euphrates, whose waters were piped up to irrigate a splendid profusion of flowering trees, shrubs, and herbs. Nebuchadnezzar added a splendid palace with a ziggurat, which was the biblical Tower of Babel, and built eight monumental arched gates in the fortified city walls. One gate (fig. 147), connected with the inner city by a processional way and dedicated to the goddess Ishtar, was faced with glazed brick. Excavated early in this century, it is installed, with missing portions liberally supplied, in East Berlin, the only place in the world where one can gain any idea of the scale and brilliance of the ephemeral brick architecture of ancient Mesopotamia. The clear, bright blue of the background glaze sets off the geometric ornament in white and gold and the widely spaced, stylized bulls and dragons in raised relief. They are composed of many separately molded and glazed bricks and form a happy postlude to the interminable slaughters of the blood-thirsty Assyrians. Nebuchadnezzar's gorgeous Babylon must have deserved the boastful title he gave it—"navel of the world."

Neo-Babylonia (605–539 B.C.)

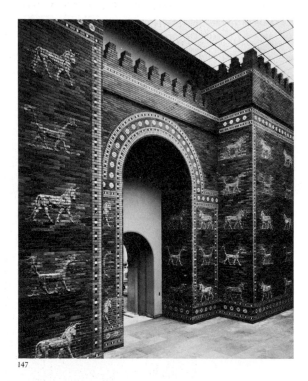

147

146. *Herd of Fleeing Gazelles* (portion of a relief from the Palace of King Ashurbanipal, Nineveh). c. 668–627 B.C. Alabaster, height 20⅞". British Museum, London

147. The Ishtar Gate (restored), from Babylon, Iraq. c. 575 B.C. Glazed brick. Staatliche Museen, Berlin

We obtain a one-sided account of the Persian Empire from the history of the Greeks, to whom the Persians appeared as a juggernaut threatening to crush the cherished independence of the Greek city-states. The tidy administration of the Persians may in fact have come as a relief to the weary peoples of the Near East. Out of the mountainous regions of what is today Iran, northeast of Mesopotamia, came the nomadic Persians under Cyrus the Great; under his successors Darius I and Xerxes I they conquered an empire that was centered on Mesopotamia but included also Syria, Asia Minor, and Egypt on one side and parts of India on the other. Although they set themselves up as kings of Babylon they styled themselves, and quite rightly, kings of the world. Only the Greeks prevented them from extending their rule into Europe, and the Greeks, under Alexander the Great, eventually brought about their downfall. Their orderly and decent government made cruelties like those of the Assyrians unnecessary. The Persian Empire, more than twice as extensive as any of its predecessors, was divided into provinces called satrapies, administered by governors, or satraps, responsible directly to the king. The capital moved about, but its great palace was at Persepolis, near the edge of the mountains above the Persian Gulf, to the east of Mesopotamia.

There Darius commenced his residence, continued and completed by his son Xerxes about 500 B.C.; it was an orderly and systematic complex of buildings and courts surrounded by the inevitable, and now vanished, mud-brick wall (fig. 148). Persian art, perhaps not as imaginative as some that preceded it, included many elements borrowed from the subject peoples; in fact, many of the artisans were Babylonians, and others were Greeks from Asia Minor. The Persians worshiped the god of light, Ahuramazda, at outdoor fire altars for which no architecture was needed, so there were no ziggurats. But the palace was built, like that of Sargon II, on a huge platform, this time of stone, quite well preserved (fig. 149).

Persia (539–331 B.C.)

148. Plan of the Palace of Darius and Xerxes, Persepolis, Iran 1. Great entrance stairway 2. Gatehouse of Xerxes 3. Apadana, or Audience Hall, of Darius and Xerxes 4. Throne Hall of Xerxes, or "Hundred-Column Hall" 5. Tachara, or Palace, of Darius 6. Palace, probably rebuilt by Artaxerxes III 7. Hadish, or Palace, of Xerxes 8. Tripylon, or Council Hall 9. Restored area of the "Harem" 10. Treasury 11. Section of northern fortifications 12. Royal tomb, probably of Artaxerxes II

149. Apadana, or Audience Hall, Palace of Darius and Xerxes, Persepolis. c. 500 B.C.

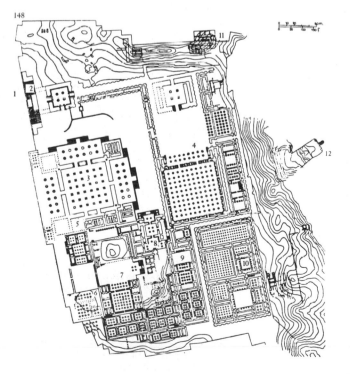

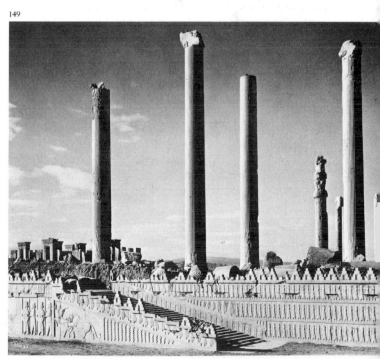

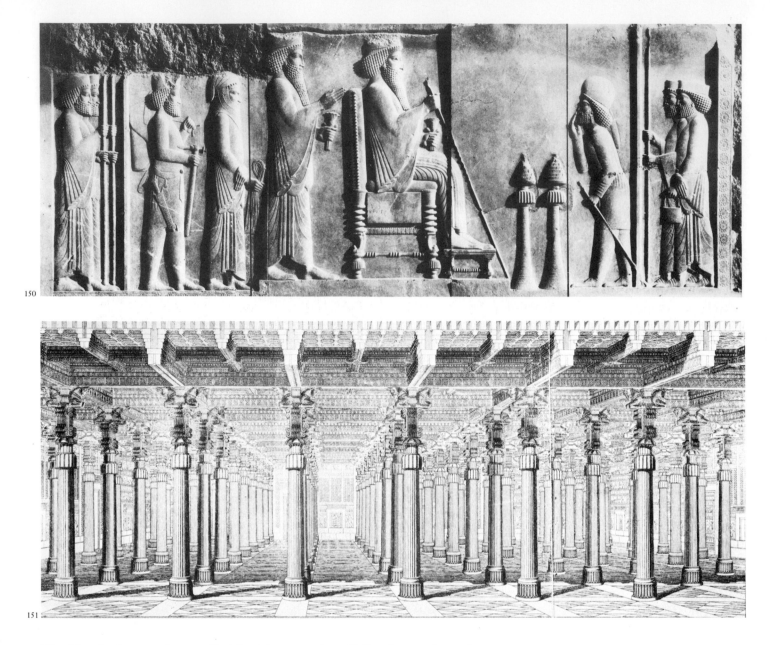

The king had no need to terrify his visitors, so the relief sculpture showed interminable superimposed rows of neatly uniformed bodyguards mounting the steps, as in reality they did, and the great king himself giving audience (fig. 150). For the first time, relief in the Near East was not just surface drawing with the background cut away, but was so carved as to give the impression that actual figures, having cylindrical volume, move on a shallow stage. This idea was derived from Greek art, and the sculptors may have been Ionian Greeks. The statue-like figures are shown in true profile, although the eyes are still frontal. The prim rows of curls in hair and beard are obviously derived from Akkadian and Assyrian forebears, but the drapery folds now have edges that ripple in long, descending cataracts as in archaic Greek sculpture (see fig. 188), and the garments clearly show underlying limbs, as in Old Kingdom Egyptian sculpture (see fig. 87). In a civilization like that of the Persians, individualization was not encouraged, but there is a crisp, fresh elegance of drawing and carving that gives Persian decorative sculpture great distinction. It was doubtless even more striking with its original brilliant colors and gilding.

Persian rooms were characteristically square, and the great hall of Xerxes must have been one of the most impressive in the ancient world

150. *Darius and Xerxes Giving Audience.* c. 490 B.C. Limestone relief, height 100″. Palace of Darius and Xerxes, Persepolis

151. Throne Hall of Xerxes, or "Hundred-Column Hall," Palace of Darius and Xerxes, Persepolis (Architectural reconstruction by C. Chipiez)

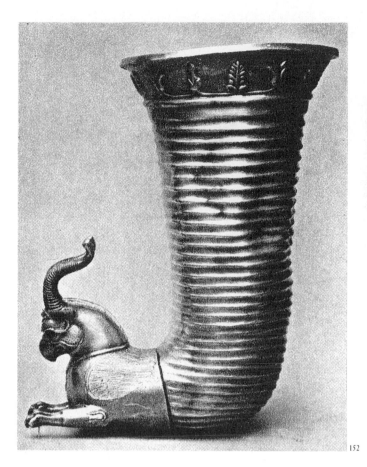

(fig. 151). Its hundred stone columns, each forty feet high (several are still standing) and brightly painted, were delicately fluted and terminated in paired bulls that acted as brackets and helped to support the gigantic beams of imported wood, also painted. No such interior had, of course, existed in the Mesopotamian world, where columns were unknown. Quite possibly the Persians drew their idea partly from the columned porticoes of Ionian Greek temples, partly from the columned temple halls of the Egyptians. The notion of a forest of columns, with no dominant axis in any direction, may have been the origin of the typical plan of many Islamic mosques several centuries later (see figs. 468, 472).

The gold and silver rhytons or libation vessels (fig. 152), with their hybrid animal forms, show the Persian love of elegance, grace, and rational organization of elements. The linear rhythms of the animals themselves still suggest those of prehistoric pottery from Susa, not far from Persepolis, three millennia earlier (fig. 153), not to speak of many characteristic elements of later Mesopotamian cultures, but the alternating palmette and floral ornament on the upper border is already characteristically Greek. Sadly enough, it is upon the Greeks that the responsibility rests for the destruction of the palace, burned by Alexander after a long and violent banquet.

152. Rhyton, from the Oxus Treasury, Armenia. Silver, height 10″. British Museum, London

153. Painted beaker, from Susa. c. 5000–4000 B.C. Height 11¼″. The Louvre, Paris

TIME LINE II

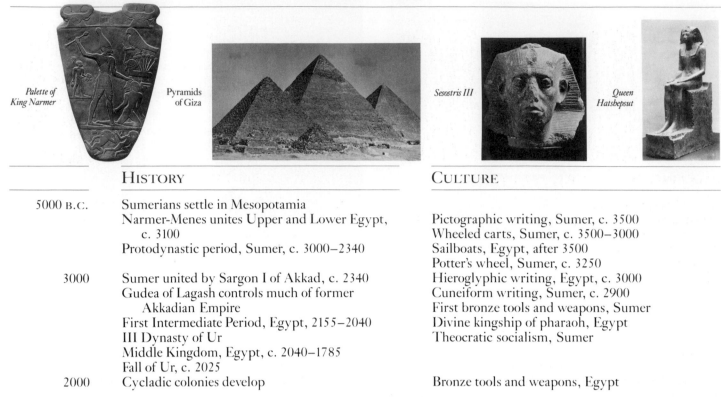

Palette of King Narmer

Pyramids of Giza

Sesostris III

Queen Hatshepsut

HISTORY	CULTURE

5000 B.C. Sumerians settle in Mesopotamia
Narmer-Menes unites Upper and Lower Egypt, c. 3100
Protodynastic period, Sumer, c. 3000–2340

3000 Sumer united by Sargon I of Akkad, c. 2340
Gudea of Lagash controls much of former Akkadian Empire
First Intermediate Period, Egypt, 2155–2040
III Dynasty of Ur
Middle Kingdom, Egypt, c. 2040–1785
Fall of Ur, c. 2025

2000 Cycladic colonies develop

Pictographic writing, Sumer, c. 3500
Wheeled carts, Sumer, c. 3500–3000
Sailboats, Egypt, after 3500
Potter's wheel, Sumer, c. 3250
Hieroglyphic writing, Egypt, c. 3000
Cuneiform writing, Sumer, c. 2900
First bronze tools and weapons, Sumer
Divine kingship of pharaoh, Egypt
Theocratic socialism, Sumer

Bronze tools and weapons, Egypt

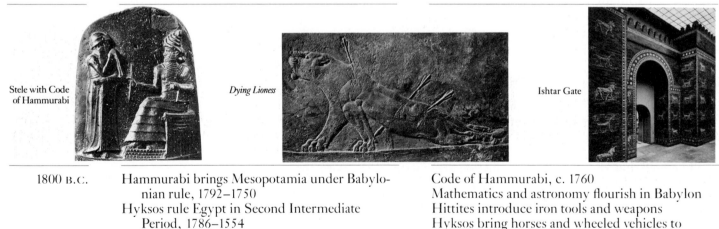

Stele with Code of Hammurabi

Dying Lioness

Ishtar Gate

1800 B.C. Hammurabi brings Mesopotamia under Babylonian rule, 1792–1750
Hyksos rule Egypt in Second Intermediate Period, 1786–1554
Minoan civilization flourishes, 1600–1400
Hittites conquer Babylon
Expulsion of Hyksos, expansion of

1400 Egyptian Empire, 1554–1080, esp.
Amonhotep I, Hatshepsut, Amonhotep III, Akhenaten, Seti I, Ramses II
Assyrian Empire, 1000–612

600 Nebuchadnezzar II of Babylon, r. 605–562, Neo-Babylonian Period
Persian Empire founded by Cyrus the Great, r. 559–529

Code of Hammurabi, c. 1760
Mathematics and astronomy flourish in Babylon
Hittites introduce iron tools and weapons
Hyksos bring horses and wheeled vehicles to Egypt, c. 1725

Monotheism of Akhenaten; worship of the disk of the Sun, the Aten, temples of Amon-Ra closed, c. 1360; Tutankhamen restores old religion

Hebrews accept monotheism

Zoroaster (born c. 666)

Court of
Amonhotep III,
Temple of
Luxor

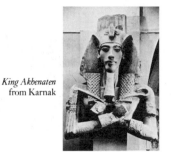

King Akhenaten
from Karnak

Female Head
from Uruk

PAINTING, SCULPTURE, ARCHITECTURE

PARALLEL SOCIETIES

		5000 B.C.

Painted beaker from Susa
Ziggurat, White Temple, and sculptured head and vase, Uruk — Sumerian
Tomb painting from Hierakonpolis — Archaic Egyptian
Palette of King Narmer — Old Kingdom in Egypt
Geese of Medum
Step pyramid, Funerary Complex, and statue of *King Zoser*, Saqqara — 3000
Statues from Abu Temple at Tell Asmar
Royal harp from Tomb of Queen Puabi; *He-Goat; Stele of King Eannatum*
King Mycerinus, Prince Ankhhaf, Seated Scribe, Kaaper; Tomb of Ti
Pyramids, Valley Temples, and *Great Sphinx*, Giza; *King Chephren*
Ziggurat at Ur
Sculpture portraits of *Akkadian Ruler* and *Gudea* — Akkadian
Cycladic idol from Amorgos; *Lyre Player* from Keros — Neo-Sumerian — 2000
Nubian mercenaries, Asyūt; Head of *Sesostris III; Princess Sennuwy* — Cycladic
Funerary Temple of Mentuhotep III, Deir el Bahari — Middle Kingdom in Egypt

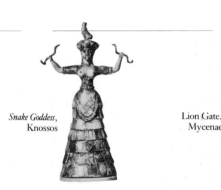

Palace at
Persepolis

Cycladic idol
from Amorgos

Snake Goddess,
Knossos

Lion Gate,
Mycenae

Stele with the Code of Hammurabi — Babylonian — 1800 B.C.
Palace at Knossos, with mural decorations; frescoes from Thera — Minoan
Octopus vase from Palaikastro; *Snake Goddess* and bull rhyton from
 Knossos; *Harvester Vase*
Citadel of Tiryns; Lion Gate and Treasury of Atreus at Mycenae — Mycenean
Three Deities, funeral mask, fresco fragments, and lion dagger, Mycenae
Funerary Temple of Queen Hatshepsut, with relief decorations — Empire or New Kingdom
Paintings from tombs of Nebamun and Sen-nedjem — in Egypt — 1400
Temple of Amon-Mut-Khonsu, Luxor; Temple of Amon-Ra, Karnak
Pillar statue and relief of Akhenaten; *Nefertiti;* Tomb of Tutankhamen
Lion Gate at Boğazköy — Hittite
Reliefs, palaces of Ashurnasirpal II at Nimrud and Nineveh — Assyrian
Citadel of King Sargon II at Khorsabad; portrait of Sargon II — *Archaic Greek*
Ishtar Gate at Babylon — Neo-Babylonian — 600
Palace of Darius and Xerxes at Persepolis; "Hundred-Column" Hall — Persian
Temple of Horus at Edfu — *Etruscan*

AEGEAN ART

c. 3000–1100 B.C.

THREE

Somewhat later than the first manifestations of the splendid cultures that flourished in the Nile Valley and in Mesopotamia, a third artistically productive civilization arose in the islands and rocky peninsulas of the Aegean Sea. The rediscovery of this vanished civilization, like that of the cave paintings and of Sumer and Akkad, has been an achievement of the past hundred years or so. Nineteenth-century scholarship had taken it for granted that the cities and events described in the poems of Homer were largely if not entirely mythical, but the excavations of the German amateur archaeologist Heinrich Schliemann, beginning at the site of Troy in 1870 and continuing later at Mycenae and other centers on the Greek mainland, made clear that the Homeric stories must have had a basis in fact and that the cities mentioned in the poems had indeed existed. Subsequent excavations, beginning with those initiated by the British scholar Sir Arthur Evans in 1900, brought to light a completely unsuspected group of buildings on the island of Crete, containing works of art of surprising originality and freshness of imagination. It has now become clear that there were two distinct cultures. One was centered on Crete and has been called Minoan, after Minos, the legendary Cretan king; the other is known as Helladic, after Hellas, the Greek mainland. The final phase of Helladic culture, and its most interesting artistically, is known as Mycenaean, from its principal center at Mycenae.

Minoan civilization is almost as much of a mystery as that of preliterate humans. The Minoan and Helladic peoples spoke different tongues, and Minoan scripts are still undecipherable. Their language, apparently non–Indo-European, is completely unknown. However, a late form of Aegean writing, found both in Crete and on the mainland, was first deciphered in 1953 and turned out to be a pre-Homeric form of Greek. The now-legible documents, of a purely practical nature and without literary interest, suggest that Minoan civilization eventually succumbed to Mycenaean overlords. Thus our slight knowledge of Aegean history, social structure, and religious beliefs must be gleaned largely from the study of Aegean buildings and other works of art and from the mythology of the later Greeks—however much distorted by the later poetic tradition that culminated in Homer—which seems to have been woven, in part at least, from surviving memories of the Aegean world. Even *Minos* may only be a generic Cretan name for "king."

Approximate dates for Minoan art have been ascertained largely by the systematic excavation of pottery. Minoan and Helladic artifacts have now been traced as far back as 3000 B.C., and some even earlier, but the great artistic periods of both civilizations belong to the second millennium B.C., roughly between the years 1900 and 1200—a period contemporary with the Empire in Egypt and with the Babylonian period in Mesopotamia. Around 1400 B.C. Minoan civilization perished in a catastrophe whose nature is still not certain, but which may have been related to the volcanic eruption which destroyed Thera. Mycenaean culture survived only another three centuries before succumbing to the combined effects of internal dissent and attacks by other Greek invaders.

Even before the rise of the Minoan and Helladic civilizations, there had been another artistically creative culture in the Aegean. Called Cycladic, from the islands where its remains are found, this late Neolithic culture flourished in the third millennium B.C. and has left no trace of writing.

The Cycladic tombs have yielded many stone sculptures, ranging from statuettes to images about half lifesize. The meaning of these figures is not known, but the female ones with their folded arms (fig. 154) seem to be descendants of Neolithic mother goddesses elsewhere (see fig. 30). Interestingly enough, however, their whole character has changed; they are no longer abundantly maternal but touchingly slight and virginal, with delicate proportions, gently swelling and subsiding shapes, and subtle contours. The simplicity and understatement of these Cycladic figures have made them particularly attractive to contemporary artists. It should be borne in mind, however, that the flattened faces originally displayed other features than the sharply projecting noses that are all that now remain. Traces of pigment make clear that eyes and mouths, as well as other details, were originally painted on. Of equal interest are the less frequently found male musicians, such as the *Lyre Player* (fig. 155), perhaps intended to commemorate a funerary celebration or even to evoke music in the afterlife. The musicians are almost tubular in their stylization, and the forms of body, lyre, and chair enclose beautifully shaped open spaces that prefigure those of some twentieth-century sculpture.

Cycladic Art

154. Cycladic idol, from Amorgos. 2500–1100 B.C. Marble, height 30″. Ashmolean Museum, Oxford, England

155. *Lyre Player*, from Keros. c. 2000 B.C. Marble, height 9″. National Archaeological Museum, Athens

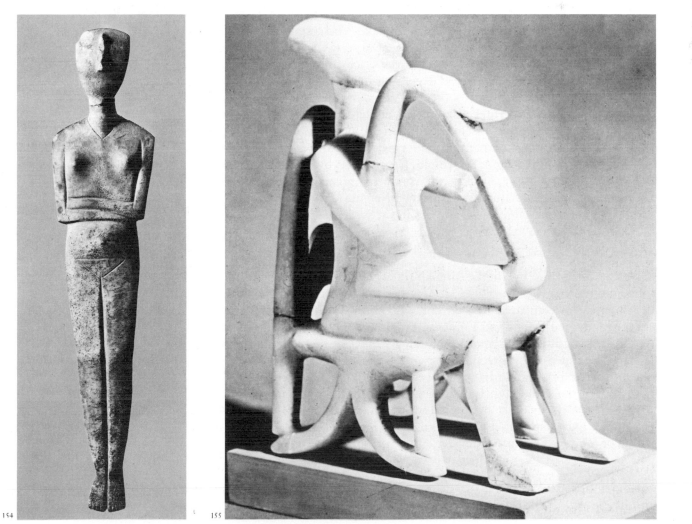

154 155

POTTERY Baked clay pots, produced in abundance by almost all Mesopotamian and Mediterranean peoples for household use, were worthless after breakage and were tossed on the dump heap. Yet pottery fragments are virtually indestructible, and the lowest layers of potsherds in any heap are naturally the earliest, the next later, and so on. Because the shapes and methods of manufacture of these pots and the style of their decoration changed from one period to the next, sometimes quite rapidly, it has been possible for archaeologists to establish a relative chronology for the development of style by recording the potsherds according to the layers in which they were found. Often the Minoan and, later, the Greek pots are supremely beautiful as works of art, in both shape and decoration, and their style is strongly related to that of wall painting and other arts. Thus their chronology is applicable to other works of art as well. Sometimes, also, the circumstances of a find link a dated group of pots to the building in or near which it was discovered.

Since we know so little of their writing, we cannot yet say whether the Minoans themselves accurately recorded dates and specific events. But luckily they were great seafarers and traders. Their pots have turned up in Egyptian sites whose dates can be determined by numerous inscriptions, and the chronology based on the potsherds can thus often be anchored to firm historical knowledge. Approximate dates have, therefore, been assigned to the early, middle, and late periods into which Minoan art has been divided.

Not until the Middle Minoan period, about the nineteenth century B.C., does the art of the potter achieve truly great artistic stature, but objects of the quality of the beaked Kamares jug from Phaistos (fig. 156) would be welcomed as masterpieces in any period. The curvilinear shapes have an extraordinary vitality and are different in style from anything we have previously seen, except perhaps for the ornamental motives of La Tène art (see fig. 486) or the carved decorations of the temple at Tarxien (see fig. 35). Palmlike shapes in soft white quiver against a black ground among curling and uncurling spirals and counterspirals, all beautifully related to the shape of the vessel itself. In Late Minoan, about 1500 B.C., the swirling shapes take on naturalistic forms. The entire front of a vase from Palaikastro (fig. 157), for example, is embraced by the tentacles of an octopus, writhing in menacing profusion. The abstract shapes on the first vase have become naturalistic, but the principle of dynamic curvilinear decoration is the same and reappears in the wall paintings as well.

THE PALACES In Middle Minoan times, after about 2000 B.C., the inhabitants of Crete, previously at a rather modest stage of Neolithic development as compared to their contemporaries in Egypt and Mesopotamia, adopted metals and a system of writing, and rapidly developed an urban, mercantile civilization. Interestingly enough, the Minoans seem to have depended for protection entirely on their command of the sea; not a trace of fortification has ever been found. This reliance may well have proved their undoing. Immense palaces were built at Knossos and Mallia on the north coast of the island, at Phaistos on the south, and elsewhere. Devastated about 1700 B.C., these first palaces were soon repaired or rebuilt. The most extensive and artistically important is the vast palace at Knossos, about which we know more than about any other palace before Persepolis. Although Knossos was again laid waste between 1450 and 1400 B.C., it has been largely—perhaps even excessively—reconstructed from the ruins. A stroll through it affords an insight into the

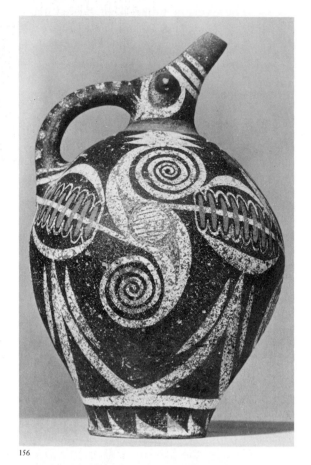

156

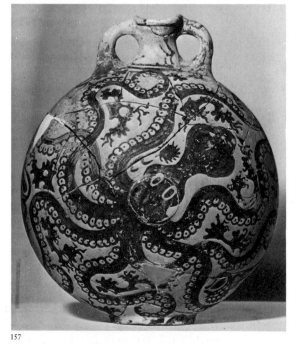

157

158

159

delightful existence of these mysterious people, who seem to have concerned themselves little with religion and not at all with the hereafter (they left no temples, only small hilltop shrines, and few monumental tombs), but entirely with the pleasures of the here and now. From the plan (fig. 158) and from the surviving and reconstructed portions, it is clear that the palace could never have presented the imposing, symmetrical, and ordered appearance of Mesopotamian royal residences. Built around a not perfectly oblong central courtyard (fig. 159), the hundreds of rooms and connecting corridors climb gently up the slopes of the hill in such a haphazard manner as to give color to the Greek legend of the Cretan labyrinth, at the center of which King Minos was supposed to have stabled the dreaded Minotaur, half man, half bull.

Clearly, the Minoan monarchs felt no need to impress visitors with royal might and cruelty. Entrances are unobtrusive; the apartments sprout terraces, open galleries, and vistas at random; even the decorated rooms intended for the royal family are small, with low ceilings and a general air of bright and happy intimacy. The walls are of massive stone masonry; some supports are square piers recalling those in the valley temple of Chephren (see fig. 85), but wooden columns were frequently used. These are now lost, but their form can be reconstructed through representations in wall paintings, from their bases, which are square stone slabs with a socket for the column, and from their cushion-shaped stone capitals, distant ancestors of the Doric capitals of the Greeks (see figs. 192, 194). Strangely enough, the columns tapered downward, a feature that further increased the feeling of lowness and intimacy in the rooms.

PAINTING The mural decorations, painted on wet plaster like the frescoes of fourteenth-century Italy, have survived only in tiny fragments, which have been pieced together; large gaps are filled by modern restorations. The painted interiors must have been joyous. A room at Knossos known as the Queen's Megaron (fig. 161; *megaron* means "great hall") is illuminated softly by a light well. The doorways are ornamented with formalized floral designs, the columns and capitals are painted red and blue. On one wall we seem to look straight into the sea, as if through the glass of an aquarium; between rocks indicated by typical Minoan free curves, fish swim around two huge and contented dolphins.

156. Beaked Kamares jug, from Phaistos, Crete. c. 1800 B.C. Height 10⅝". Archaeological Museum, Heraklion, Crete

157. Octopus vase, from Palaikastro, Crete. c. 1500 B.C. Height 11". Archaeological Museum, Heraklion

158. Plan of the Palace at Knossos, Crete. c. 1600–1400 B.C. (After J. D. S. Pendlebury) 1. West porch 2. Corridor of the Procession 3. South Inner Gate 4. Central court 5. Possible theater area 6. Pillar hall 7. Storerooms 8. Throne room 9. Palace shrine and lower verandas 10. Grand staircase 11. Light well 12. Hall of the Double Axes 13. Queen's Megaron

159. Lower section of the main staircase and light well, east wing, Palace at Knossos (reconstruction). c. 1600–1400 B.C.

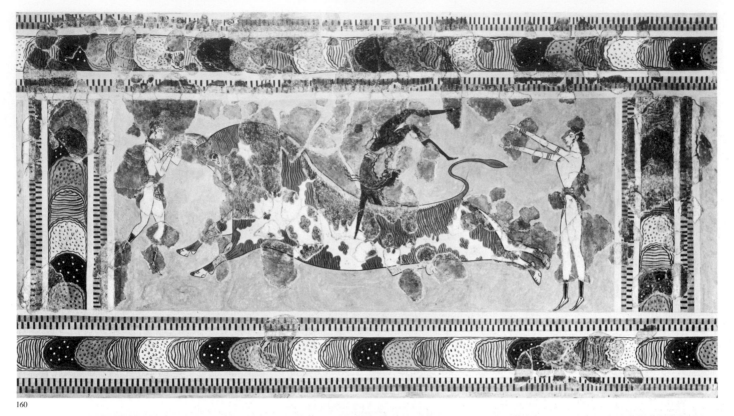

160

161

162

In murals as in ceramics, unfettered rhythmic contours—astonishing when compared to the stratified compositions typical of Egypt and Mesopotamia—are the chief delight of Minoan painting. In the still enigmatic *Bull Dance* from Knossos (fig. 160), these pulsating contours are extremely effective. Unlike the murderous bulls in Egyptian and Mesopotamian art, this resilient creature seems almost to have been trained for his role. He and his attendants are engaged not in mutual slaughter but in some kind of ritual dance. One almost nude girl dancer (painted yellow as in Egyptian art) grasps with impunity the bull's horns; a second waves from the sidelines; and the boy (red-brown) vaults over the bull with the agility of an acrobat. The forward lunge of the bull and the arching movement of the boy are enhanced by the sideward and upward thrust of the conventionalized rocks of the borders. It is believed that the bull ritual we see in

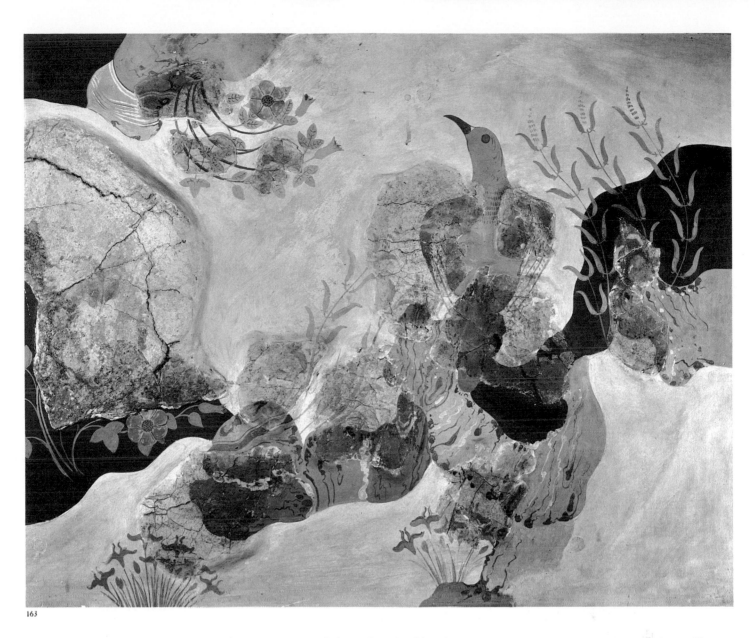

163

this fresco actually took place in the great court of the palace itself, suitably barricaded and scaled off.

The naturalism of Minoan frescoes, such as the fragment from Knossos showing a bird in a landscape (fig. 163), recalls that of Egyptian paintings, which Minoan merchants must have seen on their visits to the Nile Valley. But the spirit of Minoan art is quite different. Birds fly, animals scamper, plants grow, the very hills seem to dance with a rocking rhythm as if the waves or the sea wind were carrying them along. Some of the most brilliant Minoan paintings have only recently come to light on the island of Thera, part of which sank into the sea in a violent volcanic explosion about 1400 B.C., the rest being buried under volcanic ash. A marvelous room has now been pieced together, with red, violet, and ocher hills and precipices undulating about three walls like live things, asphodel growing from their crests and saddles in dizzying spirals, and swallows fluttering from plant to plant or conversing in midair (see fig. 1). This earliest known European landscape painting is the ancestor of the landscape frescoes of Roman art (see figs. 325, 348) and eventually of such panoramas as those in fourteenth-century Sienese painting. Among the most delightful of the Thera finds is the fresco representing two small boys boxing (fig. 162), with a single pair of gloves between them. Despite

160. *Bull Dance*, fresco from the Palace at Knossos. c. 1500 B.C. Archaeological Museum, Heraklion

161. The Queen's Megaron, Palace at Knossos (reconstruction). c. 1600–1400 B.C.

162. *Boxers* (*The Young Princes*), fragment of a fresco from the Cycladic island of Thera. Before 1500 B.C. National Archaeological Museum, Athens

163. *Bird in a Landscape*, fragment of a fresco from the Palace at Knossos. c. 1600–1400 B.C. Archaeological Museum, Heraklion

the determined expressions in their large, soft eyes, the strongest movement in the fresco is not that of their rather gentle blows but the characteristic pulsation of their fluid contours.

SCULPTURE Monumental sculpture can hardly be expected from a civilization that built no temples and revered no divine monarchs. What little Minoan sculpture survives is small in scale and often uncertain in purpose. Faience statuettes (fig. 164) have been found representing a youthful female figure with bared breasts, a tight bodice, and richly flounced skirt. This impressive personage, who brandishes a snake in either hand, is often called a priestess but is more probably a goddess of the still unknown Minoan religion. In the elegance of her contours and in the softness of her movement, she betrays the same sensibility that distinguishes the wall paintings. Minoan sculpture did just as brilliantly with the wholly nude male figure in action, as we see in the little ivory statuette of an *Acrobat* (fig. 165). This youth, sailing happily through the air with boyish ease, shows in his free contours the same fluid pulsation as the painted *Boxers* from Thera or the bull dancers at Knossos.

Surprising and thus far unique is the upper portion of a small black steatite vase known as the *Harvester Vase* (fig. 166), on which is carved in low relief a crowd of young men, nude to the waist, marching as if in ritual procession but overlapping freely—in contrast to the regimented movement of Egyptian or Mesopotamian figural groups. The harvesters carry long-handled implements, including a pitchfork, and one shakes a sistrum (rattle) with such force that his ribs and rib muscles swell within the skin of his torso; some have their mouths open as if singing in exultation. Never up until this moment have we encountered such freedom

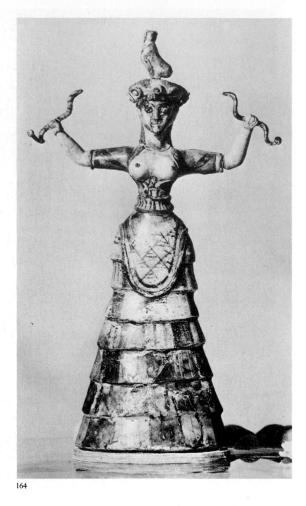

164

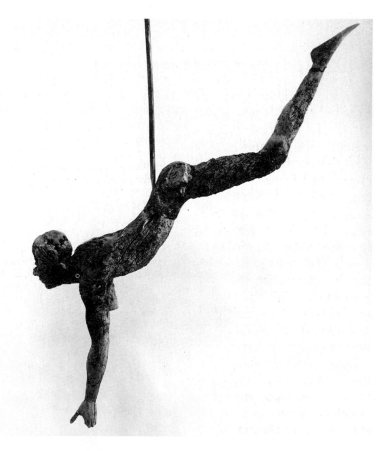

165

164. *Snake Goddess*, from the Palace at Knossos. c. 1600 B.C. Faience, height 13½". Archaeological Museum, Heraklion

165. *Acrobat*, from the Palace at Knossos. c. 1550–1500 B.C. Ivory, length 11⅝". Archaeological Museum, Heraklion

166. *The Harvester Vase* (detail), from Hagia Triada, Crete. c. 1550–1500 B.C. Steatite, diameter of vase 4½". Archaeological Museum, Heraklion

167. Rhyton, from the Palace at Knossos. c. 1550–1500 B.C. Steatite with inlaid shell and rock crystal, height of head 12". Archaeological Museum, Heraklion

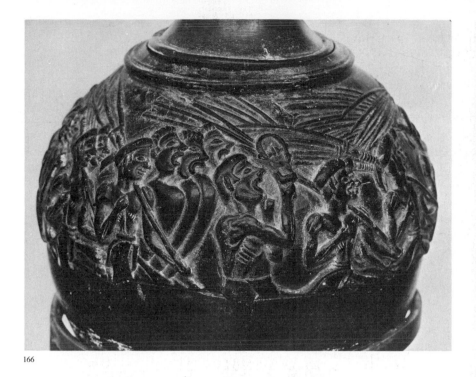

166

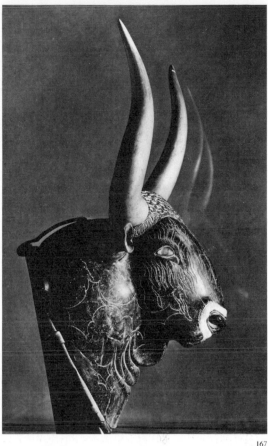

167

of emotional expression in ancient art. The bull, dear to ancient civilizations and possibly sacred to the Minoans, reappears in a splendid black steatite rhyton (fig. 167), with horns and eyes inlaid with shell and rock crystal. The powerful curves of the flaring horns contrast with the delicate, meandering motion of the incised lines indicating locks of hair.

Mycenaean Art

ARCHITECTURE The Greek mainland was inhabited by the Achaeans, an early Greek ethnic group whose commercial and political relations with the Minoans have yet to be thoroughly explored. They were soldiers, and their palaces were citadels utilizing the massive outcroppings of rock that tower above the narrow Greek valleys as natural defenses. The outer walls of such citadels were "cyclopean," built of irregular stone blocks so huge that the later Greeks thought them the work of the Cyclopes, a race of one-eyed giants. Within the wall, however, the palaces were built of sun-dried brick as in Egypt and Mesopotamia. We gain entrance to the palace proper in the thirteenth-century-B.C. citadel of Tiryns (fig. 168) through a columned gateway. Before us rises the columned facade of the royal audience hall, or megaron, whose roof was supported within by four columns around a circular hearth. Traces of rich painted decoration have been found on the plastered floor, and there were numerous wall paintings. The relative positions of gateway and megaron foretell those of the Athenian Propylaia, or entrance gate to the Acropolis (see fig. 240), and the Parthenon in Classical times.

The formidable walls of the citadel at Mycenae, also built of cyclopean masonry, were entered through a trilithon (three-stone) gate recalling the megalithic architecture of the Late Stone Age. The triangle framed by the lintel and the progressively projecting blocks above is occupied by one of the few pieces of monumental sculpture surviving from Aegean times, a massive high relief showing two muscular lions (alas, now headless) placing their front paws upon the base of a typical Minoan tapering column (fig. 169). Clearly the column had a religious significance that required it to be flanked and protected by the royal beasts.

By far the most accomplished and ambitious of these cyclopean con-

168. Citadel of Tiryns, Greece. 13th century B.C.
(Architectural reconstruction after G. Karo)

169. The Lion Gate, Mycenae, Greece (detail).
c. 1250 B.C. Limestone high relief, height
c. 9′6″.

170. Plan of the Treasury of Atreus, Mycenae.
13th century B.C. (After A. W. Lawrence)

171. Interior, Treasury of Atreus, Mycenae

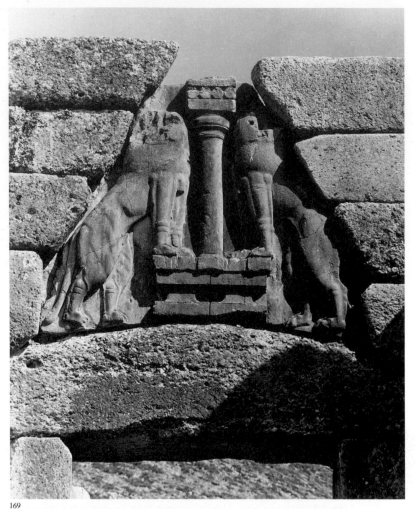

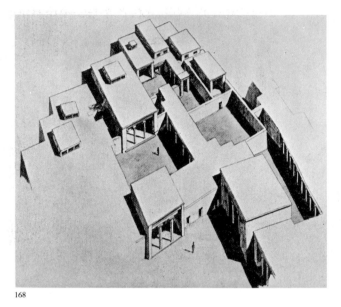

168

169

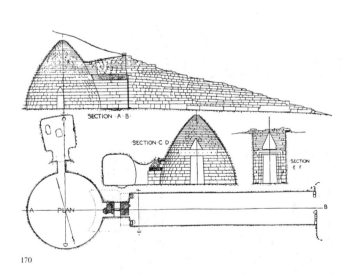

170

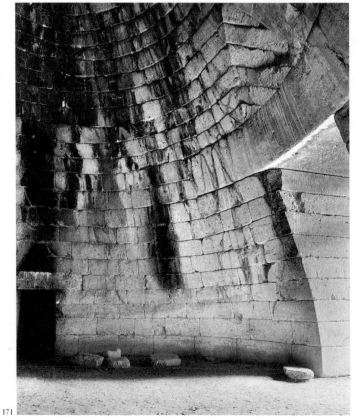

171

structions is the so-called Treasury of Atreus at Mycenae (fig. 170), actually a thirteenth-century royal tomb, some 43 feet in height and 47½ in diameter. Although all the rich decoration, possibly in precious metals, that once enlivened the interior and the entrance has been plundered, the effect of the simple masonry vault is majestic in the extreme (fig. 171). It is a corbel vault, with superimposed courses of masonry projecting one beyond the other as at Maeshowe in the Orkneys (see fig. 36). The blocks are trimmed off inside to form a colossal beehive shape of remarkable precision and accuracy. This is the largest unobstructed interior space known to us before that of the Pantheon in imperial Rome (see fig. 7).

GOLDWORK, IVORY, AND PAINTING Schliemann's excavations of the royal graves at Mycenae in 1876 yielded a dazzling array of objects in gold, silver, and other metals, some ceremonial, some intended for daily use. A number of masks in beaten gold (fig. 172) were probably intended to cover the faces of deceased kings. Although hardly to be compared with the refinement of the gold mask of Tutankhamen (see fig. 118), their solemn honesty is nonetheless impressive.

The Mycenaean warrior kings attached great importance to their weapons, and superb examples have been found. A bronze dagger blade inlaid with gold and electrum, a natural alloy of silver and gold (fig. 173), shows a spirited battle of men against lions, surpassing anything we have thus far seen in swiftness of movement. One lion assaults lunging warriors protected by huge shields, while two other lions turn tail and flee with inglorious speed, toward the point of the dagger.

Even more beautiful are two golden cups (figs. 174, 175) found at Vaphio in Laconia and datable to about 1500 B.C. These works, to be

172. Funeral mask, from the royal tombs, Mycenae. c. 1500 B.C. Beaten gold, height c. 12". National Archaeological Museum, Athens

173. Dagger, from the Citadel of Mycenae. c. 1570–1550 B.C. Bronze inlaid with gold and electrum, length c. 9½". National Archaeological Museum, Athens

174, 175. *The Vaphio Cups*, from Laconia, Greece. c. 1500 B.C. Gold, height c. 3½". National Archaeological Museum, Athens

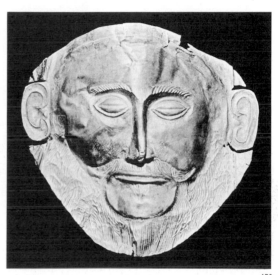

172

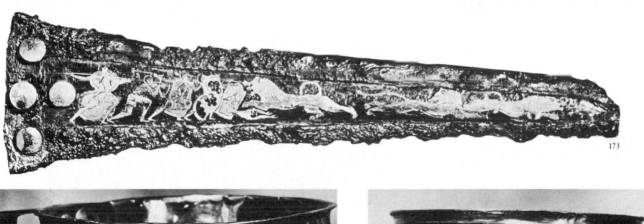

173

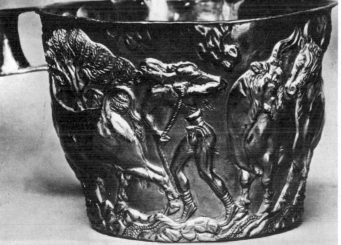

174

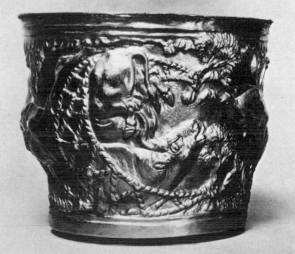

175

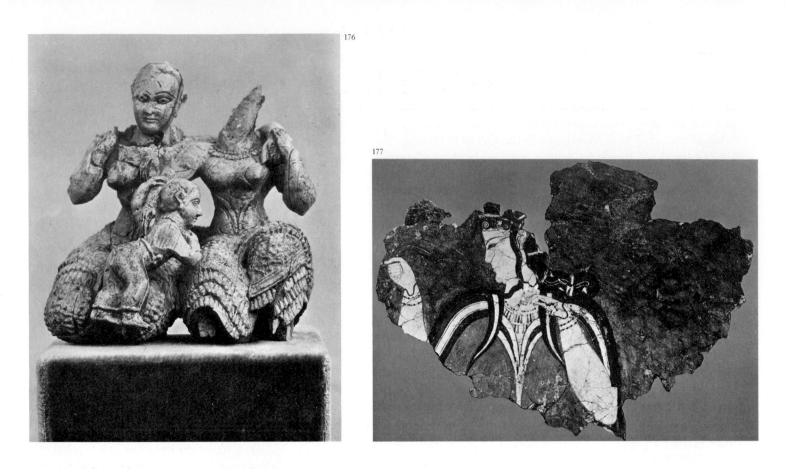

ranked among the masterpieces of ancient art, are covered with continuous reliefs of extraordinary vivacity and power showing the capture of bulls. While the style is clearly Minoan, recalling the movement and expressive intensity of the *Harvester Vase*, these violent bulls are far removed from the graceful creature that appeared in the Knossos fresco. Various methods of entrapment are shown, ranging from lassoing the ankle with a rope, held by a characteristically wasp-waisted, muscular young man, to capture by nets and enticement by a friendly cow. The cups pulsate with the movement of the powerful bodies and flying hooves; the motion subsides only in the romantic tête-à-tête of the bull and the cow.

A little ivory group of unknown purpose (fig. 176) has recently been found near a sanctuary at Mycenae. It shows three deities, possibly Demeter, the earth-goddess, her daughter Persephone, and the young god Iakchos, although this is pure conjecture. The affectionate grouping of the figures, with arms over shoulders and free, playful poses, combined with the fluid movement of the skirts, renders this one of the most poetic works of Aegean art. Little by little, paintings of high quality come to light, including a superb female head under strong Minoan influence (fig. 177).

176. *Three Deities*, from Mycenae. c. 1500–1400 B.C. Ivory, height 3″. National Archaeological Museum, Athens

177. *Female Head*, fragment of a fresco from Mycenae

Under the attacks of another group of Greek invaders from the north, the Dorians, the rich and powerful Mycenaean civilization was overwhelmed and destroyed about 1100 B.C., to be succeeded by a period often known as the Dark Ages. The darkness was deepened by obscurity and neglect. As far as we know, the great achievements of Aegean art were without influence on their Greek successors and remained unknown until our own times.

CHAPTER

GREEK ART

FOUR

Of the three great historic arts we have considered up to this point, that of Egypt alone left a measurable influence on later periods, and even Egyptian influence was only occasionally fruitful or decisive. Splendid though they were, the arts of Mesopotamia and of the Aegean world vanished almost entirely from human sight and memory until very nearly our own times. When we turn to ancient Greece, however, we are dealing for the first time with an art that has never been entirely forgotten. Greek art, like Greek culture in general, influenced in one way or another the art of every subsequent period of Western civilization, including the present, sometimes to an overwhelming degree. Even when later cultures felt they must revolt against Greek influence, each revolt in itself was a tribute to the greatness of Greek achievement. The only other culture that has left a comparable impression on later periods is that of Rome, and this is in large part because Rome was the transmitter, by commerce and by conquest, of the artistic heritage of Greece.

If we attempt to account for the great depth and the astounding durability of Greek influence, we will probably come to the conclusion that they are both due to the primacy of Greek civilization and Greek art in developing rational norms for every aspect of the arts, as distinguished from the rigid conventions imposed by Egyptian society upon Egyptian art. The Greeks derived these norms from human nature and behavior, accessible to Greek thinkers, writers, and artists through their unprecedented powers of observation, inquiry, and analysis. "Man is the measure of all things," said the Greek philosopher Protagoras in the fifth century B.C., and while Protagoras' own subjectivity aroused considerable controversy in his lifetime, his celebrated remark may still be taken as typical of the Greek attitude toward life and toward art. The dignity and beauty of the individual human being and the rich texture of physical and psychological interplay among human beings constitute at once the subject, the goal, and the final determinant of Greek artistic and literary creation.

Both land and climate stimulated the unprecedented concentration of Greek culture on the quality of human life and on physical and intellectual activity. Greece is a land of mountainous peninsulas and islands, separated by narrow, fjordlike straits and bays, with scanty arable land. It is subject to strong contrasts of winter cold and summer heat and to fierce and unpredictable sea winds. Horizons are limited by mountains and rocky islands. Under a sunlight whose intensity is credible only to those who have experienced it, the land takes on a golden color against a sea and sky of piercing blue. Day gives way to night almost without intervening twilight. Against such a background and in such light, forms and relationships are clear and sharp.

In such an environment it was neither easy nor necessary to establish cooperative relationships between communities, separated by mountain walls or by arms of the sea. A living had to be wrested by

force and by intelligence from rocky land and treacherous water. The beautiful but often hostile Greek surroundings fostered an athletic and inquiring attitude toward existence that contrasted strongly with Egyptian passivity and that precluded submission to universal systems of government. Farming was not easy in the rocky soil; grain crops required great expenditure of effort, and the olive tree and the vine needed careful tending. In addition to the limited agricultural class, a trading class eventually arose, and finally a manufacturing class engaged in the production of such characteristic Greek artifacts as pottery and metalwork, which were exported to the entire Mediterranean world. Like the Minoans before them, the Greeks were excellent sailors; like the Mycenaeans, they were valiant soldiers. Greek systems of government were experimental and constantly changing. It is no accident that so many English words for governmental forms derive from Greek—*democracy*, *autocracy*, *tyranny*, *aristocracy*, *oligarchy*, and *monarchy*, to name only a few. Even *politics* comes from the Greek *polis*, the word for the independent city-state with its surrounding territory, which was the basic unit of Greek society. All six of the forms of government just mentioned were practiced at one time or another by the Greek city-states on the mainland, the islands, Asia Minor, Sicily, and southern Italy, often in rapid succession or alternation. But even when popular liberties were sacrificed for a period to a tyrant or to an oligarchic group, the Greek ideal was always that of self-government. The tragedy of Greek history lies in the inability of the Greek city-states to subordinate individual sovereignty to any ideal of a permanent federation that could embrace the whole Greek world and put a stop to the endemic warfare that sapped the energies of the separate states and eventually brought about their subjugation. Until the time of Alexander the Great, who borrowed the idea from the Near Eastern cultures he conquered, the notion of a god-king on the Egyptian or Mesopotamian model was wholly absent from Greek history. We can find a special significance in the fact that, while the Egyptians and Mesopotamians recounted their history in terms of royal reigns or of dynasties, the Greeks measured time in Olympiads, the four-year span between the Olympic Games, an athletic festival celebrated throughout ancient Greek history.

The Greeks peopled their world with gods who, like themselves, lived in a state of constant rivalry and even conflict, often possessed ungovernable appetites on a glorified human scale, took sides in human wars, and even coupled with human beings to produce a race of demigods known as heroes. Only in their greater power and knowledge and in their immortality did the gods differ from humans. Just as no single mortal ruled the Greek world, so no god was truly omnipotent, not even Zeus, the king of the gods.

The Greeks were strongly aware of their achievements, and not least of their history, as a record of individual human actions rather than merely of events. Their art is the first to *have* a real history in our familiar sense of an internal development. Egyptian art seems to spring into existence fully formed and can hardly be said to have developed after its initial splendid creations. And certain basic forms and ideas run throughout Mesopotamian art from the Sumerians to the Persians. But Greek art shows a steady evolution from simple to always more complex phases, some of which are for convenience labeled Archaic, Classical, and Hellenistic. Although this development was not steady, nor uniform at all geographic points, it is strikingly visible and has often been compared with that of European art from the late Middle Ages through the Renaissance and the Baroque periods. From start to finish, the entire evolution of Greek art took only about seven centuries, or less than one quarter of the long period during which Egyptian art continued relatively unchanged. The Age of Pericles, often considered the peak of Greek artistic achievement, lasted only a few decades.

Despite the anthropocentric nature of Greek culture, the Greeks were under no illusions about the limitations or indeed the inevitable downfall of human ambitions. One of their favorite literary forms, which they indeed invented and in whose composition they rose to unrivaled heights of dramatic intensity and poetic grandeur, was tragedy (the very word is Greek). In Greek tragedy, human wills pitted against each other bring forth the highest pitch of activity of which men and women are capable; yet these

activities lead to disaster through inevitable human shortcomings. In all of Greek art there are no colossal statues of monarchs like those of the Egyptian pharaohs. With few exceptions, only gods were represented on a colossal scale, and although none of these statues survive, the literary accounts indicate that in spite of their size they were entirely human and beautiful. In contradistinction to the hybrid deities of the Egyptians and the Mesopotamians, in ancient Greece only monsters were part human and part animal. These hybrids were invariably dangerous (satyrs, centaurs, and sirens), often totally evil (the Minotaur).

But while Greek rationality gave rise to arithmetic, geometry, philosophy, and the beginnings of astronomy, zoology, and botany (again the words are Greek), the system had its Achilles heel (another Greek expression). Hellenic society was emphatically a man's world. Women were restricted to home-making and childbearing and were immured in their special section of the house, the *gynecaeum*. They could not attend the famous *symposia*, or banquets, at which intellectual questions were discussed and were permitted no role in Greek political, intellectual, or artistic life. Only when a woman had lost her "virtue" and became a courtesan could she attend otherwise all-male functions; many of these courtesans achieved a certain power in Greek society. Also, despite the Greek vision of the good life and the perfect state, Greek communal life was actually seldom able to achieve a lasting order. Even in the Classical period the Greek polis permitted both chattel slavery and the disenfranchisement of subject states. Notwithstanding the rationality of Greek philosophers, at no point in Greek history was there any serious or widespread threat to belief in a host of anthropomorphic deities. Yet one of the great charms of the Greeks is the fact that, side by side with the development of the intellect, the life of the passions continued with undiminished intensity, endowing the coldest creatures of reason with an irrational but poetic beauty.

What remains to us of Greek art is of such high quality that it is painful to contemplate the extent of our losses. The survivals constitute, in fact, only a small and irregularly distributed proportion of Greek artistic production. We possess some ancient written accounts of what were considered the greatest works of Greek art, notably the writings of the first-century Roman encyclopedic naturalist Pliny the Elder and the Greek traveler Pausanias of the second century A.D. From these sources we know of many celebrated Greek buildings that have totally vanished; the few that remain standing are all in more or less ruinous condition. Only two statues survive that can be attributed to the most famous Greek sculptors: one, the *Victory* of Paionios (see fig. 247), is in fragments, and the other, *Hermes* (see fig. 263), is not universally accepted as the work of Praxiteles. The other preserved Greek original sculptures are either carved by unidentified masters or quite late signed works of secondary importance, such as *Laocoön* (see fig. 287) and *Polyphemos Blinded by Odysseus* (see fig. 288), both by the same trio of sculptors from Rhodes. Many Roman copies of Greek statues were made with a mechanical aid, the pointing machine, which transferred adjustable points on a metal frame from the original to the copy, enabling the copyist to reproduce sizes, poses, proportions, and details with some fidelity. Roman copies, therefore, give us a fairly clear idea, however diluted in quality, of the appearance of many lost masterpieces. The general reliability of Roman copies is, of course, susceptible to demonstration when several copies of the same original are checked against each other. But thousands of statues must still lie underground, and a lucky find can always turn up an original of high quality, as has happened even in excavations for buildings or highways.

Monumental painting, to which the Greeks attached the highest importance, is totally and irrevocably lost. Not the smallest piece of any famous Greek painting has ever been recovered, nor, in the nature of things, is any likely to be, for the very buildings on whose walls most of them were painted have long since vanished. Only literary descriptions survive, and occasional "copies," which may not be copies in our sense at all. The local Italian artists who reproduced renowned Greek paintings may never have seen the original works in distant Greece or Asia Minor, but only portable sketches or replicas brought home by travelers. We have, therefore, only the most general idea of what the style of the great Greek painters must have been like, and only now and then are we able to reconstruct the order of figures in one of their

compositions. It is in painting, however, that women make their first appearance in the literature on art, in a passage from the Roman author Pliny, of the first century A.D., which despite its condescending tone is of the utmost importance, for it was known and quoted throughout the late Middle Ages and the Renaissance:

> Women too have been painters: Timarete, the daughter of Mikon, painted an Artemis at Ephesos, in a very ancient picture. Eirene, the daughter and pupil of the painter Kratinos, painted a girl at Eleusis, Kalypso painted portraits of an old man, of the juggler Theodoros, and of the dancer Alkisthenes; Aristarete, the daughter and pupil of Nearchos, painted an Asklepios. Iaia of Kyzikos, who remained single all her life, worked at Rome in the youth of Marcus Varro, both with the brush and with the cestrum on ivory. She painted chiefly portraits of women, and also a large picture of an old woman at Naples, and a portrait of herself, executed with the help of a mirror. No artist worked more rapidly than she did, and her pictures had such merit that they sold for higher prices than those of Sopolis and Dionysios, well-known contemporary painters, whose works fill our picture galleries. Olympias was also a painter; of her we know only that Autoboulos was her pupil.

We have, of course, no more evidence of the work of these women painters than of their male contemporaries, but we can glean from this passage that women painted even in Archaic times, that their work was highly valued, that they had male pupils, but that their work was limited almost entirely to portraits—only a single painting of a mythological or historical subject is recorded (see page 189).

Another serious loss is that of color in architecture and sculpture. Under the influence of marble statues and capitals from which the original coloring leached out centuries ago, we tend to think of Greek art—and Greek costumes, too—as white. Nothing could be further from the truth. In early periods the coloring applied to the statues was quite bright, even garish, judging from traces of the original paint still remaining here and there. In the Classical period and in the fourth century, coloring was undoubtedly more restrained but was certainly used to suggest actual life, especially in eyes, lips, and hair. Garments were colored, and certain details were added in gold or other metals in all periods. Limestone or sandstone temples were coated with fine plaster tinted to resemble marble. In all temples, including the marble ones, capitals and other architectural details were brightly painted. Wall decorations from the Hellenistic era survive to indicate that the interiors of prosperous homes were also ornamented in color (see fig. 290). If the well-known Greek sense of harmony and of the fitness of things gives us any basis for speculation, then Greek color must have been harmoniously adjusted and must have formed an essential part of the total effect of works of architecture and sculpture. We must attempt to restore this effect in our imaginations if we are to understand the work of art as the artist intended it. Only the pots, which as we have seen (page 124) are unlikely ever to be totally destroyed, survive in vast numbers and with their coloring intact. In Greek ceramics the color is generally limited to red terra-cotta; black and white slip, baked on; and an occasional touch of violet. But even the pots, made for practical, everyday purposes, were intended to be seen not, as now too often, in superimposed rows in museum cases, but as small, movable accents in richly colored interiors.

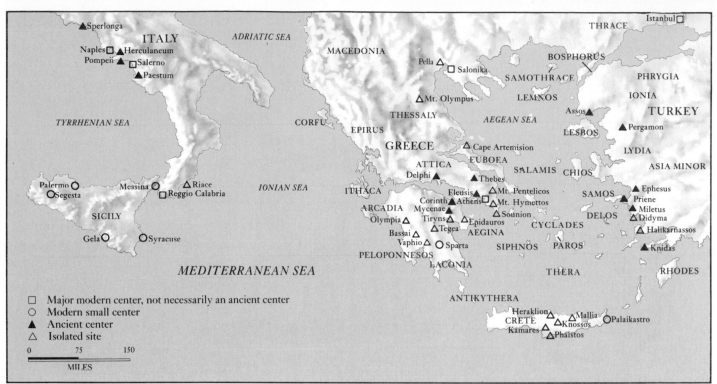

MAP 6. THE HELLENIC WORLD

The three centuries from about 1100 B.C. to about 800 B.C. are still an era of mystery and confusion, often called—by analogy with the later one following the breakup of the Roman Empire—the Dark Ages. The title is intended to suggest not only the dimness of our present knowledge of this era but also the fact that what little has been unearthed about it indicates a fairly low stage of cultural development—indeed, a sharp decline from the splendor of Mycenaean art and civilization. At the beginning of this period tribes from the north, probably the Danube basin, moved south into the areas formerly ruled by Mycenaeans, settling largely in the Peloponnesos, the cluster of peninsulas that makes up southern Greece. Later Greeks called these people Dorians; Sparta, always the most conservative and warlike of the Greek city-states, prided itself on its Dorian origin. Some of the older peoples of Mycenaean derivation fled to the islands of the Aegean and to Asia Minor, where they founded such important centers as Ephesus and Miletus. These tribes, known as Ionians, were, however, not wholly driven out of Greece by the invaders. Some were able to preserve their identity, notably the inhabitants of the peninsula of Attica, with its most important center at Athens.

Understandably enough, architectural remains from this earliest period of Greek art are extremely scanty, although some foundations of temples have been uncovered. But we possess precious evidence as to the modest external appearance of such buildings from two small terra-cotta models (fig. 178) and fragments of another, which can be dated about the middle of the eighth century B.C. by comparison with contemporary pottery. Basically, these temples appear to be direct descendants of the Mycenaean megaron type, such as that at Tiryns (see fig. 168). A single oblong room, sometimes square-ended, sometimes terminating in an apse (semicircular end), was roofed with a gable and preceded by a columned portico. Probably the walls were of rubble or mud brick and the columns of wood; the roof may even have been woven from thatch. These are humble buildings indeed, yet they are the obvious prototypes of the Greek temples of a more splendid era (see figs. 199, 229).

The finest remains of eighth-century Greek art are certainly the pots,

Geometric and Orientalizing Styles (800–600 B.C.)

178

178. Model of a temple, from the Heraion near Argos, Greece. c. Middle 8th century B.C. Terra-cotta, length c. 14½". National Archaeological Museum, Athens

179

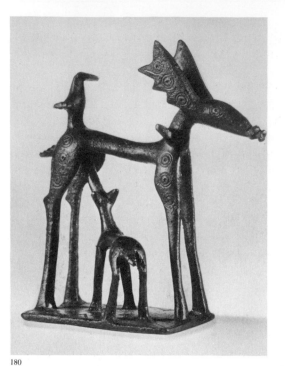

180

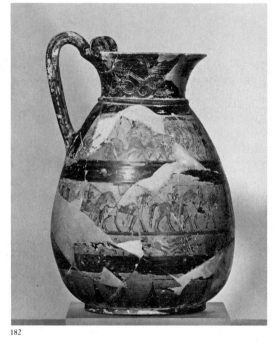

182

181

covered with the abundant ornament that gives the period its name, Geometric. Some of them are truly majestic, especially the huge *amphora* (jar for oil or wine; fig. 179) from the Dipylon Cemetery in Athens. This type of jar was placed over graves and perforated at the bottom so that offerings of oil or wine could seep through. The shape, with powerful body and lofty neck, slender handles, and slightly flaring lip, is of the greatest elegance. In contrast to the free-floating organic shapes of Minoan pottery, even the tiniest element is accessible to human reason and arranged in rational sequence. The surface is divided into almost innumerable bands of constantly varying width, ornamented with slender black lines describing against the terra-cotta background geometric figures—dots, diamonds, lozenges, and three different versions of the meander or "Greek fret" motive so common in later Greek decoration, some bands

apparently moving from right to left, some from left to right, some readable either way. A single band on the neck shows simplified and very graceful antelope grazing, moving from left to right. At the level of the handles, the frets seem to be parted, as it were, and forced to run vertically to make way for a funerary scene. The deceased, represented schematically and frontally on his bier, is flanked by identical wasp-waisted mourners with their arms elevated, looking like abstract versions of Aegean figures. Across the grand volume of the jar the slender lines of geometric ornament seem to shimmer in contrast to the strong black of the expanding and contracting figures.

A large number of statuettes in terra-cotta and in bronze remain from the Geometric period. A delightful example is the tiny bronze *Deer Nursing a Fawn* (fig. 180), hardly more naturalistic than the figures on the *Dipylon Vase* but just as intense in pattern and feeling. From none of the works of visual art, however, could we possibly guess that during this same crucial eighth century were composed the two great Homeric epics, the *Iliad* and the *Odyssey*, which seem to us in retrospect the very foundation stones of European literature. The discrepancy between these elaborate narratives—which display in a highly developed phase every facet of the skill of the oral epic poet—and the stylized images of Geometric painting and sculpture does not, however, constitute a unique instance as we follow the relations between the arts throughout history.

It is perhaps significant that words and meanings in ancient Greece developed earlier and more rapidly than visual images. But the pictorial arts did not remain long behind. Seventh-century vases show a considerable loosening of the tight Geometric style. At Eleusis, a massive amphora (fig. 181), almost as tall as the *Dipylon Vase*, is a striking example of the Proto-Attic style, so called because it precedes the full development of vase painting in Athens in the sixth and fifth centuries. The relatively inert Geometric ornament of the eighth century, which only suggested motion, has now "come alive" and depicts motion. The very shape of the vase has changed. The bottom is narrower, so that the body seems to swell, and the neck flares more sharply. The handles have grown enormously and are composed of cutout shapes, largely crosses and palmettes. The greatly reduced ornament, consisting largely of intertwined black and white bands, is extremely active. The main fields of the vase are now taken over by figures. Visible on one side of the body are two fierce, snake-haired Gorgon sisters, confronted by Athena (whose figure is only partially preserved); in the panel above is a fight between a lion and a boar. The most terrible scene is enacted on the neck, where Odysseus and two companions force a burning stake into the one eye of the Cyclops Polyphemos. The action of the figures seems reinforced by the centralized floral ornaments scattered freely throughout the background. These derive from Near Eastern sources and have given rise to the term *Orientalizing* for this second phase of Greek art. How energetic the style can be in other areas of Greece as well as in Attica is shown by the contemporary Proto-Corinthian *oenochoe* (wine pitcher) known as the *Chigi Vase* (fig. 182).

Although made at Corinth in the Peloponnesos, the *Chigi Vase* was found at an Etruscan site in central Italy and thus attests to the widespread commercial activity of the Greeks. The upper register, painted in black, white, and two tones of brown against the creamy terra-cotta background, shows foot soldiers equipped with helmets, shields, and spears hurrying into battle with a vigor and freedom that surpass even contemporary Assyrian sculpture (see fig. 144). In the central zone horses and riders move easily along, and below are lively hunters. The Macmillan

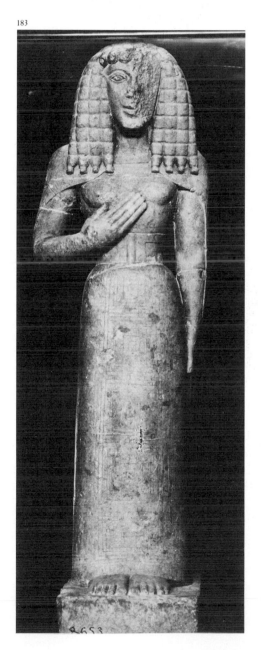

183

Painter, as the artist who decorated this vase has been called (after a private collection in which one of his works appears), was able to suggest depth in a new way by the overlapping of the limbs of humans and animals. The *Chigi Vase* is just over ten inches high; compared to the almost five feet of the Eleusis amphora, it seems a masterpiece in miniature.

Some sculpture in stone survives. Although less than lifesize, the limestone *"Lady of Auxerre"* (fig. 183), so called because she once stood in a museum in that French city, is impressive in her combination of linear precision and a rude massiveness that suggests at all points the original contour of the block. Her tight costume forms a pillowy shaft that conceals her legs, and it is decorated with a delicately incised meander pattern. About her bosom the costume tightens to reveal firm and abundant breasts. Her huge head is surmounted by a wiglike mass of hair, falling in four great locks on either side and so bound at intervals that they appear to be separated into little cushions. Her remaining eye and her mouth, with its delicate smile, are executed with a sensitivity that renders the relative clumsiness of hands and feet more surprising. Although this statue offers only a slight challenge to the then already two-thousand-year-old Egyptian tradition of figure sculpture, it is still a powerful work.

The term *Archaic*, from a Greek word meaning "early," is applied to the unexpectedly vigorous and inventive period in which the main lines of the arts in Greece were rapidly established. Enormous developments were made in a very brief span of time. Although it is a matter of personal taste, many prefer the incisive strength and brilliance of Archaic art, perhaps even because of its stylizations, to the richer, fuller, and more harmonious Classical phase that succeeded it. What is undeniable is that the sixth century B.C. is one of the great creative periods in world art. Beginning modestly, temple building achieved structures of the greatest originality, on an increasingly grand scale. Architecture was adorned with sculpture at many crucial points and was sometimes almost enveloped by it. Painting, as we know from countless thousands of painted vases, kept abreast of the other arts and perhaps—although we shall never know, since the wall paintings are forever lost—outstripped them. Since we have chosen Protagoras' famous saying, "Man is the measure of all things," as a text for our consideration of Greek art, it is perhaps best to start with the evolution of the human figure in Greek sculpture and then to consider how the figure was used as a measure for the other arts.

FREESTANDING SCULPTURE Greece is a land dominated by stone, and fortunately much of it is usable for sculpture. The Greek islands, notably Paros, and Mount Hymettos and Mount Pentelicos near Athens yielded marble of superb luminosity and clarity, far more beautiful than Egyptian limestone. Greek marble was not only easier to carve but more appropriate to the representation of human flesh than either the speckled granite or the dark diorite utilized by the Egyptians for monumental statues. And the Greeks' possession of iron gave them tools more effective than the softer bronze implements relied upon by the Egyptians. Iron points, claw chisels, and drills made it possible for the sculptor to bring out all the expressive beauty of the marble, which he could then smooth by the time-honored methods of abrasion and finally wax in order to bring the surface to the highest degree of perfection.

An impressive series of standing marble figures remains from the sixth

The Archaic Period (600–480 B.C.)

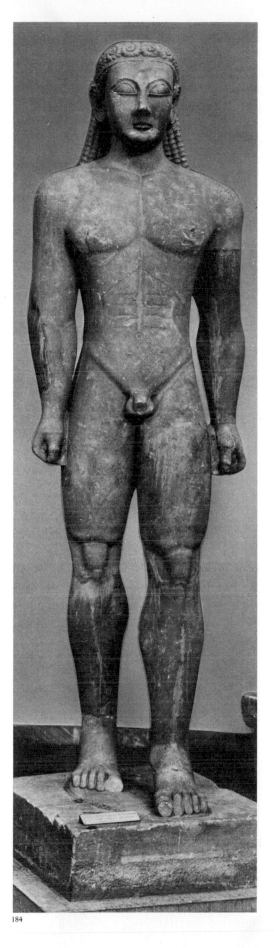

184

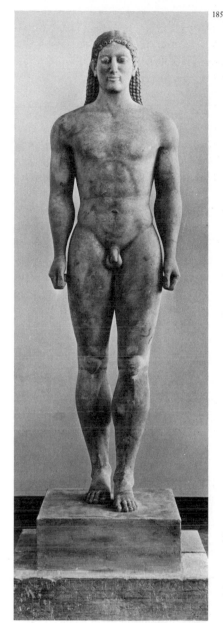

184. *Kouros of Sounion*. c. 600 B.C. Marble, height c. 10′. National Archaeological Museum, Athens

185. *Anavyssos Kouros*. c. 525 B.C. Marble, height 76″. National Archaeological Museum, Athens

century. For want of more precise terms the male statue is generally called *kouros* (youth), the female *kore* (maiden). Some statues were signed by their sculptors, others inscribed with the name of a donor. Some were dedicated to various deities; some were placed over graves. Votive and commemorative statues they certainly were, but not portraits in the sense of likenesses. Apparently, we should regard these statues as idealizations.

Strangely enough to modern eyes, the male figures are always totally nude, the female always fully clothed, but these conventions of male nudity and female modesty correspond to the fact that, while nude male athletes were seen daily in the *palaestra*, women never appeared unclothed. Moreover, men were completely free to go where they wished, while women, as we have seen, were generally restricted to their quarters.

The largest and grandest, and one of the earliest, of the kouros figures—a statue almost ten feet high—was found at Sounion near Athens and is datable about 600 B.C. (fig. 184). It shows undeniable Egyptian influence in the rigid stance of the figure, with the arms close to the sides and the left leg advanced. Given Greek commercial relations with Egypt,

GREEK ART 141

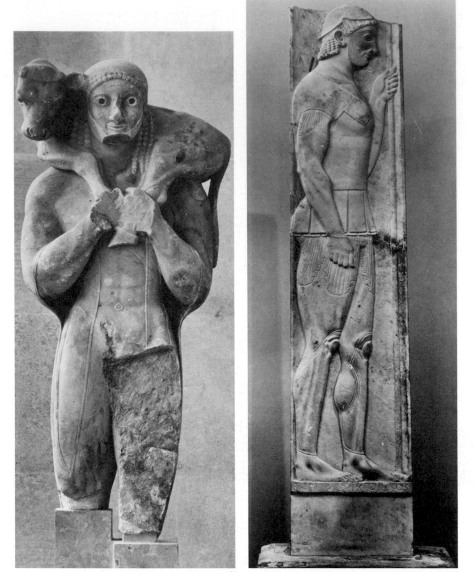

186

187

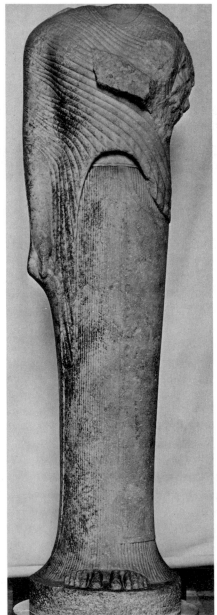

188

such influence is easier to account for than the as yet unexplained suddenness of its appearance. We still do not know why the Greeks began carving large-scale figures at the end of the seventh century B.C. At first sight the figure, for all its grandeur, seems much less advanced from the point of view of naturalism than Old Kingdom statues dating from two thousand years earlier. But there are telltale differences that suggest the enormous development soon to take place. First, although the Egyptian sculptor thought of his stone figures as freestanding (see the drawings of sculptors at work, fig. 80), in practice he invariably left a smooth wall of uncut stone between the legs and arms and the body (see fig. 87). Apparently, he was trying to avoid fracture in carving with soft bronze tools, on which enormous pressure had to be exerted. Such inert passages of stone must have been intolerable to the Greek artist as restrictions on the mobility and freedom of his figure, and he reduced them to the smallest possible bridges of stone between hand and flank. (He also did away with the kilt of the Egyptian statue to display the male figure in total nudity.) Second, while the weight of an Egyptian figure rests largely on the right (rear) leg, that of the kouros statue is always evenly distributed, so that the figure seems to be striding rather than standing. Finally, the total calm of the Egyptian figure, which never seems to have known the meaning of strain, gives way to an alert look and, where possible, to a strong

suggestion of tension, as in the muscles around the kneecap and especially in the torso, whose abdominal muscle is cut into channels as yet neither clearly understood nor accurately counted. The preternaturally large and magnificent head of the *Kouros of Sounion*, while divided into stylized parts in conformity with a lingering Geometric taste, shows the characteristic Greek tension in every line.

In the *Anavyssos Kouros* (fig. 185), done only some sixty to eighty years later and placed over the grave of a fallen warrior called Kroisos, the stylistic revolution hinted at in the *Sounion Kouros* has been largely achieved. At every point the muscles seem to swell with actual life. Although the full curves of breast, arm, and thigh muscles may as yet be imperfectly controlled, the pride of the figure in its youthful masculine strength is unprecedented. The sharp divisions between the muscles have relaxed; forms and surfaces now flow easily into each other. Even the lines of the still-stylized locks are no longer absolutely straight but flow in recognition of the fact that hair is soft.

A somewhat more mature, bearded figure, the *Calf-Bearer* (fig. 186), of about 570 B.C., shows the transition between the two phases. The sharp divisions of the muscles have softened, and the channels in the abdominal muscle are correctly placed and counted. The now largely destroyed legs originally had the characteristic kouros pose. The meaning of the famous "Archaic smile" that lifts the corners of the mouth still eludes us, but this smile is characteristic of Archaic art throughout the sixth century, after which it soon disappears. While still proclaiming the original surface of the block, the head of the calf the man bears as an offering is modeled with great sensitivity.

A superb funerary stele carved as an idealized portrait of the Athenian warrior Aristion (fig. 187) shows the rich possibilities opened up by Archaic artists. The sculptor Aristokles, who signed this work, was able to control gradations of low relief with great delicacy so as to suggest the varying distance of the left and right legs and arms from the viewer's eye and the fullness of the torso inside its armor. Aristokles' attention to visual effects freed the warrior completely from the Egyptian convention of two left hands and two left feet, and he seems to have delighted in contrasting the smoothly flowing surfaces of the body, neck, and limbs with the delicate folds and rippling edges of the *chiton* (garment worn next to the skin), which escape from beneath the armor and cling gently to the upper arm and the strong thigh.

One of the earliest of the kore figures was found in the Temple of Hera on the island of Samos (fig. 188) and is majestic enough to have been a statue of a goddess. About contemporary with the *Calf-Bearer*, the figure shows a striking change from the *"Lady of Auxerre"* (see fig. 183); the block, as is customary in Samian work, has here become a cylinder. When the missing head was intact, the hair fell over the back. The missing left hand probably held a gift. The *himation* (cloak), looped at the waist, is thrown around the torso and gathered lightly with the fingers of the right hand. The forms of the bosom are at once concealed and revealed by the streaming spiral folds, which contrast strongly with the tiny vertical pleats of the chiton. The profile of the figure, often compared to a column, has much in common with the elastic silhouette of an early amphora (see figs. 179, 181), expanding and contracting, elegant and restrained.

Another sixth-century masterpiece is the *Peplos Kore* from Athens (fig. 189), so named because the figure wears the *peplos*, a simple woolen garment. The statue is somewhat blocky in its general mass and beautifully reticent in its details. The severe peplos falls simply over the noble bosom

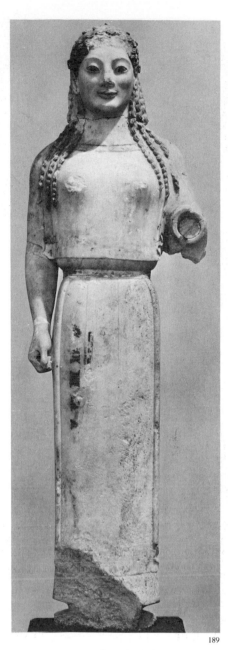

189

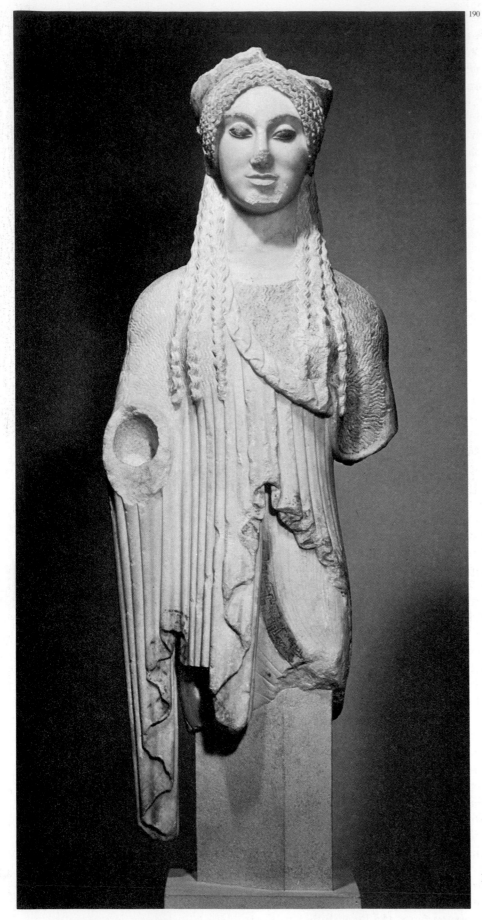

190. *La Delicata*, from the Acropolis, Athens.
c. 525 B.C. Marble, height 36″. Acropolis
Museum

and hangs lightly just above the narrow girdle about the waist. The left arm was originally extended, and thus freed entirely from the mass of the body with a daring we have never before witnessed in stone sculpture. In fact, it had to be made of a separate piece of marble and inserted into a socket, where a piece of it may still be seen. The right arm hangs along the body, the contours beautifully played off against the subtle curve of the hip and thigh, which the heel of the hand barely touches, eliminating the necessity for a connecting bridge. The broad face is unexpectedly happy, almost whimsical in its expression, and the soft painted red locks, three on each side, flow gently over the shoulders, setting off the full forms of the body. The *Peplos Kore* is datable about 530 B.C. The climax of the Archaic style can be seen in the enchanting kore nicknamed *La Delicata* (fig. 190), of just a few years later. The corners of the large and heavy-lidded eyes are lifted slightly, and the smile has begun to fade; indeed, the face looks almost sad. The folds and rippling edges of the rich Ionian himation, together with the three locks on either side, almost drown the basic forms of the figure in the exuberance of their ornamental rhythms. Some of the original coloring is preserved, which adds to the delight of one of the richest of all the kore figures. The next steps in the evolution of both male and female figures belong to another era.

ARCHITECTURE AND ARCHITECTURAL SCULPTURE

Great as were the new developments in Greek sculpture in the sixth century, they were at least equaled, perhaps even surpassed, by the achievements of Greek architects. These were not in the realm of private building, for houses remained modest until Hellenistic times. Neither kings nor tyrants, nor least of all, of course, democratic magistrates, built palaces like those of Mesopotamia, which incorporated temples into their far-flung complexes. The principal public building of the Greeks was the temple (fig. 191). Generally in a sanctuary dedicated to one or several deities, some temples were in lowland sites, others set upon a commanding height, like the Acropolis at Athens. Oddly enough, the Greek temple was not intended for public worship, which took place before altars in the open air. Its primary purposes were to house the image of the god and to preserve the offerings brought by the faithful. At first of modest dimensions and never of a size remotely comparable to that of Egyptian temples, it was impressive only in its exterior. Its appearance was dominated by the colonnaded portico, or *peristyle*, which surrounded all larger temples and existed in the form of porches even in very small ones. In a Greek polis a portico provided shelter from sun or rain and a freely accessible public place in which to discuss political or philosophical principles, conduct business, or just stroll. In fact, in Hellenistic times independent porticoes known as *stoas* were built for just these purposes. They were walled on three sides and open on the fourth, and were sometimes hundreds of feet long. The walls of early colonnaded temples were built of mud brick and the columns of wood. In the course of time stone was substituted for these perishable materials, but the shapes of wooden columns and wooden beams continued to be followed in their stone successors, just as the architecture of Imhotep at Saqqara (see fig. 74) perpetuated palm-trunk and reed-bundle construction.

Clearly differentiated systems known as orders governed all the forms of any Greek temple. The orders may be thought of as languages, each with its own vocabulary and rules of grammar and syntax, or as scales in music. At first there were only two orders, named for the two major

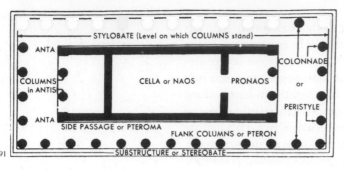

191

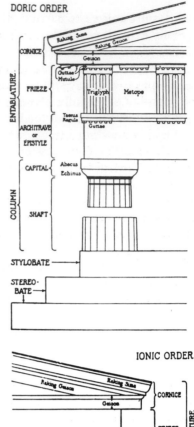

DORIC ORDER

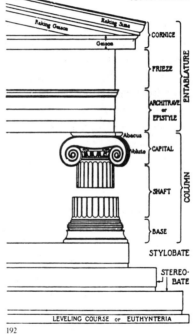

IONIC ORDER

192

ethnic divisions of the Greeks, the Doric and the Ionic. In the fifth century the Corinthian appeared; this order was seldom used by the Greeks but became a favorite among the Romans, who added two orders of their own, the Tuscan and the Composite. In Hellenistic times individual variants of the Greek orders appeared here and there, but these are occasional exceptions that prove the universal rule.

The column and the entablature, the basic components of the Greek orders (fig. 192), are simply more elaborate versions of post-and-lintel construction. The column was divided into shaft, capital, and base (Greek Doric columns had no base; one was added in the Roman version), the entablature into architrave, frieze, and cornice. The *capital* (from the Latin word for "head") was intended to transfer the weight of the entablature onto the shaft. The Doric capital consisted of a square slab known as the *abacus* above a smooth, round, cushion-shaped member called the *echinus*. The Ionic capital, more elaborate (fig. 193), had a richly ornamented abacus and echinus separated by a double-scroll-shaped member, the *volute*. The Doric architrave was a single unmolded stone beam, and the frieze was divided between *triglyphs* and *metopes*. The triglyph (from a Greek word meaning "three grooves") was a block with two complete vertical grooves in the center and a half groove at each side. The triglyphs derived from the beam-ends of wooden buildings; the metopes were the slabs between the beams. The Ionic architrave was divided into three flat strips called *fasciae*, each projecting slightly beyond the one below. The Ionic frieze had no special architectural character but could be ornamented or sculptured. The temple was usually roofed by a low gable whose open triangular ends, backed by slabs of stone, were called *pediments*.

Ancient writers considered the Doric order masculine and robust, the Ionic feminine and elegant. In every Doric or Ionic temple the basic elements were the same. The columns were made of cylindrical blocks, called *drums*, turned on a lathe. These were held together by metal dowels and were fluted, that is, channeled by shallow vertical grooves, after being erected. The earliest Doric columns had twenty-four flutes, which increased their apparent verticality and slenderness. Doric flutes met in a sharp edge; Ionic flutes were separated by a narrow strip of stone. Whatever may have been their purpose, the flutes have the effect of increasing the clarity of progression from light to shade in easily distinguishable stages around a shaft. The flutes may possibly be related to the polygonal columns occasionally used in Egypt (see fig. 104).

Unlike Egyptian polygonal and convexly fluted columns, which were always straight, and Aegean columns, which tapered downward, Greek columns tapered noticeably toward the capital. Egyptian cylindrical columns, generally based on plant forms, showed a considerable bulge near the bottom (see fig. 107); Greek columns, instead, had a slight swell, known as the *entasis*, suggesting the tonus of a muscle. They were, moreover, governed by the proportions of contemporary human sculptured figures. As the Greek figure grew slenderer and the head proportionately

191. Plan of a typical Greek temple (After I. H. Grinnell)

192. The Doric and Ionic orders (After I. H. Grinnell)

smaller, so the column diminished in bulk and its capital in size. On occasion the column could even be substituted by a human figure carrying the architrave (see figs. 198, 246).

Like the parts of the orders, the shapes of the temples were controlled by rules as stringent as those of grammar and music. Small temples often consisted only of a *cella* (the central rectangular structure housing the image of the deity), whose side walls were prolonged forward to carry the entablature and pediment directly and to frame two columns; such a temple was called *in antis*. If the portico ran across its entire front, the temple was *prostyle*; if it had front and rear porticoes, it was *amphiprostyle* (see fig. 242); if the colonnade, known as a *peristyle*, ran around all four sides, the temple was *peripteral* (see fig. 250); if the portico was two columns deep all around, the temple was *dipteral*.

Yet just as sonnets written in the same language or fugues composed according to the same rules will vary infinitely according to the ideas and talents of the poet or the musician, there are a surprising number of individual variations within what appear to be the stern limitations of Greek architectural orders and types. As we have already seen, there was a rapid change in the proportion of the columns corresponding to those of contemporary sculptured figures. The tapering and entasis also changed. The earliest examples show the sharp taper and a very muscular bulge, with sharply projecting capitals, suggesting physical strain in carrying the weight of the entablature. In later columns, along with the increase in height, both taper and entasis rapidly decrease and the projection of the capital sharply diminishes, until the lofty columns of the Parthenon in the middle of the fifth century appear to carry their load effortlessly. The changes in style and taste from temple to temple, subtle though they may at first appear, are distinct enough to enable one to recognize individual temples of either Doric or Ionic order at a glance.

The corner columns invariably caused difficulties. Since there was always one triglyph above each Doric column and another above each *intercolumniation* (space between two columns), either half a metope would be left over at the corner of the building or the corner triglyph would not be over a column. This discrepancy was solved by delicate adjustments of distances, so that a two-faced triglyph always appeared at the corner, with adjacent metopes slightly extended, and the corner column was brought a little closer to its neighbors. In the Ionic order, since the capitals had two scrolled and two flat sides, the problem was again how to turn the corner. This was solved by giving the corner capital two adjacent flat sides, with a volute coming out on an angle for both, and two inner scrolled sides (see figs. 242, 249).

But these adjustments were by no means all. Architects also toyed with the effects of varying proportions. Early temples were nearly three times as long as wide, while the Classical formula of the fifth century provided that the number of columns on the long side of a temple should be twice the number of those at either end plus one. The relatively simple interiors were lighted only by the large door. Numerous methods of supporting the roof beams were experimented with in early temples, including projecting spur walls like those at Saqqara (see fig. 78), and even a row of columns down the center, which had the disadvantage of obscuring the statue of the deity. The sixth- and fifth-century solution was generally two rows of superimposed orders of small columns, each repeating in miniature the proportions of the external peristyle (see fig. 221). Roof beams in early temples were still of wood and tiles of terra-cotta; in the sixth and fifth centuries marble was often used for roof tiles.

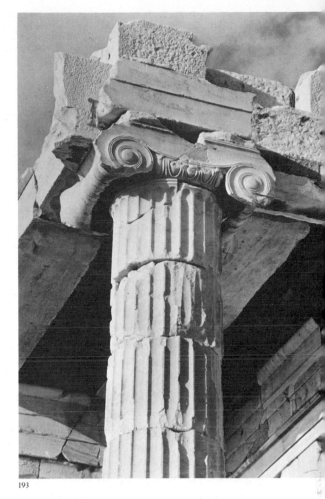

193

193. Ionic capital on a column in the central passage of the Propylaia, Acropolis, Athens

Sculpture could be placed almost anywhere in Egyptian temples; huge statues could sit or stand before or inside the temples; walls, columns, and pylons were alive with rows of figures carved in the shallowest relief, mingled with hieroglyphics, and painted. From the very start the Greeks made a clear-cut distinction between those sections of a temple that could be ornamented with sculpture and those that could not. Walls and columns were inviolable, save in the rare instances when a sculptured figure could become a bearing member (see figs. 198, 246). But into the empty spaces of a Greek temple sculpture could logically be inserted. Triglyphs were blocks of some size; the intervening metopes made splendid fields for relief sculpture. Naturally, the reliefs had to be of a certain depth in order to compete with the surrounding architectural elements, and there had to be some continuity in content among the metopes running round a large building. An Ionic frieze was also an obvious place for a continuous strip of relief sculpture. The corners of the pediments afforded the possibility of silhouetting sculptures (*acroteria*) against the sky. And above all, the empty pediments, which needed nothing but flat, vertical slabs to exclude wind and rain, provided spaces that could be filled with sculptured figures of a certain depth, preferably statues in the round. In those regions of Greece that enjoyed good stone for carving, and in those temples that could afford sculptural work, an unprecedented new art of architectural sculpture arose, never surpassed or even equaled until the Gothic cathedrals of the twelfth and thirteenth centuries were built (see Part Three, Chapter Six). For the first time in history, the architectural creations of humanity were in perfect balance with the human figure itself.

The earliest well-preserved Greek temple is not in Greece itself but in the Greek colony of Poseidonia, now called Paestum, on the western coast of Italy about fifty miles southeast of Naples. This limestone building, erroneously called the "Basilica" in the eighteenth century but more probably dedicated to Hera, queen of the gods, has lost its cella walls but still retains its complete peristyle (fig. 194). The temple is unusual in having nine columns across the ends; most others show an even number. The bulky, closely spaced columns with their strong entasis and widespread capitals appear to labor to support the massive entablature. Although the temple has no sculpture, it gives us an idea of how the slightly earlier Temple of Artemis on the Greek island of Corfu must originally have looked (reconstruction in fig. 195). Considerable fragments of one of the limestone pediments remain (fig. 196). This pediment was carved in

194. "Basilica" (Temple of Hera I), Paestum, Italy. Middle 6th century B.C.

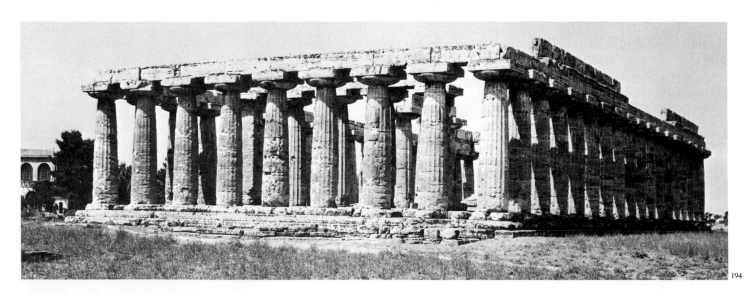

194

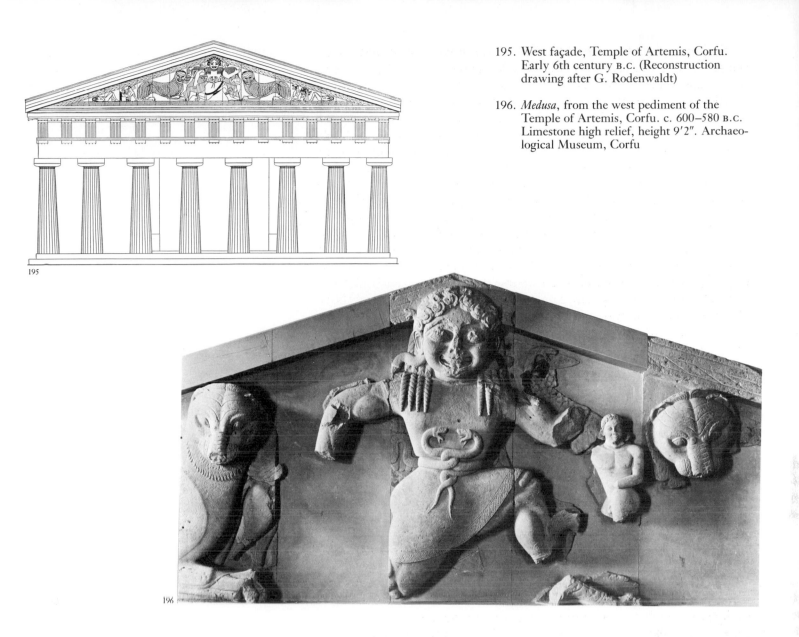

195
196

195. West façade, Temple of Artemis, Corfu. Early 6th century B.C. (Reconstruction drawing after G. Rodenwaldt)

196. *Medusa*, from the west pediment of the Temple of Artemis, Corfu. c. 600–580 B.C. Limestone high relief, height 9'2". Archaeological Museum, Corfu

high relief, approaching sculpture in the round. The central figure, so huge that she must kneel on her right knee in order to fit, is the Gorgon, Medusa, grinning hideously and sticking out her tongue. She was probably placed there to ward off evil spirits, and is aided in her task by the two symmetrical leopards that crouch on either side (one thinks of the heraldic lions of Mycenae; see fig. 169). On her left, as an odd anachronism and in smaller scale, appear the head and torso of the boy Chrysaor, who sprang from her neck when Perseus struck off her head; to her right was Pegasus, the winged horse, born in the same way and at the same moment. The modeling strongly suggests that of the *Calf-Bearer* (see fig. 186). In the empty corners of the pediment were placed smaller, battling figures of gods and giants. So symmetrical a grouping, with fillers at the corners, looks tentative when we compare it to the closely unified pediments that were created later. Nonetheless, the contrast between large and small masses of smooth stone is delightful, and so is Medusa's writhing belt, formed of live, intertwined, and very angry snakes.

A more refined and elegant, as well as more active and complex, use of sculpture appears in the little marble treasury built at the sanctuary of Apollo at Delphi around 530 B.C. by the inhabitants of the Greek island of Siphnos to hold their gifts. The Treasury of the Siphnians has been

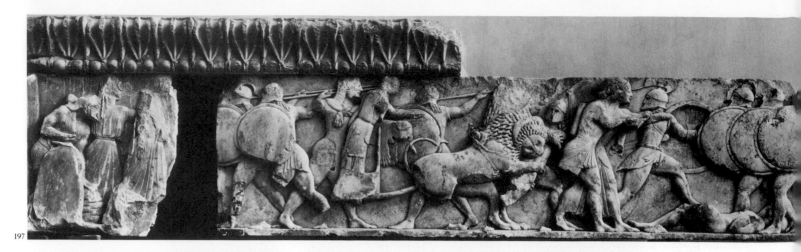

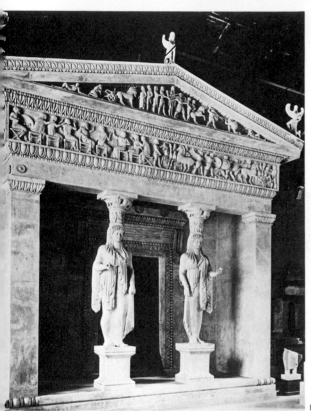

197. *Battle of Gods and Giants*, fragment from the north frieze of the Treasury of the Siphnians, Delphi. c. 530 B.C. Marble, height 26″. Archaeological Museum, Delphi

198. Façade, Treasury of the Siphnians, Sanctuary of Apollo, Delphi, Greece (partially reconstructed). c. 530 B.C. Marble. Archaeological Museum, Delphi

199. Temple of Aphaia, Aegina, Greece. c. 500 B.C.

200. Plan of the Temple of Aphaia, Aegina

partially reconstructed from fragments (fig. 198). Here columns are replaced by two graceful kore figures, known as *caryatids* (strongly resembling *La Delicata*; see fig. 190), on whose heads capitals are balanced to carry effortlessly the weight of entablature and pediment. The frieze is a continuous relief, largely depicting battle scenes. The *Battle of Gods and Giants* (fig. 197) shows that the sculptor had a completely new conception of space. No longer does he have to place one figure above another to

201

202

indicate distance. All stand or move on the same ground level and overlap in depth. Although none of the figures are in the round—they are all more or less flattened, in keeping with the character of a relief—those in the foreground are sharply undercut. The projection diminishes so that the figures farthest from the eye are only slightly raised from the background. This relief, for the first time in the history of art as far as we know, strives to achieve the optical illusion of space receding horizontally inward from the foreground. This recession is limited to a maximum of three figures (or four horses), but it is revolutionary nonetheless. The pediment contains, again for the first time, actual groups of almost free-standing statues, carved in more or less the same scale, in poses progressively adjusted to the downward slope of the pediment. The intense activity of the reliefs is kept in check only by the severity of the unrelieved wall surfaces below.

The climax of Archaic architecture and sculpture, at the threshold of the Classical period, is the temple of the local goddess Aphaia on the island of Aegina in the Gulf of Athens. The building was constructed about 500 B.C. of limestone stuccoed to resemble marble. Portions of the temple still stand (fig. 199). A plan of its original appearance (fig. 200) shows the outer Doric peristyle, with six columns at each end and twelve on each side. These columns are slenderer, taller, and more widely spaced than those at Corfu or in the Temple of Hera I at Paestum (see figs. 194, 195). For the first time the architect achieved what later became the standard solution of two superimposed interior colonnades. The marble pedimental statues were excessively restored in the nineteenth century, but these restorations have recently been removed. These statues are superb, full of the same vitality visible in the reliefs from the Treasury of the Siphnians (see figs. 197, 198) yet simpler and more successfully balanced. It is interesting to compare the *Oriental Archer* (fig. 201), so called because of his Phrygian cap, from the western pediment, carved about 500 B.C., with the *Archer* carved some five or ten years later (fig. 202). Nobly poised though the earlier statue is, it is somewhat schematic; one does not really feel the play of muscles. The masses of the later figure are held in position entirely by its beautifully understood muscular movement and tension, which must have been even more effective when the missing bronze bow

201. *Oriental Archer*, from the west pediment of the Temple of Aphaia, Aegina. c. 500 B.C. Marble, height 41″. Staatliche Antikensammlungen und Glyptothek, Munich

202. *Archer*, from the east pediment of the Temple of Aphaia, Aegina. c. 490 B.C. Marble, height 31″. Staatliche Antikensammlungen und Glyptothek, Munich

was intact. The *Dying Warrior* (fig. 203) embodies at long last the heroic grandeur of the Homeric epics in the simple, clear-cut masses of the figure and in its celebration of self-possession and calm even at the moment of violent death. The latest statues at Aegina have, in fact, brought us to the beginning of the Classical period in content and in style.

VASE PAINTING Painting was always considered one of the greatest of the arts by Greek writers, and a splendid tradition of painting on walls and on movable panels surely flourished during the late Archaic period. Yet so little survives that we cannot even form a clear idea of what we have lost. Nonetheless, a few echoes of this vanished art persist in far-off Etruscan tomb paintings (see fig. 305). Given their clear-cut, continuous outlines and flat areas of color, not unlike those of Egyptian painting, and considering also the strict limitations of Archaic sculptures with their smooth surfaces and strong, active contours, we can arrive at some notion of what the style of Archaic monumental painting must have been. Its quality, however, can only be guessed at; in this we are assisted by the beauty of the vast number of sixth-century painted vases still preserved.

The Archaic period saw the climax of Greek vase painting, which reached a high level of artistic perfection, rivaling sculpture and architecture, and which brought art of high quality into every prosperous household. Even more than contemporary sculpture, Archaic vase painting shows the flexibility of the new art, whose brilliant design is based on action and movement. How highly the Greeks themselves valued their vases is shown by the fact that so many of them were signed by the painter. Some were also signed by the potter. Through comparison with signed vases, unsigned pieces can be attributed to individual artists on account of similarities in style. In this way the development of personal styles can sometimes be followed for decades. This is the first moment in the history of art when such distinctions can be made and such evolutions traced. It is a very important consideration, because the art we are analyzing is, after all, one whose very principles of design are based on the interaction of individual human beings—in contrast to the mere alignment of standardized types so common in Egyptian and Mesopotamian art.

Vases were made for both local use and export in several Greek cities, especially Corinth and Athens. In the seventh century, Corinthian vases made of pale, yellowish clay were most popular, but in the early Archaic

203. *Dying Warrior*, from the east pediment of the Temple of Aphaia, Aegina. c. 490 B.C. Marble, 24 × 72". Staatliche Antikensammlungen und Glyptothek, Munich

204. KLEITIAS and ERGOTIMOS. *François Vase*, krater found at Chiusi, Italy. c. 570 B.C. Height c. 26". Museo Archeologico, Florence

205. PSIAX. *Oriental Between Two Horses* (detail of an amphora found at Vulci, Italy). c. 520–510 B.C. Height of amphora 14½". British Museum, London

206. EXEKIAS. *Dionysos in a Ship* (interior of a kylix found at Vulci). c. 540 B.C. Diameter 12". Staatliche Antikensammlungen und Glyptothek, Munich

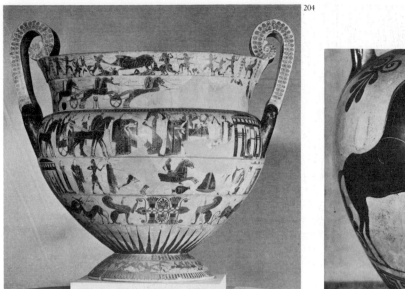

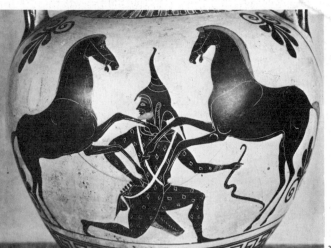

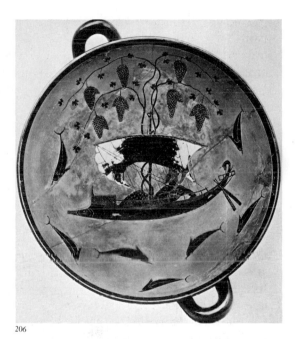

period the orange-red pots of Athens took the lead. The miniature style of the Corinthian painters could no longer compete with the strength, grace, and intellectual clarity of the Athenians.

Many of the finest Greek vases are preserved because they found their way to Etruria, whose inhabitants prized them highly and buried them in the tombs of the dead. The best Athenian vases are masterpieces of drawing and design, operating within a very restricted range of colors. The natural color of the clay was sometimes heightened by a brighter clay slip painted on for the background. The most important tone was black, used for figures and for the body of the vase. Gone is the cluttered decoration of the earlier periods. Within the contours of the black figures, details were drawn in lines incised by a metal tool. The glossy black was also a clay slip, its color achieved by controlling the air intake during the delicate and complex firing process.

One of the most ambitious sixth century vases, known as the *François Vase* (fig. 204), of about 570 B.C., was found in an Etruscan tomb at Chiusi in central Italy. It is a *krater*, a type of vase intended for mixing water and wine, the customary Greek beverage, and was proudly signed by the painter Kleitias and the potter Ergotimos. The grand, volute-shaped handles grow like plants out of the body of the vase before curling over to rest upon its lip. The vase is still divided into registers like the *Dipylon Vase* (see fig. 179), but geometric ornament has been reduced to a single row of sharp rays above its foot; the handles are decorated with palmettes. The other registers are devoted to a lively narration of incidents from the stories of the heroes Theseus and Achilles. The figures still show the tiny waists, knees, and ankles and the full calves, buttocks, and chests that are standard in the Geometric style, but they now move with a vigor similar to that of the sculptures on the Corfu pediment (see fig. 196), and both men and animals have begun to overlap in depth in a manner foreshadowing the deployment of figures in the frieze of the Treasury of the Siphnians (see fig. 197).

A splendid example of Archaic design based on organic movement is the *Oriental Between Two Horses* (fig. 205) by the painter Psiax, dating from about 520–510 B.C. The Oriental, who seems to be a horse trainer, moves rapidly forward with knees sharply bent, in the style of the Medusa at Corfu, and turns his head to look backward over his right shoulder. The forcefulness of the movement and the angularity of the bent limbs recall

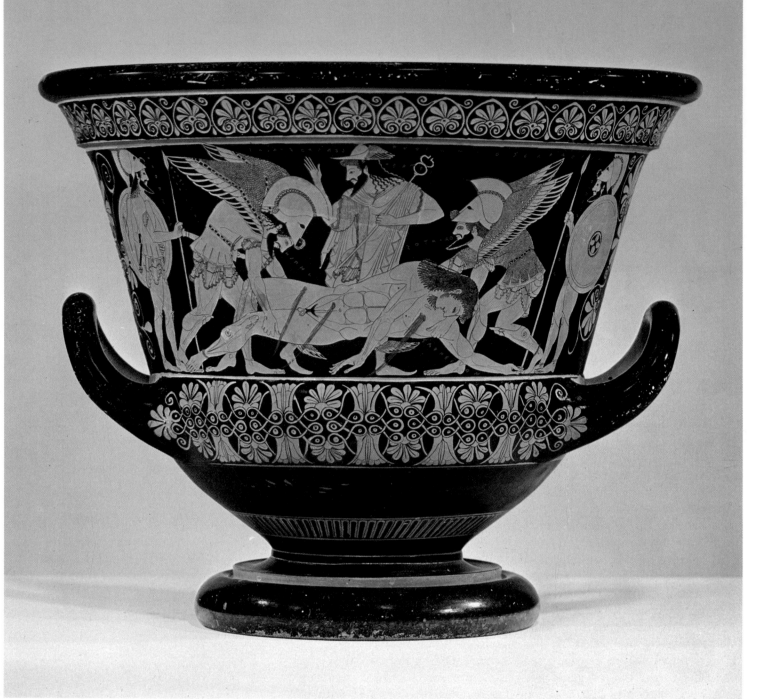

207

the almost contemporary *Oriental Archer* (see fig. 201) from Aegina. On either side horses rear in a heraldic grouping, their slender legs overlapping the archer's body, their bodies seeming to swell with the expansion of the amphora itself. The incised lines, at once delicate and firm, are left in the red of the background.

One of the most delightful of all Archaic vase paintings is on the interior of a *kylix*, or wine cup, painted by Exekias about 540 B.C. (fig. 206). Dionysos, god of wine, reclines in a ship from whose mast he had caused a grape-laden vine to spring in order to terrify some pirates who had captured him and whom he then transformed into dolphins. The almost dizzying effect of the free, circular composition is, appropriately enough, not unusual in decorations for the insides of wine cups. In this case the feeling of movement is heightened by the bellying sail (originally

207. EUPHRONIOS. *Sarpedon Carried off the Battlefield* (portion of a calyx-krater). c. 515 B.C. Height of vase 18¼". The Metropolitan Museum of Art, New York. Bequest of Joseph H. Durkee. Gift of Darius Ogden Mills and C. Ruxton Love, by exchange, 1972

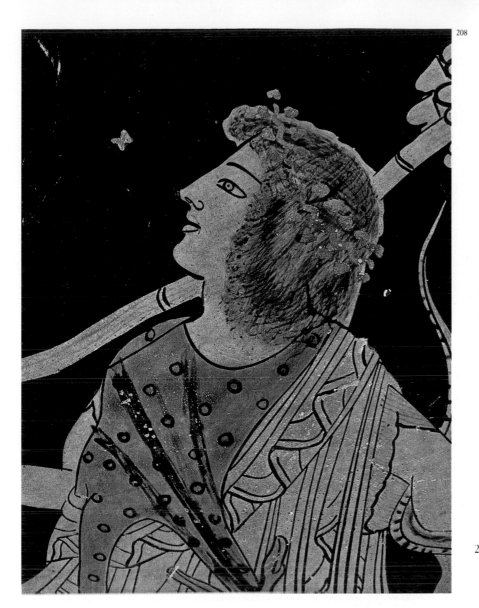

208. THE KLEOPHRADES PAINTER. *Rapt Maenad* (detail of a pointed amphora found at Vulci). c. 500–490 B.C. Staatliche Antikensammlungen und Glyptothek, Munich

all white) and by the seven dolphins circling hopelessly about the vessel. The entire scene, with all its suggestions of wind and sea, is carried off without the actual depiction of even a single wave.

Toward the end of the sixth century, vase painters discovered that their compositions would be more effective and their figures more lifelike if left in the red color of the terra-cotta, with the black transferred to the background, just as in pediments or friezes the figures shone in white or softly colored marble against a darker background of red or blue. At first the change was tentative; some vases even show red figures on one side, black on the other. But once it was generally accepted, the change was lasting. One of the earliest red-figure vases, and certainly one of the finest Greek vases in existence, is a combined kylix-krater (fig. 207) by Euphronios datable about 515 B.C. The principal scene depicts a rarely illustrated passage from the *Iliad*, narrating how the body of the Trojan warrior Sarpedon, son of Zeus, was removed from the field of battle by the twin brothers Hypnos and Thanatos (Sleep and Death) under the supervision of Hermes, so that it could be washed in preparation for a hero's grave. The extraordinary combination of great sculptural force, equaling that of the statues at Aegina, with extreme tenderness of feeling is completely unexpected. The blend is achieved by a line that surpasses almost

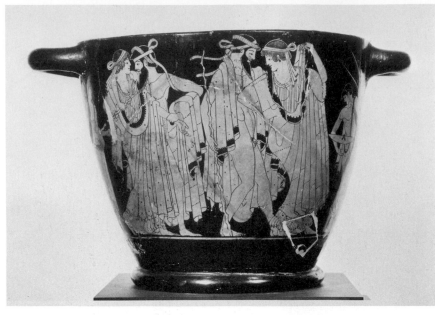

209. THE BRYGOS PAINTER. *Revelling* (portion of a skyphos). c. 490 B.C. Height of vase c. 8″. The Louvre, Paris

210. *Charioteer of Delphi*, from the Sanctuary of Apollo, Delphi. c. 470 B.C. Bronze, height 71″. Archaeological Museum, Delphi

anything in Greek vase painting in its tensile strength and descriptive delicacy. From the beautiful analysis of the muscular body of Sarpedon to the knife-sharp wing feathers of Hypnos and Thanatos, even to the slight curl at the tips of the fingers and toes, the movement is carried out with perfect consistency and control. The very inscriptions, usually naming adjacent figures, are not allowed to float freely against the black, but move in such a way as to carry out the inner forces of the composition. *Thanatos*, for example, is written backward to lead the eye toward the central figure of Hermes.

But vase painting did not always remain on the plane of high tragedy; the very fact that so many vases were destined to hold wine tended to promote a certain freedom in both subject and treatment. Among the followers of the great Euphronios, two sensitive masters have been distinguished—one called the Kleophrades Painter because his work is so often found on vases signed by the potter of that name, the other called the Berlin Painter, from the location of his principal work. How free the actual execution of red-figure vases can be is seen in the former's treatment of a rapt blonde maenad (female follower of Dionysos) in fig. 208. The deft, sure linear contours contrast sharply with the sketchy quality of the hair, painted in a different thickness of slip so that it would fire to a soft, light color, and with the garland about the head, even more rapidly brushed in soft violet. The Berlin Painter's bell-shaped krater (see fig. 6)—a triumph of rhythmic grace and poise—shows Ganymede, the favorite of Zeus, holding a rooster in one hand and glancing coyly over his shoulder as he rolls a hoop. The Brygos Painter, another master named for the potter on whose vases his paintings appear, treats an amatory subject with restrained excitement (fig. 209). Two nude men, past their first youth, have begun to embrace two clothed young women. The eye slips happily from nude forms to drapery masses swinging in a controlled abundance of linear movement.

In the early decades of the fifth century B.C., the individualism of the Greek city-states was put to its severest test in a protracted struggle against Mesopotamian autocracy in the form of the Persian Empire, first under Darius I and then under his son Xerxes I. Persia had succeeded in subjugating all the Greek cities of Asia Minor and then insisted on extending

The Classical Period—The Severe Style (480–450 B.C.) and Its Consequences

her domination to European Greece. The resistance to the Persian threat brought about one of the rare instances of near unity among the rival Greek states. In 480 B.C. Xerxes conquered Attica, occupied Athens (which had been evacuated by its citizens), and laid waste the city. Yet in this selfsame year the Greeks managed to trap and destroy the Persian fleet at Salamis, and after another defeat on land in 479, Xerxes was forced to retire. Although the struggle continued sporadically in northern Greece, the Greek states were temporarily safe. Athens, which had led the resistance, embarked on a period of unprecedented prosperity and power.

The new development of the Classical style in the years immediately following Salamis shows above all an increased awareness of the role of individual character in determining human destiny, and it incorporates the ideal of ennobled humanity in a bodily structure of previously unimagined strength, resilience, and harmony. This development was no accident, any more than it was an accident that the Classical belief in the autonomy of the individual was revived in the early Renaissance in fifteenth-century Florence under remarkably similar circumstances. We need only set the new images of heroic, self-controlled, and complete individuals that followed (especially figs. 213, 214) against the standardized soldiers of Persian autocracy in order to realize the extent of the revolution that came to fulfillment in Greek art of the Classical period.

FREESTANDING AND RELIEF SCULPTURE The brief and significant generation between the close of the Archaic period and the height of Classical art in the Age of Pericles shows a remarkable transformation not only in style but also in general tone. The term *Severe Style* suggests the moral ideals of dignity and self-control that characterize the art of the time and mirror the short-lived Greek resolve to repel the Persian invader. Complex draperies constructed of many delicate folds give way to simple, tubular masses. The face is now constructed of square or rounded forms rather than the pointed features of the Archaic period: the square, broad nose joins the brows in a single plane, the mouth is short, the lips full, the eyes wide open, the chin and jaw rounded and firm. Most important of all, the Archaic smile has given way to an utter and deliberate calm, as if the figure were wearing a mask. (It should be remembered that actors in Greek drama did indeed wear masks, but with set expressions for comedy or tragedy.)

We may well commence our consideration of this period with the earliest of the rare Greek lifesize bronzes to come down to us, the superb *Charioteer of Delphi* (fig. 210), dedicated by Polyzalos, tyrant of the Greek city-state of Gela in Sicily, to celebrate his victory in the chariot race at the Delphic Games just before 470 B.C. Originally the charioteer stood in a bronze chariot and controlled four bronze horses with their bridles; only fragments of the horses survive. The dignity and calm of the figure remind us that the metaphor of a charioteer was later used by Plato to symbolize man's control of the contrary forces in his soul. The bronze, originally polished, is relieved in the face by inlaid copper lips and eyelashes and by eyes made of glass paste. (We should mentally restore such features whenever they are missing in Greek and Roman bronzes.) The charioteer stands with a resiliency new to Greek sculpture; the folds of his long chiton drape easily across the chest and fall from the high belt in full, tubular shapes as cloth actually does, rather than in the ornamentalized folds of the Archaic period. The figure has at once the verticality and strength of a fluted Doric column and the possibility for action of any nude athlete.

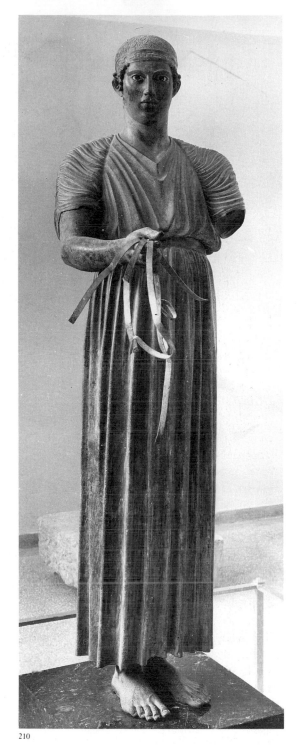

210

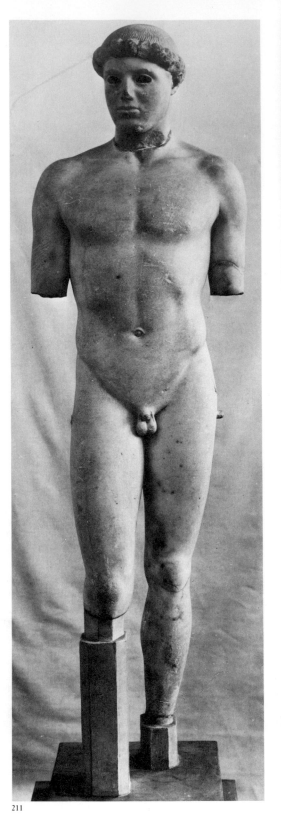

211

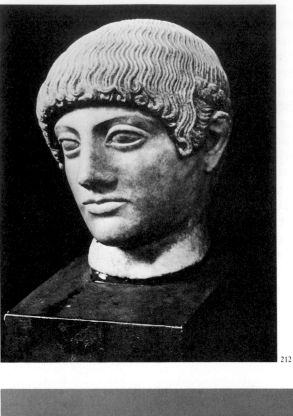

212

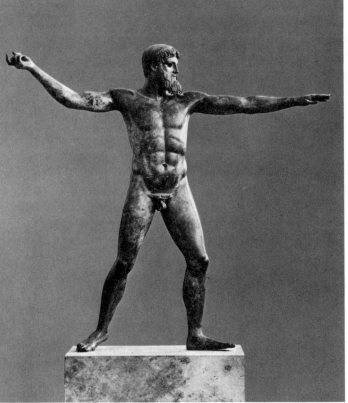

213

A slightly earlier statue (fig. 211), called the *Kritios Boy* because it embodies what is thought to have been the style of the sculptor Kritios, should be compared with the Archaic kouros figures (see figs. 184, 185) to bring out the scope of the transformation in Greek sculpture. Although the kouros figures are also standing, they appear frozen in a pose derived from walking, with the weight evenly distributed on both legs. In the *Kritios Boy*, the figure stands *at rest*, as people actually do, with the

weight placed on one leg while the other remains free. In consequence the left hip, on which the weight rests, is slightly higher than the right. In recompense, the right shoulder should be higher than the left, but the sculptor does not seem to have noticed this. He has discovered that in a resting figure the masses respond to stresses just as in a moving one, and that rest in a living being is not equivalent to inertia, as in Egyptian sculpture, or to the unreal symmetry of the Archaic, but to a balanced composure of stresses. The fullness, richness, and warmth of the human body, hinted at for the first time in the *Anavyssos Kouros* (see fig. 185), are now fully realized, as the forms blend effortlessly into each other. The firm beauty of the features and facial proportions preferred by the Severe Style is seen at its grandest in the *Blond Youth* (fig. 212), also dating from about 480 B.C., so called because traces of blond coloring could once be seen in the hair. The irises of the characteristically heavy-lidded eyes still retain considerable color, and the typical pensive, serene expression of the Severe Style is beautifully realized. The hair is still ornamentalized and worn almost like a cap, although occasionally a lock breaks free.

Fortunately, a single original bronze action statue of the Severe Style has come to light, a splendid, over-lifesize figure of the nude Zeus (fig. 213), found in the sea off Cape Artemision. The subject is often consid-

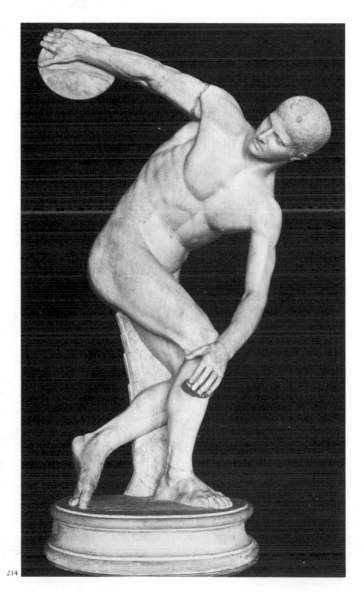

214

211. *Kritios Boy*, from the Acropolis, Athens. c. 480 B.C. Marble, height 33″. Acropolis Museum

212. *Blond Youth*, from the Acropolis, Athens. c. 480 B.C. Marble, height 9⅝″. Acropolis Museum

213. *Zeus*, found in the sea off Cape Artemision (Euboea), Greece. c. 460 B.C. Bronze, height 82″. National Archaeological Museum, Athens

214. MYRON. *Diskobolos (Discus-Thrower)*. c. 450 B.C. Roman marble copy of bronze original, lifesize. Museo Nazionale Romano, Rome

ered to be Poseidon, god of the sea, but if the trident (three-tined spear) wielded by Poseidon were to be placed in the figure's right hand it would obscure the face; more likely the figure represents Zeus hurling a thunderbolt. In no other remaining example can we see the magnificence of the Greek athletic ideal in the very person of the ruler of the gods. While the hair, bound in by a braid, and the beard and eyebrows are still stylized, the muscles of the body and the limbs vibrate with a new intensity.

The leading sculptors of the period immediately following, especially Myron and Polykleitos, were trained in the Severe Style, of which their work is an immediate outgrowth. Both were chiefly concerned with athletic subjects, which enabled them to exemplify the Classical principles of rhythmic organization derived from the poses of powerful nude male figures. In his bronze *Diskobolos (Discus-Thrower)*, of about 450 B.C., which we know only through Roman copies in marble (fig. 214), Myron chose the moment when the athlete bent forward, in a pose of great tension and compression, before turning to hurl his discus. The composition, operating in one plane like the *Zeus of Artemision*, is built on the transitory equipoise of the two intersecting arcs formed by the arms and the torso. Like all Classical figural groupings, this one dissolves the moment the action is over; its beauty lies in the lasting grandeur of a geometrical composition abstracted from a fleeting moment of action. The new dynamics of the Severe Style have been concentrated into a single image of extraordinary power.

The ultimate development of the kouros type can be seen in the *Doryphoros (Spear-Bearer)* by Polykleitos, executed probably between 450 and 440 B.C. Again the lost bronze original is accessible only through a number of Roman copies and ancient literary descriptions. A remarkably successful attempt was made in 1935 to reconstruct in bronze the probable appearance of Polykleitos' masterpiece (fig. 215). The problem of the standing figure, posed in the *Kritios Boy* (see fig. 211), has now been completely solved. The right leg bears the full weight of the body, so that the hip is thrust outward; the left leg is free; the tilt of the pelvis is answered by a tilt of the shoulders in the opposite direction; and the whole body rises effortlessly in a single long S-curve from the feet to the head, culminating in the glance directed slightly to the figure's right. Regardless of the fact that the figure is at rest—as never before—the dynamism of the pose transforms it into an easy walk and is expressed in the musculature by means of the differentiation of flexed and relaxed shapes, producing a rich interplay of changing curves throughout the powerful masses of torso and limbs. A fragmentary Roman copy in black basalt (fig. 216) shows what must have been the effect in dark bronze of the superb muscular structure of the torso, with its characteristically prominent external oblique muscles and sharply defined, U-shaped pelvic groove. Polykleitos wrote a treatise to explain his meticulous system of proportions as exemplified by this statue, but the book is lost and his system still imperfectly understood. Polykleitos called both the *Doryphoros* and the book his "Canon" (measuring rod or standard). The Greek interest in arithmetic and geometry manifested in the theories of Greek philosophers, especially Pythagoras, who saw the universe as operating on mathematical systems—was expressed in all the arts, including music. We should keep in mind that the Greek systems of human proportion, like that of Polykleitos, derive from their love of mathematical relationships; such relationships run through Greek architecture as well, down to the last detail.

Our knowledge of Classical sculpture has been dramatically enriched by the discovery in 1972 of two nude, bearded bronze warriors (figs. 217, 218), each well over six feet tall, in the sandy bottom of the Ionian Sea

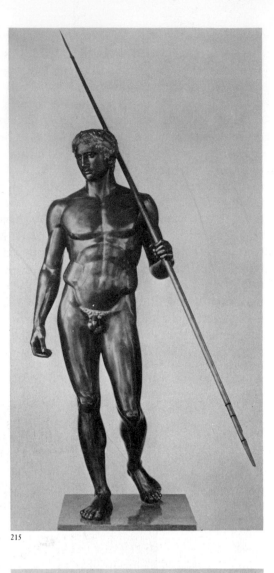

215

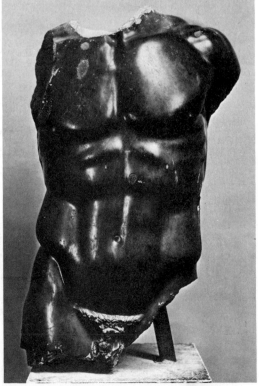

216

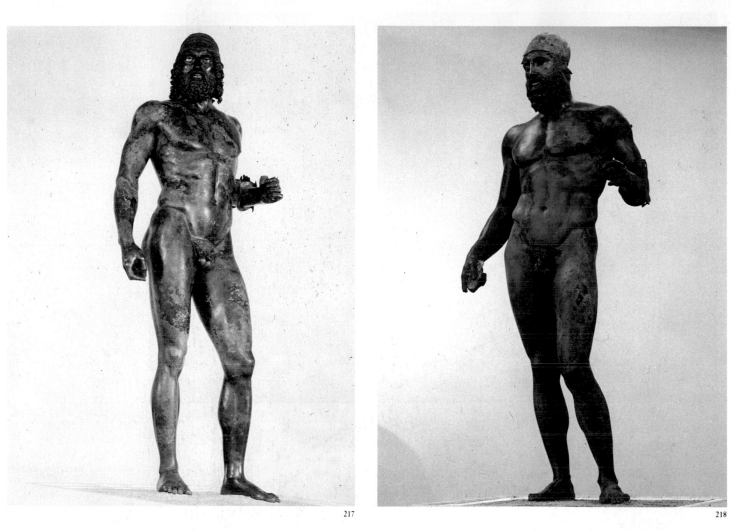

217

218

about a quarter of a mile from the village of Riace on the shore of Calabria, the toe of the Italian boot. The statues, thickly encrusted with salt and corrosion, were taken in 1975 to Florence for a lengthy and meticulous cleaning process. Only in 1980 were they placed on exhibition in their full splendor of gleaming bronze muscles. Immediately they were recognized as works of great importance, by scholars and public alike, and created a sensation—in fact, a near riot when they were eventually removed from Florence for exhibition in Rome at the Quirinal Palace, the official residence of the President of the Italian Republic. Each figure originally held a sword or spear in the right hand and had a shield strapped to the left forearm, but these have disappeared along with the helmet that once covered one of the heads. The statues are otherwise astonishingly complete, down to bronze eyelashes, copper lips and nipples, eyes made of ivory and glass paste, and in one case fierce-looking teeth plated with silver. The massive, muscular bodies quiver with life, and the unknown sculptor has been attentive even to the veins appearing through the skin in the groin, in the inner elbows, and on the lower legs, ankles, and feet. The extraordinary power of these figures, their simple, limited poses, and the combination of great naturalism in some details (the veins) with persistent ornamentalism in others (the hair and beards), coupled with the exceptionally high quality of conception and execution, have convinced most but not all specialists that these are indeed Greek works of the middle of the fifth century. Presumably they were tossed overboard to lighten ship by some small vessel caught in a storm near the treacherous Straits of Messina. More important, no one has yet even made a guess

215. POLYKLEITOS. *Doryphoros* (*Spear-Bearer*). c. 450–440 B.C. Bronze reconstruction. Universität, Munich

216. POLYKLEITOS. *Doryphoros* (fragment). Roman copy in black basalt of bronze original. Galleria degli Uffizi, Florence

217, 218. *Two Warriors*, found in the sea off Riace, Italy. c. 460–450 B.C. Bronze, height c. 80″ each. Museo Archeologico, Reggio Calabria, Italy

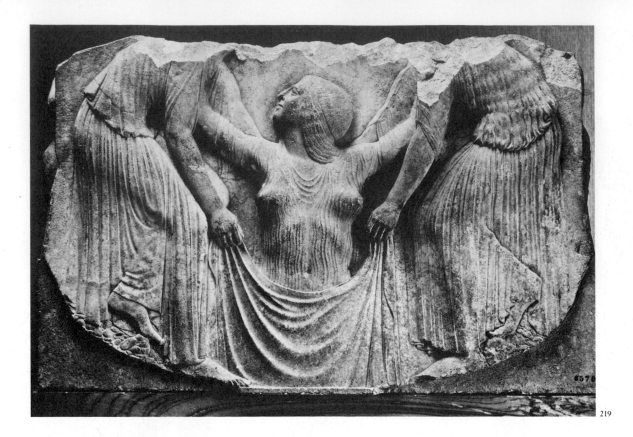

as to where they came from or what purpose these fearless warriors were intended to serve.

An exquisite example of the treatment of the female figure in the Severe Style is the group of low reliefs known as the *Ludovisi Throne*; more probably, these reliefs once formed an altar. Perhaps made in a Greek city in southern Italy, the reliefs nonetheless show early fifth-century sculpture at the height of its perfection. A relief that probably represents the *Birth of Aphrodite* (fig. 219) delineates full and graceful female figures seen through clinging garments that seem almost transparent. As Aphrodite was born from the sea, the device of sheer garments (often known as "wet drapery") seems appropriate; in any case it was used consistently in fifth-century sculpture to reveal the roundness of female forms even when fully clothed and completely dry. Experiments by the late great archaeologist Margarete Bieber have shown that the kinds of cloth used by the Greeks do not fall in such folds when draped around the body (see fig. 224), so these "wet" folds are a convention, but a very beautiful one.

ARCHITECTURE AND ARCHITECTURAL SCULPTURE

The greatest architectural and sculptural project of the first half of the fifth century was the Doric Temple of Zeus at Olympia, whose construction and decoration may be dated 470–456 B.C. The temple was the principal building of the sanctuary at Olympia, center of the quadrennial games that provided one of the few unifying threads in the chaotic life of the endemically warring Greek city-states. The temple, which has disappeared but for the stylobate and the lowest drums of the columns, has been carefully excavated, and its appearance can be reconstructed with accuracy. It was built of local limestone, coated with a plaster made of marble dust, but the sculpture and roof tiles were of Parian marble. The architect, Libon of Elis, designed a peristyle six columns wide and thirteen long. Something of the grandeur of its original appearance may be

219. *Birth of Aphrodite*, from the *Ludovisi Throne*. Early 5th century B.C. Marble low relief, width 56". Museo Nazionale Romano, Rome

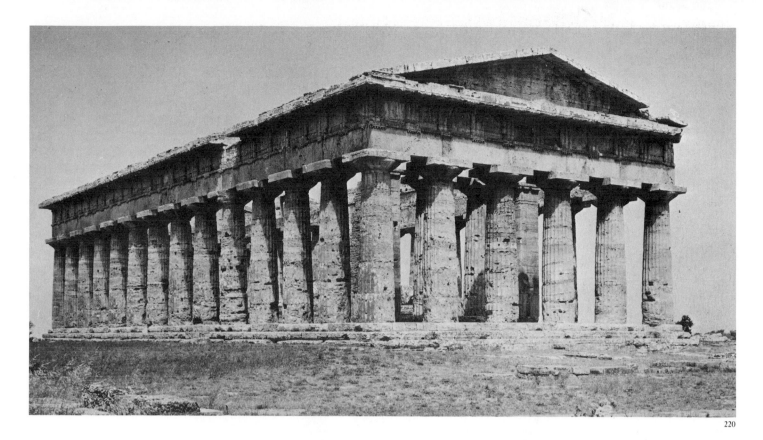

felt in the probably contemporary and somewhat smaller Temple of Hera
II at Paestum (fig. 220), despite its more massive proportions and closer
spacing of columns due to local taste. Libon's columns are slenderer and
more elegant than any we have seen so far, and both their entasis and the
projection of their capitals are slighter and subtler (fig. 221). Both interi-
ors utilized the double row of superimposed columns we saw at Aegina.

The sculpture, much of which is preserved, ranks among the noblest
Greek architectural sculpture. Neither the name of the sculptor nor the
city of his origin is known, but a single leading master and a host of
assistants must have been at work to produce so rich a cycle of sculpture
in so short a time. The mythological subjects were chosen to symbolize
the civilizing effect of the Olympic Games, held under divine protection.
The two pedimental groups are fairly well preserved, but since the exact
order and location of the statues are not clear, several conflicting attempts
at reconstruction have been made. The west pediment deals with the
Battle of Lapiths and Centaurs (fig. 222), a frequent subject in Greek art.
The centaurs, half man and half horse, descend on the wedding feast of
the Lapith king Peirithoös, and there they taste wine for the first time.
Under its influence they attempt to carry off the Lapith women, whom
Peirithoös and his friend Theseus strive to rescue. Apollo, god of light
and, therefore, of order and reason, presides over the subjugation of the
centaurs. The scene is possibly an allegory of the effect of the Olympian
sanctuary on the struggles between Greek states, since all such hostilities
had to be laid aside before contestants could enter its sacred gates.

However the statues were arranged, the poses were carefully calcu-
lated for the raking cornices, and the pedimental composition was more
closely unified than any of its predecessors. The stupendous figure of
Apollo (fig. 223), standing erect and with his right arm outstretched,
commands the centaurs to desist in their depredations. In spite of heavy
damage to the statue of a Lapith woman, her pose may be mentally re-
constructed. She struggles in the embrace of a centaur's forelegs, pushing

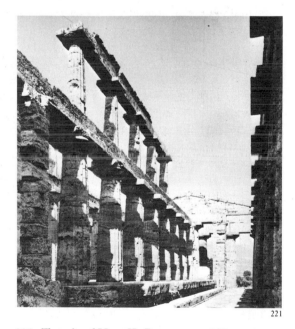

220. Temple of Hera II, Paestum. c. 460 B.C.

221. Interior, Temple of Hera II, Paestum

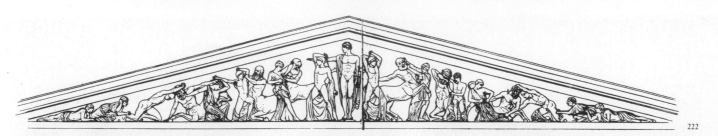

222

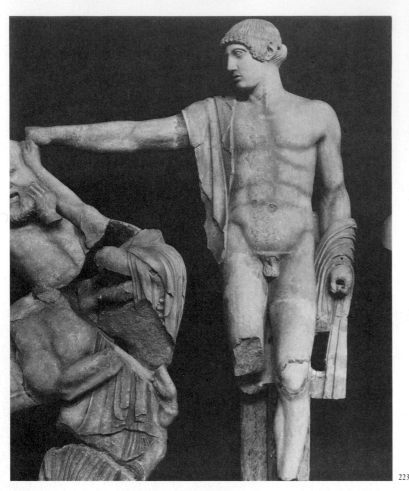

223

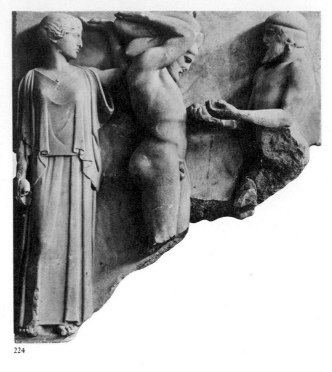

224

him off with her hands. While the stern Apollo figure shows—naturally enough, given his commanding role in the action—none of the relaxation of the *Doryphoros* (see fig. 215), the structure and definition of the musculature are in keeping with the principles of the Severe Style. So indeed is the beautiful face, with its nose descending in a straight line from the forehead, its full jaw and rounded chin, and the caplike mass of ornamentalized hair. Despite their freedom of movement, the drapery folds are proportioned to harmonize with the fluting of the columns below.

The metopes of the outer peristyle were left blank, but as observers ascended the ramp before the temple they could see between the outer columns the frieze above the two columns of the inner portico in antis at either end of the cella, each end having six metopes representing the Labors of Herakles. The high reliefs, almost statues in the round, were kept austerely simple, their broad, full masses contrasting with the flat slab behind. One of the finest (fig. 224) shows Atlas bringing back to Herakles (who has temporarily relieved him in his task of supporting the heavens) the Golden Apples of the Hesperides. The goddess Athena gently assists the hero. Garbed in her simple Doric peplos, she is one of the grandest

222. *Battle of Lapiths and Centaurs*, reconstruction drawing of the west pediment of the Temple of Zeus, Olympia, Greece. c. 470–456 B.C. (After G. Treu)

223. *Apollo with a Centaur and a Lapith Woman*, fragment from the west pediment of the Temple of Zeus, Olympia. c. 470–456 B.C. Marble, height of Apollo c. 10'2". Archaeological Museum, Olympia

224. *Atlas Bringing Herakles the Golden Apples*, fragment from a metope of the Temple of Zeus, Olympia. c. 470–456 B.C. Marble high relief, height 63". Archaeological Museum, Olympia

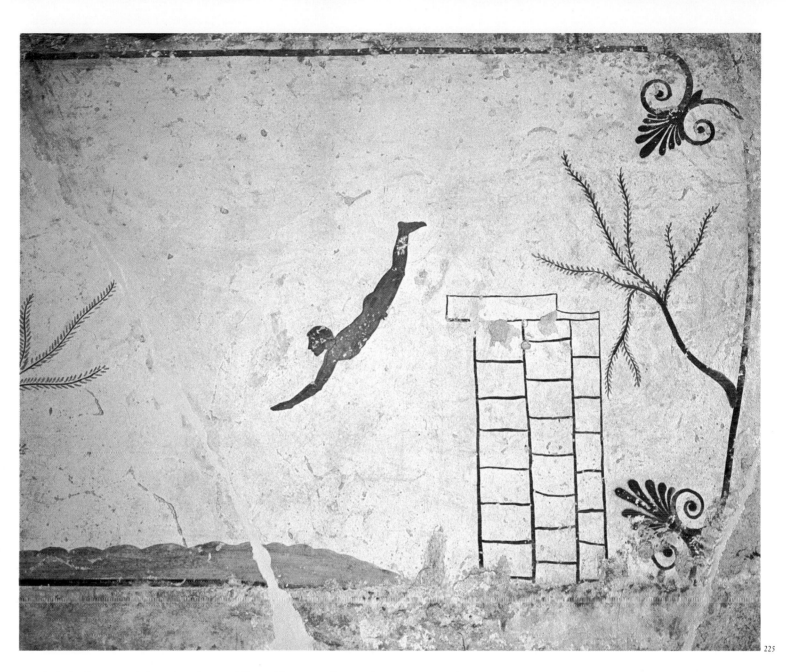

225

female figures of the century, and Herakles is sculptured with a reticence and dignity typical of the Severe Style. Some of the breadth of treatment of the Aegina sculptures remains here, but with a new roundness of shape and smoothness of transition from one form to the next.

225. *The Diver*, fresco from a Greek tomb at Paestum. c. 470 B.C. Museo Archeologico Nazionale, Paestum

PAINTING Vase painting continued throughout the Classical period, but a sharp decline in quality is notable, as if the painters had lost interest, perhaps because of the sudden increase in scope offered by the great commissions for wall paintings. One of the leading vase painters of the Severe Style is known as the Niobid Painter, after a vase depicting the slaughter of the children of Niobe by Apollo. He is less important in his own right than because his paintings may tell us something about the vanished works of mural art, particularly those of Polygnotos, the most celebrated painter of the age and, in many ways, a pictorial counterpart of Polykleitos. According to ancient literary descriptions, Polygnotos gave his figures the nobility we have found in the sculpture of the Severe Style and of Polykleitos, as well as a new quality of emotional expression. He

was also able to paint transparent or translucent draperies, through which could be seen the forms of the body (like those in the *Ludovisi Throne*; see fig. 219). While he did not use shading, and was thus constrained to rely on line to indicate form, Polygnotos was in one respect a great innovator: he scattered his figures at various points in space, freeing them for the first time from the groundline to which they had previously been confined. He also indicated such landscape elements as rocks and trees. One of the finest works by the Niobid Painter, a calyx-krater found at Orvieto in central Italy and dating from about 455–450 B.C., shows on one side a still unidentified subject that includes both Herakles and Athena and possibly Theseus (fig. 226). The noble, relaxed figures remind us of the sculpture of the Severe Style, and they correspond to the descriptions of Polygnotos' art. Even more striking is the free placing of figures at various points to indicate depth. Each is standing on a separate patch of ground, and all are united by a single wavy line running from one to the next. Another indication of the new interest in actual visual experience, freeing the painter from age-old conventions, is that, for the first time in art, the eyes of profile figures are drawn in profile rather than in full face.

There the story would have stopped had it not been for the extraordinary discovery in 1968 of a painted Greek tomb, datable about 470 B.C., in a cemetery outside the city of Paestum. The boxlike tomb was formed of six slabs of stone—for the ends, sides, top, and bottom—and all but the bottom slab were painted in fresco, that is, pigment on wet plaster. A layer of coarse plaster was first spread over the slab, and preparatory drawings were made on that. Then smooth plaster was laid on, which had to be painted rapidly so that the colors would amalgamate with the plaster before it dried. This technique was later used widely throughout Etruscan and Roman wall painting, and was revived in the later Middle Ages and the Italian Renaissance.

On the four side slabs of the Paestum tomb were painted figures playing and listening to music and drinking wine (fig. 227), while on the

226

226. THE NIOBID PAINTER. Calyx-krater found at Orvieto, Italy. c. 455–450 B.C. Height 21¼". The Louvre, Paris

227. *Banqueting Scene*, fresco from a Greek tomb at Paestum. c. 470 B.C. Museo Archeologico Nazionale, Paestum

inside of the lid appeared an unexampled scene—a nude figure in early manhood diving from a kind of springboard into the sea (fig. 225). This may represent a scene from real life, or perhaps its significance is allegorical—the soul plunging into the waters of the Beyond, in which it is purified of the corruption of the body. There are neither texts nor images to support either interpretation, but an allegory of the future life would seem probable for an image on the interior of a coffin. Whatever their significance, all the figures show a new suppleness of line, used to describe the fullness of muscular forms as well as a wide range of expressions; between the contours the solid areas of brown flesh tones contain no hint of shading. The eye is shown, as in the work of the Niobid Painter, in profile rather than full face. Schematic landscape elements appear, also for the first time in Greek painting; a tree is represented, as well as the waves of the sea. All this is in keeping with what we read about Polygnotos' paintings.

If a provincial painter, decorating the tomb of an unknown youth with images destined for eternal darkness, could draw and paint like this, what must have been the lost masterpieces of Athens?

The culmination of the Classical period in architecture and sculpture in Athens coincided with the greatest extent of Athenian military and political power, and with the peak of Athenian prosperity—also, unexpectedly, with the height of democratic participation in the affairs of the Athenian polis. This was no accident; the vision and vitality of a single statesman, Pericles, brought Athens to her new political hegemony, and it was Pericles who commissioned the monuments for which Athens is eternally renowned. And with the inevitablity of an Athenian tragedy, it was the long and disastrous war begun by Pericles that brought about the defeat of Athens in 404 B.C. and the end of her political power. Had Pericles not died in 429 the end might well have been different. Nevertheless, in some twenty dizzying years Pericles and the great architects and sculptors who worked under his direction created a series of monuments that have been the envy of the civilized world ever since, perhaps because they first proclaimed the new ideal of a transfigured humanity, raised to a plane of superhuman dignity and freedom. The sublime style of the Age of Pericles, as this transitory period should properly be called, was in many respects never equaled; it can be paralleled only by the even

The Classical Period—The Age of Pericles (450–400 B.C.)

briefer period of the early sixteenth century in central Italy, the High Renaissance, also dominated and inspired by a single political genius, Pope Julius II. It is instructive to remember that with Egypt and Sumeria we thought in millennia and with Archaic Greece in centuries, while with Classical Greece we must think in decades.

THE ACROPOLIS AT ATHENS AND ITS MONUMENTS

The massive limestone rock dominating Athens had been in Mycenaean times the site of the royal palace, and in the Archaic period it contained the principal sanctuaries of the city. When the Persians attacked in 480 B.C., they succeeded in capturing the fortress and in setting fire to the scaffolding around a great new temple to Athena, patron deity of Athens, which was then rising on the highest point of the Acropolis. When the Athenians returned to their city the following year, they vowed to leave the Acropolis in its devastated condition as a memorial to barbarian sacrilege. Nonetheless, they utilized marble fragments, including unfluted drums from the first Parthenon and many Archaic statues, as materials for new fortifications. By 449 B.C. the Athenians seem to have repented of their vow, for in that year they embarked on one of the most ambitious building programs in history. Money was, apparently, no object. But it could not be provided by the rudimentary system of taxation then in effect. Pericles' solution was simple. After the victories of 480–479 B.C., Athens had led an alliance of Ionian states, known as the Delian League because its meeting place and treasury were on the island of Delos, against the Persian invaders. For years Athens had kept the smaller states in line, and imperceptibly and inevitably the Delian League had been transformed into a veritable Athenian Empire. States that attempted to secede were treated as rebels and severely punished. Ostensibly for greater security, the treasury was moved to Athens in 454 B.C. Before many years passed, its contents were used for the rebuilding of the Acropolis and its monuments, not to speak of other splendid buildings in Athens. Pericles was sharply criticized, but the work went on with astonishing rapidity.

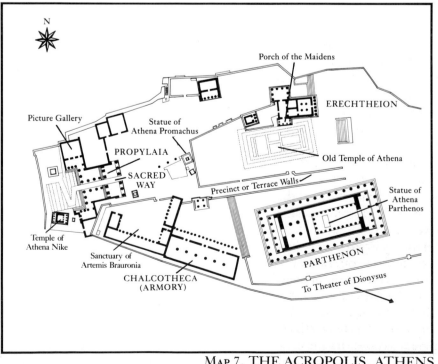

MAP 7. THE ACROPOLIS, ATHENS

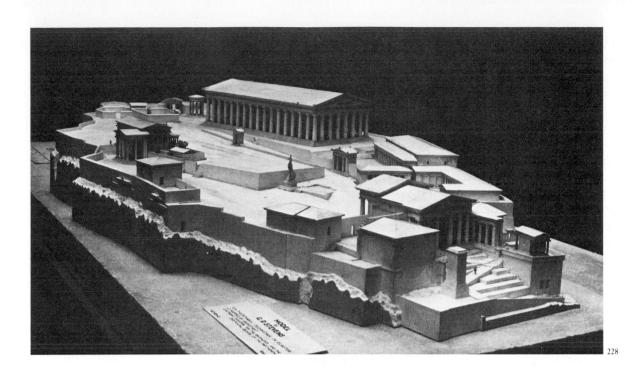

228

Given the Greek ideals of harmony and order, one might have expected the newly rebuilt center of Athenian civic pride and state religion to have been organized on rational principles at least as highly developed as those that were so successful in Egyptian temples and in Mesopotamian palaces. Nothing could be further from the truth. Only an imperial autocracy, apparently, could impose a sense of order on all the disparate elements of such a traditional center. In fact, no Greek sanctuary before the Hellenistic period was organized along symmetrical lines, or for that matter along any rational principles save those of ready accessibility. The greatest of all Greek sanctuaries, that of Zeus at Olympia, was at any moment in its history a jumble of temples large and small, shrines, altars, colonnades, and throngs of statues, each erected without the slightest consideration for its neighbors. The Temple of Zeus itself was not even centrally placed.

The Parthenon: Architecture. When Pericles rebuilt the Acropolis, he erected the temples on ancient, sacred sites, and where he could he utilized foundations remaining from older buildings, with the result that the Parthenon, the principal structure on the Acropolis and by general acclaim the supreme monument of Greek architecture, could never have been seen in ancient times in any harmonious relation to neighboring buildings. It was once thought that the view of the Parthenon from the Sacred Way, which passed through the entrance gate (see p. 176), would have been partially blocked by several intervening constructions. In fact, the small, columned structure visible in the model (fig. 228) directly in front and to the right of the Parthenon is a propylon or gateway, and its actual form and size are still in doubt. Even more important, recent archaeological investigations by John J. Dobbins and Robin F. Rhodes have shown that the projecting wing of the Sanctuary of Artemis Brauronia, whose eastern wall is shared by the Chalcotheca (Bronze Storeroom), as seen on both model and plan (map 7), constitutes the final architectural phase of the sanctuary, built after the construction of the Parthenon. So even if the projecting wing blocked the view at some later date, it did not when the Parthenon was built. The initial view of the Parthenon, to worshiper and casual visitor alike, from the northwest corner, would have been as

228. Model of the Acropolis, Athens (By G. P. Stevens)

clear and open as it is now. The great structure, seen in all its cubic majesty from front and side at once, would have seemed to grow naturally from its rocky pedestal. The slight leaning of the outer columns inward, which lessens nearer and nearer to the center of the west front, has the effect of increasing the apparent height of the building above us as we approach from the considerably lower entrance gate, and we may presume that this is just what the architects intended. Phidias' colossal bronze statue of Athena Promachos—cast from the melted-down weapons of the defeated Persians, armed with gilded helmet, breastplate, shield, and spear, and visible to ships far out at sea—would have seemed to flank and protect this sanctuary of the patron deity of the Athenians.

From a modern point of view the other aspects of the Parthenon were not quite so happily situated. The south colonnade was too close to the rampart to afford comfortable visibility, but even this fact would have had the advantage of directing the glance of anyone skirting the temple to the south upward toward the frieze around the cella wall. The north colonnade was favored by a broad, open area, but the space before the east front, the principal entrance, was too restricted to afford what we would call a good view (the small round temple visible in fig. 228 is a Roman addition). Clearly the Greeks were able to conceive to their satisfaction a mental image of a building in its entirety even from fragmentary views. But the crystalline architectural shapes of the Periclean buildings, even in their present ruinous condition, tower in unexampled majesty above the city and the narrow plain; as if set down on the great rock by a divine hand, they vie with the surrounding mountains, without recognizing the limitations of nature, except here and there to exploit them.

Most of the smaller structures of the Acropolis are known today only through excavations, and the statues that once adorned it are lost without a trace. But the Parthenon was preserved for centuries as a religious building. It was converted successively into a Byzantine church, a Catholic church, and a mosque, in which latter phase it sported a minaret. Although the interior had been repeatedly remodeled, the exterior remained intact with all its sculptures in place until 1687. The Turks, at that time at war with the Venetians, were using the temple as a powder magazine. A Venetian mortar shell struck the building, and the resultant explosion blew out its center. The Venetians carried the destruction a step further in an ill-fated attempt to plunder some of the pedimental statues, which fell to the rocky ground in the process of removal and were dashed to pieces. In 1801–3 Thomas Bruce, Lord Elgin, a British diplomat, saved most of what remained of the sculptures from possible destruction in the disordered conditions then prevailing in Athens by removing many statues and reliefs to London. In the present century the north colonnade has been carefully set up again, almost entirely with the original drums, and work has begun on the south colonnade.

Pericles is believed to have placed the Athenian sculptor Phidias in general charge of all of his artistic undertakings. It is noteworthy that he did not choose either of the great sculptors of the single athletic figure, Myron and Polykleitos, who were in their prime. The principal designer of the Parthenon appears to have been the architect Iktinos, working in a still imperfectly understood partnership with Kallikrates. Construction began in 447 B.C. and was finished in the extraordinarily brief time of nine years, save for the sculpture, which was all in place by 432 B.C. Iktinos utilized and extended the foundations of the older temple of Athena for his new structure, which was not called the Parthenon (*parthenos*, meaning "virgin," referring to Athena) until much later; originally, the

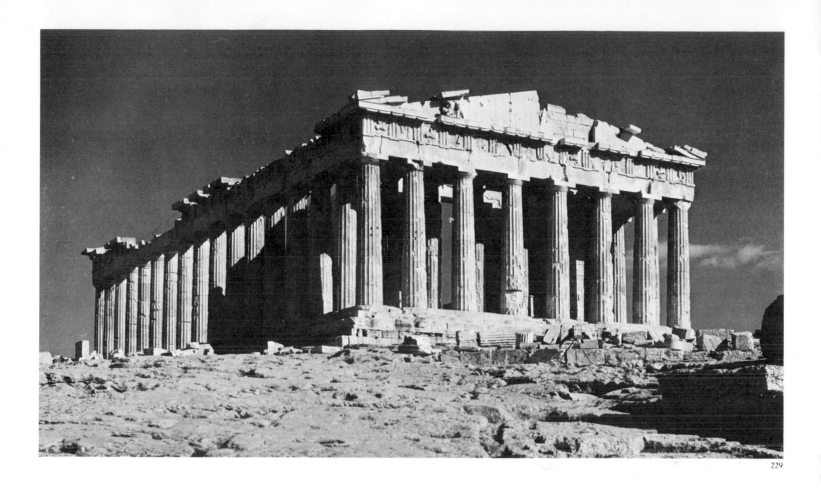

title was applied only to the treasury. While the dimensions of the "great temple," as the inscriptions call it, are not much larger than those of the Temple of Zeus at Olympia, it must have looked far larger. It is a regular Doric temple (figs. 229, 230), but differs from most of its predecessors in having eight rather than six columns across the front, and seventeen rather than thirteen along each side. The columns are far higher in proportion to their thickness than earlier Doric columns, and this greater slenderness is matched by a decrease in entasis and in the projection of the capitals, as well as in the mass and weight of the entablature. A glance at the Temple of Hera I (see fig. 194) at Paestum shows how much Greek architecture evolved in little more than a century. The wonderful sense of unity, harmony, and organic grace experienced by visitors to the Parthenon derives largely from the infinite number of refinements in the traditional elements of the Doric order. For example, the stylobate is curved upward several inches in the center to avoid the appearance of sagging, the columns lean progressively inward as we approach the corners (see page 170 for a suggested explanation), and the intercolumniations are progressively narrower toward the ends. Few of these refinements are immediately visible, but a great many have been measured, and even the most minute ones play their part in the total effect of the building. The whole structure, even the roof tiles, was built of Pentelic marble.

The Parthenon: Sculpture. The decoration of the Parthenon was by far the most ambitious sculptural program ever undertaken by the ancient Greeks. The east and west pediments were filled with over-lifesize statues; the ninety-two metopes were sculptured in high relief; and a continuous frieze in the Ionic manner, uninterrupted by triglyphs, ran right round the building along the top of the cella wall for a total length of 550

229. IKTINOS and KALLIKRATES. The Parthenon, Acropolis, Athens (view from the west and north). c. 447–438 B.C.

230. Plan of the Parthenon, Acropolis, Athens 1. Reflecting pool 2. Statue of Athena Parthenos 3. Treasury

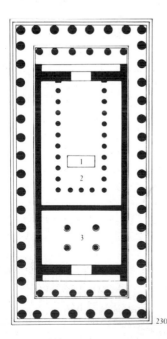

230

feet. The backgrounds of the pediments were painted bright blue, those of the metopes and friezes red. Many ornaments were added in metal. Hair and eyes were painted, and the capitals were decorated with ornament in bright colors. The whole building must have shone with color.

The interior of the cella, entered only from the east, was intended to house the colossal statue of Athena by Phidias. We do not know what the ceiling was like, but it was certainly supported by two superimposed Doric colonnades like those still in place in the Temple of Aphaia at Aegina and the Temple of Hera II at Paestum (see figs. 199, 220). No access existed between the cella and the treasury, which was entered from the west and was apparently the principal treasury of the city. Its ceiling was supported by four Ionic columns, the first in any Athenian temple.

The magnificent array of sculptures for the Parthenon was produced in only twelve years. The belief that they were all executed under the general supervision of Phidias—or at the least show aspects of his style and artistic intention—is supported by a remarkable unity of taste and feeling that runs through the entire series. But the scope of the undertaking and the speed of its execution must have required an army of artists; some of these were clearly sculptors of great ability, others were stonecutters, presumably executing ideas sketched out by the major masters in clay models or perhaps working from drawings on papyrus. That all of these preparatory studies could have been made by Phidias himself, who was then busily occupied in work on his statue of Athena, is unlikely. The surviving statues for the two pediments, in spite of the heavy damage they have sustained, are among the most majestic in the whole history of art. The east pediment represented the *Birth of Athena*, the west the *Contest Between Athena and Poseidon*. From the individual statues, as well as from sketches made by a French traveler when they were still in place (fig. 231), it is clear that the compositions were not symmetrically organized on either side of a static central figure in the manner of the Olympia

231. JACQUES CARREY. *Contest Between Athena and Poseidon* (drawing of the west pediment of the Parthenon, Acropolis, Athens). 1673. Bibliothèque Nationale, Paris

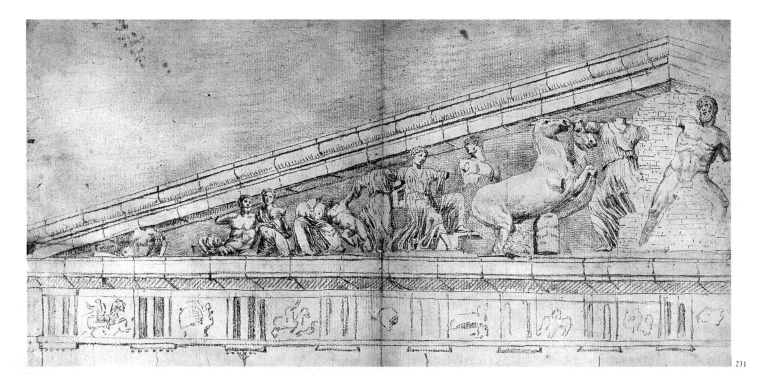

231

pediments (see figs. 222, 223), but were at every point based on action, which came to its climax toward the center.

Some of this movement runs through the *Three Goddesses* (fig. 232)—probably Hestia, Dione, and Aphrodite—who recline nobly in a group that sloped along with the downward movement of the raking cornice of the east pediment. Aphrodite rests her elbow and shoulders against her mother, Dione, while Hestia turns toward the center of the composition. The intricate drapery folds cling to the figures and reveal rather than conceal the splendid masses of the bodies and limbs. As may be expected, the folds no longer show a trace of the ornamental drapery forms of the Archaic, but neither does the drapery fall into the simple, naturalistic folds of the Severe Style. It seems to be endowed with an energy of its own, and to rush around the figures in loops and even in spirals, as if communicating to the very corner of the pediment the high excitement of the central miracle, the birth of Athena from the head of Zeus. From this moment onward drapery movement becomes a vehicle for the expression of emotion, not only in Greek art but also in that of most subsequent civilizations.

The swirling lines of crumpled drapery have still another function. Like the *Diskobolos* of Myron (see fig. 214) on a smaller scale, indeed like any Classical composition, the Parthenon pediments crystallize for eternity a moment of dynamic action, this time the *interaction* of many figures. Their compositions will dissolve once this moment has passed. The drapery lines serve as lines of energy, letting us follow the trajectory of all the interacting forces. Finally, speeding around the figures, the drapery folds allow us to grasp the fullness of their majestic volumes. But action and emotion are exercised by the poses and drapery folds alone: wherever preserved, anywhere in the sculptures of the Parthenon, the faces maintain a complete calm, as masklike as those of the Severe Style.

A splendid male figure, perhaps Herakles (fig. 233), leans back on one

232. *Three Goddesses*, from the east pediment of the Parthenon, Acropolis, Athens. c. 438–432 B.C. Marble, over-lifesize. British Museum, London

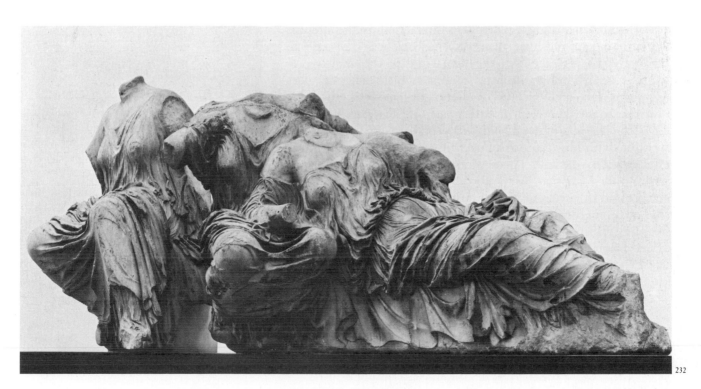

232

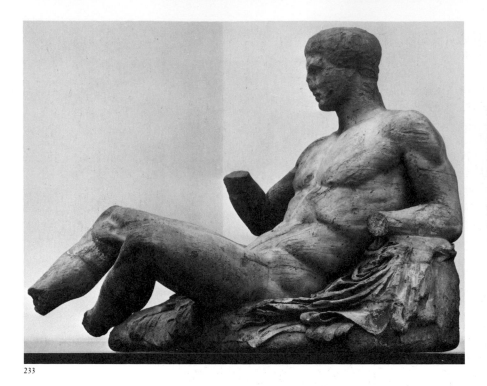

233

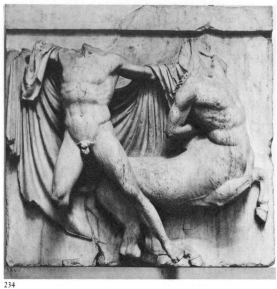

234

235

elbow in lordly ease in the opposite corner of the pediment (most of the intervening figures are lost). He is as powerful as any of the nudes of the Severe Style, if less ostentatiously athletic. New and unexpected is the beautiful relaxation of the abdominal muscles below the rib cage, which seems almost to expand with an intake of breath. In consequence of the restful pose, new and smoother transitions carry the eye from one muscular or bony form to the next. No nobler embodiment of the Greek ideal of physical perfection and emotional control can be imagined.

The metopes all depicted battle scenes—Greeks against Trojans, Greeks against Amazons, gods against giants, Lapiths against centaurs. Like the pedimental compositions, and in contrast to the static figural groups of Olympia, the metopes are dynamic scenes, each crystallizing in a composition of perfect balance a single moment of interaction. In the interests of legibility from the ground more than forty feet below, and in order to fit into the ninety-two restricted spaces, the narratives were mostly broken into pairs of figures in hand-to-hand combat, which "our side" does not invariably win. Incredible richness of invention characterizes the many variations on this single theme. One of the finest (fig. 234), in spite of the destruction of the heads, shows a Lapith in a proud action pose, charging toward his right, with his head turned over his left shoulder, as he drags a centaur backward by the hair. The tension of the composition, in which the figures are pulled together by the force of their own opposite movements, is expressed in curves of the greatest beauty; these are amplified by the broad sweep of the Lapith's cloak, which falls into crescent-shaped folds decreasing steadily in curvature as they move upward.

The frieze around the top of the cella wall (fig. 235) represented the Panathenaic Procession—an annual festival in which the youth of Athens marched to the Acropolis to pay homage to the city's patron deity and in which, every fourth year, a new peplos was brought to clothe her ancient wooden image in the nearby Erechtheion. The procession, of necessity, was not represented as if taking place at one moment but as a cumulative experience, because the observer moving around the building could see only one section at a time. Some of the most impressive parts of this long

233. Male figure (perhaps Herakles), from the east pediment of the Parthenon, Acropolis, Athens. c. 438–432 B.C. Marble, over-life-size. British Museum, London

234. *Lapith Fighting a Centaur*, fragment from a metope on the south side of the Parthenon, Acropolis, Athens. c. 440 B.C. Marble, height 56". British Museum, London

235. West entrance of the cella of the Parthenon, Acropolis, Athens, showing a portion of the *Panathenaic Procession*. c. 440 B.C. Marble frieze

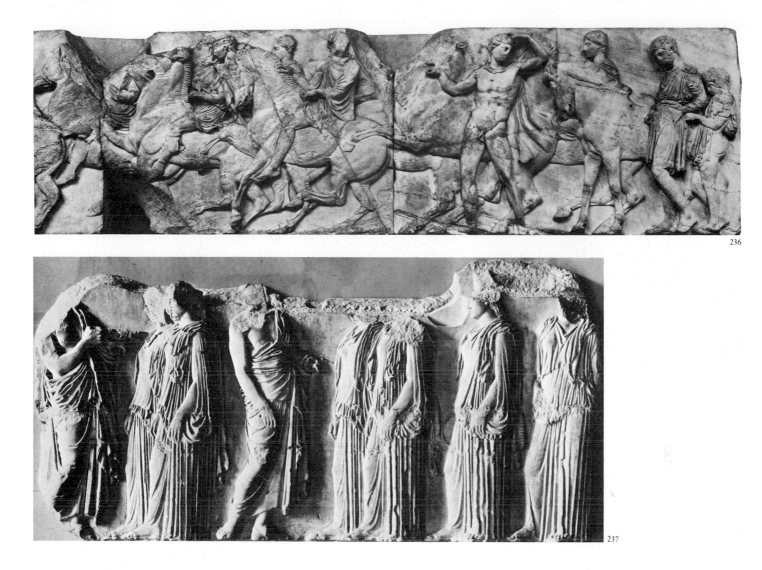

236

237

composition are those representing riders on horses and youths leading
horses in a splendid flow of overlapping figures suggesting great depth
(fig. 236). In order to maintain uniformity of scale throughout the frieze,
the sculptors adopted a convention, followed throughout Greek relief
sculpture, of reducing the size of the horses as compared with the riders.
Very beautiful is the passage (fig. 237) originally over the east doorway
to the cella, where the procession converges from both sides of the build-
ing. The standing figures show all the new ease and grace of posture and
are clothed in drapery that flows with all the new rhythmic beauty. Ad-
mittedly the frieze, in the only location permitted by the rules of the
Greek orders, was not placed in the best position for perfect visibility,
being some thirty feet above the stylobate and under the shadow of the
peristyle ceiling. Nonetheless, it was hardly as difficult to view as some
writers maintain. At most moments of the day, the strong Greek sun-
light, reflected upward from the marble stylobate and (on the south side)
from the cella wall, must have cast a soft, diffused light into the shadow
under the marble ceiling beams and slabs. Moreover, the heads and
shoulders of the figures were carved in a higher projection than the lower
portions; and, finally, the red background set off all the figures with con-
siderable sharpness.

Once inside the cella the observer stood in the awesome presence of
Phidias' forty-foot-high statue of Athena, dimly illuminated, since the
only light in the windowless temple came from the east door and was, of

236 *Mounted Procession Followed by Men on Foot*,
fragment of the *Panathenaic Procession*, from
the north frieze of the Parthenon, Acropolis,
Athens. Marble, height 41¾". British Mu-
seum, London

237. *Maidens and Stewards*, fragment of the *Pan-
athenaic Procession*, from the east frieze of the
Parthenon, Acropolis, Athens. Marble,
height c. 43". The Louvre, Paris

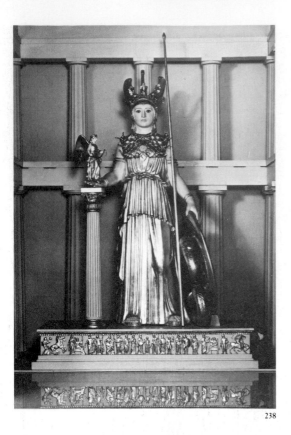

238

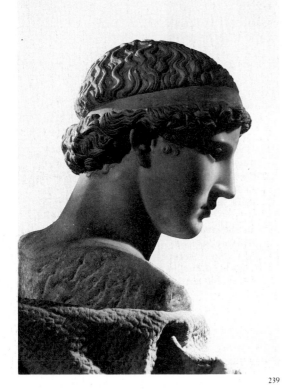

239

course, at its strongest in the morning. From literary accounts of the statue and from tiny, ancient replicas, a remarkable small-scale model has been made (fig. 238). With this as a basis, and with a good deal of poetic imagination, one can form some idea of what must have been the grandeur of the original. Thin plates of ivory and sheets of gold attached to plates of wood were arranged on a framework of great complexity so that it looked as though all the flesh portions were solid ivory and all the drapery solid gold. A shallow basin of water in the floor before the statue served as a humidifier to protect the ivory in the dry climate of Athens and also, doubtless, as a pool to mirror the majestic goddess and as a source of reflected light to play upward on her features. No large-scale copy remains to suggest how her face may have looked, but we do have a convincing Roman marble copy of the head of the destroyed *Lemnian Athena* by Phidias (fig. 239), also once on the Acropolis. Although this work was much smaller and thus more informal in pose than the hieratic *Athena Parthenos*, we can glean from its calm, clear, harmonious features at least a hint of the beauty we have lost. Athena's left hand sustained a shield above the folds of the sacred serpent, and on her extended right hand stood a golden statue of Victory six feet tall. So enormous was the *Athena Parthenos* that splendid reliefs by Phidias decorated both sides of the shield, the pedestal, and even the thickness of the soles of the goddess' sandals. According to ancient literary sources, Phidias also executed an even finer gold-and-ivory statue of the enthroned Zeus for the Temple of Zeus at Olympia. It was so tall that if Zeus had risen to his feet his head would have burst through the temple roof.

Although we possess not a scrap of sculpture that we can with certainty attribute to Phidias' own hand, the work done under his direction and possibly from his models on the Parthenon is consistent with the architecture of the building and with the literary accounts of Phidias' style. He invented new ways of combining figures on foot and on horseback into free action groups; he was responsible for a new majesty of proportions and harmony of movement; he was the first to use drapery in order to reveal the masses of the figure, increase the impression of movement, and express the drama of the subject; he was responsible for a new dynamic harmony between figural compositions and architecture. Clearly, we are confronted by a universal genius, the first in history, the only one in the visual arts in the ancient world, and probably one of the greatest who ever lived. It is sad to record that Phidias, like so many of the great men of Athens (one recalls Themistocles, who was exiled; Socrates, who was forced to drink poison), met an ignominious end. He was imprisoned (or perhaps exiled) on trumped-up charges of impiety by jealous citizens of the very city to whose lasting glory he had contributed so much.

The Propylaia. The Acropolis was entered through a monumental gateway called the Propylaia, constructed—doubtless under Phidias' supervision—by the architect Mnesikles from 437 to 432 B.C., while the sculptures of the Parthenon were being completed. The problems posed for the erection of a suitable gateway were not easy. One could approach the site only by means of the Sacred Way, a ramp not zigzagging steeply up the rock as it does today but ascending sharply from the west (then the city center) and turning from about eighty meters out, for a dramatic rise straight to the entrance. A formal entranceway was clearly needed. The solution was a central pedimented Doric portico of six columns facing west, flanked by two smaller and lower Doric porticoes at right angles (figs. 240, 241). Pedestrians could climb steps on either side, but a ramp

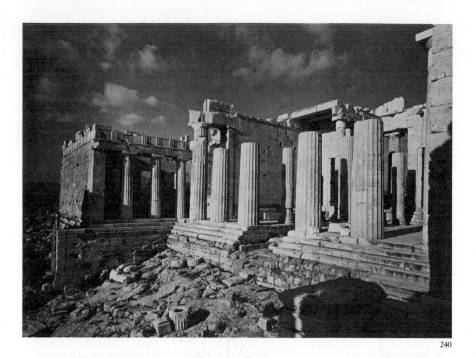

240

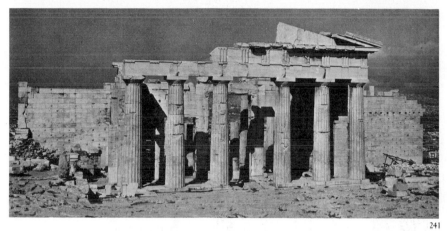

241

was required for horses and sacrificial animals, and to accommodate this the central intercolumniation was widened by one triglyph and one metope—not an ideal solution, perhaps, but the only one consistent with the strict principles and limited vocabulary of the Doric order. Inside the building the roadway was lined with Ionic columns, three on each side, and the inner gateway was again a pedimented Doric portico. This inner gateway was to have been flanked by two halls, whose prospective use is not known; construction was halted by the outbreak of the Peloponnesian War, and the halls were never built. Whether seen from below as one toils up the ramps, or from the higher ground within the Acropolis, the exterior of the Propylaia is noble and graceful; the columns are similar in their lofty proportions and elegance of contour to those of the Parthenon. The small flanking structure to the north (on the south only the portico was built) was a picture gallery, the earliest one on record, erected to accommodate paintings on wood to be set around the marble walls below the windows.

The Temple of Athena Nike. About 425 B.C., four years after the death of Pericles, the tiny Temple of Athena Nike (Victory) was constructed, presumably by Kallikrates, co-architect of the Parthenon, on the bastion flanking the Propylaia to the south in celebration of the victories of Alci-

238. PHIDIAS. *Athena* (reconstruction), from the cella of the Parthenon. c. 438–432 B.C. Wood covered with gold and ivory plating, height c. 48″. The Royal Ontario Museum, Toronto

239. PHIDIAS. *Lemnian Athena*. c. 450 B.C. Roman marble copy of the bronze original, height 17¼″. Museo Archeologico, Bologna

240. MNESIKLES. The Propylaia, Acropolis, Athens (view from the southwest). c. 437–432 B.C.

241. The Propylaia, Acropolis, Athens (view from the east)

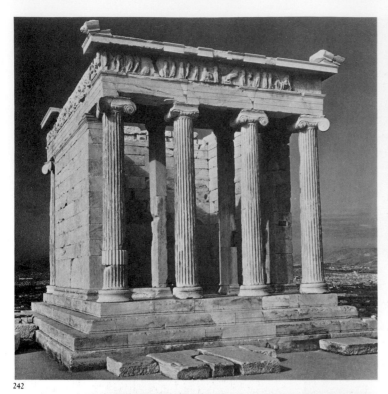

242

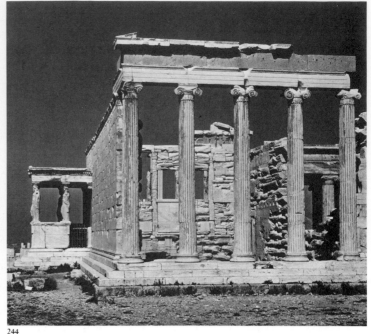

244

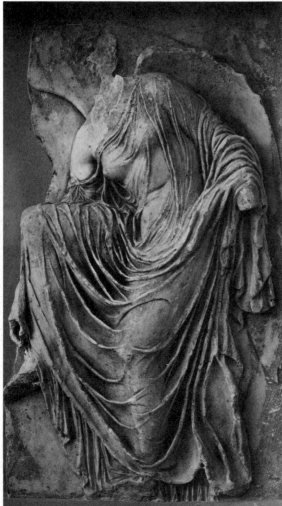

243

242. KALLIKRATES. Temple of Athena Nike,
Acropolis, Athens. c. 425 B.C.

243. *Victory Untying Her Sandal*, from the parapet
of the Temple of Athena Nike, Athens.
c. 410 B.C. Marble, height 42″. Acropolis
Museum

244. The Erechtheion, Acropolis, Athens (view
from the east). c. 421–405 B.C.

245. Plan of the Erechtheion, Acropolis, Athens

246. Porch of the Maidens, the Erechtheion,
Acropolis, Athens

247. PAIONIOS. *Victory*, from Olympia. c. 420 B.C.
Marble, height (including base) 85″. Ar-
chaeological Museum, Olympia

biades, which brought about a temporary lull in the catastrophic Peloponnesian War. The amphiprostyle temple has four Ionic columns on each portico (fig. 242). The proportions are unusually stocky, possibly so as not to contrast too strongly with the Doric columns of the Propylaia. The little structure was dismantled by the Turks and its stones used for fortifications; it was reassembled only in the nineteenth century. The finest sculptures carved for this temple originally decorated the parapet and showed personifications of Victory either separately or before Athena. These reliefs were apparently carved by masters trained initially under Phidias in the sculpture of the Parthenon. The loveliest is the exquisite *Victory Untying Her Sandal* (fig. 243), in which the transparent drapery of the Phidian style is transformed into a veritable cascade of folds bathing the graceful forms of the Victory. It has been suggested that the taste of the sculptor Kallimachos, credited with the invention of the Corinthian capital, is responsible for this refined, late phase of fifth-century style, which, however ingratiating its melodies may be, has certainly lost the grand cadences of Phidias.

The Erechtheion. The final fifth-century building on the Acropolis, the Erechtheion, built from 421 to 405 B.C., was named after Erechtheus, a legendary king of Athens; it contained the ancient wooden image of Athena and possibly sheltered the spot where the sacred olive tree sprang forth at Athena's command. Rarely for a Greek temple, and presumably because of the now not entirely understood requirements of the religious rites for which it was designed, the Erechtheion is strikingly irregular. The four rooms culminate in three porches of sharply different sizes facing in three separate directions (figs. 244, 245). Yet from any view the proportions are so calculated that the effect is unexpectedly harmonious. Two porticoes are Ionic, with extremely tall, slender columns and elaborate capitals; the taller portico had four columns across, the smaller six (see fig. 242; one column is lost). On the third portico (fig. 246), instead of columns, six korai uphold modified Doric capitals and an Ionic entablature, in the manner of the caryatids in the Treasury of the Siphnians at Delphi (see fig. 198). Despite disfiguring damage, the figures stand so calmly that the masses of marble above them seem almost to float. Anyone who has ever watched Mediterranean women carry heavy loads on their heads without the slightest apparent effort will recognize the pose.

MASTERPIECES FROM THE AGE OF PERICLES Perhaps the most spectacular outgrowth of the Phidian style was Paionios' *Victory* (fig. 247), a marble statue set up at Olympia about 420 B.C., on a tall shaft, triangular in cross section, with its apex presented to the spectator so that in most lights it would almost disappear. The impression was thus given that the Victory—with arms and wings (now lost) extended, tunic pressed by the breeze against her full body, and her drapery billowing behind in the wind—were really flying. Although the experiment was daring, one misses the grandeur of the Phidian style, whose absence from this work makes it seem a bit pretentious.

The deeper aspects of Phidian style seem to have been better understood by modest artisans, such as the sculptors of the grave stelai carved in great numbers in Athens; these were often for export and uniformly of high quality. An especially touching example is the *Stele of Hegeso* (fig. 248), which shows the deceased seated in a chair holding a piece of jewelry (painted, not carved) and accompanied by a standing girl, perhaps a daughter. The gentle melancholy of the group is not achieved by expressions—as usual in the fifth century, the faces are almost blank—but rather

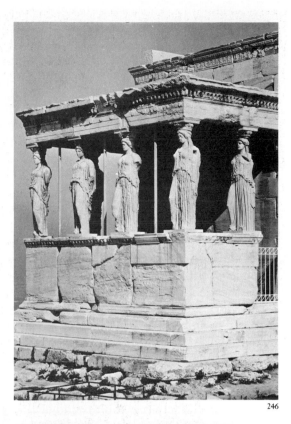

246

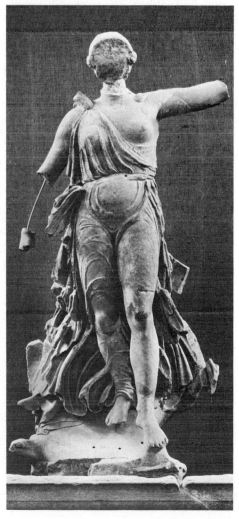

247

by the rhythm of their poses, especially the bowed heads suggesting resignation. The sculptor, who may well have been among the host of stonecutters trained on the Parthenon, has an unusual command of space. He has placed his two figures so that the back of the standing woman and the chair of Hegeso overlap the frame, causing them to emerge into our space. Yet the veil over Hegeso's head is so slightly projected from the marble background as to indicate an airy space within the frame.

Although the principles of the Doric and Ionic orders as applied to temples were by now firmly established, experimentation was still possible. One of the most striking variants, dating from around 420 B.C., the Temple of Apollo at Bassai in the wilds of Arcadia, has been attributed to Iktinos himself. The peripteral exterior is not exceptional (fig. 250); in fact, it shows fewer refinements than the Parthenon. The dramatic effect of the interior, however, is utterly new (fig. 249). The cella was lined with Ionic columns, engaged to the walls by projecting piers, supporting capitals with three equal faces. At the west end stood at least one, perhaps three, Corinthian columns, the earliest known. The abacus of a Corinthian capital (see fig. 254) resembles that of the Ionic, but the volutes are rudimentary; the distinguishing feature is the profusion of carved acanthus leaves (the acanthus is a Mediterranean plant of the thistle family) enveloping it, in at first one row, later two, and giving a rich and splendid appearance. The frieze above the columns made the cella interior even more exciting. It was carved in high relief with the typical subjects of battles between Lapiths and centaurs, Greeks and Amazons (fig. 251), but with unusually energetic poses and sharp exaggerations of movement and gesture—still in the Phidian tradition, but with a touch of wildness unexpected after the equilibrium of the Parthenon metopes.

Another large Doric temple at Segesta (fig. 252), in Sicily, commenced possibly by Attic builders for a local community in the process of Hellenization, was abandoned for unknown reasons in an unfinished condition; the cella was, in fact, not even started. We have, therefore, the privilege of seeing the columns already set up, preparatory to being fluted in place, and the stones of the stylobate retain the bosses left to provide holds for the tackle used in transporting them to this wild, lonely spot.

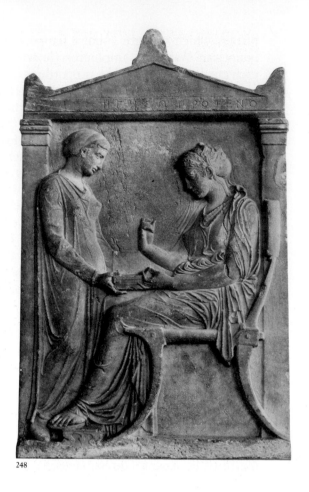
248

248. *Stele of Hegeso*, from Athens. c. 410–400 B.C. Marble, height 59″. National Archaeological Museum, Athens

249. Iktinos. Interior, Temple of Apollo, Bassai, Greece (Architectural reconstruction after F. Krischen)

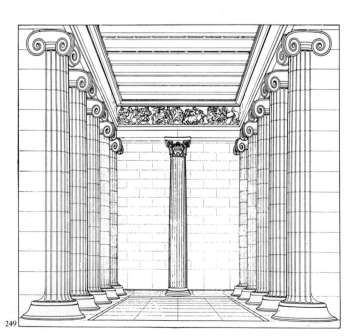
249

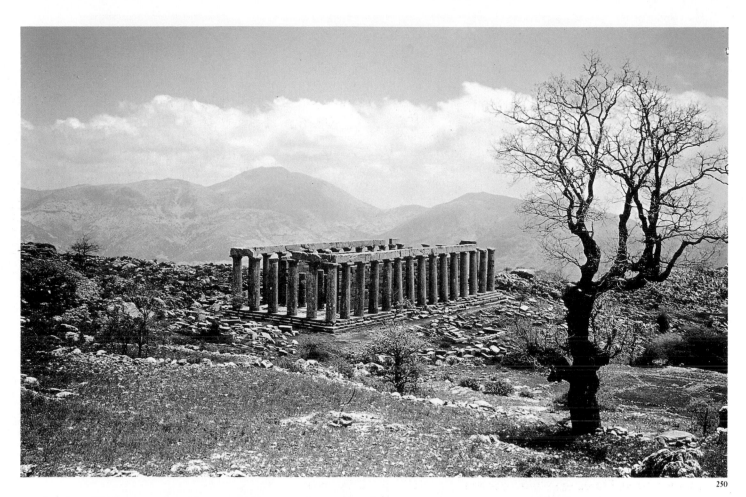

250

250. Iktinos. Temple of Apollo, Bassai.
c. 420 B.C.

Ancient literary accounts have much to say about the advances made by painters in the second half of the fifth century, especially a new realism in depicting everyday life and a new ability in rendering the expression of intense emotion. Even more important, the masters of the period are credited with having invented the means of painting light and shade in order to give form its full roundness and set it into depth. No Classical paintings showing these new achievements have yet come to light. Their effect on vase painting seems to have been to weaken even more the firm linearity and the attachment of flat design to the vase surface, which had been the delights of Archaic vase painting, and to lure the best masters away from that limited art to more exciting new fields. Only faint hints of the new pictorial freedom can be detected in the white-ground *lekythoi* (vases made to contain oil or perfume). In these, a painted white background could be used because they were intended as funeral gifts and would never be washed. In the enchanting *Muse on Mount Helikon* (fig. 253) by the Achilles Painter, we can see a new softness of form and a wavering, sketchy line which suggests space and light.

Looking back at the meteoric development of Greek art in the fifth century, it is sobering to reflect that an Athenian born toward the end of the Archaic period could have watched during a long lifetime the entire evolution of the Classical style.

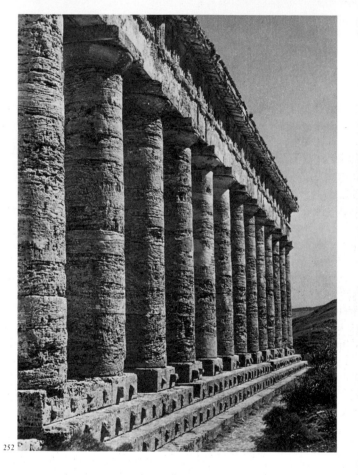

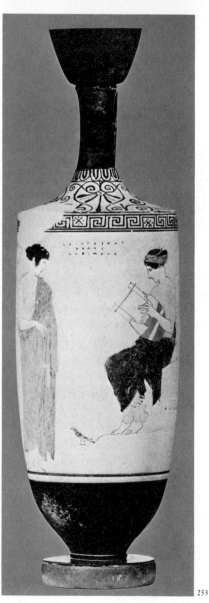

251. *Battle of Greeks and Amazons*, portion of a frieze from the cella of the Temple of Apollo, Bassai. c. 420 B.C. Marble high relief, height 25¼″. British Museum, London

252. Unfinished temple, Segesta, Sicily. c. 416 B.C.

253. THE ACHILLES PAINTER. *Muse on Mount Helikon* (portion of a lekythos). c. 440–430 B.C. Height of lekythos c. 14½″. Staatliche Antikensammlungen und Glyptothek, Munich

Toward the end of the fifth century B.C. a succession of military disasters stripped Athens of her imperial role and left the city a prey to severe social disorders. First Sparta, then Thebes exercised leadership among the Greek city-states in the first half of the fourth century, except for the Ionian cities of Asia Minor, which submitted to Persian rule. By the middle of the century the final threat to Greek independence had appeared. Philip II, king of Macedon, ruler of a land just to the north of Greece which had previously been considered outside the sphere of Hellenic civilization, established Macedonian primacy over the Greek mainland. His son, Alexander III (the Great), in a series of lightning military ventures absorbed and then attempted to Hellenize the entire Persian Empire, carrying his domination even into India. Alexander adopted Persian dress and court customs, claimed Zeus as his father, and had himself worshiped as a god in the manner of Mesopotamian and Egyptian monarchs. Despite her diminished political power, Athens remained the center of Greek intellectual life. The foundations of Western philosophy were laid in this period in the work of Plato and Aristotle, who first submitted traditional standards to the questioning test of reason. Under the changed circumstances, the balance, integration, and control of the Classical style—so largely a product of Athenian nationalism—were sure to be dissolved in the expanded world of Alexander's conquests, to be replaced by wholly new interests in space, movement, and light.

The Classical Period—
The Fourth Century

ARCHITECTURE Clearly, the fourth century was not to be a period of ambitious building programs in mainland Greece, but some splen-

254. POLYKLEITOS THE YOUNGER. Tholos of Epidauros (reconstructed section). c. 360 B.C.

255. Monument of Lysikrates, Athens. c. 334 B.C.

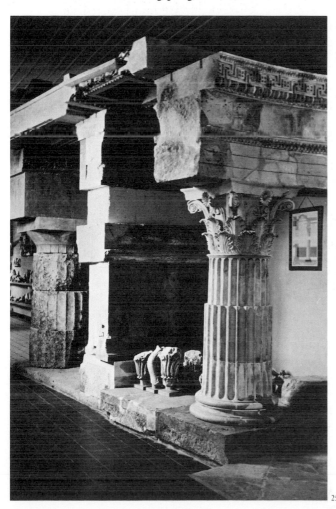

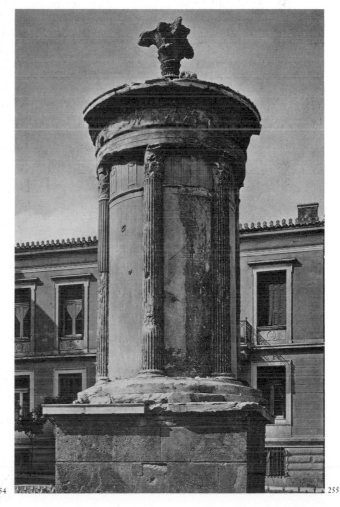

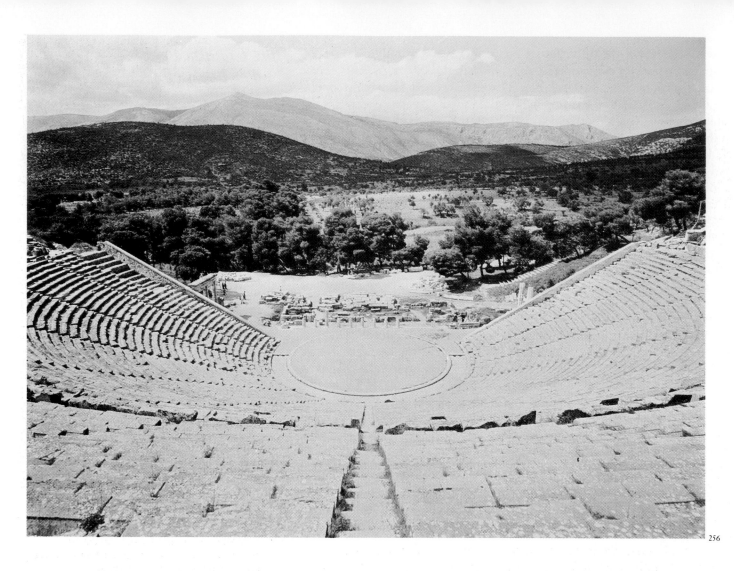

256. POLYKLEITOS THE YOUNGER. Theater, Epidauros. c. 350 B.C.

did new structures did make their appearance. One of the handsomest must have been the *tholos* (circular building), dating from about 360 B.C., at Epidauros. The tholos plan, derived from the round huts and tombs of Helladic times, could be devoted to a variety of purposes. For example, a fifth-century tholos in Athens served as a dining hall for the city administration. The Tholos of Epidauros, designed by Polykleitos the Younger as a place for sacrifices, consisted of a cylindrical wall surrounded by an outer Doric peristyle supporting a conical roof. The inner colonnade was composed of Corinthian columns—the first such colonnade we know. Sections of this tholos have been recomposed (fig. 254) and show extreme elegance and refinement of carving. The Corinthian capital already appears in very much the form later adopted by the Romans and revived in the Italian Renaissance, with two superimposed, staggered rows of acanthus leaves. The volutes are undercut, and so is each leaf, curving over at the tip with a jagged contour of great technical virtuosity. The earliest example we know of a Corinthian peristyle on the exterior of a building is the Monument of Lysikrates at Athens (fig. 255), a charming little structure intended to support the tripod Lysikrates won in 334 B.C. when he provided a chorus for the theater in Athens. The Corinthian columns are really only half columns, engaged to the central cylinder, which although hollow has no entrance; the conical roof, a single block of marble, supports an acanthus pedestal resembling a somewhat overblown Corinthian capital.

A new type of building that appeared in the fourth century is the

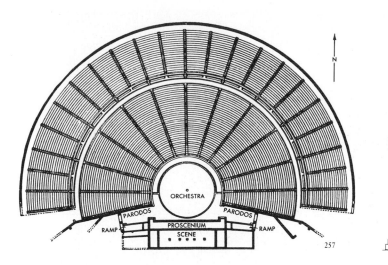

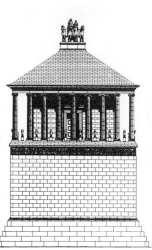

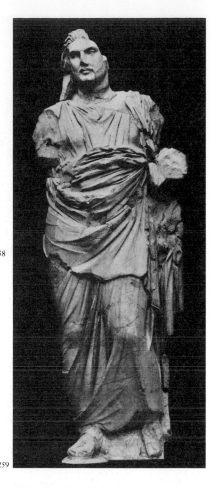

monumental outdoor theater. The largest and finest of these—so considered even in antiquity—is the well-preserved theater at Epidauros, designed, like the Tholos, by Polykleitos the Younger (fig. 256). During the great age of Greek drama in the fifth century, theaters had consisted of mere rows of wooden benches on a hillside, grouped roughly around the *orchestra* (meaning "dancing place"), a circular area where the chorus and the actors—never more than three at a time—sang and spoke. This idea is monumentalized at Epidauros in the form of a half cone of some fifty rows of marble benches separated by radiating aisles (fig. 257), still built around slightly more than half the orchestra circle. Originally, the theater had no stage; the building behind the orchestra circle supported temporary scenery. For all its simplicity, the harmony and grandeur of the space are as impressive as its acoustics. A word uttered in the orchestra circle can be clearly heard in the farthest reaches of the vast space.

The traditional elements of Greek architecture were forced to perform new functions in buildings erected outside of Greece. The most spectacular of these was the Mausoleum at Halikarnassos; the familiar name derives from its function as the tomb of Mausolus, prince of Caria in Asia Minor, who died in 353. Work began during his lifetime and continued after his death under the direction of his widow, Artemisia. The tomb, some 150 feet in height, was demolished by the Knights of St. John in the Middle Ages, and the pieces incorporated in their castle in the present-day port of Bodrum. Only fragments of sculpture and architecture have been recovered. Ancient literary descriptions, unfortunately, were incorrectly copied, so that it is now impossible to tell exactly what the building looked like (fig. 258 is one of several possible reconstructions). We do know that the Mausoleum had a lofty pedestal supporting a peristyle of thirty-six Ionic columns, each forty feet high, either in a single or a double row, surrounding the burial chamber. The whole was surmounted by a pyramid, in imitation of the Egyptians, culminating in a great marble chariot with four horses, presumably driven by Mausolus and Artemisia. At several still uncertain locations on the tomb, perhaps in the customary and inconvenient position at the top of the base, ran friezes representing the traditional battle subjects, carved by four of the most prominent Greek sculptors of the age.

In order really to understand the Mausoleum's sculpture preserved in the British Museum and the bare lines of the various architectural reconstructions, we must keep in mind the landscape for which the immense structure and its decorations were designed. Little is visible at the excavation today, but the site is a saddle between two hills, about three hundred

257. Plan of the Theater, Epidauros

258. Mausoleum, Halikarnassos (present day Bodrum), Turkey. c. 353 B.C. (Architectural reconstruction after F. Krischen)

259. *Mausolus*, from Halikarnassos. c. 353 B.C. Marble, height 9′10″. British Museum, London

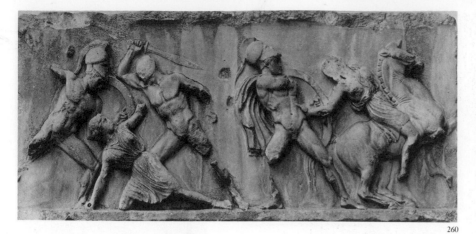

260

261

feet above the port, looking down the long harbor, flanked by hills on either side, to the distant sea. The immense space is filled with light, including that reflected from the water below, and all must have come to a dramatic climax in the towering pyramid with its culminating chariot against the sky. We do not know for certain the name of the master who executed the grand statue of Mausolus (fig. 259)—it may have been Bryaxis—but clearly it is animated by the new dramatic spirit of the time. While this realistic portrait, one of the earliest known, lacks the sense of majestic control visible in all Athenian sculpture of the fifth century, the movement of the drapery, the depth of the carving, and the intensity of the expression produce a great sense of excitement. It is instructive to compare this swaying, windblown charioteer with the serene *Charioteer of Delphi* (see fig. 210), of little more than a century earlier.

SCULPTURE The most eminent of the Halikarnassos sculptors was Skopas, born on the island of Paros but trained in Athens, known in antiquity for his ability to render movement and to convey drama. He may have been responsible for the *Battle of Greeks and Amazons* (fig. 260), in which the free movement of the figures in space is carried even beyond the stage of the frieze at Bassai (see fig. 251). In the section illustrated here, two Greek warriors are about to slay an Amazon who has fallen to her knees and cries for mercy, while a third Greek pulls an Amazon from her horse. The impression of speed is produced largely by the wide spacing of the figures, which leaves considerable areas of blank background to be traversed. Despite their mutilation, fragmentary heads from the Temple of Athena Alea at Tegea (fig. 261) show how Skopas revealed new depths of passion by means of an exceptionally deep eye cavity, thus producing a powerful shadow around the eye and intensifying the expression of wildness. Even the surging rhythms of the ornaments on the helmet are used to heighten the excitement of the moment.

A complete contrast to Skopas is furnished by the Athenian Praxiteles, whose fame was based on the grace and softness of his style. His most celebrated work in antiquity was the marble statue of Aphrodite in her sanctuary at the city of Knidos in Asia Minor, which we know only from Roman copies (fig. 262). This is the first nude statue of the goddess, and one of the earliest Greek statues of a female nude, which in itself indicates a sharp change in the status of women, increasingly liberated from the *gynecaeum*. Compared to the partially nude female figures of the fifth century, and in spite of faulty restorations (the head comes from another statue, and the hands and feet are new), the copy shows a greater fullness of forms and an almost imperceptible transition from one form to the next. The result is a wholly new sense of warmth and life.

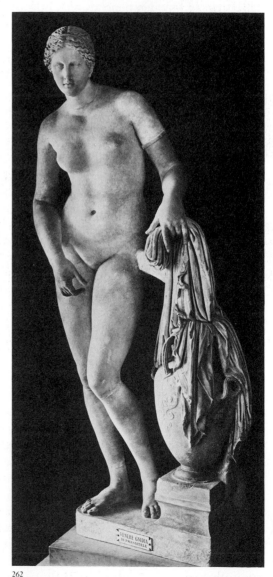

262

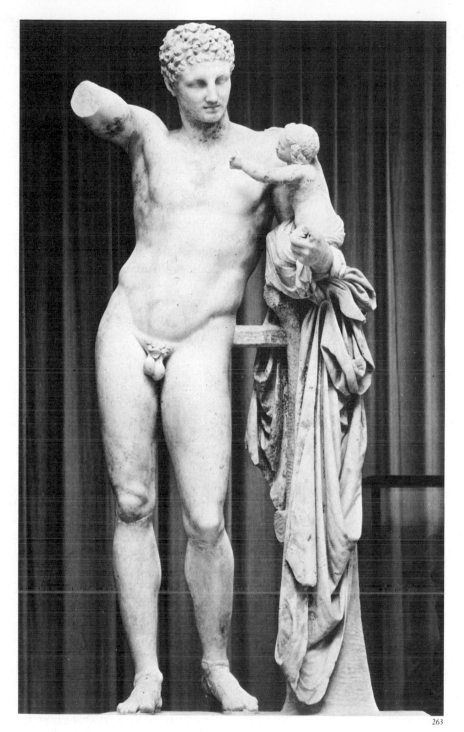

263

260. *Battle of Greeks and Amazons*, portion of a
frieze from the Mausoleum, Halikarnassos.
Middle 4th century B.C. Marble, height 35".
British Museum, London

261. SKOPAS. *Head*, from the Temple of Athena
Alea, Tegea, Greece. c. 350–340 B.C.
Marble, height c. 11¾". National Archaeo-
logical Museum, Athens

262. PRAXITELES. *Aphrodite of Knidos.* c. 350 B.C.
Roman marble copy of marble original,
height 80". Vatican Museums, Rome

263. PRAXITELES. *Hermes with the Infant Dionysos*,
from Olympia. c. 330–320 B.C. Marble,
height 85". Archaeological Museum, Olympia

In recent years the beautiful *Hermes with the Infant Dionysos* (fig. 263)
at Olympia has been dismissed as a Hellenistic or even Roman copy of a
lost original by Praxiteles, but the quality of this statue is so much higher
than that of any ancient copy known to us that this judgment is hard to
accept. The least that can be said of the *Hermes* is that no other surviving
ancient work approaches its consistent pitch of refinement in the treat-
ment of surface. Apparently, Praxiteles was one of the first to become
fully aware of the crystalline and translucent nature of marble, and to
discover a way of exploiting its special quality by softening and veiling
all transitions, abrading and polishing them until sharp edges could no
longer be seen. Eyelids, for example, and the edges of lips are deliber-
ately blurred, as is the transition from muscle to muscle in the soft and
glowing torso and limbs of the god. Shadows play gently over the fluid

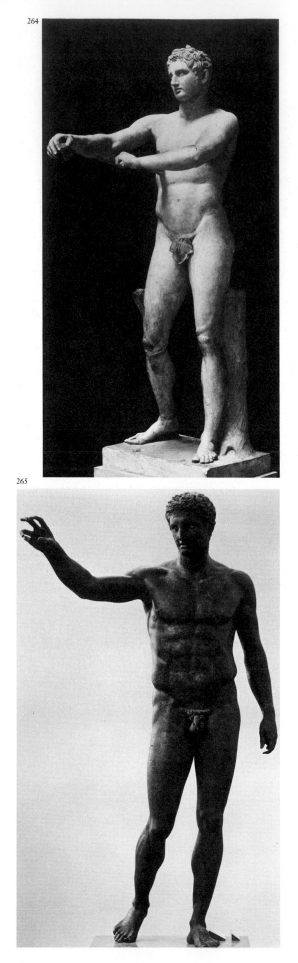

surfaces, and light is reflected from within the crystalline structure of the marble. Even the curly locks of the god's hair are softly sketched in the marble, particularly when compared to the still clear-cut definition of hair in the fifth century. The subject itself, far from the majestic themes of the fifth century, has a quality of gentle, aesthetic dalliance. Hermes dangles a bunch of grapes to tease the infant Dionysos; a dreamy half smile plays about his luminous features. In many ways this kind of attitude and treatment seem to have more in common with the nature of painting than with sculpture, and is thus often called "pictorial." Soon such pictorial ideals were to be pursued in a spectacular manner by Hellenistic and Roman sculptors, and later they were revived briefly in the Florentine Renaissance and triumphantly in the Italian Baroque.

The third great sculptor of the fourth century, Lysippos, took up again, but from a new point of view, the athletic themes of Myron and Polykleitos. If one judges from the surviving Roman copies, his lost bronze *Apoxyomenos* (fig. 264) showed a subject visible wherever athletes gathered—a young man scraping dust and sweat from his body with an S-shaped terra-cotta instrument called a strigil. Again according to the Roman copies, Lysippos employed a new system of proportion in keeping with the increased slenderness, height, and grace of Greek columns after the middle of the fifth century. The head is smaller, the torso and limbs longer and lither, the divisions between the muscles less strongly marked (in common with Praxiteles) as compared with fifth-century sculpture in general. More important, the arms are raised in such a way as to make use of the space in front of the body, thereby finally breaking through the invisible frontal plane to which even such vigorous action figures as the *Diskobolos* (see fig. 214) and the *Zeus of Artemision* (see fig. 213) had been restricted. How a Lysippan bronze statue would have looked may perhaps better be seen in the wonderful figure of a youth (fig. 265) found in the sea off Antikythera, in the wreck of a Roman vessel presumably laden with works of Greek art. Originally, the bronze did not have the greenish patina we now admire, but must have been polished to a luminous brown to suggest the deep tan of a Mediterranean youth who constantly exercised in strong sunlight. The inlaid eyes and copper lips are, luckily, still preserved. The brilliant naturalism of the work takes us across the centuries straight into a Greek palaestra.

PAINTING For no moment in the history of art, perhaps, do we mourn the disappearance of painting so keenly as for the fourth century. According to voluminous and graphic literary accounts, painters had made almost incredible strides since the not-too-distant days when Polygnotos was content to define form with line and to fill in the areas between contours with flat color. The names of many painters are known, and their styles were described in great detail. The leading master was apparently Apelles, whose studio was visited by Alexander himself. Artists no longer chiefly painted monumental murals on commission. Instead they specialized in panel paintings done on easels in the studio, working to satisfy themselves and hoping for sales to the wealthy and powerful. Painters employed either *encaustic*, using colors dissolved in hot wax and painting while the wax was still soft, or *tempera*, utilizing colors mixed with egg yolk. Both techniques were fairly laborious, but the effects the artists achieved were totally new. Most important, they had discovered the full meaning of light for the first time in the long story of the art of painting. They were able to indicate the source of light and follow its effects in diffusion, transparency, reflection, and cast shadow. So many of these

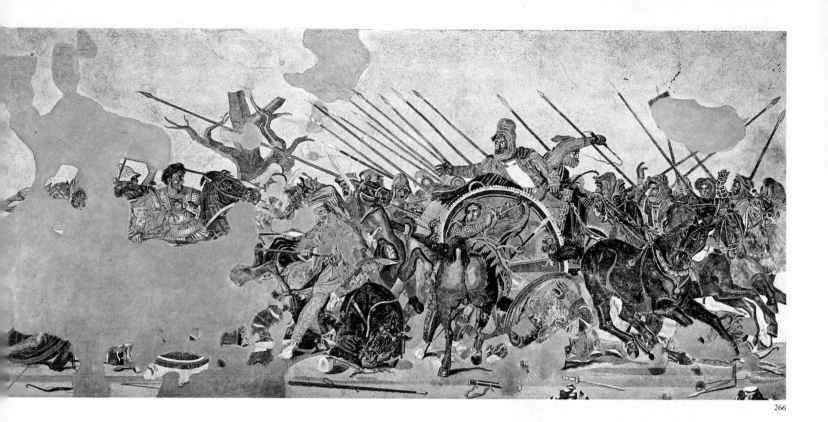

266

264. LYSIPPOS. *Apoxyomenos* (*Scraper*). c. 330 B.C.
Roman marble copy of bronze original,
height 81″. Vatican Museums, Rome

265. *Youth*, found in the sea off Antikythera,
Greece. c. 340 B.C. Bronze, height 77″. National Archaeological Museum, Athens

266. *Victory of Alexander over Darius III*. Roman
mosaic copy of a painting possibly by Philoxenos or by Helen of Egypt. c. 300 B.C.
Height 10′ 3¼″. Museo Archeologico Nazionale, Naples

light effects turn up as common practice in the Roman paintings done at
Pompeii and Herculaneum (see figs. 290, 323, 324) by anonymous provincial artists three centuries later that the literary accounts are more than
believable. Furthermore, these effects correspond to those that the sculptors were seeking to achieve in marble and in bronze. The painters were
also able to indicate depth, especially by means of foreshortening objects
placed at an angle to the picture plane; and finally they were greatly
interested in human character and emotion. Many portraits are described
and many dramatic scenes in which passion was represented with great
success. One extremely important device discovered by fourth-century
masters was glazing, or covering the surface of a painting with a quick-drying, transparent coating (which could be a varnish) in which small
amounts of color had been dissolved. This gave otherwise very brilliant
tones an effect of greater depth and resonance, much like the soft colors
transmitted by sunlight at certain times of day.

We do at least possess occasional attempts, however halting, to reconstruct fourth-century paintings. One is a mosaic (a technique of building
up a pictorial image by combining small pieces of hard, colored material:
in Classical times stone was used) found at Pompeii. This mosaic appears
to be a Roman copy of the *Victory of Alexander over Darius III* (fig. 266),
painted about 300 B.C. by Philoxenos for King Cassander of Macedon.
The original has been attributed, without firm evidence, to a painter called
Philoxenos, although Pliny the Elder, who died at Pompeii, believed it to
have been the work of a woman, Helen of Egypt. Despite the difficulty
of translating a painting into such a picture-puzzle technique, and the
heavy damage that has destroyed most of the left side of the mosaic copy,
we can still experience the grandeur of a very noble composition. The
artist has not tried to show the whole battle, but to sum up its central
action in a selected grouping of figures and accessories. He has represented very effectively the impact of Alexander's cavalry on the routed
army of Darius, who turns in his chariot with a gesture of intense compassion for his fallen bodyguard, run through by the Macedonian king.

Tides of battle surge through what is clearly deep space within the picture, even though the background is a flat white. The horses turn and twist in depth, some foreshortened from the front, others from the back; still others are seen diagonally. A sheaf of long Greek spears shows that Darius is almost surrounded, but the spears also serve as a compositional device pointing to Alexander, who can be seen over the damaged area, reining in his rearing horse. The ground is littered with weapons. Light, as we have never seen it represented before, gleams on Alexander's armor, on the tree, the shields, and the glossy bodies of the horses, and casts strong shadows on the ground. A fallen Persian is reflected in the polished surface of his shield. Anguish contorts the faces and dilates the eyes of the defeated. Certainly the great fourth-century discoveries—light, space, and emotion—appear to an extraordinary degree in this picture, which opens artistic vistas leading to modern times.

The Hellenistic Period (323–150 B.C.)

During the Archaic and Classical periods Greek culture had spread, through a steady process of colonization, as far west as the Mediterranean coast of Spain. The conquests of Alexander produced almost overnight a veritable explosion of Hellenism throughout the entire eastern Mediterranean region as well, including Egypt, and throughout all of western Asia extending to the Indus River. Ironically enough, the propelling energy for this new burst of Hellenism came from the ruler of Macedon, a country previously considered to lie on the fringe of the Greek world; yet so durable were the effects of Alexander's conquests that Greek remained the principal language spoken in Lower Egypt and in the eastern Mediterranean region, even under the Roman Empire. Throughout the conquered countries Alexander founded new Greek cities, some of which grew rapidly to enormous size; meanwhile, the older Ionian centers in Asia Minor, freed from Persian domination, enjoyed a new period of great prosperity. After Alexander's death in Babylon in 323 B.C., at only thirty-three years of age, his generals divided his empire among them and ruled as kings. Among the major divisions were Macedon itself under the Diadochi, the kingdom of the Seleucids in Asia Minor with its capital at Antioch in Syria, and the kingdom of the Ptolemies who ruled Egypt as pharaohs from the new Greek capital at Alexandria. Antioch and Alexandria eventually became the first cities of the ancient world with populations of a million or more.

The riches of the eastern kingdoms contrasted sadly with the poverty and relative impotence of the Greek city-states, left with only a semblance of their former autonomy to carry on their usual fratricidal warfare, except when interrupted by one or another of the Hellenistic kingdoms. Athens was respected for its distinguished history and cultural achievements, but it had slight commercial or political importance. As the city-states declined so did their old cults; religious feeling became intensely personal, and the individual sought direct and often ecstatic contact with the gods in such Oriental religions as the worship of Cybele, the mother-goddess, or the cult of Isis, imported from Egypt. Learning flourished, not only in Athens but also in the great new cities, especially Alexandria, with its Mouseion, or gathering place of philosophers, scientists, and scholars, and its library, the largest in the ancient world. The newly Hellenized populations, with their mystery religions, provided an insatiable demand for an art that could carry the discoveries of the fourth century regarding space, light, movement, and above all emotional drama to extremes of sensuality and violence that would have shocked the Athenians of the Classical period. Yet the artists themselves were Greek, and

without the discoveries of their fifth-century predecessors they could have done little.

TOWN PLANNING Not all Greek cities grew up higgledy-piggledy like Athens, with bits of rational planning inserted here and there. But to build a planned city requires either starting from scratch, as Akhenaten did at Tell el Amarna, or tearing down a preexisting town. Seldom in Classical Greece could either of these be done. Straight streets intersecting at right angles do appear, as in those outlying sections of Miletus, a Greek city in Asia Minor, planned by a local architect, Hippodamos, around 470 or 460 B.C. But the Hellenistic cities, especially the new princely capitals, required planning on a grand scale. Their straight streets intersecting at right angles, open spaces, and public buildings were necessary for all the varied activities of metropolitan life within a rational system.

A beautiful example of late Classical and early Hellenistic town planning is Priene, situated across from Miletus, on the other side of what is now a broad plain but was then an immense bay. High above the port, a perfect Hippodamian plan was superimposed about 320 B.C. on a sloping hilltop, with the result that all the straight streets tilt sharply according to the terrain (fig. 267), affording spectacular views of the bay and landscape and of distant Miletus. A highly irregular fortification wall, exploiting the most defensible positions, surrounded the city. Fortunately for us, Priene contained within its territory the principal sanctuary of the Ionian League of Greek cities, so the Romans deliberately neglected it and spared us later remodeling. The city has been largely excavated, and although few walls are standing more than ten feet or so in height, we can serenely walk (or climb!) the straight streets today and gain a wonderful idea of how a Hellenistic city worked. At the lower edge of the reconstruction we see the stadium, used for athletic events and activities. At the center is the *agora*, an open square to be found in all Greek cities; surrounding the agora is that most typical of Hellenistic buildings, the *stoa*, essentially a continuous colonnade, closed by a wall behind, intended for the transaction of business or just for strolling, and generally

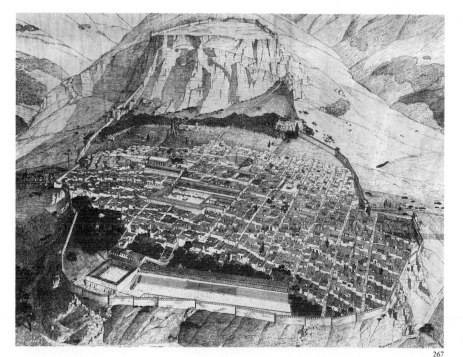

267

267. View of the city of Priene, Turkey (Reconstruction drawing by A. Zippelius)

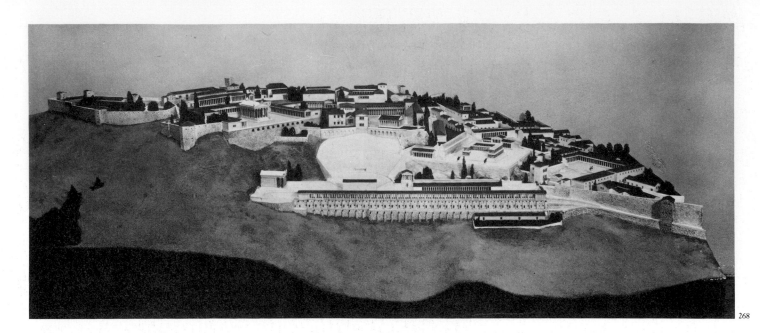

268

connected with shops and markets. To the upper left, at the highest point in the city, stands the Ionic Temple of Athena, and at upper center the theater, a gem of a building, still almost intact, with a columned stage so planned that painted scenery panels could be inserted between the columns. The Acropolis, not visible in the illustration, is a mighty crag soaring 1,000 feet above the port.

Town plans were designed to be as regular as possible, even when, as at Pergamon in Asia Minor, the rocky slopes of the terrain made planning extremely difficult. A restored model shows some of the principal buildings of this splendid city (fig. 268), even more dramatically situated than Priene. The large temple in the center of a square at the upper left is Roman and should be disregarded in this context. In the center is the theater, higher and narrower than that at Epidauros, because it was not built around an orchestra circle; in fact, only a semicircle was planned, and the action took place on a stage dominated by a high building for the support of scenery. Above the theater every attempt was made—in contrast to the free arrangements of the Classical period—to impose the appearance of regularity on the mountainous terrain. At the extreme right of the model is the usual agora, in the center foreground the stadium, above the right end of which rises the Altar of Zeus (see fig. 284), a monumental structure in itself. Higher up and just behind the theater, at right angles to one of its aisles, is the Temple of Athena; it is isolated and clearly visible from all sides in a plaza, formed by a two-story stoa, not in exact alignment but handled as if it were. The second story of the stoa, towering above the exact center of the theater, gave access to the royal library, second only in importance to that of Alexandria.

An agora of the Pergamene type at Assos in Turkey (reconstruction in figs. 269, 270) had handsome stoas, divergent but treated as if parallel, along both sides, a temple at one end, and at the other the *bouleuterion* (council hall). With their long, straight colonnades such complexes must have made magnificent spatial impressions. The traditional orders were still used, although Doric columns are often as tall and slender as Ionic, and Doric entablatures are correspondingly light. Generally, in two-story buildings the lower story is Doric, the upper Ionic. A superb bouleuterion of about 170 B.C. (reconstruction in fig. 271) at Miletus was preceded by an enclosure, entered through a Corinthian portico resembling a small temple. The courtyard was surrounded on three sides by a Doric colon-

268. Model of the city of Pergamon, Turkey. Staatliche Museen, Berlin

269, 270. The Agora, Assos, Turkey (Architectural reconstruction after A. W. Lawrence)

271. The Bouleuterion (Council House), Miletus, Turkey. c. 170 B.C. (Architectural reconstruction after A. W. Lawrence)

272. The Arsinoeon (with roof in section), Samothrace, Greece. Before 270 B.C. (Architectural reconstruction after A. W. Lawrence)

192 THE ANCIENT WORLD

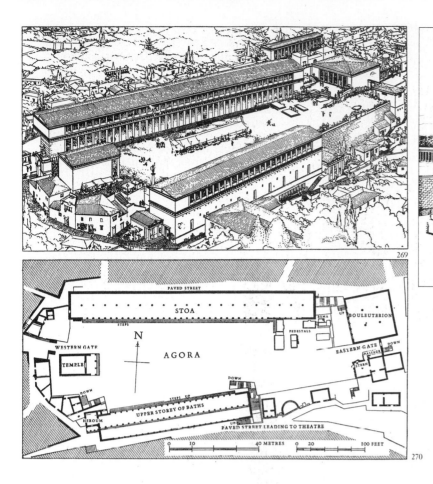

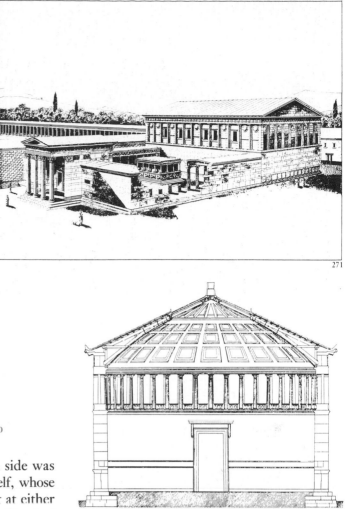

nade, in the center of which was an open-air altar. The fourth side was formed by the lower story of one long side of the council hall itself, whose upper story was an engaged Doric colonnade, with a pediment at either end. The Doric columns are more widely spaced than in the Classical period, with three rather than two triglyphs per column. Windows admitted light to the interior.

Large Hellenistic public buildings posed new problems for which the Greeks, thinking always in terms of post-and-lintel construction, had no organic structural solutions. Generally, interiors were roofed with wood, with sloping beams upheld in a stoa by a central row of taller columns, or sometimes in a bouleuterion by four interior columns so placed as least to obstruct the view. An ingenious device was employed at Samothrace, in a tholos called the Arsinoeon (reconstruction in fig. 272). Its cylindrical wall was surmounted outside by an engaged peristyle of Doric pilasters, inside by engaged Corinthian columns, supporting a wooden roof with a conical inner ceiling of wood, elegantly coffered (divided into recessed panels). Here is an early approach to the problem of the centralized interior without inner supports, which was solved later by the Romans through new and more imaginative construction methods (see figs. 1, 358) and taken up again in the great domes of the Byzantine (see figs. 427, 429) and Renaissance periods.

Hellenistic temples, when compared with those of the Archaic and Classical periods, represent a strong departure from what archaeologists have liked to consider "good taste." Nonetheless, if we are willing to forget for a moment preferences based on Classical style, and see these buildings in the context of the overriding Hellenistic concern with space and light, we must agree that they were very dramatic structures. A completely original example was the so-called Didymaion, the Temple of Apollo at Didyma, near Miletus, begun about 300 B.C. by the architects Paionios

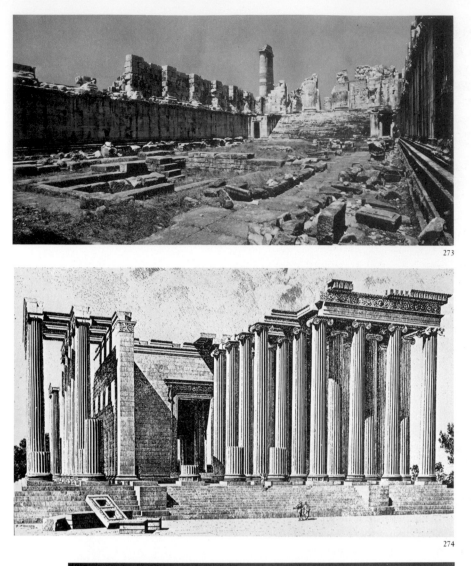

273

273. PAIONIOS OF EPHESUS and DAPHNIS OF MILE-
TUS. Temple of Apollo, Didyma, Turkey
(view of the inner courtyard looking east;
ruins of sanctuary in foreground). c. 300 B.C.

274. Temple of Apollo, Didyma (east front; ar-
chitectural reconstruction by H. Knackfuss)

275. COSSUTIUS. Temple of the Olympian Zeus,
Athens (view from the east). c. 174 B.C.–2nd
century A.D.

274

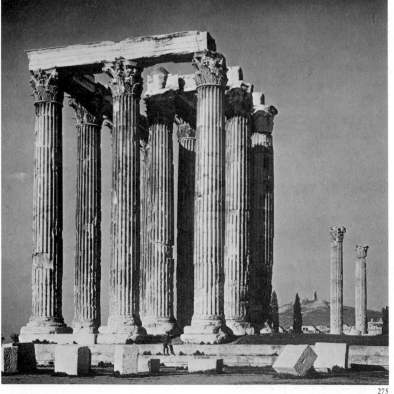

275

of Ephesus and Daphnis of Miletus (figs. 273, 274). Like a number of earlier temples in this region, the Didymaion was dipteral (with two peristyles, one inside the other). The structure was gigantic—358 feet long by 167 feet wide, with 110 columns. These were the tallest of all Greek columns, sixty-four feet in height, and there were ten across each end and twenty-one along each side; the entrance porch, with no pediment, was five columns deep. The central doorway, whose threshold was raised to make it inaccessible to the public, was used only for the promulgation of oracles. By means of a dark, barrel-vaulted passageway the few who were admitted to the sanctuary emerged not into the expected dim interior, but into a giant courtyard blazing with Apollo's sunlight and lined with pilasters, whose capitals carved with griffins correspond to no conventional order. At the end of the court stood the sanctuary proper, an elegant Ionic temple approached by a flight of steps erected over a hot spring, from which arose the fumes that inspired the oracles. Not only the dimensions and the enormous number of columns but also the stages in approach to the sanctuary and the general air of mystery remind us of the great temples at Luxor and Karnak (see figs. 107, 110). The immense building was so ambitious that its construction dragged on for centuries; a number of columns are still unfluted and their capitals and bases uncarved.

Temple architecture intended to produce a similar overwhelming emotional experience appeared in the second century in Athens itself, the center from which the intellectual style of the Classical period had emanated. The Temple of the Olympian Zeus (fig. 275), begun in 174 B.C. by the architect Cossutius (a Roman citizen working in Greek style) and commissioned by Antiochos IV, king of Syria, belongs to the same dipteral type as the Didymaion, which it almost equaled in scale. It is the first major Corinthian temple, and was so elaborate that it was not finished until the second century A.D. under the Roman emperor Hadrian. The small sections still standing, with their towering columns and rich capitals, hint at the majesty of the entire building, especially when it was surrounded by its original immense walled precinct.

SCULPTURE The sculptors of the Hellenistic age must have been almost embarrassed by the richness of their Classical heritage. Through the teaching of the innumerable followers of the great fourth-century masters—Skopas, Lysippos, and Praxiteles—Hellenistic sculptors were enabled to master the entire repertory of Classical virtuosity; they could represent anything in marble or bronze, from the vibrant warmth of nude flesh in the sunlight to the soft fluffiness of youthful hair. There are, in fact, works in which Hellenistic sculptors strove consciously to emulate their predecessors, even those of the sixth and fifth centuries, and since the great artistic conquests had already been made, it is not possible to follow in Hellenistic sculpture the steady evolution so clearly visible in earlier periods of art. Consequently, unless we have inscriptions or external evidence, Hellenistic sculpture is extremely difficult to date. Strikingly new in Hellenistic sculpture are an increased interest in naturalism and a new dimension given to drama, which violates at times all previous boundaries and standards, in keeping with the new geographic frontiers of this period and with the new spaces and light of its architecture.

Distinct schools of sculpture grew up at Athens, at Alexandria, on the island of Rhodes, and at Pergamon, to name four of the most important. It is appropriate to begin with a second-century portrait of Alexander himself (fig. 276), who was the motive force behind the new era and its art. The head was found at Pergamon, and it once formed part of a

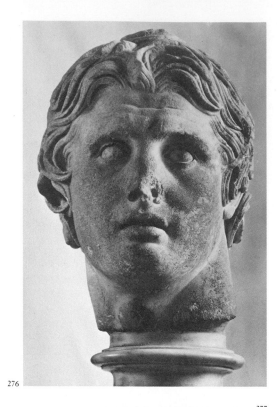

now-lost, larger-than-lifesize statue of the brilliant young monarch. Although done long after his death, it is a convincing portrait of the strange hero—part visionary, part military genius—driven by the wildest ambition, stranger to no physical or emotional excess, restrained by no moral standards (he ordered his own nephew executed and murdered his closest friend in a wild debauch). The rolling eyes, the shaggy hair, the furrowed brow, the already fleshy and sagging contours of cheeks and neck, all betray the character of this astounding man. As in all sculptures of the Pergamene school, the master—one of the most gifted sculptors of his time—has maintained a carefully controlled system of exaggerated incisions and depressions in eyes, mouth, and hair in order to increase light-and-dark contrasts and to achieve a heightened emotional effect.

A different kind of portraiture—more searching perhaps and less dramatic, but equally influential on the later art of Rome—must have characterized the lost original bronze of the archenemy of Macedon, the Athenian orator Demosthenes. This work is known from several Roman copies (fig. 277; the hands and forearms are an accurate modern restoration). The sculptor has embodied with great success the quiet intensity of the pensive, aging statesman, enveloped in his worn cloak; no realistic detail is spared. Hellenistic sculptors, in fact, shrank from no representations of decay or deformity in their attempt to present an intense and

276

277 278

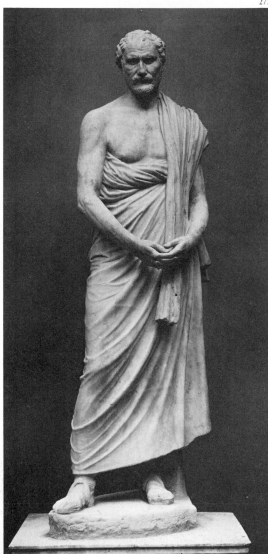

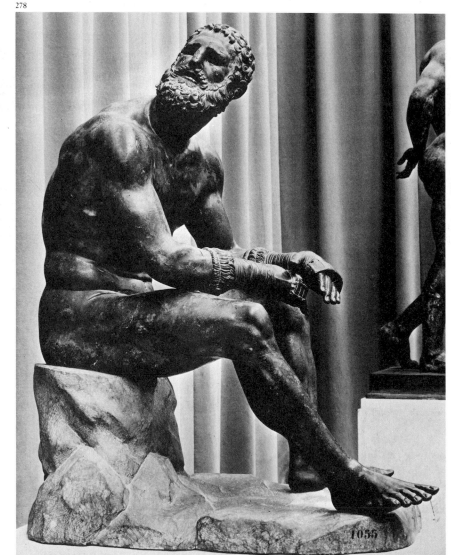

convincing picture of human life. A tragic example of human degradation is shown in the bronze *Seated Boxer* (fig. 278), probably dating from about the middle of the first century B.C., about a hundred years after Athens had lost its independence to Rome. The sculptor controlled the entire repertory of anatomical knowledge and bronze technique known to Polykleitos and Lysippos, but instead of a graceful athlete in serene command of his own destiny, he preferred to show us a muscle-bound, knotty boxer, with broken nose, cauliflower ears, swollen cheeks, and hands armed with heavy leather thongs to do as much damage as possible. Blood oozes from the still-open wounds on his face. What is left of a human soul seems almost to ask for release in the expression of the stunned face, possibly even more harrowing when the inlaid eyes were preserved.

Mythology itself was seen from the point of view of the new naturalism; the satyr, a happy and irresponsible denizen of the glades in Archaic and Classical art, is shown heavy with wine (fig. 279) in an excellent Roman copy of a lost Hellenistic original from about the middle of the third century B.C. The bestially sensual anatomy and the brutal face disturbed by dreams in its drunken stupor radiate the same sense of tragic imprisonment so impressive in the *Seated Boxer*. The dreamy, languorous naturalism of Praxiteles lingers on throughout the Hellenistic period, even in representations of divinities, who never radiate the impersonal grandeur of the fifth century. The *Aphrodite of Cyrene* (fig. 280), found in a bath in that North African Greek city, is an exquisite work of the early first century B.C. The curving surfaces and soft, warm flesh of the goddess, who has just risen from the sea (in emulation of the *Aphrodite of*

276. *Portrait of Alexander*, from Pergamon. 1st half of 2nd century B.C. Marble, height 16⅛". Archaeological Museum, Istanbul

277. *Demosthenes.* c. 280 B.C. Roman marble copy of bronze original, height 79½". Nationalmuseet, Copenhagen

278. *Seated Boxer.* Middle 1st century B.C. Bronze, height 50". Museo Nazionale Romano, Rome

279. *Satyr.* c. 220 B.C. Roman marble copy of Greek original, over-lifesize. Staatliche Antikensammlungen und Glyptothek, Munich

280. *Aphrodite of Cyrene*, from Cyrene, North Africa. Early 1st century B.C. Marble, height c. 56". Museo Nazionale Romano, Rome

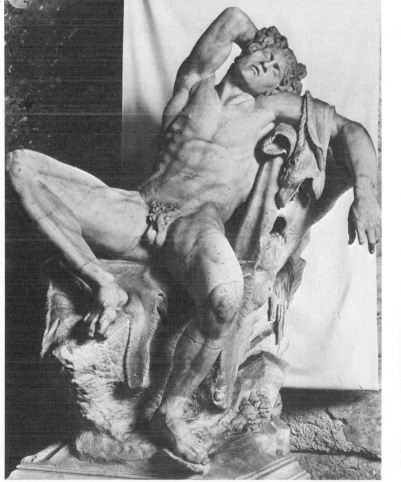

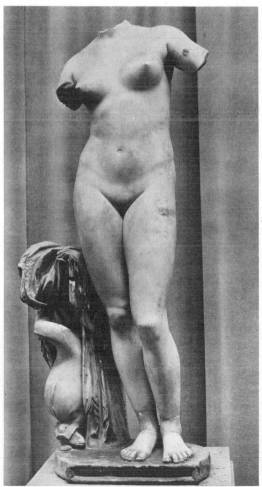

Knidos of Praxiteles, see fig. 262), contrast with the beautiful curves of the dolphin and with the delicate folds of the garment beside her. In the *Head of a Girl* (fig. 281), probably of the third century, from the island of Chios, Praxitelean style is carried to its furthest extreme. The marble head was doubtless inserted in a statue made of another kind of marble, part of which was carved into drapery covering the girl's head. The upper lids melt into the brows, so soft has definition become, and the lower lids are hardly represented at all. The face is a masterpiece of pure suggestion, through luminous surfaces of marble and tremulous shadow.

In the magnificent *Nike of Samothrace* (fig. 282), we have an echo of Paionios' famous statue at Olympia (see fig. 247), but this time the unknown Hellenistic sculptor has won; his statue is far more dramatic than its Classical prototype. It was originally erected in the Sanctuary of the Great Gods at Samothrace by the Rhodians in gratitude for their naval victory over Antiochos III of Syria about 190 B.C., and it stood upon a lofty pedestal representing in marble the prow of a ship. The right hand, discovered in 1950, shows that the fingers originally held a metal victor's fillet; the head is turned partly to the left. The sea winds whip the drapery into splendid masses, producing a rich variation of light and shade. The contrast between the tempestuous movement and the power of the outstretched wings renders this one of the grandest of ancient statues.

The most dramatic of all the Hellenistic schools of sculpture flourished at Pergamon, which in the third century B.C. was attacked by tribes of Gauls from the north. The victory of King Attalos I over the invaders was celebrated in a series of bronze statues and groups, known through Roman copies. A strikingly naturalistic example, the *Dying Trumpeter* (fig.

281. *Head of a Girl*, from Chios, Greece. c. 3rd century B.C. Marble, height 14⅛". Museum of Fine Arts, Boston

282. *Nike of Samothrace*. c. 190 B.C. Marble, height 96". The Louvre, Paris

281

282

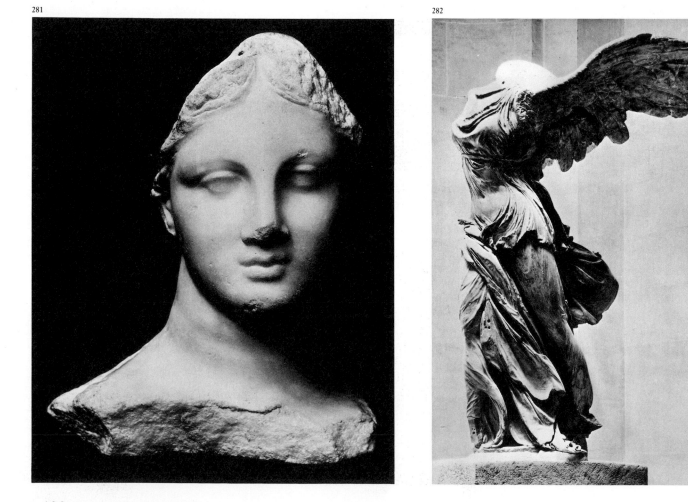

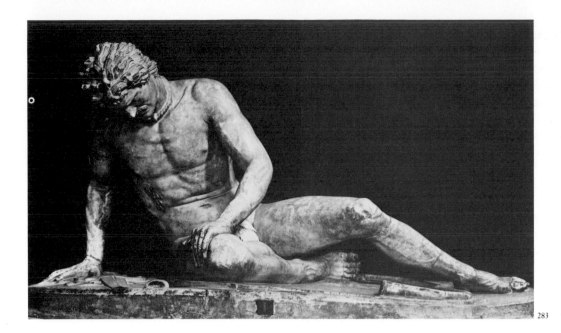

283), is obviously a descendant of such works as the *Dying Warrior* of Aegina (see fig. 203). But the beautiful reticence and geometric clarity of Late Archaic sculpture should not blind us to the accomplishments of Pergamene art here in representing the collapse of the barbarian, from a wound in his side streaming blood, with a deep and unexpected sympathy of the victor for the vanquished.

The triumph of the Pergamenes is celebrated allegorically in the huge Altar of Zeus (figs. 284, 285) built between 181 and 159 B.C. and partially reconstructed in Berlin. Appropriately enough for the king of the gods, it was erected as an altar in the sky, looking over a vast landscape and out to sea (see fig. 268 for its position in the city). It stood on a raised platform, in the manner of a ziggurat, in the center of a court, and was accessible by a steep flight of steps. Around the altar were two peristyles, the outer one of widely spaced Ionic columns, with wings projecting on either side of the staircase. Around the entire base ran a frieze more than seven feet high, representing the *Battle of Gods and Giants* (symbolizing, of course, the triumph of the Pergamenes over the barbarian hordes), second only to the Parthenon frieze as the largest sculptural undertaking of antiquity. But the great artist who designed the frieze changed the customary place

283. *Dying Trumpeter*, from Pergamon. c. 230–220 B.C. Roman marble copy of bronze original, lifesize. Museo Capitolino, Rome

284. Altar of Zeus, from Pergamon (northern projection). c. 181–159 B.C. Pergamonmuseum, East Berlin

285. Plan of the Altar of Zeus, Pergamon

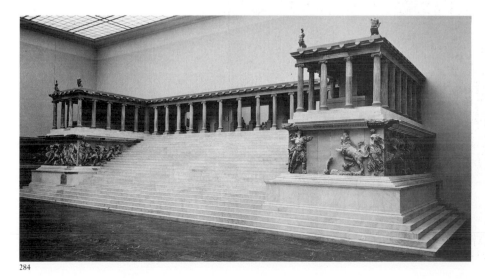

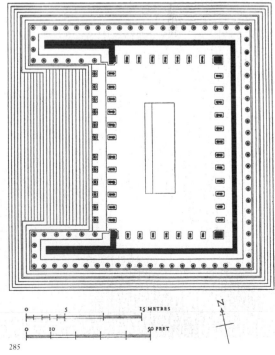

for such a decoration from the top of a high wall or entablature (Treasury of the Siphnians, Parthenon, Temple of Apollo at Bassai, and possibly the Mausoleum at Halikarnassos), where it could be read only with difficulty, to a position only just above eye level, where the larger-than-lifesize figures, almost entirely in the round, seem to erupt from the building toward the spectator; some have even fallen out of the frieze so that they are forced to support themselves on hands and knees up the very steps that the worshiper also climbs.

No pains were spared to achieve an effect of overwhelming power and drastic immediacy. The fragile architecture is borne aloft, as it were, on the tide of battle. So dense is the crowding of intertwined, struggling figures as at times to obscure the background entirely. Figures of unparalleled musculature lunge, reel, or collapse in writhing agony. To our left Zeus has felled a giant with a thunderbolt aimed at his leg (fig. 286), and the giant bursts into flames; to our right a giant with serpents for legs beats against the thundering wings of Zeus' eagle. Projections and hollows, large and small, were systematically exaggerated so as to increase both the expressive power of the work and the changes of light and shade as the sun moved around it (the intense light from the sky, the valley, and the sea, reflected upward from the marble steps, would have eliminated the black shadow we see in the photograph, taken in the Berlin Museum). The sculptures must have been experienced like forces from the surrounding sky and clouds. Compared to this wild surge of violence, the battle reliefs of the fifth and fourth centuries look restrained, governed by laws of balance and measure which here are swept aside. The reliefs bear several sculptors' signatures; unfortunately, we do not know the name of the master who designed the entire work and who also may well have carved the giant head of *Alexander* (see fig. 276), which has so much in common with this relief.

By analogy with the art of the seventeenth century A.D., the style of

286. *Zeus Fighting Three Giants*, from the Altar of Zeus, Pergamon. Marble, height 90″. Pergamonmuseum, East Berlin

287. Hagesandros, Polydoros, and Athenodoros. *Laocoön and His Two Sons*. 2nd century B.C.–1st century A.D. Marble, height 96″. Vatican Museums, Rome

288. Hagesandros, Polydoros, and Athenodoros. *Head of Odysseus*, part of *Odysseus Blinding Polyphemos*, from Sperlonga, Italy. 2nd century B.C.–1st century A.D. Marble, lifesize. Museo Archeologico Nazionale, Sperlonga

289. Hagesandros, Polydoros, and Athenodoros. *The Wreck of Odysseus' Ship* (detail), from Sperlonga. 2nd century B.C.–1st century A.D. Marble, lifesize. Museo Archeologico Nazionale, Sperlonga

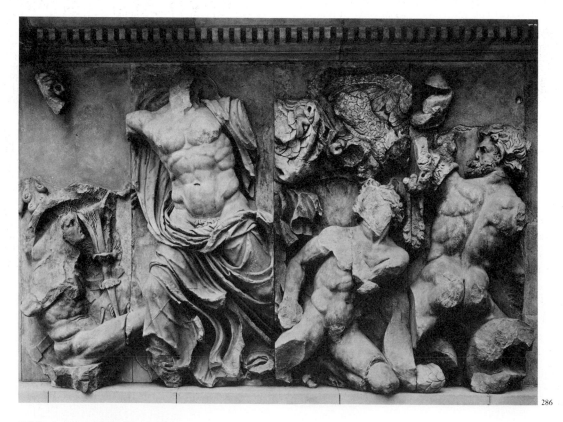

286

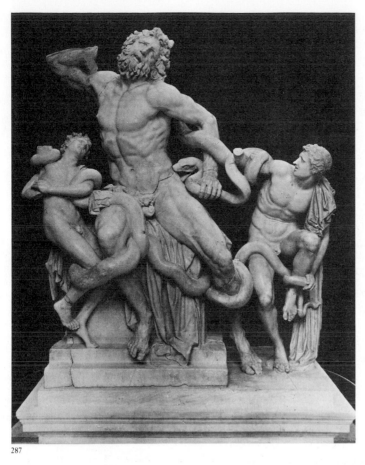

287

288

289

the Altar of Zeus has often been called the "Pergamene Baroque." It continued throughout Hellenistic times and was revived repeatedly in the art of the Roman Empire. One of the most extraordinary examples of the style is the group representing *Laocoön and His Two Sons* (fig. 287), generally identified with the group mentioned by the Roman writer Pliny. The Trojan priest Laocoön was assailed by sea serpents sent by Poseidon and was strangled before the walls of Troy. The group is the work of three sculptors from Rhodes—Hagesandros, Polydoros, and Athenodoros—but we do not know when it was created. Its customary dating in the second century B.C. has recently been upset by an extraordinary find at Sperlonga on the coast of Italy, about halfway between Rome and Naples. Fragments of five huge sculptural groups, like the *Laocoön* depicting themes from Homer, were discovered placed around the interior of a cave that had been turned into a pleasure grotto by some wealthy Roman, only to be later systematically smashed, presumably by early Christians. One of these groups, repeating the old Homeric subject of *Odysseus Blinding Polyphemos* (see fig. 181), was signed by the same three Rhodian sculptors. It has recently been suggested that both the *Laocoön* and the Sperlonga sculptures may have been done as late as the first century A.D., possibly for the Emperor Tiberius, and should thus be considered under Roman art. Even so, the sculptors were Greek and the style, whatever its date, is a direct descendant of the Pergamene Baroque. The head of Odysseus, who was probably helping to hold the burning pike (fig. 288), shows strong similarities to that of Laocoön—the same cutting of the marble, the same wildly rolling eyes, and the same treatment of hair and beard. The legs of Polyphemos are those of a figure about twenty feet high. In contrast to the intense light that bursts upon Pergamon for most of any year, the five groups must have struggled mysteriously in a dim grotto lighted only by oil lamps.

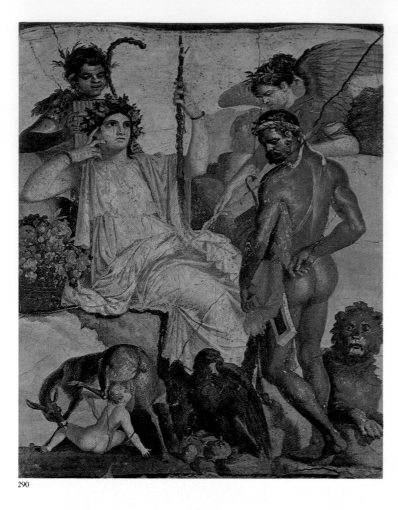

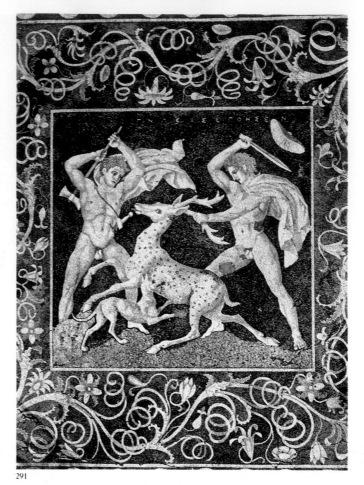

290

291

The sharp impact of the moment of dramatic action and the utter freedom from conventional restraints typical of Hellenistic sculpture may be seen again in the fragment of another group, *The Wreck of Odysseus' Ship* (fig. 289), which depicts in detail the stern of the vessel from which the helmsman, every muscle tense with the disaster, falls forward before our astonished eyes. Although the expert rendering of muscular strain, and even swelling veins, in the *Laocoön* may seem forced to us, in comparison to the Altar of Zeus, it was a revelation to the Italian Renaissance when the group was unearthed near Rome in 1506.

PAINTING AND DOMESTIC DECORATION Unfortunately, we possess few more original paintings from the Hellenistic period than we do fourth-century ones, but many of the finest Roman paintings preserved at Pompeii and Herculaneum are believed to reflect lost Hellenistic originals. A fresco of *Herakles and the Infant Telephos* from Herculaneum (fig. 290) even repeats a composition carved in the interior of the Altar at Pergamon. The sensuous richness of the style appears at its height in the painting of Herakles' deeply tanned body, in the shadows on his fierce lion, and in the range of light and shade on the doe suckling Herakles' infant son, Telephos. Hellenistic pictorial style can be clearly seen in a number of pebble mosaics used for floors, especially the beautiful third-century series unearthed at Pella in Macedon, the birthplace of Alexander. Even through the difficult medium of colored pebbles, the artist has been able to show the movement of light and shadow across the nude bodies and flying cloaks of two youths engaged in a *Stag Hunt* (fig. 291). Each pebble is treated as if it were a separate brushstroke, and the blue-

290. *Herakles and the Infant Telephos*, fresco from Herculaneum, near Naples. Roman copy of a Greek painting. 2nd century B.C. Museo Archeologico Nazionale, Naples

291. *Stag Hunt*, from Pella, Greece. Pebble mosaic. 3rd century B.C. Archaeological Museum, Pella

292. Amphora with sculptured handles, from Panagyurishte, Bulgaria. c. 300 B.C. Gold, height c. 10″. National Archaeological Museum, Plovdiv, Bulgaria

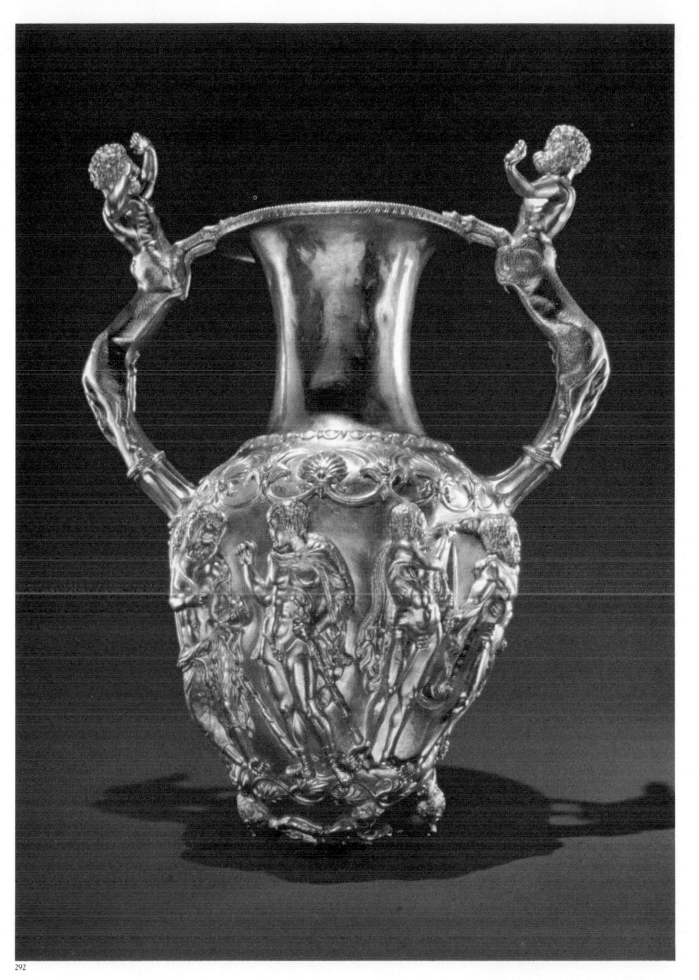

gray background accentuates the play of light. The motion is enhanced by the rhythmic surge of the vinescrolls framing the scene and is played off against the wave pattern in the border.

A final word should be said about the Hellenistic houses lavish enough to have such floors. Throughout Greek history up to this moment the private residence had been meanly simple—rough stone or mud-brick walls, supporting a tiled roof around a central court whose pillars were mere wooden posts. Demosthenes writes that in his time, the end of the fourth century, houses in Athens were becoming larger and richer, and during the wealthy Hellenistic period every city could boast entire streets of luxurious residences. These houses were invariably blank on the exterior and flush with the street, but once the visitor entered the interior through a hallway (L-shaped to keep out prying eyes), he found himself in a handsome courtyard graced at least on the north side, and sometimes on all four, by a peristyle, and giving access to a splendid dining room (fig. 293). Other rooms opened off the court, and the houses were often two stories high. The walls were decorated with an elaborate system of panels painted to resemble marble slabs (the so-called incrustation style taken up later by the Romans). Figural paintings appeared here and there, as if hanging on the wall.

Hellenistic palaces, temples, and prosperous private houses must have been sumptuously furnished with objects making lavish use of luxurious materials and precious metals. We are aided in forming a mental picture of such vanished splendors by a treasure comprising eight wine vessels of pure gold, dating from about 300 B.C., which was discovered by accident at Panagyurishte, near Plovdiv, Bulgaria. Probably intended for ritual use, these wine vessels were produced at Lampsacus, a Greek city on the Asiatic shore of the Dardanelles, the strait dividing Europe and Asia; the measurements of wine indicated on them use the units of that city. The technique, known as *repoussé* (pressed outward), consisted of hammering the gold plates from the reverse before they were joined together. The central object of the group is a superb amphora (fig. 292). The handles—produced as if by chance—are formed by sprightly, youthful centaurs whose forehoofs overlap the rim and whose arms are uplifted in delight at the sight of the wine within. Traditional ornament is restricted to four bands widely scattered so as not to compete with the refulgence of the smooth, gold surfaces in the neck of the vessel and in the human and animal figures. The body of the amphora is covered with a vigorous relief, whose figures, mostly nude, enact still-unidentified mythological scenes. On the side illustrated a nude youth carrying a staff converses with an older man, possibly Herakles. In the youth's lithe and supple figure, relaxed and resplendent, as well as in those in violent action on the other side of the vessel, the unknown craftsman has shown himself in full command of all the resources of Hellenistic monumental sculpture, reduced to the scale of an object that can be held in the hand. He has translated into smooth surfaces of flashing gold the luminary values that are the essence of Hellenistic art in every medium and at any scale.

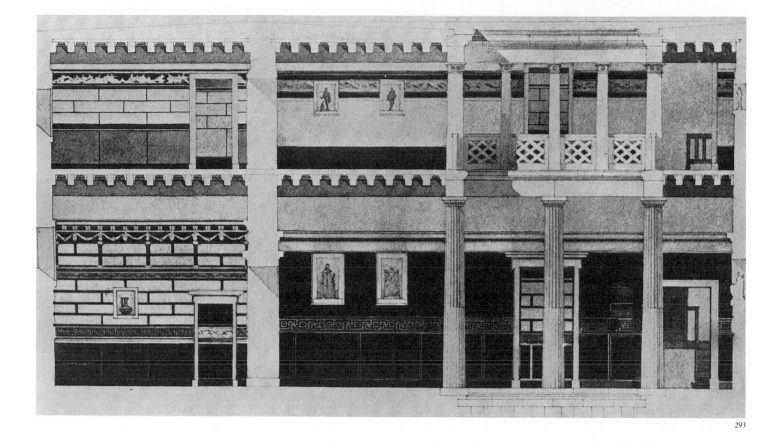

293. Section of a house at Delos, Greece, showing mural decoration. c. 2nd century B.C. (Architectural reconstruction after A. W. Lawrence)

In many ways Greek art may be regarded (along with Greek literature, Greek philosophy, and perhaps Greek music) as the greatest triumph of the ancient world. Unlike the arts of Egypt, Mesopotamia, and the Aegean, Greek art never really died. The Romans stole it by the shipload and adopted and adapted Greek artistic ideas, even employing Greek artists. The Greek sense of beauty and order gave structure to Christian imagery in the art of the Byzantine (Greek) society. Even in the darkest moments after the barbarian invasions of Western Europe, Greek culture was never wholly forgotten. Greek forms and principles have been revived repeatedly throughout the Middle Ages, the Renaissance, and modern times, and the Greek analytical approach to the phenomena of a dynamic, ever-changing world has formed the basis of human thought and vision ever since.

TIME LINE III

Model of a temple

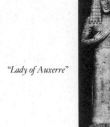

"Lady of Auxerre"

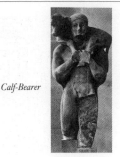

Calf-Bearer

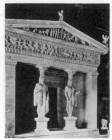

Treasury of the Siphnians

HISTORY

1200 B.C.	Dorians invade Greece
800	Ionians resettle in Asia Minor
	Mycenae destroyed
	First Greek colonies established in Southern Italy
700	and Sicily
600	
	Draconian laws in Athens
	Athenians expel Hippias and establish democracy
500	Persian Wars, 499–478; Battle of Marathon, 490;
	Persians destroy much of Athens, 480
	Battle of Salamis, 480; Delian League, 479–461
	Periclean Age, 460–429

CULTURE

Phoenicians develop alphabet, c. 1000;
 Greeks adopt it, c. 750
First Olympic Games, 776; begin time-reckoning
 by Olympiads
Epic poems by Homer (fl. 750–700) collected to
 form *Iliad* and *Odyssey*, 750–650
Coinage invented in Asia Minor, c. 700–650, soon
 adopted by Greeks
First tragedy performed at Athens by Thespis, 534;
 Aeschylus (525–456)
Pythagoras (fl. c. 520)

Sophocles (496–406); Euripides (d. 406)
The Persians by Aeschylus performed; Socrates
 (469–399); *Oresteia* by Aeschylus (458)
Hippocrates (b. 469)

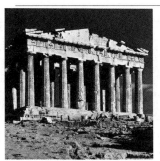

Parthenon

Hermes by Praxiteles

Stag Hunt mosaic, Pella

450 B.C.	Peloponnesian War, 431–404
	Death of Pericles, 429
	Oligarchic revolution in Athens, 411
	Sparta defeats Athens
400	Philip of Macedon (r. 359–336) defeats allied
	Greeks at Battle of Chaeronea, 338
	Alexander the Great, King of Macedon (336–323)
	occupies Egypt and founds Alexandria, 333
	Battle of Issus, 333; Battle of Arbela, 331
	Fall of Persian Empire; death of Alexander, 323;
300	five monarchies develop out of his empire

The "Sophist" Protagoras in Athens, 444
Antigone by Sophocles, 440
Plato (427–347) founds Academy, 386
Trial and death of Socrates, 399
Aristotle (384–322)
Epicurus (341–270); Zeno (336–264)

Theophrastos of Athens, botanist (fl. c. 300)
Euclid (fl. c. 300–280)
Archimedes (287–212)
Eratosthenes of Cyrene measures the globe, c. 240

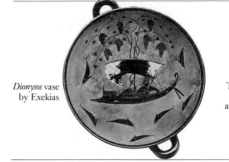

Dionysos vase
by Exekias

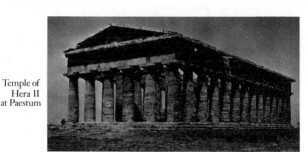

Temple of
Hera II
at Paestum

Apollo from
Olympia

PAINTING, SCULPTURE, ARCHITECTURE

PARALLEL SOCIETIES	
Empire in Egypt	1200 B.C.
Greek: Geometric and	800
Orientalizing	
Assyrian	
Greek: Archaic	700
Neo-Babylonian	600

Dipylon amphora; amphora from Eleusis; *Chigi Vase*
"Lady of Auxerre"; Kouros of Sounion; Medusa, Temple of Artemis, Corfu
Black-figure vases by Psiax and Exekias
Anavyssos Kouros; Calf-Bearer; Stele of Aristion by Aristokles
Hera of Samos; Peplos Kore; La Delicata
"Basilica" at Paestum; Treasury of the Siphnians, with relief sculpture
Red-figure vases by Euphronios, Kleophrades Painter, Berlin Painter,
 Niobid Painter, Achilles Painter; painted tomb at Paestum
Temple of Aphaia at Aegina, with pedimental sculpture
Blond Youth; Charioteer of Delphi; Zeus of Artemision
Temple of Zeus at Olympia, with pedimental and relief sculpture
Temple of Hera II at Paestum

Persian
Etruscan

Greek: Classical

500

Celtic tribes

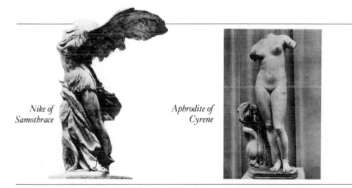

*Nike of
Samothrace*

*Aphrodite of
Cyrene*

*Herakles and
Telephos*

Laocoön

Diskobolos by Myron; *Doryphoros* by Polykleitos; *Riace Bronzes*
Parthenon at Athens, with pedimental and relief sculpture
Propylaia; Erechtheion and Temple of Athena Nike, with sculpture
Athena Parthenos and *Lemnian Athena* by Phidias
Victory by Paionios; Monument of Lysikrates
Temple of Apollo at Bassai; unfinished temple at Segesta
Tholos and Theater at Epidauros
Mausoleum at Halikarnassos; Temple of Apollo at Didyma
Head by Skopas; *Apoxyomenos* by Lysippos; *Hermes* by Praxiteles
Originals of *Victory of Alexander over Darius III* and *Herakles and Telephos*
Alexander; Demosthenes; Dying Trumpeter; Seated Boxer; Nike of Samothrace
Laocoön and *Odysseus* by Hagesandros, Polydoros, and Athenodoros
Altar of Zeus, Pergamon, relief sculpture of *Battle of Gods and Giants*
Cities of Priene and Pergamon
Agora at Assos; Bouleuterion at Miletos; Arsinoeon at Samothrace;
 house at Delphi

Greek: Age of Pericles	450 B.C.
Etruscan	400
	300
Hellenistic	
Roman: Republican	

ETRUSCAN ART

Beyond the borders of the coastal Greek city-states of southern Italy, the hinterland was inhabited by less developed, indigenous peoples. To the north, in the region between the Tiber and the Arno rivers, flourished an extraordinary and still-mysterious culture, that of the Etruscans. Herodotus, the Greek Classical historian, reported that the Etruscans came from Lydia in Asia Minor, and there is a good deal of evidence to support his contention. Another ancient tradition, however, causes some modern scholars to believe that the Etruscans inhabited Italy from prehistoric times. This view is difficult to reconcile with the fact that the Etruscans spoke a non–Indo-European language which, as ancient authors noted, had nothing in common with the other tongues current in ancient Italy, not even with their roots. On account of this linguistic discrepancy the Etruscans were, in fact, sharply isolated from their neighbors. The discovery on the Aegean island of Lemnos of an inscription in a language resembling Etruscan adds weight to the arguments for an Eastern origin.

Regardless of how the debate may eventually be settled, the fact remains that for about four hundred years this energetic people controlled much of central Italy, the region of Etruria, which has retained the name of Tuscany (from the Latin *Tuscii* for "Etruscans") until the present day. They never formed a unified nation, but rather a loose confederation of city-states, each under the rule of its own king. Many of these cities are still inhabited, among them Veii, Tarquinii (Tarquinia), Caere (Cerveteri), Perusia (Perugia), Faesulae (Fiesole), Volaterrae (Volterra), Arretium (Arezzo), and Clusium (Chiusi). Although presently populated centers are generally impossible to excavate, others, since abandoned, such as Populonia and Vetulonia, have been systematically uncovered. We often know more about Etruscan cemeteries, which have been excavated, than about Etruscan towns.

During the sixth and fifth centuries B.C., the Etruscan states colonized an ever-expanding domain in central Italy, including Rome itself, which was ruled by a succession of Etruscan kings until the founding of the Roman Republic at the end of the sixth century. In fact, Etruscan rule spread into Campania in the south, and into the plain of the Po River to the north, as far as the foothills of the Alps. Etruscan commerce in the Mediterranean vied with that of the Greeks and the Phoenicians, both of whom had reason to dread Etruscan pirates. From the fifth century onward, the expanding military power of Rome doomed the Etruscan hegemony, and eventually even Etruscan independence. During the fourth century, constant warfare against the Romans attacking from the south and the Gauls from the north forced the Etruscans to develop the urban fortifications for which they were renowned. During the third century, Roman domination destroyed Etruscan power forever, and in the early first century B.C. the Etruscan cities were definitively absorbed into the Roman Republic.

Etruscan literature is lost; we know of no Etruscan philosophy or science, nor can it be claimed that the Etruscans developed an art whose originality and quality could enable it to compete with the great artistic achievements of the Egyptians, the Mesopotamians, or above all the Greeks. In many respects Etruscan art follows, about a generation behind, the progress of the Greeks, whose vases the Etruscans avidly collected. Yet many works of Etruscan sculpture and painting are very attractive in their rustic vigor, and every now and then in museums of Etruscan art we encounter a real masterpiece.

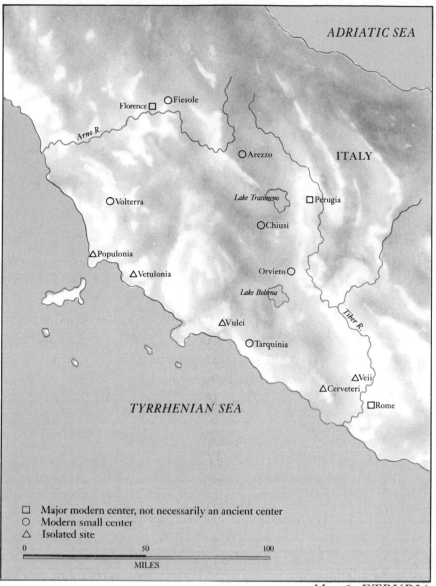

MAP 8. ETRURIA

Architecture

Little Etruscan architecture is standing, even in fragmentary condition, although recent excavations have disclosed very original plans of early date. A detailed prescription for an Etruscan temple based on examples visible in his day is given by Vitruvius, a Roman architect and theoretical writer of the first century B.C. If we judge from Vitruvius, a typical Etruscan temple was roughly square in plan (fig. 294) and placed upon a high podium of stone blocks, often tufa (a volcanic stone which was handy and easy to cut). Access was provided by a flight of steps in the front, unlike the continuous, four-sided platform of the Greek temple. The mud-brick cella occupied only the rear half of the podium; the rest was covered by an open portico; the low-pitched wooden roof had widely overhanging eaves to protect the mud-brick walls. Early columns were of wood, with stone capitals and bases; later examples were of stone throughout. Vitruvius thought that all Etruscan columns were unfluted, with molded bases and capitals close to those of the Doric order, including both echinus and abacus; he therefore postulated a fourth or Tuscan order. However, surviving examples show that the Etruscans did on occasion flute their columns, and did imitate, however roughly, both Ionic and Corinthian capitals. The heavy roof beams and protecting tiles left little room for pedimental sculpture. But the Etruscans were extremely adept at terra-

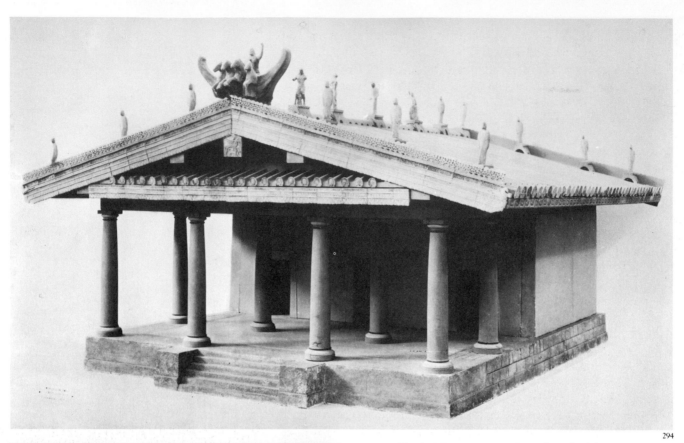

294

294. Typical Etruscan temple as described by Vitruvius (reconstruction)

295. Porta Marzia, Perugia, Italy. 3rd or 2nd century B.C.

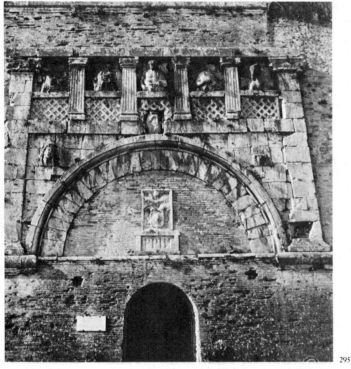

295

cotta (baked clay) work, having learned the technique from the Greeks to the south, and their roof lines and ridgepoles often bristled with a sizable terra-cotta population.

The appearance of an Etruscan temple, with its squat proportions and crowded roof, could scarcely rival the elegance and harmony of Hellenic proportions, but the Etruscan examples were, nonetheless, the basis for the Roman experience of a temple. Several existed in Rome itself, and a very large one, 175 feet by 204 feet, with a triple cella and columns con-

tinuing along the sides, was dedicated in 509 B.C. on the Capitoline. Although this great temple burned down in 83 B.C., it was rebuilt in 69 B.C. with lofty marble columns on the Greek model. This very circumstance tells us much about the double derivation of Roman architecture, with Greek elements grafted, so to speak, onto Etruscan trunks.

The Greeks knew the arch but used it very rarely, mostly in substructures. One of the few Greek arches above ground is in the city wall of Velia, a Greek town south of Paestum. Borrowing the idea from their Greek neighbors, the Etruscans embellished and elaborated it. Like the Babylonians, they displayed the arch proudly, at the major entrances to their cities—places which had special religious meaning. The gates of Perugia—for example, the Porta Marzia (fig. 295; originally open, later filled in with brick)—are true arches, composed of trapezoidal stones called archivolts, each of which presses against its neighbors so that the structure is essentially self-sustaining. The arch proper is flanked by pilasters of two different sizes, in rather clumsy imitation of Greek originals; nonetheless, these are important early examples of the combination of the arch with the Greek orders that later typified Roman architectural thinking.

Etruscan sculpture, most of which we know from funerary examples, shows from the beginning the typical Etruscan facility in terra-cotta. The material was modeled with the fingers, and the fine details added with the use of tools, which were probably wooden. Many terra-cotta statuettes of the deceased have been found; small terra-cotta urns, made to hold incinerated remains, were widely used. A seventh-century urn of hammered bronze from Chiusi (fig. 296) is surmounted by a staring terra-cotta head of great expressive power, and the whole is set upon a bronze model of a chair. The Etruscans developed a new kind of funerary sculpture in painted terra-cotta that shows the deceased, singly or in couples, relaxing happily on the left elbow on a couch, in the pose of banqueters. The finest of these is from Cerveteri (fig. 297). These delightful images,

Sculpture

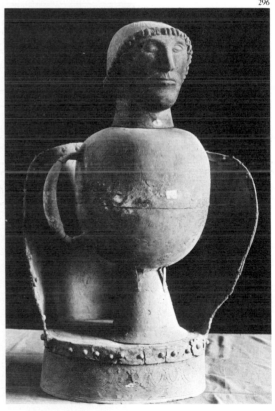

296

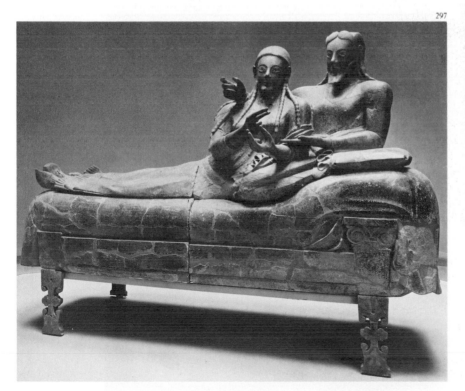

297

296. Cinerary urn, from Chiusi, Italy. 7th century B.C. Hammered bronze with terra-cotta head, height c. 33". Museo Etrusco, Chiusi

297. Sarcophagus, from Cerveteri, Italy. c. 520 B.C. Painted terra-cotta, length 79". Museo Nazionale di Villa Giulia, Rome

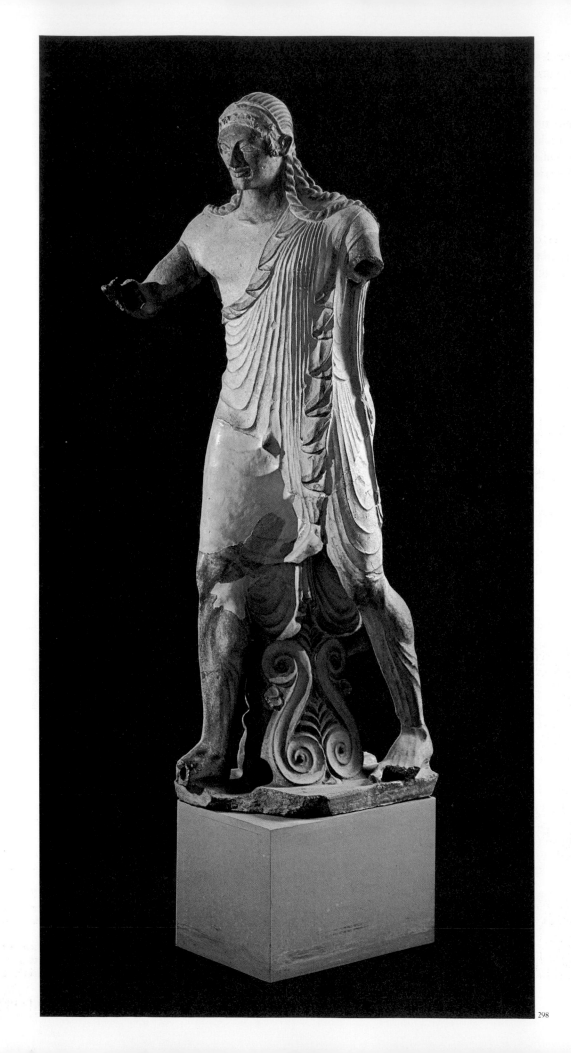

whose smooth bodies, braided hair, and Archaic smiles remind us of Greek sculpture, seem to show a very happy view of the future life, in keeping with the festive paintings (see below, pp. 216–18) that decorate the interiors of the tomb chambers. But the most imposing Etruscan terra-cotta works were such rooftop statues as the famous *Apollo of Veii*, which still retains some of its original coloring (fig. 298). This figure was part of a group showing Herakles carrying off the sacred hind, with Apollo in hot pursuit. Provincial though he may appear in comparison with such contemporary Archaic Greek works as the earliest sculpture at Aegina (see figs. 201, 202, 203), the athletic god, with his grand stride and swinging drapery, shows a freedom of motion which in Archaic Greek sculpture is generally restricted to reliefs; the borrowed Archaic smile and stylized folds seem almost anachronistic. This statue helps us form an idea of the terra-cotta statue of Zeus once in the Etruscan temple on the Capitoline

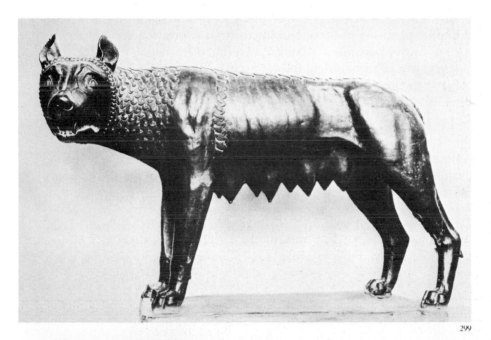

299

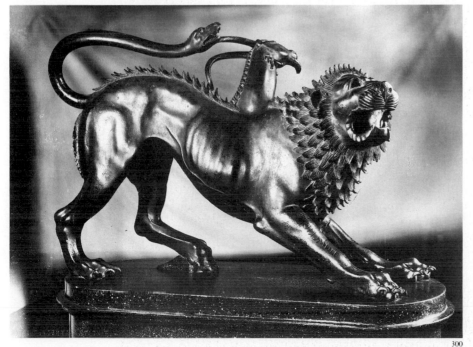

300

298. *Apollo of Veii*. c. 515–490 B.C. Painted terra-cotta, height c. 70″. Museo Nazionale di Villa Giulia, Rome

299. *She-Wolf*. c. 500–480 B.C. Bronze, height 33½″. Museo Capitolino, Rome

300. *Wounded Chimaera*, from Arezzo, Italy. Early 4th century B.C. Bronze, height 31½″. Museo Archeologico Nazionale, Florence

ETRUSCAN ART 213

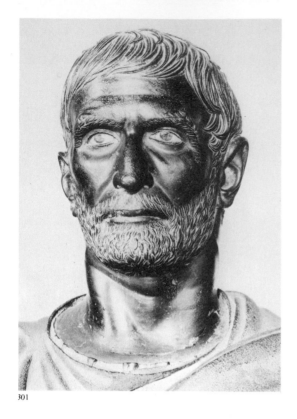

301

(see above, pp. 210–11), whose sculptor also came from Veii, a town eight miles north of Rome.

The fierce bronze *She-Wolf* (fig. 299), a symbol of the origins of Rome because a she-wolf suckled Romulus and Remus, the legendary founders of that city, is an Etruscan work of about 500 to 480 B.C., but the bronze-caster may have been a Greek. Its crisp and brilliant detail was incised in the bronze after casting. The sculptor was clearly interested in representing a fierce and defiant animal as a symbol of Rome, newly released from Etruscan tyranny, and perhaps for that reason substituted the mane of a lion, rendered in stylized Archaic curls, for the thick coat of a wolf. An equally impressive if more fantastic animal is the *Chimaera* (fig. 300), from the late fourth century, found at Arezzo. This three-headed beast was adopted by the Etruscans from Greek mythology. The ornamentalized locks of its lion mane and the equally stylized horns of the goat-head rising from its back derive more from sculptural tradition than from any naturalistic observation, but the ferocity of the expression and the tension of the muscles and rib cage display the power of Etruscan art at its best. A similar precision of detail and intensity of expression are still seen in the impressive portrait of a *Bearded Man* (fig. 301), dating from the third century, whose air of strong resolution has given it the nickname of Lucius Junius Brutus, the leader of the Roman revolt against the last Etruscan king. The head may have belonged to a lost equestrian statue.

Bronze Implements

An entirely different aspect of Etruscan taste is seen in the lovely incised images on Etruscan bronze implements, especially the backs of bronze mirrors (the fronts were highly polished for reflection). In a fairly Archaic example (fig. 302) found at Praeneste—the modern Palestrina (see p. 225)—dating from around 490 B.C., a remarkably chunky Aphrodite is being clothed by two nude small boys, who have been identified as Eros and Himeros (Love and Desire). Her shoes are winged, and enormous wings

303

301. *Bearded Man* (*Lucius Junius Brutus*). Head, c. 300 B.C. Bronze, height 12⅝". Palazzo dei Conservatori, Rome

302. Mirror back, from Praeneste (present-day Palestrina), Italy. c. 490 B.C. Engraved bronze. British Museum, London

303. NOVIOS PLAUTIOS. *The Argonauts in the Land of the Bebrykes*, frieze from the *Ficoroni Cist*, from Praeneste (Palestrina). Late 4th century B.C. Engraved bronze, height of cist c. 21". Museo Nazionale di Villa Giulia, Rome

sprout not from her shoulders as we would expect but from her fertile loins. The line flows with a delicate ease we would hardly predict after the intensity of the preceding sculpture in bronze, an ease not only in the bodies and wings but in the ornamental border, especially the wave pattern indicating the sea from which the goddess was born.

The Etruscans commissioned many cists, bronze vessels which were intended to hold objects used in the rituals for the worship of Bacchus and Demeter and were decorated with linear images like those on the mirrors. The most elaborate cist yet found is a splendid example also from Praeneste, the so-called *Ficoroni Cist* (fig. 303), datable in the late fourth century B.C. The cylindrical body of the cist, topped by three bronze figures on the lid, is best seen in a photograph that unrolls the story like a scroll, reading from right to left. The Argonauts, needing fresh water, have landed in the territory of Amykos, who will permit no one to drink from his spring who cannot beat him in boxing. We see the lion-headed mouth of the spring, with a figure drinking from a kylix, then the hero Pollux practicing with a punching bag, the lofty stern of the ship Argo in the background with reclining Argonauts, but alas, no boxing match. Athena stands in the center, while Pollux vigorously binds Amykos to a tree, and Victory flies overhead. At the left Pollux, now hatted again for the journey, chats affectionately with his twin Castor, while other Argonauts fill their amphorae. The exquisite mastery of the nude body in the flowing contours is matched by the representation of rocks and even mountains in the landscape background. The signature Novios Plautios indicates that the artist was a Greek (not a Roman, as often mistakenly supposed), probably a freed slave of the Roman family of the Plautii. He indicates that he made the work in Rome for a Praenestan patroness, and it has been suggested that he copied the design from a now lost but then famous painting of this subject by the Greek master Kydias, a work known to have been in Rome in the first century B.C. and presumably earlier. This is a fascinating documentation of the complex interrelations of Greek, Etruscan, and Roman cultures.

304. *Dancing Woman and Lyre Player*, wall painting, Tomb of the Triclinium, Tarquinia, Italy. c. 470–460 B.C.

305. *Hunting and Fishing*, wall painting, Tomb of Hunting and Fishing, Tarquinia. c. 510–500 B.C.

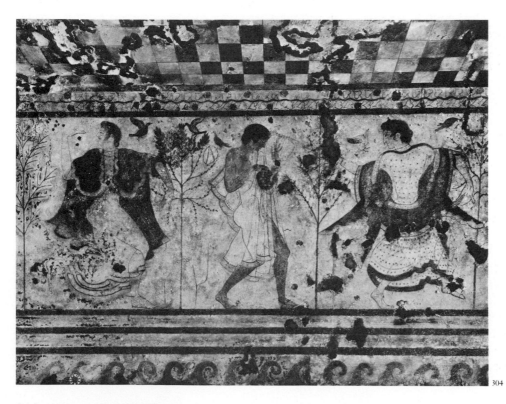

304

We know the most about the Etruscans from their innumerable tombs, of which hundreds have been explored and thousands more still lie unexcavated, a prey to tomb robbers. Most of the Greek pottery so far recovered has been found in these tombs. Typically, the Etruscan tomb was covered by a simple conical mound of earth, or tumulus, whose base was often held in place by a plain circle of masonry. Some tomb chambers were also circular with corbel vaults like that of the so-called Treasury of Atreus at Mycenae (see figs. 170, 171). More often they were rectangular, rock-cut rooms, which at Tarquinia and other cities contain some of the richest treasures of ancient wall painting we know. Early fifth-century tombs, such as the Tomb of the Triclinium at Tarquinia (fig. 304), were sometimes painted with scenes of daily life; at other times, the funeral feast was shown, as in Egyptian tombs. In the absence of firm knowledge of Etruscan religion, it is impossible to say whether these wall paintings were meant to comfort the deceased or to indicate the existence that awaited them in the afterlife. Their energetic contours and flat surfaces betray the influence of Greek vase painting, especially in the handling of the drapery, but also show a typically Etruscan vigor of movement, as in the depiction at Tarquinia of the dancers frolicking happily outdoors among the trees. The most spectacular of these paintings, representing hunting and fishing (fig. 305), derives from such Greek originals as the *Diver* from Paestum (see fig. 225). Interestingly enough, both the dolphin and the red and blue birds joyously elude capture, taking refuge in the billowing sea or the endless air.

Tombs

306

Later tombs, such as the burial chamber in the Tomb of the Reliefs at Cerveteri (fig. 306), take a more gloomy view of the other world. The rock-cut pillars, whose capitals are derived from Greek sources, are supplied with stucco reliefs of household instruments, weapons, and even a small dog, all for the use of the deceased, but a demon of death appears at the end of the chamber, with snaky legs like those of the giants at Pergamon (see fig. 286), and he is accompanied by Cerberus, the three-headed dog who guarded Hades. The tomb has become an image of the underworld; the earlier joyous vitality has been forgotten.

306. Burial chamber, Tomb of the Reliefs, Cerveteri, Italy. 3rd century B.C.

The Etruscans and their art were eventually submerged in the larger life of the Roman state, and like those of the Egyptians, the Etruscan tombs were not seen again until relatively modern times. But Etruscan art was certainly a major ingredient in the rich artistic mix of Roman culture. And the descendants of the Etruscans still lived on in Tuscany in the Middle Ages and the Renaissance. It was these descendants who produced not only some of the most original and imaginative works of medieval art but also the Renaissance of the fifteenth century A.D.

ROMAN ART

The culminating phenomenon of ancient history was the rise of a single central Italian city-state from total obscurity to imperial rule over most of the then-known world. Far-reaching as were the effects of Alexander's rocket-like trajectory, they can scarcely be compared to the steady, inexorable expansion of Rome. At the start the Romans were chiefly concerned with maintaining their autonomy against their aggressive neighbors. In 510 B.C. they threw off the Etruscan yoke, yet in 386 B.C. the invading Gauls were strong enough to sack and burn Rome itself. Then the tides reversed; in the third century B.C. Rome, in constant warfare with her African rival Carthage, first dominated, then absorbed all of Italy, Sicily, and most of Spain. In the course of the second century B.C., she conquered the Balkan peninsula including Macedon and Greece, destroyed Carthage and annexed its territory, and expanded into Asia Minor and southern Gaul (modern France). In the first century B.C., the rest of Gaul, Syria, and Egypt fell into Roman hands; in the first century A.D., Rome conquered Britain and much of Germany; in the second, Dacia (modern Romania), Armenia, and Mesopotamia.

At the death of the emperor Trajan in A.D. 117, the Roman Empire extended from the Tigris River in Mesopotamia to the site of the Roman wall built by his successor Hadrian across Britain, close to the present Scottish border, and from the banks of the Elbe to the cataracts of the Nile. This incredible expansion, which not even the Romans could have foreseen, was partly forced upon them by their enemies, especially the Gauls and the Carthaginians, and partly engineered by well-disciplined armies and ambitious generals operating at great distances from any political control. Wherever the Romans went, they took with them their laws, their religion, their customs, and their extraordinary ability to organize. Moreover, on these lands they also imposed the Latin language, with its rigorous grammatical structure and its capacity to express complex ideas. This process of Romanization did not extend to Greece or to the Hellenized East, whose people continued to speak Greek and to preserve many elements of Greek culture. Given the universal extent of Roman power, the history of Roman art is really the history of Mediterranean and European art for half a millennium—so rich, so complex, and so many-sided that only a few of the principal types and historical phases can be treated carefully in a general account.

Quite early in the expansionist career of Rome, two developments became manifest which were destined to have profound artistic consequences. First, the almost continuous process of imperial growth led to a rapid increase in the population of Rome itself and of most of the cities under its control; this growth of population was accompanied by such inevitable problems as mass unemployment and poverty. As a result, not only the prosperous productive classes but also a numerous, idle proletariat required food, water, housing—and entertainment. New types of public buildings—especially vast interior spaces—were needed on an unprecedented scale, and the traditional emphasis of Mediterranean architecture and decoration was thus transformed. Second, the conquest of the Hellenic world—and to a more limited

extent that of Egypt and Mesopotamia as well—opened Rome to the influence of cultures that far surpassed its own in their antiquity, intellectuality, and aesthetic achievement. Parallels to the Roman gods were found in Greek religion and mythology, so that Zeus became Jupiter, Hera Juno, Athena Minerva, and so on. Borrowed artistic elements were superimposed on the practical inventions of the Romans, and foreign artists, especially Greek, were often employed to carry out typically Roman projects. Thus, Rome found itself in the odd position of becoming the vehicle through which Greek forms and ideas were conveyed to western and northern lands that had previously had little or no contact with Hellenism.

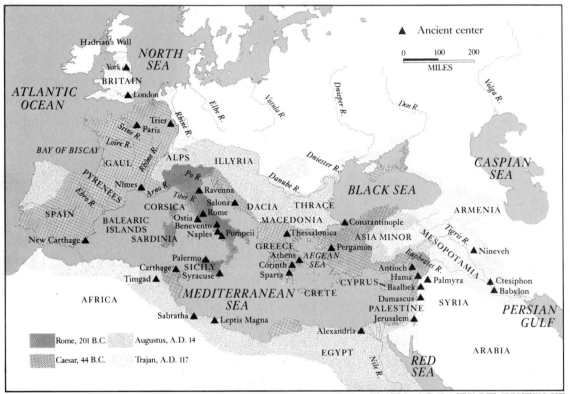

MAP 9. THE ROMAN EMPIRE AT ITS GREATEST EXTENT

The Republic (509–27 B.C.)

If we judge from Roman literary accounts, we must conclude that the Romans of the early Republic were a resolutely anti-aesthetic people. Scornful of what they considered the luxurious ease of their chief competitors in Italy, the Etruscans and the Greeks, the early Romans prided themselves on their austere virtues, frugal life, and military valor. Oddly enough, at first they do not even seem to have paid much attention to town planning—in spite of the example of the Greek cities in southern Italy and Sicily, which were laid out on regular plans, and the planned Etruscan towns in the plain of the Po River. Rome itself was the last Roman city to receive a plan. After its destruction by the Gauls in 386 B.C., the town was rebuilt along the same disorderly lines. During the Republic and the first years of the Empire, Rome was a pell-mell collection of structures, often rebuilt to the height of several stories, with the most slipshod methods, in order to accommodate its ever-increasing population. Contemporary descriptions record vividly the discomforts and hazards of life in the metropolis. Public buildings, such as the great temple

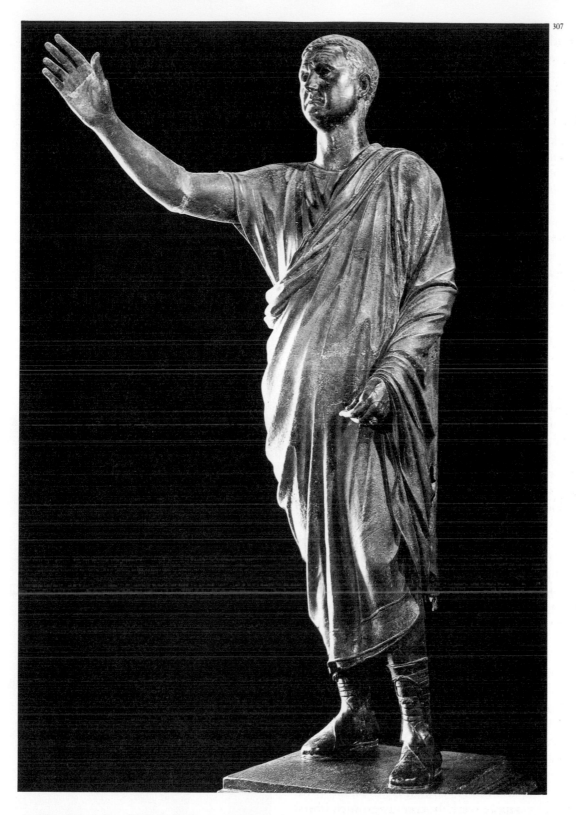

on the Capitoline Hill (see above, page 210), were rebuilt from time to time, however, according to new and imported Greek principles of style. The rectilinear layout of Roman military camps, on which the Romans prided themselves and which they later adapted for their colonial cities, was borrowed from the Etruscans. From them, in fact, the Romans appear to have received their first lessons in building fortifications, bridges, aqueducts, and sewers, in which practical undertakings they took a great deal of pleasure and found—and were able to communicate—a special kind of austere beauty.

307. *L'Arringatore* (portrait of Aulus Metellus), from Sanguineto, near Lake Trasimeno, Italy. 90–70 B.C. Bronze, height 71″. Museo Archeologico, Florence

SCULPTURE Significantly enough, the most impressive witnesses to the formative period of Roman Republican art that have come down to us are the portraits of these sturdy Romans themselves. We have already seen the bronze Etruscan portrait from the third century, whose subject may be a Roman (see fig. 301). Another splendid example in bronze, the so-called *Arringatore* (*Orator*), dates from the first century B.C. (fig. 307). Found at Sanguineto near Lake Trasimeno in southern Etruscan territory, the statue bears an Etruscan inscription which includes the Roman name Aulus Metellus, the subject of the portrait. Whether the sculptor himself was Roman or Etruscan is almost beside the point, since the work was done at a period when the territory had already been Romanized; Aulus Metellus may have been a Roman official. The directness and force of the representation show a new and characteristically Roman attitude toward portraiture. The simple stance, with some weight on the free leg and the hand thrust forward in an oratorical gesture, has nothing to do with the tradition of organic grace that runs through even the most naturalistic poses of the Hellenistic period. The subject himself, with close-cropped hair, wrinkled forehead, and tight lips, is represented with an uncompromising directness that makes no concessions to Hellenic beauty.

The Greeks never accepted the idea of the separate portrait head or bust because to them a separate portrait bust made the head appear to have been decapitated. But as we have seen, such heads were in the Etruscan tradition (see fig. 301). In Roman Republican times, exact portrait masks of the deceased were made of wax and were preserved in a wooden cabinet in the home, to be carried by relatives at later funeral ceremonies. This custom reflects a kind of ancestor worship, by means of which the old patrician families preserved their identity. The artistic result was uncompromising realism. A statue of a *Patrician Carrying Two Portrait Heads* (fig. 308) embodies this atavistic tradition with a brutal directness that would have horrified the Greeks and, incidentally, illustrates several stages in the early development of Roman portraiture. The heads, which show a strong family resemblance, represent wax images— that in the right hand an original of about 50–40 B.C., that in the left done around 20–15 B.C. Both show stern, bleak Romans, but the statue itself, with its elaborately draped *toga* (the outer garment worn in public by male citizens), can be dated in the early years of the Empire, about A.D. 15. By an irony of fate, the statue's original head is missing and was replaced in recent times with an unrelated one dating from about 40 B.C.

The typical Roman Republican portrait strove to render the subject with a map-maker's fidelity to the topography of features, in keeping with the air of simplicity stoutly maintained by even the most prosperous citizen. A striking example is the portrait bust (fig. 309), dating from the mid-first century B.C. and possibly representing the dictator Sulla, which shows an irredeemably homely man in late middle age, whose bald forehead is creased by a frown. His cheeks are slashed by deep wrinkles, his lower lip crumpled in the middle, and above his bulging eyes one of his heavy eyebrows is punctuated by a huge wart. In contrast to such brutal Roman honesty, an unexpectedly subtle Republican *Head of Pompey* (fig. 310) dating from around 55 B.C., although thought by some to be an early imperial copy, was almost certainly carved by a Greek sculptor. This master had at his fingertips all the traditional devices of Hellenistic art for the differentiation of the textures of the full cheeks, the wrinkled forehead, the bulbous nose, the sharp eyelids, and the short, crisply curling locks of hair, and for the manipulation of the play of light over marble surfaces. Yet if we compare this head to the *Portrait of Alexander* (see fig.

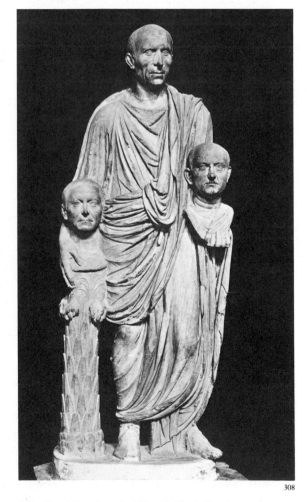

308

308. *Patrician Carrying Two Portrait Heads.* c. A.D. 15. Marble, lifesize. Museo Capitolino, Rome

276), we can see that the Roman subject is treated with a psychological reserve respected by men who placed ultimate value on decisive action.

But the influence of Greek art on Roman culture was by no means limited to the importation of Greek artists; beginning with the sack of Syracuse in 212 B.C., actual works of Greek art—sculpture, painting, and minor artifacts of all sorts—arrived in Rome in great numbers. Stripped from their original settings, these works, often intended for religious or political purposes, became to the Romans only objects of adornment. In the homes of wealthy Roman patricians, extensive collections of Greek art were rapidly built up by plunder or by purchase. When no more originals were available, copies were manufactured by the thousands, often in Athens and in other Greek centers as well as in Rome, to satisfy the voracious market.

ARCHITECTURE It is significant that, although Roman literature gives us admiring accounts of Greek art and artists, doubly precious to us in the absence of the original Greek works, the Romans had little to say about their own art; they seldom recorded the names and never discussed the styles of the many artists—some of them great—who carried out ambitious Roman projects. Most of the few recorded names are Greek. The profession of painter or sculptor had little social standing, and the necessity of making numerous quasi-mechanical copies must have lowered the artists' own self-esteem. In consequence no distinct artistic personalities comparable to those known to us from Greek art emerge from the thousands of preserved Roman works. In its anonymity and in its collective character, Roman art can be more easily paralleled with that of Egypt or Mesopotamia. Only in the field of architecture—in the writings of the first-century-B.C. architect Vitruvius—do we find much interest in theory, and even here it is largely applied to the codification of an already accepted body of architectural knowledge, for much of which Vitruvius was obliged to resort to Greek terminology.

In the absence of extensive knowledge about the magnificent Temple of Jupiter Optimus Maximus, rebuilt on the Capitoline Hill in 69 B.C., with lofty marble columns imitated from Greek models and bronze roof tiles covered lavishly with gold leaf, we have to rely on comparatively modest examples for an idea of Republican architecture. One of these is the well-preserved second-century building known as the Temple of Fortuna Virilis (fig. 311; a misnomer—the building was probably dedicated to Portunus, the god of harbors), near the Tiber in Rome. Elements of Etruscan derivation are immediately visible—the podium, the flight of steps at the front, and the deep portico. But equally obvious is the attempt to Hellenize the building. The slender proportions were derived from Greece, as was the Ionic order (see figs. 193, 242). A compromise is apparent in the way in which the peristyle was carried around the sides and back of the temple only in engaged columns rather than in the free-standing columns generally preferred by the Greeks. Also, when compared to Hellenic architecture, there is something cold and prim about this little building; the capitals, in particular, lack the organic fluidity of Greek models.

Even more illuminating for the future of Roman architecture was the circular so-called Temple of the Sibyl (fig. 312) at nearby Tivoli. Although this Corinthian structure may derive ultimately from Roman circular huts, some of which were religiously preserved on the Palatine Hill

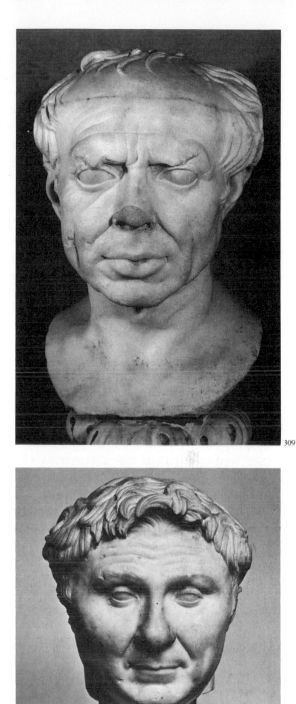

309. *Head of a Roman with a Wart over His Eye.* c. middle 1st century B.C. Marble, height 37⅜". Vatican Museums, Rome

310. *Head of Pompey.* c. 55 B.C. Marble, height 9⅞". Ny Carlsberg Glyptothek, Copenhagen

into imperial times, it owes its immediate formulation to the Greek tholos type (see fig. 170). The round temple at Tivoli has one remarkable feature. Instead of the coursed masonry characteristic of almost all Greek historic architecture, the cella is built of concrete. Roman concrete was not the semiliquid substance in use today, but a rougher mixture of pebbles and stone fragments with mortar, poured into wooden frames or molds. While the concrete was being formed, wedge-shaped stones (and later flat bricks) were worked into its sides, thus forming an outer skin that both protected the concrete and served to decorate the surface when it was exposed. This technique, used occasionally by the Greeks for fortifications in Asia Minor as early as the third century, was adopted by the Romans for architecture on a grand scale. They were thus freed from the limitations of the post and the lintel—which had governed architecture since the days of the Egyptians—and were able to enclose huge areas without inner columnar supports. They could for the first time sculpture space itself, so to speak. Rapidly in Roman architecture the column became residual, an element of decoration to be applied to the rough concrete walls, like the marble paneling or stucco with which the concrete was often veneered. Most Roman ruins, stripped of their gorgeous coverings, look grim; to gain a true idea of their original effect, we must resupply them in imagination with their missing decoration.

As early as the second century B.C., the Romans appear to have discovered how to exploit the new opportunities given to them by concrete by establishing an architecture based not on straight colonnades but on open spaces of constantly changing size and shape. They also learned how to combine their new discoveries with a dramatic conquest of landscape itself. In this respect the great civic centers built by the Hellenistic monarchs in Asia Minor were pioneers. However, Hellenistic spaces were limited by the convention of the straight colonnade, and irregular terrain could prove embarrassing, forcing an unwanted asymmetry on the architects. The flexibility of concrete construction gave Roman architects new

311. Temple of Fortuna Virilis (Temple of Portunus), Rome. Late 2nd century B.C.

312. Temple of the Sibyl, Tivoli, Italy. Early 1st century B.C.

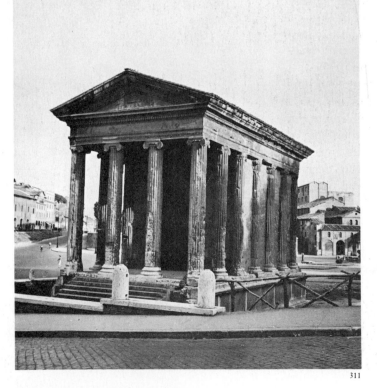

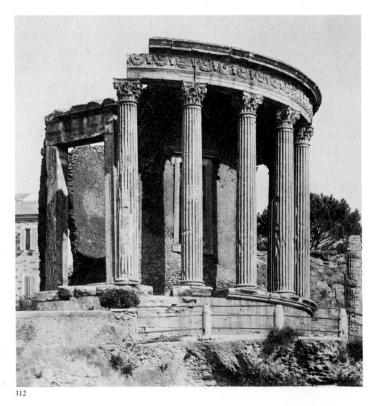

311

312

freedom of action, and they pressed home their advantage with imaginative boldness.

A striking early example of such planning is the sanctuary of the goddess Fortuna at Praeneste—the modern Palestrina—long thought to be a work of the early first century B.C. But the date has been pushed back well into the second century by newly discovered evidence. The city on the plain was connected with the temple of the goddess some three hundred feet above by an elaborate system exploiting to the maximum the dramatic possibilities of the steep slope. A destructive air raid in World War II stripped from the Roman ruins the medieval buildings that had covered them for centuries, and made visible the underlying concrete constructions (fig. 313). A model of the sanctuary as it originally appeared (fig. 314) shows that worshipers entered by means of two covered ramps, which converged on either side of a central landing, affording an immense view of the new city, the surrounding plain, and the distant sea. From this landing a steep staircase led upward to four terraces of different sizes and shapes. On the first a remarkable vaulted colonnade, punc-

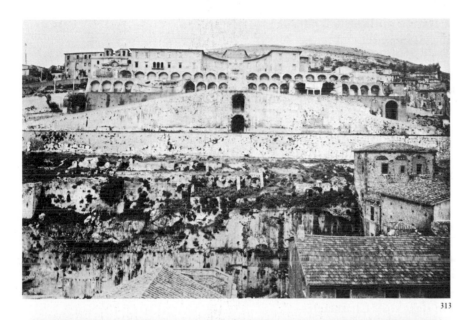

313

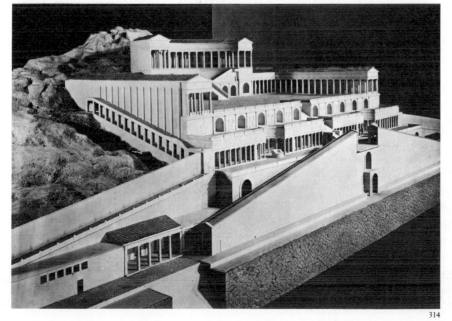

314

313. Sanctuary of Fortuna, Praeneste (present-day Palestrina), Italy. 2nd century B.C.

314. Sanctuary of Fortuna, Praeneste. Museo Archeologico Nazionale, Palestrina (Architectural reconstruction)

tuated by two semicircular recesses called *exedrae*, protected a continuous row of barrel-vaulted rooms (now clearly visible; see fig. 313). On the second similar rooms were enclosed by an engaged colonnade—one of the earliest appearances of the arch embraced by columns and entablature, a motive that became standard in Roman imperial architecture and was revived enthusiastically in the Renaissance. The third terrace was a vast, open square, surrounded on two sides and part of a third by L-shaped colonnades reminiscent of Hellenistic stoas, terminating in pediments. Finally came a theater-like structure, apparently intended for religious festivals, surmounted by a lofty colonnaded exedra, also terminated by pediments. Almost hidden behind the exedra was the circular Temple of Fortuna. This series of ascending and interlocking masses and spaces of constantly changing character shows a new kind of architectural thinking, made possible only by the sculptural freedom afforded by concrete. Such thinking later found its grandest expression in the forums (open civic centers) which were the chief architectural glory of imperial Rome.

A vast number of Roman town houses are known, many from recent excavations in all parts of the Roman Empire but the majority from the southern Italian cities of Pompeii and Herculaneum, which were buried by the eruption of Vesuvius in A.D. 79. The excavation of these two cities, begun in the middle of the eighteenth century, disclosed not only the houses themselves but furniture, implements, and even food in a sufficiently good state of preservation to enable a detailed reconstruction of the daily life of their inhabitants. In fact, by pouring plaster into holes in the hard-packed ash, it has been possible to rediscover the long-dissolved forms of humans and animals in their death agony.

Pompeii and Herculaneum were designed according to a grid plan imitated from their Greek neighbors (for Greek city-plans, see p. 191), although in the case of Pompeii the plan is somewhat irregular (fig. 315), since a grid had to be imposed on preexisting streets. Both cities were inhabited by a mixture of Greeks and Italians, among whom the Samnites, an indigenous people related to the Romans, were predominant. Both cities were brought under Roman rule by the dictator Sulla in 80 B.C. Pompeii was badly damaged by an earthquake in A.D. 62; some of its public buildings were under reconstruction, but others were still in ruins when Vesuvius buried the city for good seventeen years later. Among these were the structures surrounding the Forum (fig. 316). Characteristic of all Italic settlements, this central gathering place usually barred to all but pedestrian traffic was the result of haphazard growth in many cities, including Rome. But in Pompeii the Hellenized Samnites had designed an impressive layout, which was later adopted throughout the Roman world. The design resembled the Greek agora, such as that at Assos (see fig. 270), but with colonnades lining both the long sides and the south end. The long, relatively narrow space was dominated by the temple of the Capitoline triad (Jupiter, Juno, and Minerva) at the north end.

Toward the south end stood the Basilica, dating from about 120 B.C. (fig. 317), the earliest known example of a type of building destined for a long and honorable history. The word is of Greek origin, but the building was developed in Italy for the same purpose as the stoa, for gatherings of businessmen and eventually for law courts. Generally a basilica was built with a long, narrow central space, or *nave* (from the Latin word for "ship"), supported by colonnades, which separated the nave from the side aisles and which were customarily carried across both ends as well, forming a division before the spaces where judges held court (the *apses*). The side aisles often supported colonnaded galleries. Light came through the windows

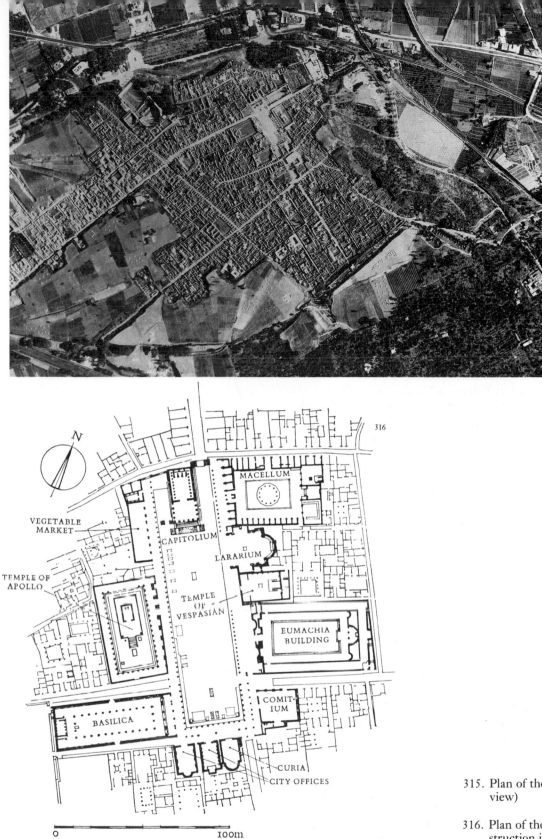

315. Plan of the city of Pompeii, Italy (aerial view)

316. Plan of the Forum, Pompeii, under reconstruction in A.D. 79

in the galleries and from a *clerestory* of windows in the walls above the galleries, which were roofed separately from the nave. Until the fourth century, basilicas were always roofed with timber, protected by tiles. The nave, side aisles, and galleries should be imagined as crowded with businessmen, clients, and scribes, the apses with plaintiffs, defendants, and attorneys. (The Basilica at Pompeii has neither clerestory nor apse.)

The basic plan of the private house, called by the Romans the *domus*

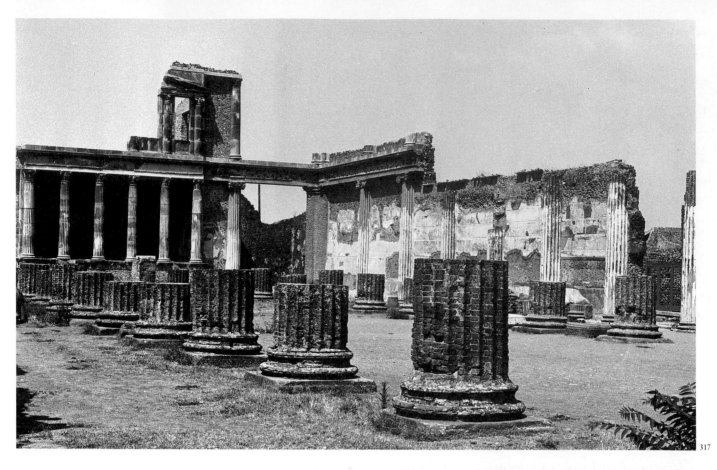

(from which the English word *domestic* is derived), seems to have been common to the Etruscans, the Samnites, the Romans, and other Italic peoples. As often in Italian town houses even today, the street entrance was flanked by shops. A corridor led to a central space called the *atrium*, bordered by smaller, generally windowless rooms. The atrium roof sloped toward a central opening which let rainwater into a basin in the floor, at first of tufa or terra-cotta, later of marble, whence it drained into a cistern. At the far side of the atrium was the *tablinum*, a shrinelike room for the storage of family documents and wax portraits. By the second century B.C. every fine domus was also provided with a peristyle court, entered through the tablinum and remarkably similar to the contemporary Hellenistic examples at Delos (see fig. 293). In the center of the court might be a garden with fountains and statues. The family living and sleeping rooms were entered from the peristyle. The House of the Silver Wedding at Pompeii (fig. 318; see also the plan of the House of the Faun, fig. 319) is one of many such residences, more luxurious than the palaces of the kings at Pergamon. The corners of the atrium were sustained by stately Corinthian columns of marble; the open tablinum provided a delightful view of the garden in the peristyle court. Plaster casts of the holes left by roots in the earth have made it possible to identify the original flowering plants, and these have been replaced today.

The earliest known Roman apartment houses were also discovered at Pompeii. Careful examination has determined that these were formed in the later decades of the Republic, probably by real-estate operators who bought up numbers of domus houses, joined them together, and built second or even third stories on top—not to speak of rooms on balconies jutting into the street—all erected sloppily enough to justify the bitterest complaints of ancient writers regarding similar dwellings in Rome.

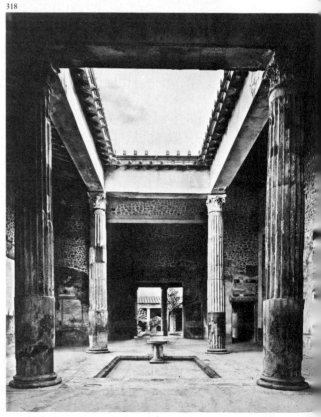

317. The Basilica, Pompeii, c. 120 B.C.

318. Atrium, House of the Silver Wedding, Pompeii. Early 1st century A.D.

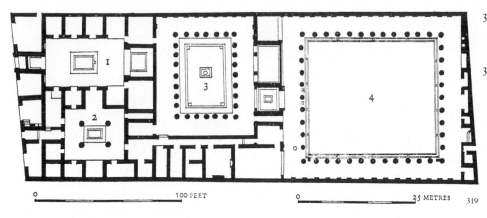

319. Plan of the House of the Faun, Pompeii.
2nd century B.C. 1. Atrium 2. Atrium
tetrastylum 3. Peristyle 4. Peristyle

320. Room in the House of the Centaur, Pompeii, with First Style decoration

PAINTING Late Republican houses glowed with color. The interior
walls were often decorated, as in contemporary second-century houses at
Delos (see fig. 293), with painted and modeled stucco panels imitating
marble incrustation. The stucco was mixed with marble dust, like that
used for the exteriors of Greek temples (see p. 162), and was smoothed to
give the appearance of marble. Panels of rich red, tan, and green were
enclosed by white frames modeled in stucco, as in a room from the House
of the Centaur at Pompeii (fig. 320). This method has been called the
First Pompeiian Style, although late examples date from just before the

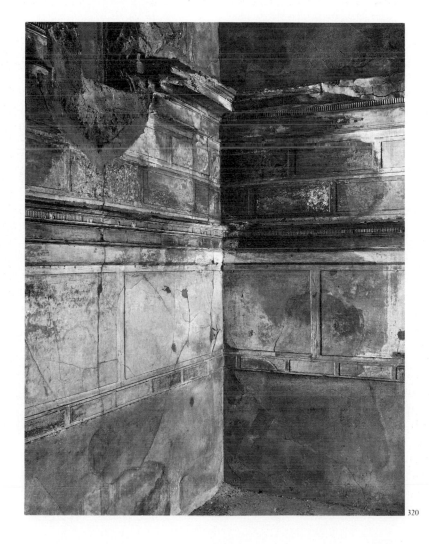

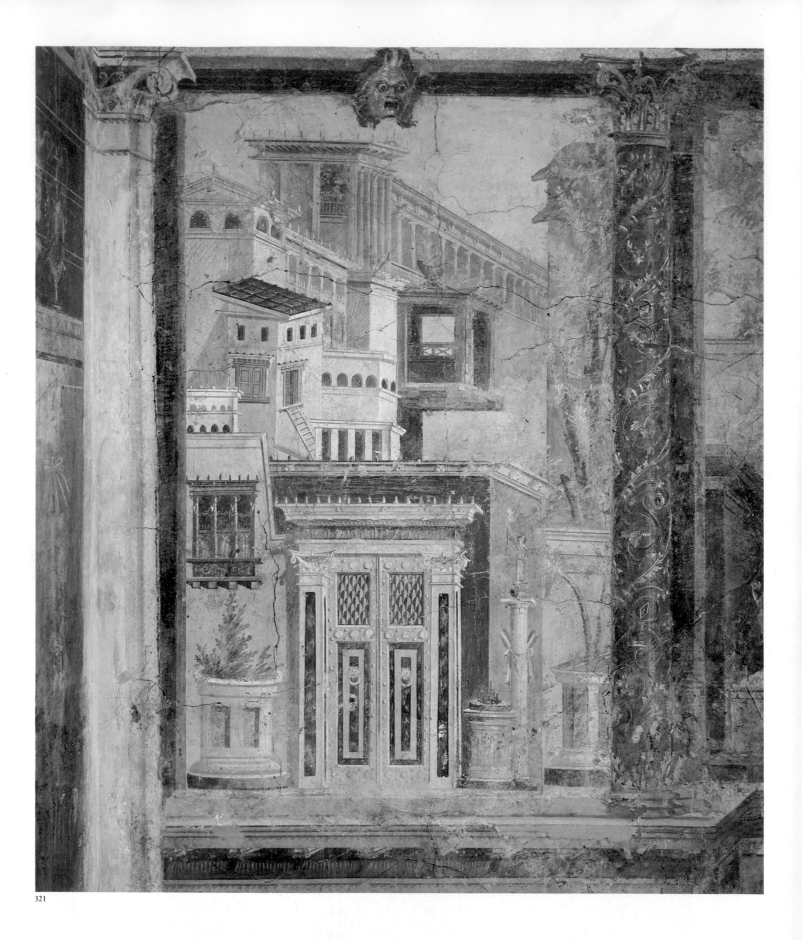

321

eruption of Vesuvius. The Second Pompeiian Style, which appears to be roughly contemporary with Julius Caesar (c. 80–15 B.C.), is far more imaginative; instead of being paneled, the wall was transformed into an architectural illusion by paintings, often of amazing skill. In a delightful little room from a villa of the late first century B.C., found at Boscoreale near Naples (fig. 321), the walls have been simply painted away. Rich red porphyry columns, entwined with golden vinescrolls and surmounted by gilded Corinthian capitals, appear to support the architrave, to which is attached a superbly painted mask. Through this illusionistic portico we look into a sunlit garden, then out over a gilt-bronze gate framed by a marble-encrusted doorway into a view of rooftops and balconies rising in the soft, bluish air and culminating in a grand colonnade, somewhat on the principle of the view up the hillside to the sanctuary at Praeneste (see fig. 314). For all the apparent naturalism of the painting, which shows such details as a balcony room accessible only by a ladder, it is evident that the painter felt no responsibility to depict the entire scene as it would appear from a single viewpoint at a single moment in time. Disconcertingly, some buildings are seen from below, some from head on, and some from above. Both artist and patron were apparently content with an arrangement that stimulated without ever quite satisfying a desire to explore distant space. To our eyes the evident contradictions contribute a dreamlike quality of unreality, which is enhanced by the absence of even a single person in this magical city.

The Second Pompeiian Style could also utilize the illusion of a portico as a springboard into a mythological world of the past, as in the landscapes with scenes from the *Odyssey* (fig. 322) discovered in the nine-

321. *Architectural View*, Second Style wall painting from a villa at Boscoreale, near Naples. c. 50–40 B.C. The Metropolitan Museum of Art, New York. Rogers Fund, 1903

322. *The Laestrygonians Hurling Rocks at the Fleet of Odysseus*, wall painting from a villa on the Esquiline Hill, Rome. Middle 1st century B.C. Vatican Museums, Rome

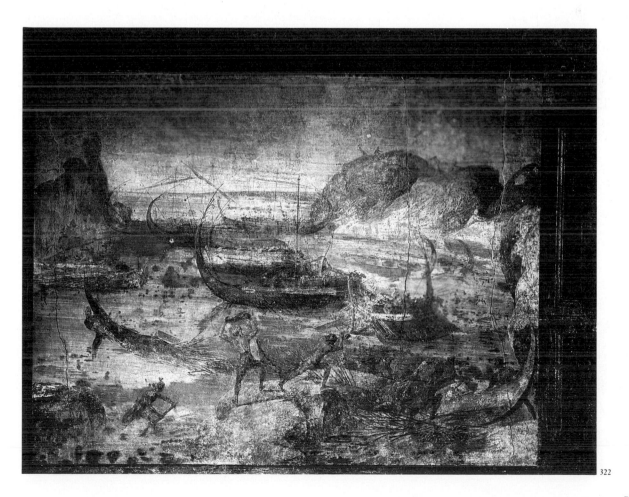

322

teenth century in a villa on the Esquiline Hill, and datable about the middle of the first century B.C. Although the painters may not have been Greek (there are errors in the occasional Greek inscriptions), it is now believed they were working on the basis of Greek originals of the second century B.C., possibly Alexandrian or southern Italian. The square piers, bright red with gilded Corinthian capitals, form a shadowed portico through which one looks happily, as from a tower, into a far-off land of sunny rocks and blue-green sea, toward which Odysseus and his companions escape in their ships from the attacks of the fierce Laestrygonians. The landscapes were painted with ease and speed in a fluid style contrasting deliberately with the uncanny precision of the architecture.

A grand room still in place in the Villa of the Mysteries at Pompeii (fig. 323) shows another aspect of Second Style illusionism. The actual walls have been transformed by painted architectural elements into a sort of stage on which gods and mortals sit, move, converse, even turn their backs to us, their attitudes ranging from quiet, classical serenity to occasional and startling terror. Apparently, the subject—still not entirely understood—was drawn from the rites attending the worship of the Greek god Dionysos, one of several competing mystery cults brought to Rome from various parts of the Empire. The nobility of the broadly painted, sculptural figures, almost lifesize, is heightened by contrast with the brilliance of the red background panels, green borders and stage, vertical black dividing strips, and richly veined marble attic.

323. *Dionysiac Mystery Cult*, wall painting, Villa of the Mysteries, Pompeii. c. 60–50 B.C.

324. *Still Life*, wall painting from the House of Julia Felix, Pompeii. 1st century B.C.–early 1st century A.D. Museo Archeologico Nazionale, Naples

323

Often the illusionistic skill of the Second Style painters, doubtless deriving from Hellenistic tradition, could be dazzling, as in the frequent still lifes painted on the walls of Roman houses. An example of such virtuosity repeated in the later (Fourth Style) House of Julia Felix in Pompeii (fig. 324) shows a corner in a kitchen, with dead birds, a plate of eggs, metal household instruments, and a towel, all arranged in a strong light from a single source, which not only reveals forms and casts shadows, but conveys beautifully reflections in the polished metal. An even more spectacular illusionistic work, in fact unparalleled in all of ancient art, is the garden room from a villa at Prima Porta which once belonged to Livia, the third wife of the emperor Augustus, possibly before their marriage (fig. 325). All four walls disappear, in a manner attempted more modestly long before in the Minoan landscape room at Thera (see fig. 1). A fence and a low wall are all that separate us from an exquisite garden, half cultivated, half wild, in which no earthbound creature can be seen; only fruit trees and flowering shrubs compete for the attention of the songbirds which perch here and there or float through the hazy air. Our vision roams freely around this enchanted refuge which, however, encloses us so entirely as to exclude all but the blue sky. The poetic delicacy of the conception and the consummate skill of the rapid brushwork make this a masterpiece among the world's landscape paintings.

The Early Empire (27 B.C.–A.D. 96)

For more than a century, it had been apparent that the traditional political machinery of the Roman city-state—the popular assemblies, the patrician senate, and the two consuls chosen annually—was inadequate to cope with the problems posed by a vast and expanding empire and a set of freewheeling armies, often separated by weeks or even months of travel

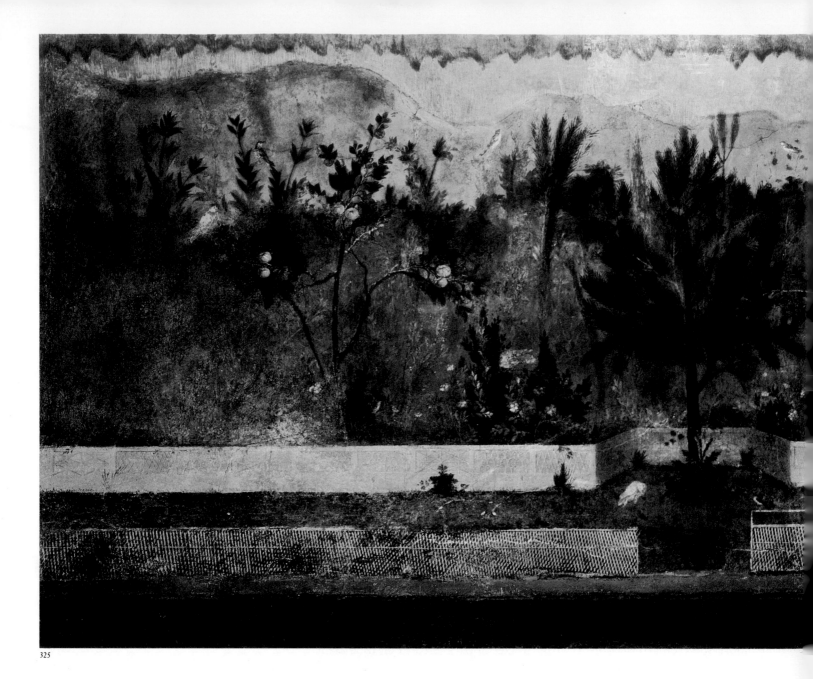

325

from any decree that might be issued in the capital. In several periods of
bloody civil warfare, the armies competed with each other for power.
Only briefly, under the dictatorships of Sulla (82–79 B.C.) and Julius Cae-
sar (49–44 B.C.), could any form of stability be maintained. In 31 B.C.
Octavian, Caesar's great-nephew and adopted son and heir, defeated An-
tony and Cleopatra in the Battle of Actium, sealing the fate of both the
Roman Republic and the Hellenistic world. Cleopatra was the last inde-
pendent Hellenistic monarch; after her defeat Egypt became Roman. Four
years later, in 27 B.C., the Roman senate voted Octavian the title of *Au-
gustus*, and he became in effect the first legitimate Roman emperor.

Augustus ruled as emperor for forty-one years, a period of unprece-
dented peace and prosperity. The façade of republican government was
piously maintained, but power was in fact exercised by Augustus and his
successors, who controlled all military forces and appointed governors
for the important provinces. The title *Imperator* meant "army com-
mander"; nonetheless, the emperors, who rarely held office in the obso-
lete but well-nigh indestructible framework of the Republic, in truth gov-

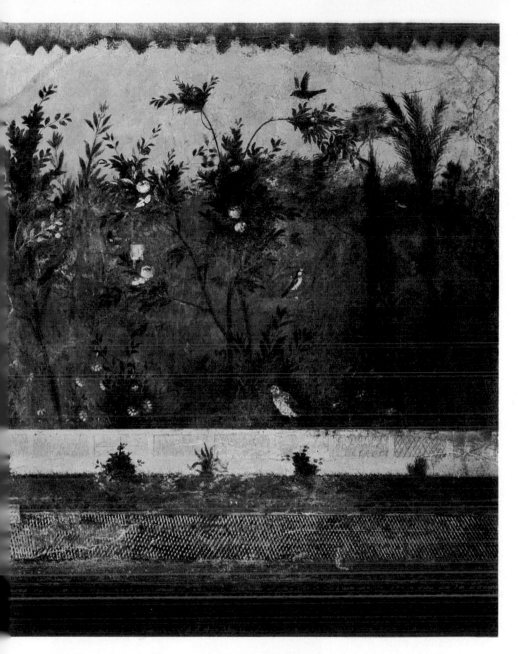

325. *Garden Room*, wall painting from the Villa of Livia, Prima Porta, near Rome. Late 1st century B.C. Museo Nazionale Romano, Rome

erned as monarchs. Augustus' hybrid compromise survived for more than four centuries. With predictable immediacy the emperors were deified after death; Augustus erected a temple to Julius Caesar, and some of his successors demanded worship as gods while still alive, in the manner of Egyptian and Mesopotamian divine monarchs.

SCULPTURE Now that the Romans had had time to digest their avidly devoured diet of Greek culture, they were able to profit by it and to bring forth a new art of their own. It was to be expected that its Etruscan and Greek sources would at first be plainly visible. Equally predictable was that the new art would deal less with religion and mythology, the primary concerns of the Greeks, than with transforming the often brutal facts of Roman military and political life into partly mythologized images for public consumption. In the celebrated statue of Augustus from the imperial villa at Prima Porta (fig. 326), the new ruler is seen as *Imperator*, in a grand pose easily recognizable as a blend of the *Doryphoros* (see

fig. 215) and the *Arringatore* (see fig. 307) in equal proportions. The statue was probably a replica carved immediately after Augustus' death (otherwise, he would have been shown wearing military boots, which, as a god, he did not need), but the emperor is represented as a young man. The head is a portrait, belonging to an official type known in all parts of the Empire through its appearance on coins. Yet the features have been given a distinct Hellenic cast, idealized and ennobled. The figure stands easily, as if the oratorical gesture of the right arm grew from the very stone below the left foot. The cloak seems to have fallen accidentally in coldly Phidian folds from the shoulders to drape itself around the waist and over the arm, thus revealing a relief sculptured on the armor, narrating the return by the Parthians, about 20 B.C., of the military standards they had captured from the Romans.

A deliberate contrast is offered by the statue of *Augustus as Pontifex Maximus* (the *pontifex maximus* was the Roman high priest; fig. 327), in which the emperor is shown about to perform a sacrificial rite, his head veiled in a fold of his toga. Unbelievably, the statue must have been made when the emperor was more than seventy years old; all signs of advancing age have been blurred by an almost Praxitelean softness in the handling of the marble. The still-recognizable face radiates a godlike wisdom and benignity.

In a detailed account of the achievements of his reign, Augustus boasted that he "found Rome of brick and left it of marble." Although this could scarcely be said to apply to the multistory tenements inhabited by the populace, Augustus energetically continued the building program initiated by Julius Caesar and constructed innumerable public buildings on his own. He desired first of all to celebrate the *Pax Augusta* (Augustan peace) with buildings in which the new imperial power was to be dignified by the cadences of an imitated Attic style.

Chief among these monuments was the Ara Pacis (Altar of Peace; fig. 328), commissioned by the Senate in 13 B.C. and finished in 9 B.C. Although the monument suggests in form the Altar of Zeus at Pergamon (see fig. 284), it is on a far more intimate scale and is in every respect less dramatic. The altar itself is surrounded by a marble screen-wall, visible as a square block divided by delicate pilasters. These and the lower half of the wall are covered with a tracery of vinescrolls of the utmost delicacy and elegance. Above a meander pattern are a series of reliefs, some illustrating events from Roman history and religion, some showing contemporary events. The emperor himself, his head veiled for sacrifice, leads the numerous and recognizable members of the imperial family (fig. 329). In the rhythmic movement of the drapery, the frieze recalls that of the Parthenon (see fig. 237) and was doubtless intended to. But there are instructive differences: first, the Panathenaic Procession was represented on the Parthenon as a timeless institution, while the scene on the Ara Pacis shows a specific historic event, probably that of 13 B.C., when the altar was begun; second, the figures on the Ara Pacis are far more closely massed, as undoubtedly they would have been in reality; finally, the background slab of the frieze seems to have moved away from us, allowing room for figures behind figures, with progressively reduced projections. One of the reliefs flanking the east doorway shows Mother Earth with a personification of Tellus (Earth) accompanied by Air and Sea (fig. 330); all are portrayed as gracious, very Hellenic-looking goddesses, seated respectively on a rock, on a swan, and on a sea monster. The delicately observed landscape elements come from Hellenistic sources, and the same type of billowing, parachute-like veils over the heads of Air and Water

326

327

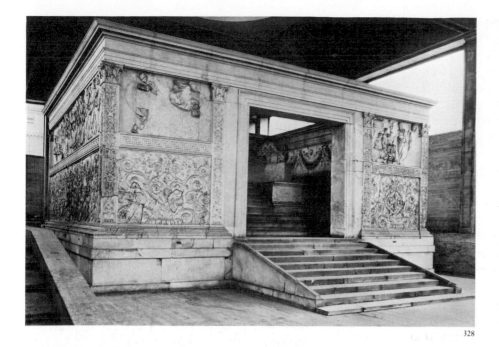

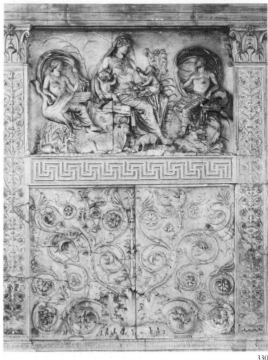

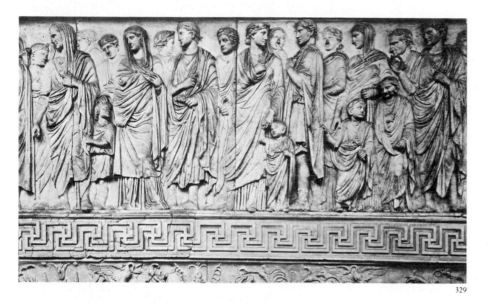

326. *Augustus of Prima Porta*. c. A.D. 15, probably after original of c. 20 B.C. Marble, height 80″. Vatican Museums, Rome

327. *Augustus as Pontifex Maximus*. 1st-century-A.D. replica of original of c. 20 B.C. Marble, height 81½″. Museo Nazionale Romano, Rome

328. *Ara Pacis*. c. 13–9 B.C. Marble, width of altar c. 35′. Museum of the Ara Pacis, Rome

329. *Imperial Procession* (detail of the *Ara Pacis* frieze). Marble relief, height c. 63″

330. *Earth, Air, and Sea Personified* and *Vinescroll Ornament* (details of the *Ara Pacis* frieze). Marble reliefs

turn up again and again in later Roman and in Byzantine art to characterize personifications.

In a marvelous cameo, the *Gemma Augustea* (fig. 331), probably cut for Augustus' son-in-law and successor, Tiberius, the seminude emperor shares a benchlike throne with the goddess Roma, made to resemble a Greek Athena; he is attended by relatives and by allegorical figures, one of whom is about to place a laurel wreath on his head. Above Augustus is his zodiacal sign, Capricorn. In the lower zone two barbarians, male and female, crouch disconsolately while Roman soldiers erect a trophy, a pole carrying armor stripped from the barbarian; two other barbarians are pulled in by the hair. With consummate skill and grace, the artist has worked the intractable semiprecious stone into a delicate relief, constantly suggesting space in the foreshortening of the human figures, the chariot, and the horse. In its allegorical version of history and in its exquisite refinement, this work sums up the ideals of the early Empire.

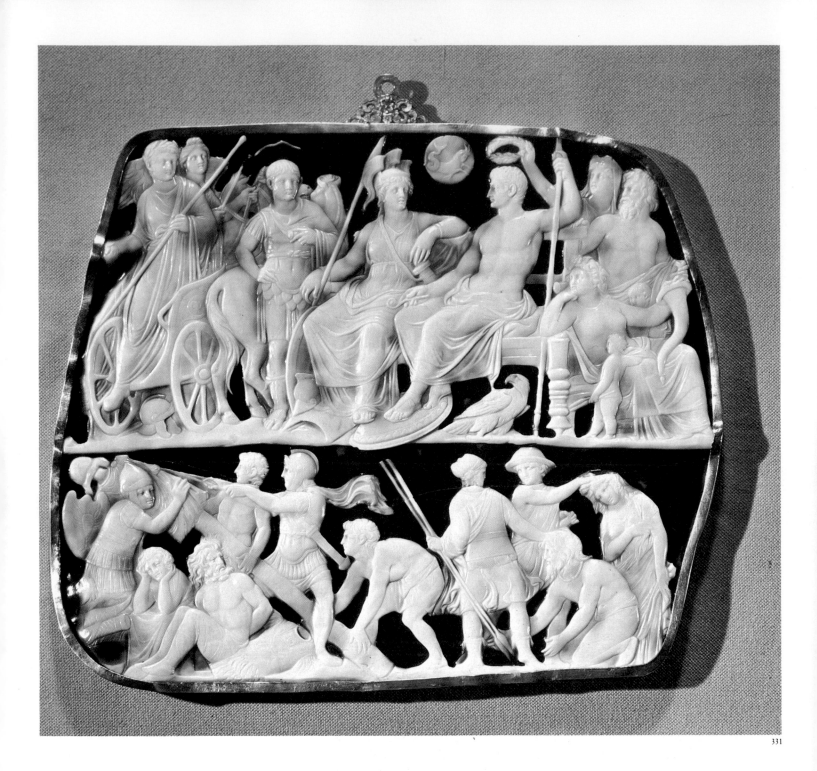

331

ARCHITECTURE Unfortunately, no Augustan temple survives in
Rome in sufficiently good condition to enable us to appreciate the quali-
ties of style the emperor desired. Luckily, this gap can be partly filled by
an Augustan temple at Nîmes in southern France; nicknamed the Maison
Carrée (fig. 332), it was begun about A.D. 1–10 and was based on the
Temple of Mars Ultor (see below). This little structure can claim to be
the best preserved of all Roman buildings. We recognize the familiar po-
dium, front steps with flanking postaments, deep porch, and shallow cella
of the Etrusco-Roman tradition. The temple, moreover, revives the Re-
publican system of ornamenting the cella wall with an engaged
pseudoperistyle. But the Corinthian order, henceforward the favorite in
Roman buildings, is far richer than the austere Ionic of the Temple of

331. *Gemma Augustea*. Early 1st century A.D.
Onyx cameo, 7½ × 9″. Kunsthistorisches
Museum, Vienna

332. Maison Carrée, Nîmes, France. Begun
c. A.D. 1–10

238 THE ANCIENT WORLD

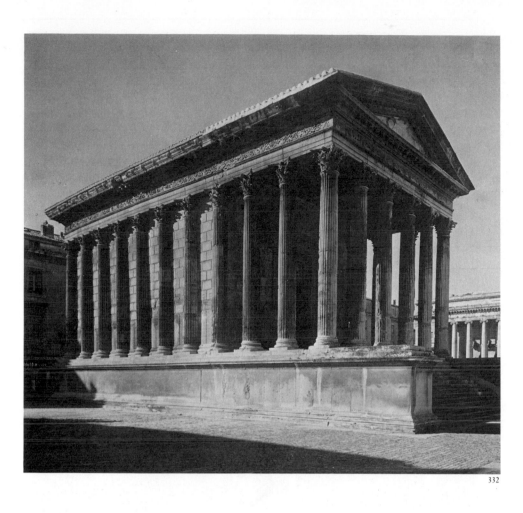

332

Fortuna Virilis (see fig. 311), and its frieze, no longer blank, is enriched by the kind of delicately carved vinescroll we have seen in the Ara Pacis.

It is with all these aspects of Augustan art in mind that we should attempt to reconstruct mentally the vanished magnificence of the ruined Forum of Augustus, which met the Forum of Julius Caesar at right angles (plan, fig. 333; reconstruction, fig. 334). The Temple of Mars Ultor (Mars the Avenger; fig. 335), of which four side columns remain standing, stood at the end of the Forum of Augustus on the usual podium, like that of the Capitoline Jupiter at Pompeii. Its back abutted an enclosing wall 115 feet high, which described an exedra on either side of the temple, cut off the view of surrounding buildings (including a slum), and protected the forum from the danger of fire. The eight lofty Corinthian columns across the front formed part of a freestanding peristyle that continued on both sides as well, but ended at the enclosing wall. In front of the exedrae and along either side of the rectangular plaza in front of the temple ran a row of smaller Corinthian columns, upholding an attic story which was ornamented with a row of caryatid figures, mechanical copies of the maidens of the Erechtheion porch (see fig. 246). The white marble columns shone against back walls paneled in richly colored marbles, producing on a grand scale an effect as brilliant as that of the *Gemma Augustea*.

Not all of Augustus' successors shared his concern with maintaining the public-spirited "image" he desired for the Julian-Claudian dynasty (the family relationships were often tenuous). Nero, last of the line, was known for the most extravagant abode of antiquity, the famous Golden House, of which only fragments remain. This residence was, in effect, a country villa in the heart of Rome, stretching from the Palatine to the

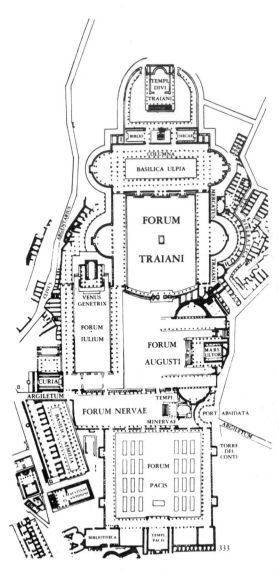

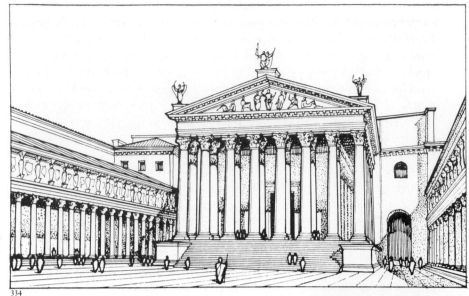

334

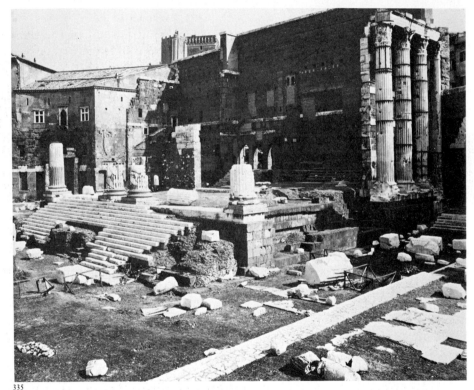

335

333. Plan of the Imperial Forums, Rome. c. 46
B.C.–A.D. 117

334. Reconstructed view of the Temple of Mars
Ultor and part of the Forum of Augustus,
Rome

335. Temple of Mars Ultor, Forum of Augustus,
Rome. Late 1st century B.C.

336. Reconstruction of an insula, Ostia, Italy.
2nd century A.D.

337. Pont du Gard, near Nîmes. Late 1st century
B.C.

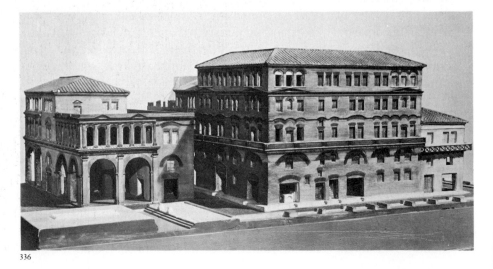

336

Esquiline, with gardens that enclosed an artificial lake. The delights of the villa included a banqueting-room ceiling that showered perfumes upon guests, a statue of Nero more than one hundred feet high, and a dome that revolved so guests could follow the motions of the heavenly bodies.

The caprices of Nero should not blind us to the fact that, after the well-nigh inevitable fire of A.D. 64 (for which he has often been unjustly blamed), he promulgated a building code designed to prevent recurrences of such disasters. Streets were widened, excrescences limited, building materials controlled, and structures rebuilt in stronger form and along more rational lines. The eventual outgrowth of Nero's code was the block-shaped apartment house known as the *insula* (island), strikingly similar to those built in Italy almost up to our own times. These insulae were massive buildings (fig. 336), four or five stories in height and made of brick or stuccoed concrete. Many are partially preserved at Ostia, the port of Rome. The ground floor usually contained shops, including perhaps a tavern, and common latrines. Staircases led from a central court to the apartments. Exterior balconies were provided for some of the lower suites, which were the most desirable. Every effort was made to give these insulae a monumental character and to avoid uniformity.

An extraordinary witness to Roman ability to deal with utilitarian structures in monumental terms is provided by the aqueducts erected by the Romans. These aqueducts were essential to the growing cities of the Empire; some still extend for miles in partially ruined state across the rolling plains outside Rome. One of the most daring is the Augustan aqueduct called the Pont du Gard (fig. 337) in southern France, constructed in the late first century B.C. by Augustus' lieutenant Agrippa to carry the water for Nîmes across a river gorge. The arches were built from unadorned, giant blocks of masonry, beautifully proportioned, in three stories; four smaller arches of the third story correspond to each single arch of the lower two. The majestic effect is, if anything, enhanced by the frankness with which the architect left blocks of stone protruding here and there as supports for scaffolding to be erected when repairs were necessary. Once an aqueduct reached a city, however, a richer treatment was appropriate, as can be seen in the Porta Maggiore at Rome (fig. 338),

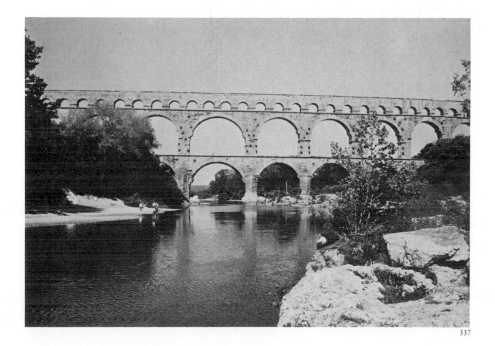

337

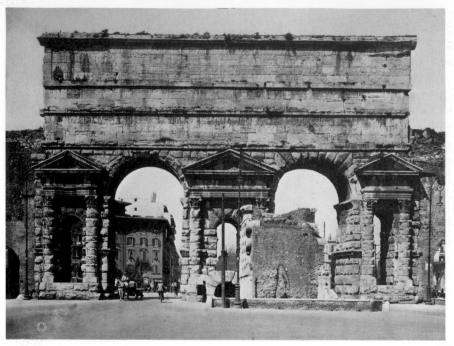

a double archway of travertine erected by Claudius, the fourth emperor of the Julian-Claudian dynasty, to carry water across two major Roman streets. The piers supporting the arches are adorned by Corinthian *aediculae* (small shrines) with pediments, but interestingly enough all the stones save those of the capitals, bases, and pediments were left untrimmed, as if to indicate the basically utilitarian nature of the enterprise and to convey a sense of rude power. This treatment, known as *rustication*, was revived extensively in the Italian Renaissance.

338. Porta Maggiore, Rome. c. A.D. 50

FLAVIAN ARCHITECTURE Following the suicide of Nero in A.D. 68 and the year A.D. 69, in which three emperors succeeded each other, the soldier and farmer Vespasian founded the Flavian dynasty, which set about to erase the memory of the self-indulgent Nero and to reestablish Augustus' imperial system. On the site of the artificial lake of Nero's Golden House, Vespasian commenced the largest arena ever built before the enormous stadiums of the twentieth century. The Colosseum (fig. 339), as this building is generally known, was dedicated in A.D. 80 by Vespasian's son and successor, Titus. It belongs to a new type of structure invented by the Romans and built throughout the Empire except, significantly enough, in the Greek world now reduced to Roman provinces. Its purpose was to house the spectacles with which vast audiences, including the jobless proletariat, were amused. These buildings were known as *amphitheaters* (double theaters) because, in order to bring the greatest number of spectators as close as possible to the arena, two theaters were, in effect, placed face to face. The resultant shape is always elliptical, and an earlier example, the amphitheater at Pompeii, c. 80 B.C., is the first elliptical building known. While the kind of spectacle in which Roman audiences delighted—gladiatorial combats, mock naval battles, fights between wild beasts, and contests between animals and humans—hardly bears contemplation, the remains of the Colosseum enable us to see that it was one of the grandest of ancient structures. The now-vanished marble seats were supported on multilevel corridors of concrete and masonry, providing for rapid handling of as many as fifty thousand spectators, each of whom entered by a ticket numbered to correspond to a specific gate.

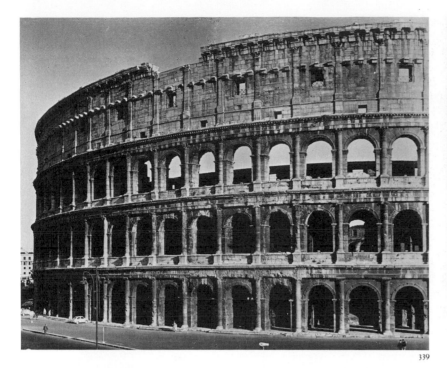

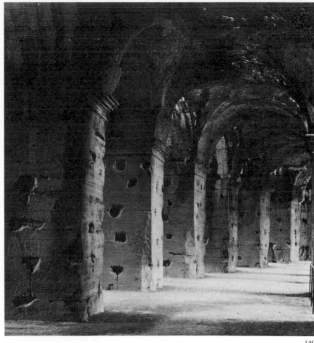

The exterior is composed of blocks of travertine, the somewhat porous, warm tan stone preferred also by Renaissance and Baroque architects for Roman church and palace façades. (Unhappily, these architects used the Colosseum as a quarry for their buildings.)

The arcades were decorated by columns that no longer served any structural function but acted only as a means of dividing the surface harmoniously and as a bridge between the otherwise bleak arches and the spectator. Three major orders stood one above another: Tuscan (probably used in place of Doric because the triglyphs would have been aesthetically troublesome), Ionic, and Corinthian. Above the uppermost order was a lofty wall, articulated by Corinthian pilasters; sockets at its summit were used for the insertion of masts, from which gigantic awnings were stretched across the arena to protect spectators from the sun. Windows in this fourth story alternated with applied shields of gilded bronze.

The corridors were covered with concrete, both in the familiar barrel vault and the groin vault (fig. 340), the latter formed by two barrel vaults intersecting at right angles, thus directing all weight to the four corners. The groin vault, like the barrel vault, was known to the Greeks, but they never used it for monumental buildings. Eventually (see page 269), the groin vault became extremely useful to the Romans as a means for covering vast spaces. The vaults of the Colosseum, now bare, were originally enriched with an elaborate surface decoration of stucco.

The Flavian emperors pulled down much of the Golden House of Nero, erecting on part of the site the now-vanished Baths of Titus, one of the earliest examples in Rome of a type of monumental building extensively built by later emperors throughout the city and the Empire (see below, pp. 269–70, and see fig. 378) as a means of providing useful public services for growing populations. Having thus converted to public use much of the land Nero had enclosed for his private pleasures, the Flavians built their own extensive imperial residence on the Palatine. Now visible only in stripped condition, from which little idea of its original magnificence can be gained, the Flavian Palace contained grand-scale vaulted audience halls in which the emperor could be seen in fitting splendor, and it was thus in a sense a public building; the Flavian Palace remained the official imperial residence until the late Empire.

339. The Colosseum, Rome. c. A.D. 72–80

340. Interior (second story), the Colosseum

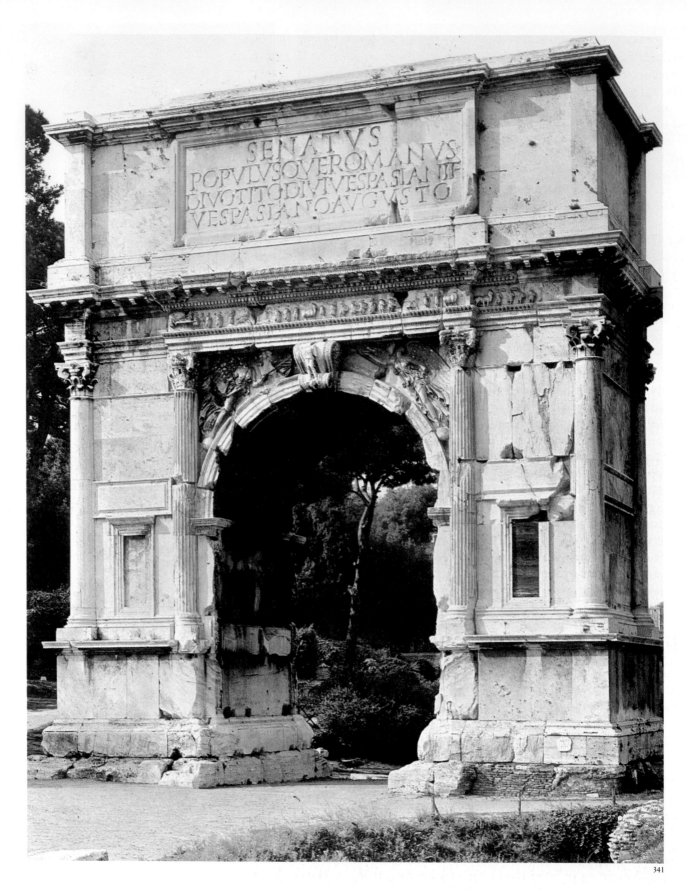

341

341. Arch of Titus, Rome. c. A.D. 81

342. *Triumph of Titus*, Arch of Titus, Rome.
c. A.D. 81. Marble relief, height 79″

To commemorate his brother Titus' capture of Jerusalem in A.D. 70 and destruction of the Temple, the emperor Domitian dedicated, eleven years later, a white marble triumphal arch at the summit of the Sacred Way, the street which connected the imperial forums with the Colosseum. The Arch of Titus (fig. 341) was a permanent version of the kind of temporary arch customarily built by Roman commanders to celebrate their triumphal return to the capital at the head of armies bearing the spoils of war and leading fettered prisoners. By the end of the Roman Empire, some sixty-four marble triumphal arches adorned Rome, and others were scattered throughout the Empire. The Arch of Titus, built of Pentelic marble around a concrete core, is a relatively simple structure (for a more elaborate version, see the later Arch of Trajan at Benevento, fig. 355). A single arch between square piers is crowned with an attic story, undoubtedly once supporting a bronze, four-horse chariot driven by the emperor. The applied decorative (or "screen") architecture is formed of paired columns upholding an entablature with a sculptured frieze. Two special innovations are apparent: first, the capitals are no longer strictly Corinthian, but Composite, an even richer fifth order mentioned by Vitruvius and distinguished from the Corinthian in that the volutes have been enlarged to the scale of those in the Ionic; second, the entablature is no longer continuous, but broken so that it projects over the lateral columns, recedes close to the massive piers, and projects again over the central columns and the connecting arch. Thus screen architecture is now being molded with the same liberty as the underlying architecture of concrete, in the interests of freedom of shape and the movement of light and dark. The last shackles of the post-and-lintel system, with its endless, straight horizontals, have been thrown off.

FLAVIAN SCULPTURE The spectator passing along the Sacred Way in Rome was addressed by two reliefs in the inner surfaces of the piers of the Arch of Titus, one depicting the *Triumph of Titus* (fig. 342) and the other the *Spoils from the Temple at Jerusalem* (fig. 343), in which

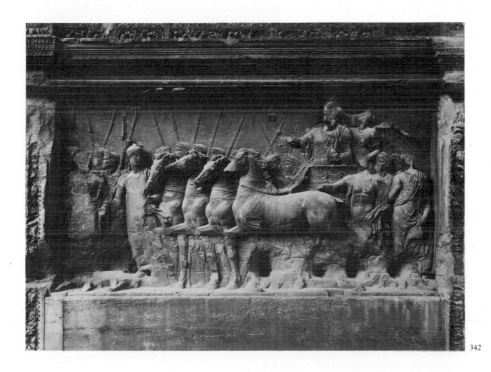
342

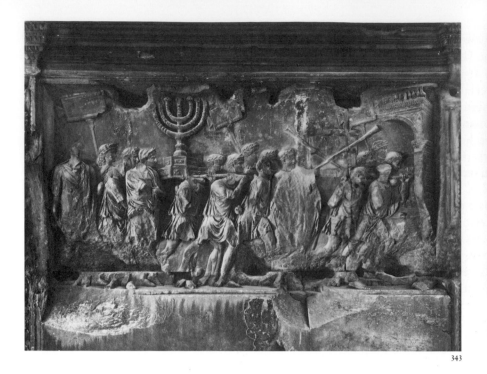

343

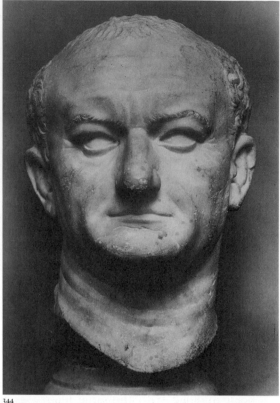

344

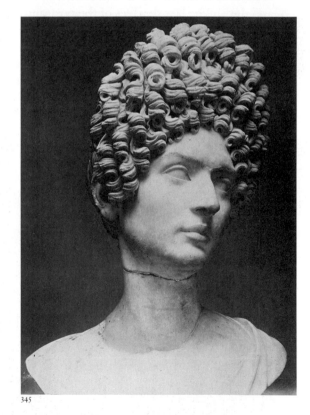

345

Roman legionaries are seen carrying off the trumpets, the seven-branched candlestick, and the golden table. These reliefs were, if anything, more revolutionary than the architecture. For the first time Roman historical relief came into its own. Memories of the Ara Pacis still linger, but the Attic stateliness of Augustan relief has been swept away by a new dynamism in keeping with that of the architecture. We are reminded less of the Parthenon than of Hellenistic Baroque—although those relatively small reliefs lack the grandiloquence of the Altar of Zeus at Pergamon (see fig. 290). The relief space is much deeper than that of the Ara Pacis, and several devices have been utilized to increase its apparent depth. At the right, an archway has been placed at an angle to the spectator so that it dissolves into the background. Even with the loss of much of the relief, it is clear that the figures exploit their newly gained space, moving freely at various levels in depth as if passing before us on a stage. Some are so sharply projected that they are almost freestanding—and thus have suffered the most damage—while others, deeper in space, are represented in slight projection. As in the varying levels in depth of the surrounding architecture, light and shade have been utilized to enrich the drama.

In Flavian portraiture this new dynamism of form and new interest in light and shade were richly explored. A superb *Portrait of Vespasian* (fig. 344) shows that lessons from Praxitelean and Hellenistic sculpture have been applied to bring out in marble the full play of light and dark across the weather-beaten face of the old general. The eyeballs are no longer fully carved; they are actually slightly recessed so that the shadow of the eyelids can give the impression of the colored iris. The folds of flesh are rendered with the same pride in ugliness we found in Republican portraiture (see figs. 309, 310), and the subject seems to be caught in a transitory moment between reflection and speech. A brilliant example of a standard type of Flavian female portraiture is a beautifully poised young matron (fig. 345), whose elegant and sensitive features are almost overpowered by a lofty Flavian coiffure of curls. The contrast of the rich shadows in the headdress with the translucency of the features suggests the actual coloration of hair and flesh, and again a slight depression hints at the color of the eyes. The Flavian portrait style is often characterized

as coloristic, which is a very expressive term for the range of tonal values embodied in each head.

PAINTING In the late Augustan period, the illusionistic achievements of the Second Style were overlapped and eventually succeeded by paintings in the Third Style that show an unexpected combination of pure architectural fantasy with prim refinement, such as in a painted wall from the house of M. Lucretius Fronto at Pompeii (fig. 346). The lower two thirds of the wall, painted glossy black or red, is divided by columns prolonged into spindles; against the side panels stand equally attenuated lamps, on which appear to be suspended tiny panel paintings showing views of villas by the sea, and a mythological painting is "hung" against the center panel. Above the wall one looks out into an array of fantastic structures, reduced to toylike slenderness—columns like reeds, open pergolas—all in a perspective that takes us deep into unreal space, but is exactly repeated in reverse on the opposite side. Undeniably, this style shows some of the mannered elegance and grace of official Augustan art.

Most fantastic of all Pompeiian art is the Fourth Style, which flourished after the earthquake of A.D. 63 and was terminated at Pompeii and Herculaneum only by the eruption of Vesuvius in A.D. 79, a period corresponding to the last years of the reign of Nero and the first decade of the Flavian dynasty. A new and wildly imaginative manner appeared, with architectural vistas even more fantastic and far more convincingly lighted and painted in an astonishing array of rich colors (fig. 347 shows a fine example from Herculaneum). Curtains, masks, broken pediments, and simulated bronze statues are irradiated with a sunlight as warm as that which charmed us in the Second Style.

343. *Spoils from the Temple at Jerusalem*, Arch of Titus, Rome. c. A.D. 81. Marble relief, height 94"

344. *Portrait of Vespasian*. c. A.D. 75. Marble, life-size. Museo Nazionale Romano, Rome

345. *Portrait of a Lady*. c. A.D. 90. Marble, life-size. Museo Capitolino, Rome

346. *Architectural View and "Panel Paintings,"* wall painting from the House of M. Lucretius Fronto, Pompeii. Middle 1st century A.D.

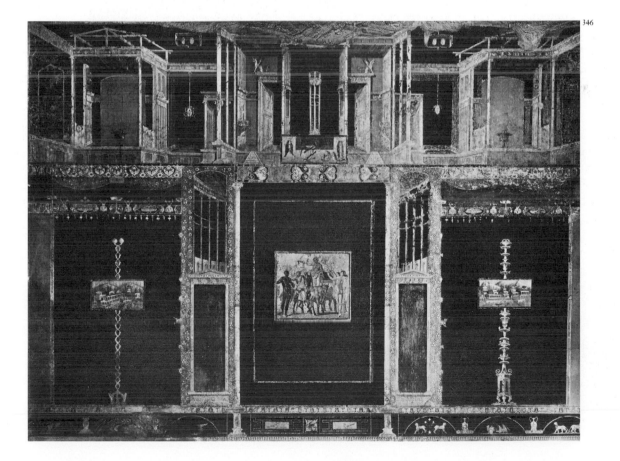

346

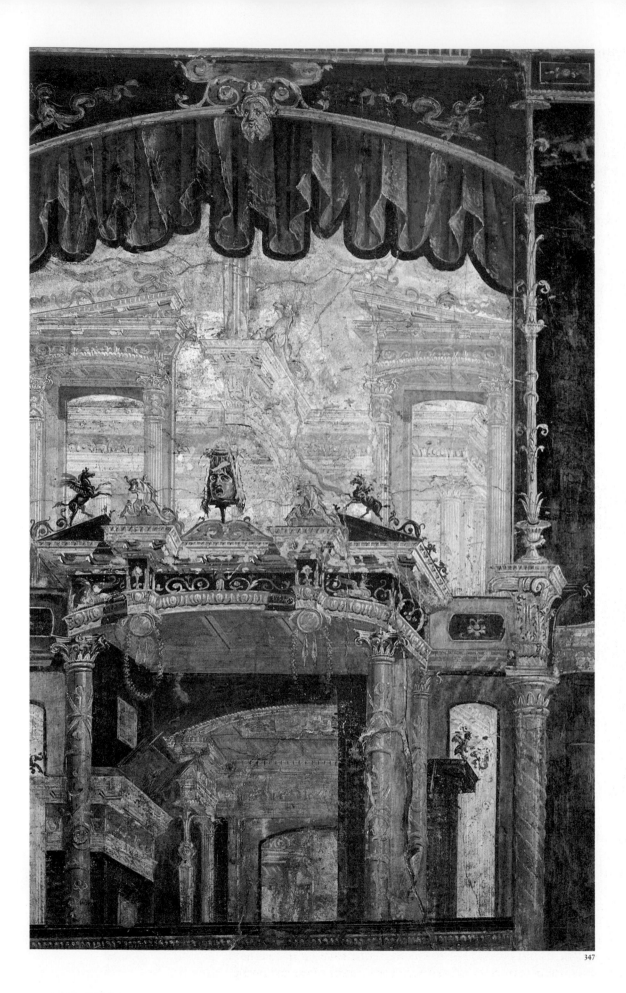

347

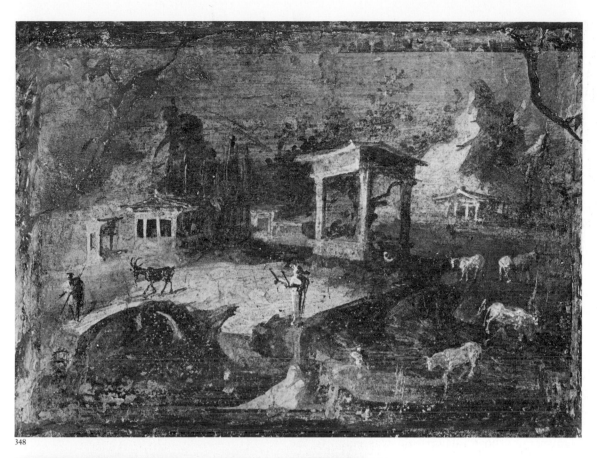

347. *Architectural View*, wall painting from Herculaneum, near Naples. c. A.D. 63–79. Museo Archeologico Nazionale, Naples

348. *Sacred Landscape*, Fourth Style wall painting from Pompeii. c. A.D. 63–79. Museo Archeologico Nazionale, Naples

349. *Landscape with Figures*, from an Augustan house near the Farnesina Palace, Rome. c. 19 B.C. Stucco relief, 18⅛″ high. Museo Nazionale Romano, Rome

Especially beautiful are the Fourth Style landscapes (fig. 348). In these views of an imagined nature, the artists exploited every device then known in order to render sunlight and atmosphere. Rapid brushstrokes sketched in a delightful dream world of mountains and glades, shrines, Etruscan-looking temples, cattle, and lakes and bridges, all dissolved in light and air in a manner that has often been compared with nineteenth-century Impressionism. Interestingly enough, the whole subject matter of Roman landscape painting could be modeled in stucco, with remarkably convincing effect and without any color whatever, in the reliefs often appearing

on Roman ceilings. Stucco dries rapidly and requires a working speed comparable to that of the sketchy paintings so impressive in the Second, Third, and Fourth styles. A typical example, from an Augustan house near the Farnesina Palace in Rome (fig. 349), shows the usual shrines, trees, little figures, animals, and rocks so arranged and so treated as to suggest distance, light, and air.

The assassination in A.D. 98 of the tyrannical Domitian, last of the Flavian dynasty, resulted in the rule of a new and stable succession of six emperors, the first five of whom have become known—in contrast to their immediate predecessor and several of their appalling successors—as the "good emperors."

The Second Century (A.D. 96–192)

TRAJAN The first, the aged Nerva, lived only two years before he was succeeded by his adopted son, the brilliant general Trajan, born in Spain—the first non-Italian emperor. Under Trajan the Roman Empire reached its greatest expansion, and his achievements were fittingly commemorated by the dedication in A.D. 113 of the grandest of all the imperial forums (fig. 350; see also fig. 333). The Forum of Trajan, in fact, covered more ground than those of Julius Caesar, Augustus, and Nerva together. To design this project Trajan called on a Greek architect from Syria, Apollodorus of Damascus, whose imagination was equal to the grandiose ideas of his imperial patron. Apollodorus combined elements from Roman tradition with others, eventually tracing their ancestry to the bygone architecture of Egypt. The axial plan of the forum, in certain aspects, recalls strikingly the general layout of Egyptian temples, although there could have been no direct influence. A vast colonnaded plaza, similar to the Egyptian peristyle court, contained a bronze statue of the emperor on horseback. Beyond was the Basilica Ulpia—corresponding in its position to the Egyptian hypostyle hall—a columned space which the visitor must traverse before arriving at the Temple of the Divine Trajan, erected by his successor Hadrian. We do not know what kind of structure was originally destined for this position. The plaza and the basilica were each flanked by semicircular spaces; exedrae, like those of the Forum of Augustus, rose behind the colonnades at either side of the plaza; apses closed off either end of the basilica; in the center of a single huge exedra stood the temple. As was by now the universal custom, the exedrae were built of concrete and faced with brick, but details were made of travertine; beyond the east exedra of the plaza is Trajan's market.

The Basilica Ulpia (fig. 351), named after Trajan's family, was the largest of Roman basilicas, some four hundred feet in length. Two earlier basilicas stood near it in the great complex of Republican and imperial forums; the Basilica Ulpia seems to have differed from its predecessors only in size and magnificence. Two aisles on each side of the nave were supported by a forest of monolithic columns carved of gray Egyptian granite. The roof was concealed by a coffered ceiling, covered with plates of gilded bronze.

On leaving the Basilica Ulpia, visitors found themselves in a small court between Trajan's Greek and Latin libraries. Through the columns they could look out to the final exedra with its temple, if their attention could be distracted from the extraordinary monument in the center of the court (fig. 352), a marble column that, together with its podium, rose to

a height of 125 feet and was topped by a statue of Trajan in gilded bronze (destroyed in the Middle Ages and replaced in the sixteenth century by a statue of Peter). The podium was decorated with captured weapons carved in low relief; a golden urn containing the ashes of the emperor was placed within it after his death in A.D. 117. The column base was carved into a giant laurel wreath. In a spiral around the column winds a relief some six hundred and fifty feet long, on which are narrated events from Trajan's two successive Dacian campaigns.

No precedent for this extraordinary idea has ever been found, but it is noteworthy that the column was placed between two libraries. Ancient books did not have pages; they were *rotuli* (scrolls) wound between two spindles (see Part Three, Chapter One). The reader saw a column of text at a time—sometimes with an accompanying illustration—then wound it away to read the next column. Just under the Doric capital of the Column of Trajan, a glimpse of fluting appears above the scroll-like relief. It has been suggested that the idea of the historiated column was derived from rotuli with endless narrative illustrations, but the only such rotuli known are much later (see fig. 440) and were influenced by the Column of Trajan and other monuments imitating it, rather than the reverse. The originality of the idea—and we do not know whether to attribute it to Apollodorus or to an artist working under his supervision or even to the emperor himself—lies in the idea of the continuous narrative, unfolding with cinematic power in more than one hundred and fifty incidents. Through camps, sacrifices, harangues, embassies, sieges, river crossings, pitched battles, routs, tortures, suicides, and mass slaughters, the story of the campaigns is told. In contrast to the battle reliefs of Assyria, which spring constantly to mind, the Trajanic narrative possesses an impressive objectivity. Nowhere is the enemy underrated, and the Romans must put up a good fight for their victories. In the reliefs of the Column of Trajan,

350. APOLLODORUS. Forum of Trajan, Rome. Dedicated A.D. 113

351. Basilica Ulpia, Rome. Dedicated A.D. 113 (Architectural reconstruction after Canina)

350

351

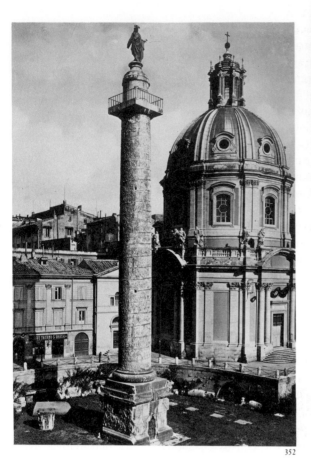

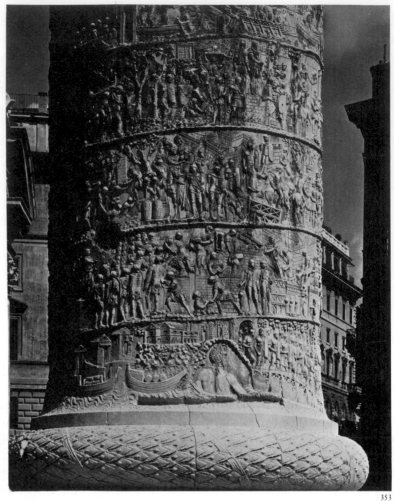

352

353

Roman sculpture at last came into its own; these creations owe no debt to any previous period. Doubtless the work, like that of the sculptures adorning the Parthenon, was executed by many different assistants. But the breadth and dignity of the narration—which has been compared with Caesar's literary account of his Gallic wars—the power of the individual scenes, and the overall uniformity of accents and design show the conception of a single great master, whose name, unfortunately, is unknown.

In fig. 353, several incidents can be read. At the bottom, a personification of the Danube River, represented as a bearded giant, rises from the waves in amazement as the Roman legions issue forth from a city gate onto a bridge of boats to cross the river. In the second level, Roman soldiers carry blocks of stone to reinforce a fortification. In the third, Roman cavalry emerges from the gate of a walled camp and crosses a wooden bridge over a moat to embark on a patrol. In the fourth, the emperor stands upon a high podium to address his troops. As in almost all Classical reliefs, the sculptures on the column were painted to bring out the figures and the details of the narrative with greater clarity.

Four major differences, however, separate this continuous narrative from the illusionistic reliefs on the Arch of Titus (see figs. 342, 343). First, because deep carving such as that on the Arch of Titus would have destroyed the integrity of the column and created ragged contours, the work on the Column of Trajan was carried out in low relief. Second, concern with narrative legibility caused its sculptors to give every figure an almost uniform degree of accentuation. Third, the figures are displayed as if on a steeply mounting terrain, providing a panoramic view,

352. Column of Trajan, Rome. Dedicated A.D. 113. Marble, height 125'; length of spiral low relief 650'

353. Column of Trajan, Rome (detail)

354. Market of Trajan, Rome. Dedicated A.D. 113

355. Arch of Trajan, Beneventum (present-day Benevento), Italy. Marble. c. A.D. 114–17

rather than overlapping in depth. Finally, just as in the Parthenon frieze (see fig. 236), a different scale was adopted for the horses from that of the figures; buildings are also shown relatively small, while city walls are the same height as people. Since these principles were by no means uniformly followed in other Trajanic reliefs, it must be assumed that they were adopted here because of necessity. The difficulty of reading the upper episodes was overcome to some extent by increasing the scale slightly as the spiral mounted. Legibility would have been enhanced, in all probability, by viewing the upper portions from the terraces above the libraries and from the roofs of the Basilica Ulpia and the connecting colonnade. Even so, the topmost levels must have been very difficult to distinguish.

Nothing of the Temple of the Divine Trajan is now above ground, but we know that it had a portico even higher than that of the Temple of Mars Ultor, with a peristyle of monolithic columns in the same gray Egyptian granite that was used for the Basilica Ulpia. A handsome utilitarian structure connected with the Trajanic complex still stands on the slope of the Quirinal Hill—a two-story market (fig. 354), whose concrete, groin-vaulted central nave is flanked by barrel-vaulted shops, built of concrete faced with brick; each travertine opening, serving as entrance and shop window, was surmounted by a window to provide ventilation for the mezzanine story, where the shopkeeper or his clerk resided. Traditional wooden centering was supplemented in the construction of the groin vault by forms molded in terra-cotta.

Entrance to the entire Trajanic complex was afforded by a triumphal arch, which has disappeared. However, a noble marble arch built by Trajan in A.D. 114–17 at Beneventum (modern Benevento) in southern Italy, to celebrate the opening of a highway, still stands in remarkably good condition (fig. 355). The general shape of the relatively modest Arch of Titus is here enriched by a series of panels sculptured in high relief, which fill every surface not occupied by the commemorative inscription. Large, rectangular panels alternate with narrower strips. The public deeds

354

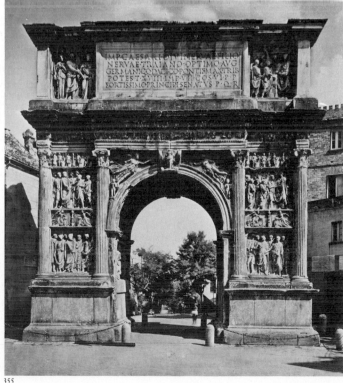

355

of the emperor are shown here, rather than his military exploits; the folds of the togas are obviously scaled to harmonize with the fluting of the Composite columns. The relation between architecture and sculpture here can only be characterized as symphonic, in the bewildering variety of accents and cross-accents grandly sustained by the columns, bases, and entablature. This arch is unquestionably the finest example of balance between architecture and sculpture remaining to us from the Roman world.

HADRIAN Trajan was succeeded by his nephew Hadrian (ruled 117–38), an administrator who had little interest in military conquests—he, in fact, let some unruly border provinces slip from Roman grasp. Hadrian was, however, deeply concerned with cultural activities and artistic monuments, especially those of the Hellenic world, with which he felt a strong kinship. He undertook several long tours of his vast empire, embellishing provincial centers with new buildings and doing his utmost to support the continuing intellectual life of Athens. Hadrian seems to have had little interest in the epic themes of Trajanic sculpture, and sculpture surviving from Hadrian's reign reflects the emperor's Hellenism. Several medallions made for a Hadrianic monument but later incorporated into a new triumphal arch in the fourth century by the emperor Constantine, who had the imperial heads recarved to portray himself, vibrate with echoes of Classical and Hellenistic sculpture (fig. 356). In the muscular horses and the free drapery rhythms of the *Wild Boar Hunt*, memories of the Parthenon frieze and the Temple of Apollo at Bassai (see figs. 235, 251) are very clear; in the soft treatment of the nude and in the gentle drapery folds of the *Sacrifice to Apollo*, the graceful tradition of Praxiteles and Lysippos is quoted. Interestingly enough, although the horse in the *Sacrifice* emerges from a space clearly indicated as behind that of the attendant, the horses and riders of the *Hunt*, to show that they are behind the wild boar, appear above it. Illusionism is at an end, and the artist's

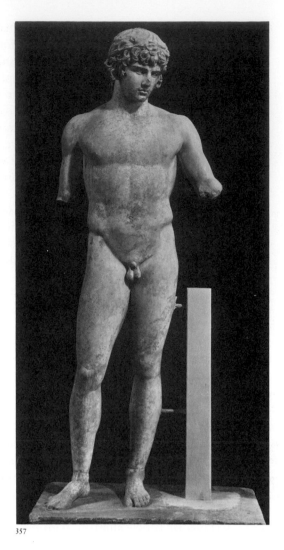

357

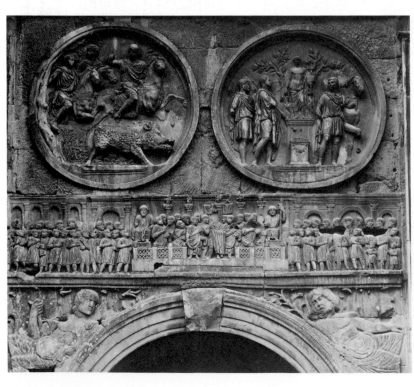

356

356. *Wild Boar Hunt* and *Sacrifice to Apollo* (details of the Arch of Constantine, Rome). Medallions c. A.D. 131–38; frieze c. A.D. 312–15. Marble, height of frieze c. 40″

357. *Portrait of Antinoüs*. c. A.D. 131–38. Marble, height 70⅞″. Archaeological Museum, Delphi, Greece

358. The Pantheon, Rome. c. A.D. 118–25

359. Plan of the Pantheon, Rome

devices are directed toward informing the observer rather than describing a visual situation.

Perhaps the most Hellenic of all Hadrianic sculptures is the *Portrait of Antinoüs* that Hadrian gave to the sanctuary of Apollo at Delphi (fig. 357). The emperor had showered statues of his favorite throughout the Empire; these works are recognizable by the portrayed youth's slightly aquiline nose, full lips, and deep chest. Most of these statues show a figure at least partly draped, but this example is connected with an older Roman tradition in which realistic portrait heads were superimposed on idealized nude bodies copied from Greek statues. Generally, the results were grotesque. In the *Antinoüs* of Delphi, however, a Greek sculptor working for Hadrian was able to treat this unlikely combination with convincing unity. Revivalist though it is, the statue achieves great success in its contemporary adaptation of a Classical Greek concept.

Interestingly enough, Hadrianic architecture in Italy owes little to Hellenic tradition, but in fact sums up authoritatively the most progressive spatial tendencies of Roman building. The grandest of all Hadrianic monuments is the rebuilt Pantheon in Rome (figs. 358, 359), which owes its extraordinary state of preservation to its rededication as a church in the early history of Roman Catholicism. The Pantheon has exercised an incalculable influence on all the architecture of the Middle Ages, the Renaissance, the Baroque period, and modern times. The building must be imagined in its original state, approached by parallel colonnades flanking a central plaza, and elevated on a podium now concealed by the sharp rise in the level of the surrounding terrain. Viewed from below, the circular cella (derived, of course, from the tholos tradition), which is the remarkable innovation of the building, would have been sensed rather than seen. The Corinthian columns of the portico are monoliths of pol-

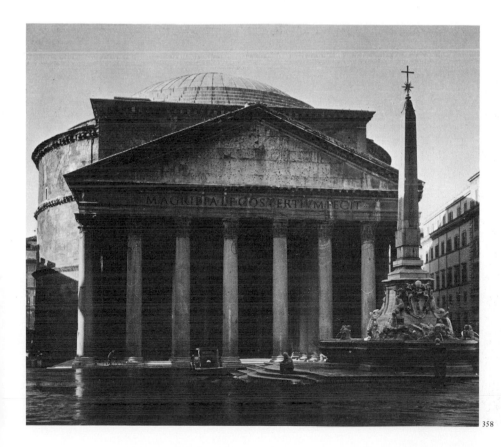
358

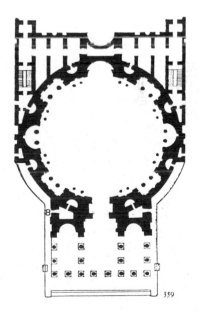
359

ished granite; the cella is built of formed concrete, faced with fine brick-work. The roof was covered with gilded tiles. The crowning dome is an exact hemisphere of concrete 143 feet in diameter, at the top formed of lightweight materials and very slight in thickness. Farther down, the shell becomes both thicker and heavier, and it is supported not only by the walls of the cylindrical drum but by relieving arches within the walls and invisible from the interior. The height of the drum is equal to its radius, which is identical to that of the dome.

Once one enters the Pantheon its revolutionary character becomes apparent—it is one of the few truly overwhelming spatial experiences in architecture, so grand in fact that it cannot be represented convincingly by photographic means. We must have recourse to a painting done in the eighteenth century (see fig. 7). The interior of the Pantheon conveys the effect of a colossal sphere, whose perfect beauty is untroubled by excrescences. The continuous entablature is upheld by paired, fluted Corinthian columns of softly colored marble in front of eight recesses, alternating with eight flat wall surfaces encrusted with colored marble from which project aediculae, once containing statues of the gods, framed by unfluted columns of polished granite. The now-bare concrete coffering of the dome was originally painted blue; each coffer contained a rosette of gilded bronze. A single great circular opening at the apex is the sole and abundant source of light, and it allows the eye to move freely out into the sky above. The effect of this vast, spherical space, whose enclosing wall is softened by the fluid colors of the marble, can only be described as sublime. No interior before or after the Pantheon has achieved quite this impression. A long tradition in ancient times associated architectural domes with the Dome of Heaven, the sky itself, a tradition also appropriate for a building dedicated to the worship of all the gods, as was the Pantheon. The breathtaking interior space of this great building arouses in us a sense of liberation analogous to what we feel when we gaze into the open sky.

The most imaginative architectural achievement of Hadrian's reign was the villa he constructed near Tivoli (fig. 360); to modern eyes it suggests nothing so much as the pleasure dome of Kubla Khan as described in Coleridge's poem. Several square miles of gently rolling countryside were adorned with a rich array of buildings and gardens. In contrast to

360. Hadrian's Villa, Tivoli. c. A.D. 125–35. Museo della Civiltà Romana, Rome (Architectural reconstruction by I. Gismondi)

360

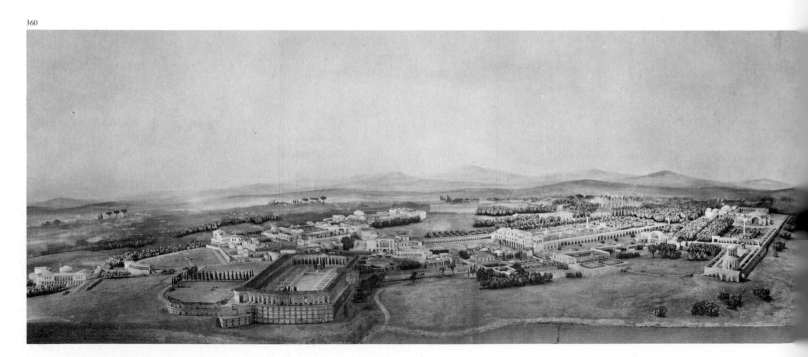

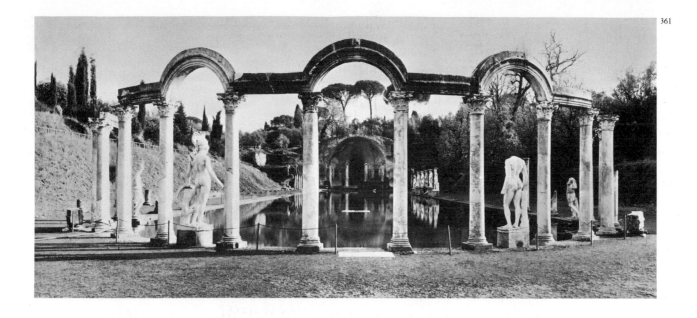

361. The Canopus of Alexandria, Hadrian's
Villa, Tivoli. c. A.D. 125–35 (Reconstruction)

the rigorous axial planning of the imperial forums, the constructions and spaces of Hadrian's Villa were freely scattered in groups in order to take advantage of varied levels, exposures, and vistas. Within each group, however, the buldings were arranged with close attention to harmonious and generally symmetrical relationships. The individual spaces were seldom large but almost infinitely complex, exploiting all the freedom of shape offered by Roman concrete architecture. Some interiors contained not a single straight line, only alternating convex and concave forms.

The villa had several elaborate *nymphaea* (fountain buildings), Greek and Latin libraries, a theater, baths both large and small, courtyards, plazas, and temples. A circular colonnaded pool was adorned with a central island, attainable by bridges on wheels, on which stood a tiny, self-contained abode. Many reproductions—more symbolic than accurate—of sights that Hadrian had seen on his travels throughout the Empire were constructed at the villa. These included the Grove of Academe and the Stoa Poikile (painted porch), both of Athens, and the Canopus of Alexandria (fig. 361), a long canal culminating in a temple to the Egyptian god Serapis. This temple was also a nymphaeum, and it was ornamented with Egyptian sculptures preserved today in the Vatican Museums. The end opposite the temple was colonnaded, and the entablature seems to have been bent into arches as if made of clay. When intact, Hadrian's Villa offered an unimaginable richness of forms, spaces, and colors to excite the senses and to enshrine the intellectual life of the imperial hedonist, who unfortunately died before its completion.

THE ANTONINES The uneventful reign of Hadrian's successor, Antoninus Pius, was appropriately memorialized by an undecorated column of pink marble, erected after the emperor's death in A.D. 161. The cubic base, which is all that remains, is a powerful work of art in itself. On the front face is shown the flight of the emperor and the empress to heaven; on either side is represented the ceremonial circular gallop of the cavalry around groups of armored infantrymen holding standards at the imperial funeral (fig. 362). Surprisingly, the hard-won illusionistic space of the Hellenistic tradition, already compromised by the devices of Trajanic narrative style, has been completely dismissed. Although the distinction has been preserved between near figures in high relief and those

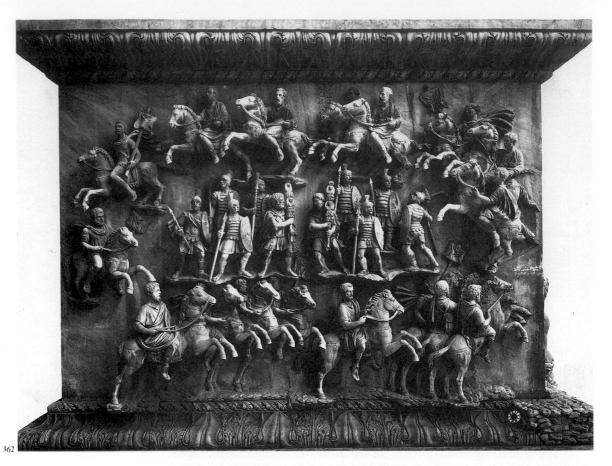

362

362. *Ceremonial Circular Gallop of the Cavalry,*
from the base of the Column of Antoninus
Pius. Marble relief, 8′ 1¼″ × 11′ 1⅛″.
c. A.D. 161. Vatican Museums, Rome

363. *Equestrian Statue of Marcus Aurelius.* c. A.D.
161–80. Bronze, over-lifesize. Piazza del
Campidoglio, Rome

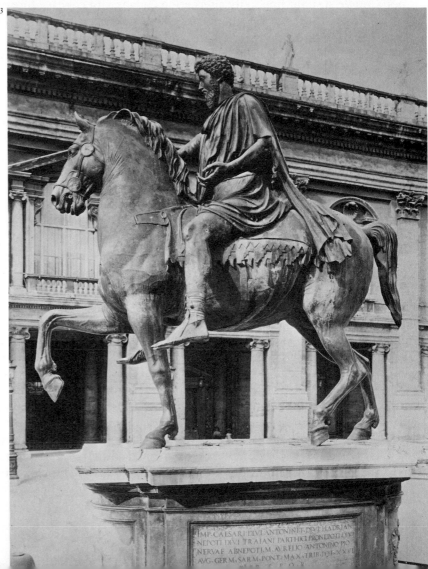

363

farther from us in low relief, all that remains of the traditional setting is a few patches of ground under the feet of men and horses. The figures seem to float in a free space, unregulated and unenclosed, in front of the neutral marble background. What is behind is now represented as above, as if in reversion to the far-off days of Polygnotos.

The new abstract conception of space and the new carving techniques were employed in the relief sculpture on the column of Antoninus' successor, Marcus Aurelius. As an emperor, Marcus Aurelius was an extraordinary blend of an efficient general, on the model of Julius Caesar and Trajan, with a Stoic philosopher. Marcus Aurelius loathed war, and he fought only defensive actions aimed at preserving the Empire from incursions of Germanic tribes, particularly in the Balkans. For him duty was man's highest goal and only reward; his own duty was to administer the Empire as a brotherhood of man under the rule of an all-pervasive God, which involved the sacrifice of his own well-being in favor of the unity of the state.

One of the most memorable works of art from Marcus Aurelius' reign is his noble equestrian statue in bronze (fig. 363), originally in front of the Lateran Palace in Rome, in which the emperor was born, but transferred to the Capitoline unwillingly by Michelangelo in 1536 at papal command. The statue owes its preservation to the mistaken belief that it represented Constantine, the first imperial protector of Christianity, and is the only well-preserved ancient equestrian statue in bronze to come down to us; needless to say, it has been imitated countless times from the Renaissance almost to our own day. The statue shows the emperor unarmed, his right arm outstretched in the characteristic Roman oratorical gesture (see figs. 307, 326) and his left guiding the now-vanished reins of his spirited horse. As we have seen in relief sculpture, the rider here is also represented in a larger scale than the horse. The bearded emperor (the beard was a Hadrianic innovation, in imitation of the Greeks) looks out calmly on the world; the rich curls of his hair and beard, in contrast to the smooth parts of his face, show a revival of Flavian colorism, which precludes the traditional device of inserting eyes made of glass paste. The horse is superbly modeled, revealing extensive knowledge of the proper position and function of bones, muscles, tendons, and veins.

One of the most significant and lasting of all Roman achievements was the foundation throughout the Empire of hundreds of towns and cities, many of which are still inhabited, and the extensive rebuilding of Hellenistic cities in Greece and Asia Minor. Where possible, the typical Roman town followed the foursquare Hippodamian plan, with straight perimeter walls leading to major thoroughfares, oriented north and south, east and west, and crossing at right angles in the center, and minor streets also intersecting in a grid. (Such a plan was out of the question in Rome itself, because of its haphazard prior growth on an irregular, hilly site; see fig. 364 for the appearance of the center.) Such self-contained, crystalline plans were, of course, fairly rigid, leaving no room for expansion. Later growth outside the square inevitably betrays the suburban sprawl all too familiar in our own world. Most cities had a central capitol dominating a forum, temples to Roman and indigenous deities, a basilica, a bath or two, a theater, and an amphitheater. The latter was rare in Greek provinces, which resisted the Roman gladiatorial combats until very late; only three amphitheaters were built in all of Asia Minor.

But these architectural undertakings were by no means uniform in style at any one moment in all parts of the Empire. For example, urban complexes and country villas in Britain, Gaul, and Germany were far

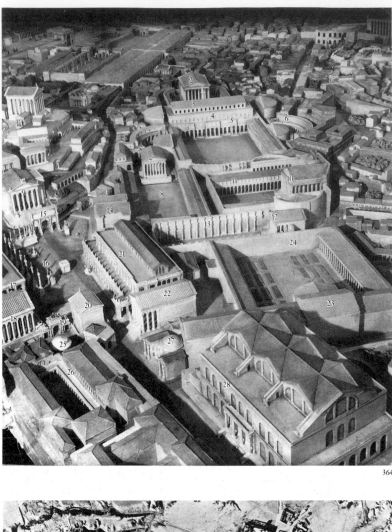

364. The Republican and Imperial Forums, Rome. c. A.D. 310. Reconstructed in a model of ancient Rome. Museo della Civiltà Romana, Rome (Starred numbers are works mentioned in this book) *1. Temple of Capitoline Jupiter *2. Temple of Trajan *3. Column of Trajan *4. Basilica Ulpia *5. Forum of Trajan *6. Market of Trajan 7. Temple of Venus Genetrix 8. Forum of Julius Caesar 9. Temple of Concord *10. Temple of Mars Ultor *11. Forum of Augustus 12. Temple of Minerva 13. Forum of Nerva 14. Curia (Senate Chamber) 15. Arch of Septimius Severus *16. Roman Forum 17. Basilica Julia 18. Temple of Castor and Pollux 19. Arch of Augustus 20. Temple of Julius Caesar 21. Basilica Aemilia 22. Temple of Antoninus and Faustina 23. Temple of Peace 24. Forum of Peace 25. Temple of Vesta 26. House of the Vestal Virgins 27. Temple of Romulus *28. Basilica of Maxentius and Constantine

364

366

365

367

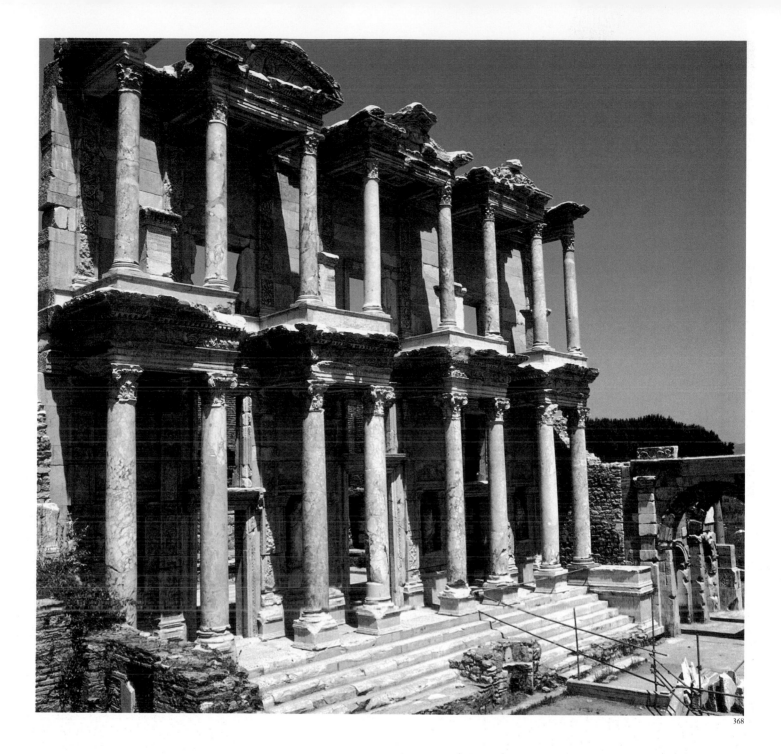

368

less sumptuous than those designed for provinces that still cherished a Hellenistic tradition of architecture and decoration. The most dazzling provincial centers were perhaps those in Asia Minor, such as Ephesus, Miletus, Aspendus, Side, and Perge; in Syria, such as Baalbek and Palmyra; and in North Africa, especially Leptis Magna, Sbeitla, and Timgad (fig. 365), large portions of which are still standing. A vista (fig. 366) down the central colonnaded street of Timgad toward a late-second-century gateway erroneously known as the Arch of Trajan gives some inkling of the splendor of these North African and eastern Mediterranean cities in the time of Marcus Aurelius. The great central arch for horse-drawn traffic is flanked by two smaller ones for foot passengers, embraced by columns designed to culminate the colonnaded walkways rather than to re-

365. Plan of the city of Timgad, Algeria

366. Colonnaded street with arched gateway, Timgad. Late 2nd century A.D.

367. Theater (partial reconstruction), Sabratha, Libya. Late 2nd century A.D.

368. Façade, Library of Celsus, Ephesus, Greece. C. A.D. 135

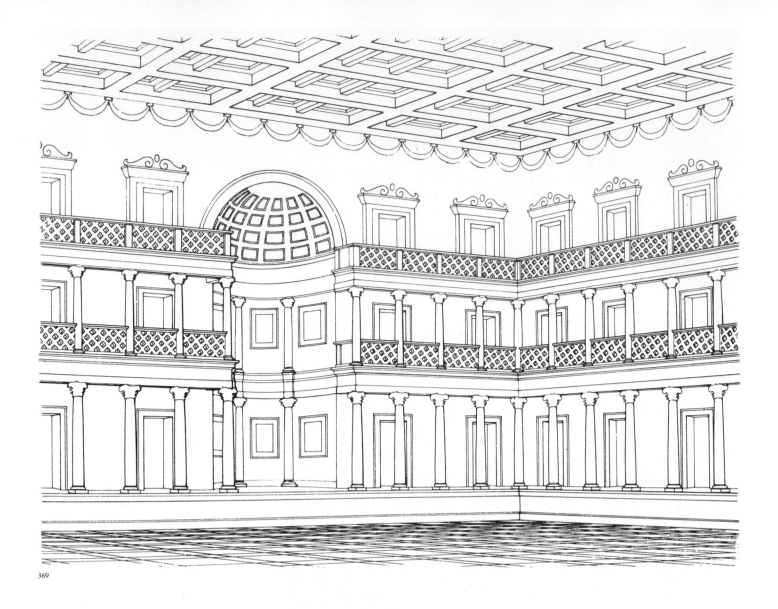

369

late to the central arch. These columns are united at the top by a new invention, an arched pediment, whose lower cornice is broken.

This kind of pictorial freedom in architecture can be seen at its extreme in a number of splendid eastern Mediterranean and North African gateways, façades, fountains, libraries, and above all theaters, such as that at Sabratha dating from the late second century A.D. (fig. 367). The relatively simple Greek and Hellenistic structures are far behind us. In the Roman theaters a high stage, here with a front composed of alternating square and semicircular recesses ornamented with carved reliefs, is dominated by a towering structure designed only for pictorial richness. With the greatest imaginative freedom three stories of Corinthian columns, now smooth, now fluted, are superimposed; some are single, some paired, some grouped in fours, some receding, some projecting for a maximum pictorial effect which may be said to capture in stone the fantasies imagined in paint by the Pompeiian decorators of the Fourth Style.

A spectacular Hadrianic library in the same style, the most nearly complete ancient library we possess, is that of Celsus completed about A.D. 135 at Ephesus. The façade (fig. 368) has been recently rebuilt from its original fragments and shows the appearance of a fine second-century structure, rich in its architectural relationships and in its sculptural ornament. The alternating arched and triangular pediments of the second

369. Interior, Library of Celsus, Ephesus (Drawing after W. Willard and J. B. Ward-Perkins)

370. *Commodus as Hercules.* c. A.D. 192. Marble, height 42½". Palazzo dei Conservatori, Rome

story are inherited from Hellenistic art. But what one might call (borrowing a term from music) the syncopated arrangement of the columns—so that one pair straddles an opening flanked by two pairs below—is a device used in Roman architecture in Italy as early as the middle of the first century A.D. The interior (fig. 369), doubtless roofed with wood, was three stories high. Elegantly spaced superimposed colonnades gave access to storage rooms for the rotuli, on which as always in pre-Christian culture the manuscripts were written.

The reigns of the five "good emperors" were followed in A.D. 180 by that of Marcus Aurelius' unworthy son and successor, Commodus, who took part in gladiatorial combats, experimented with imported mystery cults, and went about dressed as Hercules, complete with lion skin and club. A celebrated bust (fig. 370) shows Commodus in the role of Hercules, extending nervously the Golden Apples of the Hesperides, al-

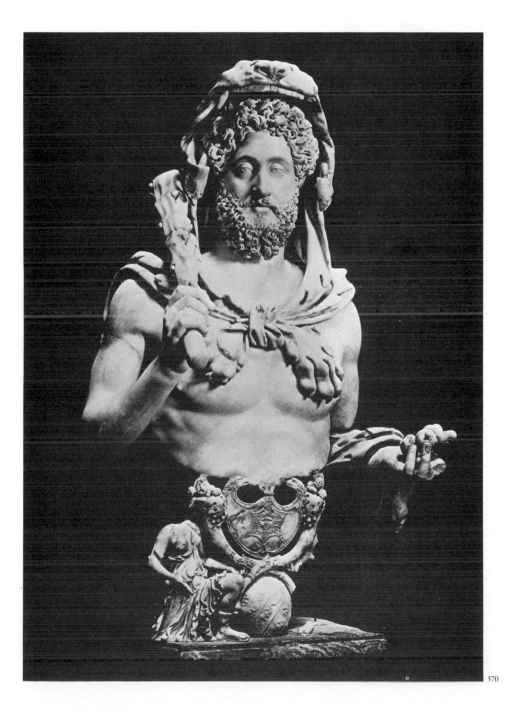

370

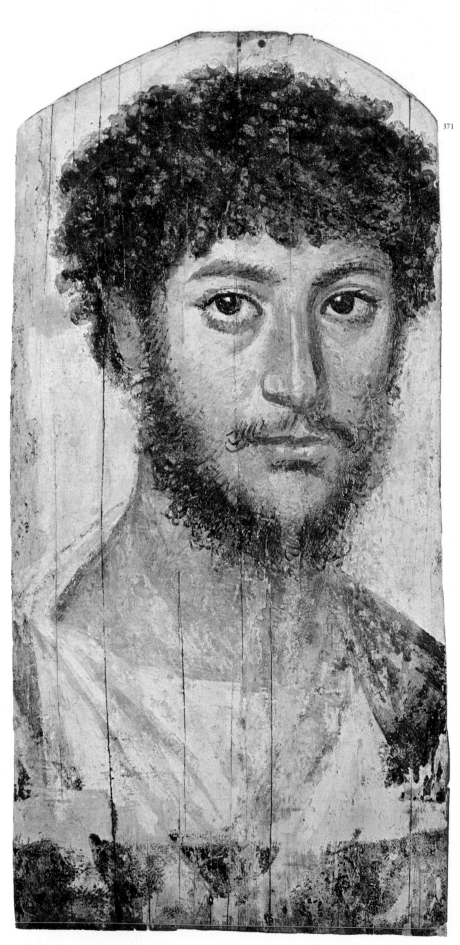

371. Portrait of a Graeco-Roman Egyptian, from a mummy case found at El Faiyûm, in the Nile Valley. 3rd quarter of 2nd century A.D. Encaustic on panel, 17⅝ × 9″. Staatliche Museen, Berlin

though his unsparingly rendered effete expression and slight physique are completely incongruous. As throughout Antonine sculpture, the locks of hair and beard, roughened and deeply undercut to suggest their color, are contrasted with the transparent pallor of the face. The eyes too are now rendered coloristically, the irises and pupils actually carved, a device that frees sculpture entirely from applied pigment and allows it to function pictorially in its own right. The serpentine complexity of the shapes, as disturbing as the portrait itself, reminds one of the nervous forms and patterns used in the sixteenth century in an Italian style known as Mannerism. In A.D. 192, members of Commodus' household conspired to have him strangled by a wrestler inappropriately named Narcissus. So ended the Antonine line, in a manner that prepared the way for the near chaos of the third century.

Little second-century painting remains, except a numerous series of portraits discovered at El Faiyûm in the Nile Valley. These images of the deceased were substituted for the traditional masks in mummies, which the Egyptians continued to make. They are the only ancient paintings in the encaustic, or hot wax, technique that have been discovered. Many are strikingly expressive, rendering with great vividness the members of the multiracial society of the Roman world. A Graeco-Roman Egyptian (fig. 371) looks at us with utter candor from superbly painted brown eyes, showing that in the rendering of light on flesh and hair the painters of the second century A.D. still retained the knowledge gained from half a millennium of Hellenic tradition. These paintings also admit us to the very presence of a sensitive and graceful people, in whom are summed up the traditions of more than three thousand years of continuous civilization.

The Third Century (192–284)

The assassination of Commodus inaugurated a period of almost unbelievable deterioration in Roman life and, consequently, in that of the entire Mediterranean and European world, culminating in a loss of Roman and even Italian preeminence and power in the Empire at large. For the next ninety-two years one brief imperial reign followed another. Except for those of Septimius Severus (ruled 193–211) and Claudius II surnamed Gothicus (ruled 268–70), each reign was terminated by violence, usually assassination by troops or by the Practorian Guard. This bodyguard of the emperor was the single agency in the Empire still strong enough to make and unmake emperors. With provincial and uneducated soldiers serving as emperors, the vast structure of the international and intercontinental imperial state tottered virtually leaderless; only the administrative bureaucracy maintained a semblance of order. Coinage was rapidly and alarmingly debased; inflation followed; agriculture and trade stagnated. The sole uniting factor was the all-pervasive fear of invasion by Germanic tribes to the north and by Parthians to the east.

SCULPTURE In imperial portraiture the penetrating frankness of the portraits of Commodus had already opened up new and unpleasant psychic vistas. Three third-century imperial portraits lead us even further into this hitherto unexplored realm. Caracalla (ruled 211–17), the brutal son and successor of the energetic Septimius Severus, appears so frighteningly his true self (fig. 372) that we hardly need to be told that he caused the murder of many persons, including his own brother Geta. The fea-

tures, the skin, and above all the hair and eyes are still rendered with a sense of the Hellenistic heritage of colorism, handed down from Flavian and Antonine art. But the cruelty concentrated in the intense gaze and fixed frown is new and terrible.

The insecurity of the third-century emperors could scarcely be more graphically rendered than by a detail (fig. 373) from a carved marble sarcophagus. These stone coffins had already in the second century replaced funerary urns as incineration gave way to burial. The boy shown to the left is generally taken to be the pathetic Gordianus III (ruled 238–44), who was made sole emperor by the senate at the age of thirteen after his grandfather and father, Gordianus I and Gordianus II, had both been murdered in the same year. The Genius of the Senate is shown as a bearded figure pointing to the unfortunate youth, whose countenance looks terror-struck. Under the anxious faces, the traditional curving folds of the voluminous togas still play about the figures, but there is a world of difference between these exaggerated, often meaningless lines and the firm structure of the Classical folds in the Ara Pacis (see fig. 329). The hand of a bald-headed man who looks over Gordianus' shoulder is stretched forth as if in protection—a useless gesture, for the young emperor was murdered when he was twenty years old by an Arab officer called Philip, who assumed the imperial power. The face of *Philip the Arab* (ruled 244–49) has been preserved for us in a masterpiece of characterization (fig. 374) even more devastating than the Caracalla portrait. The eyes peer out furtively below the endemic frown of the period; the expression is wretched and without intelligence; behind the brutish features the remnants of a debased mind cringe in fear of inevitable assassination. One recalls with nostalgia the far-off days of the godlike Augustus portrait (see fig. 326).

To delineate such psychological factors, a new and unsparing technique came into being; the features were constructed in broad, harsh planes; short, quick strokes of the chisel rendered the close-cropped hair

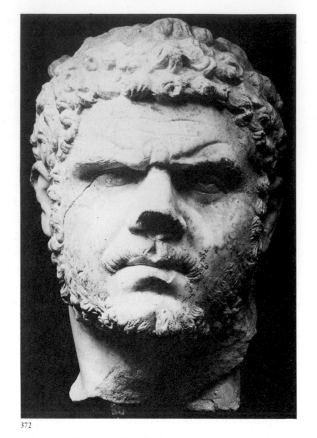

372

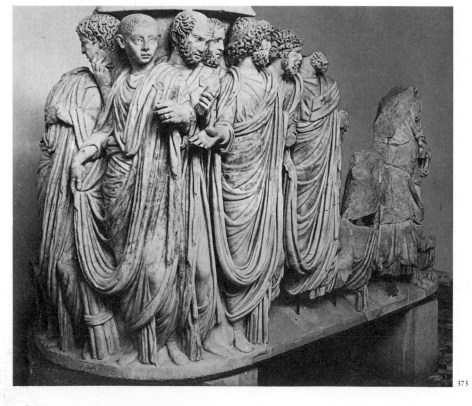

373

372. *Portrait of Caracalla.* c. A.D. 211–17. Marble, lifesize. Vatican Museums, Rome

373. *The Genius of the Senate Pointing to Gordianus III* (detail of a sarcophagus from Acilia, near Ostia). c. A.D. 238–44. Marble, height 58⅝". Museo Nazionale Romano, Rome

374. *Philip the Arab.* c. A.D. 244–49. Marble, lifesize. Vatican Museums, Rome

375. *Battle Between Romans and Barbarians* (detail of the *Ludovisi Battle Sarcophagus*). c. A.D. 250. Marble, height c. 56". Museo Nazionale Romano, Rome

and beard. The last remnants of Hellenic structure and Hellenic vision have vanished from images such as this portrait, just as the last echoes of Hellenic humanity seem to have deserted a society whose hero was the gladiator instead of the athlete.

Sarcophagus sculpture of the third century reflects the inner disorder of the period in a transformed relief style. The *Ludovisi Battle Sarcophagus* (fig. 375) is one of the most powerful examples. In comparison with the historical reliefs of the Arch of Titus and the Column of Trajan (see figs. 342, 343, 353), through which the Romans move in evident command of their own destiny and triumph through their own valor, here both Romans and barbarians seem trapped in a perpetual conflict for which even victory offers no solution. The Romans conquer by sheer weight, pressing down on a shapeless tangle of anguished barbarian faces and tormented torsos and limbs. Space, mastered through centuries of Greek and Roman effort, has been swallowed up. Neither depth nor background is represented; the wall of bodies is piled in the foreground plane like the heap of weapons on the base of the Column of Trajan (see fig. 352). And along with space the integrity of the human body has disappeared; not a single figure in this strange composition retains the capability of motion.

The new emotional style of third-century relief sculpture required still other methods than those we noted had been employed in the bust of Philip the Arab; a direct and extensive use of the drill, for example, was necessary to reinforce with dark holes the shadows in eyes and mouths and between the writhing locks of hair. Third-century art has been described as expressionistic; the word is as inexact as is impressionistic for first-century landscape painting, but at least it underscores the new emphasis on raw emotion to the detriment of structure and tradition.

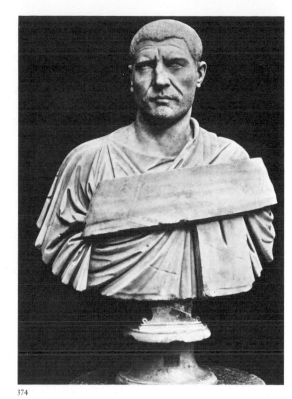

374

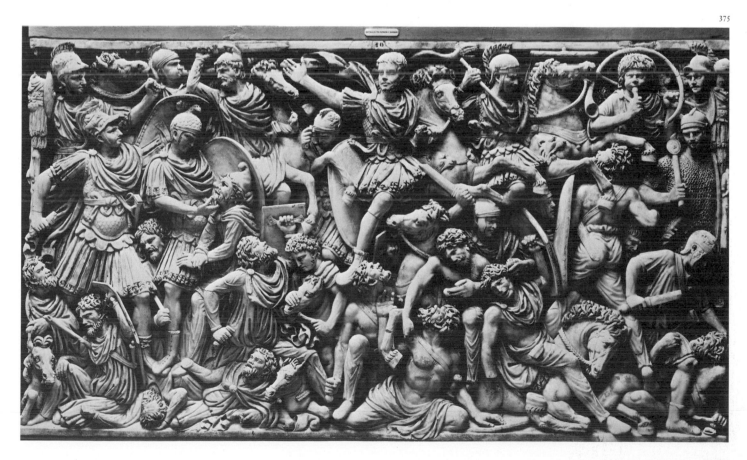

375

PAINTING AND MOSAICS We turn almost with relief from the atmosphere of chaos and terror suggested by such sculptures to the tiny portraits on gold leaf between panels of glass, which are among the rare treasures of third-century painting. The people shown in the *Family of Vunnerius Keramus* (fig. 376) may not have been Christian, yet they project an image of the dignity and self-possession we ideally assign to early Christians. This gentle family's special cast of countenance and the size and depth of their eyes seem to point to a Near Eastern origin, far from uncommon in Italy under the later Empire. Their name is Greek and written in Greek letters, but in an odd hybrid of Greek and Latin grammar. The painter still retains the ability to project features in depth—note the beautifully foreshortened ears—and to render with great precision the play of diffused light on features, costumes, and jewelry. But it is above all the calm composure of the figures that affords us a glimpse into a counterculture that retained human dignity in a hostile world.

An equally intimate and even more informative view of private life in the later Roman Empire is afforded by the enchanting third-century floor mosaic unearthed in 1960 near Hama in modern Syria (fig. 377). The central panel measures approximately 11 by 15 feet, and so the figures are lifesize. The subject is a small house orchestra completely composed

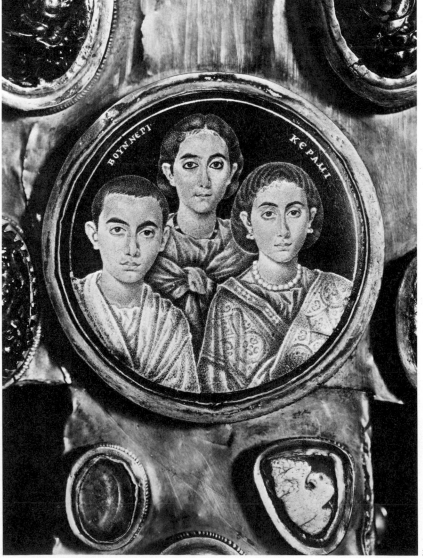

376.

376. *Family of Vunnerius Keramus.* c. A.D. 250. Painting on gold leaf sealed between glass, diameter 2⅜"; set into a cross, 7th century A.D. Civico Museo dell' Età Cristiana, Brescia, Italy

377. *House Orchestra.* Mosaic, Hama, Syria. 3rd century A.D.

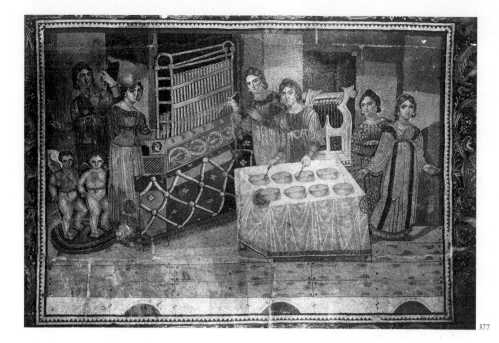

377

of women, which tells us something about the position of women as mere entertainers in the Roman world. While the play of light on the figures and the instruments is rendered with the same delicacy as in the gold-glass group portrait, the poses and the arrangements of the figures have already suffered the compression and distortion visible in relief sculpture of the period.

ARCHITECTURE During the early part of the third century, under Septimius Severus and his immediate successors and before the crisis of imperial power had really set in, extensive building projects were undertaken in the constantly growing capital. The most ambitious of these was the Baths of Caracalla (fig. 378), built well to the south of the older city center. Now stripped of their marble paneling, the vast concrete ruins presently form a grandiose historical setting for opera performances. Baths, ever more luxurious, were typical constructions of the Empire; there were 952 baths in operation in Rome in the middle of the fourth century. Caracalla clearly desired to outdo in magnificence the largest baths before his time, the second-century Baths of Trajan. The compact, carefully planned central structure (fig. 379), more than seven hundred feet in length, was divided into interconnecting halls for hot, cold, and tepid baths (*caldarium*, *frigidarium*, and *tepidarium*); a swimming pool on one side; and at each end a palaestra for exercise. In the thickness of the masses of masonry were rooms for services, including the heating of the air and of the water, which arrived in its own aqueduct and was piped to the appropriate baths in terra-cotta conduits. The caldarium, whose foundations are visible in the foreground of the aerial view, was a circular, domed structure (only slightly smaller than the Pantheon), illuminated by a row of windows under the dome. Openings between the halls must have provided magnificent architectural vistas.

A reconstruction of the central tepidarium (fig. 380) shows a hall about two hundred feet long, roofed by groin vaults apparently supported by eight colossal Composite columns, together with their intervening blocks of entablature, but actually resting more heavily on the piers concealed behind the columns. Under galleries on either side were four small cold bathing pools. Light came from clerestory windows grouped in threes

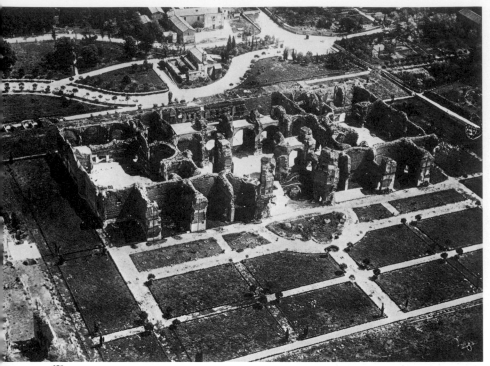

378

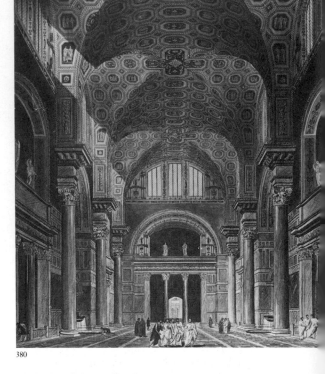

380

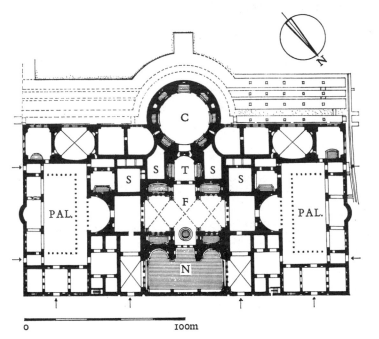

379

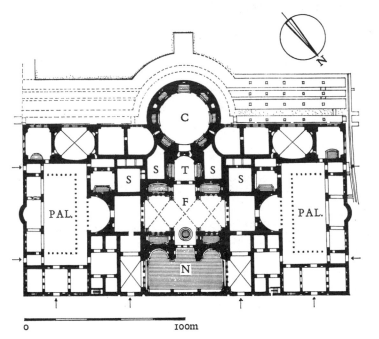

378. Baths of Caracalla, Rome. c. A.D. 211–17

379. Ground plan of the Baths of Caracalla, Rome C Caldarium; T Tepidarium; PAL. Palaestra; S Services; F Frigidarium; N Natatio

380. Tepidarium, Baths of Caracalla (Restoration drawing by G. Abel Blonet)

381. Temple of Venus, Baalbek, Lebanon. 1st half of 3rd century A.D.

under the arches of the groin vaults, which were coffered, stuccoed, painted, and gilded; the walls, floors, and columns were sheathed in colored marbles. The interior must have made an impression not only of great spatial openness but also of constantly changing light and color.

The most extraordinary structure of the third century is the little Temple of Venus, which was added to the vast second-century Roman sanctuary of the Syrian deity Baal at Baalbek (now in Lebanon; fig. 381). The portico is conventional enough, but the cella behind it is circular. The peristyle is carried around it, supported on free-standing Corinthian columns. Here the architect had his most brilliant idea, making the podium and entablature curve inward from each column to touch the cella, and then outward again to the next column, producing a scalloped shape.

381

This flow of outer concavities against inner convexity produces a free architectural fantasy as astonishing as some of the painted examples in the Fourth Pompeiian Style. The Temple of Venus at Baalbek has often been proclaimed an ancestor of the highly imaginative architectural inventions of the Italian Baroque. At this moment, it is almost more useful to regard it as one of the last examples of such fantasy before it was terminated by the rigidity of the later Empire.

The End of the Pagan Empire (284–323)

Under the "barracks emperors" of the third century, the government of the Empire degenerated into a situation bordering on anarchy and was frequently rent by civil war among rival claimants to imperial power. A rugged general of peasant stock from Illyria (modern Yugoslavia), the emperor Diocletian (ruled 284–305), attempted to put an end to disorder and in so doing imposed upon the Roman world a system that can only be compared with the despotism of Mesopotamian rulers. Even the shadowy authority still cherished by the Senate was set aside; personal rule was directly exercised by the emperor through an elaborate system of administrative levels, military and governmental, that functioned better in theory than in fact. Since the days of Septimius Severus, the imperial person had been considered sacred, a notion that contrasts bitterly with the ease with which individual emperors were murdered. Debasement and consequent collapse of coinage had led to economic breakdown and reversion to barter. A wealthy landowning class, precursors of the medieval nobility, had arisen throughout the Empire. Agricultural workers were increasingly attached to the land and workmen to their trades. Communications throughout the Empire had deteriorated.

The rigidity of Diocletian's system was a formal expression of an economic and political paralysis that was beyond any then-known cure. Because of the difficulty of governing the entire imperial territory from a

single center—and Rome had largely given way to Milan as the seat of administration in Italy—Diocletian divided power between two theoretically coequal emperors, each known as Augustus, one ruling in the West, the other in the East. Each Augustus took on a deputy and successor with the title of Caesar. This short-lived experiment was known as the tetrarchy (government of four rulers), and it heralded the inevitable breakup of the Empire, whose numerous political subdivisions were already infiltrated with barbarians. Under emperors as different as Nero and Marcus Aurelius, Christianity had long been recognized as a danger to the state, in that the Christians refused to burn incense before imperial statues and to render military service. Sporadic persecutions of Christians became intense; the last was ordered by Diocletian in 303. Two years later he abdicated and retired to a palace he had built in Split, near his birthplace.

A rapid succession of tetrarchies only perpetuated the anarchic situation that had existed before Diocletian. After a six-year struggle one tetrarch, Constantine the Great (ruled 306–37), seized sole imperial power

382. *The Tetrarchs*. c. A.D. 305. Porphyry, height c. 51″. Façade of S. Marco, Venice

383. Arch of Constantine, Rome. c. A.D. 312–15

382

after defeating his rival Maxentius at the Milvian Bridge over the Tiber River in 312, reportedly after a dream in which an angel appeared to him bearing the Cross and saying, "In this sign thou shalt conquer." In the Edict of Milan in 313, Constantine proclaimed toleration of Christianity, which had become the single most powerful spiritual and intellectual force in the Empire; in the same year Diocletian died in retirement. In 325 Constantine called and participated in the Council of Nicaea, which considered questions essential to the new religion. But Helleno-Roman polytheism did not rapidly die out; it was necessary in 345 to decree the death penalty for adherence to pagan cults. A short-lived attempt was made to restore paganism under Julian the Apostate (ruled 361–63), but at his death Christianity rapidly triumphed. In point of fact, however, the ancient gods were never entirely forgotten, but lived a subterranean existence in folklore as well as in the literary heritage. They were to surface at unexpected moments in the Middle Ages, and on occasion they triumphed in the Renaissance.

SCULPTURE An astonishing, in fact rather touching, red porphyry group, about half-lifesize (fig. 382) and formerly attached to a column, represents four tetrarchs—we are not sure which ones, but probably Diocletian and his colleagues. Each Augustus embraces a Caesar with his right arm, and each figure firmly grasps the hilt of a sword. The style would have impressed Gudea of Lagash as archaic (see fig. 134). Nothing remains of the naturalistic tradition in the representation of the human body, which had evolved in Egypt, Mesopotamia, and the Hellenic world throughout more than three thousand years. The figures have been re-

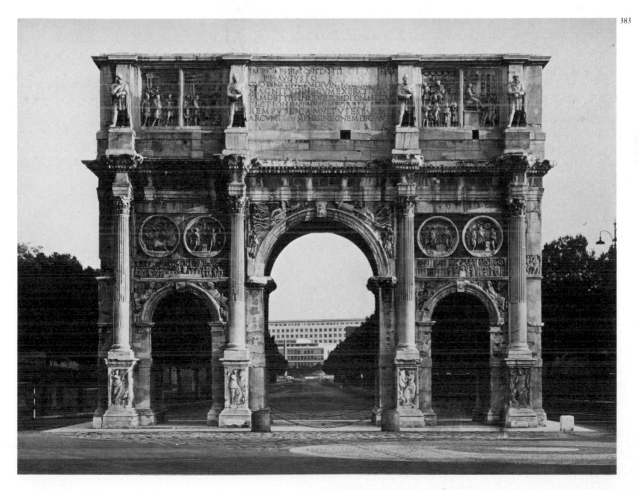

duced to cylinders, their legs and arms to tubes, their proportions to those of dolls, and their faces to staring masks. But if freedom and beauty of face and body have been sacrificed, anxiety has not. The figures clutch each other like lost children, and an art that no longer cares to analyze features cannot forget frowns. In fact, only the individuality of their frowns differentiates these figures.

The grand triumphal arch that Constantine erected in Rome from 312 to 315 to celebrate his assumption of sole imperial power owes much of its splendor to its predecessors (fig. 383). The three-arched shape was used earlier in the Arch of Septimius Severus in the Roman Forum, and most of the sculpture was lifted bodily from monuments built by Trajan, Hadrian, and Marcus Aurelius, whose heads were recarved into portraits of Constantine and his generals. The sculpture contributed by Constantine's artisans (see fig. 356) is startling. Tiny figures with huge heads, stiffly posed, are aligned on either side of the emperor as he addresses the people from the rostrum in the Roman Forum, whose buildings have been reduced to toys in the background. A few channels made by the drill suffice to indicate what had been the glory of Roman ceremonial sculpture, the melodic cadences created by the folds of the togas. Only here and there in faces and gestures can one distinguish a trace of the Hellenic tradition. Figures and architecture have been locked into an embracing structure of pattern allowing for no independent movement.

Technical inadequacy may account for part of the change; no official relief sculpture had been made in Rome for eighty years, and only artisans were available to Constantine. But the renunciation of the Classical tradition seems to have been deliberate. A new and impressive Constantinian style was rapidly formed, to be carried out by better-trained artists. One gigantic remnant is the marble head of a colossal statue of the emperor (fig. 384), which once was enthroned in the apse of his basilica. Head, arms, and legs were of marble, and the drapery probably of bronze plates over a masonry core. It is hard to keep from thinking of an august predecessor—the Zeus of Phidias at Olympia. No accusation of technical decline can be leveled at this magnificent head. The features and the neck muscles are superbly modeled, showing a full understanding of Hellenistic tradition—with one significant and disturbing exception: the eyes are enlarged beyond all verisimilitude. Carved with all the colorism of Antonine sculpture, even to the extent of a tiny fleck of marble having been left in each eye to represent the reflection of light in the transparent cornea, they stare above and beyond us as if we could never reach their owner, as if his godlike gaze were fixed upon eternity. This enormous enlargement of the eyes as an indication of sanctity or of inspiration became a convention in Early Christian and Byzantine art.

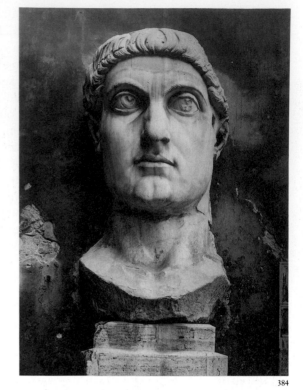

384. *Constantine the Great.* c. A.D. 315. Marble, height 96″. Palazzo dei Conservatori, Rome

ARCHITECTURE Two structures of great size and importance from this brief transitional period between the ancient world and the early Middle Ages still remain partially standing. One is the gigantic palace which Diocletian began to build in 293 for his retirement near his birthplace at Salona. Much of the present-day city of Split is built inside the palace walls, but its original appearance has been reconstructed in a model (fig. 385). The plan (fig. 387) and appearance of the palace reflect the changed conditions of the Empire. A free arrangement of structures like Hadrian's Villa at Tivoli (see fig. 360) was no longer possible in this unstable portion of the Empire, and so close to the sea. The complex had to be defended, and it was thus laid out on the plan of a Roman camp, with the main streets intersecting in the exact center. The palace was sur-

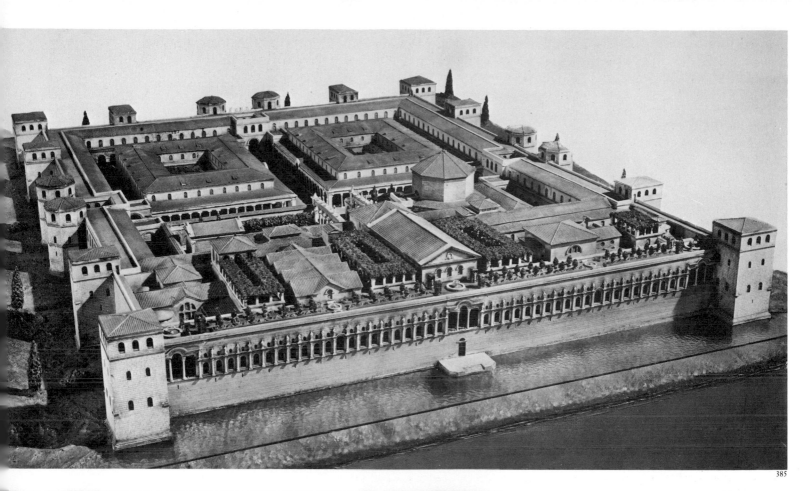

385

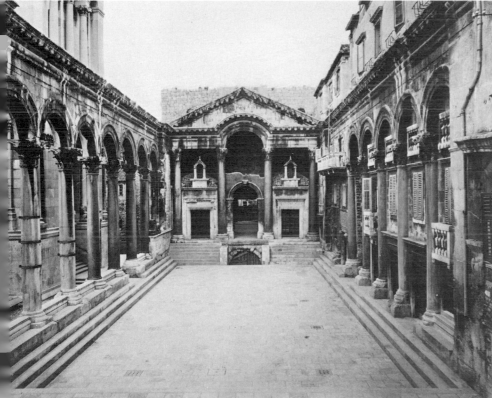

386

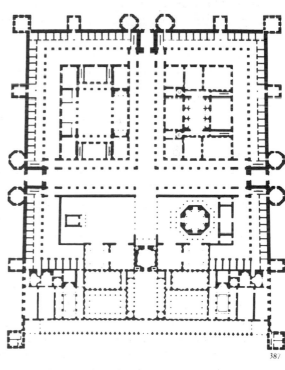

387

385. Palace of Diocletian, Split, Yugoslavia.
c. A.D. 293. Museo della Civiltà Romana,
Rome (Architectural reconstruction by
E. Hebrard)

386. Peristyle court, Palace of Diocletian, Split

387. Plan of the Palace of Diocletian, Split

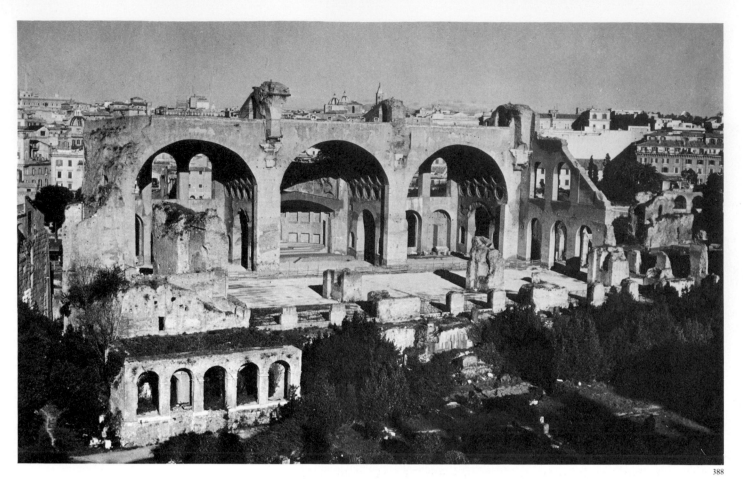

388

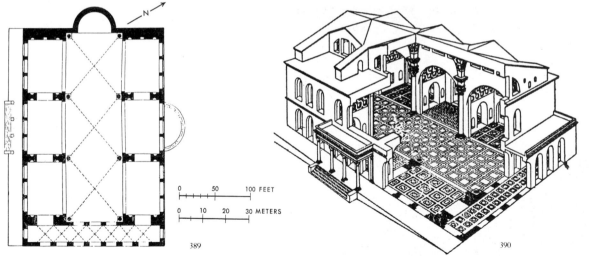

389 390

rounded by walls and towers except on the south side, which overhung
the sea and could be approached only by boat; the imperial apartments
ran along this side, with arched windows embraced by an engaged colon-
nade. An octagonal structure visible toward the right side of the model
was designed as the emperor's mausoleum; it is in good condition and is
now in use as a cathedral. A peristyle court, now forming the principal
square of Split (fig. 386), gave access to the mausoleum on the left and
the imperial apartments at the end through a sort of triumphal arch once
crowned with the customary bronze group of a four-horse chariot driven
by the emperor. In the center of this arch the Emperor made his formal
appearances. The most remarkable feature of this court is the complete
change in the customary relationship of column and arch since the first

388. Basilica of Maxentius and Constantine,
Rome. c. A.D. 306–13

389. Plan of the Basilica of Maxentius and Con-
stantine, Rome

390. Basilica of Maxentius and Constantine,
Rome (Architectural reconstruction after
Huelsen)

391. Basilica of Trier, Germany. Early 4th cen-
tury A.D.

century B.C. Under the central pediment the entablature is bent upward to form an arch, as we have previously seen at Hadrian's Villa (see fig. 361). But the monolithic Corinthian columns in gray granite along both sides of the court no longer *embrace* arches; for the first time in Roman architecture, the columns *support* the arches directly. This decisive step prepares us for the structural innovations of Early Christian architecture in the mid- and late fourth century.

The other great pagan structure of the early fourth century is the basilica started by Maxentius in 306 and terminated under Constantine in 313 (figs. 388, 389, 390), a massive section of which still dominates the imperial forums in Rome. Curiously enough, the architect decided to relinquish the traditional basilican plan as we have seen it in the Basilica Ulpia (see fig. 351), with its long nave, side aisles, twin apses, and timber roof, in favor of the groin-vaulted form of hall used in the tepidaria of Roman baths, such as that of Caracalla (see fig. 380). The downward thrust of the heavy groin vaults upon the eight colossal Corinthian columns and the piers behind them must have been to a certain extent abutted by the six massive, octagonally coffered barrel vaults running at right angles to the nave; these replaced the usual side aisles of a basilica. The grandeur, simplicity, and openness of the interior seem to us so easily adaptable for religious use that it is hard at first sight to realize why the building was not adopted as a model for Early Christian churches. The answer (see Part Three, Chapter One) tells us much about the nature of early Christianity. Equally important is the fact that this mighty ruin was universally believed in the Renaissance to have been a temple.

A strikingly austere brick basilica (figs. 391, 392) of the early fourth century still stands at Trier, now in Germany but then one of the major cities of northern Gaul. Constantius, one of the tetrarchs, selected Trier as his capital in 293, and it remained the center of the whole western Empire until the removal of the administration to Milan. Interestingly enough, the basilica is still used as a church, and it forms a remarkable link with Early Christian architecture. The nave is an exact double square in plan, 100 by 200 Roman feet (95 by 190 modern feet), ending in a

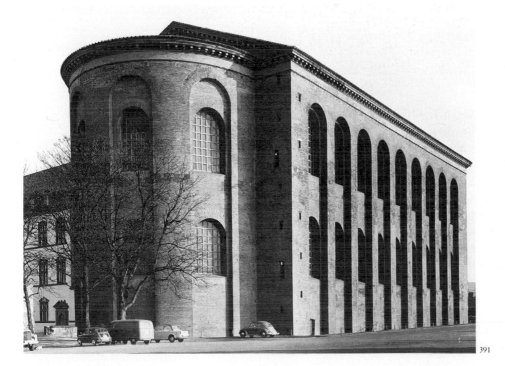

391

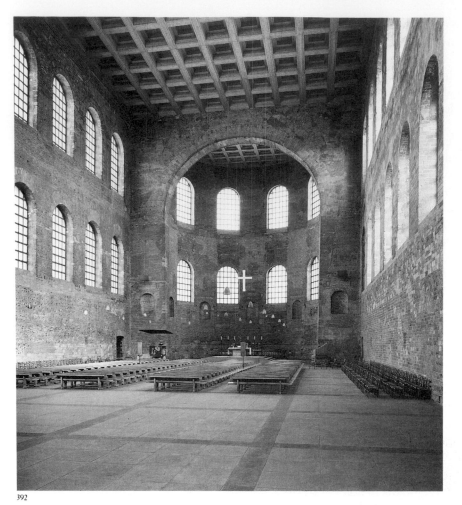

392

392. Interior, Basilica of Trier

393. *Exploits of Hercules*, detail of a floor mosaic at the Imperial Villa, Piazza Armerina, Sicily. Early 4th century A.D.

plain arch through which one looks into a semicircular apse. The equally plain walls are pierced by two superimposed stories of arched windows. Neither the interior nor the exterior shows ornamentation of any sort, not even columns, although the exterior windows are embraced by a blind arcade. By a clever optical device, the apse is made to look deeper than it really is: the window sills at both levels are about four feet lower than those in the nave, and the central windows are narrower. The effect of the blank walls and vast spaces is majestic.

MOSAICS In a final glance at the dying pagan tradition, we might note its survival, well into the fourth century, in floor mosaics in North Africa and in Syria, where these decorations have been discovered in great numbers. But the most spectacular find of all has been the villa, excavated since World War II, at Piazza Armerina in Sicily. In striking contrast to the fortified palace of Diocletian, this country residence, which may have been designed for the contemporaneous retirement of Diocletian's colleague Maximian, is freely arranged on the slope of a hill in a manner recalling the improvised plan of Hadrian's Villa at Tivoli. The complete series of late imperial mosaics that enliven the pavements of all the interiors of the villa at Piazza Armerina must have been done by a workshop from North Africa over a considerable span of time. Among the most striking is the group representing *Exploits of Hercules*, seen as separate episodes scattered over a white background. A nude warrior, sprawled over his dead horse and with one leg in the air (fig. 393), plunges

393

his sword into his breast. The powerful masses of his muscular body recall the Pergamene style of half a millennium earlier (see figs. 283, 286), and the rich changes of light, shade, and color which play over his tanned skin and establish the volumes of his body and limbs in depth show that even at this late date Hellenistic colorism was very much alive. In the next part of this book, we shall see this colorism employed not in the rendition of violence and bloodshed but in the depiction of hitherto unsuspected aspects of spiritual experience.

The heritage of Hellenism, preserved, transformed, and expanded by the systematic nature of Roman civilization, not to speak of the enormous original contributions of the Romans themselves, was to form the basis for the art and thought of all succeeding periods. Roman art blends almost imperceptibly into that of early Christianity, and the great monuments of Roman civilization, many of them in better condition than they are now, remained as a source of wonder and inspiration for the Middle Ages, the Renaissance, the Baroque, and modern times. Subsequent European and Near Eastern art, in any field, is unthinkable without the Roman contribution.

TIME LINE IV

Model of
Etruscan
temple

She-Wolf

Apollo of Veii

HISTORY

800 B.C.	Rome under Etruscan domination; overthrows Etruscans to establish Republic, 509
	Gauls sack Rome, 387
300	Rome extends rule to southern Italy, Sicily, Sardinia, Corsica
	Rome defeats Carthage in First Punic War, 264–241; expels Carthaginians from Spain, invades Africa, 202–201
100	Rome victorious over Macedon, 168, extends rule over Macedonia, Asia Minor, Egypt
	Sack of Athens, 86
	Sulla becomes dictator, 82–79
	First triumvirate (Pompey, Caesar, Crassus), 60

CULTURE

Invention of paper, China
Vast quantities of Greek sculptures brought to Rome in triumph after victory over Macedonia
Earliest water mills
Golden Age of Roman Literature: Cicero, Catullus, Virgil, Horace, Ovid, Seneca

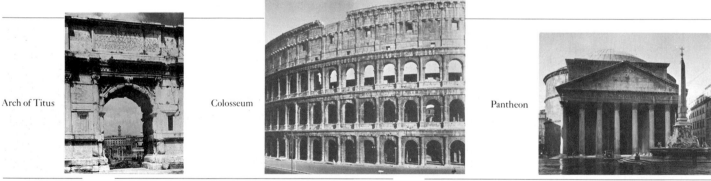

Arch of Titus

Colosseum

Pantheon

50 B.C.	Caesar assumes power, 49; assassinated, 44
	Second triumvirate, including Octavius, 43
A.D. 1	Octavius first Emperor as Augustus Caesar, 27 B.C.–A.D. 14
	Principal later imperial reigns:
100	Julio-Claudians (Tiberius, Claudius, Nero), 14–68; Flavians (Vespasian, Titus, Domitian), 69–96
	Trajan, 98–117; Hadrian, 117–38
	Antonines (Antoninus Pius, Marcus Aurelius, Commodus), 138–80
	Septimus Severus, 193–211; Caracalla, 211–17
300	Diocletian, 284–305 (Tetrarchy, 293)
	Constantine the Great, 324–37

Vitruvius completes his ten books on architecture, *De Architectura*
Jesus Christ (c. 3 B.C.–A.D. 30)
Invention of glassblowing; Pliny the Elder, *Natural History*
Paul (d. 65) spreads Christianity to Asia Minor, Greece, and Italy
Tacitus (55?–after 117)
Ptolomy, astronomer (d. 160)

Galen, physician and anatomist (d. 201)
Plotinus (d. 270)

*Patrician
Carrying Two
Portrait Heads*

*Temple of the
Sibyl, Tivoli*

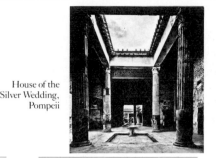

*House of the
Silver Wedding,
Pompeii*

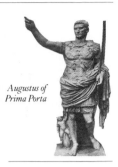

*Augustus of
Prima Porta*

PAINTING, SCULPTURE, ARCHITECTURE

Etruscan temple as described by Vitruvius
Cinerary urn, Chiusi; sarcophagus, Cerveteri; *Apollo of Veii*
Hunting and Fishing and *Dancing Woman and Lyre Player,* Tarquinia
Tomb of the Reliefs, Cerveteri
She-Wolf; Wounded Chimaera; Bearded Man (Lucius Junius Brutus?)
Bronze mirror and *Ficoroni Cist* from Praeneste
Porta Marzia, Perugia
Temple of Fortuna Virilis, Rome; Temple of the Sibyl, Tivoli
Patrician Carrying Two Portrait Heads; Head of a Roman; L'Arringatore
Head of Pompey
Forum, Pompeii
Wall paintings: from the *Odyssey*, Rome; Villa of Mysteries, Pompeii
Garden Room, Villa of Livia, Rome
Still Life, House of Julia Felix, Pompeii
Architectural View, from Boscoreale

PARALLEL SOCIETIES

Persian	800 B.C.
Greek: Archaic	
Etruscan	
Gauls	300
Roman Republic	
	100

*Marcus
Aurelius*

*Faiyûm
Portrait*

*Constantine
the Great*

*Palace of
Diocletian*

Statues of Augustus; *Ara Pacis*
Forum of Augustus, with Temple of Mars Ultor
Pont du Gard; Maison Carrée
Gemma Augustea; houses of Silver Wedding and Faun, Pompeii; wall
 paintings: House of M. Lucretius Fronto, Pompeii; *Architectural
 View* from Herculaneum; landscapes, Rome and Pompeii
Porta Maggiore; insulae at Ostia
Flavian portrait sculpture; Arch of Titus, with sculpture; Colosseum
Forum of Trajan with Basilica Ulpia, Column, and Market; arches and
 streets of Trajan
Hadrian's Villa, Tivoli; Pantheon; *Portrait of Antinoüs*
Base of Column of Antoninus Pius; statue of Marcus Aurelius; *Commodus*
Library of Celsus at Ephesus; Theater at Sabratha; Faiyûm Portrait;
 Family of Vunnerius Keramus
Caracalla; Philip the Arab; relief of Gordianus III; Ludovisi sarcophagus
Temple of Venus, Baalbek; Palace of Diocletian; *Tetrarchs;* mosaics at
 Piazza Armerina
Portrait and Arch of Constantine; Basilica of Maxentius; Basilica, Trier

Roman Empire	50 B.C.
	A.D. 1
	100
Early Christian	
	300

THE MIDDLE AGES

THREE

Two overriding circumstances separated the Middle Ages from the ancient world. The first was the gradual dissolution of the Roman Empire into a wide variety of successor states. Some of these retained or revived imperial pretensions, while others frankly proclaimed their ethnic basis; however, all achieved only limited territorial jurisdiction, thus preparing the way for the modern nation-state. The second was the dominance of two religions with universal claims, first Christianity and then, in competition with it, Islam. Each religion demanded total allegiance on the part of the worshiper, sometimes to the point of active judicial and military hostility to other faiths—as seen in religious executions and holy wars. Each ordered the worshiper's ethical standards and daily life. In ultimate decisions each valued revelation above reason, that supreme goal of ancient thinkers. Each prepared the worshiper in detail for an afterlife.

Both circumstances were to have profound consequences for art. The first resulted in a far greater repertory of artistic forms, corresponding to the necessities of individual states and regions, than was possible even under the large tolerance of the Roman Empire. The second demanded a religious architecture that could handle ceremonially vast masses of people, and whose interior spaces, therefore, tended to determine the character and appearance of their external forms. Equally important, the emphasis of religion on an otherworldly goal tended to weaken interest in naturalistic representation of the spaces and objects of this world. It also prohibited outright the depiction of the nude human body, the pride and glory of Helleno-Roman art, save when required by a specific religious or historical subject; even in such an instance, no beauty is discerned in the body. Explicit Scriptural support for this attitude is unfindable, but it may derive from the shame of Adam and Eve at recognizing their nakedness and from Saint Paul's distrust of all sexuality. Early in the period, therefore, representations of even the clothed human figure betray a lack of knowledge of or interest in the underlying structure of the body. As an inevitable corollary of religious antinaturalism, schemata inherited from one generation to the next were inexorably substituted for the active pursuit of visual reality which, in one form or another, had occupied the attention of Mediterranean artists for more than three millennia.

At the same time, the emphasis on faith and the consequent transcendence accorded to the inner life opened up for artistic exploration rich areas of human experience hardly touched by the visually oriented art of the Helleno-Roman tradition. Formalized shapes, patterns, and color relationships, whether based on nature or wholly abstract, had been permitted only an ornamental role in ancient art. In the Middle Ages such elements took on extreme importance as vehicles for feeling and imagination. In certain aspects of Celtic and Islamic art, in fact (see figs. 11, 466), abstraction entirely replaces elements derived from observation. Paradoxically enough, in the service of otherworldly religions, engineering science took enormous strides in the Middle Ages. Such brilliant achievements as the lofty domes on pendentives, which

crown Byzantine churches (see figs. 429, 447); the interlacing arches, which opened up new possibilities for mosques (see fig. 472); and the soaring ribbed vaults sustained by external buttressing, which roof Gothic cathedrals (see figs. 585, 597), were feats beyond the imaginings of Roman architects.

The dividing line for both the political and the religious determinants fell within the reign of the emperor Constantine (A.D. 312–37). The breakup of the Empire was heralded by his removal of the capital from Italy (where Milan had for decades replaced Rome as the chief administrative center) to Byzantium, on the shores of the Bosporus, which he rebuilt and renamed Constantinople. The direct result of this move was a new and eventually permanent division of the Empire under Constantine's successors along more or less the same lines as the tetrarchy. The Eastern Roman (or Byzantine) Empire survived for more than a thousand years, although constantly diminished by foreign inroads, until Constantinople was conquered by the Turks in 1453. The Western Roman Empire was repeatedly invaded during the fifth century by Germanic tribes, who twice succeeded in sacking Rome. These tribes had already eaten away at the outlying provinces, and had infiltrated the very administration of the Empire; many had become Christianized. The deposition in 476 of the last Western Roman emperor, Romulus Augustulus, by the Gothic king Odoacer merely gave formal expression to what had long been a fact, the take-over by Germanic tribes of the whole of the Western Empire as a series of separate kingdoms.

Possibly the religious policy of Constantine, beginning with his promulgation of the Edict of Milan in 313 along with his co-emperor Licinius, would have been inevitable no matter who sat on the throne. The number of Christians in all parts of the Empire, even in the imperial administration and in the imperial family, had become too great either to persecute or to ignore. Constantine's later activities as sole emperor—for example, his presiding role at the Council of Nicaea in 325—reinforced the new importance of the Christian religion. His transfer of the capital to the most heavily Christianized region of the Empire made the supremacy of Christianity all but inevitable.

Christianity rapidly replaced Roman and other forms of polytheism as the official, indeed the only legal, religion of the entire Mediterranean world. Adherence could be enforced by the full machinery of Roman imperial government, and by almost all the successor states for many centuries. Poor at its humble beginnings, the Church was now rich. Thus began a wholly new era in human history, in which political and religious phenomena were inextricably mixed, not within national boundaries, as often in the ancient world, but on an immense scale, with worldwide claims. Even after the West had been overrun by barbarians, who set up their own monarchies, the title of the Roman Empire was revived by Charlemagne in 800 and maintained until extinguished by Napoleon in the early nineteenth century. The Emperors were still called "Caesar"—the origin of the German *Kaiser* and the Slavic *czar*. Although their capital was mobile, and the emperors were almost uniformly Germanic, their authority over lesser sovereigns was not firm until they had gone to Rome to be crowned. For the bishop of Rome had come to be recognized as pope (from the expression for "father"), supreme head of the Christian Church—in the West, at least—and however little his person might at times be respected, divine authority was considered to be in his hands. The language both of the Church and of all official documents and learned writing throughout most of the Middle Ages in the West remained Latin. In the largely Greek-speaking East papal preeminence was not recognized, nor was there any equivalent to papal authority among the patriarchs holding sway over the regional divisions of the Eastern, or Orthodox, Church.

Gradually, under the dominance of interlocking church and state authority, a new phenomenon perhaps too easily characterized as the "medieval mind" came into being. In sharp contradistinction to the generally unfettered intellectual life of Greek and Roman antiquity, all knowledge in the Middle Ages was subordinated to the transcendent belief in divine revelation through Scripture and Church tradition. Accepted theological principles known as *dogma*, belief in which was considered necessary to salvation, were adopted at Church councils, proclaimed by popes, and refined by theological writers. Deviation was

considered *heresy*, a crime punishable in theory and too often in fact by the most painful forms of death. Yet heresies arose and spread, sometimes throughout entire regions, until they were suppressed, occasionally with a ruthlessness that might have startled the pagan persecutors of the gentle early Christians. Surprisingly, the greatest of the theologians were well read in Greek and Latin literature and philosophy, and while rejecting pagan deities as demons, they systematically incorporated ancient wisdom and scientific knowledge into the structure of Christian faith. Many, indeed, maintained that there was no conflict between faith and reason. We owe most of our knowledge of Classical writings to the Church's practice of copying ancient manuscripts for preservation in their libraries. Still more unexpected, a great deal of scientific investigation in the Islamic world permeated Christendom, partly because of the Crusades designed to rescue the Holy Land from its Arab conquerors.

A special feature of Christianity in East and West was the new institution of *monasticism*. In the troubled conditions of the later Empire, invaded and dismantled by the barbarians, and throughout the Middle Ages, thousands of men and women sought refuge in a total renunciation of worldly life, including marriage, by founding communities of single persons known as monasteries (from the Greek word for "one"). Many monks and nuns, especially in the East, were hermits, living a life of perpetual penance, meditation, and prayer in complete solitude, in caves, huts, or eventually groups of separate structures, and coming together only for corporate services. In contrast to these *eremitic* groups, there arose organized *cenobitic* orders (from the Latin word for "dining place"), who inhabited separate cells in larger structures, ate together—in silence, while listening to sacred readings—and celebrated all liturgical rites in common. Both monks and nuns were often trained as scribes, and one of their principal duties was to copy the Bible, liturgical books, and theological writings as well as those works of pagan authors considered worth preserving. The monasteries, therefore, became the main centers of learning before the year 1000. In the convents for women, the first all-female communities we know except for such tiny Roman groups as the nine Vestal Virgins, the role and authority of women were vastly enriched. Although they still needed male priests to celebrate Mass, women ruled their own convents and indeed governed whole orders of nuns, subject to the often distant authority of a bishop. Women in the convents, just as men in the monasteries, painted the illustrations for the manuscripts they copied. Thus for the first time in human history we have works of art indisputably created, and sometimes signed, by women; such works often also illustrate theological writings by women authors (see figs. 569, 620).

In the largely illiterate world outside the monasteries, cities had shrunk to a fraction of their original size or had even disappeared. Barbarian chieftains, soon Christianized, ruled as local or regional lords, with their practice of hereditary tenure of land giving rise to the concept of a "noble" class, foreign to the ancient world. The *feudal system* (based on a Latin word for "oath") gradually arose and held sway throughout most of the Middle Ages. The peasant held his land from his local lord, who had sworn loyalty to a higher regional nobility, who in turn had taken an oath to a national king; over all, in theory, ruled the emperor. Marriages often generated conflicting loyalties through the inheritance of lands pledged to different overlords. And in point of fact regional nobles, throughout the Middle Ages, ruled with slight regard for royal power, just as the kings, supreme only in their own immediate territory, obeyed the emperor only when he could enforce his wishes. But imperial secular authority was held to be worldwide, corresponding to the universal spiritual authority of the pope. The system was formalized and justified in the thirteenth century by the great Italian poet and humanist Dante Alighieri in his *De Monarchia* (On Monarchy).

Not long after the year 1000 a disruptive element made its appearance within the feudal system—the rise of cities. Often these were revived Roman centers, but sometimes important towns, such as Florence, grew up on sites that were mere villages in antiquity. Owing their growth and rapidly increasing prosperity to manufacture, finance, and trading with each other and with the monarchies on a surprising scale, by land and sea, these cities were ruled by a new class of bourgeois merchants, unwilling to recognize the

authority of kings and nobles, but often unable to defend their rights. In most of Italy and parts of northern Germany the cities established themselves as wholly independent republics, recalling vividly the city-states of ancient Greece. And they were often able to extend their rule over considerable regions and even disenfranchise the nobles. In the later medieval cities, whether or not they were independent, the *cathedrals* (churches containing the bishop's *cathedra*, or chair of authority) assumed a new importance and eventually colossal size, as symbols of civic dignity within the church-state structure. In the cities the universities rapidly replaced the monasteries as repositories of knowledge and incubators of new thought and, since any qualified male could attend, provided some social mobility within the system.

The theologians and philosophers of the Middle Ages, through the universities, necessarily had to work in harmony with Christian dogma, and they were eventually able, after many centuries of constant thought and writing, to erect a philosophical system that corresponded intellectually to the codified church and state governing their world at every level. *Scholasticism*, as the system came to be known, was perhaps the most characteristic expression of the "medieval mind." Every observable phenomenon of the natural world and human existence could be set in its proper place in this towering structure, justified by Scriptural authority, theological argument, and the reasoning of ancient philosophers. By the thirteenth century, in the *Summa* of Saint Thomas Aquinas, the system attained its peak of complexity and logical interrelationship of elements, reaching from the mysteries of heaven to the tiniest aspect of life on earth to the certitude of human destiny. Unlike the companion system of political and ecclesiastical authority, beset by all the frailties of human nature, Scholasticism worked very well indeed and proved all of its points to its own satisfaction. No one could have foreseen that free human observation and inquiry beginning in the Renaissance would eventually bring Scholasticism down, just as the example, at least, of the independent republics was to undermine both feudalism and the Empire and as the new emphasis on individual conscience was to split the Western Church.

It is sometimes maintained that Early Christian art and Byzantine art are in reality continuations of tendencies that had begun under the later pagan emperors and that they should be treated, therefore, as a final phase of ancient art. But there is a fundamental change between the conceptions of the human figure and surrounding space—and indeed the very nature and purpose of architecture, sculpture, and painting—prevalent in Greek and Roman art and those strongly evident in the new art of Christianity. This change was felt by the early Christians themselves, who used pagan buildings as quarries for materials and architectural elements, and destroyed pagan statues and paintings as idolatrous and sinful, without regard for artistic value. The attitude of the early Christians toward the past contrasts strongly with that of the Romans, who protected their own earlier buildings wherever possible and cherished the statues and paintings of the Greeks. It would be more significant for us to consider the surprising developments of third-century pagan art as already partly medieval. In any event, the new appreciation of both the antinaturalistic art of the late Empire and that of the Middle Ages is an intellectual reconquest, dating from the Romantic period of the later eighteenth century and strongly reinforced in modern times.

CHAPTER

EARLY CHRISTIAN AND BYZANTINE ART

ONE

The earliest Christians had no practical need for art of any sort. Jesus himself, and after him the Apostles, preached and taught in houses, on hillsides, from ships, in streets and squares, and even in the Temple. Persecutions of Christians were by no means as continuous and thorough as is popularly believed. Between persecutions Christianity flourished and spread in its own quiet way. The new religion had its competitors, of course, among the mystery cults which had abounded even in the days of the Roman Republic—the religions of Dionysos, Isis, Cybele, Attis, and Mithras were the most important. But it would be a mistake to regard early Christianity as in any way comparable to these cults. True, they all promised salvation in an afterlife through the intervention of a particular divinity. But, unlike Christianity, they either culminated in orgiastic rites or included sanguinary ceremonies. For example, votaries of Mithras, the god of the favorite mystery cult of the Roman soldiery, lay on couches surrounding an altar before which a live bull was sacrificed and then drank his warm blood.

Early Christianity was nonviolent in essence. Would it had remained so! Alone save Judaism among the religions of the Roman Empire, it proclaimed a system of ethics that governed the entire behavior of the worshiper in all aspects of daily life, and alone save Judaism it possessed written authority embodied in a rich library of Scriptures, whose authenticity was generally accepted despite disagreement on specific elements and interpretations. And even Judaism, always an ethnic religion, could not vie with the universal claims of Christianity. Thus, Christianity held not only a promise of individual salvation, but it also rapidly became a corporate religion, which created a counterculture inside the Roman state. Enthusiasts of the mystery cults had no objection to participating in the largely perfunctory aspects of Roman state religion, which included burning incense before the statue of the divine emperor. To the Christian such rites were anathema, and thus the very strength and pervasiveness of the Christian faith were interpreted as threats to the stability of the Empire. A tribute to the extraordinary success of early Christianity is that the two most systematic persecutions, those of Decius in 249–51 and Diocletian in 303–5, came so shortly before the Edict of Milan in 313, which marked, if not the final triumph of the new religion, at least its liberation from fear.

During the later first and second centuries, Christian communities remained small, and believers worshiped in private houses. The basic ceremony, doubtless simple, was the communal meal, celebrating the Last Supper, which began with the breaking of bread and concluded with the drinking of wine, in ritual perpetuation of Christ's sacrifice. The ceremony included prayers, the reading of passages from the Gospels and the Epistles, discourses on the part of successors to the Apostles, and sometimes "speaking in tongues," which is today so mysterious an aspect of early Christianity. A dining room was essential, and

the early Christians used the Roman triclinium (a dining room with a three-part couch extending around three sides of a table). In the crowded cities of the Eastern Empire, the triclinium was often located on an upper floor—the "upper room" mentioned in the Gospels and in Acts. Christianity was at first a religion chiefly for the lower classes, whom it sought to wean from the bloody spectacles of the arenas. Often, therefore, religious meetings took place in humble apartments in tenements, such as the insulae of Rome and Ostia (see fig. 336). By the third century the structure of the Mass—the word derives from the Latin *missa*, meaning "sent" or "finished"—had become clear; it was presided over by *episkopoi* (bishops; literally, overseers), whose qualifications are listed in 1 Tim. 3. A clear distinction was maintained between the Liturgy of the Catechumens, consisting of the reading of Epistles, Gospels, prayers, and hymns (today the Ordinary and Proper of the Mass), which those under instruction could attend, and the Liturgy of the Faithful, the actual Eucharist—from a Greek word for "thanks"—or sacrifice of bread and wine (today the Canon of the Mass), to which only baptized Christians were admitted. The catechumens were required to leave before the Eucharist, and could only hear but not see the Liturgy from an adjoining room. No altar was used, only a table brought in for the Eucharist and another table to receive offerings.

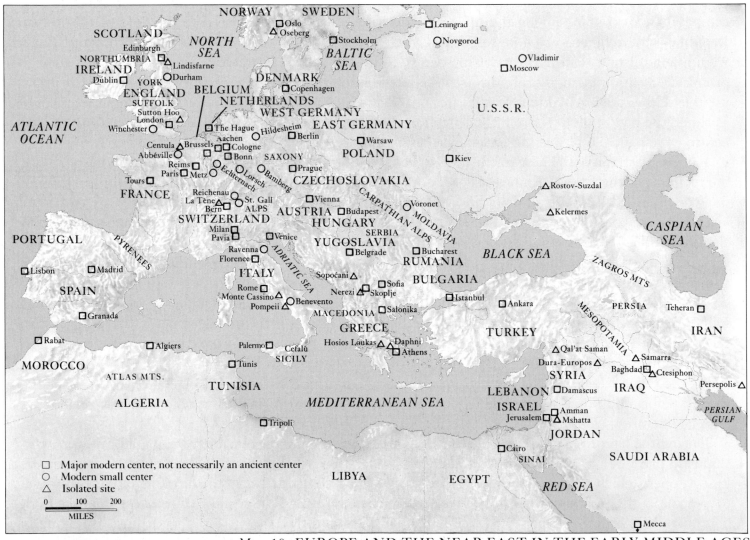

MAP 10. EUROPE AND THE NEAR EAST IN THE EARLY MIDDLE AGES

THE DOMUS CHURCH A special sort of house devoted exclusively to the observance of the Eucharist—a *domus ecclesia* (house of the church, from which the Italian *duomo* and the German *Dom*, both words for cathedral, were derived)—became the first type of church building. The earliest known, dating from just before 231, was found at Dura-Europos in Syria (fig. 394). It is an ordinary Greek peristyle house, somewhat remodeled for Christian use, with a separate room for the catechumens, a library, and a vestry. It could not have accommodated a congregation of more than sixty and can scarcely be said to have had any pronounced architectural character; if it contained works of art, they have perished. This building had a dais for a bishop's chair, and thus it can be regarded as a cathedral. The baptistery at Dura-Europos, however, did contain very modest wall paintings. The earliest Christian churches, like early synagogues, generally were inconspicuous; their sites were selected in popular quarters near the city walls. There is, however, evidence for the erection of one substantial Christian meeting hall in Rome just before the issuance of the Edict of Milan. The existence of many others, in cities throughout the Empire before the persecution by Diocletian, is mentioned by Eusebius of Caesarea, fourth-century bishop and historian.

THE MARTYRIUM A second kind of structure, the martyrium, was built over a martyr's grave or employed as a cenotaph to commemorate a martyr whose body was interred elsewhere. The earliest such structure known, dating from around A.D. 200, is a simple aedicula, or shrine, recently excavated under Saint Peter's in Rome (fig. 395). Inscriptions show that at that time the Christians believed it was the tomb of Peter.

394

394. Christian community house, Dura-Europos, Syria. Shortly before A.D. 231

395. Shrine of Saint Peter, Rome. Late 2nd century A.D.

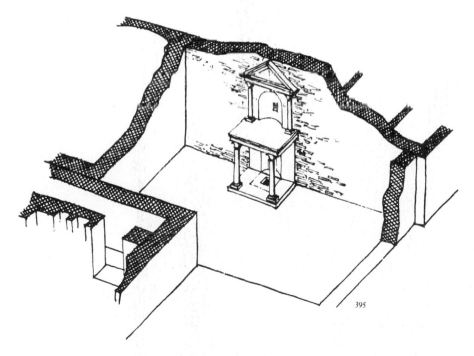

395

CATACOMB PAINTING The early Christians also dug catacombs. Since Christian belief in the resurrection of the body then prohibited cremation, the Christians could not use the *columbaria* (dovecotes) cemeteries of lower-class Roman burial societies, where urns were kept in little niches, many tiers high. Also the Christians felt the necessity of segregation from pagan burials. Like other Roman citizens, they could and did acquire property—as, for instance, their church buildings—and

they bought land outside many cities, choosing sites where it was possible to excavate passages in the rock. Often these catacombs took advantage of local quarries as starting points. From these, tunnels were dug systematically according to plans; to conserve space, the catacombs were sometimes excavated four or five levels deep. Superimposed niches for sarcophagi, and from time to time small chapels for funeral feasts and for commemorative services, were hollowed out.

The earliest known works of Christian figurative art have been found in these chapels. These simple paintings on plaster, spread over the rock surface, were executed by modest artisans working by lamplight in the dark, dank, and probably odoriferous surroundings. Most of these paintings were on ceilings, a position that required the painter to work with his head tilted. One of the earliest, on the underside of an arch in the Catacomb of Saint Priscilla, Rome (fig. 396), dates from the time of the Antonine emperors in the late second century. Four men and three women are seated—they no longer recline—around a table on which only plates of bread and a small pitcher are visible. The central figure is shown in the act of breaking the bread, which represents the culminating moment of the Eucharistic sacrifice. The style is a sketchy version of Roman illusionism, but is adequate to convey deep excitement, transmitted from face to face by earnest glances revealing the exaltation of the participants.

A somewhat less intense ceiling fresco (fig. 397), probably painted in the early fourth century, in the Catacomb of Saints Peter and Marcellinus, Rome, is interesting chiefly from the symbolic standpoint. The circular design, like a miniature Pantheon dome, was doubtless intended to suggest the Dome of Heaven. Four semicircles are arranged about the central circle and are united by bands forming a Cross to show that this universal Christian symbol both embraces and reveals Heaven itself. In the central medallion, flanked by resting sheep, is the figure repeated countless times in Early Christian paintings and sarcophagus sculpture, the Good Shepherd. These are the earliest images of Christ and, of course, were not intended to inform us about his actual appearance (about which we know nothing). The youthful, beardless shepherd, with a lamp over

396. *Breaking of Bread* (detail of a fresco, Catacomb of Sta. Priscilla, Rome). Late 2nd century A.D.

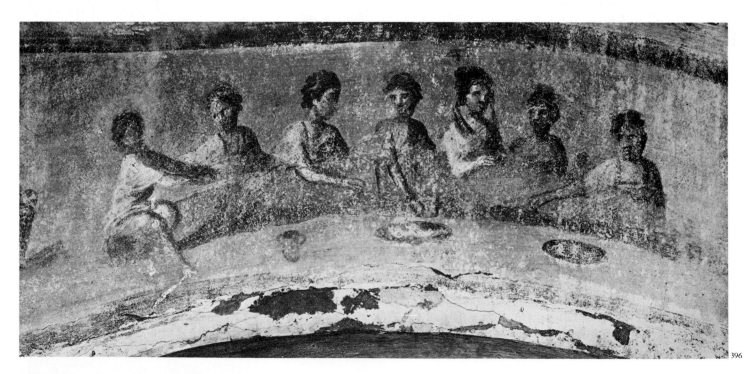

396

397. *The Good Shepherd*, ceiling fresco, Catacomb of SS. Pietro e Marcellino, Rome. Early 4th century A.D.

his shoulder, is a *symbol* of Christ, who said, "I am the good shepherd; the good shepherd giveth his life for the sheep" (John 10:11). One semicircle is lost, but the remaining three tell in simple imagery the story of Jonah, tossed from his ship at the left, swallowed by the whale at the right, and at the bottom reclining below the gourd vine. Here again we are instructed by Christ's own words, "and there shall no sign be given to it, but the sign of the prophet Jonas: For as Jonas was three days and three nights in the whale's belly; so shall the Son of man be three days and three nights in the heart of the earth" (Matt. 12:39–40). Thus, as always in Christian thought, the Old Testament is interpreted in the light of the New; in the apparent death and miraculous deliverance of Jonah are prefigured the Crucifixion and Resurrection of Christ, and through faith in him, the salvation of the true believer. The "sign of the prophet Jonas" is the Cross, between whose bars stand figures in what is known as the orant pose, the arms-wide gesture of prayer in Early Christian times, still used by the celebrant at certain moments in the Mass.

The only biblical wall paintings of truly monumental character that have come down to us from this early period are, however, not Christian but Jewish; they form a remarkable series and originally decorated the entire interior of a synagogue at Dura-Europos. However provincial in execution, these paintings are impressive in the solemn directness with which they set forth the biblical narratives. In *Haman and Mordecai* (fig.

398. *Haman and Mordecai* (detail of a wall painting from the Synagogue, Dura-Europos). c. A.D. 250. National Museum, Damascus, Syria

The Age of Constantine

398) these two figures move against a flat background with no indication of groundline, reminding us of the floating figures on the base of the Column of Antoninus Pius (see fig. 362). Mordecai stands in a Roman speaking pose, his right arm outstretched and his body enveloped in the folds of a cloak that strongly recall those of a toga. We can only surmise that Christian counterparts to this large-scale Jewish painting existed; none have yet been found.

The Edict of Milan brought about immediate and far-reaching transformations in the life of the Church through the new relationship between church and state it established. Given the strong interest and active role of Constantine, Christianity became to all intents and purposes an official religion, inheriting the splendors of the dethroned Roman gods. Although no complete colossal statue of the emperor is still preserved, the solemn *Colossus of Barletta* (fig. 399), a bronze statue probably representing one of his successors in the fifth or sixth century, clearly indicates the majestic and superhuman authority accorded to the person of the emperor in early Christian times. No longer divine, he was nonetheless sacred—the Unconquered Sun, the Vicar of Christ on earth.

THE EARLY CHRISTIAN BASILICA The newly official religion, encouraged as an effective arm of imperial administration, soon took on imperial magnificence. It could no longer aim at small and intimate congregations bound together by no other ties than those of Christian love. Huge crowds of worshipers had now to be accommodated and given access to sacred places and to the sacraments of the Church. Enclosed and roofed spaces were needed in great numbers. In rapid succession and under direct imperial patronage, scores of churches rose throughout Rome and other great cities of the Empire, especially Milan and Constantinople, and at sacred sites in the Holy Land.

A model for these new buildings was needed. Although the Christians had no compunction about utilizing architectural elements taken

from pagan structures, the temples themselves, even when not too small for the crowds of worshipers, were manifestly unsuitable; their very sites were regarded with abhorrence. The obvious solution was the Roman basilica, or meeting hall, which existed in every inhabited Roman center. As we have seen, there was no strict uniformity of plan for these meeting halls. Many Roman basilicas, some quite large ones, were simple halls with no side aisles; most were entered along one side, and had apses at either end. One apse soon proved convenient for the installation of the clergy and the enthronement of the bishop, but the entrance had to be placed at the opposite short end. The early portable communion table was replaced by a fixed altar, which had to be visible from a considerable distance and accessible to all worshipers at Communion. The long row of columns on either side of the nave played a double role in dramatizing the approach of the faithful to the altar and in segregating, by means of curtains hung between the columns, the catechumens from those who could witness the Mass of the Faithful.

The colonnades characteristically supported a lofty wall pierced by a clerestory. The roof was usually of an open timber construction, as was the case in so many ancient buildings. The large number of churches begun in the reign of Constantine required columns in great numbers and at great speed. It may be fairly doubted whether, in Constantinian Rome, it was possible either to produce so many or to order them from other regions. However, temples and other monuments of the Roman past offered an inexhaustible supply. Borrowed columns were thus uncritically installed in the new basilicas, with little or no regard for consistency of style, color, or size. Granite and marble columns, Corinthian and Ionic capitals, were placed side by side; capitals were sometimes set on columns they did not fit.

Saint Peter's was the largest and grandest of the Constantinian basilicas, in fact the largest church building in all Christendom (fig. 400, illustrating a fresco painted when the apse and part of the nave had already been destroyed, but much was still standing). It differed from most other basilicas not only in its stupendous size—an inner length of 368 feet—but also in its very nature as a combined basilica and martyrium. The apse enshrined the tomb of Peter under a marble canopy supported by four spiral columns (later used by Bernini as a model for his colossal construction in the seventeenth century). In order to accommodate the crowds of visitors to the tomb, a large hall—the transept—was erected at right angles to the nave between the nave and the apse (figs. 401, 402). Before the transept came the so-called triumphal arch, a common feature of Early Christian basilicas. The altar, at the head of the nave, was probably movable. The columns of the basilica were either Corinthian or Composite and of many different materials, including green marble, yellow marble, red granite, and gray granite. They were closely spaced, and supported a continuous, straight entablature. As in the Basilica Ulpia, Saint Peter's had double side aisles; the colonnade separating them supported arches. The building was not completed when Constantine died in 337 nor for some time thereafter. It is not known what wall decorations were originally planned; the frescoes covering the nave walls between the colonnade and the clerestory were painted in the fifth century, but the half-dome of the apse was filled with an immense pictorial composition in mosaic (see page 299 and figs. 407, 408).

Initially, there was certainly no suggestion that the transept plan symbolized the Cross, as it did in later times. The plan of Santa Sabina, erected in Rome from 422 to 432 (fig. 403), is more typical of Early Chris-

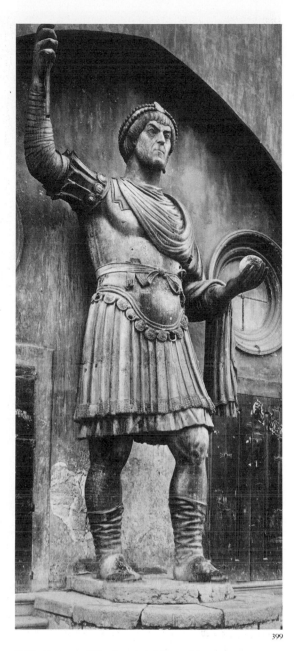

399. *Colossus of Barletta*. c. 5th or 6th century A.D. Bronze, height of original part (head to knee) 11′ 7¾″. Barletta, Italy

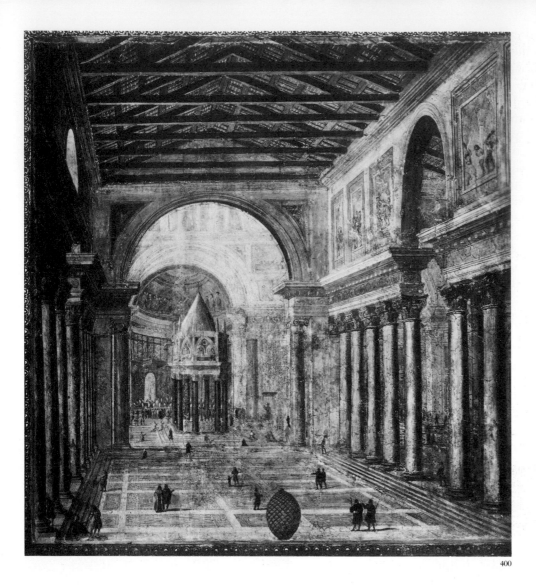

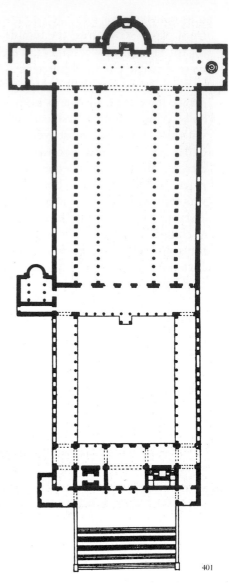

400. *Old St. Peter's, Rome*, fresco, S. Martino ai Monti, Rome. 16th century A.D.

401. Plan of Old St. Peter's, Rome. 1st half of 4th century A.D.

402. Isometric view of St. Peter's, Rome. c. A.D 400 (Dotted lines indicate conjectural outline of atrium and entrance portal)

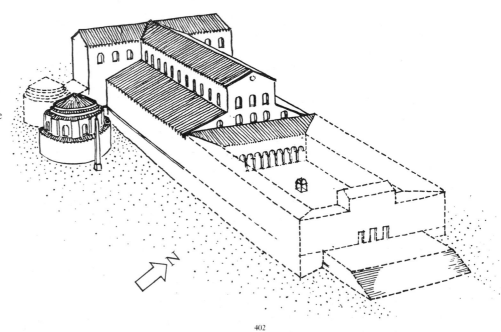

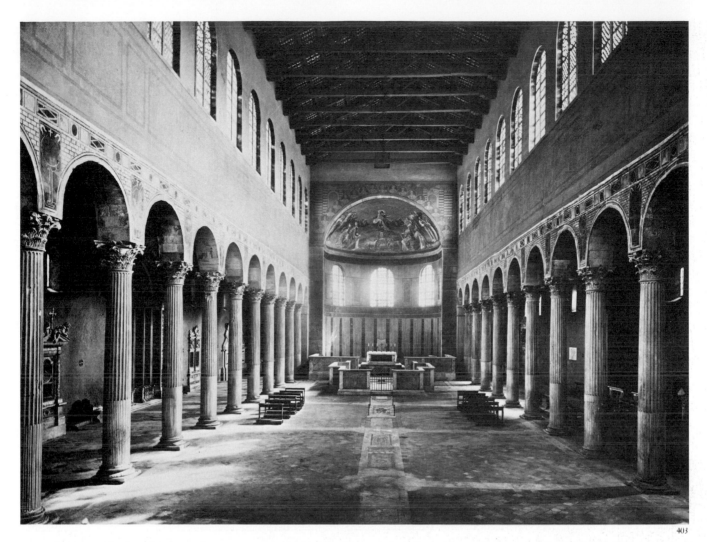

403. Interior, Sta. Sabina, Rome. A.D. 422–32

tian churches. It was built without a transept so that the triumphal arch embraced the apse directly. Throughout the Early Christian period, the apse was used only by the clergy, and often it contained a throne for the bishop. Arches were substituted for straight entablatures, as at Santa Sabina, in the course of the fifth century. None of the Constantinian basilicas survive in their original state. Saint Peter's, in fact, was demolished section by section in the Renaissance, to be replaced by a new building. The beautifully restored interior of Santa Sabina is almost the only one that still conveys the appearance of an Early Christian basilica in Rome, but it is unusual in having carefully matched Corinthian columns—purloined as usual.

All Early Christian buildings were devoid of external decoration, presenting unrelieved brick walls of the utmost simplicity (as in the Basilica at Trier, fig. 391; see also figs. 411, 418). The pilgrim to Saint Peter's (see fig. 402), for example, arrived at the blank, outer wall of an atrium—in reality a large peristyle court—then proceeded to the narthex or vestibule, and finally emerged into the richly colored nave with its splendid columns and bright frescoes, scores of hanging lamps, jeweled altar cloth, gold and silver vessels of the Mass, and clergy in gorgeous vestments—a far cry from the simplicity of the first centuries of Christianity. The processional principle on which the church was laid out has often been compared with the basic plan of the Egyptian temple, but it should be remembered that a similar processional principle governed the alignment of spaces and structures in the Roman forum as well, especially that of Trajan (see fig. 350).

THE CENTRAL PLAN A considerable number of variations could occur in the basilican plan, depending on the purpose of the building and on local traditions and requirements. An entirely different arrangement, the circular plan, was also widely used (fig. 404). A handsome early example is the Church of Santa Costanza (fig. 405), built in Rome about 350. Circular churches, unsuitable for celebrating Mass before large congregations, were almost always erected as martyria; this one was destined to contain the tomb of Princess Constantia, daughter of Constantine. Basically, of course, the circular plan is that of the Greek tholos type (see fig. 170) and of its lineal descendant, the Pantheon (see fig. 358), but the Early Christian circular church was usually enveloped by a circular side aisle, known as the ambulatory, which was intended for pilgrimages and for ceremonial processions. In cross section such a church, with its elevated clerestory, would suggest a basilica, save only for the central dome. In Santa Costanza the rich mosaic decoration is still preserved in the barrel vault of the ambulatory, although that of the central portion of the church has disappeared. The coupled Composite columns in granite create an impression of outward radiation from the central space, which is enhanced by the swelling, convex frieze of the entablatures.

Any number of variations were eventually possible in the circular plan, such as its expansion into radiating apses and chapels in the sixth century (see fig. 419). A circular martyrium could also be combined with a basilica, as in the great church commissioned by Constantine for the

404. Plan of Sta. Costanza, Rome. c. A.D. 350

405. Interior, Sta. Costanza, Rome

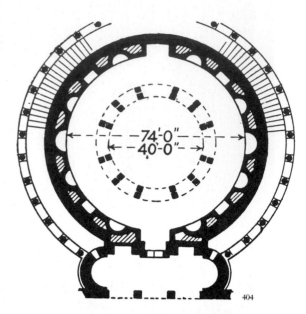
404

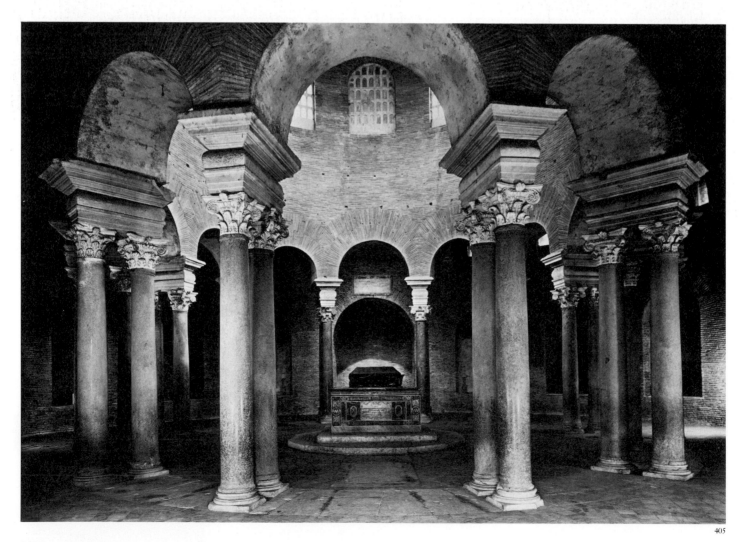
405

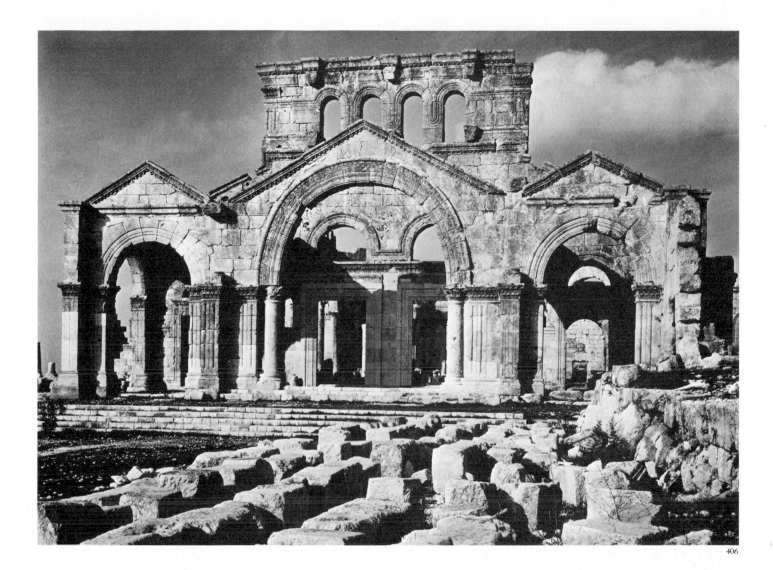

406. St. Simeon Stylites. c. A.D. 470. Qal'at Saman, Syria

Holy Sepulcher in Jerusalem. Perhaps the most spectacular fusion of a central martyrium with the basilican plan was the Church of Saint Simeon Stylites (fig. 406), built about 470 at Qal'at Saman in Syria. This consists of four distinct basilicas, three with splendid entrances and the fourth with three apses, radiating outward from a central octagon, which enshrined under an octagonal timber roof the pillar on the top of which Saint Simeon spent the last three and a half decades of his life. Syrian architecture is far richer in carved elements than its Early Christian counterparts in the West. Its buildings were constructed in the old Hellenic tradition of large, rectangular blocks of stone. The corners of the octagon are supported by piers, flanked by sixteen freestanding, monolithic, and rather stumpy columns of granite, with acanthus capitals derived from Corinthian models; the richly molded entablature sweeps up to form arches, which lead into the four basilicas and into four small chapels fitted into the reentrant angles. The general appearance of Syrian churches is squat and massive as compared with the lofty, brick-walled basilicas of the West; the treatment of moldings and other architectural members is extremely free and imaginative.

MOSAICS The new churches completely renounced the screen archi-
tecture so dear to the Romans and had little use for monumental sculp-
ture. A series of lifesize silver statues of Christ and the Apostles, long
since disappeared, once stood below a colonnade across the apse of San
Giovanni in Laterano, but they were an exception. These churches pos-
sessed no pediments or acroteria for statues, no metopes for relief, and
when friezes existed, they contained no sculpture. This art, so crucial to
the Greeks and Romans, was continued in Early Christian times on a
grand scale only in the imperial portraits, arches, and columns erected
by the emperors in Constantinople. The Christians, on the other hand,
relegated sculpture almost entirely to the more modest position of sar-
cophagi and ivory carvings (see below, pages 307–8). The wall surfaces
of Early Christian churches may have been deliberately kept flat so that
they might be adorned in brilliant colors with complete narrative illustra-
tions of the new religion for the instruction of the faithful.

Where these wall decorations consisted of frescoes, as, for example,
the narrative cycles in the nave of Saint Peter's, they have perished, with
few exceptions. Luckily for posterity, however, Early Christian artists
had another and more durable alternative, the medium of mosaic, which
Hellenistic and Roman artists had habitually used where wear or water
required it, that is, for floors and for fountains and pools.

The Romans had generally employed colored stones for their mosa-
ics, which certainly made for a resistant floor covering but presented se-
vere limitations in the range of available colors. Both Hellenistic and Ro-
man floor mosaics (see figs. 266, 291, 393) often restrict the background
to a single color plane so as to preserve the integrity of a surface intended
primarily for walking. Early Christian artists, however, seem to have pre-

407. Apse mosaic, St. Peter's, Rome (fresco copy)

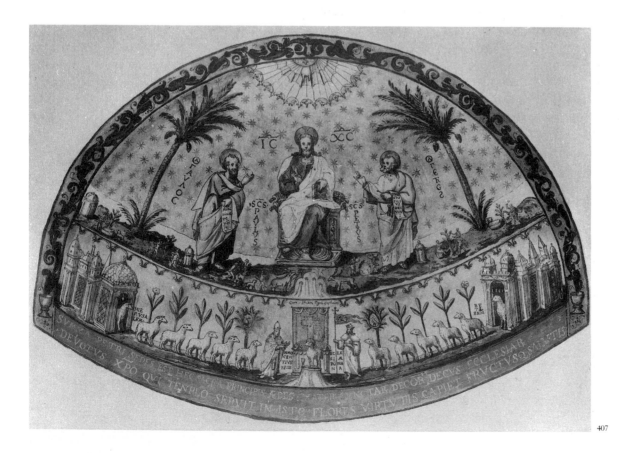

407

ferred an abstract background, at first a radiant sky-blue and later gold, for its transcendental effect in many large-scale wall mosaics. When landscape or architectural elements are required, they are either reduced to vague suggestions or else sharply schematized. Yet the techniques of pictorial representation inherited from Roman art are not forgotten, but float like severed but still green branches on a tide of essentially nonintellectual religious experience.

The earliest large-scale Christian mosaic was probably the one that filled the semidome of the apse of Saint Peter's in Rome, apparently using marble *tesserae* (cubes) as in pagan Roman work. The original was lost in the destruction of the basilica in the sixteenth century, but its composition is preserved in a fresco copy (fig. 407), which shows it to have been the ancestor of many other apsidal mosaics. Christ is enthroned in the center, blessing with his right hand and holding the Gospel book with his left. He is shown with long hair and beard, as usual in East Christian art, and since one set of inscriptions is in Greek, the artist may well have come from Constantinople. The scalloped semicircle above Christ symbolizes the tabernacle, or tent, of Heaven, and on either side grow palm trees, signifying the Christian victory. Below the throne flow the four rivers of Paradise, from which stags, symbols of the human soul, are drinking (Psalm 42 in the King James Version, 41 in the Douay Version). On either side of the lower register appear two cities, labeled Jerusalem and Bethlehem, from which twelve sheep, meaning the twelve Apostles, proceed toward a central throne on which rests the Lamb of God. The two cities were reworked in the thirteenth century under Pope Innocent III, who added figures of himself and of the Roman Church, and a set of inscriptions in Latin. A single, noble fragment of the original survives (fig. 408) and corresponds closely, even to details of the drapery folds, to the figure of Saint Paul in the fresco. The roughly matched gold-glass tesserae of the background must have been substituted in the thirteenth century for the original, doubtless a resounding deep blue as in other Early Christian mosaic backgrounds in Rome. But the figure, of exactly fitted marble tesserae like those of Roman floor mosaics, helps us to reconstruct in our imaginations the lost original mosaic, which must have been a magnificent work, and forms a precious witness to its remarkably Classical style and appearance. Saint Paul's bald forehead and straight Greek nose are beautifully modeled in tone, and his hair, beard, and drapery are executed in patches of clear, bright color that preserve in the fourth century all the radiance of Pompeiian illusionism.

Later on, the early Christians used glass tesserae, which instantly opened up a whole new world of glowing colors. Moreover, they exploited gold lavishly, not only for the representation of golden objects but also for that of light and even of illuminated surfaces, and with splendid effect. Entire backgrounds came to be made of gold, on a grand scale, particularly in the Eastern Empire, and the practice was perpetuated for the next millennium and longer in the gold-leaf backgrounds characteristic of Byzantine icons and early Italian painting. The glass tesserae were pressed into soft plaster, laid a section at a time over minutely planned preparatory drawings on the wall surfaces. The tesserae were never exactly leveled off, so that each one presented a slightly varied surface to the light; thus, observers, as they move, behold a constantly changing sparkle across the surface. The technique of gold glass—gold leaf applied behind clear glass cubes—was not exact, so that the gold mosaic backgrounds have a shimmering appearance rather than the hard uniformity of more precise modern imitations.

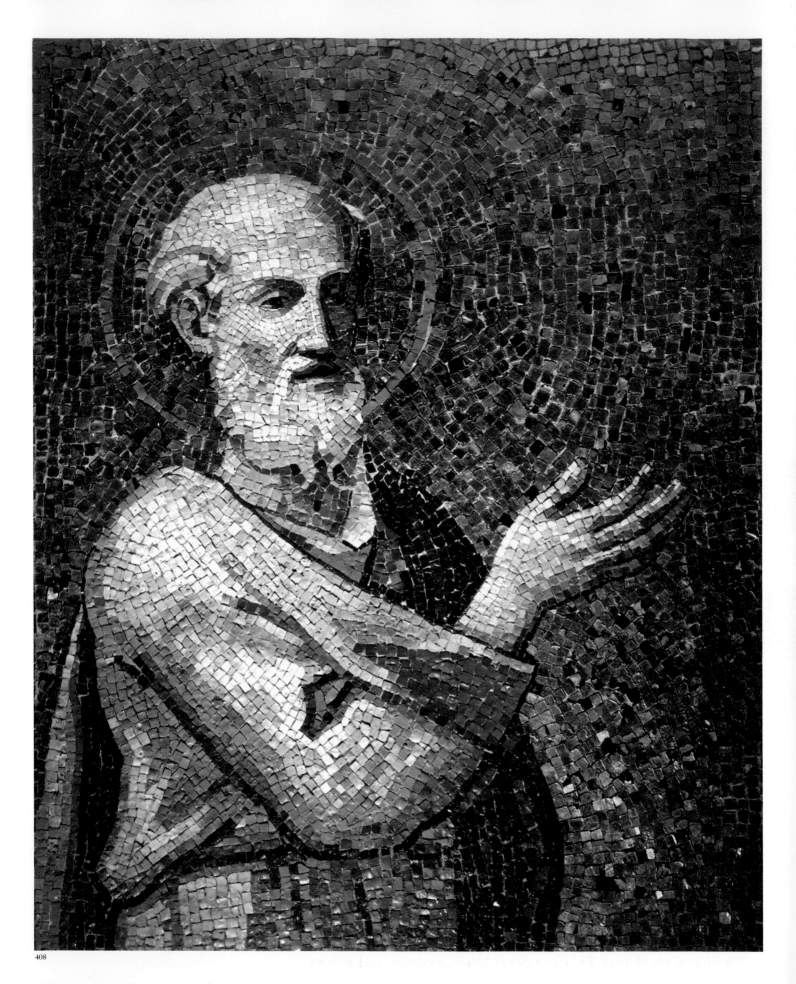

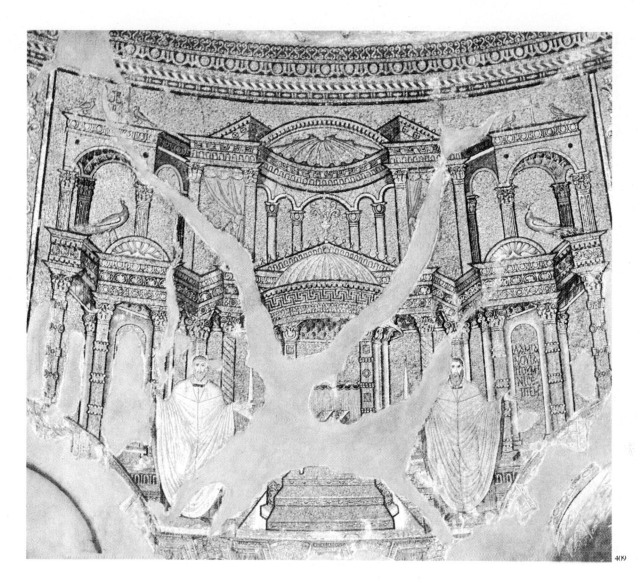

409

Hagios Georgios. One of the earliest preserved series of Early Christian mosaics (fig. 409 shows one section) ornaments the dome of Hagios Georgios (originally a mausoleum, later transformed into a palace chapel) in Salonika in northeastern Greece. In direct imitation of the towering, fantastic architecture of late Roman stages and other ornamental façades (see fig. 347), a visionary architecture, whose two stories are composed of richly interlocking columns, arches, broken pediments, niches, and coffered groin vaults, rises before us in illusionistic space. The architecture, like the background, is entirely of gold glass, but brown tesserae are used to indicate shadows; these shadows have been so subtly deployed as to convey an illusion of light reflected from below into the coffered groin vaults at either side. Shades of brilliant blue were used for curtains and to pick out such details as arches, shell niches, and the crosses at either side, the latter each accompanied by three blue-green peacocks, symbols of eternal life. Some columns are spirally fluted, others embraced here and there by collars studded with jewels. Under the dome of the tiny central tholos can just be seen an altar bearing a book with a jeweled cover. Before the structure stand Saints Cosmas and Damian, the two physicians, in orant poses, dressed in white chasubles whose soft shadows repeat the palest blue of the architecture.

Santa Maria Maggiore. A series of mosaics radiating imperial grandeur survives in the Roman Basilica of Santa Maria Maggiore, dating from

408. *Saint Paul*, from the apse mosaic, St. Peter's, Rome

409. Dome mosaic, with Saint Cosmas and Saint Damian. c. A.D. 400. Hagios Georgios, Salonika, Greece

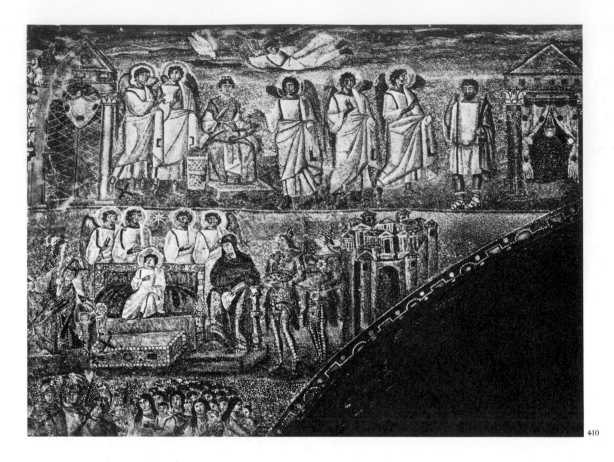

410. *Annunciation* and *Adoration of the Magi.* Mosaics, Sta. Maria Maggiore, Rome. c. A.D. 432–40

about 432–40. Instead of the architectural framework, which in Roman wall painting tied the images to the structure of the room, the triumphal arch is sheathed in mosaic. As so many Early Christian and Early Byzantine interiors show, this practice has the effect of seeming to dissolve the underlying architecture so that it is superseded by a new world of pictorial imagination. The entire left side of the arch is occupied by the first subjects drawn from Gospel narrative to be used in art, the *Annunciation* and the *Adoration of the Magi* (fig. 410). According to Christian doctrine, the Annunciation—the announcement to the Virgin Mary that she is to become the Mother of Christ—is the moment of the conception of his human body, brought about by the Divine Word (the Logos, or Second Person of the Trinity), conveyed by the Archangel Gabriel. Mary is seated upon a throne, robed and crowned exactly as an Augusta (empress) of the fifth century, in all the splendor due her since the Council of Ephesus in 431 had officially proclaimed her the *Theotokos* (Mother of God). She is regally attended by four white-robed angels, not mentioned in the biblical text (Luke 1:26–36). She listens with one hand lifted in surprise, while Gabriel flies above her like a Roman Victory, and the white dove, which in Christian art symbolizes the Holy Spirit, descends upon her according to Gabriel's words: "The Holy Ghost shall come upon thee, and the power of the Highest shall overshadow thee." What we witness, therefore, is the moment of the Incarnation, one of the most sacred in Christian belief. At the left appears a closed gate, symbol of Mary's virginity; at the right, by a little aedicula whose hanging lamp indicates night, a majestic angel announces the momentous tidings to Joseph (Matt. 1:20). The background behind both scenes is a wide plain whose horizon fades off into the sky and strips of cloud.

In the lower register the Christ Child, later usually shown on Mary's lap since he was, at the time of the Three Magi's visit, only twelve days

old, appears as a boy of six or seven years seated on an imperial throne and attended by four angels, while the star of Bethlehem shines over his head. Mary is barely visible, standing to Christ's right; the woman to his left may be a personification of Holy Wisdom. Christ and the angels, but oddly enough not Mary in either scene, are endowed with the golden halos used henceforward in Christian art to distinguish sacred figures. Two of the Three Kings from the East stand on one side of Christ; dressed in that fantastic Oriental garment, trousers, they present their gifts. Bethlehem is represented in the manner of one of the cities on the Column of Trajan as a little nugget of walls, temples, and roofs.

Twenty-seven smaller mosaics, immediately under the clerestory windows of the nave, tell stories from the Old Testament. Fig. 412 shows two superimposed scenes from the Book of Joshua. Above, Joshua commands the priests to bear the Ark of the Covenant across the Jordan River, which is shown piling itself "upon a heap" as the text states; the twelve men commanded by Joshua to bear stones from the Jordan to their lodging place have been reduced to four for the purposes of the scene. Below, Joshua sends out two spies to Jericho, this town also represented like those on the Column of Trajan. In both scenes Joshua is dressed as a Roman general, and the parallels with the Column of Trajan in poses, attitudes, and groupings are compelling. Distant space is suggested by hills of several colors, and the sky is striped with gold clouds against the blue-and-white tesserae. The construction of the almost cylindrical figures suggests the *Tetrarchs* (see fig. 382), but the use of color to build up these and the masses of the landscape is prophetic of the devices employed by Cézanne in the later nineteenth century rather than of the Impressionists of whom illusionistic Roman paintings reminded us.

The Tomb of Galla Placidia. The finest and best-preserved ensemble of fifth-century mosaics is that which decorates the interior of the tiny mausoleum built at Ravenna, on the Adriatic Coast of northern Italy, by the empress Galla Placidia about 425–26 for members of her family. The administrative capital of the Western Empire had been moved to Ravenna from Milan in 402 by Galla Placidia's half brother, the emperor Honorius. In the following century the Empire reached its height under the

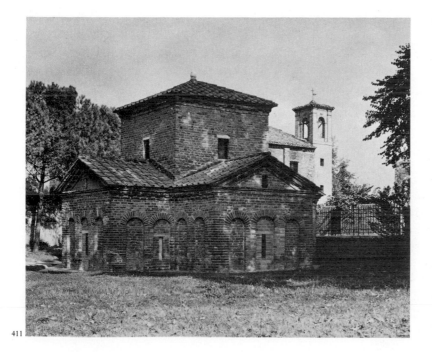

411. Mausoleum of Galla Placidia, Ravenna. c. A.D. 425–26

411

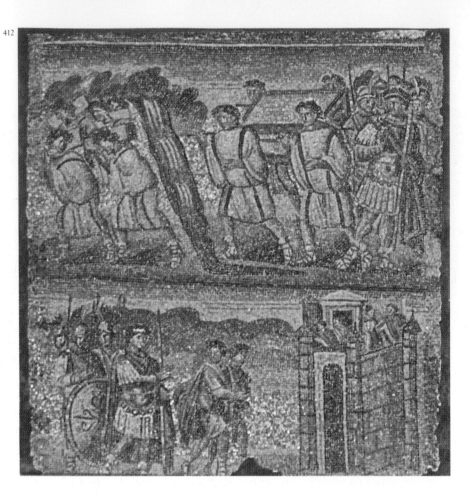

412. Scenes from the *Book of Joshua*, mosaic, Sta. Maria Maggiore, Rome. c. A.D. 432–40

413. *The Good Shepherd*, mosaic, Mausoleum of Galla Placidia, Ravenna. c. A.D. 425–26

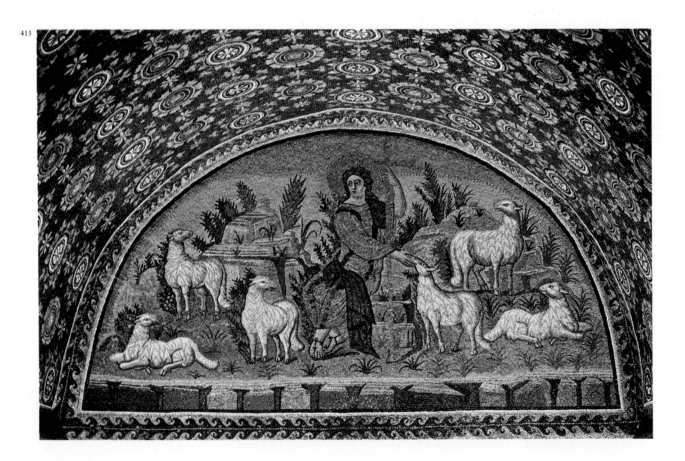

Gothic kings and the Byzantine emperors. The customary simple brick exterior of the mausoleum (fig. 411), ornamented only by a blind arcade and an entablature, gives no hint of the splendors within. The walls are sheathed in smooth slabs of soft gray veined marble. The barrel vaults, the lunettes, and the walls and vault of the central lantern almost disappear under their continuous covering of mosaic. In spite of the alabaster slabs in the windows that now yellow the light, the interior is one of the most beautiful in the history of art, its effect impossible even to suggest in photographs. The dominant color in all the mosaics is a deep sky-blue, which in the barrel vault of the nave is studded with white, blue, and gold floral patterns in medallions that float like magic constellations in some perfect heaven.

The lunette above the portal (fig. 413), framed by a delicate wave pattern in blue and gold, shows the Good Shepherd seated among six of his sheep in a rocky landscape, which derives from those of Roman painting. His graceful pose becomes almost a spiral, as he holds the cross-staff with his left hand and with his right reaches to feed a sheep. Conventionalization of the rocks has begun, but each one contains a gamut of colors, ranging from gold in the lights to violet and gray in the shadows. The gold of Christ's tunic and the violet of his mantle are echoed in the distant rocks, but in softer and paler values. Rocks of about the shape shown here, but always more and more stylized, remained in the standard repertory of landscape settings throughout the millennial history of Byzantine art, after which they were taken over by early-fourteenth-century Italian painters.

THE ILLUMINATED MANUSCRIPT In addition to mural decoration, a second extremely important field for paintings was the "illumination" (illustration) of manuscripts, which were the only form of books made in Europe until the importation of printing from China in the fifteenth century. Egyptian manuscripts had been written on long rolls of papyrus (see above, page 101; see fig. 122), and such rolls, known as *rotuli*, were adopted from the Egyptians first by the Greeks and then by the Romans. The rotulus was wound between two spindles, and only two or three vertical columns of text were visible at any one moment. Greek and Roman rotuli were illustrated only when necessity demanded, as, for example, diagrams to explain scientific matters; to avoid flaking, these illustrations were usually drawn in line and colored, if at all, with thin washes. The Hebrew Bible was written on rotuli; the scroll form of the Torah, although it is no longer written on papyrus, is a still-surviving example. But the Christians were above all the People of the Book; they needed to be able to refer immediately to any verse in the Bible for authority and to move from one section to another to verify prophetical relationships and Gospel correspondences. They also required books for their increasingly formalized, complex, and uniform Liturgy.

An individual rotulus could only be wound to about thirty feet in length before becoming unmanageable; thus, each Greek or Roman literary work had to be divided into a number of rotuli, or "books"; the Bible required scores of them. Even in antiquity the difficulty of using rotuli for ready reference gave rise to the copying of key passages on thin wooden tablets, hinged together at the back. These were the ancestors of the familiar *codex* (paged volume), which became a practical reality only when parchment came into general use. This material, whose name is a corruption of Pergamon, where it was invented in the second century

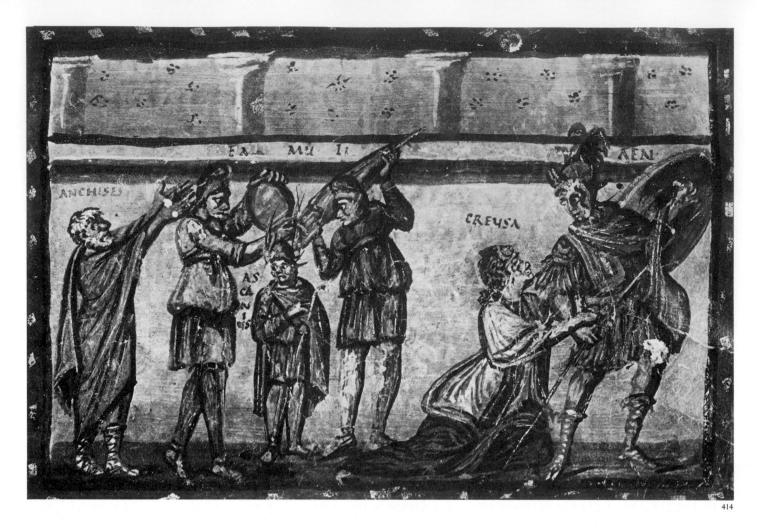

414

B.C., consisted of the carefully scraped, washed, dried, and stretched skins of young animals, especially lambs, kids, and calves. It could be dried to extreme whiteness, provided a smooth surface for writing and painting, and was durable enough to stand up under constant usage in the Liturgy.

We do not have enough early examples to be sure just when the parchment codex began to replace the rotulus, but recent investigations indicate that the change began during the first century A.D. and was complete by the fourth century. As we have seen (page 285), the copying of such manuscripts was one of the principal functions of the monasteries. Paradoxically enough, the finest early illuminated codex we know is a pagan work, the *Vatican Virgil*, dating from the fourth or perhaps the early fifth century. It should be remembered, however, that Virgil was considered by Christians throughout the Middle Ages as a prophet of the universality of Christianity, and his works were greatly respected. The *Vatican Virgil* is in fragmentary condition, and the paintings were executed by several hands of widely varying style and quality. One illuminator set forth his portion of the narrative with great vivacity, even if he lacked the refinement of the best Pompeiian painting. His *Miracle of Ascanius* (fig. 414; *Aeneid* II:1.680ff.) shows the cap of Ascanius, Aeneas' small son, catching fire mysteriously in the midst of the siege of Troy, the holy flames resisting all efforts to douse them. The aged Anchises, Aeneas' father, raises his hands to the gods, and is informed that this miracle is a sign that Aeneas should leave doomed Troy to found Rome. The wildly dramatic poses, especially that of Creusa throwing herself before the departing Aeneas, recall a long tradition of Helleno-Roman sculpture (and possibly painting as well). The expression of the alarmed Ascanius may

414. *Miracle of Ascanius*, illumination from the *Vatican Virgil*. Rome, 4th or early 5th century A.D. Biblioteca Apostolica Vaticana, Rome

appear comic, but the coarse, rapid style with its strong contrasts of light and dark is very effective—on a level with catacomb painting. It is just this vivid, cursive method of narration that later formed a basis for the Christian manuscript illuminations we know from the following century.

SCULPTURE As previously noted (see page 298), little monumental sculpture was produced in the early Christian period, and very few works survive. But marble sarcophagi were carved in great quantities. The *Sarcophagus of Junius Bassus* (fig. 415), made for a man who died in 359, while hardly comparable in quality with the best of Helleno-Roman sculpture, is far more accomplished than the rude fourth-century reliefs on the Arch of Constantine (see fig. 356). Its two stories are divided into ten compartments by stumpy, spirally fluted or vine-encrusted Corinthian columns, supporting niches, entablatures, and pediments drawn from the repertory of Roman stage architecture. From upper left to lower right, the scenes read as follows: the Sacrifice of Isaac, Peter Taken Prisoner, Christ Enthroned Between Peter and Paul, Christ Before Pilate (occupying two compartments), Job on the Dunghill, the Temptation of Adam and Eve, Christ's Entry into Jerusalem, Daniel in the Lions' Den, and Paul Led to Martyrdom. As quite generally in Early Christian art in Western Europe, Christ is shown youthful and beardless. In contrast to the dramatic style of the *Vatican Virgil*, the little figures stand or sit quietly no matter how intense the biblical narrative being enacted; they remind us, in fact, of the stately calm of the scenes on the Arch of Trajan at Benevento (see fig. 355). This is probably because they serve a similar purpose as the coher-

415. *Sarcophagus of Junius Bassus.* c. A.D. 359. Marble, 46½ × 96". Museo Petriano, St. Peter's, Rome

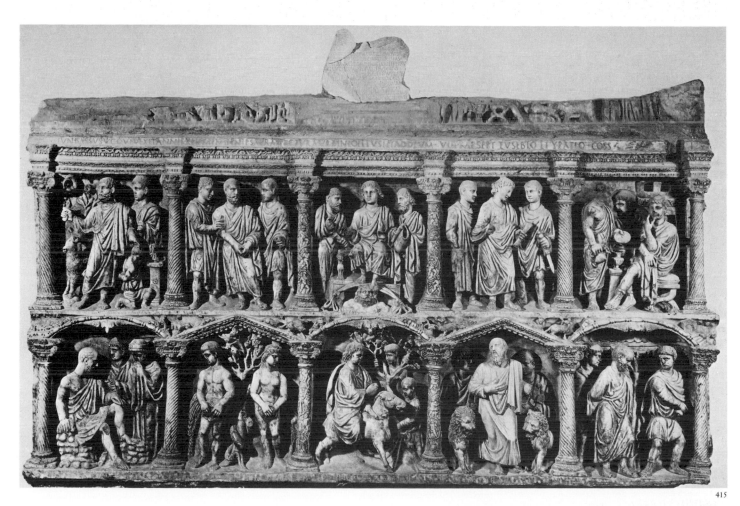

415

ent exposition of a single symbolic theme, in this case Christian victory over suffering and death. In the upper central compartment Christ appears in triumph both on Earth below and in Heaven above. Under his feet is a bearded personification of Heaven, like the personification of the Danube on the Column of Trajan (see fig. 353), holding a scarf over his head like those held by the personifications of Water and Air in the Ara Pacis (see fig. 330). In other compartments Peter and Paul are shown fearless before their captors, as Christ was before Pilate. Adam and Eve represent the origins of death through their sin. The extreme trials of Job, Isaac, and Daniel were declared by early Christian theologians to be "types" (foreshadowings) of the Passion (suffering) and death of Christ. A properly instructed Christian could read the scenes in any order and derive the same meaning: Christ's conquest over death was predicted in the Old Testament; through Christ, man will triumph over death; like Peter and Paul, man should not fear death.

When necessary, the Early Christian sculptor could handle dramatic situations with simplicity and beauty, as in the numerous ivory plaques on which he carved scenes from the Old and New Testaments. One of the finest panels (fig. 416), dating from the late fourth or early fifth century and probably Italian, shows at the bottom right the Three Marys coming to the Sepulcher on Easter morning; the authoritative figure of the angel who tells them that the Lord is risen has been likened visually to Christ himself. At the upper right is an early form of the Ascension; Christ strides vigorously up a mountain, assisted by the hand of God the Father extended from the clouds, while two of the Apostles cower in terror. The fullness and beauty of the figures, the flow of the drapery, the power of the poses, and the intensity of the dramatic realization reveal that the most accomplished Early Christian artists remained in touch with the great Helleno-Roman repertory of form and content.

For the Western Roman Empire the fifth century was a period of almost unmitigated disaster. Rome was sacked in 410 by the Visigoths, a Germanic people led by Alaric, and threatened in 452 by the Huns, a ruthless Mongol nation, under their king Attila, who died suddenly in 453. Another Germanic group, the Vandals, sacked Rome a second time, very methodically, in 455. Largely in ruins, the city was reduced to the status of a provincial town, with a greatly decreased population. By the time of the deposition of Romulus Augustulus, the last Roman emperor of the West, in 476, Italy lay devastated from constant warfare, and large areas of farmland had returned to wilderness. In 493 the Christianized Ostrogothic chieftain Theodoric captured Ravenna from the Visigoths and attempted to bring order out of the chaos. He made Ravenna the capital of his new kingdom of Italy and established a splendid court there.

Soon after Theodoric's death in 526 his kingdom fell apart. A powerful new figure, Justinian I (reigned 527–65), ascended the throne of the Eastern Roman Empire—which from now on we may as well call by the name it has acquired in history, the Byzantine Empire. Although they generally spoke Greek and were in many respects the custodians of Greek culture, the Byzantine rulers maintained to the end their position as legal heirs to the Roman Empire and always referred to themselves as Romans. Justinian (who spoke Latin) dedicated his reign to restoring the stability of the Empire against the Huns, the Slavs, and the Parthians in the East and to reconquering the West, especially North Africa and Italy, from the Vandals and the Ostrogoths. In 540 the imperial forces captured Ra-

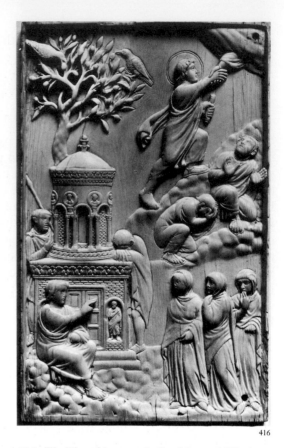

416. *The Three Marys at the Sepulcher* and *The Ascension*. Late 4th or early 5th century A.D. Ivory panel, height 7¼". Bayerisches Nationalmuseum, Munich

The Age of Justinian

venna and afterward maintained it as their center of power; by 555 Justinian's armies had reestablished Byzantine rule throughout Italy, driving the Ostrogoths across the Alps to a still-unknown fate. The Byzantines could not hold all of northern Italy, but before the end of the sixth century they had established the Exarchate of Ravenna, which kept Adriatic Italy and much of southern Italy in the Byzantine fold for two centuries.

Like Constantine, Justinian maintained firm imperial control over the affairs of the Church in the East, especially in regard to the establishment of dogma as well as the extirpation of heresies, which flourished like weeds in the early centuries of Christianity. During the interregnum of Visigothic and Ostrogothic overlordship of Italy, the popes had acquired a certain independence from the constantly changing and always insecure secular control. This freedom encouraged papal claims of supremacy over the other patriarchs of Christendom, who by no means agreed. Pope Gelasius I (492–96) went so far as to proclaim ecclesiastical superiority to imperial power, a claim renewed countless times by his successors for more than a millennium. Meantime, the chaotic conditions prevailing throughout the West strongly favored the establishment of monastic communities, which had long flourished in the East, as a refuge from secular disorder. In 529 Saint Benedict of Nursia founded the great order that bears his name and that spread throughout Western Christendom. Ruled from the Abbey of Monte Cassino in southern Italy, the Benedictine order, in fact, not only became the greatest single force directed toward the reform and discipline of monasticism, but also assumed responsibility for the transmission of the heritage of Classical learning to the early Middle Ages through the preservation and copying of manuscripts—a responsibility discharged in the East by Byzantium.

ROME Remarkably enough, considering that Rome had by then been reduced to a town of about fifty thousand inhabitants living under conditions of great economic and political disorder, Roman pictorial tradition was by no means dead. About 530 Pope Felix III commissioned the creation of one of the finest mosaics of the entire Middle Ages to celebrate the remodeling of a Roman temple into the Church of Saints Cosmas and Damian. The mosaic, later reduced in size and disfigured by the addition of a plaster arch, fills the entire triumphal arch and apse (fig. 417), but is difficult to photograph on account of its concave surface. On either side the white-robed figures of Peter and Paul turn to look toward the spectator as they present Saints Cosmas and Damian, who in turn offer their crowns of golden oak leaves. At the extreme left, hardly visible in the photograph, Pope Felix holds forth a little model of the temple that he caused to be transformed into the church. In the center of the triumphal arch, the Lamb of God is shown upon his throne, which stands among the seven candlesticks of Revelation (Rev. 1:12–20); on the footstool lies a rotulus sealed with seven seals. Four angels appear, two on either side, and at the extreme right and left another angel and an eagle, holding codices, are visible. The angel and the eagle are the symbols of the Evangelists Matthew and John (the winged lion of Mark and the winged bull of Luke have disappeared), and they are among the earliest monumental examples of a theme that reappears throughout Christian art.

The center of the mosaic is filled with a vision of overpowering splendor to which the entire composition is directed: on a pathway of sunset clouds, gold, yellow, orange, and red, against a sky of dazzling blue, the gold-robed Christ walks to us from beyond the stars, his left hand holding a scroll, his right extended in the familiar oratorical gesture of Roman

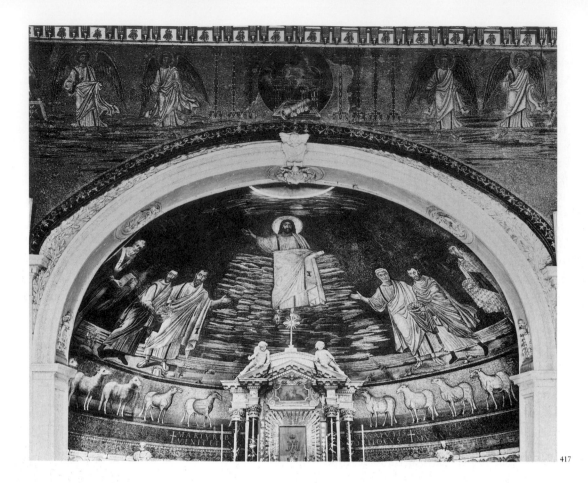

tradition (see figs. 307, 326). As in the apse mosaic of St. Peter's (see fig. 407) Christ is represented as bearded in contrast to the boyish figure in images of the Good Shepherd and on sarcophagi (see figs. 413, 415). Below the vision appear the twelve apostles symbolized by twelve sheep, as at St. Peter's. In the apse mosaic of the Church of Saints Cosmas and Damian, the real world is restricted to a narrow band of green plain traversed by the shadows of the standing figures; we look above and beyond it into a heavenly realm, which replaces the time and space of our experience, just as all worldly phenomena yield to the coming of the Son of Man "in the clouds of heaven with power and great glory" (Matt. 24:30). This revelation of ultimate spiritual power may well have been a source of consolation to the shattered Rome of the sixth century. The composition was extremely influential, being copied again and again in Rome throughout the early Middle Ages, and it deeply impressed the Italian artists of the Renaissance.

RAVENNA During the last years of the Ostrogothic kings and the first decades of Byzantine rule in Ravenna, the city was enriched by a series of new ecclesiastical monuments; even the most complex were built of local brick, adorned by columns and incrustations in colored marbles. It is not hard to account for the brick rather than concrete construction of Early Christian basilicas in Rome, since their flat walls posed few masonry problems. While in purpose it derived from the central-plan martyrium, such as Santa Costanza (see figs. 404, 405), San Vitale at Ravenna (figs. 418, 419) was built about 525–47 on a subtle and intricate plan deriving from such Roman ancestors as the concave-and-convex structures in Hadrian's Villa at Tivoli. Concrete would seem to be called for; its absence may be explained by the difficulty of obtaining the great

417. *Christ with Saints*, mosaic, SS. Cosma e Damiano, Rome. c. A.D. 530

418. S. Vitale, Ravenna. c. A.D. 525–47

419. Plan of S. Vitale, Ravenna

420. Interior, S. Vitale, Ravenna

421. Marble capital with vinescroll interlace, S. Vitale, Ravenna

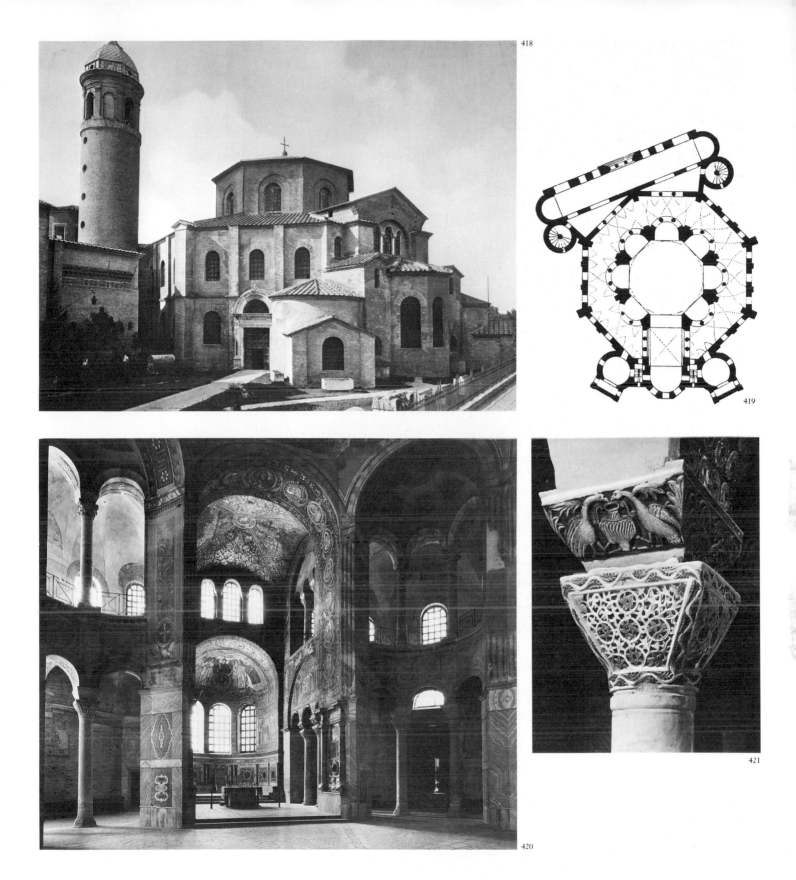

quantities of timber required for molds and centering during the chaotic
economic and political conditions of the early Middle Ages.

San Vitale is an octagon which, from the outside, looks simple enough.
Its bare brick walls, rising to the height of the second story, are broken
only by arched windows and buttresses. The central octagonal lantern is
equally simple. The plan and view (fig. 420), however, show that only

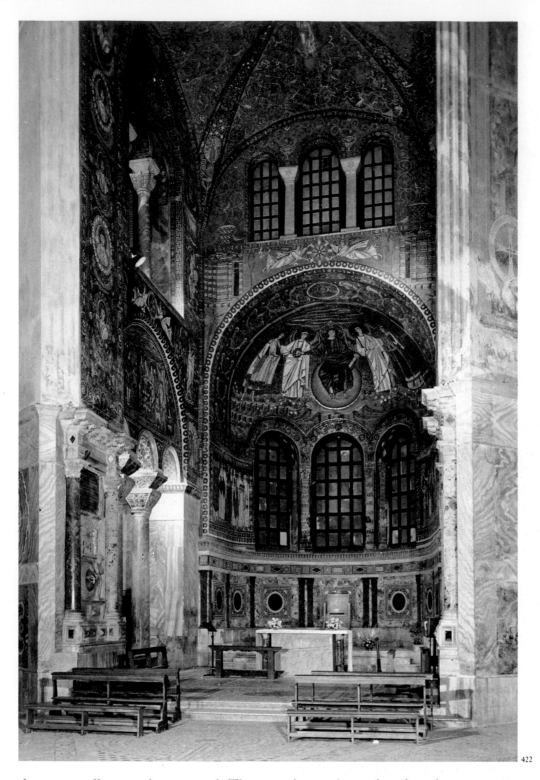

422. Chancel, S. Vitale, Ravenna

the outer walls are truly octagonal. The central space is enveloped on the ground story by an ambulatory and on the second by a gallery. At the eight inner corners of the ambulatory stand large piers, sustaining eight great arches, which embrace the smaller arcades of ambulatory and gallery. Instead of being flat, as we would expect, these arcades are concave with respect to the central space, expanding from it to form, as it were, seven transparent apses; the eighth is replaced by the chancel with its central altar. Even the crowning lantern is not octagonal; its corners are rounded off by tiny arches, called *squinches*, between the windows, which cut the drum in the interior into sixteen sides. The squinches are difficult to make out through the later decoration.

THE MIDDLE AGES

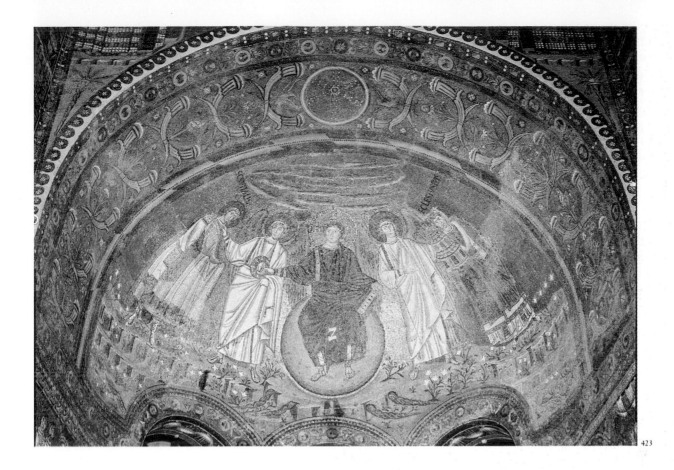

423. *Christ Enthroned Between Angels and Saints*, mosaic, S. Vitale, Ravenna. c. A.D. 525–47

Entering the church through the narthex, whose odd angle deflects the presbytery and apse from the east-west axis and is as yet unexplained, the worshiper proceeds through the ambulatory and then into the central octagon, with its expanding spaces, filled with light from the eight arched windows of the lantern. The impression of dazzling spatial complexity is enhanced by the colorism of the interior. The columns are of veined marble, and richly colored marble sheathes each pier up to the springing point of the smaller arches. The very capitals have been transformed (fig. 421); no longer is there the slightest reference to any of the Classical orders with their elegant articulation of parts. These capitals resemble baskets, and their smooth sides mask a subtle transition of shape from a square at the top to a circle at the bottom; instead of acanthus leaves, sculptured in depth, they are covered with a continuous interlace of vinescrolls drawn on the surface, incised, and then painted to make them appear even more intricate. All the marble work was imported from the East, where Theodoric, who died in 526, had spent ten years as a hostage.

The entire chancel—apse, side walls, lunettes, jambs, arches, and crowning groin vault—is clothed with a continuous garment of mosaics in gold and other bright colors (fig. 422). Most of the subjects were drawn from the Old Testament, and chosen so as to prefigure the Eucharistic sacrifice. For example, as one looks across the chancel before the altar, one sees in the lunette of the arch, below two soaring angels carrying the Cross in a golden medallion, two scenes from the story of Abraham. On the left Abraham brings to the three angels—whose appearance to him was considered by theologians a revelation of the Trinity (see fig. 607)— a meal believed symbolic of the Eucharist. On the right he prepares to sacrifice his son Isaac, an event believed to foreshadow the sacrifice of Christ. Christ appears in the semidome of the apse (fig. 423) as a youth-

ful, short-haired, and beardless figure, robed as usual in West Christian art in imperial purple and gold, and enthroned upon the orb of the heavens. From the rocky ledges below him gush the four rivers of Paradise. On either side stands a white-robed angel; one presents Saint Vitalis, to whom the church is dedicated and who holds forth hands veiled by his gold-embroidered cloak to receive from Christ a jeweled crown; the other angel introduces Bishop Ecclesius, who commenced the construction of the church, of which he holds a charming if inaccurate model. Rocks, flowers, rivers, even the figures are strongly conventionalized: no hint of bodily structure underlies the thick, tubular folds of their drapery; their feet seem hardly to rest upon the ground. In ostensible conversation with each other, these solemn figures exchange not a glance; they gaze outward, above and past us. But none of the conditions of the real world apply any longer to this symbolic and timeless realm. Christ does not really sit upon his orb, but floats in front of it; nor does the orb rest upon the ground, but is divided from it by a strip of gold. Most of the work was completed before the Byzantine conquest in 540.

On the side walls of the chancel are two imperial mosaics. To the left of the altar is the emperor Justinian, flanked by high officials, soldiers, and priests (fig. 424), and, to the right, the empress Theodora (fig. 425), even more richly crowned than her husband, among the ladies of her court. Both figures, robed in imperial purple, stare calmly at the observer; without looking up Justinian presents a golden bowl, and Theodora a golden chalice, to Christ in the semidome above. Attempts have been made and disputed to connect these scenes with moments in the Liturgy, especially the processional offering of bread and wine at the altar. But Theodora never took part in such processions in Constantinople, going straight from the palace to the gallery reserved for women, and although she appears here before a shell-niche flanked by two different kinds of curtains and next to a small fountain, Justinian and his attendants stand on plain green, against a gold background. Clearly one symbolizes the palace, the other the outer world. Moreover, both bowl and chalice are conspicuously empty. And finally, neither Justinian nor Theodora ever saw Ravenna.

More likely the two mosaics, in keeping with the rest of the cycle, are symbolic. Emperor and empress, confirming their power, status, and new patronage of the church started by Theodoric, present rich liturgical gifts to Christ, just as the Three Magi are doing on the border of the empress's *pallium* (interestingly, only two are visible, both holding bowls resembling that of Justinian). If anything, these figures are more completely rigid and immobile than those of the apse mosaics, oddly enough since the faces are strongly characterized portraits, doubtless copied from models sent from Constantinople. Both Justinian and Theodora wear golden halos with red borders, like that of Saint Vitalis, startling enough considering Theodora's early life as an entertainer of easy virtue. (As empress, it should be mentioned, she carried on a determined campaign to stamp out prostitution as a degradation of women.) The emperor appears as Vicar of Christ on earth, the empress as his divinely ordained helpmeet. Haunted as Justinian was by his dreams of revived Roman glory, his anxiety-ridden countenance is quite as believable as the steady gaze of his astonishing wife. We might also recall that it was Theodora's courage fifteen years earlier that saved the day (see page 317) when Justinian was about to flee for his life before his enemies. "Purple," Theodora announced to the vacillating emperor and his generals, "makes a fine shroud." Sadly enough it did, the year after the probable date of this mosaic.

424. *Emperor Justinian and Attendants*, mosaic, S. Vitale, Ravenna. c. A.D. 547

425. *Empress Theodora and Attendants*, mosaic, S. Vitale, Ravenna. c. A.D. 547

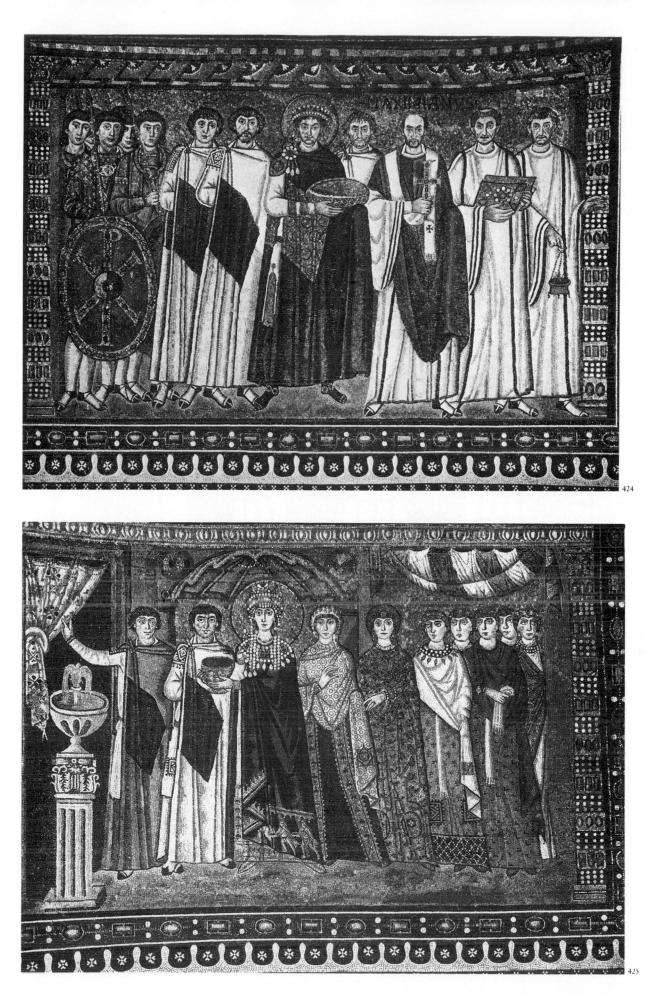

424

425

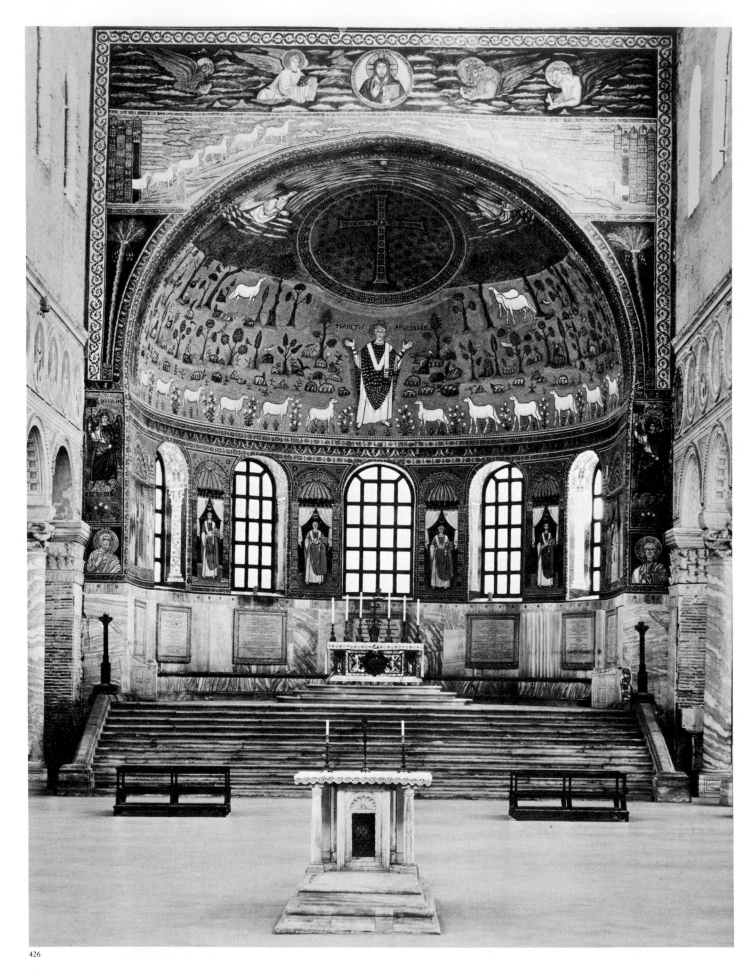

Theodora died of cancer in 548, leaving Justinian desolate and, for a while, completely unnerved. In the midst of all this splendor, other portraits must be accurate as well, especially that of Bishop Maximianus, during whose episcopate the church was consecrated, which depicts even the gray stubble on his cheeks and chin. What we witness in these mosaics is the transformation of a highly developed, naturalistic art into a transcendental and symbolic one, which still retains traces of the old Helleno-Roman illusionism in the treatment of light and surface.

A wholly symbolic representation, executed in mosaic between 533 and 549, fills the apse of Saint'Apollinare in Classe (fig. 426), located at the site of the old Roman port of Classis, a few miles outside Ravenna. As in the Basilica at Trier (see fig. 391), the exterior walls are of unadorned brick. Curtains part in the little aediculae between the windows to reveal deceased bishops of Ravenna in orant postures (several are buried in the church). The half dome is partly filled with a green pasture, at the bottom of which twelve sheep, symbolizing the Twelve Apostles, march in single file on either side of the orant Saint Apollinaris. Above him, against the gold background, a circle of jewels encloses a disk of blue sown with gold stars, on which floats a golden cross studded with gems, as if appearing to the saint in a vision. On either side of the disk Moses and Elijah, depicted to the waist only, are surrounded by clouds to show that they, too, are visionary apparitions, while below them among the trees three lambs look upward. These figures in the upper part of the apse symbolize the Transfiguration and portray that moment when Christ, who had climbed to a mountaintop with Peter, James, and John, was suddenly transfigured in raiment "white and glistening" (Luke 9:29) and Moses and Elijah were miraculously revealed in conversation with him. Christianity, no longer a new religion, has created its own language of symbols in which it can address the faithful with complete confidence that it will be understood. The mosaics of the triumphal arch, which show sheep emerging from Bethlehem on one side and from Jerusalem on the other before Christ flanked by the symbols of the Four Evangelists, were added in the seventh or eighth century.

CONSTANTINOPLE After a catastrophic revolt in 532, in which half the city was destroyed and Justinian nearly lost both his crown and his life, the emperor embarked on an ambitious program of rebuilding the churches of his devastated capital, including the Constantinian Basilica of Hagia Sophia (Holy Wisdom), which had burned to the ground. He dreamed of an entirely new kind of church bearing slight relation to the accepted basilican form. Instead of entrusting his bold idea to an experienced architect, he called in two noted mathematicians, Anthemius of Tralles and Isidorus of Miletus. They carried out the emperor's bidding faithfully; despite its many later vicissitudes, Hagia Sophia is an utterly original and successful structure, which makes surprising departures from the Roman tradition of building and—save for the imitations built by the Turks a thousand years later—remains unique.

Its plan (fig. 428) combines the longitudinal axis typical of a basilica with a centralized arrangement of elements. At the corners of an area one hundred Byzantine feet square (a perfect proportion of perfect numbers) rise four piers, each seventy feet high, upholding four great arches (fig. 427). The arches are connected by pendentives, which may best be described as triangles with concave sides drawn upon the inner surface of a sphere. The upper edges of the pendentives join to form a continuous

426. Apse mosaic, Sant'Apollinare in Classe, Ravenna. c. A.D. 533–49

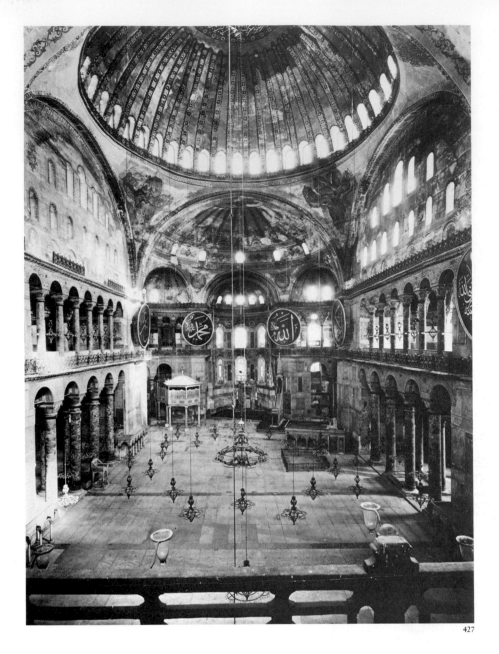

427

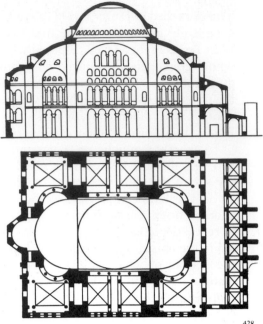

428

427. **ANTHEMIUS OF TRALLES** and **ISIDORUS OF MILETUS.** Interior, Hagia Sophia, Istanbul (Islamic medallions are later)

428. Section and plan of Hagia Sophia, Istanbul. c. A.D. 532–37 (Section after Gurlitt; plan after V. Sybel)

circle on which a dome may be erected. Not only do pendentives provide a more graceful transition from a square or polygonal base to a round dome than is possible with the use of squinches, but they also permit the covering of a far greater area of floor space than is allowed by a circular base. The origin of pendentives remains unknown, but they were used for the first time on a large scale in Hagia Sophia. Henceforward, they were employed exclusively to support large domes in Byzantine architecture, and later in the Renaissance, the Baroque period, and modern times. The pendentive was undoubtedly the greatest Byzantine contribution to the technique of building. The dome of Hagia Sophia is somewhat less than a hemisphere, and is composed of forty ribs meeting at the center. The web of masonry connecting the ribs is slightly concave, so that the shape has been compared to that of a scallop shell. On the east and west sides the central square is prolonged by half circles, culminating in semidomes, each of which embraces three smaller semidomes, crowning three apses. Such a structure would probably have been impossible to build employing the concrete construction techniques of the Romans. Anthemius and Isidorus achieved their domes and semidomes by means of ma-

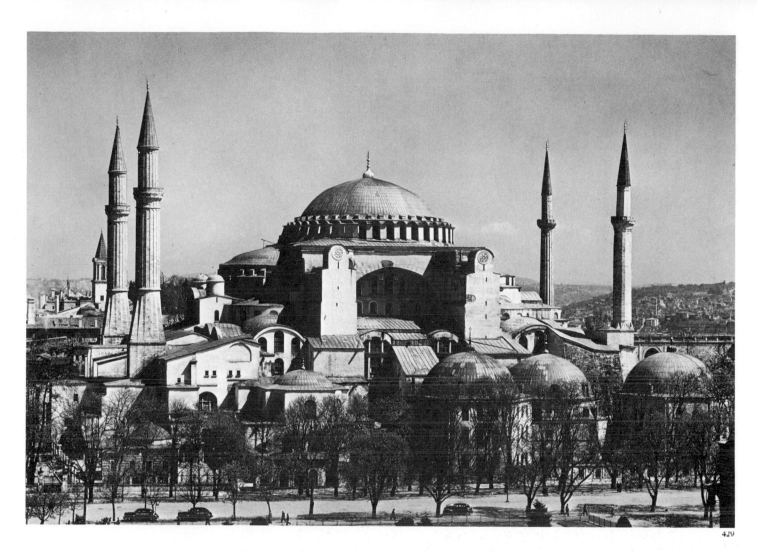

429. ANTHEMIUS OF TRALLES and ISIDORUS OF
MILETUS. Hagia Sophia, Istanbul (Minarets
are later)

sonry constructed of bricks set edge-to-edge and only one brick deep—
forming a mere shell.

The building is entered from a groin-vaulted narthex, twice the length
of the central square, through a portal directly opposite the eastern apse,
which sheltered the altar. The arcaded side aisles and the arcaded galler-
ies above them are roofed by groin vaults. The cornice of the galleries
marks the springing point of the pendentives and of the four arches.

Great efforts were made to support the dome. To absorb the thrust of
its immense weight, and to keep it from pushing the corner arches out,
huge *buttresses* (masses of solid masonry) were erected, clearly visible on
the exterior (fig. 429). Beautiful as they are, the four minarets, built when
the church was transformed into a mosque by the Turks after the capture
of Constantinople in 1453, change considerably the appearance of the
building. The reader should cover them up in the photograph in order to
gain an idea of how this enormous pile of semidomes and buttresses cul-
minating in the great central dome, towering 184 feet, originally looked.

The enclosing membrane of masonry is pierced by arched windows
and by arcades in careful numerical arrangements—seven arches in the
galleries above five in the side aisles, five windows above seven in the
lunettes, and forty windows in the dome above five in each semidome.
Since the side walls are nearly flush with their enclosing arches, the piers
are hardly visible; the whole immense structure with all its shining win-
dows and dark arches, with great domes embracing smaller ones, seems
to be floating in light, an impression that must surely have been even
stronger when the original decoration of gold mosaic, covered over by

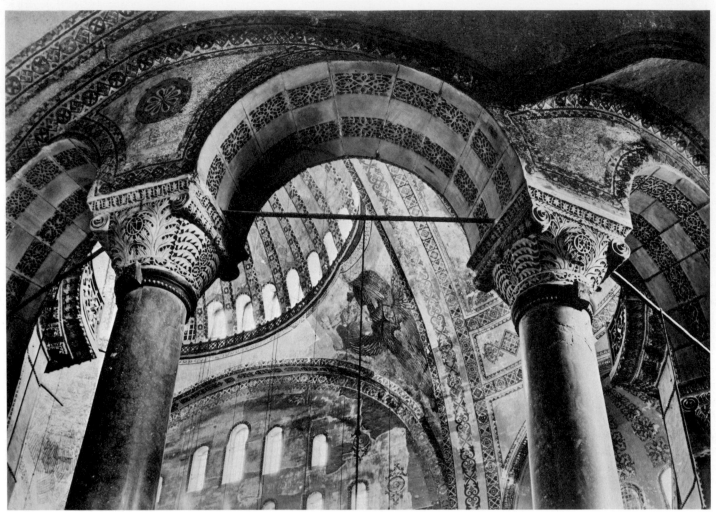

430. Hagia Sophia, Istanbul (view from the galleries)

the Turks, delicately harmonized with the richly colored marble and porphyry of the columns and piers, and when the windows, originally more numerous than now, retained their colored glass. In fact, the chronicler Procopius wrote that the structure "seems not to rest upon solid masonry, but to cover the space with its golden dome suspended from Heaven."

The meaning of the heavenly light of Hagia Sophia can be understood only in symbolic terms. The Gospel of John (1:4–9) had defined Christ as the "light of men," shining in darkness, and Christ in the same Gospel proclaimed himself to be "the light of the world" (8:12). The Nicene Creed, adopted in 325 and still in use in Orthodox, Catholic, Anglican, and many other churches, declares universal belief in Christ as "God of God, light of light." The building itself was dedicated to Divine Wisdom, which was believed manifest in the Virgin Mary, Mother of God, in the words of the Book of Wisdom (7:26–29, omitted from Protestant Bibles): "For she is the brightness of eternal light . . . for she is more beautiful than the sun, and above all the order of the stars. Being compared with light she is found before it." In the apse over the altar the colossal shining mosaic image of the Theotokos reminded worshipers of this mystical identification, eternal light made visible. Nor did the emperors as Vicars of Christ renounce their share of supernal splendor; one went so far as to unite pagan and Christian light by setting up a Greek nude bronze statue of the sun god Apollo in the principal square of Constantinople, substi-

tuting his own portrait for the original head, surrounded with a sunburst whose rays formed nails like those of Christ on the Cross.

The glorious impression of harmoniously blended space and light we receive in the interior today should be supplemented in imagination by visualizing the majestic processions of the Byzantine emperor and his court to the imperial enclosure at the right of the sanctuary in the south side aisle, the gleaming vestments of the patriarch and the clergy, and the incense and chanting that accompanied many of the rites. The congregation, restricted to the aisles, could witness only a small portion of the Liturgy, which took place, as it does to this day in Orthodox churches, behind an enclosure. The clergy emerge only at specified times, for example, for the reading of the Epistle and the Gospel and for the rite of Communion. Women and catechumens, confined to the galleries, could obtain only a fragmentary view of the vast interior (fig. 430), but it was a wonderful one, with the forms of the arches—curved in plan—playing against the half-seen, half-imagined spaces of the colorful nave. They could also delight in a closeup view of the new and special beauty of the Byzantine capitals—far more delicately designed and carved than those of Ravenna—out of whose undulating ornamented surfaces remnants of Classical shapes protrude like half-sunken ships.

The colossal structure, by far the largest of the several major central-plan churches with which Justinian embellished his rebuilt capital, was finished in 537, after only five years' work (and a huge expenditure of money and effort). One can hardly blame Justinian for his supposed boast: "Solomon, I have vanquished thee!" However much Anthemius and Isidorus knew about conic sections, they were certainly less familiar with coefficients of safety, since their dome soon started to push its pendentives out of line and indeed collapsed in 558. The original dome was certainly lower than its replacement, completed in 563, and it perhaps continued the shape of the pendentives, forming a giant sail. The present dome has also had its mishaps, but it has been repaired, and Justinian's church has taken its place as one of the most imaginative architectural visions in the entire history of mankind.

SINAI The other-worldly light symbolism of Justinianic art comes to its climax, appropriately enough, in a mosaic on Mount Sinai, where Moses saw the Lord in the light of the Burning Bush. This sole surviving mosaic composition commissioned by Justinian outside of Ravenna has come to general attention only very recently because of the almost inaccessible position of the church in which it is located. The fortified Monastery of Saint Catherine lies more than five thousand feet above sea level on the desert slopes of the sacred mountain. This mosaic, done after 548 and probably before 565, and recently cleaned, restored, and photographed, fills the apse of the monastery church with a representation of the Transfiguration (see page 317), a New Testament equivalent of the luminary revelation to Moses, stated in terms of unearthly abstraction and heavenly radiance (fig. 431). The Transfiguration (known as the Metamorphosis, or Transformation, in Greek) is depicted as at once sudden and eternal. The real world has shrunk to a mere strip of green at the bottom, as in the Justinian mosaic at San Vitale; all the rest of the surrounding space is gold. Blessing with his right hand, and staring over and beyond us, Christ stands at the center in an almond-shaped glory, an early appearance of the *mandorla* (the Italian word for "almond") that surrounds him in countless representations in the later Middle Ages. Seven

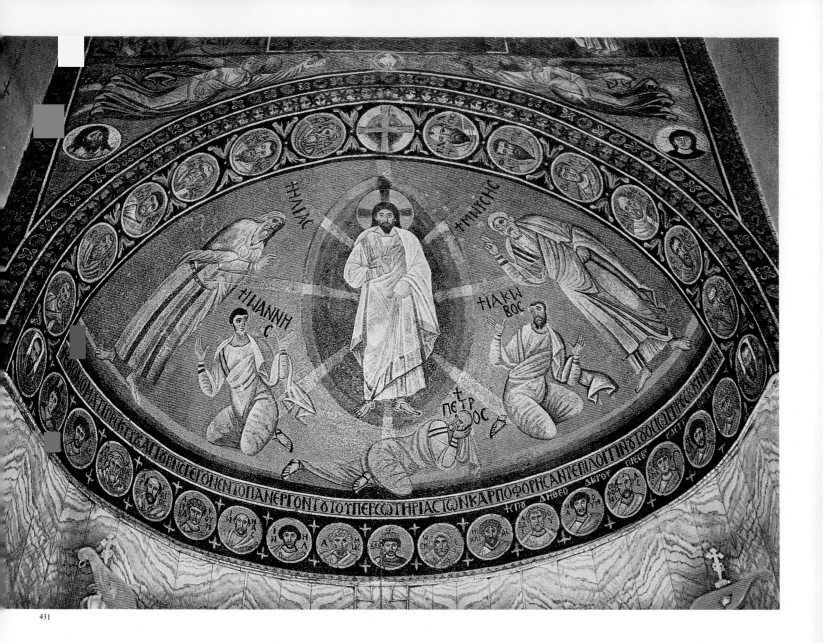

431

rays of light stream from his raiment. The Apostles appear locked in the kneeling or prone positions into which the force of the miracle has thrown them, yet turn to look backward at the wondrous light with open eyes. The mandorla seems to weigh upon the back of the kneeling Peter. James and John float against the gold, while Moses and Elijah, who in the biblical text are apparitions, stand with their toes touching the green.

Faces, bodies, and drapery are reduced to hard, clear, almost geometric shapes, sometimes defined by heavy contours, showing a sharp change in style during the later years of Justinian's long reign. But if the great artist who designed the mosaic treated earthly forms as unreal, he rendered with minute precision the effects of the heavenly light, which reveals Christ's divinity to the Apostles and to Moses and Elijah. Against the four shades of sky-blue into which the mandorla is graded, Christ's glistening raiment stands forth in a pearly hue over which play magical tones of velvety white. As they cross the zones of the blue mandorla, the seven rays turn a shade lighter in each zone; they become stripes of white and cream as they traverse the gold; the rich mauves, tans, lavenders, and grays of the garments of the Apostles and Prophets are bleached out as

431. *Transfiguration*, mosaic, Monastery of St. Catherine, Mount Sinai, Egypt. c. A.D. 549–64

432. *The Virgin and Child Enthroned Between Saint Theodore and Saint George.* c. 6th century A.D. Panel painting, 27 × 18⅞". Monastery of St. Catherine, Mount Sinai

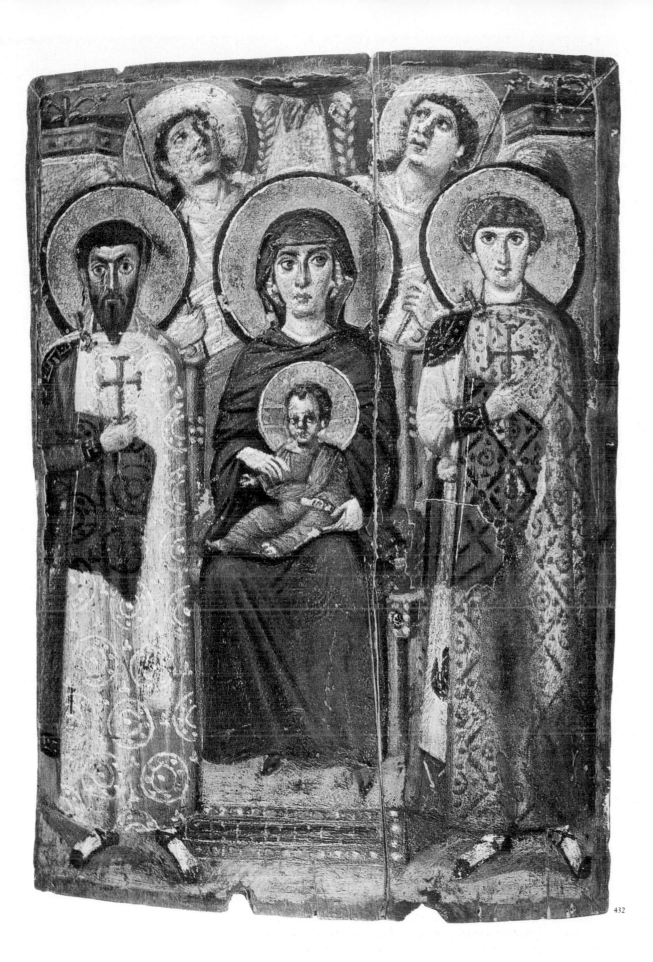

432

the rays pass over them. No more compelling vision of the actual effects and spiritual meaning of light survives from the early Middle Ages.

A similar contrast between abstraction in the statement of form and naturalism in the rendition of light appears in a picture in encaustic, which is at once one of the oldest-known Christian panel paintings and one of the earliest surviving examples of that favorite among all themes in the late Middle Ages and in the Renaissance, the Virgin and Child (fig. 432). This *icon* (image), also in the Monastery of Saint Catherine at Sinai, probably dates from the sixth century. Throughout human history, as we have seen, many peoples have tended to consider images to be in some way magical (the tomb statues of the Egyptians, the images of deities of the Greeks, the emperor portraits of the Romans) and to venerate them, usually on account of the subject. However, in Christian art icons began rapidly to be endowed with miraculous powers in themselves; innumerable stories have been told throughout Christian history of the wonders performed by sacred images, and many are firmly believed to this day. As early as the sixth century, chroniclers reported accounts of suppliants kneeling before images, and the icon preserved at Saint Catherine's may well have been intended to inspire such reverence. The Virgin and Child are shown royally enthroned between the warrior saints Theodore (bearded) and George, dressed as officers of the imperial guard. Behind the throne two angels look up to an arc of blue, representing the heavens, in which appears the Hand of God (the typical method of showing God the Father in Early Christian art), from which a band of white light descends toward the figures on the throne. The Virgin appears in an almost exactly frontal pose, and the Christ Child extends his right hand in teaching while his left holds a scroll, very nearly as in the work of the Italian painter Cimabue, who was brought up in the Byzantine tradition, some seven centuries later. The saints stand as rigidly and frontally as the imperial attendants at Ravenna (see figs. 424, 425), and the four gold halos are so aligned that they can be read, together with the Hand of God, as a cross. Even though the principal figures are so locked within this pattern that they can move only their eyes, the play of light is unexpectedly rich and the brushwork free. Variations in flesh tones, the dark circles under Mary's eyes, and the shimmer of the damasks are beautifully represented. Illusionist vision and technique, then, survive in the rendering of the play of light, while the grouping of the figures has been subjected to new laws of symbolic rather than naturalistic arrangement.

Another, and in many ways more impressive, early icon at Mount Sinai (fig. 433) depicts a long-haired, bearded Christ against an architectural background reduced to the mere suggestion of a niche. His right hand is lifted in blessing and his left holds the customary Gospel book, adorned with massive, jeweled gold covers and clasps. Probably sixth-century, although an eighth-century date has also been proposed, this may be the earliest icon of Christ to come down to us and is certainly the earliest pictorial image of the *Pantocrator* (all-ruler) type known. In later Byzantine art the Pantocrator reappears in colossal size and majesty at the center of domes or semidomes, as once in Hagia Sophia, gazing down at the awestruck worshiper (see figs. 445, 450). The Sinai icon might be a copy of the *Christ Chalkites*, a famous icon greatly venerated by the populace and improbably believed to have been set over the entrance gate by Constantine himself. Indeed some aspects of the painting suggest knowledge of Classical Greek and Roman practice, especially the clear, sculptural modeling of the eyelids and nose, reminding us of the mosaic fragment from St. Peter's (see fig. 408). Above all, however, the subject,

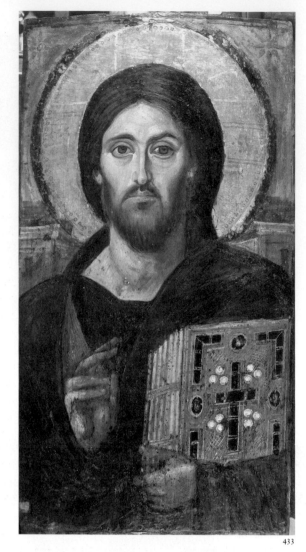

433

433. Christ icon, Monastery of St. Catherine, Mount Sinai. c. 6th–8th century A.D. Courtesy the Michigan-Princeton-Alexandria Expedition to Mount Sinai

with his pallid countenance, solemn, clear, wide-open eyes, and expression of one who has suffered—"a man of sorrows and acquainted with grief" (Isaiah 53:3)—strikes to the very heart of the observer. Instead of the terrifying images of the later mosaics the *Christ Icon* conveys an impression of overpowering humanity and compassion. It is certainly one of the deepest expressions of the spirituality of Early Byzantine art.

MANUSCRIPTS AND IVORIES The earliest preserved Christian illuminated manuscripts seem to have been made for the imperial court. In contrast to the utilitarian character of Classical books, this group of codices is written in letters of gold or silver on parchment dyed imperial purple. The finest of them is a sixth-century fragment of the Book of Genesis, now in Vienna (fig. 434); in reality it is a picture book, for the illustrations appear at the bottom of each leaf with just enough text to explain them written above. These little narratives move along at a lively pace on the foreground plane, like scenes on an imperial column (see fig. 353) without any enclosing frame or any divisions between the separate incidents, on a continuous strip of ground. No more background is represented than exactly what the story requires. For example, when Jacob tells Joseph to join his brothers where they feed the flock in Shechem (Gen. 37:13–17), there is no setting except a wayside pillar to indicate the journey and a hillside when Joseph actually finds his brothers and the flock in Dothan. Otherwise, we see only the little figures themselves, shimmering in fresh and lovely colors against the parchment, which becomes by suggestion a kind of purple air. Doubtless by direction, the artist has added an element here and there. These include a touching farewell between Joseph and Benjamin, which is not in the text any more than is the angel shown accompanying Joseph on his journey.

Somewhat less luxurious is a Gospel book whose text was copied by the monk Rabula in a monastery in Syria in 586. The codex contains several full-page illustrations of great dramatic power. One of the earliest representations of the *Crucifixion* (fig. 435) shows Christ crucified between the two thieves; he wears a long garment—a survival of the Near Eastern tradition that nakedness was shameful (even Ionian kouroi in Archaic times were clothed). We can distinguish a Roman soldier with a sponge filled with vinegar on the end of a reed and another with the lance that pierced Christ's side, the repentant thief turning his head in a beautiful motion toward the dying Saviour, Mary and John at the left, the other Marys at the right, and in the center below the Cross the soldiers playing dice for the seamless robe. Above, over the blue hills, hang the sun and moon, which were darkened at the Crucifixion. Below, in another register, can be seen the empty tomb, with the guards sleeping before it; on the left the angel tells the two Marys that Christ is risen; on the right Christ himself appears in the garden to the Marys, prostrate before him. Even the zigzag chevrons of the border play their part in heightening the excitement of the narrative. The bold sketchy style recalls in some ways the handling of the *Miracle of Ascanius* in the *Vatican Virgil* (see fig. 414).

A considerable number of ivory panels survive from Justinian's time, notably *diptychs* (two panels hinged together), made to be coated with wax on one side for writing and to be carved into representations on the other. These diptychs were customarily given as presents to high officials on their assumption of office. A splendid example (fig. 436) shows on one leaf the Virgin and Child enthroned between two angels, and on the other Christ enthroned between Peter and Paul; in the first the Christ Child

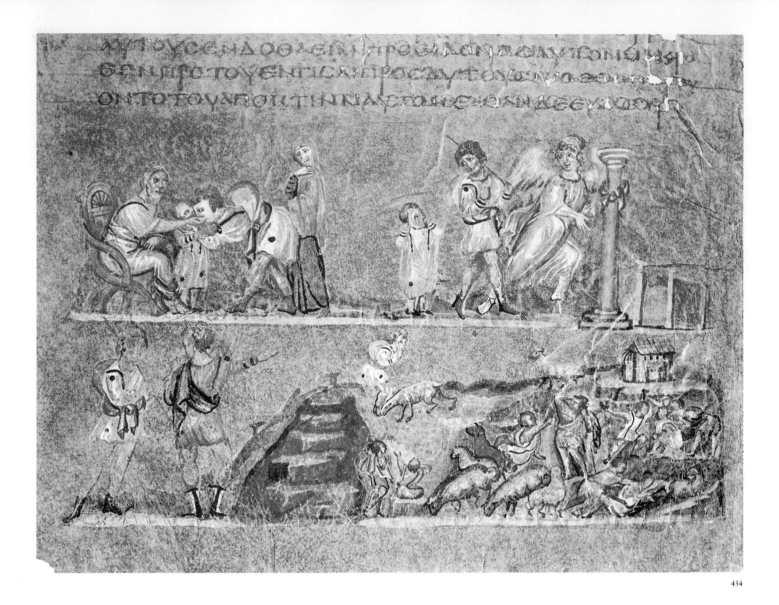

434. *Joseph and His Brethren*, illumination from the *Vienna Book of Genesis*. Antioch or Constantinople, early 6th century A.D. Österreichische Nationalbibliothek, Vienna

carries a scroll to indicate his Nativity as the fulfillment of Old Testament prophecies, and in the second the adult Christ displays the codex of the New Testament. In the background of both, architectural space survives only as remembered fragments, beautifully carved, yet without any real suggestion of depth. The majestic figures seem to float before their thrones rather than to sit upon them. Mary is a full-featured young matron; the angels who turn their heads with such grace still retain the beauty of the Hellenic tradition. In the strange representation of the adult Christ, shown with an unusually long beard, he seems to have assumed the dignity we associate with God the Father. The drapery folds, as often in Justinianic art, no longer describe the behavior of actual cloth, but begin to develop an intense existence of their own as abstract patterns.

Justinian had overextended himself; the Byzantine forces could not continue to hold all the territory he had reconquered. But in sections of Italy and in Asia Minor the Empire continued (it held sway in the Balkans for nearly nine hundred years longer), a treasure-house of Classical Christian culture and a fortress against the onslaughts of Islam from the east and the Slavs and Bulgars from the north.

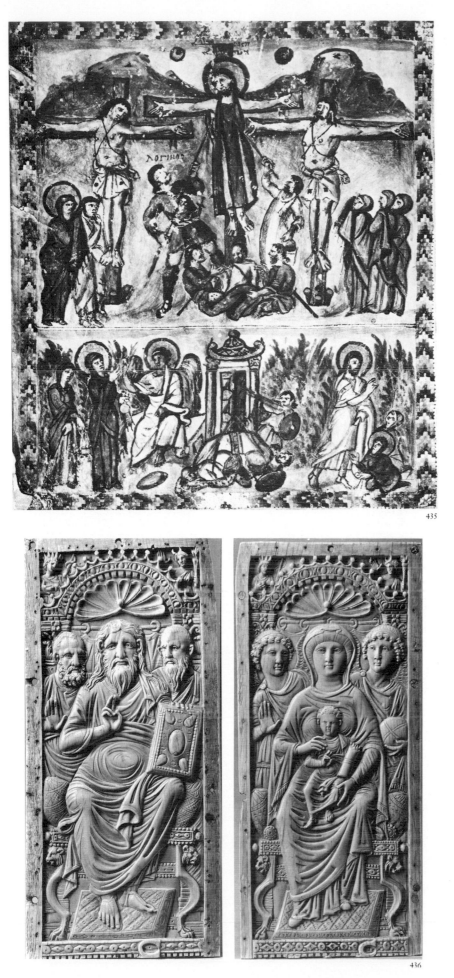

435. *The Crucifixion* and *The Women at the Tomb*, illumination from the *Rabula Gospels*. Zagba on the Euphrates, Syria, c. A.D. 586. Biblioteca Laurenzianæ, Florence

436. *Christ Enthroned Between Saint Peter and Saint Paul* and *The Virgin Enthroned Between Angels*. Ivory diptych, height c. 12″. Middle 6th century A.D. Staatliche Museen, Berlin

In 1944 a stroller in a dense forest of fairly young trees just west of the heavily traveled road connecting Milan with the Lake of Como came upon a small, rudely built, and totally unknown church near the village of Castelseprio; this church contained a series of small-scale frescoes of scenes from the Infancy of Christ, freely painted in an extraordinarily fresh and spontaneous style, reminiscent in some respects of the Hellenistic qualities of Pompeiian painting. In the *Appearance of the Angel to Joseph*, for example (fig. 437), one of the frescoes in this church, the figures, the draperies, the foliage, the rocks, and even the wayside pillar with its votive scarf must have been set down with great freedom, though on closer examination the schematic patterns in the brushwork betray that the style was not derived from observation of nature but from repeated, learned methods of rendering the effects of light. It is worthwhile noting, in this connection, that as recently as the early nineteenth century a visitor to a Greek monastery on Mount Athos watched a Byzantine master sketch an entire scene, full-scale, on a wall prepared for fresco in one hour without the aid of any drawing or model whatsoever. This combination of inherited compositions and techniques with great manual freedom runs through the entire course of Byzantine painting.

A controversy over the date of the Castelseprio frescoes arose soon after they became generally known at the close of World War II. Although their date remains uncertain, one early in the eighth century now seems probable. Apparently, a Greek painter was traveling through northern Italy, then controlled by the barbarian Lombards, painting wherever he could find work. Isolated though this single incident may seem, it is symptomatic of a Western need that later became endemic; when Western patrons wanted paintings or mosaics of a high quality, they often sent to Constantinople for competent artists brought up in a pictorial tradition that, from Archaic Greek times through the successors of Justinian, had remained virtually unbroken.

It is all the more tragic, therefore, that the Byzantine pictorial tradition, which for centuries constantly recharged the depleted batteries of the West, was itself menaced and for a while almost extinguished by a violent internal controversy that broke out about 726 at the court, led by the emperor himself, who deeply disapproved of the increasing attribution of miraculous powers to icons as a form of idolatry. At the height of the controversy, the possessors of images were tortured, blinded, mutilated, even executed, and representations of all sorts, including the figured mosaics that once adorned the interior of Hagia Sophia, were systematically destroyed. All the great pictorial art of the age of Justinian perished in this campaign, save only that in Byzantine Italy and in such remote fastnesses as Sinai (see figs. 431–33). For more than a century the struggle raged between the *Iconoclasts* (image breakers), who would permit only the Cross and ornament based on animal and plant forms in church decoration, and the *Iconodules* (image venerators), who hid their icons at great personal risk.

Although the triumph of Orthodoxy and the Iconodules was celebrated in 843, it was not until 867 that the patriarch Photios could preach a sermon in Hagia Sophia mourning the loss of the mosaics that had been scraped off the church's walls and rejoicing that the image of the Theotokos could now be restored to its former glory and that the restoration of the images of the saints would soon follow. Photios was doubtless referring to the mosaic of the *Virgin and Child Enthroned* (fig. 438), which still appears in the apse of Hagia Sophia, although today in somewhat damaged condition because of the Turkish whitewash that covered it for

437

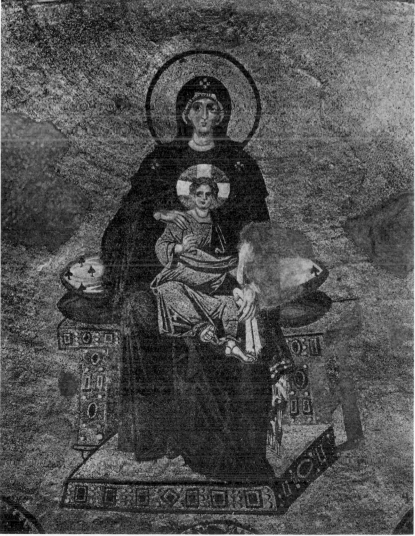

437. *Appearance of the Angel to Joseph*, fresco, Sta. Maria Foris Portas, Castelseprio, Italy. Early 8th century. A.D.

438. *Virgin and Child Enthroned* (detail of the apse mosaic, Hagia Sophia, Istanbul). Before A.D. 867

438

centuries. The figures are three times lifesize, but the dimensions of Hagia Sophia are so vast that the image seems tiny and is best appreciated through binoculars. It is tempting to see in the grave beauty of the Virgin's oval face and in the depth of her great eyes traces of sadness occasioned by the terrible period her devotees lived through before Photios' sermon. We can certainly discern in the grace of her delicate hands, in the precision with which the drapery folds are shown as they appear along the contour, and above all in the clear definition of the masses of the body and limbs under the shimmering blue garments a new artistic ideal of refinement and definition very different from the light-mysticism of the Sinai mosaic or the entranced solemnity of the Sinai icons. The Virgin is remote, almost lost in the immensity of the golden semidome. Within a few years, however, during the latter quarter of the ninth century, many other mosaics were added to Hagia Sophia, the greatest of which was a Pantocrator in the center of the dome with angels in the pendentives. The entire ninth-century cycle has perished either in structural collapses or at the hands of the Ottoman Turks.

The last six centuries in the life of the Byzantine Empire were only intermittently peaceful. The emperors had to wage almost continuous defensive war against invasions of the Turks, Slavs, Bulgars, Avars, and Russians. Time and again invaders appeared under the very walls of Constantinople, and sieges of the capital, frequently imminent from one direction or another, were often protracted and severe. By one means or another, the Byzantines always repelled the invaders, and from time to time they regained portions of Justinian's former empire. Unexpectedly, their pagan enemies (but not the Muslims) were converted to Christianity; after some oscillation most accepted the Eastern Orthodox form. Quite as dangerous as invaders were internal dissensions, which could break out at any moment in the form of palace revolutions, often engineered by members of the emperor's family or entourage. Nonetheless, the person of the emperor was still regarded as sacred, and palace ritual was controlled by an elaborate scenario. For example, the emperor received ambassadors while seated on the Throne of Solomon, which was flanked by bronze lions and gilded trees bearing gilded birds. As the ambassadors prostrated themselves, the lions put out their tongues and roared, the birds sang (each its own tune), and the throne bearing the emperor rose nearly to the ceiling; when it descended, he was wearing a different costume. The number and riches of the palace halls, adorned with marble columns and gold mosaics, were legendary in the West. The Great Palace must have been laid out in informal groupings of chambers and buildings, somewhat on the order of Hadrian's Villa (see fig. 360). Possibly the Alhambra (see fig. 479) reflects some of the character of the Byzantine imperial palaces, whose chambers were interspersed with courtyards, fountains, and pools. When Constantinople was captured by the Crusaders in 1204, the Great Palace, like the rest of the city, was sacked and left a burned-out ruin. Little of its splendor remains.

THE MACEDONIAN RENAISSANCE The Macedonian dynasty ushered in a period of intense cultural activity, especially under Constantine VII (Porphyrogenitos), a scholar and amateur painter who reigned from 913 to 959. Although their dating is still by no means certain, a group of illuminated manuscripts, whose Classicism is even more impressive than that of the works of the Palace School in the Carolingian

439. *David the Psalmist*, illumination from the *Paris Psalter*. c. A.D. 900. Bibliothèque Nationale, Paris

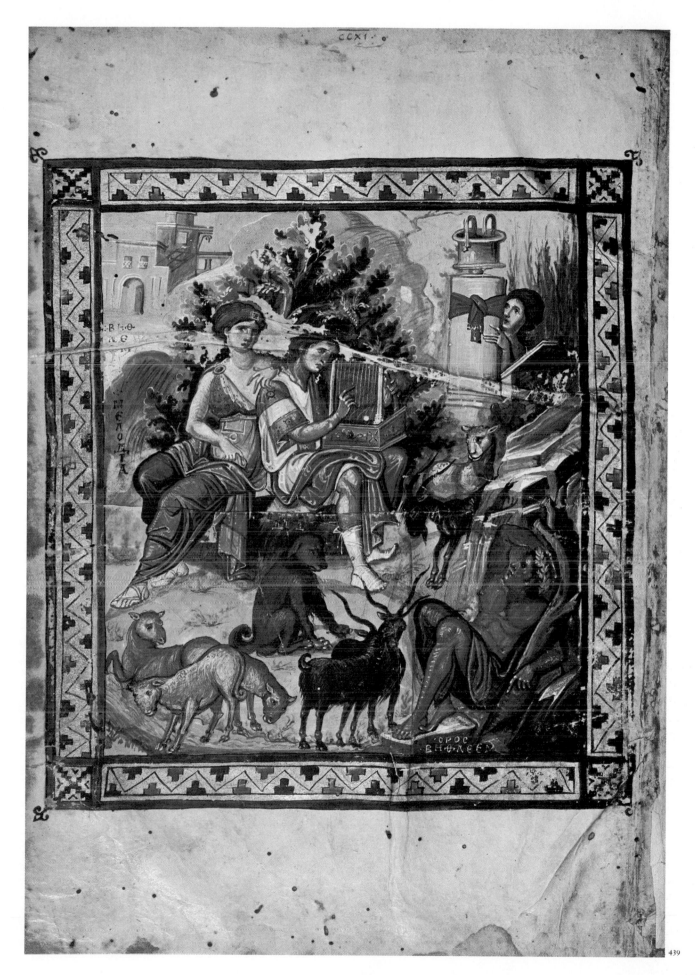

439

period (see fig. 502), is now attributed by most scholars to the tenth century and to the personal influence of Constantine VII.

The Joshua Roll. A wholly unique work is the *Joshua Roll* (fig. 440), the kind of continuously illustrated rotulus mentioned in the discussion of the Column of Trajan (see Part Two, Chapter Six; see fig. 352). Undoubtedly, however, the *Joshua Roll* was influenced by Roman imperial columns, two of which stood in Constantinople. The commissioning of a rotulus to depict the military campaigns of a great biblical hero may well have been prompted by a desire to commemorate allegorically the victories of the Macedonian emperors against the Muslims. In the section illustrated, two Israelite spies are sent out toward distant Jericho, then ride in search of Joshua, and finally Joshua, dressed as a Byzantine general and provided with a halo, leads his army toward the Jordan River.

Landscape elements are depicted much as they were in the Vienna Genesis (see fig. 434) and in the Castelseprio frescoes, but are not restricted to the foreground plane. The illuminator has worked out an extremely effective technique for rendering foliage, rocky hillsides, and distant cities in a soft, golden-brown wash, which suggests great distances and atmospheric haze. Certain details (in one instance Joshua prostrates himself before the angel in the posture dictated by tenth-century court ritual) indicate that the work may not be a copy. But in all certainty the artist studied paintings of the Helleno-Roman tradition with great care. The complex, vivid action poses and the movement of the horses show a firm control of the basic principles of Classical art; the rhythmic movement of the figures through landscape space is totally unexpected.

The Paris Psalter. The brilliant work of this group is the *Paris Psalter*, which contains several full-page illustrations in color, richly painted in a style so close to that of Pompeiian art (see figs. 323, 346) that it is hard to convince ourselves that we are not looking at a Classical original. *David the Psalmist* (fig. 439) has all the appearance of an Orpheus charming the animals with his music (they are, of course, David's goats, sheep, and

440. *Joshua Leading the Israelites Toward the Jordan River* (detail of an illumination from the *Joshua Roll*). Constantinople (present-day Istanbul), 10th century A.D. Biblioteca Apostolica Vaticana, Rome

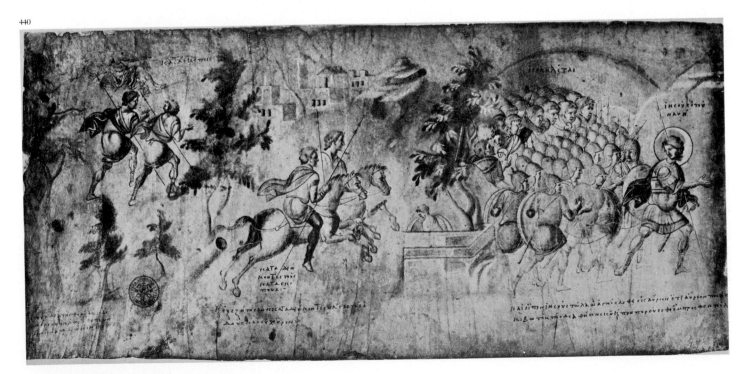

440

dog). As he plays, he is attended by a lovely Greek female figure labeled Melody; a nymph peeps shyly from behind the usual wayside column; and in the lower right-hand corner a muscular, deeply tanned, superbly painted male figure, clinging to the stump of a tree, is—of all things—the divinity of Bethlehem! Classicism could hardly have been carried further. The scene is painted with such grace and luminosity that it is a shock to be called back to chronological reality by the stiffness and mannered quality of the drapery folds and by the parallel striations used to render light. These medieval artists could emulate Classical models, possibly at the behest of the scholar-emperor, and even feel the beauty of the Hellenic style they were learning without clearly understanding the analysis of space and light that had originally given rise to it.

MONASTIC CHURCHES AND MOSAICS When the Macedonian renaissance began, Hagia Sophia and other grand-scale churches already existed in the capital, and the other large cities of the Empire were also graced with elaborate churches. These buildings were well maintained, and there was no need for more of their kind. Eleventh- and twelfth-century builders could devote their efforts to the construction of monastic buildings, intended for communities numbering a few monks, and a profusion of such churches was erected. Despite all their richness of marble paneling and mosaic decoration, therefore, these churches are surprisingly intimate in scale. The basic plan, which had countless individual variations, was the so-called Greek cross with four equal arms inscribed within a square and crowned by a dome. This plan maintained a central axis in that the church was prolonged on the west by a narthex and in that the east wall was broken by one or more apses. The interior was small and designed chiefly for the celebration of the Liturgy by monks.

Hosios Loukas. At the Monastery of Hosios Loukas in Phocis, between Athens and Delphi in west-central Greece, two connected monastic churches were built early in the eleventh century. Both the Katholikon and the Theotokos (fig. 441) were laid out on Greek-cross plans; the

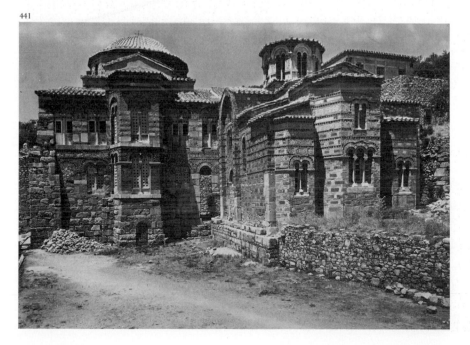

441. The Katholikon and Theotokos (churches), Monastery of Hosios Loukas, Phocis, Greece. Early 11th century A.D.

Katholikon was provided with galleries girdling its interior. In both churches the central dome was lifted on a high drum, pierced by windows. Compared with the austerity of Early Christian exteriors, the churches at Hosios Loukas seem ornate indeed, yet the richness is one of construction, not mere decoration. Courses of stone alternate with courses of brick, set at an angle to provide even greater variety of texture. This kind of construction was used throughout Greece and the Balkans from the eleventh through the fifteenth century.

When compared with the apparently measureless space of Hagia Sophia (see fig. 427), the interior of the Katholikon seems at first cramped (fig. 442); the movement is, however, entirely vertical, and carries the eye aloft into the dome, which is the only part of the central space lighted directly by its own windows. The light in the church is subdued, originating from windows in the galleries, in the corner spaces flanking the sanctuary, in the prothesis and the diakonikon (areas intended respectively for the preparation of the sacred elements of the Eucharist, and for the storage of vessels and vestments, much like the sacristy of a Roman Catholic church), and in the arms of the transept. The dome, interestingly enough, does not spring from pendentives as at Hagia Sophia but rests on squinches as at San Vitale. In all Byzantine churches the bema (sanctuary) is closed off by means of an iconostasis, a screen bearing icons whose subjects and order are largely predetermined by tradition. Tradition also determined the order of the mosaics in a church interior. The Theotokos, invariably enthroned or standing, adorned the semidome of the apse; the Pantocrator looked down from the center of the dome, surrounded by the heavenly hierarchy between the windows and by scenes from the life of Christ pictured in the squinches, vaults, and upper wall surfaces. Figures of standing saints decorated the lower wall surfaces. These soaring interiors, with their rich and subtle variations of spaces and lights, must always be imagined not only with their marble and mosaic decorations but also with their Liturgy, accompanied by clouds of incense and by chanted music whose deep sonorities bear little relation to the sound of Western plainchant.

Daphni. The finest remaining mosaics of the Middle Byzantine period are those in the Church of the Dormition at Daphni, not far from Athens, dating from about 1100. The *Annunciation* (fig. 443), unfortunately damaged at the right, fills one of the four squinches. The artist has utilized this space so that the angel Gabriel makes his salutation to Mary across the corner; as there is no indication of groundline, the figures seem to float in glittering golden air. Mary is represented in the state of mind indicated by Luke 1:29: "And when she saw him, she was troubled at his saying, and cast in her mind what manner of salutation this should be." The subtlety of the psychological characterization is in keeping with the refinement of the style. Especially beautiful is the harmony between the convex curvature of the angel's wings and the concave line of his arm, and the integration of these curves with those of his himation and tunic. As in Ottonian and Romanesque painting, the light is generalized and the drapery formalized, but at Daphni this formality is always under careful control, so that one is constantly aware of subtle balances and counterbalances of movement.

Although the *Christus patiens* (Suffering Christ) type was chosen for the *Crucifixion* at Daphni (fig. 444), the representation is timeless and symbolic; there are no soldiers, no Apostles, no thieves, only the grieving Mary and John on either side of the Cross, and, originally, mourning angels above the Cross on either side. The emotion is intense, but it is

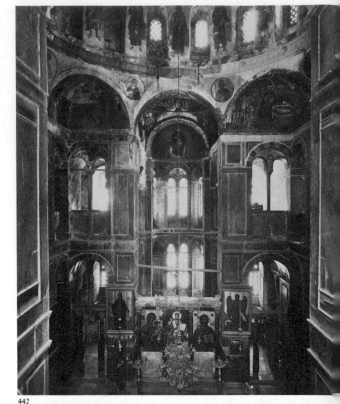

442

443

442. Interior, Katholikon, Hosios Loukas, Phocis

443. *Annunciation*, mosaic, Church of the Dormition, Daphni, Greece. c. A.D. 1100

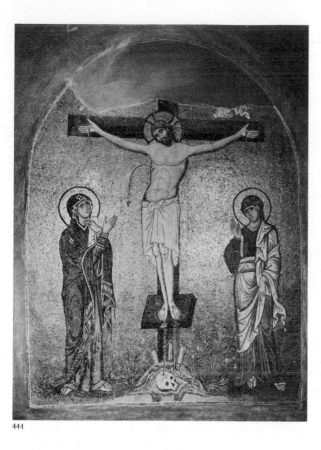

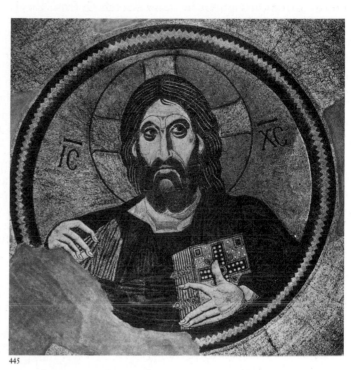

held in check by a reserve comparable to that of the Classical period in Greek sculpture; in fact, the three figures have been disposed with the grand simplicity of those on a metope. Christ hangs upon the Cross, his arms describing a shallow curve, his hips toward his right in a pose repeated in most Crucifixions under Byzantine influence. His head is gently inclined toward Mary as she gazes up at him with one hand slightly extended, John, on the other hand, turns toward us. Formalized though the broad flow of the drapery masses may be in detail, it remains sculptural in feeling. As is characteristic of much Middle and Late Byzantine pictorial art, the modulations of tone are delicate in the extreme. Christ's side has been pierced, and blood accompanied by water spurts from it in a bright arc (John 19:34), symbolizing the sacraments of the Eucharist and Baptism. The streams of blood that flow from Christ's feet strike the skull at the foot of the Cross. Golgotha means "the place of a skull" in Hebrew (John 19:17). Theologians have always interpreted the skull as that of Adam. Paul had said (I Cor. 15:22): "For as in Adam all die, even so in Christ shall all be made alive." As if in fulfillment of Paul's promise, flowers grow from the rocks below the Cross.

From the lyrical *Annunciation* and the elegiac *Crucifixion*, we turn with amazement to the revelation of the *Pantocrator* (fig. 445) at the summit of the dome. We may possibly gain from this image some idea of the vanished mosaic that in the Macedonian renaissance adorned the center of the dome at Hagia Sophia. The light from the windows of the drum illuminates the rainbow circle in which the colossal Christ appears, his face worn and deeply lined by suffering ("Surely he hath borne our griefs, and carried our sorrows," Isa. 53:4). The extraordinary human sensitivity of the great mosaicist at Daphni appears in the drawing of the long, aquiline nose, the flow of brows and cheekbones, the light on the half open mouth, the streaming lines of the hair, and above all in the incomparable depth and power of the eyes.

444. *Crucifixion*, mosaic, Church of the Dormition, Daphni. c. A.D. 1100

445. *Pantocrator*, dome mosaic, Church of the Dormition, Daphni. c. A.D. 1100

THE EXPANSION OF BYZANTINE STYLE In the Middle and Late Byzantine periods, the artistic achievements of Greek masters were carried throughout territory stretching from Russia to Sicily.

Venice. The most ambitious of all Byzantine monuments outside the Empire is San Marco in Venice (figs. 446, 447); this state enjoyed strong if not always cordial commercial relationships with Constantinople. The church, now the Cathedral of Venice, was commenced in 1063 as a ducal basilica connected directly with the Doges' Palace. Its plan was imitated from that of the destroyed sixth-century Church of the Holy Apostles at Constantinople, built by Justinian. It is basically a Greek cross, designed on five squares, each surmounted by a dome on a high drum, crowned by a helmet-like structure of wood and copper, which imparts a verticality unknown to Early Byzantine domes. The exterior was greatly modified in the Gothic period by the addition of elaborate pinnacles and foliate ornament along the skyline, but the original Byzantine arches and unusual clustered columns are still visible. The vast interior spaces of the basilica (fig. 448) have much more to do with the spatial fluidity of Hagia Sophia than with the usual compressed Middle Byzantine interiors. The domes, set on pendentives rather than on the insistent squinches of the era's monastic churches, seem to float above their arches.

Powerful barrel vaults separate the bays and abut the thrust of the pendentives; the vaults in turn are supported on massive cubic piers, pierced by arches connecting with the galleries, which are entirely open in contrast to the arcaded galleries of Eastern churches. The nave galleries are sustained by triple arcades supported by modified Corinthian columns. The veined marble columns and the gray marble paneling of walls and piers were, of course, imported from the Byzantine East. Dim at all times, the interior shines with a soft, golden radiance shed by the continuous mosaics that line the domes, barrel vaults, and lunettes and softly veil all architectural demarcations. Mosaic artists were brought from Constantinople, but how much they accomplished is not known; presumably much

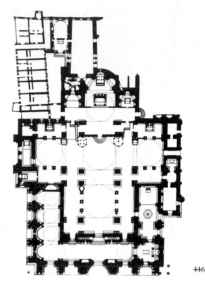

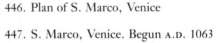

446. Plan of S. Marco, Venice

447. S. Marco, Venice. Begun A.D. 1063

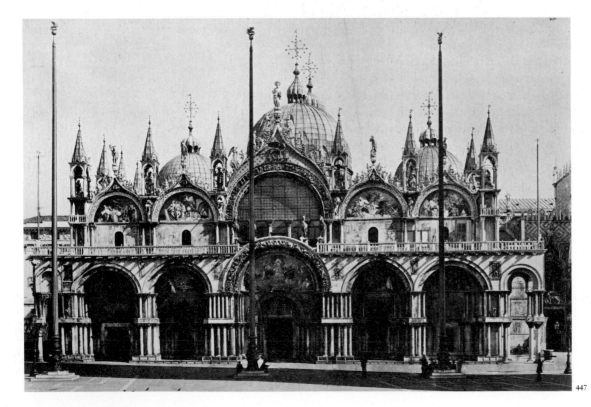

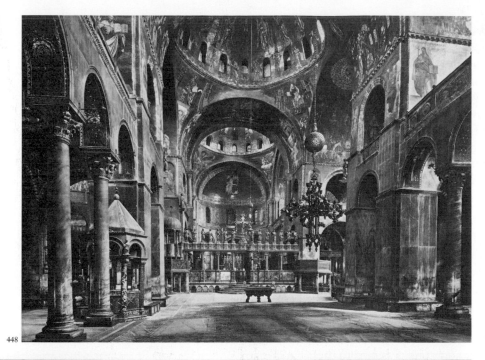

448. Interior, S. Marco, Venice

449. *Pentecost*, dome mosaic, S. Marco, Venice.
c. A.D. 1150

of their work was destroyed in a disastrous fire in 1106. Many of the
present mosaics, in Byzantine style but with Romanesque influence here
and there, were done by Venetian artisans during the twelfth and thir-
teenth centuries; several, however, were completely replaced in the late
Renaissance or in the Baroque period. Those that remain are important
as witnesses to the beginning of the Venetian school of painting, which
in the Renaissance became one of the two leading Italian schools.

In the earliest of the five dome mosaics, executed about 1150 in the
dome above the nave, the *Pentecost* (fig. 449) is represented. The Descent
of the Holy Spirit upon the Apostles is described in Acts as "a sound

from heaven as of a rushing mighty wind." As the Apostles met "there appeared unto them cloven tongues like as of fire, and it sat upon each of them"; they then began to speak in many tongues, which were understood by people from all nations who were in the streets outside. The event is reorganized in conformity with the architecture of the dome. In the center is a throne, on which stands the dove of the Holy Spirit; from the throne rays extend to the Apostles, enthroned in a circle above the windows. Between the windows stand pairs of people from all nations. The design is like a vast wheel, but it contains a startling discrepancy: there are Twelve Apostles over sixteen windows, as if three-four time in music were being played over four-four, each measure being marked by an archangel in one of the spandrels.

Sicily. At the other extreme of Italy, Roger II ruled as the first Norman king of Sicily from 1130 to 1154. Like other monarchs in southern and eastern Europe, he called Byzantine artists to his court to decorate a series of religious buildings and the salon of his palace. The church at Cefalù was raised to cathedral status at the request of Roger II, who intended it as his tomb-church. The team of Greek artists, who finished the mosaic decoration of the apse in 1148 (the later mosaics in the choir are by local masters), had to adapt Byzantine iconographic systems to the architectural requirements of a Western basilica and the desires of a royal patron (fig. 450). In the two lowest registers stand the Twelve Apostles. In the next register the beautiful Theotokos, robed in white with soft blue shadows, extends her delicate hands in orant position between four magnificent archangels, bending their heads as they hold forth scepters and orbs. Above this heavenly court, in the semidome (the church has no dome), appears the Pantocrator, as he does later at Monreale. In contrast to the austere Saviour at Daphni, the Cefalù Christ seems a poet and a dreamer, sensitive and merciful. His right hand is outstretched in blessing; in his left, instead of a closed book as at Daphni, he upholds the Gospel of John, written in Greek and Latin, open at Chapter 8, Verse 12, for all of King Roger's Christian subjects to read: "I am the light of the world: he that followeth me shall not walk in darkness, but shall have the light of life." The light we have learned to expect in Byzantine art shimmers through the Cefalù mosaics with a delicacy that proclaims them one of the finest achievements of Byzantine art—not the radiance of revelation we saw represented at Sinai (see fig. 431), but the light of Paradise, a soft, uniform radiance resulting in the subtlest refinement of gradations in hue and value throughout the drapery masses, the feathers of the angels' wings, and above all in the modeling of faces and hands. Even the ornament sparkles with a new and special brilliance—the decoration above and below the arch, the jewels that stud the cross of Christ's halo, and an entrancing bit of illusionism, the mosaic acanthus capitals crowning the real colonnettes that uphold the arch. Along with the light at Cefalù, line proliferates in amazing multiplicity through the countless strands of Christ's hair and beard and the crinkled folds of the drapery. On the brown tunic appear for the first time sunbursts of gold rays, fusing light and line, soon to be adopted by such Italo-Byzantine painters as Cimabue.

Macedonia and Serbia. An extraordinary series of frescoes (less expensive to produce than mosaics) is still preserved in churches, cathedrals, and monasteries throughout Macedonia and Serbia, in what is today Yugoslavia. At least fifteen major cycles remain, executed from the eleventh well into the fifteenth century, the last of them done barely ahead of the invading Turks. These cycles form the richest and most consistent body of mural painting left from Middle and Late Byzantine art. The finest paint-

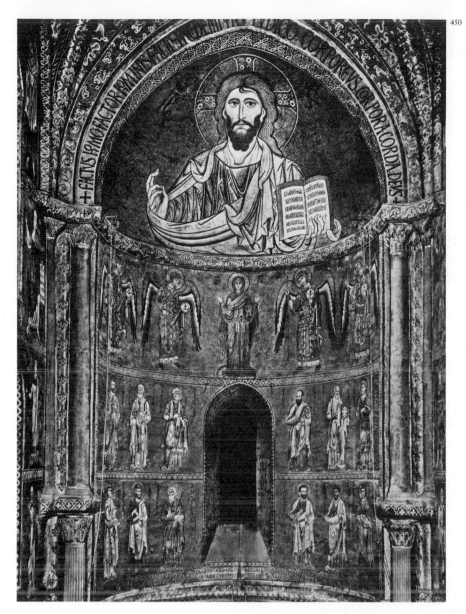

450 Apse mosaics, Cathedral of Cefalù, Sicily. Completed A.D. 1148

ings in each series were almost invariably done by artists from Constantinople or from other Greek centers; some were painted by refugees after the conquest of the capital by the Crusaders in 1204. Many of the signatures on these works are Greek, and some painters can be traced from one cycle to the next. Local, presumably monastic, artists often completed a cycle begun by an artist from Constantinople or elsewhere with frescoes of considerably less interest (usually those farthest from the eye).

An especially impressive cycle covers all of the interior walls of the beautiful little domed church of Saint Pantaleimon at Nerezi, high on a mountainside overlooking the Macedonian city of Skopje; the church was completed in 1164 by a grandson of the emperor Alexius I Comnenus. The styles of several painters can be distinguished in the cycle, which is held together by an overall unity of color—especially the intense blue of the backgrounds—and by its intimacy of scale. The painter who set down the scenes of the Passion with a directness and intensity of emotion not seen in Eastern art since the days of the *Rabula Gospels* (see fig. 435) was undeniably a master. The *Lamentation* (fig. 451) shows Christ laid out for burial, his body turned toward us, his eyes closed in death. John holds Christ's left hand to his face, and the Virgin enfolds her dead son in her arms; both faces are contorted with grief. The scene must have been

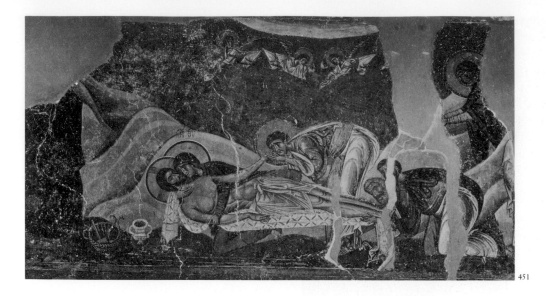

painted at dizzying speed; the authority of the brushstrokes and the brilliant handling of light on the drapery show that Greek painters had lost nothing of their mastery since the distant days of Castelseprio (see fig. 437). The expressive power shown in the Nerezi fresco leads us far in the direction of early Italian art.

The greatness of the Italian debt to Byzantine art is again indicated by the large-scale fresco cycle in the long-abandoned, recently restored Church of the Trinity at Sopoćani in Serbia. This church was one of a series of monasteries built by the Serbian kings (who wore Byzantine dress and imitated Byzantine court ritual) so that monks could celebrate the Liturgy before the royal tombs. In all of these Serbian churches the entire west wall of the interior above the doorway was given over to a vast fresco representing the Dormition of the Virgin, a non-Scriptural scene in which the grieving Apostles, who surround the bier of the Vir-

451. *Lamentation*, fresco, St. Pantaleimon, Nerezi, Yugoslavia. c. A.D. 1164

452. *Dormition of the Virgin*, central section of a fresco, Church of the Trinity, Sopoćani, Serbia, Yugoslavia. A.D. 1258–64

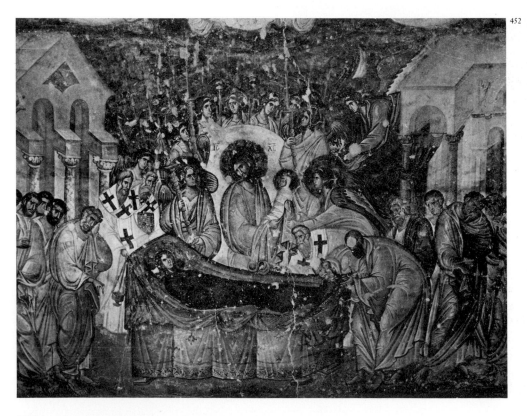

gin Mary, are astonished by the appearance of Christ from Heaven, attended by angels, who takes her soul in his arms in the form of a tiny child. The Sopoćani frescoes must have been done between 1258 and 1264, and although the artist did not go to the same expressionistic lengths as the twelfth-century master at Nerezi, he had quite as much understanding of drama and deployed both figures and architecture with authority. Movement and emotion sweep through the scene with tremendous effect. The coloring is unexpectedly delicate; Christ and Peter, for example, are wrapped in lemon-yellow mantles, and Mary's bier is draped in alternating passages of blue and rose. The illustration (fig. 452) shows only the central section of the fresco, which stretches out at the sides to involve both additional grieving figures and more architecture. The new sense of drama and of scale in the Sopoćani frescoes was accompanied by increasing powers of observation; throughout this scene faces are strongly individualized. Most powerful of all is the new sense of unified modeling in light and shade, of both features and draped figures, as compared to the divided drapery shapes of Middle Byzantine art. The creation of volumes in light has always been credited to Giotto and his immediate predecessors, especially Pietro Cavallini, but it is clear from the Sopoćani frescoes that Greek painters shortly after the middle of the thirteenth century already knew how to bring out a volume in depth by the action of light, even though that light has as yet no single, identifiable source.

LATER BYZANTINE MOSAICS AND PAINTING IN CONSTANTINOPLE In 1261 the emperor Michael VIII (Palaeologus), who had been governing in exile from Nicaea as coemperor, returned to Constantinople and started cleaning up the devastation left by the Crusaders. To the Palaeologan period is generally attributed a very large, fragmentary, but beautiful mosaic in the south gallery of Hagia Sophia (fig. 453) representing the *Deësis (Christ Between the Virgin and Saint John the Baptist*;

453. *Deësis*, south gallery mosaic, Hagia Sophia, Istanbul. Late 13th century A.D.

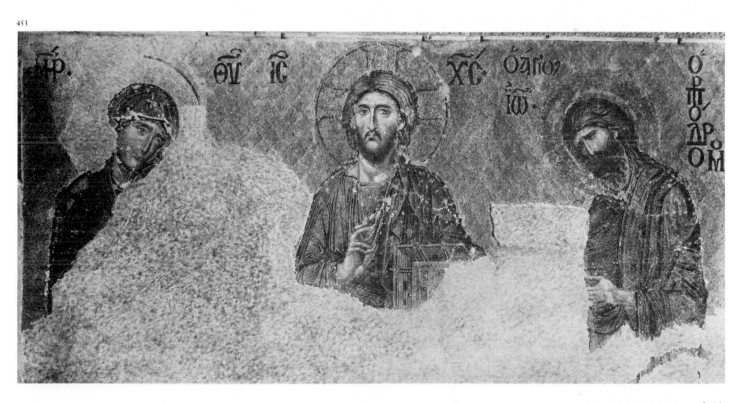

453

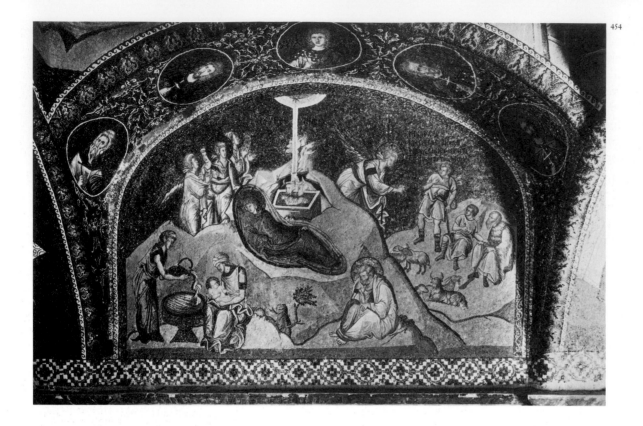

for its later reappearance, see the *Ghent Altarpiece* by Jan van Eyck). The tenderness of the expressions, the grace of the poses and the linear movement, and the extraordinary sensitivity to light in the rendering of faces, hands, and hair mark a master very different from the bold dramatist at Sopoćani, but, nonetheless, one who had a similar understanding of the role of light in creating volume. In the *Deësis* mosaic the diffused light, apparently from an external source, is also very different from the allover glow of the Cefalù mosaics.

Church of Christ in Chora. During the reign of Michael's son and successor Andronicus II, the Monastery and Church of Christ in Chora, adjacent to the imperial palace in Constantinople and now known under the Turkish name of Kariye Djami, were rebuilt, the church and its narthex decorated with mosaics, and the parecclesion (an adjacent funerary chapel) painted in fresco. This extensive cycle, which has been dated between 1315 and 1321, was carried out after the creation of Giotto's revolutionary works, and it is just possible that the cubic rocks and massive figures in the *Nativity* mosaic (fig. 454) were influenced by Giotto's new ideas (see fig. 2). The scene is represented according to Eastern tradition, derived partly from the account in Luke, and partly from the apocryphal stories of the fifth and sixth centuries, which were widely accepted in the East. For example, the cave in the background does not derive from the Gospels, but from one of these later accounts, and is represented throughout Byzantine art (the Church of the Nativity in Bethlehem was later erected over the cave where Christ is believed to have been born). The first bath of the Christ Child, also apocryphal, is depicted at the lower left.

In the startling frescoes of the parecclesion, Late Byzantine style is exemplified in its most vigorous and imaginative phase. The technique of these frescoes has recently been analyzed; they were executed in the method Italian artists call *secco su fresco* (dry on fresh). The color was suspended in a vehicle containing an organic binding material (such as oil, egg, or wax) and laid on over the still-damp plaster. Paint thus applied forms a contin-

454. *Nativity*, narthex mosaic, Church of Christ in Chora (Kariye Djami), Istanbul. A.D. 1315–21

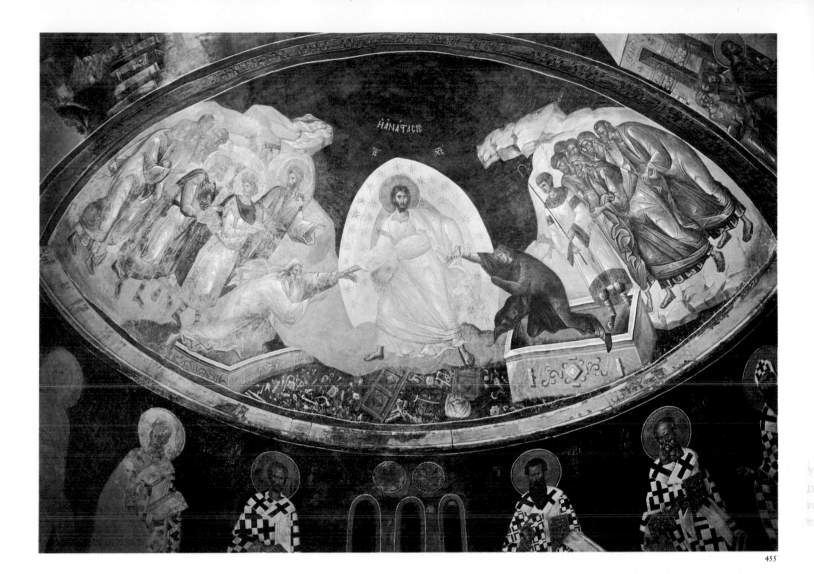

455

455. *Anastasis* (*Resurrection*), apse fresco, Church of Christ in Chora (Kariye Djami), Istanbul. A.D. 1315–21

uous and very hard skin. This method also allows free and rapid painting over large areas. This technique differs sharply from the "true fresco" method generally used by Italian artists during the Gothic period and the Renaissance. Probably, the *secco su fresco* technique was also used in the Macedonian and Serbian frescoes, but this has not been proved.

The fresco filling the semidome of the apse (fig. 455) represents what the Greeks call the *Anastasis* (*Resurrection*). Although the Gospel accounts do not describe this scene, both the Apostles' Creed and the Nicene Creed declare that during the three days when Christ's body lay in the tomb he descended into Hell. Apocryphal accounts, widely believed throughout the Christian world, tell how Christ caused the gates of Hell to burst open before him, filled its darkness with light, commanded that Satan be bound until the Second Coming, and lifted Adam and Eve, followed by all the patriarchs and prophets, from the unhappy realm to which they had been doomed by Original Sin. This theme, known in Western art as the Harrowing of Hell or the Descent into Limbo, is highly appropriate for a funerary chapel, as it sets forth vividly the Christian hope for resurrection. The composition is unusual in that in order to centralize the scene in the apse the artist has shown Christ lifting Adam with one hand and Eve with the other. The unknown painter represented the subject in a style strongly related to that of the vivid frescoes of Sopoćani (see fig. 452) in freedom of movement, in brilliance of color, in naturalism of facial

expressions, and in the effect of light in modeling volumes. As in the mosaics of Sinai (see fig. 431), Christ is clothed in pearly garments whose white highlights create the impression of blinding radiance. Shadow fills the tombs from which Adam and Eve are drawn up, and the side of Eve's sarcophagus opposite to the source of light in Christ remains deep in shadow. As with the contemporary frescoes of Giotto and his followers in Italy, this apparently naturalistic observation of the effects of light proceeding from a single source is in reality bound up entirely with its religious meaning. The Old Testament kings and patriarchs to the left are led by Saint John the Baptist, who accompanied Christ into Hell, and to the right the prophets are grouped behind Abel. The brilliant colors of the drapery and the creamy, off-white of the rocks shine against the intense blue of the background. Satan, bound, prone, partly across the shattered gates of Hell, is surrounded by a veritable shower of locks, hasps, and bolts.

RUSSIA AND RUMANIA

Kiev. Russian religious architecture owes its origins to Byzantine models, and throughout its long and rich development, it has retained the central plan for churches because of this arrangement's suitability to Orthodox liturgical requirements. In 989 Vládimir, grand prince of Kiev (who ruled most of the territory now comprising the European U.S.S.R.), married Princess Anna, sister of the Byzantine emperor Basil II, and brought Byzantine craftsmen back with him from Constantinople to build and decorate churches in his newly converted principality as well as to instruct local artisans. In 1037 construction was begun on the magnificent Cathedral of Hagia Sophia at Kiev. This church, in Byzantine style, with five aisles surrounded on three sides by an open arcade, has thirteen domes, representing the number of Christ and the Apostles. Its mosaics date from 1043 to 1046. The apse mosaics have miraculously survived the abandonment and partial ruin of the cathedral in the sixteenth century, its rebuilding in the seventeenth century, and its partial destruction in World War II. A monumental *Theotokos* (fig. 456) in orant position adorns the semidome; her powerful drapery folds recall those at Hosios Loukas. She appears to stand in a golden niche, supporting its arch like one of the maidens of the Erechtheion (see fig. 246). Below her unfolds an extraordinary scene, seldom represented in Western art—the *Communion of the Apostles.* Christ officiates as priest at the central altar, distributing bread on the left and wine on the right.

Vladímir. Soon local tastes began to modify the Byzantine heritage; artisans imported from Western countries to carry out Russian projects added their own traditions to the amalgam. An early example of Russian hybrid style is the Cathedral of Saint Demetrius (fig. 457), built about 1193–97 at Vladímir in the principality of Rostov-Suzdal, far to the northeast of Kiev and beyond the sway of its metropolitan (archbishop). The square block of Saint Demetrius, showing traces of the inner Greek-cross plan into whose arms the corner blocks housing prothesis, diakonikon, and galleries are fitted, and the central dome on its high drum pierced by round-arched windows are immediately recognizable as Byzantine. The screen architecture, consisting of two-story blind arcades whose arches appear along the roof line and are supported by lofty colonnettes, is also derived from Byzantine churches of the tenth and eleventh centuries. But the elaborate fabric of stone sculpture that fills the arches of the upper story and the walls of the drum with figural and ornamental reliefs of

456. *Theotokos* and *Communion of the Apostles,* apse mosaics, Cathedral of Hagia Sophia, Kiev, Ukraine, U.S.S.R. A.D. 1043–46

457. Cathedral of St. Demetrius, Vladímir, U.S.S.R. c. A.D. 1193–97

458. BARMA and POSTNIK. Cathedral of St. Basil the Blessed, Moscow. A.D. 1554–60

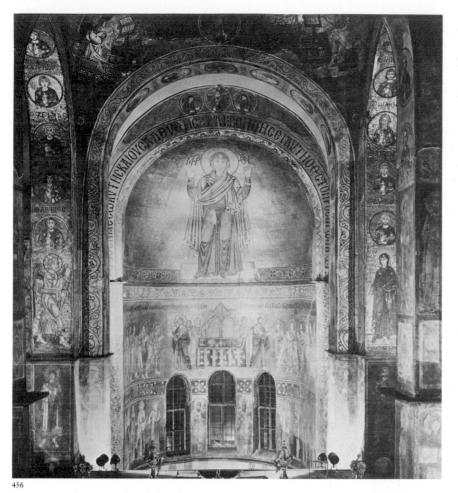

456

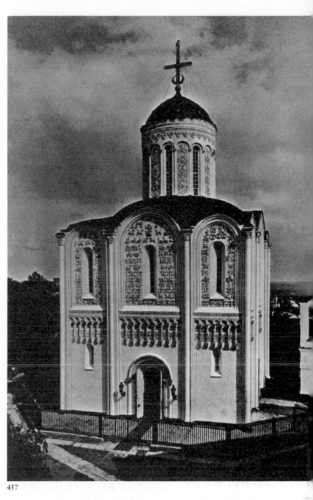

457

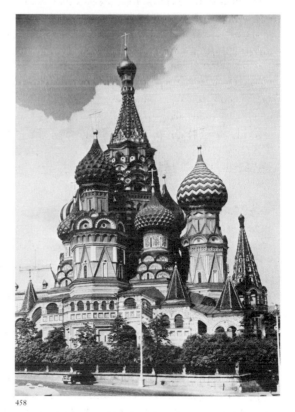

458

great decorative effect is derived from such Western Romanesque models as Notre-Dame-la-Grande at Poitiers (see fig. 538) and is wholly alien to Byzantine tradition.

Saint Basil. The domes of many Russian churches built in the following centuries are lifted on drums so high that they look like towers; the need to protect these domes against snow and ice led to the erection of bulbous external shells, generally onion-shaped. The Kremlin at Moscow contains several such churches, some designed by Italian architects in a style combining Renaissance details with Russian architectural tradition. A final expression of pure Russian architectural fantasy, in which Byzantine elements, detached from their original meaning, were multiplied in unbelievable extravagance, is the Cathedral of Saint Basil the Blessed in Moscow (fig. 458). It was built for Czar Ivan IV the Terrible from 1554 to 1560 by the architects Barma and Postnik in what is today called Red Square, adjacent to the Moscow Kremlin. The plan is more rational than the startling appearance of the exterior might lead one to believe. A tent-like octagonal central church (a favorite shape in the sixteenth century in the region of Moscow) is surrounded by eight smaller but lofty separate churches arranged in a lozenge pattern. Each of the corner churches is octagonal and supports a towering onion dome. The architects inserted four even smaller churches, two of which are square and two heart-shaped, all four crowned by onion domes, between the corner churches. The connecting gallery and the conical bell tower, however, are seventeenth-century additions. The drums of all eight domes are ornamented with innumerable arch-shapes derived from the Byzantine blind arcade but reduced to ornaments, and with gables that become zigzags. The onion domes are fluted, twisted, or reticulated (reminding us of pineapples) and

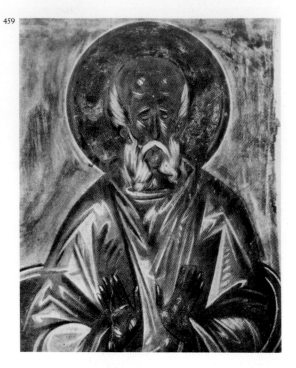

459. THEOPHANES THE GREEK. *Stylite* (detail of a fresco, Church of Our Saviour of the Transfiguration, Novgorod, U.S.S.R.). A.D. 1378

painted green and white in stripes that make a vivid contrast to the orange-red of the brick.

Russian Painting. The rich tradition of church murals and icon painting in Russia, which began perhaps as early as the tenth century with the importation of Byzantine icons, continued unabated into the nineteenth. Many of the innumerable examples are of extremely high quality, and at least two early painters are major figures, known to us by name. Theophanes the Greek, born between 1330 and 1340, had worked in Constantinople and in other Byzantine centers and brought to Russia the dramatic Palaeologan style we have seen at the Kariye Djami. In 1378 Theophanes was at work in Novgorod, and at the turn of the century in Moscow, then the center of a powerful principality. Theophanes is known to have been able to paint from memory with great rapidity and sureness, and his technique can be appreciated in his few surviving works, such as the wonderful fresco of a stylite (pillar sitter) in the Church of Our Saviour of the Transfiguration at Novgorod (fig. 459). The free, brilliant pictorial style of Castelseprio, with all its echoes of Helleno-Roman illusionism, still continues in the work of Theophanes seven centuries later. However, his brush dashes along at such speed carrying a message of religious mysticism that we are reminded of the great Greek painter El Greco, who worked in Spain in the sixteenth century. The lightning strokes of Theophanes show a personal variant of the Byzantine tradition and vibrate at an intensity that could not be transmitted to a pupil.

In Moscow Theophanes worked in association with a younger and native Russian artist, the monk Andrei Rublev, who painted a fine series of frescoes that still survives at Vladímir but who is best known for his icons. In the fourteenth and fifteenth centuries, the iconostases in Russian churches had been heightened with the addition of upper rows of images, and thus the demand for icons was very great. The style of Russian icons is usually distinguished by flat masses of only slightly modulated color, often of great brilliance, and by a keen sense of the importance of contour. Rublev was content to work within the limitations of this style, but he certainly raised it to its highest level of aesthetic and spiritual achievement. His best-known work is the *Old Testament Trinity* (fig. 460), an icon painted in memory of the Abbot Sergius, who died in 1411. The painting is heavily damaged; almost all of the background is lost and much of the drapery gone, but even in its present state, it is a picture of haunting beauty. The scene is a traditional one in Russian icons, but Rublev did not handle it in the traditional manner. The meeting of Abraham and Sarah with the three angels, who sat down to supper under a tree in the plains of Mamre (Gen. 18:1–15), was interpreted in Christian thought as a revelation of the Trinity. In Russian icons Abraham and Sarah had always been represented, and a lamb's head, symbolic of the sacrifice of Christ, substituted for the textual calf. Rublev goes to the heart of the mystery, showing us only the three angels as if we were Abraham and Sarah experiencing the vision. The relationships among the three angels are treated with the greatest poetic intensity and linear grace; the contours flow from body to body as the glances move from face to face. Throughout the area that now comprises the European U.S.S.R., icons were produced in great numbers long after the fall of Constantinople to the Turks in 1453.

Rumania. The region of Moldavia, the eastern portion of present-day Rumania, preserves a handsome group of monastic churches erected in the late fifteenth and early sixteenth centuries and frescoed not only in

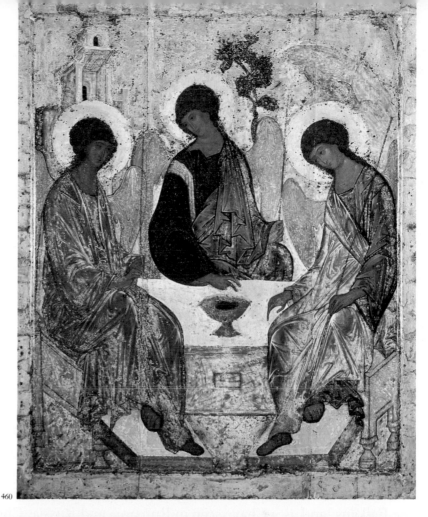

460. ANDREI RUBLEV. *Old Testament Trinity.*
c. 1410–20. Panel painting, 55½ × 44½".
Tretyakov Gallery, Moscow

461. *Last Judgment*, fresco on the west wall of the
narthex, Church of St. George, Voroneţ,
Rumania. c. A.D. 1550

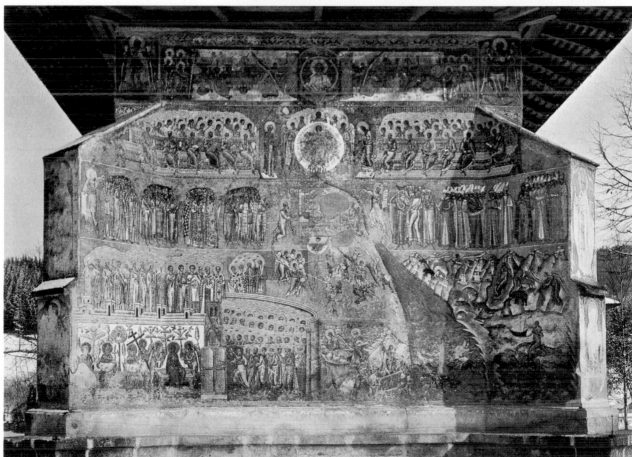

the interior but also over all the outside walls, where the frescoes are protected only by wide, overhanging eaves. Unlikely though it may seem in view of the severe winters of this region in the foothills of the Carpathian Alps, the exterior frescoes on all but the north walls are better preserved than those in the interiors; apparently, rain, sun, and wind are not as injurious to paintings as are candle smoke and incense.

Among the best of the Moldavian fresco cycles is that of the *Last Judgment*, which adorns the west front of the former Voroneţ monastery church. The *Last Judgment* (fig. 461), dating from about 1550, covers the entire west wall of the narthex above the entrance. At the top angels roll up the heavens as a scroll (Isa. 34:4; Rev. 6:14). In a circle in the center is God the Father; below him is the Deësis with six Apostles enthroned on each side and angels behind them. In the next tier below, choirs of ecclesiastical saints are grouped on either side of the throne prepared for Christ's Second Coming. A river of fire pours from the throne of Christ and falls upon the damned in Hell to Christ's left, penetrating earth and sea, which give up their dead. On his right Heaven opens up in two tiers of the blessed, whose halos blend into an almost continuous surface of gold.

Counting only from the founding of Constantinople in 330 until its fall in 1453, the Byzantine Empire had lasted longer than any political entity since Egypt. It was, however, in law still the Roman Empire and in fact the continuation of not only Roman but Greek culture, which was by no means extinguished under Turkish rule or outside it. Throughout subject Asia Minor and the Balkans, and as we have seen in Rumania and Russia, Christian communities needed pictorial art to figure forth the structure of their beliefs. Many mural paintings and thousands of icons, often of high quality, continued to be made in Byzantine style into the nineteenth century. Even more important, perhaps, than this astonishing continuity of Byzantine tradition, is the role Byzantine art played for the entire Middle Ages and Early Renaissance in Western Europe as a treasury of Classical forms and ideas.

CHAPTER

ISLAMIC ART

TWO

A disaster far worse than that threatened by any barbarians, and unlike their endemic attacks totally unexpected, burst upon the Byzantine Empire in the seventh century. The lightning expansion of Islam combined a speed approaching that of Alexander's conquests with a political tenacity rivaling that of Rome and with at least as much religious unity as Christianity. At the death of Muhammad, its founder, in 632 Islam ruled Arabia, though few in the Christian world were then aware of the existence of so dangerous a rival. Thirty years later Egypt, Syria, Palestine (including the Hebrew and Christian holy places), Mesopotamia, and Persia had fallen into Muslim hands. By 732 Islam had reached into Turkestan, Afghanistan, and the Indus Valley to the east, and its domains to the west, including Spain, Portugal, and southwestern France, stretched to the Atlantic Ocean. In southwestern France the Muslims were stopped—and eventually expelled—by the Franks. The Byzantines and Sassanid Persians crumbled before Islam; Constantinople soon controlled only Asia Minor and the Balkans. All the Asiatic and African regions conquered by Islam in its first century of life, with the sole exception of modern Israel, remain predominantly Islamic today.

The rapid spread of Islam was due to the military genius of the Arabs and to their intense religious fervor. In contrast to the spontaneous diffusion of the initially gentle Christianity which took place in spite of the official opposition of the Roman Empire, not a single country or region has ever willingly adopted Islam. Muhammad himself spread his doctrines with the sword, and he directed and personally participated in the mass slaughter of inconvenient resisters. Throughout the history of Islam, determined pockets of Christianity remained—relatively unmolested, to be sure, but nonetheless unyielding—in Egypt, where the Coptic Church survives, and in Syria, Lebanon, and Palestine. In assessing the expansion of Islam, its attractions as a religion should be weighed against the great material advantages attending submission to a militarily dominant Arabic culture. But it would be a mistake to assume that this culture, at least in its developed stages, was inferior to those it conquered, particularly in France and in Spain. One of the most surprising aspects of Muslim growth is the rapidity with which Islam assumed the role of conservator and continuator of the Helleno-Roman philosophical and scientific heritages. We owe much of our knowledge of Classical science, especially botany and medicine, and the invention of algebra (and of the very numbers used in this book) to the Arabs. However, Muhammad's prohibition of graven images ruled out sculpture, and his disapproval of representation put painting into an ambiguous position. But under Islam architecture made gigantic progress, and the natural mathematical bent of the Arabs, coupled with their highly developed aesthetic sense, produced an art of abstract architectural decoration that is one of the artistic triumphs of mankind.

Compared with the increasing theological complexity of organized Christianity, in either its Roman

or Eastern Orthodox form, Islam (the word means "submission"—i.e., to the will of Allah) is a remarkably simple and clear-cut religion. It dispensed with priesthood, sacraments, and liturgy from its very start; every Muslim has direct access to Allah in prayers. But its caliphs, at first deriving authority from their degree of family relationship to Muhammad, exercised supreme political power in a theocratic state. Islam's one sacred book, the Koran, embodies the divinely revealed teachings of Muhammad as set down by himself on either palm leaves or camel bones, or as recalled by his companions and edited by his early followers. These teachings include the doctrine of one indivisible God, who has many Prophets (including those of the Old Testament and Jesus), of whom the greatest was Muhammad. Islam posits a Last Judgment, a Heaven, and a Hell, but it makes no clear division between the demands of the body and those of the soul. The good life on earth and the afterlife of Paradise can include many forms of self-indulgence, including a host of concubines, thus strengthening a tendency to view women solely as instruments of pleasure. In contrast to the celibacy imposed upon Catholic clergy of all ranks, and upon Orthodox bishops, no such sacrifice was required of the caliphs or the *imams* (teachers). The duties of a Muslim include circumcision, daily prayer at five stated hours, abstention from certain foods and from alcohol, fasting during the lunar month of Ramadan, charity, and a pilgrimage to Mecca.

Muhammad had no greater need of architecture than had Jesus; he could and did teach anywhere, but much of his discourse was carried on in his own house, which served as the model for building the first mosques. His followers required only a simple enclosure, one wall of which, known as the *qibla*, at first faced Jerusalem, later Mecca. A portico on the qibla side was a practical necessity as a protection from the sun. The sacred well near the Ka'bah in Mecca suggested a pool for ritual ablutions; every mosque has one in the center of its courtyard, which is known as the *sahn*. Soon the qibla was given a sacred niche, called the *mihrab* (see fig. 475), which pointed in the direction of Mecca. To the right of the mihrab stood the *minbar* (see fig. 475), a lofty pulpit from which the imams read the Koran to the assembled faithful and preached the Friday sermons. These simple early mosques always contained the qibla, the sahn, the mihrab, and the minbar, but unfortunately none of the first mosques have been preserved. As in the case of Christianity, and indeed following its example, the taste for splendor soon accompanied success.

Early Architecture DOME OF THE ROCK As early as 670 the mosque at Kufah in Mesopotamia (located in present-day Iraq) was rebuilt with a roof forty-nine feet high, supported by a colonnade in apparent imitation of the Hall of a Hundred Columns at Persepolis (see fig. 151). When Caliph Omar I captured Jerusalem in 638 he left the Christian sanctuaries undisturbed and built on the ruins of the last Temple (which Titus had totally destroyed in A.D. 70) a square shrine of bricks and wood to enclose the rock on which Abraham had attempted to sacrifice Isaac and from which Muhammad had made an ascent to Heaven on a human-headed horse. But toward the end of the seventh century, the caliph 'Abd al-Malik, as a chronicler tells us, "noting the greatness of the Church of the Holy Sepulcher and its magnificence, was moved lest it should dazzle the minds of the Muslims, and hence erected above the Rock the dome which is now to be seen there." 'Abd al-Malik's new building, the earliest preserved Muslim structure, was magnificent from the start (fig. 462). The rich fabric of blue, white, yellow, and green tiles which now clothes the upper portion was added only in the sixteenth century, but it replaces decorative glass mosaics that emulated those in Christian churches and were in fact sheathed in their original slabs of veined marble, in which one may

462. Dome of the Rock, Jerusalem. Late 7th century A.D.

note the modest beginnings of the abstract, geometric ornament that became so dazzling in later Muslim architecture. The wooden dome (regilded in 1960, alas, in anodized aluminum!) was covered originally with gold leaf.

The plan is not that of the typical mosque, but derives from the central-plan Christian martyrium because pilgrims were required to walk in procession around the sacred Rock just as the Christians did around a martyr's tomb. A simple octagon is surmounted by a graceful, slightly pointed dome, the idea for which may have been suggested by the almost pointed barrel vault of the palace of the Sassanid Persian monarch Shapur I at Ctesiphon in Mesopotamia (fig. 463), near the later site of Baghdad. The shape is repeated in the delicately pointed arches used throughout the building, in the surrounding courtyard, in the blind arcade and windows of the exterior, and in the two concentric ambulatories around the Rock. The pointed arch offers great advantages over its round counterpart, since it can be designed in almost any proportion, thus freeing the architect from the tyranny of that inconvenient quantity pi (π) in working out his calculations. As we shall see, the pointed arch is only one of the many flexible features introduced by Muslim architects in the course of time. The pointed arch later found its way to the West where it was employed in the late eleventh century in Romanesque architecture, as at Cluny (see fig. 528), and where it became the standard shape for arches in the Gothic period. As in most mosques, the windows of the Dome of the Rock are filled with a delicate grille of stone in order to temper the harsh rays of the sun. The Muslims, like the early Christians, pressed into service columns and capitals from Roman buildings, but their sensibility admitted none of the gross discrepancies—between juxtaposed Ionic and Corinthian capitals, let us say—which did not seem to bother the early Christians. The exterior capitals of the Dome came from Roman monuments of the fourth century. The interior, with two concentric arcades around the Rock, is sheathed with veined marble and decorated with glass mosaics.

463. Palace of Shapur I, Ctesiphon, near present-day Baghdad, Iraq. c. 3rd–6th century A.D.

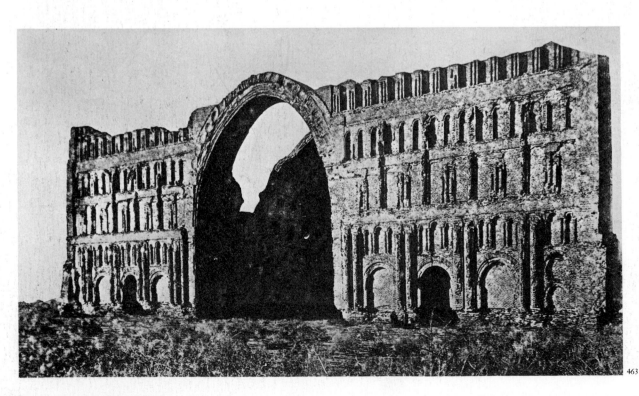

463

GREAT MOSQUE AT DAMASCUS The earliest Muslim building on a gigantic scale is the Great Mosque at Damascus (fig. 464), built from 705 to 711, inside the fortified outer enclosure of a Roman sanctuary, measuring 517 by 325 feet, originally containing the temple of Jupiter. The Christians had converted the temple into a church, and for decades after their conquest the Muslims left the Christians undisturbed. Then al-Walid demolished everything inside the enclosure, utilizing the salvaged masonry blocks, columns, and Corinthian capitals still in perfect condition for a grand arcade, supported by columns on the short sides and piers on the long; across the south arcade he ran a lofty transept leading to the mihrab. The square corner towers, built for defense, were utilized as minarets, and they are the earliest known. Minarets, still in use today for the muezzin's call to prayer, were not strictly necessary; a rooftop or a lofty terrace could serve the same purpose. But henceforward they became a common if not indispensable feature of the mosque. The present minaret crowning the Roman tower of the Great Mosque is a much later addition. The building has been repeatedly burned and rebuilt; originally, its dome was slightly pointed like that of the Dome of the Rock. Some of the interior mosaic decoration still survives (fig. 465), consisting of dreamlike architectural fantasies in the tradition of Roman screen architecture as we have seen it in early Byzantine mosaics at Salonika (see fig. 409), interspersed with city views like those of the mosaics at Santa Maria Maggiore in Rome (see fig. 410). These mosaics look like a richly designed Islamic textile. The artists who made them were probably Syrian Greeks.

464. Courtyard and façade, Sanctuary of the Great Mosque, Damascus, Syria. c. A.D. 705–11

464

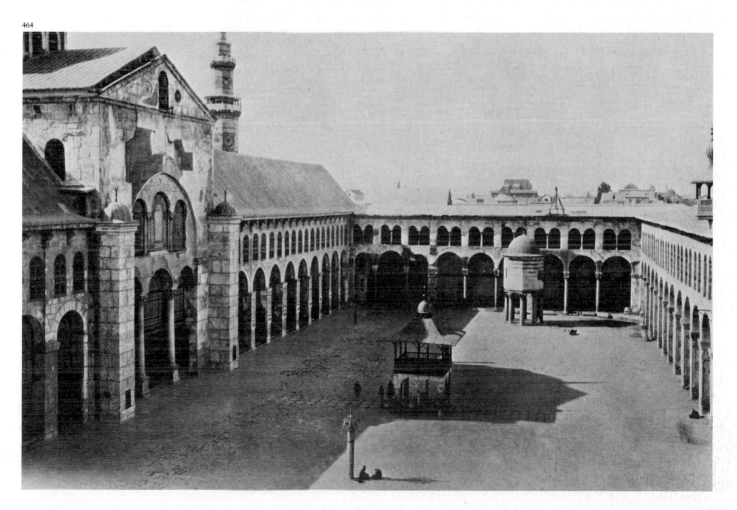

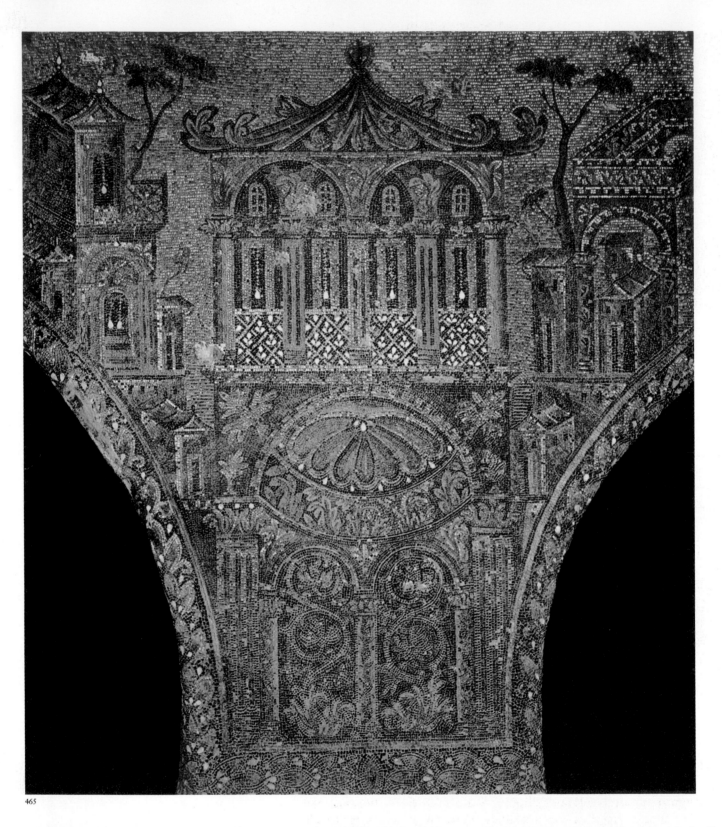

465

SECULAR MUSLIM BUILDINGS Much of the ornamentation of early Islamic palace architecture gives a similar effect of textile design. For example, the façade of the palace built about 743 in the desert at Mshatta, in what is now Jordan, had a lower zone of almost incredible richness (fig. 466). Here rosette forms and floral interlace derived from later Roman and early Byzantine traditions mingle with confronted winged griffins of Mesopotamian derivation to clothe considerable areas of masonry with a flickering tissue of light and dark. The resultant pattern,

465. *Architectural View* (portion of a mosaic, Great Mosque, Damascus). c. A.D. 705–11

466

466. Façade, Palace at Mshatta, Jordan (portion).
c. A.D. 743. Staatliche Museen, Berlin

known as *arabesque*, is quite as bewildering in its complexity as that of Germanic ornament and Hiberno-Saxon manuscripts, but it is equally disciplined and organized into zones by broad zigzags. The ornamentation at Damascus and Mshatta foreshadowed the Islamic intoxication with the mysteries of pure geometric interlace, which dominates Islamic interiors instead of wall paintings (see figs. 473, 479).

The original Umayyad dynasty of caliphs was succeeded by the 'Abbasids, whose great caliph al-Mansur (reigned 754–75) removed his capital from Damascus to Baghdad on the upper Tigris in Mesopotamia. Here he built a round city, considered unique by Arab historians, but actually derived from the circular camps of the Assyrians and from later Mesopotamian models. It had two concentric circles of walls, four gateways, streets radiating outward from the center like the spokes of a wheel, and in the central area stood a great mosque and the caliph's palace. Unfortunately, al-Mansur's wonderful round city, immortalized by the stories of his great successor Harun ar-Rashid, who developed an unlikely penpalship with the emperor Charlemagne, must remain a dream. Like most Mesopotamian monuments, it was made of mud brick, and when the Mongols swept down in the thirteenth century, they destroyed everything.

SAMARRA Caliph al-Mu'tasim built the city of Samarra upstream from Baghdad after 836. It was twenty miles in length and counted a population of about a million; Caliph al-Mutawakkil built between 848 and 852 a mosque that could accommodate at any one time a considerable proportion of the city's inhabitants. The external rectangle, measuring 784 by 512 feet (fig. 468), forms the largest of all mosques and greatly exceeds the dimensions of any Christian house of worship. The fired-brick exterior walls still stand, but little is left of the 464 mud-brick piers that supported the wooden roof, and nothing remains of the mosaics that once ornamented the interior. The stupendous spiral minaret, of fired brick (fig. 467), towers to a height of 176 feet; it forcefully recalls the principle of the Mesopotamian ziggurat adapted to spiral form.

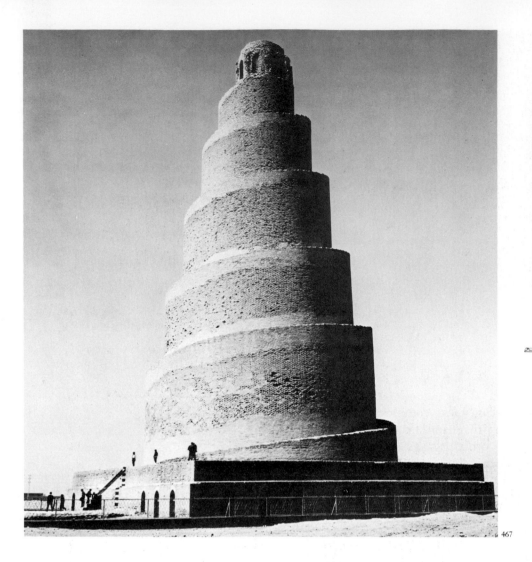

467

468

CAIRO Something of the grandeur of the Great Mosque at Samarra, and much of its original character, can be seen in the well-preserved mosque built at Cairo by a former inhabitant of Samarra, Ibn Tulun, from 877 to 879. This new Muslim city rose near the vanished Memphis of the pharaohs, and its surviving Islamic buildings rank second in quality only to the nearby monuments of ancient Egypt. Many of these buildings were of great importance to the medieval architecture of Europe. The Mosque of Ibn Tulun is the earliest (fig. 469). The rectangular structure, measuring 460 by 401 feet, was built on a slight eminence and enclosed by a crenellated outer wall. A double arcade lines the wall on three sides (fig. 470), and a five-aisled portico on the fourth contains the mihrab. As at Samarra the piers are of brick, but here they were protected with a thick coating of fine, hard stucco, which has survived almost intact and which makes the building appear monolithic. The sharply pointed arches, of noble simplicity, are supported by massive rectangular piers of brick, into whose corners *colonnettes* (little columns) are set, an early example of a device used extensively in Christian architecture of the Middle Ages. The ceiling was originally coffered below the wooden beams; little of the coffering is intact, but the rich floral ornament, carved into the plaster of the arches as if into stone, has survived in splendid condition. Especially remarkable are the smaller arches that pierce the spandrels of the larger ones to no apparent purpose; they produce an impression of lightness and variety, treating the arch—as often in Islamic architecture—as something that can be freely played with.

467. Spiral minaret, Great Mosque of al-Mutawakkil, Samarra, Iraq. Fired brick, height 176′

468. Great Mosque of al-Mutawakkil, Samarra. c. A.D. 848–52 (Plan after Creswell)

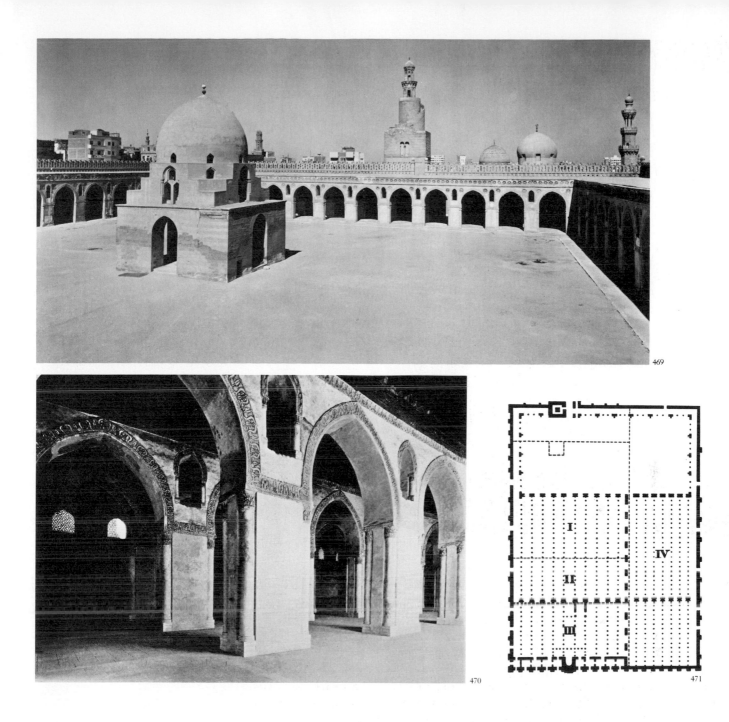

469. Courtyard, Mosque of Ibn Tulun, Cairo. c. A.D. 877–79

470. Arcades, Mosque of Ibn Tulun, Cairo

471. Plan of the Great Mosque, Córdoba, Spain, showing successive enlargements. c. A.D. 786–987 (Plan after Marçais)

CÓRDOBA One of the most brilliant achievements of Islamic architecture, the Great Mosque (now the Cathedral) of Córdoba (fig. 471), was built in Spain. The original mosque, erected in 786, had all its aisles on the qibla side of the sahn. As necessity required, these aisles were repeatedly lengthened in the late eighth century and again in the tenth; eventually, the location of the Guadalquivir River forbade further lengthening in that direction, so the structure was extended on the east. Unfortunately, in the sixteenth century the canons of the Cathedral (the mosque had been converted into a Christian place of worship long since) built a choir inside it, greatly to the displeasure of the emperor Charles V, who rightly accused them of having ruined a monument unique in the world for the sake of something they could have built anywhere. But from most viewpoints the interior still presents an enthralling spectacle of seemingly infinite extent in any direction (fig. 472)—an endless forest of columns and arches without an axis. The hundreds of marble or granite columns

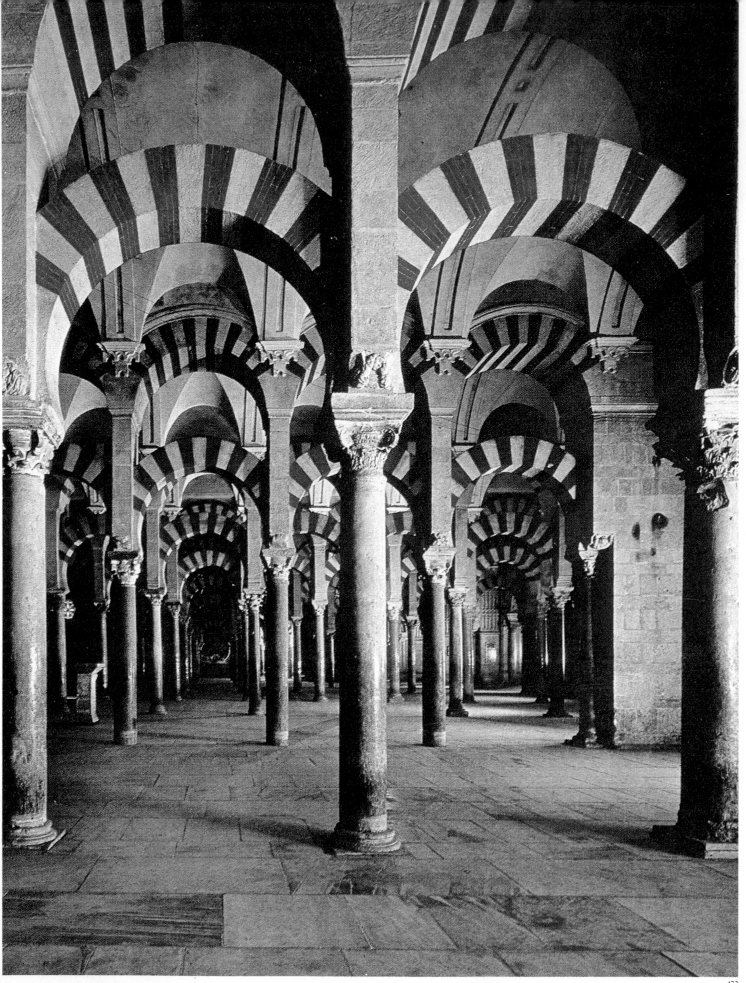

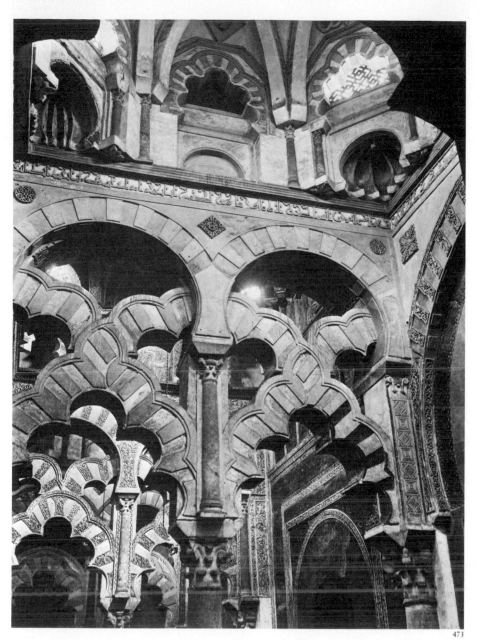

472. Interior, Great Mosque, Córdoba. c. A.D. 786

473. Vestibule of the mihrab, Great Mosque, Córdoba. c. 10th century A.D.

were, of course, cribbed from Roman and Early Christian buildings, but visually they play second to the striped arches, unknown in architecture before Muslim builders employed them. The uniqueness of the Great Mosque of Córdoba demonstrates a principle common to many mosques—that Islamic space, originally at least, was not determined by the requirements of a set ritual as was that of Christian interiors. In the basilica the columns, like the worshipers, unite in obedience to the longitudinal vista extending toward the altar; in the mosque the columns are endless and uniform like the worshipers, who are united only in common prayer.

Another striking feature of the Great Mosque of Córdoba is the introduction of a second set of freestanding arches above the first. These spring from square piers that stand on the Roman columns as though on stilts. These flying arches, intended to uphold a wooden roof (the vaulting was added in the sixteenth century), ingenious as they are, are outdone by the inventions in the mihrab, which was built during the last southward extension of the mosque in the tenth century. The arches here are scalloped and intertwine freely in open space (fig. 473). Other arches soar from the upper corners to cross as ribs for the vault. Here and there, in

the archivolts, in the inner surfaces of the arches, and in the vertical panels, appear passages of pure arabesque; the area that in Classical architecture would constitute the frieze is decorated with passages from the Koran in fluid, richly ornamental Arabic writing.

THE MADRASAH OF SULTAN HASSAN Among the host of splendid religious structures that rose throughout the Islamic world, we must present a completely new type, the *madrasah*, a building intended for religious and legal instruction (because the two were fused in the Islamic theocracy). The first such combined theological seminary and law school seems to have been built in Persia about A.D. 1000. The architectural requirements were a customary central sahn and separate quarters for each of four schools, each school to be administered by one of the four orthodox Muslim sects. The solution was a series of cells for each school at one of the four corners of the sahn; in the center of each face of the sahn a spacious prayer hall separated one school from its neighbor. These halls, with one side entirely open to the court, were known as *iwans*; the iwan on the Mecca side, of course, contained the mihrab and the minbar. Apparently, the shape of the iwan was suggested by the giant, almost pointed barrel vault of the open audience hall in the third-century palace of Shapur I at Ctesiphon (see fig. 463), a building that could be easily visited from Baghdad. The arches of the iwans, however, were always sharply pointed, in more or less the shape of the pointed arches of the Mosque of Ibn Tulun (see fig. 469), and their majestic open spaces dominate the sahn. Once established, the madrasah became the model for all large mosques in Persia.

In fourteenth-century Egypt the Mamluk sultans (descendants of Turkish slaves who had seized power) built a number of madrasahs in Cairo. Their size was limited, however, by the existing buildings of the

474

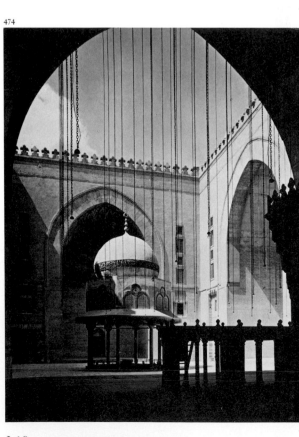

475

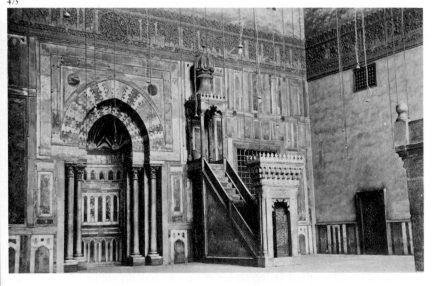

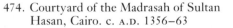
474. Courtyard of the Madrasah of Sultan Hasan, Cairo. c. A.D. 1356–63

475. The East Iwan containing the mihrab and minbar, Madrasah of Sultan Hasan, Cairo

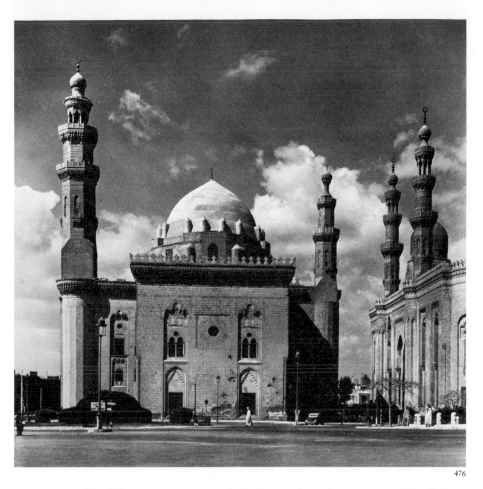

476. Madrasah and Mausoleum of Sultan Hasan, Cairo

metropolis. The grandest example is the madrasah constructed by Sultan Hasan in 1356–63 (fig. 474), whose towering iwans leave little room for windows in the four stories of student cells at the corners of the restricted sahn. With their pointed barrel vaults, the iwans give an overpowering impression of mass and space, increased by the chains of the seventy bronze lamps that still hang in the sanctuary (as once in Early Christian basilicas). The east iwan, richly paneled in veined marble, contains the usual mihrab and minbar (fig. 475), surmounted by a superb arabesque frieze. Behind the gate to the minbar can be seen the bronze grille that gives access to the domed interior of the sultan's tomb, a new type of structure which the Muslims appear to have emulated from Western examples. From the exterior (fig. 476) the two buildings seem almost separated, both blocklike, their walls pierced with pointed windows, some single, others paired with a round window above, in a grouping that may reflect the tracery of French Gothic cathedrals (see Chapter Six, and fig. 583). The tomb is crowned with a handsome pointed dome; the adjacent minaret, square in plan with several superimposed octagonal stories, rises to a height of nearly three hundred feet.

THE OTTOMAN TURKS The achievements of Islamic religious architects, like those of Roman imperial builders, stand throughout North Africa, Spain, the Balkans, and the Near East—and also in northern India, Pakistan, and even western China. The Ottoman Turks, who, in 1453, conquered Constantinople and put an end to the Byzantine Empire, were by no means as inventive as their Arab predecessors, and the capital renamed Istanbul does not offer the infinite surprises that delight the visitor bold enough to brave the dusty and tumultuous alleys of Cairo. Hugely impressed by Hagia Sophia, which along with the other churches

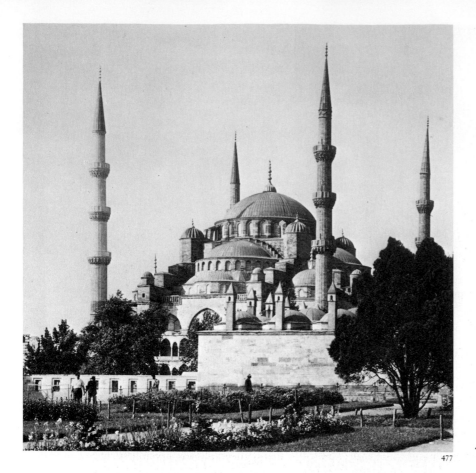

477. Mosque of Ahmed I, Istanbul. c. A.D. 1609–17

of the capital the Turks turned into mosques, the Ottomans confined themselves to producing innumerable variations of Justinian's masterpiece in large, medium, and small sizes. It is thus extremely difficult to pick out from a distance Hagia Sophia itself in Istanbul's romantic skyline of domes and minarets. Although the interiors of the Ottoman central-plan mosques seem heavy when compared with the seraphic lightness of Hagia Sophia, their exteriors, such as that of the Mosque of Ahmed I, built from 1609 to 1617 (fig. 477), often resulted in a considerable refinement and systematization of the free arrangements of domes and semi-domes designed by Anthemius of Tralles and Isidorus of Miletus eleven hundred years earlier.

THE TAJ MAHAL The Mogul conquest of India in the sixteenth century brought to power over that subcontinent, with a long and rich artistic tradition, an art-loving Islamic dynasty that built palaces and entire cities of a magnificence rivaling that of imperial Rome. It is no accident, therefore, that perhaps the best known of all Islamic monuments is the Taj Mahal (fig. 478), outside Agra in northwestern India, erected by the Mogul Emperor Shah Jehan from 1623 to 1643 as a tomb for his favorite wife, the beautiful Mumtaz Mahal, and later for himself. Much sentimental legend has gathered about the building. While the emperor was undoubtedly deeply attached to his wife, he was able to console himself for her loss with any number of concubines. It has recently been shown that the inscriptions from the Koran that ornament the building refer neither to the empress nor to Shah Jehan's devotion, but exclusively to the Last Judgment and to the Garden of Paradise, symbolized by the splendid surrounding formal gardens (the present Italianate planting is nineteenth century). The entire park, enclosed by lofty red sandstone walls with

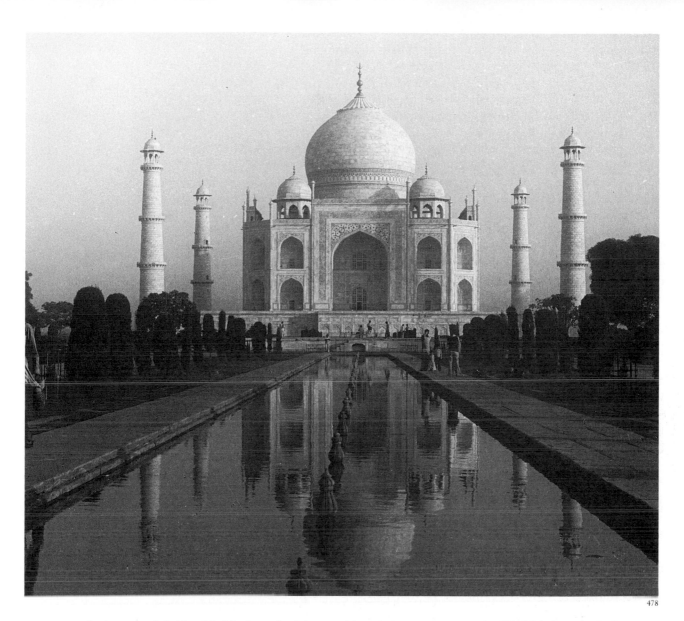

478. Taj Mahal, Agra, India. 1623–43

ornamental gateways inlaid with black-and-white marble, covers an area larger than that of Saint Peter's in Rome and its entire Piazza.

The central mausoleum is flanked by two mosques (not shown in the illustration), also in red sandstone and marble. But the mausoleum itself, including the lofty platform on which it stands and its four delicately tapering cylindrical minarets, immediately suggests a different spiritual realm. All are constructed entirely of snowy marble, smooth but not polished, so that its crystals both absorb and radiate the intense Indian sunlight. While the basic principle—a central block surmounted by a pointed dome—derives eventually from such buildings as the Madrasah of Sultan Hasan, every effort has been made to dissolve the sense of mass. As in earlier Mogul tombs, such as the Mausoleum of Hamayun at Delhi, the four iwans have been transfered to the exterior, opening up the four faces of the block. The corners are cut to provide four new diagonal faces, each of which, as well as the spaces remaining between them and the central iwan, has been pierced by two superimposed smaller iwans—this six for each corner, or a total of twenty-four, creating as much void as solid. The central dome, over 250 feet high, slightly bulbous, and extremely graceful in its swelling curves, is flanked by four smaller domes, surmounting open octagonal pavilions. Similar structures crown the minarets. Thus domes in three sizes and openings in six repeat in solid and void with the

utmost refinement the basic motive of the pointed arch with slight double curvature at the top.

The white marble surfaces are inlaid with floral ornament and Koranic inscriptions in black marble and colored, semiprecious stones, so calculated that every petal can be clearly distinguished with the naked eye from the platform below, and every inscription, increasing in inverse proportion to perspective diminution, read by anyone versed in Islamic script. Even the joints between the white marble slabs cladding the minarets are filled by delicate strips of black marble. The light is reflected upward with such intensity from the white marble terrace that shadows are greatly lightened, and the dome seems to float against the sky like a colossal pearl.

Shah Jehan was confined in his old age by his own usurping son Aurangzeb, but his prison was enviable—the splendid Red Fort of Agra. From an octagonal white marble pavilion set amid delicious gardens cooled by ingenious fountains and artificial waterfalls, the deposed monarch could look out across a broad curve of the Jumna River to the Taj Mahal, where he was eventually to rejoin his departed wife.

THE ALHAMBRA To many the supremely original creation of Islamic architecture will always be the Alhambra, the palace built by the Nasrid kings on a lofty rock above Granada in southern Spain in the fourteenth century, only a century and a half before the Moors were expelled from this last European fortress by Queen Isabella and King Ferdinand. The rich valleys and fertile slopes that surround Granada made the final Moorish kingdom in Spain a paradise during the fourteenth and fifteenth centuries, darkened only by the internal strife that eventually laid the kingdom open to Spanish conquest. The extreme refinement of the scholarly and art-loving court of the kingdom of Granada finds its embodiment in the beauty of the Alhambra. Surrounded on its hilltop by towered fortifications, against a backdrop of snow-covered mountains, the palace seems from the outside to be colossal; on entering, the visitor is all the more surprised at the intimacy, human scale, and jewel-like refinement of the porticoes, vaulted chambers, courts, gardens, pools, and fountains. A view across the Court of the Lions (fig. 479) suggests the disembodied fragility of this architecture, cloudlike in its lightness, flowerlike in its delicacy, but pervaded even in its last refinements by a rigorous sense of logic.

The colonnettes we first saw tucked into the corners of massive piers in the Mosque of Ibn Tulun (see fig. 469) reappear here freed from brute substance, standing singly in twos or threes, upholding vaults whose underlying bricks are covered with hard stucco carved into fantastic shapes—a honeycomb of microvaults, or airy structures made up entirely of arabesque interlace, of arches from which hang stalactites of pure ornament. While the individual elements can all be found in structures in Egypt and throughout North Africa, and especially in Persian buildings of the fourteenth century, nothing like this brilliant combination of them had ever been executed before or ever would be again.

Caught in their last redoubt between the Mediterranean Sea and the Spanish sword, the Nasrid kings lived an existence in which luxury was refined to its ultimate distillation. One could contemplate the arabesques at the Alhambra (see fig. 10) for days on end, and only begin to sample their delights. Such contemplation induces a passivity akin to transcendental meditation, freeing the intellect for the pursuit of the endless ramifications of pure logic. At first it may seem difficult to tarry over such complexities; the Western mind used to literal representation and clear-

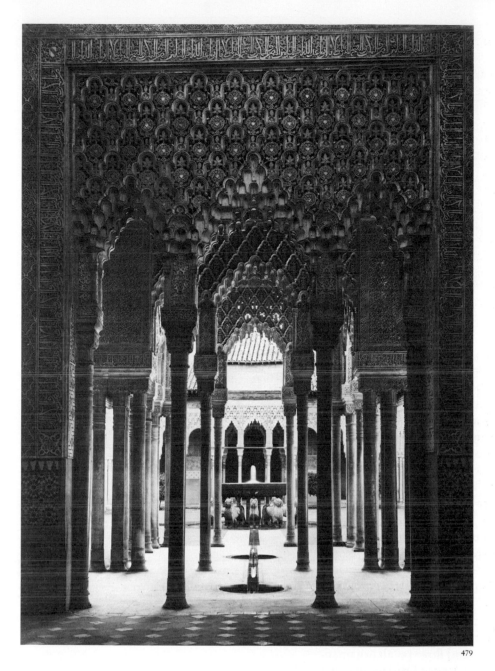

479. Court of the Lions, the Alhambra, Granada, Spain. c. A.D. 1354–91

cut definition turns away frustrated—one has not quite been able to experience it all. But like contrapuntal music, or like the carvings at Mshatta or at Córdoba (or for that matter like the interlace of Hiberno-Saxon manuscripts; see figs. 11, 494), these arabesques of Granada are severely separated into parts and regions, each assigned its own duty in the final intellectual structure.

To Muhammad sculpture was idolatrous by its very nature, and the device of Satan himself; he cleared all of it out of the Ka'bah, and all the paintings, too, for that matter, save one—strangely enough—of the Virgin and Child. Occasionally, sculpture sneaked back into Islamic art, but usually in the forms of decorative animals, like the richly carved lions that support the Alhambra fountain. Painting, while not permitted on a monumental scale, was useful enough for manuscripts—though always secondary to the art of calligraphy. Islam was blessed with a singularly graceful form of writing. The earliest script, a massive style called Kufic, was especially appropriate to carving in stone. A page from a Koran writ-

Painting

ten in the ninth century in either Syria or Iraq (fig. 480) shows how bold and harmonious this writing can be in manuscripts as well, with its noble black characters punctuated by red dots and adorned with a broad band of gold leaf used to emphasize an especially important passage. But there is more than at first meets the eye. One watches for a moment, and then the written characters come to life, transforming themselves into Muslims with red turbans, seated, prostrate, or kneeling in prayer, or lifting up their hands to Allah. This form of double imagery was not achieved in Western art until the sixteenth century.

By the thirteenth century lively explanatory or narrative illustrations were common in Islamic manuscripts, usually with the parchment as the sole background and sometimes without borders. Only a summary indication of setting is given, such as curtains or a plant here and there. Under the Mongol conquerors considerable changes appeared later in the century, partly due to Oriental influence—Chinese artists had been imported into Persia. An example of this hybrid art is the disarming *Temptation of Adam and Eve* (fig. 481) from a manuscript of the *Chronology of Ancient Peoples* of al-Biruni, painted at Tabriz in Persia in 1307. The Garden of Eden is represented by fruit trees, rocks, and flowers, all ornamentalized in a style derived from Chinese painting. A very Oriental-looking Adam and Eve appear naked (almost unparalleled in Islamic art), except for ineffectual bits of transparent drapery, and with halos which to Christian eyes are undeserved. In fact, even Satan, garbed in a robe shaded in a very Chinese style and shown importuning a coy Eve with a golden fruit, has been provided with a halo. The real explosion of pictorial art in Persia occurred under the Mongol conqueror Tamerlane and his successors toward the end of the fourteenth century. Although converted to Islam, the Mongols paid slight attention to its prohibitions and restrictions against representation, and they covered their palace interiors with figurative mural paintings, of which we possess only mouth-watering descriptions by contemporary writers.

But the manuscripts remain, and they are dazzling. An especially beautiful example is the manuscript of the poems of Khwaju Kirmani by Junaid, one of the leading Persian painters, illuminated in 1396. In *Bihzad in the Garden* (fig. 482), a considerable expanse of landscape has been indicated by means of a division of the page into areas—the smallest being left for the text. The ground in this painting seems to rise like a hillside,

480. Page written in Kufic script from a Koran. Syria or Iraq, c. 9th century A.D. Illumination. The Metropolitan Museum of Art, New York. Rogers Fund, 1937

481. *Temptation of Adam and Eve*, illumination from the *Chronology of Ancient Peoples* manuscript of al-Biruni. Tabriz, Iran. A.D. 1307. Edinburgh University Library

482

although horizontal extent was clearly intended. At the back a wall encloses the garden from the outside world, and above it one sees only the blue sky dotted with gold stars and a gold crescent moon. Even with the exquisite grace of his representation of foliage, flowers, figures, and drapery in a style that seems utterly relaxed, Junaid was never unaware of the inner rhythmic relationships of motives apparently strewn at random. Nor did he neglect the harmonies of rose, soft green, soft red, pale blue, and gold that make his picture sing. Junaid's joyous rediscovery of the visual world came, significantly enough, in the same century as the rebirth of naturalism in the work of the Late Gothic European masters.

482. JUNAID. *Bihzad in the Garden*, illumination from the manuscript of the poems of Khwaju Kirmani. Persian, A.D. 1396. British Museum, London

The great naturalistic achievements of ancient art in the West were renounced by Islam even more thoroughly than they had been by Christianity. The new religion favored a largely abstract planar art, ruled by the extremely subtle and flexible geometric relationships that appealed to the mathematical tendencies of the Arabic mind, and the resultant linear patterns achieved an unsurpassed richness and beauty. The hostility between the Islamic and Christian civilizations seemed only to increase Western fascination with the creations of Islamic art, which Westerners by the thousands, from every level of society, wondered at as the endemic conflict carried them back and forth across the Middle East, North Africa, Spain, and Eastern Europe. In spite of warfare, commercial and intellectual relationships flourished between the two societies. Islamic artifacts were imported in great numbers to adorn Christian homes, Kufic inscriptions found their way mysteriously into the tooled gold halos of Christian madonnas, and the great innovations of Islamic builders influenced Christian structures as late as the seventeenth century. The shapes and patterns of Islamic art formed ingredients as important to the creativity of the West as did the intellectual heritage of Islam to the philosophic thought and scientific knowledge of the High Middle Ages and the Renaissance.

CHAPTER

BARBARIAN AND CHRISTIAN ART IN NORTHERN EUROPE

THREE

Throughout the history of the ancient world and the early Middle Ages, preliterate and literate societies, which we tend to think of as separate stages in human development, were in fact, at almost any given moment, locked in endemic conflict with each other. Ever since the Mycenaean civilization succumbed to the Dorian invaders the patterns of European history in many ways repeated themselves from age to age. Settled, literate, urban cultures in the sunny Mediterranean basin were magnets for wave upon wave of preliterate barbarian tribes (*barbarian* from the Latin word for "beard"; throughout most of their history the Romans were clean-shaven), from the dark forests, cold mountains, and windy steppes of the unsettled world to the north and east of the Alps, the Carpathians, and the Urals.

Sometimes the attack was completely successful, as with the Dorians in the years before 1000 B.C., in which case the defeated culture was obliterated and the barbarians took over, eventually to bring forth their own civilization. With the later waves of Celtic, Germanic, Mongol, and Slavic invaders the story was more complex. The Gauls, a Celtic people, besieged Asia Minor unsuccessfully in the fourth century B.C., then wandered along the eastern and northern perimeter of the Hellenistic world, to settle in northern Italy and in modern France, which they renamed Gaul. There they were conquered and annexed, like the indigenous peoples elsewhere, by the Romans in the course of their expansion. So were the Celtic Britons who had invaded Britain. Such tribes were first converted to the Roman state religion, then after Constantine to Christianity, but in spite of physical differences they were soon indistinguishable in dress and behavior from other Roman provincial populations; in fact they became Roman citizens and soldiers, assuming their role in defending the perimeter of empire against later waves of invaders.

By the fifth century A.D., in the third great wave of migrations, Germanic peoples, notably the Ostrogoths in Italy, the Visigoths in Spain, and the Vandals in North Africa, conquered both Romans and Romanized populations of whatever origin and again in turn became Romanized and Christianized. After the departure of the Romans from Britain in the early fifth century the Germanic Jutes, Angles (origin of the word *England*), and Saxons began their slow conquest of the island, driving the Britons into Wales. In the later fifth century another Germanic tribe, the Franks, took over Gaul and gave it their own name. In the sixth the Lombards entered Italy some time after the expulsion of the Ostrogoths and divided the peninsula irregularly and unstably with the Byzantines, who retained most of the ports, and with the popes, who had assumed political as well as spiritual control over Rome and a considerable surrounding area. Both Lombards and Franks were soon Christianized and so, in the later sixth century A.D., were the Anglo-Saxons, although by now Roman culture had been diluted to such a degree that we could scarcely speak of Romanization. Under these last invaders the feudal system grew up as a method of holding society together with ties of tribal loyalty. And finally there were the never-civilized tribes, above all the fierce Huns, Mongols who pushed the others along before them in their westward and southward

BARBARIAN AND CHRISTIAN ART IN NORTHERN EUROPE 369

migrations. The mobility of the barbarians is astonishing in a world without roads or bridges—for example, the transcontinental trajectory of the Gauls or the even more spectacular zigzag of the Vandals from Asia Minor to central Europe to Spain to North Africa, before they disappeared entirely in Justinian's short-lived attempt to revive Western Roman power.

More important than the disappearance of the Roman imperial title in the West were the virtual collapse of Roman administration, economy, manufacture, agriculture, transportation, education, and art and the depopulation of the cities. Only in the Church—especially the monasteries—did learning remain alive. The destruction in the West in two centuries of much of what the ancient world had built up throughout three millennia was by no means compensated for by the Christianization of the invaders. The ensuing era, generally known as the Dark Ages, was not as protracted as historians once believed, as we shall see when we come to the extraordinary figure of the emperor Charlemagne at the end of the eighth century.

In contrast to the monumental architecture of the Early Christian and Byzantine world, on whose inner walls is figured forth in pictorial imagery the full complexity of Christian iconography, the barbarians, as long as they lived in the wilds, had no permanent buildings at all, only structures of timber and wattles. As far as we can discover, the art of painting was unknown to them. The surviving buildings and images created by the invaders once they had settled (with the exceptions of the partially Byzantinized Theodoric and the Visigoths in Spain) are for the most part small, rough, and unpretentious, giving little indication that the Germanic tribes had learned much from the culture they destroyed. Astonishingly enough, few of these examples are comparable in quality to the metalwork, an ancient and highly refined art, that the tribes brought with them and presumably continued to practice.

This metalwork art was generally foreign to Mediterranean culture, but was especially relevant to the needs of nomadic peoples. Its practice was restricted to the manufacture of objects of daily life that the migrants could carry on their wanderings—weapons, personal adornments, and horse gear for the most part, often made of precious metals and studded with precious or semiprecious stones, but also objects of unknown ritual use. It is crucial to consider this barbarian art because both Celtic and Germanic ornament, generally free from all Classical restraint, formed a countercurrent to the humanistic heritage of antiquity throughout European art in the Middle Ages up to the dawn of the Renaissance and was later to burst forth in certain aspects of the art of the twentieth century. How far back these motives go, and how difficult they are to trace, can be seen in a magnificent hammered gold bracelet (fig. 483), of completely unknown ethnic origin, found at Bellye in present-day Hungary. The object, dating from some time in the second millennium B.C., consists of a triple armband ornamented on the inner flanges by an incised scallop pattern; on the outer the scallop becomes tendrils. The back flares into broad scrolls, also ornamented by tendrils. These ornamental motives turn up everywhere in primitive art—the tendrils, for example, appear not only in Tarxien in Malta (see fig. 35) but also in a gigantic burial mound recently excavated at Newgrange in Ireland. The scrolls suggest the volutes of Ionic capitals centuries later. Is it possible that certain forms are endemic in human creativity at any age and in any country?

483. Bracelet, from Bellye, Hungary. c. 2nd millennium B.C. Gold. Naturhistorisches Museum, Vienna

484. Cult wagon, from Strettweg, Austria. c. 7th century B.C. Bronze, height of goddess 8¾". Landesmuseum Joanneum, Graz, Austria

485. Tiara, from Poiana-Coţofeneşti, Rumania. c. 4th century B.C. Gold, height 9½". Museum of History of the Socialist Republic of Rumania, Bucharest

The Celts, a race of great imaginative powers but, insofar as we know from Classical sources, given to horrifying sacrificial and funerary rites, swept across Europe in the fourth century B.C. and appear to have picked up a number of elements and ideas from settled cultures with which they had already come in contact. For instance, one of the finest examples of Northern European art we possess from the Bronze Age, a small bronze wagon found at Strettweg in Austria (fig. 484), shows contacts with Greece of the Geometric period. A product of the Hallstatt culture, known by the name of the village near which the original finds were made, the wagon probably dates from the seventh century B.C. What religious ritual it was intended to commemorate we do not know. A tall female figure, apparently a goddess, dressed only in a belt, supports a bronze bowl in the center of the wagon; she is followed by pairs of warriors on horseback and on foot, and by pairs of male figures flanking stags. This figure, and others like it, may suggest a leading role for women in some barbarian cultures. It has been shown that the goddess must have been directly imitated from Greek Geometric figures—at that distance from Greece! The animals also suggest Geometric art (see fig. 180), and the bronze work, not hammered but cast by the lost wax method, differs from the usual barbarian art.

Another splendid object of complex derivations (possibly not Celtic) and unknown purpose is the great gold tiara, perhaps a royal or priestly crown, found at Poiana-Cotofenești in Rumania (fig. 485) and apparently dating from the fourth century B.C. Certain motives, such as the shape of the headdress, the stylized curls, and the flaring horns above the eyes, have been traced to a possible derivation in the art of far-away Persia (see, for example, figs. 150 and 152). Giving even more credence to this theory is the figure kneeling on the neck of an animal as he slaughters it, represented in relief on the cheek-piece. But the staring eyes below the horns have just the disturbing effect we like to imagine as barbarian, whatever their original meaning.

In striking contrast to the eclecticism of these works are those identified with the richly productive La Tène culture, named after a site on

483

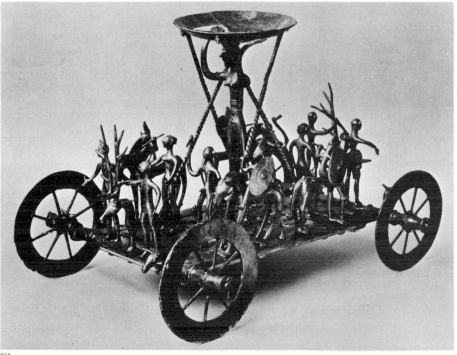

484

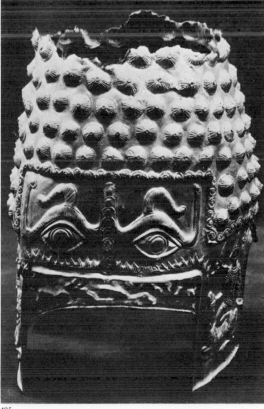

485

Lake Neuchâtel in Switzerland, where immense numbers of objects of a characteristic style were found in peat bogs, which indicates that they were thrown into lakes, ponds, or rivers. Since many were useless from any practical standpoint (gold swords, let us say), it seems probable that they were made from the start as offerings to water gods. Appropriately enough, all La Tène metalwork is characterized by a beautiful, sometimes bewildering fluidity of style. One of the most complex examples is an openwork ornament in bronze of about the third century B.C., found near a Celtic site at Brno-Malomeřice in Czechoslovakia (fig. 486). The organic shapes well outward and upward, expanding freely to enclose far more open space than solid form; a spatial pattern of surprising elegance and grace centers upon an antelope head with wide-open staring eyes and upward-twisted horns, but ends in delicate hooves. La Tène motives and shapes continue in Celtic art for the next thousand years or so, reappearing in some surprising places.

La Tène monumental art, as in the huge stone shaft-figure from Holzgerlingen in Germany (fig. 487) of about the second century B.C., shows no comparable proficiency in dealing with stone, which bronze instruments could hack only roughly. The grim, horned figure is two-headed like the Roman god Janus, looking forward and backward, but no one knows its true cult significance.

The most mysterious of Northern metal objects is the *Gundestrup Caldron* (fig. 488), a huge silver bowl made of several pieces soldered together around an inner frame. Found in Jutland, the mainland of Denmark, it has been dated all the way from the second century B.C. to the fifth or sixth A.D. La Tène it is certainly not, but is it even Celtic? No one knows for sure. Its relief, on the outside, inside, and even the bottom, seems to

486. Openwork ornament, from Brno-Malomeřice, Czechoslovakia, c. 3rd century B.C. Bronze, 4¾ × 5¾". Moravian Museum, Brno, Czechoslovakia

487. Figure, from Holzgerlingen, Germany. c. 2nd century B.C. Stone, height 79⅞". Württembergisches Landesmuseum, Stuttgart, Germany

487

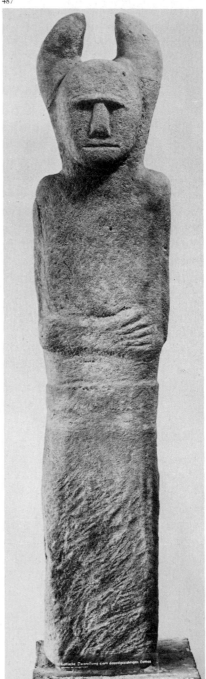

486

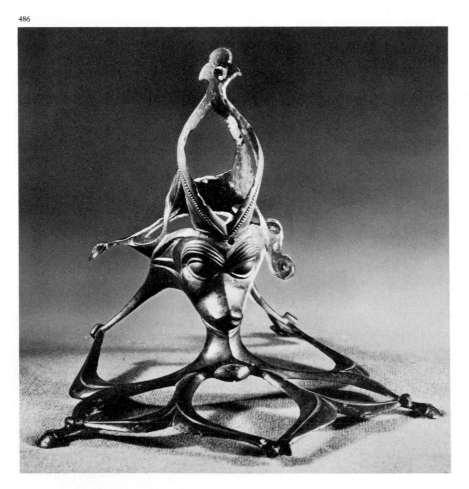

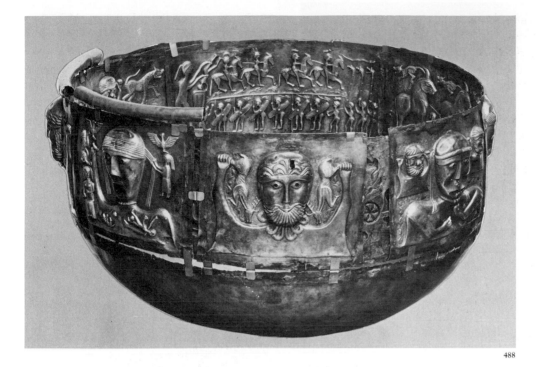

contain an entire world of mythology: raised busts whose extended hands grasp stags by the hind legs or birds with extended wings, warriors on horseback or on foot, elephants, griffins, leopards, winged horses, and seahorses, most of which obviously are not of North European origin. About the expressive and ornamental quality of the work there is no doubt, but the rest is sheer conjecture. The workmanship and some of the motives have been connected with craftsmen near the Black Sea, and it has been suggested that the great bowl was either carried all that distance, or made in Denmark by craftsmen brought along by some powerful chieftain. But the significance of the *Gundestrup Caldron* transcends even the mystery of its origin, date, and workmanship; it serves as a symbol of the incredibly complex tissue of later medieval art in Western Europe, in which not only all these motives turn up but many more as well.

A further ingredient in the medieval mixture was the art of Slavic groups, who apparently never reached Western Europe, although as we shall see, some of their products did make the journey and had decisive effect on the arts of Scandinavia, Ireland, and the islands between Ireland and England. Unlike La Tène art, in which mere portions of animals are occasionally embedded, the very subject of this nomadic art was animals. For this reason the term *Animal Style* is often applied to it. To find its origin we have to go back to the Scythians, a people who lived in what is today the southern U.S.S.R. They were regarded by the Greeks as arch-barbarians, but before they were Hellenized they produced gold objects of great beauty and frightening intensity, such as the crouching panther (fig. 489) of the sixth century B.C., found in a burial mound at Kelermes. No work of twentieth-century sculpture has surpassed the power of the harsh masses and rhythms into which this animal is divided, nor the sheer ferocity of its snarling expression. The paws and the tail of the beast are beaten into the shapes of panthers, and the ears are executed in cloisonné. This technique consists of soldering small strips of metal to the underlying surface so that the small compartments they form may be filled with enamel, glass, or inlaid stones.

488. Caldron, from Gundestrup, Denmark. 2nd century B.C.–5th or 6th century A.D. Silver, height 16½″, width 27″. Nationalmuseet, Copenhagen

The Animal Style

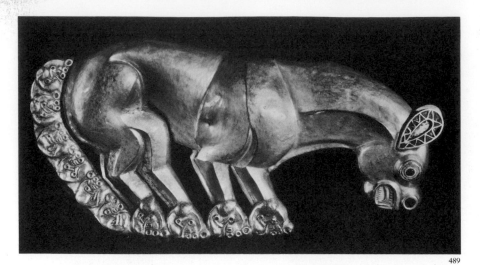

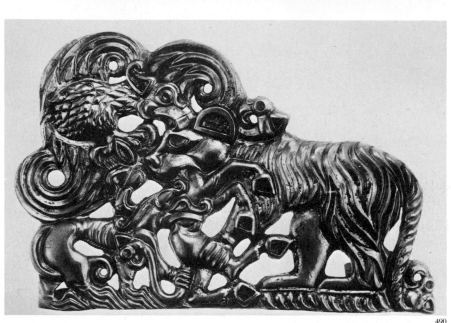

489. *Panther*, from Kelermes. Scythian, c. 6th century B.C. Gold, length 11⅝". The Hermitage, Leningrad

490. Scythian plaque with animal interlace, from the Altai Mountains, Siberia. Gold, 5⅛ × 7¾". The Hermitage, Leningrad

491. Shield ornament, found at Helden, the Netherlands. Scythian(?), c. 1st century B.C.–3rd century A.D. Gilded silver, diameter 8⅝". Rijksmuseum van Oudheden, Leiden, the Netherlands

492. Animal interlace, from a ship burial at Sutton Hoo, Suffolk, England. c. A.D. 655–56. Purse lid, originally ivory or bone, set with cloisonné plaques. British Museum, London

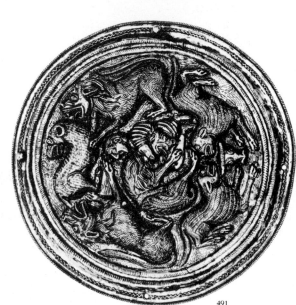

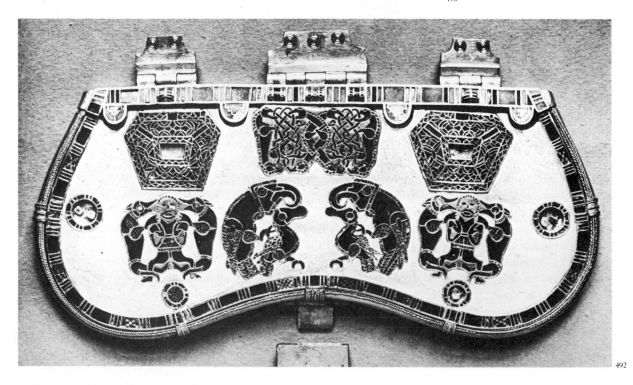

Another Scythian gold plaque (fig. 490) apparently came from the Altai Mountains far to the east in southern Siberia, just above the border of Mongolia. After a moment's gaze this seething caldron of destruction resolves itself into a wolf and a tiger that are tearing a colt apart, while an eagle in turn attacks the tiger with beak and wings. The fighting animals have begun to form an interlace, of bewilderingly fluid and complex shapes, whose parallel striations are derived from the stripes of the tiger, the feathers of the eagle, and apparently the shapes of grasses below. An indication of the immense geographic spread of this style may be seen in the discovery of an obviously related gilded silver disk, possibly a shield ornament, at Helden, the Netherlands (fig. 491). It may have been made at any time between the first century B.C. and the third A.D., either by Scythians or under Scythian influence, and was quite possibly carried for thousands of miles. The disk shows at least seven animals, including wolves and lions—not common in the Netherlands—in conflict over a cow, tearing at each other in the form of a spiral.

What eventually happened to this interlace of fighting beasts may be seen in a purse lid (fig. 492) from an Anglo-Saxon royal ship burial at Sutton Hoo in Suffolk, England, dated A.D. 655–56. The lid, originally ivory or bone, is set with cloisonné plaques, of which those at upper right and left are ornamented with purely geometric patterns. The central panel is composed of fighting animals whose jaws are prolonged to form interlaced ribbons. Below are two plaques, each composed of an eagle capturing a duck, while at either side appears that rarest of animals in migrations art, man, highly stylized and standing between two hostile wolves in a configuration that recalls the far-off days of the ancient Sumerians (see fig. 129); in fact, the motive may have been derived from heraldic groupings in Mesopotamian art. Surprisingly—and very important—this polyglot Sutton Hoo ship burial included a beautiful Celtic bronze mirror, with whorls and spirals in pure La Tène style. A final stage in the development of the animal interlace is seen in a fierce animal head in the carved wood of a prow (fig. 493), from a ship burial of Viking seafarers at Oseberg, Norway, datable about A.D. 825. The animal itself is frightening enough, with open mouth and glaring eyes, reminding one of its ancestry in the panther of Kelermes (see fig. 489), but the wood-carver has embellished its head with a rich interlace of crisscrossing and entwined ribbon-like shapes that one would have difficulty tracing back to their probable origins in animal combat.

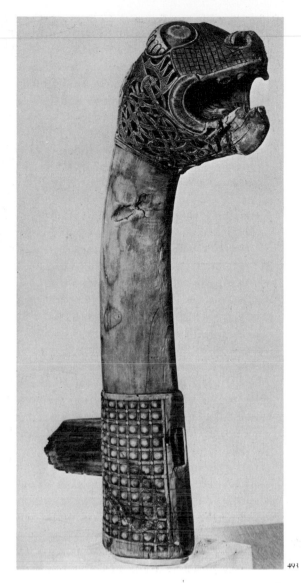

493. Animal head for a prow, from a ship burial at Oseberg, Norway. c. A.D. 825. Wood, height of head 5″. University Museum of Antiquities, Oslo

Hiberno-Saxon Art

The Anglo-Saxon pagan conquest of Britain in the fifth and sixth centuries A.D. left Christianized Ireland cut off from easy access to Continental Europe. Under such circumstances it is not surprising that a highly individual form of monasticism flourished in Ireland, a form adapted to the needs of an isolated country without urban centers. What was less to be expected was the rise of an intense Irish missionary activity, directed toward the Continent and toward England. From the sixth through the ninth centuries, Irish monks traveled through northern and central Europe, founding monasteries as far south as Switzerland and Italy. In 633, at the invitation of the king of Northumbria, one of the seven Anglo-Saxon kingdoms, an Irish monastery was established on the island of Lindisfarne, off the northeast coast of England. Quite independently, the Roman missionary Augustine arrived in England in 597 to commence the conversion of the southern Anglo-Saxons to the Roman form of Christianity, from which the Irish by that time had deviated in a number of

respects. At the Synod of Whitby in 664 the two missions met head on, not without fireworks. Eventually, the Irish submitted to Rome but continued to maintain a certain independence.

An activity essential to the Irish missions was the copying of religious books, especially the Gospels. For the enrichment of their manuscripts, the Irish drew on established metalwork traditions, both Germanic and Celtic, as well as on examples of Early Christian illumination. The resultant art, carried out in all probability by Anglo-Saxon artists (although this is by no means certain) under Irish inspiration, is best known as Hiberno-Saxon. The transformations of Early Christian originals produced by these artists are interesting, but these pale in comparison with the marvels they turned out in a tradition they knew and understood. For example, one of the earliest of the Hiberno-Saxon manuscripts, the *Book of Durrow*, done in Northumbria in the second half of the seventh century, contains a brilliant decorative page (see fig. 11) whose ornamentation, surprisingly enough for a work of Christian art, can be traced directly to three of the four types seen in the purse lid from Sutton Hoo (see fig. 492): the animal interlace, the abstract interlace, and the pure geometric, translated from metal into painting. All of it is carried out in a style based on clear contours bounding flat areas of color obviously derived from the cloisonné technique. But a momentous change has taken place. Instead of being freely scattered across the area as in the purse lid, the three types of ornamentation are combined into a unified whole by powerful embracing shapes and movements. Two horizontal panels of animal interlace at the top and two at the bottom are united by smaller vertical panels to bound a square, in which floats a circle containing abstract interlace. Within this interlace are embedded three smaller circles of geometric ornament, arranged in an equilateral triangle. In the center a smaller circle surrounds a cross, composed of four equal triangular elements. This total grouping combines within itself the numbers of the Gospels and the Trinity, and by means of these numbers—the three outer circles, the four corners of the square, and the four horizontal bands, whose widths and lengths are related to each other as one to four—imposes its own proportional unity on the pagan magnificence of the ornament. The animals-biting-animals pattern now proceeds in a beautiful rhythmic motion, which also obeys distinct laws of repetition, alternation, and reversal as well as those of color and shape, all of which may be deduced if one is willing to look long enough.

An even more splendid book, the Gospels illuminated at Lindisfarne from 698 to 721, shows a more highly developed form of this harmony between Christian symbolism and pagan ornamental tradition in a symbolic structure of dizzying complexity and cosmic grandeur (fig. 494). Cross, circle, and square, extended at top and bottom to fit the oblong format, embrace the entire page in a manner recalling the heavenly Cross of the catacomb frescoes (see fig. 397). All three symbols are filled with abstract interlace, so divided into different color zones that at the ends of the crossbars four smaller crosses emerge. Between the crossbars the fields are filled with animal interlace of violent activity. The comparatively serene ornament in the central circle discloses one large and four smaller crosses. Tabs projecting from the four outer corners are formed by animal ornament; on the center of each side is another tab composed of facing birds whose beaks show sharp teeth. Most surprisingly, pure La Tène ornament, whose origins go back a thousand years, fills the corners of the extensions with active whorls.

If the Hiberno-Saxon artists had a Continental model before them,

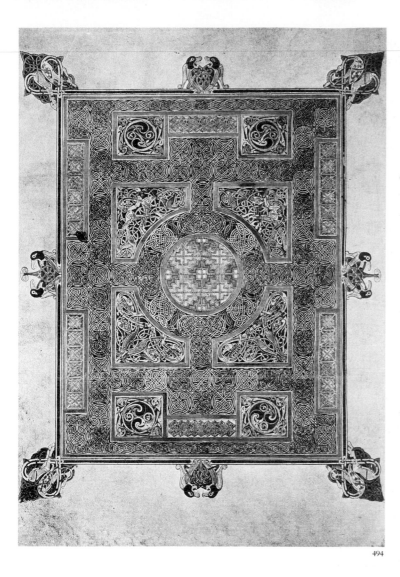

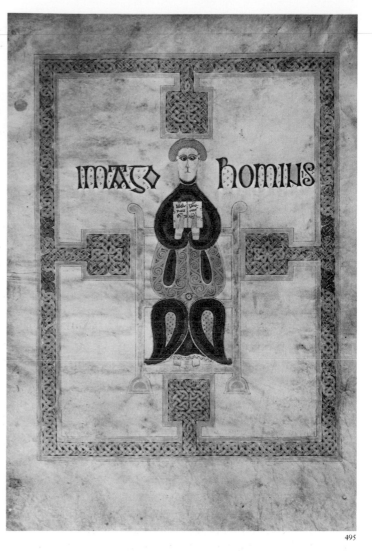

they translated its imagery recognizably enough into a geometrized equivalent, but when they invented their own figures, the result can be startling. The *imago hominis* (image of man) page from the Gospels illuminated in the first half of the eighth century by a Northumbrian artist at Echternach in Luxembourg (fig. 495) is conveniently labeled, for otherwise we might not know a human being was intended. The little head, with its endearing cross-eyes, appears caught in the mechanism of the cruciform interlace that proceeds from all four sides of the border seemingly to form a vise. The artist, asked to paint the winged man symbolizing Matthew, treated him as a six-winged seraph. Locked in place by the four bars, he completes the form of the Cross.

The freest compositions of the Hiberno-Saxon manuscripts are those that display enormous letters engulfing the entire page. No pagan scribe would have thought of endowing initial letters with exceptional importance. But since the Bible was divinely inspired and therefore sacred, its very letters—and most of all the initials—were regarded as exerting magical potency. What we might call the Baroque phase of the Hiberno-Saxon development is exemplified by the *Book of Kells* (fig. 496), a copy of the Four Gospels illuminated in southeastern Ireland between 760 and 820. The words *Christi liber generationis* (the book of the generation of Christ; Matt. 1:1) fill the entire page. The name of Christ, reduced to its Greek contraction XPI, becomes like the Cross an immense celestial apparition

494 Cruciform page from the *Lindisfarne Gospels*. Northumberland, England, c. A.D. 698–721. Illumination. British Museum, London

495. *Imago Hominis (Image of Man)*, illumination from the *Echternach Gospels*. Luxembourg, c. 1st half of 8th century A.D. Bibliothèque Nationale, Paris

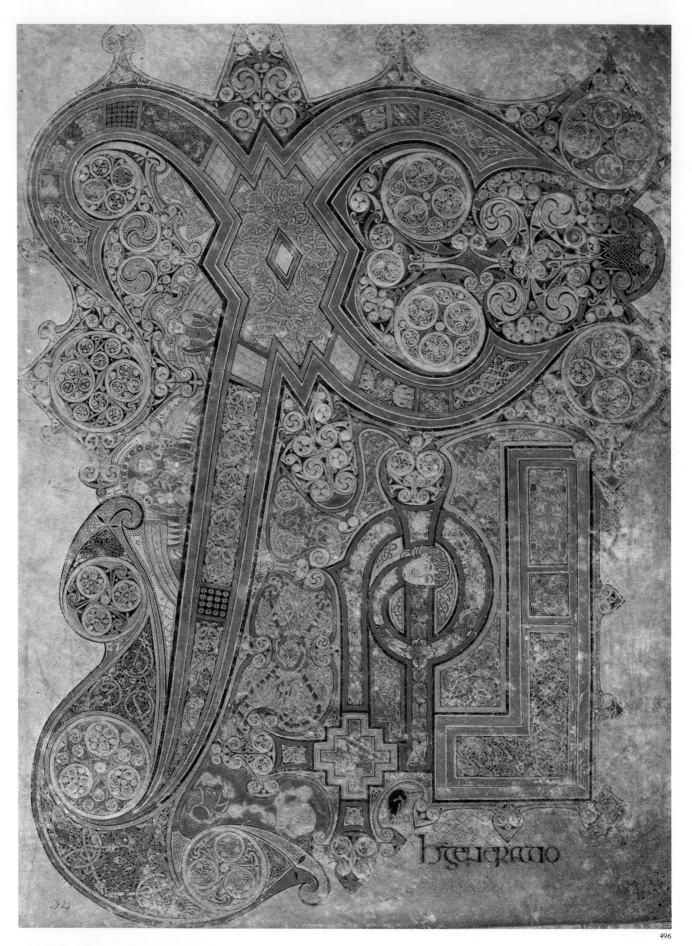

496. *XPI* page from the *Book of Kells*. Ireland,
 c. A.D. 760–820. Illumination. Trinity Col-
 lege, Dublin

(divided neatly, of course, into successive areas of animal interlace, abstract interlace, and geometric ornament). The powerful diminishing curves, like comets, involve whole galaxies of La Tène circles-within-circles, large and small, filled with vibrant whorls—all going at once. After contemplating this revelation for a while, we are astonished to see emerging from its intricacies the faces and upper torsos of three unhappy little people, trapped among feathers and teeth along the clean outer edge of the mighty X, like the antelope head in the ornament from Brno-Malomeřice (see fig. 486). Stranger yet, in the second spiral from the bottom of the page, at the tail of the same shape, two naturalistic mice appear in a heraldic grouping on either side of a small round object (a piece of cheese?), contemplated by two sleepy cats, each with a mouse on its back.

Barbarian and Hiberno-Saxon artifacts, wherever preserved or whenever excavated, seem always to have been admired, even in periods dominated by realistic standards of representation. Animal fantasy and the animal interlace, reflecting symbolically the realities of barbarian existence in the steppes and the forests, persisted—Christianized only partially if at all—as a major ingredient in the imagination of the illuminators in the Hiberno-Saxon monasteries. For reasons about which we can only speculate, the interlace was not to outlast for long the year 1000, but animal fantasy flourished for the duration of the Middle Ages. Its wildness, ferocity, sometimes even obscenity formed an astonishing countercurrent to the official piety of Romanesque and Gothic church decoration and manuscript art, turning up in the most unexpected places and inundating with a fresh wave of intensity the art of certain Northern Renaissance masters. Living a submerged existence in the folk legends and superstitions of rural regions, this animal fantasy was to surface in a wholly new form in the subconscious symbolism of Surrealism in the first half of the twentieth century.

TIME LINE V

Sarcophagus of
Junius Bassus

Good Shepherd,
Galla Placidia

San Vitale,
Ravenna

	HISTORY	CULTURE
200	Shapur I, Sassanian king of Persia, r. 242–72	Christian persecution in Roman Empire, 250
	Constantine the Great, r. 324–37	Emperor Gallienus grants Christians right to pos-
	Constantinople (Byzantium) new imperial capital,	sess churches, 260
300	330	Great persecution, 303–05
	Theodosius divides Empire: East (Arcadius), West	Constantine proclaims toleration, Edict of Milan,
	(Honorius), 395	313
	Honorius makes Ravenna capital of West, 402	First Council of Nicea, 325
400	Alaric I, Visigothic king, sacks Rome, 410	St. Jerome translates Bible into Latin, 382
	Galla Placidia regent of West, 423–25	St. Augustine writes *City of God*, 412
	Vandals invade North Africa, 429	Council of Ephesus; Mary proclaimed *Theotokos*
	Attila, king of Huns, destroys Milan, 450;	(Mother of God), 431
	Pope Leo persuades him to spare Rome	Silk cultivation brought from China
	Odoacer takes Empire of West, Ravenna, 476;	St. Patrick (d. 461) said to have founded Christian
	end of Western Roman Empire	church in Celtic Ireland

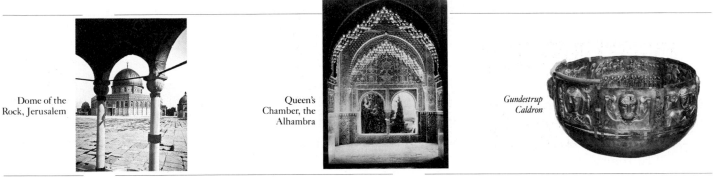

Dome of the
Rock, Jerusalem

Queen's
Chamber, the
Alhambra

Gundestrup
Caldron

500	Theodoric founds Ostrogothic kingdom in Italy,	
	488–526	
	Justinian Emperor of Byzantium	Justinian initiates "Golden Age," 527–65, codifies
	Byzantine army reconquers Ravenna, 540	Roman laws
	Lombards establish kingdom in Italy, 568	Muhammad, prophet of Islam (c. 570–632), flees
600	Muslims conquer Byzantine provinces in Near	Medina (Hegira), 622
	East and North Africa, 637–40	Text of Koran established, 651
700	Omayyad caliphate, Damascus, 661–750	
	Muslims take Visigothic Spain, 711	
	Abbasid caliphate, Baghdad, 750–1256	Iconoclastic controversy, 726–843; Second Council
800	Macedonian Dynasty, 829–976	of Nicea rejects Iconoclasm, 787
	Vladimir I, duke of Kiev, r. 980–1015	Macedonian "Renaissance" marks return to
		Hellenistic ideals
		Conversion of Russia to Orthodox Church, c. 990
1000–	Schism between Eastern and Western churches	
1600	becomes final, 1054	

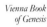

Vienna Book of Genesis

Hagia Sophia, Istanbul

Pantocrator, Daphni

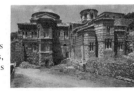

Hosios Loukas, Phocis

PAINTING, SCULPTURE, ARCHITECTURE

PARALLEL SOCIETIES

PAINTING, SCULPTURE, ARCHITECTURE	PARALLEL SOCIETIES	
Scythian gold objects	Scythian, Celtic	200
Gundestrup Caldron	*Roman Empire*	
Ceiling fresco, Catacomb of Sta. Priscilla	Early Christian	
"Domus ecclesiae" and *Haman and Mordecai*, Dura-Europos	Sassanian Persian	300
Palace of Shapur I, Ctesiphon		
Ceiling fresco, Catacomb of SS. Pietro e Marcellino		
Old St. Peter's; Sta. Gostanza		
Mosaics at Hagios Georgios, Salonika		400
Mosaics at Sta. Maria Maggiore		
Mausoleum of Galla Placidia at Ravenna, with mosaics		
Sarcophagus of Junius Bassus; The Three Marys at the Sepulcher		
Vatican Virgil		
St. Simeon Stylites, Qal'at Saman; *Colossus of Barletta*		

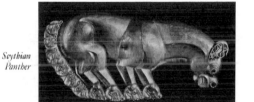

Scythian Panther

Animal-head prow, Oseberg Ship

Echternach Gospels

San Vitale and S. Apollinare in Classe, Ravenna, with mosaics	Lombards	500
Hagia Sophia; *Vienna Genesis; Rabula Gospels; Christ and Virgin* diptych	Muslims	
Purse lid, Sutton Hoo; *Book of Durrow; Echternach* and *Lindisfarne* gospels	Hiberno-Saxon	
Book of Kells; Oseberg Ship		
Dome of the Rock; Great Mosque, Damascus, with mosaics	Byzantine	
Great Mosque, Córdoba; frescoes at Castelseprio		600
Great Mosque, Samarra; Mosque of Ibn Tulun, Cairo		
Virgin and Child mosaic, Hagia Sophia; *Paris Psalter; Joshua Roll*		700
Churches at Hosios Loukas; Hagia Sophia, Kiev, with mosaics	*Carolingian*	
S. Marco, Venice, with mosaics; mosaics, Cathedral of Cefalù	*Ottonian*	
Lamentation, Nerezi; St. Demetrius, Vladímir	*Romanesque*	800
Frescoes, Sopoćani; frescoes and mosaics, Kariye Djami; *Stylite,* Novgorod		
Alhambra; Madrasah of Sultan Hasan; *Bihzad in the Garden*		
Old Testament Trinity by Rublev	*Gothic*	1000–
Last Judgment, Voroneţ; Cathedral of St. Basil, Moscow; Taj Mahal		1600

THE ART OF THE HOLY ROMAN EMPIRE

FOUR

The victorious advance of the Muslims in Europe was stopped in 732 at Tours, two thirds of the way from the Pyrenees to the English Channel, by Frankish forces under Charles Martel. It is sobering to contemplate how different European history, and consequently European art, might have been had Charles Martel lost this battle. Charles Martel (the word *martel* means "hammer") was a high official under the weak Merovingian kings, and he gave his name to the Carolingian dynasty that, under his son Pepin the Short, replaced them. Pepin entered Italy, in answer to the pope's appeal, to defend the papacy against the Lombards; in 756 he gave Ravenna and the surrounding territory, which rightly belonged to the Byzantine Empire, to the pope, thereby at once strengthening the ties between Rome and the Frankish kingdom and weakening those between the Eastern and the Western Church.

Pepin's son, known to history as Charlemagne (Charles the Great), ruled as Frankish king from 768 to 814, a reign of forty-six years that transformed the cultural history of northern and central Europe. On Christmas Day in A.D. 800 he was crowned Roman emperor in Saint Peter's by Pope Leo III. While it appeared that Charlemagne revived the fifth-century division between East and West, in fact he ruled a region which included modern France, the Low Countries, Germany, much of central Europe, a small slice of northern Spain, and Italy down to a borderline not far south of Rome. He governed this territory from his court in the German city of Aachen (also known by its French name of Aix-la-Chapelle), near the modern border of Germany with Belgium and the Netherlands. Charlemagne actually founded a wholly new institution, a northern dominion known after the thirteenth century as the Holy Roman Empire. For more than a thousand years his successors exercised an often disputed and never clearly defined authority over much of Europe, until Napoleon dissolved the Holy Roman Empire in 1806. In the imagination of the Middle Ages, the emperor exercised in temporal affairs the sovereignty that in spiritual matters belonged to the pope. Since the latter was by now a temporal monarch as well, largely by courtesy of the Carolingian rulers, Pepin the Short had opened a Pandora's box, which none of his successors ever quite succeeded in closing.

Abbot Einhard, Charlemagne's biographer, said of him that "he made his kingdom which was dark and almost blind when God committed it to him . . . radiant with the blaze of fresh learning hitherto altogether unknown to our barbarism." If we discount courtly hyperbole, Einhard's claim still contains much truth. We must imagine the Roman cities of Charlemagne's realm as largely in ruins and very nearly depopulated, and there is no indication that he tried to rebuild them. To his court at Aachen, however, he brought Greek and Latin manuscripts, and foreign scholars, especially Alcuin of York, who supervised imperial campaigns aimed at the revival of Greek and Roman learning and the establishment of the correct text of the Bible, which, through constant recopying, had grown corrupt. Such concerns are remarkable in an emperor who retained Frankish dress and who, although he understood spoken Greek and could converse in Latin, never succeeded in learning to write. The emperor's architectural ambitions seem to have been limited to the embellishment of the imperial court and of the monasteries that, under the Benedictines based at Monte Cassino in southern Italy and under the Irish monks who had founded monasteries in much of the territory to which Charlemagne fell heir, had established themselves as Western guardians of Classical Christian culture.

ARCHITECTURE Little of what Charlemagne built is still standing in anything like its original condition; luckily, the chapel of his palace at Aachen is preserved, although it was extended by a Gothic choir in the late Middle Ages and stripped of its splendid decorations. The architect, Odo of Metz, is the first builder known to us by name north of the Mediterranean. The Palatine Chapel of Aachen is an octagon (figs. 497, 498),

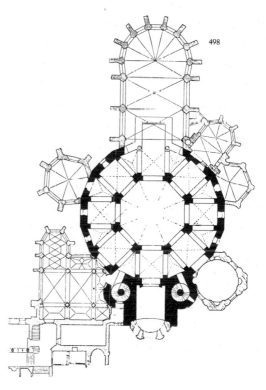

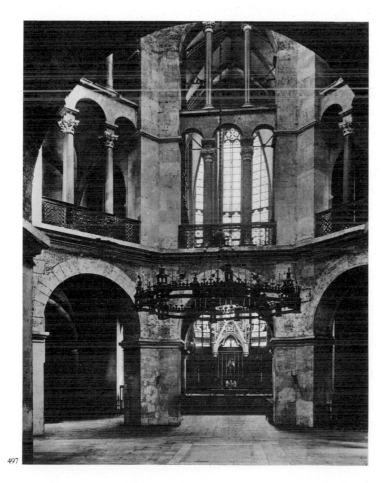

497. ODO OF METZ. Palatine Chapel of Charlemagne, Aachen, Germany. 792–805

498. Plan of the Palatine Chapel of Charlemagne, Aachen (Later additions in fine line)

and a first glance will show that Odo modeled it on San Vitale at Ravenna, a church that Charlemagne must have greatly admired. The next look, however, discloses crucial differences. The flexible, expanding plan of San Vitale (see figs. 418, 419) has been abandoned, possibly because it was unbuildable in stone, possibly because no one knew enough about architectural draftsmanship in 792 to reproduce it; Odo may never have visited Ravenna. Each of the seven transparent apses of San Vitale has been replaced by two superimposed round arches. The upper arch embraces two levels, the lower of which is a straight arcade formed by three round arches, and the upper of which is sheer fantasy—two columns that support the crowning arch at just the point on either side of the keystone where it needs no support, as these lateral archivolts tend to be pushed up, not down, by the pressure of the central keystone. Such a use of Early Christian—in fact, Roman—motives, shorn of their original function and deprived of their true spatial extension, was significant for Carolingian figurative art as well. Needless to say, many if not all of the colored marble and granite columns and white Corinthian capitals were imported from Roman buildings in Italy. The heavy masonry is built of massive blocks of stone, but the cores of the piers are rubble. Originally, the dome was resplendent with a mosaic representing Christ enthroned in Heaven among the four-and-twenty elders rising from their thrones to cast their crowns before his throne, according to the vision of John (Rev. 4:1–10), an appropriate subject for a patron who claimed divine authority for his own imperial rule. (Recently, it has been suggested that the enthroned Christ is a later interpolation, and that the original mosaic showed the Lamb upon the throne.)

Interestingly enough, the customary narthex, set at an angle at San Vitale, is replaced here by a central portal flanked by two circular towers and entered from the main court of the palace. The emperor could thus attend Mass in the gallery as though in a box at the theater, and he could appear at an opening above the portal to the populace in the court outside. Here Charlemagne had set up a bronze equestrian statue of Theodoric (a worthy model, as a Romanized Germanic chieftain), which he had brought across the Alps from Ravenna. The court could hold about seven thousand persons. The design of the Palatine Chapel was so successful that it was repeated several times in different parts of Germany.

Centula. In the still largely agricultural and patriarchal society of the Franks and their Germanic and Gallic subjects, there was no need for new urban churches, but monasteries were essential to Charlemagne's program, and he rebuilt them and founded new ones in great numbers. Only a few remain, largely remodeled, but plans exist that show how crucial these monasteries were for the late Middle Ages. The plan of the now totally vanished Abbey Church of Saint-Riquier at Centula (fig. 499), near Abbéville in northern France, is basically that of a Constantinian basilica with a nave and two side aisles for the congregation, the whole structure roofed with timber. The extensive transept was necessary for processions from the sacristies, where the vestments and vessels for the Mass were kept, to the altar. The apse is separated from the transept by a rectangular space called the choir, intended for the use of the monastic community in chanting the complex music of the Mass and of the Divine Office (the prayers at the seven stated hours). The choir, generally supplied with elaborately carved seats rising in tiers on either side, became a fixture in monastic and cathedral churches from then on. The church plan thus assumed, almost accidentally, the shape of a cross.

At the west end (churches where possible faced east toward Jerusa-

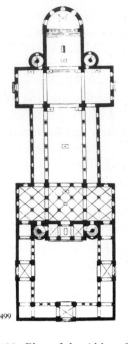

499. Plan of the Abbey Church of St.-Riquier, Centula, France. Late 8th century (After Wilhelm Effmann)

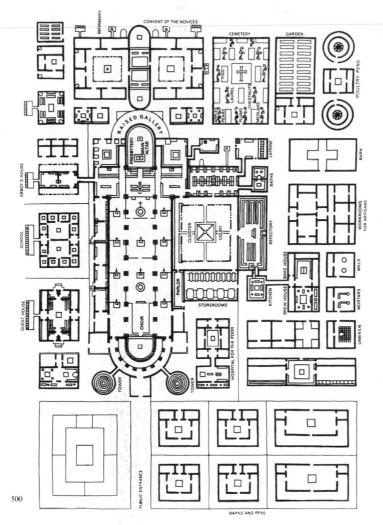

500. Schematic plan for a monastery at St. Gall, Switzerland. c. 819 (Drawing after a 9th-century manuscript)

lem) is an important addition—a narthex running at right angles to the nave and projecting beyond it, forming in effect a second transept. This addition is known in German churches as the *westwork* (fine later examples are shown in figs. 509, 550). The westwork was divided into two or even three groin-vaulted stories; the upper levels could be used as chapels for smaller services. Before the westwork is a large atrium, as at Saint Peter's. In the corners of the atrium, on either side of the westwork, are two cylindrical staircase towers, and two more are visible flanking the choir in the angles of the transept. These towers apparently rose to a considerable height. It may fairly be asked what their use could have been. We do not know whether bells were employed in European churches at this time, but if they were, a single tower would have sufficed for this purpose. Four clearly represent an attempt to assert the existence of the church and to render it visible from afar. To make its appearance still grander, Saint-Riquier also sported massive round towers above the crossing points of the nave with the westwork and with the transept. These towers culminated in round lanterns; both corner towers and lanterns had conical roofs. All at once the lofty skyline of the medieval cathedral appears in germ, replacing the low profile of the Early Christian basilica.

Saint Gall. In 816–17 a council at Aachen devised an ideal plan for a monastery, which was sent to the abbot of Saint Gall in Switzerland (fig. 500); although he did not follow it exactly, the plan is revealing in that it shows all the major features of a later Western medieval monastery. The

plan is dominated by the church, whose semicircular westwork is flanked by two cylindrical towers. The customary nave and side aisles of the interior lead as usual to transept, choir, and apse. The buildings to the left of the church include a guest house, a school, and the abbot's house. Behind the apse and to the right is a building for novices. Adjacent to the novitiate and to its right lie the cemetery (frugally used also as an orchard), the vegetable gardens, and the poultry pens. In the position that became customary in all oriented churches, in the southwest corner of the transept—the warmest spot in the monastery—is the cloister, a courtyard surrounded by arcades, under which the monks could walk, write, and converse. Storerooms flank the cloister to the west, the monks' dormitory with connecting bath and latrine lies to the east, and a refectory for meals with a nearby kitchen is to the south. To the right of the refectory are workshops, brewhouse, bakehouse, and other work buildings. A hospital for the poor is adjacent to the southwest tower. The whole was laid out with the same sense of system and order that prevailed in a Hellenistic or Roman civic center, for the monastery was indeed a town in itself.

The Carolingian period is often characterized as a renaissance, since Charlemagne made a deliberate effort to revive Classical antiquity. But each renaissance (that of Augustus or of Hadrian, for example) picks and chooses among the treasures of the past only those it feels it needs. Charlemagne did not revive temples or nude statues; he was interested in establishing in the North a durable Christian society after an interregnum of tribal chaos. He went to considerable trouble to work out an administrative system for his empire, and widespread knowledge was necessary for the fulfillment of his purpose. For the acquisition and diffusion of knowledge, the monasteries, with their libraries and busy scriptoria (rooms for copying manuscripts), staffed by disciplined and devoted monks, were essential. As we have seen, the earliest extant copies of many ancient, even pagan, authors were made in these very scriptoria.

Lorsch. It is interesting, therefore, to see what dignity could be given to the gateway leading to the imperial Abbey of Lorsch, in the central Rhineland (fig. 501). This little building was imitated from the now-vanished triple gateway that gave access to the atrium before Saint Peter's (see fig. 402). Charlemagne has let his gateway stand free like a triple arch of triumph. Undoubtedly, the columns and capitals were culled from a Roman building. But the pilasters above the columns support colored marble zigzags that savor more of Germanic metalwork than of ancient Rome, and the overall effect of the monument, agreeable as it is, is anything but Classical with its flickering background of inlaid colored marble lozenges on the first story and octagons on the second, not to speak of its steep, northern roof.

PAINTING AND LITURGICAL ARTS From contemporary accounts we know that Charlemagne heard evidence on both sides of the iconoclastic controversy then raging in the East (see Chapter One, page 328); he rejected the views of those who would destroy religious images and would forbid the creation of new ones, yet even more firmly he opposed the worship of images. The emperor was deeply interested in the instructional value and the quality of the mural paintings and mosaics throughout his realm; he commissioned an inventory of their subjects (which still survives) and expected periodic reports on their condition. He ordered that paintings done during his reign were to depict Christ

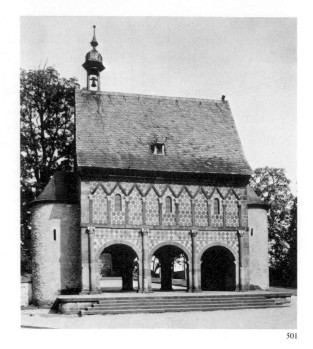

501

501. Gateway, Abbey of Lorsch (Hesse), Germany. 768–74

and the Apostles, narratives from the New Testament and to a lesser extent from the Old, and the lives of the saints. Military leaders from ancient history could be shown if paralleled with their Christian counterparts (for example, Alexander/Constantine), but Classical deities and Classical personifications were to be avoided in paintings visible to the public. Alas, little but the written accounts remains of the presumably splendid Carolingian art of mural painting, and what does survive is either so provincial or so fragmentary that we can gain no clear idea of how the murals once looked. But illuminated manuscripts from the period are preserved by the score, often in well-nigh perfect condition. They glow with color and gold and are so beautiful that we mourn the loss of the wall paintings all the more.

The manuscripts illuminated for the emperor himself were often written, like those commissioned by Justinian, in letters of gold on purple parchment. Although he could not write, Charlemagne laid great stress on legibility. He caused the often indecipherable script of Merovingian times to be replaced by a new form of letters, more useful than the capitals that the Romans employed exclusively. (In fact, the capitals used on this page are based on those in inscriptions dating from the reign of Trajan, while the small letters descend from the script invented for Charlemagne and taught throughout his dominions.) Schools of illumination were set up at various centers, including the court at Aachen and the bishoprics of Reims, Metz, and Tours. Although the large initial letters often proudly display the complex interlaces of Hiberno-Saxon tradition, the illustrations are figurative, either copied from Early Christian originals (this is a hypothesis, since no such originals are known) or invented anew. Christ and the Evangelists were often given full-page illustrations—Christ as King, the Evangelists as authors. King David, naturally enough, was another favorite of the emperor and was often prominently depicted. Pages were also filled with canon tables (which show the correspondence of passages in the four Gospels), written in under illusionistic arcades.

Coronation Gospels. One of the finest Carolingian manuscripts is the *Coronation Gospels*, which is said to have been found on Charlemagne's knees when his tomb was opened in A.D. 1000. Like most manuscripts of the Palace School, the *Coronation Gospels* are illuminated only with canon tables and with full-page portraits of the Evangelists. The Evangelist Matthew (fig. 502) is painted in a manner so Classical that it is hard to realize we are looking at a work done between 795 and 810, rather than five hundred years earlier. The Evangelist, seated on a folding stool, is robed in snowy white and holds his inkhorn above the page with his left hand while his right, grasping a reed pen, is poised as if he were awaiting inspiration. The background landscape, with its rich blue-greens and with rose-and-white clouds streaking the sky, not to speak of the lights and shadows and the soft brushwork of the mantle, comes straight from the Helleno-Roman illusionistic tradition. This beautiful illustration has often been compared with Roman author representations, especially the *Portrait of Menander*, of the Fourth Style, dating from about A.D. 70, from the House of Menander at Pompeii (fig. 503). But as Meyer Schapiro has pointed out, there is a fundamental difference, which tells us much about the essential character of illuminated manuscripts. Like all authors in Classical art, Menander is shown reading from a rotulus, in a relaxed and patrician manner. Matthew is pictured *writing*, in a codex, of course. To the Greeks and Romans writing was a manual activity they relegated to slaves, and books were copied quasi-mechanically in shops, which were the ancestors of modern publishing houses.

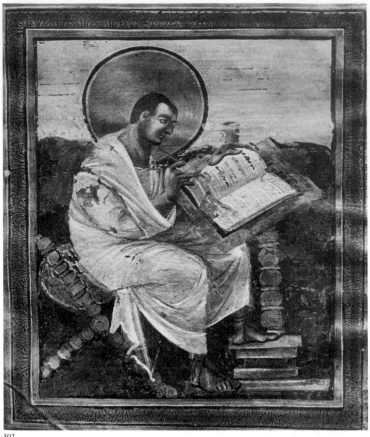

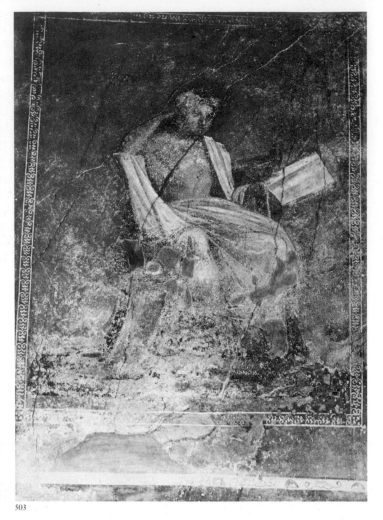

Christians believe that "In the beginning was the Word, and the Word was with God, and the Word was God" (John 1:1). Thus, copying the Word was a sacred duty; how much more elevated, then, the activity of writing under direct divine inspiration! It is to this solemn moment that the Carolingian painter admits us. And, like all medieval artists, he was not really interested in an exact representation of earthly relationships. We look at the portrait through a Classical acanthus frame as though through a window, but one leg of the stool is clearly outside the frame, the other rests on its edge, and the Evangelist's right foot is placed somewhere near the base of the writing desk, not really on it. The question of the homeland of the artist who illuminated the *Coronation Gospels*, at once so serenely Classical and so profoundly Christian, has often been asked but never answered. He may have been an Italian trained in the Byzantine tradition, but in the absence of any paintings of this style in Italy itself, we cannot say.

Ebbo Gospels. A startling transformation of the calm, Classical image takes place in the manuscript of the Reims School, of which the outstanding example is the *Ebbo Gospels*, illuminated for Ebbo, archbishop of Reims between 816 and 841. The same Matthew (fig. 504), seen through the same acanthus frame, has suddenly been seized as if by the *furor divinus*. He bends over as he writes, clutching his quill pen, his eyes almost starting from their sockets with excitement, his drapery dashing madly about his form, the very locks of his hair on end and writhing like serpents. Both the figure and the quivering landscape have been so rapidly set down in quick, nervous strokes of the brush that they seem to participate in his

502. *Saint Matthew*, illumination from the *Coronation Gospels*. c. 795–810. Weltliche Schatzkammer, Hofburg, Vienna

503. *Portrait of Menander*, wall painting in the House of Menander, Pompeii, Italy. c. 70

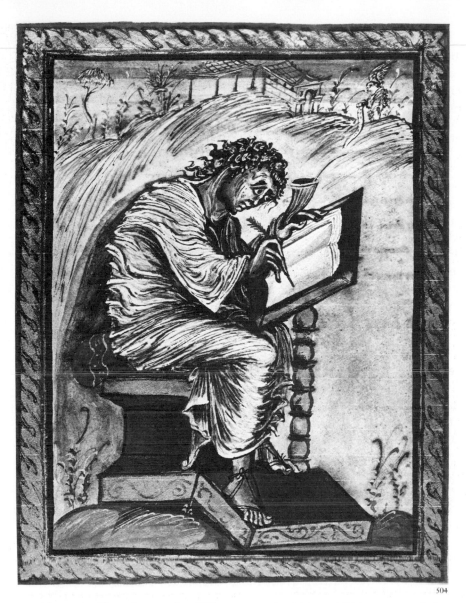

504. *Saint Matthew*, illumination from the *Ebbo Gospels*. Reims, France, 816–41. Bibliothèque Nationale, Paris

emotion, recalling the words: "The mountains skipped like rams, and the little hills like lambs" (Ps. 114:4). The tiny structures in the background seem seriously endangered in this cosmic dance, and even the acanthus leaves of the frame run like flames about the edges—left and upper borders together, right and lower borders meeting. The angel, Matthew's symbol, is sketchily brushed in on the right horizon; he brandishes a scroll, the source of the Evangelist's inspiration. We are here confronted with a form of ecstatic mysticism that we shall seldom see again so eloquently expressed before El Greco in the sixteenth century. Free brushwork, till now the recorder of vision, has become a vehicle for inspiration.

Utrecht Psalter. One of the masterpieces of Carolingian art is the *Utrecht Psalter*, a book of psalms written and illustrated in the Reims School (which comprised several monasteries) at about the same moment the *Ebbo Gospels* was being illuminated and in a similar passionate style. This psalter was illustrated entirely with quill pen, and in the course of time the ink has turned a rich brown, running from quite dark brown to soft golden tones. The little drawings are frameless, scattered freely about the page between the psalms, some invading the Latin text (still written, by the way, in traditional Roman capitals, without spaces between the words). The compositions may derive from earlier models, and the sprightly drawings in the psalter are the work of several different hands of varying degrees

of quality. However, the style is so consistent that one major master must have inspired the unflagging freshness of the scenes and their rapidly moving and gesticulating figures. The illustrations are quite literal. Fig. 505 illustrates both Psalm 82 in the King James Version (81 in the Douay Version), which is written in the central register, and Psalm 83 (82 in the Douay Version), whose text appears on the following page of the psalter. Psalm 82 is pictured in the top register. The illustrations can best be read juxtaposed with the appropriate verses.

Verse 1	God standeth in the congregation of the mighty; he judgeth among the gods.	In the center the Lord, in a mandorla and holding a cross-staff, addresses crowds on either side of him; farther out three angels on each side keep a respectful distance.
Verse 4	Deliver the poor and needy; rid them out of the hand of the wicked.	At the lower left an angel with a sword welcomes the poor, while their tormentors slink away.
Verse 5	. . . all the foundations of the earth are out of course.	At the lower right a giant (Tellus, the Roman god of the earth, shown nude in this manuscript intended for the elite) shakes the earth gleefully, and things fall to bits.
Verse 7	But ye shall die like men, and fall like one of the princes.	Crowned figures watch while an angel sets fire to a statue on a column; two angels knock a statue down, and two men die at the base of its column.

Psalm 83 (82 in the Douay Version) is illustrated in the bottom register.

Verse 2	For, lo, thine enemies make a tumult: and they that hate thee have lifted up the head.	At the left a confused crowd of armed men lift up their heads.
Verse 12	. . . Let us take to ourselves the houses of God in possession.	In the center people fill the arches of a pedimented house; one defies the Lord, who bears shield and spear.
Verse 14	. . . as the flame setteth the mountains on fire; . . .	Right and left, on either side of the Lord, angels set fire to the mountains with torches.
Verse 17	Let them be confounded and troubled for ever . . .	At the bottom an army on horseback retreats rapidly; three of the horsemen are trapped in rope snares.

The artist never loses either the compositional coherence of the entire image, made up of several moments in time with the Lord always pictured in the center, or the speed of a sprightly pen style, which fairly dashes across the page.

Bible of Charles the Bald. After Charlemagne's death his descendants partitioned his domains and proved incapable of continuing his great dream of a newly revived Roman Empire. Nonetheless, the lively narrative and

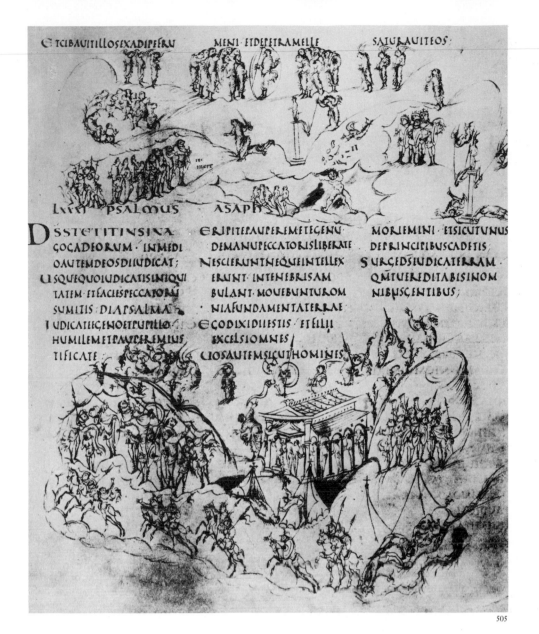

CTIBAUITILLOSEXADIPEERU MENI ETDEPETRAMELLE SATURAUITEOS

LXVII PSALMUS ASAPH

D SSTETITINSINA
GOGADEORUM · INMEDI
O AUTEMDEOSDIIUDICAT;
U SQUEQUOIUDICATISINIQUI
TATEM ETFACIESPECCATORU
SUMITIS DIAPSALMA ·
I UDICATIEGENOETPUPILLO ·
HUMILEMETPAUPEREMIUS
TIFICATE

E RIPITEPAUPEREMETEGENU
DEMANUPECCATORISLIBERATE
N ESCIERUNTNEQUEINTELLEX
ERUNT INTENEBRISAM
BULANT · MOUEBUNTUROM
· NIAFUNDAMENTATERRAE
E GODIXIDIIESTIS · ETFILII
EXCELSIOMNES/
CIOSAUTEMSICUTHOMINES

M ORIEMINI · ETSICUTUNUS
DEPRINCIPIBUSCADETIS
S URGEDSIUDICATERRAM
QM TUEREDITABISINOM
NIBUSGENTIBUS;

expressive style of the Reims School continued to influence the development of manuscript painting under Charlemagne's grandson, Charles the Bald, who ruled over a region corresponding more or less to modern France. Charles briefly wore the imperial crown (875–77). The splendid *Bible of Charles the Bald*, now in Rome, contains a rich series of succinct visual narrations, in brilliant colors, picturing scenes from both Old and New Testaments. One full-page illustration (fig. 506) gives incidents from the ninth chapter of Acts in three registers. At the left of the upper register Saul (not yet Paul) receives a scroll from the high priest on which are written letters for Damascus. At the right, on the way to Damascus, he falls to the ground before the Lord, who appears as the conventional Hand of God, to the astonishment of his companions, who hear a voice but see no one. At the left of the central register Saul is led blind into Damascus. At the right the aged Ananias, asleep on his bed, lifts his hand to the Lord, from whom he receives the command to restore Saul's sight. The miracle, in which Ananias places his hand on Saul's eyes, has been moved out of order to the center of the register and also occupies the center of the page. At the lower left Saul confounds the incredulous Jews; at the right he is let down over the walls of Damascus in a basket.

505. *The Last Judgment* (above) and *Angels of the Lord Smiting the Enemies of the Israelites* (below), illuminations from the *Utrecht Psalter*. Reims, c. 820–32. University Library, Utrecht, the Netherlands

506

The scenes unfold according to the continuous method we have seen in all manuscript narrations so far, a scheme derived ultimately from Roman historical reliefs. But the naturalistic concepts of support and of enclosure have been dismissed. Green earth runs under most of the scenes, with blue sky and white clouds above, but often the feet of the figures in one scene project beyond the ground strip into the clouds of the scene below. Likewise, the simple baldachin on four columns, which does triple duty for the Temple in the first scene, for the house of Judas in which Saul receives his sight in the fifth, and for the locale where Saul con-

506. *Scenes from the Life of Saint Paul*, illumination from the *Bible of Charles the Bald*. Rome, c. 875–77. S. Paolo fuori le mura, Rome

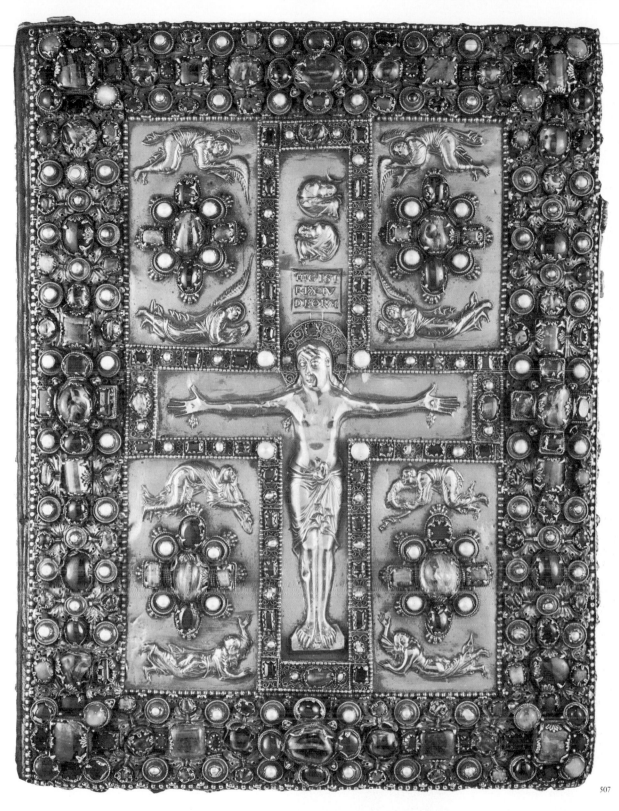

507

founds the Jews in the sixth, does not enclose the figures, who stand or walk in front of columns they should be behind. The little cities of late Roman and Early Christian art are now toylike. The broad strips of energetic figures and ornamental architecture have been worked into a pattern uniting the whole page, enlivened and reinforced by the systematic distribution of blues, greens, red-browns, rose tones, and lavenders.

How precious the illuminated Christian codex, the work of many months and even years, had become as compared with the utilitarian rotulus of antiquity may be seen in the magnificent covers that protected

507. Front cover of the *Lindau Gospels*. c. 870. Gold with precious and semiprecious stones, 13¾ × 10½". Pierpont Morgan Library, New York

the painted pages. The back cover of the *Lorsch Gospels* (fig. 508), probably carved at the court of Aachen in the early ninth century, is made of ivory, as were the Early Christian and Byzantine diptychs from which the style derives. In the central relief a beardless Christ stands under an acanthus arch supported by modified Corinthian columns, as mentioned in Psalm 91 (90 in the Douay Version), Verse 13: "Thou shalt tread upon the lion and the adder: the young lion and the dragon shalt thou trample under feet." A rabbit appears at the right, a very wavy adder at the left, and under Christ's feet the lion and the dragon are being firmly trampled. The arches of the side panels shelter the angels who, in Verse 11, are given "charge over thee, to keep thee in all thy ways." In the upper strip two angels uphold a medallion containing the Cross; in the lower left the three Magi come before Herod and on the right they present their gifts to the Virgin and Child. Clearly, the style is directly imitated from Early Christian or Byzantine originals (see fig. 416, for example); the beardless Christ suggests a source in Ravenna. However, as in the manuscripts, the drapery patterns, still fluttering freely at the edges, are beginning to crystalize into ornamental motives that do not derive from the actual performance of cloth over bodies.

Most dazzling of all the covers are, of course, the ones made of gold and studded with precious and semiprecious stones, whose craftsmanship

508. Back cover of the *Lorsch Gospels*. Early 9th century. Ivory, 14¾ × 10¾". Vatican Museums, Rome

508

shows that the Germanic tradition of metalwork was by no means extinct. The front cover of the *Lindau Gospels* (fig. 507), made apparently in the third quarter of the ninth century for a Carolingian monarch, is almost unbelievable in its splendor. Not only the massive acanthus frame but also the interlaced border of the Cross are set with gems, not faceted as is customary today, but smooth and lifted above the gold to receive light from all sides. Christ is represented calmly alive (a type known as the *Christus triumphans*), seeming to stand on the footrest and to extend his arms voluntarily. He is shown as one who has conquered death. Above his head little half figures representing the sun and the moon hide themselves, and in the upper panels four angels float in beautiful poses of grief. In the panels beneath the Cross, in the style of the flying angels, crouch the figures of Mary, John, and the other Marys. The still-Hellenic delicacy of the floating drapery contrasts strongly with the barbaric richness of the jeweled setting.

Under the uncertain conditions prevailing in northern Europe in the ninth century, the continued maintenance of imperial administration throughout so great an area would have required a dynasty of rulers of Charlemagne's exceptional ability. Unfortunately, his successors divided his empire among themselves and were unequal to the task of repelling renewed waves of invasion. The Vikings made inroads into France, established themselves in Normandy as semi-independent dukes, and became Christianized. In the east the Carolingian kings were menaced by incursions from Magyars and Slavs. As the dynasty disintegrated, the Holy Roman Empire lapsed. Royal power in France passed to Hugh Capet, whose fourteen dynastic successors ruled without interruption until 1328. In Germany the duke of Saxony was elected king as Henry I, but avoided ecclesiastical coronation. His extraordinary son, Otto I (reigned 936–73), was determined to revive imperial power on a Roman scale, but he succeeded only in reestablishing direct rule over Germany and Italy, often by installing members of his family in crucial positions. He set up relatives as dukes throughout Germany; married the widow of Lothair II, king of Italy; and arranged the marriage of his son, later Otto II, to Theophano, daughter of the Byzantine emperor Romanus II, thereby laying claim to Byzantine southern Italy. Otto I also made three expeditions to Italy, had himself crowned king at Pavia, deposed two popes and nominated their successors, and reinforced the imperial claim to the right to approve papal elections. Before Saxon hegemony came to an end in the eleventh century, two descendants of Otto I had occupied the throne of Peter. The five Ottonian rulers (919–1024) brought Germany to the artistic leadership of Europe in the construction of monastic buildings, in painting, and in the revived art of monumental sculpture.

ARCHITECTURE Only a few Ottonian church buildings remain, including the westwork of the Benedictine Abbey Church of Saint Pantaleon at Cologne, consecrated in 980 (fig. 509); the church was especially favored by Archbishop Bruno of Cologne, the brother of Otto I. Although most of the church was transformed in the late Middle Ages, the surviving original fragment shows us something of the grandeur of Ottonian architecture. The two arms of the westwork and the western porch (the latter a modern addition) are of almost equal length, radiating from a square crossing tower with a pyramidal roof. In the angles stand tall towers, which begin square, continue octagonal, and end cylindrical. We

Ottonian Art

509. Westwork, St. Pantaleon, Cologne, Germany, c. 980

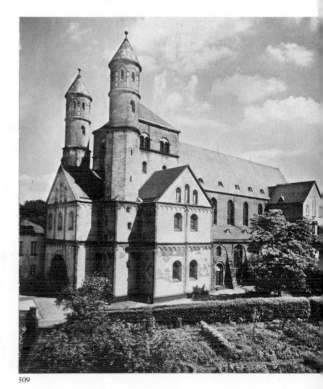

509

are at once aware of two new traits of style. First, the powerful impression exerted by the exterior is achieved by block masses of heavy masonry rather than by the thin, flat walls used by Early Christian architects. The splaying of the windows, to admit more light, increases the apparent thickness of the walls. Second, the stories are separated by corbel tables (tiny blind arches without supports, upholding a continuous cornice). The establishment of a strong exterior view of the church building, begun in Carolingian architecture, thus culminates in a dramatic massing of clearly demarcated cubes, pyramids, octagons, and cylinders.

One of the most active patrons of the arts during the Ottonian period was Bishop Bernward of Hildesheim, who had been a tutor of Otto III and who had traveled to Rome. The great Church of Saint Michael at Hildesheim (fig. 510), which Bernward rebuilt from 1001 to 1033, was considerably altered in later times and largely destroyed in World War II. It has since been reconstructed so as to reproduce as far as possible its eleventh-century appearance. The exterior view shows the westwork to the right, the choir and apse to the left, and identical square towers over the two crossings. The side-aisle windows are later Gothic additions. The transept towers have been moved from the inner corners to the ends. In the interior the westwork is raised above the level of the rest of the church in order to provide an entrance to a crypt with an ambulatory (fig. 512 was photographed from the level of the westwork). Especially original is the way in which the sometimes monotonous impression of the customary basilican interior is broken up. The massive masonry construction permitted a high clerestory, separated from the nave arcades by an expanse of unbroken wall surface, doubtless intended for frescoes. The nave arcade itself, as in some Eastern basilicas, is broken by a pier after every second column into three groups of three arches on each side, there being twelve columns and four piers in all. It can scarcely have escaped Bernward's attention that he was founding this numerical arrangement on the number of persons in the Trinity, the number of the Twelve Apostles, and the number of the Four Evangelists.

510. Plan of St. Michael's, Hildesheim, Germany. 1001–33 (Architectural reconstruction after Beseler)

511. St. Michael's, Hildesheim (rebuilt after destruction in World War II to conform to its appearance in the 11th century)

512. Interior, St. Michael's, Hildesheim (view from the westwork)

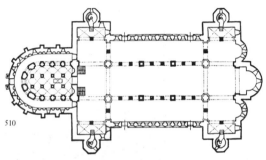

510

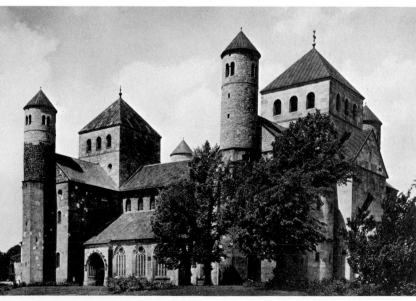

511

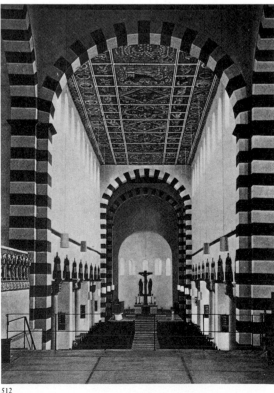

512

SCULPTURE Bernward commissioned for the south portal of Saint Michael's a pair of bronze doors (fig. 513), completed by 1015 and probably before 1035 installed in Hildesheim Cathedral. Bronze doors were traditional in ancient times (the Pantheon had a splendid set), and plain bronze doors without sculpture had been made for the Palace Chapel at Aachen. Bernward is recorded to have been an amateur artist and is generally believed to have supervised not only the iconographic program but also the actual execution of the doors. These massive plates of bronze, about fifteen feet in height, appear each to have been cast in one piece. They begin a long succession of figured bronze doors created throughout

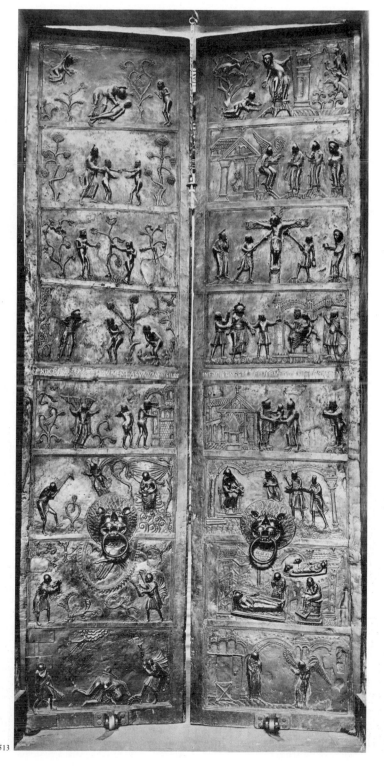

513. Bronze doors with scenes from the Old and New Testaments. c. 1015. Height c. 15'. Cathedral of Hildesheim

513

the Middle Ages and the Renaissance in Germany, Italy, and Russia, culminating in Ghiberti's masterpieces for the Baptistery in Florence. In sixteen scenes (the number of the Gospels multiplied by itself), the story of man's Fall down through Cain's murder of Abel is told on the left door, reading from top to bottom, and that of man's Redemption through Christ is narrated, reading upward, on the right, a sort of *Paradise Lost* and *Paradise Regained*. Each of the eight scenes on either door is so matched with its counterpart on the other that they complement each other precisely. For instance, in the third pair from the top, the *Temptation of Adam and Eve* (man falls through eating the forbidden fruit of the Tree of the Knowledge of Good and Evil) is opposite the *Crucifixion* (man is redeemed through Christ's sacrifice on the Tree of the Cross). There is little indication of ground, and broad areas of background appear between the figures, so that each scene conveys a strong impression of enveloping space.

The individual narratives are intensely and spontaneously dramatic, and most of them give every sign of having been inspired by a direct reading of the text rather than drawn from iconographic tradition. The fourth scene from the top of the left door, *Adam and Eve Reproached by the Lord* (fig. 514), could hardly be more effective in its staging. An angry God (note that the triune God appears, as often in Creation scenes, in the form of Christ, with a cruciform halo) in a gesture of anger and dismay expostulates with the cowering Adam and Eve, who hide their nakedness with fig leaves. Adam blames Eve, Eve points to the serpent—a dragonlike creature, which in turn snarls back at her. The freely arranged little figures, with their heads almost in the round, contrast strongly with the ornamentalized vegetation, including the fateful tree. Below the scene is a Latin inscription in inlaid silver, added shortly after Bernward's death, which translates: "In the year of Our Lord 1015 Bernward the bishop of blessed memory cast these doors."

514. *Adam and Eve Reproached by the Lord* (detail of the doors of the Cathedral of Hildesheim). Bronze, 23 × 43"

515. Column of Bishop Bernward. Early 11th century. Bronze, height c. 12'. Cathedral of Hildesheim

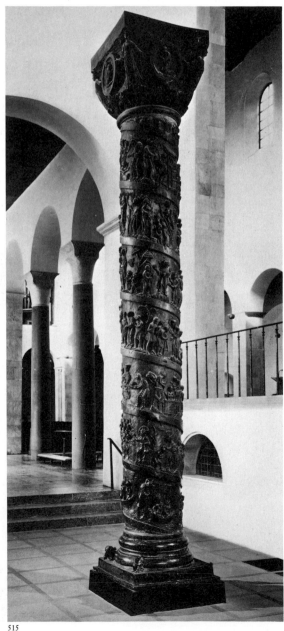

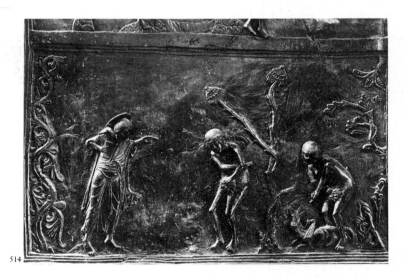

514

A less influential but equally original creation of Bernward's workshop is a bronze column, more than twelve feet in height, which he also gave to Saint Michael's (fig. 515). The crucifix it originally supported is now lost, and the present capital is a nineteenth-century reconstruction. The column itself, obviously derived from the imperial columns of Rome and Constantinople, shows the triumphant deeds of no earthly emperor but of the King of Kings—Christ's earthly ministry in twenty-four scenes, beginning at the bottom with the Baptism in the River Jordan and ending

515

with the Entry into Jerusalem. Like each door, the hollow column was cast in one piece, a remarkable technical achievement. The scenes are more densely spaced than on the doors, but quite as dramatic, and may have been the work of the same team of sculptors. The column gains considerable architectural strength from the broad spiral bands that separate the levels.

An unexpectedly powerful example of the new Ottonian art of monumental sculpture is the lifesize wooden *Crucifix* (fig. 516), given to the Cathedral of Cologne by Archbishop Gero between 969 and 976. This is the oldest surviving large-scale crucifix. The Ottonian sculptor, doubtless under ecclesiastical direction, has represented a type not yet seen in the West and apparently adopted from Byzantine art—where, in fact, Christ was never depicted with such intense emotion or such emphasis on physical torment. Instead of the *Christus triumphans* of the *Lindau Gospels* (see fig. 507), the *Christus patiens* (Suffering Christ) is shown, and the viewer is spared little. The eyes are closed, the face is tense with pain, the body hangs from the crossbar, and the lines of tension in arms and legs are strongly indicated; the belly is swollen as if with gas. Christ's hair seems to writhe upon his shoulders. This kind of expressiveness, which achieves its end even by showing the most repulsive physical conditions, is char-

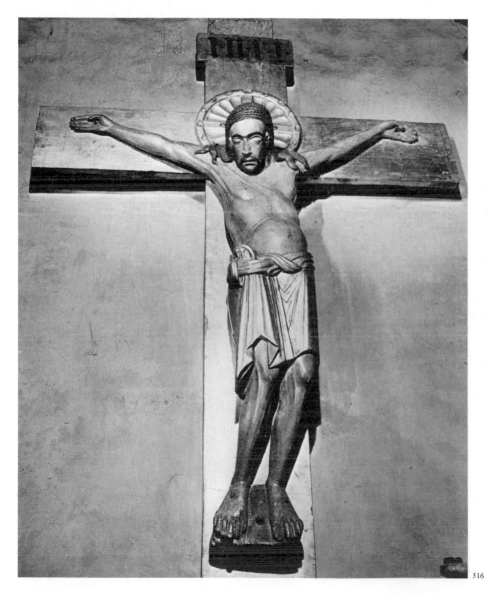

516. Crucifix of Archbishop Gero. c. 969–76. Wood, height 74". Cathedral of Cologne, Germany

acteristic of German art throughout its long history, and reappears again and again at different moments.

A small ivory plaque representing *Doubting Thomas*, made about the year 1000 (fig. 517), raises Ottonian expressionism to the level of spiritual exaltation. The artist has made the relief look higher than it is through the illusion of a niche that encloses and compresses the two figures. In the spandrels appear Christ's words to Thomas, "Reach hither thy finger. . . ." in Latin (John 20:27). Christ lifts his right arm, draws aside his mantle, and bends his head with a look of deep compassion, while Thomas inserts his finger into the wound. Every line of Christ's body and drapery is receptive, and every line of Thomas' pose and garments ascends; Thomas' head is turned backward so that we can see his expression. Master and disciple are bound together in a mystic union of faith and love, in which even the ascending shapes of the framing acanthus leaves seem to share.

PAINTING As so often in the fragmented history of painting from antiquity through the early Middle Ages, we are left with nothing but tantalizing descriptions of the cycles of wall paintings that once brightened the interiors of Ottonian churches. Only in the Church of Saint George on the island of Reichenau in Lake Constance is a fairly complete cycle preserved, and that, like the fragmentary frescoes that survive else-

517

517. *Doubting Thomas.* c. 1000. Ivory plaque, 9½ × 4″. Staatliche Museen, Berlin

518. *Otto Imperator Augustus*, detached page from an unknown illuminated manuscript. c. 985. Musée Condé, Chantilly, France

518

where, is too badly faded for reproduction here. Again we must turn to manuscripts to assuage our loss, and again the consolation is great. The expressive and visionary qualities so evident in Ottonian architecture and sculpture are concentrated in Ottonian manuscripts.

Emperor Otto. In a detached leaf from an unknown volume, we behold a youthful crowned emperor (fig. 518), labeled *Otto Imperator Augustus*, probably Otto II, majestically enthroned under a baldachin. He holds his staff of office with his right hand and his golden orb of power in his left, while crowned women representing subject countries, optimistically entitled *Germania*, *Francia*, *Italia*, and *Alamannia* since he ruled only Germany, present him their orbs as well. In the awesome detachment of Ottonian art, naturalism of expression is unaccompanied by concern with real space. Any attempt to deduce the spatial relationships of the columns upholding the baldachin will leave the observer in a quandary. In order not to cut up the noble Latin inscription, the artist represented only three columns; the throne levitates partly within and partly forward of the front columns, being even higher than their bases. But these unreal spatial relationships are part of the magic of Ottonian manuscripts, and if anything enhance their expressive and spiritual depth. Contours are smooth and unbroken, colors richly and subtly contrasted, surfaces strongly modeled, but the Helleno-Roman careful observation of light has now turned into a conventional pattern of strokes of graduated value.

Lectionary of Henry II. The half-real, half-unreal Ottonian style is very grand when turned to narrative purposes, as in the *Annunciation to the*

519. *Annunciation to the Shepherds*, illumination from the *Gospel Lectionary of Henry II*. Reichenau (Lake Constance), c. 1002–24. Bayerische Staatsbibliothek, Munich

Shepherds (fig. 519) from a Gospel lectionary (the Gospel texts arranged in the order in which they are read at Mass) given to the Cathedral of Bamberg by Henry II (reigned 1002–24). The background, partly gold and partly blue, is abstract. On a mountain formed of conventionalized rocks stands a colossal angel, his mantle floating against the gold, ready to announce to the awestruck shepherds the "good tidings of great joy." Yet all seem more overcome with the mystery of the message than by its gladness. The last traces of illusionism have given way to strongly ornamental and unbroken contours; only a few parallel stripes remain to suggest the origin of such strokes in reflections of light.

Bamberg Commentary. The highest attainment of Ottonian art is the series of visions from both Old and New Testaments, represented with an explosive power never seen before in figurative art. As if pervaded by something of the ornamental splendor that had flowered in Hiberno-Saxon art, these illuminations yet overflow with the expressiveness of Ottonian religiosity. The *Vision of Isaiah* (fig. 520), from a commentary illuminated in the late tenth or early eleventh century, should be contemplated along with the text it illustrates, Isa. 6:1–4:

> 1 . . . I saw also the Lord sitting upon a throne, high and lifted up, and his train filled the temple.
> 2 Above it stood the seraphims; each one had six wings; with twain he covered his face, and with twain he covered his feet and with twain he did fly.
> 3 And one cried unto another, and said, Holy, holy, holy, is the Lord of hosts: the whole earth is full of his glory.
> 4 And the posts of the door moved at the voice of him that cried, and the house was filled with smoke.

The Ottonian artist was less literal and more imaginative than the masters who illustrated the *Utrecht Psalter* (see fig. 505). He has shown the beardless Lord sitting upon and within a fantastic shape composed of an overlapping golden disk and a golden mandorla, both with rainbow borders, with his arms outstretched and eyes gazing forward as if he were in a trance. Nine threefold tongues of gold flame spurt from the mandorla. The smoke, which the text tells us filled the house, is shown as concentric bursts of blue and violet with white edges, like the petals of a gigantic flower. In reciprocal and often double curves, the six-winged seraphim float about his throne, making wonderful patterns of feathers. Below the throne is an altar from which, as related in verses 6 and 7, an angel takes with tongs the live coal he will place upon Isaiah's tongue. And yet with the same surprising disregard for the theme of the principal illustration we found in the *Book of Kells* (see fig. 496), two unconcerned rabbits in the lower corners gnaw on pieces of fruit. Perhaps a contrast between their blind greed and the beauty of revelation was intended.

Two of the most sumptuous manuscripts remaining from the Ottonian era were ordered by abbesses, who in both Carolingian and Ottonian society were often personages of considerable economic and political influence. In illustrations in both works a special attempt was made to dramatize pictorially the relation of the abbess and her community of nuns to the means of salvation. The two manuscripts, both Gospel books, also reveal strikingly different aspects of Ottonian style.

Hitda Codex. Not dated, but probably executed shortly after the year 1000, the *Hitda Codex* was ordered by Hitda, Abbess of Meschede, near

520. *Vision of Isaiah*, illumination from a Commentary. Late 10th or early 11th century. Staatsbibliothek, Bamberg, Germany

521. *Abbess Hitda Presenting Her Book to Saint Walburga*, illumination from the *Hitda Codex*. Germany, Cologne, 1st quarter of 11th century. Hessische Landes- und Hochschul-Bibliothek, Darmstadt, Germany

Cologne in the Rhineland, in northwest Germany, and is considered the masterpiece of the Cologne school of illumination, characterized by a remarkably free and sketchy use of the brush. Among the many brilliant and often intensely expressive illustrations, the most interesting for us is the page which shows the donor herself, labeled *Hitda Abbatissa*, under a symbolic arch above which rises a jumble of monastic buildings—walls, clerestories, gabled roofs, and towers. With an expression of great fervor, the abbess presents the gold-covered book to Saint Walburga, female patron of the abbey (fig. 521). The soft, pictorial touch and the understanding of the play of light have been connected with the influence of the Macedonian renaissance.

Uta Codex. Illuminated for the Abbess Uta of Niedermünster, near Regensburg on the Danube in south-central Germany, between 1002 and 1025, the *Uta Codex* shows in the density and mathematical complexity of its design the intellectuality of the extraordinary city of Regensburg, known for its philosophical and theological interest. Regensburg was especially devoted to the cult of Saint Denis, whose relics were believed to be enshrined there and who was identified with the mysterious Early Christian philosopher known today as Dionysius the Pseudo-Areopagite (who will reappear in Chapter Six). Saint Erhard, bishop of Regensburg

522. *Saint Erhard Celebrating Mass*, illumination from the *Uta Codex*. Regensburg, Germany, 1002–25. Bayerische Staatsbibliothek, Munich

about 700, whose relics were venerated at Niedermünster, is shown celebrating Mass (fig. 522) under a ciborium—usually a domical structure supported by four colonnettes—which generally covered altars in both East and West in the early Middle Ages. This time, however, there are distinct references to the Old Testament. It has been shown that the ciborium is constructed according to a linkage principle as directed for the Tabernacle in Exodus 36:18 and that the saint's vestments, while conforming in general to those still required for the celebrant at High Mass, contain elements drawn directly from those of the Hebrew High Priest. He stands with hands extended in orant posture, a deacon on the right as assistant and on the left an altar, of a movable type (*altare semifixum*), on which can be seen among other objects the missal, the chalice for the wine, and the paten, or plate for the Eucharist.

Above the ciborium the Lamb of God holds an open book, before the Latin inscription "The Spouse of Virgins," obviously meaning the nuns. In the upper right corner of the frame sits Uta herself, labeled "Lady Abbess"; at upper left "Piety," hands crossed on breast; at lower right "Rigor of Discipline," a woman pointing to her closed lips; at lower left "Temperament of Discretion," a woman teaching two children. Below the altar rise the domes, towers, and battlemented walls of the abbey. Clearly the illustration is an allegory, demonstrating in visual terms the

possiblity of bringing Christ in the Mass, by means of portable altar and ciborium, into the lives of the community of women at any proper point in the monastery. The whole is converted into a design of brilliant complexity and geometrical rigor.

The least that can be said of these two powerful abbesses (among their many women contemporaries in similar positions of monastic leadership all over Christendom) is that they stood at the apex of the intellectual, spiritual, and artistic life of their times. Were the scribes and painters of these two magnificent works, whose illustrations correspond so closely to the ideas of Hitda and Uta, actually nuns in the convents of Meschede and Niedermünster? That the question seems never to have been raised is surprising in view of the host of texts recording the training, the achievements, and even the names of many women scribes and illuminators, beginning as early as the sixth century. The biographer of the two eighth-century women painters Harlinde and Relinde expressed wonder that they excelled in "writing and painting, a task laborious even for men." The burden of proof really rests on those who would maintain that Hitda and Uta had to turn to male scriptoria for their manuscripts.

The Classical and Byzantine heritage of Carolingian manuscript painting and ivory sculpture was formalized in the brief Ottonian period and replaced the last remnants of Classical illusionism with a grandly conceived art dominated by linear contours and patterned compositional structure. The innovations of Carolingian architecture were adopted and expanded. Except for Bishop Bernward's brilliant bronze sculpture, which had no immediate followers, Ottonian art formed a bridge to the Romanesque. Its greatest achievements are majestic in form and color, witnesses of an artistic creativity and a profound spirituality unmatched in the rest of Europe.

CHAPTER

ROMANESQUE ART

FIVE

The name *Romanesque* was a catchall term coined in the nineteenth century to designate a style that was no longer Roman but not yet Gothic. But *Gothic* itself, as we shall see in Chapter Six, was a misnomer from the start. The word *Romanesque* has other shortcomings as well: originally, it had to cover both Carolingian and Ottonian art, which have assumed distinct identities only in the last hundred years or so; some scholars still so use it. Even worse, it is a term implying transition, inappropriate for a period that has strong positive qualities of its own. Today, the name is so deeply rooted in common usage that it cannot be eradicated. For want of a better term, then, *Romanesque* is now applied to the art of the eleventh and twelfth centuries in western Europe (in France, for special reasons, it is used for the arts only up to the middle of the twelfth century).

For a rarity in this book since the chapter dealing with the Roman Republic, neither headings nor subheadings in the discussion of Romanesque art will contain the name of a single monarch or dynasty. After the year 1000, there were many competing monarchies, and the very institution of kingship had acquired a powerful competitor—a rising commercial and industrial class. No monarchy could any longer enforce claims to universal rule. In the eleventh and twelfth centuries the emperors were, in effect, kings of Germany only. The kings of France ruled as feudal lords a region in north-central France centering on Paris and had next to no control over the rest of the area that makes up modern France, which was governed by several dukes and counts, and even by another king. Norman barons wrested Sicily from the Arabs in 1105 and set themselves up as kings, controlling most of formerly Byzantine southern Italy as well. In addition to the Muslims in the south, at least four Christian kingdoms divided Spain. Under the kings and dukes were feudal lords, ruling from their castles and acknowledging often conflicting feudal allegiances. The system was chaotic in the extreme and constantly shifting; the general disorder often involved the papacy, which found itself at times the football of rival monarchs.

But the towns were growing at a pace that exceeded even that of the monarchies. Cities were still small—medieval Rome and Renaissance Rome, for example, each occupied only a fraction of the center of the ancient city. Yet in France, England, Germany, and the Low Countries, cities devoted to manufacture, trade, and banking demanded and received clear-cut legal rights and charters as corporate persons equal to the feudal lords and sheltered by dukes and kings who depended on them in many respects. In Italy, with the collapse of the remnants of Lombard power in the eighth century and the infrequent visitations of emperors, northern cities became independent communes. At first they were ruled by their bishops, but soon developed republican forms of government with administrations, often chosen by lot among the leading commercial families, succeeding each other for very brief terms. Venice (long a republic), Genoa, Naples, and Amalfi built merchant marines for trade throughout the Mediterranean and navies to protect their commerce from Arab pirates. Venice, in fact, established a commercial empire, with bases in islands and seaports throughout the eastern Mediterranean and a fixed extraterritorial seat

in Constantinople, the capital of the Byzantine Empire. The capture of Sicily and the mass movements of the first three Crusades, the latter culminating in the institution of a Western kingdom of Jerusalem (1099–1187), also assisted in opening Western eyes to the worlds of Byzantine and Islamic cultures.

It is hard to find enough surviving Carolingian and Ottonian churches to illustrate the architectural styles of those periods; in contrast, so many hundreds of Romanesque churches, large and small, most in excellent condition, still stand in Europe, that even a general treatment of Romanesque architecture would require a book as thick as this one. Even more would have been preserved if in the Gothic period many had not been replaced by more sumptuous edifices. An oft-quoted and invariably misinterpreted passage, written in 1003 by the French monk Raoul Glaber, tells us about the new wave of church construction after the year 1000:

> Therefore, after the above-mentioned year of the millennium, which is now about three years past, there occurred, throughout the world, especially in Italy and Gaul, a rebuilding of church basilicas. Notwithstanding the greater number were already well established and not in the least in need, nevertheless each Christian people strove against the others to erect nobler ones. It was as if the whole earth, having cast off the old by shaking itself, were clothing itself everywhere in the white mantle of churches. Then, at last, all the faithful altered completely most of the episcopal seats for the better, and likewise the monasteries of the various saints as well as the lesser places of prayer in the towns. . . .

Considering how many years it took to build a Romanesque church, Raoul Glaber's account should be read as a prophecy of what was soon to come about.

But the passing of the millennium and the new growth of cities were not the only factors that spurred the building of churches; the requirements of pilgrimages also had to be considered. Populations in the Middle Ages were surprisingly mobile. Pilgrimages, a feature of many religions, were ostensibly undertaken for religious reasons, but in the fourteenth century the wise Geoffrey Chaucer hinted at other motives as well, once April stirs the blood:

> *Than longen folk to goon on pilgrimages*
> *(And palmers for to seken straunge strondes)*
> *To ferne halwes, couthe in sondry londes;. . .*

Palmers, of course, were those who had been to the Holy Land and were entitled to wear palms (the travel stickers of the Middle Ages) on their garments. Among the *ferne halwes* (distant saints) was James, whose shrine at Santiago de Compostela in the far northwestern corner of Spain attracted pilgrims by the thousands, who had to be cared for along the way, thus encouraging the development of churches along the main routes. (The pilgrimages, of course, could account only for the great *size* of the new churches, far larger than necessary for their monastic or urban communities, but not for their *style*. Some scholars have doubted whether the pilgrimages really were an important factor in Romanesque art.)

Just as dramatic as the great new wave of church building in the Romanesque period was the revival of architectural sculpture. Save for a few scattered examples, monumental sculpture in stone very nearly died out in Europe after the collapse of the Roman Empire. Contemporary accounts relate that some Carolingian and Ottonian church façades were ornamented with sculptures, but no examples have survived; as far as we now know, sculpture connected with church buildings was mostly limited to doors, pulpits, baptismal fonts, and other interior features. But the new Romanesque churches demanded architectural sculpture just as the Greek temples had—not as additions to fill predetermined spaces, however, but as integral parts of the architecture. Romanesque church portals, especially, were enlivened with sculptures so as to present in vivid form essential elements of Christian doctrine in order to excite not

only the piety but also the imagination of the worshiper at the moment of entry into the church. The typical Romanesque portal, which often included a number of reliefs and statues attached to supporting elements, was centered on a large-scale composition that filled the tympanum (the semicircular space bounded by the arch and the lintel). A Romanesque tympanum was not made up of separate statues or groups, as in Greek temple pediments, but was drawn on the surface of the component slabs, then cut deeply to form a kind of relief, and finally painted in brilliant colors. An unexpected field for sculpture was a new type of capital, which appeared at the end of the eleventh century, showing human figures and sometimes narrative scenes. Figured capitals were relatively rare in Roman art and were seldom used before the third century; Romanesque artists, however, produced them in enormous numbers before the taste for them died out in the Gothic period.

As in the Ottonian period, churches were often richly decorated with mural paintings of great size and splendor. We have no records of any women architects, sculptors, or mural painters during the Romanesque period any more than in earlier times, but as in Ottonian days, magnificent manuscripts were written and illustrated by women, whose special contribution seems to have been an unusual and very exciting freedom of imagination.

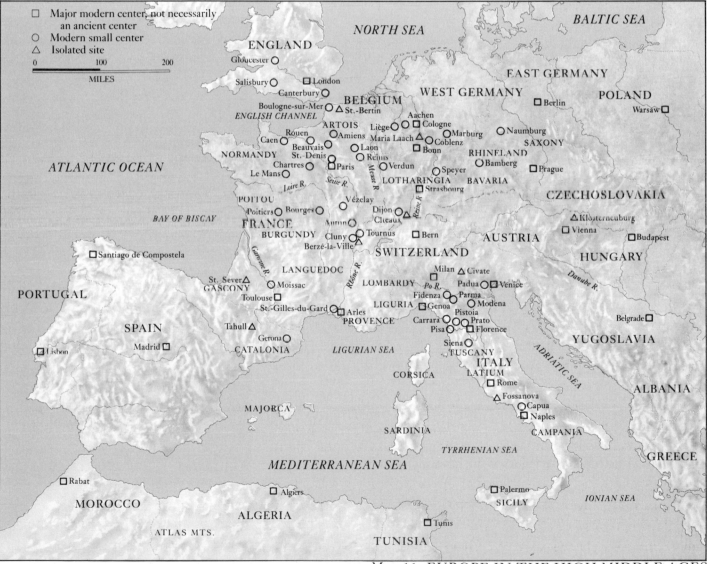

MAP 11. EUROPE IN THE HIGH MIDDLE AGES

Throughout the old Roman cities of northern Europe and of central and northern Italy (with the exception of Rome, whose basilicas were pilgrimage goals in themselves), many Early Christian, Carolingian, and Ottonian churches gave way to larger Romanesque ones. A prime requirement, based on bitter and oft-repeated experience, especially in France where cathedrals were in urban centers constantly subject to conflagrations, was that the new structures be fire-resistant, therefore vaulted in masonry. For some as yet unknown reasons, the Roman technique of vaulting with concrete seems never to have been considered by Romanesque builders, although a manuscript of Vitruvius, in which he explained the technique, was in the monastic library at Cluny. The new vaults of brick or stone masonry required massive systems of support. As long as the static problems were imperfectly understood—medieval engineering was unequal to the task of calculating stress scientifically—the massive supports for the vaulting could block out the light. A three-way balance among great church size, stable vaulting, and adequate illumination had somehow to be struck; the dramatic changes in the form and appearance of church buildings in the Romanesque and Gothic periods are bound up with many trial-and-error attempts to refine this balance.

TOURNUS But there was a fourth factor, seldom taken into consideration in modern studies of medieval architecture and yet doubtless the final determinant: the result had to be aesthetically satisfying. One striking instance should be considered, the Benedictine Abbey Church of Saint-Philibert at Tournus in central France. The church was rebuilt after a fire in the early eleventh century. In the course of the eleventh or in the early twelfth century (the date is still in question), the building was vaulted. The impressive interior (fig. 523) would seem to fulfill all practical requirements for a Romanesque church: it is capacious, stone vaulted, and well lighted due to an ingenious constructional system. The nave arcades are sustained by powerful cylindrical columns, without capitals. Engaged half columns are visible in the side aisles. The columns and the half columns provide excellent support for the groin vaults that cover the side aisles. In the nave above each column rises a shorter, engaged column, sustaining a massive arch that bridges the nave. These arches, in turn, support a series of small barrel vaults, which unexpectedly cross the nave at right angles. The weight of the transverse barrel vaults is adequately borne by the arches. But barrel vaults also thrust outward, and this thrust must be abutted. At Tournus this problem was settled by having the transverse vaults abut each other. The outer walls, relieved of all weight, were pierced by clerestory windows admitting ample light. Why, then, was this practical system never again adopted in any other church? The answer seems to be that the effect of the heavy arches, cutting up the ceiling into a succession of separately barrel-vaulted compartments, was unacceptable aesthetically; architects and patrons wanted a more unified look. It is also possible that such a ceiling had a bad acoustical effect, perhaps creating echoes that blurred the chanting of the services.

TOULOUSE The solution utilized on a grand scale for pilgrimage churches erected in the late eleventh and early twelfth centuries may be seen in the Church of Saint-Sernin at Toulouse (fig. 524), the capital of the southern French region of Languedoc. Built about 1080–1120, this structure repeats in many respects the plan and disposition of elements at

Architecture and Sculpture in France

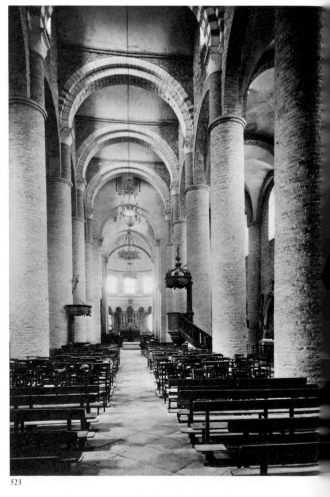

523

523. Interior, Abbey Church of St.-Philibert. 11th–early 12th century. Tournus, France

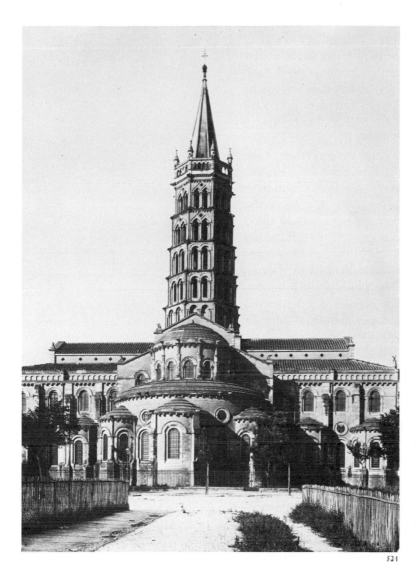

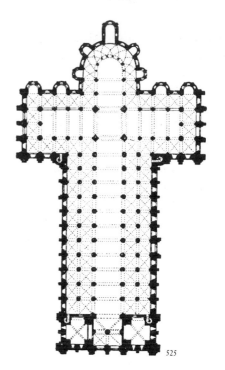

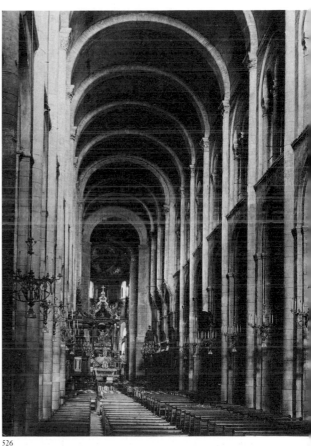

Santiago de Compostela, the goal of the pilgrimages, whose construction began in the 1070s. In contradistinction to Early Christian basilicas, the plan (fig. 525) is unmistakably a cross. The immense nave (eleven bays) is flanked by double side aisles. The inner aisle is continuous, stretching around both ends of the transept and the apse—like the ambulatory in a martyrium—so that crowds of pilgrims could move along constantly and easily. (Medieval sources tell us about the difficulty and danger of handling large crowds in the old basilicas.) Along their way the pilgrims could stop and pray at small chapels, each containing the relics of a saint. The cult of relics was intense in the Romanesque period, and the need for relics to venerate was often satisfied by worse than dubious means. Two chapels open off the east side aisle of each arm of the transept, and five more radiate outward from the ambulatory around the apse. Ambulatory and radiating chapels became an indispensable feature of pilgrimage churches, and were uniformly adopted for cathedral churches in the Gothic period, save only in England and Italy.

The nave, transept, and choir of Saint-Sernin are barrel vaulted (fig. 526); the triumphal arch has vanished, and the apse (now partly obscured by a much later altar) is a half dome at the same height as nave and choir. The downward pressure of this barrel vault, but not its outward thrust, could have been supported by the arches of the usual clerestory; without abutment, the vault would have collapsed. At Saint-Sernin a gallery (which doubtless also accommodated crowds of pilgrims) runs around the build-

524. St.-Sernin. c. 1080–1120. Toulouse, France

525. Plan of St.-Sernin, Toulouse (After Kenneth John Conant)

526. Nave and choir, St.-Sernin, Toulouse

ing above the side aisles, stopping only at the apse. This gallery is roofed by a half-barrel vault, which rests against the piers of the nave at the springing point of the nave vault and abuts the thrust, directing it back inside the piers to the ground. Unfortunately, the gallery windows light only the galleries; little light filters into the nave. Churches roofed by barrel vaults are inevitably dark. The Abbey Church at Cluny, as we shall see, was an exception.

The continuous barrel vault, however, does have a grand effect. Like a great tunnel, it draws attention rapidly down the nave toward the altar. The barrel vault is crossed at every bay by transverse arches, which have an aesthetic rather than a functional purpose; they *seem* to support the barrel vault, and may have helped in its construction, but it would stand quite well without them. The arches spring from capitals, which belong to slender colonnettes of entirely unclassical nature, although their capitals preserve Classical elements, looking like those in the Great Mosque of Ibn Tulun (see fig. 470). These colonnettes run two stories in height, from floor level, where they are engaged to the piers that support the nave arcades, up to the transverse arches and down the other side. At Saint-Sernin, therefore, we encounter a basic feature of Romanesque architecture, the compound pier, which replaces the Early Christian column (see fig. 403) and the square pier of Ottonian buildings. As in the Great Mosque of Ibn Tulun, which to be sure utilizes compound piers for a very different purpose and effect, each pier is made up of several elements, each with its own function in the general scheme.

The plan shows that the side aisles, which are relatively low, are groin vaulted (see fig. 525; a groin vault is indicated on a plan by a dotted X). The outward thrust of the groin vaults was met by external buttresses. Each bay of the side aisles is square; the width of the nave corresponds to the width of two of the side-aisle bays, so that each nave bay is an oblong of one to two. This proportion between nave and side-aisle bays was generally maintained in later churches.

From the east end the exterior (the west façade was never completed) shows a superb massing of clearly distinct elements, resembling that we saw in Ottonian churches but far richer and more complex. The transept chapels, radiating chapels, ambulatory roof, semidome over the apse, gallery windows in the transept, gallery roof, transept roof—all culminate in a grand octagonal crossing tower. This tower is Romanesque only in its first three stories; the last two were added in the Gothic period. The clear, rational articulation of the building is carried into smaller elements as well: each bay of the transept is demarcated by a buttress countering the thrust of the vaults within; below each roof runs a sculptured corbel table; each arched window is framed by a larger blind arch, supported in the gallery windows by engaged colonnettes.

CLUNY The grandest of all Romanesque buildings was the third Abbey Church of Saint-Pierre at Cluny in Burgundy, in eastern France; it was the mother church of the Cluniac Order, which, in the eleventh and twelfth centuries, comprised hundreds of monasteries scattered throughout western Europe. Its greatest abbot, Saint Hugh, entrusted the building to an ecclesiastical architect, a retired abbot named Gunzo, known also as a musician. Until the rebuilding of Saint Peter's in Rome in the sixteenth and seventeenth centuries, Cluny was the largest church in Christendom (fig. 527). Construction began in 1085 or 1086 and was virtually completed by 1130. Cluny's dimensions were staggering; the total

527. Plan of the third Abbey Church of St.-Pierre, Cluny, France. c. 1085–1130 (After Kenneth John Conant)

528. Interior, third Abbey Church of St.-Pierre, Cluny (Reconstruction drawing by Kenneth John Conant and Turpin Chambers Bannister)

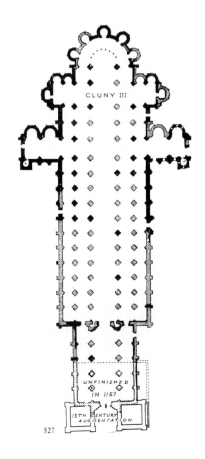

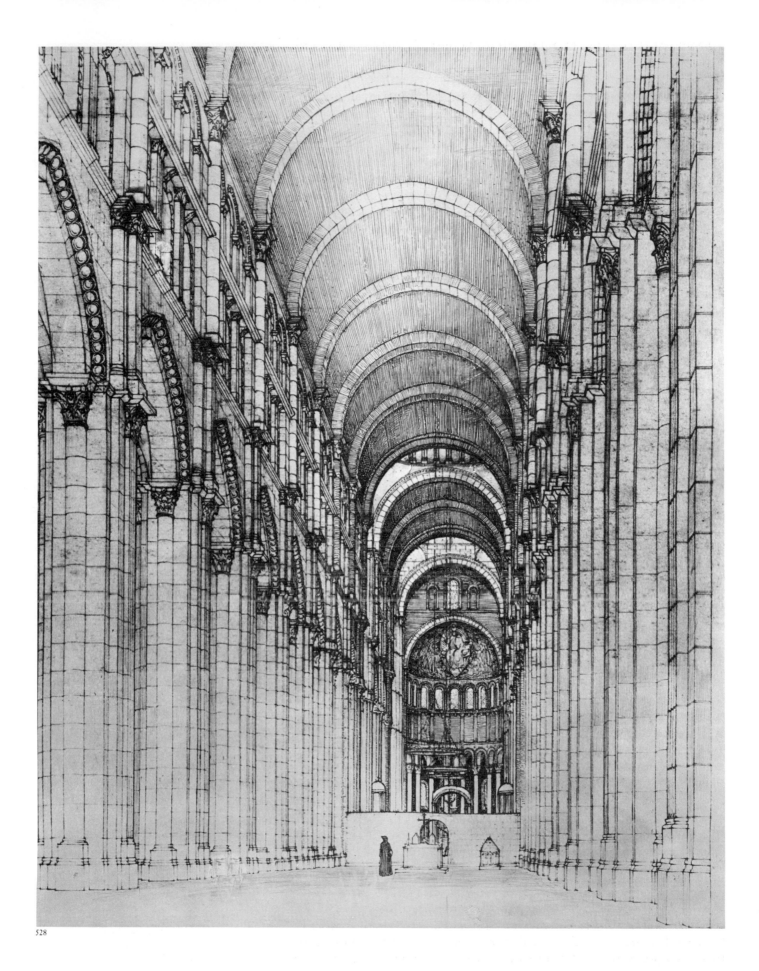

528

length was 531 feet, the height of the nave vaults above the floor more than 100 feet, and the richly sculptured central portal was 62 feet high. The nave of eleven bays was preceded by a five-bay narthex; there were four side aisles, double transepts, and five large and two small towers. Only portions of one transept remain. The rest of the vast fabric was demolished by a group of real-estate speculators in the years following the French Revolution, and the stone and other materials sold for profit; it took twenty-five years to blow the church up, section by section.

From the remaining fragment it is possible to gain a clear idea of what the church was once like (fig. 528). The barrel vault was slightly pointed to reduce the outward thrust so that the supporting gallery could be eliminated. Unfortunately, this device proved insufficient, and external supports (flying buttresses, which will be discussed in Chapter Six) had to be added later, although no one knows exactly when. Unexpectedly, the church's architectural details were derived partly from Roman, partly from Islamic sources. The compound piers were cruciform in plan. Engaged colonnettes supported the nave arcade and the transverse arches of the double side aisles, which were groin vaulted, but fluted pilasters were attached to the inner faces of the piers, their long, parallel lines increasing the effect of height. All the capitals were imitated directly from Corinthian models. The arches, however, were strongly pointed, somewhat like those of the Great Mosque of Ibn Tulun (see figs. 469, 470).

Above the arcades, in a space measured by the height of the sloping side-aisle roof, was the triforium (so called because it generally has three openings in each bay). The triforium arches, barely visible in the reconstruction, were ornamented all round with little horseshoe-shaped lobes, patterned after Islamic examples. The arches were separated by fluted Corinthian pilasters. Above the triforium was the clerestory, with three windows to each bay, each window framed by a round arch connecting engaged columns. The apse was slightly lower than the three-bay section between the two transepts; its semidome was filled with a gigantic fresco of Christ enthroned in glory. Gunzo's colossal interior was proportioned throughout according to the intervals in medieval music, and contemporary accounts tell us that the barrel vaults carried the chanting beautifully throughout the entire length of the church.

The sculpture of Cluny was of the highest quality. The destroyed tympanum was the largest of all such Romanesque reliefs, about twenty feet in width. Although Kenneth John Conant, to whom we owe our knowledge of the abbey in every stage of its history, has identified and reassembled the fragments of the tympanum, so as to reconstruct its composition, even down to its original coloring, only a few small pieces have been exhibited. Luckily, the ten beautifully carved capitals of the tall, round columns that once stood in the apse are preserved. The Cluny capitals are in most architectural details quite correctly Corinthian. In one of them (fig. 529), against the acanthus leaves, as if suspended, is a beautifully shaped mandorla, hollowed out to contain a figure playing a lyre, the relief representing the Third Tone of Plainsong. The energetic pose recalls the tradition of Carolingian manuscripts, as does the floating cloak, but the sculpture already shows a complete mastery of high relief, being strongly undercut, in fact almost in the round. The drapery lines were treated like overlapping layers rather than folds of cloth and executed with crisp, clean curves.

VÉZELAY A highly original plan and vaulting solution is seen in another Burgundian church, Sainte-Madeleine at Vézelay, constructed be-

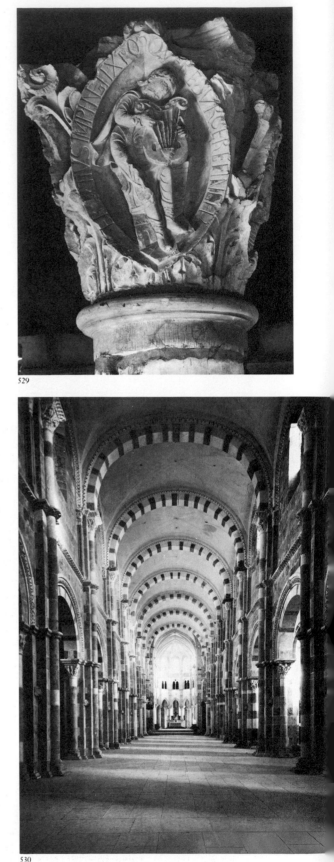

529

530

tween about 1104 and 1132 (fig. 530); this represents one of the earliest French attempts to roof an entire nave with groin vaults (the choir was rebuilt in the Gothic period). The church has the expected compound piers, almost all of which are enriched with figured capitals; the bays are separated by heavy transverse arches. The eye is immediately struck by a color contrast new to the North, and surely borrowed from such Islamic buildings as the Great Mosque at Córdoba (see fig. 472). The soft golden limestone of which most of the church is built alternates in the arches with blocks of pale pink granite, achieving a brilliant effect further enhanced by the white limestone used for the capitals. The unknown architect did not dare to carry his edifice to the height of Cluny, nor did he quite understand how to support his massive groin vaults. The illustration shows that they have pushed the walls slightly outward, and the vaults would have fallen if in the Gothic period the walls had not been strengthened by external flying buttresses.

The glory of Vézelay is its set of three sculptured portals, opening from the narthex into the nave and side aisles, carved between about 1120 and 1132; the sculpture of these portals is in such high relief that many of the figures are almost entirely in the round. The central portal represents the *Mission of the Apostles* (fig. 531). Romanesque artists reverted to the archaic system of scale, according to which the size of a figure indicates its importance. A gigantic Christ is enthroned in the center in a

529. Capital with relief representing the Third Tone of Plainsong, from the choir, Abbey Church of St.-Pierre, Cluny. Musée Lapidaire du Farinier, Cluny

530. Interior, Ste.-Madeleine, Vézelay, France. c. 1104–32

531. *Mission of the Apostles*, tympanum of the central portal of the narthex, Ste.-Madeleine, Vézelay. c. 1120–32

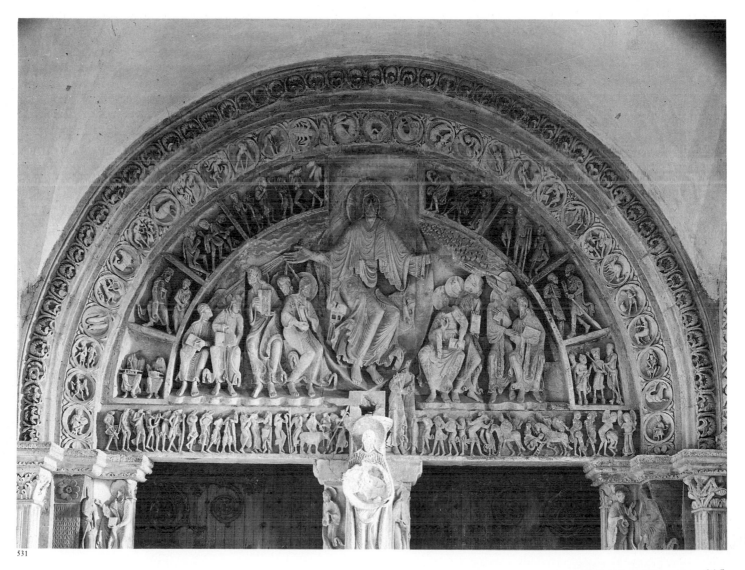

531

mandorla, his knees turned in a zigzag position, his arms outstretched. From his hands (the left one is missing) stream rays of light to the Apostles, who start from their seats to go forth and evangelize the world. On the archivolts, divided into separate compartments, and on the lintel are represented the peoples of many lands, as described in medieval travelers' tales. All of these people—some with heads of jackals, some with pig snouts, some covered with hair and shading themselves with enormous ears, some so small that one must mount a horse with a ladder—await Christian enlightenment. In spite of the heavy damage suffered by projecting portions, the entire scene radiates intense excitement. Partly this is due to the composition, in which each of the central figures breaks through into the area above it, partly to the use of wavy or swirling lines for the drapery, the clouds on either side of Christ, and the trembling floor below the Apostles' feet. The fantastic whorls of drapery on the right hip and knee of Christ take us back through Hiberno-Saxon manuscripts to La Tène (see fig. 487). When the original brilliant colors and gold were intact, the effect of the portal must have been electric. Scholars have shown that the meaning of this Vézelay portal was closely related to the Crusades, which were intended not only to redeem the holy places but also to carry the Gospel to the infidels, in effect a new Mission of the Apostles; the First Crusade was to have been preached from Vézelay in 1095, the Second actually was (by Saint Bernard) in 1146, and the Third Crusade started from Vézelay in 1190.

AUTUN An equally awesome, if somewhat less energetic, Burgundian tympanum is that of the Cathedral of Autun (fig. 532), probably dating from about 1130 and representing the *Last Judgment*. This work is an early example among the many representations of the Last Judgment

532. Gislebertus. *Last Judgment*, west tympanum, Cathedral of Autun, France. c. 1130

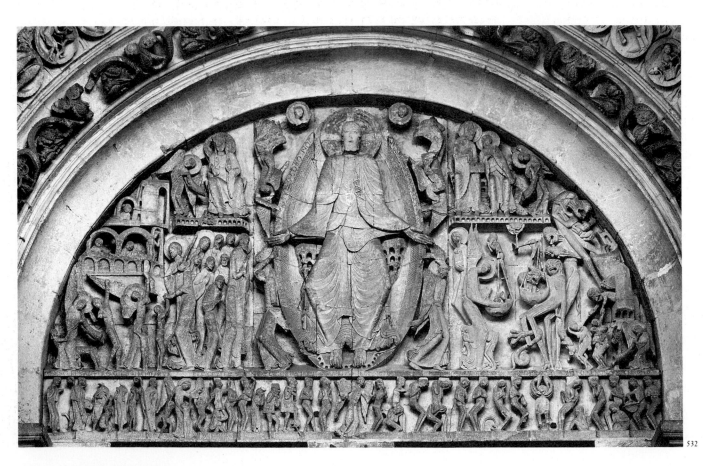

532

that later appeared in the portal sculptures of almost every Gothic cathedral. Their purpose was to remind Christians of their final destination before the throne of Christ. Again in a mandorla, the huge, impersonal figure of the Judge stares forward, his hands extended equally on either side. In the lintel the naked dead rise from their graves; on the left souls grasp the arms of a friendly angel; in the center the Archangel Michael, wielding a sword, sends the damned to their fate, and their little bodies quiver with terror. In the tympanum fantastically tall and slender Apostles, on Christ's right, superintend the process of salvation, and angels lift the blessed into Heaven, represented as a house with arched windows. On Christ's left a soul's sins are weighed against its virtues, as in the Egyptian *Book of the Dead* more than two thousand years earlier (see fig. 122). Monstrous demons grasp the damned and thrust them into the open mouth of Hell. The sculptor of this amazing work signed his name, Gislebertus; with Renier de Huy (see fig. 539), he is one of the first figurative artists of the Middle Ages whose name can be connected with a surviving work.

MOISSAC An extraordinary complex of Romanesque sculpture enriches the cloister and the portal of the Abbey Church of Saint-Pierre at Moissac in Languedoc, not far from Toulouse. The corner piers of the cloister were sculptured about 1100 with reliefs showing standing saints. In this relatively early phase of Romanesque sculptural style, the tradition of Byzantine, Carolingian, and Ottonian ivory carving is still evident. An arch supported by slender colonnettes frames a flattened niche, on whose sharply rising floor stands Peter, to whom the church is dedicated (fig. 533). Save only for the head, turned sharply to the right, the figure is frontal; under the garment the legs appear cylindrical, and although the drapery lines are raised in welts from the surface and given an ornamental linear coherence, they flow about the figure sufficiently to suggest its existence in depth. The figure generally appears stable enough, but the right hand is not; in fact, it is turned violently against the forearm and displays the Keys to Heaven, as though they were weightless, by merely touching them with thumb and forefinger. The columns of the cloister, alternately single and double, are crowned with capitals of a radically new design, which taper sharply toward a small band above the column; each is a unique and brilliant work, some ornamented but the majority carved with scenes from Scripture.

The sculptural activity of Moissac flowered between about 1120 and 1125 to produce another masterpiece of portal sculpture. A deep porch with a pointed barrel vault, whose supporting walls are enlivened by splendid high reliefs, leads to the pointed tympanum in which the Heavens open to reveal the Lord upon his throne—the *Vision of Saint John* (fig. 534), the same scene that had been represented in the mosaic, now lost, of the Palace Chapel at Aachen (see above, page 384; for another treatment of this scene, see fig. 564). A colossal crowned Christ is flanked by the symbols of the Evangelists, twisting and turning in complex poses, and by tall and slender angels waving scrolls. The rest of the tympanum is filled by the four-and-twenty elders in three registers, all of whom turn to gaze at the majestic vision. The relative stability of the cloister relief has now given way to an excitement as intense as that of the later central portal at Vézelay, although produced by subtler, linear means. Wavy lines representing clouds separate the registers; the border is formed by a Greek fret motive treated as if it were an infinitely folded ribbon. Three successive layers of rich foliate ornament of Classical derivation, separated by the slenderest of colonnettes and pointed arches, frame the portal; this is

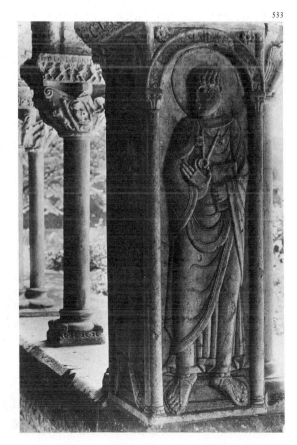

533. Corner pier with relief of Saint Peter, in the cloister, Abbey Church of St.-Pierre, Moissac, France. c. 1100

533

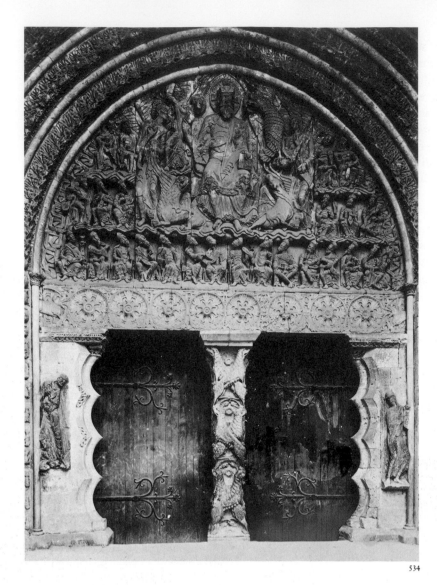

534

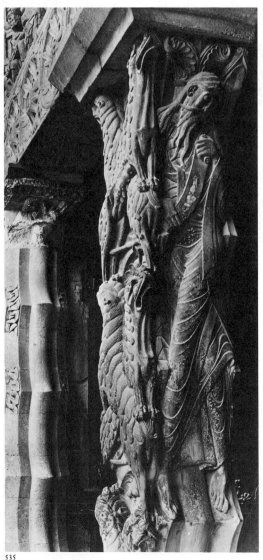

534. *Vision of Saint John*, tympanum of the south portal, Abbey Church of St.-Pierre, Moissac. c. 1120–25

535. *Prophet*, south portal, Abbey Church of St.-Pierre, Moissac

the first example we have seen of splayed enframement, which became a constant feature of church architecture in the Gothic period.

The lintel is ornamented with recessed rosettes, strangely enough cut at each end by the colonnettes as if disappearing behind them. To our surprise the jambs are scalloped (an Islamic element), and so, as a close look shows, are the colonnettes that border them, as if they were collapsing with the earthquake effect of the vision. The trumeau (central support) is even more startling; it consists of lions and lionesses crossed so that the forepaws of each rest on the haunches of the other—an obvious reminiscence of the old tradition of the animal interlace. On the right side of the trumeau (fig. 535), wedged in against the quivering colonnette and the inner scalloped shape, is one of the strangest figures in the whole of Western art, a prophet (possibly Jeremiah) whose painfully slender legs are crossed as if in a ritual dance, which lifts the folds of his tunic and his cloak in complex linear patterns. He clutches nervously at his scroll of prophecy; his head turns languidly as the long locks of his hair and beard stream over his chest and shoulders, and his long mustaches flow across his cheeks. For all the fervor of his inspiration, the unknown prophet (doubtless his scroll once bore a painted inscription that identified him) seems trapped in the mechanism of this fantastic portal, a situation that would be completely baffling to us if we did not recall its forebears in Hiberno-Saxon illuminations (see figs. 495, 496).

535

SILOS The mystical style of Languedoc was strongly related to an earlier northern Spanish work, probably dating from about 1085–1100, the cloister reliefs of the Monastery of Santo Domingo de Silos, near Burgos. Under the characteristic arch appears the *Descent from the Cross* (fig. 536), a subject that became popular during the Romanesque period on account of its direct appeal to the sympathies of the spectator. The expressions of the figures are quiet; the carrier of intense emotion is the line itself—the sad tilt of Christ's head, the stiff line of his right arm liberated from the Cross, the gentle line of Mary's head pressed to his right hand, the delicate lines of the drapery, and the looping folds of Christ's garments upheld by two angels. Three more angels emerge from swirling clouds to swing censers above the Cross.

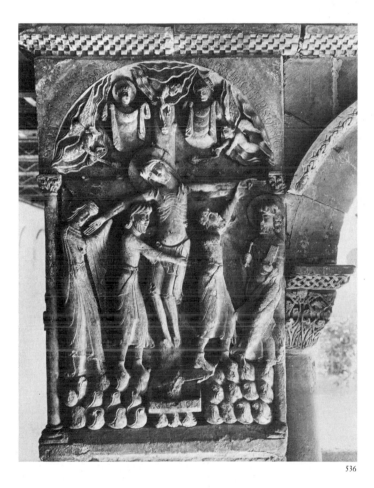

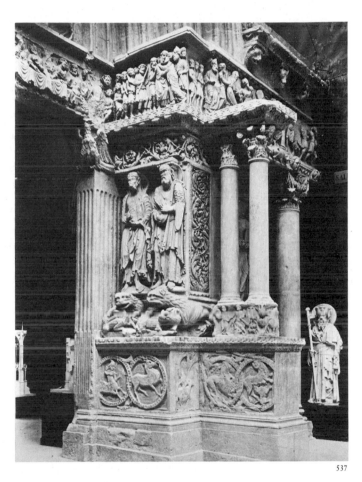

536

537

SAINT GILLES-DU-GARD A more Classical manner characterizes the sculpture of the region of Provence in southeastern France, rich in monuments of Roman architecture and sculpture. The triple portal of the Priory Church of Saint-Gilles-du-Gard (fig. 537), whose dating has varied enormously but should probably be set about 1130–40, has often been compared to the triumphal arches of the late Empire. The general arrangement, superficially at least, looks Roman, and the details of vine-scroll ornament, Corinthian capitals, fluted pilasters, and cascading drapery folds are often directly imitated from Roman originals. More important, when compared with the nervous undercutting of Burgundy and the linear style of Languedoc, the figures at Saint-Gilles do not look as if they had been first drawn on the surface and then cut in to a certain degree, but as if they had been fully three-dimensional in the artist's mind

536. *Descent from the Cross*, relief in the cloister, Monastery of S. Domingo de Silos, near Burgos, Spain. c. 1085–1100

537. Triple portal of the Priory Church (detail), St.-Gilles-du-Gard, France. c. 1130–40

from the start. They show the gravity, weight, and richness of form and surface and the constant play of light and dark that betoken either a continuing Classical tradition or an interest in Roman art, or perhaps both.

But the relationship between the various elements is unclassical in the extreme. Two small central columns shorter than those at the sides and jutting out from the jambs in tandem, eagles doing duty for capitals, fierce lions capturing men or sheep, figures moving freely around column bases—all these are unthinkable in a Roman monument. Characteristically Romanesque are the entwined circles on the high socles; these circles, with their enclosed animals, like the lintel rosettes at Moissac (see fig. 534), are not complete within their spaces. The frieze tells the story of the Passion of Christ (the incidents of the last week in his life, beginning with the Entry into Jerusalem) in great detail. Over the central lintel can be seen the richly draped table of the Last Supper, although the figures of the Apostles are badly damaged. Better preserved, in low relief to the right of the central lintel, is the Betrayal, the dramatic scene in which Judas indicates to the Roman soldiers the identity of Christ by an embrace.

POITIERS In western France the tide of sculpture and sculptural ornament broke loose about 1150 and inundated portals, apses, and entire façades, mingling with and almost submerging the architecture, as in the mid-twelfth-century façade of the Church of Notre-Dame-la-Grande at Poitiers (fig. 538). The clustered columns of the lower story of each corner turret appear to—but do not—carry the arcaded second story, whose paired columns, oddly enough, are arranged side by side on the left, tandem on the right. Even more irresponsible are the conical caps, cov-

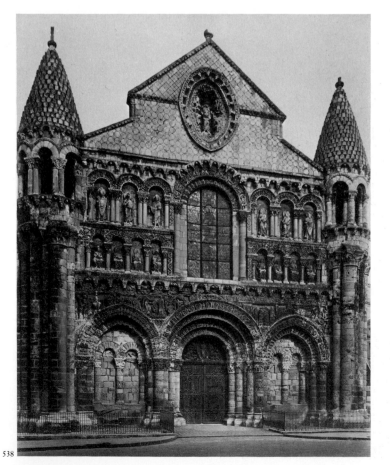

538

538. West façade, Notre-Dame-la-Grande, Poitiers, France. Middle 12th century

ered with scales imitating Roman tiles, which pointed downward to shed rainwater; these point up but are said to do the job just as well. In the central portion of the façade no register corresponds numerically to that below it, and the arch of the central window even moves upward into the irregularly shaped gable. Time has treated the porous stone unkindly, but the light-and-dark effect of the deeply cut ornament remains dazzling.

RENIER DE HUY We conclude this brief survey with the consideration of a work in a totally opposite style—one of the most classical works of sculpture made in Europe during the Romanesque period, the bronze baptismal font (fig. 539) now in the Church of Saint-Barthélémy at Liège in modern Belgium, done between 1107 and 1118 and attributed in a fifteenth-century document to the master Renier de Huy. The Meuse Valley, in which Liège is situated, was known in the Middle Ages as Lotharingia, after Lothair II, one of Charlemagne's grandsons, and was now under the rule of French-speaking monarchs, now of German. The entire region preserved from the Carolingian period a strong classical tradition derived from the Palace School and the Reims School, and Renier's font is probably the most strongly classical work of Romanesque sculpture made outside Italy. The idea for the font, which appears to be supported on twelve half-length bronze oxen in the round (only ten survive), was drawn from the Old Testament account of Solomon's bronze basin in the forecourt of the Temple. The Baptism of Christ takes place against an impenetrable cylinder of bronze, quite the reverse of the almost atmospheric backgrounds of Bernward's doors (see fig. 513). The figures are modeled nearly in the round, with no hint of the fantastic, visionary styles of Burgundy and Languedoc. The fullness and grace of the figures,

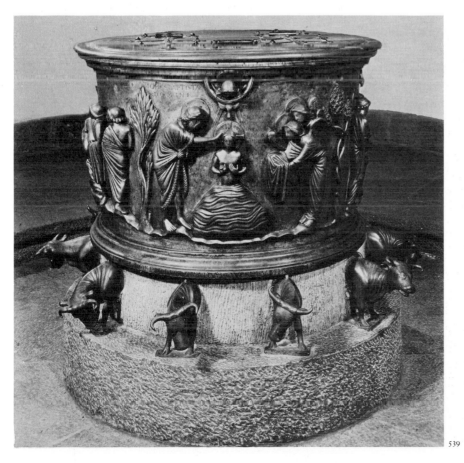

539

539. RENIER DE HUY. Baptismal font. 1107–18. Bronze, height 25″. St.-Barthélémy, Liège, Belgium

their harmonious balance and spacing, and the sculptor's sensitive understanding of the play of drapery over bodies and limbs are unequaled in any French stone sculpture of the time. The lovely classical figure seen from the back at the left may well have derived from an ancient model; one very like it appears in Ghiberti's famous Gates of Paradise of the Early Italian Renaissance. Renier's figures actually seem to move forward into our space; the head of God the Father (instead of the Hand of God we have seen up until now) leans downward from the arc of Heaven so strongly as to appear foreshortened from above.

Throughout the eleventh and twelfth centuries, the prosperous communes of central and northern Italy and the cities of the kingdom of Naples and Sicily built Romanesque churches on a grand scale. The tradition of basilican architecture had never quite died out in Italy. In addition to the persistence of classical tradition and the presence of many Roman monuments—far more than are standing today—central Italy possessed an unlimited source of beautiful white marble in the mountains of Carrara, to the north of Pisa, as well as green marble from quarries near Prato, just to the west of Florence. While the use and emulation of classical elements and classical details in the Romanesque architecture of Tuscany are so striking as to have caused art historians to speak of a Romanesque renaissance (like the Carolingian renaissance), these classical elements were generally played against an accompaniment of strongly unclassical Romanesque green-and-white marble paneling, in some cases very sprightly and witty in its combination of shapes and intervals.

BAPTISTERY OF FLORENCE The most remarkable Tuscan Romanesque building is certainly the octagonal Baptistery of San Giovanni in Florence (fig. 540). In many communes in central and northern Italy, all children born in the commune were baptized in a centrally located building, which was separate from the cathedral and took on considerable civic importance. The Florentine Baptistery was consecrated in 1059, but it is so classical, in so many ways, that the controversy over the original date of its construction has never been entirely settled. The Florentines of a later era believed that the building had once been a Roman temple dedicated to the god Mars; the foundations of the present edifice are certainly of Roman origin, but the weight of evidence indicates that the building itself dates from the eleventh century. The external decorative work on the Baptistery went on through the twelfth century, and the corners were not paneled in their zebra-striped marbles until after 1293. The interior is crowned by a pointed dome, masked on the outside by an octagonal pyramid of plain white marble.

The classical aspect of the exterior is limited to the blind arcades and pilasters, whose Corinthian capitals are carved with a precise understanding of Roman architectural detail. But nowhere in Roman architecture can one find anything like the vertically striped green-and-white engaged columns or the striped arches. The most vividly anticlassical feature is found in the second story, in the succession of tiny paneled arch shapes too small to connect with the pilaster strips that should support them. Such effects are in the tradition of irresponsible linear activity, which was strong in Romanesque ornament throughout Europe.

Architecture and Sculpture in Italy

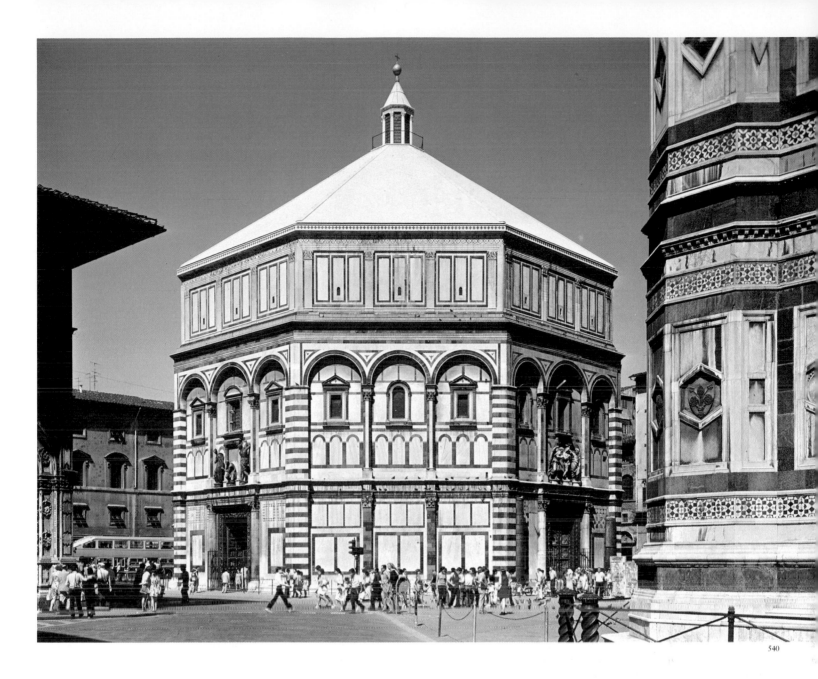

SAN MINIATO AL MONTE Somewhat more accurately classical at first sight is the twelfth-century façade of the Abbey Church of San Miniato al Monte (fig. 541). The church was built between 1018 and 1062 high on a hill and commands a superb view of Florence. This building represents a quite successful attempt to integrate the inconvenient shape of a Christian basilica, with high nave and low side aisles, into a harmonious architectural façade by the ingenious device of setting a pedimented, pilastered temple front on a graceful arcade of Corinthian columns. But the triangles formed by the low roofs of the side aisles are paneled in a diagonal crisscross that again recalls the tradition of the interlace. Both the Baptistery and San Miniato were influential in establishing the style of Early Renaissance architecture in Florence, particularly in the work of the great innovators, Brunelleschi and Alberti. But it is instructive to note how these masters always strove to regularize the capricious shapes of the Romanesque marble paneling they imitated.

540. Baptistery of S. Giovanni, Florence. 11th century

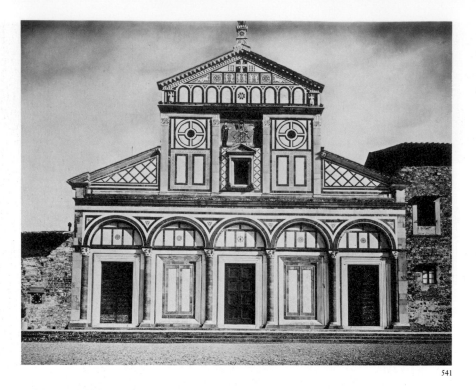

541

PISA The grandest of the Tuscan Romanesque architectural complexes is that at Pisa (fig. 542). The Cathedral (begun in 1063), the Baptistery (begun in 1153), whose upper stories and dome were completed in the Gothic period, the Campanile or bell tower (begun in 1174), and the Campo Santo or cemetery (dating from 1279–83) form a snowy marble group set apart from the buildings of the town on a broad green lawn. The Campanile—the famous Leaning Tower—started to lean before construction was far advanced; the builder's efforts to straighten the tower by loading the upper stories and bending its shaft resulted in a noticeable curve. The earth beneath has continued to settle, and all efforts to stop

541. West façade, Abbey Church of S. Miniato al Monte, Florence. 1018–62

542. Aerial view of the Baptistery (begun 1153), Cathedral (begun 1063), Campanile (begun 1174), and Campo Santo (1278–83), Pisa, Italy

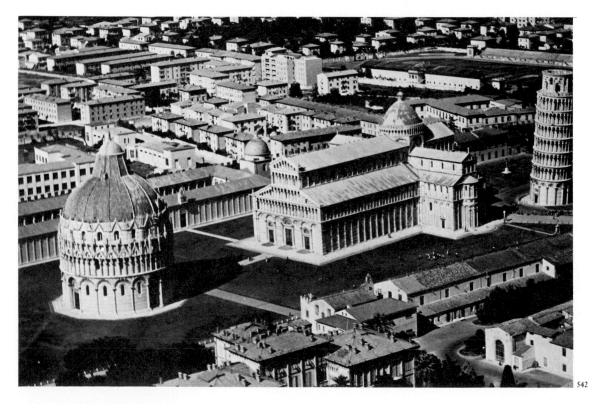

542

the tower's increasing tilt have proved futile. The Cathedral was designed by a Greek architect named Busketus on the plan of Hagios Demetrios at Salonika. As in all the Romanesque churches of Pisa and nearby Lucca, superimposed arcades divide the façade and are continued in blind arcades that run around the entire building. Each arm of the transept ends in a small apse, and a pointed dome crowns the crossing. The total effect is serene and harmonious; so indeed is the grand interior of the Cathedral (fig. 543). The pointed arch at the crossing is Gothic, and the timber roof was masked by a flat, coffered ceiling during the Renaissance, but the rest of the interior is original. The steady march of freestanding columns upholding an arcade is familiar from Early Christian basilicas, as is the use of Roman gray granite columns. It is often difficult to tell at first glance which of the capitals are Roman and which are Romanesque imitations. The widely separated, narrow strips of black marble on the exterior have become an insistent zebra striping in the triforium.

MONREALE The Pisan style strongly influenced church building in southern Italy, but Sicily in the eleventh and twelfth centuries was a special case. The local population was part Greek and part Muslim; the conquerors were French-speaking Normans. In this polyglot land, mixture resulted in unexpected architectural juxtapositions. One might have encountered in Palermo during this era Norman architects, sculptors from the Île-de-France (the territory ruled directly by the French kings), a bronze caster from Pisa and another from southern Italy, Muslim craftsmen, and Byzantine mosaicists directing artisans of all these races.

The Cathedral of Monreale, founded in 1174 by King William II of Sicily on a mountainous slope above Palermo (fig. 544), is a spacious, three-aisled basilica, whose Roman gray granite columns support pointed Islamic arches. The floors and lower wall surfaces are paneled in Byzantine style in white-and-gray marbles, every inch of the timber roof is brilliantly painted in Islamic designs, and all the rest of the interior, in-

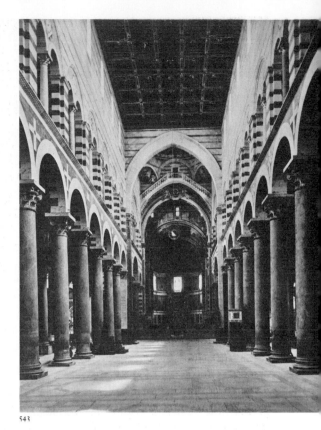
543

543. Interior, Cathedral of Pisa

544. Interior, Cathedral of Monreale, Sicily. Founded in 1174

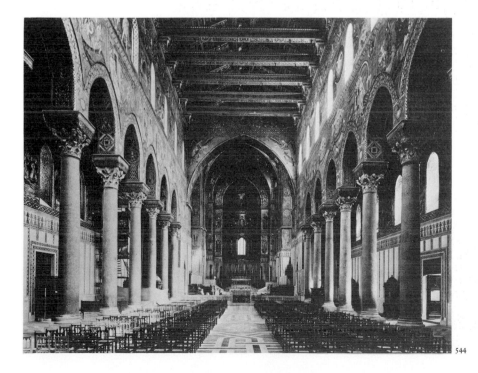
544

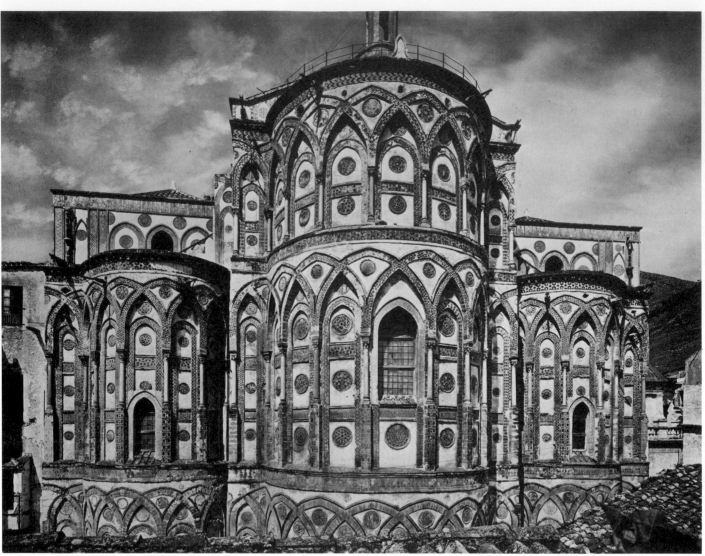

545

545. Cathedral of Monreale (view of the apses)

cluding the arches and the impost blocks above the Roman capitals, is covered with a continuous fabric of Byzantine mosaics—the most extensive still in existence. Despite misguided restorations, the total effect of the interior is overwhelming in its coloristic richness, in the completeness of its narrative sequences, and in the rhythmic movement of its elements, which reach a climax in the gigantic mosaic of the *Pantocrator* (Christ as the All-Ruler) that fills the pointed semidome of the apse (for earlier Pantocrators, see figs. 443, 445).

The exterior of the Cathedral is even more fantastic (fig. 545). Its three apses are clothed with blind arcades in the Pisan manner, but the imaginative Muslim craftsmen interlaced them (Norman architects had done this in England) as in the flying arches of the Great Mosque at Córdoba and enlivened both the arches and the intervening spaces with sparkling patterns in inlaid marbles that seem more appropriate to the decoration of a mihrab or a minbar.

WILIGELMO DA MODENA The most pronounced individual personalities among Italian Romanesque sculptors were two gifted masters both of whom we know by name. Both worked in a region of north-central Italy known today as Emilia-Romagna, at the southern edge of the Po Valley. The earlier of these was Wiligelmo da Modena, whose

principal work is a signed series of reliefs, executed about 1100–1110, on the façade of the Cathedral of Modena. In one relief strip (fig. 546), the Lord is first shown half length at the left in a mandorla upheld by two angels, then placing one hand on the head of the still-strengthless Adam to "make him a living soul," then creating Eve from the rib of the sleeping Adam; finally, at the right, Adam is shown eating the apple with one hand and keeping his fig leaf in place with the other while Eve places her left hand in the serpent's mouth. Wiligelmo treated the enframing architecture with complete irreverence. Rarely do the figures correspond to the corbeled arches above; more often they move in front of the corbels, and their feet overlap the edge of the groundline. At the extreme right a column has been transformed into the trunk of the Tree of Knowledge of Good and Evil, around which is wound the hissing serpent. These strange figures, with their heavy heads, hands, and feet, give the impression of clumsiness, but the block masses have great power, and the moments chosen for illustration bring out intense human feeling.

546. WILIGELMO DA MODENA. Scenes from the Old Testament, reliefs on the façade, Cathedral of Modena, Italy. c. 1100–10

547. BENEDETTO ANTELAMI. *Descent from the Cross*, relief, Cathedral of Parma, Italy. 1178

BENEDETTO ANTELAMI A more accomplished phase of northern Italian Romanesque style is seen in the work of Benedetto Antelami (c. 1150–c. 1230), an architect as well as a sculptor. His earliest known work is a *Descent from the Cross* (fig. 547) in the Cathedral of Parma and is

signed and dated 1178 in an inscription in the background; the artist's name appears above the left arm of the Cross. Perhaps under the influence of such Provençal sculpture as that at Saint-Gilles-du-Gard (see fig. 537), certainly through study of Roman reliefs, but above all through his native genius, Antelami composed a beautiful melodic flow from one figure to the next, so that the lifting of Christ's right hand from the Cross becomes an act of ritual grace accomplished with the aid of an angel. Accents of grief ebb and rise, suggesting and then avoiding symmetry; the solemn chord progression of the figures at the left, with their clustered drapery folds, is contrasted with the huddle of oblivious soldiers at the right around the flowing, seamless robe. The background is enriched with a delicate web of melodic lines in the vinescroll ornament and in the inscription, which forms an accompaniment to the foreground scene.

Probably during the following decade Antelami contributed some sculptures to the façade of the Cathedral of Fidenza; the town was then called Borgo San Donnino. His statues of *King David* (fig. 548) and *Ezekiel*, in which each Old Testament figure has been treated as if he were having a vision, appear in niches under scenes from the New Testament. The *Presentation of the Christ Child in the Temple* hovers over David's crowned head. He turns to look over his shoulder as if inspired, holding his long scroll of prophecy. The cadences of his flowing beard and of the folds of his garments are recognizable as permanent elements of Antelami's style. Although not entirely in the round, the figure—pedestal and all—seems to issue from its niche when compared with its direct ancestor, the low-relief *Saint Peter* at Moissac (see fig. 533). Antelami's *King David*, in turn, is a worthy precursor of such great niche statues of the Early Renaissance as those created by Donatello.

548

Many more solutions to the insistent problem that concerned twelfth-century builders—how to construct a lofty, safe, well-lighted, yet aesthetically unified interior—were advanced than can possibly be treated here. It is a significant fact that the regions that produced the most elaborate sculpture and richest decoration did not contribute much toward solving the vaulting problem. This solution was brought close to its final form in several widely scattered churches that are notable rather for their austerity—in fact, for their virtual elimination of sculptural enrichment.

SPEYER One of these churches is the immense Cathedral of Speyer, originally built in the early eleventh century as a timber-roofed basilica, in the Rhineland. Between 1082 and 1106 the interior was considerably remodeled in order to receive groin vaults, towering about 107 feet at the crown line, the highest of all Romanesque vaults (fig. 549).

A firm supporting structure was essential; to that end, every second pier of the nave arcade was reinforced by the addition of a massive colonnette sustaining a transverse arch. This is the earliest datable example of the alternating system of large and small piers, or piers and columns, which became a standard feature of vaulted churches by about the middle of the twelfth century. Longitudinal arches were built, each uniting two bays of the clerestory, and each intervening lunette was pierced by a window, thus forming a second series of small clerestory windows. Over each double bay bounded by transverse and longitudinal arches groin vaults were constructed. The method of building, starting from masonry arches

Vaulting in the Rhineland, Lombardy, Northumbria, and Normandy

supported on temporary wooden centering, was strikingly different from the Roman technique employing formed concrete, which resulted in groin vaults with horizontal crown lines (painted in modern times to resemble ribbed vaults; see Sant'Ambrogio below). At Speyer each double bay was treated almost like a separate dome, with its crown several feet above the keystones of the arches.

The heavy outward thrust of this construction was supposed to be absorbed by the thick walls and reinforced piers, but although the supports were better calculated than the somewhat later ones at Vézelay (see fig. 530), they tended to push the walls out, as can clearly be seen in the illustration. At a later period the springing points of the vaults had to be joined together by iron tie rods in order to prevent collapse. The Cathedral, though provided with a western entrance, preserved the westwork of Carolingian and Ottonian churches. Later rebuilding has severely altered the west end; the church's original appearance, with octagonal crossing lantern, central western tower, and a smaller tower on each arm of the transept and westwork, can be imagined from a somewhat smaller version of this type, the Abbey Church of Maria Laach near Coblenz (fig. 550), consecrated in 1156. The double-ended shape (fig. 551) appears in several of the massive Romanesque cathedrals that dominate Rhenish cities.

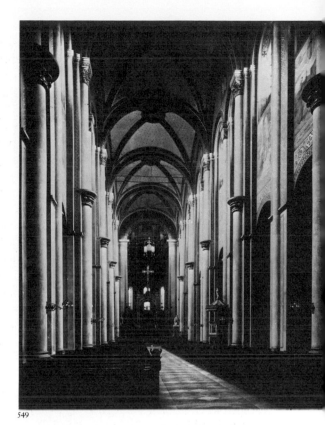

549

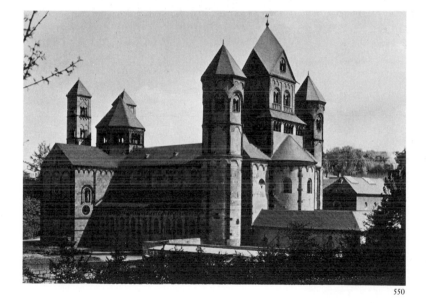

550

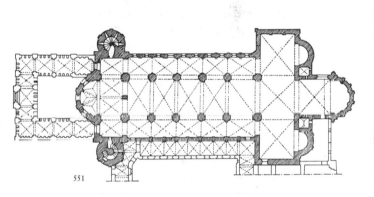

551

548. BENEDETTO ANTELAMI. *King David*, west façade, Cathedral of Fidenza, Italy. c. 1180–90

549. Interior, Cathedral of Speyer, Germany. c. 1082–1106

550. Abbey Church of Maria Laach, near Coblenz, Germany. c. 1156

551. Plan of the Abbey Church of Maria Laach

SANT'AMBROGIO, MILAN An important innovation was made in the Church of Sant'Ambrogio at Milan (fig. 552), the principal city of Lombardy, whose nominal subjection to the Holy Roman Empire kept it in relatively close touch with events in Germany. A glance at the plan (fig. 553) shows that vaulting must have been intended for the nave from the very start. Each double bay of the nave is square, exactly twice as long as one of the side-aisle bays. The alternating system was also built in from the beginning. Stone piers support brick arches and vaults; in the angle between each heavy pier and the nave arcade (fig. 554) was set an additional colonnette, which supports an entirely new feature—a diagonal arch intersecting its counterpart from the other side in the center of the bay. In other words the groin vault has now been provided with ribs *along the groins*, on the principle of the ribs of an umbrella. The account

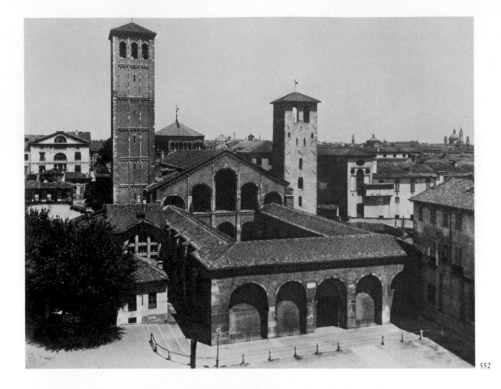

552

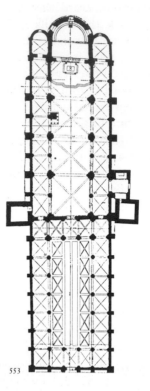

553

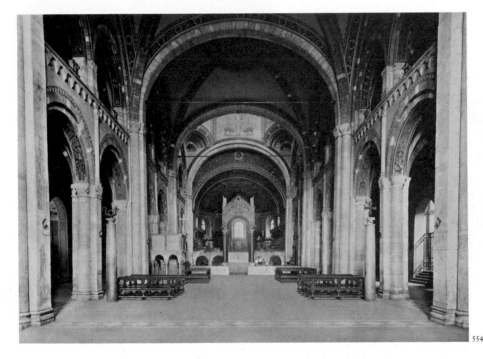

554

552. Sant'Ambrogio, Milan, Italy. Late 11th–
early 12th century

553. Plan of Sant'Ambrogio, Milan

554. Interior, Sant'Ambrogio, Milan

by Abbot Suger of the rebuilding of Saint-Denis in France in 1140 (see Chapter Six) makes clear that the three pairs of arches, longitudinal, transverse, and diagonal, were customarily built first, the centering was then removed, and when the mortar was thoroughly dry, the intervening compartments were filled with a web of masonry.

This use in Sant'Ambrogio is possibly the earliest example of what has come to be known as the ribbed vault. As we shall see, this invention was the absolute essential for the creation of Gothic architecture in northern Europe. Unfortunately, we do not know the date of the vaulting at Sant'Ambrogio, but it is generally agreed that this pioneer attempt must have been started about 1080 and that the church may not have been vaulted until after the earthquake of 1117. The outward thrust of the

vault at Sant'Ambrogio was intended to be contained by a vaulted gallery, which not only darkens the interior badly but also appears not to have done its job. The ominous tie rods have had to be installed.

DURHAM Norman architects built at Durham in northern England one of the most forceful interiors of the Middle Ages, a massive cathedral that was clearly intended for ribbed vaulting from the start (fig. 555). Construction began in 1093, and the choir had been vaulted by 1104 (the rose window is a Gothic addition). The building was completed about 1130. As may be seen in the plan (fig. 556), the double bays are oblong rather than square, and the diagonal ribs cross only a single bay. As a result each double bay is cut into seven vaulting compartments. This device may have been used in order to flatten out the crown line, which was also partly accomplished by pointing the very heavy transverse arches. The most dramatic feature of the interior is the use of powerful cylindrical pillars in alternation with compound piers; the pillars are boldly ornamented with enormous incised chevrons, lozenge patterns, and other designs in a style that recalls the geometric ornament of Hiberno-Saxon art. Originally, the whole interior was even painted in bright colors. The capitals are plain blocks, each trimmed to a circle at the bottom, and are without ornament.

The alternating diagonal ribs rest only on small corbels above the capitals of the triforium, which looks like a constructional gallery in-

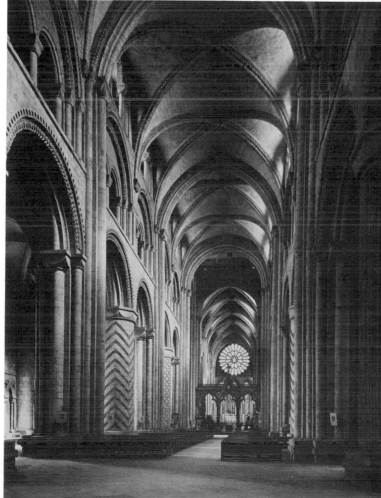

555

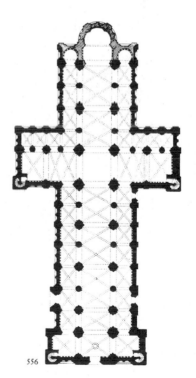

556

555. Nave, Cathedral of Durham, England. c. 1093–1130

556. Plan of the Cathedral of Durham (After Kenneth John Conant)

tended to abut the thrust of the vaulting but is actually covered only by the side-aisle roofs, which do, however, hide relieving arches. The architects seem to have relied on the immense mass of the piers, pillars, and walls to contain the thrust of the vaults, and their confidence was well placed. Tie rods have never been required. A small, columned clerestory is let into the thickness of the walls at the level of the vaulting, and a catwalk runs behind the conoids of the vaults. These conoids (conelike shapes) are formed by the convergence of the triangular compartments of a groin or ribbed vault on the capital of a colonnette or on a corbel. As twelfth-century builders experimented with this form, they were to discover that they could shape the conoids so as to concentrate all weight on the compound piers or on pillars, thus freeing the walls entirely. As we shall see, the manipulation of the conoids will be one of the major goals of Gothic builders.

CAEN The most influential building for early Gothic architecture, however, was the Abbey Church of Saint-Étienne at Caen in Normandy (fig. 557). Started in 1067 by William the Conqueror, it was completed by the time of his interment there in 1087. The nave does not seem to have been planned for vaulting, but the square double bays (as at Sant'Ambrogio) easily accommodated the daring and very refined system of ribbed vaulting built over the nave about 1115–20 (or perhaps later; the vaults were rebuilt in the seventeenth century). Its thrust is strongly abutted by the vaults of the gallery, which act as a gigantic girdle.

As at Durham a small clerestory was built at the level of the vaulting with a catwalk running behind the conoids (fig. 558). The alternating system was preserved only through the addition of two oblique colon-

557. Plan of the Abbey Church of St.-Étienne, Caen, France. 1067–87

558. Interior, Abbey Church of St.-Étienne, Caen

559. West façade, Abbey Church of St.-Étienne, Caen (Gothic spires added later)

560. *Crucifixion*, nave fresco, Sant'Angelo in Formis, near Capua, Italy. Before 1087

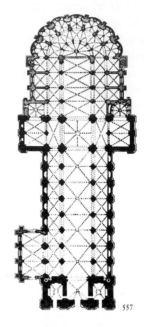

557

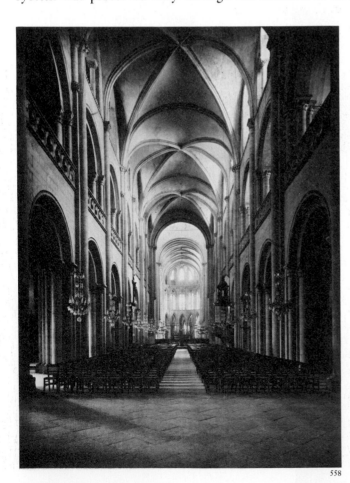

558

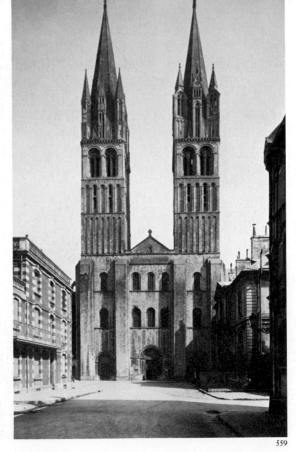

559

nettes, much slenderer than their counterparts at Sant'Ambrogio, to every second compound pier. The striking innovation at Saint-Étienne was the introduction of a second transverse rib, cutting across the vault from side to side and splitting it into six compartments. The six-part vault may have been thought necessary to sustain the slender diagonal ribs before they could be anchored together by the masonry webs of the vault compartments; in any event, it was adopted in the first cathedrals of the Gothic style. The six-part vaults succeeded, at long last, in creating a far more unified interior appearance than had any earlier technique.

Another decisive feature of Saint-Étienne is the three-part, two-tower façade (fig. 559), which later became standard for all French Gothic cathedrals. The elaborate—and indeed very beautiful—spires were added in the Gothic period; they must be thought away in order to recreate the effect of austere simplicity intended by the original builders. Of crucial importance to our understanding of the symbolic basis of medieval architecture is the division of the façade of Saint-Étienne so as to embody in almost every reading the number of the Trinity. For example, the façade has three stories, each of which is divided into three parts; the church possesses three portals (those at the sides enter the towers); the second and third stories of the central part are each lighted by three windows; finally, the towers themselves are each divided into three stories.

Mural Painting

In contrast to Carolingian and Ottonian mural painting, a great deal of Romanesque painting survives, some in fairly legible condition, including complete cycles of high quality. We may, however, mourn the loss of the mosaics done by Greek artists, who were brought to Monte Cassino by Abbot Desiderius in the eleventh century to reform painting, which—in contrast to its achievements in Carolingian France and Ottonian Germany—had sunk to a low ebb in Italy. Desiderius, according to a delight-

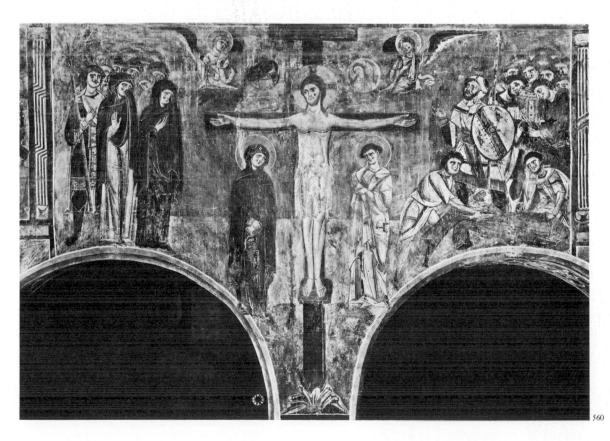

560

ful contemporary account by his archivist and biographer, Leo of Ostia, made provision for the Greek artists to train Italian monks and craftsmen in the techniques of religious art. The most impressive example of the Monte Cassino style is the almost complete cycle of frescoes commissioned by Desiderius before 1087 for the interior of the Church of Sant'Angelo in Formis on a mountainside above Capua, north of Naples. As in all such cycles, the cumulative effect of the whole is far greater than the sum of its parts. Although the frescoes have faded sadly in recent years, the succession of biblical narratives and the great *Last Judgment* on the entrance wall still exert a profound emotional effect on the visitor. In spite of the teaching of Byzantine masters, the style of the Sant'Angelo frescoes seems somewhat rough in comparison with the extraordinary refinement achieved by the art of Constantinople. Yet their dramatic and decorative power depends in no small measure on their naïveté.

Especially beautiful among the Sant'Angelo frescoes is the *Crucifixion* (fig. 560), which fills most of the space above two arches of the nave. Christ is represented as alive, triumphant over suffering as in the *Lindau Gospels* (see fig. 507), his perfect serenity in sharp contrast to the grief of the Virgin and John and to the two mourning angels in midair. The forces of the architecture have been allowed to determine the disposition of the elements: the Cross is planted over one of the columns of the nave arcade; on the arch to the left stand weeping women and Apostles; on that to the

561. *Christ Enthroned, with the Archangel Michael Battling a Dragon*, wall painting, S. Pietro al Monte, Civate, Italy. Late 11th–early 12th century

561

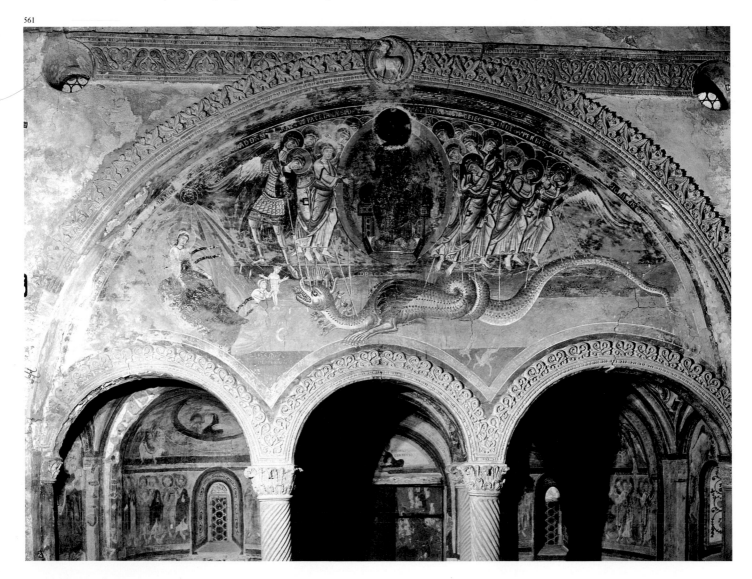

right the Roman centurion, having been moved by the revelation of Christ's divinity, detaches himself from the soldiers' dice game for the seamless robe. The coloring is limited to gray-blue for the background and to terracotta red, tan, oranges, greens, and grays. As in Romanesque sculpture, the drapery is strongly compartmentalized. The simplified faces, with enormous eyes, show startling disks of red on each cheek.

CIVATE A very nearly contemporary cycle of Italian Romanesque painting, dating from the late eleventh or early twelfth century, adorns the simple Romanesque church of San Pietro al Monte in Civate, a remote spot in the foothills of the Alps. The lunette above the triple arcade at the west end of the nave (fig. 561), framed by crisp acanthus ornament in stucco, is filled by the celestial drama related in Rev. 12. Christ is enthroned in a mandorla (unfortunately, his head is lost), and all about him angels led by the Archangel Michael spear a magnificent dragon, who unfolds his scaly coils below the throne. On the left a woman "clothed with the sun" reclines upon a couch, while her newborn child is saved from the dragon. "And there was war in heaven: Michael and his angels fought against the dragon . . ." (Rev. 12:7). The scene floats toward the top of the arch in a mighty involvement of linear curves and stabbing spears, forming one of the most powerful pictorial compositions of the Middle Ages.

562. *Martyrdom of Saint Lawrence*, wall painting, Cluniac Priory Church, Berzé-la-Ville, France. Early 12th century

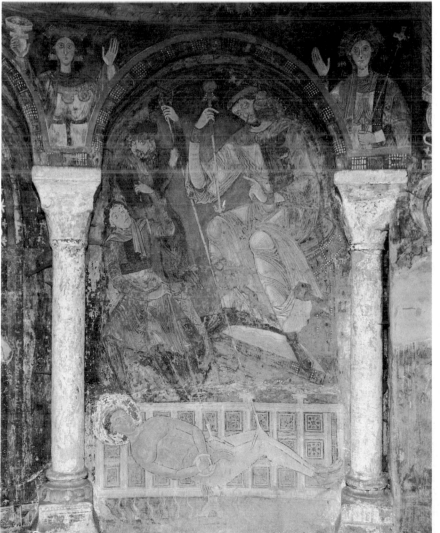
562

BERZÉ-LA-VILLE A number of Romanesque fresco cycles survive in France in varying stages of preservation; most are very difficult to reproduce adequately. The small former Cluniac Priory of Berzé-la-Ville in Burgundy, whose apse shows a colossal *Christ in Majesty* imitated from the larger one at Cluny, has well-preserved wall frescoes that include the *Martyrdom of Saint Lawrence* (fig. 562), a work of immense power. From its coloring we may gain an idea of how the tympanum at Vézelay (see fig. 531) must have looked when its original painted surface was intact. Saint Lawrence lies upon the gridiron, which is arranged schematically parallel to the picture surface, and stylized flames rise from below it. The rest of the arched space is completely filled by the two executioners and the gigantic judge. The diagonal thrust of the two long rods ending in iron forks, which hold the victim on the gridiron, crosses the compartmentalized drapery masses, whose striations show the influence of Byzantine drapery conventions but whose folds move with a fierce energy totally alien to the elegant art of Constantinople. Note also that the French limestone columns flanking the fresco have been painted to resemble the veined marble ones of Byzantine architecture.

TAHULL The Romanesque frescoes that once decorated the great metropolitan churches of Europe have for the most part been replaced by later and more fashionable works of art; the best-preserved group of Romanesque frescoes originally adorned the mountain churches of Catalonia in the picturesque and productive northeast corner of Spain. Almost all of these have been detached from their original walls and are today in museums. A powerful example is the *Christ in Majesty* (fig. 563), painted about 1123 in the Church of San Clemente de Tahull. The style is somewhat less accomplished than that of the Burgundian masterpiece we have just seen, but it is by no means less expressive. Christ's mandorla is signed with the Alpha and Omega (the first and last letters of the Greek alphabet), and he holds a book inscribed (in Latin): "I am the light of the world" (John 8:12), as at Cefalù (see fig. 450). The drapery is rendered in broad, parallel folds, shaded arbitrarily with little elegance and much force. The delicacy of Christ's hands and feet and the portrait quality of his face are therefore the more surprising.

Romanesque manuscript illumination shows as rich a profusion of regional styles as do the churches, the sculptures, and the murals. England in the late tenth century produced a strongly independent style characterized by a freedom recalling that of the Reims School. This energetic art, which flourished especially at Winchester in southern England, was carried across the Channel to France.

GOSPELS OF SAINT-BERTIN An English painter was surely responsible for the illustrations in the *Gospel Book* illuminated at Saint-Bertin, near Boulogne-sur-Mer on the Channel coast, at the end of the tenth century. The first page of the *Gospel of Matthew* (fig. 565) is divided in two vertically; on the right a large initial *L* (for *Liber generationis*) preserves echoes of the old Hiberno-Saxon interlace, but carried out with little interest and already invaded by acanthus ornament. What really fascinated the artist was the figurative side of the page. On a little plot of ground at the top a benign angel gives the glad tidings to two shepherds (the scene is very different from the solemn apparition in the Gospel lectionary of Henry II; see fig. 519). Directly below, Mary is stretched out on a couch, apparently already lonely for her Child, after whom she reaches out her hands. A midwife bends over to comfort her, while Joseph ad-

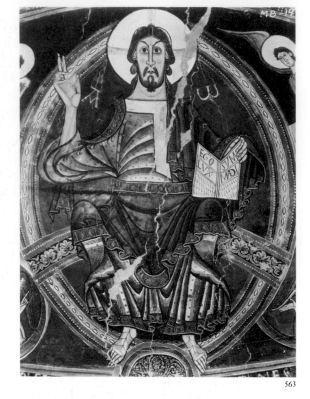

563

563. *Christ in Majesty*, fresco from S. Clemente de Tahull, Spain. c. 1123. Museo de Bellas Artes de Cataluña, Barcelona

Manuscripts

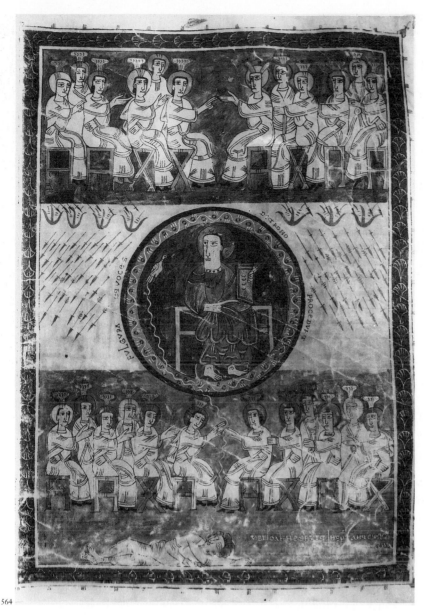

564

564. ENDE. *Vision of Saint John*, illumination from the *Commentary on the Apocalypse* by Beatus of Liebana. Monastery of Távara (León), Spain, 975. Cathedral of Gerona, Spain

monishes her vehemently from his seat at the right. At the bottom of the page Joseph bends affectionately over the Christ Child, wrapped in swaddling clothes and lying in a manger, as the ox and ass look on astonished. Above the initial letter the arc of Heaven discloses five delighted angels. The human, narrative style is matched by the sprightly drawing, the delicate and transparent colors, and the rippling drapery folds.

THE BEATUS MANUSCRIPTS A rich treasury of fantasy and imagination was unlocked for artists of the Middle Ages in Spain and later in France by a theological work, the *Commentary on the Apocalypse*, written by the Spanish monk Beatus of Liebana in 786, during the period when the Moors ruled central and southern Spain and when Christian communities were in a state of constant struggle with Islam. The second earliest of the many surviving manuscript copies of Beatus' work, and also one of the finest, was written in 975 in Visigothic script by two priests at the monastery of Távara, in the north Spanish kingdom of León, and was illustrated largely, if not entirely, by a woman painter called Ende, characterized in the text as *pictrix et adiutrix Dei* (woman painter and helper of God). Like most manuscript illuminations Ende's compositions were probably based to some extent on those of earlier illustra-

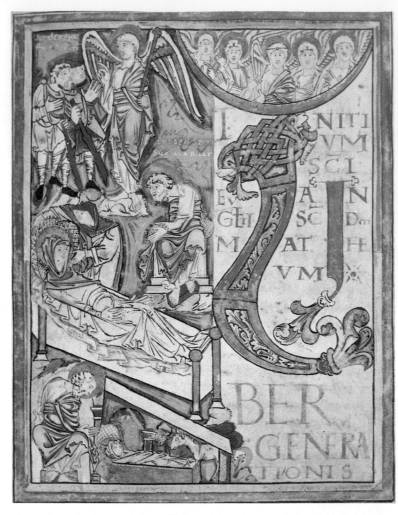

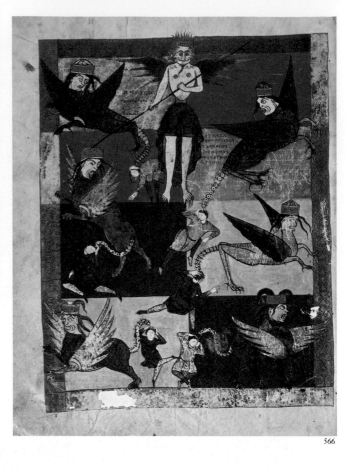

tions, but their special qualities of freedom and buoyancy are her own.

The visions of Saint John, of course, provide exciting material for artists, and Ende exploited them to the full in page after splendid page. In one of the grandest (fig. 564) she depicts a vision that was to reappear in the sculpture of the Romanesque portal at Moissac (see fig. 534)—the heavens opening before Saint John, to disclose the Lord upon his throne among the four-and-twenty elders (Rev., or Apoc. 4:2–5). Ende shows the sleeping visionary at the bottom of the page, and his spirit as a white bird whose wavy path can be followed all the way from the saint's mouth to the throne on which the Lord sits, surrounded by "a rainbow . . . in sight like unto an emerald," holding the usual book in his left hand, and blessing with his right. The elders sit in freely distributed groups of six on either side of the throne, against the upper and lower stripes into which the background is divided. Surprisingly they are beardless, and their "golden crowns" become curious bloops, each with three vertical grooves and three groups of vertical marks. The rainbow is translated as a circular glory, intersecting the lower stripe and floating against the central one, but not quite touching the upper. Seven lamps, "the seven spirits of God," float at the top of the central stripe, and the "lightnings and voices" (labeled in Latin) proceeding from the throne are rendered as showers of alternating arrows and spears. The four beasts, indispensable in later renderings of the vision, are unaccountably omitted. The astonishingly simple facial drawing increases the power of the composition.

Another magnificent Beatus manuscript was illuminated at Saint-Sever in Gascony, in southern France, by a certain Garsia, probably also Spanish. An especially powerful illustration (fig. 566) shows the plague of

565. Initial *L* and scenes of the Nativity, illumination from a Gospel Book. St.-Bertin, France, late 10th century. Bibliothèque Municipale, Boulogne-sur-Mer, France

566. STEPHANUS GARSIA. *Plague of Locusts*, illumination from the *Commentary on the Apocalypse* by Beatus of Liebana. St.-Sever (Gascony), France, middle 11th century. Bibliothèque Nationale, Paris

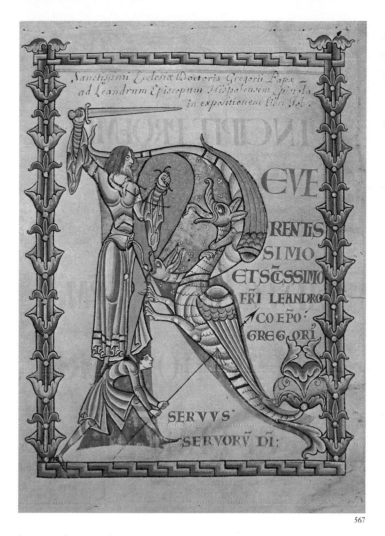

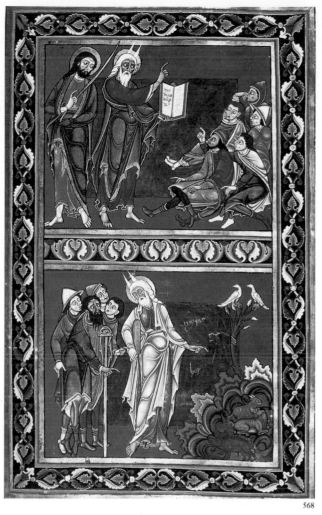

567

568

locusts loosened upon the earth to strike men with their scorpions' tails so that they "seek death and shall not find it." So vividly is the passage (Rev., or Apoc., 9:7–11) illustrated that it demands quotation:

> And the shapes of the locusts were like unto horses prepared unto battle; and on their heads were as it were crowns like gold, and their faces were as the faces of men.
>
> And they had hair as the hair of women, and their teeth were as the teeth of lions.
>
> And they had breastplates, as it were breastplates of iron; and the sound of their wings was as the sound of chariots of many horses running to battle.
>
> And they had tails like unto scorpions, and there were stings in their tails: and their power was to hurt men five months.
>
> And they had a king over them, which is the angel of the bottomless pit, whose name in the Hebrew tongue is Abaddon, but in the Greek tongue hath his name Apollyon.

The ferocity of the linear style in which these terrible beasts are drawn is intensified by the harsh coloring of the background rectangles: red ocher, brown, green, yellow, and blue.

CÎTEAUX Still another possibility for the Romanesque manuscript style is seen in a highly imaginative illumination from the *Moralia in Job* of Saint Gregory (fig. 567), painted at the very beginning of the twelfth

567. Initial *R* with Saint George and the Dragon, illumination from the *Moralia in Job.* Cîteaux, France, early 12th century. Bibliothèque Municipale, Dijon

568. Frontispiece, Book of Deuteronomy, *Bible of Bury St. Edmunds.* Abbey of Bury St. Edmunds, England, 1st half of 12th century. Illumination. Corpus Christi College, Cambridge, England

century at the Burgundian monastery of Cîteaux, the mother church of the reforming Cistercian Order. A border of floral ornament at the sides and of zigzag at top and bottom, in delicate tones of orange, lavender, green, and blue, surrounds the initial letters of Gregory's dedication of the book to Bishop Leander. The *R* (for *Reverentissimo*) is partly formed by a standing knight, possibly Saint George, whose left leg in blue hose emerges elegantly from his orange tunic. He holds a green shield and brandishes a blue sword high above a delightful dragon, which makes up the rest of the *R* and which has two heads and green, blue, orange, and gold wings. The knight's pose is actually an unnecessary ritual, because the hapless squire on whose back the knight stands has already taken the precaution of running the dragon through with a spear. Here again are the linear energy and brilliance of design we have seen in Burgundian architecture, sculpture, and painting, accompanied by a wit that could be given free rein only in manuscripts intended for the few. At this point it is interesting to quote from Saint Bernard's famous letter of 1127 on the subject of the impieties of Romanesque art:

> . . . what profit is there in those ridiculous monsters, in that marvelous and deformed comeliness, that comely deformity? To what purpose are those unclean apes, those fierce lions, those monstrous centaurs, those half men, those striped tigers, those fighting knights, those hunters winding their horns? Many bodies are there seen under one head, or again, many heads to a single body. . . .

In fact, Saint Bernard, who clearly enjoyed and understood what he was condemning, put an end to all figurative art not only at Cîteaux but also throughout the Cistercian Order—luckily not before the illumination of this and other beautiful manuscripts. It almost seems as if he had correctly traced, whether consciously or not, such animal fantasies to their ultimate source in the art of the pagan barbarians.

THE BIBLE OF BURY ST. EDMUNDS The apex of skill in Romanesque illumination is achieved in the lavishly illustrated *Bible of Bury St. Edmunds*, illuminated in England probably just before the middle of the twelfth century. At the top of an illustration to Deuteronomy (fig. 568), Moses and Aaron reveal the Law to the assembled Hebrews, delightfully individualized in their faces and in their reactions. Moses is pictured with the horns he was given in art according to Saint Jerome's translation of the Hebrew word that also means rays, but that, it has been shown recently, is also connected with a long tradition of horned deities and even with the shape of the Christian miter. In the lower illustration Moses points out the clean and the unclean beasts; two defiant red pigs rejoice in their uncleanness. This style is a very elegant and accomplished one, with its enamel-like depth and brilliance of color and high degree of technical finish. The sparkling perfection of the ornament, the smooth linear flow of poses and draperies, and the minute gradations of value have brought the art of painting about as far as it could go within the conventions of Romanesque style. Marion Roberts Sargent says, referring to this illustration, "The real achievement of Romanesque illumination is the complete domination of two-dimensional space. Figures, border, ornament, architecture, and landscape, even the text, are treated equally in brilliant color, resulting in total mastery of surface design."

SAINT HILDEGARDE OF BINGEN Among all the visionaries of the Romanesque period the most original and unpredictable was Hil-

degarde of Bingen (1098–1179), the first of a long line of influential women mystics throughout the Middle Ages, the Renaissance, and the Baroque. Interestingly enough, considering his attitude toward the fantastic strain in Romanesque art, Saint Bernard firmly championed the validity and importance of Hildegarde's visions. Although the procedures for her canonization were never completed, Hildegarde's name is today officially inscribed among the saints because of her long life divided between mystical revelations of other-worldly powers of light and darkness, which began during her childhood, and intense scholarly activity. In 1136 Saint Hildegarde was elected prioress of her convent, which she then transferred to Rupertsberg near Bingen, on the Rhine. There she wrote books on medicine and history, allegorical sermons, and both the words and the music of canticles and hymns. She even invented a language of her own with nine hundred words and twenty-three letters. Her most important work for our purposes is the *Liber Scivias* (abbreviation of *Scito vias lucis*, "know ye the ways of light"). Whether or not she painted any of the illuminations with her own hand, she certainly directed the work, which was lettered and illustrated by her nuns. Among the twenty-six visions, all of startling beauty and originality, we may choose that of the ball of fire (fig. 569).

569

569. HILDEGARDE OF BINGEN. *Vision of the Ball of Fire*, illumination from the *Liber Scivias*. Rupertsberg, Germany, 12th century (Original destroyed)

Then I saw a huge image, round and shadowy. It was pointed at the top, like an egg. . . . Its outermost layer was of bright fire. Within lay a dark membrane. Suspended in the bright flames was a burning ball of fire, so large that the entire image received its light. Three more lights burned in a row above it. They gave it support through their glow, so that the light would never be extinguished.

Whatever the wonderful visions may have been in the transfigured mind of the saint, it is significant that her nuns set them down in the visual language of the Romanesque—two-dimensional surfaces and ornamental line. It is tragic to record the destruction of the original manuscript in World War II.

THE BAYEUX TAPESTRY One of the largest and also best-preserved pictorial efforts of the Romanesque period is the so-called *Bayeux Tapestry.* (In point of fact, this is an embroidery, done on eight bolts of natural-colored linen with only two different stitches of wool; in tapestry the design is woven along with the fabric.) Originally somewhat longer, the work now measures 230 feet in length by only 20 inches in height. It was designed and executed to run clockwise around the entire nave of the Cathedral of Bayeux in Normandy, from pier to pier. Especially interesting since Romanesque secular works are rare, the hanging narrates for the populace the detailed story of the invasion of England by William the Conqueror, including the background of political intrigue, from the official Norman point of view and complete with titles in Latin for the benefit of those who could read.

Traditionally the immense project is supposed to have been embroidered by the ladies of Queen Matilda's court. There seems little reason to doubt that the needlework was done by women, who in the Middle Ages made all the gorgeous embroideries for church vestments, altar cloths, altar frontals, and so on—and indeed quite generally still do. Some one of the women seems to have been an Anglo-Saxon, judging from the peculiar forms of some of the letters. The hanging was probably ordered by William's brother Odon, Bishop of Bayeux (also Duke of Kent), for the consecration of his cathedral in 1077. But were the designers of the splendid narrative also women? This seems unlikely, since the actors are exclusively male and the scenes are depicted with close knowledge of military operations and instruments. For example, a ship with others behind it (fig. 570), strikingly like those the Vikings (ancestors of the Normans) had used during their raids in earlier centuries, is beached in a reverse D-Day operation. The mast is being lowered and horses disembarked upon the English beach. But the needlewomen may well have been left free to add their own birds and beasts, sometimes fantastic enough to have irritated Saint Bernard, and even little nudes, in the margins.

Space was required for this continuous method of narration, descending of course directly from Greek and Hellenistic friezes and Roman historical columns—doubtless scattered here and there throughout the Empire—and emulated in Bishop Bernward's column (see fig. 515) and in such rotuli as the *Joshua Roll* (see fig. 440). No excerpt can convey the cumulative force of the *Bayeux Tapestry.* Exhibited today around a single long room, the typically Romanesque figures move with such vivacity that every aspect of the Norman Conquest seems to take place before our eyes, and we easily accept the Romanesque convention of flatness and linearity.

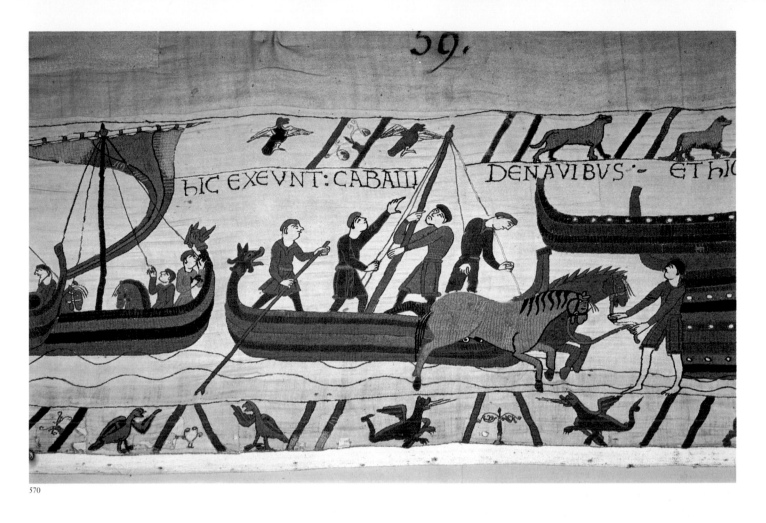

HIC EXEVNT:CABALLI DENAVIBVS :· ET HI[C

570. *The Landing of Horses from Boats*, detail of the *Bayeux Tapestry*. c. 1073–83. Wool embroidery on linen, height 20″. Courtesy the City of Bayeux

One of the astonishing things about the Romanesque period is its brevity. The great creative moment began at the end of the eleventh century. By 1140 the Gothic style had already replaced the Romanesque in the Île-de-France, and long before the twelfth century was over, the onrush of the Gothic, which was to rule in northern Europe at least for more than three hundred years, had banished the Romanesque to remote provincial centers.

TIME LINE VI

Palatine Chapel, Aachen

Ebbo Gospels

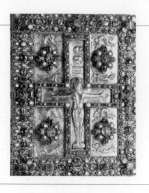

Lindau Gospels

HISTORY

700	Battle of Poitiers, 732; Charles Martel defeats Muslims
800	Charlemagne crowned Emperor at Rome, 800
	Vikings begin raids on England, 835
	Charles the Bald, Carolingian king, r. 840–77
900	Carolingian Empire divided among sons of Louis the Pious at Treaty of Verdun, 843
	Charles the Simple cedes Normandy to Vikings, 911
	Otto I, German king, crowned Holy Roman Emperor, 962
	Hugh Capet, French king, r. 987–96, founds Capetian dynasty

CULTURE

Alcuin (735–804) begins revision of the Vulgate (Latin Bible)

Ebbo, archbishop of Reims, r. 816–35
Carolingian revival of Latin classics
Earliest documented church organ, Aachen, 822
Einhard writes *Life of Charlemagne*, 821
Cluniac Order founded, 910
Gero, archbishop of Cologne, r. 969–76

St. Bernward, archbishop of Hildesheim, r. 993–1033

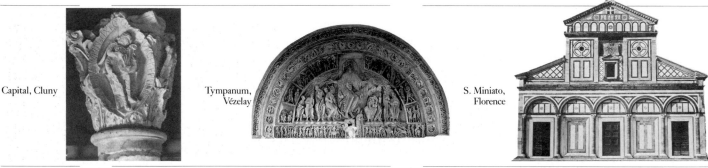

Capital, Cluny

Tympanum, Vézelay

S. Miniato, Florence

1000	William the Conqueror, Norman duke, r. 1035–87
	Normans begin conquest of Sicily, 1043
	Battle of Hastings, 1066; William the Conqueror wins England
	First Crusade, 1095–99
	Crusaders found Latin kingdom of Jerusalem, 1099
1100	Louis IV the Fat of France, r. 1108–37, strengthens monarchy
	Roger II, Sicilian king, r. 1130–54
	Second Crusade initiated by St. Bernard, 1147
	Saladin captures Jerusalem, 1187

St. Dominic of Silos (d. 1037)
Leif Ericson sails to North America, 1002
Avicenna, 980–1037, chief medical authority of Middle Ages
College of Cardinals formed to elect popes, 1059
Pope Gregory VII, r. 1073–83
St. Bruno founds Carthusian Order, 1084
Cistercian Order founded, 1098
Hildegarde of Bingen (1098–1179)
Song of Roland composed, c. 1098
Monk Theophilus' *De diversis artibus*, c. 1100
St. Bernard, abbot of Clairvaux, r. 1115–53
Order of Knights Templars founded in Jerusalem, 1119

HOLY ROMAN EMPIRE/ROMANESQUE

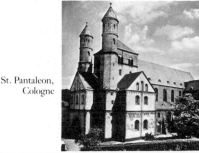

St. Pantaleon, Cologne

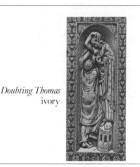

Doubting Thomas ivory

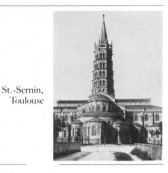

Otto Imperator Augustus

St.-Sernin, Toulouse

PAINTING, SCULPTURE, ARCHITECTURE

Abbey Church of St.-Riquier; Abbey of Lorsch and gateway
Palatine Chapel, Aachen; plan for monastery at St. Gall
Coronation Gospels; Lorsch Gospels; Ebbo Gospels; Utrecht Psalter; Lindau Gospels; Bible of Charles the Bald
Otto Imperator Augustus
Vision of Isaiah; Vision of St. John, by Ende
Crucifix of Archbishop Gero

Wall paintings, St. George, Reichenau; *Lectionary of Henry II*
Doubting Thomas ivory
St. Pantaleon, Cologne; St. Michael's, Hildesheim
Bronze doors and Column of Bishop Bernward, Hildesheim
Hitda Codex; Uta Codex

PARALLEL SOCIETIES

Franks	700
Byzantine	
Carolingian	800
Viking	
Muslim	
Ottonian	
	900

King David by Antelami

S. Angelo in Formis

Moralia in Job, Cîteaux

Durham Cathedral

S. Miniato, Baptistery, Florence; Cathedral, Speyer; Cathedral, Pisa
St.-Étienne, Caen; S. Ambrogio, Milan; Cathedral, Durham
Abbey Church and sculpture, Cluny; St. Sernin, Toulouse
Frescoes, Civate; fresco cycle, S. Angelo in Formis; *Bayeux Tapestry*
Sculpture, S. Domingo de Silos
Ste.-Madeleine, Vézelay, with sculpture; *Last Judgment* by Gislebertus, Autun; tympanum, portal, and cloister sculpture, Moissac; portal, sculpture, St.-Gilles-du-Gard; Notre-Dame-la-Grande, Poitiers
Martyrdom of St. Lawrence, Berzé-la-Ville; *Christ,* S. Clemente de Tahull
Apocalypse of St.-Sever; Gospels of St.-Bertin; Moralia in Job; Bible of Bury St. Edmunds; Liber Scivias by Hildegarde of Bingen
Reliefs by Wiligelmo da Modena; *King David* and *Descent from the Cross* by Antelami; baptismal font by Renier de Huy
Baptistery and Campanile, Pisa; Abbey Church, Maria Laach; Cathedral, Monreale

Norman	1000
Italian city-states	
French Monarchy	
German Monarchy	
	1100
English Monarchy	

GOTHIC ART

The term *Gothic* is used today to designate the style that began in northern France before the middle of the twelfth century and in the rest of western Europe anywhere from a generation to a century later. We now know that the name is a misnomer, for Gothic art has nothing whatever to do with the Goths, who swept down on Roman Italy in the fifth century (see Chapter Three). But the Italians of the Renaissance thought that it had. The medieval buildings surrounding them seemed so barbaric in comparison with the beauty of Roman architecture that they believed this style could have been imported into Classical Italy only by the Vandals, the Goths, the Lombards, and the Huns. Giorgio Vasari, the Renaissance artist and writer who characterized Byzantine pictorial style as "the rude manner of the Greeks," was even more caustic about medieval architecture, which he claimed "was invented by the Goths." The disparaging term *Gothic* took root; by the seventeenth century the great French dramatist Molière was referring to the "torrent of odious Gothic monsters" that had been unleashed on France. Not until the beginnings of Romanticism in the late eighteenth century did Gothic art begin to catch hold of the imaginations of a cultivated elite as a welcome escape from the rules of Classical art into a past that seemed both natural and intriguingly remote. And only with the historical studies of the early nineteenth century did it become clear that so-called Gothic art was really a phenomenon separated from the Gothic invasions by at least seven centuries. Soon Gothic art became recognized as the refined intellectual and aesthetic achievement of a highly developed society, but there was no longer any possibility of changing the name.

Non-French European regions in the late twelfth and early thirteenth centuries, however, were well aware of the origin of the Gothic style. They referred to it as *opus francigenum* (French work), and they were right—in the narrow and restricted sense denoted by the term *French* at the time. The Gothic style was born in that region of north-central France centering around Paris, known as the Île-de-France, which as we have seen (see page 407) was the personal domain of the French kings. Today art historians are in a position to add the birthdate of the Gothic style: shortly before the year 1140, when the first stage of the reconstruction of the royal Abbey Church at Saint-Denis was completed. From the Île-de-France the style radiated outward, winning acceptance in region after region, first throughout northern France, then almost immediately in England, then in Germany, the Low Countries, central Europe, and Spain, and finally in a reluctant Italy—which never fully understood or accepted it and was, as we have noted, the first to brand it barbarous and to rebel against it.

In contrast to the individuality of the local Romanesque schools, their wide diversity of styles and technical methods, and the extreme brevity of their period of full bloom, five outstanding phenomena characterize the Gothic. First, the Gothic is remarkably consistent throughout wide areas of central and northern France; it was carried almost unaltered into Germany, the Low Countries, and Spain; and it was only somewhat modified by local requirements in England. Second, it developed a competitive mo-

mentum; architects, sculptors, and painters were well aware of what was being done elsewhere and were constantly trying to beat their rivals at their own game. Third, the Gothic lasted, although transformed by regional tastes and requirements, well into the sixteenth century (everywhere except Italy, of course). Fourth, the Gothic created structures completely without precedent in the history of art, surpassing in technical daring anything ever before imagined. Finally, after the long interregnum of the early Middle Ages, the Gothic was the first Western art to present a believable image of a complete human being.

We tend to think of Romanesque as the architecture of the monasteries, and to a great extent this is true, but largely because in most Western cities, even some very small ones, the Romanesque cathedrals of the eleventh and twelfth centuries were replaced in the late twelfth or thirteenth by Gothic ones. But the distinction is valid in a general sense because, with the exception of Saint-Denis, which as we shall see proves the rule, it was cathedrals, not monasteries, that required rebuilding. By the beginning of the Gothic period, the great cultural and economic mission of the monasteries had largely come to an end. Their role as conservators of learning was being assumed by the universities, and their economic importance had been superseded by that of the towns. It has long been pointed out by Meyer Schapiro that the Gothic cathedrals were the largest economic enterprises of the Middle Ages. The cathedrals absorbed the activities of architects, builders, masons, sculptors, stonecutters, painters, stained-glass makers, carpenters, metalworkers, jewelers—utilizing materials brought sometimes from great distances—and gave back nothing in a material sense.

Monasteries were generally located in the country; a cathedral, by definition the seat of a bishop, was in a town, and it became a symbol of the town's corporate existence. To a great extent this is still true. A contemporary Florentine will boast of being *fiorentino di cupolone* (Florentine from the great dome [of the Cathedral]); during the air attacks of World War II, Londoners kept watch nightly, risking their lives, on the roofs and towers of Saint Paul's Cathedral in order to extinguish fire bombs as they fell. In the Gothic period communal devotion to the construction of the cathedrals was so great that, according to contemporary chroniclers, not only did the rich contribute financially to the limit of their ability to the building and decoration of the cathedrals, but also rich and poor alike joined with laborers and oxen to pull the carts laden with building materials.

With their soaring height, their immense interiors, their pinnacles, towers, and spires, their innumerable images and narratives in stone, paint, and glass, the cathedrals summed up the knowledge and experience of humanity's brief earthly tenancy in artistic forms and iconographic cycles of astonishing completeness, united in a structure that constituted a comprehensive medieval picture of the universe from the heights of Heaven to the depths of Hell. But we have not defined the Gothic style, and that will not be easy. It is best to illustrate its nature and main lines of development with a few selected works.

SAINT-DENIS On June 9, 1140, in the presence of King Louis VII of France and his queen, Abbot Suger consecrated a new façade, with a triple, sculptured portal and two square towers (of which only one was ever completed) on the Carolingian church of the Abbey of Saint-Denis, just north of Paris; on June 11, 1144, the same abbot brought to completion a new choir with ambulatory and radiating chapels that replaced the Carolingian apse. Both additions were necessary to accommodate the crowds of pilgrims who came to venerate the relics of Saint Denis and other saints preserved in the apse. Saint-Denis was not only a pilgrimage monastery but also a royal foundation in which French monarchs were buried. As its abbot, Suger was a person of great political importance, the power behind the thrones of two kings and regent of France (1147–49) during the absence of one king on the Second Crusade.

Suger intended eventually to replace the Carolingian nave of his church as well. Ironically, when this nave was replaced in the thirteenth century by a Gothic one, Suger's choir was also demolished, except for the ambulatory, which is an extraordinary achievement (figs. 571, 572). At first sight the ambulatory with its radiating chapels recalls Saint-Sernin at Toulouse (see fig. 524), but the ambulatory of Saint-Denis is doubled at the expense of the chapels, which are reduced to hardly more than bay windows, expanding and contracting at regular intervals so as to carry the crowds easily around the high altar with its reliquary shrine.

Suger left a written account, unique in the annals of patronage, explaining his feelings about the work and his reasons for doing as he did, recounting its history (not without miracles), and preserving valuable information about architectural practices in the twelfth century. According to a famous study by Erwin Panofsky (see Bibliography), Suger believed that the writings of an obscure fifth-century Syrian mystic, known as Dionysius the Pseudo-Areopagite, preserved at Saint-Denis, were in fact those of Saint Denis, the patron saint of France and of the abbey (*Denis* is French for "Dionysius"). The complex Neoplatonic system according to which Dionysius identified light with divinity was seen by Panofsky as the justification for Suger's enthusiasm for the light from the "circular string of chapels, by virtue of which the whole [church] would shine with the wonderful and uninterrupted light of most luminous windows. . . ."

One is tempted to ask why such a theological explanation of light would not refer just as easily to Hagia Sophia, for example, with its rows on rows of windows under and around the floating dome. One notices also that Suger reserved his special raptures for the beauty of the gold used to cover the new doors and for the gold and jewels of the reliquary shrine, without mentioning the design of either. He was so unresponsive, in fact, to the style of his time that he caused a gold mosaic instead of sculpture to be set up in the tympanum of the left portal, although he admitted it was contrary to "modern" practice. One is almost more impressed by what Suger omitted from his account, such as the name of the architect, than by what he mentioned. Suger was also silent about the master's technical and stylistic innovations, but he recounted with admiration the architect's ability to measure the Gothic choir so accurately that when the Carolingian apse left standing inside it was finally taken down, the new choir was found to be in perfect alignment with the old nave. About the columns Suger said no more than that their number corresponds to the numbers of the Apostles and the minor prophets.

So far from being in any way responsible for the new style evolving around him, Suger in his account reveals himself to have been unaware that it was new. Modern studies of the development of ribbed vaults have

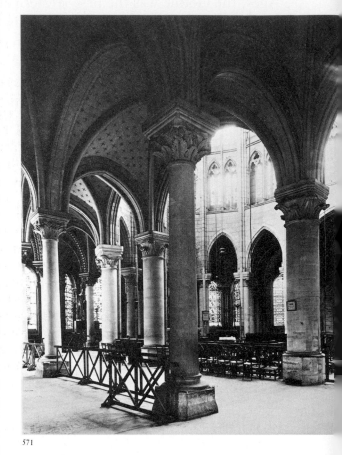

571

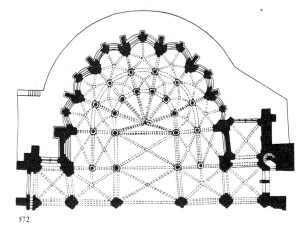

572

571. Ambulatory, Abbey Church of St.-Denis, Paris. 1140–44

572. Plan of the ambulatory, Abbey Church of St.-Denis, Paris (After Sumner Crosby)

shown that for a decade or so before the rebuilding of Saint-Denis, architects—under probable Norman influence—had been experimenting with ribbed vaults in the parish churches of the Île-de-France. Whoever he was, the architect of Saint-Denis was probably of local origin (only the stained-glass makers, Suger tells us, were brought from throughout France). A glance at the illustration (see fig. 571) makes clear what is really new: for the first time we have an architecture not of walls but of supports. Columns or compound piers including colonnettes support the ribs, between which the concave vault surfaces are constructed. Walls tend to be replaced by windows. From this moment walls in French cathedral architecture are residual, and architects will vie with one another to reduce them to a minimum, while at the same time they refine the connection between the supports and slim down the supports to the ultimate. In each of the trapezoidal bays and pentagonal chapels of the ambulatory at Saint-Denis, the transverse ribs are pointed so as to lift the sides of the bays as high as possible, thereby concentrating the outward thrust of the vaults on the columns and piers. The plan shows that this thrust is carried to the exterior of the church where it is met by the buttresses, which appear as black, rectangular projections between the windows.

Architecture at Saint-Denis has become an organic system of interacting supports (columns, colonnettes, ribs, buttresses), both inside the church and outside, enclosing vaulting surfaces above and windows on the sides. Four thousand years of post-and-lintel construction and at least a thousand years of massive vault design have suddenly become obsolete. The only derivation of early Gothic architecture from the past can be found in the ribbed domes of Byzantine architecture, such as that of Hagia Sophia (see fig. 427), but even Byzantine ribs stop at the pendentives and walls remained necessary. Suger recorded his gratitude for divine intervention when the bare ribs of the incomplete choir vaults of Saint-Denis, protected by the outer roof but still without the stabilizing factor of the inner triangles of the vaulting, were shaken by a terrible storm; they vibrated visibly, but remained standing. It would have been more to the point for Suger to congratulate his architect on his extraordinary knowledge and skill.

Like many medieval patrons before him, Suger thought of plundering Rome for marble columns and even worked out the route by which they could be transported. Luckily (again, according to Suger, by miracle) he found an inexhaustible quarry of local limestone. But it was not by accident that in this new organic architecture not only Roman columns but also Roman, Byzantine, and Romanesque capitals have been abandoned. The new capital shapes are based, however schematically, on the growth of actual foliage that the architects had seen rather than on Greek acanthus leaves that they had not. It is worth remembering that several Renaissance writers felt that Gothic architecture had originally been suggested by primitive shelters formed by tying trees together.

CHARTRES One masterpiece of transitional Gothic architecture, sculpture, and stained glass survives intact: the façade of the Cathedral of Chartres (figs. 573, 574), to the southwest of Paris. In 1134 the façade of the eleventh-century cathedral was damaged by fire, necessitating its replacement. The north tower was built first without a spire. Then about 1142 the south tower was erected to its full height, culminating in one of the most beautiful spires of the Gothic period. The simple addition of one element to the next, visible throughout Romanesque structures (see fig. 525), has here given way to a delicately adjusted interconnection.

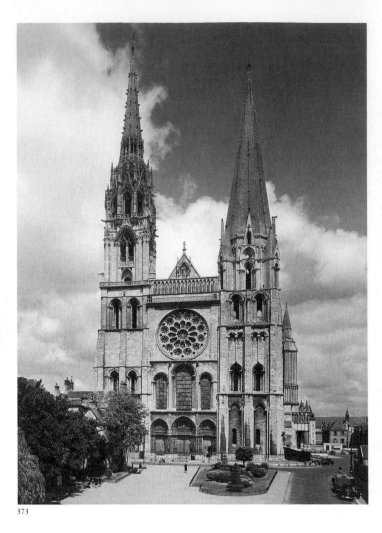

573

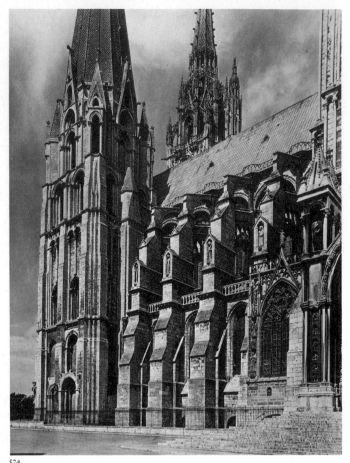

574

The transition from the square to the octagon, for instance, is prepared as early as the second story by placing the colonnettes of the blind arcade directly on the keystones of the arched windows and by the splaying of the corner buttresses. By the time the eye rises to the fourth story, which is clearly octagonal, the transition has been accomplished almost unnoticeably. The tower rose high above the roof of the Romanesque cathedral at the beginning of the third story; its effect was somewhat diminished by the taller Gothic structure commenced in 1194 (see page 455).

The façade was built to connect the towers at their eastern flanks, so that they would project on either side and appear partly to enclose it. At some undetermined time these plans were changed, and the Royal Portal (fig. 575), dating from about 1140–50, was set up in its present position flush with the towers. The splayed triple portal is completely sculptured, and devoted to a unified theme: the Nativity and scenes from the Infancy of Christ on the right, the Ascension on the left, scenes from Christ's life in the capitals of the colonnettes, and in the center his heavenly apparition according to the Vision of John, as at Moissac, but including the Twelve Apostles (see fig. 534). The freedom of Romanesque sculpture has been abandoned here in favor of a disciplined structure that embraces every element in the portal, and of which Christ himself is the center. In contrast to the rich confusion of the Moissac tympanum, the central lunette at Chartres is immediately legible. Each of the symbols of the Evangelists occupies its predetermined position. Each of the four-and-twenty elders of the Apocalypse in the outer archivolts and the twelve angels in the inner archivolts moves in conformity with the motion of the arch,

573. West façade, Cathedral of Chartres, France. 1140–50

574. South tower, Cathedral of Chartres. c. 1142

575. Royal Portal, west façade, Cathedral of Chartres. c. 1140–50

576. Jamb statues, Royal Portal, Cathedral of Chartres

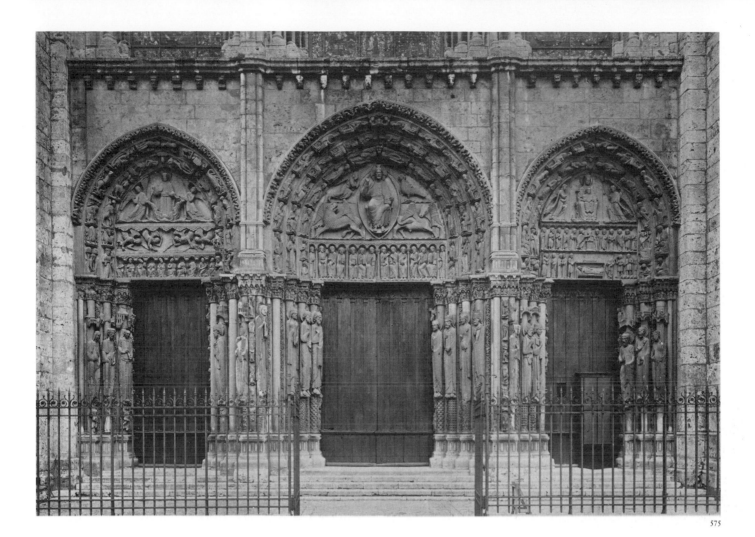

575

even though that involves tilting over, till they converge at the keystone, where two other angels uphold a royal crown.

The tall, infinitely slender figures on the jambs of the doors (fig. 576) represent in all probability kings, queens, and prophets from the Old Testament. They, too, obey the forces of the architecture to the extent of assuming the shapes of the colonnettes of which they form a part. They stand upon firm pedestals, and the long, taut drapery lines contrast in their severity with the luxuriance of the interlaced ornament between the colonnettes. Paradoxically, the columnar figures support nothing; each usurps the shape of a column, but not its function, in contrast to the maidens of the Erechtheion (see fig. 246), for example, who took over the function of columns without relinquishing their own shapes. Calm has settled over the scene after the wildness of Vézelay and Moissac only twenty years or so before. The figures seem to enjoy their role in a perfect system, which, incidentally, includes among its minor sculptures the seven liberal arts, the signs of the zodiac, and the labors of the months. The figures assume a cylindrical existence in depth, which in Romanesque sculpture had been seen only in Provence (see fig. 537). The delicacy of the parallel drapery lines, recalling those of Archaic kore figures (see figs. 176, 190), is surpassed only by the sensitive delineation of the quiet faces. The serenity of this royal allegory was never again achieved, but the decisive step in the creation of a new architectural sculpture had been taken. Henceforward, the figure could assert its individual existence in harmony with the forces of an all-embracing architecture.

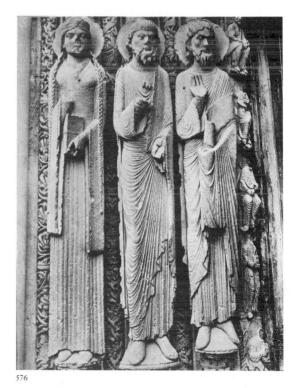

576

The story of French cathedral building in the late twelfth and thirteenth centuries is made more exciting by the element of intense competition. No sooner was a new form or a new device established in one cathedral than it was outdone in another. One architect and sculptor, Villard de Honnecourt, went from cathedral to cathedral drawing the latest architectural and sculptural achievements (fig. 577).

LAON The earliest Gothic cathedral is that at Laon, to the northeast of Paris. The situation is spectacular because Laon itself is a hill town lifted high above an almost flat plain; the cathedral with all its towers may thus be seen for many miles (fig. 578). It was to have had seven towers, one over the crossing between nave and transept, two on the nave façade, and two on each transept. Although even some specialists do not know this, all save the crossing tower—a total of six—were actually completed. During the French Revolution one tower on each transept façade was torn down for its stone, to the dismay of the local population; only four now remain. The number seven had mystical significance, since it was the sum of the Trinity and the Gospels, the number of the Virtues (and the Vices), the number of the gifts of the Holy Spirit, the number of the liberal arts, and the number of the candlesticks in Heaven. No Gothic cathedral ever boasted all seven towers, but many were planned for that number (Chartres was to have had eight). Whether the towers at Laon were also intended to receive spires is uncertain but unlikely; the tiny steeple on one of the transept towers is a much later addition.

The façade, begun about 1190, is unexpectedly dramatic. The triple portal is protected by three porches; above the central porch is an early example of a rose window. Radiating from the center of this circular window is an elaborate network made of separate pieces of stone, known as *tracery*, one of the great inventions of the Gothic period. Pierced slabs of stone, or grilles, had been used in Byzantine and Islamic windows, and the Gothic rose window derives from this tradition. However, the tracery, intended to hold stained glass, obeys precise geometrical laws. Above the rose and its flanking arched windows runs an open arcade, broken to indicate on the exterior the relation of the clerestory and side aisles within. The façade towers are flanked by superimposed aediculae with pointed arches, square on the first two stories and octagonal on the third. In contrast to the lofty pointed central windows these aediculae create a broken and irregular silhouette. The towers are transparent, skeletal structures, through which the wind blows easily. From the uppermost aediculae protrude statues of oxen, popularly believed to be those who dragged the stones for the cathedral up the steep hill of Laon. For some as-yet-unexplained reason, the round apse at Laon, begun about 1160, was replaced only a few years after completion by a square east end on the English model (figs. 579, 580). The present great length of the noble interior—eleven bays for the nave, ten for the choir—is as dramatic as the towers.

In looking at the interiors of Gothic cathedrals throughout Europe we should remember, however, that the vista was originally broken in almost every one by a monumental stone screen running across the entrance to the choir. This screen was provided with a central Crucifixion group, twin pulpits from which the Epistle and Gospel were read at Mass, and sometimes even small chapels. The purpose of these choir screens was to separate the laity's Masses and preaching services, held in the nave, from the Divine Office (prayers at seven stated times) and other liturgical functions, which had to be chanted in the choir by the clergy of the cathedral

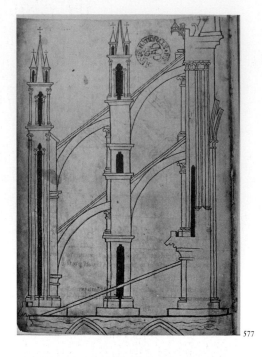

577

577. VILLARD DE HONNECOURT. *Flying Buttresses.* c. 1230–35. Pen and ink. Bibliothèque Nationale, Paris

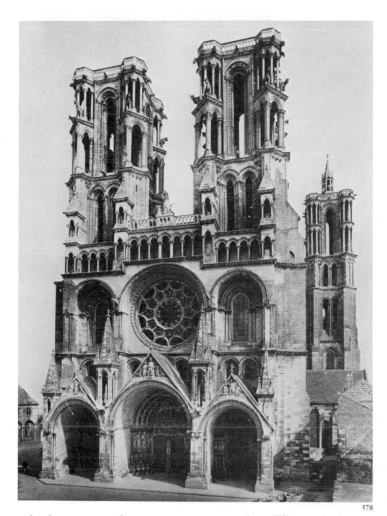

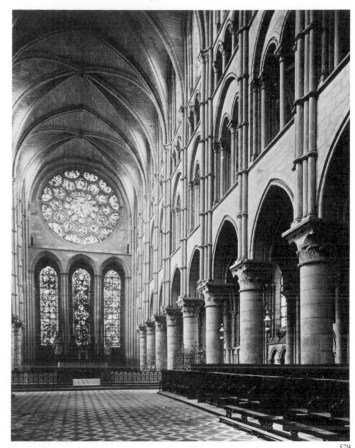

whether or not there was a congregation. These choir screens, with all their precious sculpture, were systematically destroyed in the Baroque period in order to unify the interiors for enormous congregations. Their original effect can be judged by a surviving example at Saint Elizabeth at Marburg in Germany (see fig. 613).

The interior at Laon is four stories high. The nave arcade, supported by heavy cylindrical piers instead of compound square ones, is surmounted first by a gallery with coupled arches under an embracing arch, then by a small triforium, and finally by a clerestory tucked into the vaults. As at Caen (see fig. 558), the vaults are six part, but somewhat less domical. There is an even more significant difference, too often overlooked by art historians, in which resides the secret of Gothic as opposed to Romanesque vaulting: the conoids (the conelike shapes formed by the convergence of ribs and vault surfaces on the capitals of the colonnettes) are sharply pinched together on the side next to the clerestory. This pinching of the conoids frees the diagonal ribs from the clerestory, allowing them to establish their own positions in space. The thrust of the vaults seems to have been contained by the girdle of the gallery, but in the thirteenth century cautious architects added flying buttresses on the exterior (for an explanation of and a look at flying buttresses, see page 455; figs. 577, 591).

NOTRE-DAME AT PARIS The façade of Notre-Dame at Paris (fig. 581) was planned about 1200 and completed about 1250. The dramatic effects of Laon are avoided; the elements are brought under the control

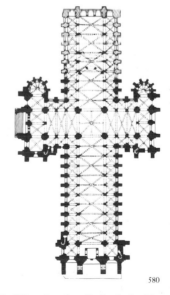

578. West façade, Cathedral of Laon, France. c. 1190

579. Choir, Cathedral of Laon

580. Plan of the Cathedral of Laon. Begun c. 1160 (After E. Gall)

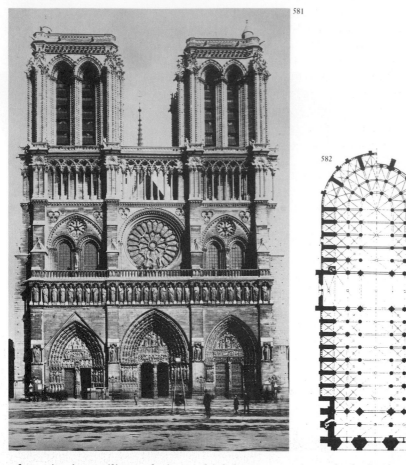

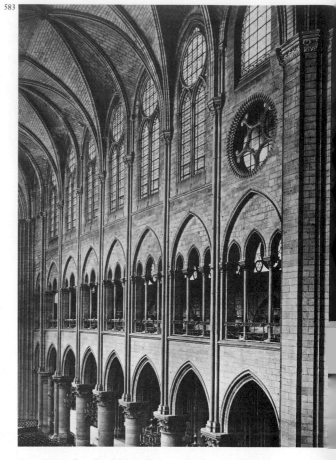

581. West façade, Notre-Dame, Paris. c. 1200–50

582. Plan of Notre-Dame, Paris. 1163–c. 1250

583. Nave, Notre-Dame, Paris. 1163–c. 1200

of a majestic rectilinear design, which has won universal admiration. The porches are retracted into the mass of the building, and the towers rise only a single story above the nave roof, which can be seen through the screen of tracery. The coupled windows of the towers were widely imitated. The plan of the church (fig. 582), laid out about 1163, is much more regular than that of Laon. The nave is ten bays long, the choir before the apse exactly half that; the apse vault is divided into five compartments. Instead of the wide transepts of Laon, those of Notre-Dame are retracted like the porches so that they hardly project beyond the church. Intended for a larger city, Notre-Dame has four side aisles rather than the customary two (the outer line of chapels was added between the buttresses in the thirteenth century, thereby darkening the interior).

But the interior design of Notre-Dame proved obsolete within sixty years. Only the last bay on the right (fig. 583), next to the crossing, shows the original four-story design of the nave, with a triforium made up of tiny rose windows (the remaining one has been much restored) and a small clerestory. About the middle of the thirteenth century, the original row of flying buttresses in the nave (required to supplement the containing action of the gallery) was replaced by the present ones, and the clerestory was greatly enlarged into tall windows filled with tracery extending well below the springing points of the vaults, influenced by developments at Chartres, Reims, and Amiens. The photograph renders it clear that the pinching of the conoids by the original architect made this "modernization" possible, as it allowed the diagonal ribs to pass freely across the edge of the clerestory windows. Each rib, incidentally, is channeled so that the appearance of a cluster is maintained at all points from the capitals to the vault. The vaults are still slightly domical, but have been carried to a height of 107 feet, 27 feet higher than those at Laon and higher than any Romanesque vaults except those of Speyer Cathedral.

CHARTRES The fire of 1194, which consumed the town and the Romanesque Cathedral of Chartres, except for the two towers and the Royal Portal, gave Gothic architects the opportunity to take the next and definitive step, which ushered in the phase known as High Gothic. After the conflagration at Chartres, almost every old cathedral in northern France and some in Germany caught fire when it seemed most opportune to replace them with Gothic ones. The Cathedral of Chartres is the most nearly complete of all in architecture, sculpture, and stained glass, and it demands study as an integrated whole. Smaller than Paris, the town of Chartres needed a cathedral with a nave of only seven bays and a choir of four, and two side aisles (fig. 584). Nonetheless, the vaults rise to a height of 118 feet in one unbroken ascent.

The architect eliminated the gallery, since flying buttresses were, for the first time, planned from the start. Only a small triforium separates the clerestory from the nave arcade (fig. 585). Liberated from the vaults, the clerestory has become almost equal in height to the nave arcade, and now dominates the interior. The cylindrical piers, still inviolate at Laon and at Notre-Dame in Paris, have now been absorbed into the skeletal system; the colonnettes supporting the transverse ribs are coupled to the piers and run straight to the floor. The resulting new type of compound pier became universal. The six-part vault is given up as unwieldy, and the interior thus presents a more unified appearance. In the choir the enlarged clerestory is composed of simple lancet (single pointed-arch) windows, but in the nave the windows are filled with tracery, achieved by piercing the wall of each bay with two lancets under a small rose; this form is known as plate tracery. At the crossing the four supporting piers have been enriched with colonnettes, in the manner of clustered organ pipes, to great effect.

The massive buttresses (see fig. 574) rise in steps to a height far above the sloping roof of the side aisle, to be connected with the clerestory by means of two slanting, superimposed arches joined together by a tiny arcade. These are flying buttresses, which "fly" from the buttresses to make contact with the clerestory at the two points where, so the architects believed, pressure was necessary to counteract the outward thrust of the nave vaults. A third flying buttress, above the other two, added a few years later, was probably intended to help the heavy timber and lead roof over the vaults resist the action of the wind. With the adoption of flying buttresses the concept of skeletal architecture began to determine the exterior as well as the interior appearance of a building; every exterior member corresponds to a necessity created by an interior pressure. The resultant Gothic structural system has been aptly termed an exoskeleton.

Chartres was planned for two western façade towers, two flanking each arm of the transept, and one flanking each side of the choir, or a total of eight; all but the western towers were left unfinished at the height of the vaults. The south transept façade (fig. 586), built about 1215–20, shows a richness of articulation far beyond that of the main façade of Notre-Dame, designed only a few years earlier; slender colonnettes, like those at the crossing, screen the buttresses. The projecting triple porch was an afterthought, added to the portal after the sculpture.

The three portal statues of standing saints to the right (fig. 587) are still columnar, but when compared with those of the Royal Portal, they are partially liberated from the architecture and stand on pedestals more nearly suited to their function; on these pedestals are figures or images alluding to the legend of each saint. The wealth of tiny sculptures above the statues of the Royal Portal has been replaced here by naturalistic foliate capitals, enshadowed by greatly enlarged canopies, which re-

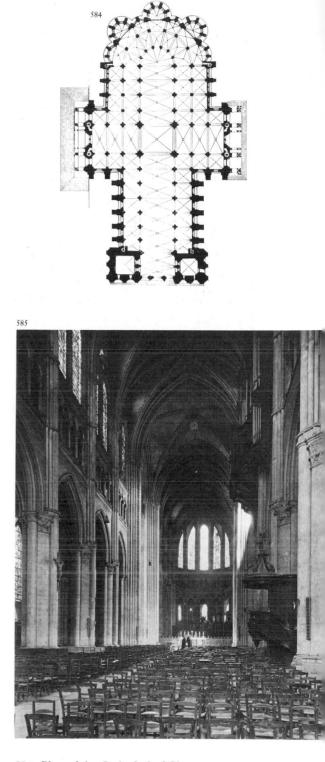

584. Plan of the Cathedral of Chartres. 1194–1220 (After G. Dehio)

585. Nave, Cathedral of Chartres. 1194–1220

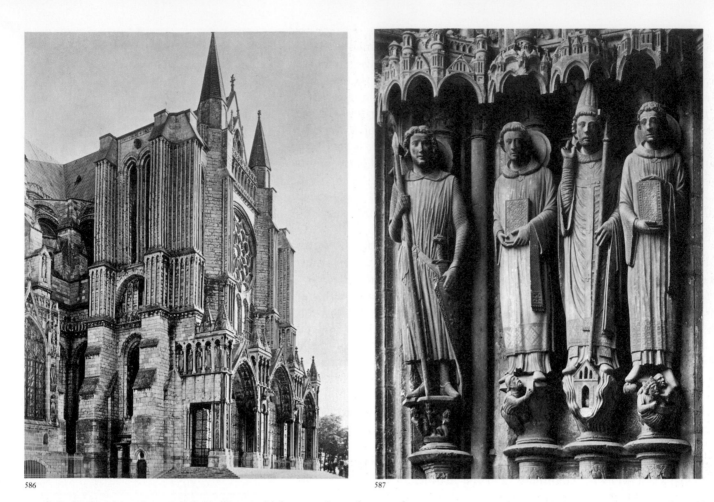

586

587

semble little city views with arches, windows, pinnacles, and towers.
The portrait-like heads are thrown into stronger light against the shadow,
and the figures, wrapped in complete cylindrical envelopes of drapery,
are far more strongly projected than those of the Royal Portal.

The statue at the left, probably representing Saint Theodore, was
added at the same time as the porch and shows an increased freedom of
style. For the first time since Roman art a figure is balanced with the
weight largely on the right foot and the left leg at least partially free.
Gothic sculpture seems in a way to recapitulate the development of
sculpture in Greece from the late Archaic to the Severe Style (see figs.
203, 212), with the crucial difference that in Christian art the movement
of the figure must be carried out under voluminous clothing. Once estab-
lished in the portal figures of Chartres, the freedom of the figure from the
architecture increased, as did the freedom of the architectural members
themselves from the obsolete concept of the wall. With his knightly atti-
tude, his spear at the ready, and his calm, handsome face, Saint Theodore
seems the very ideal of the Christian warrior fostered by the Crusades.

The lightening and heightening of Gothic cathedrals cannot be ade-
quately explained by the desire for illumination—that, as we have seen,
could have been handled by a system along the lines of Saint-Philibert at
Tournus (see fig. 523). The entire cathedral in the twelfth and thirteenth
centuries became a framework to hold stained glass. Stained glass inevi-
tably darkened the interior but had its own indescribable beauty of color
and pattern. Much Gothic stained glass has perished, some deliberately
destroyed in later times either by Protestant reformers or simply in order
to lighten cathedral interiors. Chartres contains the most nearly complete
cycle of medieval stained glass, much of it in good condition, from the
twelfth-century lancets above the Royal Portal to the thirteenth-century

586. Façade of the south transept, Cathedral of
Chartres. c. 1215–20

587. Jamb statues, south transept portal, Cathe-
dral of Chartres. c. 1215–20

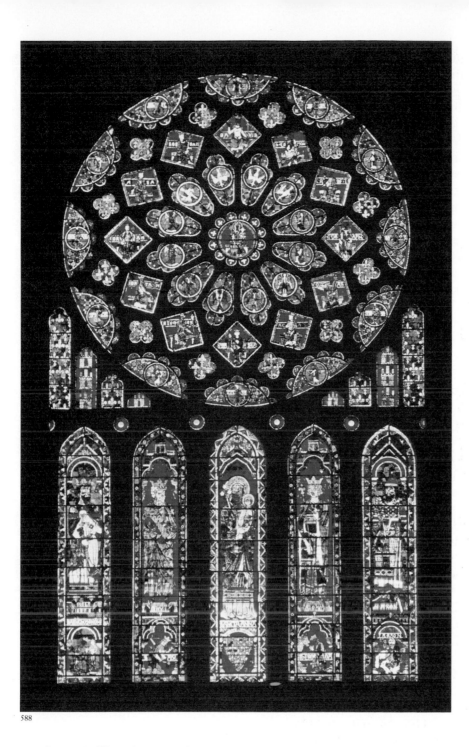

588. Rose window and lancet windows, north transept, Cathedral of Chartres. Stained glass. 13th century

windows girdling the rest of the church. Between the windows, some of which have scores of separate, carefully organized subjects, and the innumerable sculptures on the three triple portals, it takes a studious visitor several days, guidebook in hand, just to identify all the images. One comes away from such an experience with a deep respect for the Middle Ages, because the representations encompass the entire range of medieval knowledge—Old and New Testaments, lives of the saints, fundamentals of Christian doctrine, labors of the months, signs of the zodiac, Virtues and Vices, and the activities of the guilds that contributed to the building of the cathedral.

The gigantic window of the north arm of the transept (fig. 588) is a rose, still in the form of plate tracery, above five lancets. In the central lancet, Saint Anne, mother of the Virgin, holds her child; she is flanked by two kings, David to the left and Solomon to the right. Two high

priests, Melchizedek to the left and Aaron to the right, flank the kings. The rose above, more than forty-two feet in diameter, shows Mary in the center enthroned as Queen of Heaven holding the Christ Child. With the growth of the cult of the Virgin, under the direct influence of Saint Bernard, Mary has now displaced the Romanesque Christ in Majesty and the Byzantine Pantocrator. In the next circle four doves indicating the Gospels proceed toward Mary, and below them eight angels kneel or stand in adoration. Twelve kings from the Old Testament, clearly labeled, all ancestors of Christ, sit in the next circle of twelve lozenges. Finally, in the twelve semicircles around the rim stand prophets. Significantly enough, the twelve quatrefoil (four-leaf) shapes between the kings and the prophets are filled with the golden lilies of the kings of France on a blue field.

Stained glass achieves its effect by the passage of sunlight through it rather than by the reflection of light from it, as in mosaics. Stained glass is, therefore, the most brilliant coloristic medium invented by man before the light sculpture of the twentieth century. It is best to experience the stained-glass windows of Chartres (or any other Gothic church) in the gray weather all too common in northern France, for which this glass was planned; otherwise, the glitter from the south windows not only destroys their unity but also cancels out the glow from the north. In the early morning or in the late afternoon the colored windows float like immense jewels in the dim interior. Medieval theologians saw in the beauty of stained glass a symbol of the sacred mystery of the Incarnation, for as Divine Light, which is Christ (see fig. 431), entered the human body of Mary without violating her virginity and took on mortal flesh, so the light of the sun passes through colored glass without breaking it and assumes its color.

In thirteenth-century glass the predominant colors are red and blue; white, yellow, and green appear, but the red and blue contrast is what one remembers. Unlike mosaics, which are made up of uniform tesserae, stained glass is fabricated from pieces shaped as closely as possible to the contour of a section of face, figure, drapery, or background. First, a full-scale model is made, drawn on wood or later on paper, and the pieces of colored glass are cut to fit. The lines are then painted on the glass with a dark pigment. After this paint dries, a coating of pigment is sometimes applied and scraped away with a stiff brush while still wet, so that what remains in the hollows will increase the sparkle of the underlying color. The pieces are then fired (baked) in a kiln, so that the pigment will harden and at least partially amalgamate with the glass. Finally, the pieces are arranged on the model and joined together by lead soldering strips. Each scene is enclosed in an iron frame, and the frames bolted together within the tracery so that they can easily be taken down for repairs.

In two panels from a twelfth-century window in the façade at Chartres (fig. 589), a *Noli me tangere* ("Do not touch me," the words spoken by the resurrected Christ to Mary Magdalen in the garden) and a *Crucifixion*, the technique can be clearly seen. The lines of the pigment closely resemble those of the drapery and hair of the sculpture in the Royal Portal below (see fig. 576). The lead contours, a bit disturbing in black-and-white reproductions, serve in the colored original to reinforce by contrast the glowing splendor of the glass. The iron frames were often set into an elaborate master design built up of lozenges and circles. Panels of colored glass were known from early Christian times and were certainly used in Constantinian basilicas, as well as later in Hagia Sophia and in other Byzantine churches. They also appeared commonly in mosques. But glass treated in this manner does not seem to have been known before Carolingian times, and only a few fragments that date before the Romanesque

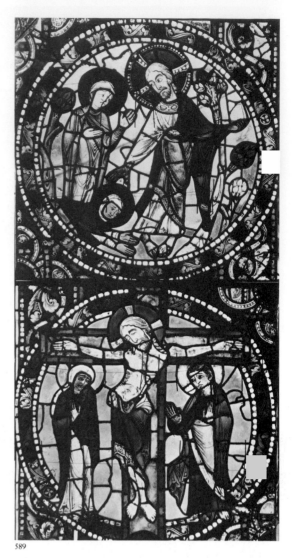
589

589. *Noli me tangere* and *Crucifixion* (details of a stained-glass window, Cathedral of Chartres). 12th century

period remain. Only in Gothic architecture does such stained glass become universal.

BOURGES The architectural arrangement established at Chartres became the model for most High Gothic cathedrals, but there is a beautiful variant at Bourges in central France, where the Cathedral has four side aisles (fig. 590) as at Notre-Dame in Paris. So that the inner side aisles would not be dark, the architect raised them above the outer side aisles, giving them triforia and clerestories of their own and thereby making them look like complete three-story naves. The nave arcade in turn rises above the inner side aisles, supporting still another triforium and another clerestory. The spatial effect is very open, with views out on every side. The absence of a transept at Bourges affords the eye a clean sweep of arches from façade to apse.

LE MANS The brilliant device at Bourges was seldom repeated in France. In the artistic vocabulary of the High Gothic, the façade with its two towers soon came to compete in interest with the *chevet*—the apse, with its radiating chapels and flying buttresses, crowned by a conical roof. Le Mans Cathedral has the most spectacular chevet in France (fig. 591), in compensation, perhaps, for its low and unobtrusive late Romanesque nave, contrasting with the High Gothic choir, built between 1217 and 1254. As at Bourges, the inner ambulatory has its own clerestory above the radiating chapels, and the windows pile up in three stories. Two flights of flying buttresses carry the thrust of the choir vaults across the intervening ambulatory, and to abut the thrust of the ambulatory

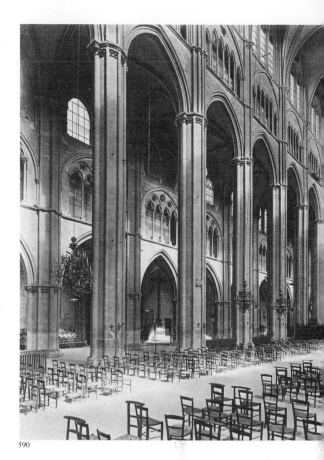

590

590. Nave and aisles, Cathedral of Bourges, France. 12th–13th century

591. Exterior of the chevet, Cathedral of Le Mans, France. 1217–54

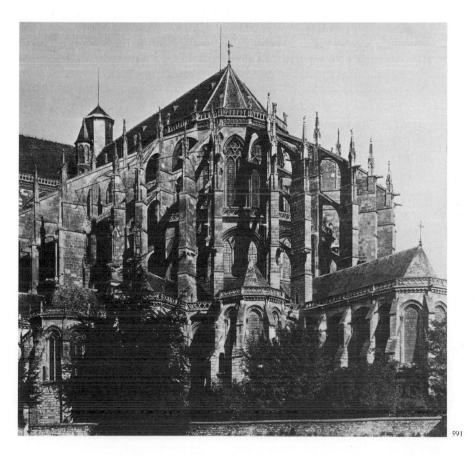

591

vaults they divide in a Y-shape. The lines have been kept as clean and orderly as those of a flight of wild geese, massing in perfect harmony buttresses, flying buttresses, pinnacles, windows, and conical roof.

REIMS The Cathedral of Reims, in Champagne in northeastern France, was traditionally the coronation church of the French kings. Designed in 1210 (after a fire), probably by Jean d'Orbais, Reims was intended for six towers and a central spire; only the façade towers rise above the roof. At first sight the interior (fig. 592) resembles that of Chartres, with four-part vaults, cylindrical compound piers, three stories, lofty clerestory, and colonnettes rising from floor to vault interrupted only by capitals and rings to mark the stories. The height of the vault has risen to 127 feet, and three additional differences are visible in the illustration. First, the arches are more sharply pointed than those at Chartres, which increases the feeling of verticality. Second, the richly sculptured capitals are composed of naturalistic foliage that seems to follow no predetermined scheme but to grow in place. Finally, a new kind of tracery appears—bar tracery, erected as a linear fabric of slender pieces of stone inside the window opening, preserving only in line the arrangement of two lancets and rose as a framework for the glass.

It will be noticed that in the apse the ribs move so freely and in so

592. Nave, Cathedral of Reims, France. Begun 1210

593. West façade, Cathedral of Reims. c. 1225–99

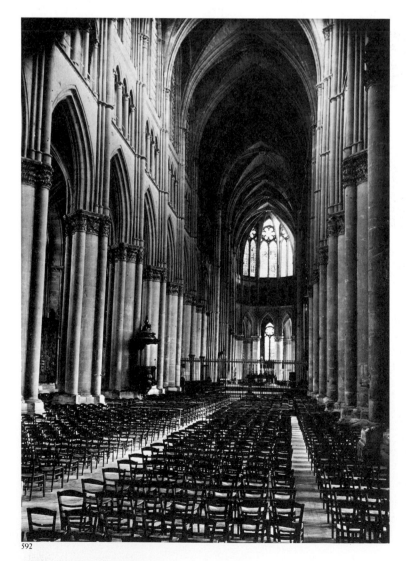

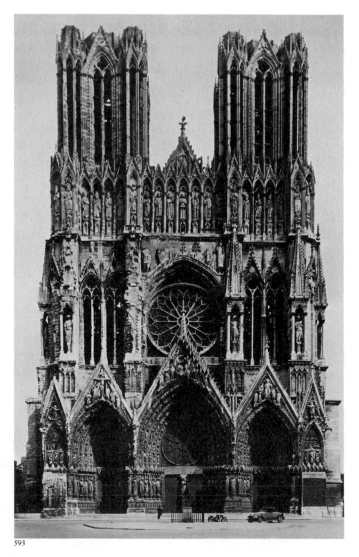

592

593

sharply pointed an arch that they actually pass in front of the clerestory windows. During World War I some of the ribs fell under bombardment, but the vaults stood, a tribute to the medieval masons. Villard de Honnecourt, as we have seen, made a careful drawing of the flying buttresses at Reims (see fig. 577), in two flights over the ambulatory as at Le Mans, and indicated the points at which they sustain the vaults. The pinnacles are not merely ornamental, but act as counterweights, helping to send the thrust of the vaults harmlessly downward to the ground.

The façade of Reims Cathedral (fig. 593) may have been started as early as 1225 but was under construction until late in the thirteenth century. The general arrangement repeats that of Notre-Dame in Paris, but the differences disclose both the rapid growth of the Gothic style and its organic character. Solid matter has been dissolved into lines moving through air, with the sole exception of the gallery in the third story, which had to be solid in order to hold statues of the French kings (added in the fourteenth century). The very tympana of the portals have given way to windows filled with bar tracery. The porches culminate in gables that move into the second story. The second story is transparent, and one looks through the open tracery of the lancet windows (they have no glass) to see the flying buttresses of the nave. The nave roof appears as a gable above the gallery. Finally, the towers, among the most beautiful creations of Gothic architecture, are entirely made of tracery with no wall surface whatever. The corner turrets, constructed completely of tracery, were intended to support corner pinnacles, whose octagonal bases can barely be distinguished, just as each central section, with its window of bar tracery and its pointed gable, was designed to support an octagonal spire.

The façade sculpture at Reims, dating from about 1225–45, continues the tendency toward freedom from architecture that had begun in the transept sculpture of Chartres, and the humanism of the figures is even more pronounced. Two groups side by side (fig. 594) were obviously made by two sculptors working in strongly individual styles and probably at slightly different times. The group to the right, done about 1225–30, depicts the Visitation, the visit of Mary to the house of her cousin Elizabeth, when the two women rejoiced in each other's pregnancy. The sculptor, while strongly aware of the call of visual reality, responds to it in a classical style. He must have seen and studied Roman sculpture during his travels. The mantles of Mary and Elizabeth sweep about their bodies and over their heads like Roman togas. Mary stands with the grace of a young Roman woman, Elizabeth with the dignity of a Roman matron. But there are differences; these poses do not entirely achieve the balance between the reciprocally tilted masses of the body that was instinctive for all ancient sculptors after about 400 B.C. The faces are only superficially classical. The folds break into more tiny facets than can be explained by the fall of the cloth. Nonetheless, we are clearly confronted with evidence of yet another renaissance of interest in ancient art, of which this is by no means the only Northern example in the thirteenth century (see fig. 615).

In the *Annunciation*, dating from the 1230s or 1240s, a very different style appears, made more apparent by the unfortunate inclusion, in a seventeenth-century restoration, of the wrong angel; he smiles a bit too broadly—though for the first time since Classical antiquity—for his religious function. His figure bends and sways in an accentuated S-curve, and his cloak is a complete and continuous fabric, which can move about his body as cloth will, responding to pressures and tugs and breaking into real folds. In the figure of Mary, shyly waiting, the change in style is

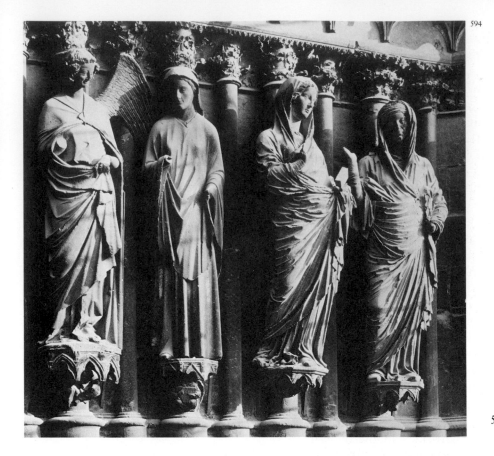

594. *Annunciation* and *Visitation*, jamb statues, west façade, Cathedral of Reims. c. 1225–45

even more surprising, because for the first time since antiquity (again) a body really shows through drapery—not just a volume of some undetermined substance, but a warm, human body. Mary's bosom can be clearly seen swelling through the soft garment that enfolds her, much as the bosom of Athena is visible through her peplos in the metope from Olympia (see fig. 224).

Another significant step was taken at Reims by the sculptor who carved, after 1251, the statues in the niches that fill the inside of the west façade. In spite of the fact that the two figures inhabit separate niches, *The Knight's Communion* (fig. 595; long misnamed *Melchizedek and Abraham*) forms a unified dramatic and compositional group. The knight, in complete chain mail, spurred, and girt with his sword (the tip has broken off), with mailed hands folded in prayer, looks from his niche toward the Eucharist extended to him from the ciborium (the appropriate vessel) by a priest who has turned toward him from a small altar. The priest, apparently a monk since secular clergy were not permitted to wear beards until the sixteenth century, is robed in a magnificent chasuble (a vestment worn by the celebrant at Mass in commemoration of the seamless robe of Christ) whose billowing folds, obscuring his body, contrast with the severe military dress of the knight. However, the artist was well aware of the proportions and movements of the masses of the body, as can be seen in the way he has handled the figure of the knight, in spite of chain mail and tunic. We have reached a Classical moment in Gothic sculpture, in which figures, fully in the round, are endowed with the capability of movement in space. The sculptor has set forth eloquently the contrast between the earnest, slightly frowning glance of the priest, with his richly curling beard, and the intense expectancy of the knight, receiving Communion presumably just before battle. The foliage of the frame is typical of High Gothic ornament, in its combination of crisp naturalism with easy rhythmic flow.

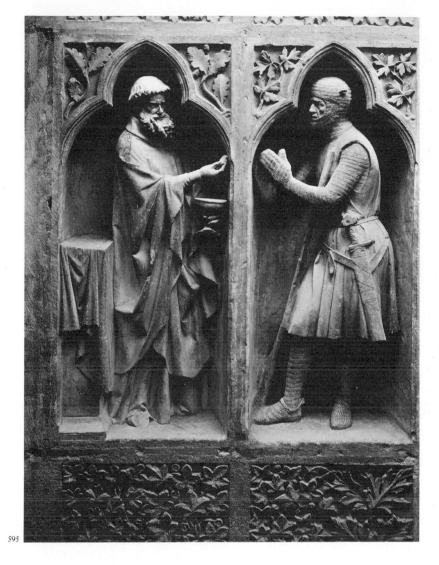

595

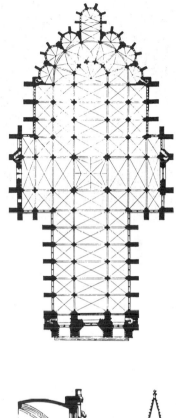

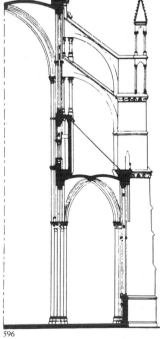

596

AMIENS The climax of the High Gothic architectural style was achieved at the Cathedral of Amiens (fig. 596), begun in 1220 by the architect Robert de Luzarches, in Picardy, due north of Paris. The soaring effect of the Amiens interior (fig. 597) surpasses that of any other Gothic cathedral; the vaults leap to a height of 144 feet. The proportions of all the elements are even more slender than at Reims. The last trace of doming is gone from the vaults, whose crown line is level. The triforium openings are filled with bar tracery rather than the continuous arcade of Reims. In the clerestory a momentous step has been taken: the same molding serves as wall rib and window frame, thus canceling out the wall. The nave of Amiens was built first; the two upper stories of the choir show still another step in the direction of dematerialization, probably taken by Robert de Luzarches' successor, Thomas de Cormont, after 1258. The roof covering the ambulatory vaults is no longer sloping, but converted into a succession of pyramidal caps, one over each bay. This change permitted the architect to turn the triforium into a second row of windows, greatly lightening the interior, which now looks bare without its stained glass. As the photograph of the choir vaults from below clearly shows (fig. 598), the entire cathedral has become a cage of delicate stone members—colonnettes, ribs, tracery—to hold the vault surfaces above and the stained glass on the sides. Mass has been almost totally replaced by linear fabric. This ultimate phase of the High Gothic style in France

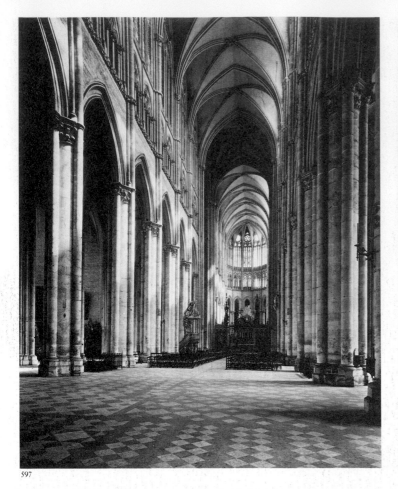

597

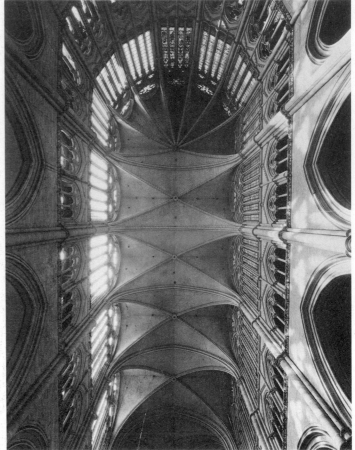

598

is called the Rayonnant on account of the tracery patterns that in the rose windows expand like rays.

The flying buttresses of the nave at Amiens resemble those at Reims, but those of the choir show a transformation, again probably due to Thomas de Cormont, and teach a striking lesson in the combined imaginative daring and structural logic of Gothic building. The architect has largely dematerialized the very device on which he depends for the support of the building: the flying buttress itself (fig. 599) is composed of bar tracery, connecting an upper strut and a lower arch, which were clearly sufficient to sustain the thrust of the slender vaults. Even the buttresses and their pinnacles have been decorated by a fabric of applied colonnettes and arches, which have no structural function but make the solid masses appear lighter and more vertical. As a final touch, the choir windows, one of which is to be seen at the right of the illustration, are surmounted by false gables made of tracery in order to dissolve the last remaining strip of wall above the window and to break the horizontal line of the cornice molding.

As compared with those of Laon, Paris, and Reims, the façade of Amiens (fig. 600), probably begun in 1220, is not a complete success. The center pinnacle marks the height of the nave roof, almost level with the south tower. From the side view the height of the church is so great as to render towers superfluous. The unity of the façade at Amiens is also disturbed by the much later—and in themselves very fine—rose window and details crowning the towers and the screen, belonging to the Flamboyant phase (see page 469). However, the Amiens portals contain sculpture of great dignity, especially the statue of *Christ Treading on the Lion and the Basilisk* (fig. 601; compare with the earlier version of the same theme in fig. 508), which stands against the trumeau of the central portal. Stylistically, the figure, with its firm stance and flowing but controlled drap-

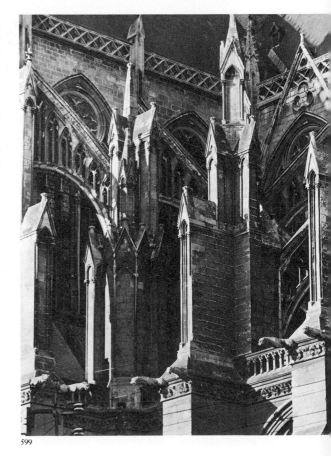

599

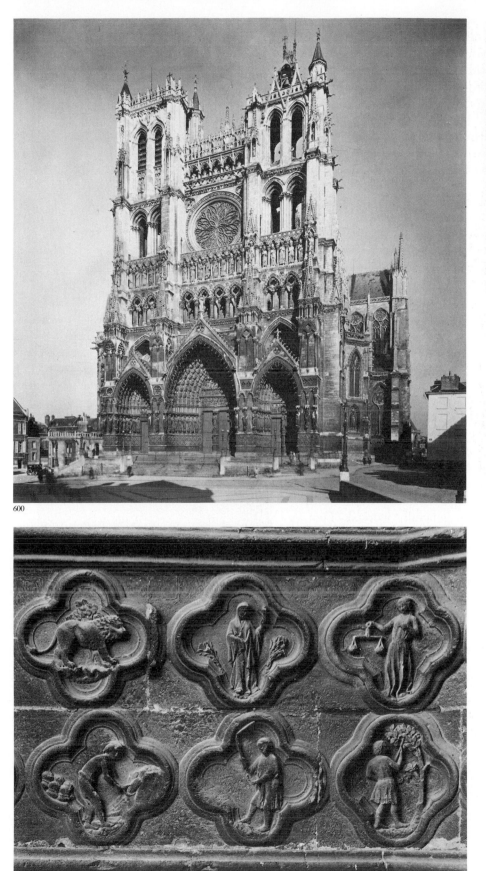

600

602

601

597. ROBERT DE LUZARCHES. Nave, Cathedral of Amiens

598. Choir vaults, Cathedral of Amiens (view from below)

599. View of choir and south transept, Cathedral of Amiens, showing flying buttresses

600. West façade, Cathedral of Amiens

601. *Christ Treading on the Lion and the Basilisk*, central portal of the west façade, Cathedral of Amiens. c. 1230

602. *Signs of the Zodiac* and *Labors of the Months* (detail), reliefs on the portal jamb of the west façade, Cathedral of Amiens. c. 1220–30

ery folds, represents a stage between that of the transept sculpture at Chartres and the highly developed naturalistic and classicistic statues at Reims. Nicknamed locally "le beau Dieu," the image is that of a man in early maturity, with straight nose, broad brow, calm expression, short beard, and flowing hair. With a few striking exceptions, this is the Christ-type that has replaced in Western imagination both the Apollonian youth of the Ravenna mosaics and the awesome Pantocrator of Byzantine art. It is a remarkable paradox that Gothic artists should have populated their dematerialized, linear cathedrals with believable, many-faceted, and very solid images of complete human beings, even when it was necessary to portray the second person of the Trinity. The canopy over Christ's head, instead of showing the usual generalized array of domes and towers, is a tiny model of a Gothic chevet, with radiating chapels, possibly a reminder that the apse of a cathedral embraces the Eucharistic Christ of the Mass. The nobility of the Amiens statues contrasts with the vivid naturalism of the little scenes from the Old and New Testaments, and from such allegorical cycles as the Virtues and Vices, the signs of the zodiac, and the labors of the months, which appear in low relief in the quatrefoils on the bases of the portal jambs (fig. 602).

BEAUVAIS The practical limit of the Gothic dream was reached at Amiens. About 1225 the architect who designed the Cathedral of Beauvais (fig. 603), located between Paris and Amiens, tried to surpass it. By 1272 the lofty skeleton of stone, with a glazed triforium as at Amiens, had reached the unbelievable height of 157 feet above the floor. Then in 1284, before the transept could be completed, the choir vault fell, leaving only the apse vault standing. Collapses like this, frequent in the Romanesque period, were rare in the thirteenth century, when architects had, through trial and error, arrived at a system that generally worked. The reason for the disaster at Beauvais is not entirely understood; it may have been a matter of inadequate foundations. In any event the choir was rebuilt, the number of supports and flying buttresses being doubled and old-fashioned six-part vaults being revived for the last time. The building of the transept lagged on into the fourteenth century, with yet another calamity, the fall of a tower, and then the money ran out. From the outside the truncated choir, towering sadly above the Carolingian nave, is a monument to the unattainable, but the effect of the interior, catapulting in one leap from floor to lofty vault, is exhilarating.

THE SAINTE-CHAPELLE IN PARIS In contrast to the Beauvais catastrophe, the small-scale Sainte-Chapelle in Paris is a brilliant achievement of the Rayonnant style. The chapel was built from 1243 to 1248 by Louis IX of France, later canonized as Saint Louis, to enshrine relics of the Crucifixion. Louis met these relics, which were brought to France from Syria and Constantinople, at the gates of Paris and walked barefoot behind them in solemn procession. Although deprived of its surrounding buildings, and badly repainted in the nineteenth century, the chapel is structurally intact. It consists of a lower and rather modest story supporting an upper chapel that represents the utter perfection of the High Gothic (fig. 604), a delicate framework of slender stone elements enclosing stained-glass windows. As there are no side aisles, flying buttresses were not required. Only a small strip of wall remains below the windows, broken at the right by a simple niche. Behind and above the usual location of the altar stands a Gothic shrine in which the relics were

603. Interior, Cathedral of Beauvais, France. c. 1225

604. Interior, Ste.-Chapelle, Paris. 1243–48

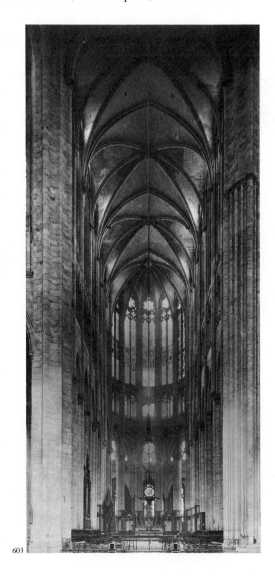

603

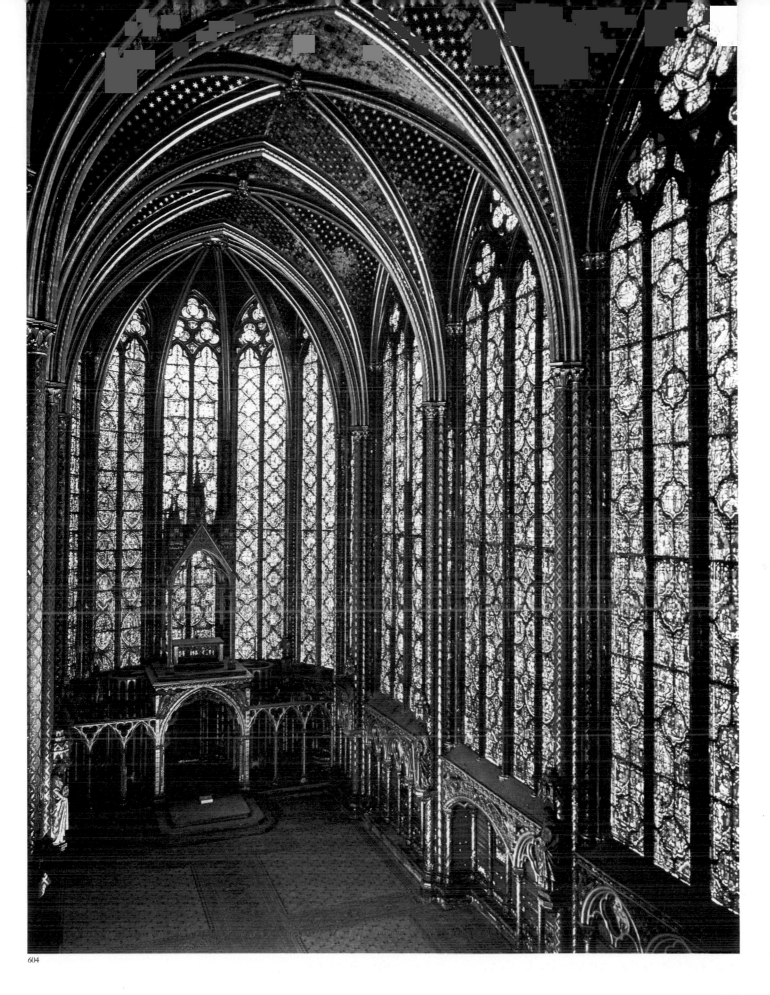

604

kept and from which they could be displayed. For completeness and for quality the stained-glass windows of the Sainte-Chapelle compete only with those at Chartres. Their innumerable scenes organized as parallels between Old and New Testaments are small, and the upper ones are not easy to read from the floor—a problem we have encountered before in the sculpture of the Column of Trajan (see fig. 352). From a slight distance the windows fuse into an indescribable radiance of red and blue.

Never before or again in the history of art was architecture so completely dominant as in the Gothic period in France. Pictorial imagination was directed toward stained glass rather than mural painting, for which few wall surfaces remained in Gothic churches outside Italy. Even illuminated manuscripts, which survive in great numbers from this period, are dominated on every page by architectural concepts. One of the finest is a *Bible Moralisée* (moralized Bible—a collection of biblical passages and illustrations arranged as parallels between Old and New Testaments, as, for example, in the manner of the windows of the Sainte-Chapelle), probably written and illustrated in the mid-thirteenth century at Reims for Thibaut V, count of Champagne and king of Navarre, and his wife Isabelle, daughter of Louis IX. On one magnificent page God himself is shown as an architect, using that indispensable tool of architectural draftsmanship, the compass, to create heaven and earth, which "was without form, and void" (see fig. 12). The artist has imagined the Deity on such a cosmic scale that the universe is literally in his hand. The border, brilliant in its flashing alternation of patterned red and blue, is insufficient to contain him as he strides through space. The folds of his blue tunic and rose mantle, lined respectively with orange and yellow, are depicted in a free pictorial approximation of the parallel folds of the classicistic sculpture of Reims Cathedral. The artist has imagined the Creation as a moment of intense artistic inspiration; the Lord's eyes are dilated, his mouth slightly open, as he measures the circle containing green and blue waters, dark blue sky with stars, sun, and moon, and a still formless earth, giving it form by a supreme act of creative will. As often in Gothic art, the Lord's appearance is youthful and his halo contains the Cross of Christ, intended to show that not just God the Father but all three persons of the Trinity, under the guise of God the Son, were present at Creation. This unforgettable image should be compared with the totally different view of Creation in the Renaissance.

A dazzling page in the *Psalter of Saint Louis* (fig. 607), made for Louis IX and datable between 1253 and 1270, represents the appearance of the three angels to Abraham and the supper served them by Abraham and Sarah, the two incidents separated by the beautifully ornamentalized oak at Mamre. The excitement of the painting, which vibrates with brilliant color and tense, incisive line, could hardly be more different from the serene icon by Andrei Rublev dedicated to a synthesis of the same subject (see fig. 460). The elegant, swaying figures with tiny hands and feet are embraced, as often in Gothic illumination, by shapes derived from cathedral architecture. The gables and tracery are recognizable as belonging to the period of the choir of Amiens (see fig. 599), and a clerestory can be seen, too. As in stained glass, red and blue, white and green predominate. The border, which Saint Bernard would have hated, repeats the theme of animal interlace, whose origin we have traced to barbarian art.

French Manuscripts

After the thirteenth century, the pace of church building slowed in the domain of the French kings; almost every town that could afford a Gothic cathedral had built one. But in spite of constant warfare with the English, who controlled Normandy and much of western France, the elaborate and expensive process of finishing towers, façades, and gables continued in an always more imaginative style. The latest phase, beginning in the middle of the fourteenth century, is known as the Flamboyant because of the characteristic flamelike shapes of the tracery, based on double curvature rather than on the logical mullions, pointed arches, and circles of the High Gothic. A striking example is the rose window of Amiens Cathedral, done about 1500 (see fig. 600).

SAINT-MACLOU AT ROUEN The climax of the Flamboyant style is represented by the façade of the Church of Saint-Maclou (figs. 605, 606) at Rouen, the capital of Normandy, built in the early sixteenth century, the moment of the High Renaissance in Florence and Rome. The lower portion of the façade bays sharply outward. Of the five apparent portals, two are blind. No inert surfaces remain; transparent, linear shapes of stone merge with each other as they flicker upward, the transparent central gable even passing in front of the rose window. Only the main contours of the flying buttresses, gables, and arches are still apparent, drawn in thin air with lines of stone; the rest is sheer fantasy.

THE HOUSE OF JACQUES COEUR The finest surviving monument of late Gothic domestic architecture is the mansion (fig. 608) built at Bourges from 1443 to 1451 by the wealthy merchant Jacques Coeur, Treasurer to Charles VIII of France during and after the unhappy period when this weak monarch, driven out of Paris by the English, was known disparagingly as the king of Bourges. The house is a freely arranged succession of blocks, with steeply pitched roofs of different heights, the highest being reserved for the owner's private chapel with a Flamboyant window located over the main entrance. Flamboyant ornament is restricted to the balustrades at the eaves, to the panels under the windows, and to the rich staircase tower, ending in an openwork octagonal cap. This delightful, asymmetrical structure, with its inviting appearance of improvisation, should be compared with the rigidly symmetrical palaces being built by the same merchant class in Italy at the same moment. Alas, Jacques Coeur had only two years to enjoy his house before he was falsely accused of attempting to poison the king's mistress and had to flee France.

SCULPTURE AND PAINTING The sculptural style of the fourteenth century does not continue either the classicistic or the naturalistic tendencies we have seen in the sculpture of the great cathedrals. A typical early-fourteenth-century example, the *Virgin of Paris* (fig. 609; originally from the Church of Saint-Aignan), moves with an elegant lassitude that embodies the ultimate in courtly aloofness. The face looks almost Far Eastern in its soft contours and slightly slanting eyes. The folds, despite the sculptor's exact observation of the behavior of cloth, are nonetheless so voluminous that they give little hint of the Virgin's body beneath them. She wears her heavy crown with languid grace, but her pose, one hip sharply moved to the left to support the Child, shows a distinct element of exaggeration. Nonetheless, the sculptor has observed a delicate and

The Later Gothic in France

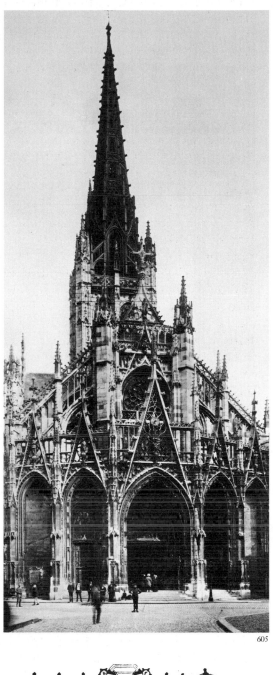

605

606

605. West façade, St.-Maclou, Rouen, France. Early 16th century

606. Plan of St.-Maclou, Rouen

607

affectionate byplay between mother and Child as the babe holds the orb of power in his left hand and toys with her mantle with his right.

Fourteenth-century painting in France, luxurious and worldly, may be represented by a delightful page from the *Belleville Breviary* (fig. 610), illuminated at Paris about 1323–26 and attributed to Jean Pucelle, a still-undefined artistic personality. The architectural frame of the thirteenth century has been replaced by a delicate border of gold and blue; at the upper left a painting of *David Before Saul* was either executed under direct Italian influence or painted by an Italian artist. At the bottom of the page the French style reappears, in the tiny strip representing at the left Cain killing Abel, in the center the Eucharist offered by a priest to the dove of the Holy Spirit, and on the right Charity as a queen, assisted in her almsgiving by the Hand of God. A breviary is a book containing the

607. *Abraham and the Three Angels*, illumination from the *Psalter of Saint Louis*. Paris, 1253–70. Bibliothèque Nationale, Paris

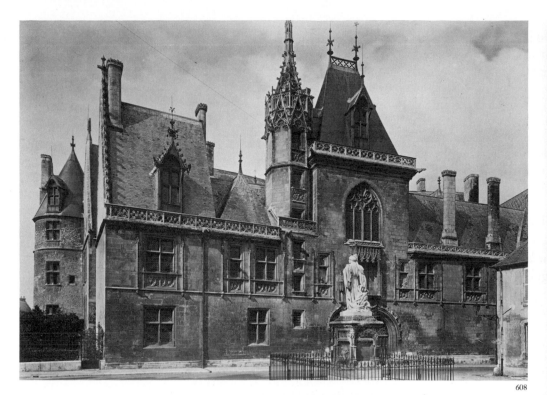

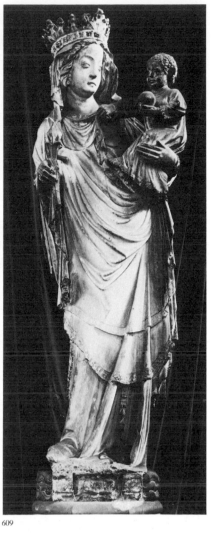

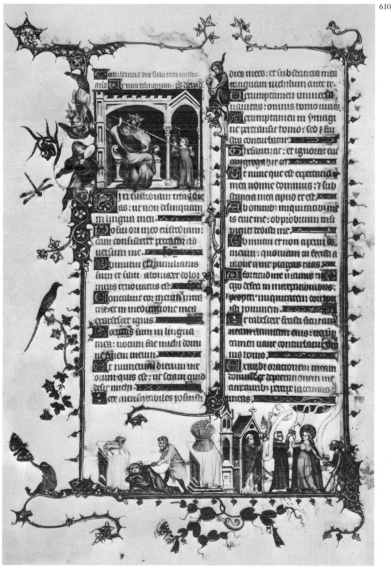

608. Palais Jacques Coeur, Bourges, France.
1443–51

609. *Virgin of Paris*, from St.-Aignan. Early 14th
century. Stone. Notre-Dame, Paris

610. JEAN PUCELLE. Page of the *Belleville Breviary*.
Paris, c. 1323–26. Illumination. Bibliothèque
Nationale, Paris

readings for the Divine Offices; yet the patron who ordered the manu-script and the artists who illuminated it had other concerns as well as the strictly religious, as a glance at the border will reveal. The animal inter-lace has disappeared, but animals, birds, and insects have been revived in very lifelike terms—a beautifully painted pheasant, a dragonfly, a but-terfly, a monkey, a snail, a dragon, among which three musicians play a lute, a bagpipe, and a flute. What we witness in these caprices of sculp-ture and painting, which lingered into the fifteenth century, is the first glimmer of a new and exciting naturalistic style.

COLOGNE CATHEDRAL At first French Gothic was imported directly into the Rhineland, which was already amply provided with massive, apparently fireproof Romanesque double-ended cathedrals. When the Carolingian Cathedral of Cologne burned down in 1248, Bishop Ger-hard was ready with complete plans for a Gothic replacement; work started within three and a half months. Building continued into the fourteenth century, then languished, and the choir remained incomplete. Only the lower story of the south tower had been built; unexpectedly, in the nine-teenth century a large and detailed drawing for the façade and the towers, dating from about 1320, came to light, and the rest of the Cathedral was then completed with remarkable accuracy.

While the details of the nave and façade betray nineteenth-century handling, the general appearance of the Cathedral (fig. 611) is correct,

Germany

611. Cathedral of Cologne, Germany. 1248–1322

612. Choir, Cathedral of Cologne

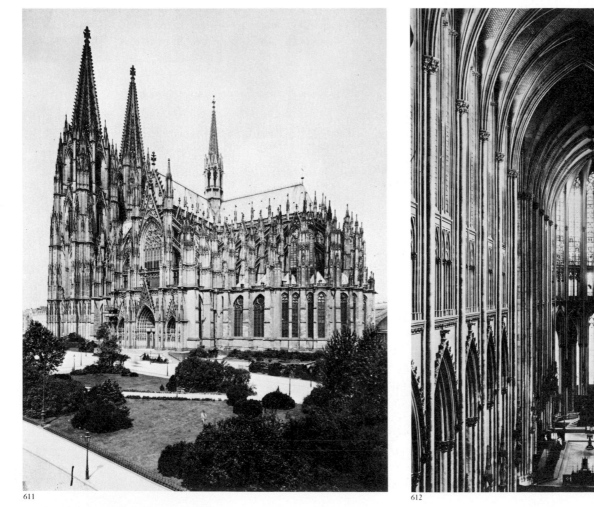

and overwhelming. The interior (fig. 612) is only slightly less daring than Beauvais in its verticality and slenderness, and the glazed triforium may even have been designed earlier than the one by Thomas de Cormont at Amiens. The French would probably never have countenanced the profusion of heavy foliate ornament around the arches of the arcade, but otherwise the interior is French. So indeed are the tracery flying buttresses and the pinnacles veiled in tracery, as well as the gables over the clerestory windows. But French architects had never solved the problem posed by the effect of a lofty church on the design of the towers. The fourteenth-century architect at Cologne made a fresh start, treating the second stories of his towers as extensions of the clerestory, imposing majestic third and fourth stories, and bringing the towers to a brilliant climax in two pointed tracery spires.

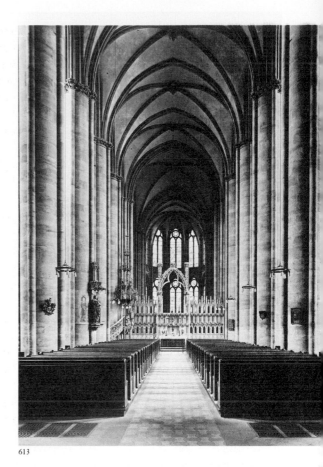

613

613. Interior, St. Elizabeth, Marburg, Germany. 1235–83

SAINT ELIZABETH AT MARBURG The basically French plan at Cologne was not popular in Germany; almost contemporary with it appeared a more influential design, the *Hallenkirche* (hall-church), of which an early example is the Church of Saint Elizabeth at Marburg (fig. 613), dating from 1235 to 1283. In this type, widely followed throughout Central Europe (and, oddly enough, also in southern France), the nave and side aisles are the same height, eliminating the necessity for flying buttresses. Although exterior forms and interior spaces are inevitably less dramatic in the Hallenkirche type, space does flow more freely throughout the church, rendering it especially suitable for preaching. Later German Gothic architecture pursues a course similar to that of the Flamboyant phase of French Gothic, concentrating, however, on strikingly original and purely ornamental solutions of vaulting problems, throughout not only southern Germany but Austria and Bohemia.

NICHOLAS OF VERDUN German thirteenth-century sculpture can scarcely be understood without a consideration of the art of metalwork, highly regarded in the Middle Ages, and without a return to the valley of the Meuse, where in the twelfth century the classicism of Renier de Huy (see fig. 539) held sway at Liège. Another master from the same region, Nicholas of Verdun, had great success in Germany. In 1181 he completed an extensive cycle of gold and enamel scenes for a pulpit at the Abbey of Klosterneuburg, not far from Vienna; these were later remounted to form an altarpiece. The persistent debate as to whether Nicholas' style should be considered Romanesque or Early Gothic should be settled by the characteristically Gothic trefoil (three-lobed) arches of the borders. Nicholas' strong classicism is also Gothic in the sense that all his figures stand or move firmly on the ground, and though the drapery lines still retain some Romanesque ornamental character, the convincing action poses and the thoroughly consistent drapery folds are Gothic. The *Sacrifice of Isaac* (fig. 614) is presented in terms of physical action; the angel swoops down to withhold Abraham's sword, as he holds Isaac bound upon the altar. The stormy movement brings back memories of Hellenistic sculpture, and perhaps more relevant echoes of Nerezi (see fig. 451). This scene should be compared with Lorenzo Ghiberti's rendering of the same incident at the beginning of the Italian Renaissance.

The Klosterneuburg plaques were followed by the gold figures of the rich Shrine of the Three Kings, made by Nicholas about 1182–90 for the Cathedral of Cologne. The *Prophet Habakkuk* (fig. 615) is surely one of the

most classicistic figures of the entire Middle Ages—even more so than the *Visitation* group at Reims (see fig. 594). The prophet is seated in a strongly Hellenistic pose, his mantle sweeping around him in folds that recall fifth-century Greek sculpture (see fig. 210) as much as they do the togas of Roman sculpture (see fig. 308). His head is turned in an attitude of tense alertness, as if he were listening to divine inspiration. The movement of surfaces has surpassed even that of the work of Renier de Huy, with which it appears in a continuous tradition.

STRASBOURG CATHEDRAL German Gothic sculpture reflects also at the start the classicism of Nicholas of Verdun. Especially impressive is the *Death of the Virgin* tympanum (fig. 616), of about 1220, in the Cathedral of Strasbourg. Today in France, Strasbourg has been throughout most of its history a German city. The ornament of the preexistent arch is Romanesque, and the heads of the Apostles radiate outward from the center as at Vézelay, but the sweep and flow of the drapery are strongly Gothic, as are the delicacy of psychological observation and the intensity of the emotion displayed by the grieving Apostles.

At the same moment a different and vividly original style was developing elsewhere in Strasbourg Cathedral. The trumpet-blowing angels attached to a choir pillar (fig. 617) vaguely suggest French prototypes, but the leg-crossed pose, reminiscent of the *Prophet* at Moissac (see fig. 535), had long been renounced by French Gothic sculpture. Nonetheless, the forthright realism of these Strasbourg angels has no more to do with the visionary quality of the Romanesque than it has with the elegance of French Gothic. The fall of the tunic is easy and natural, the face

614. NICHOLAS OF VERDUN. *Sacrifice of Isaac.* 1181. Gold and enamel plaque, height 5½″. Abbey of Klosterneuburg, Austria

615. NICHOLAS OF VERDUN. *Prophet Habakkuk* (detail of the *Shrine of the Three Kings*, Cathedral of Cologne, Germany). c. 1182–90. Gold, enamel, and precious stones, height of shrine 67″

616

homely and everyday. The wings, with their vigorous abstract curvature, would have been unacceptable in France. But these are the very qualities that make German Gothic sculpture individual.

A legend, given wide circulation in recent years, attributes some of the finest sculpture at Strasbourg to a woman sculptor called Sabina, supposedly the daughter of Master Erwin von Steinbach. Master Erwin (the name Steinbach is also legendary), a brilliant architect in a later, wholly different phase of German Gothic, was actually not recorded at

616. *Death of the Virgin*, tympanum of the south transept portal, Cathedral of Strasbourg, France. c. 1220

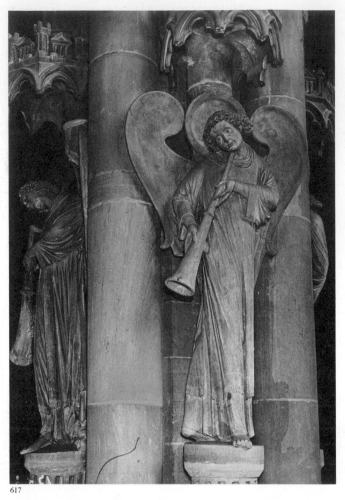

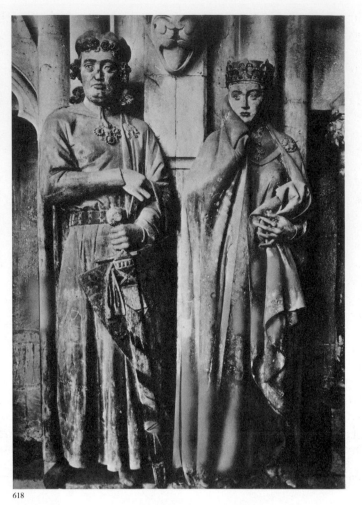

617

618

Strasbourg until 1284, sixty years after the date of the sculptural master-pieces, and survived until 1318. Sabina, no relation, whose name does indeed appear in an inscription, was a patron of the work, not a sculptor. There are no records that women in the Middle Ages were permitted to engage in the arduous work of cutting stone.

THE NAUMBURG MASTER Massive sculptural cycles like those of the French cathedral portals were apparently not needed in Germany. German thirteenth-century masters, with less compulsion to conform to a "corporate" style, are impressive in their directness. The best of these is an anonymous artist known for his work in the Gothic Cathedral of Naumburg in Saxony (today in East Germany). This powerful sculptor carved a series of statues of nobles from local history who were believed to have been founders of the Cathedral and brought these subjects—about whose actual appearance he knew nothing—to convincing life. The heavyset, pouting Ekkehard (fig. 618), with his hand resting from habit on his sword hilt, is contrasted with his wife Uta, an aloof beauty who gathers up her cloak with her left hand while with her right she draws it closer about her neck.

THE BAMBERG *RIDER* Perhaps the most memorable achievement of German Gothic sculpture is the mid-thirteenth-century *Rider* (fig. 619), who stands against one of the Romanesque piers of Bamberg Cathedral in Bavaria, under a French-style canopy that seems both inappropriate to

617. *Angels*, choir pillar in the south transept, Cathedral of Strasbourg. c. 1220–25

618. *Ekkehard and Uta*, choir responds, Cathedral of Naumburg, Germany. c. 1250–60

Germany and inadequate for a man on horseback. The earliest monumental equestrian group to survive since the days of *Marcus Aurelius* (see fig. 363), this work may preserve some memory of the vanished bronze Theodoric that once stood in front of Charlemagne's Palace Chapel at Aachen, but it is in every way unclassical. The horse is hardly to be compared with the fiery steed of Marcus Aurelius; his forefeet are planted side by side, his left hind hoof is lifted to paw the ground. He looks nervous and tense. In contrast to Classical equestrian figures, it should be noted, the Bamberg rider is represented to the same scale as his mount. We do not know the identity of the subject—he may be the emperor Conrad III—but in its calm, dignity, and apparent courage, the statue sums up as nobly as does the *Saint Theodore* at Chartres the qualities essential to the knightly idea.

HERRAD OF LANDSBERG If Sabina von Steinbach turns out to have been a myth, Herrad of Landsberg (1125/30–1195) was a magnificent reality. Abbess of Hohenburg, near Strasbourg, in Alsace, then considered German, Herrad composed between 1159 and 1180 a treatise called the *Hortus Deliciarum* (Garden of Delights) for the instruction of her nuns, who illustrated it under her direction. Some, perhaps many, of the illustrations were drawn and painted by Herrad's own hand. The book, one of the highest achievements of Gothic manuscript painting, was a compendium of medieval knowledge that was based largely on Scripture, but contained many passages drawn from classical learning and from contemporary science, especially the medieval cosmogony, as well as an explication of the Seven Liberal Arts (which, as always in the Middle Ages, included music but none of the visual arts). The author tells us her purpose in touching words:

> This book, entitled *Garden of Delights*, I myself, the little bee, composed inspired by God from the sap of diverse flowers from Holy Scripture and from philosophical works, and I constructed it by my love for you [i.e., her nuns] in the manner of a honeycomb full of honey for the honor and the glory of Jesus Christ and the Church.

The last page was a gallery of bust-portraits of the nuns of Hohenburg, sixty all told, each one labeled like a photograph in a high school yearbook, all listening intently to an address by Herrad herself—full length.

Tragically, the original manuscript was destroyed by fire in the German artillery bombardment of Strasbourg in 1870, before the photography of illuminated manuscripts had begun in earnest. Outline tracings of most of the illustrations had nonetheless been made, and from these we can now reconstruct the original compositions, although the details, of course, are seen through nineteenth-century eyes. Only one, the *Woman of the Apocalypse* (fig. 620) was copied in color. The complex text of Revelation (Apocalypse) chapters 12 and 13 has been condensed into a single majestic image, the vision of the Woman "clothed with the sun and with the moon under her feet, and on her head a crown of twelve stars." She is attacked at the lower right by the red dragon "having seven heads and ten horns and on his heads seven diadems," his tail drawing "the third part of the stars of heaven," a river coming out of his mouth to carry her away, and the earth opening up *its* mouth to swallow the river; at the lower left the beast from the sea, also with seven heads, ten horns, and

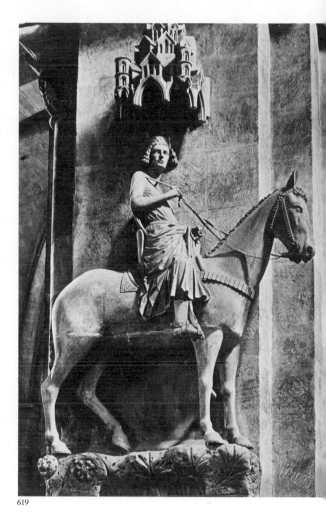

619

619. *Rider*. Middle 13th century. Sandstone, height 90½". Cathedral of Bamberg, Germany

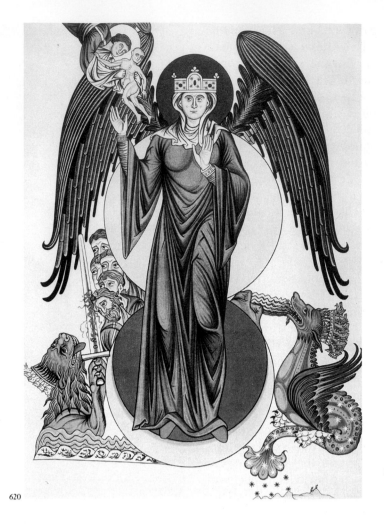

620. HERRAD OF LANDSBERG. *Woman of the Apocalypse*, illumination from *Hortus Deliciarum*. 1159–80 (Original destroyed)

seven diadems, with the mouth of a lion and the feet of a bear, makes war with the saints. The Woman, given "two wings of a great eagle," has brought forth her "man child to rule all nations," and an angel appears to take him up to God, safe from the two ferocious enemies. In her commentary Abbess Herrad interprets the Woman as the Church, bearing the name of Woman because she is always giving birth to a spiritual race, and goes on to find a symbolic significance in every aspect of the vision. Most important of all, she has succeeded in endowing her vision of Woman with a universal grandeur that survives even the destruction of the original. As artists, Herrad and her nuns control absolutely the sure sense of proportion and the classic flow of surface that are typical of their slightly later contemporary Nicholas of Verdun and that eventually ennobled the sculpture of Strasbourg Cathedral.

Spain

French Gothic architecture was also imported into Spain, and the interiors of three major Spanish cathedrals, those at Burgos, Toledo, and León, can hardly be told from their French models (their exteriors have been much reworked in a later phase of Gothic). Nonetheless French Gothic motives were brilliantly reinterpreted in Catalonia in northeastern Spain, especially in the Cathedral of Gerona, whose apse, ambulatory, and accompanying side aisles had already been constructed between 1312 and 1347 in a somewhat simplified version of French thirteenth-century style. In 1369, apparently (roughly contemporary with the Alhambra in Muslim Spain), a daring architect, Pedro ça Coma, proposed continuing the

building with a single gigantic nave consisting of four bays, with no transept and no side aisles, only lateral chapels, an obvious gesture in favor of improved visibility and audibility for the congregation. The resultant immense width of the nave vault excited the doubts of the authorities and of two successive commissions of architects, a record of whose vehement discussions has luckily been preserved. Not until 1417 did the various councils summon up the courage to proceed with Pedro's grand design, under a later and very enthusiastic architect, Jaime Bofill. The last stone of the giant vault was set in place, still in perfect Gothic style, nearly two centuries later, in 1604!

Although by French standards the height of the Gerona vault (fig. 621), approximately 110 feet, is not exceptional, its 75-foot span makes it by far the largest Gothic vault ever constructed. In comparison the naves at Cologne (see fig. 612) and Milan (see fig. 634) measure respectively 49 and 59 feet in width. In fact among all masonry vaults in history only that of Saint Peter's in Rome exceeds Gerona in width, by a mere ten feet. Relatively narrow windows, for the intense Mediterranean light, and heavy intervening walls, unthinkable in France, have insured the stability of the vault without flying buttresses. The placing of the Cathedral at the highest point of the city, accessible from the front only by a flight of no less than ninety steps, leaves the visitor breathless even before encountering the overwhelming experience of the unified interior space.

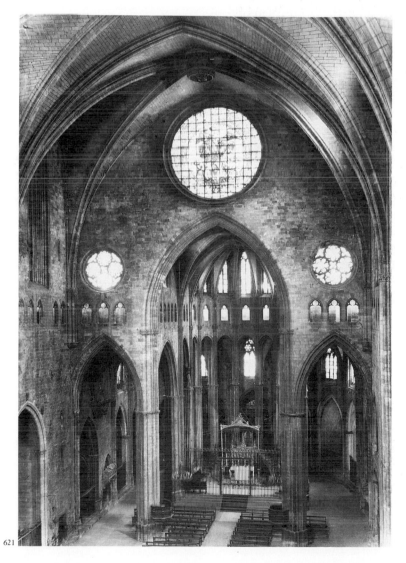

621. Interior, Cathedral of Gerona, Spain. 1312–47, 1417–1604

The sweep of the colossal vault cradles as with a giant arm the three-aisled fourteenth-century sanctuary, suggesting the toylike structures in Italian fourteenth-century painting, and further dwarfed by the insertion of a simplified rose window over each side aisle and an oculus just twice the diameter of the roses in the impressively blank wall above the sanctuary arch. Certainly the Gerona vault is one of the great triumphs of Gothic architecture. As in Germany and Central Europe, later Spanish and particularly Portuguese Gothic enjoys a luxuriant final phase comparable to the Flamboyant in France.

Gothic architectural principles were adopted immediately and enthusiastically in England, already prepared to a certain extent by the structural innovations of the Norman Romanesque. It has been claimed—and quite correctly—that in no century since the twelfth has Gothic architecture *not* been built in England. In the last quarter of the twelfth century, the French Gothic architect William of Sens brought the latest French techniques to Canterbury.

SALISBURY CATHEDRAL But the minute French ideas crossed the English Channel they became distinctly English. First of all, the English neither shared the French enthusiasm for height nor renounced their preference for the extreme length of Romanesque churches. The plan of Salisbury Cathedral (fig. 622), begun in 1220 and consecrated in 1258, with its double transept, recalls in that respect the arrangement at Cluny and resembles the layout of no French Gothic building, except that its characteristic square east end recalls that at Laon (see fig. 580). The square east end and lengthy choir of English cathedrals probably correspond to the need to accommodate a larger number of clergy than was customary in France; English cathedrals also have cloisters like those of monasteries (many, in fact, were served by Benedictine monks). Second, the majority of English cathedrals are situated not in the centers of towns but in the midst of broad lawns (originally graveyards) and massive shade trees.

In the interior of Salisbury Cathedral (fig. 623) every effort was made to increase the appearance of length and to diminish what to the French would seem a very modest height. No colonnettes rise from floor to ceiling; those attached to the compound pillars support only the ribs that make up the arches of the nave arcade. The triforium is large, and the clerestory is small—tucked away under the vaults as in French Early Gothic cathedrals. Characteristically English is the use of dark Purbeck marble for the colonnettes and capitals, establishing a color contrast similar to that of Romanesque interiors. In this chaste, unpretentious thirteenth-century style known as Early English, there is no tracery; lancet windows are grouped in threes and fives. The appearance of the interior was doubtless far richer when the stained glass (partly destroyed during the Reformation and partly removed in the eighteenth century) was intact and when the original choir screen and its sculpture were in place.

Compared with the soaring lines of French or German cathedrals, the exterior of Salisbury (fig. 624) looks earthbound. There is no true façade with flanking towers (although these are present in a number of English cathedrals), but a mere screen that extends without supports to mask the angle of the side-aisle roof. In few English cathedrals are there massive sculptural programs in the French manner; statues and reliefs were scattered over the screen façades, but few have escaped the axes of the re-

England

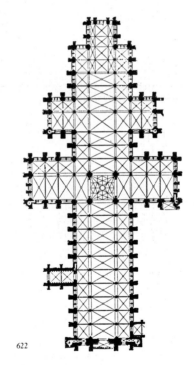

622

622. Plan of Salisbury Cathedral, England. Begun 1220

623. Nave and choir, Salisbury Cathedral

624. Salisbury Cathedral (view from the northeast)

625. Choir, Cathedral of Gloucester, England. Remodeled 1332–57

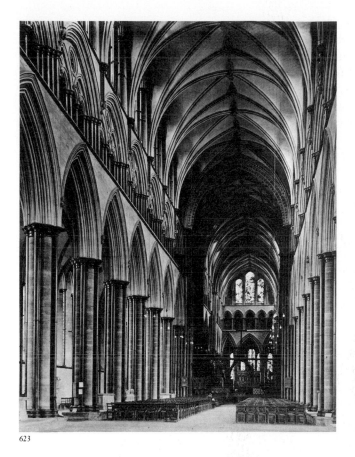

623

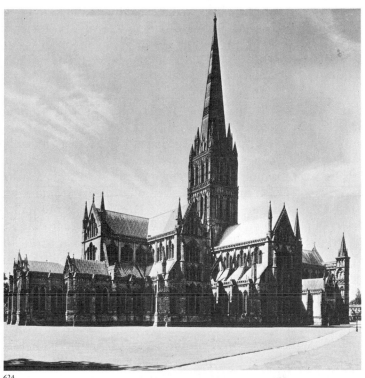

624

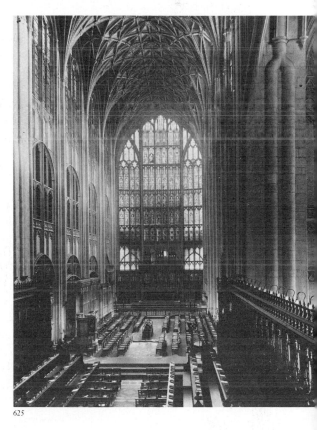

625

formers. Flying buttresses, in so low a building, did not seem necessary; nonetheless, some had to be added here and there. There is no dramatic chevet; the effects at Salisbury are obtained by the sensitive balancing of elements kept deliberately simple. The square east end is prolonged by the Lady Chapel (a chapel dedicated to the Virgin). The glorious distinguishing feature of Salisbury is the spire over the crossing, a fourteenth-century addition in the second phase of English Gothic, known as Decorated. Although the building was not originally intended for so tall a central tower, the spire, rising to a height of 404 feet, was designed so as to complete the diagonal massing of the exterior composition, and its ornamentation is restrained in order not to conflict with the purity of the Early English building. The effect of this immense weight on the interior was less happy; it required elaborate new supports.

GLOUCESTER CATHEDRAL The most original invention in English architectural history is the style appropriately known as the Perpendicular, which began to appear in the fourteenth century. The choir of the massive Romanesque Cathedral of Gloucester (fig. 625) was remodeled from 1332 to 1357 to enshrine the tomb of Edward II, murdered at the order of his estranged wife, and is a pioneer example of the new style (the Romanesque nave was left intact). The original round arches of the arcade and the gallery may still be made out under the covering screen of Perpendicular tracery. If the English were slow in adopting the idea of tracery, they soon went at it with a will; in this respect the Perpendicular may be considered the English answer to the Flamboyant, whose caprices are countered with brilliant logic. The entire interior of the choir is transformed into a basketwork of tracery, with predominantly vertical

members, which form the windows and dissolve into the vault. In this refined stage the ribs have lost any constructional function they may once have had. The triangular compartments are subdivided by additional diagonal ribs, and all the ribs are connected by an intricate system of crisscrossing diagonals. The original Romanesque apse is replaced by an east window 72 feet in height, which not only extends from wall to wall but also even bows slightly outward, doubtless to increase resistance to wind.

THE CHAPEL OF HENRY VII The final development of Perpendicular flowered in the fan vaults of the late fifteenth and early sixteenth centuries, the richest of which are those in King Henry VII's Chapel in Westminster Abbey in London (fig. 626), dating from the first quarter of the sixteenth century, nearly contemporary with Saint-Maclou at Rouen (see fig. 605). The complex shapes are as bewildering at first sight as those of Hiberno-Saxon interlace (see fig. 11) and as open to logical analysis. The vault is made up of tangent cones of tracery, each composed of tiny coupled trefoil arches, surmounted by quatrefoils and enclosed by gables—the standard repertory of High Gothic tracery, as compared to the flickering shapes of the Flamboyant. The cones radiate from central pendants; in the interstices between the cones are smaller ones, also culminating in pendants. The larger cones are held in position by cusped tracery arches, springing from between the windows. Tie rods added later indicate that on this occasion the imagination of the Perpendicular architects may have been carried too far.

626. Chapel of Henry VII, Westminster Abbey, London (detail of vault). 1503–19

626

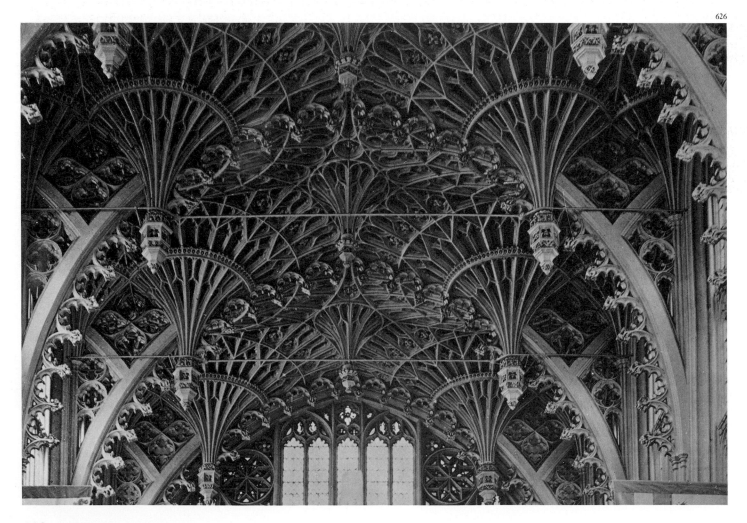

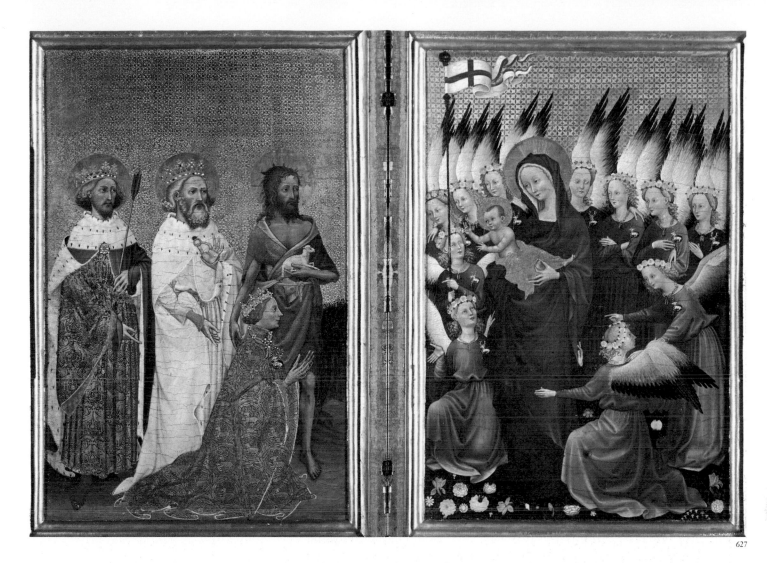

627. *Wilton Diptych.* c. 1377–1413. Each panel 18 × 11½", National Gallery, London

THE *WILTON DIPTYCH* Among the rare panel paintings surviving from the Gothic period in England one masterpiece stands out, the *Wilton Diptych* (fig. 627), a small work painted in the tempera technique. On rocky ground to the left kneels Richard II, represented as a youth and accompanied by his patron saints, John the Baptist and Kings Edward the Confessor and Edmund. Most of the background is gold, tooled in a neat, regular pattern to increase its sparkle, but beside the figure of John the Baptist we look into a deep wilderness. The young king's hands are extended less in prayer than in astonishment at the apparition in the facing panel of the Virgin Mary, holding the Christ Child and attended by eleven rose-crowned blond angels, each wearing the same badge of the white hart as the king wears (he was eleven years old at the time of his coronation in 1377). The sacred figures stand or kneel on a carpet of rich foliage, on which plucked roses and irises are strewn. The rich crimsons of Richard's damasks and the white of the ermines contrast with the sky-blues that dominate the right panel, ranging from the deep tones of the tunics in the upper row of angels through the medium value of Mary's mantle and tunic to the pale blues in the foreground; even the angels' white wings are tipped with blue.

The faces, hands, arms, and feet show an unprecedented delicacy of drawing and shading, and accuracy of anatomical observation, held in check by an extreme refinement of taste. This exquisite style is the more mysterious since so little panel painting of the period survives in England. There are many theories regarding the diptych's date (anywhere

from 1377 to 1413) and authorship, but no sure conclusions. The painter was certainly trained in the Italian tradition, and knew Sienese art, especially the work of Duccio and Simone Martini and even more intimately that of Giovanni da Milano. He was also one of the most accomplished painters of the fourteenth century in Europe. But we have no clear indication whether he was from England or the Continent; something in the poetry of the picture suggests England. The least that can be said on this subject is that the painting corresponds to the rarefied taste of the court of Richard II; since his reign was destined for an unhappy end, it is comforting to hope that the unknown master of the *Wilton Diptych* gave it a beautiful beginning.

Architecture in Italy

France's neighbors, in general, welcomed the new Gothic style and imported French architects and architecture, subject only to modifications in accordance with local taste and customs. In the kingdom of Naples, ruled by French descendants of Louis IX, the existence of French Gothic churches is not surprising. Elsewhere in Italy, however, the only French-style churches are those of the Cistercian Order, itself French and governed from Cîteaux in Burgundy. The austerity decreed by Saint Bernard forbade anything like the splendors of the cathedrals.

ABBEY OF FOSSANOVA The Cistercian Abbey of Fossanova (fig. 628), south of Rome, was commenced in 1187 and consecrated in 1208. Its essentials might as easily be found in Cistercian buildings in France or in England and clearly reflect the bleakness of Saint Bernard's tradition. The east end is square. Massive compound piers support pointed transverse arches and groin vaults over nave and choir. Only the crossing is rib-vaulted. The capitals are French transplants, close to those at Laon and Paris. As there was to be no stained glass, there was no need for the structural refinements of the Early Gothic.

SANTA CROCE IN FLORENCE In the independent republics of central and northern Italy, the Romanesque often continued into the thirteenth century, although many Gothic details were adopted. The major influence on church building emanated from two remarkably different religious figures, Saint Francis of Assisi (1182–1226) and Saint Dominic (1170–1221), both of whom founded orders with innumerable branches, devoted not to a life of work and study apart from the people but to direct preaching before urban masses and to missionary endeavors. The preaching orders revolutionized traditional Italian basilican architecture, for they required simple but very large interiors, usually timber-roofed both for economy and for speed in construction. Santa Croce in Florence (fig. 629), started in 1294, is one of the most imposing. Its octagonal columns, pointed arches, and foliate capitals and its impression of lightness and openness mark the church as Gothic, although at first sight it resembles nothing we have seen elsewhere. As the church was not planned for vaulting, there was no need for the usual French system of colonnettes rising two or more stories. The light and heat of Italian summers would have made large French windows intolerable. The windows at Santa Croce were, however, designed for stained glass, much of which is still in place, although it is very different from French stained glass.

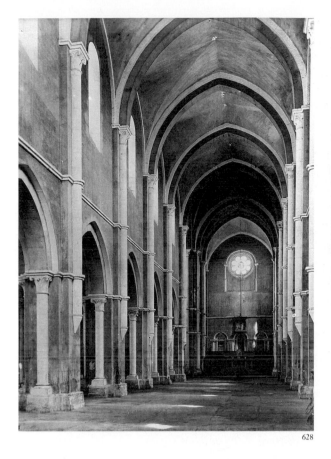

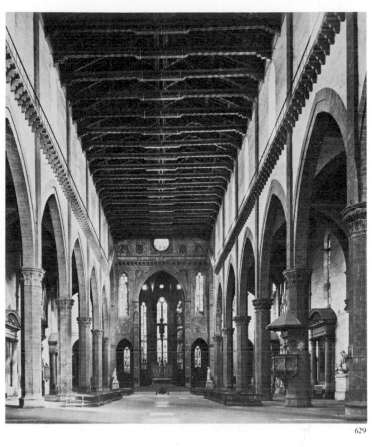

When we look at the choir of Santa Croce, beyond the triumphal arch, we see that the unknown architect (perhaps Arnolfo di Cambio, c. 1245–before 1310) did indeed understand French Gothic principles and adapted them intelligently to Italian requirements. The choir and the five chapels on either side of it, entered from the west side of the transept (two may be seen in the illustration), show a familiarity with the refinements of ribbed vaulting. The tall windows with their bar tracery resemble those inserted into the clerestory of Notre-Dame in Paris in the thirteenth century (see fig. 583). Large wall surfaces were needed in Italy, especially in Tuscany, for the highly respected art of fresco painting; the two chapels to the right of the choir were frescoed entirely by Giotto, and two others by his pupils, while the nave was under construction. The timber roof, recalling that at Monreale (see fig. 544), retains its original Gothic painted decoration.

FLORENCE CATHEDRAL An entirely different problem was presented by the Cathedral of Florence (fig. 630), which has so long and so complex a building history that its final appearance can be attributed to no single architect. A fairly large structure was planned by the architect Arnolfo di Cambio in 1296, with identically shaped apsidal choir and transept arms radiating outward from a central octagonal dome (fig. 631). In the main Arnolfo's plan was followed but much expanded by the architects, chief among whom was Francesco Talenti, who, under the close supervision of a commission, commenced building from the final design in 1368. The colossal interior (fig. 632), is only four bays long, and the impression so simple and bare in comparison with the complexity and mystery of French interiors that it is a surprise to discover that the height of the vaults is approximately the same as at Amiens. The compound

628. Interior, Abbey Church of Fossanova, Italy. Begun 1187

629. Nave and choir, Sta. Croce, Florence. Begun c. 1294

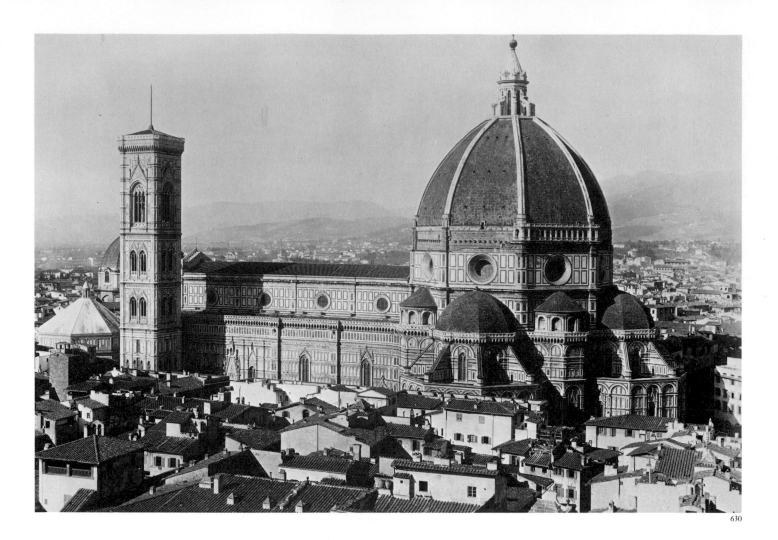

630

piers are cubic rather than cylindrical as in France, and their foliate capitals are treated as cubes of ornament. Pilasters continue above the giant arches to the catwalk supported on brackets required by the commission of 1368, which also insisted that the vaults spring directly from the level of the catwalk, thus canceling out any considerable clerestory. The interior, therefore, appears as one enormous story, lighted by oculi in the lunettes under the vaults. Walking through the building, one experiences immense cubes of space, which, as soon as their size becomes apparent, are dwarfed by the grandeur of the octagonal central space under the dome, from which the three half-octagonal apses radiate. The vaults are heavily domed and exert strong outward thrust. In the absence of flying buttresses, tie rods had to be installed.

The simple, cubic exterior masses of the nave and the more complex forms of the semidomes surrounding the central octagon were paneled in white, green, and rose marbles to harmonize with the Baptistery. The separate campanile, also paneled in marbles, was commenced by Giotto, who designed only the lower two stories; the much richer upper five stories are the work of Talenti in the middle of the fourteenth century. At the opening of the fifteenth century (so uncertain was the art of building), no one in Florence had the faintest idea how the octagonal central space could be covered. How *that* problem was solved is one of the dramas of the Early Renaissance.

631

630. Cathedral of Florence. Begun 1368

631. Plan of the Cathedral of Florence (After Arnolfo di Cambio, 1296)

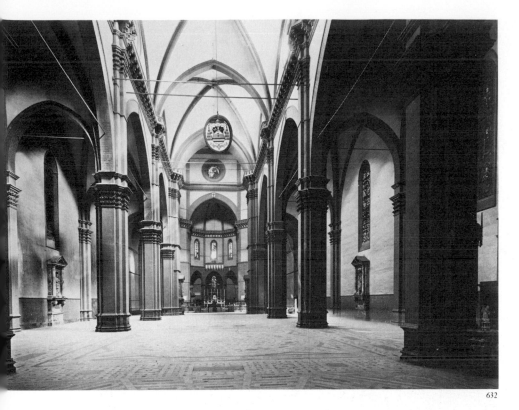

632. Interior, Cathedral of Florence

SIENA CATHEDRAL Perhaps because of the long tradition of Early Christian basilicas in Italy, the two-tower façade, universal in France and common throughout England, Spain, and Germany, was almost never adopted in Italy. In fact, the building of any sort of façade often lagged behind the construction of the rest of the church. Not one of the major churches of Florence received its façade during the period of its original construction; those of the Cathedral and Santa Croce were added only in the nineteenth century. But the Cathedral of Siena, the independent patrician republic forty miles to the south of Florence, was given a dazzling marble façade (fig. 633) in Gothic style that shows certain standard features of Gothic façades in other Italian cities, and gives some notion of what that of the Cathedral of Florence might have looked like had it been completed in the Gothic period. The lower half of the façade was designed—probably in the late 1280s—by Giovanni Pisano, one of the two leading masters of Italian Gothic sculpture.

Giovanni flanked his three gabled portals with rich tracery turrets, whose black-and-white marble bases incorporate the striping of the body of the Cathedral. The splayed jambs, with their alternating white-and-rose colonnettes, lack the statues one would have expected by French standards. Giovanni has transferred his figures to more independent positions on the turrets, where they appear to issue from shallow niches, in lively attitudes and even in conversation. This new freedom of the human figure from its architectural bonds is not only symptomatic of the role of the individual in the Italian city-republics but also indicative of the emergence of independent personalities among the artists themselves. From time to time we have encountered artists whose names we know and can associate with specific works outside Italy, and a few have even assumed a certain individuality in our minds, but they are exceptions. In Italy such instances become the rule.

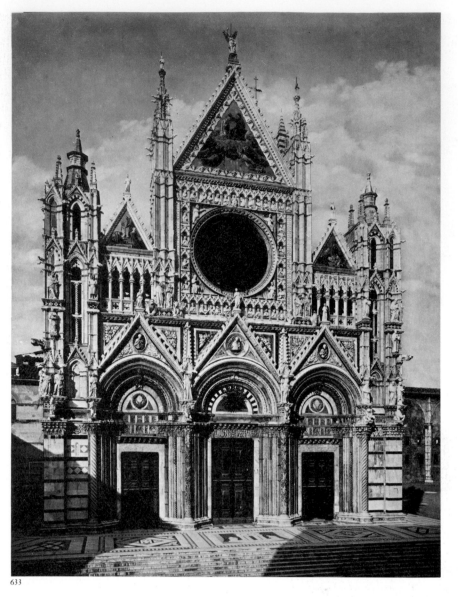

633. GIOVANNI PISANO. West façade, Cathedral of Siena, Italy. Begun late 1280s

MILAN CATHEDRAL In northern Italy the severe architecture of the Lombard Romanesque was replaced in the later fourteenth century by an especially florid phase of Gothic under the domination of the Visconti family, who had made themselves dukes of Milan and had absorbed into a powerful monarchy most of the independent north Italian communes, with the notable exception of the Venetian Republic. The construction of the Cathedral of Milan, one of the largest of all Christian churches, was subject to the committee procedure we have already seen in Florence, carried on, however, not only by north Italian masters but also by builders imported from France and Germany, each of whom brought to bear arguments based on his own national architectural tradition and theory. As in Florence, the colossal project had been commenced (probably in 1386) and the columns partly erected before anyone was certain how high they were going to go or what shape of arches and vaults they would support. The often acrimonious discussions continued, off and on, from 1392 to 1401. An Italian mathematician, Gabriele Stornaloco, subjected the fabric to the governance of an abstract system of expanding equilateral triangles, and one of the French architects, Jean Mignot, summarized his bitter denunciation of Italian methods with the oft-quoted remark, "Ars sine scientia nihil est." This should not be taken to

mean literally that art is nothing without science, but rather that practice is meaningless without theory. But that Mignot's theory should include appeals to God on his throne surrounded by the Evangelists demonstrates how far medieval builders were from being able to calculate static problems by what we would recognize as engineering science. The resultant interior (figs. 634, 636) resembles partly the arrangement at Bourges (see fig. 590) with its four side aisles of diminishing heights and partly that at Florence (see fig. 632) with its single colossal story dwarfing a tiny clerestory under the vaults. The clustered columns are surmounted by outsize capitals intended for a host of statues—eight to a column—in the gathering gloom of the arches. The four-part vaulting is based on French High Gothic examples. The exterior (fig. 635) shows the characteristic Italian desire to keep the whole structure within the limits of a block, so that the flying buttresses are invisible from street level. That they were also insufficient is betrayed by the telltale tie rods in the interior. The forest of pinnacles, intended from the beginning, was actually added in the eighteenth and nineteenth centuries. The gigantic Flamboyant windows would have been totally unacceptable to severe Florentine taste.

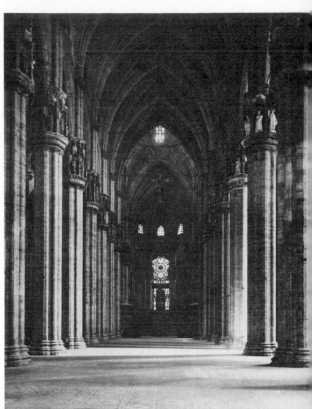

634

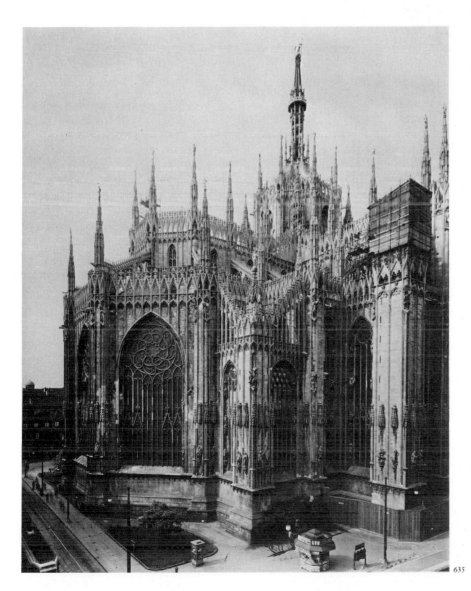

635

636

634. Interior, Cathedral of Milan. Begun 1386

635. Exterior of choir, Cathedral of Milan

636. Plan of the Cathedral of Milan

THE PALAZZO VECCHIO IN FLORENCE Italian communes demanded impressive civic centers, fortified against the chronic disorders of the period. The grandest example is the Palazzo Vecchio at Florence, built in an astonishingly short time, from 1299 to 1310; the Priori (council or cabinet members) were actually installed in the building as early as 1302. Its castle-like appearance (fig. 637) carries into large-scale civic architecture the roughly trimmed stone used for town houses in medieval Florence. This technique had a Classical precedent in the rustication of such Roman civic buildings as the Porta Maggiore (see fig. 338). The impression of block mass, relieved only by relatively small Gothic windows, was intended not only for defense but also for psychological effect. The asymmetrical placing of the mighty bell tower was due to the requirements of the site and was not followed elsewhere; yet to modern eyes the result is extremely powerful.

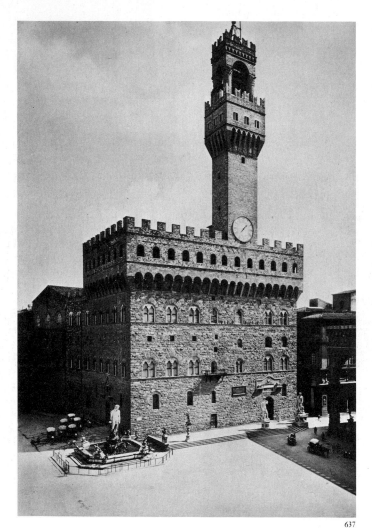

637

637. Palazzo Vecchio, Florence. 1299–1310

THE PALAZZO DUCALE IN VENICE One could hardly imagine a greater difference in appearance than that which distinguishes the mountainous structure of the Palazzo Vecchio from the elegant and largely open Palazzo Ducale (Doges' Palace) in Venice, built for a similar purpose, as the official residence of the doge (the chief magistrate of the Venetian Republic) and the grand council of a republic fortified only by

water. In spite of the fact that construction continued from 1340 until after 1424, the appearance of the building is remarkably unified (fig. 638). A simple arcade of pointed arches on low columns supports a more elaborate *loggia* (open gallery) on the second story, with twice as many columns under trefoil arches and quatrefoil tracery drawn from the standard High Gothic repertory. The massiveness of the upper story, broken only by pointed-arch windows, is relieved by an allover lozenge pattern of white-and-rose marble facing. The distinction between Florentine mass on the one hand and Venetian interest in color, texture, and light effects on the other is one we shall see maintained throughout the long history of these two leading Italian schools, especially in painting.

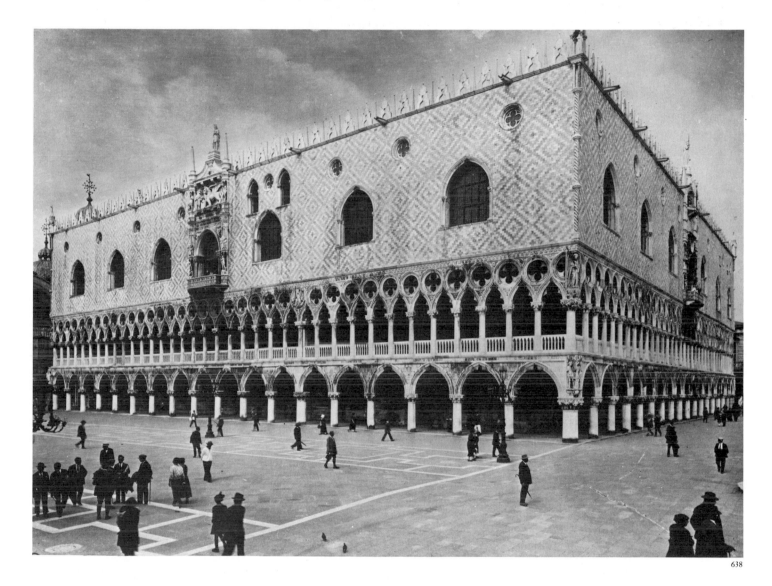

638

THE CA' D'ORO IN VENICE Through the first half of the fifteenth century (the Early Renaissance in Florence), Venetian architecture remained Gothic. The most sumptuous dwelling from this period is the Ca' d'Oro (Golden House), built between 1422 and about 1440 on the Grand Canal. The façade (fig. 639) was designed for the effect of glittering white arcades and interlaced arches against dark openings and of walls paneled in softly veined marbles in the Byzantine manner, rather than the hard contrast of white and green used in Tuscany; probably neither the architect nor the patron was oblivious to the beauty of the reflections of all

638. Palazzo Ducale (Doges' Palace), Venice. 1340–after 1424

this light and color in the blue-green water below, and the very existence of the open loggias reveals the Venetian delight in observing from such vantage points the passing spectacle of traffic on the Grand Canal. Insubstantial as such architecture may seem in comparison with the severity of the Florentine palaces built at the same time for the same class of wealthy merchants, it looks compact and unified, and thus thoroughly Italian, in contrast to the free improvisation of shapes in the almost contemporary house of Jacques Coeur at Bourges (see fig. 608).

Despite its special national variations from the European norm, Italian Gothic architecture can be considered as a part of European Gothic in general. But Italian sculpture and painting of the thirteenth and fourteenth centuries are another story. Unlike medieval artists elsewhere in Europe, about whom we seldom know even their names, the great Italian sculptors and painters of the Late Gothic period are fully rounded human beings. Their styles and achievements are so strongly individual that they demand separate consideration, not just as a prelude to the Renaissance but as an independent and impressive artistic group.

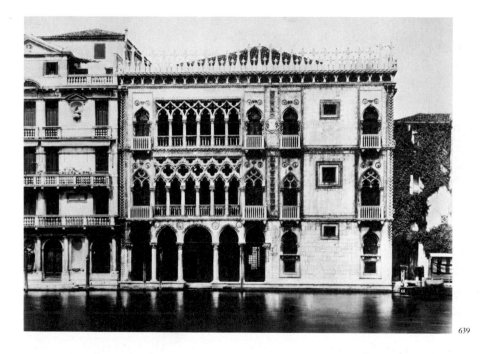

639

639. Ca' d'Oro, Venice. 1422–c. 1440

In retrospect, the achievements of the Gothic period are dazzling. This age produced the first post-Classical culture whose creations and discoveries could rival those of the vanished ancient world—and indeed, in a technological sense, surpass them. All of western Europe was united by a universal style, intended primarily for the new urban societies of the later Middle Ages and favored by the recently expanded monarchical governments. The fundamental unity of the Gothic style transcended national and regional boundaries and enabled it to be transplanted into regions as distant as Palestine and Mexico. So pow-

erful did the Gothic style become, indeed, and so well did it satisfy the needs of urban populations throughout its vast geographic extent, that an extremely large proportion of Gothic religious buildings survive today, in spite of innumerable social upheavals and two world wars, with their sculptural and pictorial decorations (in Catholic countries at least) largely intact, and are still in daily use. The Gothic flourished for four hundred years, from the mid-twelfth to the mid-sixteenth century, save only in central Italy, where it was cut short in the early fifteenth by the Renaissance. In the mid-nineteenth century the authority of the Gothic was rediscovered—in England it had never been wholly lost—and Gothic revival buildings have been built off and on ever since, all over the world.

Urban humanity required a new self-image. For the first time since the ancient world a complete, three-dimensional human being reemerges in sculpture, even though bodily surfaces are veiled by clothing except when nudity is iconographically required. And for the first time since antiquity the human physiognomy is able to command a repertory of facial expressions answering to inner emotional states.

The growing kingdoms of northern and western Europe, the Empire in central Europe, and the papacy with its worldwide claims emanating from Rome were earthly counterparts of an intricate cosmic order of being, under the monarchical rule of the Christian Deity. In this encyclopedic universal structure, whose towering symbol was the cathedral, every smallest human or natural phenomenon—however imperfectly it might be understood—found its preordained niche. In contrast to the visionary withdrawal characteristic of the monastic Romanesque, the urban Gothic may have had its head in the stars but its feet were firmly planted on earth, and every intervening connection was thought out. Gothic universality may even be, more than we realize, the source of much of our enjoyment of Gothic art. We get to understand the system, we know what can be expected, and we rejoice when Gothic artists surpass each other and themselves in fulfilling its demands.

The Italian Renaissance was to break with the Gothic, perhaps less sharply than is generally supposed. But in northern and western Europe the new styles will rise effortlessly from the old, so that the Northern Renaissance will seem a natural outgrowth of the Gothic. The Gothic era, indeed, can be considered not only as the crowning expression of the Middle Ages but as the indispensable bridge between the medieval and the modern world.

TIME LINE VII

St.-Denis, Paris Rose window, Chartres Façade, Notre-Dame, Paris Interior, Amiens Cathedral

HISTORY	CULTURE
1150 Pope Innocent III recognizes Frederick Hohenstaufen as king of Sicily, 1198, later Frederick II, HRE, r. 1215–50 Third Crusade, to rescue Jerusalem, succeeds, 1189–92	Rise of universities: Paris, c. 1150–60; Oxford, 1167 Flowering of vernacular literature; Age of Troubadours Earliest use of compass for navigation Albertus Magnus (1193–1280) Nibelung epic, 1205
1200 In Fourth Crusade, 1202–04, Crusaders sack Constantinople and found Latin Empire of the East (1204–61) Magna Carta signed in England, 1215 St. Louis IX, French king, r. 1226–70 Sixth Crusade led by Frederick II, 1228–29 Seventh Crusade led by Louis IX, 1248–54	Age of minnesingers in Germany St. Dominic founds Dominican Order, 1206 Inquisition established to combat heresy Albigensian Crusade against heretics in southern France, 1208 St. Francis (1182–1226) founds Franciscan Order, 1209 Roger Bacon (1214–92)

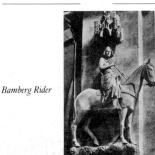

Bamberg Rider Exterior, Salisbury Cathedral *Wilton Diptych*

HISTORY	CULTURE
1250 Greeks retake Constantinople from Latins, 1261 Eighth Crusade, 1270 Marco Polo travels to China and India, c. 1275–93 Turks take Acre, last Christian holding in Holy Land, 1291 Papacy moved to Avignon, 1309 Hundred Years' War between France and England, 1337–1453	Dante Alighieri (1265–1321) Jacobus de Voragine (1266–83) St. Thomas Aquinas' *Summa Theologica*, 1266–73 Master Eckhart, German theologian and mystic (d. 1327) Spectacles invented, c. 1286 William of Occam (c. 1300–1349) First large-scale production of paper Earliest known use of cannon, 1326
1350 Black Death epidemic in Europe, 1347–50 Philip the Bold, Burg. duke, r. 1363–1404 G. Visconti, Milanese duke, r. 1378–1402 Papacy returns to Rome, 1378 Great Schism begins	Earliest cast iron in Europe Boccaccio writes *Decameron*, 1353 John Wycliffe (d. 1384) *Canterbury Tales* by Chaucer, c. 1387

GOTHIC

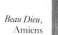

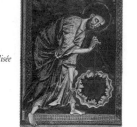

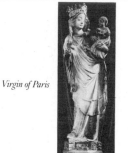

Beau Dieu, Amiens

Bible Moralisée

Virgin of Paris

Sacrifice of Isaac, by Nicholas of Verdun

PAINTING, SCULPTURE, ARCHITECTURE

Ambulatory, Abbey Church of St.-Denis; south tower and Royal
 Portal, Cathedral of Chartres; Abbey of Fossanova
Cathedrals of Laon, Notre-Dame, Chartres (architecture, sculpture,
 stained glass), Bourges, Le Mans, Reims (architecture, sculpture),
 Amiens (architecture, sculpture), Beauvais, Ste.-Chapelle
Cathedral, Cologne; St. Elizabeth, Marburg
Sculpture, Strasbourg, Bamberg, and Naumberg
Cathedral, Salisbury
Nicholas of Verdun, *Sacrifice of Isaac* and *Shrine of the Three Kings*
Campo Santo, Pisa; Giovanni Pisano, façade of Siena Cathedral;
 Sta. Croce, Florence
Bible Moralisée; Psalter of St. Louis; Herrad of Landsberg, *Hortus
 Deliciarum*

PARALLEL SOCIETIES

French Monarchy	1150
Byzantine Empire	
Holy Roman Empire in	
Central Europe	
Muslim	
English Monarchy	1200
Italian city-states	

Sta. Croce, Florence

Duomo, Florence

Cà d'Oro, Venice

Virgin of Paris
Palazzo Vecchio, Florence
Cathedral, Gerona
Jean Pucelle, *Belleville Breviary*
Choir, Cathedral of Gloucester
Palazzo Ducale, Venice

Moors

Spanish Kingdoms

Russian Empire

1250

Duomo, Florence
Wilton Diptych
Cathedral, Milan
Palais Jacques Coeur, Bourges
St.-Maclou, Rouen; Chapel of Henry VII, Westminster

1350

THE RENAISSANCE

THE DAWN OF INDIVIDUALISM IN ITALIAN ART—THE THIRTEENTH AND FOURTEENTH CENTURIES

ONE

While Italian Gothic architecture, for all its grandeur, remains essentially a late adaptation to local needs of forms and ideas imported from France and Germany (and is therefore treated in an earlier chapter), Italian painting and sculpture of this same period owe relatively little to the North. They seem to emerge from the Middle Ages into a wholly new era, with such striking force and originality that they are often and with good reason considered separately from the Gothic as forerunners of the Renaissance. For, beginning in the late thirteenth century, Italian artists are above all individuals, often intensely so. They are, of course, not the first artists since antiquity whose names we know. But the personalities and ideas of medieval artists can be deduced only from their work and occasionally their theological writings, which tell us little about their art. In most cases we have only their signatures. In contrast the Italians have left us mountains of verbal information—contracts, payment records, letters, legal documents, sometimes vividly personal inscriptions. Eventually, in the fifteenth and sixteenth centuries, they were to expound their professional traditions and theoretical ideas at great length in magnificent treatises, read avidly today. We possess precious, if scattered, accounts of Italian artists' lives and achievements by their contemporaries, and they are also mentioned glowingly by contemporary chroniclers and poets as great men of their communities. Their personalities live on in popular tradition and in the works of later writers, such as Ghiberti in the fifteenth century and Vasari in the sixteenth, both artists in their own right with strong critical opinions and historical ideas.

The individuality of Italian artists arose from the very nature of Italian political and social life. In the later Middle Ages, with the sole exception of a few scattered independent or semi-independent city-states, all of Europe outside Italy was ruled by monarchies of one sort or another still under the feudal system. The princes of central Europe, moreover, all owed allegiance to the Holy Roman Empire which, by historic right, also claimed control over Italy. But during the eleventh and twelfth centuries the rapidly growing Italian city-states, whose trade and banking connections spanned Europe from England to the Middle East, formalized their communal governments as republics (Venice, owing to special geographical and historical circumstances, had been a republic since the eighth century). Fortified by their immense commercial power, the new republics defied imperial authority. Ruled by guilds (associations of merchants, professionals, and artisans), the republics often went so far as to expropriate neighboring feudal domains, forcing the nobles to become burghers if they wished to enjoy the rights of citizenship. The artists, as guild members, participated fully in the vigorous activities of the aggressive and expanding republics, working for the leading citizens as well as for the church and the state. Under such circum-

stances their new individualism is easy to understand, in contrast to the relative docility and anonymity of the subjects of medieval monarchies. Like the burgher-artisans they were, the artists kept shops in which they produced works on commission and trained apprentices, some of whom were family members. With its strenuous manual activities, however, the Italian late medieval shop was by custom and law a man's world. No women artistic figures have been identified.

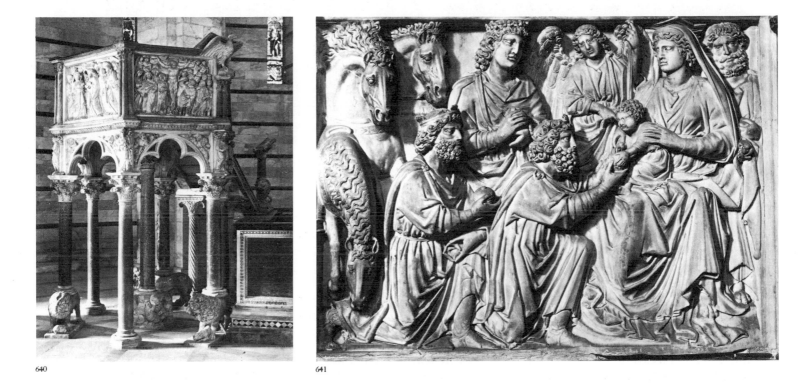

640

641

NICOLA AND GIOVANNI PISANO Two extremely original sculptors, Nicola Pisano (active 1258–78) and his son Giovanni (c. 1250– c. 1314), whom we have already encountered as the principal architect of the façade of Siena Cathedral, embody sharply different phases of the rather tardy change from Romanesque to Gothic style in Italian sculpture. Although Nicola's name indicates his Pisan citizenship, he came to Tuscany from southern Italy, where, since the days of Frederick II (reigned 1215–50)—more Italian king than German emperor—there had flourished a strong current of interest in ancient art. More to the point, perhaps, as the recent studies of Eloise M. Angiola have shown, is the classicism of Pisa, which considered itself a second Rome. Once capital of the ancient Roman province of Tuscany, Pisa, with its vast merchant marine and formidable navy, was favored by the Empire in the Middle Ages and was given sway over a wide territory along the Mediterranean and the entire island of Sardinia. In 1133, in fact, Pisa found itself briefly capital of Western Christendom, chosen as temporary residence by Pope Innocent II, who was excluded from Rome by an antipope.

Nicola's first great work was the hexagonal marble pulpit in the Baptistery at Pisa (fig. 640) that he signed with a long, self-laudatory inscription in 1260. Sculptured pulpits were traditional in Italy; that one could be needed in a baptistery may indicate the special importance of the sacrament of Baptism in the Italian republics as the moment in which a child took his place in the Christian community, not to speak of the individual Italian commune. Nicola's handsome creation combines elements already

640. NICOLA PISANO. Pulpit. 1259–60. Marble, height c. 15'. Baptistery, Pisa

641. NICOLA PISANO. *Adoration of the Magi* (detail of the pulpit, Baptistery, Pisa). Marble relief, height c. 34"

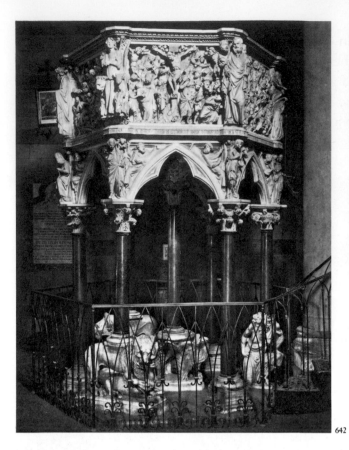

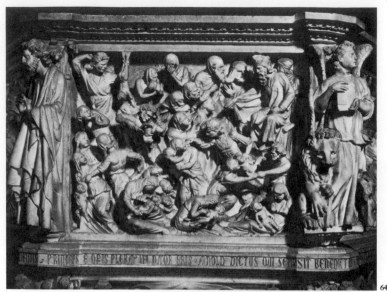

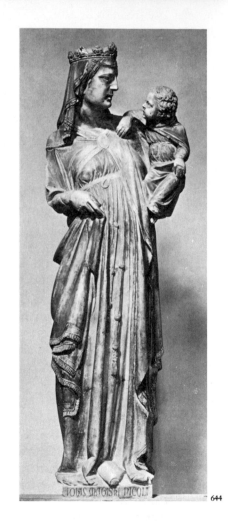

familiar from central Italian medieval art, such as columns of red por-
phyry, red-and-gray granite, and richly veined brown marble, with Gothic
trefoil arches. The capitals, partly Corinthian, partly Gothic, seem to
partake of both styles. Like his earlier namesake Nicholas of Verdun and
like the Visitation Master at Reims, Nicola had a strong interest in an-
cient art. Luckily, he had no dearth of models in Pisa. The close packing
of forms filling the entire frame of the *Adoration of the Magi* (fig. 641)
recalls the density of Roman sarcophagus relief, and in fact Nicola re-
peated almost exactly the pose of a seated figure in a sarcophagus still in
the Campo Santo in Pisa for his Virgin, who has become a Roman Juno,
impassive and grand. The carving of the beards of the Magi and the par-
allel drapery folds of all the figures also recall Roman examples, but the
angular breaking of the folds betrays Nicola's familiarity with Byzantine
mosaic art.

Giovanni, who claims in inscriptions to have outdone his father, was
responsible for a sharply different octagonal pulpit at Pistoia (fig. 642).
Dated 1298–1301, it is distinguished by its greater Gothicism in the sharp
pointing of the arches as well as in the freer shapes of the foliate capitals,
which only here and there disclose Classical derivations. As we would
expect from the unconventional shapes and animated statuary of the Siena
façade, Giovanni's sculptural style is far more dramatic than his father's
serene manner and shows almost no interest in Classical art. Instead, the
relaxed poses and free, full drapery folds of the corner statues suggest a
familiarity with the portal sculptures of Amiens and Reims; Giovanni's
inscriptions proclaim him as a traveler, and in all probability he visited
the great French cathedrals. In the *Slaughter of the Innocents* (fig. 643), a
panel of the Pistoia pulpit, he shows himself the master of a free narrative
style, depending for its effect on rapid, even violent movement of fero-
cious soldiers and screaming mothers and on considerable undercutting,

642. GIOVANNI PISANO. Pulpit. 1298–1301.
Marble. Sant'Andrea, Pistoia

643. GIOVANNI PISANO. *Slaughter of the Innocents*
(detail of the pulpit, Sant'Andrea, Pistoia).
Marble relief, 33 × 40″

644. GIOVANNI PISANO. *Virgin and Child*. c. 1305.
Marble. Arena Chapel, Padua

which produces sharp contrasts of light and dark. The expressive power of Giovanni's style is brought under firm control, possibly in emulation of the great painter Giotto, in the marble statue of the *Virgin and Child* (fig. 644), which Giovanni carved about 1305 for the altar of the Arena Chapel in Padua, whose walls and ceiling were being frescoed by Giotto (see figs. 2, 648, 649). The boldness of the masses, the clarity of the contours, and the firmness of the pose of Giovanni's *Madonna* contrast strikingly with the elegance and lassitude of earlier examples.

Changes in thirteenth-century religious ritual gave rise to the demand for a new kind of image—of immense importance for the development of art, especially painting—the *altarpiece*. Until now the Mass had been celebrated, as again in the Roman Catholic Church since Vatican II, behind the altar, with the priest facing the congregation. This practice precluded the placing of anything more than the required crucifix, candlesticks, and sacred vessels upon the altar. In the course of the century, the celebrant's position was moved to the front of the altar, thus freeing the back of the altar for the development of imagery, both sculptural and pictorial. Although the icon, that all-important focus of Byzantine devotion, had been imported into the West in the early Middle Ages, it had not taken root. But in the thirteenth century, large-scale painted crucifixes, which had already been used in other positions in Italian churches, began to appear on altars. Soon the Madonna and Child competed for this prominent place, and eventually won. The altarpieces, which rapidly grew to considerable size so as to be visible to the congregation, were painted in a technique known as *tempera*, with egg yolk used as the vehicle. The procedure was slow and exacting. A wooden panel had to be carefully prepared and coated with *gesso* (fine plaster mixed with glue) as a ground for the underdrawing. Gold leaf was applied to the entire background, and then the figures and accessories were painted with a fine brush. As egg dries fast and does not permit corrections, the painter's craft called for accurate and final decisions at every stage. Under the impulse of this new demand, and spurred by the intense political and economic life of the Tuscan republics, painting rapidly developed in a direction that had no Northern counterparts until the fifteenth century.

CIMABUE Although at least two generations of Tuscan painters had preceded him in the thirteenth century, the first Italian painter known to Vasari by name was the Florentine Cenni di Pepi, called Cimabue (active c. 1272–1302). About 1280 Cimabue painted the *Madonna Enthroned* (fig. 645), an altarpiece more than twelve feet high, which in Vasari's day stood on the altar of Santa Trinita in Florence. The derivation of Cimabue's style from that of the Greek painters with whom Vasari said he worked is clear enough in the poses of the Virgin and the Child and also in the gold-striated patterns of their drapery folds. But in the delicate modeling of the faces and drapery of the angels, Cimabue also shows his familiarity with the refined Constantinopolitan style of his own time. Clearly, Cimabue was trying to rival in paint the monumental effects of Byzantine mosaics, but the gabled shape of his huge altarpiece is unknown in the East, as is the complex construction of the carved and inlaid throne; the effect is that of strong verticality, increased by the constant flicker of color in the angels' rainbow wings. Cimabue's insistent linear tension, maintained throughout the gigantic altarpiece, is also alien to the harmony of Byzantine art: it is thoroughly Tuscan, recalling the sculpture of the Pisani.

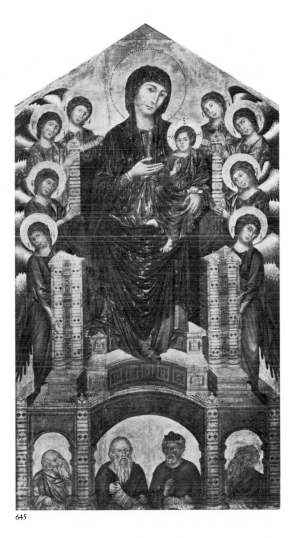

645

645. CIMABUE. *Madonna Enthroned*, from Sta. Trinita, Florence. c. 1280. Tempera on panel, 12' 7½" × 7' 4". Galleria degli Uffizi, Florence

646

CAVALLINI An exception to the dominance of the republics in Italian art was the school of Rome. After centuries of repetition of Early Christian models without major innovations, in the last decades of the thirteenth century Roman painting rose to a brief period of splendor, brought to a sudden end in 1305 when its chief patron, the papacy, unable to resist the power of the French monarchy, allowed itself to be carried off to Avignon in southern France, leaving Rome in a state of political and economic decline. The leader among all the gifted Roman painters was Pietro Cavallini, whose documented activities run from 1273 to 1308, but who was said by his own son to have lived nearly a hundred years. Vast fresco cycles by Cavallini, in part renewing, in part replacing damaged Early Christian works, once lined the nave walls of two great Roman basilicas, San Giovanni in Laterano (then the seat of the papacy and still today the Cathedral of Rome) and Saint Paul's Outside the Walls, as well as other churches. Almost all of these frescoes are now lost, but in his own time and well into the Renaissance Cavallini enjoyed a towering reputation. Certainly he had a tremendous influence on the art of the more famous Giotto, who surely saw Cavallini's work with a sense of discovery when he came to the Jubilee of 1300 called by Pope Boniface VIII.

Cavallini's major surviving work in fresco is the fragmentary *Last Judgment* of about 1290 in Santa Cecilia in Trastevere in Rome (fig. 646). This painting, impossible to photograph as a whole because of a gallery

646. PIETRO CAVALLINI. *Last Judgment* (detail of a fresco), Sta. Cecilia in Trastevere, Rome. c. 1290

later built in front of it, carries the knowledge of the effects of light to a point inaccessible to Cimabue. Light and light alone brings out the fullness and sweep of the mantles that envelop these majestic figures. Their heads, however, especially those of the beardless Apostle second from the right and the bearded James (?) on the right, show a familiarity with French Gothic sculpture. Surely Cavallini had also studied such advanced Byzantine works as the frescoes at Sopoćani, which show an extraordinary advance in the interrelationship of light and volume. But the final result, endowing the art of painting with a grandeur and nobility of form previously exercised only by sculpture and with a hitherto unknown beauty and softness of color gradations, is his own achievement.

GIOTTO The final break with Byzantine tradition was accomplished by Giotto di Bondone (c. 1267–1337), the first giant in the long history of Italian painting. Even in his own day Giotto's greatness was recognized by his contemporaries. Dante puts in the mouth of a painter in *Purgatory* (XI, 94–96) his famous remark:

> Cimabue believed that he held the field
> In painting, and now Giotto has the cry,
> So that the fame of the former is obscure.

The *Chronicles* of the historian Giovanni Villani (d. 1348) list Giotto as one of the great men of the Florentine Republic, a position such as had been accorded to no other artist since the days of ancient Greece. The sources also indicate wherein Giotto's greatness was thought to lie. Vasari summed up Italian estimates when he said that Giotto revived the art of painting, which had declined in Italy because of many invasions, and that since Giotto continued to "derive from Nature, he deserves to be called the pupil of Nature and no other." Cennino Cennini, a third-generation follower of Giotto, wrote in his *Book on Art*, a manual on technical methods, that Giotto had translated painting from Greek into Latin.

A comparison of Giotto's *Madonna and Child Enthroned* (fig. 647) of about 1310 with its counterpart by Cimabue (see fig. 645) will test these traditional observations. Nature, in the modern sense of the word, would hardly enter our minds in connection with Giotto's picture any more than with Cimabue's. Both are ceremonial representations of the Virgin as Queen of Heaven, remote from ordinary experience, and both rule out distant space by the use of a traditional gold background. But in contemporary Italian eyes the step from Cimabue to Giotto was immense in that weight and mass, light and inward extension were suddenly introduced in a direct and convincing manner. In contrast to Cimabue's fantastic throne, which needs a steadying hand from the attendant angels, Giotto's structure is firmly placed above a marble step, which can be climbed, and the Virgin sits firmly within it. The poses of the angels kneeling in the foreground are so solid, in comparison to the uncertain placing of Cimabue's angels, that we are willing to believe that the angels and saints behind them, on either side of the throne, stand just as securely. Light, still diffused and without indication of source, models the forms so strongly that they resemble sculptural masses. By "translating painting from Greek into Latin," Cennini meant that Giotto had abandoned Byzantine models in favor of Western ones, and in the early fourteenth century those could only have been French cathedral statues. Not only do Giotto's facial types and drapery motives recall Gothic sculptures, but also the Virgin's throne

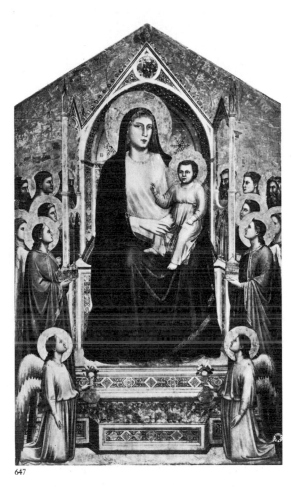

647. GIOTTO. *Madonna and Child Enthroned*, from the Church of Ognissanti, Florence. c. 1310. Tempera on panel, 10' 8" × 6' 8¼". Galleria degli Uffizi, Florence

648

is set in an aedicula whose pointed central arch, trefoil side arches, and culminating pinnacles are taken directly from the French architectural repertory. Giotto's miracle lay in being able to produce for the first time on a flat surface three-dimensional forms, which the French could achieve only in sculpture. Whether or not the Florentines would have admitted this, Giotto also owed a debt to Cavallini, but here he has gone well beyond the Roman master. Effects of shoulders and knees showing through drapery masses, of the Child's body and legs, and of the Virgin's hand holding his thigh are at every point convincing. For the first time since antiquity a painter has truly conquered solid form. Giotto did not, however, adopt as yet a naturalistic scale. The Virgin and Child are represented as almost twice the size of the attendant figures.

Cennini tells us that the painting of frescoes was the most agreeable of all pictorial activities. The technique he describes was probably based on that of Roman painting as handed down through the ages. The painter first prepared the wall with a layer of rough plaster, on which he proceeded to draw with the brush (probably on the basis of preliminary sketches) the figures and background in a mixture of red earth and water known as *sinopia* (see fig. 659). Over this preparatory drawing he laid on as much smooth plaster as he could paint in a day, and painted it while wet so that the color in its water vehicle would amalgamate with the plaster. The following day he added another section, covering up the sinopia as he went. This procedure meant that the fresco was literally built section by section, and acquired a solidity of composition and surface handling that would preclude any spontaneous painting technique such as that of the Byzantine artists.

Giotto's masterpiece is the cycle of frescoes, dating from 1305–6, illustrating the life of the Virgin and the life of Christ that lines the entire interior of the Arena Chapel in Padua in northern Italy, not far from Venice. Here he shows the full range of his naturalism in a new kind of pictorial drama for which nothing we have seen in the history of art could

648. GIOTTO. *Raising of Lazarus*, fresco, Arena Chapel, Padua. 1305–6

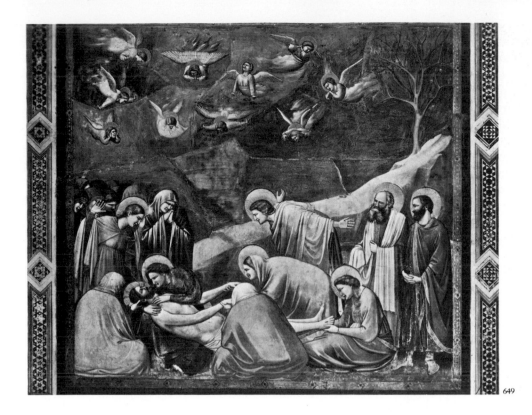
649

prepare us. In one of the early scenes, Joachim, father of the Virgin, takes refuge with shepherds in the wilderness after his expulsion from the Temple because of his childlessness (see fig. 2). Humiliated, his head bowed, he stands before two shepherds, one of whom scans his companion's face to see whether they dare receive the outcast. The subtlety of the psychological interplay is enriched by Giotto's delicate observation of the sheep crowding out of the sheepfold and of the dog, symbol of fidelity in the Middle Ages as today, who leaps in joyful greeting.

As in the *Madonna*, Giotto recognizes one scale for the figures, another for the surroundings, including the animals and the sheepfold. Cennini recounts that to paint a mountainous landscape one need only bring a rock into the studio, and that a branch could do duty for a tree. The results of this principle show that Giotto, for all his ability to project three-dimensional form, is far from accepting the notion of visual unity. His landscape, however, has an expressive purpose; the rock behind Joachim bends along with his head, and the jagged edges toward the center underscore the division between him and the shepherds. The cubic rocks form a definite stage in space, limited by the blue background, which does not represent the sky—there are no clouds—but is an ideal, heavenly color continuing behind all the scenes and covering the barrel vault above. In order to emphasize the three-dimensionality of the columnar figure of Joachim, Giotto has designed his halo foreshortened in perspective.

In the *Raising of Lazarus* (fig. 648) the composition divides into two groups: one centered around Lazarus, who has just risen from the tomb and is still wrapped in graveclothes, is read together with the rock; the other, beginning with the prostrate Mary and Martha, culminates in Christ, who calls the dead man forth by a single gesture of his right hand against the blue. The calm authority of Giotto's Christ is contrasted with the astonishment of the surrounding figures. Though in the *Lamentation* (fig. 649) the Byzantine tradition is by no means forgotten, Giotto has en-

649. GIOTTO. *Lamentation*, fresco, Arena Chapel, Padua. 1305–6

riched the dialogue between life and death with all the subtlety of his psychological observation. Instead of an explosion of grief, he has staged a flawlessly organized tragedy, the equal of Sophocles or Shakespeare in its many-faceted analysis of a human situation. The figures grieve in the manner possible to their individual personalities—John, the beloved disciple, most deeply of all. Giotto has added to the scene anonymous mourners who turn their eloquent backs to us; one upholds Christ's head, the other his right hand. Mary, with one arm around Christ's shoulder, searches his countenance, conscious of the widening gulf of death. Only the angels are released to cry in pure grief, each half-hidden in clouds to show that they are supernatural. (Significantly, in Giotto clouds appear only as accompaniments to heavenly figures.)

Giotto's brushwork remains as calm in this scene as in any other. He achieved his effect not only by the grouping of the figures but also by the inexorable diagonal line of the rock, descending toward the faces of Mary and Christ, its course weighted by the downward tug of the drapery folds. At the upper right, as if to typify the desolation of the scene, a leafless tree stands against the blue. Giotto surely expected his audience to remember that, according to medieval legend, the Tree of Knowledge was withered after the sin of Adam and Eve and made fruitful again after the sacrifice of Christ, and that Christ himself was believed to have alluded to this doctrine on his way to Calvary: "For if they do these things in a green tree, what shall be done in the dry?" (Luke 23:31).

TADDEO GADDI Giotto indeed had the cry; within a decade after his great works made their appearance, the style of Cimabue had been relegated to country churches, and Giotto, his many pupils, and still more numerous followers dominated the Florentine scene. One of the closest of his pupils, Taddeo Gaddi (active c. 1330–c. 1366), although he could never approach the heights of Giotto's achievements, continued some aspects of his style, especially in the representation of light. Probably between 1332 and 1338, and perhaps under the master's personal direction, Taddeo painted a series of frescoes in the Baroncelli Chapel of Santa Croce in Florence. In the fourteenth century natural light was always diffused and generalized, without indication of a specific source. But Taddeo has shown the traditional scene of the *Annunciation to the Shepherds* (fig. 650) as a revelation of light, which in a long Christian tradition symbolizes the second person of the Trinity. After all, every Christian knew the sublime words of John 1:4–5:

> In him was life; and the life was the light of men. And the light shineth in darkness; and the darkness comprehended it not.

As a devoted follower of Giotto, Taddeo never represents natural light, but he presents the announcing angel in the midst of a wonderful display of light, which descends upon the shepherds who have fallen to the ground in amazement and lights the whole dark landscape with its radiance. We are here experiencing the reversal of the process by which, at the beginning of the Middle Ages, the illusionistic art of the Helleno-Roman tradition was transformed into the otherworldly art of Byzantium. Techniques derived from naturalistic painting were used in the early Middle Ages to represent supernatural light. Now, at the end of the Middle Ages, that same spiritual light is used to aid the artist in the rediscovery of material reality.

650

650. TADDEO GADDI. *Annunciation to the Shepherds*, fresco, Baroncelli Chapel, Sta. Croce, Florence. c. 1332–38

DUCCIO In Siena the Byzantine tradition continued into the four-
teenth century and was refined to the ultimate in the work of Duccio di
Buoninsegna (active 1278–1318). His great altarpiece, the *Maestà* (*Ma-
donna in Majesty*), more than thirteen feet in width, was started in 1308
for the high altar of the Cathedral of Siena. It was considered such a
triumph for the artist and such an important contribution to the welfare
of the Sienese Republic (whose patron saint was the Virgin) that on its
completion in 1311 it was carried at the head of a procession of dignitaries
and townspeople from Duccio's studio to the Cathedral, to the ringing of
church bells and the sound of trumpets. The high altar was freestanding,
so that the back of the altarpiece and even its pinnacles were covered with
a cycle of scenes from the life of Christ even more complete than that
Giotto had just painted for the Arena Chapel. In the sixteenth century
the altarpiece was taken down and partially dismembered; panels from
the pinnacles at the top and from the *predella* (the lower strip at the base
of an altarpiece) are scattered throughout the world, but most remain in
Siena. The central panel shows the Virgin as Queen of Heaven (fig. 651),
adored by her court of kneeling and standing saints and angels and half-
length prophets in the arches above—a sort of cathedral façade in paint.
And, though the pose of the Virgin and Child shows that Duccio is still
working in the Byzantine tradition, he has nonetheless learned from the
works of Giovanni Pisano new and Gothic ways to handle flowing masses
of drapery and dense crowds of figures. While the oval shapes of the faces
are Byzantine, their small almond eyes bear no relation to the lustrous
orbs of the saints in most Byzantine mosaics, frescoes, and icons.

Although Duccio accepted neither Giotto's cubic rocks nor his col-
umnar figures, and although he could not achieve Giotto's subtlety of
psychological observation, he was an artist of great individuality, espe-
cially in the handling of landscape elements, as can be seen in the *Temp-
tation of Christ* (fig. 652), once a part of the *Maestà*. The kingdoms of the
world, shown to Christ by Satan, were depicted by Duccio, a good re-
publican Sienese, as seven little city-states crowded into a panel not quite
eighteen inches square. Obviously, they derive from the late Roman and

652

651. DUCCIO. *Virgin as Queen of Heaven*, center
panel of the *Maestà* altarpiece (now divided),
from the Cathedral of Siena. 1308–11. 7′ ×
13′ 6¼″. Museo dell'Opera del Duomo,
Siena

652. DUCCIO. *Temptation of Christ*, from the back
of the predella of the *Maestà* altarpiece.
1308–11. Panel painting, 17 × 18⅛″. ©
The Frick Collection, New York

Early Christian tradition of little nugget-cities, but each one is different, with its own houses, public buildings, city gates, and towers, all modeled in a consistent light. If we are willing to accept the medieval convention of the double scale for figures and setting, we must admit that within it Duccio was very successful in indicating the scope and sweep of landscape, which soon became Siena's great contribution to the history of art.

In one of the larger panels of the *Maestà*, Duccio set the stage, as it were, for the *Entry into Jerusalem* (fig. 653) in the suburban orchards outside the walls of Siena. We look over trees, garden walls, and a gate in the foreground to the road moving uphill, more garden walls on the other side, the city gates, and houses fronting a street. The towering octagonal building is the Temple, combining travelers' tales of the Dome of the Rock, built on the site of the Temple, with the familiar outlines of the Baptistery of Florence. This setting, of unexampled spatial complexity, Duccio filled with more than fifty people, all sharply individualized (within the range of Byzantine-Sienese facial types), from the solemn Christ mounted on an ass to the excited populace and children climbing trees, including some inhabitants looking out of windows and over the city wall.

THE LORENZETTI Giotto's new devices reached Sienese painting in the work of two brothers, Pietro (c. 1280–1348?) and Ambrogio (c. 1285–1348?) Lorenzetti, who, nonetheless, continued independently the Sienese tradition of the exploration of landscape and architectural settings. The Lorenzetti brought Sienese painting to a position of absolute leadership in Europe during the decade following Giotto's death. In Pietro's *Birth of the Virgin* of 1342 (fig. 654), for the Cathedral of Siena, we are aware of Giotto's cubic space and columnar figures, but Pietro has taken a significant step in the direction of illusionism. The gold background is eliminated except where it peeks through a tiny window at the left. The architectural setting has been identified with the actual carved shape of the frame, which it was customary for the artist himself to design and which was usually built and attached to the panel before the process of painting was begun. The picture thus becomes a little stage into which we can look, so that we cannot help wondering from the illustration what is carved and what is painted. Pietro's altarpiece is a pioneer attempt to build up the consistent interior space that never seems to have occurred to the Romans. His perspective is not entirely consistent, but the upper and lower portions of the interior are drawn so that the parallel lines in each converge to a single separate vanishing point. An enormous step has been taken in the direction of the unified perspective space of the Renaissance (see figs. 683, 701).

Not even Pietro's formulation of interior space is quite as startling as what Ambrogio had already achieved in the fresco representing the effects of good government in city and country. This panorama fills one entire wall of a council chamber in the Palazzo Pubblico (the Sienese counterpart of the Florentine Palazzo Vecchio) and is in fact so extensive that it requires two photographs to show it in its entirety (figs. 655, 656). Ambrogio has assumed the high point of view taken by Duccio for his exterior scenes, but he has immensely expanded it. On the right we look over the zigzag line of the city wall into open squares and streets lined with houses, palaces, and towers, some still under construction (note the masons at work under the center beam). At the upper left can barely be made out the campanile and dome of the Cathedral. Richly dressed Sienese burghers and their wives ride by on horseback; one horse has already

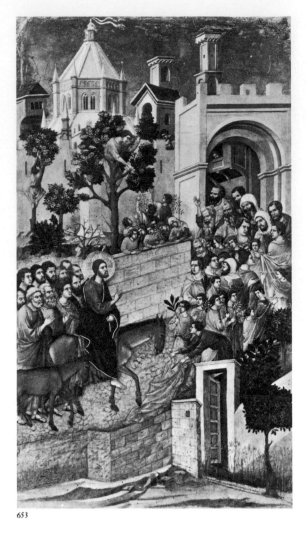

653

653. DUCCIO. *Entry into Jerusalem*, from the back of the *Maestà* altarpiece. 1308–11. Panel painting, 40 × 21″. Museo dell'Opera del Duomo, Siena

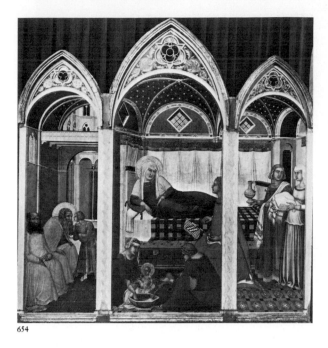

half-disappeared down a street in the center. The three arches of the building in the foreground contain (from left to right) a shoe shop, a school with a teacher at a desk on a platform and a row of pupils, and a wineshop with a little bar in front. Groups of happy citizens dance in the street.

To the right of the city wall (see fig. 656), under a friendly floating near-nude labeled *Securitas*, who brandishes a scroll with one hand and a loaded gallows with the other, the city people ride downhill into the country and the country people walk uphill into the city. The view of the countryside is amazing: roads, hills, farms and orchards with peasants hard at work, a lake, a country chapel, villas and castles, hills beyond hills, stretching to the horizon. But just where we would expect a blue sky with clouds, Ambrogio drops the Iron Curtain and reminds us that we are still in the Middle Ages. The background is a uniform gray black. This encyclopedic view of the Sienese world and everything in it is an exciting preview of the Renaissance, but there it stops. The Black Death, an epidemic of the bubonic plague that swept Europe in 1348, killed from half to two-thirds of the populations of Florence and Siena, probably including Ambrogio and Pietro Lorenzetti, and put an end to such explorations.

SIMONE MARTINI Duccio's pupil Simone Martini (active 1315–44), while fully abreast of all his master could achieve in the realm of landscape and urban settings, finally broke with the Byzantine tradition in favor of the more fashionable courtly French Gothic style of the early fourteenth century. He blended these two separate sources into a unified, and in the long run highly original, style of great lyric beauty and material splendor. Simone worked for the French king Robert of Anjou at Naples and brought back to Siena the latest French imports. Even more than the *Maestà* of Duccio, his *Annunciation* (fig. 657) is a condensed cathedral façade, Gothic this time, with all the richness of Flamboyant double curvature (which had not as yet made its appearance in the architecture of Giovanni Pisano). The elaborate frame, glittering with Gothic gables, pinnacles, and foliate ornament, all richly gilded, encloses the most sacred of all scenes in Christian art. For according to theological teaching and tradition, the Incarnation of Christ, the second person of the Trinity, in human form occurred at the precise moment when the words of the Angel Gabriel struck the ear of the Virgin Mary.

Simone has enhanced the dramatic impact of the event by a veritable explosion of forms and colors. The center of the altarpiece is occupied only by a great vase containing lilies, symbols of Mary's virginity; there are four of them, the number of the Gospels. Everything else seems to have been blown away from the gold background by the force of the angel's message, "Ave gratia plena dominus tecum" ("Hail thou that art highly favored, the Lord is with thee," Luke 1:28), embossed so as to catch and reflect light. Even the expected two colonnettes, seemingly needed to support the central arch, have been omitted, so that the capitals seem to hang in the breeze. The dove of the Holy Spirit ("The Holy Spirit shall come upon thee, and the power of the most High shall overshadow thee," Luke 1:35) flies downward toward Mary and is surrounded by tiny seraphim, whose crossed swallow wings echo in reverse the cusps of the frame. Unexpectedly, the slender and elegant Mary, "troubled at his saying" (Luke 1:29), recoils almost in terror at her fate, her face clouded with apprehension. The angel is dressed magnificently in white and gold

654. PIETRO LORENZETTI. *Birth of the Virgin*. 1342. Panel painting, 73½ × 72½". Museo dell'Opera del Duomo, Siena

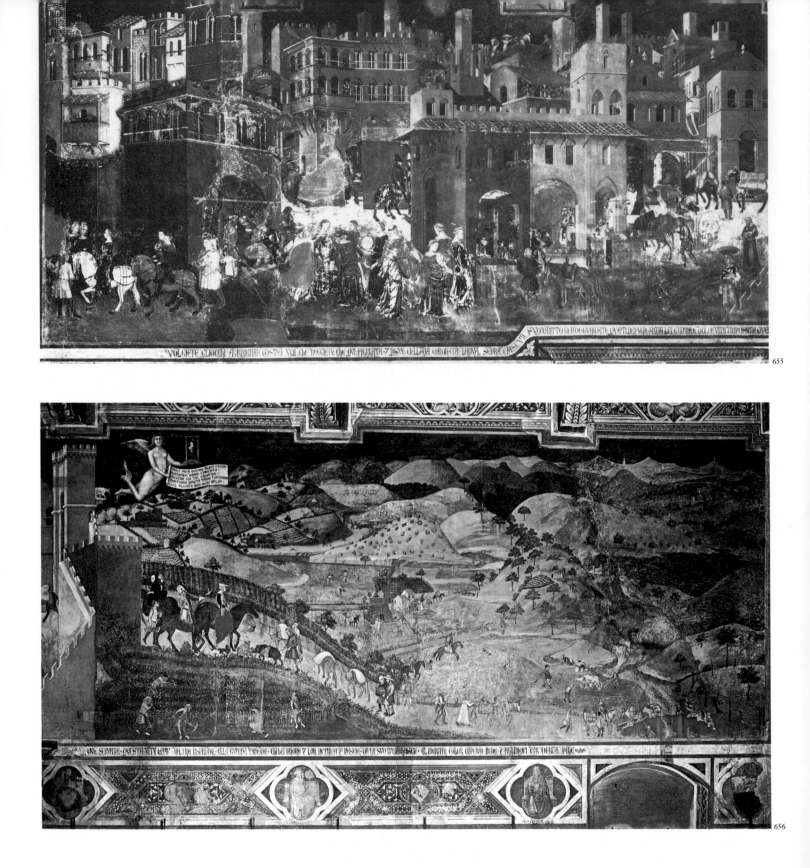

655

656

brocade with a floating, plaid-lined mantle, and the Virgin's blue mantle is edged with a deep gold border. The swirling drapery rhythms in their curvilinear exaggerations contrast strongly with the controlled shapes of Giotto and Duccio. This is an extraordinary and unexpected style, graceful in the extreme yet intensely dramatic, with all the characteristic Sienese fluency of line translated from Byzantine Greek into Flamboyant French.

655. AMBROGIO LORENZETTI. *Allegory of Good Government: the Effects of Good Government in the City and the Country* (detail of a fresco, Sala della Pace, Palazzo Pubblico, Siena). 1338–39

656. AMBROGIO LORENZETTI. *Allegory of Good Government: the Effects of Good Government in the City and the Country* (detail of a fresco, Sala della Pace, Palazzo Pubblico, Siena). 1338–39

657. SIMONE MARTINI. *Annunciation*. 1333. Panel painting, 10′ × 8′ 9″ (frame reconstructed in 19th century). Galleria degli Uffizi, Florence

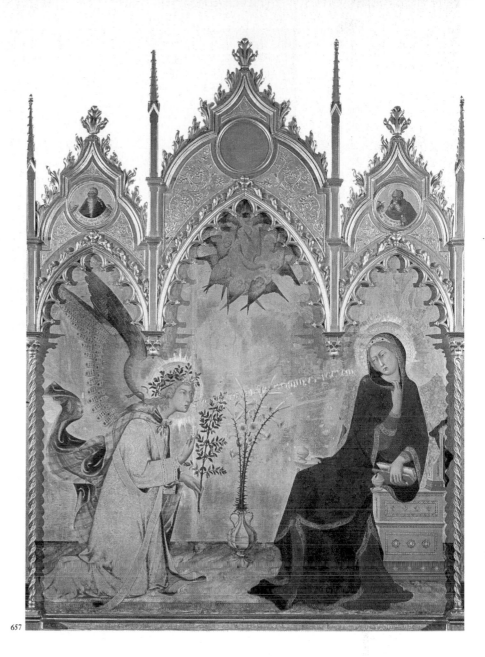

657

TRAINI The fresco representing the *Triumph of Death* in the Campo Santo at Pisa is probably the work of a local master named Francesco Traini (active c. 1321–63) and doubtless reflects the universal gloom following the Black Death. In this panorama (fig. 658), very different from the carefree world of Ambrogio Lorenzetti, no one escapes. At the left three richly dressed couples on horseback, out hunting, come upon three open coffins containing corpses in varying stages of putrefaction, a common enough sight in 1348; they draw back in consternation, one rider holding his nose. At the right in a grove of orange trees sits a happy group of gentlemen and ladies, engaged in music and conversation, reminding us of Boccaccio's *Decameron*, written at the time of the Black Death. They seem not to see Death, a winged, white-haired hag, sweeping down on them with a scythe. In the air above, angels and demons fight over human souls. The rocky path at the upper left leads to hermits' cells, as if to demonstrate that the only road to salvation is retreat from the world. The severe damage suffered by these frescoes in World War II necessitated the detachment from the wall of all those that still adhered; under-

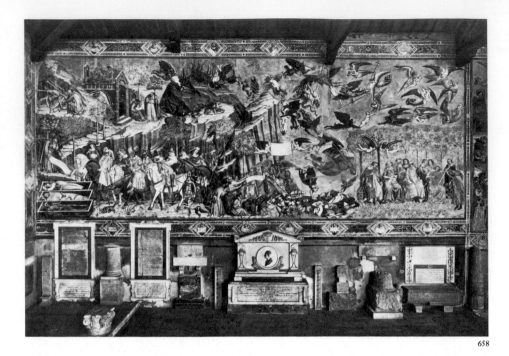

658

659

658. FRANCESCO TRAINI. *Triumph of Death*, fresco, Campo Santo, Pisa. Middle 14th century

659. FRANCESCO TRAINI. *Triumph of Death* (detail of sinopia)

660. GIOVANNI DA MILANO. *Pietà*. 1365. Panel painting, 48 × 22¾″. Galleria dell'Accademia, Florence

TIME LINE VIII

	POLITICAL HISTORY	RELIGION, LITERATURE	SCIENCE, TECHNOLOGY
1260	Siena defeats Florence at Montaperti, 1260 Ordinances of Justice in Florence disenfranchise nobles, 1293	Jacobus de Voragine writes *Golden Legend*, 1266–83	Marco Polo returns from China, c. 1295
1300	Visconti family rules Milan, 1312–1447	Dante writes *Divine Comedy*, 1302–21 Petrarch, poet and first humanist (1304–74) "Babylonian Captivity" of papacy in Avignon, 1309–78	Adoption of gunpowder in Europe, 14th century
1325	Duke of Athens expelled from Florence, ending dictatorship, 1343 Black Death in Florence and Siena, 1348	*Chronicles* by Giovanni Villani, first history of Florence, 1348	Use of guns at battle of Crécy, 1346
1350		*Decameron* by Giovanni Boccaccio, 1353 Papacy returns to Rome, 1378; Great Schism, Rome vs. Avignon, 1378–1417	Use of artillery at Aljubarrota, Portugal, 1385

neath was found the most extensive series of sinopias then known (fig. 659). These sinopias reveal the boldness and freedom of brushwork, recalling Byzantine painting, that underlie the meticulous finish of fourteenth-century frescoes.

GIOVANNI DA MILANO In the wake of the Black Death, no new figures emerged of anything near the stature of the great masters of the early fourteenth century, but some painters showed new observations and insights. One of the most gifted was Giovanni da Milano (active 1346–66), a Lombard working in Florence, where in 1365 he signed a new kind of image, a *Pietà* (fig. 660), from the Italian word for both *pity* and *piety*, both of which it was intended to excite. The intensified religious life of Italy after the catastrophe required new images, which would draw from biblical sources figures, situations, and emotions rather than narrative incidents and recombine them in timeless configurations designed to strengthen the reciprocal emotional bond between sacred figures and the individual worshiper. In an attempt at once to arouse the sympathies of observers and to demonstrate to them that Christ had shared the sufferings of all humanity, Giovanni has depicted him after death, being lifted in the arms of Mary, Mary Magdalene, and John. The emotional intensity of the painting has reached fever pitch, but it is no longer expressed in outbursts; it is felt within, rather, like a self-inflicted wound. As impressive as the content of Giovanni's painting is his new attention to muscles, bones, and tendons—not only where they affect the texture of an anatomical surface but also where they appear in profile along the sensitive contour. His art prepares the way for the great discoveries of the approaching Renaissance, in both Italy and the North.

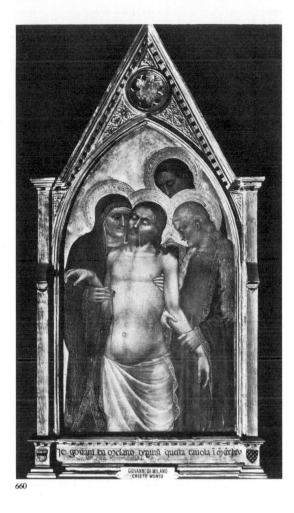

660

THIRTEENTH- AND FOURTEENTH-CENTURY ITALY

Painting, Sculpture

Nicola Pisano, Pulpit, Baptistcry, Pisa Cimabue, *Madonna Enthroned* Cavallini, *Last Judgment*	1260
Giovanni Pisano, Pulpit, S. Andrea, Pistoia; *Virgin and Child*, Arena Chapel, Padua Giotto, frescoes, Arena Chapel; *Madonna and Child Enthroned* Duccio, *Maestà*, with scenes from life of Christ	1300
Taddeo Gaddi, *Annunciation to the Shepherds*, S. Croce, Florence Simone Martini, *Annunciation* Ambrogio Lorenzetti, *Allegory of Good Government*, Palazzo Pubblico, Siena Pietro Lorenzetti, *Birth of the Virgin*	1325
Francesco Traini, *Triumph of Death*, Campo Santo, Pisa Giovanni da Milano, *Pietà*	1350

CHAPTER

THE EARLY RENAISSANCE IN ITALY—THE FIFTEENTH CENTURY

TWO

Renaissance, the French word for "rebirth," has generally been taken to signify the revival of the knowledge of Greek and Roman civilizations. Writers of the period believed that Classical literature, philosophy, science, and art had been lost in an age of darkness after the collapse of the Roman Empire under the onslaught of Germanic invaders and had awaited throughout the intervening centuries resurrection at the hands of the Italians, true heirs of their Roman ancestors. When the Tuscan poet and humanist scholar Petrarch (Francesco Petrarca), who seems to have been the first to proclaim the idea of barbarian decline and contemporary rebirth, was crowned with laurel on the Capitoline Hill in Rome in 1341, it was not in recognition of the beauty of his Italian sonnets, but rather in honor of the breadth of his knowledge of ancient history and of the purity of his Latin style.

Petrarch's literary classicism had little demonstrable effect on the art of his own time. Few fourteenth-century artists imitated Classical models; ironically, Petrarch's favorite painter was his contemporary Simone Martini and his favorite building the Gothic Cathedral of Cologne. Moreover, Petrarch could not have known that during the period he designated as "dark" repeated efforts had been made to revive one aspect or another of Classical art. When in the fifteenth century Italian artists adopted in earnest ideas and motives from the artistic vocabulary of ancient Rome (they did not know Greek buildings), they limited their efforts to architecture and decoration. Only for limited purposes were sculptors concerned with the imitation of specific models. There were almost no examples left for painters to follow.

Still, a tremendous change occurred in the visual arts in the fifteenth century, the consequences of which are with us yet, and the revival of Classical antiquity is not enough to explain it. The Swiss historian Jakob Burckhardt, writing in 1860, used "The Discovery of the World and of Man" as the title for one major division of his great work, *The Civilization of the Renaissance in Italy*. In the formation of Renaissance art, it is this discovery that distinguishes the artistic revolution of the fifteenth century from earlier Classical revivals and gives meaning to its borrowings from ancient art. The new vision of the Renaissance artist, whether in the generally Classical setting of Italy or in the still-Gothic enframement of Northern Europe, projects a believable picture of humanity and of the world. In many ways it goes further than ancient art in its inclusiveness and consistency.

At the height of the new movement, in 1451–52, the Florentine humanist Giannozzo Manetti wrote a work entitled *On the Dignity and Excellence of Man*, in which he refuted the claims of medieval theologians that man was worthless in the eyes of God. Manetti extols man as "lord and king and emperor in the whole orb of the world, and not unworthy to dominate and to reign and to rule." He finds not only man's soul but also his body beautiful, every part admirably adapted to its purpose, so perfect indeed that both

pagans and Christians were justified in representing their gods in human form, and the Greeks in calling the human body a microcosm, since it mirrors in itself the harmony of the entire world. There is no miracle that the human intelligence cannot encompass, Manetti tells us, no mystery of the cosmos that it cannot fathom. But the highest peak of human genius is speculation about the divine. The world was created not for God, who had no need of it, but for man. Man is the most perfect work of God, containing in himself all the beauties scattered in various orders of the universe, and revealing them in his creative power, the true marvel of his genius. "Ours then," says Manetti, "are everything which you see, all the homes, the fortresses, the cities, all the buildings in the entire world which are so many and such that they seem the work of angels rather than of men. . . . Ours are the pictures, ours the sculptures, ours the arts, ours the sciences, ours the wisdom. Ours are all the regions of the earth, mountains, valleys, plants, animals, fountains, rivers, lakes and seas, and all the innumerable creatures." For Manetti man has his end, not in God, but in a knowledge of himself and his own creativity.

A similar pride inspired the humanist and architect Leonbattista Alberti when he wrote in the prologue to his treatise *On Painting* in 1435, "We have dug this art up from under the earth. If it was never written, we have drawn it from heaven." In the prologue he claimed "that it was less difficult for the ancients—because they had models to imitate and from which they could learn—to come to a knowledge of those supreme arts which today are most difficult for us. Our fame ought to be so much greater, then, if we discover unheard-of and never-before-seen arts and sciences without teachers or without any model whatsoever." This attitude culminates in Leonardo da Vinci's assertion that the painter is "Lord and God" to carry out whatever idea comes into his head and in Michelangelo's comparison of the sculptural process to that of divine salvation.

With few exceptions the humanists considered themselves Christians, and some were in religious orders, but it must be remembered that they represented an elite. Medieval piety still inspired the masses of the people, even in humanist Florence, and could occasionally resume control. During the Counter-Reformation, in the middle of the sixteenth century, Manetti's work was put on the *Index Expurgatorius (List of Forbidden Works)*.

The Renaissance artist inherited from the Middle Ages such duties as the construction of churches and palaces, the painting of frescoes and altarpieces, the carving of pulpits and tombs. Interest in stained glass declined and the illuminated manuscript, still important in the early fifteenth century, was soon replaced by the printed book. The humanist attitude of the artist and his patron gave rise to three phenomena seldom seen since the eclipse of paganism—the nude human figure, the recognizable portrait, and the landscape, all in keeping with the above passages from Manetti.

In art as in politics, the early Renaissance was a man's world. Women had been excluded, for the traditional reasons, from all medieval workshops except for the highly productive convents from which so many beautiful illuminated manuscripts came. They were doubly barred from Renaissance studios because of the reliance of Renaissance art on the nude. Only rarely did convents still produce women painters (of marginal interest), and not until late in the sixteenth century, to the universal marvel of their male contemporaries, did such women artists as Lavinia Fontana and Marietta Tintoretto (neither of sufficient stature to warrant inclusion here) emerge in the studios of their painter-fathers. In this same period Sofonisba Anguissola (see page 640) appeared in a scholarly and artistic family environment and attracted great fame. By the sixteenth century extraordinary women began to play leading roles in politics—Catherine de' Medici, Mary Stuart, and Queen Elizabeth I may be especially singled out. At the court of the latter monarch, herself an accomplished musician, literature and music, but not the figurative arts, enjoyed a triumphant rebirth. Occasionally a wealthy and powerful woman played a decisive and highly individual role as a patron of the visual arts. A shining example was Isabella d'Este, marchioness of Mantua, an indefatigable collector of antiquities and gems, who employed Mantegna, Perugino, and

other famous masters to decorate her study according to iconographic programs entirely devised by the learned marchioness herself.

Especially important is the versatility of the Renaissance artist. The same man can often excel at two of the three major arts, sometimes at all three. Alberti, Ghiberti, Piero della Francesca, Leonardo da Vinci, Albrecht Dürer, and Andrea Palladio also wrote extensive treatises on the principles of their arts. But the artist did not limit himself to the practice of what today we would call "Art." In the conquest of reality, he turned his attention to the sciences of perspective, anatomy, botany, geology, and geometry. His genius could be placed at the service of the state in peace and war, for he was expected to plan cities, lay out canals and fortifications, and design bridges and arches, floats and pageants, and even weapons and engines of war. The investigation of perspective, one of his great delights, was closely allied to the exploration of *actual* space, which culminated in the late fifteenth and the sixteenth centuries in the voyages of the great discoverers and the revolutionary theories of the astronomers and cosmographers. It was no accident that the map that led Columbus to resolve to set forth on his first journey to the New World was produced in Renaissance Florence.

The humanist concerns of the artist opened him to advice from the humanist leaders of the Renaissance state, particularly Florence; he was likewise involved perforce in the destinies of those very leaders. When the fifteenth century began, the artist was still a craftsman, firmly embedded in the system of merchant and artisan guilds that controlled the Florentine Republic. By midcentury he had become everywhere, except in Venice, an adjunct of the princely society that was visibly or invisibly replacing the medieval republics. By the sixteenth century, when absolutism held sway throughout much of Italy, an artist of the stature of Michelangelo, Raphael, or Titian had acquired aristocratic social status, wealth, and influence. He could be and often was a learned man (very occasionally a learned woman). Gradually the medieval workshop, still prevalent throughout the fifteenth century, was replaced by the studio (from the Italian word for "study"), and the artist abandoned the decaying guilds for membership in the learned academies, which offered systematic training not only in the arts but in those sciences considered necessary for an artist.

Outside Italy the Gothic tradition was still strong, and few Classical remains were visible to compete with it. Possibly for this reason, Northern and Spanish architecture remains resolutely Gothic well into the sixteenth century, and in spite of the humanists and of the rich commercial contacts between Italy and the rest of Europe, there is little Classical influence on Northern painting and sculpture until the High Renaissance. But great discoveries of methods of representing the visible world were made in the Netherlands and spread from there to France, Germany, and Spain. In respect to sheer naturalism the Netherlanders, in fact, far surpassed the Italians, who were the first to recognize the special triumph of their Northern contemporaries. These discoveries, nonetheless, lack the theoretical structure responsible for the inner harmony of Italian Renaissance art.

Netherlandish towns, while possessing nothing like the independence of the Italian city-states, nevertheless enjoyed a measure of autonomy under the relatively enlightened if short-lived rule of the dukes of Burgundy. None of the artistically creative states of the Early Renaissance—the republics of Florence, Siena, and Venice, the Papal States, and the duchy of Burgundy—survive as political entities today. But with few exceptions it was in these relatively small, rich, disordered, and militarily insecure states, rather than in the kingdoms of Naples, France, England, and Spain, or the Holy Roman Empire, that the crucial developments of the Early Renaissance took place. It looks as though the turmoil that characterized the smaller states was more conducive to the development of artistic individuality than was the hierarchical structure of the monarchies. It is also important to note that, once the liberties of the Italian states had become extinguished in the sixteenth century, the Renaissance itself soon came to an end.

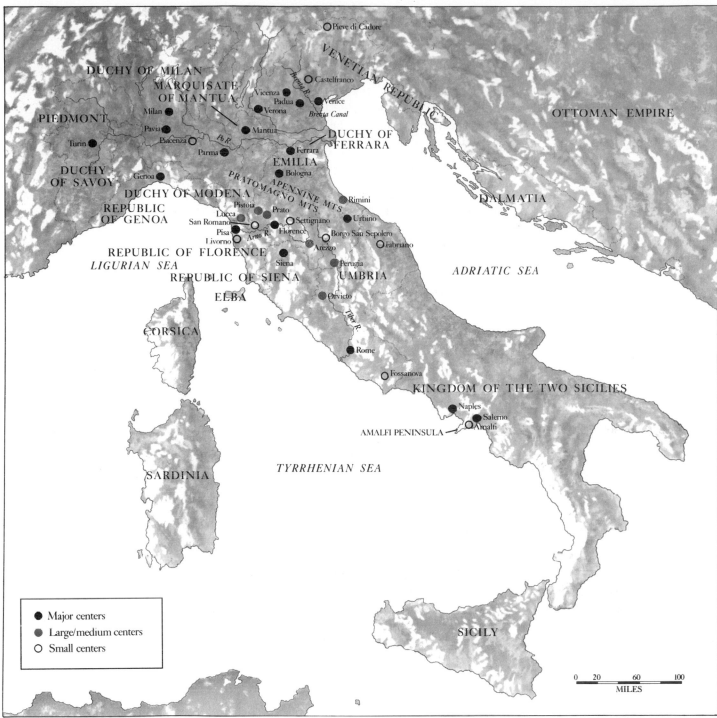

Pieve di Cadore

DUCHY OF MILAN

MARQUISATE
OF MANTUA

VENETIAN REPUBLIC

Castelfranco

Vicenza
Brenta R.
Padua
Venice
Verona
Brenta Canal

PIEDMONT

Milan

Pavia
Piacenza
Po R.
Mantua

Turin
Parma

DUCHY OF
FERRARA

Ferrara

DUCHY
OF SAVOY

Genoa

EMILIA

Bologna

OTTOMAN EMPIRE

DALMATIA

APENNINE MTS.

DUCHY OF MODENA

PRATOMAGNO MTS.

Rimini

REPUBLIC
OF GENOA

Pistoia
Prato

Lucca
San Romano
Pisa
Livorno
Arno R.
Florence
Settignano

Urbino

Borgo San Sepolcro

ADRIATIC SEA

Arezzo
Fabriano

REPUBLIC OF FLORENCE

LIGURIAN SEA

Siena
Perugia

REPUBLIC OF SIENA

UMBRIA

ELBA

Orvieto

CORSICA

Tiber R.

Rome

Fossanova

KINGDOM OF THE TWO SICILIES

Naples
Salerno
AMALFI PENINSULA
Amalfi

TYRRHENIAN SEA

SARDINIA

● Major centers
● Large/medium centers
○ Small centers

SICILY

0 20 60 100
MILES

MAP 12. ITALY ABOUT 1500

Architecture is the easiest of the arts in which to follow the rebirth of Classical motives in the Renaissance and their adaptation to contemporary needs. During a period notable for its political turbulence and almost continuous warfare, in which the very existence of the Florentine Republic was repeatedly threatened by outside enemies, the Italian city-states including Florence found the energy and the funds to adorn their still-medieval streets and squares with buildings in the new style. The harmony and dignity of these structures made them examples for later architects for five centuries—and their influence continues.

BRUNELLESCHI It is typical of the interchangeability of the arts in the fifteenth and sixteenth centuries that Filippo Brunelleschi (1377–1446), the founder of the Renaissance style in architecture, was trained as a sculptor. After his defeat in 1402 at the hands of Lorenzo Ghiberti in the competition for the bronze doors of the Baptistery of Florence (see page 530, and figs. 687, 688), Brunelleschi went to Rome, where he spent many months, perhaps together with the somewhat younger sculptor Donatello, studying and measuring the ancient buildings. In 1417 Brunelleschi won the competition to crown the unfinished Gothic Duomo (Cathedral) of Florence with a colossal dome (fig. 661). Like many crucial works of the Early Renaissance, Brunelleschi's dome still retains Gothic elements. The octagonal shape of the crossing of the Cathedral required an octagonal drum supporting a dome divided by eight massive ribs and the lantern at its apex. An inner shell of masonry and an outer shell of tiles conceal between them a complex web of smaller ribs and connecting, horizontal buttresses that ties the principal ribs together. Brunelleschi's construction system and his device for hoisting the building materials to great heights made it possible to erect the unprecedented structure without the expensive forest of scaffolding that would otherwise have been necessary.

Only the lantern (fig. 662), built from Brunelleschi's still-extant model after his death, shows direct Classical borrowings, the Corinthian order, complete with pilasters and entablatures folded about the corners of the lantern and sustained by a system of supporting arches. Brunelleschi based his masses, spaces, and enclosing surfaces on simple, proportional relationships of basic modules—one to two or two to three—utilizing the paneling of white and colored marbles characteristic of medieval churches in Florence to carry out his Renaissance system of rectangles and circles. The result is a structure of overwhelming mass, simplicity, clarity of statement, and intelligibility of design, rising (as Alberti put it) "above the skies, ample to cover with its shadow all the Tuscan people." In the early sixteenth century an attempt was made on one face to fill in the unfinished space between the drum and the dome with an ornamental gallery (see fig. 661), whose trivial scale only emphasizes the grandeur of Brunelleschi's shapes.

In the Ospedale degli Innocenti (Foundling Hospital), started in 1419 (fig. 663), Brunelleschi had a major opportunity to translate his knowledge of ancient architecture into fifteenth-century terms. The building faces the Piazza della Santissima Annunziata in Florence with a handsome arcade of eleven round arches supported on Composite columns, terminated at each side by Corinthian pilasters and surmounted by a second story of small, pedimented windows (the story above the roof is a later excrescence). Brunelleschi's proportion system can be easily followed; the height of each column equals the width of the bay between

Architecture in Florence and North Italy

661. FILIPPO BRUNELLESCHI. Dome, Cathedral of Florence. 1420–36

662. FILIPPO BRUNELLESCHI. Lantern of the dome, Cathedral of Florence. After 1446

663. FILIPPO BRUNELLESCHI. Ospedale degli Innocenti (Foundling Hospital), Piazza della SS. Annunziata, Florence. Begun 1419

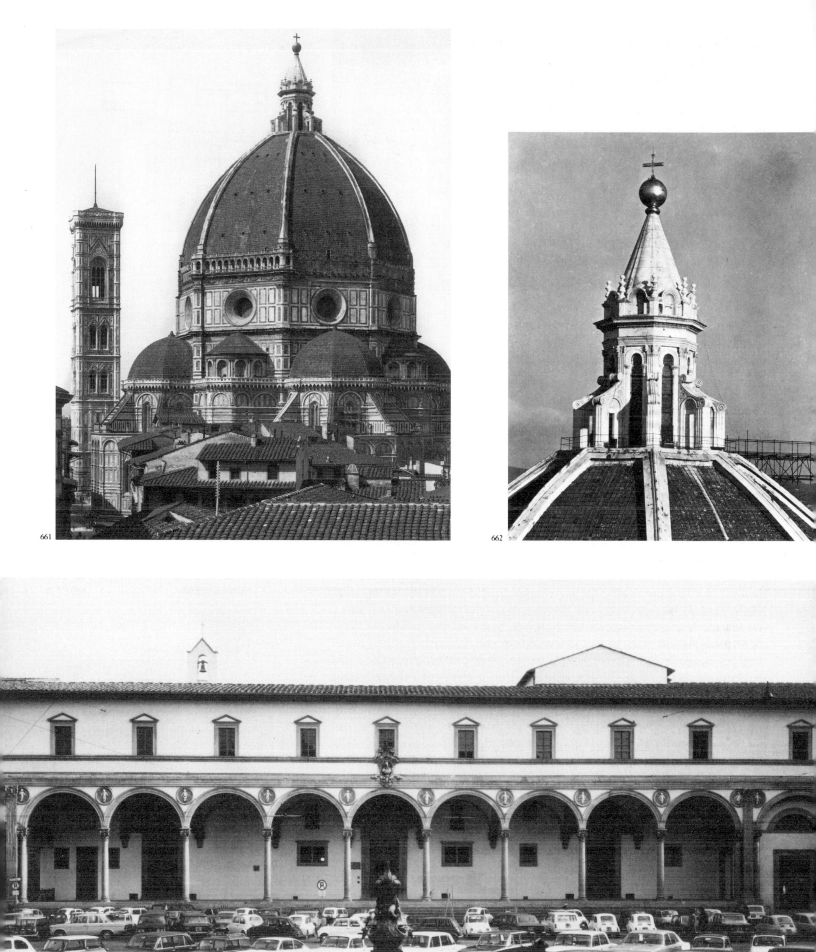

661

662

663

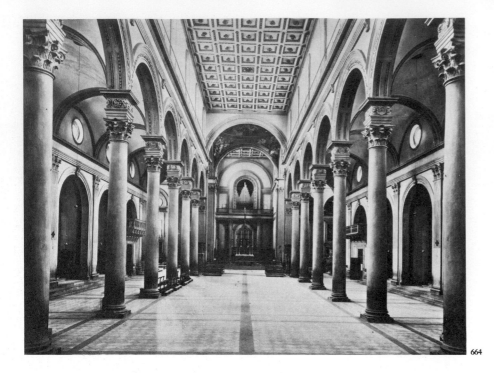

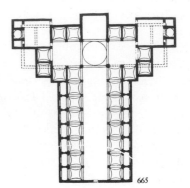

664

665

columns, and also its depth from column to wall. Each bay, therefore, becomes a cube of space, surmounted by a squared hemisphere in the shape of the pendentive vault (supported along the wall only by consoles). Both in general disposition and in the character of the capitals and entablatures, Brunelleschi has edited the splendor and richness of the Roman originals he studied in favor of an austere simplicity that emphasizes the clarity of his organization.

The great architect's mathematical turn of mind brought forth not only his sytem of basic geometrical shapes and simple proportions but also the related invention of what appears to be the first consistent system of one-point perspective—that is, a perspective in which all parallel lines in a given visual field converge at a single vanishing point on the horizon. Brunelleschi's perspective was derived from the observation of actual buildings. In the interior of the Church of San Lorenzo in Florence (fig. 664), built at intervals from 1421 well into the fifteenth century under the patronage of the Medici family, circles, half-circles, rectangles, and squares are kept, as at the Innocenti, within a clear-cut, all-embracing system of modules of surface and space, diminishing systematically as one looks down the nave.

At San Lorenzo Brunelleschi replaced the complexities of Gothic shapes and systems with the basic plan of an Early Christian basilica (fig. 665). The nave arcades, supported by unfluted Corinthian columns, sustain a flat wall, without triforium, pierced by a clerestory of arched windows. Flanked by Corinthian pilasters, the side aisles are covered by pendentive vaults supported on transverse arches; the nave is roofed by a flat, coffered ceiling, whose squares provide a convenient graph with which to measure inward spatial recession. Even the floor (the present pavement is nineteenth century) is marked off into squares by stripes, thus measuring not only the perspective recession but also the proportions between the width of the bays, the height of the columns, and that of the arches. All is measure, reason, proportion, harmony, accentuated by Brunelleschi's choice of a gray Florentine stone known as *pietra serena* (clear stone) for the columns, entablatures, arches, window frames, and other trim to contrast with the white plaster covering the masonry walls. This two-tone

664. FILIPPO BRUNELLESCHI. Nave and choir, S. Lorenzo, Florence. 1421–69

665. FILIPPO BRUNELLESCHI. Plan of S. Lorenzo, Florence

666. FILIPPO BRUNELLESCHI. Pazzi Chapel, Sta. Croce, Florence. c. 1440–61

667. FILIPPO BRUNELLESCHI. Plan of the Pazzi Chapel, Sta. Croce, Florence

668. FILIPPO BRUNELLESCHI. Interior, Pazzi Chapel, Sta. Croce, Florence

color scheme was repeated in Florentine architecture well into the nineteenth century. Within Brunelleschi's structure of harmonious spaces and surfaces, the lofty Corinthian columns stand with the cool perfection of statues.

The gem of Brunelleschi's later style is the chapel (fig. 666) given to Santa Croce by the Pazzi family of Florence to be used not only for their services but also as the chapter house in which the monks of Santa Croce could meet; it was constructed from about 1440 to 1461. A central square surmounted by a round dome on pendentives is extended on either side by arms equal to half its width (fig. 667); their barrel vaults are divided into large panels of *pietra serena* moldings against plaster. The resultant rectangular hall (fig. 668) is lined with fluted Corinthian pilasters (again in *pietra serena*, like all the trim) so placed as to appear to support the arches of the barrel vault and of the altar space and even the false arches inserted in the lunettes at either end of the chapel to complete the system. Smaller blind arches, reflecting the windows in the façade, appear in the spaces between the pilasters. These spaces furnish the basic module for the entire chapel. Over each of the twelve blind arches appears a small roundel, containing one of the Twelve Apostles in glazed terra-cotta, blue and white, by Luca della Robbia (see page 532). The pendentives display larger terra-cotta roundels of the Four Evangelists, probably by Brunelleschi himself. The dome with its twelve ribs and twelve oculi seems to be floating, since the lower cornice of the drum does not touch the supporting arches. The portico was added after Brunelleschi's death, possibly by Giuliano da Maiano.

The Pazzi Chapel is one of the masterpieces of architectural history, harmonious and graceful in its proportions and spaces, luminous and simple in its color scheme of gray, white, and blue with occasional touches of green, yellow, and violet. Here we are very far from the Gothic cathedral, which sought at once to enfold and to dazzle us with the infinite complexity of the medieval universe. Yet Brunelleschi, like all great architects of the Renaissance, had foremost in his own mind the idea of the Divine Proportion. When we analyze his relationship of shape, space, line, and number, we would do well to remember Giannozzo Manetti's declaration that the truths of the Christian religion are as self-evident as the axioms of mathematics. Ironically, Brunelleschi was not destined to see any of his major structures completed. At his death the nave of San Lorenzo was barely begun, the dome of the Cathedral lacked its lantern, and the Pazzi Chapel its façade. Nonetheless, this inspired architect established a whole new order for the art of building, as valid in the century of Le Corbusier and Mies van der Rohe as in his own.

MICHELOZZO We possess no certain example of domestic architecture by Brunelleschi, but we do know that Cosimo de' Medici, uncrowned ruler of the still ostensibly republican Florence, first commissioned him to make a model for his new palace and then rejected it as too grandiose for the Medici's pretense of being private citizens. The building, known today as the Palazzo Medici-Riccardi (fig. 669), was started in 1444 by the prolific architect and sculptor Michelozzo di Bartolommeo (1396–1472). In considering its present appearance, we have to make several mental adjustments. First, we must remember that the word *palazzo* means to Italians almost any fair-sized urban edifice, even a modern office building. Second, when the Medici Palace was bought by the Riccardi family at the end of the seventeenth century, it was extended on the right

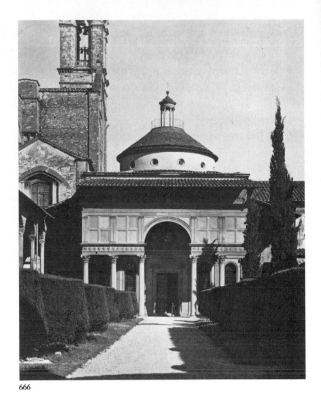

666

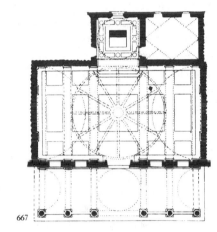

667

668

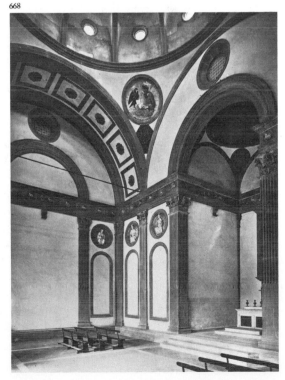

by one portal and seven bays of windows, which have to be thought away. Finally, the pedimented windows in the arches of the ground floor were added in the sixteenth century by Michelangelo. The arches originally gave access to an open loggia, for family ceremonies (fig. 670).

To modern eyes the building hardly looks palatial. Not only the fortress-like exterior, but also the lofty interiors, even when they were filled with the vanished collections of paintings (including battle scenes by Paolo Uccello, see fig. 707), sculpture, tapestries, and antiquities, must always have seemed austere. This was the taste of the time. Cosimo intended to impress the observer with the fortitude and dignity of his family. The massive lower story, more than twenty feet high, is heavily rusticated, that is, built of roughhewn blocks in a manner somewhat resembling that of the Palazzo Vecchio, but actually imitated from ancient Roman structures. The masonry of the second story, the family living quarters, is cut into flat blocks with strongly accented joints; that of the third is entirely smooth. The building is crowned by a massive cornice, towering some seventy feet above the street and after the example of Roman temples. But this is not the only Classical detail: the round arches of the second- and third-floor windows rest on delicate colonnettes with modified Corinthian capitals.

The interior courtyard (fig. 671) reminds one of the arcades of Brunelleschi's Innocenti but the columns have squatter proportions, in keeping with their function of upholding two stories instead of one. The second story is lighted by windows resembling those of the exterior, while the third (not shown in the illustration) was an open loggia, whose columns supported a beamed roof. Neither in proportions nor in detail can Michelozzo's palace survive comparison with the masterpieces of Brunelleschi, but it became the model for Florentine patrician town houses for the next two generations.

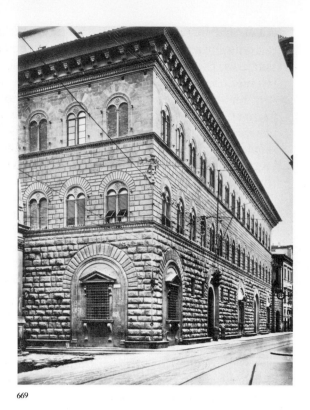

669

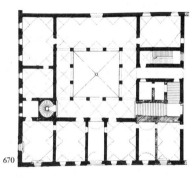

670

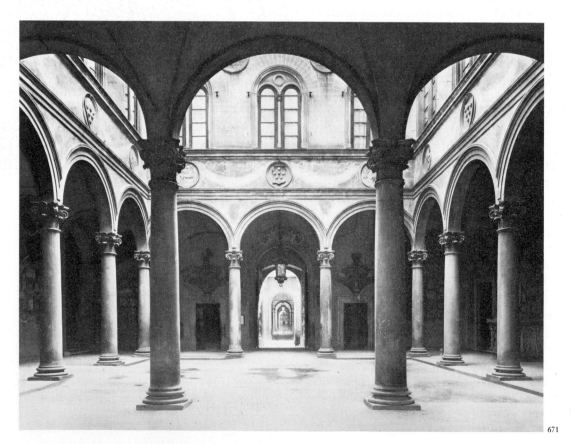

671

ALBERTI From the middle of the 1430s, the Renaissance movement, not only in architecture but also in sculpture and painting, fell under the domination of a cultural colossus, Leonbattista Alberti (1404–72). This scion of one of the most powerful Florentine families of the Middle Ages was born in exile and revisited Florence briefly and infrequently, functioning by preference as a humanist adviser at the courts of popes and princes. The author of many learned works on classical Latin, Alberti wrote three treatises, *On Painting*, *On the Statue*, and *On the Art of Building*, that had an immense influence on his own and subsequent generations, and they give us today a welcome insight into many aspects of Renaissance art. The wealthy Florentine merchant Giovanni Rucellai commissioned in 1446 the architect and sculptor Bernardo Rossellino (see page 548 and fig. 716) to build a palace from Alberti's designs. The building was later extended (the two bays at the right, still unfinished) as Giovanni acquired more land. The façade (fig. 672), an obvious commentary on that of the Medici Palace, takes us, nonetheless, into a new era of Renaissance thought. In his writings and in his designs, Alberti adopted antiquity as a way of life. While he retains the three-story division, the doubled windows on the second and third stories, and the great cornice of Michelozzo's building, he rejects the heavy rustication of Michelozzo's ground floor as if unsuitable to the residence of a citizen of wealth and taste. Instead, he establishes a uniform system of beveled masonry joints, identical on all three stories. The windows of the ground floor are given handsome, square frames. Then Alberti ornaments his façade by a superimposed three-story system of screen architecture—pilasters that do no work but only appear to uphold the entablatures above them. This device is derived from the superimposed orders of the Colosseum. It also corresponds to Alberti's doctrine that the basic proportions and divisions of the wall belong to beauty, defined as "the harmony and concord of all the parts, achieved in such a manner that nothing could be added, taken away, or altered," while the column and the pilaster belong to decoration. In contrast to Brunelleschi's columns and pilasters, those of Alberti almost never uphold arches. The arch, he tells us, is an opening in a wall and should remain as such. Today we see only a fragment of the building Alberti designed for Giovanni Rucellai; it would have been completed probably on the right by four more bays and one more portal. Alberti's design remained without a following in Florence, but its principles were of cardinal importance for the architecture of the High Renaissance.

About 1450 Alberti, although himself in Holy Orders and a secretary in the household of the pope, prepared for one of the most outrageous tyrants of the Renaissance a design for a building in which every tenet of Catholic Christianity was defied. Sigismondo Malatesta, lord of Rimini, was in the process of converting the Church of San Francesco at Rimini into a temple honoring himself and his mistress Isotta degli Atti. Their tombs were to appear on the façade, and those of the court humanists on the flanks of the nave, Greek scholars on one side, Latin on the other. At first Sigismondo seems to have desired only a remodeling of the existing Gothic church, but Alberti persuaded him to enclose it in a wholly new marble structure (fig. 673). Only the nave was completed before fortune ceased to smile on Sigismondo, but there is considerable evidence to show that Alberti intended it to terminate in a rotunda, with a hemispheric dome like that of the Pantheon. He considered the central plan ideal for a "temple" (the word *church* does not appear in Alberti's writings), not only on account of the Pantheon, but also because natural organisms are so often centralized, such as flowers, fruits, and cross sections of stems.

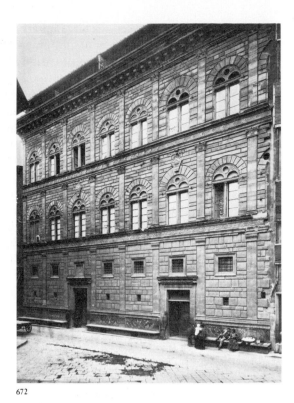

672

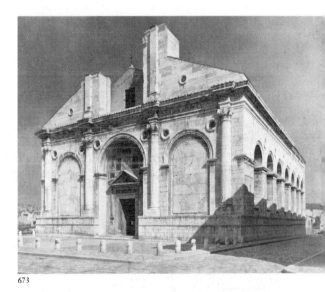

673

669. MICHELOZZO. Palazzo Medici-Riccardi, Florence. Begun 1444

670. MICHELOZZO. Plan of the Palazzo Medici-Riccardi, Florence

671. MICHELOZZO. Interior courtyard, Palazzo Medici-Riccardi, Florence

672. LEONBATTISTA ALBERTI. Façade, Palazzo Rucellai, Florence. 1446–51; core remodeled and extended 1455–after 1458 by Bernardo Rossellino

673. LEONBATTISTA ALBERTI. Malatesta Temple (S. Francesco), Rimini. c. 1450

The central plan, whether circular, square, polygonal, or cruciform, was to become the dominant ideal of church architecture in the High Renaissance, culminating in the design of various architects for Saint Peter's in Rome, because of the possibilities it offered for a harmonious composition of masses and spaces. It must be admitted that the central plan presented obstacles for the Catholic liturgy, since an altar in its logical position under the dome would turn its back to half the congregation. Alberti's churches lead up to the domed space through a great nave, which he felt should be barrel-vaulted. At the Malatesta Temple, the vault would probably have been made of wood.

As a model for the façade, Alberti chose the Arch of Constantine. Many of the details, however, were patterned on a Roman single arch still standing in Rimini. The central arch contains the portal; the side arches were intended to hold the tombs of Sigismondo and Isotta, who in fact are interred in chapels in the nave. The single arch of the second story was to have been flanked by quarter circles terminating the side-aisle roofs. As we would expect, the four massive engaged columns, with modified Corinthian capitals, uphold the entablature and embrace the arches. The arches continue on a somewhat smaller scale on the flanks of the church, each containing the sarcophagus of a humanist. In contrast to the lightness, linearity, and flat surfaces of Brunelleschi's architecture, the ponderous columns, piers, and arches of the Malatesta Temple produce an effect of imposing grandeur.

At Sant'Andrea (fig. 674), in the north Italian city of Mantua, a church designed in 1470 and built almost entirely after Alberti's death, his ideas come to fuller fruition. The plan (fig. 675) is still a Latin cross, but different from any we have seen so far. On the grounds that the ancient Romans had invented the basilica plan for law courts, and that the colonnades obstructed the view of the ceremony for those standing in the side aisles, Alberti designed a single-aisle interior, crowned by a huge barrel vault, whose inward recession leads the eye to the apse and the altar (fig. 676). The barrel vault is supported on massive piers, separating chapels covered by smaller barrel vaults running at right angles to that of the nave. A single giant order of coupled Corinthian pilasters ornaments the nave, embracing a smaller order flanking the arches of the chapels. In all

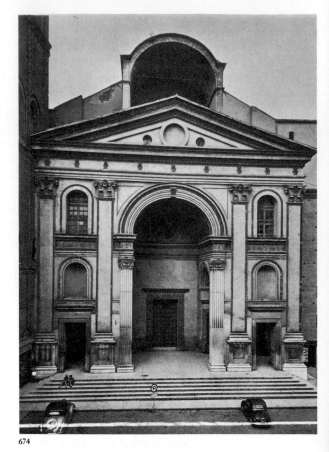

674

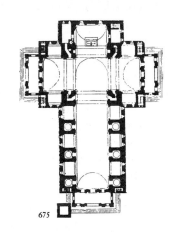

675

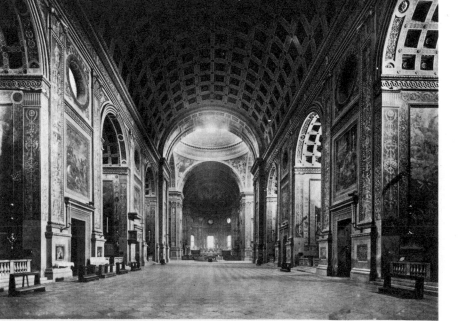

676

674. LEONBATTISTA ALBERTI. Sant'Andrea, Mantua. Designed 1470

675. LEONBATTISTA ALBERTI. Plan of Sant' Andrea, Mantua

676. LEONBATTISTA ALBERTI. Interior, Sant' Andrea, Mantua

677. GIULIANO DA SANGALLO. Sta. Maria delle Carceri, Prato. 1485–92

678. GIULIANO DA SANGALLO. Interior of the dome, Sta. Maria delle Carceri, Prato

probability a hemispheric dome would have completed the crossing, but this was never built; the present dome dates from the eighteenth century. The majestic and unified effect of the nave of Sant'Andrea was imitated by Bramante later on, especially at Saint Peter's in Rome (see fig. 911). Since the same plan was adopted by Vignola for the Gesù in Rome (see fig. 840) and subsequently followed in innumerable Baroque churches throughout Europe, Alberti may be said to have dealt the death blow to the basilica plan, which, with few exceptions, had dominated Christian church architecture for eleven centuries.

In keeping with Alberti's belief that the illumination of a temple should be high, so that one could see only the heavens in order to inspire awe and reverence for the mystery of the "gods," the interior of Sant'Andrea is lighted only by oculi in the main and transept façades (invisible from the street) and by smaller oculi between the piers and in the chapels. As in the Pantheon (and most likely in the Malatesta Temple), light would probably have come through an oculus in the center of the dome.

The façade (see fig. 674), restricted by preceding constructions, is a slightly enriched version of one bay of the nave, surmounted by a pediment. Because of the lack of building stone in Mantua, the church is constructed of brick faced with plaster, save for exposed brickwork trimming the pilasters of the façade. Imported marble, however, was used for the elegant pilasters of the smaller order, including the central arch and entablature. The façade is considerably lower than the church behind it, but, given the angle from which it must be viewed in the constricted piazza in front of it, this discrepancy is not visible. The arched excrescence over the pediment is a later addition, presumably to shade the oculus window from the direct sunlight.

GIULIANO DA SANGALLO

GIULIANO DA SANGALLO A member of a remarkable family of architects and sculptors, Giuliano da Sangallo (1443?–1516) was a close student of Roman antiquity; in fact, some of our knowledge of now-vanished Roman buildings has been gained from his drawings. Sangallo's Church of Santa Maria delle Carceri at Prato, near Florence (fig. 677), built from 1485 to 1492, owes debts to both Brunelleschi and Alberti. The ribbed dome, with its circular drum pierced by oculi, is based on that of the Pazzi Chapel (see fig. 666), as is the contrast between *pietra serena* trim, glazed terra-cotta decoration, and white stucco walls in the interior (fig. 678). But the exact centrality of the Greek-cross plan is clearly Albertian, and so is the beautiful exterior with its two stories of superimposed pilasters in white marble against white and green marble paneling.

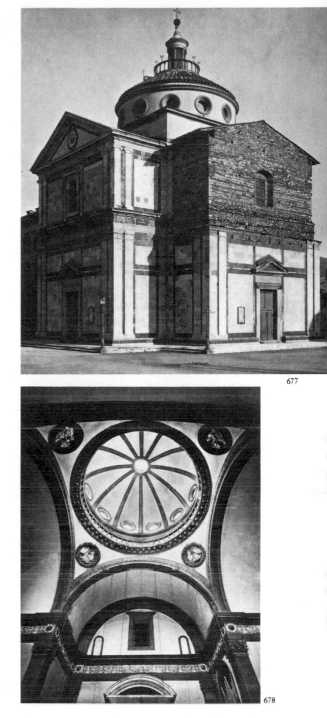

677

678

Certain ideas essential to the new style appeared in sculpture before they were adopted in painting. This phenomenon was by no means accidental. The commissions offered to painters consisted of altarpieces and frescoes in churches; many painters continued to work in the Late Gothic tradition up to the middle of the fifteenth century. Sculpture, on the other hand, was generally intended for the exteriors of buildings with a strong civic purpose, such as the façade and Campanile of the Cathedral of Florence, the bronze doors of the Baptistery, or the niches of Orsanmichele, granary of the republic, and appealed directly to the man in the street, sometimes from not far above eye level. The great sculptural works of the first third of the century were all done at a time when the Florentine Republic was fighting for its life, first against the duke of Milan, then

Sculpture in Florence: The Early Fifteenth Century

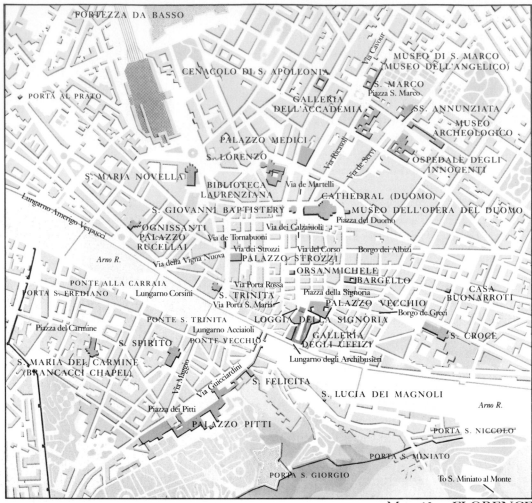

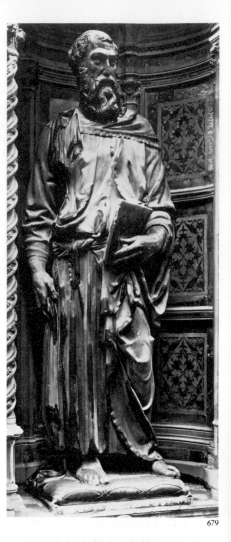

MAP 13. FLORENCE

679

against the king of Naples, then against another duke of Milan. All three of these tyrants aspired to monarchic rule of the entire Italian peninsula, wishing to absorb Florence and her somewhat less energetic ally, Venice, into an imperial superstate to the extinction of republican liberties. The new human being who appears in the works of the great Florentine sculptors, then, is the first image of the man of the Renaissance, aware of danger from without, conscious of his dignity and of the meaning of freedom, self-analytical as never before in history. In a decisive moment, comparable in importance to the fifth century B.C. in Athens or the mid-twelfth century in the Île-de-France, the stage was set for the crucial intellectual and spiritual drama, and the very nature of the sculptors' art cast them in a leading role. It is worth noting that it took another generation before the Renaissance style could be established in either Naples or Milan, and then it was a diluted importation. It should also be noted that none of the thirty-two lifesize or over-lifesize statues that made their appearance in Florence in this astounding period has any back! All were intended to be seen only as integral parts of the buildings from which they presided over civic life.

DONATELLO Donato di Niccolò Bardi (1386?–1466), to give the great sculptor his full name, scion of an impoverished branch of the Bardi banking family, was recognized in his twenties as one of the two or three leading sculptors in Italy and had established himself as one of the founders of the new Renaissance style. His first work in which his style is clearly

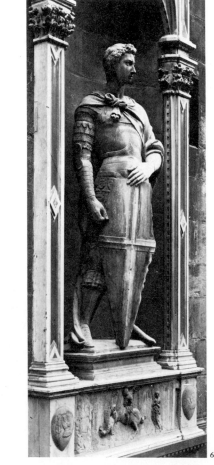

680

evident is the *Saint Mark*, executed from 1411 to 1413, for Orsanmichele. Although each of the guilds of merchants and artisans that dominated the government of the republic of Florence had possessed since 1339 the responsibility of filling its niche at Orsanmichele with a statue, only two of these were completed before the opening of the fifteenth century. Donatello's *Saint Mark* (fig. 679) is one of a series of statues commissioned of him and of his rivals Lorenzo Ghiberti and Nanni di Banco in a sudden rush by the guilds to fulfill their obligations.

In contradistinction to all medieval statues, the position and function of each limb of the *Saint Mark* and its relation to the next and to the body as a whole are visible under the voluminous drapery. Vasari, the Late Renaissance painter, architect, and first art historian, described how a sculptor, in making a clothed statue, first models it in clay in the nude, then drapes about it actual cloth soaked in a thin slip of diluted clay, arranging the folds to cling or to fall as he wishes. There is evidence to show that Donatello was the first to use this method, so suggestive of the "wet drapery" of fifth-century Greek sculpture, and one must presuppose such a draped clay model for the marble *Saint Mark*. Appropriately enough, the statue was ordered by the guild of linen drapers. Donatello has represented not only a figure whose physical being is fully articulated, but also a complex personality summoning up all his psychological resources to confront an external situation. "The depth and passion of that earnest glance," to borrow a phrase from Robert Browning, the anxiety so brilliantly depicted in every detail of the lined face, the beauty of the free and sketchy treatment of the curling hair and beard place the statue in the forefront of the battle for the depiction of the whole human being.

Donatello's next commission for Orsanmichele, the famous *Saint George* (fig. 680), carved about 1415–16 for the guild of armorers and swordmakers, crucial for beleaguered Florence, gave him no opportunity to display the movements of the body. But the energetic stance of the young warrior saint, feet apart, both hands resting on the shield balanced on its point, shows the tension characteristic of all the great sculptor's works, down to the tautness of the folds converging on the knot that fastens the cloak about Saint George's shoulders. The sensitively modeled face is hardly that of a conventional hero, but rather that of one who knows fear, yet can marshal the strength to overcome it. The head was once helmeted and the right hand carried a sword, jutting out of the niche and into the street.

Perhaps more important historically than the statue itself is the relief representing *Saint George and the Dragon* (fig. 681) on the base of the niche. Here Donatello abandoned the time-honored concept of a background treated as a continuous flat surface, which the sculptor either carved down to as he cut away the original block, or built up from if he was working in clay, wax, or plaster. Donatello's innovation was to cut into the slab to any desired depth, counting on protrusions and depressions, as they reflect light or accumulate shadow, to produce on the eye the effect of nearness or distance. He has, so to speak, dissolved the slab, using it as a substance to paint or draw with, relying for his effects on what the eye *sees* to be there rather than what the mind *knows* to be there. This point marks, as sharply as any event can mark, the separation between ancient and medieval *ideal* art and Renaissance and modern *optical* art. From Donatello's discovery, adopted with varying rapidity by most sculptors and painters of his own day, spring all the other optical advances of later times, not excluding Impressionism (see Part Six, Chapter Four). Given

681

679. DONATELLO. *Saint Mark*. 1411–13. Marble, height 94". Orsanmichele, Florence

680. DONATELLO. *Saint George*, from Orsanmichele, Florence (where it has been replaced by a bronze copy). c. 1415–16. Marble, height 82". Museo Nazionale del Bargello, Florence

681. DONATELLO. *Saint George and the Dragon*. Marble relief at base of niche that contained statue in fig. 680. Height 15¾". Orsanmichele, Florence

682

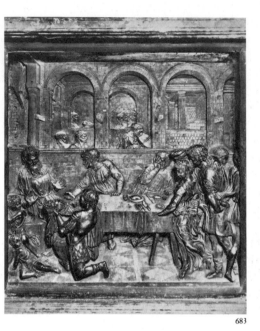

683

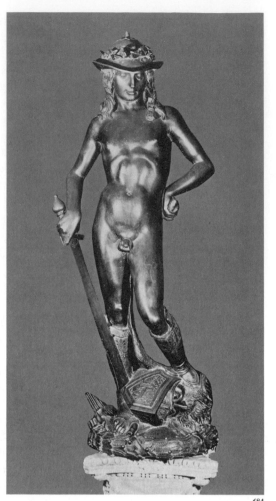

684

682. DONATELLO. *Habakkuk (Lo Zuccone)*, from the Campanile of the Cathedral of Florence. 1423–25. Marble, height 77". Museo dell'Opera del Duomo, Florence

683. DONATELLO. *Feast of Herod*. c. 1425. Gilded bronze relief, 23⅝ × 23⅝". Baptismal font, Cathedral of Siena

684. DONATELLO. *David*. c. 1440. Bronze, height 62¼". Museo Nazionale del Bargello, Florence

Donatello's optical method, it is no surprise to find that the little building behind the princess is rendered in an approach to one-point perspective, or that between her and the rearing horse we can see in the distance low hills and a sky filled with clouds—perhaps the first in Italian art, preceded in Europe only by those of the Boucicaut Master and of the Limbourg brothers (see Chapter Three).

Donatello's series of prophet statues for the niches of the Campanile of the Cathedral of Florence are conceived in optical terms, cut in brutal masses with the features barely sketched in so that they could produce a powerful effect of light and shade from the street about thirty feet below. The most striking of these, possibly representing Habakkuk (fig. 682), was nicknamed *Lo Zuccone* (Big Squash, i.e., "Baldy"), for obvious reasons, in Donatello's own time. Fierce, like all of Donatello's prophets, he has little in common with the suave, beautifully draped and groomed prophetic figures, courtiers of the King of Heaven, on the portals of Gothic cathedrals. Swathed in a huge cloak that hangs in deliberately ugly folds, his eyes dilated, his mouth open, he denounces spiritual wickedness in high places.

In a gilded bronze relief representing the *Feast of Herod* (fig. 683), done about 1425 for the baptismal font of the Cathedral of Siena, Donatello makes, as far as we know, the first complete visual statement of the new science of one-point perspective, controlling the inward recession and diminution of the masonry of Herod's palace—walls, arches, and columns, down to the very floor tiles—about ten years before Alberti wrote his description of the method of one-point perspective in his treatise *On*

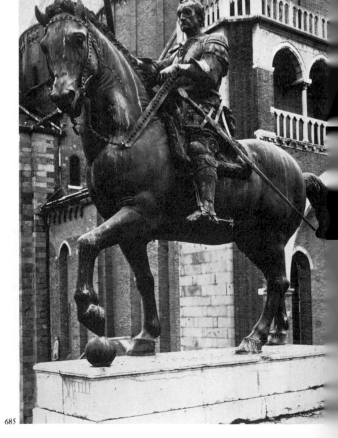

685

Painting of 1435. But this epoch-making centripetal system is used by Donatello as a setting for an episode of passion, a composition organized only by its inherent centrifugal force. The presentation of the severed head of Saint John the Baptist at Herod's table has the effect of a bursting grenade, scattering the spectators to left and right in attitudes and expressions of horror.

In the early 1430s Donatello spent a prolonged period in Rome, reinforcing his knowledge of ancient art. Some time after his return he must have made for the Medici family his bronze *David* (fig. 684), which is not only the first nude David but also possibly the first freestanding nude statue since ancient times (but note in fig. 691 that Nanni di Banco shows a sculptor carving one). It is an astonishing work, whose beauty derives more from the sinuous grace of Donatello's line and surface than from the physical properties of the soft and unheroic youth. The sculptor has exploited the contrast between the detached, impassive stare of the victor and the tragic expression of the severed head, with which David's left foot lightly toys, and between the fluidity of the brilliant surfaces of bronze and the opaque roughness of the shaggy hair. In assessing the meaning of the statue, clothed only in open-toed leather boots and a laurel-crowned hat, it should be remembered that in the Middle Ages and in the Renaissance David's conquest of Goliath symbolized Christ's victory over sin and death, and that nudity still meant the nakedness of the soul before God. So, despite its appearance the statue may have had a moralistic content.

In 1443 Donatello was called to Padua to create a colossal equestrian statue in bronze representing the Venetian general Erasmo da Narni (fig. 685), nicknamed Gattamelata (Calico Cat), which still stands on its original pedestal before the Basilica of Sant'Antonio. Donatello was doubtless impressed by the Roman statue of Marcus Aurelius, but the differences are instructive. The emperor appears unarmed, astride a horse reduced in scale as throughout ancient art. Donatello shows the general clad in a hybrid of Roman and contemporary armor, girded with a huge sword, wielding a baton as if marshaling his troops and guiding his gigantic charger by sheer force of will (the spurs do not touch the flanks and the bridle is slack). Throughout the statue the shapes are simplified to increase their apparent volume. A unifying diagonal axis runs from the lifted baton to the tip of the scabbard. Typical of Donatello's tension are the tail tied so as to describe an arc (repeating those of the buttocks and the neck) and the left forehoof toying with a cannonball, as David's left foot does with the head of Goliath. The general is a powerful portrait, but an ideal image of command rather than a likeness; Donatello could never have seen Gattamelata, who died years before the sculptor's arrival in Padua.

On Donatello's return to Florence in 1454 the city was in the throes of a religious reaction dominated by its archbishop, later canonized as Saint Antonine. Donatello in his later years seems to have been swept along by this antihumanist current, whose effects are evident in his Mary Magdalene (fig. 686) of about 1454–55. This polychromed wooden statue shows the Magdalene in penitent old age, clothed only in her own matted hair, which a recent cleaning has revealed to be lighted by streaks of gold. Horrifying in its extreme emaciation, but even more because of the air of spiritual desolation that radiates from the ravaged features, this work seems the negation of the Renaissance faith in the nobility of man and the beauty of the human body. Writing about the Magdalene, Saint Antonine quotes from Saint Augustine, "O body, mass of corruption, what have I to do with thee?"

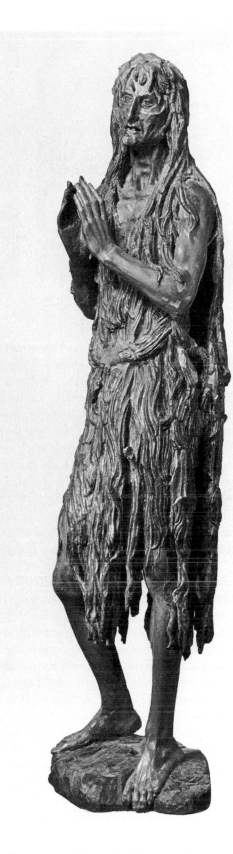

686

685. DONATELLO. *Equestrian Monument of Gattamelata*. 1443–53. Bronze, height 12'2". Piazza del Santo, Padua

686. DONATELLO. *Mary Magdalen*. 1454–55. Polychromed and gilded wood, height 74". Baptistery of S. Giovanni, Florence

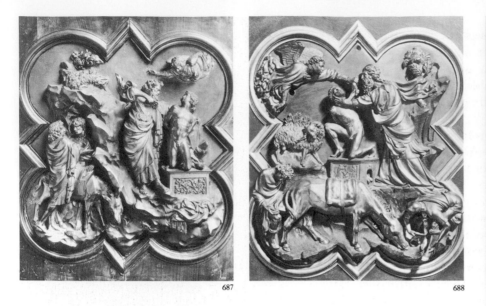

687

688

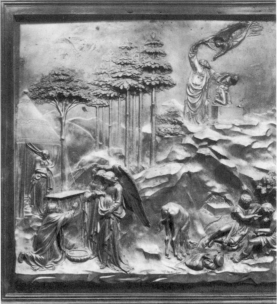

689

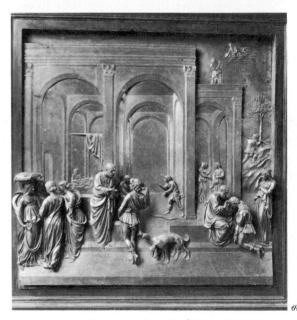

690

GHIBERTI In following Donatello's long life, we have gone past the point where he shared the glories of the Early Renaissance with his slightly older contemporary, Lorenzo Ghiberti (1381?–1455). Also the author of three statues at Orsanmichele, Ghiberti is important for this book on account of his two sets of gilded bronze doors for the Baptistery of Florence, especially the second, known as the *Gates of Paradise*. Ghiberti won the commission in competition with several other Tuscan sculptors, including Jacopo della Quercia. In the finals, in 1401–2, he found himself competing only with Brunelleschi, then still a sculptor, and their sample reliefs in bronze (figs. 687, 688), with the figures and landscape elements gilded, record the dawn of the Renaissance in the figurative arts. The assigned subject was the Sacrifice of Isaac, and the required shape, the quatrefoil (four-leaf clover), was a French Gothic form previously adopted by the sculptor of the earliest set of doors for the Baptistery in the fourteenth century. Brunelleschi's relief shows the angel grabbing the hand of Abraham, who twists Isaac's screaming head the better to thrust the sword into his throat. Despite Brunelleschi's close observation of naturalistic details, especially in the boy's body, the donkey, and the crouching attendant, his relief is lacking in just the qualities of linear grace and harmony of proportion that we have found essential to his architecture.

Ghiberti's relief (see fig. 687) substitutes for the jagged shapes and often abrupt and jerky motion of Brunelleschi a marvelous smoothness and grace, achieved by curves that move as if the figures were performing a slow dance, following in their motions and in the flow of their drapery the curves of the quatrefoil frame. This motion could be described as still Gothic were it not for an ease and balance that make one wonder whether Ghiberti had not seen Greek originals. His Isaac is surely the first nude figure since ancient times to show real interest in the beauty of the human body and knowledge of the interaction of its parts—a generation before Donatello's *David*.

In the doors themselves, whose execution took Ghiberti more than twenty years and whose subject was changed to the Life of Christ, Renaissance elements enter piecemeal. Only in the *Gates of Paradise*, 1425–50, representing scenes from the Old Testament, did Ghiberti absorb the spatial devices of Donatello and the architectural and perspective discoveries of Brunelleschi and Alberti. Gone are the small quatrefoils; instead, Ghiberti has enclosed several episodes from each Old Testament story in

687. LORENZO GHIBERTI. *Sacrifice of Isaac*, from the competition to design the north doors of the Baptistery of S. Giovanni, Florence. 1401–2. Gilded bronze relief, 21 × 17½" (inside molding). Museo Nazionale del Bargello, Florence

688. FILIPPO BRUNELLESCHI. *Sacrifice of Isaac*, from the competition to design the north doors of the Baptistery of S. Giovanni, Florence. 1401–2. Gilded bronze relief, 21 × 17½" (inside molding). Museo Nazionale del Bargello, Florence

689. LORENZO GHIBERTI. *Story of Abraham* (detail of the *Gates of Paradise*). 1425–50. Gilded bronze relief, 31¼ × 31¼". Baptistery of S. Giovanni, Florence

690. LORENZO GHIBERTI. *Story of Jacob and Esau* (detail of the *Gates of Paradise*). 1425–50. Gilded bronze relief, 31¼ × 31¼". Baptistery of S. Giovanni, Florence

single, square frames. Each entire relief is gilded, thus unifying figures and background in a space suffused with golden light into which we can look as into a picture. In comparing the *Story of Abraham* as actually carried out (fig. 689) with the competition relief, it is easy to see the depth and extent of this spatial revolution. As in Donatello's pictorial reliefs, the flat background is dissolved, and the eye carried by easy stages into great distances, past the scene where Sarah prepares a table for the three angels, beyond the rocky eminence where Abraham is about to sacrifice Isaac, and between the trunks of lofty trees to the mountains on the far horizon.

Especially striking in all ten scenes on the *Gates of Paradise* is the sense of space, not only *behind* the figures—Donatello and, as we shall see, Masaccio (see figs. 683, 699) had already achieved that—but *around* them. This effect is managed by keeping the scale of the foreground figures roughly the same as in the competition relief, within a frame whose area is quadrupled. Thus at one blow Ghiberti has demolished the age-old convention of a double scale for figures and setting and established a single, unified space in keeping with Alberti's admonitions. This is evident in the *Story of Jacob and Esau* (fig. 690). The open portico of Isaac's dwelling, Albertian in the use of pilasters as decorations and arches as supports, is Albertian also in the accuracy of its perspective recession, taking the observer through one arch after another into what appears to be great depth. (The actual projections are never more than an inch or so, and generally a mere fraction.) Renaissance art has here achieved a cubic graph of space, in which the dimensions of every object and every person are determined by the square on which he stands, and therefore by his imagined distance from the spectator's eye. The last traces of Gothicism in line and pose have been transmuted into Hellenic grace and ease. Despite their diminutive scale, such figures as the angry Esau standing before his perplexed father or the three beautiful female figures at the left can be set against the masterpieces of Greek sculpture. All ten reliefs were modeled in wax by 1437, two years after the appearance of Alberti's *On Painting*. Well could Ghiberti boast that the new art of his time had achieved values unknown to the ancients. Like Alberti, Ghiberti was the author of a theoretical treatise, called in good Roman fashion *The Commentaries*, a remarkable amalgam of optical knowledge and Renaissance learning.

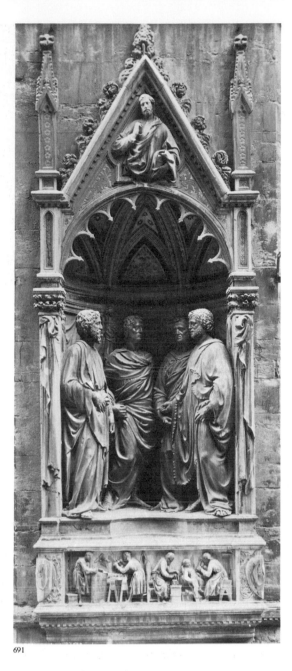

691

NANNI DI BANCO A third sculptor highly influential in the development of the Early Renaissance was the short-lived Nanni di Banco (1385?–1421), the most openly classicistic of the entire group. Like Donatello and Ghiberti, he was entrusted with the sculptures for three niches at Orsanmichele. The most impressive is the group of *Four Crowned Martyrs* (fig. 691), for the guild of workers in stone and wood, commemorating four Christian sculptors who, according to legend, preferred death to betraying their faith by obeying an imperial command to carve a statue of the god Aesculapius. Nanni intended the observer to draw the comparison between the martyrs and the contemporary Florentines united in defense of liberty. In spite of their still-Gothic niche, the figures are dressed in mantles that fall about them like Roman togas and impart a Roman gravity. Both the mantles and the forthright carving of the individualized faces were doubtless emulated from Roman originals in order to reinforce the resolve of the Florentine Republic by the example of stoic dignity. The stoneworkers in the scene below, who are building a wall, carving a column, measuring a capital, and finishing a statue, are dressed in con-

691. NANNI DI BANCO. *Four Crowned Martyrs*. c. 1413. Marble, lifesize. Orsanmichele, Florence

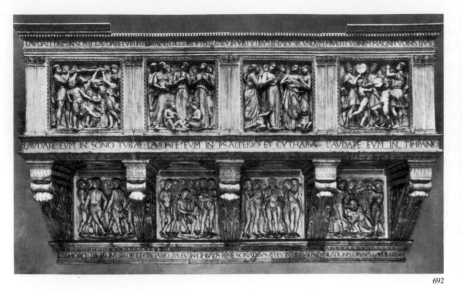

692

temporary clothes. To the end of his brief career Nanni opposed the optical innovations of Donatello, never violating the flat background nor sketching a detail he could carve in the round.

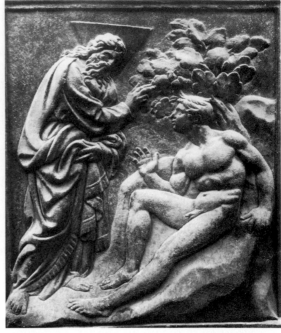

693

LUCA DELLA ROBBIA Nanni di Banco's classicism was continued in a gentler manner by Luca della Robbia (1400–82), whose name was included by Alberti with those of Brunelleschi, Donatello, Ghiberti, and Masaccio as founders of the new style. Alberti must have been thinking of Luca's *Cantoria* (musicians' gallery; 1431–38; fig. 692) for the Cathedral of Florence, in whose reliefs the sculptor combined a Classical harmony of fold structure, emulated from such a monument as the Ara Pacis, with the warm, contemporary naturalness of Filippo Lippi (see fig. 704). Alberti could not have foreseen that Luca would not progress beyond this point. Luca did invent a new technique of producing architectural sculpture in terra-cotta, glazed white for the figures, sky-blue for the background, and relieved by occasional touches of color in the ornament. This terra-cotta sculpture was not only cheap and resistant but also extremely effective in the decoration of architecture in the Brunelleschian tradition (see figs. 663, 668). Luca's many works in this delightful manner conveyed the grace and charm of his personality, but the technique was obviously limited. In the hands of Luca's relatives and successors, who operated well into the sixteenth century, it eventually degenerated into manufacture.

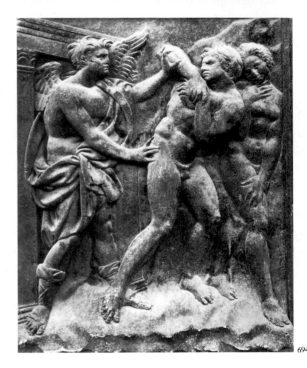

694

JACOPO DELLA QUERCIA Alberti's inclusion of Luca della Robbia in his list of the founders of Renaissance art is no more surprising than his omission of Nanni di Banco and a contemporary Sienese, Jacopo della Quercia (1374?–1438), the elemental power of whose style entitles him to be ranked above every Early Renaissance sculptor except Donatello and Ghiberti. Alberti's oversight is especially remarkable since Jacopo was one of the runners-up in the competition for the Baptistery doors, left important works in Siena and Lucca, and, at the time Alberti wrote, was engaged in carving the reliefs for the main portal of the Church of San Petronio in Bologna. True, Jacopo's backgrounds were limited to the rock masses and miniature architecture familiar to us from fourteenth-century painting, but never since Hellenistic art had human figures been raised to such a plane of heroic action as in the San Petronio reliefs. In this

692. LUCA DELLA ROBBIA. *Cantoria*, from the Cathedral of Florence. 1431–38. Marble, length 17'. Museo dell'Opera del Duomo, Florence

693. JACOPO DELLA QUERCIA. *Creation of Adam*, relief on the main portal, S. Petronio, Bologna. 1425–38. Marble, 33½ × 27¼"

694. JACOPO DELLA QUERCIA. *Expulsion from Eden*, relief on the main portal, S. Petronio, Bologna. 1425–38. Marble, 33½ × 27¼"

695. GENTILE DA FABRIANO. *Adoration of the Magi* altarpiece. Completed 1423. Panel painting, 9'10" × 9'3". Galleria degli Uffizi, Florence

respect Jacopo can be considered a real pioneer. Although the *Expulsion from Eden* was done after Masaccio had finished painting his version of the subject (see fig. 699), it was derived not from Masaccio but from an almost identical composition in Siena by Jacopo himself, executed between 1414 and 1419. In the first of these panels (fig. 693) the magnificent Adam, whose name in Hebrew means "Earth," awakes from the ground at the Lord's command to a realization of his own power; in the second (fig. 694), in tragic contrast, Adam and Eve (the latter's pose surely derives from a Classical Venus type) struggle helplessly against a powerful angel who lightly expels them from the gate of Eden.

GENTILE DA FABRIANO The appearance in Florence in 1421 of Gentile da Fabriano (1380/5?–1427), a painter from the Adriatic coast of Italy, marked the beginning of a revolution in the art of painting, which

Painting in Florence: The Early Fifteenth Century

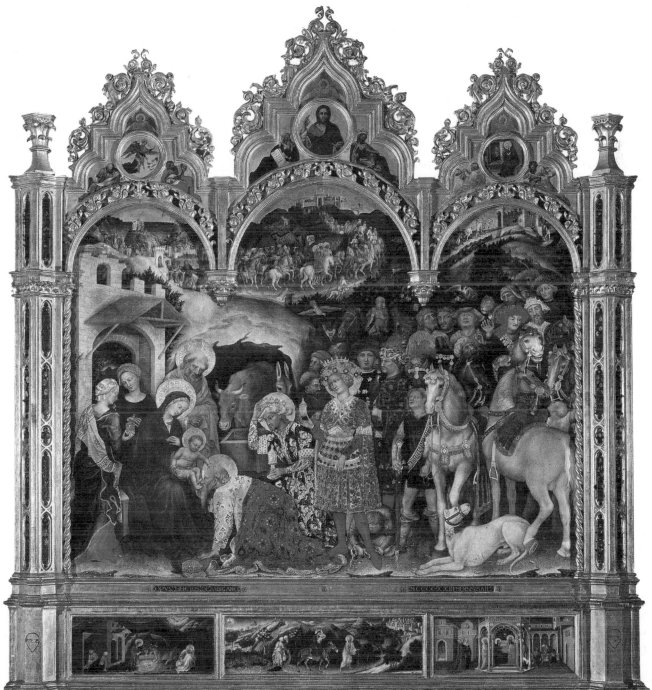

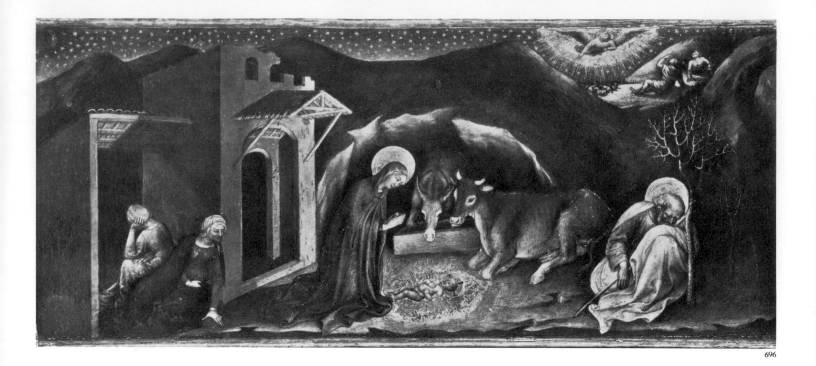

thus far had shown little interest in the developments that had just transformed architecture and sculpture. Gentile was probably in his middle or late thirties, and under strong influence from the art of the Burgundian region, where, as we shall see (Chapter Three), a vivid new naturalism paralleled the discoveries of the Florentine sculptors. He had been highly successful in Venice as early as 1408. If we judge by the completion date of May 1423, inscribed along with his signature on his masterpiece, the elaborate altarpiece representing the *Adoration of the Magi* (fig. 695), Gentile must have started it soon after his arrival in Florence. The altarpiece was painted for Palla Strozzi, the richest man in Florence, and he spared no expense. The Three Magi in the foreground stand or kneel before the cave of the Nativity and an adjacent ruin, inundating the desolate scene with the splendor of their richly colored and gilded robes, crowns, and spurs and disturbing its silence with their restive horses and dogs and their chattering attendants, some of whom play with monkeys while others launch falcons upon their prey. In the distance the Magi and their train can be seen journeying across sea and land and winding up distant hills toward walled cities. Undoubtedly, Gentile had seen works, such as those of the Limbourg brothers (see fig. 742), that this scene strongly recalls.

The Flamboyant frame, alive with prophet figures in the spandrels, the *Annunciation* in two roundels with a blessing God the Father in a third between them, and red-winged seraphim in the gables, and bursting with carved and gilded ornament, must have seemed both outlandish and outdated to Brunelleschi and Donatello. But the painting itself overflows with innovations. The horses are foreshortened in a manner unknown to Italian art before this time, and such figures as the groom in blue crouching toward us to remove the spurs of the youngest Magus, and the spherical heads of some of the attendants, are treated in a new manner, revolving convincingly in space. In the body of the altarpiece the landscape goes beyond Ambrogio Lorenzetti (see fig. 656) in sheer extent, but shows no assimilation of Florentine perspective innovations and ends up with a gold background instead of a sky. Not so the predella scenes, set on little

696. GENTILE DA FABRIANO. *Nativity*, from the predella of the *Adoration of the Magi* altarpiece. Completed 1423. Panel painting, 12¼ × 29½". Galleria degli Uffizi, Florence

stages and betraying study of Donatello's *Saint George and the Dragon* relief (see fig. 681) and with arcades looking a bit like those of Brunelleschi's Innocenti (see fig. 663).

Above all, the magical *Nativity* scene (fig. 696) shows a new understanding of the nature of light. It is the first night scene we know in which all foreground illumination comes from a single source (in this case, the shining Child) within the picture. Gentile must have experimented with an actual model of the ruined shed, the cave, and the figures, placing a candle in the foreground in order to study how light played upon the objects and the behavior of the shadows (the first cast shadows in Italian art). Nevertheless, the pool of spiritual light around the Child is still gold leaf. The scene, with the adoring Virgin, the gentle animals, the sleeping Joseph, the curious midwives, the secondary illumination from the angel descending toward the shepherds on their dark hilltop under the stars, is intensely poetic. But its importance for developing Renaissance painting is that here Gentile has not only adopted but extended the optical principles first enunciated by Donatello. Gentile's altarpiece was the most advanced painting in Europe in 1423.

MASACCIO An astonishing genius appeared upon the scene to capture Gentile's title almost immediately; Tommaso di Ser Giovanni (1401–28?) was known to his contemporaries as Masaccio (untranslatable, but *Maso* means "Tom," and the suffix *accio* usually signifies "ugly"), possibly because he was so completely devoted to his art that he paid little attention to practical matters, including his appearance. In his mid-twenties Masaccio revolutionized the art of painting, and, if the generally accepted date of his death is correct, died just before his twenty-seventh birthday. His innovations are visible in the frescoes he painted about 1425 in the chapel of the Brancacci family in the Church of Santa Maria del Carmine in Florence. A glance at the principal scene in this series, the *Tribute Money* (fig. 697), would seem to place Gentile's *Adoration* two decades in the past instead of only two years. The lessons of the new optical style, which Gentile had learned piecemeal, were absorbed by Masaccio at once and in their totality, and he created a new and almost hallucinatory sense of actual masses existing in actual space.

The unusual subject (Matthew 17:24–27) recounts how when Christ and the Apostles arrived at Capernaum, the Roman tax-gatherer came to collect the tribute; Christ told Peter he would find the tribute money in the mouth of a fish in the nearby Sea of Galilee; Peter cast for the fish, found the coin, and paid the tax-gatherer. The solemnity with which Masaccio has endowed so trivial an event may derive from its relevancy to a new form of taxation then being debated among the Florentines to finance their war of survival against the duke of Milan. The artist has arranged the Apostle figures in a semicircle around Christ, with the discovery of the money placed in the middle distance at the left and the payoff at the right. The Apostles (fig. 698), as intense, as plebeian, as individualized as Donatello's contemporary prophets for the Campanile, are enveloped in cloaks that give them not only the grandeur of sculpture but also a sense of existence in space that recalls Giotto (see figs. 648, 649) more than a century before.

But unlike Giotto, Masaccio has performed his miracle almost entirely without the use of line, which for him exists only when a mass of certain color and degree of light overlaps a different mass. Form is achieved by the impact of light on an object. Masaccio does not need Gentile's

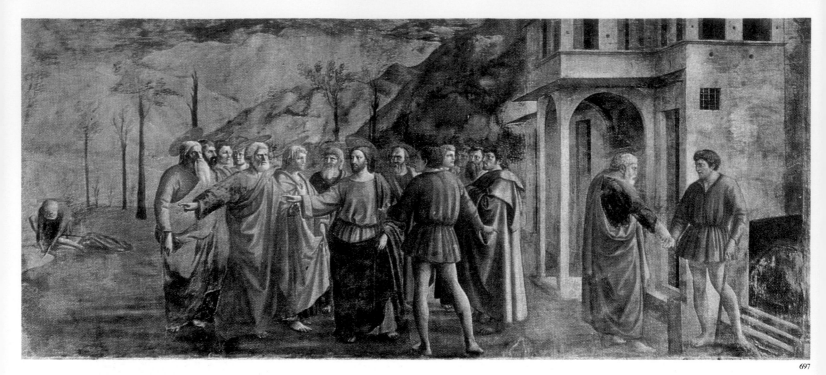

697

candle in the darkness before a model; the actual light of the window of the Brancacci Chapel is enough for him. The window, obviously to the right, appears to throw light into the fresco as into a real space, to send the towering figures into three-dimensional existence, and to cast their shadows upon the ground, just as it affirms the cubic shapes of the simple building at the right with actual light and cast shadow. In this picture Masaccio proves the justice of a simple maxim in Ghiberti's *Commentaries*, "Nessuna cosa si vede senza la luce" ("Nothing is seen without light").

Giotto had attempted to take us only a few yards back into the picture, where we immediately encountered the flat, blue wall. Following Donatello and Gentile, but more convincingly than either, Masaccio leads the eye into the distance, over the shore of Galilee, past half-dead trees, apparently with new branches and foliage coming forth, to range on range of far-off mountains, and eventually to the sky with its floating clouds. The foliage, as indeed the faces of the Apostles, is painted in with quick, soft strokes of the brush, akin to Donatello's sketchy sculptural surface.

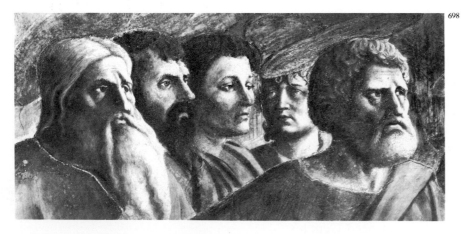

698

697. MASACCIO. *Tribute Money*, fresco, Brancacci Chapel, Sta. Maria del Carmine, Florence. c. 1425

698. MASACCIO. *Heads of the Apostles* (detail of the *Tribute Money*)

The sense of real space is so compelling that we tend to forget the remnants of medievalism that remain (architecture and figures not yet represented according to the same scale). The setting is Florentine; the lakeshore resembles a curve in the Arno, and the mountains the familiar line of the Pratomagno, the range towering beyond Florence to the east. Even more, the simplicity and grandeur of the scene are intensely Florentine. Gone is the magnificence of Gentile's gold and of his splendid fabrics, along with the richness of his detail. Masaccio's style, characterized by Cristoforo Landino, the fifteenth-century commentator on Dante, as "puro, senza ornato" ("pure, without ornament"), deals in this sublime work with the essentials of man's relationship to the natural world and, even more, with God's mindfulness of the doings of men.

On the narrow entrance wall of the chapel, Masaccio painted his version of the *Expulsion from Eden* (fig. 699), obviously related to the composition of Jacopo della Quercia (see fig. 694), yet profoundly different. Quercia had characterized the scene as a losing battle between the resisting Adam and the expelling angel. In Masaccio the clothed angel floats lightly above, sword in one hand, the other hand pointing into a desolate and treeless world. Adam, his powerful body shaken with sobs, covers his face with his hands in a paroxysm of guilt and grief; Eve covers her nakedness with her hands as in Quercia, but lifts up her face in a scream of pain. Never before had nude figures been painted with such breadth and ease, their volume indicated almost solely by light and shade. Never before had man's separation from God been represented with such tragic intensity. By the late fifteenth century the Brancacci Chapel had become the place where young artists, including Michelangelo, went to learn—by drawing from Masaccio—the basic principles of form, space, light, and shade of the Renaissance style in painting.

Masaccio's *Madonna* (fig. 700), the central panel of a now widely scattered altarpiece painted in 1426 for the Church of Santa Maria del Carmine in Pisa, is less than half the height of the *Madonna* by Giotto (see fig. 647), which it nonetheless rivals in majesty. In spite of the still-Gothic pointed arches used for the panels and the gold background (possibly both demanded by the conservative Pisan patron), this is a fully Renaissance picture. Masaccio has set the Virgin so high that her feet are about at our eye level, and enthroned her upon a remarkable three-story construction with Corinthian columns, which tends to increase the apparent bulk of the figure. Masaccio's strong side light throws the figures, the drapery, the details of the architecture, even the angels' lutes into compelling relief against the shadows they cast on other masses. The Virgin, the Child, and the angels are homely types, as if Masaccio were deliberately avoiding the tradition of physical beauty.

Probably the last work of Masaccio we possess before his departure for Rome and his untimely death is the fresco of the *Trinity* (fig. 701), whose painted architecture is so Brunelleschian that it seems impossible he could have painted it before the works we have just seen. The perspective view from below, which we have noticed in the *Madonna*, is employed systematically here to produce a striking illusion of three-dimensional reality; Vasari speaks of the architecture as a painted chapel piercing the real wall. The Corinthian pilasters, similar to those that terminate the Innocenti (see fig. 663), flank a massive barrel vault supported on Ionic columns two thirds the height of the pilasters. Diagonals drawn from the Corinthian to the Ionic capitals would exactly parallel the orthogonals of the coffered vault. The viewpoint is precisely that of a person of average height standing on the floor before the fresco. Below the

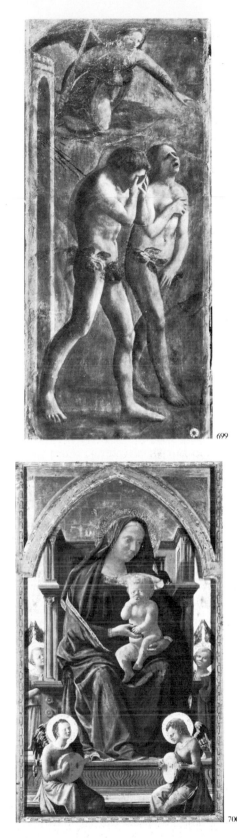

699. MASACCIO. *Expulsion from Eden*, fresco, Brancacci Chapel, Sta. Maria del Carmine, Florence. c. 1425

700. MASACCIO. *Enthroned Madonna and Child*, center panel of a polyptych from Sta. Maria del Carmine, Pisa. 1426. Panel painting, 53¼ × 28¾". National Gallery, London

altar slab (now incorrectly restored), recent investigation has uncovered a painted skeleton, accompanied by an Italian inscription that reads in English: "I was once that which you are, and that which I am you also will be." On either side, on a step above the altar, outside the architecture and therefore in the space of the church, kneel two members of the Lenzi family praying for the soul of the departed, portraits of remarkable dignity and power. Within the painted chapel a solemn Mary and an adoring John flank the Cross of Christ, behind which, on a projecting pedestal, stands God the Father, his arms outstretched to the bars of the Cross, while the Holy Spirit in the form of a dove floats between the heads of Father and Son. The vertical pyramid of figures, from the praying donors through the interceding saints, intersects the descending pyramid of perspective in the body of the crucified Christ. Never have the essential mysteries of Catholicism—the sacrifice of Christ at the will of the Father to redeem man from sin and death, and the daily perpetuation of that sacrifice in the Mass—been presented in more compelling terms than in this painting, which also sums up all that the Early Renaissance was trying to say.

FRA ANGELICO Masaccio left no gifted pupils; after his death the mantle of leadership fell on the shoulders of two monks who could scarcely have been more different: Fra Angelico, who was popularly believed to have been raised to the rank of *Beatus* (Blessed), just below sainthood, and Fra Filippo Lippi, who was eventually defrocked. Somewhat older than Masaccio but, if anything, more precocious, Fra Angelico (c. 1400–55) was still a layman named Guido di Pietro in 1417 and already a painter in the Late Gothic tradition. About 1423 he entered the Dominican Order, and in 1445, succeeding Saint Antonine, became prior of the Monastery of San Marco in Florence. His unworldliness and his veneration for the tradition of Giotto (who came from the valley called the Mugello where Angelico was born) have perhaps been responsible for his incorrect classification as a "conservative" painter. Although he was closed—perhaps by choice—to the world of inner crisis so powerfully set forth by Donatello and Masaccio, Angelico was the greatest master of landscape and light of the 1430s. In 1438 he was mentioned by Domenico Veneziano (see page 543) as one of the two leading masters of Florence (the other was Fra Filippo Lippi), and in the 1440s he was known at the papal court as "famous beyond all other Italian painters."

Before 1434 Palla Strozzi commissioned Angelico to paint a *Descent from the Cross* (fig. 702) for the family chapel, the sacristy of the Church of Santa Trinita, where in 1423 he had placed the *Adoration of the Magi* by Gentile da Fabriano (see fig. 695). The panel had been prepared and the Gothic frame carved and partly painted by an older master, Lorenzo Monaco, whose work was interrupted by death in 1425. Despite the initial handicap of the pointed arches, Angelico was able to create a composition of the greatest formal, spatial, and coloristic beauty, utilizing the central arch to hold the Cross and the ladders and the side arches to embrace landscape views.

In keeping with its placement in a sacristy, where the clergy prepare to celebrate the Mass in which the sacrifice of Christ's body is perpetuated, the picture places less emphasis on dramatic elements of pain and grief than on the ritual presentation of the sacrificed Saviour. Bathed in strong sunlight, the scene sparkles with bright colors. The ground is a continuous lawn, receding into the middle distance and dotted with wild-

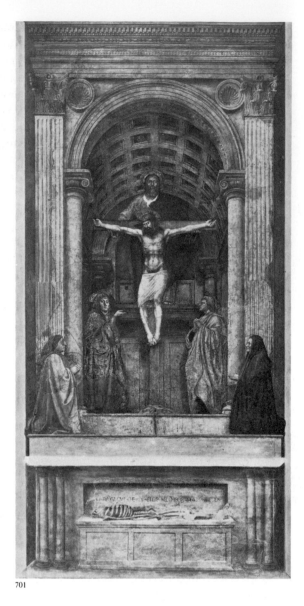
701

701. MASACCIO. *Trinity*, fresco, Sta. Maria Novella, Florence. c. 1428

flowers. A single rocky outcropping supports the Cross and receives streams of the sacred blood from the footrest. The figures are scattered throughout the foreground and even into the middle distance, which is utilized more successfully than in any earlier Italian painting. At the left the Holy Women gather about the kneeling Mary, extending the shroud before her; Mary Magdalene kisses the feet of Christ. At the right a group of Florentines in contemporary dress, contemplating the Crown of Thorns and the nails, may include portraits of Palla Strozzi and his sons. The body of Christ, suffused with sunlight yet still showing the marks of the scourges, is reverently lowered, and at the same time displayed, by five men including John, Nicodemus, and Joseph of Arimathea. Although Angelico's reluctance to indicate the movements of the limbs within the tubular drapery masses makes his figures look at times Giottesque, he establishes them as freestanding volumes in space, modeled by light, in the manner of Masaccio. And in his delicate treatment of the body of Christ he shows an understanding of the nude worthy of the great contemporary sculptors.

The background landscapes are the most advanced in Italian art of the time, startling in the beauty of their space and light. On the left one looks over field and farm to the cubic, distinctly Florentine ramparts of Jerusalem, saturated by the late afternoon sun. A cloud mass has just rolled away from the city, as if in naturalistic explanation of the darkness that fell over the land while Christ hung upon the Cross. To the right, between the tall trunks of trees, the eye moves into an enchanting view of the landscape visible to the north of Florence, with rolling, olive-colored hills capped by villas and castle towers, receding range on range to the cloud-filled horizon. In the poetry of this fully Renaissance picture, Christian mysticism is blended with a new joy in the loveliness of created things, transfigured by faith.

The mistaken notion of Angelico's conservatism, easily dispelled by the masterpieces of the 1430s, is doubtless based on his renunciation of natural beauties, in order to enhance contemplation, in the small frescoes he and his pupils painted during the early 1440s in each of the monks' cells in the Monastery of San Marco. In the *Annunciation* (fig. 703), for example, the background is reduced to two bays of a white-plastered, vaulted corridor. Mary kneels; the angel appears before her, along with the light. The rhythms of the architecture flow in harmony with the delicate, almost bodiless figures. Mary receives the Incarnate Word with quiet joy, as the monastic spectator, following the example of the adoring Dominican saint, was expected to do in solitary meditation. Superficially, the picture may seem primitive, yet the knowledge of space and light proclaims it as a Renaissance work; so, in a deeper sense, does its appeal to the individual. This painting is the ancestor of some of the mystical pictures of the seventeenth century, above all those of Zurbarán (see fig. 968).

FRA FILIPPO LIPPI Placed in the Monastery of the Carmine at Florence by his father at an early age, Filippo Lippi (c. 1406–69) was said by Vasari to have decided to become a painter when, at about nineteen years of age, he watched Masaccio at work in the Brancacci Chapel. An early work, the *Annunciation* (fig. 704), beautifully placed in San Lorenzo, Florence, shows what this wayward master made of his artistic heritage. The cloister background starts as an inward extension of the Brunelleschian frame, but that great architect would have been less than

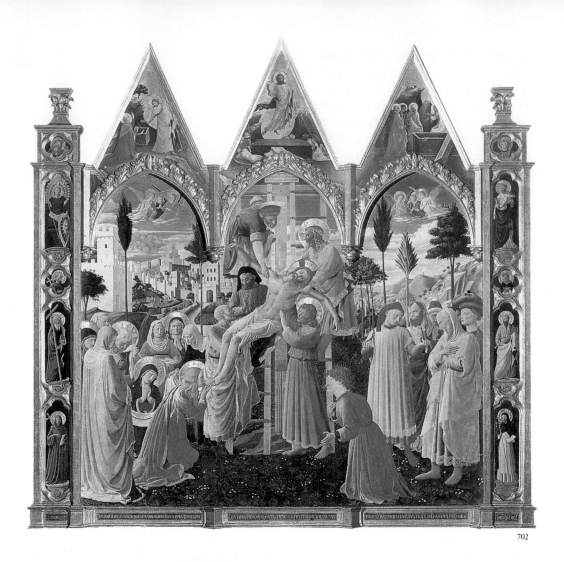

702

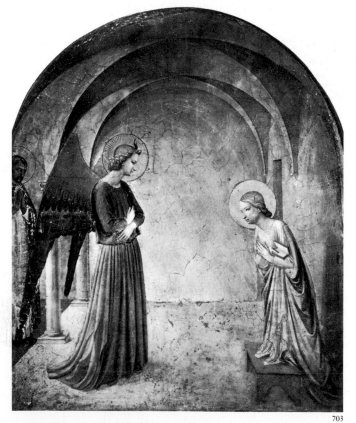

703

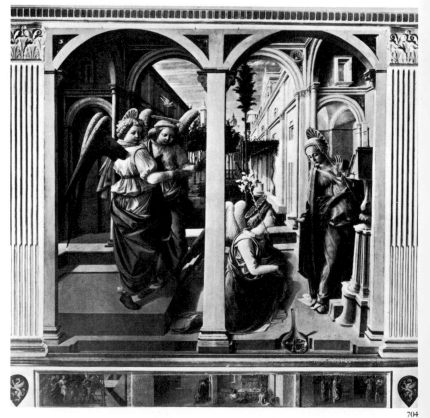

704

pleased by the constantly shifting levels and odd architectural shapes and proportions. Nonetheless, the perspective view of the closed garden (age-old symbol of the virginity of Mary, drawn from the Song of Solomon) is delightful, with its trees and trellis and blue sky streaked with filmy clouds. Within the Masaccesque light and shade of his deep space, Filippo has set not only the agitated Virgin drawn from her reading by the kneeling boy-angel, but also two supernumerary angels not mentioned in Scripture, one of whom looks out at the spectator while he points to the action, according to Alberti's directions for composing a picture. The chubby faces and blond curls, as well as the bright and sometimes arbitrary colors (one angel has bronze-green wings, another bright orange), have little to do with Masaccio's severity. The figures are powerfully modeled by direct light and deep shadow but, like all the elements in Filippo's paintings, are bounded by the neat, linear contours that Masaccio had rejected. An element of special beauty is the little crystal vase half full of shining water, in a niche cut out of the foreground step, from which the announcing angel seems to have plucked the lily.

Perhaps the finest example of Filippo's late, even more worldly style is the *tondo* (meaning "round," a shape favored in the middle and late fifteenth century for pictures made to be hung in private homes), representing the *Madonna and Child* (fig. 705). The wistful, delicate girl who posed for the Virgin is believed, following an unlikely tradition recorded by Vasari, to have been the runaway nun Lucrezia Buti, mother of the artist's son Filippino and the principal reason for Filippo's expulsion. Painted with a grace that already points toward Filippo's great pupil Botticelli, the foreground figures introduce us to agreeable views of an upper-class Florentine home of the fifteenth century, with its cubic rooms and marble floors, as a setting for the Birth of the Virgin on the left and the Meeting of Joachim and Anna on the right. In this elegant world the severity of Masaccio has been all but forgotten.

702. FRA ANGELICO. *Descent from the Cross* (frame and pinnacles by Lorenzo Monaco). Completed c. 1434. Panel painting, 9' × 9'3". Museo di S. Marco, Florence

703. FRA ANGELICO. *Annunciation*, fresco, Monastery of S. Marco, Florence. 1438–45

704. FRA FILIPPO LIPPI. *Annunciation*. c. 1440. Panel painting, 69 × 72". S. Lorenzo, Florence

705. FRA FILIPPO LIPPI. *Madonna and Child*. c. 1452. Panel painting, diameter 53". Palazzo Pitti, Florence

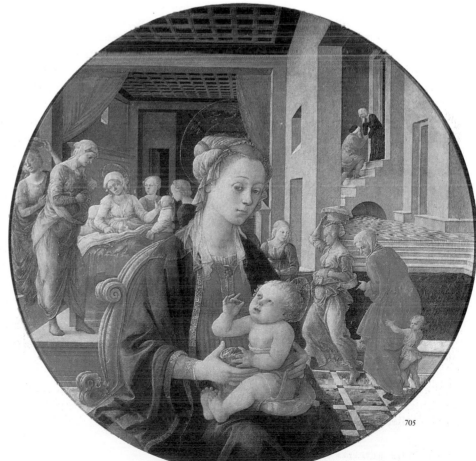

705

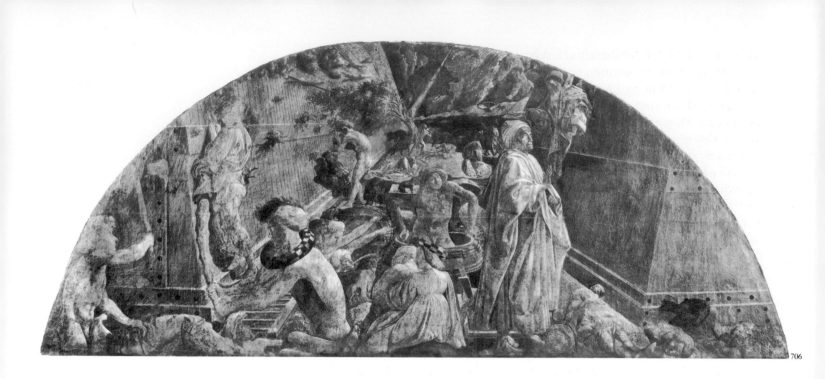

UCCELLO Albertian perspective is carried to extremes in the work of a master known even in the Renaissance as an eccentric. Paolo Uccello (1397–1475) is said to have burned the midnight oil over perspective constructions, including a seventy-two–sided polyhedron, from each facet of which projected a stick bearing a scroll, all designed in flawless perspective. His *Deluge* (fig. 706), one of a group of frescoes done largely in *terra verde* ("green earth") in the Chiostro Verde of Santa Maria Novella in Florence, shows two episodes from the Flood within a single frame. On the left towers the Ark, its massive sides receding rapidly toward the vanishing point, just missed by a bolt of lightning, which illuminates the humans, clothed and nude, trying to keep afloat or clutching desperately at the planks of the Ark. Not only these but also a ladder with its rungs diminishing according to plan and even a *mazzocchio* (the wood-and-wicker construction that supported the turban-like headdress of the Florentine citizen), which has slipped down around the neck of a hapless youth, serve to exhibit Uccello's prowess in forcing unwilling objects to comply with the laws of one-point perspective. On the right the Ark has come to rest on a ground littered with corpses of humans and animals—seen in perspective, of course. Noah leans from a window of the Ark, in colloquy with a majestic but still unidentified figure, reminiscent of the prophets and apostles of Donatello and Masaccio. Almost in spite of Uccello's obsession with perspective, the *Deluge* exerts great dramatic power.

This power is less evident in the three episodes from the *Battle of San Romano*, now split between three different museums, which once formed a continuous frieze fitted into the elaborate wooden paneling of a principal bedroom of the Medici Palace. In one of them (fig. 707), which shows the Florentine commander directing the counterattack against the Sienese forces, the hilly landscape near San Romano, in the Arno Valley near Pisa, appears only in the background. The foreground becomes a stage on which the artificial-looking horses with armored riders prance delightfully. Uccello seems less interested in the ferocity of battle than in the patterns that can be formed from armor and weapons. Broken lances have a tendency to fall according to the orthogonals of one-point perspective, and a fallen soldier even manages to die in perspective.

Painting in Florence and Central Italy: The Mid-Fifteenth Century

706. PAOLO UCCELLO. *Deluge*, fresco, Chiostro Verde, Sta. Maria Novella, Florence. c. 1445–47

707. PAOLO UCCELLO. *Battle of San Romano*. c. 1445. Panel painting, 6′ × 10′6″. National Gallery, London

DOMENICO VENEZIANO The new understanding of light and color brought to Florentine art by Fra Angelico was extended and enriched by an outsider, Domenico Veneziano (c. 1410–61), who, as his surname indicates, came from Venice. In a letter of 1438 written to Piero de' Medici, Domenico promised that he would show the Florentines marvelous things, never before seen. This he indeed did in his *Saint Lucy Altarpiece* (fig. 708), depicting the Madonna and Child flanked by Saints Francis, John the Baptist, Zenobius, and Lucy, although it is clear that in turn he had learned much from the Florentines. The setting is a partly Gothic, partly Renaissance courtyard, whose pointed arches are supported on colonnettes resembling those by Michelozzo in the windows of the Medici Palace. Both the architecture and the intricate inlay patterns of the marble terrace are drawn in strict adherence to one-point perspective. The projection of figures and drapery and the close attention to anatomical construction, as well as the firm modeling of the features, betray careful study of the great sculptural and pictorial achievements of the founders of the Florentine Renaissance. But the chiaroscuro of the Masaccio–Filippo Lippi tradition and the brilliant coloring of Fra Angelico are alike muted by a new sensitivity to the effects of light. There are no dark shadows in Domenico's masterpiece. The figures and much of the architecture are saturated with sunlight, but so indeed are the shadows—with light reflected from the polished marble surfaces. Domenico takes a special delight in observing how the colors of the marble niche behind the Virgin are transformed as the eye moves from light to shadow, just as he sets intense greens against luminous blues in the Virgin's costume with an un-Florentine sense of the value of a momentary dissonance in the enrichment of an allover harmonic structure of color. Entirely his own, too, is the exquisite grace in his observation of faces, particularly that of Saint Lucy. The later work of Filippo Lippi, such as his tondo (see fig. 705), was deeply influenced by the new poetry of light introduced into Florence by Domenico.

The predella panels of the *Saint Lucy Altarpiece*, each a miracle of light and color, have been widely scattered; the most surprising is perhaps the tiny panel representing *Saint John the Baptist in the Desert* (fig. 709), in

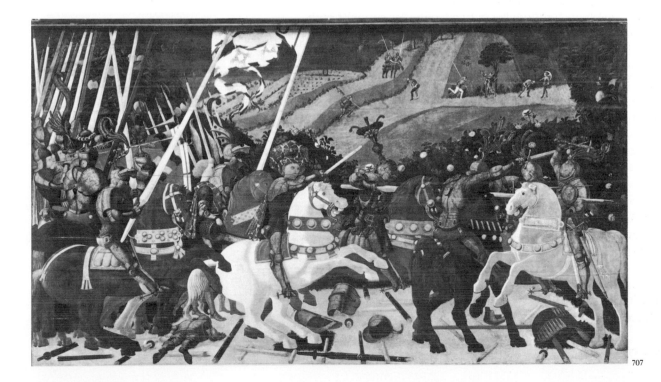

707

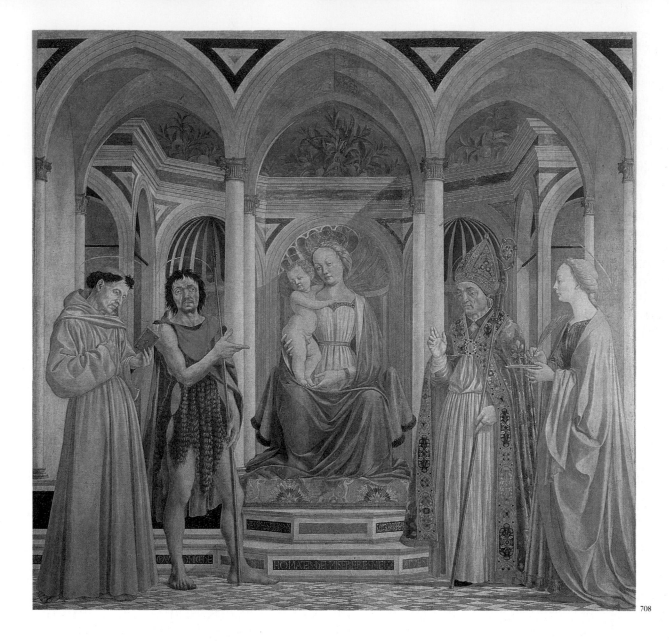

708

which Domenico was able to combine his native feeling for sunlight with a knowledge of the nude worthy of Ghiberti or Donatello. The youthful saint is shown wistfully shedding his garments in the wilderness in order to don a camel's skin. Domenico has turned the incident into an almost pagan enjoyment of the body; the boy seems to revel in the sunlight, which pours upon him from above and is reflected from the spiring rocks. The brushwork with which the artist has depicted the scrubby vegetation is remarkable for its freedom from any Gothic linear convention, recalling the sketchy foliage in Masaccio's *Tribute Money* (see fig. 697).

709

CASTAGNO The third great Florentine master at midcentury was the short-lived Andrea del Castagno (1417/19–57), who for centuries was believed, following Vasari's account, to have murdered Domenico Veneziano out of jealousy of the latter's skill in the use of the oil medium, until it was discovered that Andrea died four years earlier than his supposed victim. Nonetheless, other stories of the artist's irascible temperament probably have some basis in fact. (Whether Domenico used oil or not is a matter yet to be determined by scientific analysis.)

708. DOMENICO VENEZIANO. *Saint Lucy Altarpiece (Madonna and Child with Saints).* c. 1445. Panel painting, 82 × 84″. Galleria degli Uffizi, Florence

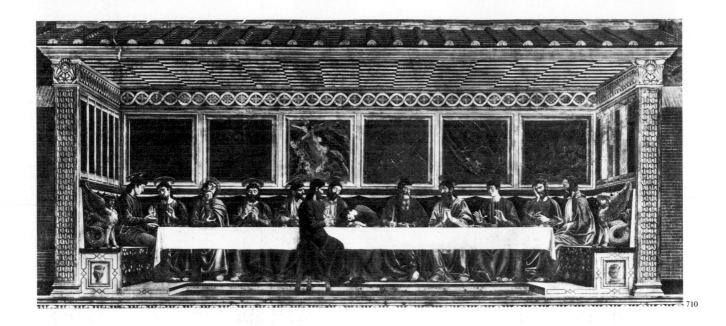

Castagno's best-known work is the fresco of the *Last Supper* (fig. 710), situated in the refectory of the convent of Sant'Apollonia in Florence, then a convent of nuns *in clausura*. Following a doctrine that the monastic life is a living death, Catagno paneled the room in which the Last Supper takes place (and which sanctifies the daily meals of the nuns) with a marble paneling strikingly similar to that used in contemporary Florentine tombs (see especially fig. 716). Although the construction gives a convincing illusion that the spectator is looking into a stage lighted by actual windows from the right, this effect is achieved by the handling of light and dark on massive forms, reminding us of Masaccio and of the statues at Orsanmichele and on the Campanile—poles apart from the soft textures and glowing sunlight of Domenico Veneziano. An experiment with a straight edge will show the reader that the painter has ignored the laws of one-point perspective; there is no vanishing point governing the recession of the orthogonals, and the distance between the transversals is uniform, both in the ceiling and the floor, instead of diminishing as it ought.

Castagno's mountaineer background seems to have affected his choice of rugged types for the Apostles, indeed even for Christ. He conceived the scene within a tradition of Last Suppers painted for refectories, in which Judas is easily distinguishable, given a chair by himself on the outside. The moment chosen for illustration is that in which Christ signifies who will betray him by saying (John 13:26): "He it is, to whom I shall give a sop, when I have dipped it." Some Apostles converse with each other, but most are shown in intense meditation, each apparently foreseeing the moment of his own death. Bartholomew, for instance (the third on Christ's left), who was later flayed alive, folds his hands and gazes at a knife held up to him by Andrew. In a startling new way Castagno has managed to suggest intense emotion by the activity of the veins within the marble paneling, especially in the expressionistic violence of the veining above the group of Christ, Judas, the grieving John, and the skeptical Peter.

Castagno's sculpturesque figures can sometimes move with unprecedented force, as in his *David* (fig. 711), whose odd shape is explained by the fact that it was painted on a leather ceremonial shield. Two moments are shown in one; David is striding forward, his left hand raised, about to cast the fatal stone from his sling, and the severed head of Goliath is

709. DOMENICO VENEZIANO. *Saint John the Baptist in the Desert*, from the predella of the *Saint Lucy Altarpiece*. c. 1445. Panel painting, 11 × 12¾". National Gallery of Art, Washington, D.C. Samuel H. Kress Collection

710. ANDREA DEL CASTAGNO. *Last Supper*, fresco, Cenacolo di Sant'Apollonia, Florence. c. 1445–50

711. ANDREA DEL CASTAGNO. *David*. c. 1448. Paint on leather, height 45½". National Gallery of Art, Washington, D.C. Widener Collection

shown already lying at his feet. Admittedly a bit stiff, this is a remarkable experiment in the depiction of motion, soon to be investigated much more fully by Antonio del Pollaiuolo (see pages 550–51) and by the masters of the High Renaissance. Every element of the landscape background is painted with as much insistence on sculptural modeling and sharp contour line as on the figures themselves.

PIERO DELLA FRANCESCA For our own time the greatest Tuscan painter of the mid-fifteenth century is Piero della Francesca (c. 1420–92). He is, however, a relatively recent rediscovery, slighted before the beginning of the twentieth century and hardly appreciated in contemporary Florence, for we know of only one sojourn there, in 1439 as assistant of Domenico Veneziano. His work was largely done for provincial centers in southern Tuscany. More than any contemporary Florentine, however, Piero managed to exemplify not only the knowledge of form that had been achieved by Masaccio and continued by Castagno, and of light and color in which Fra Angelico and Domenico Veneziano had pioneered, but also the principles of space and perspective laid down by Alberti. In fact, in his later years, Piero wrote an elaborate treatise on perspective, postulating and proving propositions in the manner of Euclid's geometry.

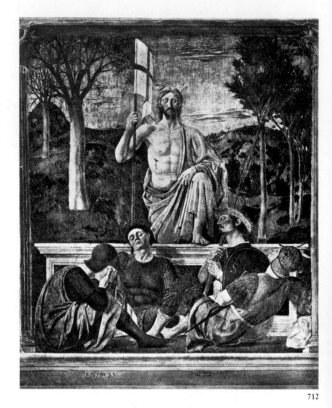

712

Probably in the late 1450s Piero painted the majestic fresco of the *Resurrection* (fig. 712) for the town hall of his native Borgo San Sepolcro (now renamed Sansepolcro), on whose coat of arms the Holy Sepulcher appears. Piero has paid little attention to drama, but has instead represented the event as a timeless truth. One foot still within the sarcophagus (whose paneling recalls that of the *Bruni Tomb* by Bernardo Rossellino [see fig. 716] and that of Castagno's *Last Supper*), the other planted on its edge, Christ stands as grandly as a Roman statue, gazing calmly toward us and beyond us. Below, the soldiers sleep in varied poses; above, we look into an almost barren landscape. On the left the trees are leafless, on the right covered with foliage, doubtless a symbol of the rebirth of nature in Christ's Resurrection. The cool light of dawn has just touched the gray clouds in the sky and bathes alike the marmoreal surfaces of Christ's body and the gently glowing colors of the soldiers' garments.

Every figural and architectural element in Piero's art was prepared for in perspective drawings and simplified to bring out its essential geometrical character. The grandeur and the mathematical basis of Piero's compositions are nowhere more impressive than in his great fresco series,

712. PIERO DELLA FRANCESCA. *Resurrection*, fresco, Town Hall, Sansepolcro. c. Late 1450s.

713. PIERO DELLA FRANCESCA. *Discovery of the Wood from Which the True Cross Was Made*, and *Meeting of Solomon and the Queen of Sheba*, from the *Legend of the True Cross*, fresco, S. Francesco, Arezzo. c. 1453–54

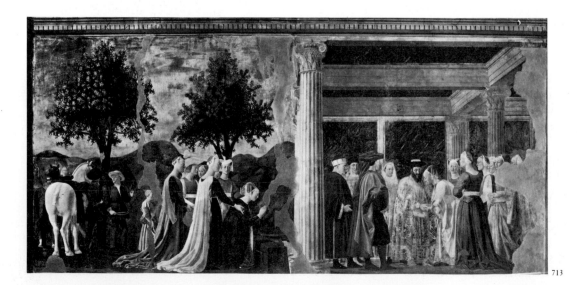

713

dating probably from 1453–54, in the Church of San Francesco in Arezzo. In the *Discovery of the Wood from Which the True Cross Was Made* and the *Meeting of Solomon and the Queen of Sheba* (fig. 713), the queen kneels before a beam that, it has been revealed to her, will furnish the wood of the Cross; then she is received by Solomon in the portico of his palace. The Albertian architecture, with its fluted Composite columns of white marble and its green marble panels, is no more strongly geometrical than the figures, especially the heads and robes of the attendants of the kneeling queen.

Piero's later work shows increasing evidence of his having studied Netherlandish painting, and he used either an oil-and-tempera emulsion or perhaps oil alone to produce the effects of atmospheric perspective and of light on fabrics and jewels that characterize his profile portraits of *Federigo da Montefeltro* and *Battista Sforza* (figs. 714, 715). Shortly before the pictures were painted Federigo, count of Urbino, a principality owing fealty to the papacy, had been promoted to duke. The countess, who died in 1472 in her twenties after the birth of her ninth child, in a desperate attempt to achieve a male heir, was portrayed from a death mask. There could be no more vivid illustration of the Early Renaissance belief in the inherent nobility of man and his domination over nature than the ascendancy of these impassive profiles over the light-filled landscape. Doubtless at the direction of his noble patron, Piero has not concealed the deformity of Federigo's nose, mutilated in battle. His understanding of light enabled him to render the reflections of boats on a distant lake, the glow of sunlight from a chain of square towers as from the countess's necklace of spherical pearls, and the softness of the haze that begins to dim the hills on the far horizon.

714. PIERO DELLA FRANCESCA. *Battista Sforza*. After 1475. Oil (and tempera?) on panel, 18½ × 13″. Galleria degli Uffizi, Florence

715. PIERO DELLA FRANCESCA. *Federigo da Montefeltro*. After 1474. Oil (and tempera?) on panel, 18½ × 13″. Galleria degli Uffizi, Florence

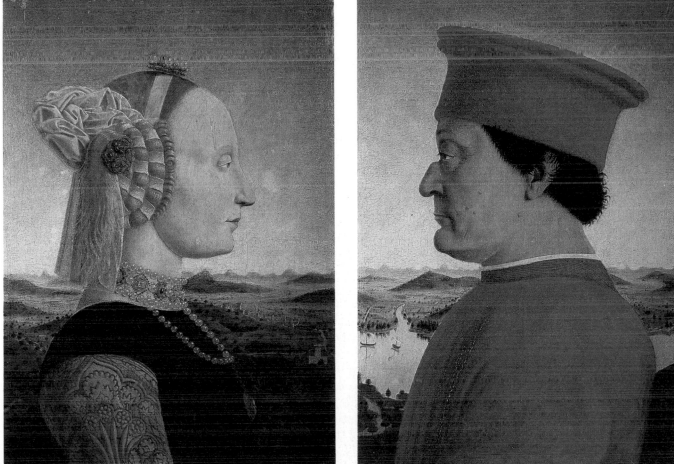

714

715

A number of gifted sculptors in marble carried well past the middle of the fifteenth century principles laid down by the innovators of the Early Renaissance. But no extensive statuary series were again attempted before the early sixteenth century. The role of the sculptor was reduced; he was called upon for funerary monuments, pulpits, altar furniture, reliefs that looked like paintings and were intended for private homes, and above all unsparing portrait busts of contemporary Florentines.

BERNARDO ROSSELLINO The fourth of five brothers, all stonecutters from Settignano outside Florence, Bernardo Rossellino (1409–64) was an architect as well as a sculptor and carried out the building of the Palazzo Rucellai (see fig. 672) from Alberti's designs. The architecture of the *Tomb of Lionardo Bruni* (fig. 716), erected for the historian, humanist, and statesman, is so far superior to anything we know Bernardo to have designed by himself that it is probable that Alberti provided the inspiration. After his death in 1444, Bruni was given a state funeral by the republic in "ancient style"; at its close the orator Giannozzo Manetti (see page 514) put a laurel wreath on the dead man's brow. This event is immortalized in the monument, which shows Bruni recumbent on a bier, crowned with laurel, his hands folded upon a book.

Wall tombs were common in Florence in the Late Middle Ages and the Early Renaissance, but this is the first to be enclosed in a round arch, supported on Corinthian pilasters of great elegance. The tomb is colorful, with three red porphyry panels set in white marble frames. Originally many of the details, especially the sculptured damask covering the bier, were painted and gilded. On the sarcophagus a tablet bears a Latin inscription recording how the Muses mourned at the death of Bruni. Angels (or are they Victories?) in low relief, resembling the style of Ghiberti, uphold the tablet. Roman eagles support the bier. Nude boy angels (or are they genii?) steady an oak garland surrounding the rampant lion of the Florentine Republic. In the lunette a roundel flanked by praying angels holds a relief representing the Virgin with the blessing Child. This mixture of Classical and Christian is typical of the ambiguous position of humanism in the fifteenth century. The face of the deceased was probably carved after a death mask, a universal custom at the time. Grand though it is, the *Bruni Tomb* tells us less about Bernardo's style as a sculptor than about the society the monument was intended to address. It became the standard for Florentine wall tombs for a generation.

ANTONIO ROSSELLINO A far more sensitive and individual sculptor than his older brother Bernardo, Antonio Rossellino (1427–79) transformed the wall-tomb in his monument for the cardinal of Portugal (fig. 717), a prelate of royal blood who died in Florence at the age of only twenty-five years. The niche is retained, but the arch is partly masked by curtains carved in marble, drawn aside as if to show a vision. The youthful cardinal lies upon a bier above a sarcophagus copied from a Roman original. Winged angels kneel on either side of a cornice above him, as if they had just alighted; other angels, still flying, silhouetted in white against a solid porphyry background, carry a garland containing the Virgin and her smiling Child; against a blue disk dotted with gold stars the sacred figures look gently down toward the dead prelate. Forms and ideas that were static in the *Bruni Tomb* become dynamic in that of the cardinal of Portugal, which leads the way to the new sculptural action

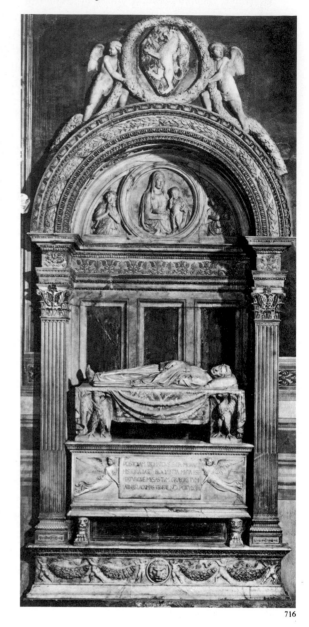

716

716. BERNARDO ROSSELLINO. *Tomb of Lionardo Bruni*. After 1444. White and colored marbles, Sta. Croce, Florence

717. ANTONIO ROSSELLINO. *Tomb of the Cardinal of Portugal*. 1460–66. White and colored marbles. Chapel of the Cardinal of Portugal, S. Miniato al Monte, Florence

718. ANTONIO ROSSELLINO. *Giovanni Chellini*. 1456. Marble, height 20″. Victoria and Albert Museum, London

719. DESIDERIO DA SETTIGNANO. *Christ and Saint John the Baptist*. c. 1461. Marble. The Louvre, Paris

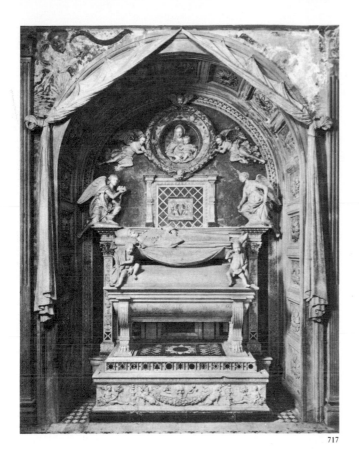

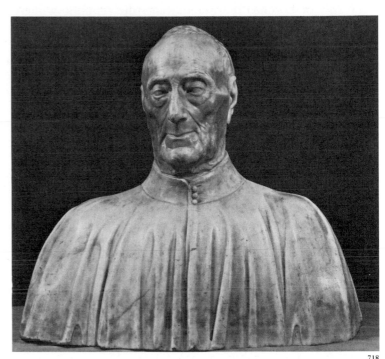

717

718

style of the late fifteenth century, especially that of Antonio del Pollaiuolo and Verrocchio (see pages 550, 552, and figs. 722, 723).

Antonio's portrait of the aged physician Giovanni Chellini (fig. 718) is one of the finest examples of the new type of portrait bust—head and shoulders, without ornamental pedestal—which made its appearance in Florence at midcentury. The glance is always directed straight forward, and the head never turned, raised, or lowered. Yet in spite of the rigid requirements of the mode, Antonio shows extraordinary sensitivity in the modeling of the wrinkled skin, which betrays the position of the underlying bony structure and yet is so smoothly polished as to reflect the gradations of light over the almost translucent surface. Above all, he communicates to us a convincing characterization of the old gentleman, learned, shrewd, yet kindly.

719

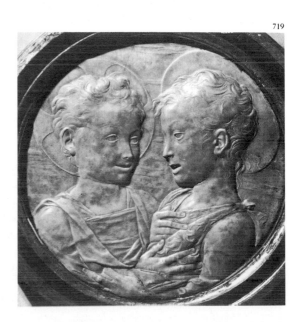

DESIDERIO DA SETTIGNANO From a technical point of view the most remarkable of the marble sculptors is Desiderio da Settignano (c. 1430–64). He carried Donatello's relief style to a new pitch of delicacy and was probably the finest sculptor of children the world has ever known. In a small marble tondo Desiderio shows *Christ and Saint John the Baptist* (fig. 719) as boys of about seven or eight. (Although no scriptural evidence indicates their meeting at that time, this was a favorite subject for painting and sculpture at midcentury.) Saint John opens his mouth in speech and places his hand on the wrist of the Christ Child, who gently touches John's camel's-hair garment. Clouds are shown in the background, and a soft breeze agitates the saint's curly locks. The gradations of marble have been so delicately handled that changes of a millimeter in projection alter the effects of light and shadow. Often details are blurred by filing so as to create soft, atmospheric effects as in painting.

In the last third of the century, few of the founders of the Renaissance remained alive; with the exception of Alberti, none were still influential. Florence itself had changed—under Medici domination, culminating in the rule of Lorenzo the Magnificent, the republic withered; so did the banking and commercial activity on which its prosperity was founded. Patrician life in urban palaces and country villas acquired a new tone of ease and luxury. Humanism was concerned less with the moral virtues of the ancients than with an elaborate structure of speculation that under Marsilio Ficino sought to reconcile Neoplatonism with traditional Christianity. In the last decade of the century, Savonarola, one of the successors of Saint Antonine as prior of San Marco, sparked a religious reaction that united large sections of the populace against the Medici, who in 1494 were expelled for the second time from Florence.

During this period of deepening crisis, three major currents may be distinguished in Florentine art: a strongly scientific tendency on the part of painter-sculptors exploring the natural world and especially the structure and movements of the human body; a poetic tendency on the part of painters alone, inspired by Neoplatonism and characterized by withdrawal into a world of unreality; and a prosaic tendency on the part of both painters and sculptors, who sought to represent people as they were and upper-middle-class Florentine life under the guise of religious subject matter.

ANTONIO DEL POLLAIUOLO The most inventive of the scientific artists, and the master preferred by Lorenzo the Magnificent (who spoke scathingly of Botticelli) was Antonio del Pollaiuolo (1431/2–98), tapestry designer, silversmith, sculptor, and painter. Antonio's major extant painting is a huge altarpiece representing the *Martyrdom of Saint Sebastian* (fig. 720), finished in 1475, for which three claims can be made: the background is the most extensive, comprehensive, and recognizable "portrait" of a landscape yet attempted in Italy; the figures are carried beyond anything achieved in the realm of action since ancient times; and, most important, the composition itself is, for the first time in Renaissance art, built up from the *actions* of the figures rather than their *arrangement*.

Let us take up these claims in order. Although the gap between the foreground and the middle distance, always the Achilles heel of a fifteenth-century painting, has yet to be bridged convincingly, the distant landscape is a view of the Arno Valley at the right and the telescopically remote city of Florence (difficult to make out in reproductions) at the left. The rich plain, the ranges and peaks of the Apennines, the clusters of trees, the Arno rushing toward us—now dimly reflecting the trees along its banks in its troubled surface, now broken into turbulent rapids—have no parallel in the relatively schematic landscape backgrounds of Masaccio or Piero della Francesca. For a competitor one has to look to the landscapes of Flemish masters, such as those of Jan van Eyck (see fig. 754), some of which Pollaiuolo may well have known.

The muscular figures, influenced by Castagno's pioneer attempt at motion (see fig. 711), are shown under strain as they crank up their crossbows or pull taut their longbows to pierce the patient saint with their arrows. Pollaiuolo may even have made models from life, because the longbowmen at left and right seem to be the same figure painted from front and rear, as do the crossbowmen between them, differing only in their clothing (or lack of it). Finally, the figures form a pyramid not because of their placement but by virtue of their actions. The moment that

the arrows are discharged the figures will assume other poses and the pyramid will dissolve. Whether or not Pollaiuolo could have foretold it, this kind of dynamic composition represented a long step in the direction of the pictorial and architectural principles of the High Renaissance.

Pollaiuolo seems to have placed mankind on a lower level than his Florentine contemporaries or forebears. In many of his works, humans are as cruel as wild beasts, for example, in his famous engraving entitled, for lack of any knowledge of its real subject, *The Battle of the Ten Nudes* (fig. 721). Before a background of dense vegetation ten men are slaughtering each other in a surprising variety of poses, unprecedented in their freedom of action, though as yet here and there uncertain in their precise anatomical construction. The medium of engraving, known earlier as a means of ornamenting suits of armor, was adopted at first by relatively few Italian artists, and this is an early example. The method consisted of incising lines on a plate of copper with a steel instrument called a burin, which dug up a continuous shaving of metal and left a groove. The plate was then inked, and the ink wiped off except that remaining in the grooves; a moistened piece of paper was placed over the plate and, under pressure, absorbed the ink from the grooves, resulting in a print or engraving.

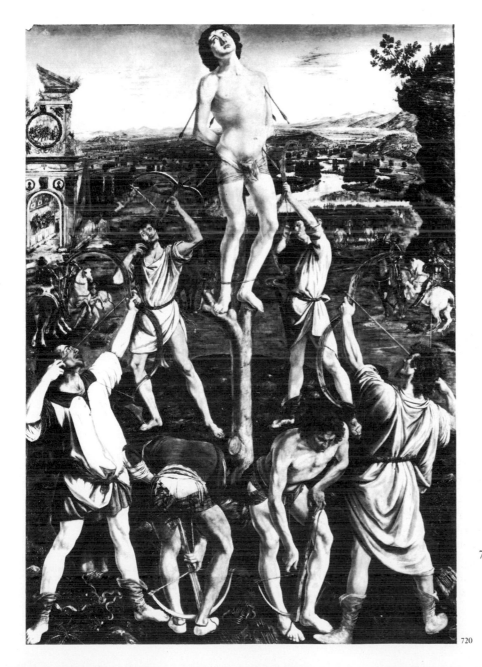

720

720. ANTONIO DEL POLLAIUOLO. *Martyrdom of Saint Sebastian*. Completed 1475. Tempera on panel, 9'7" × 6'8". National Gallery, London

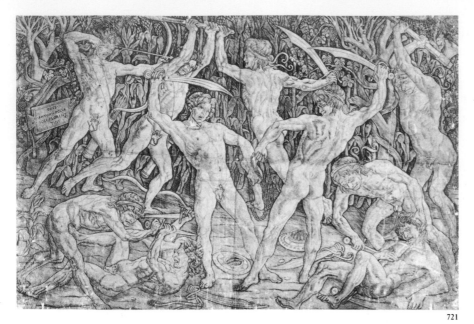

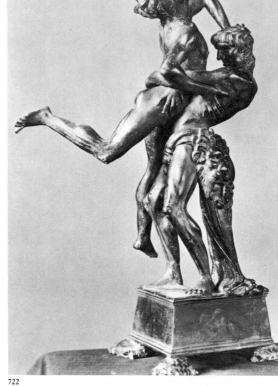

Antonio's most brilliant piece of sculpture is a small bronze group representing *Hercules and Antaeus* (fig. 722). Antaeus was the son of the earth-goddess, invincible as long as he was in touch with her. Hercules broke this contact by lifting Antaeus off the ground, and then crushed him to death. Pollaiuolo rendered fiercely the details of the struggle, and created thereby a new kind of sculptural group, as dynamic as his paintings and engravings. Head, arms, and legs fly off in all directions, against the embrace of Hercules, enlisting the space around and between the figures in the total composition. Pollaiuolo's invention of the action group was not taken up by his contemporaries; action groups were not seen again until the dynamic sculptures of the later Mannerists and the Baroque (see figs. 837, 913). It is worth mentioning that we know of nothing by Pollaiuolo in marble; only bronze, cast from a model in wax or clay, was suitable for compositions of this sort.

VERROCCHIO Known to posterity principally as the teacher of Leonardo da Vinci, Andrea del Verrocchio (1435–88) tends to be overlooked. He was a good painter, but a superb sculptor—in fact, the major monumental sculptor in Florence between the death of Donatello and the first large-scale statues of Michelangelo. His noblest work is the *Doubting of Thomas* (fig. 723), placed in a niche at Orsanmichele that had been carved by Donatello and Michelozzo for another statue in 1423. The loose grouping of figures—hardly more than high relief, for they have no backs—flows beyond the limits of the Early Renaissance frame. This composition is again dynamic, seizing the moment when Thomas is about to place his finger in the wound in the side of the risen Christ, who lifts his pierced hand above the Apostle and looks gently down at him, waiting for doubt to be dissolved by belief. The drama of the composition is enhanced by the vitality of the surfaces of hands, faces, and hair; the harsh realism of the open wounds; and the flickering lights and darks produced by the intricate succession of folds and pockets into which the drapery masses are shattered. Not a trace of the broad drapery construction of Donatello or Nanni di Banco remains.

Verrocchio's colossal equestrian statue of the Venetian general *Bartolommeo Colleoni* (fig. 724) invites comparison with Donatello's *Gattamelata*

721. ANTONIO DEL POLLAIUOLO. *The Battle of the Ten Nudes*. c. 1465. Engraving. The Metropolitan Museum of Art, New York. Joseph Pulitzer Bequest, 1917

722. ANTONIO DEL POLLAIUOLO. *Hercules and Antaeus*. 1470s. Bronze, height 18″ (including base). Museo Nazionale del Bargello, Florence

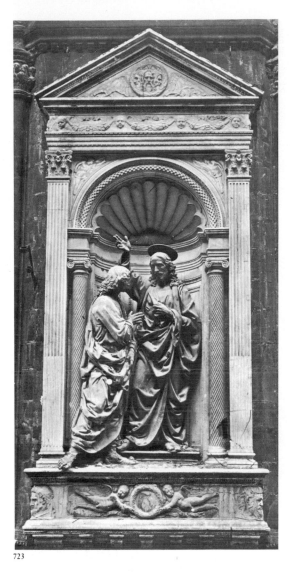

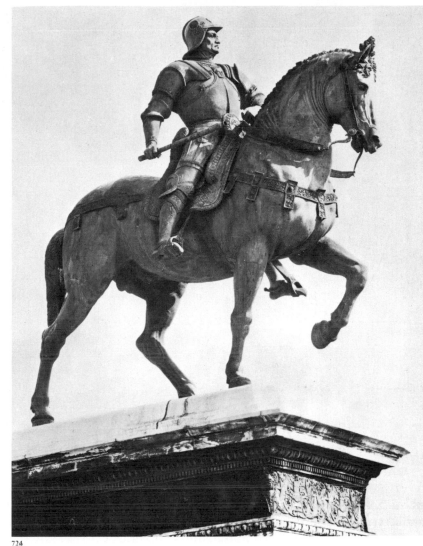

(see fig. 685). The Early Renaissance sculptor's conception of an ideal commander, wearing classicized armor, is replaced by a dynamic one of a helmeted warrior, armed with a mace, glaring fiercely as he leads his forces into battle. Placed before the Church of Santi Giovanni e Paolo in Venice, the composition builds up powerfully from every point of view, as the general twists in his saddle and the mighty charger strides forward. As in the *Doubting of Thomas*, the *Colleoni* is dependent for much of its effect upon the emotions of the moment and on the brilliant handling of surfaces, especially the tense muscles of the horse, his distended veins, and dilated nostrils.

BOTTICELLI Among the painters of the poetic current in the late fifteenth century, Sandro Botticelli (1445–1510) stands alone in depth of feeling and delicacy of style. So intense is his concentration on line, so magical his research into the unreal, that it is hard to believe that he studied with Filippo Lippi, a follower of Masaccio. Although aloof from the scientific current and criticized by the young Leonardo da Vinci, Botticelli was the leading painter resident in Florence in the 1480s and 1490s. He was profoundly affected by the preaching of Savonarola, turned to an intensely religious style in his later life, and after 1500 seems to have given up painting altogether. His most celebrated pictures, the *Pri-*

723. ANDREA DEL VERROCCHIO. *Doubting of Thomas.* 1465–83. Bronze, lifesize. Orsanmichele, Florence

724. ANDREA DEL VERROCCHIO (completed by Alessandro Leopardi). *Equestrian Monument of Bartolommeo Colleoni.* c. 1481–96. Bronze, height c. 13'. Campo Ss. Giovanni e Paolo, Venice

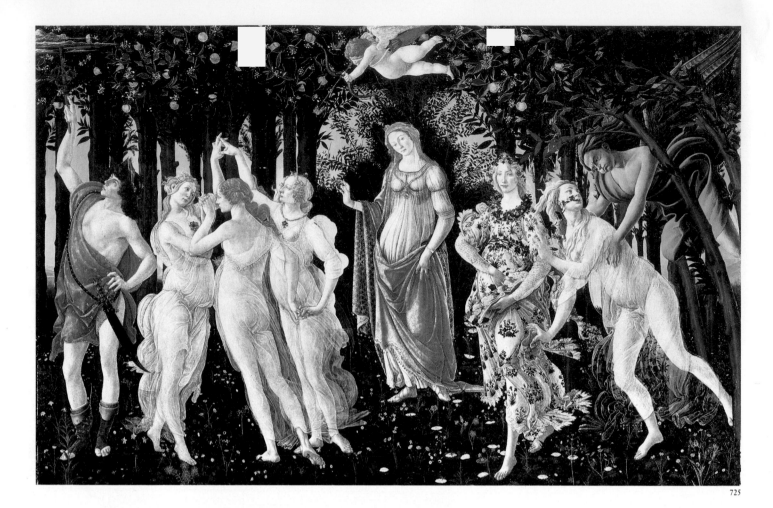

725

mavera (*Spring*; fig. 725) and the *Birth of Venus* (fig. 726), were apparently painted at a slight distance from each other in time, the first on panel, the second on canvas (rarely used in the fifteenth century); Vasari saw them in the same room in the villa of Lorenzo di Pierfrancesco de' Medici, a second cousin of Lorenzo the Magnificent, and apparently the two paintings were then considered companion pieces.

Both have been interpreted in different ways, of late largely through the writings of Marsilio Ficino, leader of the Neoplatonic movement in Florence. While no interpretation of the *Primavera* is wholly successful, the most convincing is based on a letter written by Ficino in 1478 to his pupil Lorenzo, then a lad of fourteen or fifteen years, to whom the philosopher recommends Venus as his "bride" to make happy all his days. By Venus Ficino meant Humanitas, that is, the study of the Liberal Arts. Very recently it has been shown that the painting was incorporated in the paneling above a daybed in the antechamber to Lorenzo's marital bedroom, and thus probably symbolizes his real wedding in May 1482.

What has been well described as a Christianized Venus, modestly clothed and strongly resembling Botticelli's Madonnas, presides in the midst of a dark grove of trees bearing golden fruit. At the right Zephyrus, the wind-god, pursues the nymph Chloris, from whose mouth issue flowers; she is transformed into the goddess Flora, clothed in a flower-covered gown, from whose folds she strews more blossoms upon the lawn, whose flowers are those that bloom in the surroundings of Florence in the month of May. At the left Mercury, in a pose reminiscent of Donatello's *David*, is dispelling tiny clouds from the golden fruit, which suggest the golden balls symbolic of the Medici family. Between Mercury and Venus dance the Three Graces, emanations of Venus, as described in a

725. SANDRO BOTTICELLI. *Primavera*. c. 1482. Tempera on panel, 6'8" × 10'4". Galleria degli Uffizi, Florence

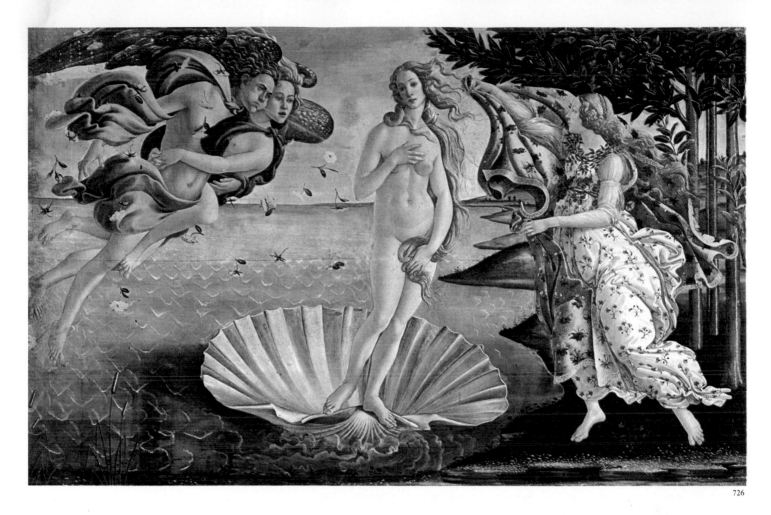

726.

passage from the Roman writer Apuleius. Alberti recommended them as
a fit subject for painters, who were instructed to show these lovely crea-
tures either nude or in transparent garments, dancing in a ring, their
hands entwined. Botticelli has depicted this complex allegory in an image
of utmost enchantment. As in all his mature works, the figures are ex-
tremely attenuated, with long necks, torsos, and arms and sloping shoul-
ders. Their delicate faces and the soft bodies and limbs appearing through
the diaphanous garments seem almost bloodless as well as weightless;
their white feet touch the ground so lightly that not a flower or a leaf is
bent. Although individual forms are beautifully modeled, the composi-
tion is based on an interweaving of linear patterns, formed of drapery
folds, streaming or braided hair, trunks, and leaves, like the many voices
of a fugue. Such a picture, both in content and in style, represents a
withdrawal from the naturalism of the Early Florentine Renaissance. In-
terestingly enough, Botticelli at this stage has renounced not only the
mass and space of Masaccio and succeeding generations but also their
strong coloring, preferring grayed tones of rose, green, and blue and pal-
lid flesh colors.

The *Birth of Venus* may show the effects of Botticelli's residence in
Rome in the early 1480s. Venus, according to an ancient myth, was born
from the sea, fertilized by the severed genitals of the god Saturn; this
cruel legend was interpreted by Ficino as an allegory of the birth of beauty
in the mind of man through the fertilization by divinity. Upon a sea rep-
resented without concern for space, and dotted with little V-shaped marks
for waves, Botticelli's Venus stands lightly upon—rather than in—a
beautiful cockleshell, wafted by two embracing wind-gods toward a highly
stylized shore. The *Venus pudica* (modest Venus) type, used by Quercia

726. SANDRO BOTTICELLI. *Birth of Venus*. After
1482. Tempera on canvas, 5'9" × 9'2". Gal-
leria degli Uffizi, Florence

and Masaccio for Eve, now appears for the first time in her own right as Venus. But what a difference from the splendid Venuses of Classical antiquity! Botticelli's wistful lady, proportioned much like the Three Graces, uses the curving streams of her long hair, lightly touched with actual gold pigment, to conceal her nakedness, and seems hardly to be able to wait for the cloak that one of the Hours is about to spread around her. Again Botticelli's allegory is related to the Christian tradition with which the Neoplatonists were trying to reconcile pagan legend; the composition has been compared to medieval and Renaissance representations of the Baptism of Christ.

While the unreality of Botticelli is a blind alley in the development of Renaissance painting, the brilliance and beauty of his line are not, and it may have influenced considerably the pictorial style of Michelangelo.

GHIRLANDAIO While Pollaiuolo painted for Lorenzo the Magnificent and Botticelli for a learned elite, Domenico del Ghirlandaio (1449–94) pleased most of all a solid class of bankers and merchants. The host of frescoes and altarpieces produced by Domenico and his numerous assistants rendered his shop the most prolific in Florence in the 1480s and 1490s. Not unconcerned with the rediscovered works of Classical antiquity, Ghirlandaio nonetheless had little interest in the mythological fantasies that charmed Botticelli and his followers. His solid paintings are conservative, still Albertian in their emphasis on one-point perspective and clear organization of masses, but matter-of-fact in their attitude toward subject matter. For example, when he filled the chancel of the Church of Santa Maria Novella in Florence with frescoes representing the lives of the Virgin Mary and John the Baptist, he introduced contemporary Florentines in everyday dress as onlookers in the sacred scenes. He set the *Birth of the Virgin* (fig. 727), much as Filippo Lippi had (see fig. 705), in a wealthy Florentine home, properly decorated with a sculptured frieze of music-making children above a wainscoting of inlaid wood. Ludovica,

727. DOMENICO DEL GHIRLANDAIO. *Birth of the Virgin*, fresco, Cappella Maggiore, Sta. Maria Novella, Florence. 1485–90

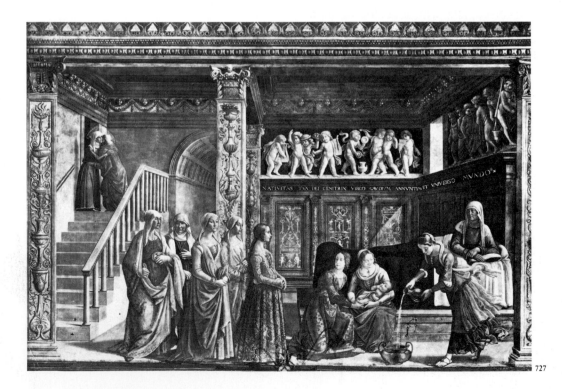

daughter of Giovanni Tornabuoni, the wealthy Florentine who commissioned the frescoes, appears, hands folded before her and accompanied by four ladies-in-waiting, all dressed as in real life. The workmanship is good, the drawing solid, the forms agreeable, the colors bright, and imagination is lacking.

Two outsiders complete the roll of major painters working on and off in Florence in the last decades of the century.

PERUGINO A master from Perugia, the capital of the region known today as Umbria, Pietro Perugino (c. 1445–1523) was the leading painter of central Italy outside of Florence in the 1480s and 1490s, with a flourishing school that included the young Raphael; Perugino enjoyed, in fact, considerable success in Florence as well. With Botticelli, Ghirlandaio, Luca Signorelli (see below), and a number of other painters, he was called to Rome in 1481 to decorate the walls of the chapel in the Vatican newly built by Pope Sixtus IV and known as the Sistine Chapel. One of Perugino's frescoes, the *Giving of the Keys to Saint Peter* (fig. 728), shows him at the height of his powers. The figures are aligned much as in the paintings of Ghirlandaio along the foreground plane, and, as in Ghirlandaio, contemporary figures have intruded at right and left. But unlike Ghirlandaio, whose figures are often rigid, those of Perugino appear remarkably supple, in spite of their voluminous mantles. They unfold from the ground upward like growing plants, arms moving, heads turning, with a grace that is Perugino's own.

Characteristic of Perugino's art is his extraordinary sense of distance, partly achieved by means of Florentine one-point perspective, by which he constructs the vast piazza, with its scattering of tiny figures forming two more Gospel scenes. Entirely Perugino's own is the remote landscape, its hills sloping on either side to form a bowl of space and filled with soft atmosphere under a serene, blue sky.

The architecture in the middle distance, symbolic rather than real,

728. PIETRO PERUGINO. *Giving of the Keys to Saint Peter*, Sistine Chapel, Vatican, Rome. 1481

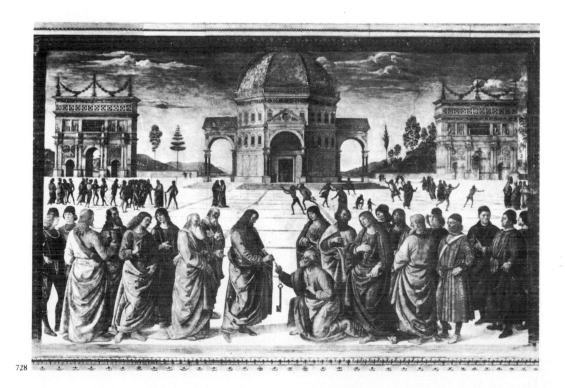

728

places between two triumphal arches, modeled on that of Constantine, a central-plan structure suggesting the dome of the Cathedral of Florence, but adorned with four airy porticoes; this building probably signifies the Church that Christ is depicted founding on the rock of Peter, between relics of the power of imperial Rome.

SIGNORELLI Since the lifetime of Luca Signorelli (1445/50–1523) spans the turn of the century (although slightly older than Leonardo da Vinci, he outlived both Leonardo and Raphael), it is hard to know whether to consider him an artist of the Quattrocento or the Cinquecento. For pure convenience he appears here in this book, although his major work, the series of frescoes in the Cathedral of the Umbrian town of Orvieto representing episodes from the Last Judgement, was influenced by the researches of Leonardo and the youthful works of Michelangelo. Some of the scenes, especially the *Damned Consigned to Hell* (fig. 729), represented the most daring venture into a composition made up of a great number of struggling nude figures. The whole scene looks like a colossal sculptured relief. At the upper right three archangels in shining armor exclude the damned from Heaven; they are carried off shrieking by demons into Hell, whose flaming mouth opens at the left. The foreground stage is populated with a struggling web of human and demonic bodies, the mortals colored white or tan, the demons parti-colored in shades of orange, lavender, and green. Fierce tortures are inflicted by the demons, who bite, twist, and tear at various portions of their victims' vividly projected anatomies. From such a work one would hardly realize that Signorelli had been a pupil of Piero della Francesca.

729. LUCA SIGNORELLI. *Damned Consigned to Hell*, fresco, S. Brixio Chapel, Cathedral of Orvieto. 1499–1504

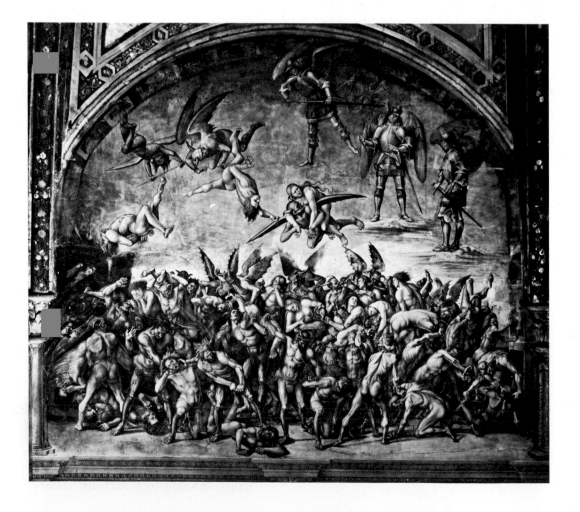

In the first half of the fifteenth century, Venice, the splendid city of the lagoons, empress of a chain of islands and ports protecting her rich commerce in the eastern Mediterranean, gradually extended her dominion over the north Italian mainland so that her frontiers reached within thirty miles of Milan. Becalmed in a local style blended of Byzantine and Gothic elements, Venetian art was occasionally enlivened by visits of great masters from elsewhere. In their youth Gentile da Fabriano, Paolo Uccello, Filippo Lippi, and Andrea del Castagno had stayed for varying lengths of time and left traces on what remained a provincial art. But the eleven-year sojourn of Donatello, champion of the Renaissance, in the Venetian subject-city of Padua brought about a revolution in the art of the Venetian region. Florentine doctrines of form, perspective, and anatomy, not to speak of the Florentine ability to adapt Classical architectural elements to contemporary needs, took firm hold and united with a Venetian predilection for richness of color and surface. Before long the last traces of medievalism disappeared from Venetian art, and a parade of great masters developed a new Renaissance style, which, in the sixteenth century, eventually unseated Florence from her throne in painting and at least equaled her in architecture.

MANTEGNA Already a full-fledged painter at seventeen, signing altarpieces on his own, Andrea Mantegna (1431–1506) was the first major north Italian artist to experience the full force of the Florentine Renaissance. In 1454, the year of Donatello's departure from Padua, Mantegna began, with several older artists, a series of frescoes in the chapel of the Ovetari family in the Church of the Eremitani in Padua. His competitors having been eliminated by death or discouragement, Mantegna finished the series himself in 1457, when he was twenty-six years old. *Saint James Led to Execution* (fig. 730) is a triumph of Renaissance spatial construction and Renaissance Classicism. The perspective is calculated for the eye level of a person of average height standing on the floor below, and the effect of figures moving in an actual space is even more startling than in Masaccio's *Trinity* (see fig. 701) because this fresco begins above eye level. Accordingly, the ground disappears, and as the figures recede and diminish first their toes, then their feet, and then their ankles are cut off by the lower border. The vanishing point, below this border, controls the rapid recession of the Roman arch at the left and the medieval and Renaissance houses that tower above us at the right.

Mantegna's perspective, however, does not recognize a vertical vanishing point. In actuality, the vertical lines of the architecture should converge as we look up, but that would have dissolved the unity of the wall surface with its superimposed rows of scenes and, consequently, was not attempted till the sixteenth century. Within Mantegna's carefully constructed space, the figures look like animated statues, carved rather than painted. But their marmoreal hardness only intensifies the drama. James, on his way to martyrdom, turns to bless a kneeling Christian who has broken through the Roman guards. The movements of the figures, the gentleness of the saint, and the emotion of the moment are as severely controlled as the perspective.

In Mantegna's maturity his austerity relaxed a bit, especially in the frescoes he finished in 1474 for the castle of the Gonzaga family, marquesses of the principality of Mantua, at whose court Mantegna remained as official painter until his death. Alberti, let us remember, had also been in Mantua more than once, and in 1470, when Mantegna was already in

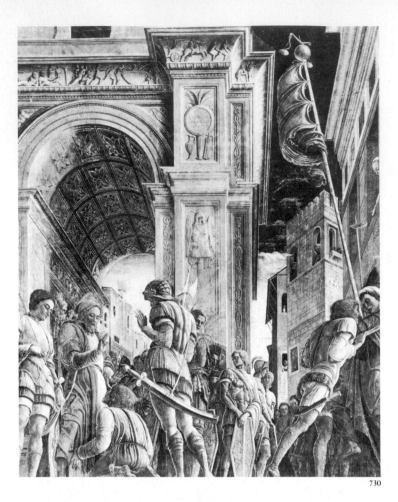

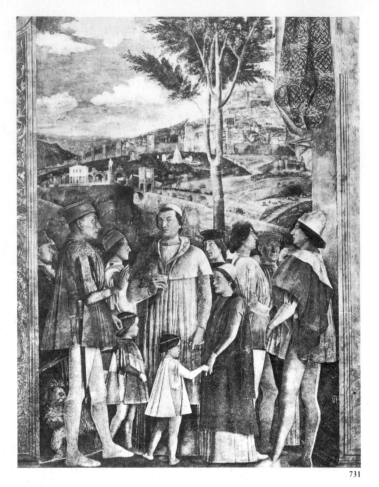

residence, provided the designs for the epoch-making Church of Sant'
Andrea (see fig. 675). The Gonzaga frescoes are continuous around two
sides and over the vaulted ceiling of a square chamber, called the Camera
degli Sposi, and represent scenes from contemporary court life. In one
(fig. 731), the thirteen-year-old Francesco Gonzaga is greeted by his fa-
ther, the marquess Ludovico, and by the bishop of Mantua, other digni-
taries, and some charming children on his return from Rome, where he
had just been made a cardinal. The background is not Mantua itself,
which is perfectly flat, but an ideal Italian city on a conical hill; the cir-
cular walls are, of course, seen in perspective. Outside them can be dis-
tinguished assorted Roman ruins and statues. Mantegna still takes plea-
sure in geometrical forms and relationships, especially in the north Italian
costumes. The coloring, vivid as it yet is, was undoubtedly more brilliant
before certain portions, painted *a secco* (the hose of the marquess and the
tunic of the central child, for instance), peeled off in the course of time.

The center of the ceiling (fig. 732) is Mantegna's most astonishing
perspective prank. We seem to be looking up into a circular parapet as up
through the mouth of a well, above which are sky and clouds. Winged
children clinging to the parapet are seen in sharp perspective from front
and rear, and across one end runs a pole, which, if it rolled a bit, would
allow a large tub of plants to fall on our heads. Ladies-in-waiting, includ-
ing one black servant, peer over the edge, smiling at our discomfiture.
With this odd beginning commences the long series of illusionistic ceiling
and dome paintings that continued for three centuries and spread from
Italy throughout Europe (see Correggio's dome fresco for the Cathedral
of Parma, fig. 831).

730. ANDREA MANTEGNA. *Saint James Led to Exe-
cution*, fresco (destroyed in 1944), Ovetari
Chapel, Church of the Eremitani, Padua.
1454–57

731. ANDREA MANTEGNA. *Arrival of Cardinal
Francesco Gonzaga*, fresco, Camera degli
Sposi, Palazzo Ducale, Mantua. Completed
1474

732. ANDREA MANTEGNA. Ceiling fresco, Camera
degli Sposi, Palazzo Ducale, Mantua. Com-
pleted 1474

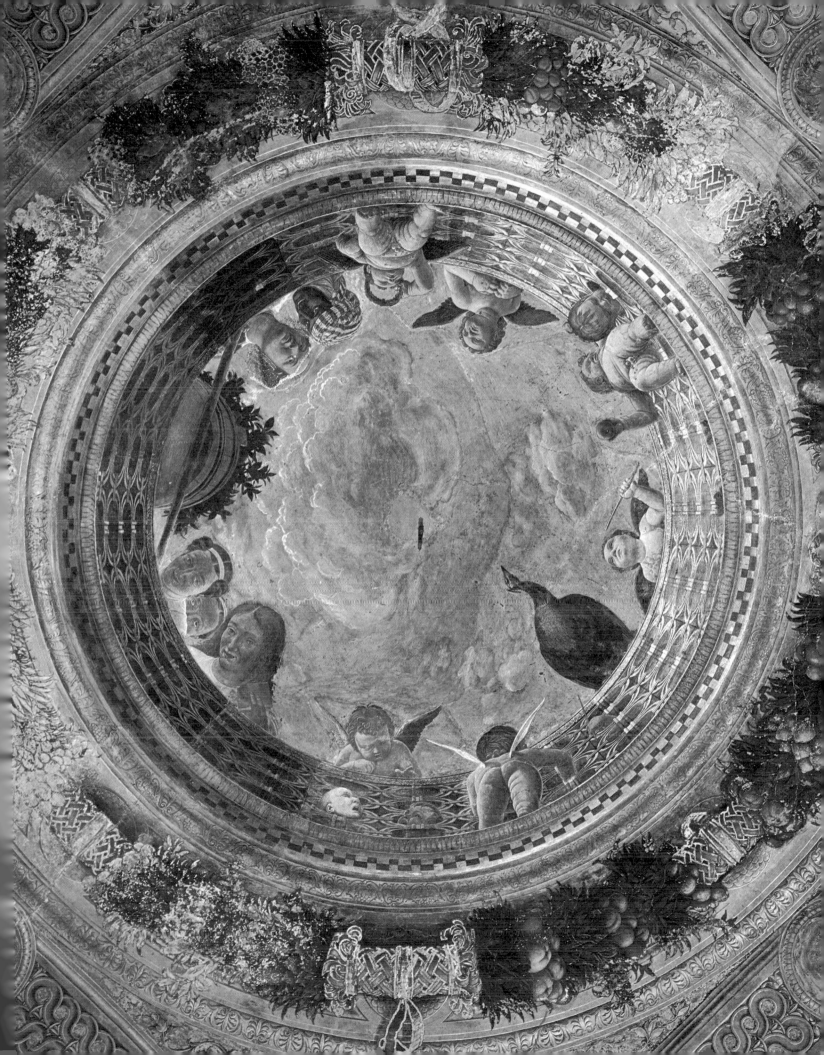

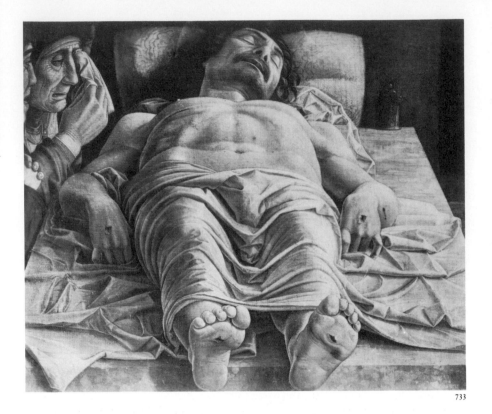

Probably late in life, Mantegna painted the *Dead Christ* (fig. 733) on canvas and *in scurto* (extreme foreshortening), intended not as a trick in this case but as a device to bring home to the meditating observer with the greatest possible intensity the personal meaning for him of Christ's sacrificial death. The weeping Mary and John, very likely later additions, jeopardize neither the picture's scientific exploitation of perspective nor its profoundly psychological effect.

ANTONELLO DA MESSINA At this point an unexpected ingredient—more important than all the science of the Florentine Renaissance—was added to the amalgam of Venetian style. This essential element, the oil technique fully developed by the painters of the Netherlands (as we shall see in the following chapter), seems to have been brought to Venice by a painter from Sicily, which, since the days of its great Byzantine mosaics, had been something of an artistic backwater. As we know from the discussions of Domenico Veneziano, Castagno, and Piero della Francesca, oil painting, long known to the Italians in theory, was certainly practiced in Italy earlier in the fifteenth century, often in combination with tempera. But the little picture *Saint Jerome in His Study* (fig. 734), painted in Sicily by Antonello da Messina (c. 1430–79) long before the artist's departure for Venice, was done in the oil technique, including glazes, as practiced by the Netherlandish masters, especially Jan van Eyck (see Chapter Three). No one has yet been able to determine where Antonello learned the Northern method, but his observation of almost microscopic detail and of minute gradations of light on reflecting or light-absorbent objects is so close to the great masters of the North that he must have had personal instruction from one of them. It has recently been suggestsed that, in the manner of Netherlandish symbolic representations under the guise of realism, every object and animal in this little

733. ANDREA MANTEGNA. *Dead Christ*. After 1466. Tempera on canvas, 26¾ × 31⅞". Pinacoteca di Brera, Milan

734. ANTONELLO DA MESSINA. *Saint Jerome in His Study*. c. 1450–55. Oil on panel, 18 × 14⅛". National Gallery, London

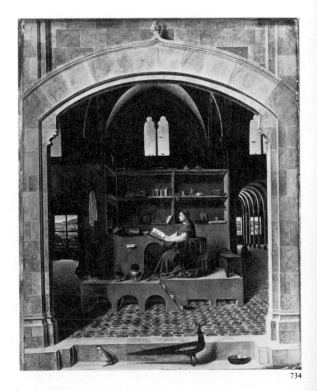

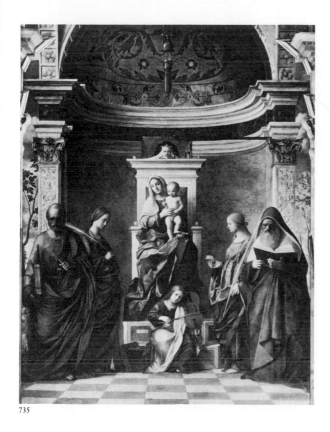

painting has in fact a strong religious significance. Antonello's eighteen-month stay in Venice, beginning in 1475, changed the whole course of Venetian painting.

BELLINI Among the host of good painters who now appeared in Venice and its surrounding territory, the towering master in the last forty years of the fifteenth century, without competition until the appearance of Giorgione in the first decade of the sixteenth (see Chapter Six and figs. 842, 843), was Giovanni Bellini (c. 1430–1516), who came from a family of excellent painters and whose sister married Andrea Mantegna. The early phase of Bellini's long career shows, indeed, considerable relation to the style of his brother-in-law, but the arrival of Antonello put an end to all that. Without abandoning in any way the ideal breadth that is the essence of Italian art, Bellini was able to absorb rapidly all the wonders that the oil technique was to offer him. In his *Transfiguration of Christ* (fig. 736), painted when the artist was perhaps almost sixty, he placed the scene in the midst of a subalpine landscape of a richness and depth that no Italian painter had been able previously to achieve.

A fence of saplings and the edge of a cliff separate us from the sacred figures. In traditional poses, Peter, James, and John crouch in terror, while on the knoll behind and slightly above them the Lord is revealed "in raiment . . . white and glistering" (Luke 9:29) between Moses and Elijah in what appears to be merely the intensified light of the late afternoon; he stands calmly against the sky, apparently consubstantial with the white clouds above the distant mountains. Halos have disappeared, as in Netherlandish painting; only a soft yellow glow surrounds the head of Christ. The long light models the Old Testament prophets and saturates the landscape and the distant towns at the right, while at the left a cowherd leads his cattle against the gathering shadows. In Bellini's art a new joy in nature is effortlessly blended with profound religious reverence into a landscape poetry the like of which had never been seen before.

When the great German master Albrecht Dürer (see page 659 and figs. 862, 868) visited Venice for the second time, in 1506, he found that Bellini, although very old, was still the leading Venetian painter. A work of this time, the *Madonna and Child Enthroned* (fig. 735) in San Zaccaria in Venice, proves Dürer's point. In a stately shrine, whose lateral arches open to sky and trees, the Virgin is seated on a marble throne. A soft light bathes her and the four meditating saints, and throws into shadows the gold and peacock-blue mosaic of the semidome above the Virgin's head. The solemnity of the composition, the perfect balance of the figures, and the breadth and freedom of the construction of the forms became the basis of the great Venetian style of the High Renaissance.

The achievements of the Early Renaissance in Italy, transformed in a single century not only the visual arts but the nature and purpose of art itself and the social position of the artist more radically than they had been changed in the preceding thousand years. On the basis of the pioneer conquests of the Late Gothic masters, the great innovators of central Italy—then, a generation later, those of northern Italy—produced a new art able to represent credibly anything the eye could see, approximating

735. GIOVANNI BELLINI. *Madonna and Child Enthroned*. 1505. Oil on canvas (transferred from panel), 16'5½" × 7'9". S. Zaccaria, Venice

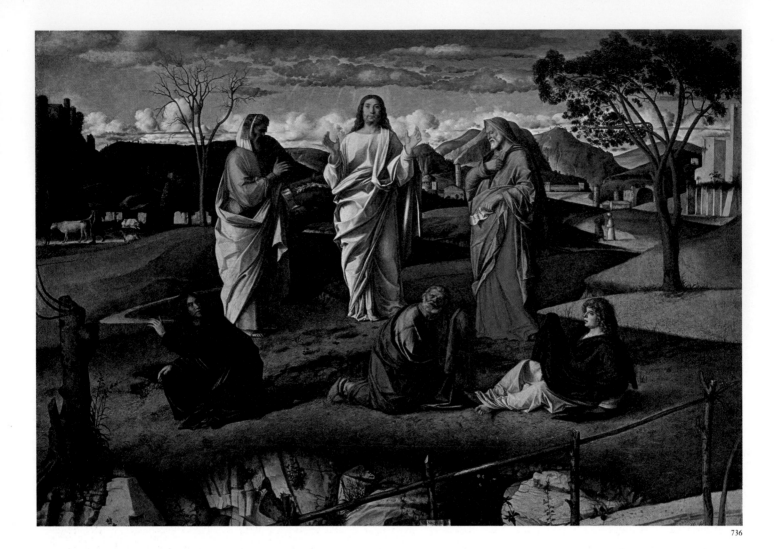

736

reality in form, space, and color. They infused these optical impressions of the visible world with a sense of inner structure that derived from their own researches in the sphere of proportional, perspective, and anatomical theory, perhaps even more than from their study of antiquity. On this balance between sight and structure depends the beauty of early Italian Renaissance art. Yet in central Italy, in art as in political life, the century ended in a degree of confusion and uncertainty. Venetian art glided serenely from the triumphs of Antonello and Bellini to the even more ambitious achievements of the masters who followed them in the sixteenth century, but it remained for a handful of central Italians, for the most part youthful at the turn of the century, to reinvigorate and synthesize the diverse currents of the Early Renaissance into a completely new style that we call the High Renaissance. Only at the very beginning of this new phase did these developments take place in Florence; due entirely to far-reaching political changes, for the first time since Cavallini Rome was to become the great artistic center of Europe.

736. GIOVANNI BELLINI. *Transfiguration of Christ.* Late 1480s. Oil on panel, 45¼ × 59″. Museo di Capodimonte, Naples

564 THE RENAISSANCE

CHAPTER

THE EARLY RENAISSANCE IN NORTHERN EUROPE

THREE

The developments we have just followed in Italy constitute only one aspect of a complex European situation, and cannot be entirely understood without a knowledge of the equally important events going on in northern Europe, although not in architecture, which, as we have seen (page 498), remained Gothic. For visiting Italian humanists or for Italian bankers and merchants looking out of the windows of their branch offices in Bruges, Ghent, or Paris, Flamboyant Gothic architecture can have held little interest; if we judge from written accounts, Italians considered it barbarous.

Painting was another story. The Italians looked on the achievements of the Northerners with open-mouthed wonder. Here were kindred spirits! Even more—here were artists who had made visual conquests that to the Italians, notwithstanding their articulate theory, came as a total surprise. Cyriacus of Ancona, an Italian humanist who had been to Athens and looked at the Parthenon, recorded in 1449 his astonishment at beholding in a Northern triptych in the possession of Lionello d'Este, duke of Ferrara:

> . . . multicolored soldiers' cloaks, garments prodigiously enhanced by purple and gold, blooming meadows, flowers, trees, leafy and shady hills, ornate halls and porticoes, gold really resembling gold, pearls, precious stones, and everything else you would think to have been produced, not by the artifice of human hands but by all-bearing nature herself.

The revolutionary developments of Northern art took place, for the most part, in the state of Burgundy. It all started in 1363, when King John the Good of France conferred the duchy of Burgundy on his youngest son, Philip the Bold. Through a series of marriages and inheritances Philip and his descendants acquired a region stretching from the Rhone Valley to the North Sea, including much of eastern France, most of Holland, and all of Belgium and Luxembourg.

Philip called numerous artists to his capital at Dijon, and another royal duke, John of Berry, Philip's older brother, brought equally gifted masters to his court in central France. The French artistic tradition seems, for the moment at least, to have been played out; all the inventors of the new style in the North came from the Netherlands (modern Belgium and Holland), which, during the thirteenth and fourteenth centuries, had not contributed notably to the development of figurative art—except for the metalworkers of the Meuse Valley. In 1430 Duke Philip the Good (reigned 1419–67), grandson of Philip the Bold, transferred his capital to Brussels, where he held the most splendid court in Europe, profiting by the revenues from the prosperous Netherlandish commercial cities. In 1477 his son, Charles the Bold, lost his throne and his life in the Battle of Nancy against King Louis XI of France, and the rich Burgundian dominions reverted to other overlords (Burgundy itself to the French crown, the rest to the Habsburg Empire). But the Northern school of painting was by then firmly established, handing down its marvelous skill from one generation to another, and Bruges, Ghent, Tournai, Brussels, Louvain, and Haarlem became artistic centers to rival Florence, Siena, Perugia, Rome, and Venice.

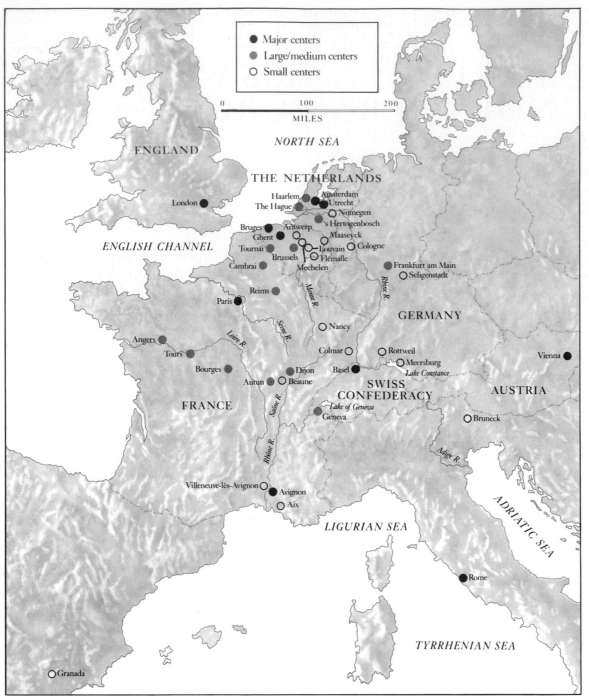

MAP 14. NORTHERN AND CENTRAL EUROPE IN THE RENAISSANCE

The relations between France and Italy were strong in the fourteenth century. French manuscript illuminators were influenced by fourteenth-century Italian painting, and many Italian artists came to France. The Italian masters at Milan Cathedral showed firsthand knowledge of Notre-Dame in Paris; Giovanni Pisano and Giotto probably experienced in person the majesty of French cathedral sculpture. Simone Martini we know worked at Avignon from 1340 to 1344 and may have been to Paris. Doubtless, there were others.

Netherlandish Art in France

SLUTER The first revolutionary developments in late-fourteenth-century France, however, show no trace of this Italian heritage. The crucial figure is not a painter but a vigorous sculptor, Claus Sluter (active

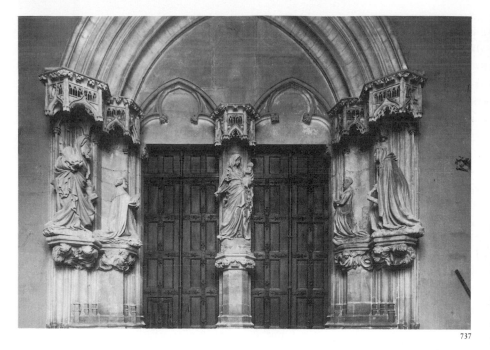

737

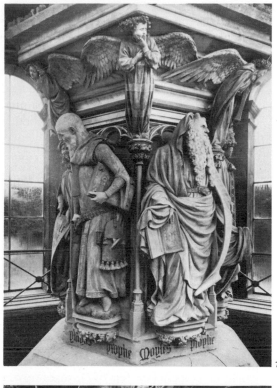

738

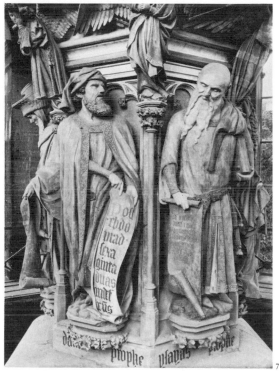

739

after 1379/80–1405/6) from Haarlem, near Amsterdam, who arrived at Dijon in 1385 and was set to work as the assistant of the Netherlandish sculptor Jean de Marville, who had planned out the sculptures for the portal of the Chartreuse de Champmol, a Carthusian monastery built by Philip the Bold near Dijon. The Virgin and Child appear in their traditional place on the trumeau; the kneeling duke and his duchess, Margaret of Flanders, attended by their patron saints, flank them on either side as in paintings. At Jean de Marville's death, only the conventional Flamboyant canopies were ready. Sluter has imbued the portal sculptures (fig. 737) with the sense of a dramatic event. Originally, the central canopy supported angels holding forth the symbols of the Passion (Cross, column, lance, crown of thorns, etc.), from which the Christ Child recoils in terror as his mother endeavors to comfort him. Passionate conviction radiates from these central figures as from the ducal couple and the saints; the billowing drapery movement unites them. Witness the expressive strength of Sluter's art.

The only work that we know Sluter planned from the start is the *Well of Moses*, 1395–1403, in the cloister of the Chartreuse de Champmol; originally, the monument was a giant crucifix rising from the center of the fountain to symbolize the Fountain of Life in Christ. Only fragments of the crucifix survive, but the pedestal with its six prophet statues and six grieving angels stands in its original position (figs. 738, 739). Architecture is reduced to a secondary role, providing a perch for the angels whose powerful wings uphold the cornice below the original position of the Cross. From his projecting ledge each prophet juts forward, ignoring the architecture and holding a scroll bearing his prophecies of the sacrifice of Christ as he looks either upward toward the Cross, downward in meditation, or out into the future. The aged faces are carved with every facet of flesh, hair, wrinkles, and veins in a boldly naturalistic style.

Claus Sluter's revolution is immediate and far-reaching; in one thrust he has carried us from the delicacy of French court art to the humanism of the Renaissance. His fierce Moses, with his traditional horns and two-tailed beard, his body submerged by drapery folds as he holds with his almost veiled right hand the Tables of the Law, is a worthy precursor to the world-famous *Moses* of Michelangelo (see fig. 794). While we are ad-

737. CLAUS SLUTER. Portal of the Chartreuse de Champmol, Dijon. 1391–97

738. CLAUS SLUTER. *Well of Moses* (*Isaiah* and *Moses*). 1395–1403. Stone, height of figures c. 6'. Chartreuse de Champmol, Dijon

739. CLAUS SLUTER. *Well of Moses* (*Daniel* and *Isaiah*). 1395–1403. Stone, height of figures c. 6'. Chartreuse de Champmol, Dijon

miring the powerful sculptural style of this majestic figure, the weary Daniel, and the tragic Isaiah, we should recall that the naturalism of the moment required that these stone statues be completely covered with lifelike color applied by a professional painter; Jean Malouel, uncle of the Limbourg brothers (see page 570), finished the work on Sluter's statues, which had been started by a local painter. Considerable traces of color remain; one prophet was even supplied in 1402 with a pair of bronze spectacles.

BROEDERLAM Sluter's exact contemporary was the Netherlandish painter Melchior Broederlam (active 1385–1409), who contributed the exterior painted wings for an elaborate carved and gilded altarpiece done in 1394–99 for the Chartreuse de Champmol. A delightful painter, if by no means a personality of the creative power of Sluter, Broederlam in his graceful style shows us the somewhat subservient role still occupied by painting—but not for long. His drapery motives are derived from those of Sluter but treated more lightly and with great ornamental delicacy. The fantastic architectural interiors of the *Annunciation* (fig. 740) from the left wing recall remotely those of Pietro Lorenzetti, but diminish in perspective at a dizzying rate, just as the fanciful background landscape of the adjacent *Visitation*, which can trace its immediate ancestry to the rocky world of Duccio (see fig. 652), soars upward like flames. God the Father appears in the *Annunciation* waist-length in a circle of blue angels against the gold; from his mouth a flood of light pours through the tracery of Mary's window, which, as we have seen (see page 539), is a symbol of the Incarnation.

THE BOUCICAUT MASTER Early in the fifteenth century a very observant painter known as the Boucicaut Master after his principal work, the *Hours of the Maréchal de Boucicaut*, illuminated probably between 1405 and 1408, was at work in Paris. The patron who ordered the splendid book was a soldier, whose military service took him to points as distant as Prussia and Mount Sinai. The artist may have been the painter Jacques Coene of Bruges, who was called to Milan in 1398 as an advisory architect for the Cathedral.

In contrast to breviaries, intended for the clergy, *Books of Hours* were written and illuminated for secular patrons. They contained, in addition to the prayers and readings for the seven canonical offices, a varying selection of other services, including the Hours of the Cross, the Hours of the Holy Spirit, the Office of the Dead, litanies, Masses for feast days, the penitential psalms, and a calendar of religious observances. They were illuminated, as splendidly as the patron could afford, with illustrations often not directly related to the text. The best of them were luxury objects in whose perusal our thoughts, like those of the patron, only now and then turn to pious matters; we were intended to be lost in delight at the richness of the gold-studded borders and the brilliance of the color, the delicacy of the style, and the manifold beauties of represented nature.

That the Boucicaut Master was an unusually discerning artist can be seen in the *Visitation* (fig. 741), a page from the *Boucicaut Hours*. The heritage of Classical landscape elements seen through Sienese eyes has been so thoroughly transformed that we hardly observe the traditional features. The Boucicaut Master has placed Broederlam's two figures in similar poses (but how much more gentle and gracious!) in front of a distant scene in which we can distinguish a lake with rippling waves and a swan, a hillside with a farmer beating his donkey, grazing sheep (whose shep-

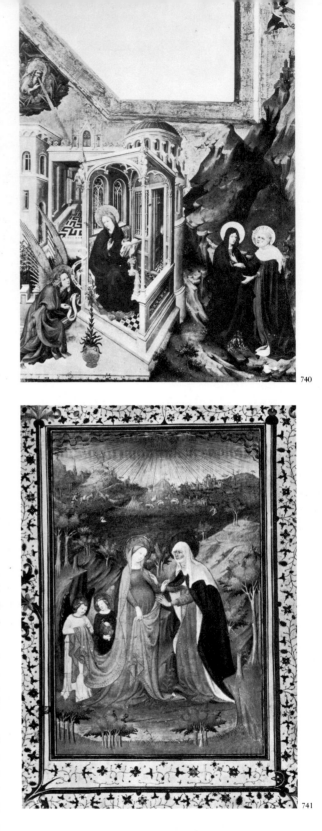

740. MELCHIOR BROEDERLAM. *Annunciation and Visitation*, exterior of left wing of the Chartreuse de Champmol altarpiece. 1394–99. Panel painting, 65¾ × 49¼". Musée des Beaux-Arts, Dijon

741. THE BOUCICAUT MASTER. *Visitation*, illumination from the *Hours of the Maréchal de Boucicaut*. c. 1405–8. Musée Jacquemart-André, Paris

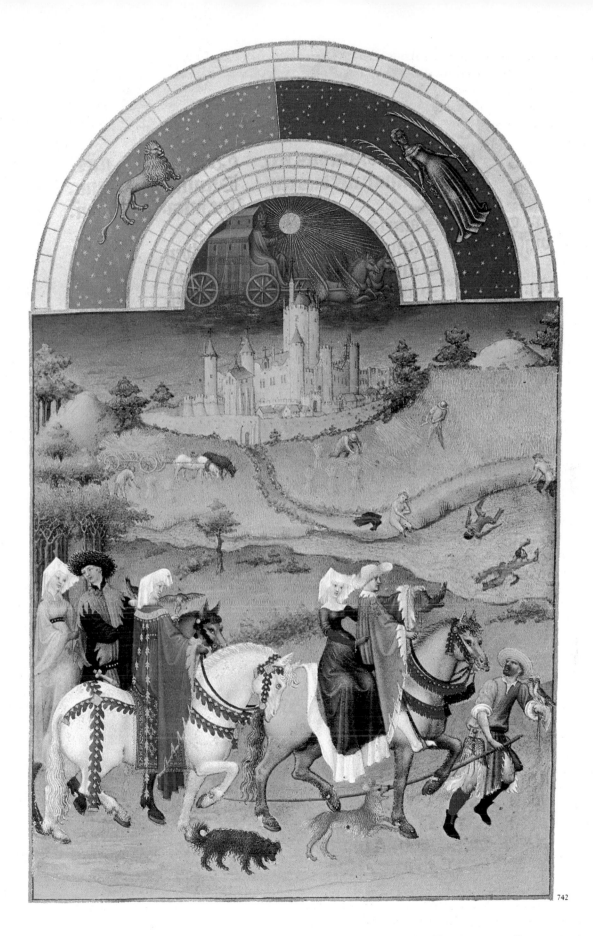

742. THE LIMBOURG BROTHERS. *August*, illumination from the *Très Riches Heures du Duc de Berry*. 1413–16. Musée Condé, Chantilly

herd is down by the lake instead of looking after them), and a château with pointed towers, all indicated by delicate touches of the brush. This much we can parallel in Ambrogio Lorenzetti's *Good Government* fresco (see figs. 655, 656), but immediately above the hills and towers we notice what is the Boucicaut Master's historic breakthrough—just where Ambrogio stopped us at an inert background the Boucicaut Master carries the eye into the hazy horizon, floating clouds, and the bright blue zenith of an infinite sky. This is the first time, to our knowledge, since Roman painting that limitless natural extent has been recognized by an artist— some fifteen years earlier, in fact, than Gentile da Fabriano's Strozzi altarpiece (see figs 695, 696). The decisive step in the conquest of nature has been taken. But it is still tentative. The artist retains the still-traditional double scale for figures and setting, underscored by his introduction of tiny clumps of trees in the foreground less than a quarter the size of the figures. Nonetheless, this enchanting painter has made a still further crucial distinction, that between real and spiritual light. In contrast to Giotto and Taddeo Gaddi (see figs. 649, 650), natural light in the Boucicaut Master is depicted as the eye sees it; spiritual light is rendered with rays of gold pigment ruled with the precision of an architectural draftsman. This distinction remained in Renaissance art with few exceptions until in his *Transfiguration* (see fig. 813) Raphael perfectly fused natural and spiritual light.

THE LIMBOURG BROTHERS The next joyous assault on the real world was led by three young men, the brothers Paul, Herman, and Jean (also called Jeannequin or Hennequin) de Limbourg, from Nijmegen, now in Holland. They were nephews of Jean Malouel, who finished painting the statues of Claus Sluter. None of the three could have been born before 1385 and all were dead by 1416, possibly dying in the same epidemic that carried away their princely patron, the duke of Berry. He seems to have thought very highly of his three youthful artists, especially Paul, who by all accounts was the strongest personality and for whom the duke went to the unusual length of kidnapping a wife and settling the couple down in a lovely house in Bourges. When the duke's estate was inventoried, among the tapestries, jewels, gold and silver plate, and splendid costumes of gold brocade and rich fur, as well as the precious illuminated manuscripts (including some Italian examples) that this insatiable collector loved so dearly, and which filled his seventeen châteaux, were found the unfinished and unbound gatherings of a *Très Riches Heures* (*Very Rich Book of Hours*), which later, in the hands of another collector, were finished by a lesser master. The sections done by the Limbourgs between 1413 and their untimely deaths are among the loveliest creations of Northern painting. Beautiful as are the traditional illustrations from the Life of Christ and the Life of the Virgin, it is the calendar scenes that above all attract our attention.

These are, so to speak, dramatizations of the paired Signs of the Zodiac and Labors of the Months sculptured on cathedral façades. Here, however, the appropriate signs appear in gold over the chariot of the sun in the blue dome of heaven, and the labors go on in the landscape below. In ten of the months these are contrasted with the delights of the aristocracy, but in such a way as to make the peasants appear carefree children of nature while the lords and ladies are prisoners of their own elegance. *August* (fig. 742) is hot. A party of gentlemen and ladies, sumptuously dressed in the doubtless smothering fashion of the time (note the sleeves

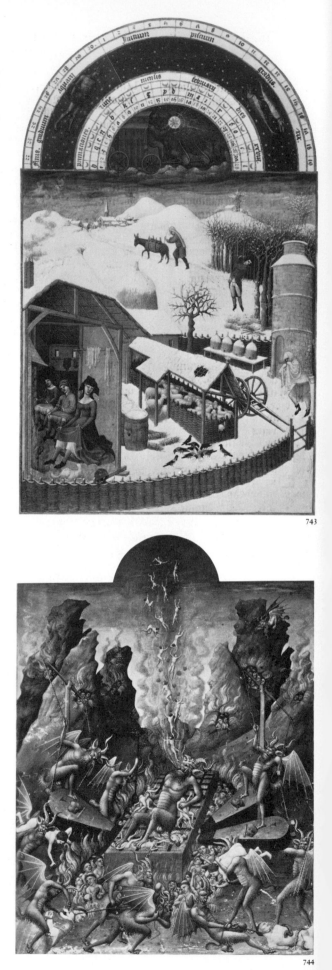

743

744

trailing below the horses' bodies) ride off a-hawking. The background has been brought forward as compared with the Boucicaut Master and is dominated by one of the duke's favorite residences, the Château d'Étampes, below which peasants reap wheat, bind it into sheaves, and pile them into a cart. In the middle distance peasants have cast off their clothes and swim delightedly in the River Juine. The artist has even studied the distortion caused by the refraction of light penetrating the water.

February (fig. 743) is bitterly cold, and the world is deep in snow, never convincingly represented before. Among white hills nestles a tiny village under a leaden sky. A peasant cuts branches for firewood, another guides his wood-laden donkey along the snowy road. In the foreground snow makes fluffy caps on a hayrick and a row of beehives, sheep huddle for warmth in their sheepfold (which has a hole in its roof), magpies peck at grain, and a shepherd stamps up and down and blows upon his freezing hands. The gentlemen and ladies are nowhere to be seen. Inside the farmhouse, with smoke curling from its chimney and the front wall removed for our convenience, clothing and towels hang against the walls, and two peasants, conspicuously male and female, lift their garments, somewhat too high, to warm themselves before a (gilded) fire while the lady of the house turns disdainfully from such coarseness to warm considerably less of herself.

In contrast to the delights of earthly life, the Limbourg brothers let their imaginations produce a searing image of *Hell* (fig. 744), a gray immensity of spiring rocks on which there is, to quote John Milton, "no light but rather darkness visible." Crowned king of this desolate region, Satan extends himself on a giant grill, on which he roasts the helpless damned, while demons on either side work the giant bellows, whose mechanisms are meticulously represented. From the far dome of Heaven a torrent of souls pours down—into Satan's open mouth (for a Baroque transformation of this theme, see fig. 962). To render the scene even more impressive, all the demons and flames in this grim and otherwise colorless region are rendered in gold.

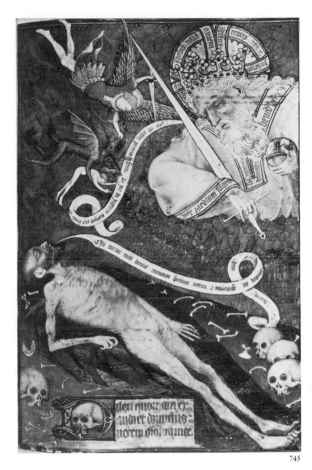

745

THE ROHAN MASTER After the delicacy of the *Très Riches Heures*, the macabre expressionism of the Rohan Master comes as a shock. So called because he and his assistants illuminated the *Grandes Heures de Rohan* (commissioned by Yolande of Aragon, wife of Louis II of Anjou), this artist is of unknown nationality. He could have been a Netherlander, a German, or even a Spaniard. The only thing certain about him is the devastating originality of his style. In one full-page illustration (fig. 745), before the Office of the Dead, he depicts a dying man from whose mouth issue the words, in Latin, "Into thy hands I commend my spirit; thou hast redeemed me, O Lord God of Truth." The first clause was uttered by the dying Christ from the Cross (Luke 23:46), and the rest is a quotation from Verse 5 of Psalm 31. The man's emaciated body, rendered with gruesome fidelity to detail, is stretched upon a black silk shroud embroidered with gold and with a red cross; on the barren ground about him are strewn bones and skulls. From a blue heaven, made up entirely of tiny angels drawn in gold, Christ (so labeled in the halo) bends down, hair and beard as white as wool, and bearing a sword, as in Revelation 1:14. He replies, in French, "For thy sins thou shalt do penance; on the day of judgment thou shalt be with me." An angel and a demon struggle over the dead man's soul. The strength of the drawing, the boldness of the composition, and the terrifying reality of the image show an artist of

743. THE LIMBOURG BROTHERS. *February*, illumination from the *Très Riches Heures du Duc de Berry*. 1413–16. Musée Condé, Chantilly

744. THE LIMBOURG BROTHERS. *Hell*, illumination from the *Très Riches Heures du Duc de Berry*. 1413–16. Musée Condé, Chantilly

745. THE ROHAN MASTER. *The Dying Man Commending His Soul to God*, illumination from the *Grandes Heures de Rohan*. c. 1418. Bibliothèque Nationale, Paris

unusual stature, one who leads toward the majesty of Robert Campin (see fig. 748) and Rogier van der Weyden (see figs. 759, 760), just as the Limbourg brothers point toward the serene perfection of Jan van Eyck.

The glowing pages of the *Books of Hours* could be turned only by the rich and by their fortunate guests. The new style found its complete expression in altarpieces, which, whoever may have commissioned them, were visible to all in churches and addressed a public drawn from every class. Consequently, religious narratives were set in the context of daily life in Netherlandish towns and among the familiar activities of the merchants who dominated them. From a tentative beginning in such rare examples as Broederlam's pair of panels for the Chartreuse de Champmol, these altarpieces were painted with increasing frequency in the 1420s and before the end of the century numbered in the thousands.

The oil technique invented by the Netherlanders was new. Not that oil was unknown—the Romans used it for painting leather or shields that were exposed to weather, and some aspects of oil technique are described in medieval treatises, culminating in Cennini (see page 503). But it had never before been used for altarpieces. Apparently, the Netherlanders were dissatisfied with the appearance of a tempera surface, which, notwithstanding the varnish universally applied as protection, was dry, mat, and enamel-like, achieving its best effects with brilliant colors. Instead of egg yolk, then, the Northerners used a very refined oil vehicle, starting with linseed or walnut oil that had been fused when hot with hard resin, such as amber or copal, and then diluted with oil of rosemary or lavender. On the gesso panel, smoothed to porcelain finish, the painter drew his forms and light effects with a brush dipped in a single color, usually gray. On this base he applied his colors suspended in oil. The final layers were glazes, that is, solutions of oil and turpentine mixed with color to give a transparent or translucent effect. The final varnishes were also often mixed with color, so that the earlier layers were seen through them as through colored glass. The Netherlanders thus achieved a depth and resonance of color and effects of shadow and half light unobtainable in tempera. Given the optical interests of the fifteenth century, it was only a matter of time, as we have seen, before oil superseded tempera entirely, even in Italy.

CAMPIN A tormenting aspect of early Netherlandish painting is the frequency with which the actual name of a master eludes us, however keen may be our feeling that we know his personality from his work. One of the leading pioneers of panel painting is a case in point. His work has been assembled on the basis of fragments of altarpieces thought to have come from the Abbey of Flémalle (see fig. 748), and it is clear from their style that the artist who painted them must have been the teacher of Rogier van der Weyden (see figs. 759, 760). We have documentary accounts of a painter from Tournai called Robert Campin (c. 1378–1444), whose principal pupil was Roger de la Pasture. Since *Pasture* is French for *Weyden*, this would make Campin identical with the Master of Flémalle. Although many scholars accept the hypothesis, others maintain that all the paintings attributed to the Master of Flémalle are in reality early works of Rogier van der Weyden, and all must mournfully admit the lack of absolute proof.

An early work by this brilliant master is the *Nativity* (fig. 746), which is thought to have come from a monastery near Dijon, perhaps even the

Netherlandish Panel Painting

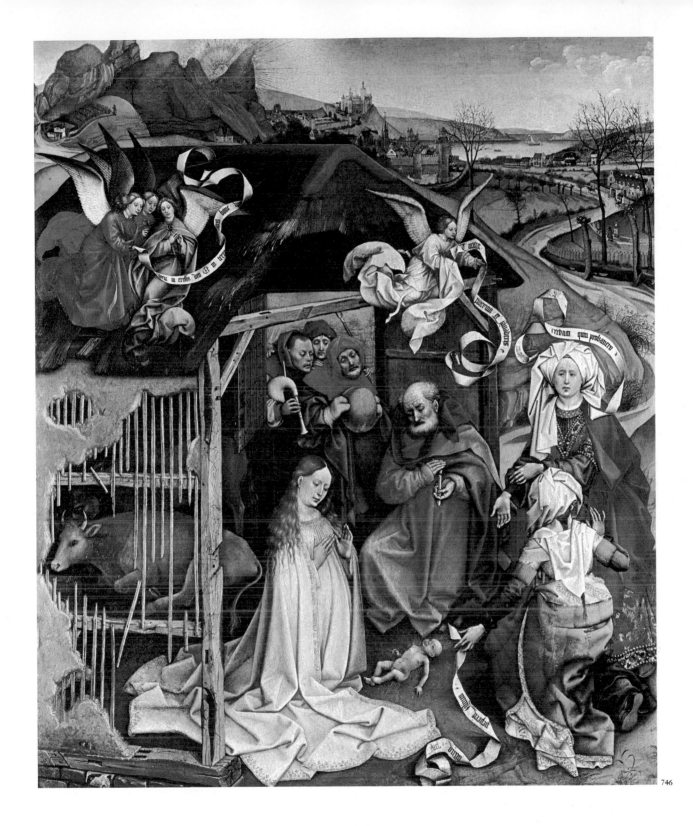

746

familiar Chartreuse de Champmol, and to have been painted about 1425. Campin (to use the name the majority want to use) has shown the very moment of birth, according to the vision of Saint Bridget, a Swedish princess who in the late fourteenth century on a visit to Bethlehem saw the naked Christ Child appear miraculously on the ground before the kneeling Mary, while Joseph held a candle whose flame and even the light of the rising sun were set at nought by the light from the shining Child. Campin has grouped densely before a humble shed Mary, Joseph, and two midwives—one who believes in the miracle, the other incredulous—

746. MASTER OF FLÉMALLE (Robert Campin?).
 Nativity. c. 1425. Oil on panel, 34¼ ×
 28¾". Musée des Beaux-Arts, Dijon

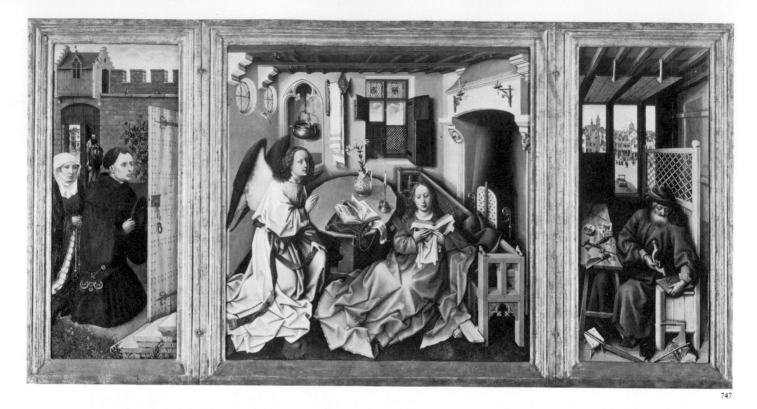

while angels float above. Their glad tidings and the dialogue of the mid-wives are represented, comic-strip style, on floating scrolls as in the Rohan *Hours* (see fig. 745). All the figures and their massive, broken drapery folds are projected with a sculptural power obviously under the influence of Sluter, whose sharp vision has also stimulated the care and subtlety with which the head of the aged Joseph and the faces of the three shepherds who lean through the open window are delineated, wrinkle by wrinkle.

The landscape is brought closer to the foreground even than in the *Très Riches Heures*, and the leafless trees, the rider who has just rounded the bend in the road, the wayside inn that had no room for the Holy Family, the distant (Gothic) Bethlehem, and the lake with its sailboat and rowboat are all shown with scrupulous care. However, in contrast to Masaccio in the almost contemporary *Tribute Money* (see fig. 697), Campin has adopted a high point of view, which we might call "rising perspective," so that the background can be seen over the heads of the figures. Although he has rendered beautifully the shadows of the banks and the bushes thrown by the rising sun on the road, he has attempted nothing like the light effects of Gentile da Fabriano's predella for the Strozzi altarpiece (see fig. 696), possibly considering such darkness unsuitable to his larger panel. The sun, symbol of Christ, shines with gold rays, as does the Child on the ground below. With the oil medium Campin is able to achieve a new softness and richness in the tones, from the russet colors of the landscape and the rich garments of the midwives to the muted gold of the rays and the delicate lavenders and blues in the shadow of Mary's white tunic. Like all Netherlanders henceforward, Campin omits the halos still customary in Italian painting.

A slightly later work, called the *Mérode Altarpiece* because for generations it belonged to the Mérode family, painted about 1425–26, takes us into a contemporary Netherlandish interior as a setting for the Annunciation (fig. 747). Unlike the generally stationary altarpieces in Italy, Netherlandish equivalents were usually hinged, so that the side wings close

747. MASTER OF FLÉMALLE (Robert Campin?). *Kneeling Donors*; *Annunciation*; and *Joseph in His Carpentry Shop*, view of the *Mérode Altarpiece* (open). c. 1425–26. Panel painting, center, 25³/₁₆ × 24⁷/₈"; each wing approx. 25³/₈ × 10⁷/₈. The Metropolitan Museum of Art, New York. The Cloisters Collection. Purchase, 1957

over the central panel like doors; they were generally painted on the outside as well. The three panels of the *Mérode Altarpiece*, under the guise of descriptive realism, form a richly stocked triple showcase of symbols. In the central panel, the Virgin is seated, probably on a cushion, and is still reading (doubtless Isaiah 7:14, as often in representations of the Annunciation: "A virgin shall conceive, and bear a son") as she leans against a bench before a fire screen. On the polygonal table are another open book, a vase of lilies (symbol of the Virgin's purity), and a still-smoking candle, symbol of the Incarnation (Isaiah 42:3: "the smoking flax shall he not quench"); a copper ewer, hanging in a niche, and a towel on a rack have been claimed as an allusion to Christ's washing of the Apostles' feet, and to the washing of the world from sin, predicted for the morrow in the breviary prayers for Christmas Eve. The Christ Child can be seen gliding down golden rays from the nearest round window, carrying the Cross over his shoulder, a representation frequent in *Annunciations* until now but soon to be forbidden as heretical. The closed garden in the left panel, in which the kneeling donor and his wife (a couple from Mechelen named Inghelbrechts) receive their view of the miracle through the door left open by the angel, is the closed garden of Mary's virginity (Song of Solomon 4:12: "A garden inclosed is my sister, my spouse"), and is filled with flowers symbolic of Mary.

The right wing, Joseph's carpentry shop, is packed with symbols. He is contriving a mousetrap, and according to Saint Augustine the Cross is the mousetrap and Christ the bait to catch the Devil. Not only are the ax, saw, and rod in the foreground all mentioned in Isaiah 10:15, but also the ax "laid unto the root of the trees" signifies the fate of sinners in Matthew 3:10. The saw is the instrument of Isaiah's martyrdom, and the rod is Joseph's rod, which bloomed miraculously to designate him as the Virgin's husband (see examples by Fouquet, fig. 779, and by Raphael, fig. 805). This listing by no means exhausts the symbols recently identified by scholars among the collection Campin exhibits. Well may one ask who, in 1425, was supposed to know all these things, and how an artist, who presumably had no theological training, could find them out. One must suppose the existence of a learned adviser, consulted by both patron and painter.

The identification of the interior of the altarpiece as an inward extension of its frame obviously recalls Pietro Lorenzetti's invention (see fig. 654), and the drapery folds are clearly Sluteresque. Although the rising perspective is a bit dizzying, Campin's delight in rendering as accurately as possible not only the real objects in the interior but also the views out of Joseph's window and the garden gate into a little Netherlandish town is infectious.

Single-handedly, Campin took painting from miniature to lifesize, as is displayed dramatically by a fragment of the Flémalle altarpiece showing the *Impenitent Thief Dead on His Cross* (fig. 748). The entire altarpiece, a *Descent from the Cross*, is known only from a copy, but, if one judges from the scale of the fragment, the lost original must have been about twelve feet wide and about seven and a half feet high. Campin's combination of linear precision in the rendering of anatomy with strong shading makes this tormented figure seem prophetic of Michelangelo's struggling nudes (see figs. 796, 818), although there is slight possibility of direct influence. Especially impressive is Campin's ability to present as profoundly tragic such pieces of naturalistic observation as the dead man's agonized expression and the torn flesh of his broken legs, which in the work of the Rohan Master would have been merely frightening. Campin's ability to emulate

748

748. MASTER OF FLÉMALLE (Robert Campin?). *Impenitent Thief Dead on His Cross* (fragment). c. 1428–30. Panel painting, 52⅜ × 36⅜". Städelsches Kunstinstitut, Frankfurt

in paint the monumentality and power of Sluter's sculpture is comparable to the relationship between Masaccio and his sculptural predecessors in contemporary Florence (see Chapter Two).

JAN VAN EYCK Among all the masters who outdid each other in efforts to enhance the new naturalism in the early fifteenth century, Jan van Eyck (c. 1385–1441) stood out in the eyes of his contemporaries; about 1456 the Italian humanist Bartolommeo Fazio called him the "prince of painters of our age." Without a doubt he was one of the greatest artists who ever lived, and to many he shares the summit among Northern painters only with Rembrandt in the seventeenth century. The absoluteness and self-sufficiency of van Eyck's work, which render all words about him superfluous, may be illustrated by a passage from one of Fazio's descriptions of paintings by him that have now disappeared. This passage describes a triptych painted for the Genoese Giovanni Battista Lomellino; he appears in one wing "lacking only a voice, and a woman whom he loved, of remarkable beauty, she too carefully represented just as she was; between them, as if peeping through a crack in the wall a ray of sun which you would take to be real sunlight." Other naturalistic artists *represent* nature; van Eyck seems to *present* it. Nor can his pictures be reproached with the modern term "photographic," for no camera can approach the reality revealed by his pictures. One immediately accepts that what he shows really exists, down to the most minute detail, not separately catalogued as in the work of Campin but unobtrusively there. And nothing in his paintings is more convincingly real than the segment of atmospheric space his frame circumscribes, in which light, bright or dim, is dissolved, reflecting back to us from countless surfaces and textures. It is strange, therefore, that when the chips are down there should be any doubt as to which paintings are really by a master so universally acknowledged as great and which are not. Yet such is the case with this most enigmatic of artists, around whose work the arguments show no signs of subsiding.

We know little about Jan van Eyck's early life. A sixteenth-century tradition maintains that he came from Maaseyck in the northeast corner of present-day Belgium, across the Maas (Meuse) River from Holland. The first reference to him records his painting a Paschal candle at Cambrai in 1422; thereupon, he entered the service of John of Bavaria, count of Holland, and made decorations for his palace at The Hague. After John's death in 1425, van Eyck became *varlet de chambre* (doubtless, an honorary title) to Philip the Good, duke of Burgundy, and retained the position until his own death. Philip not only considered him irreplaceable as a painter, but also sent him on diplomatic missions, including short trips and "long and secret journeys" in 1426, as well as a trip to Portugal in 1428–29 to bring back Philip's bride, Princess Isabella. At least one of his journeys took him to Italy, where he must have seen the work of Masaccio and met Florentine artists. In 1430 he settled for good in Bruges, and then the signed and dated works begin, continuing until his death eleven years later.

Part of the controversy centers around the authorship of certain illuminations in the *Turin-Milan Hours*, begun for the duke of Berry, left unfinished at his death, and worked upon thereafter by several painters at different dates. The group in question, done by an illuminator known as Hand G, contains at one point the arms of the house of Bavaria, and thus were presumably painted before the death of Count John in 1425

749. JAN VAN EYCK. *Baptism of Christ*, illumination from the *Turin-Milan Hours*. c. 1422–24. Museo Civico, Turin

and perhaps before that of William IV in 1417. The author adheres to the view that Hand G was Jan van Eyck. One tiny miniature, scarcely two inches high, at the bottom of a page, shows the *Baptism of Christ* (fig. 749) as only a genius could have painted it, at this or any date. On a rocky ledge in the foreground crouches John the Baptist; he pours water from a pitcher over the head of Christ, who stands in the river. On the distant bank a castle rises from the water's edge; to our right other figures keep their distance, half-concealed by rocks. Upstream the eyes move off to mountain ranges, tiny in the distance, yet hardly above the heads of the figures—rising perspective is abandoned. For the most part the water is smooth, disturbed only by an occasional ripple; behind the Baptist, it breaks over the rocks.

Above this vividly real scene descends the dove of the Holy Spirit, sent by God the Father enthroned in the initial *D* and shedding rays of gold, or "spiritual" light. This illumination is contrasted with natural light as it has never before been observed. Its source is the sun, which has already set, leaving a pearly radiance in the sky; this afterglow is reflected by the water; the water in turn sends the light up to the castle from below; and finally the image of the castle, thus illumined, is mirrored in the stream. Within the microscopic limits of the painting, therefore, the light from the sun (which is no longer there) moves through the atmosphere in no less than four different directions, each serenely recorded. How far away and how naïve the Boucicaut Master seems!

The next controversial work, the altarpiece in twenty panels in Saint Bavo's, Ghent (figs. 750–53), takes us from the microcosm to the macrocosm, encompassing as it does the entire range of Salvation. An inscription tells us that the work was begun by Hubert van Eyck and finished by Jan for the leading citizen and later mayor of Ghent, Jodocus Vyd, in May 1432. Here is another riddle. We know from an old copy of the epitaph that a now-vanished tombstone in Saint Bavo's recorded the burial of a painter Hubert (no surname) in 1426. The story that Hubert and Jan were brothers cannot be pushed farther back than the sixteenth century. It has recently been proposed by Lotte Brand Philip that the Hubert of the inscription was not Jan's brother but merely came from the same village (Maaseyck means Eyck on the Maas), and that he was not a painter but the sculptor who carved an elaborate frame, destroyed in 1566 by Protestant iconoclasts from whose depredations the paintings of the altar-

749

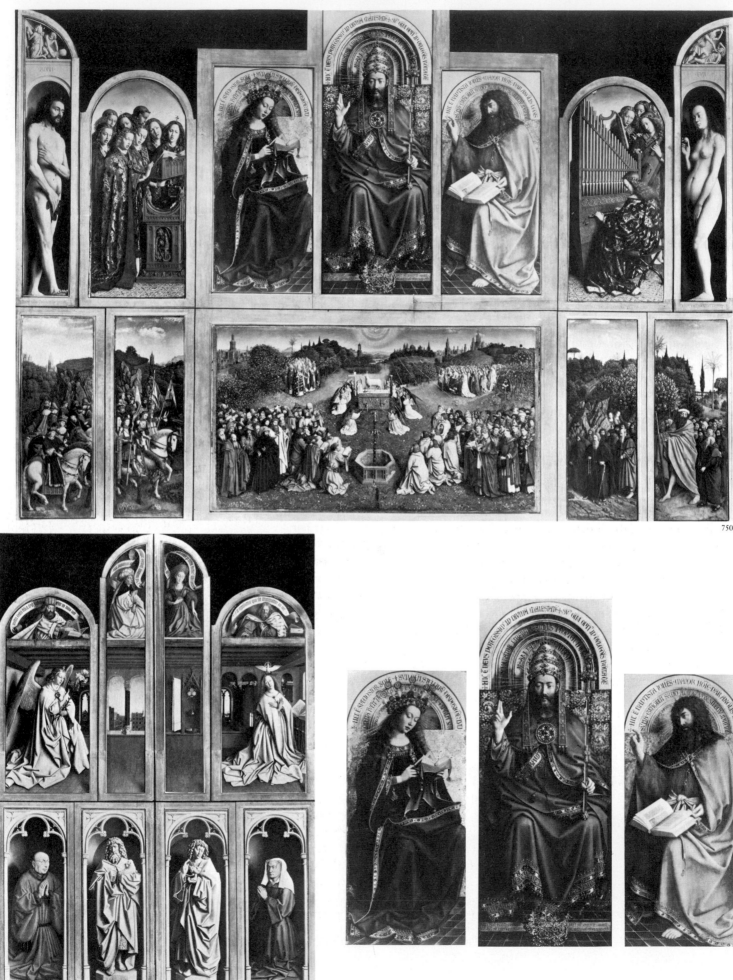

750

751

752

piece were hidden by the clergy. The proposal is attractive, since no signature of Hubert van Eyck appears on a single painting and all attempts to distinguish different hands in the remarkably consistent altarpiece have met with defeat. Jan would then have painted the entire altarpiece after his return from Portugal in 1429.

With the wings closed, the upper level shows the Annunciation (fig. 751) taking place as in the *Mérode Altarpiece* in a Netherlandish interior, although more spacious and on an upper floor; from the windows one looks out at the gables of a town, with people in the streets and storks in the sky. The adjoining, otherwise empty panel is devoted to an almost ceremonial representation of the familiar niche, towel, and gleaming ewer, with the addition of a basin and a trefoil window, which makes the Trinitarian symbolism explicit. Above the rafters, as in an attic, appear the prophets Zechariah and Micah and the Erythraean and Cumaean Sibyls, surmounted by scrolls that contain their prophecies of the coming of Christ. Beneath the floor are four identical niches; in the central pair stand white simulated stone statues of Saint John the Baptist and John the Evangelist (amusing in that van Eyck was paid for painting the surfaces of actual stone statues in Bruges), and at left and right kneel unsparing portrait figures of Jodocus Vyd and his wife Isabel Borluut. These figures forcefully recall the patrons of Masaccio's *Trinity* (see fig. 701), which van Eyck might have seen in Florence only a year or two before, but are here freed from the foreground plane and turned in three-quarters view.

In order to maintain a sense of unity throughout the panels, Mary and Gabriel are robed in white, in keeping with the white statues below, and the four niches and the room are pervaded by a light from the front, clearly the actual light of the chapel because it has thrown the shadows of the vertical supports of the frame onto the floor of the room. This source conflicts with the sunlight from outside, which prints the shape of a double-arched window on the wall behind Mary—a light that could only come from the north, and is therefore a symbol of the miracle taking place. The stillness and perfection of the panels are so compelling that we realize almost with a shock that there is no room in their niches for the donors' lower legs, and that in the Annunciation figures and setting are still represented in different scales. The angel's greeting to Mary is beautifully lettered from left to right; her response (in Latin), "Behold the handmaiden of the Lord," is inscribed with equal care but, since it must run from right to left, is written upside down!

The wings open to reveal in the upper story the Deësis. The Lord appears in the guise of Christ (fig. 752), crowned with a papal tiara, robed in scarlet with borders of gold and gleaming jewels, and holding a scepter whose component rods of shining crystal are joined by bands of gold ornament; at his feet rests a jeweled crown. On his right sits the Virgin in brilliant blue, wearing a jeweled crown from which spring roses and lilies, and over which hover twelve stars; on his left is John the Baptist, whose camel-skin garment is almost hidden by a cloak of emerald green. On either side are angels robed in gold and velvet brocade, singing and playing on musical instruments; van Eyck has even defined the mechanism of the carved wood and brass revolving music stand and indicated a figure working the bellows of the organ. In the dark niches at the extreme sides, and seen from below so that they belong to our space, stand Adam and Eve (fig. 753), sullen with guilt and shame, Eve still holding the long-withered forbidden fruit. In simulated relief sculptures in the half lunettes the Sacrifice of Cain and Abel and Cain Killing Abel are represented with terrifying power.

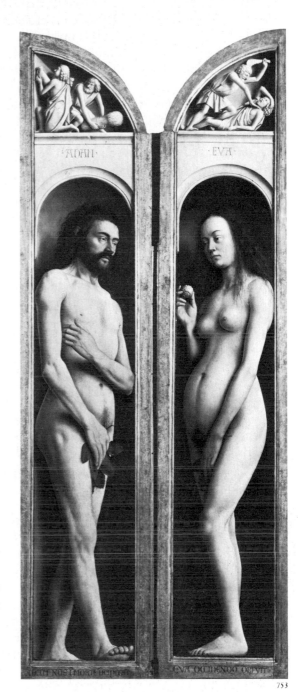

753

750. HUBERT (?) and JAN VAN EYCK. *Ghent Altarpiece* (open). Completed 1432. Oil on panel, 11'5¾" × 15'1½". Cathedral of St. Bavo, Ghent

751. HUBERT (?) and JAN VAN EYCK. *Ghent Altarpiece* (closed)

752. HUBERT (?) and JAN VAN EYCK. *Deësis (The Virgin Mary, The Lord, and Saint John the Baptist)*, detail of the *Ghent Altarpiece* (open)

753. HUBERT (?) and JAN VAN EYCK. *Adam and Eve*, upper wings of the *Ghent Altarpiece* (open)

The five lower panels form a continuous view in rising perspective (see fig. 750); in the emerald-green meadow of Paradise, dotted with wild flowers, the Lamb of God stands upon an altar, the blood from his breast pouring into a chalice, surrounded by angels holding the Cross and the column at which Christ was scourged. Below the altar the Fountain of Life pours from golden spigots into an octagonal basin, and thence around the fountain and toward the observer "a pure river of water of life, clear as crystal, proceeding out of the throne of God and of the Lamb" (Revelation 22:1). Through the water one can see (only in the original) that the stream bed is composed of rubies, pearls, and emeralds. On the left kneeling prophets holding their books precede standing patriarchs and kings from the Old Testament; on the right Apostles kneel in front of standing saints, many of whom wear papal tiaras or bishops' miters. From groves in the middle distance at the left advances a choir of confessors; at the right virgin martyrs bear palms. On the far horizon can be seen the Gothic domes, pinnacles, and spires of the heavenly Jerusalem. In the left-hand panels the just judges and knights approach on beautiful, placid horses through a rocky landscape; in those to the right hermits and pilgrims, led by the giant Saint Christopher, proceed on foot. Above the wonderfully real crowd and the landscape represented down to the tiniest pebble and the last blade of grass, white clouds hang high up in a summer sky. In the center, above the Mystic Lamb, and below the throne of God, the dove of the Holy Spirit sheds golden rays, contrasted with the light reflected from armor, gold, and glossy leaves, glowing from grass, flowers, rich fabrics, and the depths of jewels, muted in the footprinted dust. No sun is represented, no source is shown, for "the city had no need of the sun, neither of the moon, to shine in it: for the glory of God did lighten it, and the Lamb is the light thereof" (Revelation 21:23). With total precision van Eyck has encompassed the drama of Salvation in images of another world containing all the beauties of this one, raised as it were to a higher power.

Probably in the year following the *Ghent Altarpiece* van Eyck painted a work of lesser dimensions but equal beauty, the *Madonna of Chancellor Rolin* (figs. 754, 755), given by this high official of the duchy of Burgundy to the Cathedral of Autun when his son was made bishop in 1437. The chancellor, grimly calm, kneels before the Virgin in her palace, while over her head an angel floating on peacock wings holds a crown similar to that placed before the Lord in the *Ghent Altarpiece* (see fig. 752), and from her lap the Christ Child, his nude flesh soft against her scarlet mantle, holds in his left hand a crystal orb surmounted by a jeweled gold cross, while blessing his brocade-clad worshiper with his right. The palace is largely Romanesque, a style symbolic (in the fifteenth century) of things ancient and venerated. Van Eyck has displayed his prowess in the minute representation of sculptured scenes from the Old Testament and in the interlace of the capitals, in the distinction between stained-glass and bottle-glass windows, and in the softly diffused light over the inlaid marble patterns of the floor. Through the three arches we look into Mary's garden of roses and lilies and onto a terrace on which peacocks stroll and from whose battlemented wall two men in fifteenth-century costume look down to the river below. The city in the middle distance is complete; its cathedral, resembling that of Utrecht, rises above a square scattered with strollers; on the bridge move scores of people, to or from the suburb whose pleasant houses are graced with trees. The river, rich with reflections of banks and islands, flows toward the distant mountains, some covered with snow, veiled in the luminous haze.

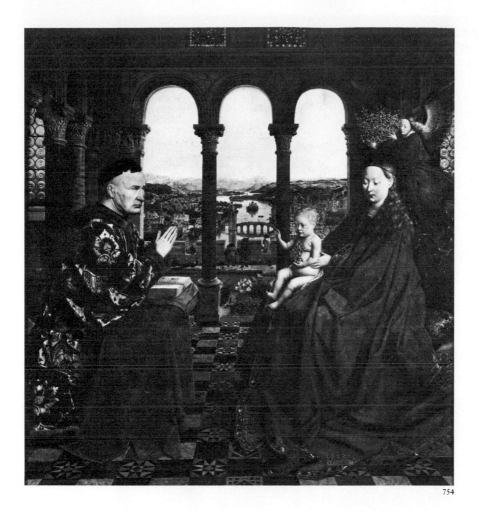

754

One of van Eyck's most celebrated works is the *Arnolfini Wedding* (fig. 756), which Erwin Panofsky showed represents the sacrament of Marriage (the only sacrament not necessarily dispensed by a priest) being contracted between Giovanni Arnolfini, a silk merchant from Lucca resident in Bruges, and Jeanne Cenami, born in Paris of Italian parents. In their bedchamber Arnolfini takes his wife's hand and lifts his right in an oath of fidelity. All the objects in the room, represented with van Eyck's customary accuracy, are so arranged as to participate symbolically in the ritual. The little dog in the foreground is a traditional symbol of fidelity; the clogs, cast aside, show that this is holy ground; the peaches, ripening on the chest and on the windowsill, suggest fertility; the beautifully painted brass chandelier holds one lighted candle—the nuptial candle, according to Netherlandish custom the last to be extinguished on the wedding night. The post of a chair near the bed is surmounted by a carved Margaret, patron saint of childbirth. On the rear wall is the conspicuous signature (fig. 757) adorned by many flourishes, "Johannes de Eyck fuit hic 1434" ("Jan van Eyck was here 1434"); the artist thus takes part as witness in the solemn event. So, too, does the mirror, whose convex shape was essential for large reflections in an era when only small pieces of glass could be manufactured. Not only does the surface reflect the room and the couple from the back but also, barely visible between them, two figures, one possibly an assistant and the other—Jan van Eyck. The "mirror without spot" was a symbol of Mary, and its sanctity is reinforced by the garland of ten Gothic paintings of scenes from the Passion of Christ inserted in its frame and by the rosary hanging beside it. In none of his paintings

751. JAN VAN EYCK. *Madonna of Chancellor Rolin*. c. 1433–34. Oil on panel, 26 × 24⅜". The Louvre, Paris

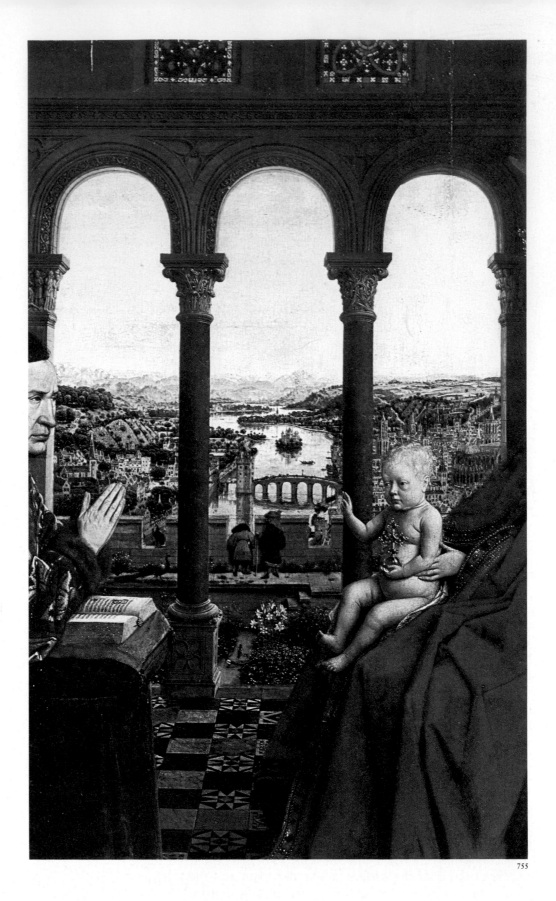

755

755. JAN VAN EYCK. *Madonna of Chancellor Rolin*
(detail)

756. JAN VAN EYCK. *Arnolfini Wedding (Giovanni
Arnolfini and His Bride).* 1434. Oil on panel,
32¼ × 23½". National Gallery, London

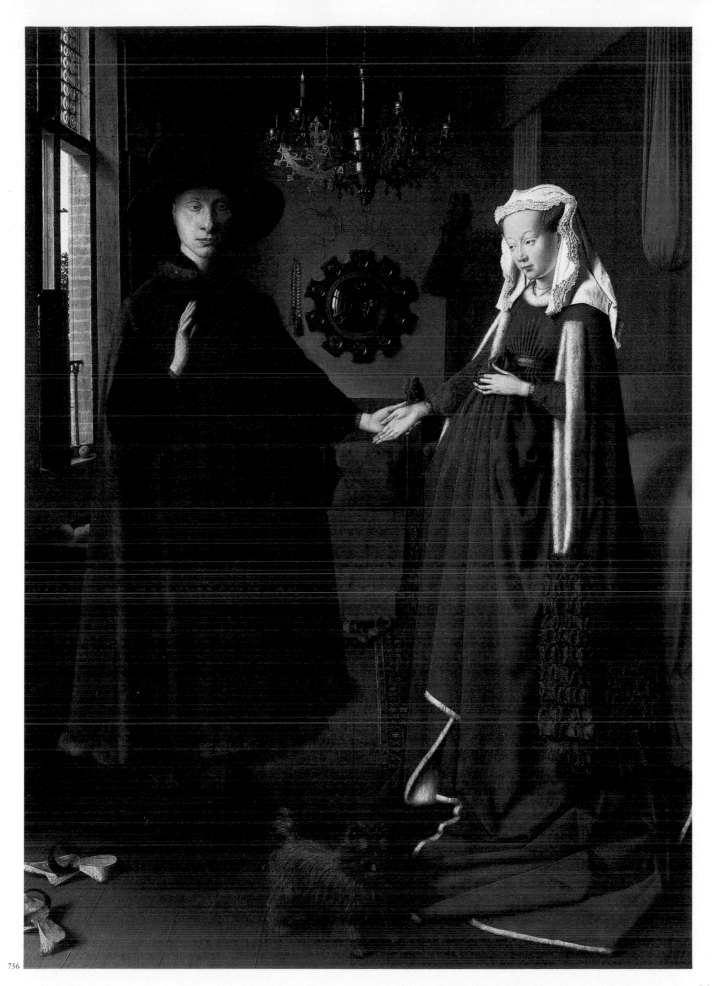

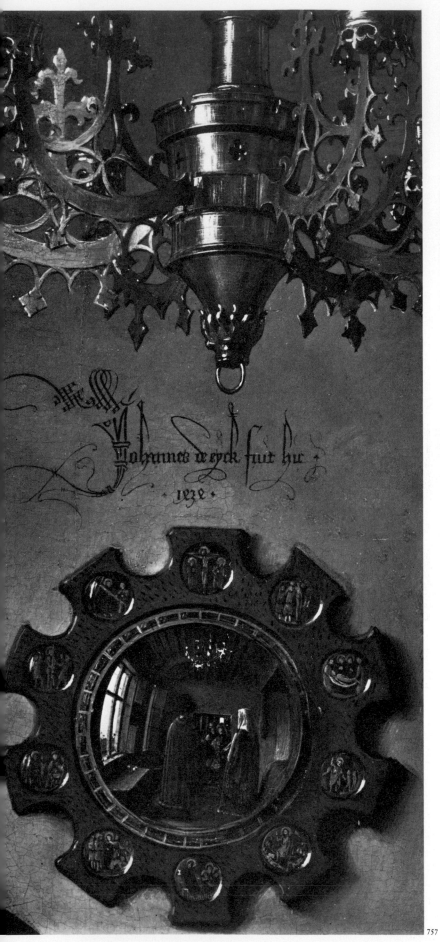

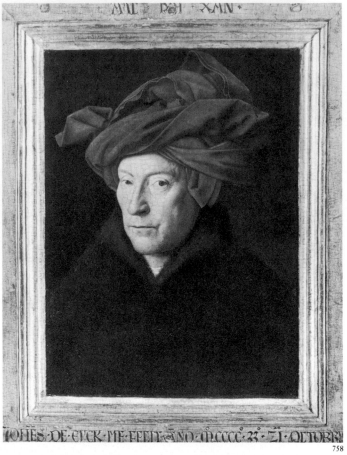

758

757. JAN VAN EYCK. *Arnolfini Wedding* (detail)

758. JAN VAN EYCK. *Man in a Red Turban (Self-Portrait?)*. 1433. Oil on panel, 10¼ × 7½".
National Gallery, London

757

does van Eyck surpass this subtlety of interior illumination, bringing out the resonance of the red bedspread and hangings and the green costume of the bride, as well as the depth of the groom's purple velvet tunic edged with sable, and leaving on the window frame reflections of the peaches and on the wall light prints from the amber beads.

Jan van Eyck was at once one of the first and one of the greatest painters of independent portraits, a new art form for the fifteenth century. His painting of a *Man in a Red Turban* (fig. 758) shows the subject in middle life, illuminated so as to bring out every facet of the face and even the growth of stubble. The controlled expression and the calm, analytic gaze (this is the earliest known portrait whose sitter looks at the spectator) mask but do not conceal the possibility of deep emotion; it has been plausibly suggested that he may have been no less a person than Jan van Eyck, who signed the picture boldly on the frame, with the date October 21, 1433, and his motto, "Als ich chan" ("As I can"). In view of what we have seen he could do, such reticence is sobering.

VAN DER WEYDEN Van Eyck had imitators but no followers approaching his stature; his style depended on his unique gifts of mind and vision. Rogier van der Weyden (1399/1400–1464), the leading Northern painter of the middle of the fifteenth century, turned sharply away from van Eyck's quiet world of color and light toward monumental pictures whose dramas are played in human terms on stages close to the observer. Both the linearity and the ability to characterize emotional expression, which he had possibly learned from Campin, aided him immeasurably in the establishment of his own loftier and more aristocratic style. The large *Descent from the Cross* (fig. 759), perhaps once the central panel of a triptych, painted about 1435 for a church in Louvain, shows to the full the brilliance of van der Weyden's early period. The setting is entirely symbolic; the Cross is placed inside the sepulcher. Sacrificing entirely van Eyck's luminous shadows, van der Weyden reveals the figures to us by a pitiless light that incises every wrinkle, every hair, every tear. The relentless pull toward death is emphasized by the way in which the pose of the swooning Virgin repeats the curve of the body of Christ lowered from the Cross, her hand almost touching Adam's skull. The Sluteresque folds that dominate the paintings of Campin, and even reappear in those of van Eyck, are swept away by a line or melody that is perhaps van der Weyden's most effective device for sustaining strong emotion on the plane of high tragedy. Such expressions as that of Joseph of Arimathea at the right, or such poses as the pain-wracked contortion of the Magdalene's shoulders, are never permitted to disturb the beauty of the whole conception.

In 1435 van der Weyden was made official painter to the city of Brussels, an office he held for nearly thirty years. At the time of the papal Jubilee of 1450 he visited Italy, and not only influenced the Italians deeply but also returned with his vision enlarged by the monumentality of Italian painting. Probably in 1451 he finished his most ambitious work, a polyptych representing the *Last Judgment* (fig. 760) for the Hôtel-Dieu at Beaune, a splendid Gothic hospital founded by Chancellor Rolin in Burgundy, where it still stands. Van der Weyden has treated the nine panels as one and minimized their frames, except for inscribing through the corners of the panels flanking the central section the slender rainbow of the Judge's throne. At either end of the rainbow Mary and John half-sit, half-kneel, and around it in two quarter circles Apostles and saints are seated on the clouds. Below the sphere that is Christ's footstool the drama

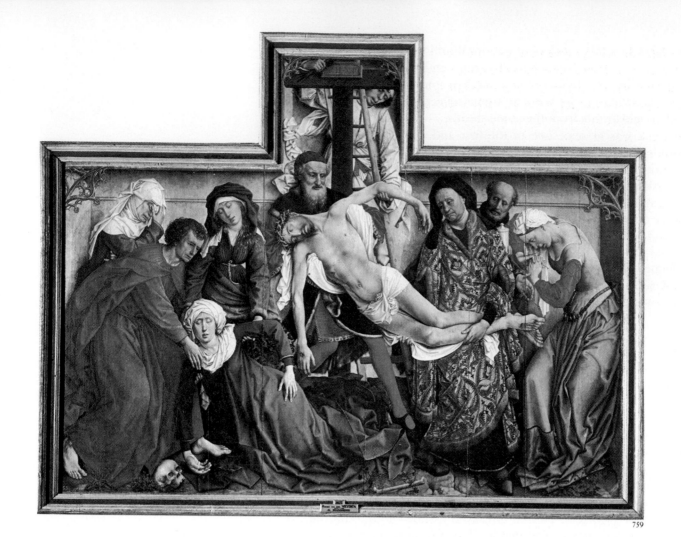

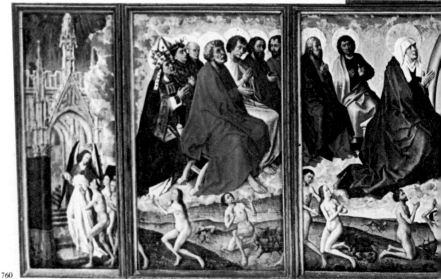

759

760

759. ROGIER VAN DER WEYDEN. *Descent from the Cross*. c. 1435. Panel painting, 7'2⅝″ × 8'7⅛″. Museo del Prado, Madrid

760. ROGIER VAN DER WEYDEN. *Last Judgment* altarpiece (open). c. 1444–51. Panel painting, 7'4⅝″ × 17'11″. Musée de l'Hôtel-Dieu, Beaune

centers on Gabriel, solemn and peacock-winged, weighing souls in the balance. Heaven and Earth have passed away; the barren ground gives up its naked dead in an amazing variety of beautifully drawn poses. On Christ's right a gentle angel leads the naked blessed into the golden portal of a Gothic Heaven; on his left Hell opens before the damned, its horrors limited, in deference to the sick in the neighboring ward of the hospital, to the expressions on the faces of those about to fall into its depths.

The perfection of Jan van Eyck's vision lay beyond the possibility of effective imitation. Not surprisingly, therefore, it was the grand, monumental style of Rogier van der Weyden that exercised the strongest influence on the art of the next generation, not only in the Netherlands but throughout northern Europe.

BOUTS Among the host of excellent painters working in the Netherlands later in the fifteenth century, Dirc Bouts (c. 1415–75) is impressive because of his striking combination of great technical accomplishments, in the tradition of van der Weyden, with touching naïveté of expression. Born probably in Haarlem, Bouts worked in later life in Louvain, where he painted in 1464–68 a major altarpiece whose central panel represents the *Last Supper* (fig. 761). The setting is the familiar Netherlandish interior—a room softly lighted from the side by windows through which the town can be seen, a view out the door into a garden, a patterned marble floor seen in rising perspective, a richly veined column with a carved capital. Although Bouts can control every resource of Netherlandish nat-

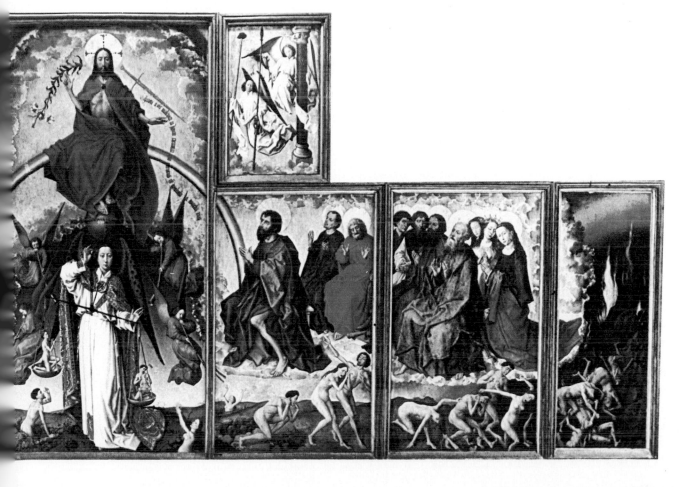

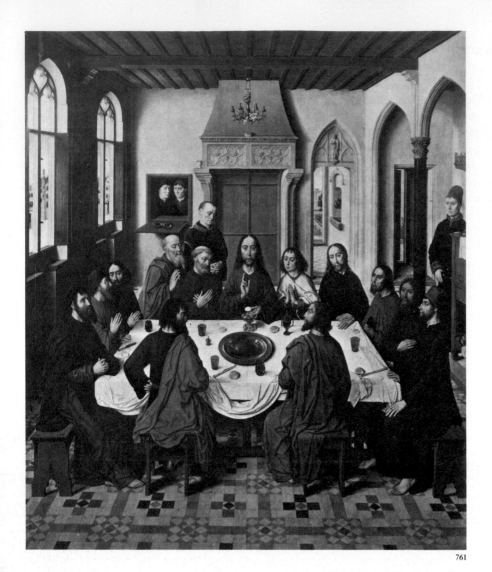

uralism, the arrangement of the figures seems stiff until one realizes that the composition has been interpreted in the light of its destination for an organization of laity called the Confraternity of the Holy Sacrament.

Two professors of theology at the University of Louvain are known to have dictated the theme. At the moment when Christ says, "This is my body which is given for you: this do in remembrance of me" (Luke 22:19), he holds up not an ordinary piece of bread but the disk-shaped wafer of the Western Eucharist, and instead of a wineglass a chalice stands in front of him. Christ's head arrives exactly at the intersection of two mullions in the screen that closes off the fireplace when not in use to suggest a cross, and his face is exactly frontal. All the Apostles' faces are turned so that we can see them, and light falls on them to reveal their reverent expressions; even the two seen from the back are shown in profile, Judas instantly recognizable with his left hand, a symbol of treachery, hidden behind his back. The combination of symmetry, even lighting, and perspective lines concentrating directly above Christ's head gives the picture a meditative intensity appropriate to its liturgical theme.

VAN DER GOES In the decades following the death of van der Weyden, the greatest Northern painter was Hugo van der Goes (c. 1440–82). Probably born in Antwerp, he moved to Ghent, joined the artists' guild in 1467, and in 1474 was made its dean. In the following year, notwithstanding his worldly success, van der Goes retired to a monastery

761. DIRC BOUTS. *Last Supper*, center panel of an altarpiece. 1464–68. Panel painting, c. 72 × 60⅛". Church of St. Peter, Louvain

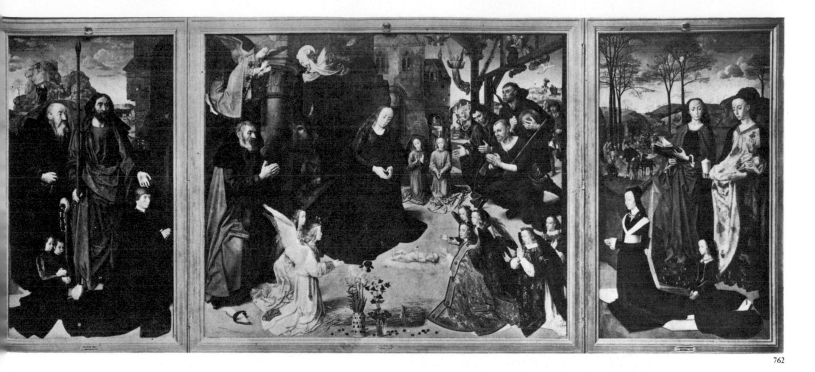

near Brussels as a lay brother, but continued to paint. In 1481 he experienced a severe mental collapse, followed by fits of insanity, and the next year he died. His pictures are not numerous; all are marked by deep and, at times, disordered feeling and by sonority of color and sensitivity of drawing. His introspective personality stands at the antipodes from the carefree Limbourg brothers. Although he never emulated the jewel-like perfection of van Eyck, the richness of his color and the depth of his shadows owe much to the great master of Bruges. His debt to van der Weyden is somewhat less, residing largely in the beauty of his drapery rhythms.

Van der Goes's major work is the *Portinari Altarpiece* (figs. 762, 763), painted about 1476 for Tommaso Portinari, an agent for the Medici Bank in Bruges. Probably in 1483, after the master's death, the altarpiece was sent to Florence, where it made a sensation, and was set on the altar of the Chapel of Sant'Egidio, whose walls had been frescoed by Domenico Veneziano and Andrea del Castagno. Although the Florentines were familiar with the work of van Eyck and van der Weyden, they had never seen anything like the emotional power of van der Goes, nor the directness with which his new range of content was visually expressed.

The central panel of the *Portinari Altarpiece* shows the Adoration of the Shepherds in a new way. Mary has just given birth to the Child, miraculously while kneeling as in the vision of Saint Bridget, and he lies on the ground inside the half-ruined shed, shining with the gold rays of spiritual light. The brilliantly painted flowers in the *majolica albarello* (apothecary jar) and glass tumbler in the foreground are symbolic—the scarlet lily signifies the blood of the Passion, the columbine is a frequent symbol of sorrow, and the iris (in Latin, *gladiolus*: little sword) refers to the prophecy made by Simeon to Mary in the Temple, "Yea, a sword shall pierce through thy own soul also" (Luke 2:35). These allusions to the sacrifice of Christ are made explicit by the sheaf of wheat (the Eucharist) alongside the flowers, and the mood is established by the reverent poses and expressions and folded hands of Mary, Joseph, and the nearest shepherd, and even by the alert ox, who has stopped eating; the ass, who symbolizes the infidels, keeps on munching.

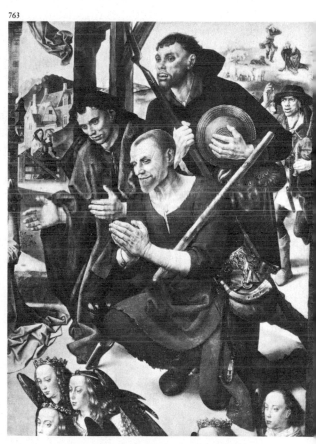

762. HUGO VAN DER GOES. *Donors and Their Patron Saints* and *Adoration of the Shepherds*, view of the *Portinari Altarpiece* (open). c. 1476. Panel painting, center 8′3⅝″ × 9′10⅝″; each wing 8′3⅝″ × 4′7½″. Galleria degli Uffizi, Florence

763. HUGO VAN DER GOES. *Adoration of the Shepherds*, detail of center panel of the *Portinari Altarpiece*

EARLY RENAISSANCE IN NORTHERN EUROPE 589

It has been shown that the angels who attend the scene are dressed as the assistant ministers (archpriest, deacon, subdeacons, and acolytes) would be at the first Solemn High Mass of a newly ordained priest, yet no one wears the chasuble, the garment of the celebrant. This is because the celebrant, the priest, is Christ himself (repeatedly extolled as priest in Hebrews). The deserted house in the background has been shown to symbolize the house of David, whose harp is sculptured over the door. It is noted here for the first time that this centrally placed door has other meanings: its role as the closed door of Mary's virginity is underscored by the fact that her face partly overlaps it, and the connection of the altarpiece with the Portinari family lies in their very name (i.e., "door-keepers"). The atmosphere pervading the picture can best be described as that of solemn joy; the delight that a Child is born is tempered by foreknowledge of his sacrifice, and sadness is in turn transfigured by the revelation of the Eucharist. In the faces of the three shepherds (fig. 763), one can discern three stages of understanding, in terms of nearness to the mystery. The furthest, almost bestial, has removed his hat in mere respect; the second, deeply human, opens his hands in wonder; the third, saintlike, joins his hands in prayer. The wealth of emotion in the central panel is shared by the adults and children of the Portinari family in the wings and by their gigantic patron saints. Even the wintry landscapes participate in the story; in the distance, on the left, Joseph assists Mary, who can no longer stand the pain of riding the donkey on the mountainous road to Bethlehem; and among the leafless trees on the right, an outrider of the Three Magi asks a kneeling peasant the way to the stable.

MEMLINC Van der Goes's passionate and mystical style is worlds apart from that of his pious and prolific contemporary in Bruges, Hans Memlinc (c. 1440–94). Born at Seligenstadt, Germany, Memlinc was trained in the Netherlands, perhaps by van der Weyden, whose influence shows in his work. He became a citizen of Bruges in 1465, and must have

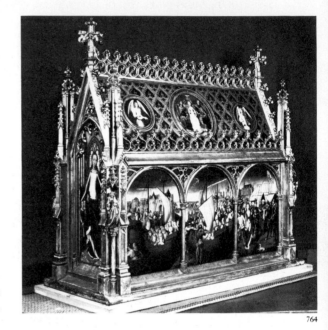

764. HANS MEMLINC. *Shrine of Saint Ursula*. Consecrated 1489. Gilded and painted wood, 34 × 36 × 13". Memlinc Museum, St. John's Hospital, Bruges

765. HANS MEMLINC. *Embarkation from Rome*, panel of the *Shrine of Saint Ursula*

766. HANS MEMLINC. *The Martyrdom of Saint Ursula's Companions*, panel of the *Shrine of Saint Ursula*

767. HANS MEMLINC. *The Martyrdom of Saint Ursula*, panel of the *Shrine of Saint Ursula*

764

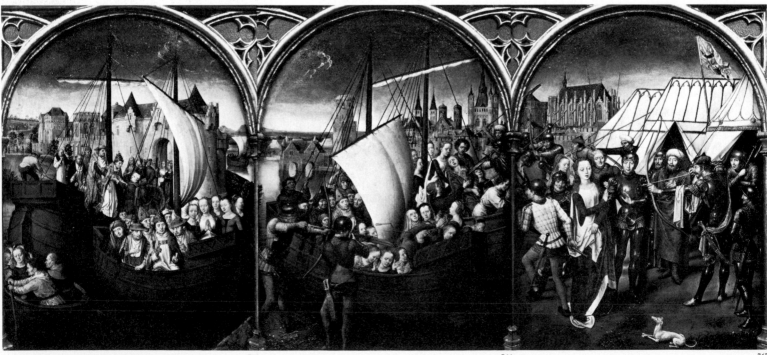

765

766

767

studied the work of Jan van Eyck, his predecessor in that city, with whom he was even confused in the eighteenth century as "John of Bruges" (*Hans* and *Jan* both mean "John"). His tranquil art represents a personal synthesis of those tendencies in Netherlandish painting open to his comprehension, and in that sense he may be considered a parallel to his Florentine contemporary Ghirlandaio (see Chapter Two). Among his numerous works, one that shows his technical ability and his narrative charm is the *Shrine of Saint Ursula*, consecrated in 1489 (fig. 764), a carved and gilded reliquary casket less than a yard high, built like a little Gothic chapel with tracery and pinnacles and painted on all four sides as well as on the gabled roof. Memlinc's depiction of the Martyrdom of Saint Ursula would win him no drama prizes, but its naïveté is irresistible. In figure 765, the saint, attended by pope and cardinals, leaves Rome accompanied by as many of her eleven thousand virgins as Memlinc could crowd into two ships. On their arrival at Cologne, in the central panel (fig. 766), the waiting Huns slaughter both boatloads of virgins with crossbows, longbows, and swords, in a scene explicitly and calmly represented. In the final panel (fig. 767) Ursula, saved on account of her exceptional beauty, refuses an offer of marriage from Julian, prince of the Huns, who has her shot on the spot. With the boats, of course, Memlinc is merely following the age-old principle of double scale for people and settings; otherwise, he would not have been able to depict the martyrdoms in such detail. In the shining armor and in the beautiful landscape, which continues behind all three scenes with great understanding of light and color, Memlinc shows himself a superb technician in the tradition of van Eyck. His delineation of Saint Ursula's loveliness goes far to justify the prince's interest. German by origin, Memlinc has depicted faithfully the Romanesque churches of Cologne and its great, then-unfinished Cathedral (see fig. 767). Accepted on its own terms, this little reliquary is a work of *magical beauty*.

GEERTGEN TOT SINT JANS The magic deepens in the art of a painter called Geertgen tot Sint Jans (Little Gerard from Saint John's) because he was a lay brother at the Monastery of Saint John's in Haarlem. We know little else about him. At his death, which seems to have occurred about 1495, he was only twenty-eight years old, according to Carel van Mander, the Netherlandish Vasari. The brief list of his works includes one of the most enchanting pictures of the fifteenth century, a tiny panel of about 1490 (fig. 768) that takes up the theme of the night Nativity where Gentile da Fabriano left off. Mary kneels before the manger at the right, angels at the left; in the shadows Joseph, the ox, and the ass are dimly discernible. The Child in the manger, although he sheds golden rays of *spiritual* light, is depicted as a *real* miracle, in that all the illumination in the foreground comes from his tiny incandescent body. In the background the announcing angel glows with real light high in the night, which outshines the fire on the hillside. The poetry of the scene is the more intense in that Geertgen has reduced the faces to egg shapes, whose purity accentuates the calm with which these figures gently accept as fact the miracle of miracles, that a tiny Child can shine in a dark world.

BOSCH The fifteenth century comes to an unbelievable close and the sixteenth to a fantastic beginning in the art of a lonely painter about whose external existence we know little, not even the date of a single picture,

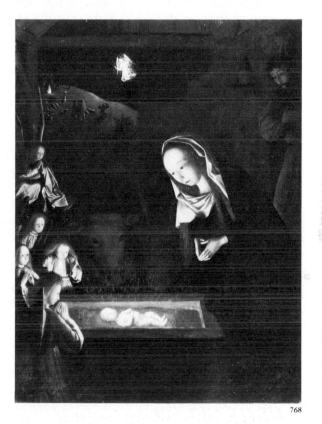

768. GEERTGEN TOT SINT JANS. *Nativity*. c. 1490. Oil on panel, 13⅜ × 9⅞". National Gallery, London

and whose inner life is revealed to us only in symbols of a defeating complexity. Hieronymus Bosch (c. 1450–1516) worked largely in the city of 's Hertogenbosch, in present-day southern Holland. His highly personal art is perhaps best accessible through what is generally considered a late work, that is, one after 1500, the *Crowning with Thorns* (fig. 769). With no setting whatever, and therefore in the space of our own minds, Christ stands, surrounded by four tormenters whose carefully delineated faces remind us of those seen daily in our own lives. A shriveled old man, marked as a Muslim by the star and crescent on his headcloth, an archer with a crossbow bolt stuck in his turban, a soldier wearing a spiked dog collar, and an ordinary character with a downturned lower lip surround the surprisingly red-haired Christ, as the archer raises the crown of thorns to place it on Christ's head. Yet Christ shows no suffering—his bright blue eyes look out at *us* with searching yet calm accusation, as if we were the guilty ones. This look will not be easily forgotten, nor will the transparent delicacy of Bosch's light, nor the sensitive quality of his drawing, which in this picture at least owes little or nothing to Netherlandish tradition.

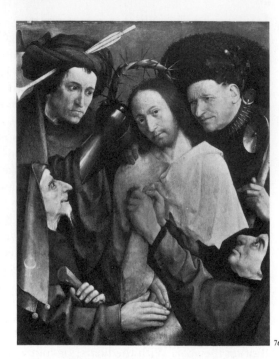
769

The inexhaustible wealth of Bosch's imagination fills the enormous triptych known as the *Garden of Delights* (figs. 770–73). The left panel, the *Creation of Eve* (fig. 770), is easy enough to read. The Lord, strangely tiny and ineffectual, presents to Adam the already perfectly formed Eve. Clearly, the trouble starts here. In the pool below and in the one around the fountain above move countless animals and birds, including a giraffe, an elephant, and unicorns. All is not happy even here; at the lower left a cat stalks off with a mouse it has caught, and a serpent more than halfway up on the right slithers ominously around a tree—the palm tree, symbol of eternal life, endangered from this moment. Fantastic rocks rise in the background, from one of which emerges a dense spiral of birds.

The central panel (figs. 771, 772) shows a plain with rocky outcroppings punctuated by pools and leading toward a lake in whose center is a monstrous mechanism, a gigantic egg from which sprout pinnacles and fishlike forms; round it are four more fantastic combinations of rocks and living beings. In this landscape frolic hundreds of naked young men and women, emerging from or hidden in eggs, a colossal mussel shell, and spheres, domes, and cylinders of glass. All the figures are pale pink, youthful, unmuscular, and weak, and although many appear in couples (or threes and fours), no explicit sexual activity is shown. But the erotic nature of the imagery is unmistakable; some figures caress or embrace gigantic strawberries or other fruit, as well as birds and fish, that have sexual significance in several languages. In the center the little people gaily ride not only horses but also animals legendary for their appetites, such as pigs and goats, in a circle around a little pool in which nude women bathe.

A full description would be endless. Obviously, Bosch is condemning all erotic activity and yet is fascinated by it. His ambivalence is so strong that some writers have suggested that he belonged to a secret sect that looked forward to a Paradise not unlike the one in this picture. This idea has not won wide acceptance, especially since several of Bosch's major works, including this one, were later bought by the fanatically religious Philip II of Spain. Perhaps Bosch is saying that all people really want to do is to indulge their fleshly desires; in the words of Saint Paul (Romans 3:10), "There is none righteous, no, not one." The visual language Bosch uses is in itself so fascinating that he has been claimed as one of theirs by the Surrealists in the twentieth century. But the vocabulary should not

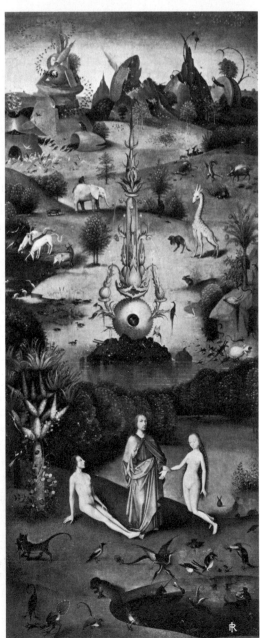
770

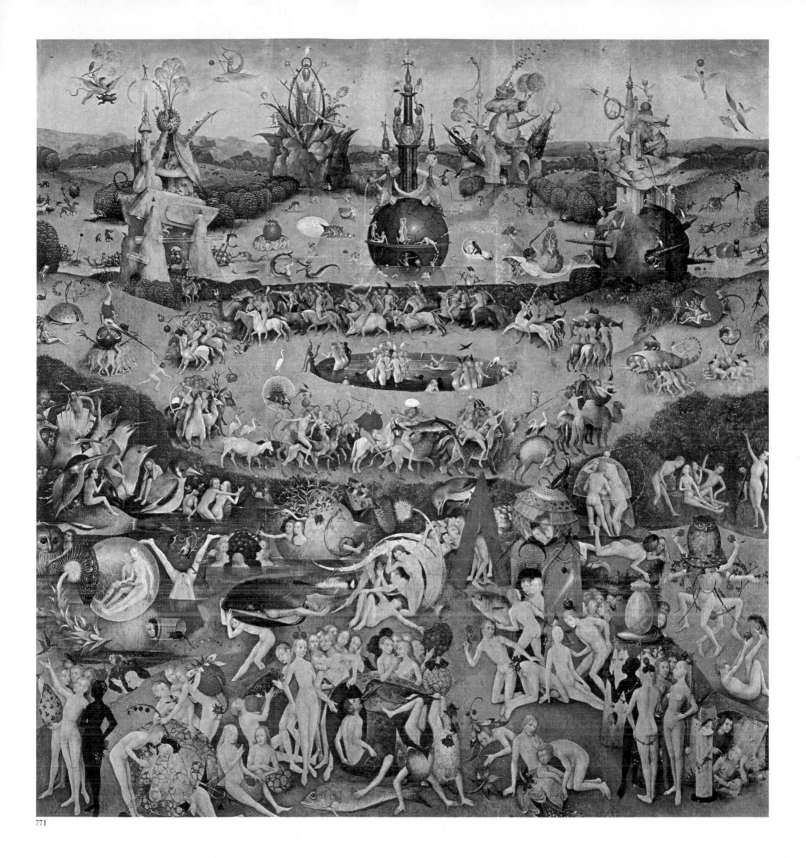

771

769. HIERONYMUS BOSCH. *Crowning with Thorns.* After 1500. Panel painting, 29¼ × 23⅝". National Gallery, London

770. HIERONYMUS BOSCH. *Creation of Eve*, left panel of the *Garden of Delights* triptych. c. 1505–10. Panel painting, 86⅝ × 38¼". Museo del Prado, Madrid

771. HIERONYMUS BOSCH. Center panel of the *Garden of Delights* triptych. c. 1505–10. Panel painting, 86⅝ × 76¾". Museo del Prado, Madrid

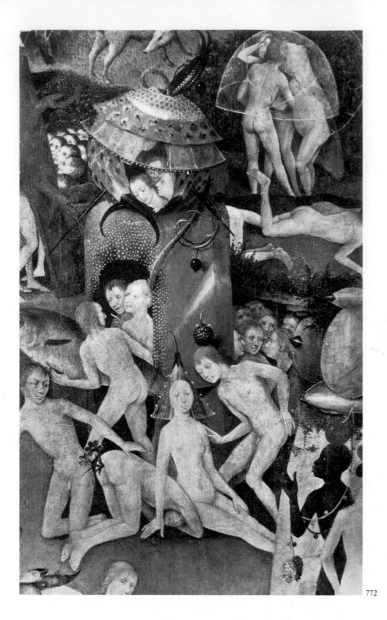

surprise us; by and large, it is drawn from the pagan tradition of animal symbolism incorporated in medieval art. What renders the central picture intoxicating is that this incredible repertory of symbols is brightly illuminated, daintily drawn, and suffused with high, pale color.

And yet Bosch is heretical; for such a world he can see no salvation. The common doom is Hell, a panorama of darkness illuminated by firelight, shown in the right panel (fig. 773). Instead of Satan this kingdom is presided over by a pathetic monster whose body is a broken egg, whose legs are tree trunks plunged through the bottoms of boats, whose head is crowned with a disk and bagpipe, and whose face turns toward us in despair as tiny people crawl in and out of him like vermin. Above him two immense ears impaled by an arrow and flanking an erect knife blade are pushed like an engine of war across the dark plain; below, the damned are impaled on the strings of musical instruments or eaten by a hawk-headed monster seated on a tall *chaise percée* and then excreted in bubbles. At the top we look across the Styx to the burning city, lost in flame and smoke. Never before had an imagination that could conceive such things been coupled with the ability to paint them. Rather than backward toward the Middle Ages, the imagination of Bosch leads us in the direction of the Protestant doctrine of predestination and eventually toward the inner world of dream symbols revealed by psychoanalysis.

772. HIERONYMUS BOSCH. Center panel of the *Garden of Delights* triptych (detail)

773. HIERONYMUS BOSCH. *Hell*, right panel of the *Garden of Delights* triptych. c. 1505–10. Panel painting, 86⅝ × 38¼". Museo del Prado, Madrid

774. STEFAN LOCHNER. *Presentation in the Temple*. 1447. Oil on panel, 54¾ × 49⅝". Hessisches Landesmuseum, Darmstadt

The influence of Netherlandish art was immediate and far-reaching, more so in the fifteenth century than was that of the Italian Renaissance, which in the sixteenth broke like a flood over western Europe. Germany developed a host of competent masters, more or less formed by Netherlandish style, but only a few strong individualities.

LOCHNER One charming painter of the early fifteenth century stands out. Stefan Lochner (c. 1415–51/52), from Meersburg on Lake Constance, was trained in the studio of Campin and achieved great success in Cologne. A delightful late work is his *Presentation in the Temple*, of 1447 (fig. 774). Although he adopts the rising perspective of Netherlandish painting for the floor in the foreground, he never relinquishes the gold background of medieval art. In his figures he reveals all the delicacy of his famous "soft" style, dissolving the sculpturesque forms he inherited from Campin into a free movement of brilliant colors. Even when they are old, Lochner's people, with their round foreheads, chubby cheeks, and shy gazes, always resemble children. And such children! His procession of boy-choristers, placed according to size and led by the tiniest of tots, is disarming.

774

WITZ A very different German master, Konrad Witz (c. 1400/10–45/ 46), was born at Rottweil in Württemburg, but moved to Basel in Switzerland, then the center of a church council that attracted princes and prelates from throughout Europe. Witz was accepted in the artists' guild in Basel in 1434 and bought a fine house. Much of his work fell a victim to Protestant iconoclasm during the Reformation, but what survives shows a vigorous and independent personality, with little patience for the niceties of perspective or anatomy but with acute powers of observation, particularly where nature is concerned. His *Miraculous Draft of Fish* (fig. 775), part of an altarpiece containing a cycle of scenes from the life of Peter installed in 1444 in the Cathedral of Geneva, displays all his best qualities. The background is the Lake of Geneva, a landscape "portrait" in the tradition already established by Masaccio and Fra Angelico, exactly painted, with farms and hills in the middle distance and a glittering array of snowcapped Alpine crags on the horizon. More surprising is Witz's observation of water, complete not only with reflections but also with refractions, distorting the stones on the bottom and the legs of Peter seen through its transparent surface; Witz even painted the bubbles thrown up, apparently, by passing fish.

PACHER As a woodcarver Michael Pacher (c. 1435–98) exploited to the full the splendors of the fifteenth-century Austrian version of the Flamboyant style. But his Tirolean home at Bruneck (modern Brunico; in Italy since 1919) was in the valley of the Adige, along the trade route descending from the Alps into northern Italy, and this location influenced his art profoundly. Such a painting as *Pope Sixtus II Taking Leave of Saint Lawrence* (fig. 776), from a cycle of scenes from the life of Saint Lawrence

775. KONRAD WITZ. *Miraculous Draft of Fish*, from an altarpiece (now divided) depicting scenes from the life of Saint Peter. c. 1444. Panel painting, 52 × 60⅝". Musée d'Art et d'Histoire, Geneva

776. MICHAEL PACHER. *Pope Sixtus II Taking Leave of Saint Lawrence*, from an altarpiece depicting scenes from the life of Saint Lawrence. c. 1462–70. Panel painting, 41 × 39½". Österreichische Galerie, Museum Mittelalterlicher, Österreichischer Kunst, Vienna

777. MARTIN SCHONGAUER. *Temptation of Saint Anthony*. c. 1470–75. Engraving. The Metropolitan Museum of Art, New York. Rogers Fund, 1920

in an altarpiece painted about 1462–70, is strikingly Italianate. Pacher's strong interest in perspective recession, the solidity of his forms, and the construction of his drapery show so close a study of Mantegna's frescoes in Padua (see fig. 730) that the Northern gable seen through an arch at the left comes almost as a surprise. Yet in spite of these Italian elements, he handles light like a Northerner, especially in the exquisite play of tones across Saint Lawrence's brocade dalmatic.

SCHONGAUER An important aspect of German art, and the means by which German influence spread throughout Europe, was engraving, whose most important practitioner and innovator was Martin Schongauer (c. 1450–91), from Colmar in Alsace. Schongauer was an excellent painter, in the tradition of Rogier van der Weyden, but was especially known for his copper engravings. As we have seen (Chapter Two), engraving was well known to the Italians and was practiced with distinction by Pollaiuolo (see fig. 721), Mantegna, and others. But Pollaiuolo's combination of contours and parallel hatching was simple compared to the elaborate refinements of Schongauer, who stippled and dotted the surface of the copper to produce a veil of shadow ranging from tones of filmy lightness to concentrated darks. His engraving of the *Temptation of Saint Anthony* (fig. 777) shows that the demons generated by Northern imagination were far from being the exclusive province of Bosch. The saint floats above the rocks, lifted, beaten, pulled at, mocked by hideous hybrid devils, their bodies prolonged and twisted into a dense foreground composition that recalls the persistent animal interlace of Hiberno-Saxon manuscripts and of the migrations period. Schongauer's engraving so impressed the boy Michelangelo that he copied it carefully in pen and watercolor in 1488 or 1489 when he was a fourteen-year-old assistant in Ghirlandaio's studio.

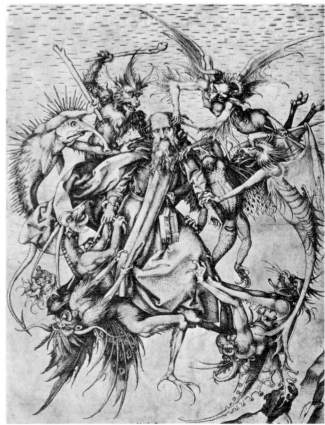

776

777

The political and military chaos of the early fifteenth century in France, during which the Hundred Years' War with England drew to a close, was not conducive to the development of either bourgeois prosperity or local schools of painting patronized by the merchant class. Nonetheless, a few artists of great sensitivity were active, largely in the entourage of royal courts; although under combined influences from both Italy and the Netherlands, they were striking in their own individuality of feeling.

FOUQUET The finest fifteenth-century French artist was Jean Fouquet (c. 1420–before 1481), from the central French city of Tours. Fouquet worked for Charles VII. Certainly before 1447 Fouquet visited Rome, while Fra Angelico was working there. About 1450, probably in Paris, he painted the quiet and sensitive portrait of Étienne Chevalier, finance minister to Charles VII (fig. 778); this is the left wing of a diptych, whose other panel represents the Virgin and Child. The Renaissance architecture with its veined marble paneling is strongly Italianate, in fact Albertian, but the treatment of light and the detailed rendering of the surface, along with the deep inner glow of the coloring, reveal that Fouquet is still a Northern master, well aware of what was going on in Netherlandish art. His instinctive reticence masks great depth of feeling. Saint Stephen, dressed in a deacon's dalmatic, holds in his left hand a book and the jagged stone of his martyrdom (a few drops of blood still cling to his scalp), while his right rests gently on the shoulder of his namesake.

Fouquet continued with great brilliance the art of illumination, which was not renounced by the French in the fifteenth century, although in Italy and the Netherlands it became increasingly relegated to specialists. One of the approximately sixty miniatures that originally adorned the *Book of Hours* he illustrated for Étienne Chevalier in 1452–56 shows the *Marriage of the Virgin* (fig. 779). The scene takes place before a triumphal arch that reminds us of that of Constantine, but which is labeled *Templum Salomonis* and decorated with two of the four spiral columns, apparently of Syrian origin, that the artist must have seen in Saint Peter's, Rome, where they were believed to have come from Solomon's Temple. (For a later, monumental use of this motive, see Bernini's tabernacle, fig. 914.) In the brilliant coloring and the harmonious grouping of the figures, the dominant influence is that of Fra Angelico, although the portly character at the left is a meticulously rendered portrait type seldom found outside Northern art.

ENGUERRAND QUARTON Apart from Fouquet, the leading panel painter of France at midcentury was Enguerrand Quarton, also known as Charonton (1410/15–after 1466). The celebrated *Avignon Pietà* (fig. 780) has now been successfully attributed to him. In the pose of the dead Christ over the Virgin's knees, as well as in the spareness and austerity of the forms, the picture looks very Italian, but the angular motions and haunting expressions are quintessentially French. Especially touching is the head of Christ, whose mouth hangs slightly open while his eyes are not entirely closed, and whose face is gently illuminated from below. The Pietà seems almost to be a vision of the kneeling priest at the left, whose face has been searchingly portrayed. After the muted color and quiet intensity of this panel, the splendor of the *Coronation of the Virgin* (fig. 781), still in the hospital at Villeneuve-lès-Avignon, comes as a surprise. Painted in 1453–54, according to a minutely detailed contract with

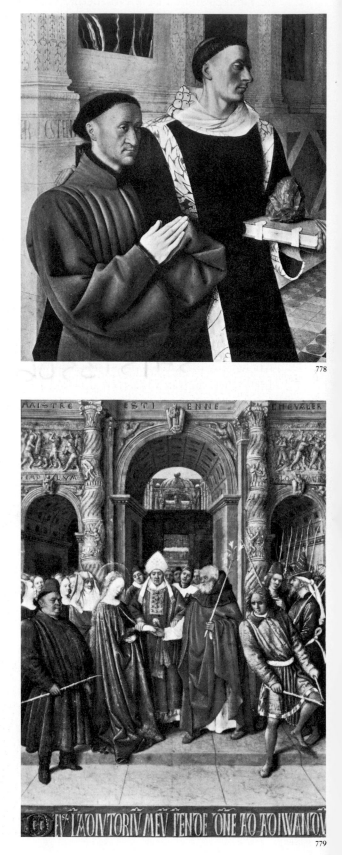

778

779

the prior Jean de Montagnac, which spelled out everything to be repre-
sented, the work shows the coronation taking place against a still-golden
Heaven, with the Virgin and the Trinity depicted on a colossal scale com-
pared to the medievally grouped ranks of saints on either side. Father and
Son, exactly alike, wear mantles of royal crimson, dissonant against the
sharp orange of the surrounding seraphim, and almost meeting before the
kneeling, porcelain-faced virgin. Her red and gold tunic is partly covered
with a mantle of the same resounding blue as that of the sky below her,
which is strewn with tiny clouds and tinier white angels bearing souls
upward. The real world is reduced to a strip at the bottom of the panel,
showing Rome on the left (a south French Gothic town), with the Mass
of Saint Gregory (a miraculous appearance of the sacrificed Christ on the
altar before Saint Gregory as he was saying Mass) taking place in Saint
Peter's; Jerusalem on the right, with bulbous domes on its towers; and in
the center the crucified Christ, before whom kneels the white-clad donor.
At the lower left angels assist souls, naked save for their distinguishing
headgear, out of Purgatory, while at the right the damned suffer endless
torments in Hell.

778. JEAN FOUQUET. *Portrait of Étienne Chevalier*,
left wing of the *Melun Diptych* (now divided).
c. 1450. Panel painting, 36⅛ × 33½".
Gemäldegalerie, Staatliche Museen, Berlin

779. JEAN FOUQUET. *Marriage of the Virgin*, illumi-
nation from the *Book of Hours of Étienne Che-
valier*. 1452–56. Musée Condé, Chantilly

780. ENGUERRAND QUARTON. *Avignon Pietà*. c.
1460. Panel painting, 63¾ × 85⅞". The
Louvre, Paris

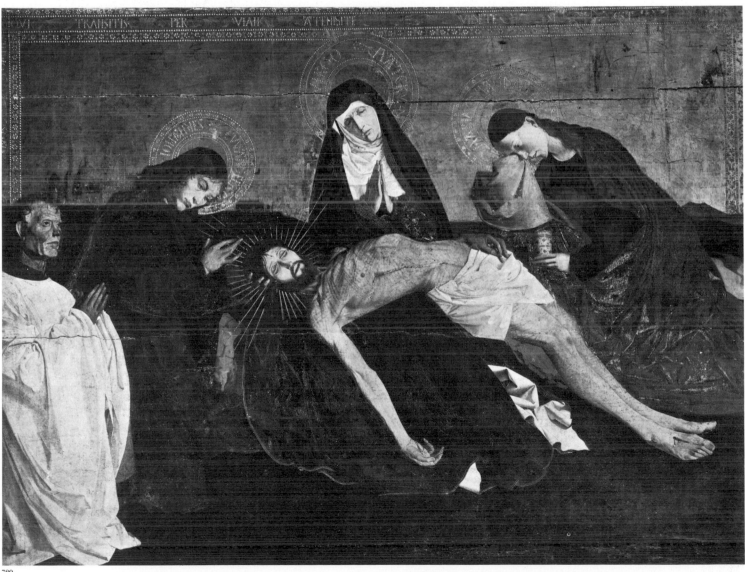

780

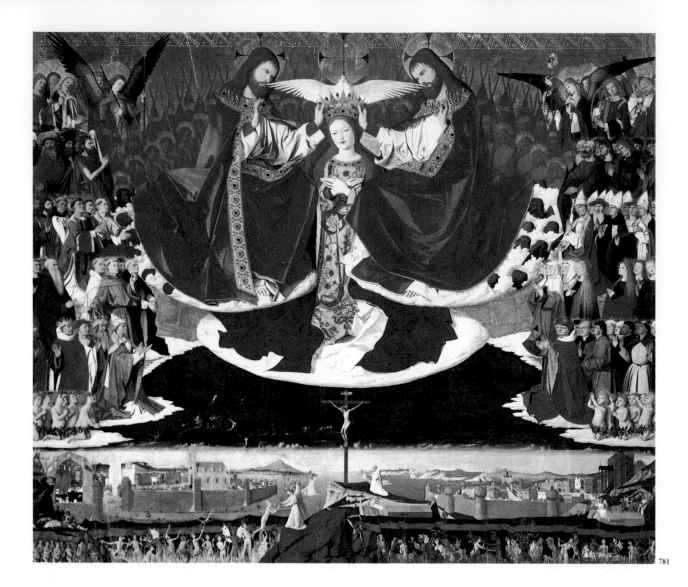

The brilliant naturalistic art of the Netherlanders, which seemed in the early fifteenth century so miraculous to their contemporaries, held not only the Netherlands but France, Germany, and Spain under its spell for the entire century. Before 1500 the magic of Netherlandish art affected even the Italians, but a discovery can be made only once, at least before the same audience. Repetition can have a dulling effect, and this actually happened to Netherlandish painting in the early sixteenth century. The Northerners, however, remained basically loyal for hundreds of years to their intense attachment to visual reality, even when, in the early sixteenth century, the new art of the High Renaissance was turning Italian artists onto a sharply different course, as we will see in Chapters Four through Six. Reality, in, for example, the minute sense of van Eyck, was eventually to mean less throughout Europe than the higher realm of ideas. The consequences of this perhaps inevitable collision between the Northerners and Italian art we will study in Chapter Seven.

781. ENGUERRAND QUARTON. *Coronation of the Virgin*. 1453–54. Panel painting, 72 × 86⅝". Musée de l'Hospice, Villeneuve-lès-Avignon

THE HIGH RENAISSANCE IN CENTRAL ITALY

FOUR

The last decade of the fifteenth century was ominous for the Italians. The year 1492 was crucial not on account of Columbus's first voyage to the New World, which attracted little immediate attention, but because in that year the death of Lorenzo the Magnificent removed from the government of Florence, and from the turbulent Italian political scene, a firm and wise hand. The throne of Peter was occupied by the sinister Alexander VI, whose son, Cesare Borgia, was doing his best to turn the Papal States into a hereditary monarchy. In 1494 Piero de' Medici and his brothers were expelled from Florence and the republic was restored; that same year Charles VIII of France descended upon Italy to press his claims to the throne of Naples, thus commencing the cycle of foreign dominations that soon put a virtual end to Italian independence. The Italian response was mixed and confused, but the Florentines, at first under the leadership of Savonarola, rallied to the defense of their reestablished republic against the Borgia, and a coalition expelled the French in 1495—to no avail; in 1499 the French returned under Louis XII and occupied Milan. The death of Alexander VI in 1503 gave the new pontiff, Julius II, a free hand in the organization of papal military power in order to drive out the French and to reform internally the Church, grown corrupt under recent popes.

Nothing less than political unity, which was a practical impossibility, could have maintained Italian independence against the newly consolidated Western monarchies—France, Spain, and the Holy Roman Empire. Nonetheless, the resistance of the Florentines and the counterattack of Julius II created a heady atmosphere that did much to inspire a new style, the High Renaissance, which can be understood as an attempt to compensate on a symbolic plane for the actual powerlessness of the Italian states through a new vision of human grandeur and of heroic action and through a dynamic architecture to match. This new vision was expressed in systems of total compositional order and harmony that transcended any imagined by the Early Renaissance, and to these systems all details were firmly subordinated. Like the images and norms created by Periclean Athens in a similarly precarious situation, those of High Renaissance Italy long outlived the collapse of the political entities that gave them birth. Despite the brevity of the High Renaissance—twenty-five years at the most—the principles established in Florence and Rome in the early sixteenth century provided a set of norms for much of European art for at least three centuries.

High Renaissance style was founded upon the research and experiments of one of the most gifted individuals ever born. Leonardo da Vinci (1452–1519) was not only a great painter and sculptor but also an architect of genius, although he never erected a building. In addition, he was the inventor of an incredible variety of machines for both peaceful and military purposes (some have recently been constructed from his drawings and actually work), an engineer, a musician, an investigator in the field of aerodynamics, and the leading physicist, botanist, anatomist, geologist, and geographer of his time. Much has been said about the ideal of the universal man in the Renaissance; in actuality, there are few examples. Leonardo is the one who most closely approaches the ideal, having left untouched only the fields of Classical scholarship, philosophy, and poetry. In a sense he began where Alberti left off; it is a remarkable coincidence that both were illegitimate, and perhaps thus freed from the trammels of convention. There is, however, a crucial difference between the two. In an era when the continuing power of the Church competed in men's minds with the revived authority of Classical antiquity, Alberti decided for the latter; Leonardo, a lifelong skeptic, accepted neither. Throughout the thousands of pages he covered with notes and ideas, God is seldom mentioned, but nature appears innumerable times. Classical authorities were never cited. For Leonardo there was no authority higher than that of the eye, which he characterized as the "window of the soul." In many respects his pragmatic attitude was comparable to that of nineteenth-century scientists. Although he never focused his ideas concerning either science or art into an organized body of theory, Leonardo felt that the two were closely interrelated in that both were accessible to the eye.

Throughout Leonardo's writings we encounter the lament, "Who will tell me if anything was ever finished?" Little that he started was, least of all his lifelong pursuit of the elusive mysteries of nature. It is, therefore, to his drawings that we must look for the secrets of his art. In them, as in his notes, generally side by side on the same page, he analyzed the structure of rocks, the behavior of light, the movement of water, the growth of plants, the flight of birds, and the anatomy of insects, horses, and human beings. Although he derisively termed men "sacks for food," unworthy of the wonderful machine nature had contrived for them, he nonetheless wanted to see how that machine functioned, and did so by means of dissection. Possibly, Pollaiuolo's pioneer anatomical studies (see fig. 721) had been based on dissection, which was frowned on by the Church. Certainly in 1495 the young Michelangelo had dissected bodies, but for another purpose, as we shall see when we consider his profoundly different art.

Leonardo's dissections were scientific and went as far as studying the process and the very moment of conception and the growth of the fetus in the womb; his studies of blood vessels enabled him to arrive at a preliminary statement of the circulation of the blood a century before William Harvey expounded his thesis. Hundreds of drawings of human anatomy remain. Fig. 782 shows the progressive dissection of the arm and shoulder of a cadaver in order to clarify the shapes of the muscles and tendons, their functions, and their insertion into the bones. In the upper right-hand corner Leonardo has substituted ropes for the muscles so as to clarify the mechanical principles involved. Since he was left-handed, he wrote his notes (but not his letters) from right to left, so that to read them requires not only a knowledge of fifteenth-century handwriting but also a mirror.

Nothing in Leonardo's scientific drawings is quite as exciting as his

Leonardo

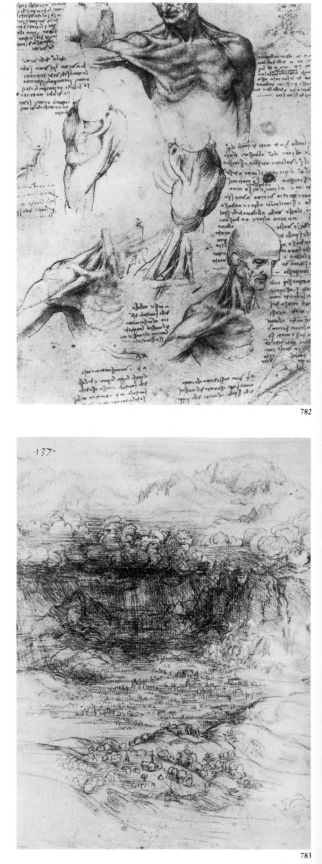

782

783

Olympian views of nature, which illustrate his standpoint in the Renaissance debate about the relative importance of the various arts. Leonardo maintained that painting deserved a position as one of the liberal arts, more so than music or poetry. Music, he noted, is dead as soon as the last sound has expired, but a work of painting is always there to be seen. Also, he pointed out, no one ever traveled to read a poem, but people journey hundreds of miles to see a painting. Ingenuous as these arguments may seem, in the Renaissance the issues they countered were burning questions. But Leonardo was unwilling to admit sculpture to the liberal arts; the painter could work in quiet, sitting down, richly dressed, and listen to music while he worked, while the sculptor, poor man, was covered with sweat and dust, and his ears deafened by the noise of hammer and chisel on stone. It is by no means irrelevant that when Leonardo began his campaign to upgrade painting the artist was still a craftsman and a guild member; before the High Renaissance was over a great master could live like a prince, and in the late sixteenth century academies rendered the guilds obsolete.

Whatever the painter wants to do, said Leonardo, he is "Lord and God" to do it, the reverse of the medieval attempt to show that God is an architect. The painter's mind "is a copy of the divine mind, since it operates freely in creating the many kinds of animals, plants, fruits, landscapes, countrysides, ruins, and awe-inspiring places." The painter's genius can take us from the "high summits of mountains to uncover great countrysides," and whatever is in the universe "he has it first in his mind and then in his hands." This claim sounds like an extension of Giannozzo Manetti's paean of praise for humanity (see pages 514–15). In one of Leonardo's comprehensive landscape drawings (fig. 783), we look from a high place upon rolling hills bordering a rich plain in whose center rise the domes and towers of a city, then beyond to a valley walled in by mountain crags and shadowed by rain clouds, and finally above the clouds to Alpine summits under eternal snow. Leonardo was an indefatigable mountain climber. Once his exhilaration at seeing the world at his feet subsided, he examined the rocks to discover how they were formed and deduced from fossilized sea animals that they were laid down under water. The world, therefore, could not have been created in 4004 B.C., although this biblical tradition was not again seriously doubted until the nineteenth century.

To Leonardo as to Alberti, architecture was based on the twin principles of geometric relationships and natural growth, and, therefore, nothing was so important as the central-plan structure. Although we shall see this new organic architecture realized in Bramante's plans for Saint Peter's, Rome, the idea for it originated in the mind of Leonardo. What Vasari called his doodles were important for his architecture since he was trying to elucidate the permutations and combinations that determine the forms of buildings. Leonardo abandoned both the planar architecture of Brunelleschi and the block architecture of Alberti, and began with plans and perspective drawings of the same structure (fig. 784), such as an octagon surrounded by eight circles, and a Greek cross whose arms, terminating in four semicircular apses, embrace four additional octagons on each of which a tower was to be erected (changed to cylinders in the perspective drawing).

ADORATION OF THE MAGI Leonardo's knowledge of Albertian perspective was absolute and was important for him as a mathematical

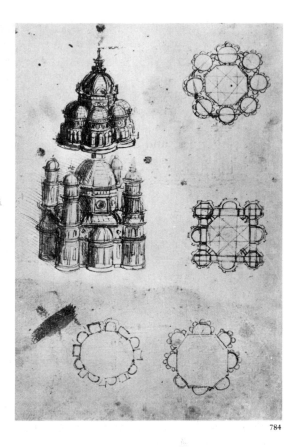

784

782. LEONARDO DA VINCI. *Anatomical Drawings of a Man's Head and Shoulders.* c. 1510. Pen and ink. Royal Library, Windsor

783. LEONARDO DA VINCI. *Storm Breaking over a Valley.* c. 1500. Red chalk. Royal Library, Windsor

784. LEONARDO DA VINCI. *Plans and Perspective Views of Domed Churches.* c. 1490. Pen and ink. Institut de France, Paris

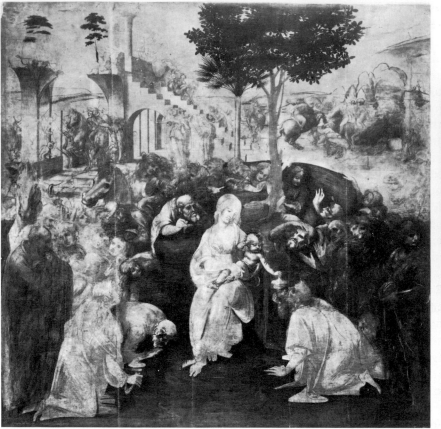

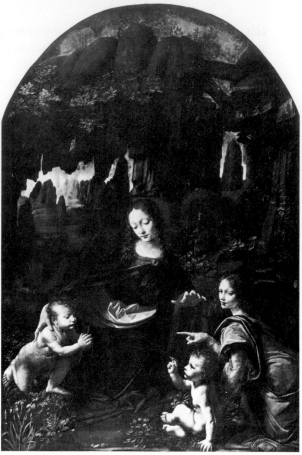

structure for the understanding of space. But no sooner did he establish the linear structure than he began to dissolve it. For he was also acutely conscious of the forces of growth and decay, which provoke continuous change and renewal, and thus precluded his faith in the perfect, unshakable, and therefore somewhat artificial world of Piero della Francesca. A study (see fig. 8) was made for the architectural setting of one of Leonardo's earliest paintings, an *Adoration of the Magi* commissioned in 1481 for a church outside Florence, but it was never carried any further than the monochrome underpaint. With a dark wash he began by brushing in the shadows and only gradually defined the forms in light on the assumption that darkness comes first in the world and light penetrates it. This is the exact opposite of the traditional method of drawing the outlines first and then bringing forms into relief by means of shadow (see the sinopia in fig. 659).

Leonardo's pyramidal composition (fig. 785) is constructed along a principle already established by Pollaiuolo (see pages 550–51; fig. 720): that groups are based on the actions of the component figures and will dissolve as soon as they move. Although Leonardo could not have known it, this very discovery had been made in Greece in the fifth century B.C. The enclosing shed that Leonardo had been at such pains to construct in the drawing is gone, leaving only the ruined arches and steps. Although these are projected in perspective, they no longer show any signs of the mathematical construction on which they are based. With the faces as with the composition, Leonardo starts with the moment of feeling and perception, defining expression first; form will follow. In the background at the right appears for the first time the composition of rearing horses

785. LEONARDO DA VINCI. *Adoration of the Magi.* Begun 1481. Underpainting on panel, 96 × 97". Galleria degli Uffizi, Florence

786. LEONARDO DA VINCI. *Madonna of the Rocks.* Begun 1483. Probably oil on panel (transferred to canvas), 78½ × 48". The Louvre, Paris

that has little to do with the ostensible subject of the painting but that will turn up again in magnificent form in the *Battle of Anghiari* (see fig. 788).

MADONNA OF THE ROCKS Many of Leonardo's crucial works were executed away from Florence in traditionally hostile Milan at the court of Lodovico Sforza, who had seized the duchy from his nephew and ruled it with wisdom, foresight, and artistic taste, making it during his brief reign the most energetic and lively artistic center in Europe. Lodovico was a perfect patron for so great an artist and Leonardo's almost exact contemporary (b. 1451; reigned 1481–99; d. 1508). When offering his services to Lodovico, interestingly enough, Leonardo mentioned first his military inventions and his work as a hydraulic engineer, architect, and sculptor, and only at the close his ability to paint. His first great work in Milan was the *Madonna of the Rocks* (fig. 786), begun in 1483 for the Oratory of the Immaculate Conception. The doctrine of the Immaculate Conception, unrelated to that of the Virgin Birth, means that at her *own* conception Mary was freed from the taint of Original Sin so that she could be a worthy vessel for the Incarnation of Christ. Leonardo has interpreted the doctrine dramatically by illuminating Mary in the midst of a dark, shadowy world of towering rock forms and views into mysterious distances. She raises her hand in protection over the Christ Child, who blesses the kneeling infant John the Baptist, indicated by a pointing angel. The picture, almost certainly in oil, adopts many of the techniques invented by the Netherlanders, and in its concentration on the tiniest details of rocks and of plant life in the foreground, as on the glow of light from flesh, eyes, and hair, owes a debt to the encyclopedic naturalism of van Eyck; as in Netherlandish painting, traditional halos disappear. The wonderful sweetness and grace of faces and figures, treasured by Leonardo's patrons, are his own and inimitable.

LAST SUPPER Contrary to iconographic tradition, especially in Castagno and in Dirc Bouts (see figs. 710, 761), Leonardo's *Last Supper* (fig. 787), painted on the end wall of the refectory of the Monastery of Santa Maria delle Grazie in Milan in 1495–97/98, is only partially concerned with the institution of the Eucharist. Instead, Leonardo has based his composition on the passage that recurs in Matthew, Mark, and Luke, in which Christ says, "Verily, I say unto you that one of you shall betray me. And they were exceeding sorrowful, and began every one to say unto him, Lord is it I?" As in the *Adoration of the Magi*, the composition is a product of the moment of action and of meaning. Donatello had done something similar in the *Feast of Herod* (see fig. 683), but with a bombshell effect; Leonardo utilizes the revelation to throw the Apostles into four groups of three each, as if bringing out the inherent properties of the number twelve. Each of these numbers has many meanings—the multiplication of the Gospels by the Trinity is only one, and twelve itself is not merely the number of the Apostles but of the months of the year and of the hours of the day and of the night. Even the hangings on each of the side walls and the windows at the end number respectively four and three. The numerical division helps to throw the fundamental character of each of the Apostles into full relief (Leonardo even labeled them in his preparatory drawings), from the serene innocence of John on Christ's right to the horror of James on his left to the protestation of Philip, who

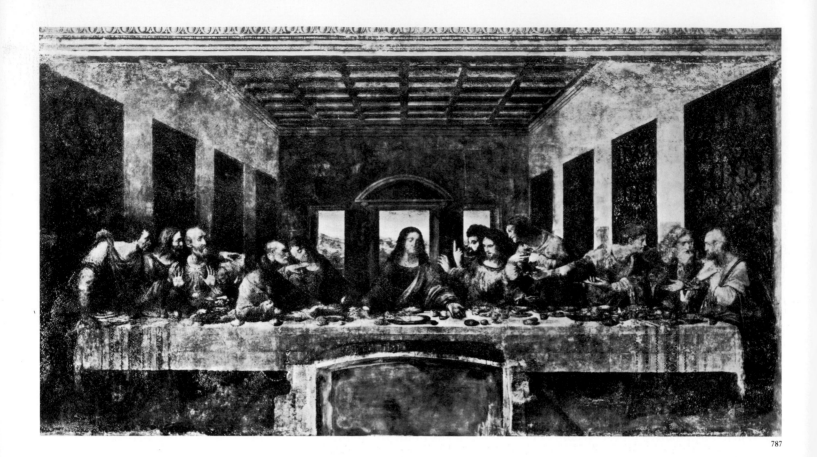

places his hands upon his breast. Only Judas, also revealed by the moment of truth, has no doubt, for he already knows, and the light does not shine upon his face.

The *Last Supper* is really a humanistic and mechanistic interpretation of the narrative, yet in composing it the artist, almost without conscious intention, produced figures of superhuman scale and grandeur. These figures operate within a perspective that, for the first time in any major work since Masaccio's *Trinity* (see fig. 701), is not related to the actual space of the room; there is no place in the refectory where one can stand to make the perspective "come right." It is as if Leonardo were painting for us a higher reality incommensurable with that in which we live, thus making a complete break with Early Renaissance tradition and establishing the ideal world in which both Michelangelo and Raphael later operated. Tragically enough, Leonardo's masterpiece could not be painted at a speed consistent either with true fresco in the Italian manner or with the Byzantine *secco su fresco*. In order to register all the shades of feeling and veils of tone necessary to his conception, he painted in what is apparently an oil-and-tempera emulsion on the dry plaster, and it began rapidly to peel off. As a result, the surface is severely damaged throughout, but a recent delicate restoration is slowly bringing to light far more of the original painting than anyone had thought possible.

BATTLE OF ANGHIARI For a year the great master worked for the infamous Cesare Borgia, designing battle engines and siege devices and making maps. The Florentines commissioned him in 1503 to paint the *Battle of Anghiari* on a wall of the newly constructed Hall of the Five Hundred in the Palazzo Vecchio. This painting, depicting an event from

787. LEONARDO DA VINCI. *Last Supper*, mural (oil and tempera on plaster), Refectory, Sta. Maria delle Grazie, Milan. 1495–97/98

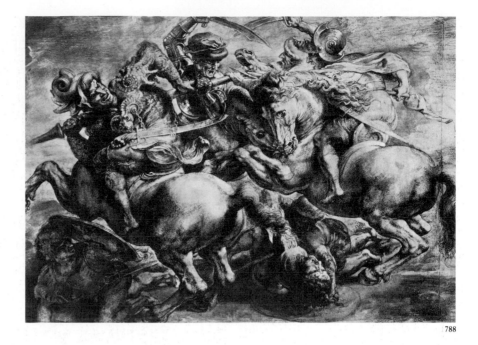

fifteenth-century history, was part of a general program of decoration (including a never-executed painting by Michelangelo) to celebrate the newly revived republic. The work was executed according to experimental and unsuccessful methods and was finally abandoned, but we have some knowledge of what the central section must have looked like through an imaginative re-creation made in the seventeenth century by Peter Paul Rubens (fig. 788) on the basis of copies. Leonardo's own firsthand experience with battles is transmuted into what may be termed the first completely High Renaissance composition, produced by figures that are, so to speak, no longer added to each other but multiplied by each other. The nucleus, the battle around the standard, is formed of a pinwheel of violently struggling horses and riders, whose whirlwind ferocity makes fifteenth-century battle scenes, such as those by Uccello (see fig. 707), seem toylike by comparison. The beautiful fury of Leonardo's rearing horses was never forgotten; his lost composition became the model for scores of battle scenes throughout the late Renaissance, the Baroque period, and even the nineteenth century.

MADONNA AND SAINT ANNE Leonardo's *Madonna and Saint Anne* (fig. 789) was designed in Florence in 1501, but probably not completed until a dozen or so years later in Milan. Again he intertwined the figures to form a pyramidal composition. The Virgin, who sits on her mother's lap, as in traditional representations of this theme, is shown reaching for the Christ Child, who in turn attempts to ride upon a lamb, the symbol of his sacrificial death. Saint Anne, from the summit of the composition, smiles mysteriously at the drama being enacted. Even though the painting has been overcleaned in the past, and the surfaces have darkened under later varnish, the magic and beauty of the composition are unsurpassed in any of Leonardo's other surviving works. The background, in fact, is one of the most impressive mountain pictures ever painted; it makes one believe Leonardo had seen and explored the Dolomites, those finger-like Alpine crags in northeastern Italy. Valleys, rocks, and peaks diminish progressively into the bluish haze of the distance until they can no longer be distinguished.

788 PETER PAUL RUBENS. Copy of central section of Leonardo da Vinci's mural *Battle of Anghiari* (1503–6, destroyed). c. 1615. Pen and ink, and chalk. The Louvre, Paris

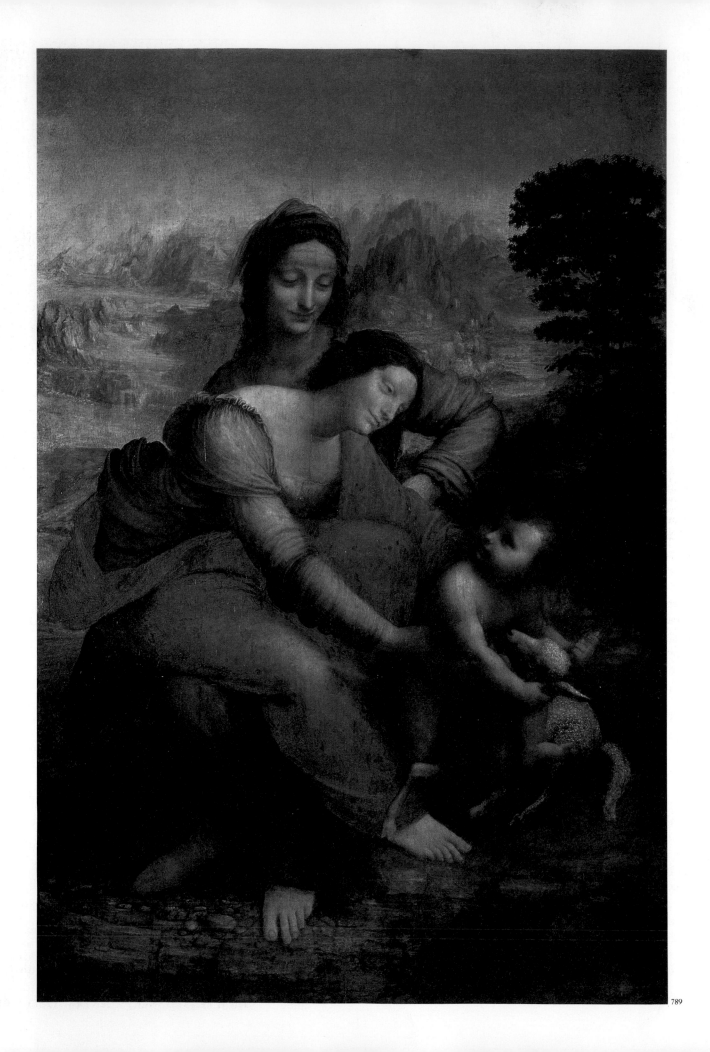

MONA LISA From 1503 until 1506, during the same period in which he was at work on the *Battle of Anghiari*, Leonardo was painting a portrait of the wife of a prominent Florentine citizen; this painting is known today as the *Mona Lisa* (fig. 790). It is inseparable from the *Madonna and Saint Anne*, since it must have been done between the date of the cartoon for that work and the finished painting. As compared with the rigid profile portraits by Piero della Francesca (see figs. 714, 715), the figure sits in a relaxed position, with hands quietly crossed, before one of Leonardo's richest and most mysterious landscape backgrounds, traversed by roads that lose themselves, bridges to nowhere, crags vanishing in the mists. This attitude of total calm became characteristic for High Renaissance portraits. The face, unfortunately, has suffered in the course of time—the eyebrows have disappeared—but nothing has spoiled the sad half smile that plays about the lips.

Leonardo's later life was a succession of trips between Florence, Milan, and Rome, where he could see what his younger competitors, Michelangelo and Raphael, had accomplished with principles he had laid down. He painted little in his later years; in 1517 he accepted the invitation of King Francis I of France to retire to a small château on the Loire, where his sole duty was to converse with the king. The *Mona Lisa*, the *Madonna and Saint Anne*, and a *Saint John the Baptist*, the latter now in bad condition, went with him because they had absorbed so much of his inner life that he could no longer part with them. At his death, in 1519, Leonardo's artistic influence was immense, but much of his scientific work had to await later rediscovery.

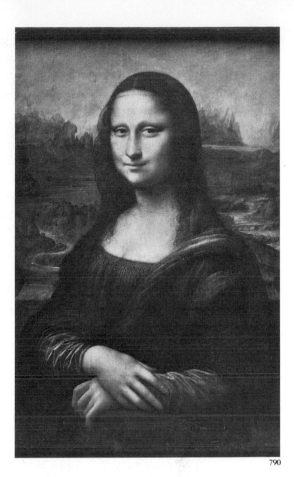

790

Michelangelo Before 1516

The sixteenth century in central Italy was dominated by the colossal genius of Michelangelo Buonarroti (1475–1564), whose long life makes it necessary for us to consider him in two separate chapters (see also Chapter Five). His personality could scarcely have been more different from that of Leonardo. In contrast to Leonardo's skepticism, we must set Michelangelo's ardent faith; against Leonardo's scientific concern with natural objects Michelangelo's disinterest in any subject save the human body; against Leonardo's fascination with the mysteries of nature Michelangelo's search for God, whose sublime purpose he saw revealed in the beauty of the human form, that "mortal veil," as he put it, of divine intention. Characteristically enough, poetry, the one art in which Leonardo did not excel, was a lifelong vehicle for Michelangelo's meditations.

When the long controversy as to the relative merits of painting and sculpture, sparked by Leonardo's claims for painting, was brought before Michelangelo in 1548, he claimed that sculpture was superior to painting as the sun is to the moon, which shines only with reflected light. By sculpture he meant that which is produced "by force of taking away" rather than "by process of putting on"; that is, he meant carving in stone instead of modeling in clay or wax. He began by drawing roughly on the surfaces of the block (in a manner that recalls that of the Egyptians) the contours of a figure, predetermined by preliminary sketches and perhaps models, and then proceeded to carve away the surplus stone. Contour line was, therefore, his dominant concept, and he pursued it passionately around the figure so as to free it from the block. From his many unfinished works one can watch the principles of Michelangelo's style in operation. In *"Crossed-leg" Slave* (fig. 791), the portion of the figure that the sculptor had thus far shaped is almost finished, save for the final process of smoothing and polishing; the rest is rough marble. Often the figure

789. LEONARDO DA VINCI. *Madonna and Saint Anne*. c. 1501–13(?). Panel painting, 66¼ × 51¼". The Louvre, Paris

790. LEONARDO DA VINCI. *Mona Lisa*. 1503–6. Oil on panel. 30¼ × 21". The Louvre, Paris

seems to struggle for liberation within the block, but sometimes, especially at the beginning and the end of Michelangelo's life, human forms are weightless and serene. There is a more than accidental correspondence between Michelangelo's method of liberating the figure from the block and the doctrine of the Neoplatonic philosophers (among whom Michelangelo was brought up as a boy at the court of Lorenzo the Magnificent) that man at death is freed from the "earthly prison" to return to his final home in God. To Michelangelo, as to Leonardo, artistic creation partakes of divinity, but in a diametrically different way: to Leonardo, the artist is himself a kind of deity, who can see with infinite range and precision and who can create objects and beings out of nothing; to Michelangelo, the artist's tools and his stone are instruments of the divine will, and the creative process an aspect of salvation.

Michelangelo learned the techniques of painting during a year of his boyhood spent in Ghirlandaio's studio; sculpture he studied with Bertoldo di Giovanni, a pupil of Donatello, and from works of ancient art in the Medici collections. His earliest masterpiece, the *Pietà* (fig. 792), done in 1498–99/1500 during his first sojourn in Rome, is still a fifteenth-century work, almost Botticellian in its grace and delicacy. The perfect formation of the bones and muscles of the slender Christ, lying across the knees of his mother, excited the intense admiration of Michelangelo's contemporaries; this anatomical accuracy is undoubtedly the result of the dissections Michelangelo had been permitted to carry out in 1495 at the Hospital of Santo Spirito in Florence. The exquisite Virgin, whose left hand

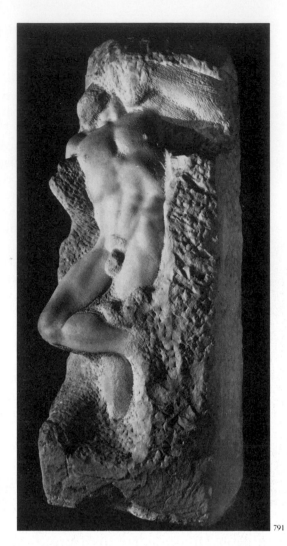

791

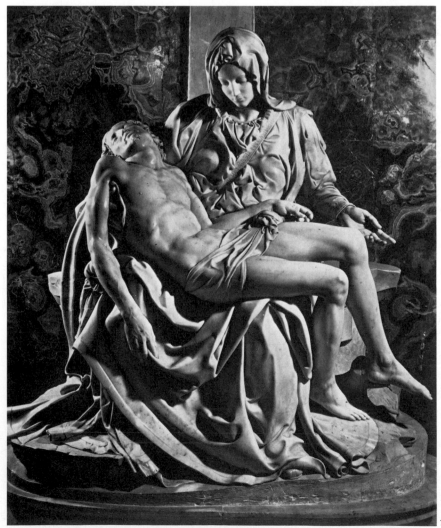

792

791. MICHELANGELO. *"Crossed-leg" Slave.* 1527–28. Marble, height 8′10″. Galleria dell'Accademia, Florence

792. MICHELANGELO. *Pietà.* 1498–99/1500. Marble, height 68½″. St. Peter's, Vatican, Rome

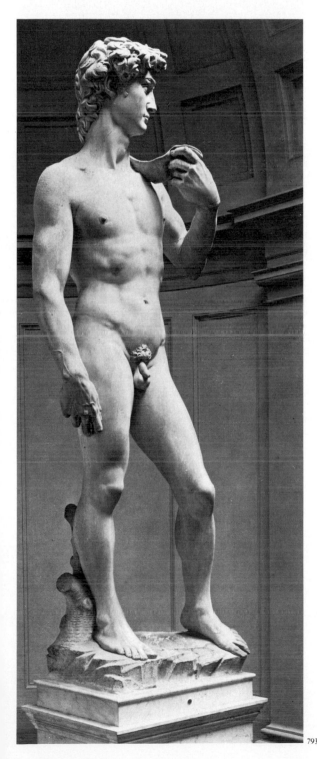

is extended less in grief than in exposition, looks as young as her son; contemporary queries were greeted by Michelangelo's rejoinder that unmarried women keep their youth longer. The explanation is more probably to be sought in a line from Dante, "Virgin Mother, daughter of thy son," which was elaborately paraphrased in a comment by Giovanni Strozzi, a contemporary of Michelangelo's. The ageless Virgin is a symbol of the Church, who presents for our adoration the timeless reality of Christ's sacrifice. The extreme delicacy in the handling of the marble and the contrast between the long lines of Christ's figure and the crumpled drapery folds produce passages of a beauty Michelangelo was never to surpass, despite the grandeur of his mature and late work.

THE *DAVID* The heroic style for which Michelangelo is generally known is seen in the *David* (fig. 793), more than fourteen feet in height, which Michelangelo carved in 1501–4 for a lofty position on one of the buttresses of the Cathedral of Florence. (Donatello had done a *Joshua* in terra-cotta, now lost, for an adjoining buttress, and Ghiberti had planned a *Hercules*.) When the work was completed, its beauty seemed to the Florentines too great to be sacrificed in such a position; after long deliberation the statue was placed in front of the Palazzo Vecchio, where it became a symbol of the republic ready for battle against its enemies, much like the statues by Donatello, Nanni di Banco (see figs. 679, 680, 691), and Ghiberti at Orsanmichele nearly a century before. Almost by accident, therefore, the *David* became the first true colossus of the High Renaissance. (For protection against the weather, it was moved indoors in the nineteenth century, and replaced by a copy.)

The block had been cut in the 1460s probably, as has been recently shown, for a *David* designed by the aged Donatello, after whose death the block remained unused. Michelangelo's conception is totally new; as compared with any earlier *David*, the bronze one by Donatello for instance (see fig. 684), Michelangelo's youth is no longer a child but a heavily muscled lad of the people, still not fully grown, with large hands, feet, and head. As with all Michelangelo's figures, there is nothing anecdotal here; the sling goes over David's left shoulder, and the stone lies in the hollow of his right hand, but he is not about to launch it. He stands forever alert in body and spirit, every muscle vibrant with Michelangelo's newly gained anatomical knowledge and with his ability to communicate the life of the spirit through the beauty of the body. The strong undercutting of the hair and the features can be explained by the high position for which the statue was originally destined. Brought to near ground level, the figure towers above us as a revelation of a transfigured humanity; such a vision had inspired no one since the days of Phidias. It is characteristic of the High Renaissance that such a figure should appear dreamlike as compared to the everyday simplicity of Giotto, Masaccio, or even Donatello.

THE *TOMB OF JULIUS II* Mindful of his place in history, the warrior pope Julius II called Michelangelo to Rome in 1505 to design a tomb for him; it was projected as a freestanding monument with more than forty over-lifesize statues in marble and several bronze reliefs. It is typical of the unreality of High Renaissance imagination that it occurred to neither Michelangelo nor the pope that so ambitious a project would require a lifetime (we cannot account for forty over-lifesize statues from Michel-

angelo's entire career, including the lost works). The idea of the tomb was first abandoned by the pope in 1506, possibly because of his plans for rebuilding Saint Peter's, and revived after his death in 1513. After several successive reductions, the tomb was brought to completion only in 1545. Three statues remain from the 1505 version, the last of which was finished only after 1513.

This statue is the world-famous *Moses* (fig. 794), intended for a corner position on the second story of the monument so that it could be seen from below as a composition of powerful diagonals. Like all of Michelangelo's works, the *Moses* is symbolic and timeless, and the reader is cautioned to ignore fanciful explanations that suggest that Moses is about to rise and smash the Tables of the Law or that he is glaring out at the Israelites. Moses is conceived as an activist prophet, a counterpart to Saint Paul, who also would have appeared on the second story of the tomb. The bulk of the figure is almost crushing, as is the powerful musculature of the left arm, so unlike any statue created since Hellenistic times. Michelangelo knew the *Laocoön*, found in Rome in 1506, and studied it carefully. Moses' head, with its two-tailed beard, is one of the artist's most formidable creations; the locks of the beard, lightly drawn aside by several fingers of the right hand, are a veritable Niagara of shapes. The drapery masses, instead of concealing the figure, as in the Virgin of the *Pietà*, are used to enhance its compactness.

The two *Slaves* for the 1505 and 1513 versions of the tomb were planned to flank niches around the lower story, in which were to stand Victories, an apparent contrast between the soul, held by the bonds of sin and death, and the Christian victory over both. The figure called the *Dying Slave* (fig. 795) is actually not dying but turning languidly as if in sleep; one hand is placed lightly upon his head, while the other plucks unconsciously at the narrow bond of cloth across his massive chest. The strikingly different companion figure (the two may have been intended for corner positions directly below the *Moses*), the *Rebellious Slave* (fig. 796), twisting in a powerful contrapposto pose, exerts all his gigantic strength in vain against the slender bond that ties his arms. The new figure type created by Michelangelo in the *David*, and for the first time here set in action, established a standard that was impossible to ignore, and influenced even artists who were temperamentally incapable of experiencing the deep spiritual conflict taking visible form in Michelangelo's heroic nudes. Throughout the late Renaissance and the Baroque period, it is the Michelangelesque heavily muscled figure that was almost universally imitated.

SISTINE CEILING In 1508 Michelangelo was given his greatest commission, a work of painting rather than sculpture: the ceiling of the Sistine Chapel, the private chapel of the popes in the Vatican, used for important ceremonies and for conclaves of the College of Cardinals. As we have seen (Chapter Two), the upper walls had been frescoed by several of the leading central Italian painters in the 1480s, including Botticelli, Ghirlandaio, Perugino (see fig. 728), and Signorelli, with scenes from the Life of Christ on one side and that of Moses on the other. The ceiling, a flattened barrel-vault more than 130 feet long, was merely painted blue and dotted with gold stars, as was common in Italian interiors, including that of the Arena Chapel. Well aware of the powers of Michelangelo's imagination, Julius II asked this sculptor—with the statues for the tomb temporarily in abeyance—to paint the ceiling, the most ambitious picto-

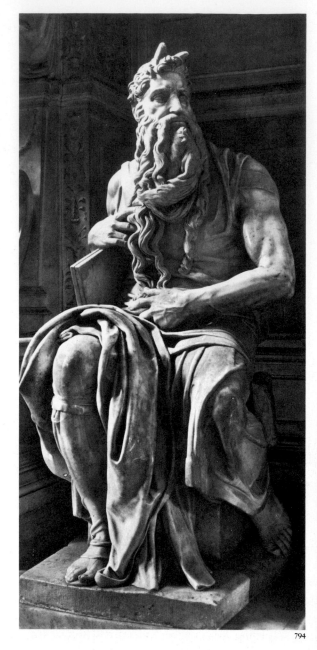

794

794. MICHELANGELO. *Moses.* c. 1515. Marble, height 92½". S. Pietro in Vincoli, Rome

795. MICHELANGELO. *Dying Slave.* Before 1513. Marble, height 90". The Louvre, Paris

796. MICHELANGELO. *Rebellious Slave.* Before 1513. Marble, height 84⅝". The Louvre, Paris

rial undertaking of the entire Renaissance. While Michelangelo did complain that painting was not his profession, there is no indication that (as he later claimed) he accepted the commission unwillingly.

Originally, the project was to consist of the Twelve Apostles seated on thrones in the spandrels between the arches round about the ceiling. In the minds of the pope and Michelangelo the program rapidly expanded to its final scope (fig. 797), representing the world before Moses, a synopsis of the drama of the Creation and Fall of Man reduced to nine scenes, four large and five small, beginning with the *Separation of Light from Darkness* and ending with the *Drunkenness of Noah*. These scenes are embedded in a structure of simulated architecture, whose transverse arches spring from twelve thrones, five along each side and one at either end, on which are seated the prophets and sibyls who foretold the coming of Christ. Above the thrones, at the corners of the scenes, sit twenty nude youths in poses of the greatest variety, clearly related to the *Slaves* of the tomb but not bound; they hold bands that pass through medallions of simulated bronze. In the vault compartments above the windows and in the lunettes around the windows are represented the forty generations of the ancestry of Christ, and in the spandrels at the corners of the Chapel are pictured *David and Goliath*, *Judith and Holofernes*, the *Crucifixion of Haman*, and the *Brazen Serpent*.

In this intricate iconographic structure, resembling in its completeness the cycles of Gothic cathedrals and Byzantine churches, the coming of Christ is apparently foretold in the nine scenes from Genesis, according to the principle of correspondence between Old and New Testaments that was announced by Christ himself and illustrated repeatedly throughout Christian art. An added element is the oak tree of the Rovere family, to which Julius II and his uncle Sixtus IV belonged, a symbol repeated innumerable times in the decorations of the lower walls of the Chapel as well as in the oak garlands, some wrapped and some open, held by many of the twenty nudes. It has been suggested that the Rovere oak tree, even allowed to invade the scenes of Creation, was intended to allude poetically to the Tree of Life in the Garden of Eden, whose fruit in medieval theology was Christ.

The ceiling was frescoed by Michelangelo, with minimal mechanical help from assistants, in the short time of four years (1508–12); during this period he also produced the hundreds of preparatory drawings and the cartoons (full-scale working drawings), which had by this time replaced the traditional sinopias. Michelangelo began painting in reverse chronological order, with the three scenes dealing with the Life of Noah and the adjoining prophets and sibyls; he soon realized that he had underrated the effect of the height of the ceiling, more than sixty feet above the floor, and that the figures looked crowded and small. In the other two early scenes, in the central section, painted in 1509–10, and in the final section, done entirely in 1511, the size of the figures was greatly increased and the compositions simplified. In the last campaign, 1511–12, he painted the lunettes above the windows (not shown in the reproduction).

When one stands in the Chapel, it is impossible to get a comprehensive view of the entire ceiling. When one looks upward and reads the scenes back toward the altar (fig. 797), the prophets and sibyls appear on their sides; if one turns so that those on one side are upright, those on the other are upside down. The contrary directions are bound together by the structure of simulated architecture, with its transverse arches and its diagonal bands separating the vault compartments. The placing of the twenty nudes at the intersections harmonizes the oppositions, since the

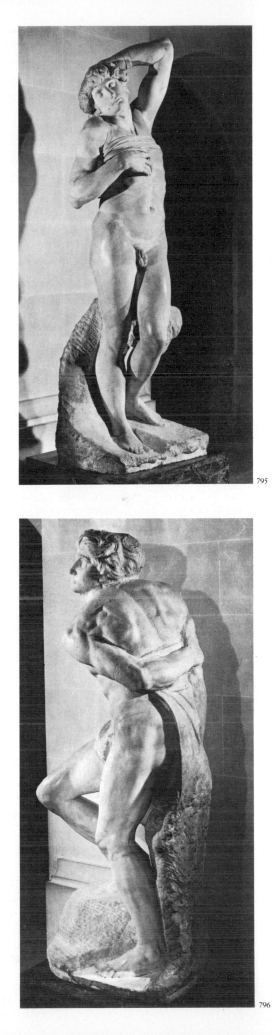

795

796

797

798

nudes can be read together with the prophets and sibyls enthroned below them or with the Genesis scenes at whose corners they are placed. Thus the basic High Renaissance principle of composition created by the interaction of the component elements is embodied in the very structure of the ceiling. The sober coloration is established by the large passages of simulated stone, and even the figures are clearly painted by an artist whose major interest is sculptural form.

The *Fall of Man* (fig. 798) combines the Temptation and the Expulsion in a single scene. Michelangelo was aware that his audience would recognize his allusion to the representations of the *Expulsion* by Jacopo della Quercia (see fig. 694) and Masaccio (see fig. 699), and for that very reason worked the two into a single scene, which in one motion leads the eye from the crime to the punishment, linked by the Tree of Knowledge, represented as a fig tree. It is noteworthy that the tree has only one branch; what appears to be a branch on the other side is the angel who expels the guilty pair from the Garden, and he is read together with the leaves of the Rovere oak coming from the nude above the scene at the right. Never in history had nude figures been painted on such a colossal scale; the powerful masses, simple contours, and intense expressions of Michelangelo's figures operate with great success even at this size.

Michelangelo's vision of a new and grander humanity reaches its supreme embodiment in the *Creation of Adam* (fig. 799). Instead of standing on earth as in all earlier Creation scenes (see fig. 693), the Lord floats through the heavens and is enveloped in the violet mantle he wears in all the scenes in which he appears. It is noted here for the first time that this violet color conforms to that required for the vestments of the clergy during Advent and Lent, the penitential periods before the coming of Christ at Christmas and his resurrection at Easter. The Lord is borne aloft by wingless angels; with only a single youthful exception, all of Michelangelo's angels are wingless, as if he could not tolerate violation of the beauty of the human body by an attachment from any other form of life. (In a widespread misconception, the angel under the Lord's left arm has been called the soul of Eve or even of Mary. Aside from the theological impossibility of either identification, the figure is just as male as any of the twenty nudes.) In comparison with the ceremonial, iconic

797. MICHELANGELO. *Sistine Ceiling* (west section). Fresco, Sistine Chapel, Vatican, Rome. 1511. From bottom to top of illustration (westward from altar): *Separation of Light from Darkness*, between *Jeremiah* (left) and *Libyan Sibyl* (right); *Creation of Sun, Moon, and Plants*; *The Lord Congregating the Waters*, between *Persian Sibyl* and *Daniel*; *Creation of Adam*; *Creation of Eve*, between *Ezekiel* and *Cumaean Sibyl*

798. MICHELANGELO. *Fall of Man*, ceiling fresco, Sistine Chapel, Vatican, Rome. 1509–10

Deity of Jan van Eyck, or in fact almost any earlier representation of God, Michelangelo's Creator for the first time makes believable the concept of omnipotence. A dynamo of creative energy, God stretches forth his hand, about to touch with his finger the extended finger of Adam. It was shown by the late Charles Seymour that this image of the creative finger derives from the famous medieval hymn "Veni Creator Spiritus" ("Come, Creator Spirit") sung at Pentecost, the festival of the Descent of the Holy Spirit, but also at conclaves in the Sistine Chapel, before the afternoon scrutiny for the election of a new pope. In this hymn the "finger of the paternal right hand" is invoked to bring speech to our lips, light to our senses, love to our hearts, and strength to our bodies. Adam reclines on the barren ground below, longing for the life and love about to be instilled by this finger. As we have seen in the discussion of Jacopo della Quercia (see pages 532–33 and fig. 693) *Adam* means "Earth," and the figure is shown not as in Jacopo's relief, merely astonished at the appearance of the Lord, but ready to be charged with the energy that will lift him from the dust and make of him "a living soul" (Genesis 2:7).

Adam's body is probably the most nearly perfect Michelangelo ever created, a structure embodying all the beauty of Classical antiquity and all the spirituality of Christianity. As in all High Renaissance compositions, the action in this one—based on the mirroring of the convex curve of the fecundating Creator in the concave curve of the receptive creature—will vanish in seconds, and yet it is preserved forever. It should be noted that the oak garland is permitted to enter the scene directly below Adam's thigh, so that the Incarnation of Christ, the second Adam (I Corinthians 15:45), fruit of the Tree of Life, is foretold by the creation of the first Adam.

The final scenes as one moves toward the altar (see fig. 797) were also the last in order of execution. *The Lord Congregating the Waters* was held to foreshadow the foundation of the Church; the *Creation of Sun, Moon, and Plants* shows the Lord twice, once creating sun and moon with a cruciform gesture of his mighty arms, then seen from the rear creating plants, among which the Rovere oak intrudes from under the neighboring nude. Just above the altar, the Lord separates the light from the darkness, which recalls the words of John 1:1: "In the beginning was the Word, and the Word was with God, and the Word was God." The figures have grown

799. MICHELANGELO. *Creation of Adam*, ceiling fresco, Sistine Chapel, Vatican, Rome. 1511

to such a scale that the frames will no longer contain them, and the athletic nudes exemplify every possibility of seated pose and a range of expression from terror to rapture.

The seated prophets and sibyls show the majestic possibilities of the draped figure, related to the conception of the seated *Moses* (see fig. 794); Vasari wrote that even when Michelangelo's figures were clothed they looked nude, by which he meant that the powerful motions of his figures could only have been achieved by his total mastery of the nude. The *Persian Sibyl* is represented as immensely old, *Jeremiah* as grieving above the papal throne, *Daniel* aflame with prophecy as he writes in a small volume, the *Libyan Sibyl* no longer needing her book as she looks down upon the altar, the eternal Tree of Life. The final phase of the *Sistine Ceiling* is one of the supreme moments in the spiritual history of mankind. It is also significant that it was created during the years when Julius II, who commissioned and to a certain extent inspired the *Sistine Ceiling*, was fighting on the battlefield for the continued life of the Papal States against the armies of King Louis XII of France, and when the outcome of the struggle was in the balance.

For the moment we must leave Michelangelo to consider the work of the last two masters who assisted in creating the High Renaissance style. Julius II's favorite architect was Donato Bramante (1444–1514), from Urbino (where in his youth he may have collaborated with Piero della Francesca), a congenial spirit, who used to read Dante to the pope, who was almost exactly the same age. Bramante, also a painter, had enjoyed a long and distinguished architectural career in Milan, where he had worked in close touch with Leonardo da Vinci, many of whose ideas he reflects. In fact, the Tempietto (fig. 800), a small circular shrine built after 1511 in Rome on the spot where Peter was believed to have been crucified, is a concentration and simplification of Leonardo's central-plan schemes (see fig. 784). The cylindrical cella is surrounded by a circular peristyle, in the manner of an ancient tholos of Roman Doric columns, crowned by a balustrade. The cella rises one story above the peristyle and culminates in a slightly more than hemispheric dome, ribbed on the outside. The proportions are simple, harmonious, and unified; in its smooth movement round the building, the peristyle has no equal in Renaissance architecture.

But the basic radial principle is derived from Leonardo, as can be seen in a sixteenth-century engraving (fig. 801) that shows the surrounding circular courtyard as it would have looked had Bramante's complete design been carried out. The reader should trace with a ruler the relationship between the niches in the cella, the columns of the peristyle, the columns of the circular colonnade, and the niches alternating with chapels that ring the colonnade. The result is a radial relationship of all forms and spaces from the center outward, like the rays of a snow crystal, the petals of a flower, or the spokes in a Gothic rose window.

This radial principle determined Bramante's design for rebuilding Saint Peter's in Rome. In 1506 it occurred to Julius II to tear down the Constantinian Basilica of Saint Peter's, then more than eleven hundred years old, and to replace it with a Renaissance church; this new project may well have been the reason for the interruption of work on his tomb by Michelangelo. Several different possibilities for the church's plan may have been considered by Bramante, whom the pope entrusted with the commission, but the one he chose was strikingly Leonardesque (fig. 802).

800. DONATO BRAMANTE. Tempietto, S. Pietro in Montorio, Rome. Authorized 1502; completed after 1511

801. DONATO BRAMANTE. Plan of the Tempietto (From Sebastiano Serlio, *Il terzo libro d'architettura*, Venice, 1551)

Bramante

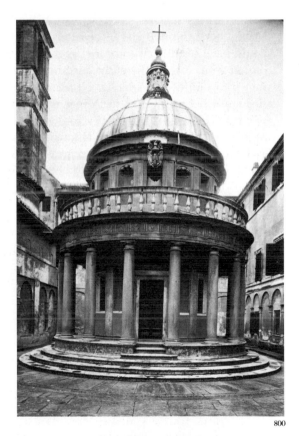

800

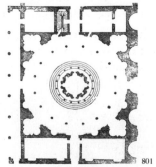

801

Basically, it was a Greek cross with four equal arms terminating in apses. Into each reentrant angle was set a smaller Greek cross, surmounted by a dome, two of whose apses merged in those of the central cross. Four lofty towers were to be erected in the angles of the smaller crosses and linked with the four major apses by triple-arched porticoes. The striking feature of the exterior was the culminating dome, which for the first time in the Renaissance entirely abandoned the vertical-ribbed form in the tradition of Brunelleschi (see fig. 661), still followed by Leonardo, and replaced it with an exact hemisphere modeled on that of the Pantheon. But Bramante did not wish to sacrifice the Renaissance notion of the drum, which gives a dome greater height; his drum is again a tholos, surrounded by a peristyle of Corinthian columns. How the whole structure would have looked from the exterior may be seen in the commemorative medal struck by Bramante's collaborator, the sculptor Caradosso, in 1506 (fig. 803).

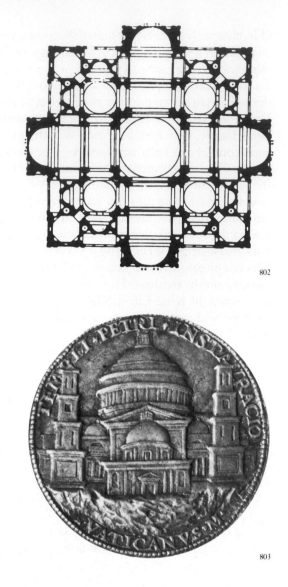

802

At the time of the pope's death in 1513 and of Bramante's the following year, only the eastern half of the basilica had been demolished, but the four giant piers with their Corinthian pilasters upholding the four arches on which the dome was to rest had already been built. Although Bramante's dome remained a dream, his interior plan was substantially realized (fig. 804), though the floor level was raised about three feet and the pilasters thus correspondingly shortened. The idea of the coupled pilasters in one giant story sustaining the barrel vaults and embracing smaller arches was drawn from Alberti's nave of Sant'Andrea in Mantua (see fig. 676). Nonetheless, the interior as Bramante originally planned it would have been very complex, as the reader can see by moving in imagination from one of the eight entrance porticoes into the adjoining apse, then into one of the smaller Greek crosses with its central dome, then through a barrel-vaulted arch into the greater barrel vault of one of the four transept arms, and finally into the central space to look up into the interior of the colossal dome. Bramante's radial design was never carried out in its entirety, but his basic central structure was standing at his death; it was on such a scale that it could not be altered by any of the subsequent architects.

803

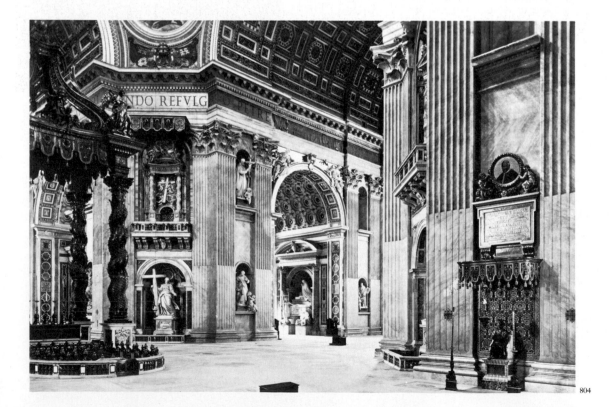

804

The fourth great master of the Florentine and Roman High Renaissance was Raffaello Sanzio (1483–1520), known by the Anglicized form Raphael. It is in his art that the High Renaissance ideal of harmony comes to its most complete expression. First taught in Urbino by his father, Giovanni Santi, a mediocre painter, Raphael worked for some time in the studio of Perugino, whose manner he approximated so exactly that it is often difficult to ascertain whether certain works are by the master or his young pupil. In 1504 Raphael painted for a church in the little town of Città di Castello the *Marriage of the Virgin* (fig. 805), which at once recalls the *Giving of the Keys to Saint Peter* by Perugino (see fig. 728). Differences are instructive; what is diffuse in Perugino is brought to a focus in Raphael. His central group is unified around the motive of Joseph putting the ring on Mary's finger, and the lateral figures are made to join in this movement, including the disgruntled suitor breaking his rod over his knees. The architecture of the distant polygonal Temple grows out of the wide piazza, and is more carefully unified, in the spirit of the Tempietto, than the abrupt shapes of Perugino's octagonal building. Its dome is almost tangent to the arch of the panel, identifying the dome of the Temple with that of Heaven. Moreover, the doors of the Temple are open so that the perspective of the squares in the piazza moves serenely through the building to the point of infinity. This combination of perfect unity and airy lightness in Raphael's composition breathes through the figures as well. Perugino's characteristic S-curve is transformed by Raphael into an ascending spiral beginning at the tip of the toes and rising harmoniously and effortlessly to discharge in the glance.

About 1505 Raphael, twenty-two years old, arrived in Florence, and achieved immediate success. Leonardo and Michelangelo had established the High Renaissance style in Florence, but they were accessible to few private patrons. Raphael met the demand with ease and grace, and during his three-year stay painted a considerable number of portraits and Madonnas, one of the loveliest of which is the *Madonna of the Meadows*, dated 1505 (fig. 806). The pyramidal group established by the interaction of its members in Leonardo's design for the *Madonna and Saint Anne* (see fig. 789), and certainly the pose of the Virgin with her foot extended, were strongly influenced by Leonardo's composition. But the Raphael picture is simpler; the gentle master from Urbino dissected no corpses and was only slightly interested in anatomy. Harmony was to him the basic purpose of any composition, and the harmony is beautifully consistent throughout this work, from the balancing of ovoids and spheroids in the bodies and heads of the children to the encompassing shapes of the protective Virgin and finally to the background landscape, which is brought to a focus in her neckline and head, as is that of the *Marriage of the Virgin* in the dome of the Temple. The landscape bears the same relation to the figural composition as does the encircling courtyard to the Tempietto. Although Raphael reinstated the traditional halos in his Florentine Madonnas, perhaps at the insistence of his patrons, they appear as slender circles of gold, delicately poised in depth, and as an added element in his composition of circles and ovoids.

Julius II chose the twenty-six-year-old Raphael to supplement in the Stanze (chambers) of the Vatican the massive program of imagery being painted by Michelangelo in the locked Sistine Chapel across the narrow intervening court. Raphael maintained his position as court painter until his early death. His ideals of figural and compositional harmony, expanding and deepening from their relatively slight Florentine beginnings, came to be recognized as *the* High Renaissance principles, and it was to Ra-

Raphael

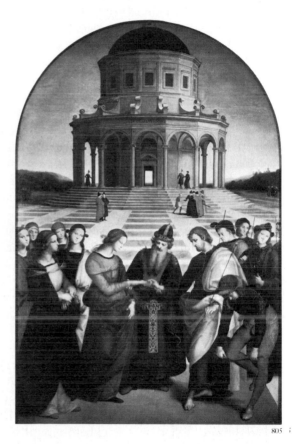

805.

802. DONATO BRAMANTE. Original plan for St. Peter's, Vatican, Rome. 1506 (After Geymüller)

803. CRISTOFORO CARADOSSO. Bronze commemorative medal showing Bramante's design for the exterior of St. Peter's, Vatican, Rome. 1506. British Museum, London

804. Interior view at crossing, St. Peter's, Vatican, Rome (After plan by Bramante)

805. RAPHAEL. *Marriage of the Virgin*. 1504. Panel painting, 67 × 46½". Pinacoteca di Brera, Milan

phael, therefore, rather than to Michelangelo, that Classicistic artists of succeeding centuries, especially Poussin in the seventeenth century (see fig. 938) and Ingres in the nineteenth (see fig. 1063), turned as the messiah of their art and doctrine. The first room to be frescoed was the Stanza della Segnatura (1509–11), used for the papal tribunal whose documents demanded the personal signature of the pontiff. From the complex iconographic program we can single out the two dominant frescoes on opposite walls; they typify the Classical and Christian elements reconciled in the synthesis of the High Renaissance. The *Disputa* (*Disputation over the Sacrament*; fig. 807), the most complete exposition of the doctrine of the Eucharist in Christian art, faces the *School of Athens*, an equally encyclopedic presentation of the philosophers of pagan antiquity.

The *Disputa* begins in Heaven (still represented with gold, but for the last time in any major work of Christian art). God the Father presides over the familiar Deësis, with Christ enthroned, displaying his wounds; on either side, in a floating semicircle of cloud recalling the arrangement in van der Weyden's *Last Judgment* (see fig. 760), Apostles and saints from the New Testament alternate with prophets and patriarchs from the Old. Below the throne of Christ, the Dove of the Holy Spirit, flanked by child angels bearing the four open gospels, flies downward toward the Host, displayed in a gold and crystal monstrance on the altar. On either side of the altar sit the Four Fathers of the Church, and farther out groups of theologians from all ages of Christianity engage in argumentation over the nature of the Eucharist, their vitality and agitation contrasting with the serenity of Heaven, where all questions are set to rest. Among the recognizable portraits are those of Dante, to the left of the door, and, in front of him, Sixtus IV. From the angels above the Deësis, whose spiral forms take on substance along the incised beams of golden spiritual light, down to the statuesque groups of theologians on earth, every figure is based on Raphael's fundamental spiral principle.

More revolutionary in its composition, the *School of Athens* (a misnomer applied in the eighteenth century; fig. 808) presents under an ideal architecture the chief philosophers from all periods of Greek antiquity engaged in learned argument. The figures form a circle in depth within the lofty structure, culminating under the central arch, where against the distant sky Plato, holding the *Timaeus*, points toward Heaven as the source of the ideas from which all earthly forms originate, while Aristotle, holding the *Ethics*, indicates earth as the object of all observations. At the upper left Socrates may be discerned discussing philosophical principles with the youths of Athens; at the lower left Pythagoras delineates his proportion system on a slate before pupils; at the right Euclid (a portrait of Bramante) uses another slate to demonstrate a geometric theorem.

The embracing architecture, with its statues of Apollo and Minerva in niches (the legs of Apollo repeat those of Michelangelo's *Dying Slave*, but in reverse; see fig. 795), is strongly Bramantesque, and in its single giant story and coffered barrel vaults suggests how the spaces of Bramante's Saint Peter's would have looked. Nonetheless, it is background architecture, essentially unbuildable; there are no arches to carry the outer borders of the central pendentives, which begin at the transverse arches and end in nothing. The isolated figure in the lower center, seated with one elbow on a block of stone in a pensive pose resembling that of Michelangelo's *Jeremiah* (see fig. 797), has been identified as a portrait of the great sculptor himself, inserted by Raphael after he had seen Michelangelo's frescoes in the Sistine Chapel in 1511.

In the Stanze painted afterward, Raphael abandoned the perfect but

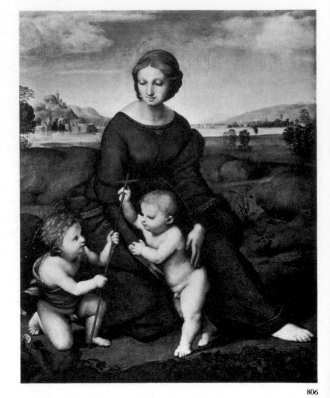

806

806. RAPHAEL. *Madonna of the Meadows.* 1505. Panel painting, 44½ × 34¼". Kunsthistorisches Museum, Vienna

807. RAPHAEL. *Disputa (Disputation over the Sacrament)*, fresco, Stanza della Segnatura, Vatican, Rome. 1509

static harmony of the Stanza della Segnatura in favor of always more dynamic compositions, which brought him to the threshold of the Baroque, under strong influence of the new style he had beheld in the Sistine Chapel. In the Stanza d'Eliodoro, 1512–14, the principal fresco (fig. 809) represents an incident from Maccabees 3 (a book of the Apocrypha, not included in Protestant Bibles), which tells how the pagan general Heliodorus, at the behest of one of the Seleucid successors of Alexander the Great, attempted to pillage the Temple in Jerusalem, but was met by a heavenly warrior in armor of gold on a shining charger, and by two youths "notable in their strength and beautiful in their glory," who beat him to the ground with their scourges so that he fell blinded. For Julius II this was an omen of divine intervention on his side against the schismatic Council of Pisa, set up by the invading Louis XII to depose him. He thus had Raphael paint him, formidable with his newly grown beard, being carried into the fresco at the left; Raphael appears as one of the chairbearers, directly below the pope's left hand. Under the influence of the marvels Raphael had seen in the Sistine Chapel, the pace has quickened, the volume has increased, and the muscular figures have been set in violent motion. But Raphael does not abandon his spiral principle; energy courses through the action figures as through figure eights. The rearing charger recalls those Raphael had seen in Leonardo's *Battle of Anghiari* (see fig. 788); this kind of reference was not considered plagiarism in the Renaissance, but recognition of greatness, in the same sense as Michelangelo's bow to Masaccio and Jacopo della Quercia (see page 615). As the figures have been enlarged to Michelangelesque dimensions, the architecture has decreased in scale but gained in mass and power. Heavy columns and massive piers have replaced the slender pilasters of the *School of Athens*.

From this same period dates the *Sistine Madonna* (fig. 810), so called because Saint Sixtus II, patron of the Rovere family, kneels at the Virgin's right. The picture was probably intended to commemorate the death of Julius II in 1513; the saint's cope is embroidered with the Rovere oak leaves, and the bearded face, a little older and less pugnacious than that in the *Expulsion of Heliodorus*, is a portrait of the aged pontiff. Saint Bar-

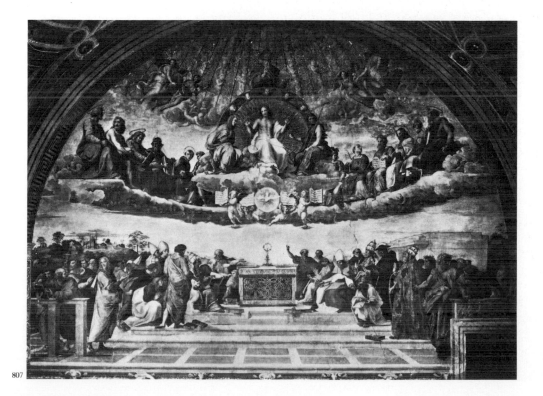

807

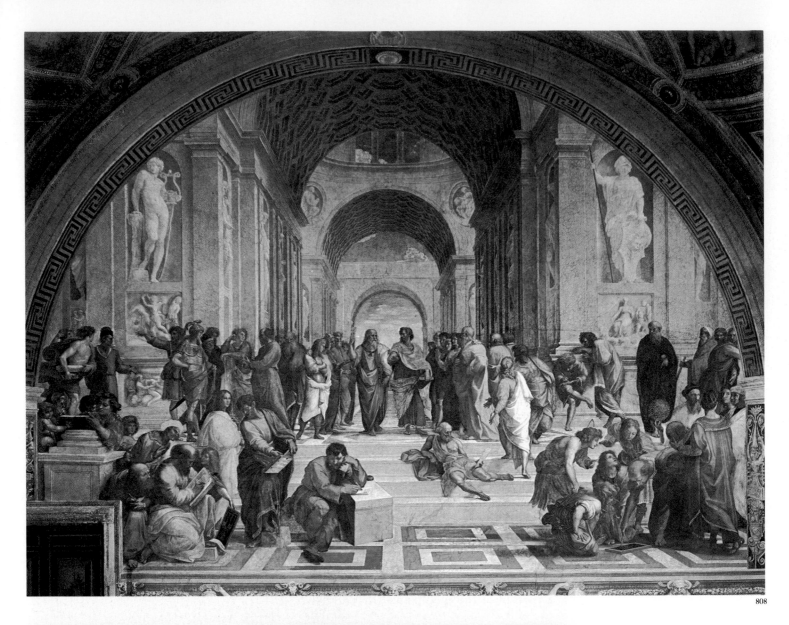

808

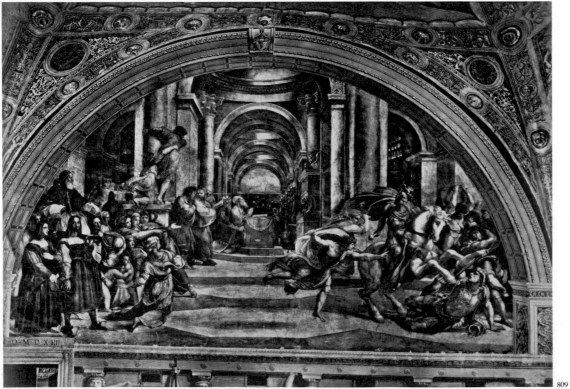

809

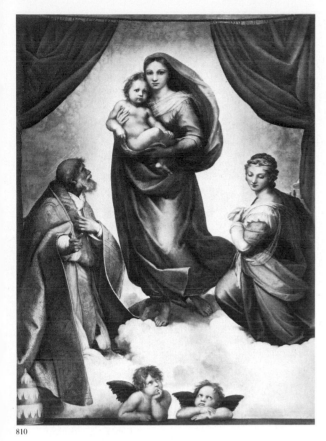

810

bara, patron saint of the hour of death, looks down on his coffin, on which the papal tiara rests, and the Virgin, showing us the Child, walks toward us on luminous clouds in which more angelic presences can be dimly seen. In harmonizing form and movement this painting represents the pinnacle of Raphael's achievement; the dynamic composition should be compared with the static one of the *Madonna of the Meadows* (see fig. 806). The broad, spiral shapes rise from the tiara through the cope of the kneeling saint up to and around the bodies of the Virgin and the Child, and downward again through the glance of Saint Barbara. Even the curves of the curtains, drawn apart to display the vision, harmonize in alternating tautness and fullness with the lines of the entire composition. The motive of the Virgin and Child walking toward us on the clouds may have been suggested by the visionary Christ of the mosaic of Saints Cosmas and Damian in Rome. The two figures in their perfect beauty, warmer and more human than their counterparts in the *Madonna of the Meadows*, represent the ultimate in the High Renaissance vision of the nobility of the human countenance and form.

The death of the warrior pope was followed by the election of Giovanni de' Medici, younger brother of the exiled Piero and a boyhood acquaintance of Michelangelo at the table of Lorenzo the Magnificent.

808. RAPHAEL. *School of Athens*, fresco, Stanza della Segnatura, Vatican, Rome. 1510–11

809. RAPHAEL. *Expulsion of Heliodorus*, fresco, Stanza d'Eliodoro, Vatican, Rome. 1512

810. RAPHAEL. *Sistine Madonna*. 1513. Oil on canvas, 8'8½" × 6'5". Gemäldegalerie, Dresden

811. RAPHAEL. *Pope Leo X with Cardinals Giulio de'Medici and Luigi de'Rossi*. c. 1517. Panel painting, 60½ × 47". Galleria degli Uffizi, Florence

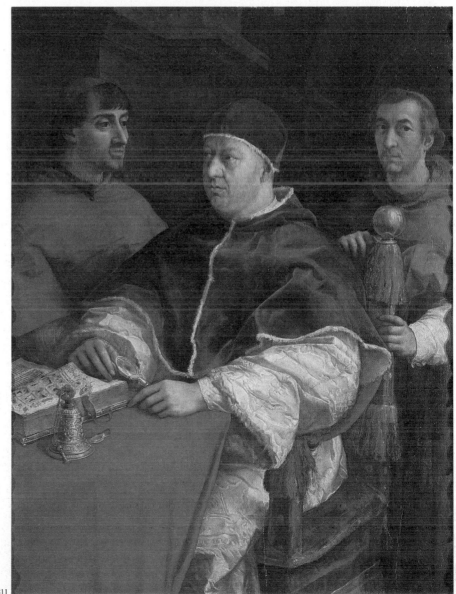

811

The thirty-eight-year-old Leo X was unmoved by the ideals of church reform and political power that had driven Julius II to such extraordinary feats; nevertheless, he was delighted with his new position, which gave him the opportunity to spend lavishly on worldly enjoyment the revenues accumulated by his predecessor to finance his conquests. In 1512, as Cardinal de' Medici, backed by Julius II, Giovanni had entered Florence and governed it through his younger brother Giuliano. Raphael has shown Leo X as he was in an unsparing portrait (fig. 811)—corpulent, shrewd, pleasure-loving, engaged in the examination of an illuminated manuscript (the original still exists) with a gold and crystal magnifying glass; a gold and silver bell to summon servants is close to the pope's hand. On his left is Cardinal Luigi de' Rossi, on his right his cousin Cardinal Giulio de' Medici, later Pope Clement VII. The portrait was probably painted in 1517, the fateful year when Martin Luther, whom the pope excommunicated in 1520, nailed his ominous theses to the door of the castle church of Wittenberg. Raphael was able to endow his subjects with the new mass and volume he had learned from Michelangelo's seated figures, but his analysis of character is unexpected, and profound. He has shown us all too clearly the pope who was incapable of holding the Roman Catholic Church together.

Among the offices to which the pope appointed Raphael was that of inspector general of antiquities, the first known attempt to place under legal authority all ancient objects excavated on purpose or by chance. The so-called Golden Age of Leo X produced as perhaps its most delightful monument the Villa Farnesina, then overhanging the Tiber, built to the order of the pope's banker Agostino Chigi, an important personage considering the huge financial demands of the Medici court. Raphael, his pupils, and other High Renaissance painters decorated room after room with frescoes entirely devoted to scenes from Classical antiquity, completely pagan in subject. In the *Galatea* (fig. 812), of about 1513, he shows the sea nymph in triumph on a shell drawn by dolphins and attended by sea nymphs and Tritons. Above her three winged Loves draw their bows in a useless attempt to inflame her heart with passion for the Cyclops Polyphemus, who is pictured in a neighboring fresco by another painter. Raphael's figure-eight form underlies the entire composition. Galatea, in her physical abundance, little resembles the slender Venus of Botticelli. She stands in a Hellenistic contrapposto pose, in the plenitude of her powers, as do the other figures, male and female, whose white or tanned anatomies glisten against the green sea. Raphael has obviously adopted the Michelangelesque heroic muscular ideal.

The identical figure-eight composition was employed by Raphael for a diametrically opposed purpose in one of his last and greatest paintings, the *Transfiguration* (fig. 813), painted in 1517 for the Cathedral of Narbonne, of which Cardinal Giulio de' Medici was bishop. The completed painting was so powerful, however, that the cardinal kept it in Rome. In contrast to the traditional renderings of the subject (see that by Bellini, fig. 736), Raphael painted an accompanying incident as well, told by Matthew and Luke. When Peter, James, and John had accompanied Christ to the top of a high mountain, the remaining Apostles were unable without his presence to cast out the demons from a possessed boy. The lower section of the figure eight is composed of the agitated and distraught figures of the Apostles and the youth (in part executed by Raphael's pupils) plunged into semidarkness, with shadows of fantastic blackness, lit only from above. The upper loop is composed of Christ, Moses, Elijah, and the three Apostles. Christ and the prophets soar in the air as if lifted up

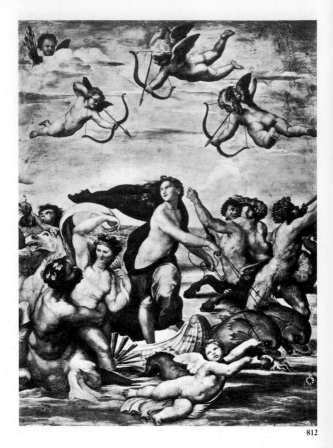

812

812. RAPHAEL. *Galatea*, fresco, Villa Farnesina, Rome. c. 1513

813. RAPHAEL. *Transfiguration*. 1517. Panel painting, 13'4" × 9'2". Pinacoteca, Vatican, Rome

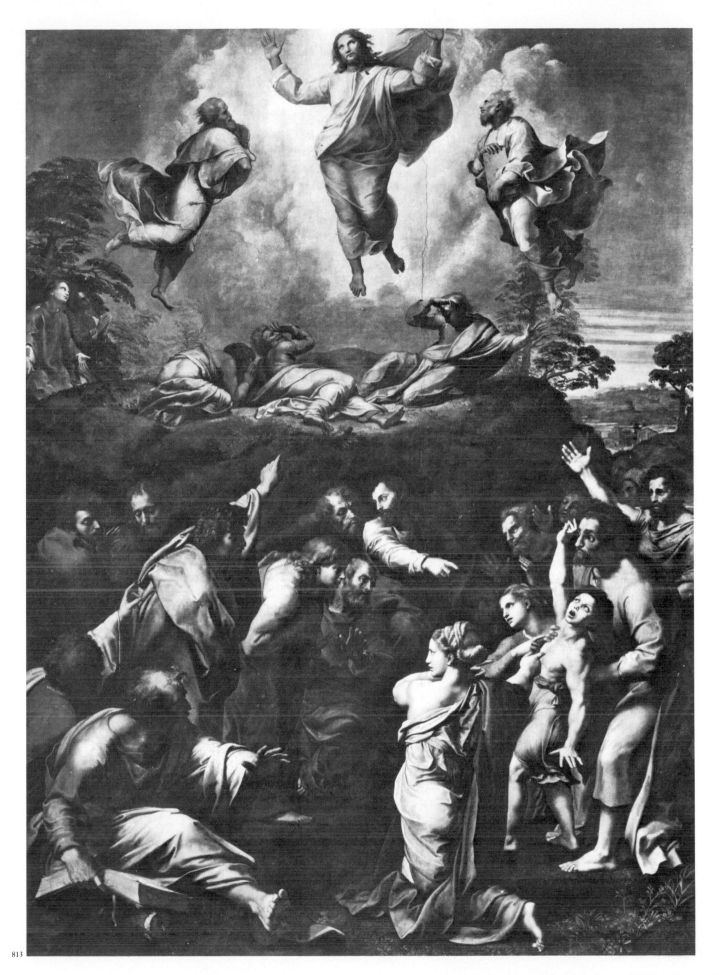

813

by the spiritual experience, their garments agitated as if from the center of brightness, which is Christ, came not only light but also the wind of the spirit, which has also cast the Apostles to the ground in terror. They, too, have fallen in Raphael's spiral poses.

Raphael, who at this point in the High Renaissance had at his fingertips the full resources of natural light, apparently no longer felt any need to distinguish it from spiritual light (gold rays are gone forever). Raphael may have been connected with a small group of priests and laymen called the Oratory of Divine Love, which, in the pagan magnificence of the Rome of Leo X, attempted to reform and rejuvenate the Church from within through frequent Communion and prayer. In this vision of Christ, shining with delicate colors through his "white and glistening" garments, Raphael may well have embodied his beliefs. The great painter died on Good Friday, April 6, 1520, at the age of only thirty-seven. At his request his funeral was held in the Pantheon and the *Transfiguration* placed above his bier; his tomb is also there, lighted only by the sky through the great round opening in the dome.

To his contemporaries Raphael's death seemed the end of an era, but a closer look shows that, in a way, the High Renaissance synthesis of Classical and Christian had already started to dissolve. Inevitably, it was an unstable equilibrium. Nonetheless the great solutions remained, on the walls of the Vatican, the ceiling of the Sistine Chapel, and in the churches and palaces of Florence and Rome. Leonardo, Michelangelo, Raphael, and Bramante left a vision of the powers of the human being—body and spirit—and the grandeur of human imagination that had not been approached since the days of the ancient Greeks. These solutions were not forgotten, but continued to inspire artists and patrons in every century after the short-lived High Renaissance itself passed into history.

MICHELANGELO AND MANNERISM

The High Renaissance in Rome and Florence was as brief as it was unpredictable—hardly more than twenty-five years from its tentative beginnings in Leonardo's *Last Supper* to the death of Raphael in 1520. A new style succeeded it, after existing for a while side by side with the latest phases of High Renaissance art. During the past two generations this new style has come to assume the name of Mannerism. The terms *Romanesque* and *Gothic* are now considered inadequate to characterize their periods, presumably because they were invented by writers of the past not fully informed about the facts. The name *Mannerism* was proposed by art historians in the twentieth century, and yet it is even less able to suggest the strange beauty and emotional depth of the art it ought to be describing. Like the terms *Romanesque* and *Gothic*, however, *Mannerism* is here to stay. Let us examine the name for only a moment before going on to an understanding of the Mannerist style itself.

Mannerism comes from the Italian word *maniera* (manner), derived in turn from *mano* (hand); it should indicate a style founded upon repetition of acquired manual techniques at the expense of new observations. True enough, in the later phases of sixteenth-century art in central Italy there is indeed much rote repetition of types and devices invented earlier, especially those of Michelangelo, but the artists involved, although numerous, are seldom of sufficient quality for inclusion in a book like this one. There is nothing mechanical about what went on in Florence, Siena, Parma, and many other Italian cities just before and just after 1520. That moment has been recognized as a genuine psychological, even spiritual crisis. For graphic evidence of this crisis we have only to compare such typical Mannerist paintings as those by Pontormo (see figs. 826, 827), Rosso Fiorentino (see fig. 828), and Parmigianino (see figs. 833, 834) with those of the great masters of the High Renaissance. Just a glance, before undertaking closer study, will show that something very strange has happened. Where in such pictures as these are the spatial depth and harmony, the beautiful arrangements of figures, the natural proportions and graceful poses, above all the mood of well-being, that we have enjoyed in High Renaissance art? In these nervous, spaceless compositions, crowded with twisting, often turbulent figures, unnaturally lengthened and sometimes arbitrarily colored, we seem to have entered a nightmare world, which comes to a special focus in the haunted or tormented expressions of the people represented. Compare also Cellini's *Perseus* (see fig. 836), heavily ornamented and dripping gore, with the noble simplicity of Michelangelo's *David*; or the structures of Vasari (see fig. 838) and Ammanati (see fig. 839), with their built-in and insoluble conflicts, with the grand harmonies of Bramante's architecture; or the later work of Michelangelo himself with the *Moses* or the *Sistine Ceiling*.

The change is real and abrupt. Obviously, the same concepts we have used for the High Renaissance will no longer describe the deeply disturbed art of the Mannerists. What can explain such a strange

phenomenon? There are, apparently, two principal causes, which eventually fused. The first was political. The Florentine Republic, while its external forms were still preserved, lost its independence to the Medici in 1512. On his election as pope in 1513, Leo X governed Florence through his brother Giuliano, and later replaced Giuliano with his nephew Lorenzo, who assumed control. After the death of Lorenzo in 1519 the rule of Florence passed to Cardinal Giulio de' Medici (on the pope's right in the Raphael portrait; see fig. 811). Conditions were dismal in Florence, and the populace resented the loss of its ancient liberties.

The second cause was religious. The split in Western Christendom grew almost daily wider and deeper. The Lutherans defied the papacy, often with reason and generally with success. Much of central and northern Europe went over to Protestantism and Luther had many followers even in Italy. The universal authority of the Roman Catholic Church was thus discredited, and one of the major bastions of spiritual strength in the Western world irretrievably weakened. When Giulio de' Medici became pope as Clement VII in 1523, after the brief pontificate of the Dutch Adrian VI (1522–23), religious and political causes became one. Clement's political machinations brought upon the papal city a scourge that had not been experienced since the days of the barbarians: armies supposedly owing allegiance to Emperor Charles V, but actually out of control, sacking Rome in 1527; German Lutherans and Spanish Catholics outdoing each other in acts of cruelty and greed; and much of High Renaissance Rome reduced to wreckage. The pope himself, a prisoner in Castel Sant'Angelo, escaped to Orvieto, where he lived under beggarly circumstances and from which he returned to an impoverished Rome.

It was painfully obvious that not only Florence but all of Italy—even the Church itself—had lost its liberty. Italian politics, including those of the papacy, were dictated by Charles V, not only as emperor but as king of Spain, the Netherlands, Milan, Naples, and Sicily, not to speak of most of the New World. In this atmosphere of gloom, economic ruin, disappointment, and foreboding, the new style developed. No wonder that so many aspects of Mannerism suggest the art and spirit of our own troubled times. The authoritarian religiosity of the Counter-Reformation, formalized in the proceedings of the Council of Trent (beginning in 1545 and continuing off and on until 1563), promised a solution, but only by surrendering most if not all of the conquests of Renaissance humanism.

814. MICHELANGELO. *Tomb of Giuliano de'Medici.* 1519–34. Marble. Medici Chapel, S. Lorenzo, Florence

815. MICHELANGELO. *Tomb of Lorenzo de'Medici.* 1519–34. Marble. Medici Chapel, S. Lorenzo, Florence

Although Michelangelo retained his own individuality and shunned some of the extremes of younger Italian artists, his overpowering presence in Florence from 1516 to 1534 inevitably meant that much of the new style would be derived in one way or another from his art. In fact, the real moment of crisis, just before 1520, was seen largely through the eyes of the "divine Michelangelo" (he was sometimes addressed that way in letters!). Before turning to the works of his younger contemporaries, therefore, we must follow the rest of Michelangelo's development.

THE MEDICI CHAPEL This was the very period when Michelangelo, despite his republican sympathies, found himself working for the Medici on a funerary chapel, begun in 1519 for the entombment of Lorenzo the Magnificent, his murdered brother Giuliano, and the two recently deceased dukes, also confusingly named Giuliano and Lorenzo, son and grandson respectively of Lorenzo the Magnificent. The Chapel was built as the right-hand sacristy of San Lorenzo, symmetrical in plan with the left sacristy by Brunelleschi (see fig. 665). Michelangelo's more or less Brunelleschian architecture of white walls and *pietra serena* supports and trim encloses the only tombs ever completed, those of the two dukes. Each tomb is a marble architectural composition, incommensurable with the enclosing architecture (figs. 814, 815). In simple rectangular niches sit the two dukes, dressed in Roman armor in their roles as captains of the Roman Catholic Church. The statues are idealized because Michelangelo said that a thousand years from now no one would know what the dukes had looked like and because he wanted to give them the dignity that belonged to their positions. The ornamental tabernacles on either side of each niche remain blank, although they may have been intended for statues.

The strangely shaped sarcophagi appear to have been split in the center to allow the emergence of the ideal images of the dukes. On either side recline figures of the times of day, Night and Day under Giuliano (fig. 814), Dawn and Twilight under Lorenzo (fig. 815). A theory to the effect that these statues were not made for their present positions has recently gained some support; Michelangelo's drawings for the tombs show how the tomb architecture and these very figures were developed together from early stages in his imagination. The compositions should, however, be completed by reclining figures of river gods, their feet pointing inward, in the empty spaces at right and left below the tombs. According to the sculptor's own explanation, written on a sheet of drawings for architectural details, Night and Day, who have brought the duke to his death, are subject to his revenge, for in death he has slain them. In other words the timeless symbol of princely power that the dukes represent has conquered the powers of time (the times of day) and of space (the four rivers). It is especially significant that when Michelangelo was engaged on this work glorifying Medici power, the Sack of Rome destroyed temporarily the power of his Medici patron; the republic was revived for the third and last time, and Michelangelo was placed in charge of its defenses. The ambivalence of his position must have been painful to the artist, who, when the Medici troops reentered the defeated city in 1530, escaped assassination only through the personal intervention of the pope.

In the languid figure of Giuliano the conviction and power of the Sistine Ceiling are absent. Muscular though the duke may be, he seems overcome by lassitude. Night, her body and breasts distorted through

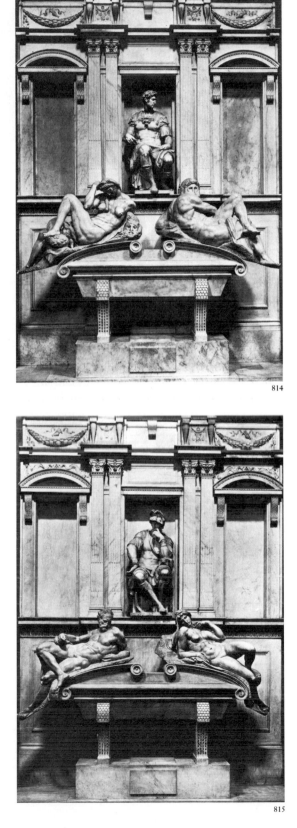

814

815

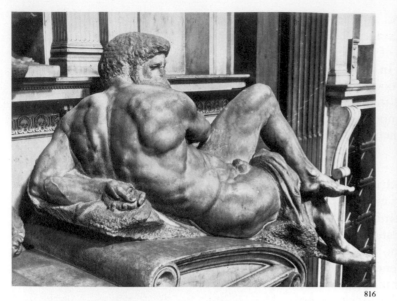

childbirth and lactation, a grinning mask (symbol of false dreams) below her shoulder, and an owl under her leg, is contrasted with the mighty Day (fig. 816), probably Michelangelo's most heavily muscled figure, turning in a gigantic motion as if to throw off his covers and arise to do battle. Yet each of these figures is trapped in a contrapposto pose that defeats the very meaning of contrapposto, originally an attempt to endow the figure with complete freedom of motion. For all their immense power, the statues of the Medici Chapel seem their own prisoners. A tragic view of human destiny has superseded the triumphant faith of the Sistine Chapel, and it is no wonder that the project, intended eventually for paintings as well, was never finished. Michelangelo continued work until Clement's death in 1534 and then, in fear of the wicked Duke Alessandro, departed for Rome, never to return, leaving such a passage as the head of Day barely blocked out and the statues strewn about the Chapel.

THE LAURENTIAN LIBRARY At the same time as his work on the Chapel, however, and beginning in 1524, Michelangelo was designing for Clement VII a library (to be placed literally on top of the Monastery of San Lorenzo) to contain the Medici collection of books and manuscripts. The reading room can be seen through the entrance door; it is divided into a succession of equal bays by continuous rows of pilasters, ceiling beams, and floor ornaments. The entrance hall (fig. 817), too high and narrow to be photographed in its entirety, is even more extraordinary, for the columns that should support the entablature are withdrawn into recesses in the wall, segments of which, bearing empty tabernacles, protrude between them. The effect is menacing, like the collapsing room in Poe's *The Pit and the Pendulum*. These columns that support nothing are themselves apparently supported by floating consoles. The narrow pilasters flanking the tabernacles are divided into three unequal segments, each differently fluted, and taper downward like Minoan columns (which Michelangelo never could have seen). Architecture as anticlassical as this would have shocked Alberti, Brunelleschi, and Bramante, but Vasari delighted in it, since it showed that Michelangelo was superior to Classical rules.

The strangest of all the spaces of the Laurentian Library would have

816. MICHELANGELO. *Day*, from the *Tomb of Giuliano de'Medici*. Designed 1521; carved 1524–34. Marble, length 80¾″. Medici Chapel, S. Lorenzo, Florence

817. MICHELANGELO. Entrance Hall, Biblioteca Medicea Laurenziana, S. Lorenzo, Florence. 1524–33; staircase completed 1559

been the never-built rare-book room at the far end of the reading room. The only remaining area was a triangle; undaunted, Michelangelo planned to turn it into a triangular room, perhaps the only one ever designed, with two triangular reading desks fitting one inside the other and encompassing a V-shaped one like a maze. For nearly a quarter of a century the library was left with a temporary staircase; Michelangelo finally sent to Vasari in 1557 the design for a permanent version from Rome, which he said had occurred to him in a dream—hardly a pleasant one, to judge from the result. While the central staircase with its bow-shaped steps seems to pour downward, ascending lateral stairs besiege it from either side. Walking up or down this amazing structure is an experience so disturbing as to leave little doubt that the harmonies of the High Renaissance have been left far behind.

LAST JUDGMENT The poverty-stricken Rome after the Sack of 1527 was very different from the splendid capital of the High Renaissance. The building of Saint Peter's was at a standstill. In 1534 Clement VII asked Michelangelo to paint the Resurrection on the end wall of the Sistine Chapel to replace two frescoes and an altarpiece by Perugino from the cycle commissioned by Sixtus IV in 1481. After Clement's death later that year, the new pope, Paul III (see fig. 850), the leader of the Counter-Reformation and initiator of the Council of Trent, ordered instead a huge fresco on an appropriate subject for the period, the *Last Judgment* (fig. 818), painted from 1536 to 1541. In order to paint it, Michelangelo had to utilize the whole end wall, thus mutilating his own masterpiece, the *Sistine Ceiling*, by tearing down the two lunettes that contained the first seven generations of the ancestry of Christ. He conceived the fresco according to the account in Matthew 24:30–31:

> And then shall appear the sign of the Son of man in heaven: and then shall all the tribes of the earth mourn, and they shall see the Son of man coming in the clouds of heaven with power and great glory.
> And he shall send his angels with a great sound of a trumpet, and they shall gather together his elect from the four winds, from one end of heaven to the other.

The earth below has been reduced to just enough ground to show the dead rising from their graves. A great circle of figures rises on the left toward Christ, following the commanding gesture of his left hand, and sinks on the right away from him in obedience to the gesture of damnation of his raised right arm. There are no thrones nor any of the other machinery of a traditional Last Judgment scene, and since, originally, all the male figures were nude, the dominant color is that of human flesh against slate blue sky and gray clouds. To Michelangelo there was nothing improper about so much nudity in such a place, but given the prudery of the Counter-Reformation, he came under severe attack, and one of his pupils was eventually summoned to paint bits of drapery here and there.

The massive figures show little of the ideal beauty of those Michelangelo had painted on the ceiling more than twenty years before. The scale changes sharply with the rising levels; the lower figures, emerging from their graves at the left or pushed from the boat crossing the Styx at the right, are hardly more than half the size of the next rank of ascending

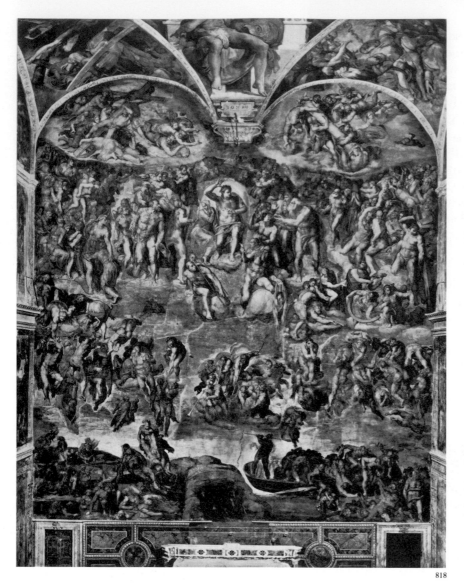

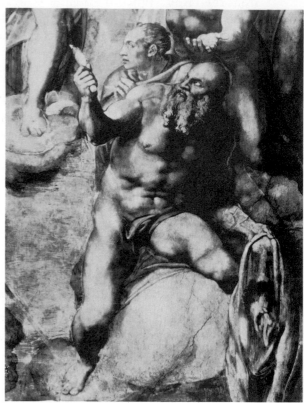

or descending figures, which are about on a level with the wall frescoes; the group of saints and blessed surrounding Christ, on a level with the windows, are almost twice the size of the figures below them. Finally, the scale diminishes again for the mighty angels in the two lunettes, bearing aloft the Cross and the column.

In contrast to the delicate, slender Christ of the *Pietà*, the Heavenly Judge is a giant, immensely powerful, his raised right arm dominating the entire scene. The mood of awe and doom and the artist's own sense of guilt become clear in the figure of Bartholomew (fig. 819), who was martyred by being flayed alive. Michelangelo has turned him into a portrait of the poet Pietro Aretino, who, despite his own authorship of scandalous sonnets, was the artist's bitterest critic of the nudes in the *Last Judgment*. Even more unexpected, the face of the empty skin dangling from the Apostle's left hand is a self-portrait of the aging Michelangelo in a moment of torment. As a final reminder of the Last Judgment, Hellmouth—a dark cavern in the rock—opens directly above the altar where the celebrant at Mass might be the pope himself. The *Last Judgment* set the pattern for many imitations, but none were so devastating because only Michelangelo could handle the human body with such authority, communicating to the tortured poses the inner tragedy of the spirit.

818. MICHELANGELO. *Last Judgment*, fresco, Sistine Chapel, Vatican, Rome. 1536–41

819. MICHELANGELO. *Saint Bartholomew* (detail of *Last Judgment*)

820. MICHELANGELO. Elevation of St. Peter's, Vatican, Rome (Engraving by Étienne Dupérac). The Metropolitan Museum of Art, New York. Harris Brisbane Dick Fund, 1941

821. MICHELANGELO. Plan of St. Peter's, Vatican, Rome. 1546–64

822. MICHELANGELO. St. Peter's, Vatican, Rome (view from the southwest)

823. MICHELANGELO. Campidoglio, Rome. 1538–64 (Engraving by Étienne Dupérac, 1569)

SAINT PETER'S In 1546 the artist, then seventy-one years old and in poor health, accepted without salary the greatest of his architectural commissions, the continuation of the building of Saint Peter's, which had been left untouched for so long that trees were growing out of the four great arches built by Bramante. Other architects had proposed extensive changes in the plan, but Michelangelo brought it back to the general dimensions laid down by Bramante, at the same time simplifying it greatly. A comparison of his scheme (fig. 821) with Bramante's plan (see fig. 802) shows the differences. Michelangelo eliminated the corner towers and porticoes, doubled the thickness of the four central piers, reduced the four Greek crosses to squares, and preceded the whole by a portico of freestanding columns. From the exterior Michelangelo's transformation was well-nigh total (fig. 822). His dome is a fusion of Brunelleschi's dome for the Cathedral of Florence and Bramante's design, retaining the verticality and the ribs of the one and the peristyle of the other. The result is a peristyle broken into paired Corinthian columns between the windows. The motive of paired supports starts from the ground, with a giant order of paired Corinthian pilasters, an attic story of paired pilaster strips, a drum with paired columns, a dome with paired ribs, and finally the paired columns of the lantern. The colossal cage of double verticals encloses firmly the stories of windows and niches, which no longer struggle against the supports as in the Laurentian Library (see fig. 817).

Instead of the light, geometrical architecture of Bramante, the appearance of Michelangelo's Saint Peter's is that of a colossal work of sculpture, whose masses are determined by the paired verticals rather than by a radial plan. This impression would have been even more powerful had the dome been completed according to Michelangelo's designs with a hemispheric inner shell and an outer shell only slightly pointed (fig. 820). He died when only the drum was completed, and his pupil, Giacomo della Porta (see below), heightened the profile of the dome considerably. Michelangelo had also intended to set colossal statues on the projecting entablatures of the paired columns of the peristyle in order to bridge the gap between their cornices and the dome. In the early seventeenth century the nave was prolonged, so that from the front the effect of Michelangelo's dome is lost; only from the Vatican gardens can this noble building be seen as the artist intended.

LAST WORKS Michelangelo's ideas are responsible for the present appearance of one of the first great civic centers of the Renaissance, the Campidoglio (Capitol) in Rome (fig. 823). His first commission was merely to build a staircase in front of the medieval Palazzo dei Senatori at the end of the piazza in 1538 and to move—much against his will—the Roman statue of Marcus Aurelius to a central position in the piazza. The refacing of the Palazzo dei Senatori and the construction of two confronting palaces were begun only in the 1560s, a little before Michelangelo's death, and do not reflect his intentions in all details. Nonetheless, the general ideas are his, especially the interlocking and radiating ovals of the pavement centering around the statue, and the giant order of Corinthian pilasters binding in, as at Saint Peter's, the smaller elements of the building masses in contrast to Sansovino's superimposed independent stories in the Library of San Marco (see fig. 858). The spatial effect is difficult to photograph and is therefore shown in a sixteenth-century engraving made before the buildings were complete, in fact, before the refacing of the tower. If Michelangelo's work can ever be described as Mannerist—and

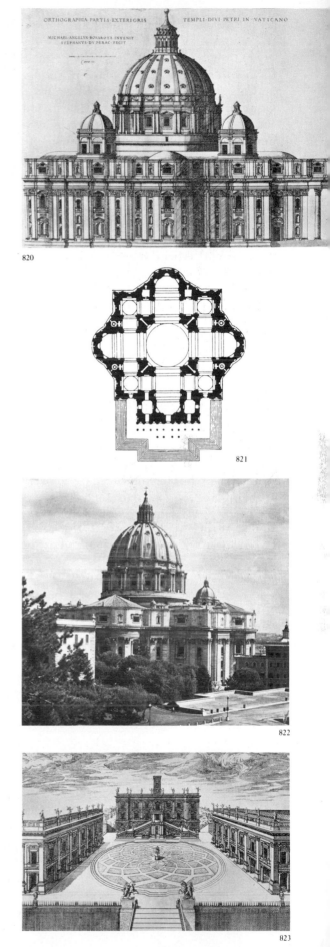

820

821

822

823

art historians are by no means agreed on this point—the powerful, positive solutions of his late architectural style certainly cannot.

During his last years, occupied with architectural projects he was too unwell to supervise in person, Michelangelo in his thoughts, his poems, and his sculpture was concerned almost exclusively with death and salvation. Many drawings of the Crucifixion and two *Pietàs* date from this final period; on one unfinished group he worked until six days before his death (fig. 824). From an earlier stage of about 1554 remain the beautifully carved slender legs, close to those of the early *Pietà* (see fig. 792), and a severed arm retained temporarily as a model for the new arm being carved below it. Rather than across her lap, as in the early *Pietà*, the Virgin holds the dead Christ up before us, as if, instead of grieving over him, she were prophesying his Resurrection. The line of the severed arm shows that the original head of Christ was hanging forward; in the last days of work Michelangelo cut it away, and began to carve a new head from what had been the Virgin's shoulder. Both figures are as slender as the early sculptures at Chartres and weightless, almost ghostly. The contrapposto, the violence, the contrasting movements have vanished; along with these vital elements mass and life itself have been dissolved. The eighty-nine-year-old artist asked the friends and pupils gathered around his deathbed to remember in his death the death of Christ, as if at the end, freed from guilt and pain, his mortality was fused in the love of the Saviour.

ANDREA DEL SARTO We now return to the moment of Michelangelo's arrival in Florence in 1516. The other Florentine artists could scarcely help but be influenced by so overpowering a personality, but one of them, Andrea del Sarto (1486–1530), remained faithful to the ideals of the High Renaissance. In his *Madonna of the Harpies* (fig. 825)—the har-

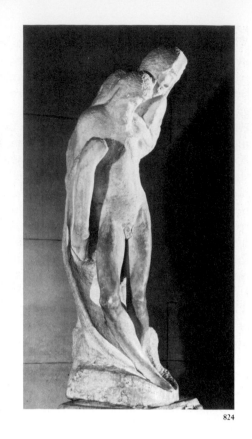

824

Painting

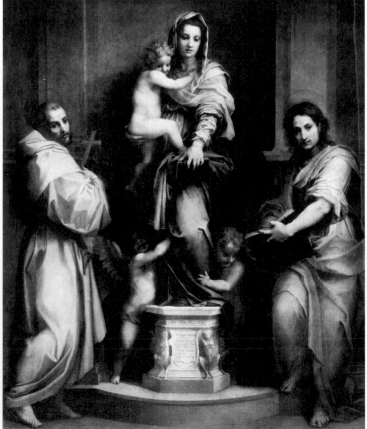

825

824. MICHELANGELO. *Rondanini Pietà*. c. 1554–64. Marble, height 63⅜". Castello Sforzesco, Milan

825. ANDREA DEL SARTO. *Madonna of the Harpies*. 1517. Oil on panel, 81½ × 70". Galleria degli Uffizi, Florence

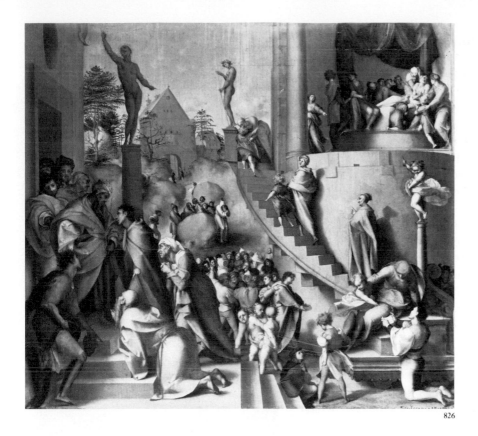

826

pies that adorn the Madonna's throne have given their name to the paint-
ing—the Virgin and Child, steadied on their pedestal by two child an-
gels, communicate something of the harmony and grace of Raphael's *Sistine
Madonna* (see fig. 810), and the figure of John reflects in reverse the pose
of the writing philosopher just to the left of the portrait of Michelangelo
in the *School of Athens* (see fig. 808). However, some of the marmoreal
quality of Michelangelo's figures is also suggested, and the folds break
into cubic masses recalling those of Michelangelo's characteristic drapery
forms in sculpture and in painting. The ideal facial types of Andrea del
Sarto, calm, grand, and often very beautiful, show in their typical mood
of reverie little of the torment that contorts the faces of his more overtly
Mannerist contemporaries.

PONTORMO A gifted pupil of Andrea del Sarto and friend of Mi-
chelangelo during this Florentine phase, Jacopo Carucci da Pontormo
(1494–1557), like most Mannerists a neurotic in this neurotic period, re-
sponded very differently to the psychic pressures of the moment. Quite
literally withdrawn, Pontormo in his later years worked in a studio acces-
sible only by means of a ladder, which he drew up on entering, closing
the trapdoor behind him, and not responding to visitors, whom he could
see through the window, sometimes even when they were his pupils and
closest friends. One of his strangest and most outspokenly Mannerist works
is a painting done in 1518, unbelievably enough while Raphael was still
alive, as one of a series painted in collaboration with Andrea del Sarto
and other eminent Florentine masters for the bedroom of a Florentine
palace. *Joseph in Egypt* (fig. 826) shows three successive scenes within the
same frame. At the upper right is Pharaoh's dream, in the center the
discovery of the cup in Benjamin's sack, and at the left Joseph's brethren
are reconciled to him. But instead of the unified space of a High Renais-
sance picture, the work is split into compartments by such devices as a

826. JACOPO PONTORMO. *Joseph in Egypt*. 1518. Oil
on canvas, 38 × 43⅛". National Gallery,
London

winding staircase to nowhere, with no balustrade and few supports, and statues gesturing like living people on columns and pedestals. The chaotic groupings of excited figures have been made even stranger by the flickering lights and darks playing over figures and drapery masses. Not only the compositional devices but also the very mood of the picture negate everything for which the High Renaissance stands.

Pontormo's *Entombment* (fig. 827), of about 1525–28, hardly seems a Renaissance picture. Once it has been established at the bottom of the picture, the ground never reappears, and there is no setting whatsoever. The figures tiptoe as in Botticelli; the towering compositional structure rises parallel to the picture plane in a web of shapes recalling Cimabue's *Madonna Enthroned* (see fig. 645) of nearly two hundred and fifty years before rather than moving harmoniously into depth in the manner of a Renaissance composition. Christ is being carried toward the tomb, yet neither tomb nor crosses can be seen. It is not clear whether the Virgin is seated or standing, or on what. Figures float upward around her with the lightness of the cloud that hangs above, curving over at the top in conformity with the forces of the frame, so designed as to amplify the upward movement of the figures. These are enormously attenuated; the bearer at the left is more than eight heads high. While the poses echo those of Michelangelo, like earthquake shocks felt on a ship at sea, the figures are devoid both of strength and substance and are deprived of their natural coloring by the adhering garments some of them wear, which look as if strobe lights were playing on them. The expressions of paralyzed wonder, rather than sorrow, contribute to the dreamlike character of the painting, poignant and lyrical, floating between earth and sky.

Rather than any specific movement in New Testament narrative, Pontormo has presented here the mystery of the Eucharist—the perpetuation of the sacrifice of Christ's body—in the Mass taking place on the altar directly below. But this essential Christian theme is no longer depicted, as in Raphael's *Disputa*, with the Scriptural passages and Christian theologians marshaled in ordered ranks to demonstrate the doctrine. Instead, Pontormo has made a direct appeal to the heart of the observer. In such pictures as these Pontormo appears as the most gifted of all Florentine painters of the period, except for Michelangelo himself.

ROSSO Even more unexpected than Pontormo is his contemporary Rosso Fiorentino (1495–1540), who painted—only a year after Raphael's death—the profoundly disturbing *Descent from the Cross* (fig. 828). Instead of centralizing the composition as in a High Renaissance picture, Rosso has dispersed the elements toward the frame, so that they make a latticework of shapes, and instead of the harmonious, spirally moving figures of Raphael, he set stiff, angular beings in the spasmodic motion of automatons. The background landscape has shrunk almost to the bottom of the picture, so that the whole structure of figures, Cross, and ladders is erected against a sky like a slab of blue-gray stone. Expressions, when we are allowed to see them, range from a look of anguish on the face of one of the Holy Women to what can only be described as a leer on that of Joseph of Arimathea at the upper left to a smile as of pleasure derived from pain on the face of the dead Christ. The nude figures look deliberately wooden, the draped ones like mere bundles of cloth. John has collapsed into broken folds like the shards of a pot; strangest of all, the prostrate Magdalene, embracing the Virgin's knees, is turned into an almost cubist construction by a sharp crease that runs down her side from shoulder to

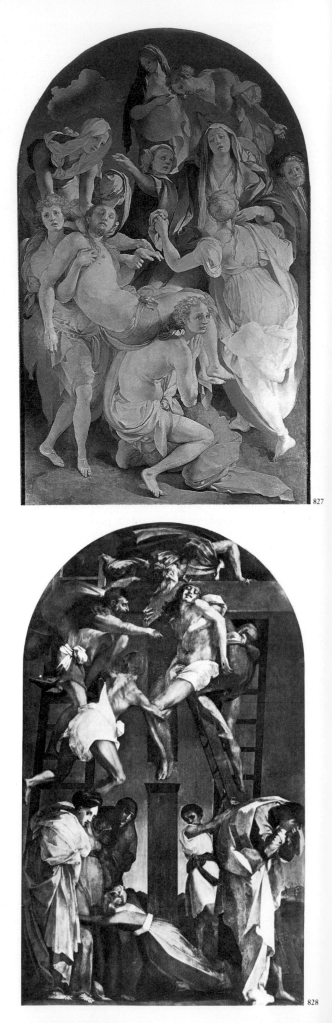

waist, from waist to knee, and then into the shadows. Even the gold sash at her waist breaks as if her body were constructed like a box.

The strangeness of both style and content in this painting—and others even more startling—together with the eccentricities of Rosso's frequently outrageous behavior give us to wonder what, if anything, he really did believe. Incapable of Pontormo's flight from unbearable reality to a spiritual refuge, Rosso seems to have responded to the desperation of this moment in history with a nihilism unprecedented in our knowledge of Christian art. Rosso suffered severely in the Sack of Rome, wandered from city to city for three years thereafter, and then went to France, where he was instrumental in founding the School of Fontainebleau.

BRONZINO The last and in some ways the most brilliant of the Tuscan Mannerists was Agnolo Tori, called Bronzino (1503–72), portrayed by his teacher Pontormo as the boy huddled on the steps in *Joseph in Egypt* (see fig. 826). Official painter at the court of Cosimo I de' Medici, duke of Florence and later grand duke of Tuscany, Bronzino developed his master's haunting style into formulas of icy refinement. His allegory painted about 1546 and formerly called *Venus, Cupid, Folly, and Time*, but more likely depicting the *Exposure of Luxury* (fig. 829), displays the ambivalence

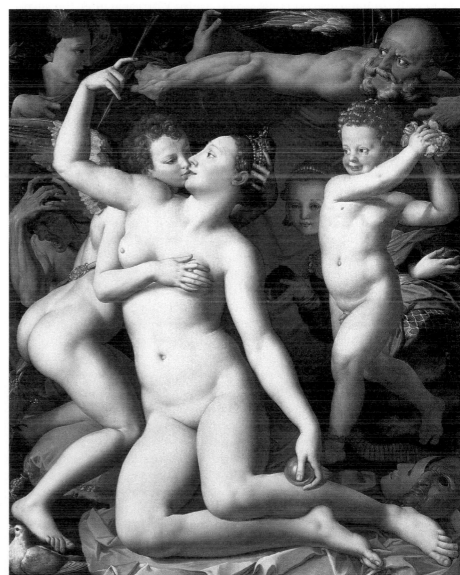

827. PONTORMO. *Entombment*. c. 1525–28. Panel painting, 10'3″ × 6'4″. Capponi Chapel, Sta. Felicita, Florence

828. ROSSO FIORENTINO. *Descent from the Cross*. 1521. Panel painting, 11' × 6'6″. Pinacoteca Communale, Volterra

829. BRONZINO. *Exposure of Luxury*. c. 1546. Panel painting, 61 × 56¾″. National Gallery, London

829

of the age in life and art. Bald, bearded Time at the upper right, assisted by Truth at the upper left, withdraws a curtain to display a scene of more than filial affection between Venus and the adolescent Cupid, pelted with roses by a laughing boy. At the lower left Venus's doves bill and coo, the old hag Envy tears her hair at center left, and at the right Fraud, a charming girl whose body ends in the legs of a lion and a scaly tail, extends a honeycomb with her left hand attached to her right arm; the message is characterized by masks, symbols of false dreams, as in Michelangelo's *Night* (see fig. 814). With magical brilliance Bronzino projects every surface, every fold, yet the substances of his nudes resemble marble more than flesh, and the hair seems composed of metal shavings. The Mannerist principle of interlaced figures seeking the frame rather than the center is brought to its highest pitch, as if to savor every lascivious complexity. Paradoxically, the very sixteenth century that repainted Michelangelo's nudes (and at the Council of Trent forbade all nudes in religious art) and condemned *Luxuria* (sensual indulgence) as the queen of vices could create and enjoy works such as this one, ordered by Duke Cosimo and presented by him to King Francis I of France, both of them delighted by what their religion told them to condemn.

CORREGGIO In Parma, a handsome city in the Po Valley, a vigorous school of painting developed unexpectedly in the sixteenth century, led at first by Antonio Allegri (1494–1534), called Correggio after the small town of his birth, and later by his younger contemporary Parmigianino. Correggio, first influenced by Mantegna and then by Leonardo, never visited Rome, but he was profoundly affected by the Roman High Renaissance, probably through works by Raphael he had seen and by engraved copies. After an uncertain start, he rapidly became a master of great importance, in fact, one of the most independent and original painters in northern Italy. Like Titian (see Chapter Six), Correggio tried to break up High Renaissance symmetrical arrangements, for example, in *Holy Night* (see fig. 830), painted in 1522. It is an Adoration of the Shepherds, the same theme as that depicted by van der Goes in fig. 763, but—for the first time—Correggio has treated the subject on a large scale with lifesize figures, entirely illuminated by the light from the Child as in Gentile da Fabriano (see fig. 696) and Geertgen tot Sint Jans (see fig. 768). The glow illuminates the soft features of the happy and adoring mother, the shepherds, and the astonished midwife, but it barely touches Joseph, the ox, and the ass against the dark sky. Far off the first dawn appears above the hills. Most unconventional is the rush of adoring angels, seen from above and from below in amazing foreshortening and exhibiting the soft, voluptuous flesh that is Correggio's specialty. As in most of his pictures, a bond of warmth and tenderness is the motive force that draws all the figures together.

Correggio was given an opportunity to demonstrate his unconventional art on a colossal scale in the frescoes of the dome of Parma Cathedral; their effect is extremely difficult to communicate in reproductions. A section of the fresco of the *Assumption of the Virgin*, 1526–30 (fig. 831), suggests the extraordinary brilliance of the young painter, who followed Mantegna's lead in dissolving the interior of the vault, so that one seems to be looking directly upward into the clouds at the Virgin borne by angels toward Heaven. The reader should mentally complete the circle of real glass windows between which, in front of a painted balustrade, move the excited Apostles; through this rim one looks upward, never

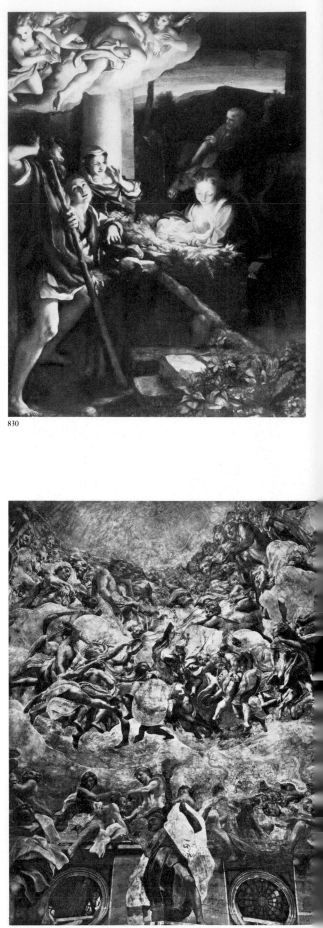

830

831

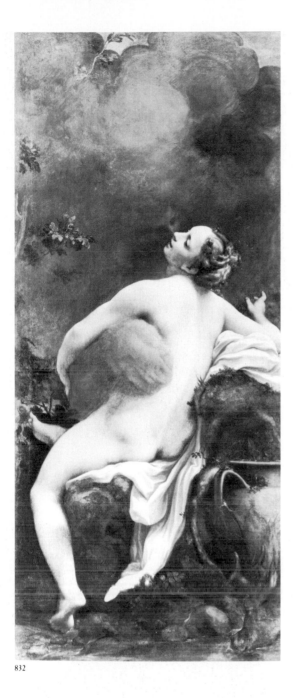

832

quite certain what is real and what is painted. Above the first circle moves a second, composed of angels uplifting clouds, past which we look into Heaven through ranks upon ranks of saints. The effect is of a colossal bouquet of beautiful legs, all seen from below in daring foreshortening. It is as if Correggio had turned Titian's *Assumption* (see fig. 846) into a cylindrical rather than a flat composition and placed the observer below it, looking up. This fresco and Correggio's other painted domes are the direct origin of the illusionistic ceilings of the Baroque (see figs. 900, 901, 927, 928).

Almost contemporary with the *Assumption* is Correggio's series of the Loves of Jupiter, painted for Federigo Gonzaga, duke of Mantua, but never delivered. To elude the jealous Juno, Jupiter visited the maiden Io in the form of a cloud; Correggio has shown us the warm, yielding Io, her face lifted in rapture in the midst of a cloudy embrace (fig. 832). The delicate quality of Correggio's flesh has never been surpassed, and, despite the strength of Venetian influence in north Italy, it retains a firm sculptural quality. The union of human and divine, frankly sensual in this uninhibited representation of physical climax, is a secular parallel to the sacred rapture of the *Assumption*. As if to emphasize Correggio's unembarrassed parallel between pagan and Christian, the stag about to drink from a spring in the lower right-hand corner is an age-old symbol drawn from Psalm 42 (41 in the Catholic Bible): "As the hart panteth after the water springs so longeth my soul after thee, O God."

PARMIGIANINO If Correggio represents a late phase of north Italian High Renaissance, almost—like the mature Roman work of Raphael—on the edge of the Baroque, his slightly younger rival, Francesco Mazzola (1503–40), called Parmigianino, was much closer to the Mannerist currents then developing in Florence and Siena; the contrast between the two leaders of the Parmesan School can be compared with that between Andrea del Sarto and Pontormo. Unlike Correggio, Parmigianino went to Rome to absorb the principles of High Renaissance style, and in fact just escaped the Sack of 1527. In 1524 the painter, then twenty one years old, executed one of the most original of all self-portraits (fig. 834), a paradigm of the Mannerist view of the world; he used the familiar convex mirror—in this case borrowed from a barber—to achieve his distorting effect, and even painted his picture on a section of a wooden sphere to complete the illusion. Jan van Eyck (and many Netherlandish imitators) had contrasted the distortions of a mirror with the correct proportions in the real world surrounding it, and although Leonardo had recommended the use of a mirror, he warned against the false reflections given by a convex one. Parmigianino has identified the distortion with the entire pictorial space, curving the sloping skylights of his studio and greatly enlarging what appears to be his right hand but is in reality his left so that it is larger than his face—which in the middle of this warped vision remains cool, serene, and detached. The work is painted with exquisite freshness of color and delicacy of drawing and touch. Contemplating this beardless youth, it is hard to convince oneself that only a few years later the gifted young painter would become a morose and bearded misanthrope. Parmigianino fled Parma in fear of a lawsuit from disappointed clients, only to die—like Raphael, at thirty-seven—in lonely poverty.

In the *Madonna with the Long Neck* (fig. 833), thus nicknamed for obvious reasons, painted between 1534 and 1540, he glories in distortion.

830. CORREGGIO. *Holy Night (Adoration of the Shepherds)*. 1522. Panel painting, 8'5" × 6'2". Gemäldegalerie, Dresden

831. CORREGGIO. *Assumption of the Virgin* (detail of the dome fresco, Cathedral of Parma). 1526–30

832. CORREGGIO. *Jupiter and Io*. Early 1530s. Oil on canvas, 64½ × 28". Kunsthistorisches Museum, Vienna

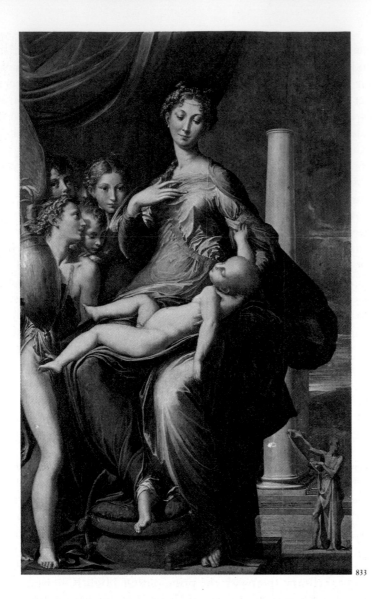

833

The Virgin is impossibly but beautifully attenuated, even her fingers represented as long and as slender as those of the Madonnas by Cimabue and Duccio (see figs. 645, 651). She looks downward with a chill prettiness—the very opposite of Correggio's warmth—at the Child, whose pose reminds one of a *Pietà* (compare fig. 792). The surfaces resemble cold porcelain, even those of the exquisite leg of the figure at the left carrying an amphora (possibly John the Baptist). Additionally, the perspective is distorted; the gaunt figure unrolling a scroll in the middle distance, perhaps the prophet Isaiah, seems a hundred yards away. In spite of the perfection to which all the surfaces of flesh, metal, stone, and drapery have been brought, the picture is unfinished. Parmigianino's drawing for the composition shows that he intended a complete Corinthian temple portico in the background, but he has painted only one of the columns, lovingly polished up to the necking band but with blank underpainting left where capitals, entablature, and pediment should be. The enigma of the unfinished painting has never been solved; possibly Parmigianino, always perverse, did not want it to be.

SOFONISBA ANGUISSOLA Although by no means the only gifted woman painter of the sixteenth century, Sofonisba Anguissola (c. 1532/35–1625) was the first to receive almost universal admiration. Under the

834

833. PARMIGIANINO. *Madonna with the Long Neck.* 1534–40. Panel painting, 85 × 52". Galleria degli Uffizi, Florence

834. PARMIGIANINO. *Self-Portrait in a Convex Mirror.* 1524. Panel painting, diameter 9½". Kunsthistorisches Museum, Vienna

prevailing circumstances, no woman could receive instruction from the human figure, but Anguissola's portraits, in which she specialized, show keen penetration into human feelings, especially those of women, and a firm mastery of brushwork in the Venetian manner (see Chapter Six for comparisons). Sofonisba was the eldest of six daughters born to a wealthy patrician in the north Italian city of Cremona, not far from Parma, where all six received special instruction in the arts. Vasari described and praised Sofonisba's work, and she even received a complimentary letter from Michelangelo. In 1559 a call to Madrid as portrait painter to the queen of Spain enabled Sofonisba to break out of Cremona into a loftier sphere. During her ten years at court, Pope Pius IV requested from her a portrait of the queen, for which he thanked her in glowing terms. In 1624, in her nineties (the only Mannerist to survive well into the Baroque period), she was painted by Van Dyck. Her *Self-Portrait at a Spinet* (fig. 835), which shows a woman of about twenty, must have been painted in the early 1550s. The artist shows herself in a strong highlight. Clearly she is proud not only of her command of the resources of painting but also of her musical ability. Anguissola is the earliest woman painter we know who was not the daughter of a painter.

835

CELLINI Mannerist sculptors were legion, but few escaped the domination of Michelangelo's personality sufficiently to become first-rate masters. One of the first to achieve partial independence was the engaging braggart Benvenuto Cellini (1500–71), whose *Autobiography* paints a vivid picture of sixteenth-century life, including the Sack of Rome in which the artist was trapped. Cellini was a skillful sculptor and metalworker.

Sculpture

836

835. SOFONISBA ANGUISSOLA. *Self-Portrait at a Spinet*. Early 1550s. Galleria Nazionale di Capodimonte, Naples

836. BENVENUTO CELLINI. *Perseus and Medusa*. 1545–54. Bronze, height 18'. Loggia dei Lanzi, Piazza della Signoria, Florence

His *Perseus and Medusa*, 1545–54 (fig. 836), like Bronzino's *Exposure of Luxury* (see fig. 829) commissioned by Duke Cosimo, shows a treatment of form that can be read as a sculptural counterpart to Bronzino's painting. Obviously influenced by the tradition of Michelangelo, the powerfully muscled figure and its elaborate pedestal are strongly ornamentalized. It is typical, perhaps, that the moment chosen—the decapitation of the dreaded Gorgon—is that when the blood gushing from her neck and severed head turns to precious coral, dripping in ornamental forms of great complexity.

837

GIOVANNI BOLOGNA The most original sculptor working in Italy between Michelangelo and Bernini was a Netherlander, Jean Bologne (1529–1608), Italianized as Giovanni Bologna. Although the identity of the subject mattered little to him, he eventually decided on the *Rape of the Sabine Woman* as the title for his colossal marble group (fig. 837) set in 1583 in the Loggia dei Lanzi, near Cellini's *Perseus*. In contrast to all earlier statues, which concentrate on a principal view to which all others are subordinated, Bologna's composition sends us constantly around the group from one view to the next; as all the figures are engaged in the spiral movement, it is impossible to choose a principal view. The way arms and legs fly off into space was, of course, a violation of everything for which Michelangelo stood, but also a dazzling display of Bologna's skill in handling marble. As the forms and spaces of Vignola and della Porta at the Gesù (see below) lead us to the brink of Baroque architecture, so does the new diffuse sculptural composition of Giovanni Bologna point toward Bernini (see Part Five, Chapter One).

Architecture

VASARI The most striking works of Mannerist architecture are those produced for princely or ecclesiastical patrons well into the sixteenth century, when Italy had recovered economically from the turmoil attendant on the imperial invasion and the Sack of Rome, and absolutist dynasties had been well established throughout the peninsula, paralleling the absolutism of the Counter-Reformation in the sphere of religion. The architectural style of Michelangelo was everywhere the dominant influence, and nowhere more strongly than in the work of Giorgio Vasari

838

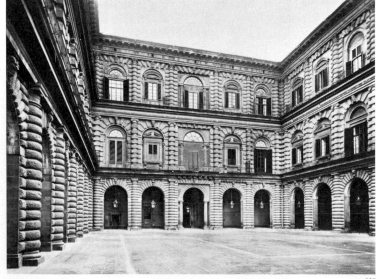

839

(1511–74), a painter of limited ability but a brilliant architect. Oddly enough, despite his activities in recording with great labor the history of the Renaissance and its fourteenth-century predecessors, as an artist Vasari is a thoroughgoing Mannerist. His solution for the Uffizi (fig. 838), a collection of preexisting structures revamped between 1560 and 1580 to house the offices of the ducal government, bears no relationship to its counterpart in Michelangelo's designs for the Campidoglio but is strongly influenced by memories of the reading room at the Laurentian Library (see fig. 817). The seemingly endless porticoes are surmounted by a mezzanine, then by a second story, and finally by what was originally an open upper portico, now unfortunately glassed in. Conceivably, one could cut the building anywhere or extend it indefinitely without altering its effect; if, as Alberti says, beauty is that to which nothing can be added and from which nothing can be taken away without damage, then the beauty of Vasari's design lies in its very endlessness. When the structure does finally arrive at the Arno, it opens in a strangely slender arch, through which one looks out not to an open prospect but only across the narrow river to the buildings on the other side.

AMMANATI A different kind of princely architecture is seen in the courtyard of the Pitti Palace (fig. 839), a fifteenth-century residence bought by Duke Cosimo I and enlarged from 1558–70 by the architect and sculptor Bartolommeo Ammanati (1511–92). The courtyard is spectacular; rather than Vasari's principle of endlessly repeated equal elements, Ammanati has superimposed on the standard succession of Doric, Ionic, and Corinthian, derived from the Colosseum, an allover rustication of all the elements except the entablatures, capitals, and bases—a kind of architectural overkill, in which every drum is enlarged in the manner of the tires in a Michelin advertisement. In its own way the effect is quite as overpowering as that of the Uffizi as an architectural symbol of political absolutism. But while these two Mannerist architects were dominant in Florence, and their style was widely emulated throughout Tuscany and northern Italy, their work was a blind alley. The Mannerist movement had come to the end of its course.

VIGNOLA Not so in Rome, where the gathering force of the Counter-Reformation, largely led by the two powerful orders of the Jesuits and the Theatines, needed a new architecture for the intense religious purposes of the times. A north Italian architect who built important churches and palaces in Rome and magnificent villas outside it, Giacomo da Vignola (1507–73) designed the most influential Counter-Reformation church plan in Rome. It was that of the Gesù, the mother church of the powerful Jesuit Order, which spearheaded Catholic revival not only in Europe but also in missionary work from Latin America to India and China. As originally built beginning in 1568, the interior was extremely austere. Its single, overwhelming, barrel-vaulted space, with paired pilasters flanking side chapels rather than side aisles, is based on Alberti's Sant'Andrea in Mantua (see fig. 676, repeated in Bramante's nave for Saint Peter's), save only for the small clerestory let into the barrel vault (the painting in fig. 840 shows the original appearance of the nave before its enrichment in the seventeenth century). The purpose of this plan, of course, was to concentrate all attention on the ceremony at the high altar. Unrelated to Michelangelo's architecture, Vignola's plan for the Gesù cannot be called

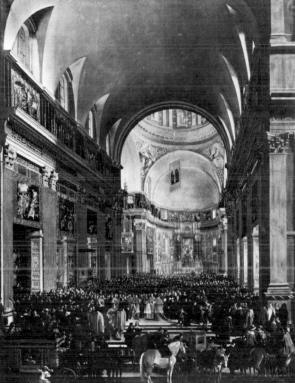

840

837. GIOVANNI BOLOGNA. *Rape of the Sabine Woman*. 1583. Marble, height 13'6". Loggia dei Lanzi, Piazza della Signoria, Florence

838. GIORGIO VASARI. Palazzo degli Uffizi, Florence. 1560–80

839. BARTOLOMMEO AMMANATI. Courtyard, Palazzo Pitti, Florence. 1558–70

840. ANDREA SACCHI and JAN MIEL. *Urban VIII Visiting the Gesù*. 1639–41. Oil on canvas. Galleria Nazionale d'Arte Antica, Rome. (Interior of the church before its pictorial and sculptural decoration)

Mannerist; neo-Renaissance might be a better term if one is needed. The new solution—really the revival of one a hundred years old—was universally adopted in the seventeenth century not only in Italy but also throughout Europe, and it became *the* Baroque plan for larger churches. But the decision was made for religious rather than aesthetic reasons. Vignola's façade plan, essentially Classicistic, was not, however, adopted.

DELLA PORTA The pupil who completed Michelangelo's dome on Saint Peter's, Giacomo della Porta (1541–1604), received the commission to design the façade for the Gesù, built from about 1575 to 1584 (fig. 841). His design was a tentative but important step in the direction of Baroque architecture, within the artistic vocabulary of Michelangelo. Basically, the scheme consists of two superimposed orders although there are no side aisles; the lateral chapels posed a similar problem and were masked by giant consoles. Coupled Corinthian pilasters enclose an inner architecture of doors, windows, and niches, increasing in concentration and projection as they approach the center. On the lower story, for example, the outside pairs of pilasters support a continuous entablature; the next is enriched by an added half pilaster (related to a device Michelangelo had invented at Saint Peter's) and more strongly projected, breaking the entablature above; and at the center of the lower story the pilasters support an arched pediment enclosing a gabled one that projects beyond it and is supported by columns in the round. The progression in projection and vitality as the elements approach the center prepares the observer for the dramatic experience of the unified interior. Like the interior, the dynamic façade prepared the way for the more richly articulated and easily moving structures of the Baroque.

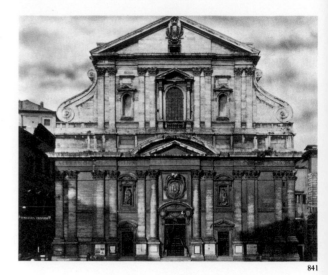

841

841. GIACOMO DELLA PORTA. Façade, the Gesù, Rome. c. 1575–84

The High Renaissance had presented perfect solutions on a fantasy plane for problems that were in reality insoluble. Under the Mannerist reaction the ideal High Renaissance system fell apart. For centralization Mannerism substituted diffusion; for harmony, dissonance; for easy figural motion, tension and strain; for emotional balance, hysteria, paranoia, or withdrawal. These are by no means symptoms of inadequacy, for the Mannerist artists were capable of extreme refinement of observation and statement. It is their hypersensitivity to the collapsing structure of the traditional Italian world of artisan guilds, merchant republics, and unchallenged Catholicism that renders their works so moving. Perhaps for that very reason they are especially accessible to us today.

THE HIGH AND LATE RENAISSANCE IN VENICE

SIX

With the exception of Michelangelo, who remained the dominant force in central Italy, artistic preeminence in the sixteenth century passed gradually from Florentine to Venetian hands. After Raphael's death, Venice was unchallenged in Europe in the field of oil painting. Politically, the Republic of Saint Mark was in by no means so favorable a position. During the papacy of Julius II, she found herself isolated, with all of Europe united against her, and temporarily stripped of her mainland possessions. By the 1520s her fortunes, like those of the other Italian states, were compromised by the continuing warfare between France and the Empire (which, under Charles V, included Venice's neighbor, the duchy of Milan). But Venice escaped the grim fate of Rome and recovered faster from the effects of the imperial invasion. Regardless of political upheavals, the Venetian School expanded in new aesthetic directions, aided by the adoption of flexible resins that made painting on canvas instead of on the traditional panels possible. Bellini survived until 1516 (see Chapter Two), still respected and productive. Under some Roman and Florentine influence, the High Renaissance style rapidly took root in Venice, even in Bellini's late works. But since Venice was the only major artistic center in Italy not to fall a prey to despotism, Tuscan Mannerism had slight influence. The increasing prosperity of the widespread Venetian empire (consisting largely of seaports throughout the eastern Mediterranean) and the success of the Venetian trade network were reinforced by the victory of Christian naval forces over the Turks at Lepanto in 1571, in which Venetian warships played a leading role. Throughout the sixteenth century there was a strong demand for grand private palaces and public buildings, whose magnificence were to make the Grand Canal the most beautiful thoroughfare in the world. In this opulent republic, dominated by wealthy merchants, there was also a special need for paintings on a wholly new scale, vibrant with a richness of color to match the splendor of Venetian life. Concomitant with their own prosperity, the oligarchs had also to meet the needs of less fortunate segments of the population, an obligation they fulfilled by commissioning huge paintings for charitable foundations. Architects and painters met the challenge of all aspects of Venetian life with new ideas for the deployment of both human figures and architectural elements, new and more energetic principles of composition, indeed, a new vision of the possibilities of art. The Florentines chided them for neglect of drawing and of form. But the Venetians were not turned inward, as were the Tuscan Mannerists, on the troubled life of the spirit, nor constrained to gratify the ambitions and tastes of absolute rulers. Rather, they were encouraged to explore highways of pictorial and architectural imagination—fortified by a continued Renaissance enthusiasm for visual reality—which opened constantly toward the future.

GIORGIONE The founder of a new and at first exclusively Venetian tendency was Giorgione da Castelfranco (c. 1475/77–1510), according to Vasari a happy and carefree personality given to a life of music and merrymaking. Among the small body of paintings attributed to Giorgione none, unfortunately, are dated. Probably about 1505, the date of Bellini's *Madonna Enthroned* (see fig. 735), Giorgione painted the same subject (fig. 842) for the cathedral of his native city of Castelfranco. At first sight the compositions are similar, but the differences are crucial. Giorgione's spacious picture is mysterious in that the Virgin and Child are placed on a high throne without visible means of access, which renders the image incommensurable with the real world, like Leonardo's *Last Supper* (see fig. 787) or Raphael's *School of Athens* (see fig. 808), in spite of Saint Francis's appeal to the observer. Also, through careful adjustments of directions, such as the parallelism between the lance of Saint Liberalis in his gleaming armor and the diagonals in the Virgin's robe, Giorgione unified his composition beyond the stage of Bellini. The landscape, seen over the low wall, dominates the picture, from the partially ruined castle at the left to the trees and port scene at the right. The soft modeling of the gracious and simplified faces is even broader than that of the aged Bellini in its reliance on light and shadow rather than on definition of forms.

Giorgione's most influential picture, painted about 1505–10, is a small canvas called *The Tempest* (fig. 843), showing a landscape in which a soldier, leaning on his lance, gazes quietly toward a young woman, insufficiently draped in a towel, who nurses her child as she looks out toward us. Scholars have ransacked literature in vain for the subject. The futility

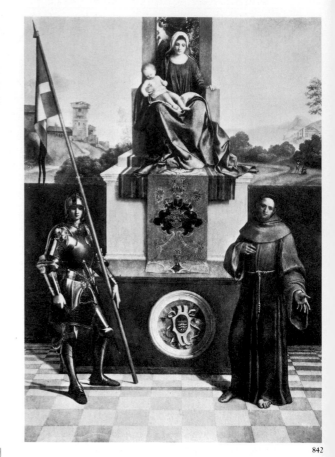

842

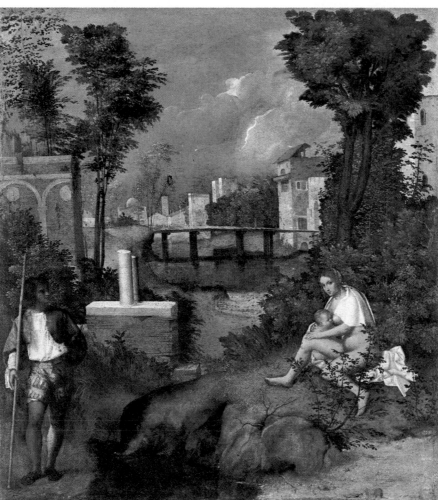

843

842. GIORGIONE. *Enthroned Madonna with Saint Liberalis and Saint Francis.* c. 1505. Panel painting, 78¾ × 60". Cathedral of Castelfranco

843. GIORGIONE. *The Tempest.* c. 1505–10. Oil on canvas, 30¼ × 28¾". Galleria dell'Accademia, Venice

of further search was indicated by the X-ray discovery of a second nude woman underneath the soldier. Moreover, a Venetian diarist in 1530 recorded the picture as "the little landscape on canvas with the tempest, with the gypsy and the soldier." Clearly, Giorgione intended us to know no more than this about the subject; it is significant that the diarist was prompted to mention the landscape first. Up to this moment we have encountered landscapes as backgrounds for figures; the roles are now reversed, and the figures are present here only to establish scale and mood for the magical landscape. Nature, around the figures, is wild, weedy, and unpruned. The air is pregnant with storm. Ruins, a river crossed by a plank bridge, and the houses of a village are illuminated by a lightning flash, which casts the shadow of the bridge upon the water. The lightning is serpentine for the first time in any painting known to us, and it looks the way lightning really looks. In this little painting, exploiting to the full the luminary possibilities of the oil medium, Giorgione established a new and immensely influential theme, which might be described as the landscape-and-figure poem.

TITIAN The monarch of the Venetian School in the sixteenth century, analogous to Michelangelo in Florence and Rome, was Tiziano Vecellio (c. 1490–1576), Anglicized to Titian. A robust mountaineer who came to Venice as a boy from the Alpine town of Pieve di Cadore, Titian was long believed to have survived well into his nineties, but recent research has shortened his life span somewhat. The young painter was trained in the studios of both Gentile Bellini and Giovanni Bellini, and then assisted Giorgione with some of the lost frescoes that once decorated the exteriors of Venetian palaces. Once independent, Titian—on the basis of the new principles of form and color announced by the late Giovanni Bellini and by Giorgione—succeeded in establishing color alone as the major determinant. He did not visit central Italy until 1515–16, when he was accorded Roman citizenship on the Capitoline Hill, but he was aware much earlier, probably by means of engravings, of what was going on in Florence and Rome, and rapidly assimilated High Renaissance innovations to his own stylistic aims. Titian generally began with a red ground, which communicated warmth to his coloring; over that he painted figures and background, often in brilliant hues. He is reported to have turned

844. TITIAN. *Sacred and Profane Love.* c. 1515. Oil on canvas, 3'11" × 9'2". Galleria Borghese, Rome

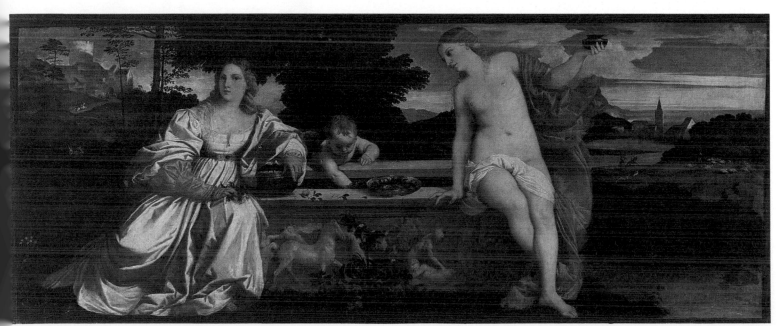

his half-finished pictures to the wall for months, then to have looked at them as if they were his worst enemies, and finally to have toned them down with glazes, as many as thirty or forty layers. Always imparting unity to the whole, these glazes became deeper and richer as Titian's long career drew toward its close.

It was a life marked by honors and material rewards. Titian's prices were high, his financial acumen the subject of caricature, and, like Raphael and Michelangelo, he made himself wealthy. His palace in Venice was the center of a near-princely court, fulfilling the worldly ideal of the painter's standing as formulated by Leonardo. In 1533 began his acquaintance with the emperor Charles V, whose rule comprised all of western Europe save France, Switzerland, central Italy, and the Venetian Republic. There is a legend to the effect that this potentate, on a visit to Titian's studio, stooped to pick up a brush the painter had dropped. Titian was called twice to the imperial court at Augsburg, and was ennobled by the emperor.

An early work, painted about 1515, is generally known as *Sacred and Profane Love* (fig. 844), although its actual subject, in spite of much research, has not been satisfactorily determined. Two women who look like sisters sit on either side of an open sarcophagus, which is also a fountain, in the glow of late afternoon. One is clothed, belted, and gloved and holds a bowl toward her body with one hand and pink roses with the other, as she listens intently to the earnest discourse of her sister, nude save for a white scarf thrown lightly about her loins and a rose-colored mantle flowing over her left arm, uplifted to hold a burning lamp against the sky. The shadowed landscape behind the clothed sister leads up to a castle, toward which a horseman gallops, while two rabbits play in the dimness; behind the nude sister the landscape is filled with light, and huntsmen ride behind a hound about to catch a hare, while shepherds tend their flocks before a village with a church tower, touched with the evening light. Cupid stirs the waters in the sarcophagus-fountain, on which is represented, to the left, a figure leading a horse and followed by attendants, and, on the right, a nude man being beaten and a nude woman grasped by the hair. A golden bowl partly filled with water rests on the edge of the sarcophagus, from which water pours through a golden spout to a plant bearing white roses. The roses and the sarcophagus filled with water are drawn from a passage in a widely read Renaissance romance, *The Strife of Love in Poliphilo's Dream*, which relates how white roses were tinted red by the blood of the dying Adonis.

What Titian's picture may refer to is the passage from virginity (symbolized by the clothed body and hands, the locked belt, the guarded bowl, the dark fortress, and the huntsman returning empty-handed) through the water of suffering, a kind of baptism through the death of the old self, to a new life in love, conceived as a sacred rite (the church spire, the lamp lifted heavenward). The picture then becomes an exaltation of the beauty and redeeming power of love in terms of the ample forms and perfect health characteristic of Titian's conception of womanhood. As compared with Giorgione's less attractive nude, Titian's glorious creation shares the Classical beauty of Raphael's *Galatea* (see fig. 812). Even the landscape, wild in Giorgione, is here subjected to discipline in the measurement of its elements. Just as characteristic of his art as the glowing colors of metal, heavy silks, white clouds, red-gold hair, and warm flesh is Titian's manner of composing the group in terms of triangles, a device that runs through his entire career.

Comparable to the pagan works that Raphael and others painted for

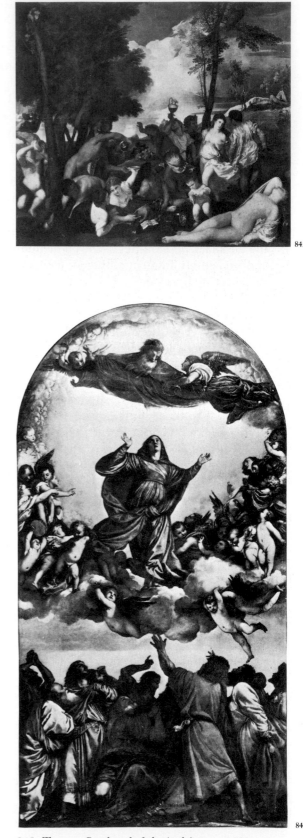

845. TITIAN. *Bacchanal of the Andrians*. c. 1520. Oil on canvas, 69 × 76". Museo del Prado, Madrid

846. TITIAN. *Assumption of the Virgin*. 1516–18. Panel painting, 22'6" × 11'10". Sta. Maria Gloriosa dei Frari, Venice

847

848

847. TITIAN. *Madonna of the House of Pesaro*. 1519–26. Oil on canvas, 16′ × 8′10″. Sta. Maria Gloriosa dei Frari, Venice

848. TITIAN. *Man with the Glove*. c. 1520. Oil on canvas, 39⅜ × 35″. The Louvre, Paris

the Farnesina in Rome is a series of mythological paintings made by Titian for a chamber in the palace of the duke of Ferrara. One of these, the *Bacchanal of the Andrians* (fig. 845), executed about 1520, is based on a description by the third-century Roman writer Philostratus of a picture he saw in a villa near Naples. The inhabitants of the island of Andros disport themselves in a shady grove in happy abandon to the effects of wine. The freedom of the poses (within Titian's triangular system) is completely new; the lovely sleeping nude at the lower right reclines in a pose later to be often imitated, notably by Goya (see fig. 1071). Titian has extracted the greatest visual delight from the contrast of warm flesh with shimmering drapery and of light with unexpected dark, such as the shadowed crystal pitcher lifted against the shining cloud and the golden light on the place deity on his hill against the dark blue sky.

Like his mythological pictures, Titian's early religious visions are warm affirmations of health and beauty. The *Assumption of the Virgin*, 1516–18 (fig. 846), is his sole venture into the realm of the colossal; it represents the moment (according to a belief not made dogma until 1950) when the soul of the Virgin was reunited with her dead body so that she might be lifted corporeally into Heaven. His dramatic composition is a Venetian counterpart to Raphael's *Sistine Madonna* (see fig. 810). Above the powerful, excited figures of the Apostles on earth, Mary—abundant and beautiful as the two sisters of the *Sacred and Profane Love*—is lifted on a glowing cloud by innumerable child angels, also rosy, robust, and warm, into a golden Heaven, where she is awaited by God the Father, foreshortened like Michelangelo's Creator in *The Lord Congregating the Waters* on the Sistine Ceiling (see fig. 797), of which the artist must surely have known. The glowing reds, blues, and whites of the drapery, the rich light of the picture, and the strong diagonals of the composition (in contrast to Raphael's spirals) carry Titian's triumphant message through the spacious interior of the Gothic Church of the Frari in Venice, upon whose high altar it still stands.

In his *Madonna of the House of Pesaro*, 1519–26 (fig. 847), Titian applied his triangular compositional principle to the traditional Venetian Madonna group (compare figs. 735, 842), breaking up its symmetry by a radical view from one side. The scene is a portico of the Virgin's palace, the actors kneeling members of the Pesaro family, including Jacopo Pesaro, bishop of Paphos, and an armored figure who presents to the Virgin as a trophy a Turk captured in battle. The steps plunge diagonally into depth, and the columns are seen diagonally, their capitals outside the frame; reciprocal diagonals in one plane or in depth, in the pose of Peter, for example, or in the angle of the Pesaro flag, build up a rich fabric of forces and counterforces. At the top clouds float before the columns, on which stand nude child angels, one seen unceremoniously from the back, bearing the Cross. As compared with other paintings of the second decade of the century, the colors have become extremely rich and deep, veiled by glaze after glaze.

One would expect Titian's portraits to sparkle with color, but this does not often happen, partly because the male costume of the sixteenth century was characteristically black. In his *Man with the Glove* (fig. 848), possibly a portrait of Gerolamo Adorno, which Titian delivered to Federigo Gonzaga, duke of Mantua, in 1527, his triangular principle is embodied in the balanced relationship of the gloved and ungloved hands to the shoulders and the youthful face. The smooth and carefully modeled hands and features are characteristic of Titian's portraits, contrasting with the ideal simplification of the heads in his allegorical and religious paint-

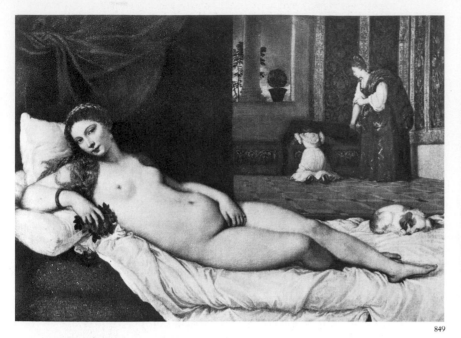

849

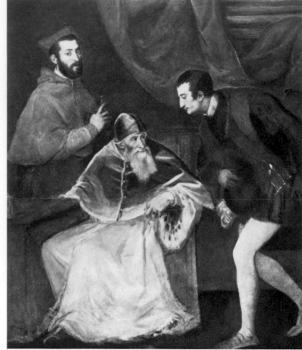

850

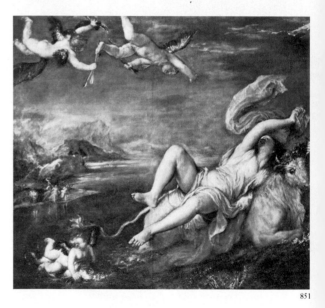

851

ings. Even in this picture, dominated by black and by the soft greenish-gray background, color is everywhere, dissolved in the glazes, which mute all sharp contrasts.

A subject that occupied Titian, and presumably delighted his patrons, in his mature and later years is the nude recumbent Venus—a pose originally devised by Giorgione. In 1538 Titian painted the *Venus of Urbino* (fig. 849) for Guidobaldo della Rovere, then duke of Camerino (the duke's eager letters refer to her only as a nude woman). Without any of the verve of Titian's earlier jubilant nudes, the opulent figure relaxes in pampered ease on a couch in a palace interior whose inlaid marble floor and sumptuous wall hangings make a golden, greenish, soft red-and-brown foil for the beauty of her abundant flesh and her floods of warm, light brown hair. Pure color, almost divorced from classical form, rules in the pictures of Titian's middle period.

In his later years form appealed to Titian even less; in fact, substance itself was almost dissolved in the movement of color. In the full-length *Portrait of Pope Paul III and His Grandsons*, painted in 1546 (fig. 850), the question even arises, as with many of Titian's later works, whether the picture is really finished, especially when compared to a central Italian High Renaissance rendering of a similar subject, Raphael's *Pope Leo X* (see fig. 811). There can be no doubt that this painting was carried to a point that satisfied both artist and patron, but as compared with the consistent surfaces of the foreground figures in Titian's early works, it is far from finished. The brushstrokes are free and sweeping, especially in the drapery, in which Titian has revived Raphael's harmony of reds. The artist has applied to the whole picture the sketchy technique characteristic of the backgrounds in his earlier works. Veils of pigment are roughly applied—with the fingers as much as with the brush, if we are to believe Titian's contemporaries—transforming the entire picture into a free meditation in color. Color, indeed, is the principal vehicle of the pictorial message.

In the paintings of his extreme old age, form was to a certain extent revived and color grew more brilliant, but always looser and freer. The old man seems to have experienced a resurgence of passion, and his late paintings of pagan subjects are unrestrained in their power and beauty.

849. TITIAN. *Venus of Urbino*. 1538. Oil on canvas, 47 × 65″. Galleria degli Uffizi, Florence

850. TITIAN. *Portrait of Pope Paul III and His Grandsons*. 1546. Oil on canvas, 78½ × 49″. Museo di Capodimonte, Naples

851. TITIAN. *Rape of Europa*. c. 1559–62. Oil on canvas, 73 × 81″. Isabella Stewart Gardner Museum, Boston

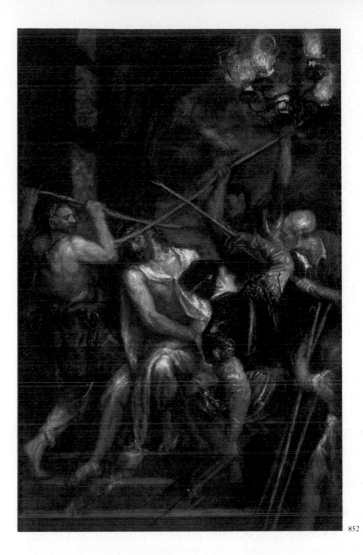

852

Like so many of the artist's later works, the *Rape of Europa* (fig. 851) was probably painted off and on during several years, in this case about 1559–62. The white bull, one of the many disguises of Jupiter, carries the distraught yet yielding Europa, in one of the most beautiful poses of Renaissance art, combining surprise, abandon, and unconscious grace, over a glittering blue-green and foam-flecked sea. Cupid floats on a dolphin, and a glittering golden fish surfaces below. The nymphs left wailing on the shore are seen against a landscape that contains no solid forms or shapes—all is dissolved in veils of blue, gold, and violet.

The same devices of rapid movement and transcendent color, ignoring detail, were used to shattering emotional effect in the very late *Crowning with Thorns* (fig. 852), probably painted about 1570, six years before the artist's death. The hail of brushstrokes creates cloudy shapes; the agony of Christ and the fury of his tormentors are expressed in storms of color. The thick masses of impasto are contrasted with the encompassing glazes to create an effect as somber as if a cloud of smoke had come before the brilliant coloring of the *Rape of Europa*. The last religious works of Titian reached a point beyond which only Rembrandt in the seventeenth century could proceed.

852. TITIAN. *Crowning with Thorns*. c. 1570. Oil on canvas, 9'2" × 5'1½". Alte Pinakothek, Munich

TINTORETTO By the middle of the sixteenth century two great painters, sharply opposed in style, temperament, and methods, disputed the field with the aged Titian. Jacopo Robusti (1518–94), called Tinto-

retto (Little Dyer) after his father's profession, was the more impulsive of the two, in fact, the most dramatic painter of the sixteenth century. Impatient with Titian's painstaking methods, Tintoretto was determined to cover as much canvas as possible with his rushing, soaring, or hurtling figures. His means could have been successful only in the hands of a painter of intense emotion and daring imagination. He began by arranging little modeled figures like puppets on small stages, or in the case of flying figures by hanging them from wires. He was thus enabled to draw the composition accurately, with the foreshortening predetermined. Then he enlarged the drawings to the enormous dimensions of his canvases by means of proportionate grids (fresco in the traditional Italian manner had been given up as hopeless in the damp atmosphere of Venice). He next primed the canvas with a dark tone, such as gray-green or deep brown, or divided it into areas of several dark hues. Once the preliminary sketch had been enlarged, he could paint in the light areas with great rapidity in bright colors, leaving the priming for the darks, and the painting would be finished save for contours and highlights. His paintings thus often look like night scenes illuminated by flashes of light.

Tintoretto advertised the drawing of Michelangelo and the coloring of Titian, but neither claim was strictly true. He has been called a Mannerist, but it is hard to find any common ground between his stormy creations and the calculated works of Pontormo or Rosso. For all their speed of execution with broad brushes (the nineteenth-century English critic John Ruskin accused him of painting with a broom), Tintoretto's paintings have an inner harmony born of their own momentum. His almost weightless figures swoop and swirl with unheard-of speed, but they never display the irresolutions and dissonances of central Italian Mannerism.

Saint Mark Freeing a Christian Slave, of 1548 (fig. 854), was Tintoretto's first brilliant success in his new style. The legend tells how a Christian slave left Provence, without his master's permission, to venerate the relics of Saint Mark in Alexandria; on his return he was condemned to have his eyes gouged out and his legs broken with hammers, whereupon Saint Mark rushed down from Heaven. The ropes were snapped and the hammers shattered, to the consternation of all, especially the master, ready to fall from his throne. Tintoretto's daring foreshortenings take up in an authoritative way what Mantegna had achieved with much labor in the *Dead Christ* (see fig. 733) and the ceiling of the Camera degli Sposi (see fig. 732). The dazzling colors against the dark priming and the summary brushwork intensify the prearranged movement of the figures, always so constructed as to achieve a tension in depth between figures pouring out of the composition and those rushing into it; Saint Mark, for example, dives in upside down and feet toward us, his figure painted with only a few rapid strokes of lighter rose and orange against the dark red priming, his head merely suggested against a sunburst of rays.

Tintoretto's style was not a matter of mere virtuosity; it sprang spontaneously from the depths of a sincere and uncomplicated personality. He had no ambition to compete with Titian's life of ease; sometimes he painted only for the cost of the materials, and he left his widow in poverty. His personal style enabled him to communicate religious experience with the force of revelation. He was an ideal painter for the societies of laypersons, the so-called *scuole* (schools), which, under ecclesiastical supervision, carried out works of charity in Venice. The walls of the hall on the lower floor of the Scuola di San Rocco, and both walls and ceilings of the great hall and chapel on the upper floor, are covered with a contin-

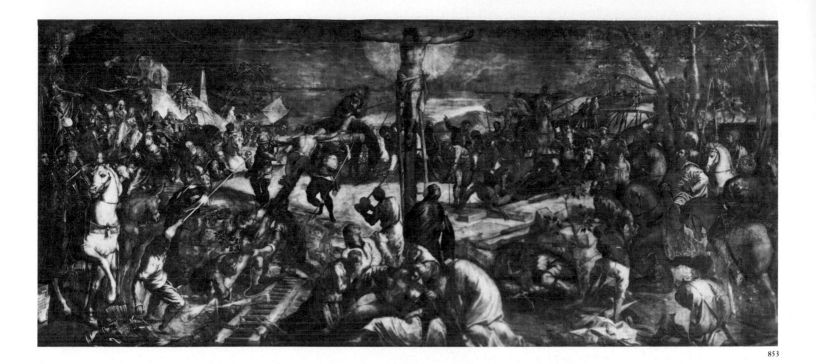

uous cycle comprising more than fifty canvases by Tintoretto, separated
only by the width of their frames, executed throughout an almost twenty-
five-year period (1564–87) for a small annual salary after 1577. These
render the Scuola di San Rocco a monument to compete with the Arena
Chapel, the *Ghent Altarpiece*, and the *Sistine Ceiling* for sustained intensity
of creative imagination.

The largest of the canvases, more than forty feet long, is the *Crucifix-
ion* (fig. 853), painted in 1565, a work of such power that no reproduction
can do it justice. The reader should attempt to imagine the enveloping
effect of the total image, stretching from wall to wall and wainscoting to
ceiling, with foreground figures more than lifesize. The Cross appears to
sustain the ceiling, at its base the swooning Mary, the comforting Holy
Women, and John looking upward form a pyramid of interlocking fig-
ures, powerfully constructed in light and dark. The turbulent crowds of
soldiers, executioners, and bystanders move about the Cross as if in the
grip of forces beyond their understanding. Rays pouring from the head
of the Crucified provide the light for the scene, the sun and moon having
been darkened at Christ's death. The ropes, the ladders, and the cross of
the penitent (but not that of the impenitent) thief move upward along
these rays, as if in fulfillment of the passage (John 12:32): "And I, if I be
lifted up from the earth, will draw all men unto me." This is indeed the
effect of the composition on all who enter the room.

Like those of Titian, Tintoretto's later works were inspired by the
intense religiosity of the Counter-Reformation, and nowhere more than
in the paintings he did in the last year of his life for San Giorgio Maggiore
in Venice, a church whose luminous beauty (see below, page 658) seems
unrelated to such outpourings. The *Last Supper* (fig. 855) breaks with the
tradition of Castagno (see fig. 710), Bouts (see fig. 761), and Leonardo
(see fig. 787). Judas is reduced to a subsidiary role on the outside of the
table, which moves into the picture in a typical Tintoretto diagonal in
depth; toward its center Christ rises in the act of distributing the bread,
which is his body, to the Apostles. In the foreground, as if to contrast
earthly with heavenly sustenance and greed with spiritual longing, the

853. TINTORETTO. *Crucifixion*. 1565. Oil on can-
vas, 17'7" × 40'2". Sala dell'Albergo,
Scuola di S. Rocco, Venice

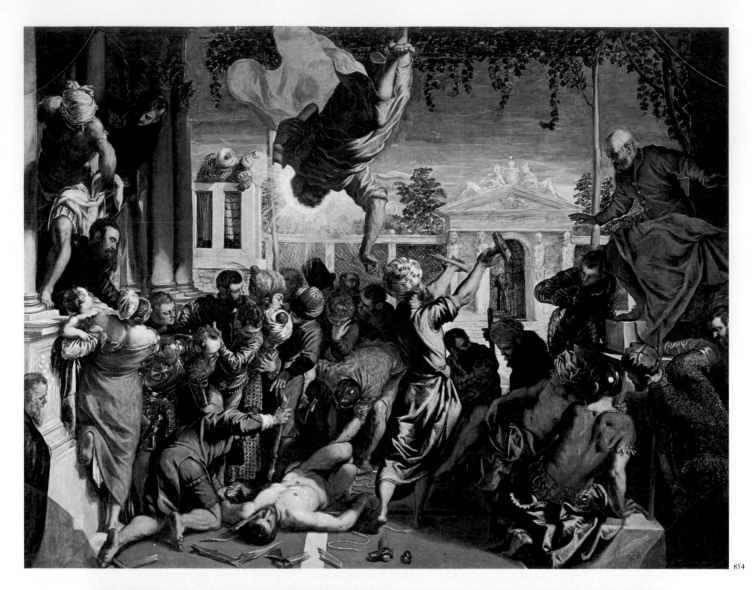

854

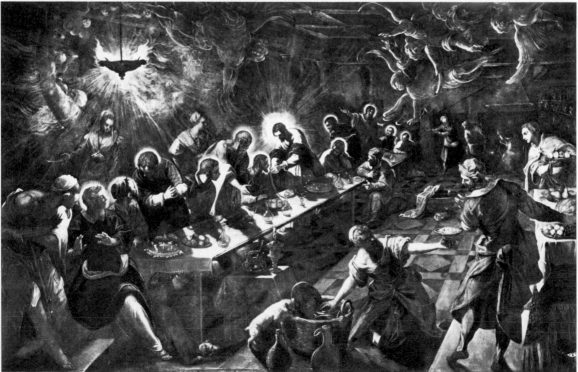

855

servants take away the uneaten food, a cat looks into the basket for tidbits, and a dog gnaws a bone. All except these foreground figures are insubstantial; the rays Tintoretto had used around the head of Saint Mark in the *Saint Mark Freeing a Christian Slave* now blaze around that of Christ; light starts like fire from the Apostles, blending with the rays from the hanging lamp. In Tintoretto's lightest of touches, angels are sketched in white strokes only, as if with chalk on a blackboard. All the substantiality and form of the Renaissance, hard-won in many an intellectual battle, are here renounced in favor of inner mystical experience, which brings us to the threshold of a new era.

VERONESE Tintoretto's chief competitor in late-sixteenth-century Venice was Paolo Caliari (1528–88), called Veronese because he came from Verona on the Venetian mainland. There is little spirituality in Veronese's works, concerned with the beauty of the material world—less landscape, which plays a minor role in his paintings, than marble, gold, and above all splendid fabrics. In contrast to Tintoretto's turbulent and dissolving world, everything in a Veronese picture appears under perfect control—solid, gorgeous, and very expensive. Venetian architecture, especially that of Sansovino and Palladio (see below), forms the setting for a succession of celebrations; in fact, Veronese is known especially for the pomp and splendor of his banqueting scenes. One of these paintings got him into trouble with the Inquisition, as the third session of the Council of Trent, 1562–63, had promulgated a series of decrees governing religious imagery. Veronese's brush with the authorities was occasioned by a canvas more than forty feet long (fig. 856) representing Christ at supper under a portico of veined marble Corinthian columns and bronze-relief sculptures intercepting a view of Renaissance (and Gothic) palaces and towers. The minutes of the trial make amusing reading. The artist was asked to justify the "buffoons, drunkards, dwarfs, Germans, and similar vulgarities" who crowded his supposedly sacred picture, and answered, tongue in cheek, that it was all a matter of the license enjoyed by artists, poets, and madmen.

854. TINTORETTO. *Saint Mark Freeing a Christian Slave*. 1548. Oil on canvas, 13'8" × 11'7". Galleria dell'Accademia, Venice

855. TINTORETTO. *Last Supper*. 1592–94. Oil on canvas, 12' × 18'8". Chancel, S. Giorgio Maggiore, Venice

856. PAOLO VERONESE. *Feast in the House of Levi*. 1573. Oil on canvas, 18'3" × 42'. Galleria dell'Accademia, Venice

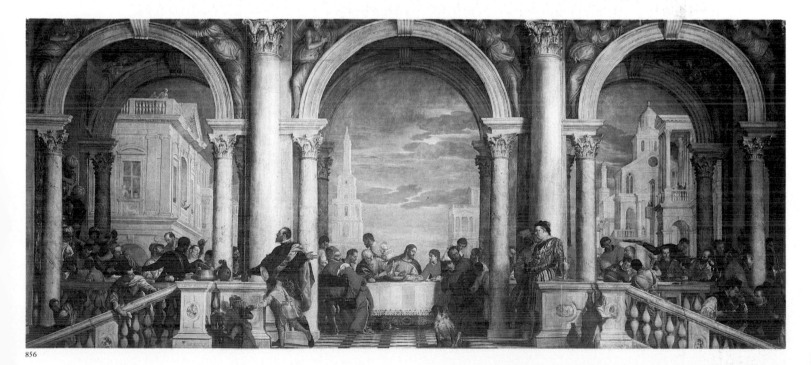

856

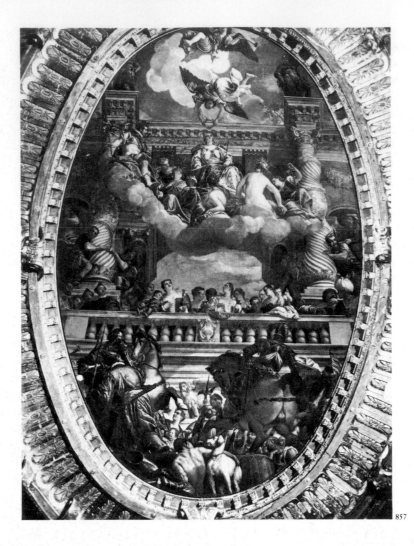

857

The Inquisitors thought they were looking at a Last Supper, so to lay all doubts to rest Veronese painted on the balustrade the number of the chapter in Luke (5:29–31) that narrates how Christ feasted in the house of Levi with "a great company of publicans and of others"—clearly casting the Inquisitors in the role of the Pharisees, who objected to his dining among publicans and sinners. Veronese was a colorist second in the sixteenth century only to Titian, although like Tintoretto he had worked out his own technical shortcuts for giant canvases. He adopted from fourteenth-century tempera technique the procedure of painting a whole area of color—the garment of one figure, let us say—in a single flat tone, then modeling highlights and shadows with lighter or darker mixtures of the same hue. His harmonies were obtained by a magical sensitivity to color relationships rather than by the overglazes that unify Titian's much smaller canvases.

Also like Tintoretto, Veronese was no stranger to the laws of perspective, which he utilized in a Mantegnesque manner. His oval ceiling decoration for the Hall of the Grand Council in the Doges' Palace, painted about 1585 with the help of his pupils (fig. 857), shows spiral columns seen from below, which carry the eye upward. Between them, above a balustrade crowded with richly dressed people, sits the allegorical figure of Venice, borne aloft on clouds, enthroned between the towers of her Arsenal, and surrounded by other allegorical figures as Fame holds a laurel wreath above her head. This work was the inspiration for many Baroque ceiling compositions (compare figs. 905, 927).

857. Paolo Veronese (and pupils). *Triumph of Venice*, ceiling decoration (oil on canvas), Hall of the Grand Council, Palazzo Ducale, Venice. c. 1585

SANSOVINO Few of the churches and palaces that make Venice one of the most beautiful cities in the world were built by Venetian architects. Until the seventeenth century Venice drew on foreign masters, generally from Lombardy. The High Renaissance architectural style was brought to Venice by a Florentine refugee from the Sack of Rome in 1527, Jacopo Tatti (1486–1570), called Sansovino after his master, the sculptor Andrea Sansovino. But Sansovino erected buildings in Venice that would have been impossible to build in the narrow streets of turbulent Florence. Moreover, the almost fleshly richness of Sansovino's buildings is so Venetian in spirit as to make us forget Sansovino's Florentine origin. His greatest achievement is the Library of San Marco (fig. 858), which he began in 1536; its construction, interrupted in 1554, was completed only in 1588, years after the architect's death. An even greater architectural genius, Palladio—who as we shall see continued the High Renaissance architecture of Sansovino on a somewhat more rarified intellectual plane—called this edifice the "richest ever built from the days of the ancients up to now."

In the two superimposed arcades that form the structure, Sansovino has translated into Renaissance terms the splendor of forms and colors of such Venetian Gothic buildings as the Doges' Palace, which the Library faces, and the Ca' d'Oro. The Bramantesque Roman Doric order of the ground story is entirely open, embracing an arcade running around three sides of the building; the second story is Ionic, and embraces a smaller order of paired Ionic columns two thirds the height of the principal ones, arranged in depth so as to flank the windows of the reading room. The vertical axes of the columns are prolonged against the sky by obelisks at the corners and by statues at every bay, interrupting the balustrade. The spandrels of the arches are sculptured with figures, and the massive frieze of the second story, interrupted by the oval windows of a mezzanine, is also decorated with figures and garlands. The great sculptural and (given the Venetian light, colored by reflections from the water) pictorial richness would provide the perfect architectural background for a Veronese feast.

PALLADIO The greatest north Italian architect of the Renaissance, indeed, the only sixteenth-century architect who ranks with Bramante and Michelangelo, was Andrea di Pietro (1508–80), known as Palladio, a nickname derived from the Greek goddess Pallas Athena and given him by his first patron, a humanist of Vicenza, a city between Verona and Padua, where Palladio was brought up. Insofar as a city can derive its character from the ideas of a single architect, Vicenza is Palladio's creation. Several of its palaces, its town hall, and its theater were built by him, and other buildings were erected by his pupils and followers. In 1570 Palladio published a beautifully illustrated work on architecture that became a kind of bible for neo-Renaissance architects everywhere, particularly in England and the United States in the eighteenth century, culminating in the designs of Thomas Jefferson (see figs. 1051, 1052).

As beautiful as Palladio's palaces are his villas, erected near Vicenza and along the Brenta Canal, which connects Padua with the Venetian lagoon. The most influential example of Palladio's villa types is the Villa Capra, nicknamed Villa Rotonda (fig. 859), begun in 1550 on an eminence above Vicenza as a summer retreat and not meant for year-round habitation. Palladio revived the form of the ancient Roman Pantheon in the central hemispheric dome, but with significant changes. The villa is

Architecture

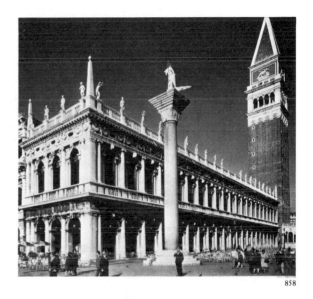

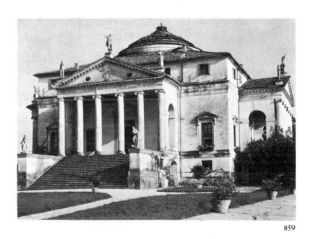

858. JACOPO SANSOVINO. Library of S. Marco, Venice. 1536–88

859. ANDREA PALLADIO (completed by Vincenzo Scamozzi). Villa Rotonda (Villa Capra), Vicenza. Begun 1550.

a square block, almost a cube, with an Ionic portico on each of its four sides affording different views over Vicenza and the surrounding sub-alpine hills. Each portico is protected against sun and wind by sidewalls pierced by arches, and the owners and their guests could therefore enjoy the views through Ionic columns according to the movement of the sun and the temperature of the day. As in the architecture of Sansovino, the axes of Palladio's buildings are prolonged by statues against the sky and, in this case, by long postaments that flank the stairs like those of a Roman temple. It has been demonstrated that Palladio's system for the proportions governing the shapes and sizes of his spaces was based on mathematical ratios drawn from the harmonic relationships in Greek musical scales; in that sense his architecture really is "frozen music."

Like Sansovino, Palladio contributed to the incomparable picture of the canal in front of San Marco, Venice. In his Church of San Giorgio Maggiore (fig. 860), begun in 1566, he at last solved the problem that had plagued architects of basilicas ever since the days of Constantine—what to do with the awkward shape determined by the high central pediment and the lower sloping side-aisle roofs. Romanesque and Gothic architects had masked the juncture with screen façades, pinnacles, and towers; Alberti had used giant consoles (see fig. 674). Palladio conceived the notion of two interlocking Corinthian temple porticoes, one tall and slender with engaged columns, the other low and broad with pilasters. His solution worked so well and became so well known that it could never be tried again without a charge of plagiarism. Visually, the relationships between the two dovetailing façades are a source of never-ending pleasure because of the alternation of low and high relief, flat and rounded forms. The interior (fig. 861) is a single giant story of Corinthian engaged columns, paired at the crossing with pilasters. Coupled Corinthian pilasters in depth sustain the nave arcade. With its contrast of stone and plaster, the interior is severely harmonious in its effect.

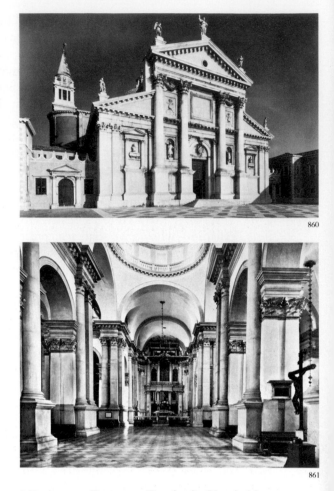

860. ANDREA PALLADIO. Façade, S. Giorgio Maggiore, Venice. Begun 1566

861. ANDREA PALLADIO. Interior, S. Giorgio Maggiore, Venice

The prolonged afterlife of the Venetian Late Renaissance is one of the most striking phenomena in the history of post-medieval art. The new pictorial and architectural standards and methods established in sixteenth-century Venice were rapidly exported to northern Europe and became dominant in the art and taste of the Catholic regions of the Netherlands in the seventeenth century and then of Protestant England and democratic America in the eighteenth and nineteenth centuries. Without Titian and Veronese, Rubens and Van Dyck are unthinkable, just as neither Christopher Wren nor Thomas Jefferson could have created their masterpieces without the example and the principles of Andrea Palladio.

CHAPTER

THE HIGH AND LATE RENAISSANCE OUTSIDE ITALY

SEVEN

Germany In the fifteenth century, Germany followed at a certain distance the great innovations taking place in Italy and the Netherlands. But in the early sixteenth century, German art moved to a commanding position, definitely surpassing that of the Netherlands in quality and inventiveness, competing with High Renaissance Italy, and at times influencing the greatest Italian masters. The sudden rise of the German School is no more surprising than its precipitate decline. All of the leading sixteenth-century German painters were contemporary with the Italian High Renaissance artists; in the second half of the century, no new artists appeared to replace them, and German art had passed its great moment.

Despite their mastery of the technique of oil painting, the Germans never understood the free Venetian interpretation of the medium or the Venetian range of coloring. Nor, try as they would, could they ever equal the Italians in their instinctive understanding of the beauty of the human body. The Classical tradition had to be imported, and was always ill at ease in a Northern environment. What the Germans did understand, and practiced with incomparable dexterity and expressive power, was line, which goes far back in the Germanic heritage, and which more immediately was exemplified in the tradition of Flamboyant Gothic architecture and in the art of engraving, at which Schongauer (see fig. 777) outshone his Italian contemporaries.

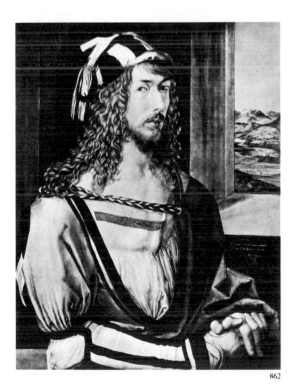

862. ALBRECHT DÜRER. *Self-Portrait*. 1498. Panel painting, 20½ × 16". Museo del Prado, Madrid

DÜRER The founder of the German High Renaissance was Albrecht Dürer (1471–1528), who, on account of the breadth of his knowledge and the universality of his achievements, is often characterized as a German Leonardo da Vinci. Yet he was not a scientific investigator in the manner of Leonardo; his research into perspective and the theory of proportion was wholly dedicated to artistic purposes. Born in the city of Nuremberg, he was raised in a tradition of craftsmanship—both his father and his maternal grandfather were goldsmiths, and he was apprenticed to a wood engraver. He shared, however, Leonardo's belief in the inherent nobility of art, which he endeavored to raise from its craftsmanly status in Germany to the almost princely level it had attained in High Renaissance Italy. He made two trips to Italy (1494–95 and 1505–7), visiting Mantua and Padua and staying for prolonged periods in Venice, but never reaching Florence, with whose intellectual activities his interests would seem to have had much in common. In fact, he absorbed the scientific, especially the mathematical interests of the Italian Renaissance masters, especially of Mantegna and Leonardo, in his studies in proportion, enriching Italian theory with a close knowledge of the Netherlanders' command of every facet of the natural world. (Oddly enough, he seems not to have shared the Italian fascination with human anatomy.) For a while, during his second Venetian sojourn, his style grew softer and his colors freer in emulation of the aged Bellini and the young Giorgione, but he never outgrew his German linear heritage and soon returned to it.

His brilliant *Self-Portrait* of 1498 (fig. 862) shows the artist at twenty-seven, three years after his return from his first Italian trip; it is one of

the earliest known independent self-portraits, and one of the finest ever painted. The artist shows himself attired in the piebald costume fashionable in the late fifteenth century (soon replaced by the sober dress of the High Renaissance), his gloved hands folded in aristocratic ease, his handsome face gazing out with calm self-possession from what appears to be a tower room, with a view over mountains and valleys. Despite the obvious Italianism of the pose, Dürer has not caught the secret of Italian form; we are everywhere conscious of lines and surfaces rather than of masses, even in the architecture. And what lines! Even Dürer's love for engraving is not enough to explain the intensity of the linear activity in the serpentine curls of the hair or in the twisted cord of the mantle whose every nuance is accurately recorded. Bellini, who in his old age was the only Venetian painter to really admire Dürer, asked him to paint something as a favor to him, and wanted to see the special brush Dürer used to paint hair. It is a strange example of the fascination of a master who had freed himself from line for the style of one immersed in it.

But Dürer's greatest achievements were always in the realm of graphic art, which, in the manner of many ventures intended for the buyer of modest means, eventually made him rich. In the very year of this self-portrait he published his series of fifteen large woodcuts illustrating the *Apocalypse* (with accompanying texts in Latin and German), which brought the technique of the woodcut to an unforeseeable level of virtuosity and expressive power. Unlike copper engraving (see page 597), in which the line is incised, woodcuts require the artist to draw his design in black on a block of wood, smoothed and painted white. All but the black lines are then cut away, leaving the lines standing in relief. A slip of the knife or a gouge cannot be repaired, so the technique requires extreme accuracy. Since in Dürer's time the blocks were printed by the same method as pages of type, woodcuts could be reproduced at considerable speed, even as illustrations for printed books incorporated in a page of text. The accepted procedure utilized the relief lines as contours only; Dürer's refinement lay in his use of lines for shading, making them resemble the parallel hatching of copper engravings. Such a page as the *Four Horsemen of the Apocalypse* (fig. 863) shows the subtlety of shading Dürer was able to achieve in the changing tones of sky and cloud and the different methods of rendering shadow on flesh, hair, and drapery. The work derives its power from the energy of Dürer's design; the four horsemen—war, conquest, famine, and death (Revelation 6:2–8)—ride in a huge diagonal over helpless humanity, drawn with a breadth of vision and a linear intensity that recall medieval art, yet fortified with the Renaissance knowledge of anatomy and drawing.

In the subtler medium of copper engraving, Dürer pushed the limits of the style even beyond those fixed by Schongauer. Dürer's *Adam and Eve*, of 1504 (fig. 864), shows his application of straight and curved hatching, cross-hatching, and stippling to Italian ideals of sculptural form and physical beauty, as well as to the menacing shadows of the forest. His interest in the religious subject seems secondary to his fascination with physical perfection; the nude Classical figures were not drawn from life but constructed after many preliminary proportion studies. They nonetheless exist in a world of dangers, by no means limited to the serpent who brings Eve the fig. The sleepy cat in the foreground has not forgotten the mouse; the distant chamois on a crag contemplates the gulf before him. Adam still holds to a bough of the mountain ash, probably signifying the Tree of Life, on which a wise parrot sits and to which Dürer has tied a tablet seen in perspective, bearing his Latinized signature.

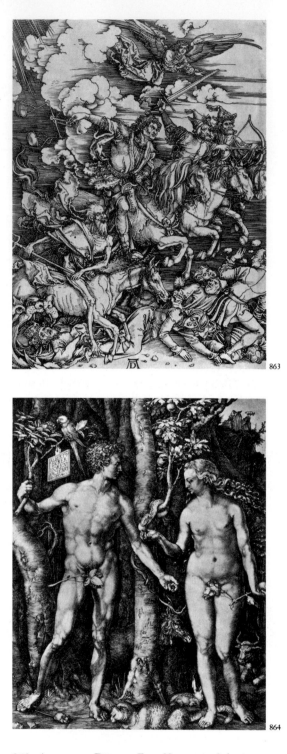

863. ALBRECHT DÜRER. *Four Horsemen of the Apocalypse*, from the *Apocalypse* series. c. 1497–98. Woodcut. British Museum, London

864. ALBRECHT DÜRER. *Adam and Eve*. 1504. Engraving. Museum of Fine Arts, Boston

865. ALBRECHT DÜRER. *Knight, Death, and the Devil*. 1513. Engraving. Museum of Fine Arts, Boston

866. ALBRECHT DÜRER. *Saint Jerome*. 1514. Engraving. The Metropolitan Museum of Art, New York

867. ALBRECHT DÜRER. *Melencolia I*. 1514. Engraving. The Metropolitan Museum of Art, New York. Harris Brisbane Dick Fund, 1943

The three so-called "master prints" of the years 1513 and 1514 show, as Dürer intended they should, that he could achieve with copper results comparable to what the Netherlanders could do with oil or the Italians with fresco or with bronze. The *Knight, Death, and the Devil*, of 1513 (fig. 865), recalls Verrocchio's *Colleoni* (see fig. 724), which was under completion when Dürer first arrived in Venice. Dürer's knight sits on a charger whose muscles ripple with all the anatomical knowledge of the Italians, but Dürer has reinterpreted the image in the light of the Christian warrior of Saint Paul's Epistle to the Ephesians, 6:11: "Put on the whole armour of God, that ye may be able to stand against the wiles of the devil." Grimly, the knight rides through the Valley of the Shadow attended by his faithful dog, impervious alike to Death, who shakes his hourglass, and to the monstrous Devil, who follows.

In contrast to the *Knight, Death, and the Devil*, which symbolizes the life of the Christian militant, *Saint Jerome*, of 1514 (fig. 866), a combined tribute to Italian perspective and Netherlandish light, depicts the existence of the Christian scholar. The saint is shown in his study, deep in thought and in writing, with the instruments of knowledge, piety, and study arranged on the window ledge and table and hanging on the wall—a skull, books, a crucifix, a cardinal's hat, an hourglass, primitive prayer beads, scissors, letters, and a whiskbroom—in an atmosphere so calm that both his tame lion and his dog are asleep. Reminiscent of the *Arnolfini Wedding* (see fig. 756) are the light from the bottle-glass window on the embrasure and the shoes put aside, for this too is holy ground.

The *Melencolia I*, also of 1514 (fig. 867), deals instead with the inner problems of the artist. The seated winged genius, invested with all the grandeur of Michelangelo's sibyls, symbolizes a special kind of Melancholy that afflicts creators; with burning eyes in a shadowed face, she sits among the useless tools of architecture, draftsmanship, and knowledge—plane and saw, a ruler, a hammer, compasses, a rhomboid, a book, a crucible, a ladder to nowhere, a tablet on which all the numbers add up to thirty-four whether one reads them vertically, horizontally, or diagonally, a chipped millstone, a silent bell, an empty purse, a sleeping dog, a child writing aimlessly, and the keys to nothing—all signifying the brooding sadness that overcomes the artist in the absence of inspiration. Her label is borne aloft by a bat below a comet and a lunar rainbow. It is no accident that in all three of these autobiographical works Dürer—in middle life—has shown an hourglass half run out.

On occasion Dürer could lift painting to the level of his beloved engraving. A brilliant example is the *Adoration of the Trinity* (fig. 868), completed in 1511 for a chapel dedicated to the Trinity and All Saints in a Nuremberg home for twelve aged and poor citizens (in commemoration of the Twelve Apostles). The lovely landscape at the bottom of the picture encloses a harbor, probably symbolic. Most of the picture is occupied by a heavenly vision: God the Father, enthroned upon a rainbow and robed and crowned as an emperor, upholds the crucified Christ against his blue tunic, while the green lining of his gold robe is displayed by angels; above, the Holy Spirit appears as a dove, and on either side angels with softly colored wings hold the symbols of the Passion. To the left kneeling and standing female martyrs, many recognizable through their symbols, are grouped behind the Virgin; to the right, Old Testament prophets flank John the Baptist. The lowest rank of floating figures includes, apparently, portraits of many still alive at the time Dürer painted the picture—popes, a cardinal, emperors, kings, and common folk; at the extreme left, bearded and with long blond locks streaming over his shoul-

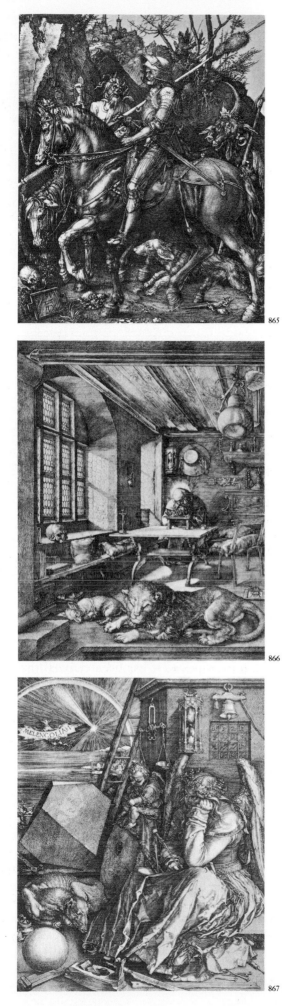

865

866

867

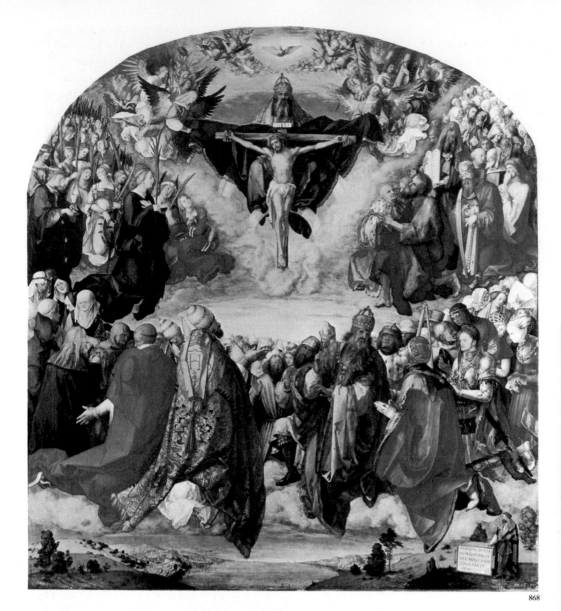

868

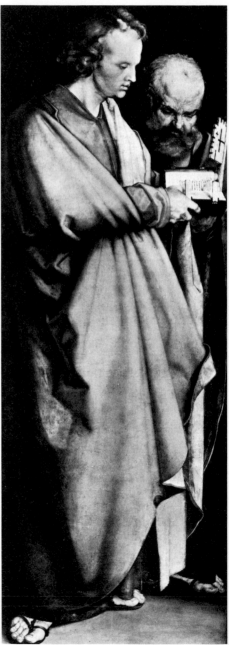

869

ders, kneels Matthaeus Landauer, one of the two patrons of the chapel. On the ground below, Dürer himself exhibits his usual tablet with its Latin inscription. It has been claimed that the picture is based on Saint Augustine's conception of the City of God, existing throughout all time, partly on earth and partly in Heaven. In its spectacle of blazing reds, yellows, blues, and greens, the *Adoration of the Trinity* can stand as one of the most beautiful religious visions of the Renaissance.

Dürer's last major work is the diptych now known as the *Four Apostles* (fig. 869), a misnomer since it represents not only the Apostles John and Peter, to the left, but also Mark, who was not an Apostle, and Paul, who only became one after Christ's death and his own conversion. These paintings were originally intended as wings for an altarpiece, whose central panel, a Madonna and Child with saints, was never painted because the rising tide of Protestantism, to which Dürer himself adhered, rendered such a picture impossible in Nuremberg in 1526. Dürer presented his panels to the city, supplying them with inscriptions from Luther's translation of the New Testament that warn all who read them not to mistake human error for the will of God. Dürer had taken his position along with Luther, against papal supremacy on the one hand and on the

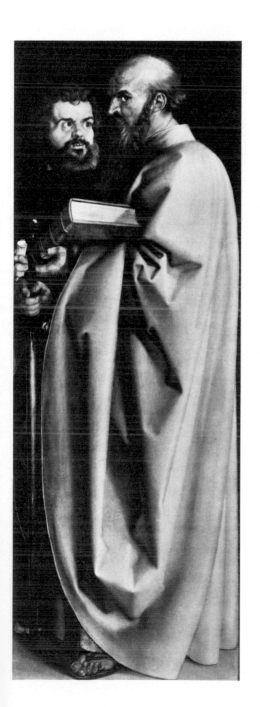

other against Protestant extremists who advocated radical experiments ranging from polygamy to a kind of communism and who instigated the Peasants' War (1524–25). The professional calligrapher who wrote the inscriptions recalled later that Dürer intended his "Four Apostles" to typify the four bodily liquids or humors—sanguine, phlegmatic, choleric, and melancholic—believed to govern the four major psychological human types. When all is said and done on this complex subject, what remains are four forthright figures of extraordinary grandeur, summing up better than anything else Dürer achieved all he had learned from the tradition of Giotto, Masaccio, Michelangelo, and Raphael.

GRÜNEWALD About Dürer's greatest German contemporary we know far less—neither the date of his birth (he died in 1528, the same year as Dürer) nor, until the present century, his real name. He was listed as Matthias Grünewald by the German writer Joachim von Sandrart in the seventeenth century, and the misnomer stands through long usage. His actual surnames were Gothardt and Neithardt. The leading humanist, Melanchthon, three years after the artist's death ranked him second only to Dürer among German masters. He may have been born in Würzburg, and worked for a while in Aschaffenburg. He was also an architect and hydraulic engineer, and remained for many years in the service of the prince-bishop of Mainz. He never went to Italy. Unlike the aristocratic Dürer, Grünewald was implicated in the Peasants' War and had to flee to Halle in Saxony, where he died. Since few of the early documents, listing only a certain Master Mathis, can be securely connected with him, guesses concerning his birthdate range from 1455 to 1483. Since the dated pictures are all within the sixteenth century, the latter date is probable.

Grünewald's greatest work is the *Isenheim Altarpiece* (figs. 870–72), probably begun in 1512 and finished in 1515 for the church of the Hospital of Saint Anthony in the Alsatian hamlet of Isenheim near Colmar, where Schongauer had lived and worked. It is a creation of such shocking intensity that many are repelled by it, yet the central *Crucifixion* (fig. 870) is one of the most impressive and profound images of the culminating tragedy in the life of Christ. The altarpiece was arranged originally in three layers, each containing pictures and sculptures (by another master) to be displayed at different seasons of the Christian year. The *Crucifixion* is on the outermost wings, visible when the altarpiece is closed. Few monumental representations make any real attempt to show the horror of the event, which is strange because devotional literature, particularly during the fifteenth and sixteenth centuries, was by no means so reticent.

Grünewald has shown the Cross as two roughhewn logs, still green, the crossbar drawn down by its dreadful weight. Christ has already expired in agony. Rigor mortis has set in; his fingers are frozen into a clutching position. The crown of thorns is a fearsome bunch of brambles, beneath which the face, contorted with pain, is greenish gray in death (fig. 871). The weight of the tormented body has drawn Christ's arms almost from their sockets. Arms, body, and legs are scarred and torn by the scourges and studded with thorns, as if Christ had been beaten by thorn switches. His feet are crushed together by a giant spike. Viscous, bright red blood drips from his wounds. Below the Cross on the right stands John the Baptist, a blood-red cloak thrown over his camel skin, and above his pointing arm his words (John 3:30) appear: "He must increase, but I must decrease."

The Lamb of God stands below, a chalice to his wounded breast. On

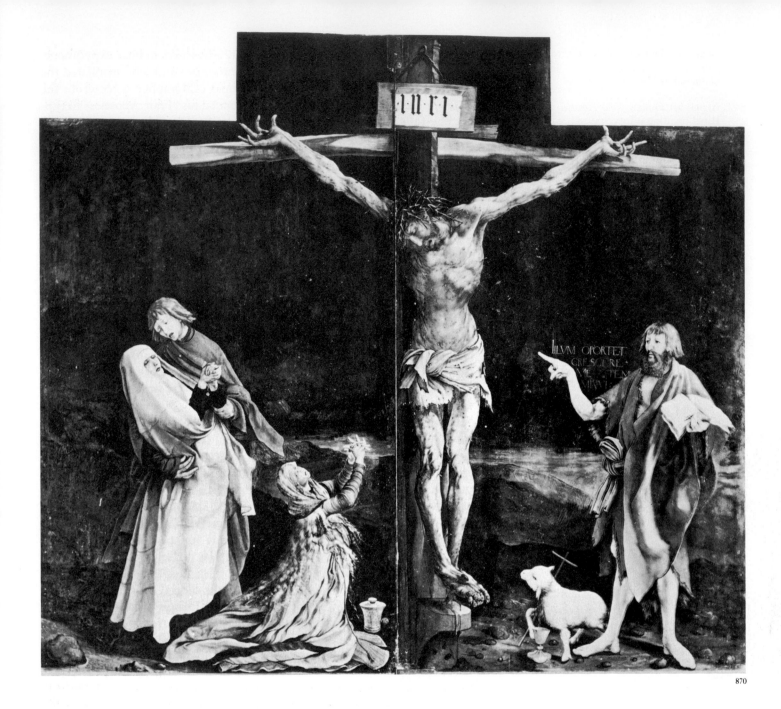

870

the left Mary Magdalene, in a transport of grief, has thrown herself at the foot of the Cross, and John the Evangelist, also in blood red, holds the swooning, death-pale Virgin. This is one of the earliest nocturnal Crucifixions; over distant hills the sky shows greenish black. While the horror of the scene can be traced to an expressionist current in German popular art and literature, indeed, as far back as the violent expressionism of German medieval works, the emphasis on the most physically repulsive details is traceable to the fact that this masterpiece was intended for a hospital church, where patients were brought before it in order to realize that Christ understood their suffering because he had suffered as they did. Only thus can we explain that Christ's loincloth is made of the old torn linen used for bandages and that Mary Magdalene's jar of ointment appears in the painting, although it relates to a much earlier scene in Christ's life. The genius of Grünewald lies in his ability to raise mere horror to the level of high tragedy and to so unify deformed and broken shapes that the final composition is as beautiful as the greatest Italian

870. MATTHIAS GRÜNEWALD. *Crucifixion*, view of the *Isenheim Altarpiece* (closed). c. 1512–15. Oil on panel (with frame), 9'9½" × 10'9". Musée Unterlinden, Colmar

work of the High Renaissance. The diagonals of the arms, for example, seem to erupt from the volcanic body as if in a gesture of self-immolation, linking the Cross to the inner angles of the T-shaped segments of the frame. These diagonals bind together all the other forces of the composition, sustaining by their positive strength the diagonals of the collapsing group at the left, of the gesture of John the Baptist, and of the distant hills. The final image is one of absolute unity and monumental grandeur.

Once the doors are open (the joint runs next to Christ's right flank), the tones of greenish black and blood red are transformed to flame red, gold, and blue (fig. 872). The left panel is the *Annunciation*, with the angel appearing to Mary in a chapel whose Gothic vaults and tracery are drawn and painted with the understanding of a trained architect. The Bible is open at Isaiah's prophecy and the Prophet himself appears in the vault above in the midst of a vinescroll in reference to another biblical passage (Isaiah 11:1): "And there shall come forth a rod out of the stem of Jesse, and a Branch shall grow out of his roots." Mary turns in terror, while the angel in his flame-colored cloak points to her with the same gesture used by John the Baptist toward the crucified Christ. Above Mary floats the dove of the Holy Spirit in a thin film of mist.

The central panel shows Mary caring for the Christ Child in the manner of a nurse for a patient before a richly carved and painted portico, symbolizing the Temple, in and before which several angels play on Renaissance viols and a viola da gamba as others sing, and a crowned saint (Catherine?) kneels in an aureole of flame. Mary holds her Child—in torn linen rags—whom she has taken from a cradle. A wooden tub covered by a towel and a perfectly recognizable chamber pot (surely its only appearance in Christian iconography) show again that Christ in his humanity took upon himself *all* the indignities of men. Yet in the heavens, far above a mass of glittering Alpine summits, the immaterial, ultimate Deity shines on his luminous throne, sending down tiny ministering angels through the blue clouds. Along with Grünewald's intensity of expression went a freedom of brushwork and color inaccessible to the tense and intellectual Dürer.

The cycle culminates in the most astonishing Resurrection in Christian art, shown in the right panel. A storm wind seems to have burst from Christ's tomb, blowing off the lid and bowling over the guards, and a flamelike apparition emerges, iridescent in blue, white, red, and gold—his graveclothes transfigured, as the patient's bandages will be—against the blue-green night dotted with stars. In the midst of an aurora borealis of red and gold rimmed with green soars the snow-white Christ, his body utterly pure, his hair and beard turned to gold, his wounds changed to rubies, surely in reference to the words of Saint Paul (Philippians 3:21): "Who shall change our vile body, that it may be fashioned like unto his glorious body." The transformation is complete; agony and ugliness have been burned away in a vision of transcendent light.

ALTDORFER A painter of great imaginative powers, closer to Grünewald than to Dürer, was Albrecht Altdorfer, probably born about 1480 in Regensburg, a Bavarian city on the Danube River, where he lived and worked until his death in 1538. His special gift was for landscape; his most celebrated painting is the *Battle of Alexander and Darius on the Issus*, of 1529 (fig. 873), in which the defeat of Darius III at the hands of Alexander the Great in 333 B.C. is seen in the guise of a "modern" battle, such as the Battle of Ravenna in 1512 or that of Pavia in 1525, the first

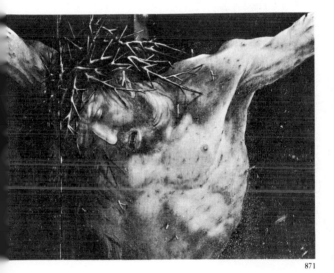

871

871. MATTHIAS GRÜNEWALD. *Christ* (detail of the *Isenheim Altarpiece*, closed)

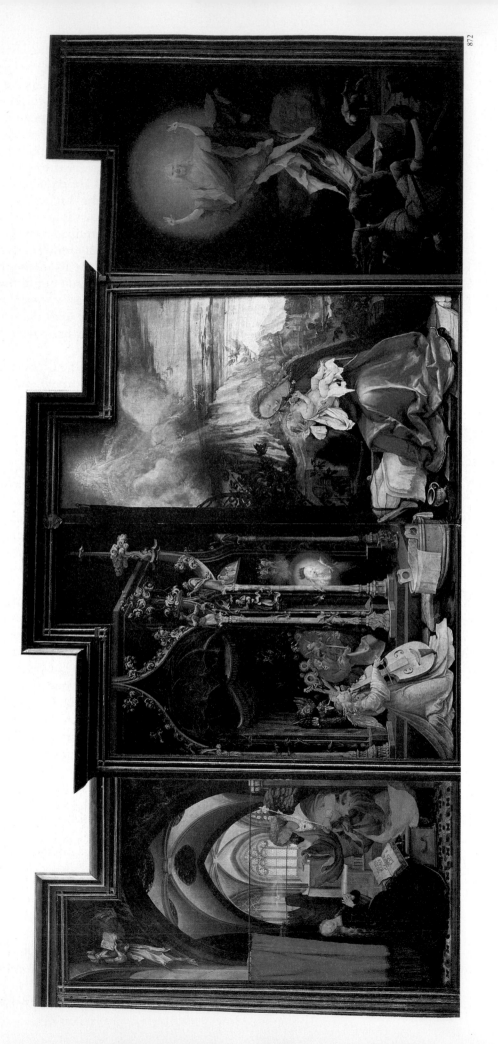

872. MATTHIAS GRÜNEWALD. *Annunciation; Virgin and Child with Angels; and Resurrection,* view of the *Isenheim Altarpiece* (open). c. 1512–15. Oil on panel, center 8'10" × 11'2½"; each wing approx. 8'10" × 4'8". Musée Unterlinden, Colmar

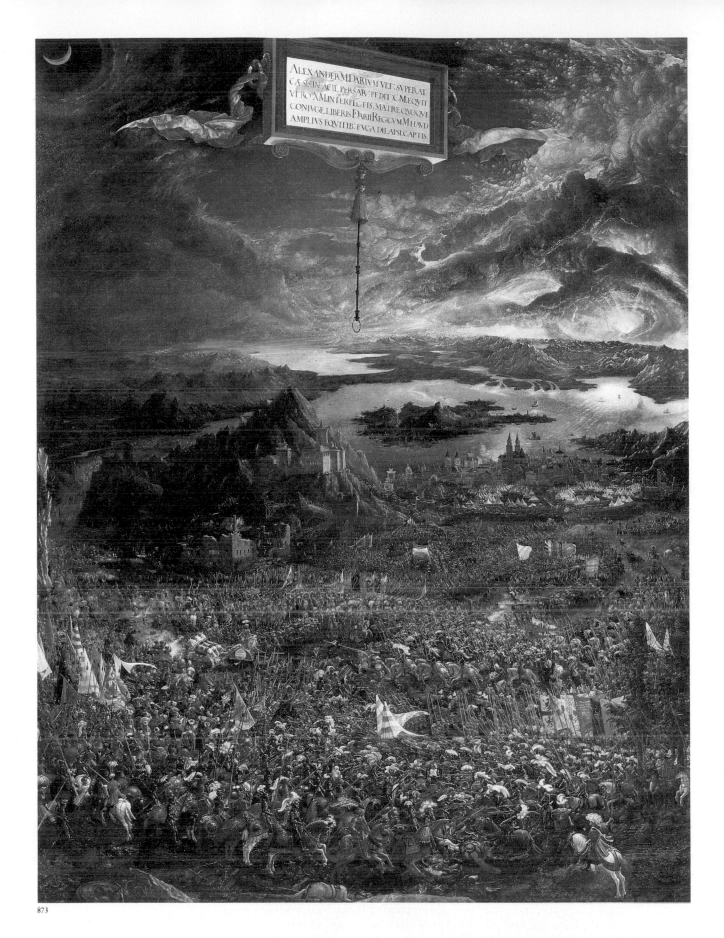

873

873. ALBRECHT ALTDORFER. *Battle of Alexander and Darius on the Issus*. 1529. Oil on panel, c. 63¼ × 48″. Alte Pinakothek, Munich

mass conflicts since late antiquity. In a picture only a little more than five feet high Altdorfer has painted so many soldiers that it would be a hopeless task to count them—doubtless there are thousands.

The picture is a complete about-face from the battle scenes by Uccello (see fig. 707) and Leonardo (see fig. 788), in which a small group of warriors pitted against each other forms the nucleus of the battle and symbolizes the whole. Altdorfer, by means of a lofty point of view as if he were in flight, has spread out before us entire armies, tides of soldiers glittering in steel armor—bristling with spears and flags—yet painted down to the last tent and the last helmet. The eye roams freely over a landscape surpassing in extent even those of Leonardo. We look over a city, castles, Alpine lakes, islands, a river delta, range beyond range—with always another row of peaks when we think we have seen the last—and finally to the sun sinking in boiling clouds, which appear themselves to be in combat, and to the moon rising on the left. The plaque with its lengthy Latin inscription and streaming drapery, like Dürer's tablets in perspective, floats as if by miracle. The accuracy of Altdorfer's panoramic vision, which could only have been obtained from a mountaintop, can be verified by any air traveler who has flown over the Alps or the Coast Ranges of California. The sparkling colors of the garments, caparisons, and flags give way before the green forests, the blue distance, and the blaze of orange and yellow in the stormy sunset.

CRANACH A charming interlude in the study of the great German painters is offered by Lucas Cranach the Elder (1472–1553), a Protestant painter and friend of Luther, attached to the court of the elector of Saxony at Wittenberg. In collaboration with his sons and pupils, Cranach in a long and productive career turned out an astonishing number of agreeable paintings. He remained a provincial; although he accepted the frank sensuality of much of Italian Renaissance art, he had no interest in such arcane matters as Classical literary texts or theories of harmonious proportion. His *Apollo and Diana* (fig. 874)—undatable like many of his pictures—should be compared with Dürer's elaborately constructed *Adam and Eve* (see fig. 864). Apollo is just a contemporary Saxon, beard and all, but minus his clothes. A slinky Diana, cuddling her right foot above her left knee, perches on a patient stag. The specialty of Cranach and his shop was the contrast of flesh, at once soft and enameled, with shaggy, wild landscape, and in this they had no peer.

HOLBEIN The last great German painter of the High Renaissance was Hans Holbein the Younger (1497/98–1543); he was also one of the greatest portraitists who ever lived. He came from a family of Augsburg painters (his father, his uncle, and his brother), but excelled them all. His wide travels included journeys in both France and in north Italy, where he was deeply influenced by the works of Mantegna and Leonardo. Nonetheless, his artistic activity was almost entirely limited to the widely separated cities of Basel and London, the last mostly after 1532, until his untimely death. From 1536 onward Holbein was the favorite painter of Henry VIII, who fitted up for "Master Hans" a studio in St. James's Palace. Although Holbein produced book illustrations by the hundreds, designs for stained glass, exterior frescoes (now lost) for houses in Basel, and a number of altarpieces, he is chiefly known for his portraits. At first he had difficulty reconciling a native interest in expressionistic wildness,

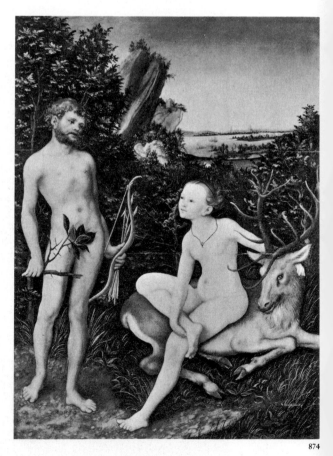

874

874. LUCAS CRANACH (the Elder). *Apollo and Diana*. Date unknown. Oil on panel. 18½ × 13¾". Gemäldegalerie, Staatliche Museen, Berlin

in the tradition of Grünewald, with his careful study of Italian art, but by the mid-1520s the synthesis had been achieved, resulting in a style of cool reserve, total control of surface and design, and a neo-Eyckian concentration on the rendering of the most minute objects. The new style was stated in terms of enameled color and a linear accuracy in which he has never been equaled. It can be counted as perhaps Holbein's greatest achievement that he transformed the Germanic linear tradition, still untamed in Dürer, into his major instrument for the conquest of visual and psychological reality.

The *Madonna of Burgomaster Meyer* (fig. 877), painted in 1526, is an early triumph of Holbein's mature style. As originally set up on the altar of the chapel of the burgomaster's castle, Gundeldingen, near Basel, the painting lacked the most distant female figure in profile, a portrait of the donor's first wife, who had died in 1511, represented with her jaws bound in death. Neither this inconvenient insertion nor the still later addition of a third kneeling woman could disturb Holbein's sense of design; he was able to work both easily into the composition. The gracious Madonna and Child, the Italianate niche, and the charming portraits of Meyer's adolescent son and nude baby boy are quite Leonardesque, but in the delineation of contour, so sensitive that it picks up the slightest nuance of form, Holbein displays the phenomenal accuracy of his vision. The flow of the Virgin's fingers, the rendering of the foreshortened left arm of the Child, and the searching definition of the burgomaster's features are the achievements of this linear analysis. Holbein went out of his way to exhibit his virtuosity in the rendering of the Oriental rug, rumpled so that every variation of its pattern had to be separately projected in perspective. By 1531, alas, the picture had become a funerary monument, for both the burgomaster and his sons were dead.

Another tour de force is the splendid *French Ambassadors*, painted in London in 1533 (fig. 875), representing the emissaries Jean de Dinteville and Georges de Selve full-length and lifesize, flanking a stand on which, along with the indispensable Oriental rug, are exhibited geographical, astronomical, and mathematical instruments, an open book of music, and

875. HANS HOLBEIN (the Younger). *French Ambassadors*. 1533. Panel painting, 81⅛ × 82¼". National Gallery, London

876. HANS HOLBEIN. *Portrait of Henry VIII*. 1539–40. Panel painting, 34¼ × 29½". Galleria Nazionale d'Arte Antica, Rome

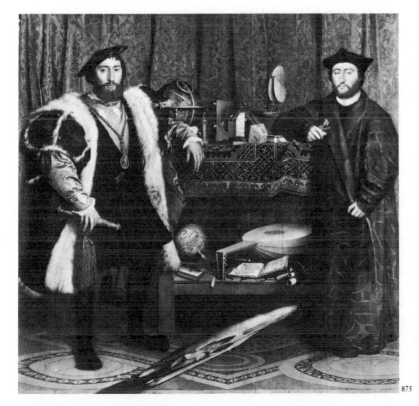

875

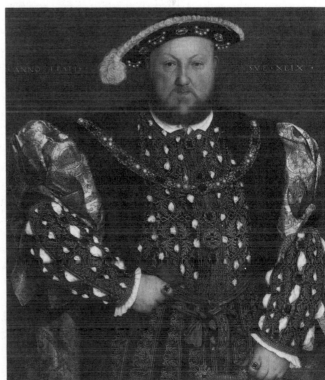

876

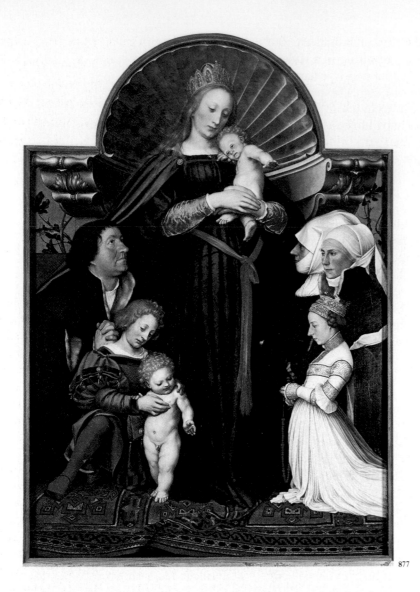
877

a lute with one of its strings broken, all seen in flawless perspective. Holbein distills the quintessence of his subjects' characters all the more effectively in that no slightest change of expression is allowed to disturb the cool faces. The green damask curtain, the white fur, and the inlaid marble floor are all rendered with Holbein's characteristic steely control. The startling object in the foreground is a systematically distorted death's head, with which Holbein has toyed in fascination with the fact that his name means *skull*.

In England Holbein painted an extensive series of portraits of Henry VIII, four of his wives, scores of his courtiers, and many German merchants of the Steel Yard, a German enclave in London; we also know of a lifesize group portrait of the king surrounded by courtiers, now lost. In their quiet strength Holbein's English portraits are so compelling as to enhance our feeling that we know the unpredictable monarch and his contemporaries. His Germanic feeling for linear pattern has adorned the ceremonial portrait of the king (fig. 876), dating from 1539–40, with an endless interlace of damask, embroidery, and goldsmith work, but this is only a frame for the royal face, drawn in all its obesity, yet endowed with demonic intensity of will. We can only mourn the fact that "Master Hans" did not survive to leave us portraits of Queen Elizabeth I and her brilliant court.

877. HANS HOLBEIN. *Madonna of Burgomaster Meyer*. 1526. Panel painting, 56¾ × 39¾". Schlossmuseum, Darmstadt

878. JEAN CLOUET. *Portrait of Francis I*. 1525–30. Tempera and oil on panel, 37¾ × 29⅛". The Louvre, Paris

879. FRANCESCO PRIMATICCIO. *Apelles with Alexander the Great and Campaspe*. Stucco and painting. 1540s (restored in the 18th century). Chambre de la Duchesse d'Étampes, Château of Fontainebleau, France

France In sixteenth-century France there were no artists of the stature of Fouquet or Quarton; nonetheless, the total picture of artistic activity at the courts of Francis I (reigned 1515–47) and Henry II (reigned 1547–59) offers a fascinating spectacle of artificial elegance. Francis, who greatly admired the achievements of the Italian Renaissance, tried to coax one Italian master after another to his court; as we have seen, Leonardo spent the last two years of his life in France, and at one time Michelangelo seriously considered accepting the king's invitation. However intensely Francis may have thirsted for the Italian Renaissance, what he eventually got was Mannerism. Cellini spent several years in his service, and Rosso Fiorentino and a lesser, decorative artist, Francesco Primaticcio, carried out the king's ambitious projects.

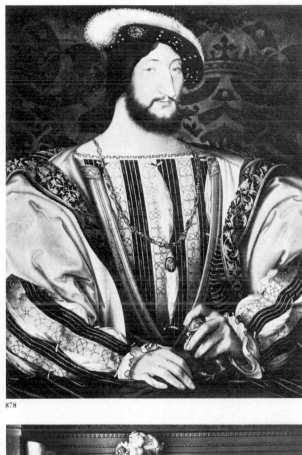

878

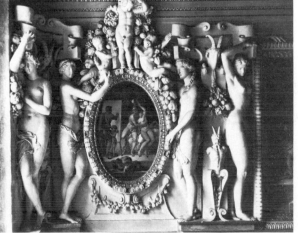

879

The best portraitists at Francis's court were, nonetheless, French, and the most important one was JEAN CLOUET (c. 1485–1541), whose stiff and formal likenesses of the king may have influenced the visiting Holbein. Although Clouet cannot be ranked with the leading Italian or German masters, his characterization of the self-indulgent, calculating monarch, whose Don Juanism was notorious, in a portrait painted between 1525 and 1530 (fig. 878) is keen and unsparing. Especially effective is the concentration of all the stripes and brocade patterns of the costume into a vortex, focused on the king's left hand, which nervously toys with his poniard.

The decorations in stucco and fresco for Francis I's palace at Fontainebleau, unfortunately much repainted, rank among the richest of Mannerist cycles. A detail from the room of the king's mistress, the Duchesse d'Étampes, stuccoed and painted in the 1540s (fig. 879) by FRANCESCO PRIMATICCIO (1504–70), indicates the character and aesthetic level of this court style. It is as though something of the spirit of Flamboyant architecture and decoration still lingered on in France to transform, willy-nilly, the imported Italian style. The Mannerist figures, with their leg-crossed poses and sly concealment of some parts while exhibiting far more, form an endless pattern of modeled plaster decoration that eclipses the paintings. This one discloses Alexander the Great in amorous dalliance with the fair Campaspe, while Apelles stands at his easel, busily recording the scene for Francis and *his* mistress.

Despite Francis I's incessant wars with the emperor Charles V and his disastrous attempts to claim the thrones of Naples and Milan and suzerainty over the southern Netherlands, his reign was prosperous, and he and his court built a chain of opulent châteaux along the Loire River in which were imaginatively combined the French Gothic heritage and Italian ideas. Chambord (fig. 880) is the most formidable example. Begun in 1519, the château has a central block with round corner towers clothed with a screen architecture of Renaissance pilasters in three stories; its plan is related to ideas developed by Leonardo for the dukes of Milan, and may have issued from the mind of the aged genius then still living at nearby Cloux, although a model was provided by Domenico da Cortona, a pupil of Giuliano da Sangallo. The central block of the château, far larger than one would suspect from a photograph, is divided into self-sufficient apartments, each concentrated on a corner tower and entered from a central double staircase, whose spirals are so intertwined that pedestrians going up can only hear but not see those coming down. The southern outer walls and corner towers were not completed. The native

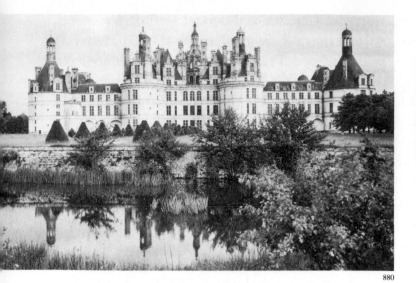

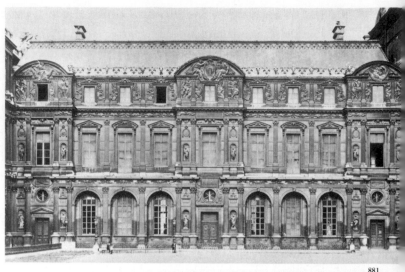

880

881

French style conquered in Chambord in an eruption of dormers, ornamented chimneys, and openwork turrets stemming directly from the Gothic tradition; in the lovely light of the Loire Valley, the two opposites coexist harmoniously.

A style at once wholly French and wholly Renaissance did not develop in architecture and sculpture until midcentury in the Square Court of the Louvre, Paris (fig. 881), begun in 1546, the last year of Francis's reign, by the architect PIERRE LESCOT (1510–78) and the sculptor JEAN GOUJON (c. 1510–68). Given the northern climate, steep roofs and large windows were necessities, but these are not the only French features; the façade is punctuated by pavilions, recalling the towers of château architecture, which are crowned by arched pediments and linked by curtain walls, rather than being a block as in the Italian manner. The pavilions project only slightly, but their dominance is underscored by the pairing of engaged Corinthian columns in contrast to the single pilasters that emphasize the transitory character of the connecting walls. The sculptures in the niches and the rich reliefs of the attic story are of a type by no means unknown in Italy (see Sansovino's Library of San Marco, for example; fig. 858), but such decorative work on Italian palazzo exteriors was more commonly painted in fresco, and little has survived.

The style of Goujon is seen at its best in the turning and twisting figures from his now-dismantled *Fountain of the Innocents*, of 1548–49 (figs. 882–86). The clinging drapery is probably derived from Roman models. But the figures, whose poses are certainly inspired by Italian Mannerism, are in the last analysis Goujon's own. Supple, graceful, moving with ease in nonexistent spaces, these lovely creatures are supremely French, foreshadowing in their diaphanous beauty the widely divergent arts of the Rococo and Neoclassicism.

The linearity of the French Renaissance takes on an unexpected expressive intensity in the sculpture of GERMAIN PILON (c. 1535–90), whose grim tombs at Saint-Denis are less interesting than some of his relief sculpture, such as the bronze *Deposition*, c. 1580–85 (fig. 887). Not the lines alone, as in the work of Goujon, but entire surfaces and underlying masses of figures and drapery heave and flow as if molten. It is this inner movement, together with the striking freedom of the poses, rather than the somewhat standardized facial expressions that act as the true vehicle for emotion.

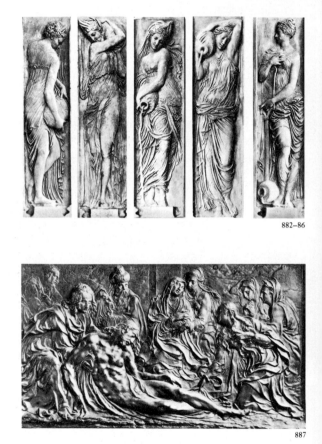

882–86

887

880. Château of Chambord, France. Begun 1519

881. PIERRE LESCOT and JEAN GOUJON. Square Court (Cour Carrée), The Louvre, Paris. Begun 1546

882–86. JEAN GOUJON. *Nymphs*, from the *Fountain of the Innocents* (dismantled). 1548–49. Marble reliefs. The Louvre, Paris.

887. GERMAIN PILON. *Deposition*. Bronze relief. c.1580–85. The Louvre, Paris

The Netherlands The reversion of Burgundy to the French crown and the Netherlandish provinces to the Holy Roman Empire after the Battle of Nancy in 1477 had slight effect on the school of painting that had developed in the Netherlands under Burgundian sovereignty. Far more important were the tides of religious reform throughout the Netherlands in the sixteenth century, especially in the northern provinces. Before the abdication of the emperor Charles V in 1558, rule over the Netherlands, as well as Spain, had been given to his fanatical son Philip II, and massive tyranny, including the Inquisition, had been imposed upon the Netherlands. The response of the Protestants, commendable enough insofar as it was directed toward political and religious freedoms, also took the less agreeable form of iconoclasm, and thousands of paintings and sculptured images were destroyed; in 1566 the *Ghent Altarpiece* had a narrow escape. The southern provinces, which today constitute Belgium, were pacified in 1576, but in 1579 the Union of Utrecht forged the northern provinces into the nucleus of present-day Holland, whose independence was assured early in the seventeenth century.

Little by little the novelty of the Netherlandish discovery of reality wore off. Although there were many competent painters in the opening decades of the sixteenth century, all were working more or less along lines laid down by van Eyck, van der Weyden, and van der Goes. Inevitably, Italian influence crept in, and just as inevitably it was misunderstood. No wonder that when Dürer—a German master—visited the Netherlands in 1520 he was hailed as a messiah. Rather than discussing conservative or Italianate works, it seems preferable to underscore what was original and new in Netherlandish art in the early sixteenth century: an increased sensitivity to the moods of nature.

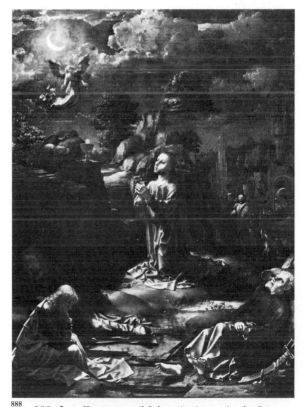

888

888. JAN GOSSAERT (Mabuse). *Agony in the Garden*. c. 1503–7. Panel painting, 33½ × 24¼". Gemäldegalerie, Staatliche Museen, Berlin

GOSSAERT Jan Gossaert (c. 1478/88–1532), who eventually signed himself Mabuse, after his native town of Maubeuge, visited Italy in 1508–9, and later won Vasari's approval as the first Netherlander to compose with nude figures in the Italian manner. In 1517 his allegiance was still so uncertain, however, that he copied a famous early work by Jan van Eyck. Gossaert's special ability to render the effects of space and light is seen at its best in the *Agony in the Garden* (fig. 888), whose composition is indebted to a celebrated one by Mantegna, which Gossaert doubtless saw in Italy; he transformed it by his new and magical rendering of moonlight and clear night air. Christ kneels, as in Luke 22:42–43:

Saying, Father, if thou be willing, remove this cup from me: nevertheless not my will, but thine, be done.
And there appeared an angel unto him from heaven, strengthening him.

The angel hovers in the moonlight, against the dark blue sky with its shining clouds; moonlight touches the edges of the rocks and the chalice (the "cup") together with the host of the Eucharist, dwells on the violet tunic of Christ, touches the face of Peter, shines on the armor of one of the soldiers, but leaves the ominous Judas among the soldiers on the right in shadow. Jerusalem looms in the distance, dim and foreboding.

PATINIR A special kind of romantic landscape was invented by Joachim Patinir (active 1515–24); his *Saint Jerome* (fig. 889), of about 1520, shows the typical wild landscape forms in which he specialized. Saint Jerome in

the Wilderness was a frequent subject in the second half of the fifteenth century in Italy, but Patinir's interpretation is his own. The figure of Saint Jerome merely establishes an ascetic mood for the wild landscape background, seen from a high vantage point. The towering, jagged rocks, introduced for expressive purposes, seem more invented than real. Invariably in Patinir's landscapes the foreground is dominated by brown, the middle distance by green; the rocks are blue gray; and a dark blue storm, generally raging in the distance, sends the crags into bright relief. The broad sweep of Patinir's landscapes emancipates them almost entirely from the ostensible subject; only after experiencing their immensity does one think to look for hermitages, travelers, and the meditating saint.

BRUEGEL The one Netherlandish master of universal importance in the sixteenth century was Pieter Bruegel the Elder (c. 1525/30–69). He may have been born near 's Hertogenbosch, the home of Hieronymus Bosch; deeply influenced by both Bosch's pessimism and his fantasy, he turned out a number of designs for engravings on Boschlike themes. He spent the years between 1551 and 1555 in Italy, going as far south as Sicily, and brought back wonderful drawings of Alpine landscapes he had traversed on his journey. As for the lessons of Italian art, always dangerous for a Northerner, Bruegel mastered them in their essence. Rather than adopting Italian nude figures, which always seem to shiver in the North, he interpreted the message of Italy as a harmony of form and space, and remained as strongly Netherlandish in his outlook and subject matter as before his trip.

Bruegel's love for the beauty of south Italian landscape prompted the blue harbor and silvery cliffs of his *Landscape with the Fall of Icarus*, c. 1554–55 (fig. 890). Icarus, who against the advice of his father Daedalus flew so high that the wax that held the wings to his body was melted by

889

889. JOACHIM PATINIR. *Saint Jerome*. c. 1520. Panel painting, 14⅛ × 13⅜". National Gallery, London

890. PIETER BRUEGEL (the Elder). *Landscape with the Fall of Icarus*. c. 1554–55. Panel painting (transferred to canvas), 29 × 44⅛". Musées Royaux des Beaux-Arts, Brussels

890

the sun, had appeared from time to time in Italian art not only as a symbol of overweening ambition but also because his depiction gave the artist an opportunity to display anatomical knowledge of a body in flight or falling. Bruegel instead concentrates on the farmer plowing furrows behind his horse in a foreground field high above the sea, on a singing shepherd, and on a galleon with bellying mainsail and lateen buffeting the whitecaps in a stiff breeze. It takes a moment to find Icarus; only his waving legs are still out of water. No one pays his tragedy the faintest attention. An old Netherlandish and German proverb maintains that "when a man dies no plow stops." That brings us to the widely held belief that Bruegel belonged to a circle of Antwerp humanists who maintained that man is driven to sin by foolishness, and that he is bound to the inevitable cycle of nature, from which it is folly to attempt escape. With his vision liberated by the wide landscape prospects of Patinir, Bruegel was able to project the monumentality of Italian art in Netherlandish terms. The plowman's ancestry can be traced from Michelangelo, through Masaccio, back to Giotto; however, he remains Netherlandish all the while.

About 1561–62 Bruegel painted the devastating *Triumph of Death* (fig. 891), a barren landscape of dead trees, burning cities, and sinking ships in which no one will survive. An amorous couple make music, with Death looking over their shoulders; a feast is overturned by Death, who assails kings and cardinals; on a pale horse he mows down the living with his scythe. The chanting monks turn out to be skeletons; corpses hang from gallows, are stretched on wheels for the ravens to eat, and float bloated upon the sea. Those who remain alive are driven toward a gigantic coffin, whose end is lifted open like a trap; it is guarded by phalanxes of skeletons defending themselves with shields. Although the Dance of Death was a subject favored by sixteenth-century artists for woodcuts (Holbein, for example), never in a single painting had such a remorseless panorama of human mortality been attempted.

891. PIETER BRUEGEL (the Elder). *Triumph of Death*. c. 1561–62. Panel painting, 46 × 63¾". Museo del Prado, Madrid

891

892

893

To Bruegel the peasant was an especially attractive subject because he typified the acceptance of man's bondage to the earth and to the cycle of the turning year. Five remaining paintings belong to a series that Bruegel made to illustrate the labors of the months, as in the calendar scenes of the *Très Riches Heures* (see figs. 742, 743). The picture signed and dated in 1565 called the *Harvesters* (fig. 892) represents July or August. A sky veiled in summer heat-haze extends over harvested fields and those still to be cut. The heads of plodding peasants are scarcely visible above the standing grain. Under what shade a tree can give on such a day, other peasants eat bread (made, doubtless, from the grain they raised last year), porridge, and fruit. One, his breeches loosened, his stomach distended, sleeps off the meal. A companion piece, the *Hunters in the Snow*, also from 1565 (fig. 893), represents January or February. The world is covered with snow, against which are silhouetted the weary hunters returning to the village and their pack of dogs with drooping tails. Below the village skaters move over the frozen ponds. A crane flies above, lending greater distance to the Alpine peaks. Never again in Netherlandish art is there anything to equal the simple humanity of Bruegel's peasants or the breadth and dignity of his landscape. The fatality that binds man and nature is stoically accepted, and in this acceptance Bruegel is able to communicate an unexpected peace.

892. PIETER BRUEGEL (the Elder). *Harvesters*. 1565. Oil on panel, 46½ × 63¼". The Metropolitan Museum of Art, New York. Rogers Fund, 1919

893. PIETER BRUEGEL (the Elder). *Hunters in the Snow*. 1565. Oil and tempera on panel, c. 46⅛ × 63¾". Kunsthistorisches Museum, Vienna

Spain Under Charles V, who lived by preference in Spain and considered himself Spanish, the Holy Roman Empire dominated most of Europe and almost all of the known New World. Under his son and successor, Philip II, who governed Spain, southern Italy and Sicily, and the Netherlands, Spanish rule of Central and much of South America was consolidated. Intense devotion to the Counter-Reformation may have played a part in blinding the Spanish conquerors to the value of the indigenous culture of Central and South America; they totally destroyed it with the same abandon with which they mutilated or slaughtered local populations all the way from Peru to the Mississippi Valley. The leaders of the Spanish Inquisition burned heretics publicly and routinely in Spain as *autos-da-fé* (acts of faith), and repressed both Calvinist belief and nationalist political movements in the Netherlands. In spite of splendid art collections formed by his father and extended by Philip himself, artistic life in Spain remained provincial. In the fifteenth century, Spanish art was dominated by the influence of the Netherlandish masters, and in the sixteenth by the Italians. Yet Spain still produced some remarkable works of Renaissance architecture, marked by a special taste for austerity and rigidity. The spiritual aspect of the Counter-Reformation was led by such ardent souls as Saint Theresa of Avila and Saint John of the Cross, and provided a fertile terrain for the amazing development of El Greco, one of the leading masters of the entire Western tradition.

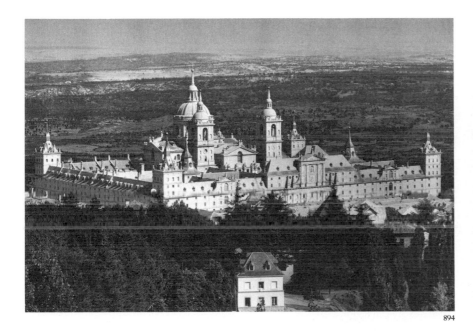

894

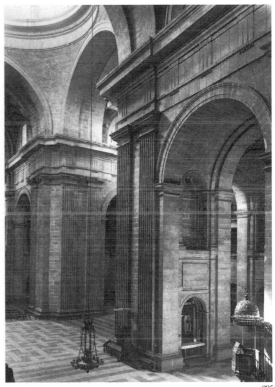

895

THE ESCORIAL The finest and also the largest Renaissance building in Spain is the Escorial (fig. 894), built at the command of Philip II in fulfillment of his father's charge to erect a "dynastic pantheon" for the Spanish Habsburgs. The immense structure, in open pastureland on a grand slope some thirty miles northwest of Madrid, with the Guadarrama range in the background, therefore combines palace, monastery, church, and mausoleum. Started by Juan Bautista de Toledo in 1563 and continued by his assistant Juan de Herrera until 1584, the building displays as much the desires and tastes of the king, who gave explicit directions and followed the construction closely, as it does the style of any architect. The monastery was dedicated to Saint Lawrence, on whose day Philip had won a victory in France, and the plan is that of the gridiron on which the saint was martyred. Although supplied with corner towers, the building was not fortified. Its austere grandeur symbolizes

894. JUAN DE HERRERA (begun by Juan Bautista de Toledo). The Escorial, Madrid. 1563–84

895. Interior of church, The Escorial, Madrid

rather the king's determination to support the Counter-Reformation by all psychological as well as material means. The Escorial marks the triumph, indeed, of sixteenth-century absolutism in both religious and secular spheres.

The local granite used for construction, hard and intractable, was perfectly suited to the design. A church façade based on Roman Mannerist prototypes severely simplified, as compared to the almost contemporary façade of the Gesù in Rome, and restricted to an Ionic temple superimposed on a Doric lower story provides the only real interruption in the monotonous succession of identical small windows piercing the seemingly endless exterior walls. Save for the heaviness of its architectural members, whose coupled Tuscan columns embrace large arched windows, the crowning dome looks very Roman. The gloom of the building comes to a grim climax in the interior of the church (fig. 895), designed and built by Herrera after Juan Bautista's death. A single colossal Doric order, classically correct but without any of the resiliency of Italian architecture, is enriched by no decoration whatever, and designed on so impersonal a scale that one realizes with a shock its actual colossal dimensions.

EL GRECO Domenikos Theotokopoulos (1541–1614), generally known as El Greco, was born in Crete, then a Venetian possession, and probably trained under icon painters still working in the Byzantine style. About

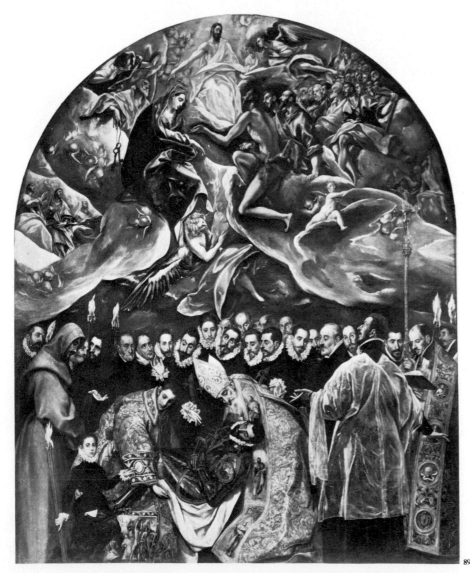

896. EL GRECO. *The Burial of Count Orgaz*. 1586. Oil on canvas, 16′ × 11′10″. S. Tomé, Toledo, Spain

897. EL GRECO. *Resurrection*. c. 1597–1604. Oil on canvas, 9′¼″ × 4′2″. Museo del Prado, Madrid

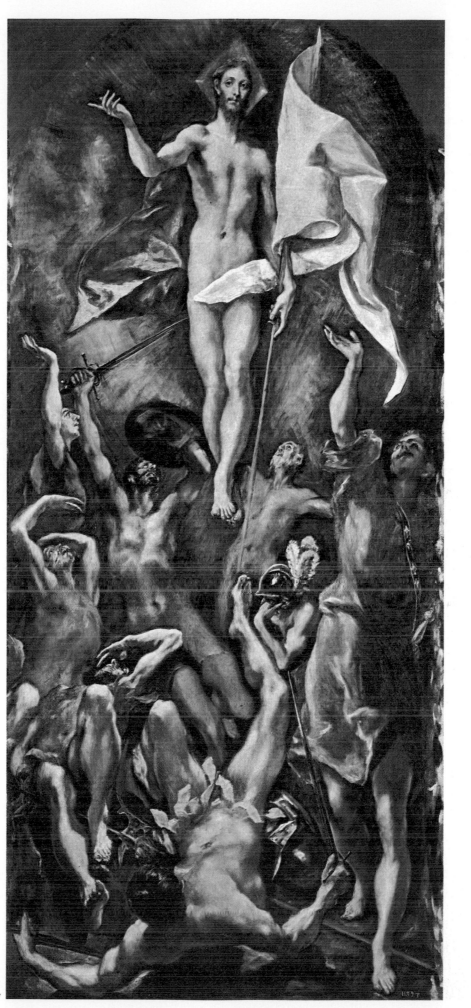

1560 he went to Venice, where a small group of Greek painters was active in translating compositions by Venetian masters from Bellini to Tintoretto into Byzantine style for the local Greek colony. During his stay in Venice El Greco absorbed from the great Venetian masters their whole range of luminary and coloristic achievements and every nuance of their brushwork. After a Roman sojourn during the 1570s, he arrived in Spain in 1576, where, in the heady atmosphere of Counter-Reformation mysticism, his work took fire. It was as if, under the new religious inspiration, he were suddenly able to re-create on a contemporary plane the splendors of Byzantine art. Undeniably, the Byzantine spirit remains in his work; in a sense he may be thought of as the last and one of the greatest of Greek painters, the heir of the Byzantine pictorial tradition.

In *The Burial of Count Orgaz* (fig. 896), painted in 1586, El Greco's synthesis of Venetian color, Spanish mysticism, and the Byzantine tradition is complete. The subject is the interment in 1323 of a nobleman who had lived a life of such sanctity that after his death Saints Stephen and Augustine came down from Heaven to lay his body reverently in the tomb. El Greco has shown the burial in the lower half of the picture as if it were taking place in his own time. The priest on the far right reading the committal office and the solemn-faced Spaniards of all ages have accepted the miracle calmly. The black sixteenth-century costumes contrast with the splendor of the priest's cope, embroidered in gold, and with the sparkle of the white-and-gold damasks of the saints. These and the myriad reflections on the polished steel armor with its bands of gilded ornamentation are painted with a brushwork and quality of light that equal the highest Venetian achievements. But the upward glance of the central mourner and the pose and gesture of the priest in a surplice at the right draw our attention upward to an even greater miracle: the clouds of Heaven have descended close above the heads of the living and have divided to allow an angel to transport the tiny cloudy soul of the count toward the Deësis above—Mary and Saint John the Baptist fairly near us, but Christ more remote, and robed in snowy white.

Here and there, vortices filled with saints open in the clouds, and frosty cloud banks pile up, within which crowd angelic heads. The figures have already begun to assume the attenuated proportions of those in El Greco's later work, and light, from no visible source, seems to originate from within the figures. It makes no sense to talk of Mannerism in connection with El Greco; his profoundly spiritual art has nothing to do either with the first generation of Florentine and Sienese Mannerists or with the later art of Counter-Reformation Rome and grand-ducal Florence. It is an anachronistic and personal amalgam, an art period in itself, and it hardly survived El Greco's death.

Every few years one or another oculist announces with an air of discovery that El Greco's astigmatism was responsible for his figural distortions. His malady must have been widely shared, for his work was commissioned by every patron in central Spain who could afford it, and was imitated, distortions and all, by a busy studio of pupils. His distortions were, moreover, abandoned at will when the subject required him to do so. His portrait of the *Grand Inquisitor Don Fernando Niño de Guevara* (fig. 898, painted about 1600, is naturalistically proportioned in the Venetian manner. The direct and piercing gaze, which makes one wonder how many heretics the Inquisitor has committed to the flames, the dry features, the grizzled beard, and the glasses are all rendered with the same close observation that picks up the nervous clutch of the jeweled fingers

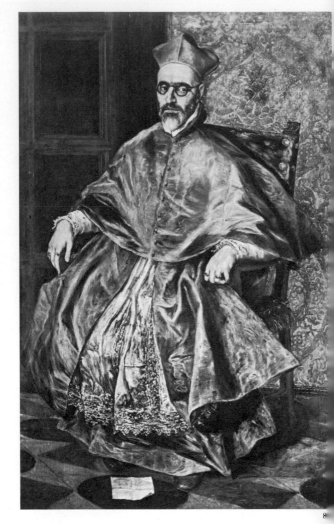

898. EL GRECO. *Grand Inquisitor Don Fernando Niño de Guevara.* c. 1600. Oil on canvas, 67½ × 42½". The Metropolitan Museum of Art, New York. Bequest of Mrs. H. O. Havemeyer, 1929. The H. O. Havemeyer Collection

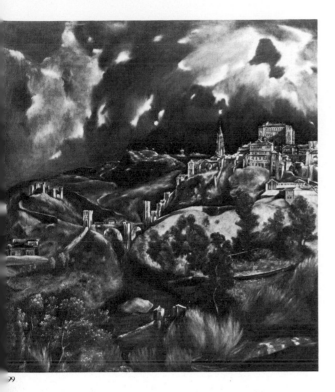

of the left hand on the arm of the chair. In the crimson tunic, however, El Greco let himself go in an outburst of lightning brushstrokes.

An astonishing production of combined mysticism and virtuosity is El Greco's compressed view of one section of his adopted city, *Toledo*, painted about 1600–1610 (fig. 899), all in greens, blue grays, black grays, and silver grays, looking as if light were glowing from within the grassy slopes and witches were riding through the wild clouds. Tiny washerwomen in the river and travelers on the road are hardly more than touches of the brush.

El Greco's mystical late style is seen at its most exalted in his *Resurrection*, of about 1597–1604 (fig. 897), in which Christ soars above us against a background of night, acting as a magnet that pulls upward the surrounding figures—drawn out to unbelievable lengths—of the Roman soldiers in an ecstasy of pain. In contrast to Christ's body in Grünewald's *Resurrection* (see fig. 872), El Greco's Christ is more solid, white and glowing like the Eucharist in the light of an altar, his eyes looking calmly toward the observer. The Renaissance is now far behind us, but, as with the visionary late paintings of Tintoretto, El Greco does not lead toward the Baroque. The utter abandonment of physical reality in his personal and spontaneous surrender has nothing in common with the calculated art of the founders of the Baroque style in Italy.

On this otherworldly note we close the Renaissance, which had begun and continued in Italy, with such noble ambitions and unbounded hopes for an idealized mankind and come to grief on the rocks of human frailty. In both its triumphs and its defeats the Renaissance, perhaps more vividly than any other period except the twentieth century, illustrates the unpredictable opposites of human character and destiny. An impartial survey of sixteenth-century art, in every region except that enlivened by Venetian genius, would have shown that the vast majority of works of art done after about 1530 belonged to a routinely imitative school justly deserving of the title of Mannerist. Yet the great works we have seen will give us new insights into the heights and depths of the human spirit.

899. EL GRECO. *Toledo*. c. 1600–10. Oil on canvas, 47¾ × 42¼". The Metropolitan Museum of Art, New York. Bequest of Mrs. H. O. Havemeyer, 1929. The H. O. Havemeyer Collection

TIME LINE IX

Dome, Florence Cathedral, by Brunelleschi

David, by Castagno

Man in a Red Turban, by Jan van Eyck

Miraculous Draft of Fish, by Witz

	POLITICAL HISTORY	RELIGION, LITERATURE, MUSIC	SCIENCE, TECHNOLOGY
1400	Death of Giangaleazzo Visconti of Milan, 1402, removes threat to political independence of Florence Death of King Ladislaus of Naples, 1414, removes second threat to independence of Florence	Council of Constance, 1414–18, ends Great Schism Martin V reestablishes united Papacy in Rome, 1420 Leonardo Bruni (1369–1444)	
1425	Joan of Arc (1412–31) Battle of San Romano, 1432 Cosimo I de'Medici exiled from Florence, 1433–34 Medici family dominates Florence, 1434–94 Habsburgs begin rule of Holy Roman Empire, 1438	St. Antonine of Florence (1389–1459) Guillaume Dufy (c. 1400–74) *Il libro dell'arte* by Cennino Cennini, c. 1430 Council of Basel, 1431–49 Leonbattista Alberti writes *De pictura*, 1435 (as *Della pittura*, 1436)	Prince Henry the Navigator of Portugal (1394–1460) promotes geographic exploration
1440	Florence and Venice defeat Filippo Maria Visconti at Anghiari, 1440	Papacy of Nicholas V, 1447–55	Earliest record of suction pump, c. 1440
1450	Sforza family rules Milan, 1450–1535 Hundred Years' War ends, 1453 Constantinople falls to Turks, 1453 Piero de'Medici rules Florence, 1464–69 Giuliano de'Medici rules Florence, 1469–78 Ferdinand and Isabella unite Spain, 1469	*De re aedificatoria* by Alberti, c. 1450 *On the Dignity and Excellence of Man* by Giannozzo Manetti, 1451–52 Papacy of Pius II, 1458–64 Giovanni Pico della Mirandola (1463–94) Marsilio Ficino (1433–99) translates Plato's works into Latin, 1463 (published 1484)	Paolo dal Pozzo Toscanelli (1397–1482), author of map used by Christopher Columbus
1470	Pazzi conspiracy in Florence; Giuliano de'Medici assassinated, 1478	Josquin des Prés, (c. 1450–1521) Papacy of Sixtus IV, 1471–84	
1480	Henry VII, first Tudor king of England (r. 1485–1509) Granada, last Muslim holding in Spain, falls to Spanish, 1492 Second expulsion of Medici from Florence, 1494 John Cabot claims eastern North America for England, 1497	Papacy of Alexander VI, 1492–1503 *Ship of Fools* by Sebastian Brant, 1494 Girolamo Savonarola (1452–98) burned at stake for heresy in Florence	Bartholomew Diaz rounds Cape of Good Hope, 1487 Columbus discovers America, 1492

EARLY RENAISSANCE

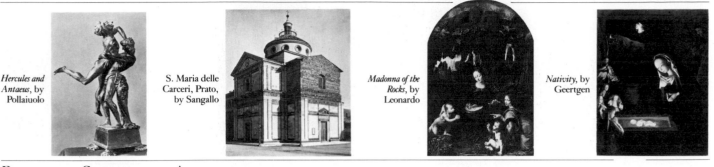

Hercules and Antaeus, by Pollaiuolo

S. Maria delle Carceri, Prato, by Sangallo

Madonna of the Rocks, by Leonardo

Nativity, by Geertgen

PAINTING, SCULPTURE, ARCHITECTURE

ITALY	NORTHERN EUROPE	
Ghiberti, Brunelleschi: competition reliefs for Baptistery doors, Florence	Sluter, portal and Well of Moses, Chartreuse de Champmol, Dijon	1400
Donatello, *St. Mark; St. George; Habakkuk; Feast of Herod*	Boucicaut Master, *Hours of Boucicaut*	
Nanni di Banco, *Four Crowned Martyrs*	Limbourg Brothers, *Très Riches Heures*	
Brunelleschi, dome of Florence Cathedral begun; Ospedale degli Innocenti	Rohan Master, *Grandes Heures*	
Gentile da Fabriano, *Adoration of the Magi*	Jan van Eyck, illuminations in *Turin-Milan Hours*	
Masaccio, frescoes, S. Maria del Carmine, Florence; *Enthroned Madonna and Child; Trinity*	Master of Flémalle, *Mérode Altarpiece, Nativity; Impenitent Thief*	1425
Della Quercia, portal, S. Petronio, Bologna	Hubert (?) and Jan van Eyck, *Ghent Altarpiece*	
Luca della Robbia, *Cantoria*	Jan van Eyck, *Man in a Red Turban; Madonna of Chancellor Rolin; Arnolfini Wedding*	
Fra Angelico, *Descent from the Cross; Annunciation*		
Filippo Lippi, *Annunciation*	Van der Weyden, *Descent from the Cross; Last Judgment*	1440
Donatello, *David; Gattamelata*	Witz, *Miraculous Draft of Fish*	
Michelozzo, Medici Palace, Florence	Lochner, *Presentation in the Temple*	
Alberti, Rucellai Palace, Florence		
Bernardo Rossellino, *Tomb of Leonardo Bruni*		
Uccello, *Deluge; Battle of S. Romano*		
Domenico Veneziano, *St. Lucy Altarpiece*		
Castagno, *Last Supper; David*		
Alberti, Malatesta Temple, Rimini	Fouquet, *Melun Diptych; Chevalier Hours*	1450
Piero della Francesca, *Resurrection; Meeting of Solomon and Sheba*	Quarton, *Coronation of the Virgin; Avignon Pietà*	
Antonello da Messina, *St. Jerome in His Study*	Pacher, *Life of St. Lawrence* altarpiece	
Donatello, *Mary Magdalen*	Bouts, *Last Supper*	
Mantegna, frescoes, Church of the Eremitani, Padua; Ducal Palace, Mantua		
Desiderio da Settignano, *Christ and St. John the Baptist*		
Antonio Rossellino, *Tomb of the Cardinal of Portugal; Giovanni Chellini*		
Verrocchio, *Doubting of Thomas*		
Pollaiuolo, *Battle of the Ten Nudes; Martyrdom of St. Sebastian; Hercules and Antaeus*		
Alberti, S. Andrea, Mantua	Schongauer, *Temptation of St. Anthony*	1470
	Van der Goes, *Portinari Altarpiece*	
Perugino, *Giving of the Keys to St. Peter*	Memlinc, *Shrine of St. Ursula*	1480
Botticelli, *Primavera; Birth of Venus*	Geertgen tot Sint Jans, *Nativity*	
Ghirlandaio, *Birth of the Virgin*	Dürer, *Self-Portrait*	
Giovanni Bellini, *Transfiguration of Christ*		
Leonardo da Vinci, *Madonna of the Rocks; Last Supper*		
Giuliano da Sangallo, S. Maria delle Carceri, Prato		
Signorelli, *Damned Consigned to Hell*		

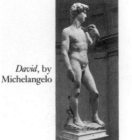

David, by Michelangelo

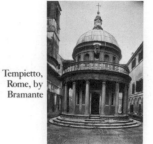

Tempietto, Rome, by Bramante

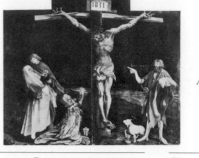

Crucifixion, by Grünewald

French *Ambassadors*, by Holbein

POLITICAL HISTORY	RELIGION, LITERATURE, MUSIC	SCIENCE, TECHNOLOGY
1500 Spain rules Kingdom of Naples, after 1504 Restoration of Medici in Florence, 1512 Charles V, Spanish king, reigns as Holy Roman Emperor, 1519–56 Hernando Cortés conquers Aztec empire in Mexico for Spain, 1519	Papacy of Julius II, 1503–13 *In Praise of Folly*, 1511, by Erasmus of Rotterdam (1469–1536) Papacy of Leo X, 1513–21 Baldassare Castiglione writes *The Courtier*, 1514 (published 1528) Niccolò Machiavelli writes *The Prince*, 1513–19 (published 1538) Sir Thomas More writes *Utopia*, 1516 Martin Luther (1483–1546) posts 95 theses at Wittenberg, 1517	Paracelsus (1493-1541) opposes humoral theory of disease; crusades for use of chemicals in treatment of disease Balboa sights Pacific Ocean, 1513 Portuguese reach China, 1514; hold trade monopoly in Far East until 1602 First circumnavigation of globe, by Magellan and crew, 1519–22
1520 Peasants' Revolt in Germany, 1524–25 Sack of Rome by Spanish and German mercenaries of Charles V, 1527 Medici power reestablished in Florence, 1530	Papacy of Clement VII, 1523–34 Society of Jesus founded by St. Ignatius Loyola and St. Francis Xavier, 1534 Papacy of Paul III, 1534–49	Copernicus refutes geocentric view of universe, 1530–43 Principle of triangulation in surveying discovered by Gemma Frisius, 1533
1535 Cosimo I de'Medici rules Florence, 1537–74 Ivan the Terrible rules Russia, 1547–84	St. Theresa of Avila (1515–82) John Calvin publishes *Institutes of the Christian Religion*, 1536 Council of Trent, 1545–63, undertakes reform of abuses and definition of doctrine in Roman Catholic Church	Andreas Vesalius writes *On the Structure of the Human Body*, first systematic treatise on human anatomy, 1543
1550 Wars of Lutheran vs. Catholic princes in Germany end in Peace of Augsburg, 1555, allowing each sovereign to decide religion of his subjects Charles V retires, 1556, and divides empire; his brother Ferdinand I, receives Habsburg lands; his son Philip II becomes king of Spain, the Netherlands, and the New World Elizabeth I rules England, 1558–1603	Giovanni Palestrina (c. 1525–94) Michel de Montaigne (1533–92) St. Charles Borromeo (1538–84) Miguel de Cervantes (1547–1616) Giorgio Vasari publishes *Lives of the Most Eminent Painters, Sculptors, and Architects*, 1550 Papacy of Paul IV, 1555–59 Benvenuto Cellini writes *Autobiography*, 1558 John Knox founds Presbyterian Church, 1560 Andrea Palladio publishes *Four Books on Architecture*, 1570	Georgius Agricola's *De re metallica*, a basic treatise on metallurgy and mining, published, 1556 Gerardus Mercator devises mercator projection, 1568 Tycho Brahe observes first supernova, 1572; accumulates accurate data on planetary and lunar positions and produces first modern star catalogue
1580 Northern provinces of the Netherlands declare independence, 1581 Spanish Armada defeated by English, 1588	William Shakespeare (1564–1616) Papacy of Sixtus V, 1585–90 Edict of Nantes, 1598, establishes religious tolerance in France Giordano Bruno (1548–1600)	Pope Gregory XIII introduces Gregorian calendar, 1582

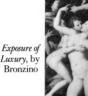

Exposure of Luxury, by Bronzino

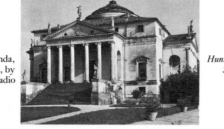

Villa Rotonda, Vicenza, by Palladio

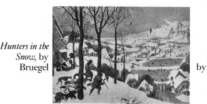

Hunters in the Snow, by Bruegel

Grand Inquisitor, by El Greco

PAINTING, SCULPTURE, ARCHITECTURE

ITALY	EUROPE OUTSIDE ITALY	
Michelangelo, *David*	Bosch, *Crowning with Thorns; Garden of Delights*	1500
Leonardo da Vinci, *Madonna and St. Anne; Battle of Anghiari; Mona Lisa*	Gossaert, *Agony in the Garden*	
Raphael, *Marriage of the Virgin; Madonna of the Meadows*	Dürer, *Adoration of the Trinity; St. Jerome; Knight, Death, and the Devil; Melencolia I*	
Bellini, *Madonna and Child Enthroned*	Grünewald, *Isenheim Altarpiece*	
Giorgione, *Enthroned Madonna; The Tempest*		
Bramante, plan for St. Peter's; Tempietto, Rome		
Michelangelo, *Sistine Ceiling; Slaves*		
Raphael, *Disputa; School of Athens; Sistine Madonna; Galatea; Transfiguration*		
Andrea del Sarto, *Madonna of the Harpies*		
Titian, *Sacred and Profane Love; Assumption of the Virgin; Bacchanal; Pesaro Madonna*		
Michelangelo, *Medici Tombs;* Laurentian Library, Rome; *"Crossed-leg" Slave*	Patinir, *St. Jerome*	1520
Rosso, *Descent from the Cross*	Clouet, *Portrait of Francis I*	
Pontormo, *Entombment*	Dürer, *Four Apostles*	
Correggio, *Holy Night; Assumption of the Virgin; Jupiter and Io*	Holbein, *Madonna of Burgomaster Meyer*	
Parmigianino, *Self-Portrait*	Altdorfer, *Battle of Alexander and Darius*	
	Cranach, *Apollo and Diana*	
	Holbein, *French Ambassadors*	
Michelangelo, *Last Judgment;* plan for Campidoglio, Rome, begun	Holbein, *Henry VIII*	1535
Titian, *Venus of Urbino; Paul III and His Grandsons*	Lescot, Square Court of Louvre, Paris, begun	
Bronzino, *Exposure of Luxury*	Primaticcio, decorations, Fontainebleau	
Sansovino, Library of S. Marco, Venice	Goujon, *Fountain of the Innocents*	
Tintoretto, *St. Mark Freeing a Christian Slave*		
Titian, *Rape of Europa; Crowning with Thorns*	Bruegel, *Landscape with the Fall of Icarus; Triumph of Death; Harvesters; Hunters in the Snow*	1550
Palladio, Villa Rotonda, Vicenza; S. Giorgio Maggiore, Venice	Herrera, Escorial	
Michelangelo, *Rondanini Pietà*		
Tintoretto, *Crucifixion*		
Ammanati, Courtyard of Palazzo Pitti, Florence		
Vasari, Palazzo degli Uffizi, Florence		
Vignola (interior), Della Porta (façade), the Gesù, Rome		
Veronese, *Triumph of Venice*	Pilon, *Deposition*	1580
	El Greco, *Burial of Count Orgaz; Resurrection; Grand Inquisitor; Toledo*	

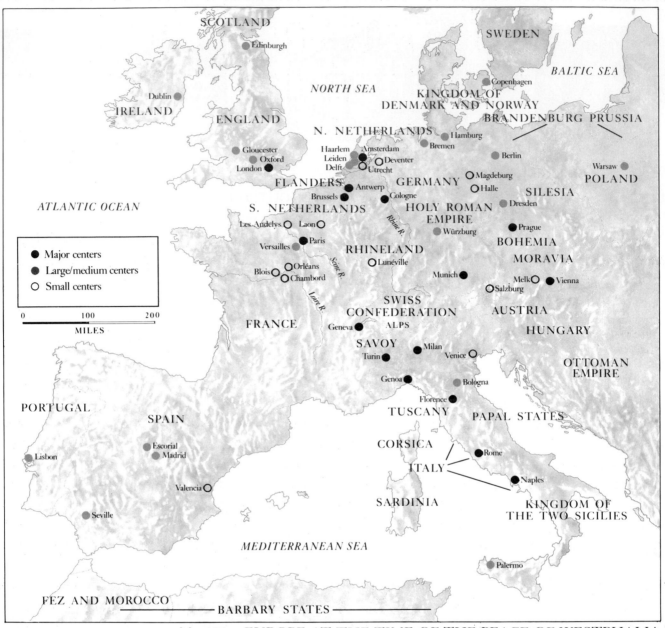

MAP 15. EUROPE AT THE TIME OF THE PEACE OF WESTPHALIA

SCOTLAND

Edinburgh

NORTH SEA

SWEDEN

BALTIC SEA

Copenhagen

KINGDOM OF
DENMARK AND NORWAY

BRANDENBURG PRUSSIA

Dublin

IRELAND

ENGLAND

N. NETHERLANDS

Hamburg

Bremen

Berlin

Warsaw

POLAND

Gloucester

Oxford

London

Haarlem Amsterdam
Leiden Deventer
Delft Utrecht

GERMANY

Magdeburg

Halle

SILESIA

ATLANTIC OCEAN

FLANDERS Antwerp

Brussels Cologne

S. NETHERLANDS

Dresden

Prague

Major centers

Large/medium centers

Small centers

Les Andelys Laon

Versailles Paris

HOLY ROMAN
EMPIRE

Würzburg

BOHEMIA

MORAVIA

RHINELAND

Lunéville

0 100 200

MILES

Blois Orléans
Chambord

FRANCE

SWISS
CONFEDERATION

Geneva

Munich

Melk
Salzburg

Vienna

AUSTRIA

HUNGARY

ALPS

SAVOY Milan
Turin Venice

OTTOMAN
EMPIRE

PORTUGAL

SPAIN

Genoa Bologna

Florence

TUSCANY PAPAL STATES

Lisbon

Escorial

Madrid

CORSICA

ITALY

Rome

Valencia

Seville

SARDINIA

Naples

KINGDOM OF
THE TWO SICILIES

MEDITERRANEAN SEA

Palermo

FEZ AND MOROCCO BARBARY STATES

PART

THE BAROQUE

FIVE

The word *baroque* is often claimed to derive from the Portuguese word *barocco*, of unknown origin, meaning "irregular" or "rough," used specifically to describe pearls of distorted shape. As originally applied to art the term conveyed the contempt felt by Neoclassicists of the late eighteenth and early nineteenth centuries for what seemed to them exaggerated and perverse in the art of the preceding period. For about the last hundred years or so, the term, shorn like *Gothic* of any derogatory meaning, has been in general use to designate the architecture, painting, and sculpture of western Europe and the Americas from about 1590 to 1750, a much briefer period than the Renaissance. The period had its own problems and its own goals, and it makes sense, therefore, to preface our study of this age's arts with a consideration of the general situation in which European humanity found itself about the year 1600.

By the end of the sixteenth century, the "discovery of the world and of man" had wrought fundamental changes in man's views of himself, of society, and of the Christian religion. The frontiers of the world known to Europeans had been extended during the Renaissance voyages of discovery to include much of the Americas, Asia, and Africa. European authority held sway throughout many of the newly discovered regions. The Copernican view of the universe was empirically confirmed after Galileo's invention of the telescope in 1609, which extended man's intellectual frontiers into outer space. In spite of his trial by the Inquisition in 1633, it was only a matter of time before the Aristotelian system, which maintained that the Earth was the center of the universe, would collapse.

The religious divisions of western Europe were well-nigh complete. After the religious persecutions, expulsions, and wars of the sixteenth century were over, Spain, Portugal, France, Italy, and the provinces that today form Belgium remained Roman Catholic. England, Scotland, Scandinavia, the Swiss Confederation, and most of the area comprising modern Holland were solidly Protestant (with Catholic minorities). In spite of continuing warfare between Holland and Spain, there was little serious possibility of change in either religious camp. In central Europe wars, religious in origin but eventually political as well, raged until the Peace of Westphalia in 1648, which left, by and large, the Rhineland, Austria, Bohemia, Hungary, and Poland Catholic, and north Germany Protestant. Along with the victory of Catholicism in the Mediterranean and in central Europe and of Protestantism in the North came the triumph of absolutism almost everywhere. With the exceptions of Holland, Venice, Genoa, and Switzerland, medieval and Renaissance republics were dead.

After the artistic experiments and achievements of the Renaissance, no problems of representation or composition offered any serious difficulties to a diligent and properly trained artist. Academies were established in major European centers, and instruction in them and in artists' studios was thorough. The wide differences in national styles can no longer be explained in terms of stages in the conquest of reality

or of changes in technical procedures, but in the light of the demands made by patrons, religious or secular, actual or potential, and local traditions. Architecture, sculpture, and painting of a dramatic nature were powerful tools in the hands of religious and secular absolutism, and flourished in the service of the Catholic Church and of Catholic monarchies. Protestant countries, on the other hand, had just completed an appalling destruction of religious images, including all Dutch religious painting of the Middle Ages and the Renaissance, and permitted no resurgence of them in their whitewashed church interiors. Even palace and villa architecture under Protestant monarchies was notably restrained, in England, for example, relying strongly on Italian Renaissance models, especially Palladio, and only occasionally accepting elements from contemporary Continental currents. With rare exceptions, in Protestant countries painters were thrown on the open market, where they competed for the attention of prosperous middle-class buyers with scenes drawn from daily life, history, or the Bible, intended for homes rather than churches.

It may well be asked what it is that draws together these widely varying styles and tendencies. The key word is probably allegiance. The religious division of Europe had placed a new emphasis on the inner life of the individual, for which both Catholicism and the various Protestant sects competed. The religious wars of the sixteenth century, still ablaze in central Europe in the first half of the seventeenth, provided an object lesson in the dangers of dissent. In Catholic countries the punitive force of the Inquisition was supplemented by a more positive campaign to enlist and intensify conviction for which there had been less need in the Middle Ages, when occasional serious heresy could be rapidly extirpated and a general unity of Catholic faith in the West was taken for granted. The decorations, the lighting, and even the shapes of Baroque churches and palaces were calculated for maximal emotional effect. Although religious outpourings on the order of those of the Counter-Reformation mystics were a thing of the past, artists in every sphere turned toward these great figures of the recent past and contrived, so to speak, rationally planned stage sets for the experience of the irrational, so that the worshiper could achieve at least the illusion of that union with the Divine that had been granted to Saint Theresa, Saint John of the Cross, and other Catholic and also Protestant mystics of the sixteenth century.

Rather than the miracles of saints (as in medieval and Renaissance art), their martyrdoms, transformed to heavenly bliss at the very moment of agonized death, and their ecstasies, interpreted as an earthly form of martyrdom, were the themes set before Baroque artists. The visual settings for divine-right monarchy in palaces, decorations, and festivals and in costumes, furniture, and carriages were conceived in the same climactic pattern. In Calvinist Holland, without either ecclesiastical or monarchical demand for art, the traditionally reverent Netherlandish approach to the most minute aspects of visual reality gave way to a climactic experience of natural forms, spaces, colors, and lights and the relationship between the observer and the literary or portrait subject in order to produce a strong, if muted, emotional experience. What unites the most disparate phases of the Baroque in European countries, therefore, is a common pattern of experience shared at all social levels by Catholic and Protestant alike.

THE SEVENTEENTH CENTURY IN ITALY

ONE

The transformation from late Mannerism to Baroque took place in Rome toward the end of the sixteenth century, where the ground had already been prepared by the late architecture of Michelangelo and his pupils, especially in the new spaces and forms of Saint Peter's and the Gesù (see figs. 822, 841). In the last decade of the century the presence of an extraordinary group of north Italian painters in Rome heralded the beginning of the new era and its expression in two strongly divergent styles. Within twenty years forms and images established in Rome began to be diffused throughout western Europe, carrying the message of a humanity at ease with both its Christian religion and its Classical heritage and conscious of newly revealed depths of inner experience.

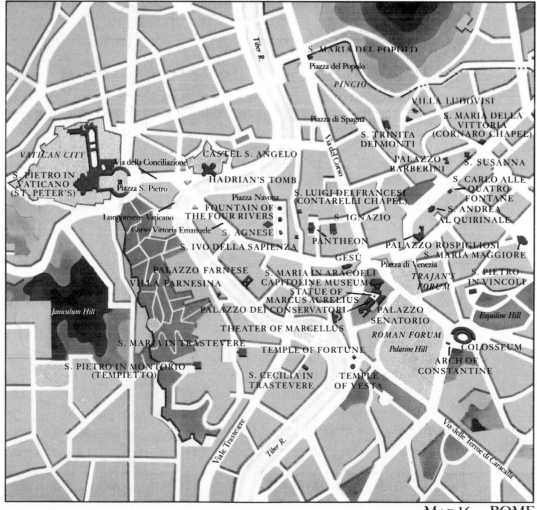

MAP 16. ROME

THE CARRACCI The pioneers of Baroque monumental painting in Rome were the brothers Agostino and Annibale Carracci and their cousin Ludovico, all from Bologna, a city to the north of Florence across the Apennines with a long artistic tradition and a heritage of Renaissance masterpieces from other schools. Bologna was the northernmost city of the Papal States and had a direct cultural connection with the Eternal City. Annibale (1560–1609) was historically the most important artist of the Carracci family and artistically the most gifted. In Bologna in the 1580s all three Carracci had been instrumental in the formation of a new kind of renaissance—not a revival of Classical antiquity nor a discovery of the world and of man (because the Renaissance had already achieved both), but a revival of the Renaissance itself after a long Mannerist interlude. The Carracci aimed at a synthesis of the vigor and majesty of Michelangelo, the harmony and grace of Raphael, and the color of Titian, less through direct imitation of these High Renaissance artists than through emulation of their method of idealizing nature. It will hardly be surprising to learn that this academic attempt at the revival in the 1580s of the situation prevailing in 1510 was connected with the Academy of Bologna, in whose life the Caracci played an important part.

The first major undertaking of Baroque painting in Rome was the gallery (or formal reception hall) of the Palazzo Farnese, painted almost entirely by Annibale Carracci in 1597–1600 (the vault) and 1603–4 (the side walls). The frescoes were commissioned by Cardinal Odoardo Farnese, son of Alessandro Farnese, late duke of Parma, and great-great-grandson of Paul III, the Farnese pope painted by Titian (see fig. 850). The ceiling frescoes (fig. 900) adopted from the *Sistine Ceiling* (see fig. 797) such ideas as large scenes, small scenes, apparently real seated nudes, and simulated marble architecture and both marble and bronze sculpture. But these were organized according to a new principle in the illusionistic tradition of Mantegna (see fig. 732) and Correggio (see fig. 831). The simulated architecture applied to the barrel vault (and at times piercing it) is "sustained" by the simulated sculptural caryatids that, along with the "real" youths, flank pictures incorporated into the structure. Four additional paintings with gilded frames, one at each end of the vault and one at each side, are made to look as if they had been applied later by their overlapping of the architecture and their covering up of parts of the medallions. The complex layer of forms and illusions comes to a climax in the central scene.

A recent study has shown that the subject matter, the Loves of the Gods, on the face of it incompatible with the ecclesiastical status of the patron, is by no means so frivolous as the decorations of the Palace of Fontainebleau (see fig. 879) and veils a deeper, Christian meaning that accounts for the complex organization and for the central climax. In summary, the four smaller lateral scenes represent incidents in which the loves of gods for mortals were accepted, the two horizontal framed pictures those in which mortals refused, the two end ones of the lunettes (of which only one may be seen in the photograph) the disastrous love of the Cyclops Polyphemus for the nymph Galatea, and the central panel the Triumph of Bacchus and Ariadne. This central scene is flanked by Mercury and Paris and by Pan and Selene. It, with its buoyant composition in which the chariots of the god and the mortal he redeemed from despair are borne along in splendid procession, accompanied by deities and Loves and victorious over all obstacles, explains the extraneous framed pictures and justifies the four unframed lateral scenes. The entire complex structure of eleven scenes thus symbolizes the Triumph of Divine Love, al-

900. ANNIBALE CARRACCI. Ceiling fresco (detail), Palazzo Farnese, Rome. 1597–1600

though in physical form. After the Mannerist interlude of public prudery and private prurience, it is typical of the new Baroque attitude that a cardinal could commission a monumental Christian interpretation of ancient erotic myths. Even more, it is essential for our understanding of the Baroque that divine love, conceived as the principle at the heart of the universe, should be the motive power that draws together all the elements of the ceiling and resolves all conflicts in an unforeseeable act of redemption.

At the time it was painted, the Farnese Gallery was widely proclaimed as a worthy sequel to the *Sistine Ceiling* and the Stanze of Raphael. While few today would place it so high, it is a superb creation, whose full beauty can be experienced only by the observer in the actual room. Seventeenth-century viewers were delighted by the coloring of the shadows, which eliminated black, and they testified to their difficulty in distinguishing reality from representation. No wonder, because "real" and "sculptured" figures are expertly foreshortened, and the light, coming from windows along one side of the room, casts their shadows onto the surrounding elements. The love of Anchises for Venus, whom he is in the last stages of disrobing before their union, which was to produce Aeneas, ancestor of the founders of Rome, is typical of the directness of the representations and the physical abundance of the figures (fig. 901). In the experience of the entire work the weight of the figures is carried easily along by the energy and gay coloring of the whole. Both the substance and the drive of the Farnese Gallery proved definitive for most other ceiling compositions of the seventeenth century, and for Baroque monumental painting in general, especially the work of Peter Paul Rubens (see Chapter Two), profoundly influenced by Annibale's style.

In addition to the principles of ceiling painting, Annibale established a new type of landscape with figures, in such works as his *Landscape with the Flight into Egypt*, of about 1603–4 (fig. 902). Although the tiny scale of the sacred figures in relation to the vastness of the landscape may recall Patinir (see fig. 889), there are two important differences. First, the high point of view has been abandoned so that the figures are on a level with the observer, and second, the landscape is no longer fantastic but based on a real one, in this case the actual surroundings of Rome—the Tiber, a fortified village, and the distant Alban Hills. The landscape in this painting, as almost always in the seventeenth century, was derived from studies made outdoors but was constructed in the studio.

901. ANNIBALE CARRACCI. *Venus and Anchises* (detail), ceiling fresco, Palazzo Farnese, Rome. 1597–1600

902. ANNIBALE CARRACCI. *Landscape with the Flight into Egypt*. c. 1603–4. Oil on canvas, 48¼ × 98½". Galleria Doria Pamphili, Rome

903. GUIDO RENI. *Aurora*, ceiling fresco, Casino Rospigliosi, Rome. 1613

904. DOMENICHINO. *The Hunt of Diana*. c. 1615. Oil on canvas, 7'4⅝" × 10'6". Galleria Borghese, Rome

905. GUERCINO. *Aurora*, ceiling fresco, Casino Ludovisi, Rome. 1621–23

903

OTHER BOLOGNESE PAINTERS IN ROME A conservative
solution to the problem of ceiling painting was offered by GUIDO RENI
(1575–1642), whose *Aurora* (fig. 903), painted in 1613 for the ceiling of a
garden house behind the Palazzo Rospigliosi, could as easily have been
designed for a wall. As the chariot of Apollo, radiant with light, sur-
rounded by dancing Hours, preceded by Cupid with a torch and by
Aurora, goddess of the dawn, rolls away the clouds of night over the
distant landscape, one can hardly help thinking of Raphael. While in no
sense a copy, the Cupid is based on the three winged Loves in the *Galatea*
(see fig. 812), and Aurora herself is close to the angels at the upper left in
the *Disputa* (see fig. 807); the spiral construction of all the figures is ob-
viously Raphaelesque. But the freshness and luminosity of the picture
are new, and so indeed is its subject. The swift pursuit of darkness, the
moment of revelation in light, were vital for Baroque subjects and for
Baroque style.

Equally conservative is the work of another Bolognese master in Rome,
Domenico Zampieri (1581–1641), called DOMENICHINO. His delightful *The
Hunt of Diana*, c. 1615 (fig. 904), with its parade of lovely figures draped
and nude, is a slightly unstable combination of Raphael and Titian, but
the harmonious way in which the figures are grouped in a Carraccesque
landscape leads the way to the Classical figural compositions of Poussin
(see Chapter Two).

The final important Bolognese painter of the Early Baroque, Gio-
vanni Francesco Barbieri (1591–1666), called GUERCINO because of his
squint, was the first to apply the lessons of Mantegna, Correggio, and
Annibale Carracci to an illusionistic ceiling fresco seen from a single point
of view. In his *Aurora* (fig. 905), painted in 1621–23 for the garden house

904

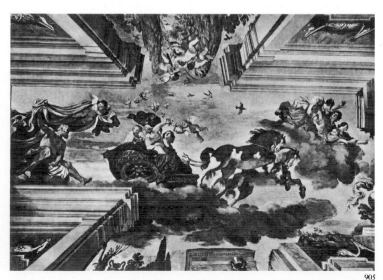

905

of the Villa Ludovisi, not far from the Palazzo Rospigliosi in which Reni's *Aurora* may be seen, Guercino makes his comment on Reni's conservatism by carrying the actual architecture of the modest-sized room upward into the vault so accurately that his prank of ruining it (at the lower right in the illustration) is alarmingly effective. The dark clouds still shadow the Villa Ludovisi and its gardens (which are right outside the actual room); above them rolls Aurora's chariot drawn by piebald horses seen from below. Birds soar beyond it, a Cupid holds a crown of roses over Aurora's head, and she drops blooming oleander twigs on the spectators below. Although the horses and chariot make a convincing impression as they thunder overhead, Guercino was obliged to place them at one side and to tilt them slightly so they would not seem grotesquely foreshortened. The opulence and grace of his style, the rich soft coloring, and the strong light-and-dark contrasts place him in a more naturalistic current than either the Carracci, Reni, or Domenichino.

CARAVAGGIO The one real giant of seventeenth-century painting in Italy is Michelangelo Merisi (1573–1610), called Caravaggio after his native town in Lombardy. After studying with an obscure local master, he arrived in Rome around 1590 as a boy of about seventeen; he lived on the fringe of respectable society, his short life being marked by violence and disaster. A lifelong rebel against convention, Caravaggio is the first artist on record who went out of his way to shock conventional people, chiefly by representing religious scenes in terms of daily life, no matter how seamy. He was in chronic trouble with authority, and had to flee Rome in 1606 after he killed a man in a tennis match. During the next years he wandered around, like Orestes pursued by the Furies, from Naples to Palermo, Messina, and Malta; he died of malaria in his thirty-seventh year on his return journey to Rome, with a papal pardon in sight. Nevertheless, it is to this unruly genius that we must look for the style that was to revolutionize European art, less on account of its visual natu-

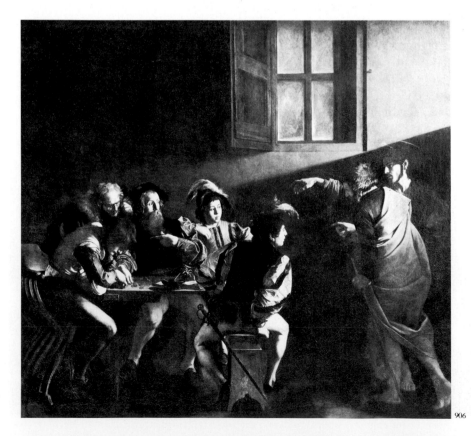

906. CARAVAGGIO. *Calling of Saint Matthew.*
c. 1599–1600. Oil on canvas, 11'1" × 11'5".
Contarelli Chapel, S. Luigi dei Francesi,
Rome

907. CARAVAGGIO. *Conversion of Saint Paul.*
c. 1601. Oil on canvas, 90½ × 68⅞". Sta.
Maria del Popolo, Rome

906

ralism—the Netherlanders had already carried that as far as it could go—than its psychological realism, which plumbed the depths of human feeling in a manner comparable in some respects to the insights of his slightly older contemporary, William Shakespeare, and its extraordinary sense of solid reality projected in actual space.

The young man came to the attention of the powerful Cardinal del Monte, who obtained for him, probably in 1597, the commission to paint three pictures of Matthew and scenes from his life for the Contarelli Chapel in the Church of San Luigi dei Francesi in Rome. The greatest of these is the *Calling of Saint Matthew* (fig. 906), painted about 1599–1600, an event often represented but never in this soul-stirring way. The background is a wall in a Roman tavern; a window, whose panes are the oiled paper customary before the universal use of glass, is the only visible background object. The publican Matthew is seated "at the receipt of custom" (Matthew 9:9) with three gaudily dressed youths at a rough table on which coins are visible; figures and objects are painted in a hard, firm style that seems to deny the very existence of Venetian colorism. Suddenly, Christ appears at the right, saying, "Follow me." His figure almost hidden by

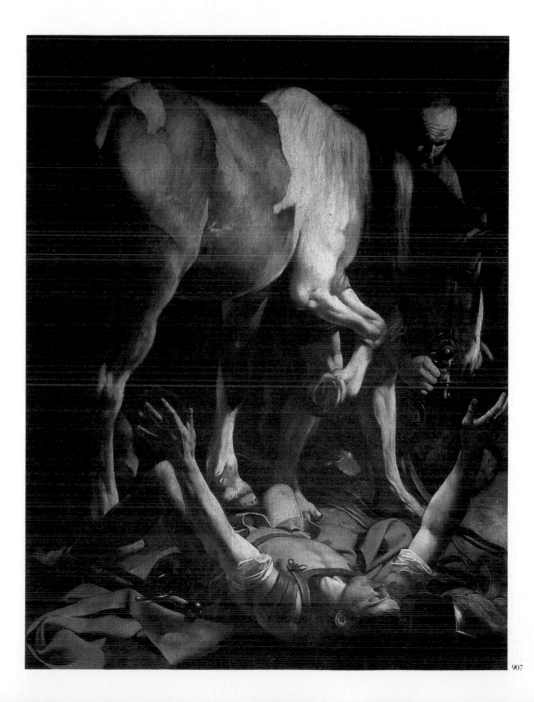

that of Peter, Christ shows only his face and his right hand, illuminated by a strong light from an undefined source at the upper right.

Despite his oft-expressed comtempt for Renaissance masters, Caravaggio never forgot that he shared a common Christian name with Michelangelo Buonarroti, whom he often quoted visually, as if in a vernacular translation. Christ points along the beam of light with a strikingly real hand whose gesture repeats that of God the Father in the *Creation of Adam* (see fig. 799). Matthew points to his own breast as if to say, "Who, me?" What happens in this apparently realistic scene is the essence of the complex contemporary allegory of the Farnese Gallery: the triumph of divine love. With the same gesture by which God made Adam "a living soul" Christ instills a new soul in Matthew.

An even more drastic breakthrough is the *Conversion of Saint Paul*, painted about 1601 (fig. 907); a favorite subject during the Counter-Reformation, this scene was usually shown with a vision of Christ descending from heaven, surrounded by clouds and angels. Caravaggio represented the miracle as an interior event. Against a background of nowhere, as in Jan van Eyck's portraits (see fig. 758), Saul has fallen from his horse toward us, drastically foreshortened like the Christian slave in Tintoretto's *Saint Mark Freeing a Christian Slave* (see fig. 854), his arms rigidly outstretched as in a catatonic trance, his eyes closed. He hears the words, "Saul, Saul, why persecutest thou me?" (Acts 9:4), but his servant hears nothing and looks down at his master, unable to account for the light that shines all around and has blinded Saul. Climax reaches in this picture the stage of cataclysm, the more intense for the hardness with which everything is represented, down to the horseshoe, the rivets in Saul's armor, and the varicose veins in the servant's leg. A remarkably similar appeal to violent inner conversion beyond reason can be seen in a sonnet by John Donne, written little more than a decade after this painting was done. It is all the more impressive as an example of a principle common to the Baroque throughout western Europe, since Donne, an Anglican clergyman, was unlikely to have had any direct knowledge of Caravaggio's painting:

Batter my heart, three person'd God; for, you
As yet but knocke, breathe, shine, and seeke to mend,
That I may rise, and stand, o'erthrow mee,'and bend
Your force, to breake, blowe, burn and make me new.
I, like an usurpt towne, to'another due,
Labour to'admit you, but Oh, to no end,
Reason your viceroy in mee, mee should defend,
But is captiv'd, and proves weake or untrue.
Yet dearely'I love you,'and would be loved faine,
But am betroth'd unto your enemie:
Divorce mee,'untie, or breake that knot againe,
Take mee to you, imprison mee, for I
Except you'enthrall mee, never shall be free,
Nor ever chast, except you ravish mee.

Caravaggio's hard, clear image, which presents inner reality less to our senses than to our minds, is almost contemporary with El Greco's diametrically opposite attempt to paint the unpaintable in the *Resurrection* (see fig. 897).

Caravaggio's paintings were understandably condemned by Bolognese artists and critics in Rome, and some were even refused by the clergy. Nonetheless, a decade after his tragic death Caravaggio's everyday

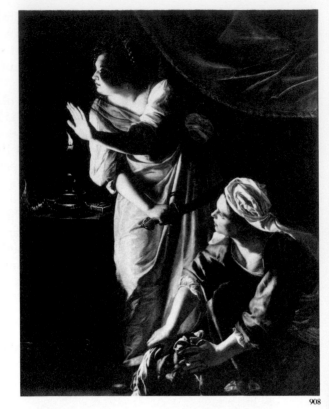

908

908. ARTEMISIA GENTILESCHI. *Judith with the Head of Holofernes*. c. 1625. Oil on canvas, 72½ × 55¾". The Detroit Institute of Arts. Gift of Leslie H. Green

naturalism, his hard pictorial style, his intense light-and-dark contrasts, and above all his way of using these as devices to open the inner recesses of the soul had inspired a host of followers in Rome, Naples, Spain, France, and the Netherlands. His revolutionary art must be considered a major factor in the formation of two of the greatest painters of the seventeenth century, Rembrandt (see Chapter Three) and Velázquez (see Chapter Two).

GENTILESCHI One of the most influential Italian artists in the tradition of Caravaggio was Artemisia Gentileschi (1593–1652/3), who was trained by her considerably less imaginative father, Orazio. Artemisia was raped by her fellow pupil Agostino Tassi in Orazio's studio. In the course of the resultant trial in Rome the victim was tortured with the thumbscrew to elicit the truth, while the attacker suffered little damage to his reputation. Artemisia's subsequent marriage to a Florentine seems to have broken up. She worked with great success not only in Rome and Florence but also in Naples, where she was responsible for consolidating the Caravaggist tradition, and also in England at the court of Charles I. Not surprisingly, a large proportion of her almost uniformly feminist subjects reflect the traumatic effect of her youthful disaster by depicting women wronged by men. Sometimes the women take heroic revenge, as in Artemisia's five separate renderings of the popular theme of Judith and the lustful pagan general Holofernes. In all Artemisia's paintings the female protagonist is a recognizable self-portrait. The magnificent *Judith with the Head of Holofernes* of about 1625 (fig. 908) shows the artist at the height of her powers. The victorious Hebrew heroine casts one last glance backward into the darkened tent as her maidservant is about to wrap the severed head. The grand diagonals of the figures and the curtain fill the space almost to bursting. The only light, throwing an ominous shadow on Judith's face, is that of a candle, soon to become the typical means of accounting for the dramatic chiaroscuro of the Caravaggist formula.

MADERNO The first definitive steps in Early Baroque architecture were taken by Carlo Maderno (1556–1629), another Lombard working in Rome. His façade for the Church of Santa Susanna, 1597–1603 (fig. 909), must be considered the first true Baroque façade in Rome. Nonetheless, it recalls della Porta's façade for the Gesù (see fig. 841) so insistently that for a moment we are hard put to define the differences. Both are two stories high, crowned by pediments; in both the lateral extension of the lower story forced by the side chapels is masked and joined to the central block by consoles; in both the movement of the orders toward the center is dramatized by an increase in projection. But the differences are crucial. The movement in the Gesù seems tentative, halting, incomplete. At Santa Susanna it is definitive, rapid, and fulfilled. The lateral sections of the façade are set back slightly so that the entire central block emerges unified and dominant.

Columns are consistently restricted to the lower story of the central block and pilasters to the upper. Both columns and pilasters are single in the outer bays, double in the center. The clumsy device of a triangular pediment enclosed by an arched one is renounced in favor of a single gabled pediment so related to the crowning pediment of the façade that diagonals drawn through the outer corners of both converge on the worshiper about to cross the threshold. This, in turn, is approached by an

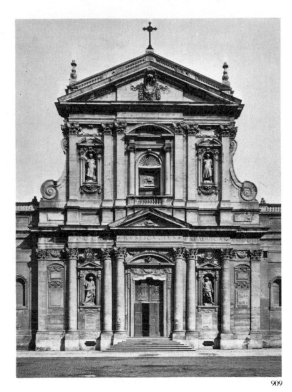

909

909. CARLO MADERNO. Façade, Sta. Susanna, Rome. 1597–1603

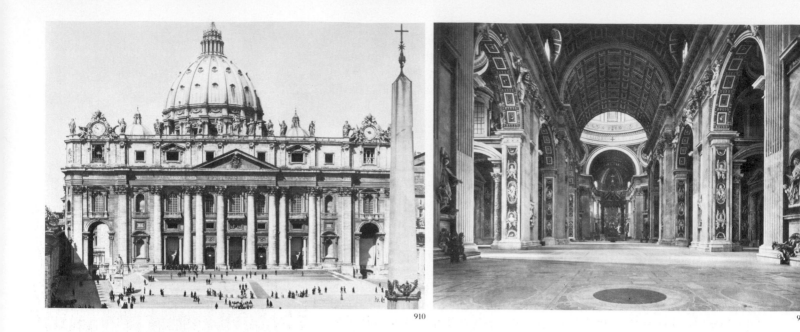

910

911

easy flight of steps. The result is a steady crescendo of forms and spaces culminating in the central climax of the portal in the lower story and the window in the upper—the breakthrough into the building, which corresponds to the stylistic and ideological climax in the Farnese Gallery and the psychological rupture in Caravaggio. From this moment on the numerous architects transforming Rome into a predominantly Baroque city outdid each other in always more dramatic effects achieved by clustered columns, broken pediments, even pulsating wall surfaces, but they concentrated all effects toward the central climax.

Maderno's work at Saint Peter's was not entirely fortunate. Pope Paul V (reigned 1605–21) commissioned him to extend the Greek-cross plan of Bramante and Michelangelo in order to cover all the consecrated ground once enclosed by the Constantinian basilica. From the exterior the effect is disastrous in that Michelangelo's dome is dwarfed by the nearer façade (fig. 910) and appears to descend behind it as one approaches; also, the effect of a close-knit sculptural mass he intended Saint Peter's to produce can now be experienced only from the Vatican Gardens. The width of Maderno's façade would have been acceptable enough if his projected campaniles over the lateral arches had ever been built. Unfortunately, a later pope commissioned Bernini to build higher towers, for which the foundations proved inadequate, and the one actually erected had to be torn down. Maderno was also trapped between his respect for Michelangelo and the ceremonial requirements imposed by the pope. He maintained the general lines of Michelangelo's façade but telescoped his projecting portico into mere engaged columns so as to provide the essential papal benediction loggia.

Although in the interior Maderno had to retain Bramante's giant order and barrel vault, he adapted these elements successfully to Baroque requirements, providing lateral views into side aisles, whose bays are divided by climactic broken arched pediments supported on richly veined columns. The splendid decoration of the gilded coffering in the vaults and arches is due to Maderno's Baroque taste (fig. 911), although the marble paneling and sculptures are the additions of Bernini (see below). Inevitably, the prolongation of the nave (now the longest in Christendom) by three bays in a single giant order, on the models of Alberti's Sant' Andrea (see fig. 676) and Vignola's Gesù (see fig. 840), led to a curious

910. Carlo Maderno. Façade, St. Peter's, Vatican, Rome. 1606–12

911. Carlo Maderno. Interior, St. Peter's, Vatican, Rome

912. Gianlorenzo Bernini. *David*. 1623. Marble, height 67″. Galleria Borghese, Rome

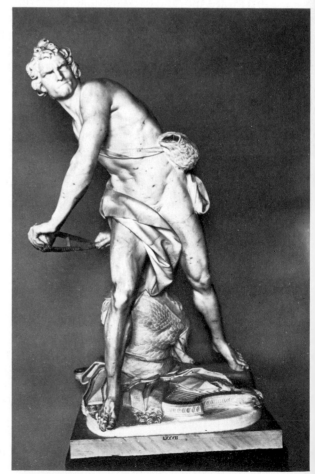

912

falsification of scale. One hardly notices the immense dimensions of the interior until one has been walking for a while in the direction of the papal altar without seeming to get much nearer.

BERNINI The undisputed monarch of the Roman High Baroque, and one of the three or four most influential artists in Europe in the seventeenth century, was Gianlorenzo Bernini (1598–1680), architect and sculptor of genius, and also painter, dramatist, and composer. Born in Naples of a Florentine father and Neapolitan mother, he seems to have combined the intellectuality of the former with the passionate nature of the latter. He was the first of the great Baroque sculptors; moreover, no sculptor until the early twentieth century was entirely able to escape his influence. A brilliant youthful work, the *David* of 1623 (fig. 912), done for Cardinal Scipione Borghese when the artist was twenty-five years old, shows the extraordinary transformation sculpture underwent at Bernini's hands (compare the *Davids* by Donatello and Michelangelo; figs. 684, 793). Bernini has captured the precise moment in which the young prophet—now a full-grown youth of about seventeen or eighteen—is twisting vigorously, about to launch the stone. The pose, derived from Annibale Carracci's *Polyphemus* (see the lunette painting in fig. 900), is carried out with complete devotion to physical and psychological reality. The left hand's tightening about the sling and stone produces sharp tensions in the muscles and veins of the arm, the toes of the right foot grip the rock for further purchase, and the expression, unprecedented even in Hellenistic sculpture, shows the boy biting his lips with the strain. A contemporary source tells how Bernini carved the face while studying his own in a mirror, sometimes held for him by Cardinal Maffeo Barberini, later Pope Urban VIII. The intensity of Bernini's personal identification with the subject can be felt in every detail of the vibrant body.

An even more transient moment of climactic action, perception, and feeling is represented by a companion work for Cardinal Borghese, the *Apollo and Daphne* (fig. 913), started the year before the *David* and finished two years later. Bernini has seized on the second in which the panting god, in hot pursuit of the chaste Daphne (Ovid, *Metamorphoses* I:450–567), is foiled when she calls on her father, the river-god Peneus, for rescue and is transformed into a laurel tree. The toes of her left foot have already taken root, bark has shot up around her left leg and started to enclose her waist, her fingers and her hair are already turning into leaves and twigs, but the change is so sudden that the expression of terror has not yet left her face nor that of desire the Classical features of Apollo. The fidelity with which the softness of female flesh; the lithe body of Apollo; the textures of hair, bark, and leaves are rendered is no more dazzling than Bernini's craftsmanship in carving the scores of minute and slender projections from fragile marble. He has reached in his mid-twenties the height of his ability at pictorial sculpture—the negation of everything Michelangelo stood for, but the fulfillment of promises made by the daring Ghiberti in the *Gates of Paradise* (see figs. 689, 690) and by Desiderio da Settignano in his marble reliefs (see fig. 719). Evanescent effects of melting texture, translucency, and sparkle so dissolve the group into the surrounding space that it is as if Bernini had been able to carve light and air as well as marble.

When his friend Cardinal Barberini ascended the Throne of Peter as Pope Urban VIII (reigned 1623–44), Bernini entered on the parade of commissions for Saint Peter's and its surroundings that was to occupy

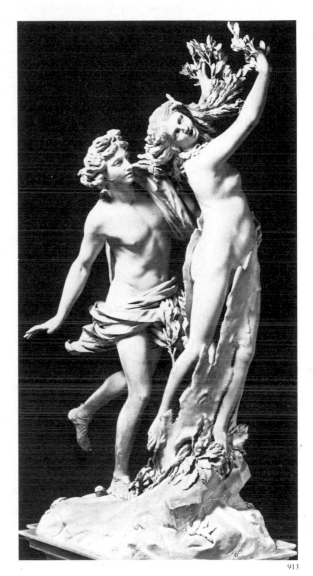

913

913. GIANLORENZO BERNINI. *Apollo and Daphne*. 1622–24. Marble, height 96". Galleria Borghese, Rome

him on and off from youth to old age and that was to determine more than any other single factor the relation of the immense structure to the individual pilgrim and tourist. His first undertaking was the baldachin or canopy of gilded bronze, nearly one hundred feet high (fig. 914), erected between 1624 and 1633 over the high altar and just behind the opening in the floor above the tomb of Peter. Bernini took as his theme the eight spiral columns (probably Syrian but supposedly from Solomon's Temple), which Fouquet had seen in Old Saint Peter's (see fig. 779) and which Bernini later incorporated in the niches he carved from the four piers upholding Michelangelo's dome (see fig. 804). It was his brilliant idea to translate these small columns to gigantic scale and to set them in a kind of dance, still upholding their massive entablatures as well as a simulated valance, angels, and the four consoles that form the open top, crowned by the orb and cross under the dome. The contrast of the columns with the piers of the dome, in fact, is the only element that helps the visitor grasp the true scale of Saint Peter's. Like their ancient prototypes, the columns are not only spiral but also divided into fluted segments and segments entwined by vinescrolls; golden bees, the Barberini emblem, displayed on the bronze valance, have alighted here and there among the leaves.

The culminating moment of that special blend of intense religiosity and theatrical splendor that constitutes the Roman High Baroque is the Cornaro Chapel at Santa Maria della Vittoria, 1645–52, centered around the *Ecstasy of Saint Theresa* (fig. 915). The entire chapel was designed by Bernini as an "environment" (to use a recent expression) for this sculptural group. The total effect eludes photography, and is best reproduced by an anonymous eighteenth-century painting (fig. 916). The barrel-vaulted ceiling is painted away in a burst of clouds and light, disclosing angels adoring the dove of the Holy Spirit, executed by a decorative painter from a sketch by Bernini. The altarpiece becomes an operatic stage, convex as if swelling toward us, the pediment breaking apart to display the vision within. The moment represented is the Transverberation of Saint Theresa, a vision in which she beheld a smiling youthful angel of surpassing beauty, who pierced her heart again and again with a golden arrow, producing a "pain so great that I screamed aloud; but simultaneously I felt such infinite sweetness that I wished the pain to last eternally." The saint hangs strengthless on marble clouds, her eyes closed, her mouth open, in an almost clinically accurate study of her rapture. (In this respect it should be remembered that Bernini not only attended Mass daily but also practiced every day the *Spiritual Exercises* of Saint Ignatius of Loyola, intended to induce in the worshiper exact physical and spiritual counterparts of the experiences of Christ and the saints.)

There could hardly be a more compelling embodiment of the Baroque climactic experience of divine love than this group, in which Bernini has reinforced the concept with his usual virtuosity in the handling of textures of flesh, drapery, feathers, and hair. The background of richly veined marble is the same that clothes the actual interior of the chapel, thus placing the saint in our own space. The gilded bronze rays descending in clusters come apparently from a concealed window, identified with the breakthrough in the ceiling. The side walls are simulated theater boxes, in which kneel in marble relief members of the Cornaro family, who appear to witness the Ecstasy.

Baroque Rome is a city of fountains, which were practical as well as ornamental, providing the water supply for the growing populace. Bernini's *Fountain of the Four Rivers* (fig. 917) was the most spectacular of its

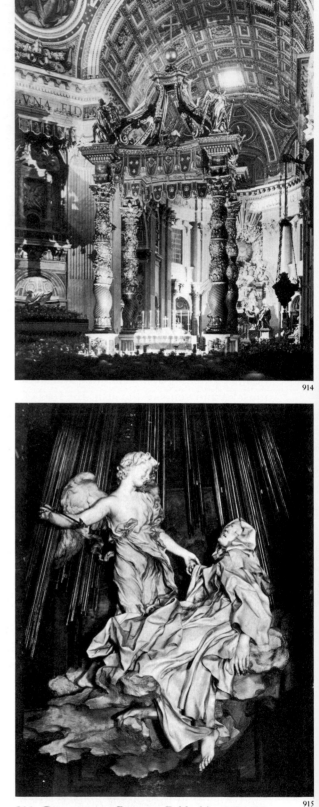

914. GIANLORENZO BERNINI. Baldachin. 1624–33. Gilded bronze, height c. 100'. St. Peter's, Vatican, Rome

915. GIANLORENZO BERNINI. *Ecstasy of Saint Theresa.* 1645–52. Marble, height of group c. 11'6". Cornaro Chapel, Sta. Maria della Vittoria, Rome

time. Pope Innocent X (reigned 1644–55) commissioned the fountain in 1648 as part of the Baroque transformation of the Piazza Navona, once the site of the stadium of Domitian; his palace fronted the piazza, adjacent to the Church of Sant'Agnese (see fig. 925) by Bernini's rival, Borromini (see below). An actual Egyptian obelisk, one of several set up as focal points in the new city plan adopted in the late sixteenth century by Pope Sixtus V, stands on a mock mountain of rough travertine, made to look "natural" but carefully calculated for its effects of light and form by Bernini in preparatory drawings. The giant marble statues of Nile, Ganges (in the illustration), Danube, and Plate were designed by Bernini and carved by his pupils. The playful contrast of the muscular white figures with the rough gray rocks, vegetation, and animals is enriched by the water jets, all designed by Bernini to emerge in spouts, ribbons, or dribbles. If he could sculpture light, why not water?

Bernini's work for Saint Peter's included the complete sculptural program for the nave—the white marble cartouches and medallions against colored marble panels in the piers, and the figures dangling out of the spandrels (see fig. 911). The scale can be imagined by recalling that the child angels upholding the holy water stoups on either side are nine feet high. Designed in 1645–46, the work was carried out in the incredibly short period of 1647–48 by no fewer than thirty-nine sculptors and stonecutters under Bernini's supervision. Like all his work at Saint Peter's, these sculptures have the effect of enlivening what had become almost too large and impersonal a structure. His final creation in the interior was the colossal Cathedra Petri (fig. 918), of 1657–66, a reliquary to enshrine what was believed to be the chair of Peter (but has turned out on recent examination to be Carolingian!). The result is an incredible amalgam of marble, bronze, gilded bronze, stucco, and stained glass between and overflowing Michelangelo's pilasters in the apse. Again we have a rupture of the surrounding structure in that the vision of the dove of the Holy Spirit in stained glass surrounded by clouds of gilded angels and golden rays, seems to have burst the very architecture above the chair, carried on clouds above four Fathers of the Church, two Latin (Augustine, Am-

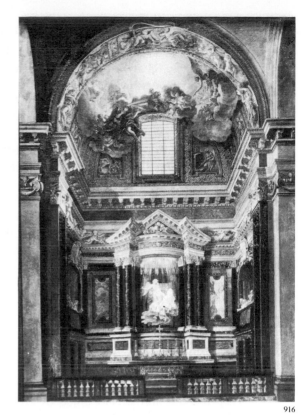

916

916. ANONYMOUS. *The Cornaro Chapel*. 18th-century painting. Staatliches Museum, Schwerin

917. GIANLORENZO BERNINI. *Fountain of the Four Rivers*. 1648–51. Travertine and marble. Piazza Navona, Rome

918. GIANLORENZO BERNINI. Cathedra Petri. 1657–66. Marble, gilded bronze, stucco, and stained glass. St. Peter's, Vatican, Rome

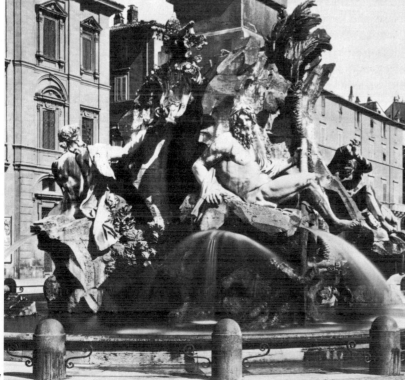

917

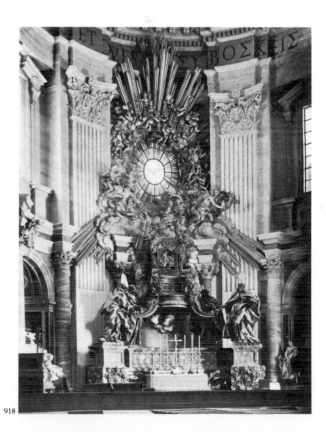

918

brose) and two Greek (Athanasius and John Chrysostom), who supported Roman Catholicism's claim to universality.

In its climactic character, exuberance of forms, textures, colors, and materials, and theatrical brilliance of effect, the Cathedra Petri would seem to have spelled the ultimate in Bernini's long career. The final surprise, therefore, is the austere simplicity of his designs of 1656, carried out over many years, for the enclosure of the whole piazza in front of Saint Peter's by means of two facing exedrae of Tuscan columns, each four columns in depth, supporting an unbroken entablature, surmounted by a statue above each column of the inner row (fig. 919). The oval form of the piazza is based on a central obelisk as its focus; two magnificent fountains flank it left and right. The dynamism of the design lies in the power of its movement; it suggests two gigantic arms outstretched to embrace the approaching pilgrim. The intended climactic effect of this experience of space and light, intense when one emerged into the piazza from the narrow dark adjacent streets, was unfortunately lost when the area between the piazza and the Tiber was modernized in the 1930s. Nonetheless, as one moves through the tall colonnades, apparently in motion, the experience of form and space, constantly changing as if in obedience to unalterable law, is one of the most compelling of any Baroque design, surpassing even the effect of the imperial Roman forums, which must have inspired Bernini.

Sculptors and architects trained by Bernini carried the principles of his style throughout Italy and into northern Europe. In 1665 he was called to France by Louis XIV, the most powerful European monarch of the age, for whose ambitions his grandiose ideas would seem to have been especially appropriate. That his projects for the completion of the Louvre were not accepted, and that his one statue of the king was altered to represent a figure from Roman history and banished to a remote spot in the park at Versailles, tell us much about the fundamental differences between Italian and French attitudes toward the Baroque style.

BORROMINI A strong countercurrent to Bernini in High Baroque Rome was offered by the at-once capricious and austere architecture of Francesco Borromini (1599–1667), a solitary genius born at Bissone, on Lake Lugano, whose brooding, introspective nature was the very opposite of that of the easygoing, expansive Bernini, and whose career ended in suicide. Rather than the splendid accompaniments of richly veined marbles and decorations in stucco and painting, as often as not designed by others, in which Bernini reveled, the essentially linear and spatial interiors of Borromini resisted encroachments from other arts and needed only occasional accents of gold against white plaster. Bernini sketched out his projects with sovereign ease and left the details to an army of assistants; Borromini instead worked obsessively on the designs for the tiniest object or decorative motive, rejecting many before approving his final choice with the word *questo* (this one) on his careful drawings, and supervised with a craftsman's care the execution of his designs.

The Baroque preoccupation with the organization of colossal spaces was matched by its concern for the very small, finding expression in the building of oratories; it is not beside the point that the seventeenth century saw the invention not only of the telescope but also of the microscope. Borromini's plan for the small monastic Church of San Carlo alle Quattro Fontane, 1638–41 (figs. 920, 921), was immediately and widely emulated throughout Catholic Europe, probably because it touched the

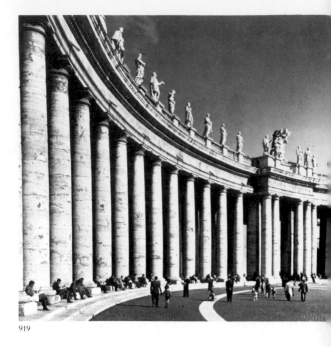

919

919. GIANLORENZO BERNINI. Colonnade of St. Peter's, Vatican, Rome. Begun 1656

920. FRANCESCO BORROMINI. Façade, S. Carlo alle Quattro Fontane, Rome. 1665–67

921. FRANCESCO BORROMINI. Plan of S. Carlo alle Quattro Fontane, Rome. 1638–41

922. FRANCESCO BORROMINI. Interior, S. Carlo alle Quattro Fontane, Rome

920

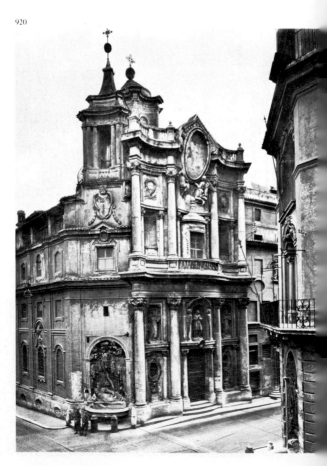

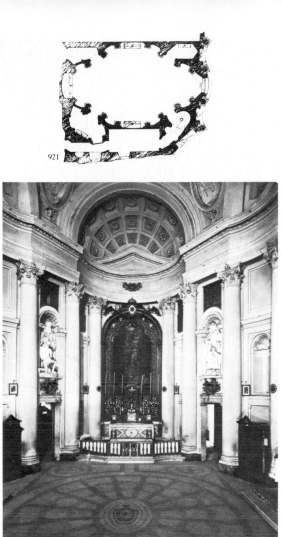

921

922

923. Francesco Borromini. Sant'Ivo della Sapienza, Rome. 1642–60

924. Francesco Borromini. Interior of dome, Sant'Ivo della Sapienza, Rome

very fountainhead of Baroque individual piety. The shape was based, after characteristically long geometrical experimentation, on intersecting ellipses dissolving into each other. Standing inside the church (fig. 922), however, one feels the effect is that of a central-plan structure, in Byzantine or Renaissance tradition, but one made of soft and elastic materials, in fact alive and pulsating; if it were compressed from side to side and lengthened along its axis, the viewer feels it could reverse itself in the next pulsation, on the principle of a beating heart. To emphasize the systolic and diastolic motion of the components, even the Corinthian capitals were so designed that the volutes of one turn over and out, the next under and in. The dynamic plan was intended to arouse a state of instability preparing the worshiper for the Baroque goal of divine union in ecstatic meditation.

The brilliance of Borromini's imagination is manifest on a considerably larger scale in his spectacular Church of Sant'Ivo, erected between 1642 and 1660 (fig. 923), set at the end of the courtyard of the Sapienza (later the University of Rome), which had been designed in the late sixteenth century by della Porta. The ornamentation of the exterior and interior of the church was carried out later during the pontificate of Alexander VII (reigned 1655–67), a member of the Chigi family, whose arms, an eight-pointed star shining from the top of a mountain, are the principal ornaments. Borromini wisely continued della Porta's Late Renaissance arcades of superimposed Doric and Ionic orders, but made the court terminate in a shallow exedra, actually a concave façade, later surmounted at each end by the Chigi mountain and star. Above towers the six-lobed drum of a fantastic dome, surmounted by a step-pyramid whose lobes are separated by concave buttresses terminating in volutes and balls. The lantern obviously suggests in its concave faces the apse of the Temple of Venus at Baalbek, whose design had been known in Europe as early as the sixteenth century. Unconventional even in his choice of sources, Borromini may have derived his spiral spire from the great minaret at Samarra; it was to be repeated again and again throughout Europe as far north as Copenhagen. The work culminates in an open construction of forged iron, a dainty linear motive carrying aloft the orb of power and the Cross. The concave and convex movements work against one another

923

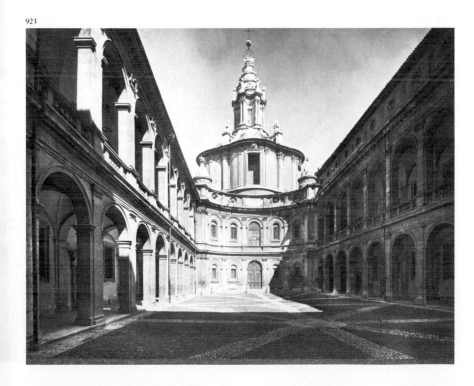

924

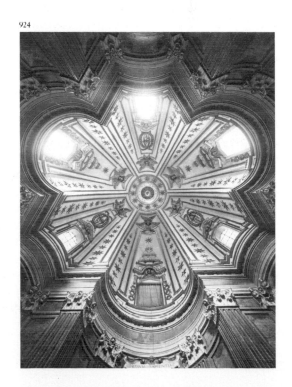

like motives in the polyphony of Bach, with whose music Borromini's architecture has often been compared; the whole design has the effect of a great organ fugue.

Not even the complexity of the exterior quite prepares us for the exquisite mathematical logic of the interior. The plan is an equilateral triangle overlapping a trefoil so that the intersections establish the points of a regular hexagon. The points of the triangle, in turn, are cut into concave arcs, the radius of each of which is equal to that of the adjacent sides. This plan, perfectly preserved in the crowning cornice, governs the convexities and concavities of the pulsating walls and their giant Corinthian order like a perfectly executed rhythmic dance figure. The fantastic shapes blend smoothly together at the apex of the dome to meet in a circle (fig. 924). Originally, the only color on the white walls, dome, and pilasters (the imitation marble is nineteenth-century repaint) was the gold of the ornamentation, the eight Chigi stars on each rib and above the windows the Chigi mountain decorated with the three crowns of the papacy, alternating with Borromini's favorite motive of interlaced palms.

In one lordly work, the design for the Church of Sant'Agnese in Piazza Navona (figs. 925, 926), where Bernini's *Fountain of the Four Rivers* (see fig. 917) was nearing completion, Borromini was able to carry his ideas into a major Roman square. His façade, on which he worked from 1653–66, was eventually completed by others. The heavy attic story and the conventional pediment are foreign to his artistic vocabulary, but the basic ideas and proportions are his. For the first time the relationship between central dome and flanking campaniles, which had been the dream of Maderno and Bernini at Saint Peter's, was actually realized. The concave façade working against the convex dome and the beautiful convex shape of the campaniles are typical of Borromini's thinking. The group was repeated innumerable times in Italy, in central Europe (see fig. 1028), in England (see fig. 1003), and even in Mexico, finding universal acceptance possibly because in essence it is a revival of the Gothic combination of two-tower façade and crossing tower or lantern.

At his death Borromini was still at work on his most subtle and complete expression, the façade added in 1665–67 to San Carlo alle Quattro Fontane (see fig. 920), whose interior he had designed nearly twenty-five years before. His favorite intertwined palms framing the windows on either side of the portal may serve as symbols of the rich interrelationships of concave and convex that continue throughout the masses of the undulating structure and all the minor elements. Had Bernini designed such a façade he would have carried the image of San Carlo Borromeo in the upper story effortlessly through the cornice—clouds, angels, and all; Borromini allows it merely to lift the elastic balustrade and compress it, as if struggling for the release from this world that the architect himself achieved, alas, only by his own hand.

ROMAN BAROQUE CEILING PAINTERS In the wake of Annibale Carracci and Guercino, many large Roman Baroque palace and church interiors—with the notable exception of Saint Peter's, too large for the purpose—were endowed with illusionistic ceiling paintings. All of them take for granted what ordinary reason denies: that with or without the support of an occasional cloud human beings customarily fly through the air. Careful study of perspective and expert manipulation of foreshortening, overlapping, and contrasts of light and dark and color precalculate the effects so accurately as to overwhelm both reason and

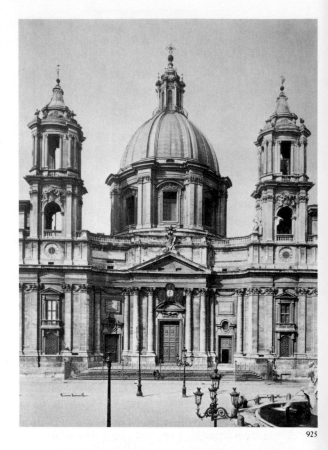

925

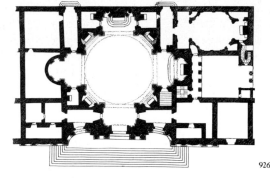

926

925. FRANCESCO BORROMINI. Façade, Sant'Agnese in Piazza Navona, Rome. 1653–66

926. FRANCESCO BORROMINI. Plan of Sant'Agnese in Piazza Navona, Rome. Begun 1652

experience, and turn the most unrealistic of situations into believable reality. All formalize the basic pattern of Baroque experience in the establishment of a reasonably acceptable order, the violation of that order by forces also presented as real, and the final deliverance in an upper luminary realm.

PIETRO BERRETTINI DA CORTONA (1596–1669), equally gifted as architect and painter, was the first to carry the idea beyond the point at which Guercino had left it. In his ceiling for the Palazzo Barberini, 1633–39 (fig. 927), *The Triumph of the Barberini*, the vault is partitioned by an illusionistic structure of simulated architecture and sculpture, whose central panel is open to the sky. In a mighty fountain figures from the side frescoes rush over the border, thus seeming to move in the very space of the room, and then ascend through the frame into the heavens. The subject is an allegory of divine support for the papacy of Bernini's old friend Urban VIII. At the apex of the ascending pyramid of cloud sits Divine Providence, glowing with light, above Time, uselessly brandishing his scythe, and the Three Fates. With a generous gesture, Providence commands Immortality to place a crown of twelve stars above the bees of the Barberini arms, which fly by in heraldic formation, and from other clouds allegorical figures weave a crown of laurels (a reference to Urban's poetic accomplishments) about the bees in space; still others uphold the papal keys and tiara, into the latter of which the perspective permits us to look. Like all Baroque effects, these must be experienced on the spot, but even in a reproduction the upward rush toward, over, and past the architecture moves with the force of a geyser.

An even more brilliant theatrical effect was achieved by the Genoese painter Giovanni Battista Gaulli (1639–1709), called BACICCIO, in collaboration with the sculptor ANTONIO RAGGI (1624–86), a pupil of Bernini. Vignola's severe barrel vault in the Gesù was covered with rich ornamentation in ribs and fields of gilded stucco between 1676 and 1679 (fig. 928). Allegorical figures modeled by Raggi in white stucco, in violent motion, flank or surmount the windows, and four white stucco angels, also by Raggi, uphold the central frame. Into and through the frame float Jesuit saints and angels on clouds painted by Baciccio on fields of plaster laid on the vault outside the frame, so that we can follow with precision their progress from the space of the church across the frame and into Heaven above, drawn upward by the dazzling brightness of the Sacred Name of Jesus, made deliberately almost indistinguishable in white on yellow as if we were looking into the sun. The same force hurls downward with alarming speed evil spirits and vices, who pour pell-mell through the opening and fall toward us as if to crash at any moment on the floor at our feet. To complete the illusion all the figures and clouds outside the frame cast shadows on the gilded ceiling.

The ne plus ultra of the illusionistic ceiling, reaching a phase properly termed Late Baroque, is represented by the allegory of the *Missionary Work of the Jesuits* (fig. 929), 1691–94, painted in the Church of Sant' Ignazio by a Jesuit lay brother, ANDREA POZZO (1642–1709) from Trent, author of an elaborate perspective treatise on how to design and execute complex ceiling projects. The entire barrel vault is painted away, and the architecture of the church carried up an additional story beyond the windows, in front of, through, and above which float allegorical figures. Between the windows appear the four continents, each labeled. America is at the upper left, wearing an Indian crown of red, white, and blue feathers. On clouds, leading Jesuit saints follow Christ, carrying the Cross over his shoulder, high in the heavens at the apex of the perspective. A

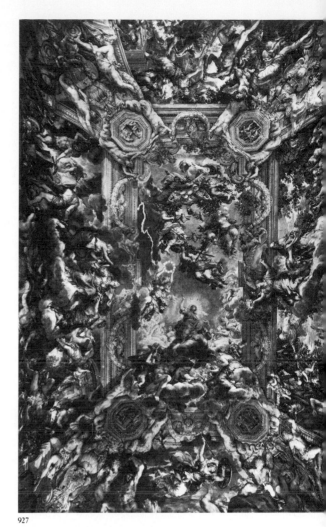

927

927. PIETRO DA CORTONA. *The Triumph of the Barberini*, ceiling fresco, Gran Salone, Palazzo Barberini, Rome. 1633–39

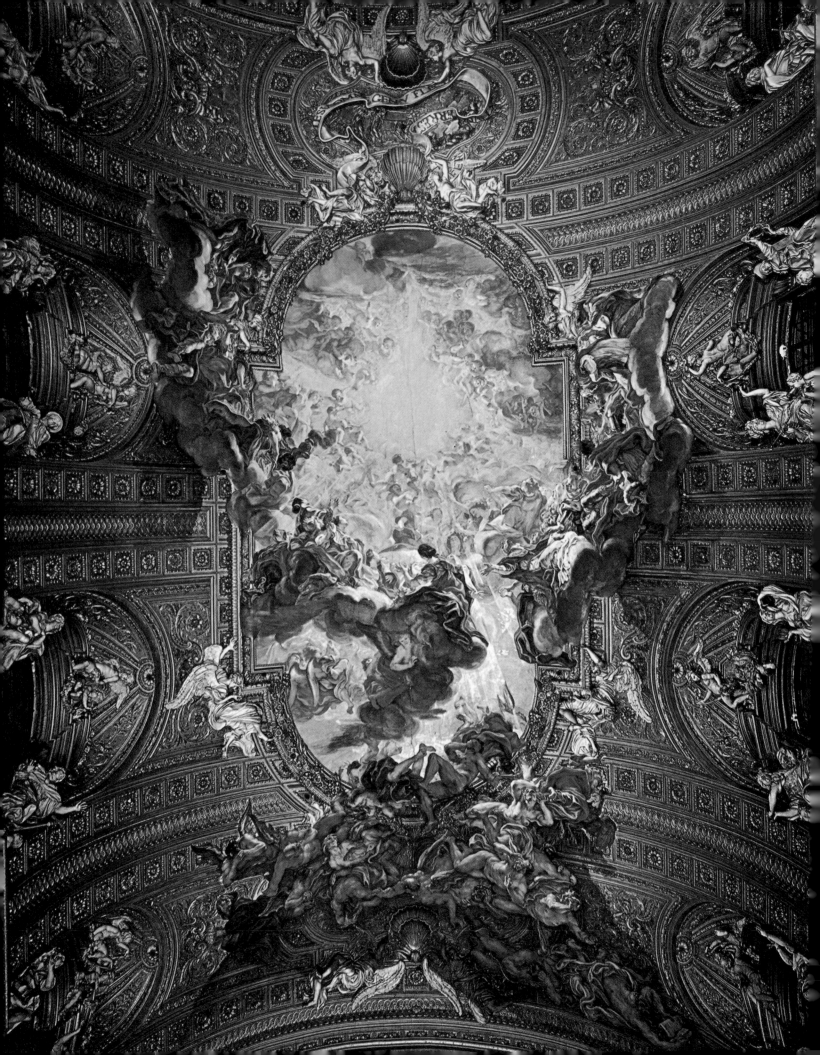

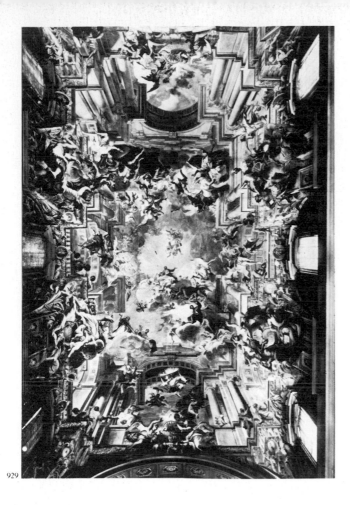

929

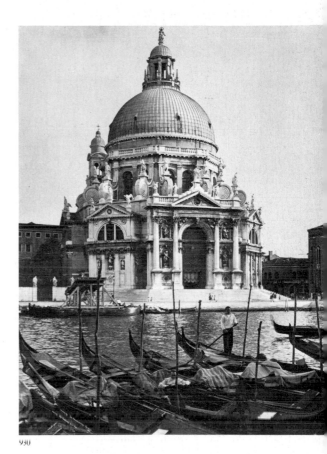

930

moment's reflection will indicate that such perspective triumphs correspond to the actual perspective lines of the church only from a single point of view. Pozzo thought of that. In each of the churches in which he painted an illusionistic ceiling, he indicated with a square of white marble in the floor just where to stand to make the illusion "come right."

NORTH ITALIAN BAROQUE ARCHITECTURE Some strikingly independent Baroque developments occurred in northern Italy. Although the Venetian school of painting was almost dormant in the seventeenth century, awaiting its triumphant reawakening in the eighteenth, Venice could boast one native architect of genius, BALDASSARE LONGHENA (1598–1682), whose masterpiece, Santa Maria della Salute (fig. 930), begun in 1631 and finished only in 1687 after the architect's death, is as inseparable a component of the central Venetian picture as San Marco, the Doges' Palace, the Library of San Marco, and San Giorgio Maggiore. The ideas we have followed throughout the Roman Baroque cannot help us here; Longhena makes no reference to them. His church was based on local Byzantine and Renaissance traditions, and only in the profusion of its shapes and in the multiplicity of its inner views can it be said to be truly Baroque. The plan (fig. 931) is an octagon surrounded by an ambulatory, obviously related to the type that from San Vitale at Ravenna was carried into Germany in the Carolingian period. Each bay of the ambulatory frames a separate projecting rectangular chapel, illuminated by mullioned lunettes as in Roman baths. The main façade with its flight of steps spilling down to the Grand Canal is related to Roman triumphal-arch designs. The sixteen buttresses of the lofty dome rest on the outer walls of the chapels. All the basic elements, therefore, are structural,

931

928. GIOVANNI BATTISTA GAULLI called BACICCIO. *Triumph of the Sacred Name of Jesus*, ceiling fresco, the Gesù, Rome (figures and ornamentation in white and gilded plaster by Antonio Raggi). 1676–79

929. ANDREA POZZO. *Missionary Work of the Jesuits*, ceiling fresco, Sant'Ignazio, Rome. 1691–94

930. BALDASSARE LONGHENA. Sta. Maria della Salute, Venice. 1631–87

931. BALDASSARE LONGHENA. Plan of Sta. Maria della Salute, Venice

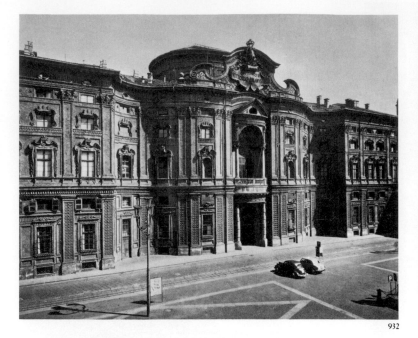

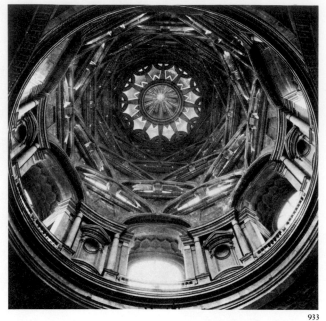

with a rational relationship between interior and exterior. But the buttresses are gratuitously prolonged into huge spirals, on which float rather than rest the podia for sixteen statues. The relatively unobtrusive Doric pilasters of the drum recede behind these splendid ornaments. The almost white tone of the Istrian stone, used here as well as in so many Venetian buildings, and the pale gray of the lead covering of the dome make the structure appear to shimmer over the water like the large, irregular pearls that may have given the Baroque its name.

More startling buildings were erected in the western side of north Italy in Piedmont, where the Theatine priest GUARINO GUARINI (1624–83), from Modena, worked out a brilliant new architectural style under the influence of Borromini, whose early work he had seen in Rome, and of Islamic architecture, which he had studied in detail in Sicily and possibly in Spain, not to speak of Gothic, which he had encountered in France and praised glowingly in his treatise on architecture for its daring lightness and fantasy. He invented a new kind of brick architecture in the Palazzo Carignano at Turin, begun in 1679 (fig. 932); for all the Classical and Baroque derivations of its ornament (Borromini's palms flanking the windows) and its undulating façade, its linearity recalls Flamboyant architecture. Guarini's structural feeling for the material forbade him from masking it with stucco as was customary; every detail of the ornament, even the capitals, is of brick or terra-cotta.

His most amazing achievements were his domes. In the Chapel of the Holy Shroud, built between 1667 and 1694, which towers above the relatively modest Renaissance Cathedral of Turin, the interior is entirely paneled in a funereal dark-gray marble, almost black. The arches of the drum (fig. 933) support segmental arches bridging the intervening spaces, from keystone to keystone. The entire fabric of the dome, in fact, is made up of such arches superimposed in a staggered system to form an open web. Although the idea was derived from Islamic flying arches, such as those in the Great Mosque of Córdoba, the result is as light as any High Gothic structure; the top of the dome has been glazed to eliminate the outer surface entirely. The light filtering through the openings into the dark sanctuary communicates to it a mysterious effect beyond description, surely one of the most original inventions of the Baroque period.

932. GUARINO GUARINI. Façade, Palazzo Carignano, Turin. 1679–92

933. GUARINO GUARINI. Interior of dome, Chapel of the Holy Shroud, Turin. 1667–94

CHAPTER

THE SEVENTEENTH CENTURY IN CATHOLIC EUROPE OUTSIDE ITALY

TWO

In the first half of the seventeenth century Europe was torn by violent divisions between Catholic countries (the Italian states, France, Spain, Portugal, and the Holy Roman Empire that included the southern Netherlands) and Protestant countries (much of central and northern Germany, the northern Netherlands, England, and Scandinavia). The Thirty Years' War (1618–48) began as a conflict for religious domination, but kept assuming more and more irrational forms, devastating and depopulating much of Germany to such an extent that it took generations for full recovery. The Peace of Westphalia, a treaty signed in 1648, brought the warfare to an end and settled major political and religious divisions in Europe for the rest of the century. German Protestant princes were fully independent, and the emperors ruled only in Austria and Hungary.

The territorial split between Catholic and Protestant regions had profound consequences for the visual arts. In general, Catholic countries were monarchical and absolutist. For such regimes the splendors of the Italian Baroque held great emotional appeal. All the dramatic Italian devices, all the riches of form, space, and color, were warmly welcomed as visual reinforcements of the intensity of Catholic faith and the grandeur of monarchical rule. Germany was in no condition to demand much in the way of works of art, especially architecture, while Calvinist Holland, predominantly bourgeois, and Protestant England, alternating between Anglican monarchism and Calvinist republicanism, destroyed wholesale as many works of art as possible in the interiors of vast Gothic churches (see fig. 983), and sternly forbade the creation of any new ecclesiastical imagery.

Diluted only by regional and national traditions and preferences, the stylistic currents set in motion in the early seventeenth century in Rome, the spiritual center of Catholicism, flowed out over Catholic Europe in an overwhelming tide.

France The earlier religious wars of the sixteenth century had left France in a prostrate economic and political condition, from which it was rescued by a succession of ambitious monarchs, each assisted by an able minister—Henry IV by Sully, Louis XIII by Richelieu, and Louis XIV (see fig. 943) by Colbert (see fig. 957). Deeply though the influence of Caravaggio and Bernini penetrated the French consciousness, in their age of power and glory the French rejected the excesses of Baroque enthusiasm and forged a temperate, elegant, classicizing style, which they are today reluctant to call Baroque. Its ties with Italy are so strong, however, that the term can hardly be avoided. Paradoxically enough, the most classicistic painter of the seventeenth century, Nicolas Poussin, preferred to live and work far from his native France, in Rome, the epicenter of the Baroque earthquake, to whose contemporary art he remained sublimely indifferent. During the seventy-two-year reign of Louis XIV in the second half of the seventeenth century and the early eighteenth, Paris began to replace Rome as the principal artistic center of Europe, a position it maintained almost unchallenged until World War II.

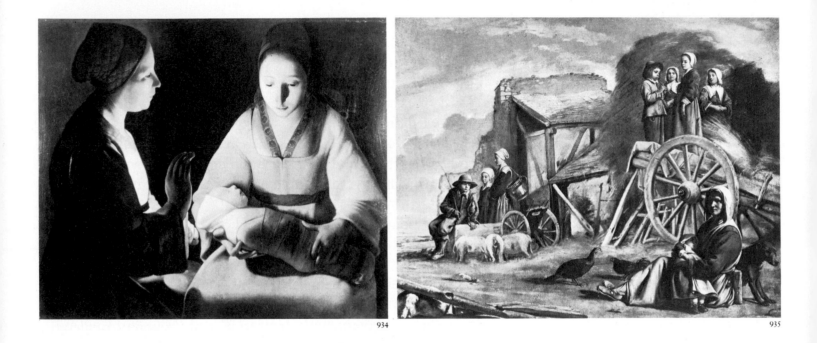

934

935

LA TOUR Like most European countries, France experienced its wave of Caravaggio imitators. The first truly important French painter of the seventeenth century, Georges de la Tour (1593–1652), was highly regarded in his own time but soon slipped into oblivion, from which he has been rescued only in the present century. Born in Lorraine, La Tour worked in Lunéville and traveled in Italy and Holland. Although there is little direct influence of Caravaggio in his work, he was affected by the tide of psychological realism Caravaggio set in motion; in his hard and polished surfaces and in his strong light-and-dark contrasts, he even intensifies elements of Caravaggio's style. But his content could hardly be more different. While his works do indeed deal with religious subjects in terms of everyday life, La Tour's special quality is an intimate poetry engendered by night light. The *Newborn*, painted about 1630 (fig. 934), is in the tradition of Geertgen (see fig. 768) and of Correggio (see fig. 830), though the light comes from a candle held by the midwife rather than emanating from the Child. Yet La Tour allows us only to surmise that the picture represents Mary and Jesus. The quiet humanity breath-

934. GEORGES DE LA TOUR. *Newborn*. c. 1630. Oil on canvas, 29⅞ × 35⅞". Musée des Beaux-Arts, Rennes

935. LOUIS LE NAIN. *The Cart*. Oil on canvas, 22 × 28¼". The Louvre, Paris

ing through all his paintings renders the question of identity almost irrelevant. The beginning of new life is a sacred moment; its mystery is silently shared by mother and midwife, and made manifest by the candle whose effect on the pure sculptural forms and surfaces, and on the glowing red garments, is exquisitely studied.

THE LE NAIN BROTHERS Another relatively recent rediscovery has been the art of the three Le Nain brothers—Antoine (1588–1648), Louis (1593–1648), and Mathieu (1607–77). Born in Laon, they lived and worked together in placid harmony in the Saint-Germain-des-Près quarter of Paris, then a suburb and, as ever since, the home of artists. Louis seems to have been the most important artist of the three; as they never signed their first names to their pictures, the assignment of many works is still conjectural. All three were devoted to scenes of daily life, although Louis was apparently responsible for the most convincing of the peasant scenes. Nothing in his *The Cart* of 1641 (fig. 935) recalls the bumptiousness of Bruegel's peasantry; there could be nothing more ordinary than their activities, yet these people are treated as reverently as La Tour's religious subjects. They stand or sit calmly among the poultry and pigs of a farmyard, in groups composed with such dignity that the rough cart is endowed with monumental grandeur. The wheat, related to the Eucharist, and the brass pot to ritual cleansing as in Early Netherlandish paintings (see figs. 747, 751) may here retain a hint of their former symbolism. The richly painted colors—muted grays, tans, and browns in the clothing with an occasional touch of red, soft grays and blues in the pearly sky, grays and greens in the landscape—make this little masterpiece a worthy ancestor of Chardin in the eighteenth century (see fig. 1020) and Corot in the nineteenth (see fig. 1101).

POUSSIN To his era and to us today, Nicolas Poussin (1593/94–1665) is the very embodiment of the Classical spirit, not in the Renaissance sense of adapting ancient ideas to contemporary needs, but rather in an attempt to take contemporaries back to antiquity. His paintings are the product not only of great imagination and pictorial skill but also of a discipline and control that grew firmer as the painter aged. Born near the small town of Les Andelys on the Seine in Normandy, Poussin went to Paris in late adolescence, and seems to have had access to the royal collection of paintings, where he was chiefly impressed by the works of Raphael and Titian, and to the royal library, where he studied engravings after Raphael. After two trips to Italy he settled down for good in Rome in 1624, returning to France only for a single unsuccessful visit. Given his stubborn personality and his overriding Classical interests, it was unlikely that he would ever enjoy official success. The world of prelates, nobles, popes, and monarchs in which Bernini moved was not for him. Poussin made only one large altarpiece for Saint Peter's, and was dissatisfied with it.

An attempt by King Louis XIII to have Poussin work on ceiling paintings for the Long Gallery of the Louvre ran afoul of the artist's refusal to consider ceiling paintings different from those on walls, to adopt a low point of view (he maintained that people do not normally fly through the air), and to turn over the execution of vast projects to assistants. The latter objection effectively ruled out the customary colossal Baroque monumental commissions. In Rome he preferred the society of learned

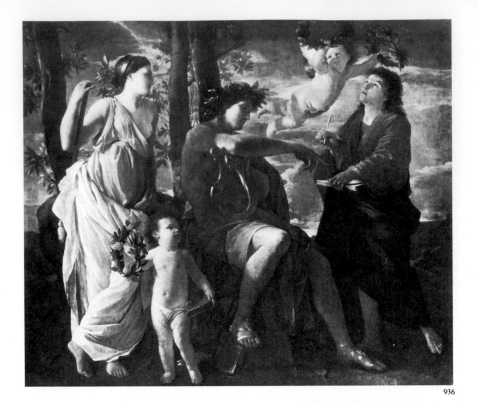

Parisian visitors, who bought (and sometimes ordered) his paintings, and the antiquarian Cassiano dal Pozzo, who commissioned artists to draw for him every work of ancient sculpture and architecture he could track down. Like his Dutch contemporaries (see Chapter Three), Poussin reflects to an extent the ideas and tastes of a class—in this case, one intensely interested in antiquity and in Stoic philosophy.

In such early works as the *Inspiration of the Poet*, painted about 1628–29 (fig. 936), with its Classical figures arranged before a landscape in low afternoon light, Poussin revealed his allegiance to the Bolognese tradition (see Chapter One). Even more important, he attempted independently to recapture the magic of Titian through warm coloring unified by soft glazes and through subtle and surprising passages of lights and darks, especially the way light touches the edge of Apollo's lyre and part of his cheek, leaving the rest in shadow. But a comparison with Titian's *Bacchanal of the Andrians* (see fig. 845), to which this picture is in some ways related, shows that Poussin had no intention of reviving the frank sensuality of the great Venetian. This is an allegorical scene in keeping with seventeenth-century ideas; the yearning poet (one could as easily view him as a painter) owes his gifts to divine inspiration. The works of ancient sculpture from which Poussin derived his poses are evoked as memories of a vanished past (existing largely in imagination), for which the artist's nostalgia makes these early paintings poignant in the extreme.

About 1630 a severe illness provided a break during which Poussin could formulate the theoretical basis of his art. He abandoned his earlier lyric style and Venetian color in favor of what in his notes and letters he called *la maniera magnifica* (the grand manner), which required first of all a subject—drawn from religion, history, or mythology—that avoided anything "base" or "low." One wonders, parenthetically, what he must have thought of La Tour, of the Le Nain brothers, or, for that matter, of the whole Caravaggist movement. Poussin maintained that the subject must first be so clarified in the painter's mind that he will not clog the

936. NICOLAS POUSSIN. *Inspiration of the Poet*. c. 1628–29. Oil on canvas, 72½ × 84¼". The Louvre, Paris

essence of the narrative with insignificant details. Then the painter must consider the conception, that is, the couching of the story in an impressive way, such as Phidias's idea of the Olympian Zeus as a god who by a nod could move the universe. Then the artist must devise the composition, which must not be so carefully constructed that it looks labored, but should flow naturally. Last comes the style or manner of painting and drawing, which Poussin considered innate in the painter.

At another point Poussin expounded his theory of the modes of painting by analogy with the modes or scales in Greek music, and mentioned five, the Dorian, the Phrygian, the Lydian, the Hypolydian, and the Ionic. He really did carry his ideas of the modes systematically into execution. His *Rape of the Sabines*, of about 1636–37 (fig. 937), exemplifies the Phrygian mode adapted to "frightful wars"; nonetheless, its "modulations are more subtle than other modes," and Plato and Aristotle "held in high esteem this vehement, furious, and highly severe Mode, that astonishes the spectator." The picture also fulfills all Poussin's requirements for the *maniera magnifica*. The subject is lofty, for the abduction of the Sabine women by the bachelor Romans assured the perpetuation of the Roman race; the conception is powerful; the composition effortless and natural for all its references to ancient and Renaissance statuary figures and groups; and the style beyond all praise. In comparison with works of Poussin's early period, the picture seems drained of atmosphere; in this vacuum his colors ring brilliantly clear, dominated by the primary hues of red, blue, and yellow, each self-contained without the tendency to melt into or to reflect one another (which forms one of the delights of much Baroque painting). The composition is staged in a limited space, flanked on one side by the temple portico in which Romulus stands and limited at the rear by a structure whose appearance is reconstructed from Vitruvius's description of a basilica. The building in the landscape in the background recalls the hill fortress of Annibale Carracci's *Landscape with the Flight into Egypt* (see fig. 902). The rhythm surges along with the driving energy of a fugue by Bach or Handel, every melody of torso or limb clearly distinguishable and perfectly modeled. Although the result may seem artificial, accepted on Poussin's own intellectual premises the painting is brilliantly effective. And, perhaps in spite of Poussin, the grand sweep of forms and colors has an undefinable something that we can call Baroque.

A later work, the *Holy Family on the Steps*, of 1648 (fig. 938), is probably in the Hypolydian mode, which "contains within itself a certain suavity and sweetness which fills the soul of the beholders with joy. It lends itself to divine matters, glory and Paradise." The pyramidal composition suggests the Madonna groups of Leonardo (see fig. 786) and Raphael (see fig. 806), which Poussin knew and studied. Like Tintoretto, but for different reasons, he arranged little draped wax figures on a stage, with the lighting carefully controlled and with a backdrop of landscape and architecture. He would experiment with figural relationships till he found the right grouping, then build a larger and definitive arrangement of modeled and draped figures and paint from it, referring to reality only when necessary. This procedure is evident in the present picture. The grave, ideal quality of Poussin's art triumphs in such Classical compositions arranged before simple, cubic architecture that bypasses the Baroque, the Renaissance, and the Middle Ages, going straight back to Roman models. While the faces of his figures often appear standardized and almost expressionless, the grandeur of Poussin's art—always on an intimate scale—appears in the balance of forms, colors, and lights. Such compositions were to inspire Ingres in the early nineteenth century (see

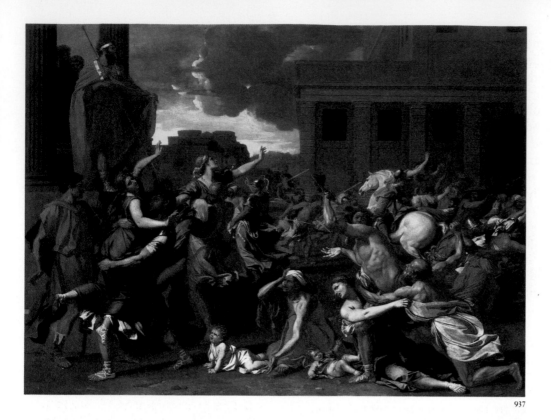

937

fig. 1063) and to form the basis for the still life and figure paintings of Cézanne in the late nineteenth and early twentieth centuries (see figs. 1144, 1145).

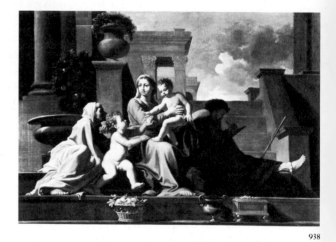

938

CLAUDE LORRAIN A diametrically different aspect of the relationship of figures and landscape forms the lifelong theme for the paintings of Poussin's fellow emigré, Claude Gellée (1600–82), called Claude Lorrain from his origin in Lorraine, who settled in Rome at an early age and never left. Lorrain had so little interest in narrative that he often commissioned others to paint the tiny figures in his pictures. Nonetheless, these figures form an indispensable element in the composition, less to suggest a mood as in Giorgione (see fig. 843) and Patinir (see fig. 889)— for historical, religious, and mythological subjects were interchangeable in his mind—than to establish scale—and scale is all-important. The tiny figures make Lorrain's landscapes at once habitable and immense. In the *Marriage of Isaac and Rebecca*, of 1648 (fig. 939), the typical spacious background of the Roman Campagna appears. The Tiber, in the center, has been widened a bit for pictorial effect. Such landscapes, like those of Annibale Carracci and Domenichino, and the landscape backgrounds of Poussin, were constructed in the studio. The giant tree on the right is an obvious *repoussoir* (a device to suggest recession in space) from which the eye moves to the trees in the middle distance, then to the shape of Mount Soracte on the horizon. The mood is provided by Lorrain's soft light, usually the idyllic and dreamy light of late afternoon or sunset, and from visual memories of landscapes he knew.

Lorrain's connection with landscape was intimate and profound. He was almost uneducated, wrote in a mixture of French and Italian, and went off for long periods to live in communion with nature with shepherds in the Campagna. In the open air he produced rapid sketches in pen and ink, with shading in ink wash (fig. 940), which not only record

937. NICOLAS POUSSIN. *Rape of the Sabines*. c. 1636–37. Oil on canvas, 61 × 82½". The Metropolitan Museum of Art, New York. Dick Fund, 1946

938. NICOLAS POUSSIN. *Holy Family on the Steps*. 1648. Oil on canvas, 27 × 38½". National Gallery of Art, Washington, D.C. Samuel H. Kress Collection

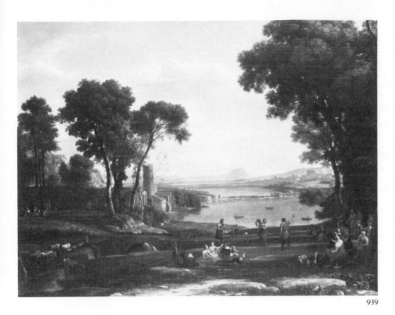

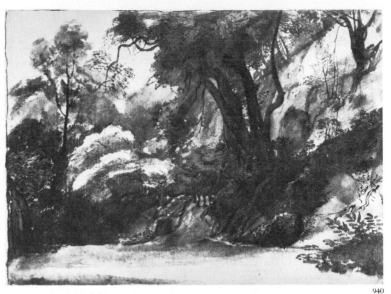

939

940

in fluid masses of dark the play of light and shade on foliage but also convey a rhapsodical response to nature. Such an attitude was the direct ancestor of that of the early-nineteenth-century English Romantics, especially Constable (see Part Six, Chapter Two). These rapid notes were the foundation of Lorrain's studio pictures.

Strikingly original are Lorrain's port scenes, recalling his love for the Bay of Naples, which he saw as a youth, and pervaded by the light of gentle Italian sunsets, which last for hours. In the *Embarkation of Saint Ursula*, of 1641 (fig. 941)—which could just as well be the embarkation of almost any other group of ladies—the rippling surface of the water leads the eye effortlessly to the point where perception dissolves in the soft gold sunlight. The foreground figures serve as a foil, and the water is framed on one side by the meticulously rendered shipping, on the other by a fanciful architecture that transports Bramante's Tempietto (see fig. 800) to the seashore, along with a two-tower Roman Renaissance villa.

939. CLAUDE LORRAIN. *Marriage of Isaac and Rebecca*. 1648. Oil on canvas, 58¾ × 77½". National Gallery, London

940. CLAUDE LORRAIN. *On the Slopes of the Janiculum*. Date unknown. Pen and ink, with bister wash shading, on paper. Accademia Nazionale dei Lincei, Rome; on loan from the Gabinetto Nazionale delle Stampe, Rome

941. CLAUDE LORRAIN. *Embarkation of Saint Ursula*. 1641. Oil on canvas, 44½ × 58½". National Gallery, London

941

OTHER FRENCH PAINTERS Among the many French painters who stayed at home the most gifted was PHILIPPE DE CHAMPAIGNE 1602–74). Born in Brussels, Champaigne was brought up in a strong Flemish Baroque tradition, but after 1643, the probable date of his conversion to the austere Catholic Jansenist movement, his work underwent a fundamental change. His most original paintings are his sober portraits, painted in a cool, exactly controlled style, such as *Arnauld d'Andilly* (fig. 942), of 1650, which shows a man in a window. His calm face is illuminated in a clear, almost Eyckian light that reveals every wrinkle and every vein. Yet the face, ravaged by time and emotion, shares the common Baroque experience of suffering undergone, assimilated, and overcome.

Such simple and unsparing portraits contrast sharply with the official art that dominated the period of Louis XIV. Among the principal practitioners, HYACINTHE RIGAUD (1659–1743), more than any other, was responsible for determining the character of ceremonial Baroque portraiture throughout Europe. His *Portrait of Louis XIV* (fig. 943), painted in 1701 when the king was sixty-three years old, is the prime example of the type. The monarch is shown in ermine-lined coronation robes tossed jauntily over his shoulder to reveal his white-stockinged legs, the feet pirouetting in the high-heeled shoes the king invented. The Baroque magnificence of the pose and the dramatic array of gorgeous fabrics and bits of architecture are clearly intended to endow divine-right absolutism with some of the air of revelation derived from the images of ecstatic saints. Rigaud worked out a production system for such official portraits; he alone painted the subject's head from life on a small canvas, and designed the whole composition; then his assistants enlarged the design, gluing the part by Rigaud in the proper place. A team of specialists in painting armor, fur, fabrics, architecture, and at times landscapes and battle scenes then went to work. The theatrical quality of the result should not blind us to the fact that as a portraitist Rigaud was unexcelled anywhere at the turn of the century; his delineation of the face of the king in old age, who still acted the Grand Monarch in spite of severe military setbacks, is chilling in its directness.

ARCHITECTURE AND DECORATION: THE ROAD TO VERSAILLES The truly original contributions of French seventeenth-century architecture lay in the secular sphere, especially the châteaus built for royalty, nobility, and wealthy officials, culminating in the Royal Palace at Versailles (see figs. 947–52). An early leader was FRANÇOIS MANSART (1598–1666), who built in 1635–38 a wing for the earlier Château of Blois (fig. 944) that takes its name (the Orléans Wing) from the patron, Gaston, duke of Orléans. The three-story façade with steep roofs and central pavilion derives from the tradition established by Lescot in the Square Court of the Louvre (see fig. 881). In its canonical superimposition of Doric, Ionic, and Corinthian orders, Mansart's façade is, if anything, more Classical than Lescot's. But the Mannerist linear web of architecture and sculptural decoration is here replaced by a new mastery of space and mass. The dominant central pavilion comes to a typically Baroque climax around and above the entrance in engaged columns, rather than the pilasters used elsewhere throughout the façade; the effect is completed by a gabled pediment in the second story and an arched pediment in the third, which receive the only sculptural decoration on the otherwise austere exterior except for that around the portal. In a bold and novel invention, a quadrant of freestanding, paired Doric columns on

942

943

942. PHILIPPE DE CHAMPAIGNE. *Arnauld d'Andilly.* 1650. Oil on canvas, 35¾ × 28¾″. The Louvre, Paris

943. HYACINTHE RIGAUD. *Portrait of Louis XIV.* 1701. Oil on canvas, 9′2″ × 7′10¾″. The Louvre, Paris

each side leads up to the entrance and bridges the gap between the central structure and the projecting wing. These dramatic effects, however, are moderated by a lightness, elegance, and precision remote from the dynamism of Italian Baroque designs.

Oddly enough, the first French Baroque venture into grandiosity, the Château of Vaux-le-Vicomte (fig. 945), was built in 1657–61 for a commoner, Nicolas Fouquet, finance minister of Louis XIV, who was determined to erect the most splendid château in France. His success also proved his undoing, because three weeks after his lavish housewarming, which included fireworks and a specially commissioned comedy by Molière in the presence of the king and queen and the entire court, Fouquet was arrested and imprisoned for life on orders from Colbert for embezzlement, and all his property, including Vaux-le-Vicomte, was confiscated by the king. The architect, LOUIS LE VAU (1612–70), the landscape designer ANDRÉ LE NÔTRE (1613–1700), and the mural painter and interior designer CHARLES LE BRUN (1619–90), who had functioned so brilliantly as a team at Vaux-le-Vicomte, were absorbed into royal service, and within a few years achieved their triumph at Versailles.

The garden façade of Vaux-le-Vicomte, despite its adoption of such Italian elements as a central dome (over an oval grand salon) and a giant Ionic order for the side pavilions, would probably have impressed an Italian of the period as timid; nonetheless, the characteristic elegance and grace of the elements and their articulation are typical of French taste of the period, and were carried out in harmony with the broken silhouette and lofty lantern that recall Chambord (see fig. 880). The formal gardens, with their elaborate geometrical planting, urns, and statues, contained the germ of ideas Le Nôtre later carried out on a colossal scale in the gardens and park at Versailles.

Louis XIV had summoned Bernini to France to complete the east façade of the Louvre. Bernini, arrogantly critical of everything French, submitted designs that would have dwarfed the sixteenth-century sections of the palace and completely encased the court by Lescot. They were rejected as impractical and incompatible with French taste, and the great Italian master returned to Rome. The design finally accepted was so classicistic that it has little connection with anything in previous French (or, for that matter, Italian) architectural history (fig. 946). The authorship of the east façade of the Louvre, 1667–70, is still a matter of dispute; apparently, both Le Vau and Le Brun helped with its design, but the decisive idea seems to have come from an amateur archaeologist and architect (and professional physican), CLAUDE PERRAULT (1613–88). All that remains of traditional French design is the idea of central and terminal pavilions and connecting walls, restated in terms of a stately peristyle of coupled Corinthian columns two stories high, with central pediment. Since the ground story is treated as a podium, for the first time a French building presents itself as a single giant story embracing the entire structure. Although both the rigorous classicism and the airy lightness of the peristyle are alien to Italian Baroque architecture, the giant order on a podium and the balustrade against the sky were taken over from Bernini's designs. The new severe mass of the east façade of the Louvre, with its hidden roof and unbroken architectural profile, proved definitive for French palace architecture for the next century.

Despite the pleas of Colbert, who wanted to keep the king in Paris, at the time the east façade of the Louvre was still under construction Louis XIV decided to move the court to Versailles, a few miles outside the capital. Here he envisioned an ideal architecture and landscape, cen-

944. FRANÇOIS MANSART. Orléans Wing, Château of Blois, France. 1635–38

945. LOUIS LE VAU. Garden façade, Château of Vaux-le-Vicomte, France. 1657–61

946. CLAUDE PERRAULT. East façade, the Louvre, Paris (original moat under restoration). 1667–70

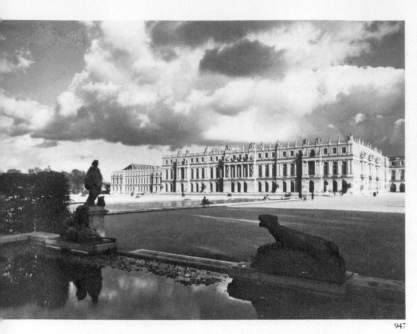

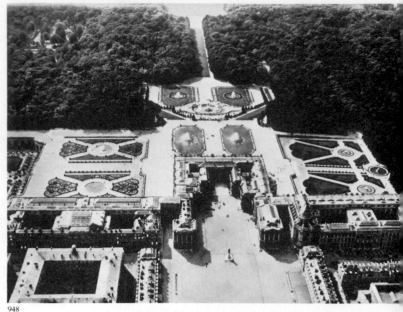

947 948

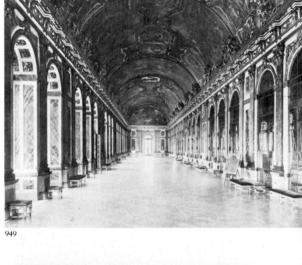

949

tering on the royal person and taking no note of the commonplaces of urban existence. The result was one of the most ambitious constructions ever conceived. The nucleus, a hunting lodge built by Louis XIII, was enveloped in 1669–85 by a new structure, originally designed by Le Vau. His west or garden façade consisted of what is now the central block (fig. 947). A lightly rusticated podium supports the principal story, with arched windows and a modest Ionic order, and a massive attic story, whose balustrade is enriched by urns and trophies. Le Vau's original façade was set back; the narrow projecting wings were united, beginning in 1678, at the king's command, by the construction of the immense Hall of Mirrors, designed by JULES HARDOUIN-MANSART (1646–1708), grandnephew of François Mansart, thus creating a unified façade.

In order to keep the nobility where the king could control them, and to house royal offices and guards, a small city was built to the east of the palace, and the original block extended by enormous wings to a total length of six hundred yards, often criticized as out of scale with the proportions of the Ionic order used throughout. Judged by Italian standards, the final effect of the palace (fig. 948) is disappointing, but viewed with the gardens, with which it forms a whole, it looks unexpectedly fragile and very beautiful, especially on bright days when the warmth of the creamy stone glows against the sky. On such a scale a giant order in the Italian manner might have proved crushing, and it also might have spoiled the festive lightness of the exterior, intended as a backdrop for gorgeous festivities, often lasting for days, with comedies, balls, music, fireworks, and torchlight suppers in the open air. Even today the full effect of the architecture cannot be appreciated unless the fountains are functioning.

The central axis of the landscape design is the east-west path of the sun—which Louis XIV adopted as his symbol—as it travels along the road from Paris and passes through the king's bedroom, at the exact center of the palace, and out along the walks and canals that extend some three miles through the park to set over the low hills in the distance. It is no accident that the great event of each day at Versailles was the *levée* (rising), a term applied indiscriminately to the appearance of the sun over the horizon and the emergence of the Sun King from his bed, a daily event accompanied by elaborate ritual and awaited by courtiers in the Hall of Mirrors (fig. 949), whose central doorway was that of the royal

950

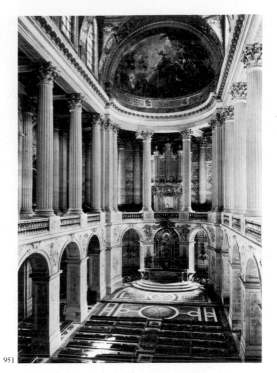

951

947. LOUIS LE VAU and JULES HARDOUIN-MANSART. Garden façade, Palace of Versailles. 1669–85

948. LOUIS LE VAU and JULES HARDOUIN-MANSART. Palace of Versailles (aerial view)

949. JULES HARDOUIN-MANSART and CHARLES LE BRUN. Hall of Mirrors, Palace of Versailles. Begun 1678

950. ANTOINE COYSEVOX. *Louis XIV on Horseback*, stucco relief, Salon de la Guerre, Palace of Versailles. 1683–85

951. JULES HARDOUIN-MANSART. Royal Chapel, Palace of Versailles. 1689–1710

952. Plan of the Palace of Versailles and the gardens designed by ANDRÉ LE NÔTRE (After a seventeenth-century engraving)

952

bedchamber. No wonder that the principal theme of the Hall of Mirrors is light; the sunlight through the seventeen arched windows is reflected in seventeen mirrors and illuminates a vaulted ceiling decorated by frescoes on mythological and historical subjects relating to royalty, framed by gilded stucco ornamentation on the model of the gallery of Palazzo Farnese (see fig. 900), all designed by Charles le Brun. Enhanced by acres of transparent or reflecting glass, the effect of the pink marble pilasters, the gilded Corinthian capitals and entablatures, and the colors and gold of the ceiling decorations yields in splendor to no Roman Baroque interior in spite of the typical French primness of long straight lines. But the frescoes, rapidly executed by battalions of painters, scarcely hold up under inspection. Le Brun, whose administrative authority extended the absolute power of the monarchy even into the sphere of the arts, was an ingenious designer, and no detail of decoration, furnishings, or hardware was too small to escape his attention, but the monarchical system was unlikely to produce great art. It had, nonetheless, been codified regarding the arts since 1648 in the formidable institution of the Royal Academy. Under Le Brun, director from 1663 until his death, a program of instruction and a series of rules were devised to enforce conformity to official standards, exalting the ancients, Raphael, and Poussin; the consequences of the academic codes and norms were felt acutely into the late nineteenth century, and periodic revolts against them characterized the initial stages of most new movements in European art.

Perhaps the single best decorative work at Versailles is the brilliant stucco relief of *Louis XIV on Horseback* (fig. 950), in the Salon de la Guerre, by ANTOINE COYSEVOX (1640–1720). Garbed as a Roman imperator, the king tramples on enemies on whom he does not deign to bestow a glance, while Eternity, embracing a pyramid, extends the French royal crown over his bewigged head. She competes uselessly for his attention with marble Victories who lean into the frame, one blowing a trumpet, the other offering a laurel crown, while wretched prisoners are fettered to consoles below, and Fame, in the lowest relief, writes the king's immortal deeds upon a shield. Strongly influenced by Bernini, the style is nonetheless French in its measured pace, its linearity, and the careful control of all details.

Hardouin-Mansart's triumph at Versailles, freed from any inheritance of Le Vau's proportions, is the Royal Chapel (fig. 951), 1689–1710, a work of extreme classicism yet brilliant lightness. The lower story, intended for courtiers, is formed by an arcade supported by piers, and serves as a support for the principal story, a widely spaced, archaeologically correct colonnade of fluted Corinthian columns running round the apse, which provides a deep gallery for the royal family. The frescoed, groin-vaulted ceiling, pierced by an arched clerestory, is subordinated to the grandeur of the columns, and the altar itself seems hardly more than a necessary piece of furniture.

The formal gardens, with their geometrical flowerbeds, urns, statuary, trimmed hedges, grottoes, planted groves, lofty fountains, canals, and pools, are an extension of the palace itself over the landscape (fig. 952). They are the masterpiece of Le Nôtre, who also designed systems of avenues through the park, radiating from circles or ovals, as if to submit the last recesses of nature to the royal will. It is not surprising that from time to time the king found it necessary to escape from his mythological self and live the life of a human being. In consequence he set aside a section of the park for a one-story dream house, the Grand Trianon (fig. 953), designed by Hardouin-Mansart in 1687. The two sections of the

house are united by a peristyle, arched on the entrance side, but supported on the garden front by an exquisite colonnade of paired, pink marble Ionic columns, continuing as pilasters between the arched windows. The enchanting little building is a triumph of grace and intimacy, in perfect union with the out-of-doors, which flows through its very center. While the peristyle provided a cool place to sit or dine in summer, the interior spaces, of modest size and unceremonious arrangement, were grouped in apartments of four rooms, united at the corners by efficient porcelain stoves for winter comfort. All glass, white limestone, and pink marble, the Grand Trianon is as colorful and insubstantial as a soap bubble.

ARCHITECTURE AND SCULPTURE AWAY FROM VERSAILLES

In his Church of the Invalides (figs. 954–56), built in 1676–1706 as an addition to a home for disabled veterans, Hardouin-Mansart displayed an unexpectedly close connection with Roman tradition as exemplified by Michelangelo, della Porta, Maderno, and Bernini. The dome with its paired columns recalls Saint Peter's (see fig. 822); the two-story façade with its central crescendo of clustered columns derives from such models as the Gesù (see fig. 841) and Santa Susanna (see fig. 909). Yet the Baroque climax is attained by methods sedately French; there are no broken pediments, no floating sculpture, no concavities or convexities. Columns are fully in the round rather than engaged as in Italian Baroque façades, and classically correct. The structure is bound together by delicate adjustments of its components, which make it one of the most harmonious exteriors of the seventeenth century. For example, to establish the dominant role of the central pediment, Hardouin-Mansart suppressed the central pair of columns directly above it in the drum of the dome and created a highly original rectangular lantern whose point, continued in the steeple, carries the angle of the pediment to the apex of the entire structure. Characteristically for Hardouin-Mansart, the four great arches upholding the dome in the interior are fronted by four pairs of huge Corinthian columns in the round (fig. 956; compare them with the pilasters fulfilling the same function at St. Peter's in Rome) to overwhelming effect. We look up through the wide central circle of the shallow dome into a second dome, painted to show Saint Louis, patron saint of France, carried up into heaven, lighted mysteriously by windows in the drum, which are invisible from below. Again the French version of the Baroque climax is achieved by exact calculation rather than by the dramatic methods of the Italians.

953

953. JULES HARDOUIN-MANSART. Grand Trianon, Versailles. Begun 1687

954. JULES HARDOUIN-MANSART. Facade, Church of the Invalides, Paris. 1676–1706

955. JULES HARDOUIN-MANSART. Plan of the Church of the Invalides, Paris

956. JULES HARDOUIN-MANSART. Cross section of the Church of the Invalides, Paris (After a seventeenth-century engraving by F. Blondel)

954

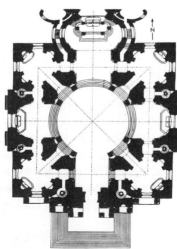

955

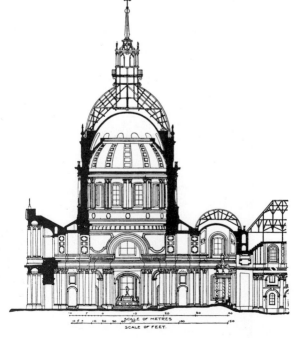

956

957

958

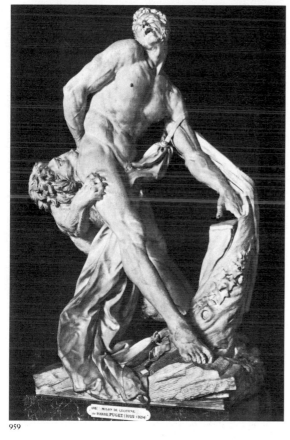

959

957. ANTOINE COYSEVOX. *Portrait Bust of Colbert.*
1677. Marble. Palace of Versailles

958. FRANÇOIS GIRARDON. *Tomb of Richelieu.*
1675–77. Marble. Church of the Sorbonne,
Paris

959. PIERRE PUGET. *Milo of Crotona.* 1671–83.
Marble, height 8′10½″. The Louvre, Paris

When not restrained by officialdom, Coysevox maintained a portrait style second only to that of Bernini in seventeenth-century sculpture. His bust of the king's great finance minister Colbert, of 1677 (fig. 957), while recalling the movement of line and surface of the great Italian sculptor who had so recently visited France, nonetheless preserves a sobriety not far from the honest pictorial style of Philippe de Champaigne (see fig. 942), and is far more impressive than the decorative works commissioned for Versailles and its gardens. Coysevox's contemporary FRANÇOIS GIRARDON (1628–1715), author of an immense amount of decorative and official sculpture of high quality, was responsible for a new type of free-standing dramatic tomb, showing the deceased at the moment of translation to a higher realm without any of the Italian machinery of angels, clouds, rays, and billowing curtains. His *Tomb of Richelieu*, 1675–77 (fig. 958), still in its original position in the Church of the Sorbonne in Paris, was intended to be seen from all sides. Its principal group, the dying cardinal upheld by Piety, facing the altar and looking toward Heaven, builds up with the dignity of a composition by Poussin, although the contrast between the crumpled masses of the cloak and the billowing pall was derived from a study of Bernini's technique. From the altar the composition, seen foreshortened in depth, is equally effective.

The maverick among French Baroque sculptors was PIERRE PUGET (1620–94), whose independence of official taste cost him popularity at court. His *Milo of Crotona*, 1671–83 (fig. 959), shows with brutal realism the fate of the Greek athlete Milo. Unable to extricate his hand from a split tree stump, he was attacked by a lion that bit him fiercely where he sat down. Obviously, Puget had studied Michelangelo's *Rebellious Slave* (see fig. 796) and Bernini's *David* (see fig. 912). The rendering of the abdominal muscles pulsating with pain and the convulsed facial expression shows that Puget had also learned a great deal from independent observation. The group is a work of tremendous emotional and compositional power. Tradition has it that the statue was uncrated at Versailles in the presence of the queen, who, when she came to a full realization of its subject, murmured, "Ah, le pauvre homme!" Puget's vivid Baroque realism was better appreciated in Italy, where he had considerable success.

Flemish Painting The separation of the Netherlandish provinces into what are today the independent kingdoms of Belgium and Holland was, first and foremost, a division along religious lines, but it had far-reaching political and economic consequences. The Calvinist northern provinces, democratic in outlook under their chosen governors, conducted a flourishing trade with most of the known world and established a major empire in the East Indies and West Indies. The Catholic southern provinces remained under Habsburg control; the archduchess Isabella of Austria and her husband Albert, brother of the emperor, encouraged learning and the arts, but commerce stagnated. During its period of artistic preeminence in the first half of the seventeenth century, the southern Netherlands was in constant political and economic difficulties. Although *Flanders* and *Flemish* properly refer to only one of the ten southern Netherlandish provinces, they are the most convenient words to designate the entire region and its inhabitants during the period before the founding of the kingdom of Belgium in 1830. None of the major European architects or sculptors of the age were Flemish; the glory of Flemish art during this brief period derives principally from the work of a single extraordinary painter.

RUBENS Peter Paul Rubens (1577–1640) exercised in Flanders a stylistic authority at least as great as that of Michelangelo in central Italy a century before and surpassing that enjoyed by Bernini in contemporary Italy. Born near Cologne, the son of a Protestant emigré from Antwerp, he spent his childhood in Germany. He received a thorough grounding in Latin and in theology, spent a few months as page to a countess, and grew up as an unparalleled combination of scholar, diplomat, and painter. He spoke and wrote six modern languages—Italian with special ease— read Latin, and was probably the most learned artist of all time. Through wide travels in diplomatic service, he established contacts with kings and princes throughout western Europe. His house in Antwerp, which still stands, well restored, was a factory from which massive works emerged in a never-ending stream. Two of its most impressive features are the balcony in the studio from which Rubens could survey the work of his assistants in the laying out of colossal altarpieces and display them to powerful patrons, and the door, only about three feet wide but at least twenty feet high, through which the monumental panels and canvases were carried sideways to be shipped to destinations near and far. He charged in proportion to his own participation in a given work, and although most paintings were designed by him in rapidly painted color sketches on wood, all the large ones were painted by pupils, and then retouched by the master, who provided his inimitable brushwork and glowing color in the final coat—or, if the price was not high enough, he left the students' work untouched. To understand Rubens's production system, one has also to grasp his extraordinary character and intelligence; one visitor recounted how Rubens could listen to a reading of Roman history (in Latin, of course), carry on a learned conversation, paint a picture, and dictate a letter all at the same time.

Rubens first emerged on the international scene during his visit to Italy in 1600, where, except for a diplomatic mission to Spain, he remained for eight years. More than anything else, artistically at least, Rubens was an adopted Italian, with surprisingly little interest in the Early Netherlandish masters, whom he apparently regarded as too remote to be any longer relevant. With rigorous system and indefatigable energy, he set out to conquer the fortress of Italian art, beginning with ancient

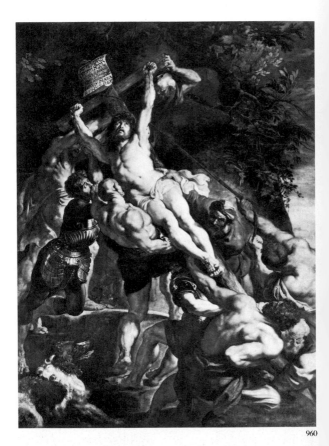

960

960. PETER PAUL RUBENS. *Raising of the Cross* (center panel of a triptych). 1609–10. 15′2″ × 11′2″. Cathedral of Antwerp

961. PETER PAUL RUBENS. *Rape of the Daughters of Leucippus*. c. 1616–17. Oil on canvas, 87½ × 82¼″. Alte Pinakothek, Munich

962. PETER PAUL RUBENS. *Fall of the Damned*. c. 1614–18. Oil on panel, 9′4½″ × 7′4⅛″. Alte Pinakothek, Munich

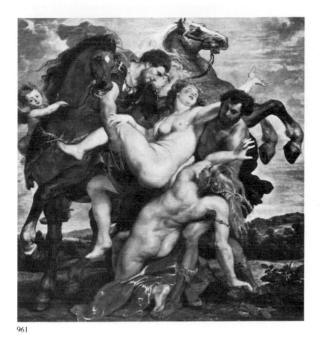

961

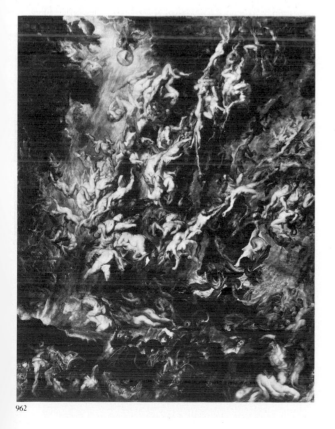

962

Rome and skipping to the High and Late Renaissance. He made hundreds of drawings and scores of copies after Roman sculpture as well as paintings by Mantegna, Leonardo (see fig. 788), Raphael, Michelangelo, Correggio, Titian, Tintoretto, and Veronese, not to speak of the Carracci and Caravaggio, then still working busily in Rome. He commissioned assistants to make hundreds more drawings, many of which he retouched. From this comprehensive record he evolved a personal style characterized by abundant physical energy and splendid color; the seventeenth-century critic Giovanni Pietro Bellori spoke of his "fury of the brush."

An early work in Antwerp Cathedral, the *Raising of the Cross* (fig. 960), a panel more than fifteen feet high, painted in 1609–10, shows the superhuman energy with which Rubens attacked his mighty concepts. The central panel of a triptych, the picture is, nonetheless, complete in itself. Interestingly enough, there is no hint of Caravaggio's psychological interests. The executioners, whose muscularity recalls the figures in Michelangelo's *Last Judgment* (see fig. 818), heave and tug the Cross upward, forming a colossal pyramid of struggling figures, an enriched version of the characteristic High Renaissance interfigural composition transformed into a Baroque climax. The sheer corporeal force of the painting makes it hard to realize that at this very moment in Spain El Greco was painting his most disembodied and mystical visions.

As his style matured, Rubens's characteristic spiral-into-the-picture lost the dark shadows of his early work and took on an always more Titianesque richness and translucency of color. His *Rape of the Daughters of Leucippus*, of about 1616–17 (fig. 961), recalls forcibly Titian's *Rape of Europa* (see fig. 851), which Rubens carefully copied while in Spain. Although the figures have been made to fit into Rubens's mounting spiral, such is the buoyancy of the composition that the result does not seem artificial. The act of love by which Castor and Pollux, sons of Jupiter, uplift the mortal maidens from the ground draws the spectator upward in a mood of rapture not unrelated to that Bernini was soon to achieve in the *Ecstasy of Saint Theresa* (see fig. 915). The female types, even more abundant than those of Titian, are traversed by a steady stream of energy, and the material weight of all the figures is lightened by innumerable fluctuations of color running through their pearly skin, the tanned flesh of the men, the armor, the horses, even the floods of golden hair. The low horizon increases the effect of a heavenly ascension, natural enough since this picture, like the ceiling of the Farnese Gallery (see fig. 900), constitutes a triumph of divine love; the very landscape heaves and flows in response to the excitement of the event.

The power of Rubens can be seen at its greatest in the *Fall of the Damned* (fig. 962), painted about 1614–18, a waterspout of hurtling figures—Rubens's spiral in reverse—raining down from Heaven, from which the rebels against divine love are forever excluded. It is hard for English-speaking viewers to avoid thinking of the torrential lines from Milton's *Paradise Lost* (I, 44–49):

> Him the Almighty Power
> Hurld headlong flaming from th' Ethereal Skie
> With hideous ruine and combustion down
> To bottomless perdition, there to dwell
> In Adamantine Chains and penal Fire,
> Who durst defie th' Omnipotent to Arms.

Nor is it difficult to see in Rubens's mighty conception the origin of the falling figures in Gaulli's ceiling for the Gesù (see fig. 928).

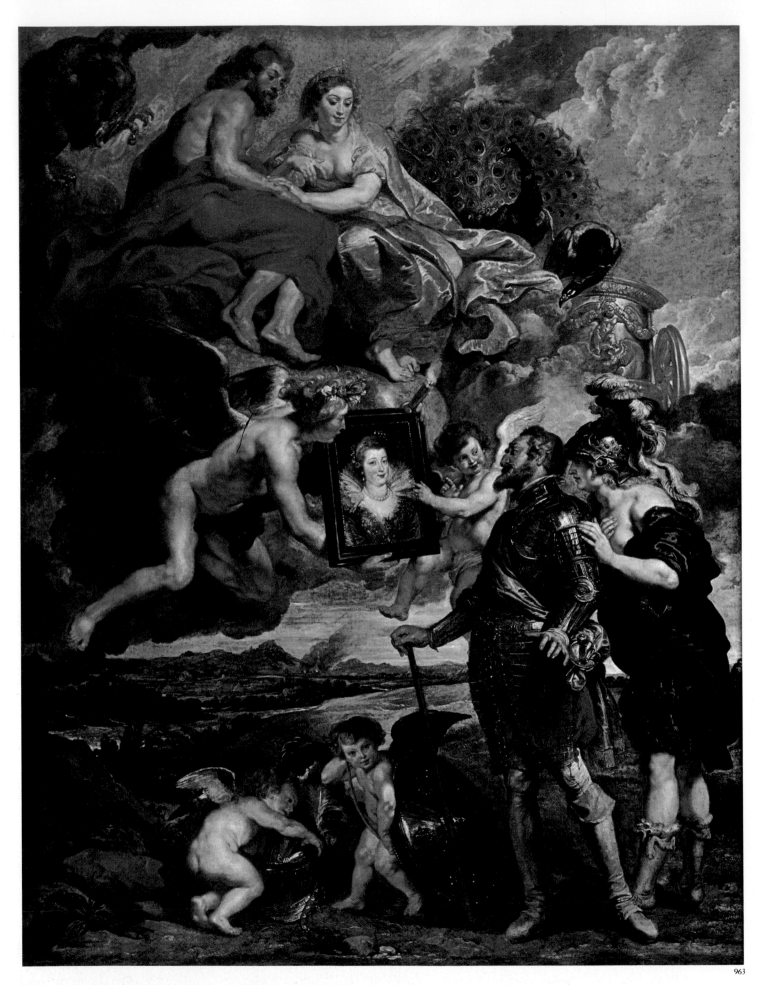

963

963. PETER PAUL RUBENS. *Henry IV Receiving the Portrait of Maria de' Medici.* 1621–25. Oil on canvas, 12'11⅛" × 9'8⅛". The Louvre, Paris

964. PETER PAUL RUBENS. *Garden of Love.* c. 1638. Oil on canvas, 6'6" × 9'3⅜". Museo del Prado, Madrid

In 1621–25 Rubens carried out a splendid commission from Maria de' Medici, dowager queen of France, widow of Henry IV, and regent during the minority of her son Louis XIII. The twenty-one large canvases represent an allegorized version of the queen's checkered career, showing her protected at every point by the divinities of Olympus. The series was originally installed in a ceremonial gallery in the Luxembourg Palace, a Baroque Parisian version of Maria's native Pitti Palace in Florence (see fig. 839). While all the canvases show the magnificence of Rubens's compositional inventiveness and the depth of his Classical learning, they are not of uniform quality in detail. *Henry IV Receiving the Portrait of Maria de' Medici* (fig. 963) is one of the best, a brilliant achievement not only in composition but also in every detail, surely finished throughout by Rubens's own hand. The aging king, whose helmet and shield are purloined by Cupids, is advised by Minerva to accept as his second bride the Florentine princess, whose portrait is presented by Mercury, as Juno and Jupiter smile upon the proposed union. The happy promise of divine intervention; the radiant health of the youthful nude figures; the sage grandeur of the armored king; the splendor of the coloring of flesh, metal, drapery, clouds, even Juno's gorgeous peacocks; and the opulence of the distant landscape render this one of the happiest of Rubens's allegorical works. Parenthetically, he decided to abandon a second series, the *Life of Henry IV*, because the first was never paid for, but when the queen, driven out of France by her former protégé Cardinal Richelieu, took refuge in Flanders, it was Rubens who helped to support her during her twelve years of impecunious exile—a remarkable tribute not only to the generosity of a great man but also to the position of a Baroque artist who could finance a luckless monarch.

During his second stay in Madrid, in 1628–29, Rubens is reported to

964

have exclaimed that he was "as in love with Titian as a bridegroom with his bride." This was not only an apt simile for the startling rebirth of poetic beauty and coloristic vitality in the artist's later works, founded on his Baroque reinterpretation of Titian, but also a prophecy as well; in 1630, then fifty-three years old and a widower, Rubens married Hélène Fourment, a girl of sixteen, who was to bear him five healthy children. Her golden loveliness illuminates a score of pictures, and the artist's radiant happiness during his final decade received its perfect embodiment in the *Garden of Love* (fig. 964), painted about 1638, a fantasy in which seven of the Fourment sisters are happily disposed throughout the foreground, some with their husbands (Rubens himself, somewhat idealized, with Hélène at the extreme left), before the fantastic fountain-house in Rubens's own garden at Antwerp. Cupids, emulated from Titian, fly above the scene with bows, arrows, a rose garland, and torches, and on the right sits a statue of Venus astride a dolphin, pressing jets of water from her abundant breasts. All Rubens's love of Titian, all the movement of his color, all the energy of his composition are summed up in the radiance of this picture, the happiest of Baroque testaments to the redeeming power of love.

965

VAN DYCK Rubens's assistant and later a friendly rival in Flanders, Italy, and England was Anthony van Dyck (1599–1641), already an accomplished painter at sixteen. His extreme sensitivity to color and shape separates him at once from the more vigorous and robust Rubens; his only large altarpiece, the *Madonna of the Rosary* (fig. 965), started in Palermo in 1624 but not completed until about 1627 in Genoa, shows the unexpected, almost Mannerist attenuation characteristic of Van Dyck's figures, rivaling the fantastic length and slenderness of Parmigianino's *Madonna with the Long Neck* (see fig. 833). The painting depicts an appeal of the stricken populace of Palermo, through their patron saints, to the Blessed Virgin for delivery from the plague, then periodically ravaging the city. The broad movement of color, light, and emotion throughout the picture is influenced by Rubens, whose personality no Flemish artist could escape, but the exquisite lightness and grace of the figures, not to speak of the expressions of the yearning saints and benign Virgin floating on clouds under her airborne arch, are Van Dyck's own.

No seventeenth-century painter could rival his aristocratic refinement and delicacy, and it is no wonder that he became famous for his portraits of nobility and royalty, which generally show the subjects as vastly more elegant and beautiful than we know them to have been. Van Dyck enjoyed his greatest success at the court of Charles I of England, where he occupied a position similar to that of Holbein under Henry VIII (see Part Four, Chapter Seven). From his superb portraits of Charles, we would never guess that in reality the king was short and undistinguished in appearance; in his *Portrait of Charles I in Hunting Dress* (fig. 966), of 1635, Van Dyck endows him with extraordinary dignity and an air of romantic melancholy. Despite the relative informality of the costume and moment—the king seems ready to mount his horse and ride off to the chase—this is a state portrait; only Van Dyck's inspired ease of composition and of statement prevents it from seeming artificial and posed. The verve of his linear movement and the sparkle of his color, even to the shimmer of the horse's mane and the liquid softness of its eyes, render this one of the most impressive of all official portraits; Van Dyck, in fact, set the tone for such images in England for more than a century.

965. ANTHONY VAN DYCK. *Madonna of the Rosary.* 1624–c. 1627. Oratorio della Compagnia del Rosario di S. Domenico, Palermo

966. ANTHONY VAN DYCK. *Portrait of Charles I in Hunting Dress.* 1635. Oil on canvas, 8'11" × 6'11½". The Louvre, Paris

Spanish Painting and Sculpture Although Spain, like England, produced writers and musicians of great importance during the Renaissance and few painters of interest, the country had been strongly impressed by the work of a foreign master of first importance, El Greco. It is surprising that the great creative development of Spanish painting in the seventeenth century owed little or nothing to El Greco's mysticism, which had vibrated in such perfect harmony with Spanish Counter-Reformation thought. Nor did the new art in Spain spring from the central region dominated by El Greco; the painters of the seventeenth century who suddenly established Spain in the forefront of Baroque visual creativity were all southerners.

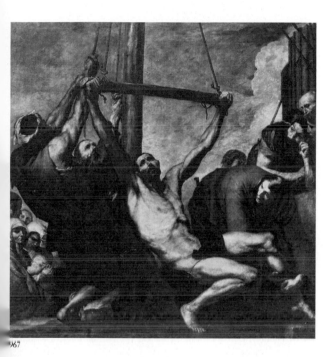

967. JUSEPE DE RIBERA. *Martyrdom of Saint Bartholomew*. c. 1639. Oil on canvas, 92⅛ × 92⅛". Museo del Prado, Madrid

RIBERA One of the earliest of these, Jusepe de Ribera (1591–1652), from Valencia province—although not the earliest Spanish master to feel the force of the Caravaggesque revolution, but probably the most important link between Spain and Italy—went to Italy probably shortly after 1610 and settled in Naples, at the time a Spanish province, where he immediately came under the influence of Caravaggio's numerous Neapolitan followers, known as the *tenebrosi* (shadowy ones) because of their exaggeration of Caravaggio's strong light-and-dark contrasts.

Ribera's best-known work, the *Martyrdom of Saint Bartholomew* (fig. 967), probably painted in 1639, shows an obvious reliance on Caravaggio in its emphasis on direct experience; it is surprising after El Greco that this experience is predominantly physical, even when the subject is religious. Bartholomew was flayed alive (see fig. 819 for Michelangelo's personal interpretation). Ribera has spared us any clinical rendering of the event, yet the picture is dominated by pain and fear. The almost naked saint is being hauled into position by his executioners, straining gigantically like Rubens's figures in the *Raising of the Cross* (see fig. 960). Ribera had no interest, however, in either Italian physical beauty or Rubens's spiral surge. These straining, sweaty figures against the blue sky look devastatingly real, and the act they are about to perform will be seen by a very real crowd, including women and children. Such vivid concentration on the immediate is significant, for Spain's greatest contribution to European art, in the painting of Velázquez at midcentury, is purely optical, without spiritual purpose or overtones. The harsh reality of the scene prefigures some of the most powerful Spanish art of later periods, notably that of Goya (see Part Six, Chapter Two).

ZURBARÁN A translation of the spiritual into direct physical terms communicates a special element of magic to the work of Francisco de Zurbarán (1598–1664), who never visited Italy, but settled and worked in Seville. Like La Tour (see fig. 934), with whose poetic work that of Zurbarán has something in common, he experienced the Caravaggesque revolution at second hand, yet his art is closer to the basic message of Caravaggio—the externalization of inner experience—than is the more strident realism of Ribera. Like Caravaggio's, Zurbarán's light is clear, sharp, and real, his surfaces hard and smooth, his darkness total. In the *Vision of Saint Peter Nolasco*, of 1629 (fig. 968), the Apostle Peter—who had been crucified upside down at his own request to avoid comparison with Christ—appears in a vision to his meditating thirteenth-century namesake in the darkness of his cell. The room has disappeared; bright light reveals vision

and visionary, both equally tangible, as if suspended, one surrounded by the darkness of this world, the other revealed by the light of the next.

PEDRO DE MENA A number of gifted Baroque sculptors carved statues and reliefs, often in polychromed wood, for Spanish churches. In many ways the most impressive of these masters is Pedro de Mena (1628– 68) from Granada, whose images are even more startlingly real and direct than the paintings of Zurbarán. To reinforce the immediate impact of his statues Mena did not shrink, at times, from inserting glass eyes and porcelain teeth. When such pieces are moved to Spanish museums the visitor comes upon them with a shock, as if real people transfixed by intense emotion were actually there in the room. To twentieth-century eyes such drastic realism suggests the contemporary work of Duane Hanson (see fig. 1276). But Hanson is profoundly pessimistic, and the message of Mena continues and reinforces that of Zurbarán—an intense spirituality within the appearance of physical reality. Mena uses this reality in a deliberately empathetic sense for the provocation of religious experience. Rough and smooth, hard and soft, sharp and blunt are felt in our very flesh as we watch.

The *Penitent Magdalen* of 1664 (fig. 969) shows the saint clothed not in the visually repellent tangle of hair Donatello carved and painted so convincingly (see fig. 686) but in a sleeveless garment of woven reeds, as harsh as a doormat, tied about her waist with a belt of reeds. Mena's Magdalen is young and beautiful, and has just begun her penitential sojourn in the wilderness. We are made to feel the sharpness of the woven reeds, like the traditional hairshirt, against her delicate skin in painful contrast with and in penance for the amorous bodies that once caressed it (Mary Magdalen was traditionally believed to have been a prostitute). Indeed, she presses the matting against her breast with her right hand, pouring forth her soul in guilty weeping as she gazes on the crucifix she holds before her, a roughly carved image nailed to a cross of untrimmed logs.

968. FRANCISCO DE ZURBARÁN. *Vision of Saint Peter Nolasco*. 1629. Oil on canvas, 70½ × 87¾". Museo del Prado, Madrid

969. PEDRO DE MENA. *Penitent Magdalen*. 1664. Polychromed wood. Museo Nacional de Escultura, Valladolid

970

VELÁZQUEZ The supreme native master of painting in Spain was Diego Rodriguez de Silva y Velázquez (1599–1660). Born in Seville, Velázquez studied with a local Mannerist named Francisco Pacheco. In 1623 he was appointed court painter, and the following year settled permanently in Madrid; by 1627 he was established in the royal household, eventually attaining the rank of court chamberlain, which gave him a residence attached to the palace and a studio inside it. For more than thirty years Velázquez painted King Philip IV and members of the royal

970. DIEGO VELÁZQUEZ. *Las Meninas*. 1656. Oil on canvas, 10'5" × 9'½". Museo del Prado, Madrid

family and court, yet such was his originality and candor that not one of his paintings can be reproached with being a mere state portrait.

Although a close friend of Rubens at the time of the great Fleming's second visit to Madrid in 1628, Velázquez never deserted the integrity of his own style, and not once did he adopt the characteristic machinery of allegorical figures, columns, curtains, and boiling clouds utilized by most Catholic painters in the seventeenth century. Temperamentally little suited to religious subjects, he painted them rarely, and with varying degrees of success. Like Hals and Vermeer (see pages 738, 746), with whose works he could hardly have been familiar, Velázquez was profoundly attached to nature as revealed to human vision through light. He visited Italy twice, and expressed a frank distaste for Raphael—and thus in all probability for the Italian idealism of which Raphael was the chief exponent—while admiring Titian and copying Tintoretto as an exercise in freedom of the brush. Lest one think that Velázquez had no interest in Renaissance ideas, however, it is worthwhile noting that his private library contained the works of the principal Italian architectural theorists. Throughout his life he was deeply concerned with the principles of composition and design, no matter how immediate his subject matter.

Caravaggesque realism had already penetrated Spain and must have been felt as a liberation by the young Velázquez. His own interpretation of the movement is original and irresistible. His *Triumph of Bacchus*, of about 1628, which has acquired the nickname of *Los Borrachos (The Drunkards)* (fig. 971), contains numerous reminiscences of Titian's *Bacchanal of the Andrians* (see fig. 845), reinterpreted in basically Caravaggesque terms. Bacchus is a rather soft Spanish youth, with nothing but a towel and a cloak around his waist, as if he had just climbed out of a neighboring stream, and is anything but Classical in appearance. Crowned with vine leaves himself, he mischievously bestows a crown upon a kneeling worshiper, who is a simple Spanish peasant. Other peasants are gathered round; one, with bristling moustache and hat pushed back to show the white forehead of a farmer's grinning, sunburned face, hands a cup of wine toward the spectator, while another tries roguishly to grab it. The genial proletarian invitation to join in the delights of wine is painted with a brilliance unequaled by any other Latin painter in the seventeenth century. Yet the crusty surface and the emphasis on the solidity of flesh, rough clothing, and crockery show that Velázquez is basically a Mediterranean painter, concerned with substance, and unlikely to indulge in such fireworks of the brush as those of Frans Hals. It is no wonder that this picture excited the admiration of Manet in the nineteenth century (see Part Six, Chapter Four).

At the time of Velázquez's second trip to Italy (1649–51), he fell even deeper under the influence of the great Venetians of the preceding century, but never that of his Italian Baroque contemporaries, nor of the austerely classical Poussin. In the gardens of the Villa Medici, he painted small studies (fig. 972), the earliest examples we know of landscapes not composed in the studio but done outdoors with a directness hitherto restricted to the preliminary sketch in wash (see fig. 940). This great historic step was not to be followed until the English landscape painters of the early nineteenth century (see Part Six, Chapter Two). In his attempt to seize the immediacy of the moment of vision, Velázquez painted with free, light strokes of differing hues—browns, greens, blue greens, and whites. Both the subject and the method were an important step in the direction of nineteenth-century landscape art.

Velázquez's acknowledged masterpiece, and one of the most original

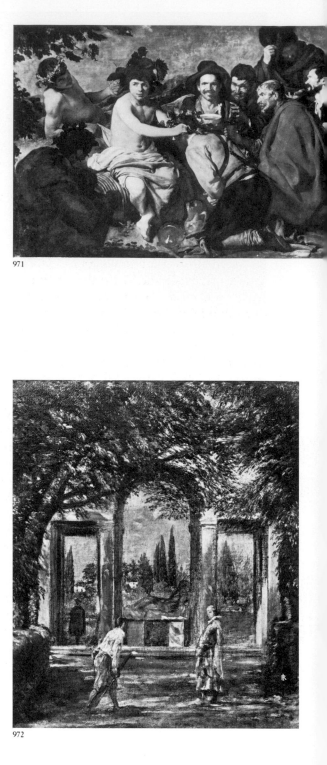

971

972

971. DIEGO VELÁZQUEZ. *Triumph of Bacchus (The Drunkards)*. c. 1628. Oil on canvas, 65 × 88⅝". Museo del Prado, Madrid

972. DIEGO VELÁZQUEZ. *Garden of the Villa Medici, Rome*. c. 1649–51. Oil on canvas, 17⅜ × 15". Museo del Prado, Madrid

paintings of the entire seventeenth century, is *Las Meninas (The Ladies-in-Waiting*; its original title was simply *The Portrait of the Family*), of 1656 (fig. 970). The painter is shown in his studio in the royal palace, at work upon a canvas so large that it can only be this very picture, unique in scale in his entire production. In the center the light falls most strongly on the glittering figure of the five-year-old princess, who has paid the painter a visit, accompanied by two ladies-in-waiting, one of whom kneels to hand her a cup of water. On the right are shown two dwarfs—those playthings of the Spanish court, whom Velázquez always painted with humanity and comprehension—one gently teasing with his foot an elderly and somnolent dog. Through an open door in the background wall, light falls on a court official, pausing for a moment on the steps. Most important of all, the mirror alongside the door reflects the king and queen, who also honor the painter with their presence.

Today the painting prompts speculations on the relationship of reality and image, space within the picture and figures outside it, as in Manet's *A Bar at the Folies-Bergère* (see fig. 1123). However, it has been recently shown that this picture is connected with Velázquez's attempts to be recognized as a noble, which met with some difficulty at first, but in 1658 were rewarded with the Order of Santiago at the hands of the king, who after the painter's death in 1660 caused the cross of Santiago to be painted on his doublet in this picture. Since the only obstacle to his admission to the order was his profession of painting, then considered a manual trade, the artist demonstrates in this picture the nobility of his art, favored with familiarity by the king, the queen, and the little princess in an allegory all the more effective for being so strikingly real. Despite the apparent ease and informality of the subject, the picture, like all Velázquez's compositions, is carefully balanced, in a series of interlocking pyramids that can be ranked with the greatest designs of the Renaissance.

Totally and dazzlingly new, however, is Velázquez's optical method of painting, paralleled (independently) only by Vermeer's. In light and dark the illusion of the picture is as startlingly real as the intimate and quiet mood. Velázquez's brush suggests convincingly the reality of objects entirely through the sparkles and reflections of light on hair, silks, flowers, and embroidery. We could hardly be further from the linear precision of Holbein, let us say (see figs. 875, 876); nothing is drawn, nothing has visible edges. Only spots of light and color, set down by dexterous touches of the brush, create an illusion of form, in the last analysis more accurate than Holbein's method because more closely related to the actual phenomena of instantaneous vision. In *Las Meninas* Velázquez demonstrates not only to his contemporaries but also to all time the nobility of his art—a rank that no king can confer.

THE SEVENTEENTH CENTURY IN PROTESTANT COUNTRIES

THREE

Dutch Painting The name *Holland*, which belonged to only one of the seven United Provinces of the Netherlands, is now popularly extended to the eleven that make up the modern kingdom: the word *Dutch* (derived from *deutsch*, meaning "German") is even less appropriate as a name for the inhabitants of the northern part of the Low Countries; but, like all the other misnomers we have encountered, these two are fixed. In democratic and predominantly Calvinist Holland in the seventeenth century the traditional patrons of art were conspicuous by their absence. Calvinism opposed imagery in church buildings. There was no monarchy, and the princes of Orange, whose function in the republic was generally military, turned to Flemish masters or to such Italianate painters as Honthorst for palace decorations. Neither was there any hereditary aristocracy.

As early as the late sixteenth century, the artist was for the first time in recorded history thrown entirely on the open market; this was fertile, and its effect on art enormous. In spite of wars with Spain, France, and England, the country was extremely prosperous. Although New Netherlands was soon lost to the English, the Dutch founded and maintained a large overseas empire and enjoyed worldwide commerce; to protect their trade, they established a powerful navy. Not only did the commercial families suddenly want pictures—so did almost everybody else, down to social levels that never before had been able to afford anything more than a crude wood-block print or a bit of folk art. Peter Mundy, a British visitor to Amsterdam in 1640, at the height of Dutch artistic activity, wrote: "As For the art off Painting and the affection off the people to Pictures, I thincke none other goe beeyond them, . . . All in generall striving to adorne their houses, especially the outer or street roome, with costly peeces, Butchers and bakers not much inferiour in their shoppes, which are Fairely sett Forth, yea many tymes blacksmithes, Coblers, etts., will have some picture or other by their Forge and in their stalle."

With great skill and industry, and in unbelievable numbers, Dutch painters set about supplying this new demand for paintings (not sculpture, which apparently nobody wanted). That they were able to do so, and to maintain so consistently high a level of quality, is one of the miracles of history; only in Periclean Athens or fifteenth-century Florence had there been anything like this number of good painters in proportion to the general population. Under such circumstances there could be no artistic dictator such as Le Brun, or dominating figures such as Michelangelo, Bernini, or Rubens. On entering the galleries devoted to Dutch painting in any museum, the visitor is struck by the difference between the character and outlook of the Dutch masters and their contemporaries anywhere else in Europe. One would never know that Rubens was working at the same time in Antwerp, less than a hundred miles from Amsterdam.

There are few large pictures; almost everything is living-room size. There are no visions or ecstasies of saints, no images of royal power, no allegorized historical events; Classical mythologies are rare, and when they do occur, they are, like biblical scenes, often stated in terms of everyday life.

In preference to such narratives or allegorical scenes, Dutch painters generally concentrated on images of daily life and the immediate environment, and in a sense were the heirs of the early-fifteenth-century Netherlandish naturalists. But there is a striking difference; almost never do we find representations of economic activity, like the farming or artisan scenes so vividly presented by the Limbourg brothers (see figs. 742, 743) and Campin (see fig. 747) or later by Bruegel (see figs. 890, 892). We are shown upper-middle-class interiors or gardens with or without celebrations, but never the shops, factories, or banks that supported them or the kitchens that prepared food for them; people dressed in silks and satins, but seldom the work of the weavers, tailors, and dressmakers who made their clothes; farmers carousing in taverns, but no scenes of plowing, harvesting, or brewing; still lifes of wine, oysters, tobacco, and exotic fruits, but not the activity of importing these delicacies; and, strangest of all, fertile landscapes whose fat clouds never rain.

In short, what people wanted to see and were willing to pay for were not images of production, in which their days were largely spent, but of leisure-time enjoyment, and for such representations they demanded a workmanly and pleasing style. They got what they wanted in immense profusion, with an optical perfection unequaled in any other country (it is not irrelevant that Amsterdam was the world center of the optical industry). Therefore, although the painters' skill was seemingly unlimited, their variety copious, and their number legion, their productions, exhibited today in endless Dutch galleries in leading museums, tend to become monotonous. No more so, however, than Italian Gothic altarpieces, which were also not intended to be seen at once in large numbers. Viewed two or three at a time, in small rooms like those of the Dutch houses for which they were painted (see fig. 979), Dutch seventeenth-century pictures are deeply satisfying. Nonetheless, only three Dutch masters of the period rise above the general high level of technical excellence into a universal sphere—Hals, Vermeer, and, above all, Rembrandt. It is an apt commentary on the effects of the free market that all three were in severe financial difficulties in their later years—Hals, in fact, throughout his whole life.

THE CARAVAGGESQUES During the late sixteenth century, Holland underwent strong influences from the final phase of Italian Mannerism. Even the naturalism of the seventeenth century was sparked by Italy, in fact by the same fire from Caravaggio that was at the same time lighting candles in France (La Tour, for example; see fig. 934). The two chief Dutch Caravaggesque painters, HENDRICK TERBRUGGHEN (c. 1588–1629) and GERRIT VAN HONTHORST (1590–1656), made the mandatory pilgrimage to Italy, where they came under Caravaggio's spell. Terbrugghen, in fact, seems to have settled in Rome as an adolescent in 1604 while Caravaggio was still there; he returned to the Netherlands in 1614. Honthorst arrived in Rome later, about 1610–12, after Caravaggio's death, and stayed until 1620. Both were from Utrecht (Terbrugghen was probably born at Deventer, but his family moved to Utrecht a few years after his birth), then as now a strong Catholic center; both were Catholics all their lives. Their religious paintings show understanding of Caravaggio's new vision of ordinary humanity reached by divine love, although they never attain the depth and power of the great Italian innovator.

Honthorst had considerable success in Italy, where he acquired the nickname Gherardo delle Notti ("Gerrit of the Nights") because nocturnal pictures were his specialty; many of his works are still on Italian altars and in Italian museums. His *Adoration of the Shepherds*, of 1621 (fig. 973), could almost be taken for an Italian painting; Caravaggio's influence can be seen in the smooth, hard style and in the mysterious background, and there is even a reference to Correggio (see fig. 830) in the light radiating from the Child. But there is something a little trivial in Honthorst's naturalism and in his too agreeable facial expressions. He distinguishes meticulously between degrees of illumination in terms of nearness to the Child (as had Geertgen tot Sint Jans; see fig. 768) and even between the light reflected from the smiling faces and that filtering through the sheet held up by Mary.

Terbrugghen was a different sort of painter, whose work is not to be seen in any Italian church. His *Incredulity of Saint Thomas* (fig. 974), painted probably between 1623 and 1625 imitates a composition by Caravaggio, and states the Baroque psychic climax in Caravaggio's physical terms— understanding of the miracle breaking through the resistance of reason by means of direct contact between the finger and the wound. Nonetheless, his painting, for all its Caravaggesque derivation (including the background of nowhere), retains echoes of Dürer, Grünewald, and Bruegel in the very un-Italian faces. Painted several years after the artist's return to Holland, the painting softens considerably the sharp light-and-dark contrasts of Caravaggio. It remained for Rembrandt to open up again, and to deepen immeasurably, the vein of Baroque experience brought to the North by these two painters.

THE "LITTLE MASTERS" The open market system, under which pictures were sold by the artists themselves, by dealers (who might also be painters), or at booths in fairs, tended to produce specialists, each recognizable by his prowess in painting a particular type of subject. There were specialists in landscapes, riverscapes, seascapes, cityscapes, even travelscapes; in skating scenes, moonlight scenes, ships, shipping, and naval battles; in interiors and exteriors, conspicuously scrubbed or conspicuously dirty; in gardens, polite conversations, genteel games, parlor intrigue, light housekeeping, riotous parties, and tavern brawls; in cows, bulls, horses, and hunting scenes; in churches with or without services

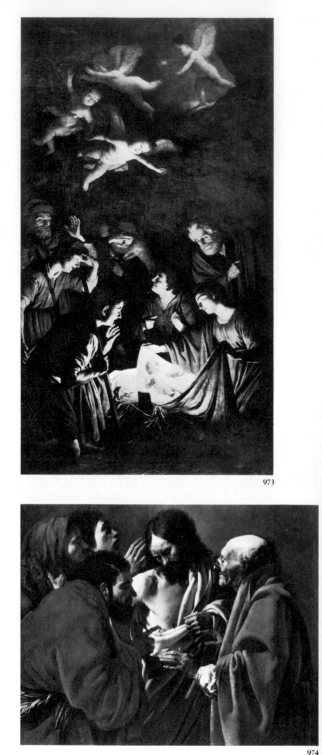

973

974

973. GERRIT VAN HONTHORST. *Adoration of the Shepherds*. 1621. Oil on canvas, 51½ × 37¾". Galleria degli Uffizi, Florence

974. HENDRICK TERBRUGGHEN. *Incredulity of Saint Thomas*. c. 1623–25. Oil on canvas, 42⅛ × 53¾". Rijksmuseum, Amsterdam

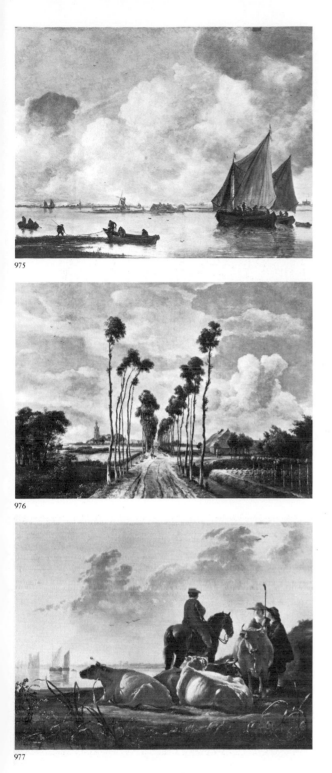

975. JAN VAN GOYEN. *River Scene*. 1656. Oil on canvas, 14⅛ × 24¾". Städelsches Kunstinstitut, Frankfurt

976. MEYNDERT HOBBEMA. *Avenue at Middelharnis*. 1689. Oil on canvas, 40¾ × 55½". National Gallery, London

977. AELBERT CUYP. *Landscape with Cattle and Figures*. c. 1650. Oil on canvas, 15 × 20". National Gallery, London

taking place; and, of course, in still lifes (raised for the first time to the dignity of independent subjects) and in portraits, single, double, or multiple. At least forty of these "little masters" are of extremely high quality, and any choice among them is sure to be arbitrary.

All Dutch seventeenth-century landscapes were, like those of the Italians and the French, painted in the studio from memory, sketches, or both and constructed according to compositional principles that involved the device of a psychological climax common to much Baroque experience—transferred from the religious, mythological, or historical spheres in which it can easily be described to the subtler, purely visual realm of space, light, and atmosphere. An early leader of Dutch landscape painting, JAN VAN GOYEN (1596–1656), although a prolific painter, dealer, valuer, and speculator in everything from land to tulip bulbs, died poor. He was one of the first Dutch masters to relegate human figures to a position in which they could no longer determine the mood of a scene but merely establish its scale. Like many of his Dutch contemporaries, Van Goyen was fascinated by water, from which the Dutch had reclaimed much land, against whose incursions they erected dikes, and on whose navigation they founded their prosperity. Even more important than water in Dutch landscape, however, is the celestial architecture of shifting clouds, which towers over the flat land and reduces the works of man to insignificance.

In *River Scene* by Van Goyen (fig. 975), painted in the last year of his life, the horizon has sunk to less than a quarter of the picture's width from the bottom, and the land, with marsh grasses, fishermen's cottages, windmills, and a distant church, is visible only as tiny patches. All else is clouds and water, save for two sloops whose slack sails, spread to catch the slight breeze, move slowly into the luminous area of cloud toward the center, reflected in the water below. People are mere spots, as are the low-flying gulls. An almost monochromatic vision, limited to translucent browns in the foreground and gray greens elsewhere, is registered by means of light, sketchy touches of the brush in ground, moving beings, shimmering water, and distant land.

A *View of Haarlem* (fig. 978), of about 1670, or later, by the younger painter JACOB VAN RUISDAEL (1628/29–82), opens up an immense prospect from the vantage point of the dunes. The city appears only on the flat horizon, a sparkle of windmills and spires dominated by the mass of the Grote Kerk (Great Church). The immensity of the space is increased by the climax falling in the form of light between clouds on the farmhouses and the linens bleaching in the foreground. The very birds fly higher and the clouds seem more remote than in Van Goyen's picture. One of the grandest of Dutch landscapes is the *Avenue at Middelharnis* (fig. 976), of 1689, by MEYNDERT HOBBEMA (1638–1709), Ruisdael's pupil, who painted little in later life, when he enjoyed a lucrative position levying taxes on wine for the city of Amsterdam. Constructed on the humble theme of a rutted country road plunging into the picture between feathery trees that have long lost their lower branches for use as firewood, the spatial climax is as compelling on a small scale as that of Bernini's colonnade for Saint Peter's (see fig. 919). AELBERT CUYP (1620–91), influenced by Dutch painters who had traveled in Italy, preserves a similar feeling for space in his *Landscape with Cattle and Figures* (fig. 977), of about 1650, intensified by the *repoussoir* effect of the animals and people arranged in the foreground with the precision of a composition by Poussin. Every form is transfigured by the soft, golden light of his favorite river background, rendering solid substance as apparently translucent.

The gentle art of PIETER DE HOOCH (1629–after 1684) celebrates the

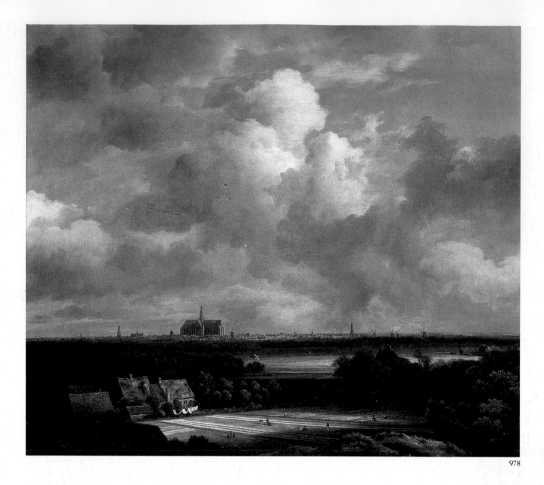

978

harmony of the perfect bourgeois household, with everything in its proper place and respect for cleanliness and order raised to an aesthetic, almost religious level. In the *Linen Cupboard*, of 1663 (fig. 979), De Hooch's Baroque climax, illuminated by an unseen window, is the simple act of counting neatly folded sheets taken from their carved and inlaid cabinet in an interior whose cleanliness matches its perfect perspective and its clear, bright colors; the black-and-white marble floor leads the eye through the door to the view across the street, reminiscent of the backgrounds of van Eyck (see fig. 754) in its rich atmospheric and spatial quality and its reverence for the object. By means of pictures on the wall the painter takes pains to show that art is a part of the ideal daily life.

The exact opposite of De Hooch's religion of order is uproariously extolled by JAN STEEN (1625/26–79), who revived the humor of the Late Gothic *drôleries*. To this day a "Jan Steen household" is the Dutch expression for a ménage in which nothing can go right. In fact, nothing does in *The World Upside Down* (fig. 980), which might well be a parody on De Hooch's linen cupboard and was probably painted in the same year. It was also, doubtless, intended as a moralizing picture in a tradition going back as far as Bruegel. Steen, the son of a brewer, dabbled in brewing and even kept a tavern; he never tired of representing the effects of his products, shown in this picture as almost universal. Here the scene shifts to the kitchen; the same lady of the house in the same costume as in De Hooch has fallen asleep; beer runs from the keg over a floor strewn with pretzels, a pipe, and a hat; children, a pig, a dog, a duck, and a monkey are where they ought not to be and are doing what they ought not to do. The sodden housemaid, over whose knee an admirer has thrown a possessive leg, hands him absent-mindedly another glass of wine, and no-

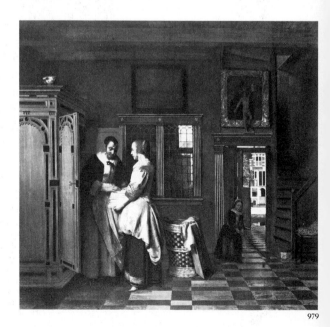

979

978. JACOB VAN RUISDAEL. *View of Haarlem.*
c. 1670 or later. Oil on canvas, 22 × 24⅜".
Mauritshuis, The Hague. The Johan Maurits
van Nassau Foundation

979. PIETER DE HOOCH. *Linen Cupboard.* 1663. Oil
on canvas, 28⅜ × 30½". Rijksmuseum,
Amsterdam

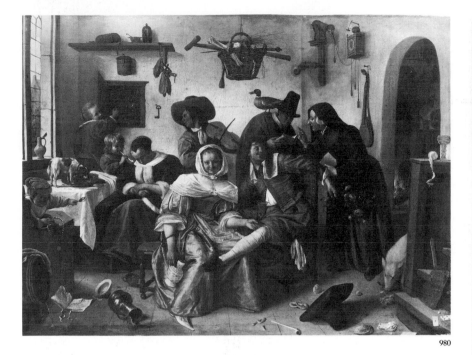

980

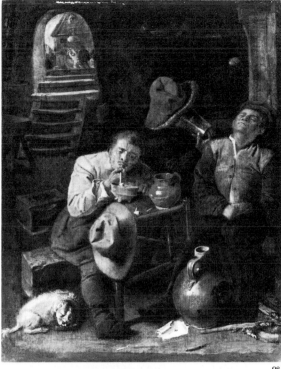

981

body pays the slightest attention to an elderly man (doctor or preacher?) reading from a book or to an old woman trying to bring some order into the situation. To make it all the more effective, Steen is at least as good a painter as De Hooch, handling his figures with conviction and power, and has a splendid sense of both composition and color. If his humor can at times be resisted, his children cannot, and his joy of life is infectious.

So indeed is the enthusiasm with which a whole group of Dutch (and Flemish) painters represented scenes several notches lower in the social scale. The best of these was a Fleming, ADRIAEN BROUWER (1605/6–1638), who spent the formative years of his brief career in Haarlem in the 1620s, working in the circle of Hals. His peasants drink, rollick, play cards, and fight. Three of them are shown in varying stages of intoxication, all fairly advanced, in his *Boors Drinking* (fig. 981). One has drowned not only his sorrows but also his face; nothing can be seen of him but his hands holding a tankard up to his hat-covered visage. The dashing brushwork and the strong light-and-dark contrasts that make Brouwer's pictures so lively derive more or less directly from Hals and Rembrandt.

Dutch still lifes were often intended to appeal to the eye and the palate at once. Some are crowded with an unappetizing profusion of fruit or game, but the most tasteful (and tasty) are those restricted to the makings of between-meals snacks (they are traditionally referred to as "breakfast pieces"). White wine, a bit of seafood or ham, lemon, pepper, and salt are the subjects, along with polished silver, knobby crystal goblets to keep wine cool, and a rumpled tablecloth. The spectator is tantalized not only by the delicacy with which the carefully selected objects are painted, but also by the expensive carelessness with which a lemon has been left partly peeled and a silver cup overturned. WILLEM CLAESZ HEDA (1599–1680/82) was one of the chief practitioners of this art in which, despite what might seem severe limitations of subject matter, he demonstrates (fig. 982) an unexpected eloquence in the rendering of golden light, as well as sensitivity in establishing the precise relationships between transparent, translucent, reflecting, and mat surfaces—a silent drama of pure sense presented in the style of a Caravaggio religious scene against the typical background of nowhere, fluctuating between shadow and light.

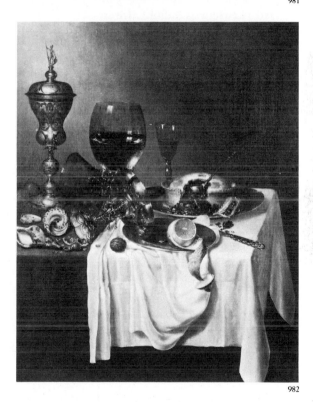

982

980. JAN STEEN. *The World Upside Down.* c. 1663. Oil on canvas, 41⅜ × 57⅛". Kunsthistorisches Museum, Vienna

981. ADRIAEN BROUWER. *Boors Drinking.* c. 1620s. Oil on panel, 11½ × 8¾". National Gallery, London

982. WILLEM CLAESZ HEDA. *Still Life.* c. 1648. Oil on panel, 34¾ × 27½". Fine Arts Museums of San Francisco. Mildred Anna Williams Collection

At the other extreme from such Epicureanism are the Spartan architectural paintings of the period, especially those of PIETER SAENREDAM (1597–1665), a lonely hunchback who found a certain solace in painting the interiors of Dutch Gothic churches, especially whitewashed Protestant ones, stripped of decorations and altars; his works show only enough figures to indicate their scale. Saenredam described his meticulous procedure; he started with exact line drawings made on the spot, then enlarged them to construction drawings in his studio on the basis of measured plans, and finally executed his painting on panel. Predominantly white, austere, apparently inhuman, these quiet pictures, nonetheless, distill their own beauty of form and tone, and an unexpected meditative poetry. The *Church of Saint Bavo*, of 1660 (fig. 983), an interior view of the great church in Saenredam's home city of Haarlem and in which he was eventually buried, is one of his finest paintings. It shows a superb control of space and a knowledge of the relationships of planes, which was not to be attained again until the wholly different but also monochromatic solutions of the Cubists in the twentieth century (see Part Six, Chapter Seven).

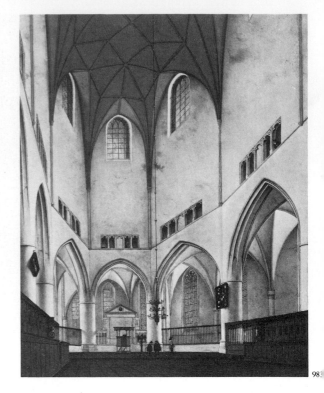

983

HALS Recognized today as one of the most brilliant of all portraitists, Frans Hals (1581/85–1666) was probably born in Antwerp and was brought to Haarlem as a child. Interested in little but the human face and figure, Hals was blessed with an unrivaled gift for catching the individual in a moment of action, feeling, perception, or expression and recording that moment with tempestuous but unerring strokes. There could hardly be a stronger contrast than that between his electric characterizations of people and the calm, deliberately controlled portraits of the essential person by such great painters of the Renaissance as Piero della Francesca, Titian, Dürer, and Holbein (see figs. 714, 715, 850, 862, 876). Although he probably saw works by the great Venetian masters in Dutch collections, there is no indication that Hals had much interest in Mediterranean art of any period; his discoveries about the rendering of light in paint seem to have been almost entirely his own. He owed something to the new naturalism of his Caravaggesque contemporaries (see figs. 973, 974), especially Terbrugghen, who were roughly the same age, but he himself never visited Italy.

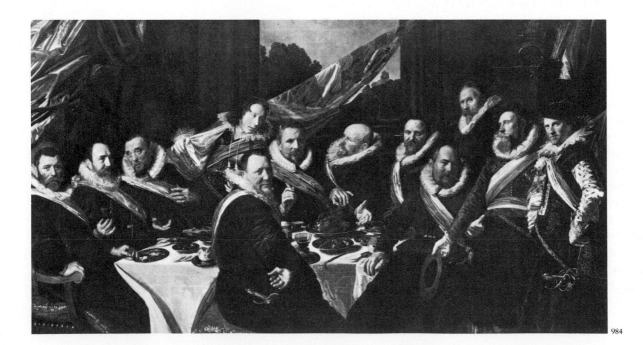

984

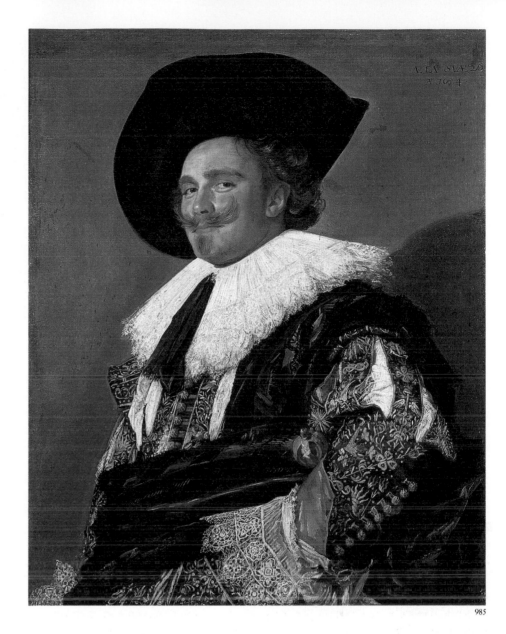

985

Among his early commissions were group portraits of the militia companies that had been largely responsible for defending the new Dutch republic in a hostile world; these paintings radiate its self-confidence and optimism. By the 1620s, however, these companies had largely outworn their military function; Hals usually shows the citizen-soldiers in the midst of one of those stupendous banquets that the civic authorities pleaded with them to reduce from a week's duration to three days or at the most four. Such compositions, picturing a dozen or more males, mostly corpulent and middle-aged, each of whom had paid an equal amount for his portrait and expected to be recognizable, were not conducive to imaginative painting. Hals's predecessors generally had composed these group portraits in alignments hardly superior compositionally to a modern class photograph, and it was to take the genius of Rembrandt to raise them to the level of high drama (see fig. 991). But Hals, in his *Banquet of the Officers of the Saint George Guard Company*, of 1616 (fig. 984), has done a superb job within the limitations of the traditional type. The moment is relaxed, the wine and beer have worked their effect, and the gentlemen turn toward each other or toward the painter as if he had been painting the whole group at once, which was certainly not the case. Massive Baroque

983. PIETER SAENREDAM. *Church of Saint Bavo*. 1660. Oil on panel, 27¾ × 21⅝". Worcester Art Museum, Massachusetts

984. FRANS HALS. *Banquet of the Officers of the Saint George Guard Company*. 1616. Oil on canvas, 5'8⅞" × 10'7½". Frans Hals-museum, Haarlem

985. FRANS HALS. *The Laughing Cavalier*. 1624. Oil on canvas, 33¾ × 27". Permission of Trustees of The Wallace Collection, London

diagonals—the curtain pulled aside, the flag, the sashes, the poses, the ruffs—tie the picture together into a rich pattern of white and flashing colors against the shimmering black costumes. Broad brushstrokes indicate the passage of light on color with a flash and sparkle unknown at this moment even to Rubens.

The genial warmth of Hals's early style is seen at its most engaging in an unusually finished portrait, *The Laughing Cavalier* (fig. 985). The date of 1624 and the subject's age of twenty-six are inscribed on the background, and since the cavalier's diagonal shadow also falls on it, it is clearly a wall; the Caravaggesque nowhere is thus converted into a definite here, yet the wall is irradiated with light and seems insubstantial. The amorous proclivities of the young man may be indicated by the arrows, torches, and bees of Cupid and the winged staff and hat of Mercury embroidered in red, silver, and gold on the dark brown of his slashed sleeve. With his glowing complexion, dangerous moustaches, snowy ruff, and dashing hat, the subject is the very symbol of Baroque gallantry; the climax of the painting is the taunting smile on which every compositional force converges.

The opposite of this glittering portrait is the somber *Malle Babbe*, of about 1630–33 (fig. 986). No one knows who the old creature was or the meaning of her probably uncomplimentary nickname, written in an eighteenth-century hand on the original stretcher. Often called an "old crone," she might be anywhere from forty to sixty years old. She has obviously soaked up the contents of the (two-quart?) tankard she holds, and Hals has caught her in the midst of a fit of insane laughter. Possibly she is the town idiot. The owl on her shoulder is a symbol not of wisdom, as with Minerva, but of foolishness. The astounding expression, seized in a storm of strokes, is rendered with a demonic intensity that shows that Hals, concerned from youth to age with human character as revealed in expression, could plumb depths that repelled even him. About 1664, when he was past eighty, Hals, already on a pension from the city of Haarlem, showed a still different side of his character and ability in the *Regentesses of the Old Men's Almshouse* (fig. 987). Painted almost entirely in black and white and shades of gray, this solemn picture is united by diagonal movements differing in tempo and verve but not in strength from those building up the composition in the *Saint George Guard Company*, even though the painter had only the devastated faces and white collars of the women as component elements. Each of the subjects has reacted in

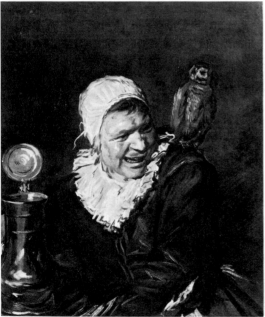

986. FRANS HALS. *Malle Babbe*. c. 1630–33. Oil on canvas, 29½ × 25¼". Staatliche Museen, Berlin

987. FRANS HALS. *Regentesses of the Old Men's Almshouse*. c. 1664. Oil on canvas, 67⅛ × 98⅜". Frans Halsmuseum, Haarlem

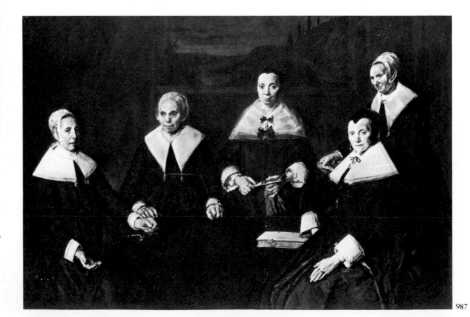

a separate way to age and experience, yet all participate in a calm acceptance of the effects of time. In its simplicity and austerity the composition shows an expressive depth unexpected in the generally ebullient Hals.

LEYSTER Frans Hals's most gifted pupil, Judith Leyster (1609–60), shares the honors with Artemisia Gentileschi as one of the two most accomplished women painters of the seventeenth century. Less original than her Italian contemporary, she was, nonetheless, a brilliant technician whose portraits are often confused with those of her master. She married a well-known painter, Jan Molinaer, whose works—attractive as they are—do not rank with hers technically. Leyster's *The Proposition* (fig. 988), painted in 1631, when the artist was only twenty-two years old, depicts a sensitive subject. A young girl, humbly but decently dressed and seated in a simple chair, quietly works away at her embroidery frame, aware of yet silently rejecting a handful of coins offered by a middle-aged man whose features and fur cap reveal him as a trader from Eastern Europe. The psychological tension of the situation, involving the young woman's human integrity to a degree that only a woman artist would have conceived and projected with such power, is intensified by the light of the oil lamp. Again, in the Caravaggesque tradition, the scene takes place in nowhere, as a symbol of the predicament of a woman of modest origins rather than as an isolated incident. In the delicacy of her brushwork and the sensitivity of her expressions, Leyster owes nothing to Hals.

REMBRANDT The greatest of Dutch masters, indeed one of the supreme geniuses in the history of art, is Rembrandt van Rijn (1606–69). To this day the art of Rembrandt (he signed his work by his first name only, and, interestingly enough, the world has chosen to remember him thus) remains at once one of the most profound and one of the most intimate witnesses of the progress of the soul in its earthly pilgrimage toward the realization of a higher destiny. Although this universal artist dealt with many worldly subjects as well as with his favorite biblical themes, and painted a great number of vivid portraits, it is always the spirituality of his art—subtly visible in his early work but overpowering in his latest masterpieces—that distinguishes Rembrandt from all his Dutch contemporaries and which, with varying degrees of success, was imitated

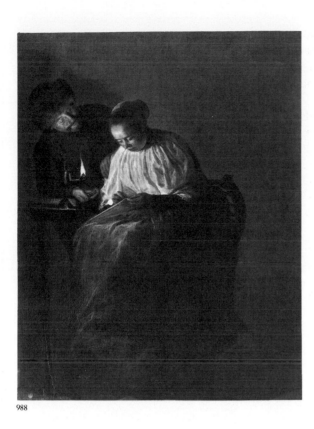

988

988. JUDITH LEYSTER. *The Proposition.* 1631. Oil on canvas, 11¹¹⁄₁₆ × 9½". Mauritshuis, The Hague. The Johan Maurits van Nassau Foundation

989. REMBRANDT. *Anatomy Lesson of Dr. Tulp.* 1632. Oil on canvas, 66¾ × 85¼". Mauritshuis, The Hague. The Johan Maurits van Nassau Foundation

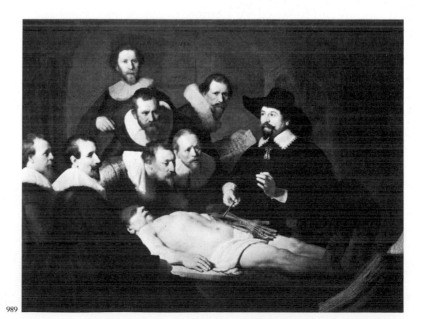

989

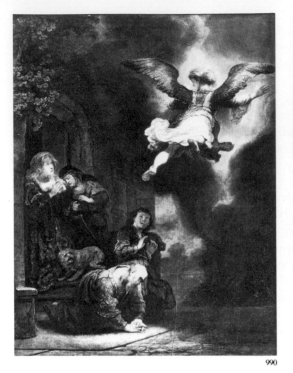
990

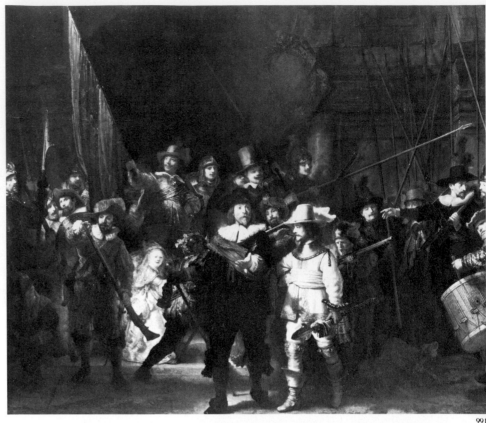
991

by a host of followers. It is ironic that the very century and society that refused artists the possibility of showing their paintings in churches produced one of the greatest of Christian artists. But this very denial of access to the *congregations* gave Rembrandt the opportunity of addressing the *individual* through his own personal means, most of all by radiant light against and through a special kind of warm, glowing, and vibrant shadow, receptive to the deepest resonances of human feeling.

The son of a prosperous miller, Rembrandt was born in Leiden. He was trained as a painter by two minor local artists and finally by the Early Baroque history painter Pieter Lastman. His rapid success prompted him to move to Amsterdam, the principal Dutch city, where early in 1632 he was commissioned to paint the *Anatomy Lesson of Dr. Tulp* (fig. 989). Since only the corpses of executed criminals could be used for dissections, such an opportunity was an event for medical research, conducted before distinguished citizens and followed by a dinner of the doctors' guild and a torchlight parade. Conventional representations of public dissections prior to Rembrandt were as stiffly aligned as those of militia companies before Hals. While Rembrandt has painted faces, beards, lace ruffs, and pleated sleeves with all the meticulous care his patrons could have desired, he has also given the composition a new drama. Against the Caravaggesque wall displaying Rembrandt's signature and the date, he has arranged the composition diagonally in depth, with the corpse foreshortened so that we see the soles of its feet; the open book is used as a *repoussoir*. Dr. Tulp lifts with his forceps the flexors of the cadaver's left hand (which operate from the forearm) and with his own left hand demonstrates how they close the fingers; the freely grouped spectators gaze intently at the stripped human mechanism, at its live counterpart, at the lecturer's face, or inward in contemplation. After a moment an unexpected element begins to dominate—mystery, in the half-shadowed white face and partly open mouth of the corpse, little by little reminding the living of their own inevitable

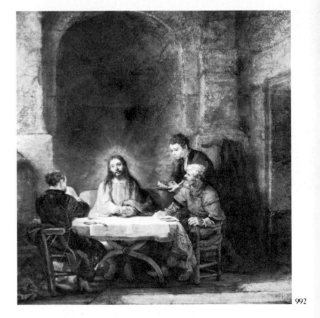
992

990. REMBRANDT. *Angel Leaving Tobit and Tobias.* 1637. Oil on panel, 26¾ × 20½". The Louvre, Paris

991. REMBRANDT. *The Night Watch.* 1642. Oil on canvas, 11'5¾" × 14'4½". Rijksmuseum, Amsterdam

992. REMBRANDT. *Supper at Emmaus.* 1648. Oil on canvas, 26¾ × 25⅝". The Louvre, Paris

993. REMBRANDT. *The Polish Rider.* c. 1655. Oil on canvas, 46 × 53". © The Frick Collection, New York

destiny. Eventually, in Rembrandt's art, mystery—in portraits, in drama, above all in religion—assumed the primary role, and rendered his message equally difficult for his contemporaries to accept or for posterity to forget.

But for the time being his worldly success was assured. He had more commissions and pupils than he could accept; he married Saskia van Uylenburgh, the lovely daughter of a wealthy family; bought a splendid house; started a collection of paintings and rarities; and, in addition to his handsome, lucrative portraits, began to paint in a highly imaginative Baroque style under two combined influences—Caravaggio for sharp light-and-dark contrast and Rubens for spiral composition and speed of execution. A dazzling example is the *Angel Leaving Tobit and Tobias* of 1637 (fig. 990). Rembrandt has followed exactly the Book of Tobit (not included in Protestant Bibles, but available to him as a source in the Apocrypha). The formerly blind Tobit, cured by the Archangel Raphael, prostrates himself in gratitude, while his son Tobias looks upward in wonder at the departing figure; Anna, the wife of Tobit, and Sarah, Tobias's bride, even the dog mentioned in the text, are shown, yet subordinated to the miracle of the "light of heaven" formerly denied to Tobit and now falling around him in floods. Seen sharply from the back, the angel is taken from their sight into an open cloud in a flash of light. Along with the luminary effects that create this resounding climax goes a new technical freedom. The smooth, detailed early manner is gone; the forms are quickly sketched, although without Hals's virtuosity of the brush, and

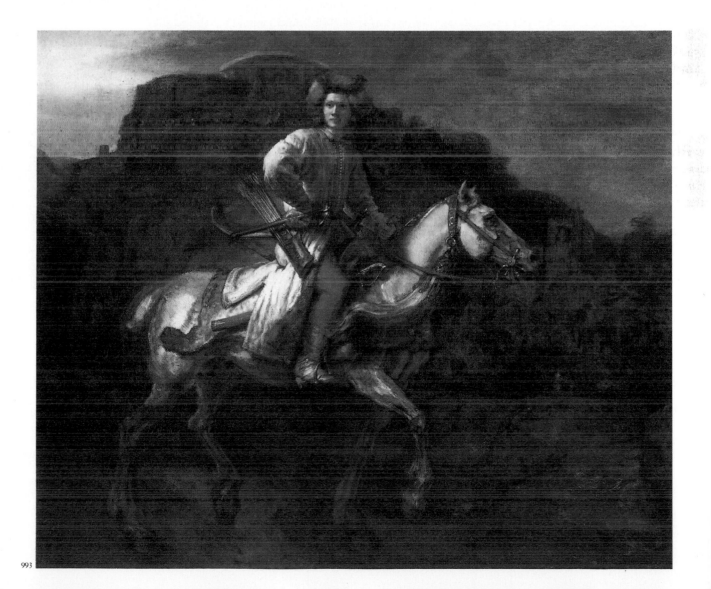

993

the light masses are done in a rich impasto against the deep, characteristically brownish glazes used to veil and intensify the shadows.

In 1642, the year of Saskia's untimely death, both the element of mystery and the technical innovations that accompany and reinforce it began to conquer even commissioned subjects, such as the Company of Captain Frans Banning Cocq and Lieutenant Willem van Ruytenburch; this painting, through a misunderstanding natural enough considering its formerly darkened condition, is called *The Night Watch* (fig. 991). The account that the members of the company were dissatisfied with their colossal group portrait is legendary, but Rembrandt's commissions in the 1640s did slacken off, whether or not as a result of this unconventional painting. It was cut down in size in the eighteenth century to fit into a space in the Town Hall of Amsterdam, and it is no longer evident that the group is about to cross a bridge. Even a cleaning, shortly after the close of World War II, which revealed the original brilliance of the color, did not restore any semblance of natural light.

The subject was probably the formation of the militia company for a parade. Not only through Hals's device of diagonals but also through irrational and wonderfully effective lighting Rembrandt has turned narrative prose into dramatic poetry. We are never really told what is happening; real events are submerged in the symphonic tide of the coloring, dominated by the lemon yellow of the lieutenant's costume and the captain's scarlet sash against shadows that, even after cleaning, are still deep and warm. As with Hals's group portraits, all the men had paid equally to have themselves depicted, yet some are sunk in shadow; one man is concealed except for his eyes. It was inevitable that Rembrandt would lose popularity as a portrait painter, although not at once.

During the 1640s Rembrandt is believed to have joined the Mennonites, who believed in the sole authority of the Bible and in silent prayer. His luminary visions of scriptural subjects become deeper and more tranquil. The Supper at Emmaus, in which Christ, on the evening of the first Easter when "the day is far spent" (Luke 24:30–31), reveals himself to two of his disciples in the breaking of bread, is a natural subject for the Baroque, and the climax is often represented with great psychological intensity, or as a burst of light. In Rembrandt's version of 1648 (fig. 992), all is still. A niche behind Christ becomes an apse, the table an altar, both gently illumined by rays from Christ's head. The servant perceives nothing, and only an involuntary motion of hand to mouth on the part of one disciple and a drawing back of the other betray their sudden recognition of their companion.

In 1655 Rembrandt found himself in the midst of severe financial troubles, which reached disastrous proportions the following year, forcing the eventual sale of his house and his collections in an attempt to satisfy his creditors. His common-law wife, Hendrickje Stoffels, and his only surviving child, Titus, formed a company to discharge the master's debts, and to assume him ostensibly as an employee. At the beginning of this unhappy period, about 1655, Rembrandt painted *The Polish Rider* (fig. 993). It recalls Dürer's *Knight, Death, and the Devil* (see fig. 865), which Rembrandt surely knew. The precise meaning of this painting has not yet been determined, but there can be little doubt that in some way it is an allegory of man's earthly journey, its many dangers and its uncertain destination. One cannot go far wrong to cite the words of Psalm 84:5–6, on which Rembrandt must often have dwelt: "Blessed is the man whose strength is in thee. . . . Who passing through the valley of Baca [i.e., tears] make it a well; the rain also filleth the pools." In the grim and rocky

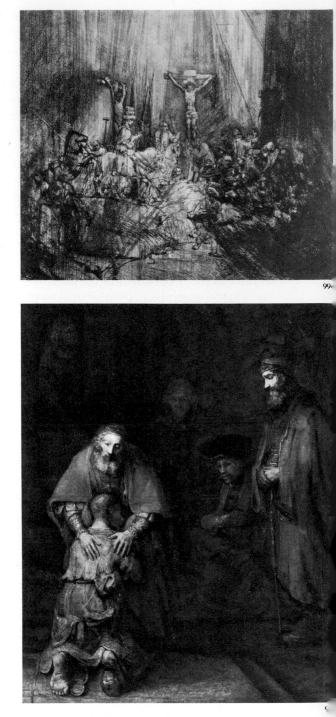

994. REMBRANDT. *The Three Crosses* (fourth state). 1660–61. Drypoint and burin. The Metropolitan Museum of Art, New York. Gift of Felix M. Warburg and his Family, 1941

995. REMBRANDT. *Return of the Prodigal Son*. c. 1669. Oil on canvas, 8'8" × 6'8¾". The Hermitage, Leningrad

valley a pool can be seen. Against the dark hill with its suggestions of habitations—here and there a hut; near the crest a ruined castle—the youth rides in light, alert, his weapons at the ready. There could not be a deeper expression of Rembrandt's own spiritual journey. The figure and his mount stand forth in a new sculptural grandeur, intensified by the fact that many of the impastos have been laid on not with a brush but with a palette knife; the artist literally carved the pigment, especially in the dark rocks and in the bony forms of the horse and the masses of his mane.

A special role in Rembrandt's vast production is played by his etchings. Etching was a medium known to the Renaissance but relatively little used. In contrast to copper engraving (see figs. 864, 866), etching exacts little manual tension. The plate is coated with wax on which lines are drawn with a metal stylus, as rapidly as desired, but always firmly enough to penetrate to the copper. The plate, wax and all, is then put in an acid bath; whatever has been uncovered by the stylus is eaten into by the acid. The plate is then heated, the wax runs off, and the bitten lines are ready for printing. Because of the greater flexibility of the process itself and the range of values attainable by sensitive printing, the results are freer and more fluid than engraving. Etching can capture the lightness of a fugitive sketch or the tonal resonance and depth of an oil painting. Rembrandt's etchings deal with every conceivable subject, from landscape and daily life to the Scriptures. Often they went through several phases, known as "states," rewaxed and in part re-etched, before Rembrandt was satisfied. In its early states *The Three Crosses* of 1653 depicts in detail an elaborate drama. In the fourth and final state (fig. 994), clusters of lines are so bitten as to flood down in darkness at the right and in rays of light at the center like those that descend upon Bernini's *Saint Theresa* (see fig. 915). The penitent thief hangs upon his cross, dimly seen, but many of the other figures sink into shadow. Only a tip of the impenitent thief's cross still appears, as if his guilt were canceled out; the rest is obliterated by the darkness that fell over the land. We are left alone in the tumult with the Crucified, on whom the rays of light fall, and with the centurion, glorifying God and saying, "Certainly this was a righteous man" (Luke 23:47).

Hendrickje died in 1662. Ill, Titus continued to help his lonely father until death claimed him, too, in 1668. Probably in 1669, the year of his own death, Rembrandt painted his *Return of the Prodigal Son* (fig. 995), which stands at the ultimate peak of Christian spirituality, illuminating the relationship of the Self to the Eternal. The parable (Luke 15:11–32) was a favorite in Baroque art; its meaning, in general, can be discerned in Saint John of the Cross's words about union with divine love: "God communicates himself to the soul in this interior union with a love so intense that the love of a mother who so tenderly caresses her child, the love of a brother, or the affection of a friend bear no likeness to it, for so great is the tenderness and so deep the love with which the infinite Father comforts and exalts the humble and loving soul."

In Rembrandt's dark background, in the original, a rich and luminous brown, one makes out two dim faces, a seated figure, and, more brightly lighted, the eldest son, hurt and uncomprehending because there was never a celebration for him, the law-abiding. In a spontaneous gesture of loving forgiveness, the gentle, aged father comes into the light to press to his bosom the cropped head of his ragged son. Faces have been reduced to little more than the essential angle between forehead and nose, framing the deep eyes. Only the hands of the father and the tired feet of the son—

the left bared by its disintegrating shoe—are painted in any detail. The picture is, as Christ intended his parable to be, an allegory of the earthly pilgrimage of man finding rest and meaning in divine redemption. But Rembrandt's language in these late works is almost entirely that of color and texture. Rich tans and ochers in the prodigal's worn garments are inundated by the glowing red of his father's festal cloak against the deep browns of the encompassing dark; solid masses in thick impastos gleam against the translucent glazes.

In paintings, etchings, and drawings, Rembrandt depicted himself, in known examples, nearly a hundred times; all except a few of the earliest lack any trace of vanity. The Baroque was the age of the self-portrait; many a minor artist has left us a self-portrait superior in quality to any of his other works. Such revelations are foreign both to the High Renaissance and to Mannerism. Dürer, for example, shows us a self-possessed, self-contained, self-directed human being (see fig. 862), Parmigianino a congealed self in a distorted world (see fig. 834). Baroque self-portraits generally aim at revealing the artist as open to the world outside and beyond him, sensitive and responsive to higher powers. The Jesuit Cardinal Robert Bellarmine, who taught at Louvain in neighboring Flanders and whose work may well have been known to Rembrandt, proclaimed that "he that desires to erect a ladder by which he may ascend so high as to God Almighty, ought to take the first step from the consideration of himself." This is indeed what Rembrandt did, with increasing depth as the difficult and often tragic circumstances of his later life compelled constantly changing self-assessments in relation to God.

In a series of self-portraits painted in the final decade of his life, he attained a spiritual level that can only be compared with that of Michelangelo in his last *Pietà* (see fig. 824). One of the most moving of these last self-portraits (fig. 996) must date from the period of grief over the loss of Hendrickje. Although the face is impassive and the hands folded in resignation, the picture radiates quiet loneliness and the head is surrounded by light as by a halo. The masses of face, hair, and garments are kept as simple as in the *Prodigal Son*—mere blocks of pigment laid on with the knife, or perhaps even with the fingers against the glowing dark. In these ultimate self-revelations, one recalls the opening words of Psalm 139, which Rembrandt must often have read, "O Lord, thou hast searched me, and known me," and in the interpenetration of impasto and glaze, mass and space, darkness and light, Verse 12: "Yea, the darkness hideth not from thee; but the night shineth as the day: the darkness and the light are both alike to thee."

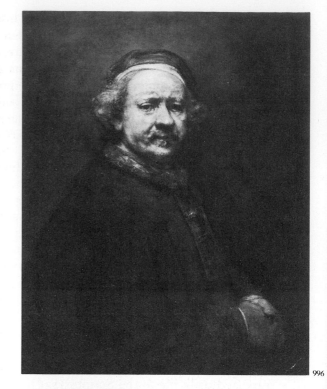

996

VERMEER In the seventeenth century, Jan Vermeer of Delft (1632–75), probably a Catholic convert, must have seemed to be another of the "little masters," hardly different in range and style from De Hooch (see fig. 979), whose domestic interiors those of Vermeer superficially resemble. Contemporary sources either barely mention Vermeer or omit his name entirely from lists of prominent artists. In the eighteenth century Sir Joshua Reynolds considered Vermeer's *Kitchen Maid*, of about 1658 (fig. 997), one of the finest pictures he saw on a trip to Holland, but only in the nineteenth, with the rise of interest in naturalistic color, were Vermeer's paintings truly appreciated. Today he is universally considered second only to Rembrandt among Dutch painters. It is not difficult to see why. Although he has none of Rembrandt's mystery or passion, and avoids the master's supernatural lighting effects, his message is immediate, deep,

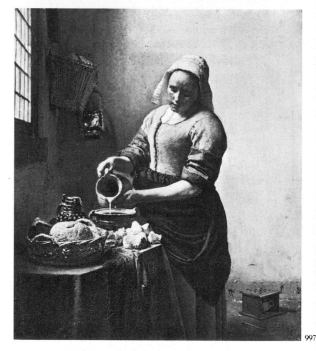

997

996. REMBRANDT. *Self-Portrait*. c. 1667. Oil on canvas, 33⅞ × 27¾". National Gallery, London

997. JAN VERMEER. *Kitchen Maid*. c. 1658. Oil on canvas, 17⅞ × 16⅛". Rijksmuseum, Amsterdam

998. JAN VERMEER. *Allegory of the Art of Painting*. c. 1670–75. Oil on canvas, 52 × 44". Kunsthistorisches Museum, Vienna

and lasting. He was able, as were none of his contemporaries (and none of his predecessors save perhaps van Eyck and Piero della Francesca), to transmute simple actions into eternal symbols through the magic of pure perception and the perfect adjustment of space, tone, and color.

Because of his slow and painstaking methods, Vermeer seems to have painted very few pictures. He earned his living principally from art dealing, at which he lost heavily; he left a wife and eleven children in debt. Only about thirty-five of his paintings survive, and all but three represent interiors modest in size and sparsely furnished. The background wall, when visible, is invariably parallel to the picture plane. All but two of

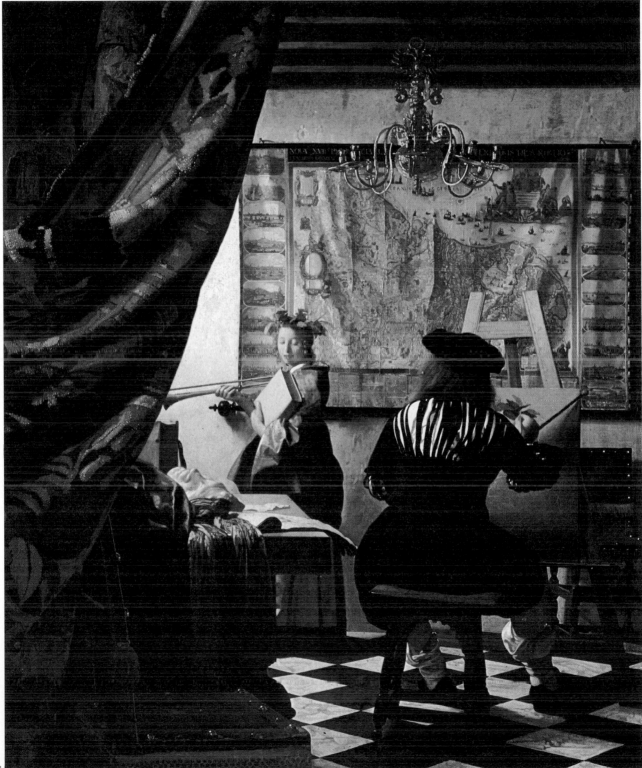

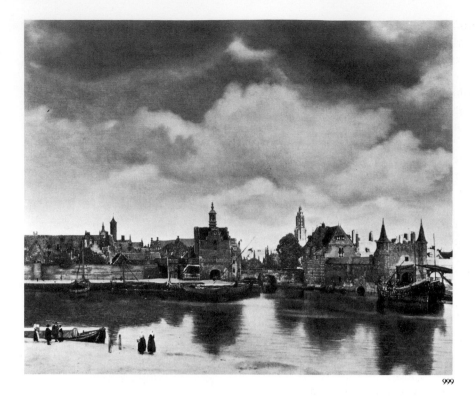

999

the interiors are lighted strongly from one side—the left in all but three instances. In all but five the source of light is represented as a window; never is the spectator permitted to see through the window to the world outside. No matter what Vermeer may suggest or summarize of the outer world or invite the spectator to imagine, wisdom begins and ends in the room, conceived as a cube of shining space in which the figures and their transitory actions seem forever suspended in light.

It has been recently suggested that Vermeer utilized for his pictorial compositions and techniques the device of the *camera obscura*, a darkened enclosure with an opening on one side and a flat, light surface on the other. Rays of light reflected from objects outside the camera obscura pass through the aperture to project the image on the light surface, upside down, even without a lens. By the interposition of a mirror before the opening, the image may be rectified, and the insertion of a lens provides the possibility of focus. The camera obscura (in principle first described by Aristotle) was used without a lens by Islamic scientists in the tenth century, and with a lens by Italians in the early sixteenth. Such devices were popular in the seventeenth century throughout Europe. There are two types, one in which the viewer is inside the box, the other in which he looks through a peephole. Only the first, which may be portable like a sedan chair or supplied with a hood to envelop the viewer, will project an image onto a flat surface on which it may be studied, drawn, or painted.

Vermeer seems to have used the camera obscura at first to unify the planes of light and dark and the patches of color into a coherent image. The camera obscura tends to turn all reflections of light into tiny blobs of white; these are clearly visible in the *Kitchen Maid*, especially on the pointed bread rolls on the table and on the fresh cheese in the basket, but also on the rim of the pitcher and on the puckered hem of the maid's apron. Vermeer has treated them as indications of volume in light, in the manner of the necklace of pearls around the subject's neck in Piero della Francesca's *Battista Sforza* (see fig. 714). The camera obscura also allowed

999. JAN VERMEER. *View of Delft*. c. 1662. Oil on canvas, 38½ × 46¼". Mauritshuis, The Hague. The Johan Maurits van Nassau Foundation

Vermeer to escape from the conventional coloring of his Dutch predecessors and contemporaries, dominated even in outdoor scenes by grays, greens, and browns, into a world of brighter, purer hues, such as the strong blue of the maid's apron and the bright yellow of her bodice. These colors are seen reflected through the other colors in the room, notably in the bluish shadows on the creamy wall. Although Vermeer depicts a brass brazier and a hamper hanging in the corner, as well as a foot warmer on the floor with a pot of hot ashes inside, with true Dutch naturalism, he concentrates all attention on the nobility of the simple action of the maid pouring milk and the purity of the spherical and cylindrical volumes, producing a composition as monumental as anything that ever issued from High Renaissance Italy.

Vermeer's careful optical studies made it possible for him to paint his rare outdoor scenes with a glowing intensity of color unknown before his time. There is nothing contrived about the composition of the *View of Delft*, of about 1662 (fig. 999). We seem really to be there, and to experience the warm red of the old bricks and tiles with our own eyes. Even the clouds have a sultriness and weight that none of the professional landscapists of the seventeenth century could quite capture, and the characteristic climax of the picture, the sudden stab of light on the distant church spire, seems wholly accidental. Never again until the work of Corot in the nineteenth century were tonal values to be so exquisitely adjusted, or the still figures of ordinary people to be used to induce so quiet a contemplation of the beauty of timeworn structures and vessels in diffused light and moisture-laden air.

Vermeer's art is summed up in his *Allegory of the Art of Painting* (fig. 998), probably dating from near the end of his brief life. The subject is not entirely clear; the artist—probably not Vermeer, as he is dressed in late-sixteenth-century costume—is painting a model robed as Clio, the muse of history, equipped with laurel wreath, book, and trumpet, according to her description in the *Iconologia*, a treatise on allegorical representations by Cesare Ripa, first published in Italy in 1593 and widely read throughout Europe. The painter is making a picture that could hardly be farther from Vermeer's own work. Steadying his right hand on a maulstick (a rod with a cushioned tip), he has already executed the general contours of Clio's pose in white, filling the canvas with her half-length figure, and is now painting the leaves of her crown. She stands in the light of an unseen window, against a huge map representing both northern and southern Netherlands, bordered by views of twenty cities (maps appear in several of Vermeer's backgrounds). Thus the outer world is permitted to invade the picture, but only symbolically, along with the muse of history. The map looks as though it could be read in detail, like the open manuscripts in the works of van Eyck; only the largest letters, however, are actually legible, as if Vermeer had interposed a threshold between the object and the viewer that permits only elements of a certain size to be clearly distinguished.

The magic fascination of the picture lies less in the subject than in Vermeer's brilliant perspective contrasts, made possible by his use of the camera obscura, which even exaggerates such phenomena. Compare, for instance, the interior by De Hooch (see fig. 979), which avoids any strong foreground elements, with this painting. In this symbolic image of the artist faced with geography and history, time and space, congealed in planes of clear, bright color in a light-filled room, Vermeer has created a perfect Baroque counterpart to the Early Renaissance interior in the *Arnolfini Wedding* (see fig. 756), which it so strongly suggests.

English Architecture The Tudor monarchs and nobles built handsome palaces and country houses, for the most part along Perpendicular Gothic lines, studded here and there late in the sixteenth century with occasional Italian details. Not until the eighteenth century did English concern for the visual arts begin to rival the passions for poetry and music that won for England so high a place in the creative life of the Renaissance and Baroque periods. During the seventeenth century the best painters in England were Flemish visitors, notably Rubens and Van Dyck (see Chapter Two), who painted some of their finest works in England. But under the Stuart monarchs English architecture designed by Englishmen entered a new period of intense productivity.

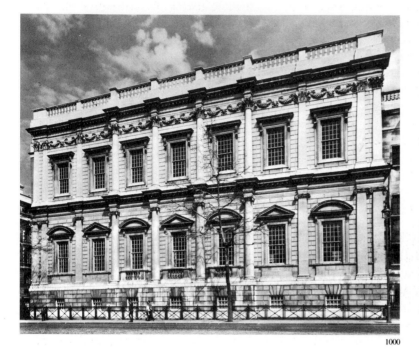

1000

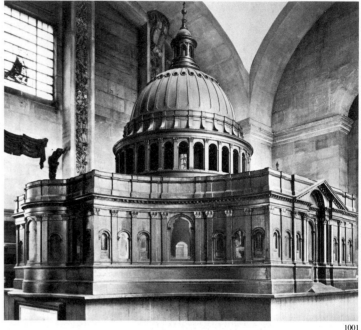

1001

1000. Inigo Jones. West façade, Banqueting House, Whitehall Palace, London. 1619–22

1001. Christopher Wren. *Great Model* (of St. Paul's Cathedral, London). 1672. Library, St. Paul's Cathedral

1002. Christopher Wren. Plan of St. Paul's Cathedral, London

1003. Christopher Wren. West façade, St. Paul's Cathedral, London. 1675–1710

1004. Christopher Wren. Interior, St. Paul's Cathedral (view of nave from choir)

INIGO JONES (1573–1652) visited Italy, but he seems to have been unimpressed by the beginnings of the Italian Baroque. The style he brought back was pure if simplified Palladianism, destined for a long and fruitful life in England and North America. The Banqueting House (fig. 1000) that Jones built for King James I in 1619–22 as an addition to the now-vanished palace of Whitehall in London does not reproduce any specific building by Palladio; in its cubic severity, in fact, it avoids any of the more pictorial aspects of Palladio's architecture. The façade is a firm restatement of basic Italian Renaissance principles; a lightly rusticated building block is articulated by a screen architecture of superimposed Ionic and Corinthian orders, pilasters in the two bays at either side, and engaged columns in the three central bays, unrelieved by any ornamentation save for the sculptured masks and swags that unite the Corinthian capitals. It cannot by any stretch of the term be called Baroque; like all of Jones's structures, it is an elegant and purified revival of a style the Italians themselves had abandoned.

WREN The great flowering of English architecture in the late seventeenth century was largely due to a single disaster and a single genius. The fire of 1666, which destroyed most of the City of London (the central

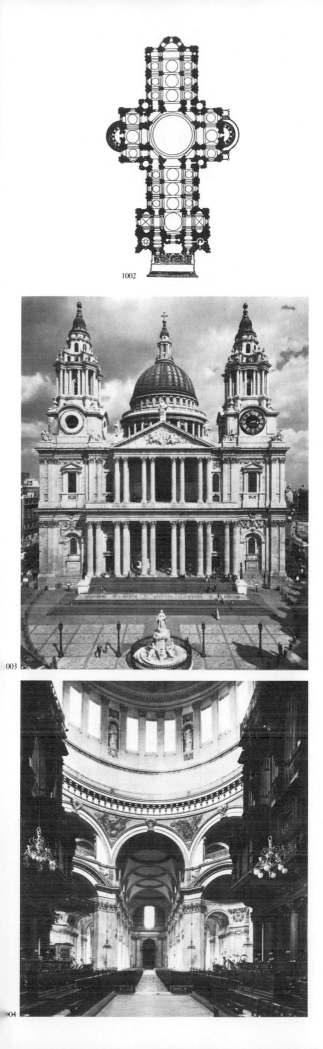

1002

003

04

district, on the old Roman site), gave an unparalleled opportunity to a youthful professor of astronomy at Oxford, Dr. Christopher Wren (1632–1723), subsequently knighted for his achievements in his adopted profession of architecture. He used it not only to bring English buildings into line with Continental developments, but also to produce in the course of his long life an array of handsome structures unequaled in number and variety by any other Baroque architect. The very year of the fire Wren had projected for the Gothic Cathedral of Saint Paul's a central dome with a Bramantesque peristyle (see fig. 803). After the fire King Charles II intended to rebuild the City on Wren's rational Baroque plan with broad avenues, squares, and vistas. For considerations of private property this proved impracticable. Wren was called upon first to redesign the choir of Saint Paul's and then to rebuild the entire cathedral; eventually, almost every church in the City was rebuilt on a Wren design, so that the present picture of bristling Baroque steeples (or those that survived the Blitz of World War II) is due to Wren. His first attempt at the total rebuilding of Saint Paul's, preserved in the so-called *Great Model* of 1672 (fig. 1001), was more Renaissance than Baroque, and in most respects brilliantly original. His Greek-cross plan, with eight piers, was to connect the arms with four concave quadrants, articulated on the exterior by a single giant story of Corinthian pilasters, with intervals varying in accordance with the fenestration, surmounted by an attic story and a dome whose drum was enveloped not by a peristyle but by an arcade of Corinthian pilasters. A Baroque climax was to be achieved in the façade by a colossal arched portal, breaking the lower cornice of the central pediment.

The novelty of Wren's design impressed the king but not the clergy; liturgy and custom demanded a longitudinal axis. Regretfully, Wren abandoned this scheme and worked out two others, one of which was substantially adopted in 1675, although the dome and bell towers did not receive their final form for years. The essentially Gothic directional plan was reinstated (fig. 1002); flying buttresses to support the vaults were concealed on the exterior by a second story that is merely a screen. The façade with its magnificent central climax (fig. 1003) derives in part from the east façade of the Louvre (see fig. 946), recapitulated in two stories of paired Corinthian columns, the lower story wider to accommodate the side portals. The flanking towers, reviving the Gothic tradition, are Baroque campaniles along lines established by Borromini in Sant'Agnese (see fig. 925). For all Wren's debt to Continental models, his cathedral, not completed until 1710, stands as one of the finest Baroque architectural compositions anywhere. The dome, combining a Bramantesque peristyle with a Michelangelesque verticality, punctuates the peristyle with a wall containing an arch after every fourth intercolumniation. The host of imitations of Wren's dome, in Europe and North America, attest to the finality of his solution. In comparison with Continental churches, the interior (fig. 1004) strikes one as cold, perhaps inevitably in view of Anglican opposition to gilding and profuse ornamentation. The long Gothic space is divided by giant Corinthian pilasters supporting transverse arches on whose pendentives are floated saucer domes; a smaller order of paired pilasters sustains the nave arcade. As in all Wren's interiors, the emphasis is placed on the linear elements of arches, frames, and circles.

Conversion of
St. Paul, by
Caravaggio

David, by
Bernini

Triumph of
Bacchus, by
Velázquez

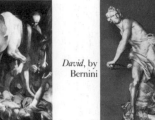

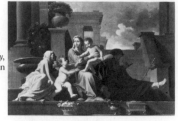

Holy Family,
by Poussin

	POLITICAL HISTORY	RELIGION, LITERATURE, MUSIC, ART	SCIENCE, TECHNOLOGY
1590		John Donne (1572–1631)	
1600	James I rules England, 1603–25 Holland's independence recognized by Spain, 1609	Papacy of Pope Paul V, 1605–21	Dutch lens-grinders construct refracting telescope and compound microscope, c. 1600
1610	Maria de'Medici regent of France, 1610–17, during minority of Louis XIII Thirty Years' War, 1618–48		Johannes Kepler (1571–1630) announces his first two laws of planetary motion, 1609; announces third law, 1619
1620	Cardinal Richelieu, chief minister and adviser to Louis XIII, consolidates power of monarchy, 1624–42	Heinrich Schütz (1585–1672)	William Harvey (1578–1627) describes circulation of the blood, 1628
1630		René Descartes (1596–1650) publishes *Discourse on Method*, 1637 Pierre Corneille (1606–84)	Galileo Galilei (1564–1642) publishes *Dialogue on the Two Major Systems of the World*, 1632
1640	Frederick William, Great Elector of Brandenburg (r. 1640–88) Cardinal Mazarin governs France during minority of Louis XIV, 1643–61	Papacy of Innocent X, 1644–55 Royal Academy of Painting and Sculpture founded in Paris, 1648 J.-B. Molière (1622–73) Blaise Pascal (1623–62)	Evangelista Torricelli (1608–47) discovers principle of the barometer and devises earliest form of the instrument, 1643
1650	English Commonwealth under Cromwell, 1649–53; Protectorate, 1653–59 Charles II (r. 1660–85) restores monarchy in England Louis XIV, assisted by Colbert, assumes absolute rule of France, 1661 Great Fire of London, 1666	J.-B. Racine (1639–99) Thomas Hobbes publishes *Leviathan*, 1651 Papacy of Alexander VII, 1655–67 French Academy in Rome founded, 1666 John Milton publishes *Paradise Lost*, 1667	Robert Boyle (1627–91) formulates law that the volume of gas varies inversely as the pressure, 1660 Charles II charters Royal Society, London, 1662; establishes Royal Observatory, Greenwich, 1675
1675	Louis XIV revokes Edict of Nantes, 1685 Glorious Revolution against James II of England, 1688; Bill of Rights	Spinoza (1632–77) John Locke (1632–1704) *Pilgrim's Progress* by John Bunyan, 1678 Giovanni Battista Vico (1668–1744)	Isaac Newton (1642–1727) sets forth idea of universal gravitation in *Principia*, 1687; publishes *New Theory about Light and Color*, 1672, and *Optics*, 1704

BAROQUE

S. Maria della
Salute, Venice,
by Longhena

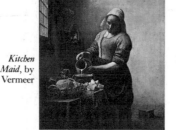

*Kitchen
Maid*, by
Vermeer

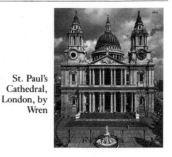

Self-Portrait, by
Rembrandt

St. Paul's
Cathedral,
London, by
Wren

PAINTING, SCULPTURE, ARCHITECTURE

ITALY	CATHOLIC COUNTRIES OUTSIDE ITALY	PROTESTANT COUNTRIES	
Annibale Carracci, Palazzo Farnese frescoes			1590
Caravaggio, *Calling of St. Matthew; Conversion of St. Paul*			1600
Maderno, S. Susanna, Rome; nave and façade, St. Peter's			
Reni, *Aurora*	Rubens, *Raising of the Cross; Fall of the Damned; Daughters of Leucippus*	Hals, *Banquet of the Officers of the St. George Guard*	1610
Domenichino, *Hunt of Diana*		Jones, Banqueting House, Whitehall, London	
Guercino, *Aurora*	Van Dyck, *Madonna of the Rosary*	Honthorst, *Adoration of the Shepherds*	1620
Bernini, *Apollo and Daphne; David;* Baldachin of St. Peter's	Velázquez, *Triumph of Bacchus*	Terbrugghen, *Incredulity of St. Thomas*	
Artemisia Gentileschi, *Judith with the Head of Holofernes*	Poussin, *Inspiration of the Poet*	Hals, *Laughing Cavalier*	
	Zurbarán, *Vision of St. Peter Nolasco*		
Longhena, S. Maria della Salute, Venice, begun	La Tour, *Newborn*	Hals, *Malle Babbe*	1630
Cortona, ceiling fresco, Palazzo Barberini, Rome	Van Dyck, *Portrait of Charles I*	Rembrandt, *Anatomy Lesson; Angel Leaving Tobit*	
	Mansart, Orléans Wing, Blois		
	Rubens, *Garden of Love*		
Borromini, interior, S. Carlo alle Quattro Fontane, Rome	Ribera, *Martyrdom of St. Bartholomew*		
Bernini, *Ecstasy of St. Theresa; Fountain of the Four Rivers*	Louis le Nain, *The Cart*	Rembrandt, *Night Watch; Supper at Emmaus*	1640
	Claude Lorrain, *Embarkation; Marriage of Isaac and Rebecca*	Heda, *Still Life*	
	Poussin, *Holy Family on the Steps*		
Borromini, S. Agnese, Rome	Champaigne, *Arnauld d'Andilly*	Cuyp, *Landscape with Cattle*	1650
Bernini, *Cathedra Petri;* colonnade of St. Peter's, Rome	Le Vau, Vaux-le-Vicomte	Rembrandt, *Polish Rider*	
	Perrault, east façade, Louvre, Paris	Van Goyen, *River Scene*	
Guarini, Chapel of the Holy Shroud, Turin	Le Vau, Hardouin-Mansart, Versailles	Vermeer, *Kitchen Maid; View of Delft*	
		Saenredam, *Church of St. Bavo*	
		De Hooch, *Linen Cupboard*	
		Steen, *World Upside Down*	
		Hals, *Regentesses*	
		Rembrandt, *Return of the Prodigal Son*	
		Vermeer, *Allegory*	
		Ruisdael, *View of Haarlem*	
Baciccio, ceiling fresco, Gesù, Rome	Girardon, *Tomb of Richelieu*	Hobbema, *Avenue at Middelharnis*	1675
	Coysevox, *Bust of Colbert*	Wren, St. Paul's Cathedral, London	
Guarini, Palazzo Carignano, Turin	Hardouin-Mansart, Church of the Invalides, Paris		
Pozzo, ceiling fresco, S. Ignazio, Rome			

CHAPTER

THE EIGHTEENTH CENTURY

FOUR

The eighteenth century did not produce a single figure in the visual arts to rank with the universal masters of previous epochs. The seventeenth century can boast Caravaggio, Bernini, Borromini, Rubens, Rembrandt, Vermeer, and Velázquez, all artists of the highest stature. In the eighteenth century the palm passed to music—Bach, Handel, Vivaldi, Haydn, and Mozart. Paradoxically, it was a period of intense creative activity, with countless artists of talent, many delightful, yet all limited. Nothing completely new was created except the Rococo style (see below), and even that was a lighthearted version of Baroque grandiloquence, as if the overinflated Baroque balloon had burst and the floating pieces had alighted wherever they could find a perch. After the grandeur of the Catholic triumph in Rome and the pomposity of the Age of Louis XIV in France, grace, charm, and wit substituted for majesty and splendor. Yet all the time in the background flowed the strains of classicism and realism, which in the seventeenth century had formed countercurrents to the more outspokenly Baroque styles, and when least expected one or the other could move into the light. Aside from its frequent lack of seriousness, the most striking aspect of eighteenth-century art is the contrast between international styles on the continent of Europe and an assertive nationalism in England, where the Rococo was never more than partially accepted no matter how much of it the English lord or wealthy merchant might have absorbed on the Grand Tour.

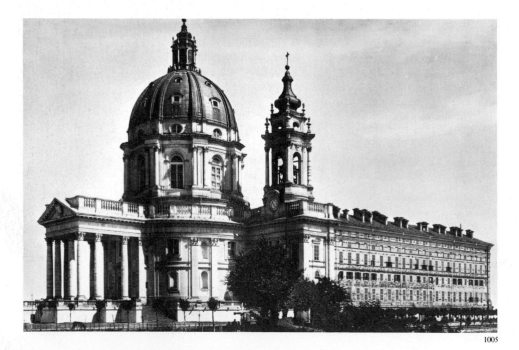

1005. FILIPPO JUVARA. Superga, monastery
church, near Turin. c. 1715–31

1005

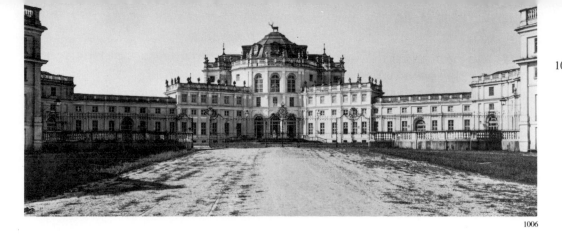

1006

Italy

JUVARA In Italy the international dimension of eighteenth-century style emerged in the architecture of Filippo Juvara (1678–1736), a Sicilian brought to Turin by Vittorio Amedeo II, duke of Piedmont and Savoy. In and around the Piedmontese capital, already studded with brilliant works by Guarini, Juvara turned out an astonishing array of churches and royal residences, and from this center he either traveled or sent designs throughout central and western Europe. A very agreeable phenomenon of the Late Baroque in Italy is the mountaintop sanctuary, intended to bring a vast landscape into focus. The shrine of Superga (fig. 1005), commissioned from Juvara by Vittorio Amedeo in 1715 or 1716 in gratitude to the Virgin for assistance in battle and completed in 1731, looks across Turin to a rampart of Alps. Only the battalions of windows and chimneys relieve the brick mass of the monastery intended to serve the shrine. Growing out of the very mountain, the structure comes to its climax in the white stone church, a circular structure on an octagonal core, preceded by a temple portico and crowned by a circular dome, and flanked by a campanile on each side. A somewhat similar arrangement of church and monastic buildings had already been devised at Melk in Austria (see fig. 1028). The coupled pilasters and columns are more widely spaced than in domes by Michelangelo or Borromini, the latter quite freely grouped in the portico, and the airy campaniles abound in double curvature.

The sprightliness of early-eighteenth-century taste finds unexpected expression in Juvara's fantastic hunting lodge of Stupinigi, outside Turin, of 1729–33 (fig. 1006), a brilliant miniature parody of Versailles. The plan of the main block is a flattened X, whose spokes radiate from a central oval hall, its dome crowned by a stag. The Classical orders barely assert themselves in the membrane-like undulation of wall and window.

PIAZZETTA Among all the Italian schools of painting, only that of Venice survived with real originality and vigor into the eighteenth century; the revived Venetian School was, in fact, the only serious rival to that of France on the Continent. Interestingly enough, the period was one of political stagnation; the thousand-year-old republic ruled by an oligarchy was incapable of competing with the imperialist monarchies to the north and west. The splendid city had become a playground for the rich and great of all Europe, the first tourist center of the modern world. Old themes, transformed in content and lightened in style, remained in the new painting that decorated church and palace interiors in a burst of creative energy. The first important master of eighteenth-century Venice was Giovanni Battista Piazzetta (1682–1754), who spent most of his long life in the city of the lagoons. While his pictures often retain something

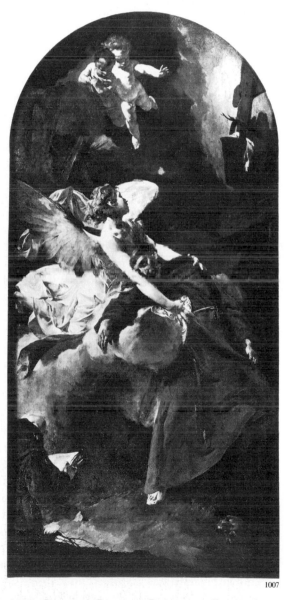

1007

1007. GIOVANNI BATTISTA PIAZZETTA. *Ecstasy of Saint Francis*. c. 1732. Oil on canvas, 12'4½" × 6'1⅛". Museo Civico d'Arte e Storia, Vicenza

of the darkness of the Caravaggio followers and the drama of the Roman High Baroque, they already show something of the lightness and grace of the eighteenth century. His *Ecstasy of Saint Francis*, of about 1732 (fig. 1007), echoes at a distance Bernini's *Ecstasy of Saint Theresa* (see fig. 915), but with far less intensity. The emphasis is less on the climax than on the moment of healing; an angel has come down to stanch the blood from the saint's miraculous wounds, and light plays softly on this scene and the two child angels above, creating delicate rhythms remote from the powerful forms of the High Baroque, just as the figures are relieved from the weight of Caravaggio and Rubens. As compared with the serious themes of the seventeenth century, the mood is exquisite and almost playful.

TIEPOLO The supreme Venetian master of the period, and one of the two or three finest painters of the eighteenth century, was Giovanni Battista Tiepolo (1696–1770), active not only in Venice and throughout the cities and country villas of northern Italy but also in Germany and in Spain; he died in Madrid while in the course of grandiose projects at the royal palace. Tiepolo's greatest achievements were his vast decorative frescoes. The damp, salt air of Venice was not kind to true fresco in the traditional Italian style; as we have seen, Venetian painters of the sixteenth century (see Part Four, Chapter Six) preferred to cover large surfaces with detachable canvases. But Tiepolo, doubtless under the influence of Roman illusionist frescoes of the High and Late Baroque (see Chapter One), wanted a completely unified surface throughout entire interiors. His technique made considerable use of sand in the mixture, and was carried out *secco su fresco*. By these means he was able to cover enormous surfaces, but with a completely new lightness, combined with a mathematical perfection of perspective in no way inferior to that of Pozzo (see fig. 929). The walls and ceiling of the great hall in the Palazzo Labia in Venice (fig. 1008), probably finished before Tiepolo's trip to Germany in 1750, are completely painted away with illusionistic architecture of such accuracy that it is often next to impossible to tell from photographs what is real and what is fiction, and difficult even when one is standing in the room. Actually, only the narrow rectangular marble doorframes shown in the illustration are real.

The story of Antony and Cleopatra is treated as a continuous festival surrounding the entire room, like a greatly expanded Veronese supper (see fig. 856), from which one picks out with difficulty even the figures of the principal actors; drama hardly matters—only the operatic splendor of the conception, the colors of the marbles and the costumes, and the free flow of forms and light. Architecture and figures are bathed in a luminous atmosphere that had not been seen since ancient Roman painting, which Tiepolo must have known at least in engravings (excavations began at Herculaneum in 1738 and at Pompeii in 1748).

Tiepolo showed his magical facility and feather lightness in decorations on an even more ambitious scale in the ceiling frescoes for the archiepiscopal Residenz in Würzburg, finished in 1753 (fig. 1009). The ceilings remind one of Pozzo's Sant'Ignazio frescoes (see fig. 929) in the central decoration of the Kaisersaal (Imperial Hall) but are shorn of all weight and solemnity. The mighty, upward-boiling geyser of the Baroque pictorial composition has dissolved into scraps floating in light and color in the pearly immensity of space, while in *The Investiture of Bishop Harold* gilded plaster curtains are drawn aside as if the ceiling itself were opening and the splendid pageantry were spilling forth into the very room.

1008

1008. GIOVANNI BATTISTA TIEPOLO. *The Banquet of Anthony and Cleopatra*, fresco, Palazzo Labia, Venice. Before 1750

1009. GIOVANNI BATTISTA TIEPOLO. *The Investiture of Bishop Harold*, portion of ceiling frescoes, Kaisersaal, Residenz, Würzburg. 1750–53

GUARDI A new category of Venetian eighteenth-century painting was that of views, whether of Venice itself or of Venetian buildings recombined in imaginary landscape settings. These works were generally intended for the wealthy international public who thronged Venice and took them back as mementos to their splendid houses throughout Europe. Some of the view-painters were accurate perspective theorists who made wide use of the camera obscura (see pages 748–49), but in modern eyes the most gifted were several brothers of the Guardi family, whose sister married Tiepolo. Experienced in the painting of altarpieces, the Guardi brought to view painting a special kind of fantasy and a dazzling lightness of touch. Francesco (1712–93) is generally considered the most important, but the situation is still very confused, and it may never be possible completely to disentangle the styles of the brothers and their assistants.

Not until he reached seventy-two was Francesco elected to the Venetian Academy, in the category of view-painter. Even for eighteenth-century Venice his technique is so brisk and his vision so unconventional that his work must have been at times hard to digest. To us his paintings seem the very embodiment of the carnival atmosphere of the last century of the republic's life. In *Piazzetta San Marco* (fig. 1010), instead of dignified monumentality, the familiar shapes of the Doges' Palace, the Library of San Marco, and the façade of San Giorgio Maggiore take on a quality of tattered age in the long light of afternoon, with elegant strollers out to enjoy the air and a bit of intrigue, lower classes busy at an awninged shop at the base of the Campanile, and two dogs in the exploratory stage of courtship. Actually, Guardi's fantasy and light touch revive an ancient tradition, that of the freely painted view we have seen in the Fourth Pompeiian style, with the same delightful combination of poetry and wit.

In France the Late Baroque took on a new flavor and lightness after the demise of Louis XIV, which freed the courtiers for a life in Paris considerably more agreeable than their virtual imprisonment at Versailles. A number of *hôtels particuliers* (town mansions) were built by the aristocracy in fashionable quarters of the capital. Although their exteriors were designed in a tradition flowing directly from that of the seventeenth century, in the interiors everything was transformed. Nothing was more odious

France—The Rococo and Classicism

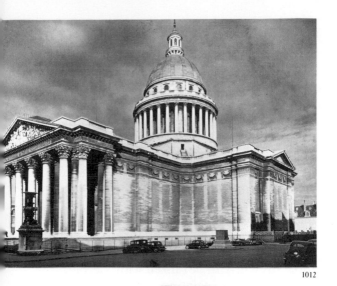

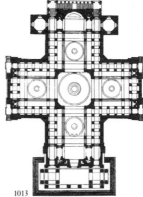

1011. GERMAIN BOFFRAND and CHARLES-JOSEPH NATOIRE. Salon de la Princesse, Hôtel de Soubise, Paris. 1732

1012. GERMAIN SOUFFLOT. The Panthéon (Church of Ste.-Geneviève), Paris. 1757–90

1013. GERMAIN SOUFFLOT. Plan of The Panthéon (Church of Ste.-Geneviève), Paris

1014. ANGE-JACQUES GABRIEL. Place de la Concorde (originally Place Louis XV), Paris. 1763

to the eighteenth century than the pomposity of *Le Roi Soleil*. The new and delightfully irresponsible style has won the name *Rococo*, derived from the word *rocaille* (the fantastic decoration of rocks and shells lining grottoes in Mannerist and Baroque gardens) because of its frequent use of shell forms, combined with scrolls, flowers, ribbons, and other caprices in a decoration that obliterates form and direction and defies analysis.

One of the most successful examples of this characteristically intimate and small-scale decoration is the Salon de la Princesse in the Hôtel de Soubise (fig. 1011), designed in 1732 by GERMAIN BOFFRAND (1667–1754), a pupil of Hardouin-Mansart, and supplied with paintings by CHARLES-JOSEPH NATOIRE (1700–77). The plan is oval, and the walls so treated that it is impossible to decide where they end and the ceiling begins. The room is a mere bubble of plaster, paint, gold, and glass. The eight openings oscillate between windows and mirrors so arranged as to provide reflections that further confuse one's sense of direction. There are no Classical orders (although there are many on the exterior); the walls are treated as panels, surrounded by gilt moldings whose only straight lines are the verticals. On them scraps of gilt decoration, blown like thistle-down, seem to have come momentarily to rest. In frames whose double curvatures elude geometrical definition, the lighthearted paintings unfold the romance of Cupid and Psyche. The central chandelier, its scores of faceted pendants reflecting and multiplying the light of the candles, is an essential element in the fragile web of color and light. In assessing such extreme examples of the Rococo, however, it should be borne in mind that Boffrand's more monumental buildings, both exteriors and interiors, derive from the sober, Classicistic Baroque style of Hardouin-Mansart (see figs. 951, 954).

The same society that demanded such frivolities as the Salon de la Princesse for aristocratic diversions required a wholly different mode for serious buildings, increasingly Classical—in fact, Augustan—toward the middle of the century. The Panthéon, in Paris (fig. 1012), built in 1757–90 after the designs of GERMAIN SOUFFLOT (1713–80) as the Church of Sainte-Geneviève, shows a classicism more thorough and severe than that of Perrault (see fig. 946). Trained in Rome, Soufflot admired High Renaissance architecture and originally planned a Greek-cross structure with a hemispheric dome reflecting Bramante's designs for Saint Peter's. Following the wishes of the clergy, he prolonged his design to its present Latin-cross shape (fig. 1013), and the dome consequently had to be heightened; Soufflot obviously followed Wren's dome for Saint Paul's (see fig. 1003), eliminating the niches. The portico is, of course, the pronaos of a Roman temple, although with a projecting wing on each side. Interestingly enough, Soufflot was an admirer of Gothic constructional principles, and concealed not only a clerestory, but an elaborate system of supports for his interior vaulting behind the lofty screen wall and balustrade, which make the two-story building appear one story high on the exterior. The cold aspect of the blank outer walls is due to the walling up of the windows during the Revolution, in 1791, when the building was converted to its present purpose as a memorial to France's illustrious dead; traces of the original windows can still be seen in the illustration.

A triumph of the new Classical tendency in French monumental architecture is the pair of palaces built by ANGE-JACQUES GABRIEL (1698–1782) on the Place Louis XV in Paris, today the Place de la Concorde (fig. 1014). In its handling of space the general idea is still Baroque. The façades were intended to flank the straight street leading to the Church of the Madeleine (eventually built in the nineteenth century on the model

of a Roman temple). Inspired by the east façade of the Louvre (see fig. 946), Gabriel's masterpieces are more strongly Classical in that the columns are single, as in Roman buildings, instead of paired. Widely spaced in a steady parade above rusticated arches, the colonnades uniting the terminal temple fronts produce an impression of extreme elegance and grace. Gabriel was also responsible for the exquisitely proportioned Petit Trianon, of 1762–68 (figs. 1015, 1016), built in the park of Versailles as a hideaway for the king's reigning mistress, Madame de Pompadour, who, in fact, governed France; her impetus was responsible for the great upsurge in building activity at midcentury, as her taste was for the Augustan style.

WATTEAU One of the greatest French painters of the eighteenth century, and one of the two or three anywhere to be ranked with Tiepolo, was Jean-Antoine Watteau (1684–1721), whose paintings embody the interests of the Rococo raised to the plane of lyric poetry. Born in the Flemish town of Valenciennes, Watteau never forgot his Flemish heritage, especially his allegiance to the Baroque colorism of Rubens. After an impoverished and difficult beginning in Paris, which undermined his health, the young painter rapidly achieved recognition. In 1712 he was invited to join the Academy, and was permitted to write his own ticket for a reception piece. His remaining nine years of life, constantly clouded by illness, were largely devoted to the production of an enchanting series of canvases idealizing the themes of courtship and of outdoor festivals and plays popular during the last years of Louis XIV, and overwhelmingly so during the Regency. His special category was the *fêtes galantes*, which can best be described as festivals attended by exquisitely dressed young ladies and gentlemen in gardens or parks.

The loveliest of these is *A Pilgrimage to Cythera* (fig. 1017), the artist's reception piece for the Academy, painted in 1717, intended to evoke fragile memories of Rubens's *Garden of Love* (see fig. 964). The subject is a day's journey of youthful couples to the island of Cythera, sacred to Venus, whose statue, hung with rose garlands, stands at the right. At its base Cupid has hung his quiver of arrows, and the couples, still exchanging vows in the light of early evening, prepare to embark for the shore in a golden boat attended by clouds of cherubs, not without a mournful look

1015. ANGE-JACQUES GABRIEL. West façade, Petit Trianon, Versailles. 1762–68

1016. ANGE-JACQUES GABRIEL. Plan of the Petit Trianon and flower garden, Versailles. 1762–68

1017. JEAN-ANTOINE WATTEAU. *A Pilgrimage to Cythera*. 1717. Oil on canvas, 51 × 76½". The Louvre, Paris

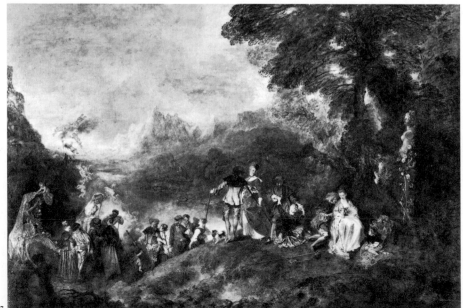

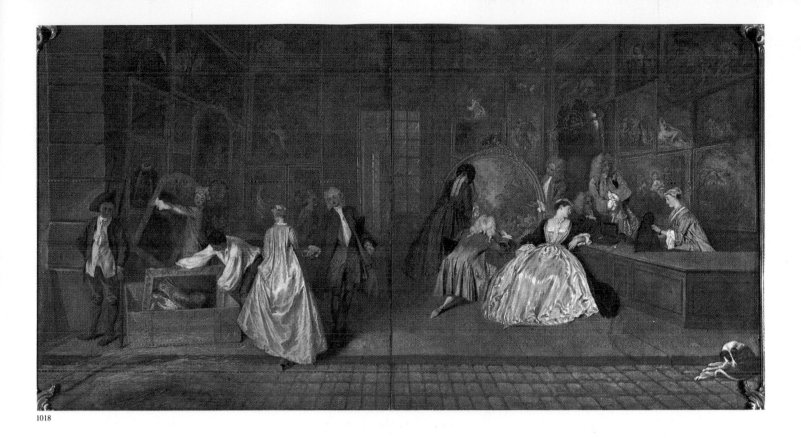

1018

backward at the pleasures of the enchanted isle. This wistful evocation of the transience of love is carried out with an unrivaled grace of drawing and delicacy of color. Watteau usually covered his canvases with a heavy coating of pearly color, shifting from white to blue and sometimes to rose. Once the underpaint was dry, he indicated the trees in swiftly applied washes of green, blue green, and golden brown, somewhat in the manner of Van Goyen (see fig. 975), but so transparent that the pearly undercoat shows through. The figures were then touched in with fairly thick impastos, in jewel-like tones predominantly of rose, blue, yellow, and white. The whole was then glazed in the manner of Titian, so that the impastos would gleam richly through an atmosphere determined by the surrounding washes. The figures are generally very small in relation to the space and invariably based on pointed forms—triangles delicately supported by the toes of shoes, the tips of canes, or the pointed ends of ladies' trains; even the faces are generally conceived in terms of pointed shapes. All were painted on the basis of drawings from life, hundreds of which survive, in which every facet of form, light and shade, and expression was carefully studied. These were then translated into paintings that depend largely on poise for their effect and on brushstrokes of great accuracy and delicacy, communicating color of jewel-like intensity.

The conditions under which works of art were bought and sold in the eighteenth century are depicted by Watteau with wit and grace in an extraordinary picture, the *Signboard of Gersaint* (fig. 1018), painted in only eight mornings during the last year of the artist's life for his friend the art dealer Gersaint. The work had to utilize two canvases to fill the space, a low arch protected by a canopy above the entrance to the shop, which was situated on the Pont Notre Dame, a bridge across the Seine in the center of Paris. The original arched shape and the break between the two canvases can still be made out in the illustration. The picture was slightly cut down at the sides and expertly extended at the top by a pupil when

1018. JEAN-ANTOINE WATTEAU. *Signboard of Gersaint.* c. 1721. Oil on canvas, 5′4″ × 10′1″. Staatliche Museen, Berlin

it was purchased, two weeks after being put in place. The shop was entitled *Au Grand Monarque*, which explains the Rigaud-style portrait of Louix XIV, who had died six years earlier, being packed into a box at the left. At the right, a lady dressed as a widow gazes into the landscape of an oval picture, while a white-wigged gentleman goes down on one knee, the better to examine the female nudes. Behind the counter salespersons engage the attention of a seated lady of exquisite beauty. The probably symbolic paintings which line the walls, frame to frame, are in the styles of masters Watteau admired and had studied in the royal collections, such as Correggio, Titian, Veronese, and Rubens, but the only one identifiable (by the Flemish painter Jordaens) is in the portion not by Watteau. At the back one can see dimly into an inner room, built out over the Seine. The rough cobblestones of the bridge pavement in the foreground contrast with the elegance and richness of the shop, brought to precise focus in the gleaming satins of the female customers.

BOUCHER The painter who more than any other epitomizes the pleasure-loving aspect of the Rococo is François Boucher (1703–70), the favorite painter of Madame de Pompadour. There is little in his work of the mystery and poetry of Watteau, but for sheer sensuous charm his paintings, overflowing with voluptuous nudes, are hard to equal. The *Triumph of Venus*, of 1740 (fig. 1019), shows the goddess of love half-seated, half-reclining on silks and satins in a huge shell, drawn across the sea by dolphins, accompanied by tritons and sea nymphs, one of whom offers her a shell of pearls, while Cupids race in twos and threes through the trailing clouds, carrying a miraculously graceful salmon-and-silver-striped

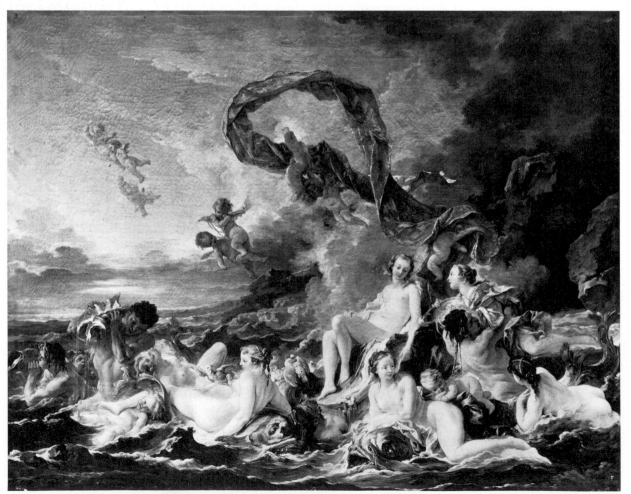

1019

scarf that resembles a gigantic banner. In contrast to Watteau, Boucher retains Rubens's device of the spiral into the picture, and his colors, reveling in sensuous shades of pink and blue, are richly enameled and dense, with little or no use of glazes. Frivolity, grace, and charm are pushed almost to the point of surfeit, but just when one has had enough sweetness, the authority of Boucher's drawing steps in, and provides solid support for his fantasies.

CHARDIN To modern eyes, one of the most impressive French eighteenth-century painters was Jean-Baptiste-Siméon Chardin (1699–1779). Yet his contemporaries held him in somewhat lower esteem, save for Denis Diderot, the encyclopedist and critic of art, literature, and music, whose reports on the Salons (the biennial exhibitions of the Royal Academy) are a major source for our knowledge of eighteenth-century French art, and a barometer of the taste of the intellectuals. In an age when the highest honors went to those who could celebrate, veiled or naked, its fantasies and gratifications, Chardin displayed a disconcerting interest in its realities. His subjects and style celebrate a lifelong allegiance to the Parisian lower-middle class, from which both he and Boucher (though one would hardly have known it in the case of Boucher) had sprung. His early work consists almost entirely of still life, but not of the Dutch epicurean variety; he transferred the scene of his pictures from the gardens of Watteau and the gilded salons or boudoirs of Boucher, and even the bourgeois living room of the Dutch, to the kitchen. It is the more surprising that aristocrats should have bought his work.

His *Copper Cistern*, of about 1773 (fig. 1021), presents the cistern as a monumental object (despite its tiny dimension), surrounded by a pitcher, a pail, and a dipper as a planet by satellites. To endow such humble objects with nobility required a sense of the density and richness of pigment equal to the artist's respect for their copper and zinc, and for the rough wall, which is the only background. His thick impastos are derived from a study of Rembrandt and communicate to his subjects a glow as satisfying as that of Watteau's silks and satins. Chardin's figure studies are concerned with Rococo ideals of transience and lightness, but without abandoning his bourgeois loyalty. The *House of Cards*, of 1741 (fig. 1020), shows us a simply dressed boy toying with his cards as delicately as a Watteau lady with her suitor, and presents an image as fragile—a breath will blow the house of cards over. Yet for as long as it lasts, the fantasy of a child is set forth as a structure of great dignity.

GREUZE AND FRAGONARD Chardin's honest devotion to bourgeois subjects was unconsciously parodied by Jean-Baptiste Greuze (1725–1805) and flouted by Jean-Honoré Fragonard (1732–1806), both of whom managed to subsist in relative independence from the Academy. Both had the ill fortune to survive into the revolutionary era, which Greuze limped through, while Fragonard had to flee Paris. Greuze's sentimental and moralizing pictures, on subjects of his own invention, struck the taste of the 1760s and 1770s exactly right; they were warmly praised by Diderot, who condemned Boucher on both moral and stylistic grounds. *The Son Punished*, of 1777–78 (fig. 1022), is a sermon on family solidarity. The young man who had braved his father's curse and gone off with the recruiting sergeant so that he might taste the adventures of military life returns to find his father dead and his family plunged in reproachful grief.

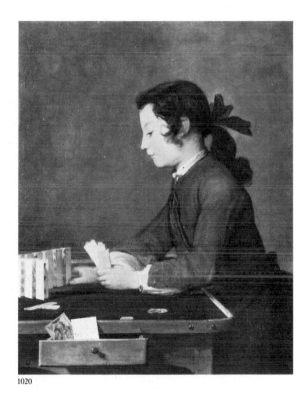

1020

1019. FRANÇOIS BOUCHER. *Triumph of Venus*. 1740. Oil on canvas, 51⅛ × 63¾". Nationalmuseum, Stockholm

1020. JEAN-BAPTISTE-SIMÉON CHARDIN. *House of Cards*. 1741. Oil on canvas, 32⅛ × 26". National Gallery of Art, Washington, D.C. Andrew W. Mellon Collection

While the types are supposedly drawn from real life, they actually echo stock Classical poses. The mother gestures like a Roman orator, and the figures move on their narrow stage in a strict relief plane. This type of composition provided the basis for the later Neoclassic formulas of David (see Part Six, Chapter One, and fig. 1059), and also for innumerable nineteenth-century storytelling pictures. A moment's comparison will show the qualitative gulf between Greuze and Chardin in such matters as the handling of furniture and crockery.

Fragonard functioned on a far higher artistic level. After six months in Chardin's studio, for which he was temperamentally unsuited, he went on to study with Boucher, whose style he was able to imitate with ease. Rapidly, however, he moved forth on his own, and developed a buoyant composition and spontaneous brushwork, both highly original. In *The Bathers* (fig. 1023), of about 1765, he adopted a Rubenesque spiral movement. The picture erupts in a geyser of nudes, water, clouds, and trees, all apparently composed of much the same soft, sweet substance. In contrast to the enameled surfaces of Boucher, Fragonard often attacked the canvas with a brushwork even more energetic than that of Hals (see fig. 986) and discharged with refreshing effervescence. Despite his attempt to recoup his lost popularity in later life by exchanging voluptuous subjects dear to the aristocracy for domestic interiors, farmyards, and even laundries, and accepting a position as a minor republican official, this delightful painter died in obscurity and poverty.

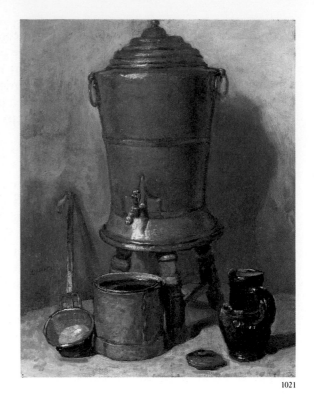

1021

LABILLE-GUIARD AND VIGÉE-LEBRUN

Two French women painters, immensely successful as artists and teachers in their own time and considered by specialists today to be among the most accomplished portraitists of the eighteenth century in any country, suffered the fate that too often has befallen women artists. Both hyphenated their family names with those of their husbands (with whom both were unhappy). Both were admitted to the French Academy on the same day in 1783. Both were roundly attacked for being painters at the sacrifice of their precious "modesty" and were libeled both verbally and in print (anonymously) for supposedly immoral conduct. Labille-Guiard was given the double-edged compliment of "painting like a man"; both were accused of having men paint their pictures for them.

Both painters depicted convincingly the post-Rococo naturalness and charm of the ill-fated court of Louis XVI. Adélaïde Labille-Guiard (1749–1803), original and direct in her compositions, seems to have been the inventor of a new type of intimate group portrait, in which the sitters do not appear to be separately posed, as in examples by Frans Hals (see fig. 984), but united with each other and with us in a common psychological situation. Her superb *Portrait of the Artist with Two Pupils*, of 1785 (fig. 1024), is the handsomest of these. The painter, wearing a plumed hat and the silks she knew so well (her father was a cloth merchant), sits on a velvet-covered chair before her easel, serenely holding the palette, brushes, and maulstick of her profession. She looks calmly through and beyond the spectator, while one of her pupils gazes happily on her teacher's work and the other looks out directly toward us, as if to admit us into the calm of the studio. In the background one sees a bust by Augustin Pajou, a friend of the family, as if to remind us that as a child Adélaïde learned much about three-dimensional form from the sculptors of the neighborhood. Her composition, grandly staged like all her full-length portraits, reveals her command of mass and space, not only in the handling of the

1021. JEAN-BAPTISTE-SIMÉON CHARDIN. *Copper Cistern*. c. 1733. Oil on panel, 11¼ × 9¼". The Louvre, Paris

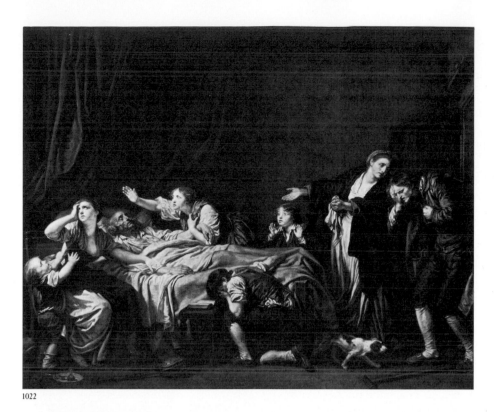

1022

1022. JEAN-BAPTISTE GREUZE. *The Son Punished*.
1777–78. Oil on canvas, 51 × 65". The
Louvre, Paris

1023. JEAN-HONORÉ FRAGONARD. *The Bathers*.
c. 1765. Oil on canvas, 25½ × 31½". The
Louvre, Paris

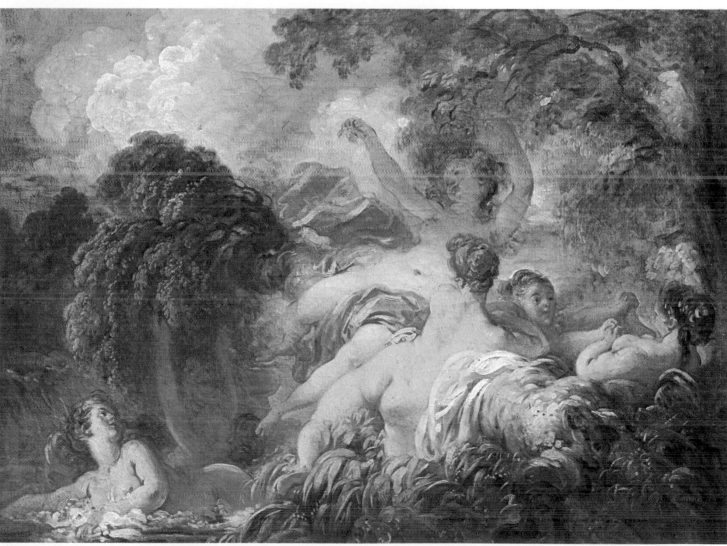

1023

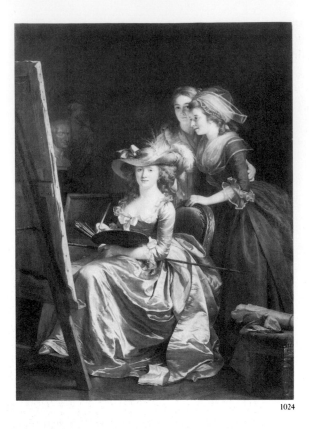

1024

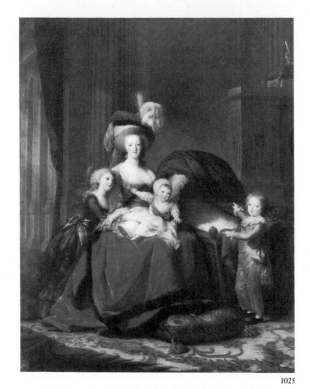

1025

figures and their drapery, freed from any trace of Rococo frivolity, but even to the projection of the easel in depth, in delicate adjustment with the parquet of the floor. In spite of her connections with the royal family—Labille-Guiard painted highly original if unflattering portraits of the king's sisters—she sympathized with the Revolution and remained in France until her untimely death. She achieved, incidentally, the abolition of the limit of four women allowed as members of the Academy.

After her death Labille-Guiard became obscured by the success of her bitter rival Elizabeth Vigée-Lebrun (1755–1842), who outlived her by nearly forty years, producing more than six hundred portraits and many other works. Vigée-Lebrun did not share her competitor's honesty or brilliance, but her remarkable ability to flatter her sitters may have been as much the secret of her worldly success as her facility with the brush. Her group portrait of *Marie-Antoinette and Her Children*, of 1788 (fig. 1025), certainly depicted the queen as she wanted to be painted, with three of her children and the empty cradle of the recently deceased fourth. The queen sits, clad in gorgeous red velvet and superbly plumed, against the traditional background of architecture, with a view of the Hall of Mirrors at the left. In 1789, a year after the completion of the painting, both king and queen were brought to Paris against their will by a cheering mob, never to leave it alive. Vigée-Lebrun fled, moving from one princely, royal, or imperial capital to the next, always pleasing her aristocratic sitters. She wrote letters and memoirs, both of them rich sources for the social and artistic life of the period. In the latter she confessed, "with those who lack character (they exist), I painted dreamy and languid poses."

CLODION In some ways a sculptural parallel to Fragonard was Claude Michel (1738–1814), known by his nickname of Clodion. His *Satyr and Bacchante*, of about 1775 (fig. 1026), revives on a miniature scale the immediacy and dynamism of Bernini. His groups of accurately modeled

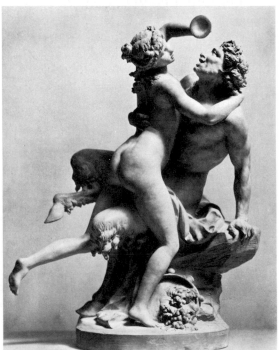

1026

figures in erotic abandon are made all the fresher and more alluring by his knowing use of pinkish terra-cotta as if it were actual pulsating flesh, rendering each incipient embrace "forever warm and still to be enjoyed." Clodion, too, outlived the popularity of his subjects, but was able to make the switch to themes more likely to be approved by the Revolution, and had a considerable success with heroic Neoclassic groups.

In central Europe the Thirty Years' War, concluded in 1648, left most countries so devastated that construction was next to impossible. Not until later in the seventeenth century did monumental projects really get under way, and the Late Baroque current at the turn of the century under Italian influence soon collided with a wave of French Rococo. Throughout the Austro-Hungarian Empire works of great brilliance were created in a hybrid style, involving at times the transformation of such medieval cities as Prague, Salzburg, and Warsaw, down even to the houses of the bourgeoisie, into constantly changing pictures of Late Baroque imaginative grace. An architect of great importance for the formation of Austrian style was JOHANN BERNHARD FISCHER VON ERLACH (1656–1723), whose career culminated in the majestic Karlskirche in Vienna (fig. 1027). Begun in 1716 and finished in 1737, this church was commissioned by the emperor Charles VI in gratitude for the delivery of Vienna from the plague. Fischer was the author of a substantial history of architecture from antiquity to the eighteenth century, at the end of which he placed his own considerable achievements. While in Rome for years of study, he had enjoyed the unplanned relationship of the Column of Trajan to neighboring Italian Renaissance domed churches. The Karlskirche gave him the opportunity to translate this historical accident into a building whose dramatic effect was increased by its relationship to a wide foreground space outside the fortifications of the city. The broad façade terminates in arches like those on the façade of Saint Peter's (see fig. 910), supporting low bell towers, hardly more than pavilions. The central portico was imitated from that planned by Michelangelo for Saint Peter's and is almost contemporary with the design by Juvara for Superga (see fig. 1005). The church itself is a Greek cross intersecting an oval, culminating in a splendid invention of Fischer's, an oval dome, whose drum is richly articulated with paired engaged columns alternating with paired pilasters, flanking the arched windows. Above the drum, oval windows crowned by arched pediments and flanked by sculptures erupt into the shell of the dome. The two gigantic columns, whose spiral relief-bands symbolize the victory of faith over disease, are tucked into exedrae between the pavilions and the portico with spectacular results. Their severity is decreased by the eagles that enrich the square corners of the abaci and little domed turrets.

Meanwhile, a different kind of pictorial effect was being achieved in the Benedictine Abbey at Melk (fig. 1028), designed in 1702 by JAKOB PRANDTAUER (1660–1726) for a spectacular site on a rocky eminence above a curve in the Danube and visible to travelers on the river in both directions. The long wings of the monastery burst forth above the river in a climax of giant orders, gables, balustrades, and a great central arch, harboring the façade of the church, with its two bell towers and central dome. The pilasters articulating the surfaces are subordinated to the rich double curvatures of the onion domes, which contrast with the severity of the monastic building, the whole producing the impression of a glittering, heavenly city, reflected in the water below. The interior (fig. 1029),

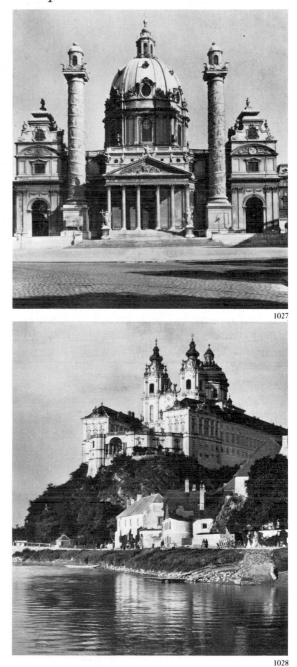

1027

1028

1027. JOHANN BERNHARD FISCHER VON ERLACH. Façade, Karlskirche, Vienna. 1716–37

1028. JAKOB PRANDTAUER. Benedictine Abbey, Melk, Austria. Begun 1702

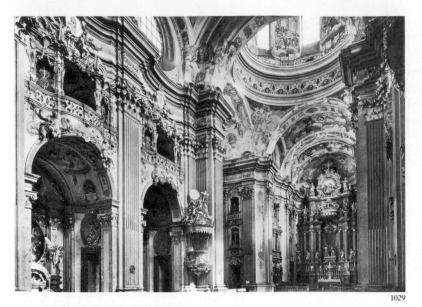

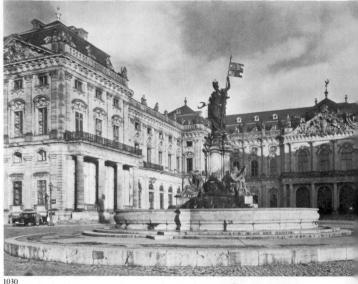

1029 1030

continued after Prandtauer's death by his cousin and pupil Joseph Mung-
genast, suggests the giant pilasters and imposing barrel vault of Mader-
no's nave for Saint Peter's (see fig. 911), but, in apparent emulation of
Borromini's undulating façade of San Carlo alle Quattro Fontane (see fig.
920), the walls between the pilasters belly outward like sails in the breeze.
Antonio Beduzzi provided galleries that, with their lighthearted Rococo
decorations, look like boxes at the opera, and were indeed intended for
nobles and distinguished visitors; sometimes in Austrian churches such
boxes were glazed so that aristocratic conversation might continue with-
out disturbing Mass.

The princely states of south Germany were not long in following the
Austrian lead. The principal German architect of the Late Baroque and
Rococo was BALTHASAR NEUMANN (1687–1753), who carried out grandi-
ose designs for the palace of the prince-bishops of Würzburg from 1719
to 1750, under direct advice from Boffrand (see page 759). The palace,
partly destroyed in World War II but since rebuilt, retains its magnificent
interiors, whose architectural splendor is fully worthy of their ceiling
frescoes by Tiepolo. After the complex monumental staircase, the build-
ing comes to its climax in the octagonal Kaisersaal (see fig. 1009), whose
pink-veined marble columns and entablature support a domed ceiling ap-
parently as insubstantial as a silken tent. Pierced by four truncated-oval
windows, the ceiling is everywhere enlivened by the floating scrolls and
leaf ornament of gilded plaster typical of Boffrand's interiors—indeed, of
developed Rococo everywhere—and opened up like a stage set for Tie-
polo's historical fresco. Even the acanthus leaves of the gilded Corinthian
capitals overflow onto the columns below. Marble, decorations, crystal
chandeliers, windows, and mirrors blend into an insubstantial vision of
light and color. On the somewhat more sedate exterior, with its two pro-
jecting wings (fig. 1030), the pilasters are absorbed into the decorative
scheme, as in Austrian structures, so that the capitals seem to dissolve
into a general frieze of ornament.

Neumann's exhilarating pilgrimage church of Vierzehnheiligen, 1743–
72, is strongly Rococo on the exterior (fig. 1031), with its undulating
façade, broken pediment, quivering bell towers crowned by onion domes
and steeples, and gesticulating statues. The gorgeous interior (fig. 1032)
is completely Rococo; the plan, based on seven adjacent or interlocking
ellipses, is an expansion of that of Sant'Ivo (see fig. 923) without any of

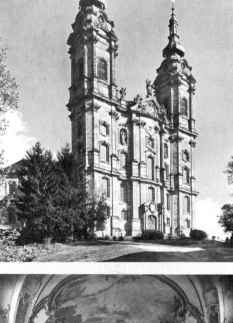

1031

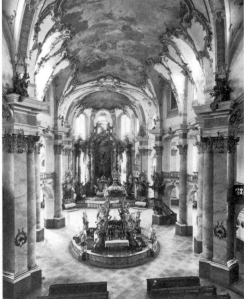

1032

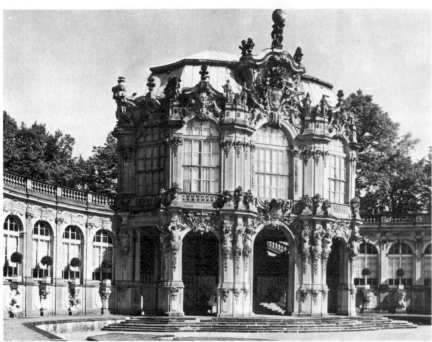

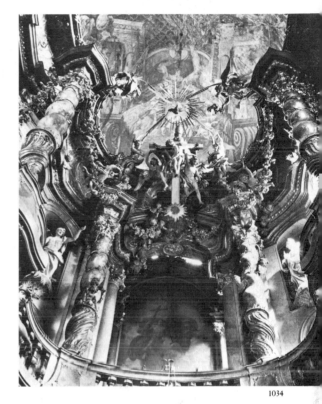

Borromini's spirituality. The ceiling, surrounded by a linear Rococo decoration of scrolls, dissolves the vault into an airy fresco so decorative that its subject scarcely attracts attention. With this and the columns and friezes painted to resemble pink marble, and the high altar pulsating with columns, decorations, and apparently dancing statues, the structure recalls the Salon de la Princesse at the Hôtel de Soubise (see fig. 1011) more than any Roman seventeenth-century church.

The triumph of secular Rococo architecture in Germany is the Zwinger by MATHAES DANIEL PÖPPELMANN (1662–1736), attached to the palace of the electors of Saxony and kings of Poland at Dresden. Erected from 1711 to 1732, it is a court whose arcades and pavilions were intended to serve as an orangery and as a gallery for the viewing of pageants and tournaments. The building is now largely composed of glass, with the Classical orders barely distinguishable in the wings of the exedra and replaced in the central pavilion (fig. 1033) by decorative sculpture. The pavilion, in fact, resembles nothing so much as a huge bouquet of flowers, the vertical straight lines having been suppressed in an insubstantial architecture that recalls forcefully the most extreme phase of Late Gothic. Devastated in the Allied bombardment of Dresden in 1945, the Zwinger has been expertly rebuilt.

In Munich EGID QUIRIN ASAM (1692–1750), a sculptor and architect, built at his own expense and endowed the Church of Saint Johannes Nepomuk, 1733–46, next to his own dwelling. His brother, COSMAS DAMIAN ASAM (1686–1742), a painter, assisted in the design of the church and its decoration. The interior (fig. 1034), embellished by paintings and sculptures from their hands, pushes the Rococo style to its ultimate limits. The spiral columns of the gallery support an undulating entablature, almost masked by garlands with child angels; the climax is a vision of the Holy Trinity, carved in wood and painted, suspended in midair against ceiling decorations and illuminated from an unseen source; the painting visible below was, unfortunately, substituted in the nineteenth century for a statue of Saint Johannes Nepomuk looking upward at this heavenly vision, and similarly lighted. The Rococo style could be carried no further, and an eventual reaction became inevitable.

1029. JAKOB PRANDTAUER. Interior, Benedictine Abbey, Melk (galleries by ANTONIO BEDUZZI)

1030. BALTHASAR NEUMANN. Residenz, Würzburg, Germany. 1719–50

1031. BALTHASAR NEUMANN. Pilgrimage Church of Vierzehnheiligen, near Staffelstein, Germany. 1743–72

1032. BALTHASAR NEUMANN. Interior, Pilgrimage Church of Vierzehnheiligen, near Staffelstein

1033. MATHAES DANIEL PÖPPELMANN. "Wallpavillon," Zwinger, Dresden. 1711–22 (damaged in World War II)

1034. COSMAS DAMIAN ASAM and EGID QUIRIN ASAM. *Holy Trinity*. Polychromed wood. 1733–46. Church of St. Johannes Nepomuk, Munich (ceiling paintings destroyed in World War II)

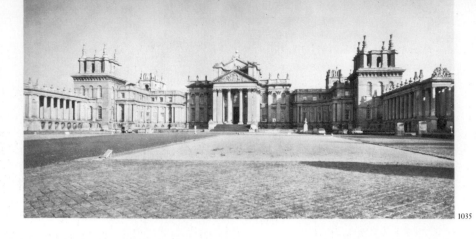

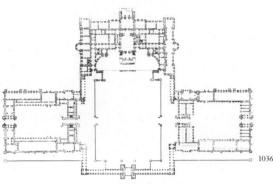

1035

1036

England

The prosperity of eighteenth-century England, little affected by the loss of her North American colonies in 1776, gave rise to a wave of building unprecedented since Gothic times and favored the development of a national school of architectural design as well as, for the first time since the Late Middle Ages, a national school of painting. The Baroque in England, founded by Wren (see pages 750–51), was continued by his pupils and by another amateur, SIR JOHN VANBRUGH (1664–1726), equally well known as one of the wittiest dramatists of the post-Restoration period. When Queen Anne decided in 1704 to present her victorious commander, the duke of Marlborough, with a suitable residence, Vanbrugh was called upon to design Blenheim Palace, 1705–22 (figs. 1035, 1036). The result was impressive, but the splendor of the building does not entirely make up for its pomposity, lacking the organic richness of Italian Baroque or the tasteful balance of the French equivalent. The colonnades of Saint Peter's did not take root easily in Oxfordshire, nor were chimneys successfully masked as Classical urns. The impracticality of the plan (the kitchens are a quarter of a mile from the dining salon) netted Vanbrugh ridicule in his own day; he was eventually dismissed by the duchess, who had taken over supervision of the project, and his grandiose dream was finished by a pupil.

The followers of Wren continued building Baroque structures, especially churches, well into the eighteenth century. JAMES GIBBS (1682–1754) was the most gifted of these. Having worked with the Late Baroque architect Carlo Fontana in Rome, he returned with a full repertory of Continental ideas; his superb Radcliffe Library at Oxford, 1739–49 (fig. 1037), is like a Roman or Parisian dome grounded; the coupled columns are derived from Michelangelo (see fig. 822) and Hardouin-Mansart (see fig. 954), and the continuous entablature from Bramante (see fig. 800) by way of Wren (see fig. 1003), but the design has a grandeur all its own, enriched by such subtleties as wide bays between the buttresses alternating with narrow ones above, the placing of the buttresses between the paired columns rather than in line with them, and the alignment of the entrances only with the central two columns of each group of four. The building profits especially by its position as the only large dome placed at ground level so one can walk around it rather than having to gaze up at it.

With the accession of George I in 1714, the Baroque became discredited as a leftover from the Stuarts, and the Palladian style of Jones (see page 750) was revived in mansions, town houses, country houses, streets, squares, circles, crescents, and eventually churches. One of the strongest supporters of the Palladian movement was Richard Boyle, third EARL OF BURLINGTON (1695–1753), a widely traveled nobleman of considerable

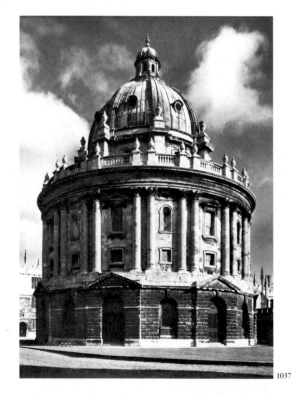

1037

1035. SIR JOHN VANBRUGH. Entrance façade, Blenheim Palace, Woodstock, Oxfordshire. 1705–24

1036. SIR JOHN VANBRUGH. Plan of Blenheim Palace, Woodstock

1037. JAMES GIBBS. Radcliffe Library, Oxford. 1739–49

learning and taste, friend of Pope, Swift, Thomson, and Handel, and a gifted architect in his own right. His best-known work is Chiswick House, 1725–29 (fig. 1038), in whose elaborate interiors he was assisted by WILLIAM KENT (1685–1748); the exterior, however, is entirely by Burlington. The little cubic structure, intended for receptions and conversation, was connected by means of an unobtrusive wing with a Jacobean manor house (torn down in 1788). While Burlington obviously emulated the general conception of Palladio's Villa Rotonda, near Vicenza (see fig. 859), the details are sharply different. As the structure was not to be freestanding and had no mountain view, it needed only a single portico. The order was changed from Ionic to Corinthian, the dome from round to octagonal and raised on a drum to admit more light to the central hall. The double staircases with their balustrades and decorative urns were derived from Italian models.

Soon, under the influence of the excavations at Pompeii and Herculaneum (see page 756), a third style made its appearance, a Classicism far more thoroughgoing than its French counterpart, led by ROBERT ADAM (1728–92). At Syon House (fig. 1039), remodeled by Adam beginning in 1762 for Sir Hugh Smithson, the entrance hall attempts archaeological correctness. Copies of ancient statues in marble or in bronze are ranged about the walls or set in an apse with an octagonally coffered semidome. Actually, Roman interiors were very richly adorned, and the austerity of Adam's design, with its unrelieved wall surfaces and sparing, chaste decoration, was symptomatic of his personal taste.

The fourth eighteenth-century style would be totally unexpected if we did not know that in England the Gothic had never really died out. Wren and his pupils, as well as Vanbrugh and Kent, all built or extended Gothic structures at one time or another. Usually, these were churches or colleges, deriving from a long Gothic tradition. By the 1740s, however, country houses were being built in Gothic style, and a textbook appeared on how to design them. Needless to say, the organic principles of Gothic building were little understood save by such masters as Guarini or Soufflot. The usual result was a merely decorative use of motives drawn from Gothic architecture. In addition to the Renaissance revival of Classical antiquity, the eighteenth-century revival of the Renaissance, and the eighteenth-century attempt to revive antiquity independently, a revival of just what the Renaissance had fulminated against—the "barbarous" Gothic taste—now occurred. The eighteenth century found the Gothic interesting in itself—always picturesque and at times sublime. Eighteenth-century Gothicism in art was, of course, connected with contemporary interest in medieval history and the vogue for "Gothic" romances and poems.

At the culmination of this movement, rather than the beginning, stands Strawberry Hill, built at intervals from 1748 onward (fig. 1040), the home

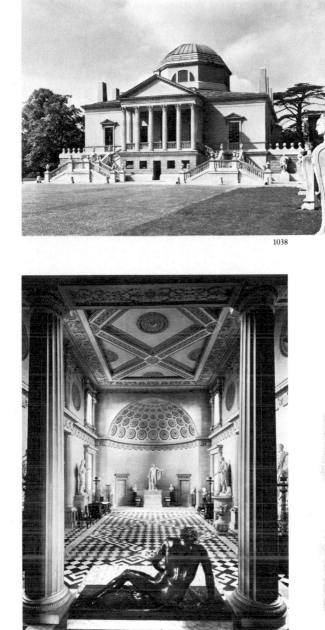

1038

1039

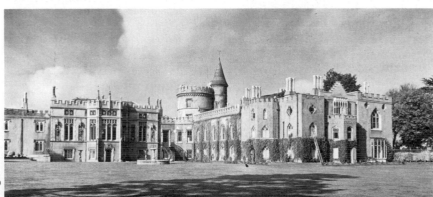

1040

1038. EARL OF BURLINGTON (RICHARD BOYLE). Chiswick House, Middlesex. 1725–29

1039. ROBERT ADAM. Entrance hall, Syon House, Middlesex. Remodeling begun 1762

1040. HORACE WALPOLE, with WILLIAM ROBINSON and others. Strawberry Hill, Twickenham, Middlesex. Begun 1748

of HORACE WALPOLE (1717–97), a wealthy amateur who hired professionals to construct it according to his own ideas. So greatly was the mansion admired by his contemporaries that he had to limit visiting parties to one a day. A completely asymmetrical disposition of elements, which in medieval art had been the result of accident rather than intention, includes a huge round tower in one angle, balanced by nothing elsewhere; windows, large and small, with or without tracery; battlements, buttresses, and other Gothic elements spread over the surface haphazardly. The library (fig. 1041) is decorated with tracery, imitated from Perpendicular churches (such as Gloucester Cathedral), used as frames for bookcases; even the rectangular eighteenth-century mantelpiece and the cast-iron forms of the fireplace frame are clothed in Gothic detail.

Fascination with the picturesque led to the construction of sham ruins in the wandering complexities of English parks, whose apparent naturalism was in fact achieved only by great labor and at vast expense. The park surrounding Hagley Hall, laid out for Lord Lyttelton, contains both a ruined Gothic castle (fig. 1042), built from scratch in 1749 by SANDERSON MILLER (1717–80), a gentleman architect, and a Greek Doric portico (fig. 1043), based on the Propylaia at Athens, added in 1758 by JAMES STUART (1713–88). The latter was the first known attempt to revive in architecture pure Greek principles based on the monuments of Athens, which Stuart, in company with NICHOLAS REVETT (1720–1804), had studied exhaustively and measured on the spot. Their sumptuous engravings were published in a famous work, *The Antiquities of Athens*, the first of four volumes appearing in 1762; the second was not issued until 1790, two years after Stuart's death. A similar study by J.-D. Le Roy also appeared in France. Studies of other Classical monuments, such as Baalbek, Palmyra, and the palace of Diocletian at Split, were also published. Along with these earliest archaeological studies came the theoretical and art historical writings of Johann Joachim Winckelmann, a German art critic, who lived in Rome and never visited Greece, but on the basis of Roman copies proclaimed Greek art as the ideal that later periods had only remotely approached. (He detested both the Rococo and the French who had invented it.) As yet, however, both Gothic and Greek buildings were built for dilettantes only; no one seemed to think either mode suitable for monumental civic structures, and no one saw in either any principles useful for political ideology. Therein lies the crucial difference between these mid-eighteenth-century revivals and those of the late eighteenth and the nineteenth century.

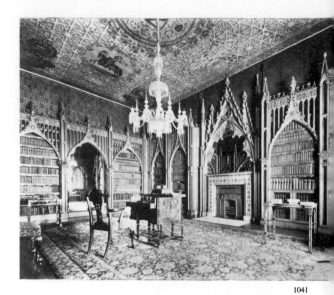

1041

1041. HORACE WALPOLE. Library, Strawberry Hill, Twickenham

1042. SANDERSON MILLER. Sham Gothic castle ruins, Hagley Hall park, Worcestershire. 1749

1043. JAMES STUART. Doric portico, Hagley Hall park, Worcestershire. 1758

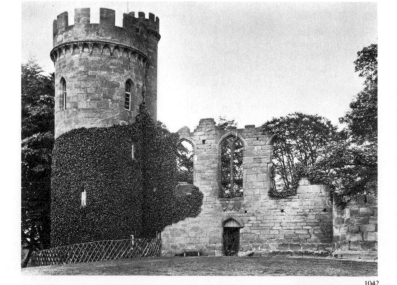

1042

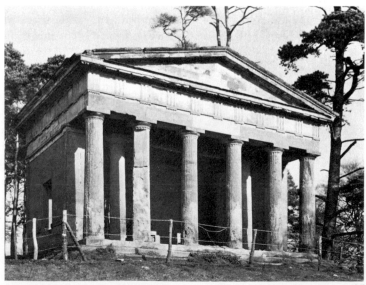

1043

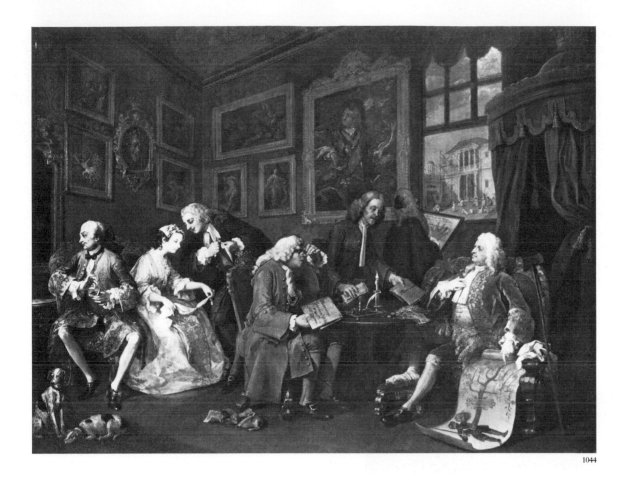

HOGARTH A strikingly original school of painting arose in eigh-
teenth-century England—the first, in fact, since the Gothic period—under
limited influence from Continental Rococo, but with little of the frivolity
so delightful in French painting of the period. The most engaging of the
new English painters and the real founder of the modern British school
was William Hogarth (1697–1764), a Londoner whose narrative candor
and satiric wit are as effective as his dazzling pictorial skill. Although he
tried his hand occasionally at mythological and historical subjects, Ho-
garth was at his best in quintessentially English portraits and in pungent
moralistic cycles, the counterparts of the novels of Fielding and Smollett;
these were painted as bases for engravings, which Hogarth sold widely
and profitably. The most successful were *A Scene from the Beggar's Opera*,
illustrating John Gay's famous work; *A Rake's Progress*; *A Harlot's Progress*;
and *Marriage à la Mode*, 1743–45, whose opening episode is *Signing the
Contract* (fig. 1044). The scene is set diagonally in depth for greater the-
atrical effect. In a room of his London house, lined with Old Masters
(which Hogarth professed to hate), the gouty alderman, father of the
bride, sits before a table spread with the golden coins of the dowry and
expatiates on his family tree, to which he proposes to add the earl. That
gentleman, who has exhausted his fortune in building the Palladian man-
sion seen out the window (Hogarth detested the Palladian style, as well
as both Burlington and Kent), admires himself in a mirror. His be-
trothed, meanwhile, is listening to the blandishments murmured in her
ear by the attorney. Clearly, the story will come to a bad end. While the
energetic composition owes much to the Rococo, Hogarth's robust han-
dling of poses and his special variety of bold yet soft brushwork are as
original as his caustic wit.

1044. WILLIAM HOGARTH. *Marriage à la Mode:
Signing the Contract*. 1743–45. Oil on can-
vas, 28 × 35⅛". National Gallery, London

GAINSBOROUGH The most accomplished and in the long run the most influential English painter of the century was Thomas Gainsborough (1727–88), who studied briefly in London with a pupil of Boucher. Until 1774 he painted landscapes and portraits in various provincial centers before settling in London for the last fourteen years of his life. Although the elegant attenuation of his lords and ladies is indebted to his study of Van Dyck, Gainsborough achieved in his full-length portraits a freshness and lyric grace all his own. Occasional objections to the lack of structure in his weightless figures are swept away by the beauty of his color and the delicacy of his touch, closer to the deft brushwork of Watteau than to Boucher's enameled surface. The figure in *Mary Countess Howe* (fig. 1045), painted in Bath in the mid-1760s, is exquisitely posed, as usual in front of a landscape background. Gainsborough has expended his uncanny ability on the soft shimmer of light over the embroidered organdy of her overdress and the cascades of lace at her elbows, sparkling in the soft English air; the only solid accents in the picture are her penetrating eyes. Although Gainsborough was country-born, his landscape elements seem artificial, added like bits of scenery to establish a spatial environment for the exquisite play of color in the figure.

In later life Gainsborough painted always more freely and openly.

1045. THOMAS GAINSBOROUGH. *Mary Countess Howe*. Middle 1760s. Oil on canvas, 96 × 60″. Courtesy of The Greater London Council as Trustees of the Iveagh Bequest, Kenwood, London

1046. THOMAS GAINSBOROUGH. *Market Cart*. 1787. Oil on canvas, 72½ × 60⅝″. The Tate Gallery, London

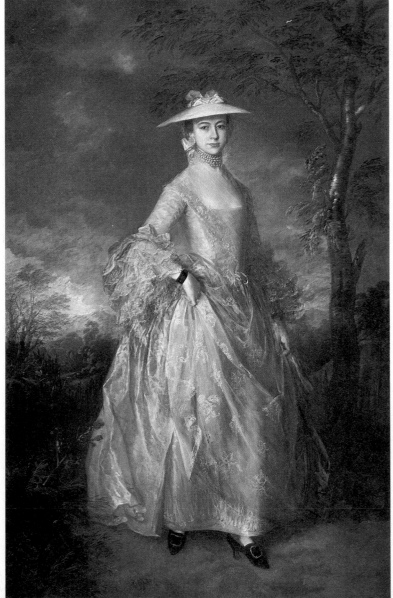

1045

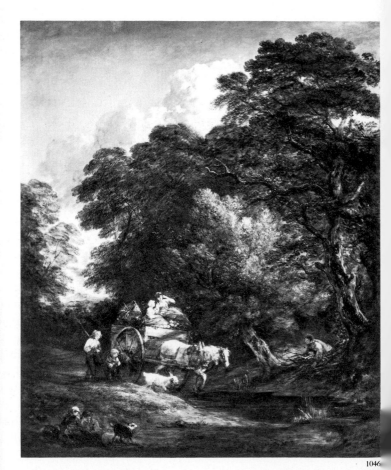

1046

Although his landscapes, which he preferred to his portraits, exhale a typically English freshness, they were painted in the studio on the basis of small models put together from moss and pebbles, still in the tradition recorded by Cennino Cennini (see page 505). Constructed in the grand manner of such a seventeenth-century Dutch master as Hobbema (see fig. 976) and painted largely with soft strokes of wash like those of Watteau, the *Market Cart*, of 1787 (fig. 1046), shows an almost rhapsodic abandonment to the mood of nature, which led as surely to the great English landscapists of the early nineteenth century (see Part Six, Chapter Two) as did the nature poetry of James Thomson to the meditative lyricism of Wordsworth. Constable said that Gainsborough's landscapes moved him to tears, and contemplating the freedom and beauty of the painting of the cart and the boy gathering brushwood, not to speak of the glow of light seeming to come from within the tree in the center, one can understand why.

REYNOLDS The third English master of the period, Sir Joshua Reynolds (1723–92), while less attractive than the other two, was in his own day a commanding figure, whose authority outlived him and who eventually became a target for Romantic attacks. Neither Hogarth nor Gainsborough traveled outside England (Hogarth once tried to reach Paris but got no farther than Calais), but Reynolds did the Grand Tour, and remained in Rome spellbound by the grandeur of Michelangelo and Raphael. He acquired a respectable knowledge of European painting of the preceding two centuries, and gave at the Royal Academy of Arts—which he helped to found in 1768—the famous *Discourses*, which, in published form, remain a formidable body of Classical doctrine and the most extensive attempt at art theory by any Englishman. Reynolds's success as a portraitist was so great that he had to hire assistants to lay out the canvases for him and to do much of the mechanical work. There is inevitably something artificial about the grandiloquence of the Classical or Renaissance poses in which he, without either the humor of Hogarth or the poetry of Gainsborough, painted the very solid English men and women of his own day, investing them with qualities borrowed from a noble past. It is, nonetheless, to his majestic portraits, with their contrived backgrounds of Classical architecture and landscape, that we owe our impression of English aristocracy in the eighteenth century. *Lady Sarah Bunbury Sacrificing to the Graces* (fig. 1047), painted in 1765, is a case in point, and speaks eloquently for itself.

KAUFFMANN No other woman painter of the eighteenth century achieved the success, reputation, and influence of Angelica Kauffmann (1741–1807). This is difficult to understand today, for in terms of quality she cannot equal either Labille-Guiard or Vigée-Lebrun, but she is a fascinating figure who hit the taste of her time exactly right. Although born in Switzerland and resident in Italy for most of her life, Kauffmann is best considered in the context of English art. Her patrons were predominantly English and the years she spent in Britain from 1766 to 1781 were crucial. She was enormously popular there, partly on account of her beauty and charm, but even more because of her ability as a composer of large pictures on Classical themes for the interiors designed by Robert Adam and others. Kauffmann was the first woman ever to work on so grand a scale. She was also respected for her quiet determination and hard work,

1047. SIR JOSHUA REYNOLDS. *Lady Sarah Bunbury Sacrificing to the Graces*. 1765. Oil on canvas, 94 × 60". The Art Institute of Chicago. Mr. and Mrs. W. W. Kimball Collection

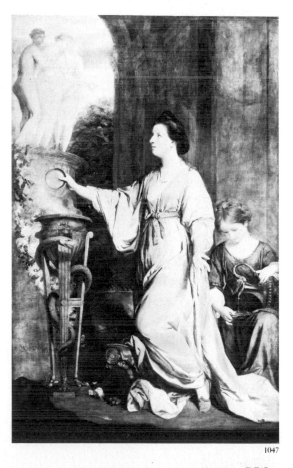

1047

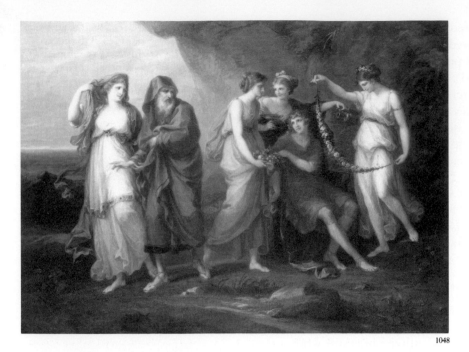

and was one of the founders of the Royal Academy of Arts. After an invalid marriage to a pretended nobleman, she eventually married the Venetian decorative painter Antonio Zucchi (the couple kept their styles firmly separate) and settled down for good in Rome, where she joined the cultural circle dominated by Goethe, who admired her work in spite of its limitations, and Winckelmann. There she was visited by many artists, including Vigée-Lebrun and the young David, whom she certainly influenced.

Like other woman painters Kauffmann was forbidden to work from the nude, either male or female, and related that all life studies she ever made were from models draped by sheets, in the presence of her father. The results of this procedure can unfortunately be seen in her historical compositions, such as *Telemachus and the Nymphs of Calypso* (fig. 1048), of 1783. The incident is drawn from Homer's *Odyssey*; the enchantress Calypso is shown trying to win over the son of Odysseus. Kauffmann has been reproached as having had little conception of Homeric grandeur. But her style and its shortcomings are best judged when her works are envisioned in the settings for which they were made. In Classicistic interiors like those of Syon House or Chiswick the airy grace of her compositions must have been delightful. If they lack the bite and force of historical paintings of the next two generations (see Part Six, Chapters One and Two), Angelica Kauffmann herself is a historical phenomenon of major importance.

Painting in Colonial America

The modest beginnings of colonial American painting in the work of self-taught limners achieved a surprising degree of maturity in the style of JOHN SINGLETON COPLEY (1738–1815), son of Irish immigrants to Boston. Whatever Copley may have known of the grand English portrait style of the eighteenth century through engravings, he rapidly evolved an original manner, which concealed occasional deficiencies of drawing under a smooth hardness of surface unexpected and refreshing in the eighteenth century, when dexterity of the brush was so highly prized (see Watteau's *Signboard of Gersaint*, fig. 1018). Copley's *Paul Revere*, of 1768–70 (fig. 1049), dispen-

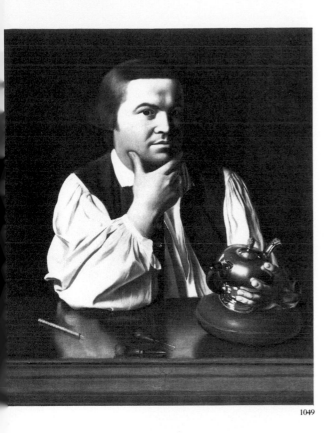

1049

ses with the column and red curtain that often seem incongruous in his portraits of stolid Yankee merchants. The firm, unflattering portrait of the eminent silversmith and patriot shows him in shirt-sleeves beside his worktable, strewn with engraving instruments, and holding a glittering silver teapot. The honest provincialism of the work and Copley's inborn sense of form make it more attractive than the accomplished portraits and historical scenes he painted after his emigration to England in 1775.

Copley's fellow American BENJAMIN WEST (1738–1820), from Pennsylvania, left for Europe in 1759, became an overnight celebrity in Rome, and settled in London, where he enjoyed a success to which neither his imagination nor his pictorial skill would seem to have entitled him. He rose, in fact, to become president of the Royal Academy of Arts and historical painter to the king. Historically, West is an important figure. His paintings of Roman historical subjects are forerunners of the more successful and significant Classical scenes by David (see Part Six, Chapter One), and his *Death of General Wolfe*, of about 1770 (fig. 1050), with its still-Baroque lighting and pathos, led directly to the great battle pieces of the nineteenth century (see fig. 1076). Characteristically, in spite of his own leanings toward classicism, he resisted the temptation to dress this celebrated event of the French and Indian War in Classical costume, which would certainly have been the recommendation of Winckelmann, his Continental and English disciples, and even the great Sir Joshua.

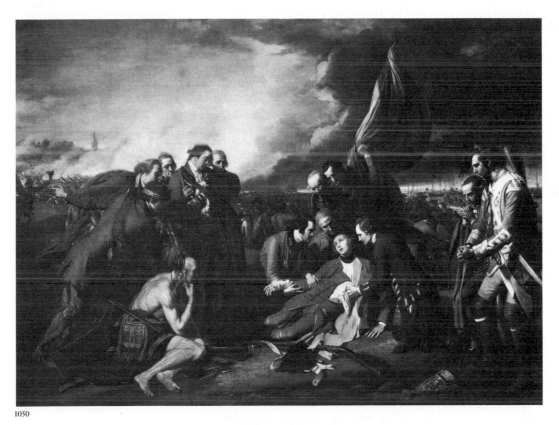

1050

In these four chapters we have followed many aspects of the Baroque climactic experience of human life and destiny, ranging from shattering immediacy to classic control; from theatrical display to spiritual inwardness; from otherworldly ecstasy to

meditation on everyday reality. We have seen works of art embodying this experience assume every extreme of style, from steely surfaces to free brushwork; from idealized forms and balanced compositions to direct images; from clustered columns, broken pediments, and ruptured ceilings to stately colonnades and organized vistas. And we have watched the serious dedication of the seventeenth century to both religious and stylistic commitments evaporate in the early eighteenth century in the frivolity of the Rococo, only to crystallize a few decades later in mutually exclusive Classical and Gothic play-worlds.

Looking back, as we attempt to organize our thoughts about such diversity of experience and of style, we begin to distinguish three major artistic currents or tendencies:

1. A current owing sovereign allegiance to Classical antiquity, and exalting qualities of intellectual command, compositional balance, structure, integrity of form, clarity of drawing, and distinctness of color
2. A tendency placing ultimate value on emotional expression, and resulting in imaginative compositions, intense movement, loose interaction of figures, spontaneous brushwork, strong contrasts of light and dark, and rich coloristic changes
3. A current closely rooted in faithful visual analysis of the nat-

TIME LINE XI

	POLITICAL HISTORY	RELIGION, LITERATURE, MUSIC	SCIENCE, TECHNOLOGY
1700	English and allies defeat French at Blenheim, 1704 Louis XV rules France, 1715–74	Antonio Vivaldi (c. 1675–1743) Johann Sebastian Bach (1685–1750) Alexander Pope (1688–1744) Voltaire (1694–1778)	G. W. von Leibnitz (1646–1716) discovers new notations of calculus; publishes *Théodicé*, 1710
1725	Frederick William I (r. 1713–40) lays foundation of future power of Prussia Frederick II the Great of Prussia (r. 1740–86) defeats Austria in War of Austrian Succession, 1740–48	*Gulliver's Travels* by Jonathan Swift, 1726 Wesley brothers found Methodism, 1738 *Treatise on Human Nature* by David Hume, 1739 Edward Young writes *Night Thoughts*, 1742–45	Charles du Fay (1698–1739) discovers positive and negative electric charge Carolus Linnaeus (1707–78) publishes *Systema Naturae*, 1737 Excavations begin at Herculaneum, 1738; later at Paestum and Pompeii
1750	Seven Years' War, 1756–63; England becomes greatest colonial and naval power Catherine the Great (r. 1762–96) extends Russian power to Black Sea	Edmund Burke (1729–97) Denis Diderot writes *Encyclopedia*, 1751–72 Samuel Johnson begins English dictionary, 1755 J. J. Rousseau publishes *Social Contract* and *Émile*, 1762	Coke-fed blast furnaces for smelting iron perfected, c. 1760–75 Textile spinning mechanized, 1764–69 Joseph Priestley discovers oxygen, 1774
1775	American Revolution, 1775–83; Declaration of Independence, 1776; articles of Confederation, 1781	Franz Joseph Haydn (1732–1809) Wolfgang Amadeus Mozart (1756–91)	Antoine Lavoisier (1743–94)

ural world, including human life at every economic level, basing composition, drawing, and color on direct observation, even through the medium of devices such as the camera obscura.

These three tendencies are only partly explicable in terms of national or religious boundaries. For instance, there were realistic still-life painters in Catholic Italy, painters of Classical history in Calvinist Holland, and painters of peasant life in monarchist France. Also these tendencies were interrelated and often influenced each other, and not every artist can be classified convincingly according to just one of the three: Caravaggio, for example, realistic enough in his psychological impact and almost photographic powers of observation, can be classic in his control of form and composition; or Rembrandt, so universal in his range and depth and original in his methods, escapes all attempts at categorization. These three are the principal currents dominating the art of the seventeenth and eighteenth centuries. In the concluding part of this book it will be easy to see that these three basic tendencies continue in full—even increased—activity and validity throughout the eighteenth, nineteenth, and twentieth centuries to the present day.

EIGHTEENTH CENTURY

PAINTING, SCULPTURE, ARCHITECTURE

ITALY AND FRANCE	GERMANY AND AUSTRIA	ENGLAND, AMERICA	
Rigaud, *Louis XIV* Watteau, *Pilgrimage to Cythera; Signboard of Gersaint*	Prandtauer, Abbey, Melk Pöppelmann, Zwinger, Dresden	Vanbrugh, Blenheim Palace	1700
Juvara, Church, Superga, Turin; Hunting Palace, Stupinigi Piazzetta, *Ecstasy of St. Francis* Boffrand and Natoire, Hôtel de Soubise, Paris Chardin, *Copper Cistern; House of Cards* Boucher, *Triumph of Venus*	Fischer von Erlach, Karlskirche, Vienna Neumann, Residenz, Würzburg Asam Brothers, St. Johannes Nepomuk, Munich Neumann, Vierzehnheiligen Church, Staffelstein	Lord Burlington, Chiswick House Gibbs, Radcliffe Library, Oxford Miller, Gothic ruins, Hagley Hall	1725
G. B. Tiepolo, frescoes, Venice, Würzburg Soufflot, Panthéon, Paris Gabriel, Petit Trianon, Versailles; Place de la Concorde, Paris Fragonard, *Bathers* Guardi, *Piazzetta S. Marco*		Adam, Syon House Gainsborough, *Mary Countess Howe* Reynolds, *Lady Sarah Bunbury* Copley, *Paul Revere* West, *Death of General Wolfe*	1750
Clodion, *Satyr and Bacchante* Greuze, *Son Punished* Labille-Guiard, *Portrait of the Artist* Houdon, *Voltaire; George Washington* Vigée-Lebrun, *Marie-Antoinette*		Gainsborough, *Market Cart* Kauffmann, *Telemachus and the Nymphs*	1775

PART

THE MODERN WORLD

SIX

Modern is an even less accurate period designation than the others we have had to use. The word means "pertaining to the present or very recent past"; it suggests that the period it denotes is still going on, but tells us nothing more. The term has been in English use since the late sixteenth century, and therefore has already referred to a number of periods. Inevitably, as the present moves along into the past, our own period will cease to be modern and will be given another name by future generations.

Judging by the standard of nearness to the present, the modern period probably began in Europe and in America in the late eighteenth century. We feel kinship with the people of that period, and can easily understand their ideas and accept their customs. The historical figures of the American and French revolutions, for example, seem near to us, although the princes of the Baroque era appear remote. We could settle down comfortably at Monticello but would feel out of place in Versailles or the Hôtel de Soubise.

The political and social conditions of the late eighteenth century recall those with which we are familiar, if not from the present, at least from the recent past. Religion, for example, was no longer a belief that could be legally enforced, or a cause to go to war about. Culture had become strongly secularized by the end of the century in western Europe and in America, and the two basic forces that shape our lives today—the idea of social democracy and the notion of scientific progress—were already clearly in operation. Before long these two forces almost fused. The idea of a universal democracy arose first in France under the influence of the philosophers of the Enlightenment, notably Voltaire and Rousseau, although its earliest successes were in America, insofar as success was permitted by the institution of chattel slavery. Scientific technology first influenced social and economic structure in England during the Industrial Revolution, spreading in the nineteenth century to all Western nations and furnishing the material foundation for modern bourgeois capitalism.

It is in its internationalism that we must seek the basic nature of the modern world, throughout vast areas of the globe, including countries with long historical traditions hitherto hardly touched by Western culture. Capitalism is by nature urban, at the expense of rural areas, which become increasingly devoted to mechanized farming and are often abandoned by their original populations. Unless they are protected by stringent laws, the centers of large cities everywhere come to look more or less alike; modern metropolises have the same utilitarian skyscrapers, the same urban traffic, the same suburban sprawl. The seeds of this new internationalism were planted in the late eighteenth century, and they have brought forth some striking similarities of customs in developed areas of the world.

For example, for the first time in history there arose in the late eighteenth century a sharp distinction in colors and materials between the dress worn by men and that worn by women, and except for blue

jeans, perhaps, this distinction remains in all countries that have accepted bourgeois capitalism and even in many Marxist societies. Indigenous forms of dress tend to disappear in urban areas. Likewise, cultural activities have begun to resemble each other across wide distances. Japanese musicians play Mozart and Bartók with technical perfection, convincing "westerns" are filmed in Italy, rock concerts take place in Belgrade, and after initial opposition Western forms of abstract art have been shown in Moscow. The open market for works of art, forcing the artist to rely on dealers, was—as we have seen—first predominant in seventeenth-century Holland; it is now universal. The commissioned work of painting or sculpture is now the exception.

In the secularized society of modern times the Church is no longer a major patron of the arts. In Catholic countries new churches have been built only where required by expanding urban populations. Hundreds of old ones have been deconsecrated, turned to secular use, or even demolished. Many new churches arose in Protestant industrialized countries, almost uniformly in imitation of traditional medieval or Renaissance models, or in America also Georgian colonial. Only occasionally have paintings or sculptures for churches been ordered from artists of importance.

Although new artistic movements are still being born or devised at single points in time and space, they rapidly spread everywhere. Impressionism, for example, invented in Paris and its suburbs, soon took hold in every Western country. In such international movements ("isms") we must look for the basic artistic phenomena of the modern world. The modern era has declared independence from its predecessors to a startling degree and has accordingly developed a perspective from which it can look at history as a study of social and cultural movements rather than the story of the deeds of great personages.

Beginning in the late eighteenth century and throughout the nineteenth, comprehensive histories of entire civilizations, as well as of art, music, literature, philosophy, and religion, were written; these volumes are still read, and they provide the foundations for today's more limited historical studies. Only in the modern period did it become evident that the forces of ceaseless change were bound to affect the works of man and render antiquated tomorrow what was new yesterday. Soon quality itself became equated with novelty, and it was enough to attack a style as old-fashioned to demolish its validity.

Along with historical detachment there arose in the late eighteenth and in the nineteenth century the ability to appreciate widely different forms and periods of artistic creation. By now the ideal (even in some Marxist countries) is the person of catholic taste who takes pride in enjoying every good thing from whatever area or period. As a result, museums have proliferated, the past is preserved where it can be protected, and conscious efforts are made to keep works of art from disintegrating, to restore them to their original appearance, to publish correct texts of older authors, and to perform older music on the instruments for which it was composed.

Along with the historical view of art, styles have arisen that deny the validity of the past search for visual reality, and that exalt as models for the art of today the arts of remote periods or cultures whose aesthetic significance has been newly discovered. Not only have nature and the object lost their control over the work of art but also such technological innovations as laser beams, taped communications, microelectric waves, and the televised image have been proclaimed as the province of artistic creation.

The modern period as we have known it may be coming to an end. The collapse of ancient Oriental empires was welcomed in the early twentieth century as heralding the spread of universal democracy. So was the dissolution of the European capitalist empires in Africa and the Far East, not to speak of the smaller American empire in the Pacific. So was the emancipation of much of Western man from daily chores and the restrictions of time by mechanical and electronic inventions. To the dismay of the West the two greatest empires, comprising nearly half the population of the globe, are now governed by totalitarian movements that have no use for Western-style democracy. Much more embarrassing, the African nations liberated from European domination and certain previously democratic countries of Latin Amer-

ica have fallen under military dictatorships. Still worse for the West, certain Islamic nations have repudiated all of Western culture save its technology and its money, and have even reinstated such ancient punishments as flogging, stoning, and mutilation.

The internal-combustion engine brought freedom from the restrictions of distance, yet it has impoverished the centers of our cities, devastated the landscape, and poisoned both atmosphere and water. Nuclear discoveries threaten universal catastrophe. Chemical innovations menace our environment, our bodies, man's genetic capacity to survive, and the ability of the planet to support him. World leaders are helpless before the economic forces now propelling and undermining society. Global industrial combines threaten the autonomy of the national state.

If we have indeed entered a different era, artistically one thing is certain: the collapse of faith in progress has been accompanied by a lull, at least, in that succession of artistic movements that used to take place every generation, then every ten years, then every year, each declaring its predecessors extinct. No one can tell as yet what this means; one encouraging sign is that so many gifted artists are working well in styles long since consigned to oblivion.

CHAPTER

NEOCLASSICISM

ONE

The forty-year period from 1775 to 1815 marks one of the great upheavals of Western history, comparable in scope only to the barbarian invasions of the fifth century and to the two world wars of the twentieth. The rebellion of England's North American colonies, the product of tensions that had developed for generations, was rapidly transformed into a genuine revolution (1775–83), resulting in independence from the mother country. Power was transferred to a republic, dominated by landowners and merchants. The success of the American Revolution encouraged the French followers of the eighteenth-century philosophers of the Enlightenment. During the extreme economic and political crisis in France in 1789, a constitutional monarchy was proclaimed, followed in 1792 by a republic. The revolutionary movement culminated in the Reign of Terror in which thousands of aristocrats, relatives of aristocrats, officials of the royal government, and suspected sympathizers of the old order lost their lives. Temporarily, at least, a classless form of government was in control.

Under the Directory (1795–99) the middle classes assumed power; then unexpectedly the Revolution, which was supposed to bring about a new era of freedom for all, fell a victim to its own most successful military leader. Under the dictatorship of Napoleon Bonaparte—the Consulate (1799–1804) and the Empire (1804–14 and 1815)—colossal military force was unleashed upon the continent of Europe and swept the Baroque monarchies great and small into the discard, dissolved the thousand-year-old Holy Roman Empire, and, in a series of military exploits unrivaled since the days of Alexander the Great, threatened Russia on the one hand and England on the other. After Napoleon's military collapse many, but by no means all, of the monarchies were restored, but the work of the Revolution and of Napoleon could not be entirely undone; the efficient revolutionary administrative system has been retained in France to this day, and the *Code Napoléon* remains the basis of many western European legal systems. Even more important, monarchy had been exposed as vulnerable, and revolutions were to erupt at intervals throughout the nineteenth century.

It might have been expected that the American and French revolutions would inspire a generation of inflammatory art. The reverse was the case; not until the Napoleonic slaughters did an art develop that registered directly the drama of the moment. Revolutionary art was by choice sternly Neoclassic. The distinction between the Classicism of the mid-eighteenth century and the Neoclassicism of the revolutionary period may seem subtle, but it is important. Although to Winckelmann Classicism was a religion, to most architects and cultivated patrons in the mid-eighteenth century it was a fashion, one that could easily be exchanged for Gothic. To the revolutionary period Neoclassicism was a way of life, affecting not only the arts but also all aspects of existence from religion to the dress of ordinary men and women, and in France even the calendar. Moreover, it was not imperial but republican Rome that the revolutionary period attempted to revive. Despite its origins, Neoclassicism survived both the Revolution and Napoleon, and persisted as a fashion throughout the continent and England well into the nineteenth century.

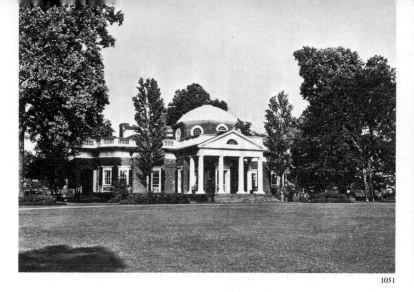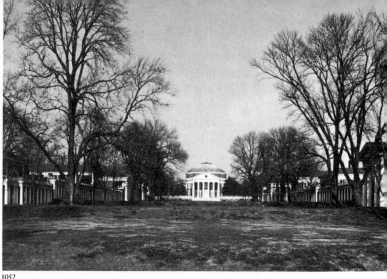

1051 1052

Architecture

The well-known shape of Monticello (fig. 1051) by THOMAS JEFFERSON (1743–1826) illustrates the process that had taken place. Jefferson intended to reform the Georgian architecture current in colonial Virginia by a thoroughgoing application of the principles he was studying in Palladio's treatise on architecture. As first built from 1770–84, Monticello, commanding from its hilltop a magnificent view of mountains, valleys, and plains, was a two-story structure, adorned with a two-story portico like those on some of Palladio's villas. During his long stay in Europe as minister to France, Jefferson had a chance to study not only the Classical French architecture of the eighteenth century but also the Roman temple called Maison Carrée at Nîmes, which he said he contemplated "as a lover gazes at his mistress." Beginning in 1796, he rebuilt Monticello as a Neoclassic temple, apparently one story high, although a second story is concealed behind the entablature and balustrade, and a third under the roof. Clearly, Jefferson had both Chiswick (see fig. 1038) and its ancestor, the Villa Rotonda (see fig. 859), in mind, but his mansion differs from both in being a permanent residence rather than a pleasure-house. It is built, moreover, of local brick rather than stone, with brick columns stuccoed and painted white and with white wood trim.

The octagonal dome is mirrored in semi-octagonal shapes at either end of the building. The central portico is treated like a Roman pronaos and united with the ground by a single flight of steps. As the citizen of a republic, Jefferson chose the Doric order, always considered the simplest and most masculine, in preference to the Ionic of the Villa Rotonda or the Corinthian of Chiswick. The illusion of simplicity, in fact, is artfully maintained throughout the building and grounds through the device of hiding the many service elements behind simple brick colonnades under the sides of the lawn terraces.

Jefferson's cherished dream was the University of Virginia, at Charlottesville, which he brought to reality only in his old age. Built from 1817 to 1825, the central "Lawn" (fig. 1052) constitutes not only the masterpiece of early Federal architecture in the United States but also one of the finest Neoclassic ensembles anywhere. From the central Pantheon-like Rotunda, planned as the library following a suggestion made by the professional architect Benjamin H. Latrobe (see below), low colonnades on either side in front of student rooms unite ten pavilions—Roman prostyle temples spaced at ever-increasing intervals. These provided lower rooms for the ten "schools" and upper rooms for the professors' living quarters. The colonnades are Tuscan; the pavilions, each different in a

1051. THOMAS JEFFERSON. Monticello, Charlottesville, Virginia. 1770–84; rebuilt 1796–1800

1052. THOMAS JEFFERSON. "The Lawn," University of Virginia, Charlottesville. 1817–25

deliberate avoidance of symmetry, exploit the varying possibilities of Doric, Ionic, and Corinthian orders drawn from Classical monuments, so that the students could have before them a full vocabulary of Classical style, the visual counterpart of the humanistic education to which Jefferson was devoted. The Composite, the richest of the orders, was reserved for the interior of the Rotunda. Although the Doric and Tuscan capitals could be turned locally, the others had to be ordered from marble carvers in Carrara, according to plates in Palladio. The result, clearly related to Hellenistic stoas, is an "environment" (to use the contemporary term) of magical harmony, still in daily use. The Neoclassic style became immediately *the* style for the buildings of the new republic and its various states, and reappeared in innumerable variations in Washington and in state capitals into the middle of the twentieth century. It was also used throughout the republic for country houses and town houses, great and small.

An English-born architect, BENJAMIN H. LATROBE (1764–1820), who furnished the self-taught Jefferson with much professional counsel, brought with him to the United States the capability of building in both Neoclassic and Gothic styles. Only the former was in demand for his work in Washington, where he collaborated in the building and rebuilding of the United States Capitol. For the Catholic Cathedral of Baltimore in 1805 he submitted designs in both styles. His Gothic design was not accepted. His handsome Neoclassic interior (fig. 1053) is roofed by a succession of hemispheric domes, lighted from above like that of the Pantheon. The grandeur of the effect is enhanced by the sparse ornamentation, recalling the austerity of Adam (see fig. 1039). The onion domes (fig. 1054), added to the towers after Latrobe's death, were not from his design, but the Ionic pronaos is substantially as he planned it, although not built until 1863.

During the French Revolution little could be built but much was dreamed, especially by ÉTIENNE-LOUIS BOULLÉE (1728–99), whose visionary plans were intended to establish a new architecture symbolizing the Rights of Man for which the revolution had, presumably, been fought. Boullée's design for a monument to Newton (fig. 1055), made in 1784, five years before the Revolution got under way, reduced the mass to essential forms of sphere and cylinder, stripped even of the conventional orders. The titanic scale can be deduced from the size of the antlike humans at the base and the groves of trees that encircle the sphere at various levels. The minute entrance was to lead the awestruck visitor through a

1053. BENJAMIN H. LATROBE. Interior, Catholic Cathedral of Baltimore. Begun 1805

1054. BENJAMIN H. LATROBE. Catholic Cathedral of Baltimore

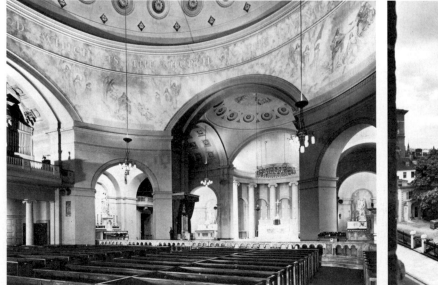

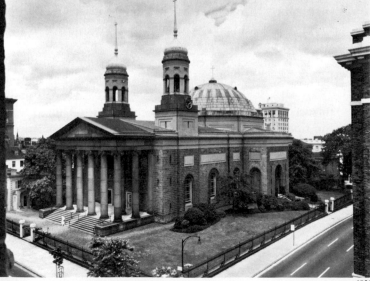

long, dark tunnel to the interior, lighted only by holes so spaced as to suggest the moon and stars of the night sky.

When architecture recommenced under Napoleon, the Classical orders in their severest form dominated. For forty years ideas for a church of the Madeleine, to head the Rue Royale between the twin palaces by Gabriel (see fig. 1014), had been under consideration. When the final competition was held in 1806, Napoleon decreed that the structure should be a Temple of Glory (he renounced the idea in 1813 after his defeat at Leipzig) and chose a Roman peripteral Corinthian temple design by PIERRE VIGNON (1762–1828), the first to be erected since the third century. The colossal structure (fig. 1056) took until 1843 to build and still dominates an entire quarter of Paris, dwarfing even from a distance the delicate masterpieces of Gabriel. The Madeleine is the most thoroughgoing example of the Neoclassic attempt to live in ancient style. Inside, of course, it could not work; a windowless Christian interior is an impossibility, and the nave had to be vaulted by domes on pendentives hidden under the roof and pierced by skylights.

A different kind of quotation from the ancient world is the Brandenburg Gate at Berlin (fig. 1057), built by KARL LANGHANS (1733–1808) in 1789–94, while Jefferson was in Europe. A direct imitation of the Propylaia at Athens, this is the first public building in Greek rather than Roman style, incongruously enough bearing an imitation of a Roman

1055. ÉTIENNE-LOUIS BOULLÉE. Design for the *Tomb of Newton*. 1784

1056. PIERRE VIGNON. Church of the Madeleine, Paris. 1806–43

1057. KARL LANGHANS. Brandenburg Gate, Berlin. 1789–94

four-horse chariot as on a triumphal arch. Doubtless the virile Doric order was connected in the minds of both the architect and his patron, King Frederick William II, with the martial vigor of the Prussian kingdom. Neoclassic architecture was carried the length and breadth of Europe from Copenhagen and St. Petersburg (the modern Leningrad)—where the mile-wide stretch of the Neva River was lined on both sides with columned structures—as far south as Rome, Naples, and Athens. Greek independence was celebrated in the 1830s by the erection of a host of Greek Revival structures within sight of the Parthenon. The loveliest of all Neoclassic cityscapes, although much of it has been lost to twentieth-century commercialism, is early nineteenth-century London. Cumberland Terrace, Eaton Square, and dozens of enchanting side streets still stand, among them the gracefully colonnaded Park Crescent (fig. 1058) by JOHN NASH (1752–1835), begun in 1812 while Jefferson's ideas for the University of Virginia were beginning to mature.

1058

Painting

DAVID The official artist of the French Revolution was Jacques-Louis David (1748–1825), who was eventually entrusted with commemorative portraits of martyred revolutionary leaders, the design of public pageants, celebrations, state funerals, and even the designs for the costumes to be worn by the citizens and citizenesses of the republic. At his decree the aristocratic powdered wigs, silk and velvet coats, and lace ruffles worn by men were replaced by natural hair (later worn short and tousled), woolen jackets, and linen shirts. Women shed their towering headdresses adorned with ribbons and feathers for a simple style imitated from the ancient Greeks, and their hoopskirts, lace, and furbelows for a muslin tunic belted high above the waist. Yet David's most rigidly doctrinaire painting, the *Oath of the Horatii* (see fig. 1059), which was the opening salvo in the Neoclassic battle against both the dying Rococo and the nostalgic classicism of the mid-eighteenth century, was commissioned in 1784 for Louis XVI. Nine years later this monarch was to lose his head under the guillotine because of the very forces David had helped to unleash.

Historical circumstances elucidate the apparent paradox. The Royal Academy held, at first in odd-numbered years, much later annually, a large public exhibition known as the Salon. In the nineteenth century this institution became a brake on artistic progress, but in the eighteenth it was a strong stimulus. The great galleries, first in the Louvre and later in the Tuileries, formed a kind of theater, with all Paris as the audience. The more dramatic a picture and the greater the attention it attracted, the better were the artist's chances of obtaining the portrait commissions that often provided his principal livelihood. In addition, pictures were commissioned by the royal superintendent of buildings, who under Louis XVI was the Comte d'Angiviller, a man with a passion for elevated subjects. Greuze, limited as he seems to us today (see fig. 1022), filled the bill nicely; so did an array of minor painters now almost entirely forgotten, who covered the walls with historical paintings intended to demonstrate moral truths. The *Oath of the Horatii*, finished in Rome in 1785, was one of these pictures, but it pointed a message whose implications neither d'Angiviller nor the king, nor probably even David at that moment, understood.

David arrived at the French Academy in Rome in 1775, a thoroughly accomplished Rococo painter in the general tradition of Boucher, but already devoted to the approved moral subjects. When he came in contact with Classical art in its native land, he said that he felt as if he "had been

1058. JOHN NASH. Park Crescent, Regent's Park, London. 1812–22

1059. JACQUES-LOUIS DAVID. *Oath of the Horatii.* 1784–85. Oil on canvas, 10'8¼" × 14'. The Louvre, Paris

operated on for cataract." This statement not only expresses vividly the new clarity demanded of Neoclassic vision, in contrast to the softness and vagueness of the Rococo, but also characterizes that voluptuous style as a malady demanding surgical removal. The new art was not achieved rapidly; during much of his first year in Rome, whose culture was dominated by Goethe, Winckelmann, and Angelica Kauffmann (see page 775), David devoted himself to drawing eyes, ears, feet, and hands from the most beautiful statues. Most of his paintings during these formative years are lost, but from all accounts they were drowned in black shadow like those of Caravaggio and the *tenebrosi* (see figs. 906, 907). But by 1781 the new style was established, and in 1783 David, then thirty-five, was elected to the Academy, which he soon came to detest, along with all royal officials, whom he called *les perruques* (the wigs).

The *Oath of the Horatii* (fig. 1059) shows the three Horatii brothers, chosen to defend Rome in combat against the three Curiatii, representing neighboring Alba, to one of whom Horatia, sister of the Horatii, was betrothed. The incident was recorded by Roman historians, and although it took place under the kingdom was believed by the French to have been an example of republican patriotism. The oath of the three brothers on the swords held aloft by their aged father appears to be an invention on David's part. As in the compositions of Greuze (see fig. 1022), the figures move in a strict relief plane, against a background of what David considered historically correct early Roman architecture, in sharp reaction to the spiral into the picture characteristic of the compositions of Boucher and Fragonard. The martial resolve of the young heroes is displayed in stances as grand as those of statues, although more rigid than most, while Horatia, her sister, her mother, and a tiny niece and nephew mourn the approaching conflict between brothers and lover in

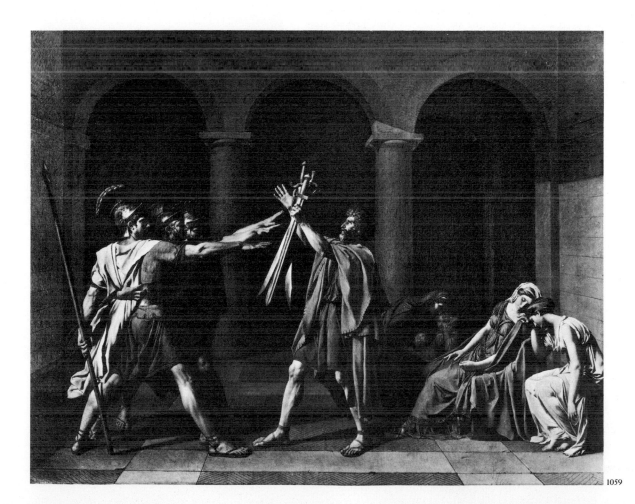

1059

attitudes of Classical grace. Every form, masculine and feminine, is exactly projected with a hallucinatory clarity going beyond anything demanded by Poussin in the seventeenth century (see fig. 937); superb male musculature and smooth female arms and legs—even drapery folds—are as hard as the steel of the uplifted swords. The coloring, inert like the surfaces, is restricted to individual areas, without any of the reciprocal exchange of colors typical of Baroque and Rococo traditions.

Although the picture was not recognized as potentially revolutionary in a political as well as an artistic sense, it was the direct forerunner of openly republican political allegories. After several such heroic paintings, David weakened his ties with the Royal Academy. During the Revolution he became a friend of Robespierre and ally of the Jacobins, and he presided briefly over the National Convention. In 1793 he had the satisfaction of seeing the Academy dissolved to be replaced with a society of revolutionary artists. Thereafter, his stern style served as the funnel through which all new talent was poured, and the most important new artists of France were either his pupils or his imitators. In enforcing his sculptural discipline, he is reported to have advised his pupils, "Never let your brushwork show."

David's most memorable work is the *Death of Marat* (fig. 1060), a painting of tragic grandeur because the subject is presented directly, stripped of allegorical disguise. Marat, one of the leaders of the Revolution, was constrained to work in a medicated bath on account of a skin disease he had contracted while hiding from the royal police in the Paris sewers before the Revolution. His desk was a rough packing box. The young counterrevolutionary Charlotte Corday gained admittance to this unconventional office with a note reading, "It suffices that I am very unhappy to have a right to your benevolence," and then plunged a knife into his chest. David was called in immediately to draw the corpse still in position, and from the drawing the painting was made, the elements slightly rearranged for greater theatricality. It should be recalled that David had arranged the actual funeral of an earlier martyred revolutionary, Le Peletier de Saint-Fargeau, exhibiting the seminude corpse propped up so as to display the wound in imitation of his own painting of the slain Hector.

Not only Classical history is recalled in the *Marat*, but also the traditional rendering of the dead Christ (Michelangelo's *Pietà*, for example; see fig. 792) and the high side lighting of Caravaggio and his followers, with the setting in nowhere (see fig. 907). The box, the bloodstained towel, and the tub were venerated as relics by the populace. David has painted the rough boards as well as Chardin might have, but arranged them parallel to the picture plane like a Classical tablet and supplied with the words (in French): "To Marat, David, Year Two." The stony treatment of head and figure shows an unexpected feeling for impasto in the handling of the flesh, and the rich treatment of the background in a basketwork of tiny, interlocking brushstrokes that endow it with a vibrant texture gives the lie to David's own advice to his students.

A new turn of the Revolution a year later brought Robespierre to the guillotine and David to prison and a narrow escape from death. On his release he became increasingly interested in Napoleon as the man who could bring order out of revolutionary chaos. Although by no means the only painter to the emperor, David was entrusted with such important commissions as the *Coronation of Napoleon and Josephine*, commissioned in 1804 and painted 1805–7 (fig. 1061), a majestic work in which the painter's hard-won Neoclassicism survives only in the projection of individual forms. The stiff solemnity of the courtiers gathered at the ceremony re-

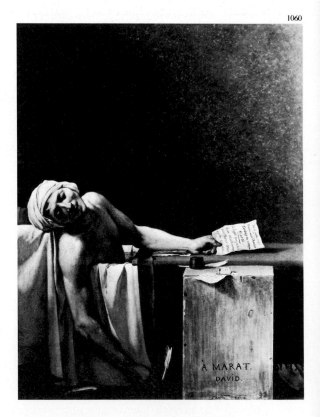

1060

1060. JACQUES-LOUIS DAVID. *Death of Marat.* 1793. Oil on canvas, 63¾ × 49⅛". Musées Royaux des Beaux-Arts, Brussels

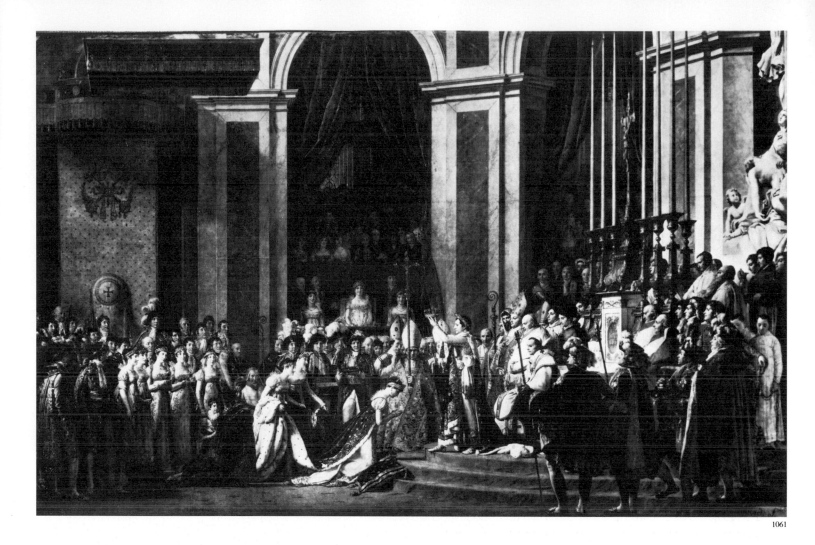

calls Byzantine mosaics rather than Roman statues, but the unexpected sparkle of color from gold, jewels, velvets, and brocades derives from the Venetian tradition, especially Veronese (see fig. 856). At the Restoration of the monarchy, the aging painter, who had turned his republican coat once for Napoleon, could not turn it again and spent his remaining years in exile in Brussels.

INGRES Although not only David's followers but also the master himself in later life turned away from the more doctrinaire aspects of Neoclassicism, Jean-Auguste-Dominique Ingres (1780–1867), the greatest of David's pupils, remained faithful to Neoclassic ideals to the end of his life, and eventually formed the center of a conservative group that utilized the principles of Neoclassicism, forged in the Revolution, as a weapon for reaction. Ingres was an infant prodigy, attending art school at eleven, and already a capable performer on the violin. He entered the studio of David at seventeen; although as long as he lived, he never let his brushwork show, neither did he accept the cubic mass of David's mature style, preferring curving forms flowing like violin melody. Winner of the Prix de Rome, he remained in that city from 1806 until 1820, and returned there from 1835 to 1841, absorbing not only ancient but also Renaissance art, especially that of Raphael. He also stayed four years in Florence (1820–24), where he was one of the first to appreciate not only the Florentine Mannerists but also Fra Angelico. The first pictures he

1061. JACQUES-LOUIS DAVID. *Coronation of Napoleon and Josephine*. 1805–7. Oil on canvas, 20′ × 30′6½″. The Louvre, Paris

NEOCLASSICISM 791

exhibited at the Salon were almost uniformly ridiculed, accused of being everything from Gothic to Chinese, and his special brand of nonpolitical Neoclassicism was worked out in isolation.

In 1808 Ingres did one of his finest paintings, whose pose he revived again and again in later works, the *Valpinçon Bather* (fig. 1062), named after the collection it first adorned. While the coolness of this lovely nude may at first sight recall Bronzino (see fig. 829), whom Ingres admired, it is drawn with a contour line as subtle and as analytic as that perfected by Holbein, but infinitely more musical, gliding in delicate cadences over shoulders, back, and legs. The surface is modeled to porcelain smoothness, but is never hard; Ingres was always at his best with delicate flesh and soft fabrics. His frequent subtle linear distortions have less to do with Raphael than with the attenuated forms of Parmigianino (see fig. 833), as does his sense of space—for example, the sudden jump between the foreground and the tiny spigot at an unexplained distance, from which water pours into a sunken bath.

Ingres fancied himself a history painter, although too many of his narrative pictures are weakened by his inability to project a dramatic situation. A work that embodies his ideal (rather than political) program for Neoclassicism is the huge *Apotheosis of Homer* (fig. 1063), a new *School of Athens* (see fig. 808), painted in 1827 and intended for the ceiling of a room in the Louvre, where it would undoubtedly have been more effective than at its present height on a wall. Ingres made no concessions to the principles of illusionistic ceiling perspective from below. Like Poussin he preferred the High Renaissance tradition, as exemplified by Michelangelo (see figs. 797, 799) and his contemporaries. Before an Ionic temple dedicated to Homer, the blind poet is enthroned, crowned with laurel by the muse of epic poetry. Below him sit two female figures, the one with a sword representing the *Iliad*, the one with a rudder the *Odyssey*. Around are grouped the geniuses from antiquity and later times whom Ingres considered truly Classical; Pindar extends his lyre, Phidias his mallet, Apelles his palette and brushes, and Aeschylus his scroll, in homage. Phidias holds by his hand Raphael, admitted to the upper level but not, alas, to the front row; on the other side Leonardo and Fra Angelico may be discerned. Dante, at the left, is presented by Virgil, and lower down Poussin may be seen, copied from the great master's self-portrait. At the lower right are grouped three French Classical writers, Boileau, Molière, and Racine. Shakespeare and Corneille just make the scene in the lower left-hand corner, and Mozart, a subject of torment to Ingres, who repeatedly put him in and dropped him out, was finally omitted from the company of the immortals. The cool light of an ideal realm binds the figures together in the kind of artificial composition that became definitive for classicizing muralists even into the twentieth century.

Much of the time Ingres was financially obliged to accept portrait commissions, which he considered a waste of time, although today his portraits are accepted as his greatest works. He even drew portraits of visitors to Rome, who trooped to his studio, in such meticulous pencil studies as the *Stamaty Family* of 1818 (fig. 1064), which show the exquisite quality of his line. Knowing that lead pencil is disagreeable in excess, he carefully kept it off the paper save where strictly necessary, only here and there suggesting the darkness of hair or of clothing, but concentrating on the precision of facial delineation and on the interweaving of the folds of the costumes into a fabric of gossamer fineness, as delicate as a pearly roulade from the keys of the piano in the background.

Ingres said, "There is no case of a great draftsman not having found

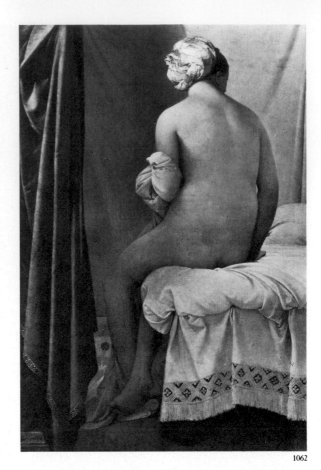

1062

1062. JEAN-AUGUSTE-DOMINIQUE INGRES. *Valpinçon Bather*. 1808. Oil on canvas, 56⅝ × 38¼". The Louvre, Paris

1063. JEAN-AUGUSTE-DOMINIQUE INGRES. *Apotheosis of Homer*. 1827. Oil on canvas, 12'8" × 16'11". The Louvre, Paris

1064. JEAN-AUGUSTE-DOMINIQUE INGRES. *Stamaty Family*. 1818. Pencil on paper. The Louvre, Paris

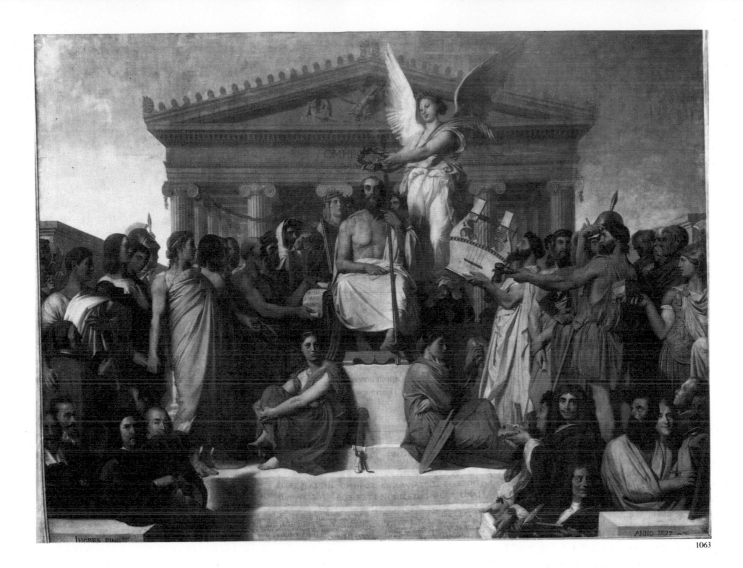

1063

the exact color to suit the character of his drawing." Debatable though the point may be, Ingres's own paintings are almost invariably perfect in color, in a high range related to that of Holbein or Bronzino or even Fra Angelico. All the beauty of Ingres's color and the perfection of his form are seen in the portrait of *Comtesse d'Haussonville* (fig. 1065), painted in 1845; she is pensively posed in a corner of her salon, in an attitude clearly derived from Classical art. No Dutch painter ever produced still lifes more convincingly than the vases on the mantle, and for all its precision the glow of the color has something in common with that of Vermeer. The reflection in the mirror, going back through Velázquez to van Eyck (see figs. 970, 757), reappears again and again in nineteenth-century art (see fig. 1123, for example), deeply concerned as it was with optical phenomena.

Although many of his subjects were drawn from the medieval history and poetry dear to the Romanticists (see Chapter Two), Ingres was resolutely opposed to their abandonment to emotion, and indeed to the artistic sources on which they drew. Rubens he called "that Flemish meat merchant." Delacroix, the leader of the Romanticists, was the devil incarnate; at a hanging at the Salon, after Delacroix had left the room, Ingres said to an attendant, "Open the windows, I smell sulfur." Yet his influence later in the century was very great. Degas (see Chapter Four), whose vision was sharpened by his knowledge of Ingres's line, was one of the great innovators of the late nineteenth century.

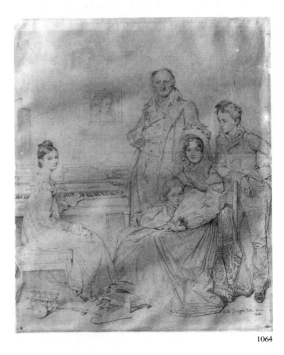

1064

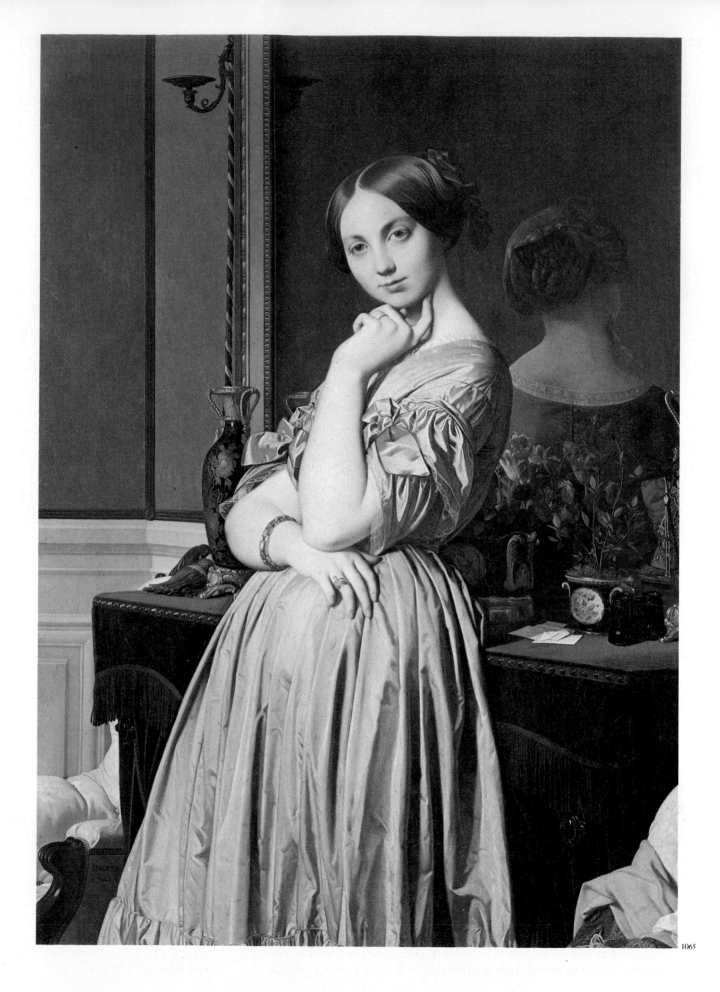

1065

1066

1067

HOUDON Although sculpture would seem to have been predestined for a dominant role in Neoclassicism, that art produced no genius to rank with David or Ingres at their best. The finest French sculptor of the eighteenth century was Jean Antoine Houdon (1741–1828). His lifespan overlaps that of David at both ends, but his style was formed in the Classicistic period of the eighteenth century and survived somewhat anachronistically during the revolutionary phase of Neoclassicism, through which he managed to function with a certain agility; the basic honesty of his style won only grudging acceptance from Napoleon. Nonetheless, Houdon pertains to this moment because his work was greatly admired by the philosophers who provided the intellectual basis of the Revolution, many of whom he portrayed with phenomenal accuracy. Houdon was devoted to perfection of naturalness; he studied anatomy with exhaustive care, and did not disdain the use of plaster casts from life and meticulous measurements. Nonetheless, his scientific precision in no way deadens his work. He declared that his purpose was "to present with all the realism of form and to render almost immortal the image of the men who have contributed the most to the glory or the happiness of their country." Every one of his portraits impresses the contemporary observer with the feeling that across the barriers of time and substance Houdon has made him actually acquainted with the subject, shown in a characteristic pose and in a moment of thought, feeling, or speech.

 Houdon's numerous busts and statues of Voltaire sparkle with the aged philosopher's wit. Seated in his armchair, a Classicistic piece typical

Sculpture

1065. JEAN-AUGUSTE-DOMINIQUE INGRES. *Comtesse d'Haussonville*. 1845. Oil on canvas, 53¼ × 36¼". © The Frick Collection, New York

1066. JEAN ANTOINE HOUDON. *Voltaire*. 1778. Marble, height c. 65". The Hermitage, Leningrad

1067. JEAN ANTOINE HOUDON. *George Washington*. 1788–92. Marble, height 74". State Capitol, Richmond, Virginia

of the taste of Louis XVI, he wears only his dressing gown and the cap donned by eighteenth-century gentlemen at home in place of the wig worn in public (fig. 1066). The folds of the gown fall like those of a toga, without sacrificing the intimacy of the moment. Every facet of the papery wrinkled skin, showing the bones beneath, is drawn with delicacy and accuracy, and the eyes twinkle in a wry, half-sad smile. Houdon brought draftsmanship in sculpture to its highest pitch, a kind of accuracy rivaled in painting only by Holbein and Ingres.

Due to his friendship with Franklin and Jefferson, both of whom he portrayed, Houdon was invited to America in 1785 to measure and study George Washington at Mount Vernon for the superb statue he carved in marble between 1788 and 1792 for the rotunda of Jefferson's State Capitol at Richmond, Virginia, where it still stands (fig. 1067). Houdon's brilliant realism was tempered somewhat by the demands of a ceremonial image. Washington, standing in a pose of Classical dignity, wears his general's uniform, leans lightly on his baton of command, and rests his left arm upon a fasces (the bundle of rods signifying authority carried before magistrates in Roman processions); attached to it are the sword and the plowshare, indicating the hero's preeminence in war and peace. Seen in the actual space for which it was designed, the statue radiates all the grandeur Houdon desired, and has succeeded in implanting its image of the Father of His Country on nearly two centuries of American thought and feeling.

CANOVA A much stricter adherence to the principles of Neoclassicism is shown by the Italian Antonio Canova (1757–1822), who, after Venetian training, moved to Rome in 1779. Revered in his lifetime, he was vilified soon after; more recently, the pendulum has come to rest in an appreciation of Canova as a gifted but limited artist, who combined great technical ability with reverence for Greek originals. He studied en-

1068

thusiastically the Parthenon sculptures brought to London by Lord Elgin but declined an invitation to restore them. Canova made no attempt at precise portraiture in the manner of Houdon, but produced idealized images, such as a nude statue of Napoleon as a Greek hero, and one of Washington in Classical garb for the State Capitol in Raleigh, North Carolina, unfortunately destroyed by fire. The alluring lifesize marble statue of Napoleon's sister, Maria Paolina Borghese, as Venus Victrix, 1805–7 (fig. 1068), shows the princess partly nude, reclining in a Classical pose on marble cushions on a gilt bronze couch, holding the apple given the goddess as the prize by Paris in the earliest recorded beauty contest—a triumph to which the subject's charms clearly entitle her. The chill of Canova's smooth surfaces, which convert the natural translucency of marble into something as opaque as cake frosting, cannot obscure the eventual Baroque derivation of his style. The head is close to that of Apollo in Bernini's *Apollo and Daphne* (see fig. 913), then as now in the Borghese collection, which Canova must have studied with loving care.

Canova transformed the character of the dramatic tomb (see the Rossellino tombs, figs. 716, 717) into imagery deprived of any reference to Christianity in his pyramidal monument to Maria Christina, archduchess of Saxe-Teschen (fig. 1069), erected to her memory by her husband, Archduke Albert, between 1798 and 1805. Her portrait is upheld by a soaring Classical figure representing Happiness, while her ashes are borne in an urn by Piety into the open door; to the right the winged genius of Mourning rests upon the lion of Fortitude, and to the left youthful, mature, and aged figures symbolize the Three Ages of Man. The contemporary Italian critic Francesco Milizia declared that a monument should "demonstrate in its simplicity the character of the person commemorated and bear no symbols that are not immediately intelligible." He must have been pleased by this one, although today's viewer requires a word of explanation. Nonetheless, the mystery of the unknown Beyond is beautifully dramatized by the soaring line of the pyramid, and by the curve of the cloth sweeping the figures inexorably on to the dark and silent door.

1069

Neoclassicism, whose gods were Poussin, Raphael, and a simplified version of Classical antiquity, held the Baroque (outside of Poussin) in abhorrence, and stood ironclad against all other currents in the nineteenth century, maintaining its own ideals and principles as the only valid ones. (Curiously enough, however, even the most doctrinaire Neoclassicists eventually proved vulnerable to the charms of North Africa.) Foredoomed to defeat as such dogmatism might appear, it did not entirely vanish but lived a submerged existence throughout the nineteenth and twentieth centuries, ready to surface at unexpected moments. For despite the exaggerated claims of the Neoclassic movement, its exponents were still in charge of the art schools, and did indeed provide essential basic training in form drawing and composition. However distasteful at times, this discipline proved of inestimable value to generations of artists, and will doubtless continue to do so.

1068. ANTONIO CANOVA. *Maria Paolina Borghese, as Venus Victrix*. 1805–7. Marble, 62⅞ × 78¾" (including bed). Galleria Borghese, Rome

1069. ANTONIO CANOVA. *Tomb of the Archduchess Maria Christina*. 1798–1805. Marble, lifesize. Augustinerkirche, Vienna

CHAPTER

ROMANTICISM

TWO

In contrast to Neoclassicism, which is easily recognizable, the parallel current of Romanticism is vague indeed. The characterizations of Romanticism, and the lists of artists to be included are as numerous as the writers on the subject. The term *Romantic* appears to have originated in the type of late-medieval narrative in which the adventures of a legendary hero were spun out to great length. From the very start, Romanticism involved connotations of unreality and of distance, in time or space or both. The Gothicism of Walpole, expressed in architecture in Strawberry Hill (see figs. 1040, 1041) and in literature in his Gothic novel *The Castle of Otranto* (1764), has often been called Romantic, although *pre-Romantic* might be a better term. By the middle of the eighteenth century, the term *Romantic* was applied to the "natural" English garden with its winding walks, pools, and groves. Thus, to the literary elements of the exotic and the remote, the ingredient of the natural was added, finding its philosophical support in the writings of Rousseau.

The culminating aspect of Romanticism is its interest in the sublime, as distinguished from the beautiful, deriving from a tradition that originated in the treatise *On the Sublime*, attributed to Longinus, a Greek Platonic philosopher of the third century A.D. The sublime, which contains elements of pain, terror, majesty, and above all awe before the unknown and the unknowable, constitutes a strong component of ancient art during the Hellenistic period, in contrast to the clearly defined Classical standards of beauty prevailing in Greek art of the fifth century B.C. The sublime was the object of meditation by the French critic Boileau in the seventeenth century and almost against his will by the rationalistic Voltaire, who had trouble with Shakespeare's greatness in spite of his violation of all classical rules—"a savage who could write."

Although so many of the elements of Romanticism already existed in the eighteenth century, like eighteenth-century Classicism they may be considered rather as an elegant pose of cultivated society; in fact, the two attitudes could easily coexist. Not until the French Revolution did a general Romantic attitude become widespread and definitive for works of art of a very high order. In English poetry the new freedom of Wordsworth, Byron, Keats, Shelley, and Scott differs from the measured cadences of their precursors, Pope, Thomson, Gray, and Cowper; in music the new movement was expressed in the greatly expanded symphonies, concerti, and sonatas of Beethoven and Schubert and in the flowering of Italian tragic opera. Eighteenth-century principles of form were swept away by a new emotionalism that generated its own forms. Like Neoclassicism, Romanticism became a way of life, affecting not only art but also conduct, an elevation of emotion above intellect, content above form, color above line, intuition and passion above judgment, resulting in an entirely new ideal hero—Byron's Childe Harold and Goethe's Werther. While Neoclassicism exalted Poussin, Raphael, and the "antique" (Classical art seen through Roman eyes), Romanticism extolled the Baroque, especially Rubens and Rembrandt, Michelangelo, the Middle Ages, and the East.

Except in architecture, Neoclassicism was relatively weak in England; even English Neoclassic architects could just as happily practice in Classical, Gothic, or Oriental styles. In France, however, Roman-

ticism, arising before he knew it in the very studio of David, eventually declared against him and the whole Neoclassic movement. Interestingly enough, Neoclassicism and Romanticism soon changed sides politically. The first allegiance of the Romanticists was to the Napoleonic dream of a united Europe. After his fall the Romanticists often sided with new revolutionary movements, while the late phase of Neoclassicism under Ingres associated itself with the restored Bourbon monarchy, eventually with the Second Empire, and as well with the ever more repressive force of the Academy. The account given here is selective in that it attempts to present only works of enduring quality, but they should be recognized as part of a vast movement invading all aspects of nineteenth-century life in every European country as well as in the United States.

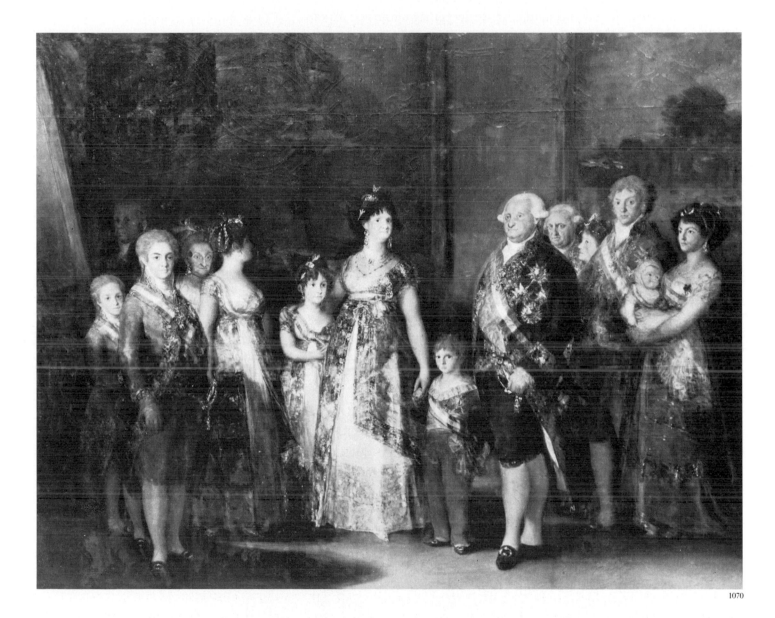

1070

GOYA Although hardly known to the French Neoclassicists or—except for his prints—even to the early Romanticists, the greatest artistic genius of the turn of the eighteenth century was a Spaniard, Francisco José de Goya y Lucientes (1746–1828), whose long lifetime overlaps that of David. Goya made the required obeisance to Italy, but only briefly, and seems to have been unimpressed either by antiquity or by the Ren-

Painting and Sculpture on the Continent

1070. FRANCISCO GOYA. *Family of Charles IV.*
 1800. Oil on canvas, 9'2" × 11'. Museo del
 Prado, Madrid

aissance. He was a lifelong rebel against artistic or intellectual straitjackets, and could never have tolerated the stern doctrines of David; in fact, he managed to skip the Neoclassic phase entirely, even though one of its most influential practitioners, the German painter Anton Raphael Mengs, friend of Winckelmann, was in a position of authority in Madrid. Goya was more influenced by Tiepolo, who worked in Madrid from 1762 till his death in 1770, and thus passed directly from a personal version of the Rococo, with a strong admixture of Spanish folklore, to a style we can hardly call anything but Romantic.

In 1786 Goya was appointed painter to the king, and in 1799, already more than fifty, first court painter. After 1792 Goya was totally deaf, which disability may have been responsible for liberating him from some of the trivialities of life for meditation on its deeper significance. Goya's brilliant portraits of the royal court may have been influenced by the light, free brushwork and diaphanous forms of Gainsborough, whose works were then widely known in accurate engravings. But his characterizations are far more vivid, intensely human, and at times bitingly satiric. His supreme achievement in portraiture is the *Family of Charles IV*, painted in 1800 (fig. 1070), an inspired parody of Velázquez's *Las Meninas* (see fig. 970). Thirteen members of the royal family, representing three generations, are assembled in a picture gallery of the palace, with Goya himself painting at a large canvas in the shadows at the left, a sardonic commentator on this parade of insolence. The king, with his red face and with his chest blazing with decorations, and the ugly and ill-natured queen are painted as they undoubtedly were. Alphonse Daudet called them "the baker's family who have just won the big lottery prize," but Goya's real purpose is deeper than satire: he has unmasked these people as evil. Only some (not all) of the children escape his condemnation. Unexpectedly, the result is a dazzling display of color in the lighting, the costumes, and the decorations—brilliant sparkles of impastos against rich, deep glazes—all touched in lightly and swiftly without a hint of the formal construction and composition of the contemporary French Neoclassicists.

A still unexplained picture, probably painted in the same year, is the *Maja Desnuda* (fig. 1071)—the word *maja* is untranslatable; *coquette* is an approximation—one of the most delightful paintings of the female nude in history. The pose is an updated and very awake transformation of the sleeping nude in the lower right corner of Titian's *Bacchanal of the Andrians* (see fig. 845), at that time in the Spanish royal collections. There exists a second, much sketchier clothed version of the picture. The nude was formerly explained as an unconventional portrait of the duchess of Alba, a patron and close friend of Goya's, and the clothed replica as an attempt to account for the artist's time, hastily painted against the duke's return. In any event the seductive pose is entrancing, as is the delicacy of Goya's unusually smooth and polished modeling of the flesh, contrasted with the crisp brushwork of the white satin sheet and pillow slips and lace ruffles and with the intensity of the blue velvet cushions.

The frivolity of the picture hardly prepares us for Goya's denunciations of the inhumanity of warfare, of which the most monumental example is *The Third of May, 1808, at Madrid: The Shootings on Principe Pío Mountain* (fig. 1072), depicting the execution of Madrid rebels by Napoleonic soldiery, commissioned by the liberal government after the expulsion of the French in 1814. This painting, done in 1814, is the earliest explicit example of what has come to be known as "social protest" in art, as distinguished from the allegorical allusions to contemporary events common enough in the Renaissance and the Baroque. Despite written

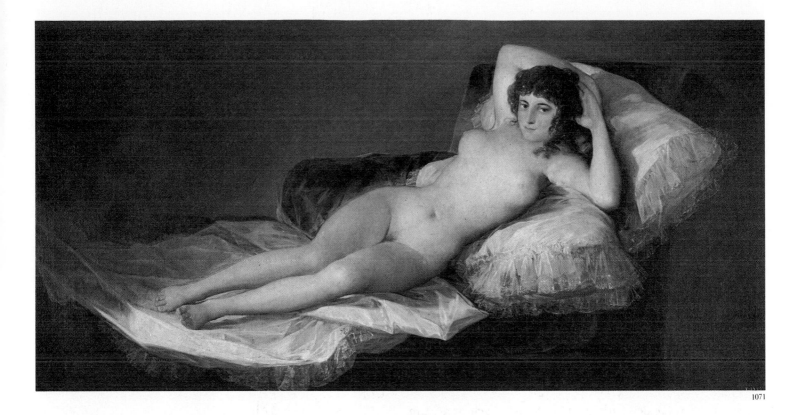

meditations, such as those of Leonardo da Vinci, on the cruelties and terrors of battle, warfare itself had generally been depicted as glorious and cruelties as inevitable (see figs. 707, 788). Goya treats the firing squad as a many-legged, faceless monster, before whose level, bayoneted guns are pushed group after group of helpless victims, the first already shattered by bullets and streaming with blood, the next gesticulating wildly in the last seconds of life, the third hiding the horror from their eyes with their hands. A paper lantern gives the only light; in the dimness the nearest houses and a church tower of the city almost blend with the earth against the night sky. The conviction of reality conveyed by the picture, painted so long after the event, is a testament to the extraordinary powers of Goya's imagination and to the depth of his inner participation in human suffering. Through the medium of brushstrokes as broad as those of Tintoretto, he communicates unbearable emotion with thick pigment, which, as if sacramentally, becomes the still living or already rent flesh and streaming blood, achieving at once a timeless universality and an immediacy that bring to mind all too effectively the reality of similar events we read and hear about almost daily.

Goya's passionate humanity speaks uncensored through his engravings. These rely for their effect on a combination of traditional etching with the newly invented technique of *aquatint*, in which rosin is utilized to cover the areas between etched lines. When the plate is heated, the rosin creates a granular surface; ink applied and wiped off then produces a rich, gray tone, greatly expanding the expressive range of the print medium and bringing it close to wash drawing. Goya made several series of etching-aquatints, the earliest of which, *Los Caprichos (The Caprices)*, of 1796–98, is wildly imaginative. The first section, dealing satirically with events from daily life, is surpassed by the second, devoted to fantastic events enacted by monsters, witches, and malevolent nocturnal beasts from the demonic tradition of Spanish folklore. The introductory print

1071. FRANCISCO GOYA. *Maja Desnuda*. 1800. Oil on canvas, 37⅜ × 74¾". Museo del Prado, Madrid

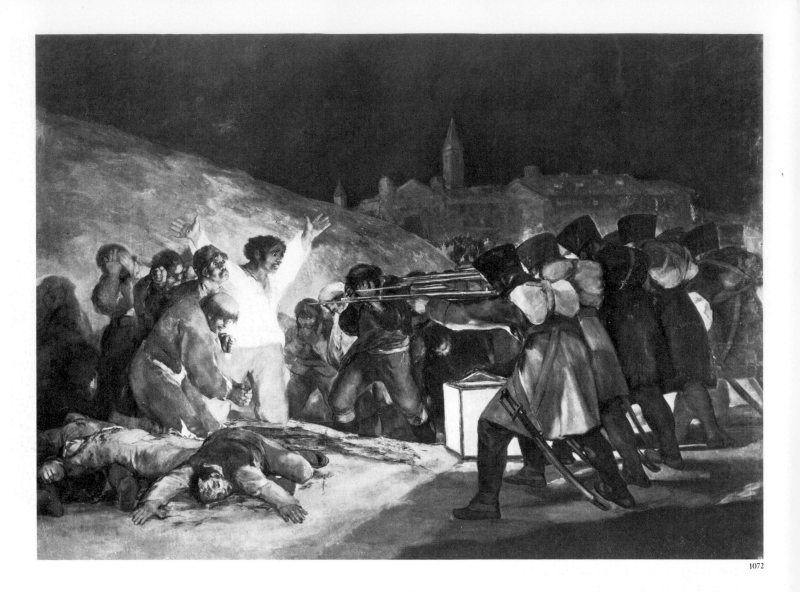

of the second section (fig. 1073) shows the artist asleep at his table loaded with idle drawing instruments, before which is propped a tablet inscribed, "El sueño de la razon produce monstruos" ("the sleep of reason produces monsters"). Reason, the goddess of eighteenth-century philosophers, to whom the Cathedral of Notre-Dame in Paris had been temporarily rededicated during the French Revolution, once put to sleep, allows monsters to arise from the inner darkness of the mind. Goya's menacing cat and the rising clouds of owls and bats glowing in light and dark are lineal descendants of the beasts of medieval art and the monsters of Bosch (see figs. 771, 773).

Instead of merely threatening human life, as in *Los Caprichos*, the monsters take over entirely in Goya's final series, *Los Disparates (The Follies)*, engraved between 1813 and 1819. In a print entitled *Unbridled Folly* (fig. 1074), a wildly rearing horse, resembling a natural force erupting from the ground, carries off a woman whose garments it has seized with its teeth, while at the left the earth turns into a bestial maw devouring humanity. The ultimate horror of Goya's imagination seethes through the series of dark frescoes the artist painted with fierce strokes on the walls of his own house from 1820 to 1822, depicting a universe dominated by unreason and terror, and making cruel mock of humanity. One of his rare references to Classical mythology illustrates the most savage of Greek

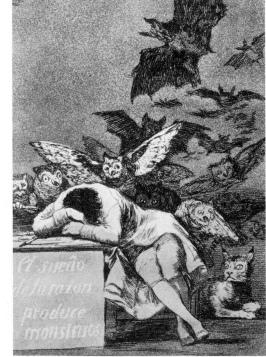

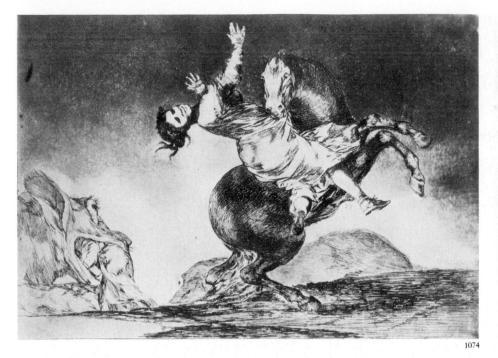

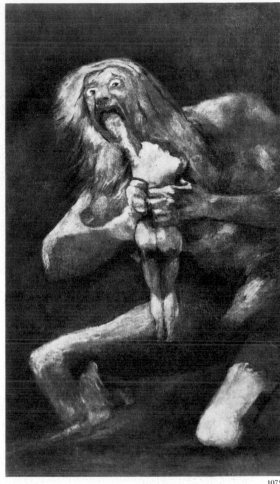

legends. *Saturn Devouring One of His Sons* (fig. 1075) is an allegory of Time, which engulfs us all. The glaring, mindless deity holds with colossal hands the body of his helpless son, from which he has torn and is chewing the head and the right arm—all indicated with brushstrokes of a hitherto unimagined ferocity.

Now nearing eighty, the great painter was not to live long with these creatures of his despairing imagination. After the restoration of a reactionary monarchic government in 1823, he left for France the following year, and, like his complete opposite David, he died in exile. In the formative stages of the Romantic movement in France, Goya's paintings seem to have been unknown; of his engravings, only *Los Caprichos* were published, but even they had a limited effect; it remained for the late nineteenth century to rediscover Goya in full.

GROS The transformation of Davidian Neoclassicism into Romanticism was initiated by one of David's own pupils, Antoine Jean Gros (1771–1835), torn between his loyalty to the doctrines of his master and his admiration for the color and movement of the hated Rubens. The young Gros actually accompanied Napoleon on his north Italian campaign. Later, he painted colossal canvases commissioned to display the alleged humanitarianism of the emperor rather than his military glory. Such subjects, aptly described as "pious lies," would have nauseated Goya, but Gros's treatment of them is impressive. *Napoleon on the Battlefield at Eylau* (fig. 1076) was painted in 1808, according to a fixed program that prescribed the persons, actions, and background to be represented. Among the heaped-up bodies of the dead and dying, after the bloody but indecisive battle, the emperor appears on a white horse as a kind of savior, commanding that proper care be taken of the wounded Russian and Prussian soldiers. Across the snowy fields in the background the imperial armies are arrayed for the triumphal march past the conqueror, while long lines of Russian prisoners are led away. The fact that the commission was intended to counteract public knowledge of the inadequacy of Napoleon's

1072. FRANCISCO GOYA. *The Third of May, 1808, at Madrid: The Shootings on Principe Pío Mountain.* 1814. Oil on canvas, 8' 8¾" × 11'3⅞". Museo del Prado, Madrid

1073. FRANCISCO GOYA. *The Sleep of Reason Produces Monsters*, from *Los Caprichos*. 1796–98. Etching and aquatint

1074. FRANCISCO GOYA. *Unbridled Folly*, from *Los Disparates*. 1813–19. Etching and aquatint

1075. FRANCISCO GOYA. *Saturn Devouring One of His Sons*. 1820–22. Fresco (transferred to canvas), 57⅞ × 32⅝". Museo del Prado, Madrid

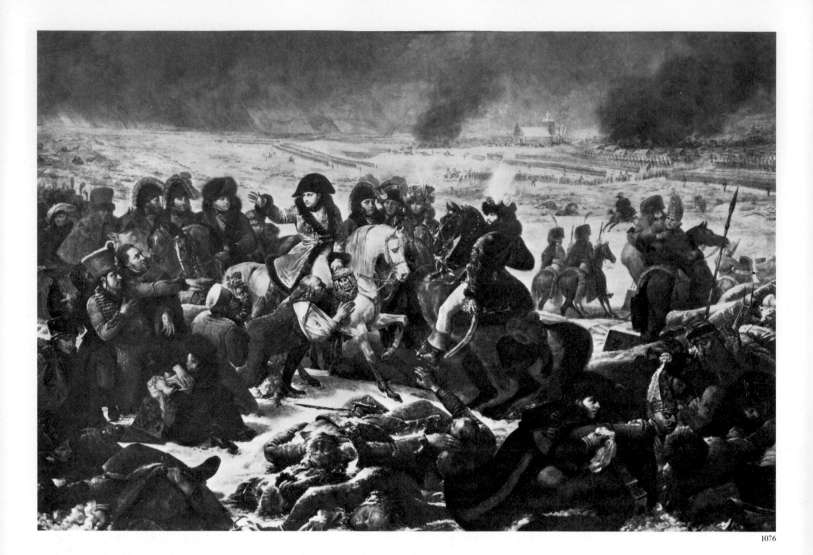

medical services does not weaken the drama of the composition, with its hundreds of near and distant figures. The reference to Roman battle compositions in the emperor's gesture and the packed bodies is all that remains of Neoclassicism. The colors of the uniforms are muted by the gray sky and the snow; the latter has sifted onto the greenish gray faces of the frozen corpses in the foreground. The painter's interest in color and in the sufferings of the wounded opened the way to the passionate outbursts of the Romantic style. Gros himself, however, bitterly criticized by David from Brussels for his contemporary subjects, could never reconcile the opposites in his life and work, and despite his elevation to a barony by the restored Bourbons, he eventually ended his life in the Seine.

GÉRICAULT The hero of the formative stage of French Romanticism was Jean-Louis André Théodore Géricault (1791–1824), a Romantic figure in his own right in his disdain for his personal safety, his dedication to the life of the emotions, and his espousal of the cause of the downtrodden and rejected. Although only three of his paintings were publicly exhibited during his brief lifetime, he exerted an enormous influence on the whole of the Romantic movement. His *Officer of the Imperial Guard* (fig. 1077), shown at the Salon of 1812, is a dazzling performance for a twenty-one-year-old artist, already in full command of pictorial technique in a

1076. ANTOINE JEAN GROS. *Napoleon on the Battlefield at Eylau*. 1808. Oil on canvas, 17'6" × 26'3". The Louvre, Paris

1077. THÉODORE GÉRICAULT. *Officer of the Imperial Guard*. 1812. Oil on canvas, 9'7" × 6'4½". The Louvre, Paris

1078. THÉODORE GÉRICAULT. *Raft of the Medusa*. 1818–19. Oil on canvas, 16'1" × 23'6". The Louvre, Paris

tradition stemming from the later Titian and Tintoretto. The guardsman is mounted on a rearing horse, which, while resembling that of Marshal Murat to the left of the emperor in the *Napoleon on the Battlefield at Eylau*, was probably also inspired by Leonardo's composition of the *Battle of Anghiari*, known to Géricault from Rubens's imaginative recreation (see fig. 788), not to speak of the spiral composition and the rich colorism of the great Flemish master himself, which have caused Géricault's style to be termed "neobaroque." Although he had studied with Pierre-Narcisse Guérin, a follower of David, Géricault lets his brushwork show brilliantly just as David claimed it should not. He wholeheartedly accepted the Napoleonic mystique, and in his painting has nothing to say about the sufferings of war; the young officer is a hero, braving not only the smoke and flame of the battle but also attempting to tame the turbulence of nature itself, expressed in the fiery stallion and the surging storm clouds. The theme of man pitted against nature in eternal combat runs through most of Géricault's paintings.

In 1816–17 he lived in Florence and Rome, but paid less attention to antiquity and to Raphael than to Italian street scenes, especially those involving horses, and to the paintings of Michelangelo, whose grandeur and violence thrilled him. Out of his study of the great High Renaissance master came the young artist's only monumental canvas, the huge *Raft of the Medusa* (fig. 1078), on which he worked from 1818 to 1819. The government vessel *Medusa*, bound for Senegal, was wrecked in July 1816. After abandoning ship, 149 passengers were crowded onto a raft in tow by the officers' boats; the cable broke and the raft was cut adrift. Only fifteen passengers were eventually rescued by the brig *Argus*, after they had suffered the torments of thirst and starvation under the equatorial sun.

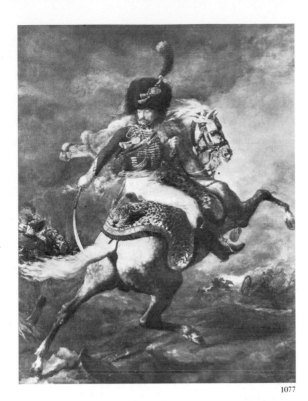

1077

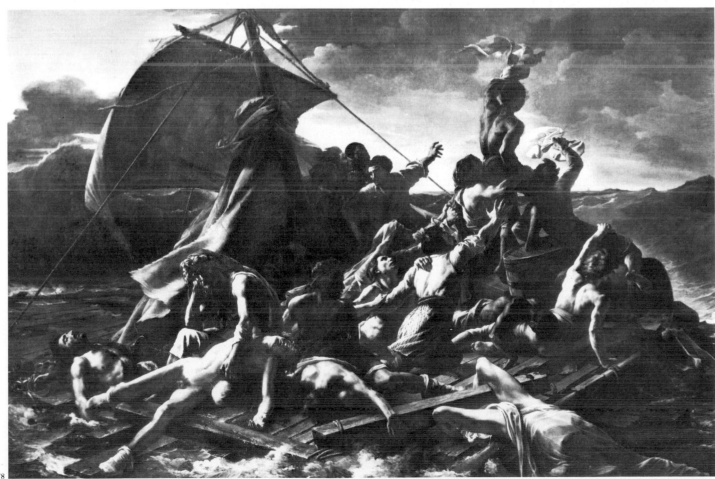

1078

A political scandal because of the incompetence of the captain, who owed his appointment to his support of the monarchy, the incident seems to have obsessed the artist rather as a supreme instance of the tragic conflict between man and nature. He interviewed the survivors, read the newspaper accounts, even painted corpses and the heads of guillotined criminals in an attempt to achieve the highest fidelity to truth. Yet the final result, achieved after endless sketches and preliminary compositions, was by no means a realistic picture. Géricault chose to depict the moment when the brig was first sighted on the horizon. The composition results from a pyramidal surge of agonized figures, rising higher than the threatening sea, and culminates in two men waving garments against the clouds. In essence, it is a translation into multifigural design of the motive of the *Officer of the Imperial Guard*, the sea substituting for the horse as a symbol of hostile nature. While the rendering of the corpses and the maddened survivors recalls Gros's *Napoleon on the Battlefield at Eylau*, their heroic muscularity and the mood of titanic struggle are clearly affected by the grandeur of Michelangelo's *Last Judgment* (see fig. 818).

The artist was far from pleased by the public reception of this work more as a political than an artistic event, and he accompanied it to London, where he showed it for a year at considerable profit from the admissions. He learned, incidentally, much about color from English painters, especially Constable (see below), and would have seemed destined for a leading role in French painting on his return. Especially impressive are his studies of the insane, done in Paris in 1822–23 at the suggestion of a psychiatrist friend, and given titles that look a little strange to present-day students of psychiatry. The *Madwoman* (fig. 1079; actually entitled the *Monomania of Envy*) discloses in the inner world of thoughts and feelings the same struggle between man and nature that the artist had previously studied in the realm of physical action. It was typical that he should lose the battle. A passionate horseman, he was injured by a fall from a horse, insisted on riding again too soon, fell a second time, and died, probably of his injuries. More than any of his contemporaries, he may be considered the founder of the veritable religion of emotional violence championed by Delacroix.

DELACROIX The torch of Romanticism passed from the hands of Géricault to those of his seven-years-younger friend and, in a sense, pupil, Eugène Delacroix (1798–1863), who shared with Ingres, despite their bitter professional enmity, the leadership of French and indeed European painting for more than a generation. He seems the archetype of the Romantic—solitary, moody, inexhaustibly imaginative, profoundly emotional. He confided to his *Journal*, the most complete record we have of the thoughts and feelings of any great artist, that he was never without a slight fever. Yet in contrast to Géricault he lived an existence marked by few external events. Although he admired Italian art and said he wanted to go to Italy, he never went there; his journeys were to England, Belgium, Holland, Spain, and North Africa. Save for one youthful adventure, no enduring amorous connections are known, and he remained unmarried. He was haughty toward most other artists. His real life, of great intensity, was lived on the canvas. "What is most real in me," he wrote, "are the illusions I create with my painting; the rest is shifting sand." In the course of his life he produced literally thousands of oil paintings and watercolors and innumerable drawings, and not long before his death he claimed that "in the matter of compositions I have enough for two human

1079

1079. Théodore Géricault. *Madwoman (Monomania of Envy)*. 1822–23. Oil on canvas, 27⅝ × 22″. Musée des Beaux-Arts, Lyons

lifetimes; and as for projects of all kinds, I have enough for four hundred years."

At first Delacroix wrote in his *Journal* lists of subjects he wanted to paint, invariably scenes of emotional or physical violence; later, discovering that the creative urge was dissipated in setting down the titles, he abandoned this practice. Often he drew his subjects from English poetry, especially Shakespeare and Byron, and from medieval history. Music enthralled him; he knew Chopin personally and analyzed his music with keen understanding, aware at once of its beauty and its limitations. At first he admired Beethoven, but later found his music noisy and exaggerated. From youth to age his one idol in music was "the divine Mozart," which tells us at once much about the fire and imagination of Mozart and about the discipline of Delacroix's art, despite its apparent impetuosity always under firm intellectual control. As a youth, he was drawn to Michelangelo, whose paintings he knew only from engravings and from the accounts of his mentor Géricault. But as Delacroix matured, the influence of the great Florentine waned along with that of the departed friend, and his lifelong loyalty to the sixteenth-century Venetians (see Part Four, Chapter Six) and to Rubens (see Part Five, Chapter Two), apostles of colorism, constantly strengthened.

In the *Bark of Dante* (fig. 1080), which Delacroix exhibited in 1822 at the age of twenty-four, he illustrates a moment from the *Divine Comedy* in which the poet, accompanied by Virgil, is steered across the dark tides of the lake surrounding the city of Dis, assailed in the sulfurous dimness by damned souls rising from the waves against a background of towers and flames. The obvious Michelangelism of the figures (compare the *Last Judgment*, fig. 818), not to speak of the frail craft on heaving waters, reminds us of Géricault's *Raft of the Medusa*, exhibited only three years ear-

1080. EUGÈNE DELACROIX. *Bark of Dante*. 1822. Oil on canvas, 74⅛ × 96⅞". The Louvre, Paris

1081. EUGÈNE DELACROIX. *Massacre at Chios*.
1822–24. Oil on canvas, 13′10″ × 11′7″.
The Louvre, Paris

lier. But there are already significant differences. Delacroix has broken up the pyramidal grouping, and is more concerned with effects of color and of light and dark than with form, however strongly modeled here and there. Some of the drops of water are painted in pure tones of red and green. Throughout his entire career his basic compositional principle is a series of free curves, emanating from the central area but always returning to it, with a responsive logic unshaken even in the moments of greatest violence. Gros praised the picture highly, calling it a "chastened Rubens."

Delacroix's next major effort, however, the *Massacre at Chios* (fig. 1081), which he exhibited in 1824, was not so easily accepted. Like that of the *Raft of the Medusa*, the subject was a cause célèbre, in this case an incident from the Greek wars of liberation against the Turks, which had excited the sympathies of Romantic spirits everywhere, notably Lord Byron. While the foreground strewn with bodies and the panoramic background are related to Gros's *Napoleon on the Battlefield at Eylau*, and the Turk on his rearing horse to Géricault's *Officer of the Imperial Guard*, great changes have taken place. The neobaroque composition is diffused in Delacroix's centrifugal curves, which part to display the distant slaughter and conflagration. And although our sympathies are supposed to be enlisted by the sufferings of the Greeks, their rendering lacks the conviction of the *Raft of the Medusa*. Clearly, Delacroix did not investigate the subject with Géricault's reportorial zeal. In fact, the expressions tend to become standardized; the head of the young woman at the lower left almost exactly repeats that of the dead mother at the lower right. Suffering, violence, emotional excess of all sorts are reveled in rather than lamented.

Gros called this picture the "massacre of painting," and not only because of Delacroix's treatment of the subject. As we see the picture today, the color shows a richness and vibrancy not visible in French painting since the Rococo. Delacroix saw and was amazed by Constable's *The Hay Wain* (see fig. 1089), brought to Paris for the Salon of 1824, and before the exhibition opened he took down his huge picture and in a few days repainted it extensively in tones emulating those he found in Constable.

From here on, Delacroix's interest in color was greatly heightened. He recounts in his *Journal* his exhaustive attempts to investigate the relationship of color contrasts through experience of their effects next to each other on the canvas, as well as from visual observation of nature, deriving from these lists a law—"the more the contrast the greater the force." His contrasting hues, set side by side unmixed, caused conservative painters great distress, but marked an important step in the direction of the color effects to be derived from sunlight by the Impressionists (see Chapter Four). In 1847 Delacroix wrote, "When the tones are right, the lines draw themselves," the exact opposite of Ingres's dictum on the same subject (see pages 792–93).

With the *Death of Sardanapalus* (fig. 1082), as much a manifesto for Romanticism as was Ingres's *Apotheosis of Homer* (see fig. 1063) for Neoclassicism (ironically enough, both paintings were exhibited at the Salon of 1827), the artist drew down upon himself the execration of conservatives and the disapproval of royal administrators. The legendary subject concerns the last of the Assyrian monarchs, besieged in his palace for two years by the Medes. On hearing that the enemy had at last breached his walls, the king had all his concubines, slaves, and horses slaughtered and his treasures destroyed before his eyes, as he lay upon a couch soon to become his funeral pyre. Lacking the pretext of humanitarianism that justified the *Massacre at Chios* and other pictures inspired by the Greek

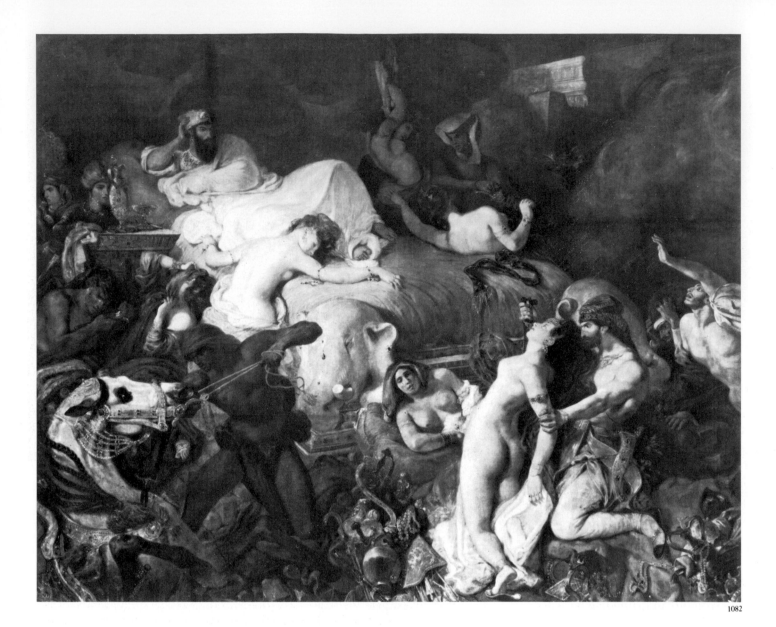

1082

struggle for independence, the painting becomes a veritable feast of violence, spread out in glowing colors against the smoke of distant battle. With the brooding king and three excited male servants as foci, the movement surges about the couch in Delacroix's characteristic curves. Yet the picture is a phantasmagoria in which no real cruelty is exerted. Faces are contorted with destructive fury or paralyzed with fear, but no blood flows from the breast of the naked woman in the foreground into which a dagger has been plunged. Quivering female flesh is heaped in every conceivable position, like flowers or fruit, among the glittering jewels and the fabrics of crimson or turquoise, all brilliantly painted. In this solitary fantasy the artist, identifying himself in imagination with the king and the executioners, discharges all his creative—and destructive—energy in an explosion of tones that foreshadows the Venusberg music of Wagner and the Immolation scene from his *Götterdämmerung*, but is in reality as harmless as a still life.

The Revolution of 1830, which placed on the throne Louis Philippe, the "Citizen King," brought Delacroix major mural commissions and relief from poverty. Early in 1832 he traveled through North Africa with a French delegation. He was the first major painter of modern times to visit

1082. EUGÈNE DELACROIX. *Death of Sardanapalus.* 1827. Oil on canvas, 12'1½" × 16'2⅞". The Louvre, Paris

1083. EUGÈNE DELACROIX. *Women of Algiers.* 1834. Oil on canvas, 70⅞ × 90⅛". The Louvre, Paris

1084. EUGÈNE DELACROIX. *Tiger Hunt.* 1854. Oil on canvas, 29 × 37". The Louvre, Paris

1083

the Islamic world, and this was the one real adventure of a lifetime otherwise fairly tranquil—externally, at least. Although he had no opportunity to paint, and sometimes found even drawing dangerous on account of Islamic hostility to representation, he managed to bring back with him hundreds of sketches in pencil or pen, some touched with watercolor. These, his memory of exotic sights and colors, and his vivid imagination provided him with endless material for paintings for the next thirty years.

Delacroix's memories of North Africa were brought to realization in the *Women of Algiers* (fig. 1083), a picture of exquisite intimacy and charm, painted and exhibited in 1834. Delacroix had managed to gain entrance to a harem, and was delighted with "the charm of the figures and the luxury of the clothing." The languorous poses, soft flesh, and somnolent eyes of the women, the varying textures and colors of the striped and figured fabrics, the light and luminous shadow of the interior, and the endless arabesques of the tiles form a constantly changing tissue of line and tone. This picture had an enormous influence on the Impressionists of the late nineteenth century and on many painters of the early twentieth, especially Matisse (see figs. 1164, 1166).

Most of the pictures of North African subjects painted during Delacroix's later years, however, were less tranquil. The *Tiger Hunt* (fig. 1084), of 1854, is typical, with forms and poses born almost entirely of the artist's unbridled imagination. "When the tones are right, the lines draw themselves," and so they do, in the movements of the raging animals and furious huntsmen, flowing out from the center and back again with passionate intensity and perfect logic. Almost weightless, liberated from matter, these late fantasies of violence carry the artist into a phase of free coloristic movement pointing directly toward the twentieth century.

1085

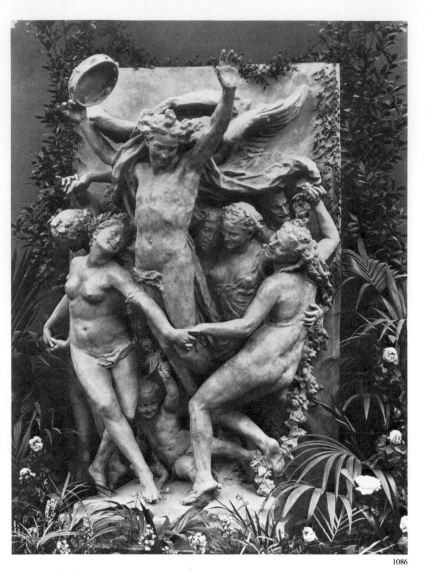

1086

SCULPTURE Romantic sculpture never quite reached the plane of painting; there were no geniuses to catch the fire of Goya or Delacroix. Nonetheless, some powerful and effective works were conceived and executed in large scale for important Parisian buildings. The grandest of these is *La Marseillaise* (fig. 1085; its full title is *The Departure of the Volunteers in 1792*), by FRANÇOIS RUDE (1784–1855). Although the work was done in 1833–36, one can still catch echoes of the *Oath of the Horatii* (see fig. 1059) in the bombastic mood and vigorous Classical poses and costumes. Under the thundering folds of Liberty's flying garments, the massed figures, with their rich light-and-dark contrasts, are deployed to great effect against the clifflike surface of the Napoleonic Arc de Triomphe at the Étoile, center of the radiating avenues the emperor designed for a new quarter of Paris. In contrast, the sculpture of JEAN-BAPTISTE CARPEAUX (1827–75) seems almost Rococo in its grace and sensuousness. In spite of its enormous scale, *The Dance* (fig. 1086), of 1867–69, reminds one of Clodion (see fig. 1026). Its energy and sparkle are seen better in the plaster cast after Carpeaux's original work in clay than in the somewhat more frigid version executed in limestone for the façade of the Paris Opéra. The irresistible verve of the work certainly influenced the sculpture of Rodin (see figs. 1134, 1136) and even the paintings of Matisse (see fig. 1163).

1085. FRANÇOIS RUDE. *La Marseillaise (The Departure of the Volunteers in 1792)*. 1833–36. Stone, c. 42 × 26'. Arc de Triomphe, Place de l'Étoile, Paris

1086. JEAN-BAPTISTE CARPEAUX. *The Dance*. 1867–69. Plaster model, c. 15' × 8'6". Musée de l'Opéra, Paris

1087. CASPAR DAVID FRIEDRICH. *Abbey Graveyard Under Snow*. 1819. Oil on canvas, 47⅝ × 66⅞". Formerly Nationalgalerie, Staatliche Museen, Berlin (destroyed 1945)

GERMAN ROMANTICISM A complete survey of Romanticism, like a thorough treatment of any other artistic style, would inevitably take in many phenomena of limited aesthetic interest. Even more than Neoclassicism, Romanticism was enthusiastically accepted in Germany, predisposed by the poetry of Goethe and Schiller and the music of the great Romantic composers. Unfortunately, no consistent pictorial tradition had existed in Germany since the sixteenth century, and many of the dreams of German Romantic painters were beyond their powers of execution, and immeasurably below the level of contemporary German music. A conspicuous exception is the art of CASPAR DAVID FRIEDRICH (1774–1840), a North German painter whose landscapes are of high artistic quality and great poetic depth. Friedrich was as deeply imbued with love of nature as his English contemporaries, but shared neither Constable's rhapsodic self-identification with natural forces nor Turner's desire to project his own emotions into natural lights and spaces. Friedrich was by inclination melancholy, even pessimistic, and his landscapes are always concerned with an immense and impersonal world, responsive to no human emotion save sadness. Meditations on solitude, alienation, and death predominate in his pictures; not surprisingly, his style shows none of the spontaneity of color and freedom of brushwork so impressive in his English contemporaries. "You shall keep holy every pure emotion of your soul," he said; "you shall esteem holy every pious presentiment. In an exalted hour it will become visible form and this form is your work."

Friedrich's mystical doctrines are set forth with great precision of form and surface. In his meticulously painted *Abbey Graveyard Under Snow*, of 1819 (fig. 1087), the ruined Gothic choir of a monastic church near his native town of Greifswald combines with the trunks of leafless, wintry trees to define a space suggesting profound desolation. Since the shattered church had long been abandoned when Friedrich painted it, and since funerals do not take place in ruins, the procession of monks moving two by two, following a coffin through the portal in the snow, is clearly intended as a visionary evocation of the vanished past. The intensity of the mood and the clarity of the surface rendering foreshadow aspects of Surrealism in the twentieth century (see below, Chapter Eight). Unfortunately, this painting was destroyed during World War II.

1087

Romantic art in England lacked the ideological impetus of the Revolution and the Napoleonic wars, and like much of English Romantic poetry was highly personal. The strangest figure of the period was WILLIAM BLAKE (1757–1827), a visionary poet and painter, who was vehemently opposed both to Reynolds and to the teaching of the Academy. Trained in a severe Classical style by drawing from plaster casts of ancient art, and influenced deeply by the art of Michelangelo he knew only from engravings, he was also familiar with medieval churches and steeped himself in the Bible, in Dante, and in Milton. In addition to his own mystical poems, which he illustrated himself, he created an amazing series of illustrations of his favorite literary works both in engravings, which he hand-tinted, and in watercolors, marked by surprising distortions of anatomical reality and by strong abstract movement of form and color. In his *Circle of the Lustful* (fig. 1088), of 1824–27, Blake illustrates Canto V of Dante's *Inferno*, in which Virgil shows the poet a whirlwind carrying lovers from the past who had abandoned reason for a life of passion and are doomed to be swept along by the tempest for eternity without rest. At Dante's request Virgil beckons nearer Paolo and Francesca, and as they tell their story of guilty love, and as their first kiss appears above in a vision, Dante falls in a swoon. Blake's startling simplifications of the human form derive from its subjection to mystical forces, in this case the mighty spiral that heaves the various lovers up and around in the foreground and off into the distance. A strong believer in genius as a Godgiven force within the artist, Blake is often cited as a precursor of certain aspects of twentieth-century art; Kokoschka, for example, may have known this watercolor when he painted *Bride of the Wind* (see fig. 1177).

CONSTABLE The mainstream of English painting in the first half of the nineteenth century was landscape; Constable and Turner, the greatest of the landscapists, approached nature with an excitement akin to that of the poets Wordsworth, Keats, and Shelley. It is not beside the point that nature itself was beginning to be swallowed up by the expanding cities of

Painting in England

1088. WILLIAM BLAKE. *Circle of the Lustful*, illustration for Dante's *Inferno*. 1824–27. Ink and watercolor on paper. Birmingham Museums and Art Gallery, Birmingham, England

1089. JOHN CONSTABLE. *The Hay Wain*. 1821. Oil on canvas, 50½ × 73". National Gallery, London

the Industrial Revolution, then in full swing. The effects of that transformation were lamented by Oliver Goldsmith in his *The Deserted Village* in 1770, and William Blake had deplored the "dark Satanic mills." John Constable (1776–1837), son of a miller on the River Stour in Suffolk, celebrated all that was natural and traditional, including the age-old occupations of farmer, miller, and carpenter, close to the land whose fruits and forces they turned to human use. As we have seen (page 775), he loved the poetic landscapes of Gainsborough, but he also studied the constructed compositions of the Baroque, especially those of Claude Lorrain, then considered the standard for all landscape painting, and of Ruisdael, whose skies he particularly admired (see figs. 939, 978). Rebelling against the brown tonality then fashionable in landscape painting—actually the result of discolored varnish darkening the Old Masters—he supplemented his observations of nature with a study of the vivacity of Rubens's color and brushwork (see fig. 963).

As early as 1802, Constable had started to record the fugitive aspects of the sky in rapid oil sketches made outdoors, the earliest series of outdoor paintings of which we have any record. "It will be difficult to name a class of landscape in which sky is not the keynote, the standard of scale, and the chief organ of sentiment," he wrote. His systematic studies of cloud formations, done in 1821–22, were influenced by the scientific research on cloud types and formations conducted by the contemporary Englishman Luke Howard. But even more important than their devotion to actual appearances, Constable's studies show an abandonment to the forces of nature, a passionate self-identification with sunlight, wind, moisture, and light. One is reminded of Shelley's invocation to the west wind, "Make me thy lyre, even as the forest is. . . ." Constable allowed nature to play upon his sensibilities as on an instrument. At first, he made dutiful sketching tours through regions of acknowledged scenic beauty (he never left England), but before long came to the conclusion that "it is the business of the painter . . . to make something of nothing, in attempting which he must almost of necessity become poetical." He

1089

1090

1091

returned to the quiet landscape of his native Stour Valley with a special delight. "The sound of water escaping from mill-dams, etc.," he wrote, "willows, old rotten planks, slimy posts, and brickwork—I love such things."

His superb *The Hay Wain* (fig. 1089) of 1821 sums up his ideals and his achievements. No longer contrived but composed as if accidentally— though on the basis of many preliminary outdoor studies—the picture, painted in the studio, shows Constable's beloved Stour with its trees, a mill, and distant fields, and all the slimy posts his heart could desire. In his orchestra of natural color the solo instrument and conductor at once is the sky. The clouds sweep by, full of a light and color not even the Dutch had ever attained, and their shadows and the sunlight dapple the field with green and gold. As the stream ripples, it mirrors now the trees, now the sky, breaking blues and greens into many separate hues, including touches of white when direct sunlight sparkles back. The trees themselves, in fact, are made up of many shades of green, set side by side, and patches of light reflect from their foliage. These white highlights were incomprehensible to many contemporary viewers, who called them "Constable's snow."

This comment is one of the first of the adverse reactions that became common in the nineteenth century on the part of a public that resented being shown what it actually saw, instead of what it had been taught by tradition and Old Masters it ought to see. Under Impressionism in the 1870s (see Chapter Four), the detachment between artist and public was to become extreme, but enough people appreciated Constable's new vision of nature that his work could be exhibited at the Royal Academy, of which he was belatedly made a member in 1829. Géricault saw and was impressed by Constable's painting during his English trip, and *The Hay Wain* was, as we have seen, triumphantly exhibited at the Salon of 1824, where Constable's broken color and free brushwork were a revelation to Delacroix. Although the later Impressionists were not directly influenced by Constable, he may be said to have set in motion a new current in French landscape art, which later culminated in the Impressionist movement.

In later life, after the death of his wife, Constable entered a period of depression in which his passionate communion with nature reaches a pitch of semimystical intensity, which competes with the visions of El Greco (see figs. 897, 899) in vibrancy and force. One of these late pictures is *Stoke-by-Nayland*, of 1836–37 (fig. 1090), a large canvas in which the distant church tower, the wagon, the plow, the horses, and the boy looking over the gate are instruments on which light plays. The symphonic breadth of the picture, and its crashing chords of color painted in a rapid technique using the flexible steel palette knife to apply the paint as much as the brush, bring to the finished painting the immediacy of the color sketch. Such pictures are equaled in earlier art only by certain landscape backgrounds in Titian (see fig. 851) or by the mystical reveries of the late Rembrandt (see fig. 993).

TURNER Constable's contemporary, Joseph Mallord William Turner (1775–1851) was like Hogarth a Londoner, and had none of Constable's mystical attachment to nature. Nor did he remain fixed in England, but for many years made frequent trips throughout the Continent, especially Germany, Switzerland, and Italy, reveling in mountain landscapes, gorgeous cities (especially Venice), and the most extreme effects of storms,

1090. JOHN CONSTABLE. *Stoke-by-Nayland*. 1836. Oil on canvas, 49½ × 66½". The Art Institute of Chicago. Mr. and Mrs. W. W. Kimball Collection

1091. JOSEPH MALLORD WILLIAM TURNER. *Ruin, Steam, and Speed*. 1844. Oil on canvas, 35¾ × 48". National Gallery, London

1092

fires, and sunsets. Once he even had himself tied to a mast during a storm at sea so that he could experience the full force of the wind, waves, and clouds swirling about him. Although he made beautiful and accurate color notes on the spot in watercolors—a traditionally English medium that he pushed to its utmost limits of luminosity—he painted his pictures in the studio in secrecy, living under an assumed name and accepting no pupils. He was the first to abandon pale brown or buff priming, still used by Constable, in favor of white, against which his brilliant color effects could sing with perfect clarity.

Turner often painted historical subjects, usually like those of Delacroix, involving violence as well as shipwrecks and conflagrations, in which the individual figures appear as scarcely more than spots in a seething tide of humanity. He liked to accompany the labels with quotations from poetry, often his own. Nonetheless, at his death a great many unfinished canvases were found that had no identifiable subject or representation at all. What he really enjoyed and painted first was the pure movement of masses of color without representational meaning, although natural forces and effects are often suggested—a kind of color music, strikingly relevant to Abstract Expressionism of the 1950s (see Chapter Nine). Shortly before the opening of an exhibition at the Royal Academy, the aging Turner would send such unfinished works, and on varnishing day paint in the details to make the pictures exhibitable to a nineteenth-century public.

The Slave Ship, of 1840 (fig. 1092), represents an incident all too common in the days of slavery, when entire human cargoes were pitched into the sea, either because of epidemics or to avoid arrest. The ship itself, the occasional figures, and the fish feasting on the corpses in the foreground were obviously painted at great speed only after the real work, the movement of fiery waves of red, brown, gold, and cream, had been brought to completion.

1092. JOSEPH MALLORD WILLIAM TURNER. *The Slave Ship*. 1840. Oil on canvas, 35¾ × 48″. Museum of Fine Arts, Boston. Henry Lillie Pierce Fund (Purchase)

1093. JOHN NASH. Royal Pavilion, Brighton, England. Remodeling begun 1815

1094. SIR CHARLES BARRY and A. WELBY PUGIN. Houses of Parliament, London. 1836–c. 1860

Rain, Steam, and Speed, of 1844 (fig. 1091), is one of the very first paintings of a railway train, and its Romantic idealization of "progress"—man conquering nature by utilizing its forces—should be compared with the more objective, visual approach of Monet in 1874 (see fig. 1121). The train with its lighted carriages (preceded by a speeding rabbit, impossible to see in the illustration) moving across the high bridge is enough of a subject already, but Turner lifts it to an almost unearthly realm in which insubstantial forces play through endless space. The veils of blue and gold are the real subject of the picture, and it was Turner's heightened and liberated color sense that proved as much of a revelation to those Impressionists (especially Monet) who took refuge in London in 1870 as had Constable's *The Hay Wain* to Delacroix nearly half a century before.

Architecture

Like Romantic sculpture, the architecture of the Romantic movement is often of uncertain and irregular quality, yet it can be extremely successful in its picturesqueness; like Romantic painting, Romantic architecture seeks above all to establish a mood. Some architects entrusted with Romantic schemes had already carried out major Neoclassical projects. John Nash, for instance, the architect of Park Crescent (see fig. 1058) in 1812, was asked in 1815 to begin the remodeling and enlargement of the Royal Pavilion at Brighton (fig. 1093), a pleasure dome for the prince regent, later George IV, with forms imitated from Islamic architecture in India. This kind of thing is a lineal descendant of the Chinese pagodas that often rose in eighteenth-century gardens, but it is one of the earliest instances of a pseudo-Oriental building intended for habitation. The interiors are derived from a variety of sources—Greek, Egyptian, and Chinese—but the exterior with its tracery and onion domes, and its chimneys masquerading as minarets, is a delightful bit of Oriental fantasy, whose changing forms and surfaces are calculated for the soft sea light of Brighton.

To the English, Gothic architecture was an indigenous style (notwithstanding its French origin), and it is hardly accidental that Gothic was adopted for the Houses of Parliament, begun in 1836 and completed only after 1860. The immense structure adjoins the older, truly Gothic Westminster Hall, and from many points of view can be seen together with the Gothic Westminster Abbey. Two architects of diverse tastes, SIR CHARLES BARRY (1795–1860), a Neoclassicist, and A. WELBY PUGIN (1812–

52), a Gothic revivalist, collaborated on the design. At first sight (fig. 1094) Gothic irregularity seems to predominate, especially in view of the asymmetrical placing of the major towers, but it soon becomes apparent that in Barry's plan around a central octagon, and especially the handling of the masses along the river front, the building is as symmetrical as any Renaissance or Baroque palace. In its linearity and abundance Pugin's detail is derived from the Perpendicular, especially such monuments as Gloucester Cathedral and Henry VII's Chapel.

Although in England the Gothic style could be used for anything from public buildings to distilleries and sewage plants, in France it appeared suitable only for churches, often built in imitation of High Gothic cathedrals. For other structures classicism continued well into the nineteenth century, gradually modified by a revival of the French Renaissance. The city of Paris itself is the triumphant result of this revival. Napoleon I had designed a system of avenues radiating outward from the Arc de Triomphe de l'Étoile, and connected this monument to imperial glory with the Louvre by a prolongation of the Champs Élysées, so that artillery could, if necessary, rake a considerable area of the city. His nephew Napoleon III (reigned 1852–71) employed the engineer GEORGES EUGÈNE BARON HAUSSMANN (1809–91) to interconnect these radiating avenues with new boulevards in order to ring the city after the destruction of the medieval walls, and with new broad avenues cut through older quarters. This network of stately thoroughfares was bordered by trees and lined with limestone façades whose design, while not absolutely uniform, was controlled in the interests of consistency, and imposed upon owners and builders alike. Generally, the houses consisted of six stories; the first was occupied by shops, the second and third were united by pilasters delicately projected like those of Lescot's Square Court of the Louvre (see fig. 881), the fourth above the entablature remained plain like a Renaissance attic story, and the fifth and sixth were tucked into a towering, bulbous roof known as a mansard (after the architect François Mansart; see page 716). The regulations prevented the construction of buildings of any great individuality, but created a homogeneous urban picture unequaled in known history, which remained intact until the tragic depredations under the Pompidou regime in the 1970s. The long avenues and gently curving boulevards provided airy, luminous vistas extremely important for the Impressionists, who found in them a new and vital subject for their paintings (see figs. 4, 1126).

Here and there in the Haussmann plan loomed monumental structures, some preexistent, such as Notre-Dame, the Panthéon (see fig. 1012),

1095

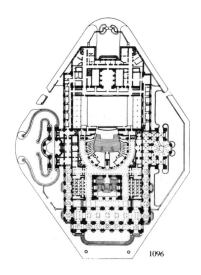

1096

and the Madeleine (see fig. 1056), some extended under Napoleon III, such as the Louvre, and some entirely new, such as the Opéra (figs. 1095, 1096), designed in 1861 by CHARLES GARNIER (1825–98) and intended as the focus of the new Paris. Actually, the structure was detested by the Empress Eugénie, who would have preferred a less ostentatious building, but it epitomized the taste of the new industrial bourgeoisie who had supported King Louis Philippe, become stronger yet under Napoleon III, and dominated the Third Republic (1871–1940); it was completed only in 1875, four years after the collapse of Napoleon III and his Second Empire. With its giant order of coupled Corinthian columns supported by an arcade and connecting two terminal pavilions, the façade is clearly derived from the twin palaces by Gabriel on the Place de la Concorde (see fig. 1014), but immensely enriched with sculptural ornament (including Carpeaux's *The Dance*; see fig. 1086). The low bulbous dome with its sculptured lantern and the allegorical groups imitated from Classical Victories create a rich, neobaroque profile sharply different from the compact masses favored by eighteenth-century classicism.

The barely tolerable splendor of the exterior becomes offensive to modern eyes in the Grand Staircase (fig. 1097), a grandiose setting for the display of wealth and luxury, which encloses approximately as much space as the auditorium itself. With its cascading flights of steps, ponderous sculptural decorations—including even the light fixtures (intended for gaslight)—and veined marble columns, the Grand Staircase is the swan song of neobaroque magnificence, the kind of aberration against which architects in that very period were beginning to react (see figs. 1111, 1112), later to be jettisoned entirely by the progressive designers of the late nineteenth and twentieth centuries. It is, however, the direct ancestor of many pompous buildings throughout the world, including the movie palaces that rose in cities everywhere in the 1920s and 1930s to gratify a different sort of collective fantasy. To be understood, the Grand Staircase, like the Hall of Mirrors at Versailles, must be peopled in our imagination with the classes for whom it was intended—men in black tailcoats and women in gorgeous fabrics, bustles, and trains, representing the old nobility; the new Bonapartist aristocracy; the industrialists; and, surprisingly enough, a wholly new class of prosperous courtesans that battened on all three.

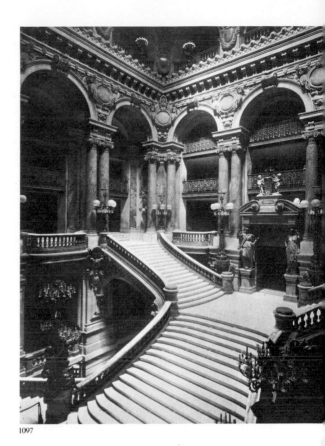
1097

The Romantic attitude toward life and experience, however gratifying as a liberation from the shackles of Neoclassicism, could not continue forever in full force. Eventually it became a pose, adopted by artists in whatever medium who also wanted to escape from the always more stultifying conventionality of nineteenth-century bourgeois society. The far away, the long ago, the strange, the new will always appeal to adventurous spirits. Romanticism, therefore, had innumerable children among the artistic movements of the later nineteenth and twentieth centuries. The Romanticists opened up a whole new world of sources in medieval and even non-European art, at first sternly excluded by the Neoclassicists. Moreover, the Romantic exploration of the nature and resources of color led directly to the most startling discoveries of Impressionism.

1095. CHARLES GARNIER. Opéra, Paris. 1861–75

1096. CHARLES GARNIER. Plan of the Opéra, Paris

1097. CHARLES GARNIER. Grand Staircase, Opéra, Paris

CHAPTER

REALISM

THREE

While the battle between the Neoclassicists and the Romanticists was reaching its height, a third group of artists was at work, inconspicuously at first—then more and more vocally—for whom the struggle had no meaning; for them, both sides were wide of the mark. The term *Realism*, applied to the new movement only in the 1840s and grudgingly accepted by its protagonists, can be extended to cover its beginnings two decades or more earlier. For the entire group, history had no artistic importance. Courbet, its most powerful champion, declared that Realism was a "human conclusion which awakened the very forces of man against paganism, Greco-Roman art, the Renaissance, Catholicism, and the gods and demigods, in short against the conventional ideal." The Realist revolt was even directed against the rendering of any contemporary events, military or political, in which the artist had not actually taken part.

To the Realists the only worthy forebears were the Dutch and Flemish naturalists of the seventeenth century, the study of whom was led by one of the principal apologists of Realism, Théophile Thoré (1807–69), who may be said to have rediscovered Vermeer. In 1850 Champfleury (Jules Fleury-Husson, 1821–89), another theorist of the movement, wrote the first appreciation of the Le Nain brothers, expanded into a book in 1862, *Les peintres de la réalité sous Louis XIII: Les frères Le Nain.* Soon critics began to reevaluate earlier naturalists—some of the neglected Venetian minor painters, for example—and the great Netherlandish and Italian masters of the fifteenth century. Chardin and other eighteenth-century naturalists were at last fully understood.

It is hardly surprising that most of the Realists were staunch republicans, dedicated along with their literary friends to the establishment of a new social order founded on justice for the working class. Artists, politicians, economists, critics, and philosophers met and exchanged ideas in the Andler Keller, a Parisian *brasserie* (a type of restaurant serving food at all hours, characteristically washed down with beer), which became known as the "temple of Realism." Significantly enough, the Realists ran afoul of organized authority. Courbet's paintings were refused by the director of the imperial museums, Count Nieuwer-kerke, at the Universal Exposition of 1855, and eventually the split between progressive artists and conservative power became so great that in 1863 a Salon des Refusés was organized, which exhibited the works of those who are now recognized as the best painters of the period. As a consequence of their participation in social movements, two of the greatest Realist masters, Daumier and Courbet, were actually forced to serve prison sentences.

The break between new and accepted art, which seems to have been heralded in the seventeenth century by the refusal of two of Caravaggio's paintings by the patrons who had commissioned them, and by the declining material success of the late Rembrandt, reached crisis stage in the mid-nineteenth century. From our present vantage point it is a little hard to understand why, for to twentieth-century eyes

Realist painting looks eminently conservative. On leaving a gallery devoted to Neoclassicism and Romanticism, one is instantly aware of a lowering of the general tonality of color, as well as of action and emotion, in Realist painting. For the Realists the brightly tinted linear constructions of Ingres and the rich chromatic fantasies of Delacroix were equally luxurious, even self-indulgent. One had to begin again, with the sensations of actual existence, the brown of the earth, the blue of the sky, the green of foliage, the gray of stone, the drab colors of everyday garments. This resolute, almost puritanical concentration on fact instead of fancy was a shock to Parisians, and by no means universally accepted. They preferred not only the work of Ingres, Delacroix, and their followers, but also meticulously painted storytelling pictures, which won prizes at the annual Salon and membership in the Academy for their painters by cheapening the ideas of both Neoclassicists and Romanticists. Determined attempts have been made in recent years by self-styled "revisionists" to reinstate the works of these official painters—Couture, Gérôme, Bouguereau, Meissonnier, Bastien-Lepage, to mention only a few, and even their imitators in central and eastern Europe—in spite of their aesthetic dullness and emotional triviality, not to speak of the role of the official painters themselves as implacable opponents of every fresh idea. Such artists could be included in a book like this only at the sacrifice of far more significant and creative personalities from the nineteenth and other centuries. The present public reaction to revisionism has been striking. Galleries in American museums newly hung with nineteenth-century reactionary art are almost empty of visitors, who throng instead to those devoted to the once-despised innovators treated in this and the following chapters.

Despite official condemnation of the Realists, many critics, notably the poet Baudelaire, found something deeply satisfying in the solidity of these matter-of-fact painters, who could and did discover poetry and even drama of a high order in the prosaic phenomena of existence as revealed by sight. Their concentration on visual reality, moreover, was to stimulate the Impressionists, all of whom began as Realists and continued to call themselves such in their revolutionary exploration of the perception of light.

For it was light that concerned the nineteenth century most intensely, in art and life. New methods of illumination, first by kerosene lamps, then by gas, and finally by electricity, irradiated homes and banished night from the streets. For the first time pictures created by light and light alone could be made permanent: The moment of the action of light on a sensitive surface—whether the human retina or a piece of metal, glass, or paper—was revealed as the source of knowledge about reality, confirming and raising to a higher power the investigations of such Renaissance pioneers as Alberti, Ghiberti, and Leonardo. The interrelations between photography and the other arts, important as they are, yield before the fact that in the amazing nineteenth century all the progressive arts including architecture moved in the same direction, with or without knowledge of each other, toward the understanding and exploitation of natural light. Unexpectedly, the rapid development and spread of photography meant that for the first time the great art of past and present in whatever country was universally accessible, in photographic monochrome translation, without the intervention of any engraver.

"Since its invention scarcely more than a century and a half ago, photography has become not only a phenomenal technical means of communication and visual expression, but unquestionably the world's most powerful image-making system. Considering its brief history, the quick growth and universal acceptance of photography have been astonishing. No one alive today, save perhaps in a handful of remote mountainous, oceanic, or jungle areas, can escape the media of illustrated publication and television, and thus photography has provided the form in which our view of the world and of ourselves is inevitably cast" (Gene Markowski, *The Art of Photography: Image and Illusion*, 1984, p. vii). As its title indicates, this book cannot accord photography the full treatment as an independent art which its importance demands, but these words of Gene Markowski show vividly why we must consider photography and photographers, however briefly, to gain an understanding of nineteenth- and twentieth-century art.

The idea of photography was not new. As we have seen, it had been known for centuries that light passing through a small aperture registers an image of objects upon any surface it may strike. Such devices as the camera obscura by which this image could be carefully controlled (see page 748) were used by many artists in the sixteenth, seventeenth, and eighteenth centuries, especially Vermeer, though academically minded painters like Sir Joshua Reynolds warned against reliance on such mechanical aids at the expense of ideal concepts. But as long as an image required the intervention of a mechanical device before it could be seen at all, and changed or perished altogether as objects moved or light waned, its usefulness was limited. During the eighteenth century scientists endeavored to sensitize by means of chemicals various surfaces to arrest the action of light after the image had been projected upon them, but not until the 1820s with the experiments of the French chemist Nicéphore Niépce (1765–1833) did the process begin to succeed. In 1826 Niépce made the first surviving photograph, a dim and hazy view of the courtyard outside his home, on polished pewter. The exposure took eight hours—a length of time too great for portraiture, and during which shadows could change totally. Dissatisfied, Niépce enlisted the collaboration of Louis-J.-M. Daguerre (1789–1851); Daguerre was a scenic artist, skilled in the elaborate construction of pictorial sets and systems of illumination for the Paris Opéra, and of dioramas, which entertained the public with gigantic moving views of cities and historical scenes.

After Niépce's death Daguerre perfected the new process using a plate of copper coated with silver, which was sensitized chemically in darkness, then inserted into a camera obscura provided with a focused lens, exposed to light, and again treated in chemical baths first to develop the image and then fix it—a procedure whose basic steps are familiar to professional and amateur photographers today. The result was an image of a degree of detail not achieved since early Netherlandish painting—silvery, shimmering, and soft brown in tone; moreover, exposure time was reduced to between ten and fifteen minutes. However, three problems remained: the daguerreotype (as its inventor called it) was unique, unless rephotographed; it was reversed, since it was, after all, a mirror image; and it could be seen only in the right light, otherwise it reflected. On August 7, 1839, the new procedure of photography was described to the French Academy of Sciences, and took the world by storm. Before the year was out the directions had been translated into all Western languages. Daguerreotypes were soon made by the hundreds of thousands, cheaply enough for most to afford, on copper plates, one-fourth the orig-

inal size, in closable composition cases. The first photo-portrait was made by Samuel F. B. Morse, inventor of the telegraph. The sitter had to be anchored to a rigid, hidden frame, and since bright sun was a requisite, the eyes had to be closed and were often painted in later. The earliest known photograph of a human being, taken by Daguerre in 1839 (fig. 1098), shows a Paris boulevard which at the time, according to Morse, was crowded with people and horse-drawn vehicles. Knowing this makes the picture a bit uncanny since all have disappeared. The only person who stood still long enough for his image to register was a man having his shoes shined—of all prosaic activities to be the first ever permanently recorded by light! Rapidly the necessary exposure times were reduced to as little as thirty seconds in bright sun.

The possibilities of the new discovery were enormous. Painters were afraid their art was doomed (and indeed the art of painting miniature portraits really did disappear as a direct result of photography) yet they used photographs consistently as short cuts for the painted portraits that were their bread and butter. Now the innumerable sittings could be reduced to just those required to assure the correctness of the coloring. Ingres objected vigorously to the photograph as an art form, but could not get away from its usefulness. His portrait of the *Comtesse d'Haussonville* (see fig. 1065), painted just six years after the announcement of the new procedure, was surely based on daguerreotypes, whose influence is apparent in the silvery precision of the painter's style. Delacroix welcomed photography as a way of fixing hard-to-hold poses and used it consistently in his later work; he also accepted photography as an independent art.

At the same time Daguerre was making his first experiments, the Englishman William Henry Fox Talbot (1800–77) was devising another process called calotypy, which involved paper negatives and paper prints, and he announced it the same month. Calotypes were a little blurred as compared to daguerreotypes, but innumerable prints could be made from the negatives, their image was not reversed, and they could be viewed in any light. An even more successful improvement was the collodion or "wet-plate" process invented by the sculptor and photographer Frederick Scott Archer, who published his discovery in 1851. At last the print could be almost as precise as a daguerreotype and the negative could be made much faster. An immense amount of equipment was required for wet-

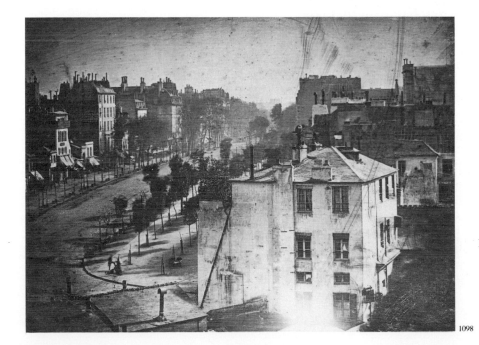

1098. LOUIS-J.-M. DAGUERRE. *Paris Boulevard.* 1839. Daguerreotype (original destroyed). Bayerisches Nationalmuseum, Munich

1098

plate photography, but clearly both daguerreotype and calotype were doomed. Archer's process flourished for the next thirty years, until the invention of the gelatine-coated dry plate. By 1858 instantaneous photography was an assured fact, and photographers were able to prove at last how living beings really look in motion, to the great discomfiture of artists in the classic tradition with their contrived poses.

The great master of wet-plate portraiture was Gaspard-Félix Tournachon (1820–1910), a French caricaturist and novelist who went by the pseudonym of Nadar. Almost immediately after its invention Nadar proved himself a master of the new art, exploiting its possibilities from every conceivable direction, including up (he invented aerial photography, from balloons). Nadar's Paris studio became a meeting place for all the intellectual and artistic figures of mid-nineteenth-century Paris, a much wider circle than that of the Andler Keller. His portraits of painters, writers, composers, and scientists are not mere documents like those of Daguerre but works of art—so conceived, posed, and lighted as to bring out the full psychological and spiritual depth of a sitter without the aid of any of the props common in nineteenth-century photography studios. For prototypes one can think only of the searching portraits of Raphael and Rembrandt. It does not matter that Nadar had no painting or drawing instrument in his hand—neither does an actor, but what he creates is art. According to Eugène de Mirecourt, a contemporary of Ingres, as early as 1855 the great Neoclassicist sent all his sitters to Nadar first, and then worked from the photographs. Nadar's *Portrait of George Sand*, made in 1870 (fig. 1099), shows the photographer at his grandest. The Romantic novelist who shocked conventional France by daring to live as freely as all men of her class (she was actually the Baroness Dudevant; like many women writers in the nineteenth century she took a pen name) appears at the age of sixty-six. A white streak is visible in the part of her dyed hair, and was not retouched. The pose, the sculptural folds of her dress, and the lighting are so arranged as to suggest all the richness of her emotional life, as if she were looking back nostalgically on the vanished loves of her youth.

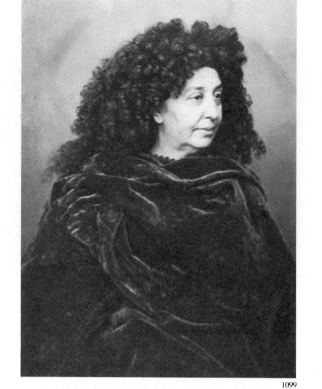

1099

COROT Conceived in total isolation from the earliest photographic experiments, yet mysteriously parallel to them, the new objective style becomes apparent first in the quiet early landscapes of Jean-Baptiste-Camille Corot (1796–1875). Son of a moderately prosperous businessman, Corot was enabled by a paternal allowance to leave business for the study of painting at the unusually late age of twenty-six. After three years of study, he made his first trip to Italy in 1825, remaining until 1828. It is typical of his attitude toward Italian art that not until his third visit to Italy in 1843 did he pay what he termed a "courtesy call" on the Sistine Chapel. What interested him was not the long Italian artistic tradition from the ancient world, the Middle Ages, the Renaissance, and the Baroque, but the harmony of man and nature in the Italian landscape and the beauty of Italian light, which erases differences of time and unifies all objects, natural or man-made, in the serenity of vision.

Although he occasionally painted pictures on religious or mythological themes for exhibition at the Salon or on commission, the figures in these paintings are usually quite small, and the artist's primary concern is the landscape. Corot's little landscape studies done out of doors, like the contemporary oil sketches of Constable, were sometimes used as themes for larger, finished works painted in the studio; in the twentieth century

Painting in France

1099. GASPARD-FÉLIX TOURNACHON (NADAR). *Portrait of George Sand*. 1870. Photograph. The George Eastman House, Rochester, New York

1100

1101

these studies are valued for their own sake, as tiny miracles of color, form, and light. In fact not since Piero della Francesca (see figs. 712–15), whose work Corot probably never saw, had form been so beautifully constructed through the play of light. Looking at such a masterpiece as the *Island of San Bartolomeo*, of 1825 (fig. 1100), it is hard to believe that Corot had only begun to paint three years before. No matter what their age or historical importance, the buildings and bridges of Rome were to him cubes bounded by planes, revealed by delicate changes of hue and value. Corot claimed that he could distinguish no fewer than twenty gradations between pure white and black, but in his landscape restricts himself generally to the upper and middle ranges; there are seldom any deep shadows. Pearly tones of blue-gray, blue, tan, and rose establish the existence of forms in clear Italian air, and prolong them in reflections on the surface of the river, disturbed only here and there by ripples. It is typical of Corot's detachment that in these early cityscapes not a human or animal can be seen—again mysteriously, as in early depopulated photographs. The timelessness of these meditations on form and light anticipates in many ways the art of Cézanne toward the close of the nineteenth century (see Chapter Five) and that of the Cubists in the early twentieth (see Chapter Seven).

Corot's keen powers of visual analysis reached their fullest expression in his *Chartres Cathedral*, of 1830 (fig. 1101). In spite of the fact that this study was painted during a visit to Chartres in company with the architect P. A. Poirot, Corot quietly suppressed architectural detail and softened the historical differences between the two towers in favor of a unity of broad planes building up masses. He even played off the unequal shapes of the Early Gothic south tower and Flamboyant north tower as reverse, man-made counterparts of the two unequal saplings in the foreground in a reciprocal system of interlocking diagonals in depth. He is reported to have said that the secret of landscape painting lay in knowing where to sit down; certainly, the success of his calm and unedited transcriptions of the essential forms in buildings and in nature depends in large measure on his selection of a perfect point of view. The painting was retouched by the artist in 1872; very likely the quiet figures were added at that time.

Although toward the end of his career Corot returned to the objectivity of his early work, in middle life he took to painting dreamy landscapes

1100. JEAN-BAPTISTE-CAMILLE COROT. *Island of San Bartolomeo*. 1825. Oil on canvas, 10½ × 17". Museum of Fine Arts, Boston. Harriet Otis Cruft Fund (Purchase)

1101. JEAN-BAPTISTE-CAMILLE COROT. *Chartres Cathedral*. 1830. Oil on canvas, 25⅝ × 19⅝". The Louvre, Paris. Moreau-Nélaton Collection

1103

in the studio either from memory or imagination. He had a house at Ville d'Avray, a hamlet on the edge of the forest of Fontainebleau, where a group of Realist landscape painters worked, with whose sober productions these lyrical canvases have remarkably little in common. The soft, silvery light of Corot's woodland studies, such as his *Ville d'Avray* (fig. 1102), is broken by fugitive touches indicating foliage, in reminiscence of the technique of Constable. The Impressionists found these later landscapes lacking in devotion to reality, and twentieth-century critics have generally preferred the cubic forms of Corot's earlier work. But the landscapes were immensely popular and widely imitated—even forged—in Corot's own time. Their velvety gray and olive tones, suggesting layers of space seen through superimposed films of light and shade, are very beautiful; so, indeed, is their unique personal poetry. A frequent visitor to Nadar's studio, Corot experimented with photographic procedures in making his engravings, and was surely influenced by photography in the nearly monochromatic and soft-focus landscapes of his later years.

MILLET Another painter who settled in the forest of Fontainebleau, at the village of Barbizon, and was not likely to be found among the Realists of the Andler Keller, was Jean François Millet (1814–75). Born in Normandy of a peasant family, he preferred to live like a peasant, with his family of fourteen children, dedicating his life to the painting of peasants in whose attachment to the soil he found a religious quality. Generally, before his time peasants had been portrayed as stupid or even ridiculous, even when Bruegel (see figs. 890, 892) permitted them to exemplify the blind forces of nature. Millet saw them as pious actors in a divinely ordained drama—a Catholic counterpart to the dominant role peasants and workers were assuming at that very moment in the thought of Karl Marx, who would have had little but contempt for Millet's peasants' acceptance of their humble lot. Millet invests the solitary figure in his *Sower*, of about 1850 (fig. 1103), with a Michelangelesque grandeur as he strides over the plowed land, and the broad strokes of rich pigment emulate Rembrandt.

1102. JEAN-BAPTISTE-CAMILLE COROT. *Ville d'Avray*. 1870. Oil on canvas, 21⅝ × 31½". The Metropolitan Museum of Art, New York. Bequest of Catherine Lorillard Wolfe, 1887

1103. JEAN FRANÇOIS MILLET. *Sower*. c. 1850. Oil on canvas, 40 × 32½". Museum of Fine Arts, Boston. Shaw Collection

1104. HONORÉ DAUMIER. *Rue Transnonain, April 15, 1834*. 1834. Lithograph. Bibliothèque Nationale, Paris

1105. HONORÉ DAUMIER. *Uprising*. c. 1860. Oil on canvas, 34½ × 44½". The Phillips Collection, Washington, D.C.

DAUMIER The earthiest of the Realists who met in the Andler Keller and in Nadar's studio was Honoré Daumier (1808–79), known to most Parisians of his day solely as a caricaturist. He worked in the lithograph technique, which involved drawing on porous stone with a fatty pencil; it could be printed easily in large numbers along with blocks of type, which made it ideal for newspaper illustration. Both Géricault and Delacroix had made lithographs, but Daumier poured out more than four thousand of them in the course of some thirty years for such satirical weeklies as *Caricature* and *Charivari*. He was one of the most brilliant and devastating caricaturists who ever lived, satirizing unmercifully the Royalists, the Bonapartists, politicians in general, and lawyers in particular, and mocking somewhat more indulgently the foibles of the bourgeois class on whom the shifting governments of nineteenth-century France depended for their support. He was imprisoned for six months in 1832 for a caricature of King Louis Philippe. Even after his imprisonment, Daumier continued his attacks. One of his most powerful lithographs (fig. 1104), called simply *Rue Transnonain, April 15, 1834*, depicts an incident during the insurrection of that month in which all the inhabitants of a working-class house were butchered in reprisal for shots fired at a soldier. The masterly sculptural rendering of the figure, the powerful foreshortening, and light and shade are in the tradition of Géricault, but the intense pathos is Daumier's own.

After the suppression of *Caricature* in 1835, he turned to social satire, and after the revolution of 1848 he took up painting in earnest and largely in secret. He developed a style at once individual, simple and powerful, and surprisingly spontaneous when compared to the precision of the early lithographs. His *Uprising*, of about 1860 (fig. 1105), depicts no single incident from any one of the many insurrections that rocked Paris in the nineteenth century but is rather a personification of the working class in a roughly dressed and single-minded young hero, who gathers old and young about him in a march through the grim streets. Suggestion works wonders; instead of depicting scores of individuals, as in the massive crowd scenes of the Romanticists, Daumier sketches in only a few heads, just as he hints at hundreds of windows with a touch of dark here and there. Yet the walls tower in shadow and light, and the crowd pushes forward, seemingly irresistible in its collective might. Although Daumier's technique is deliberately rough when compared to the precision of the earlier lithographs, his heavy impastos convey both the mass and the tension of the figures.

1105

In spite of the fact that he knew Michelangelo's paintings only from engravings, Daumier managed to invest his working people with the grandeur of the Sistine prophets and sibyls (see fig. 797). His *Third-Class Carriage*, of about 1862 (fig. 1106), is the earliest known painting to be concerned with the effect of a modern conveyance on human beings (as distinguished from Turner's hymn to modernity in *Rain, Steam, and Speed*; fig. 1091). Ordinary people of both sexes and all ages are brought together physically yet remain spiritually isolated in the cramped interior, which Daumier has painted in Rembrandtesque light and shade. The massive figures are indicated with quick and summary contours even freer than those of the late Delacroix. Not until 1878, a year before Daumier's death, when increasing blindness had forced him to give up painting, did he receive his first one-man show—organized for him by artist friends—bringing him at long last recognition as a great painter.

COURBET The most aggressive, even noisy apostle of the new school, as well as the most influential habitué of the Andler Keller, was Gustave Courbet (1819–77). Born in the bleak village of Ornans in the mountainous Jura region of eastern France, he came to Paris determined to create a lasting effect on the art of the capital, not only through his devotion to concrete reality but also through his study of the art of the past, which he hoped would place his own in the tradition of the museums. In both respects he reminds us of Caravaggio (see pages 694–97), equally truculent in his insistence on reality and respectful toward those aspects of the past he found relevant to his own art. Like Daumier, Courbet was a strong republican and champion of working-class rights and ideas. A friend and disciple of the Socialist writer Pierre Joseph Proudhon, Courbet wanted his art to embody his ideas concerning society. At the start, at least, he was completely consistent. "The art of painting should consist only in the representation of objects which the artist can see and touch . . ." he declared; "I hold that the artists of a century are completely incapable of reproducing the things of a preceding or a future century. . . . It is for this reason that I reject history painting when applied to the past. History painting is essentially contemporary."

1106. HONORÉ DAUMIER. *Third-Class Carriage*.
c. 1862. Oil on canvas, 25¾ × 35½". The Metropolitan Museum of Art, New York. Bequest of Mrs. H. O. Havemeyer, 1929. The H. O. Havemeyer Collection

1107. GUSTAVE COURBET. *The Stone Breakers*.
1849. Oil on canvas, 5'3" × 8'6". Formerly Gemäldegalerie, Dresden (destroyed 1945)

His paintings, therefore, are wholly concerned with events of his own time. *The Stone Breakers*, of 1849 (fig. 1107), fully embodies his artistic and social principles, and caused a scandal when it was exhibited at the Salon of 1850. A public accustomed to the grandiloquence of the Neoclassicists and the Romanticists, and the trivia of the new official art, had no way of understanding such a direct and hard study of reality. Impressed by a sight he had actually seen, Courbet depicted the dehumanizing labor of breaking stones into gravel for road repairs, undertaken calmly and anonymously—their faces are almost concealed from us—by an old man and a boy, without any of the religious overtones of Millet, yet with perfect dignity. Proudhon called it a parable from the Gospels. The simplicity of the relief-like composition is so deeply Classical as to render the *Oath of the Horatii* (see fig. 1059) empty in contrast. Yet its stern objectivity betrays Courbet's own devotion to the new art of photography, which he practiced as an amateur. The power of Courbet's compositions was matched by the workmanliness of his methods. His paint was first laid on with the palette knife, which both Rembrandt and Delacroix had used for expressive purposes; Courbet handled it as though it were a trowel and he were laying plaster on a wall. His unfinished works, done entirely in palette knife, are to twentieth-century eyes very beautiful. When the knifework was dry, he worked up the surface effects of light and color with a brush, but it is the underlying palette-knife construction that gives his figures their density and weight.

In the same Salon of 1850 he showed *A Burial at Ornans* (fig. 1109), which fulfilled exactly his requirements for true history painting. The inescapable end of an ordinary inhabitant of the village (the identity of the deceased is unknown) is represented with sober realism and a certain rough grandeur. Accompanied by altar boys and pallbearers, and women in regional costume, the parish priest reads the Office of the Dead before the open grave, around which stand family and friends, some with handkerchiefs to their eyes, and the mayor in his knee breeches and cocked hat, not to speak of the kneeling gravedigger and the perplexed dog (who always appears in illustrations of the Office of the Dead in Books of Hours) The canvas, about twenty-two feet long, was so large that the artist could not step back in his studio to see the whole work, yet it is thoroughly unified. In a great S-curve in depth, the figures stand with the simple dignity of the Apostles in Masaccio's *Tribute Money* (see fig. 697). Locked between the rocky escarpment above and the grave beneath, these people realize their destiny is bound to the earth (as securely as that of Bruegel's

1107

peasants), yet they seem in contrast to comprehend and to accept their fate. Each face is painted with all of Courbet's dignity and sculptural density, recalling the prophets of Donatello (see fig. 682), yet sometimes unexpectedly beautiful, as the face of the boy looking up in conversation with one of the pallbearers. This is one of the strongest and noblest works of all French painting.

In 1855, as we have seen, Courbet's paintings were rejected by the Universal Exposition. These works included not only the *Burial*, which had been accepted by the Salon of 1850, but also a more recent programmatic work, *The Studio: A Real Allegory Concerning Seven Years of My Artistic Life*, painted in 1854–55 (fig. 1108). Courbet's friend and patron J. L. Alfred Bruyas helped to finance the construction of a special shed for a large exhibition of Courbet's paintings, including the rejected works; the artist called this building The Pavilion of Realism. For the catalogue he wrote a preface setting forth the principles of his art. In *The Studio* the relationship between artist and sitters as seen by Velázquez and Goya (see figs. 970, 1070) is exactly reversed; instead of playing a subsidiary role at one side, painting a canvas seen only from the back, the artist displays himself in the center, at work on a completely visible landscape, similar to those that adorn the walls of the dim studio. A model who has just shed her clothes, probably representing Truth (painted from a photograph), looks on approvingly, her voluminous figure beautifully revealed in light. In spite of Courbet's lengthy explanation, the group at the left remains, perhaps deliberately, somewhat obscure, but it comprises figures drawn from "society at its best, its worst, and its average," with whom the painter had come in contact. Among the gathering of friends on the right is recognizable the poet and critic Baudelaire, reading a book. Few of the figures look at the artist; all are silent. Interestingly enough, Delacroix called the picture a masterpiece, reproaching the jury for having "refused one of the most remarkable works of our times."

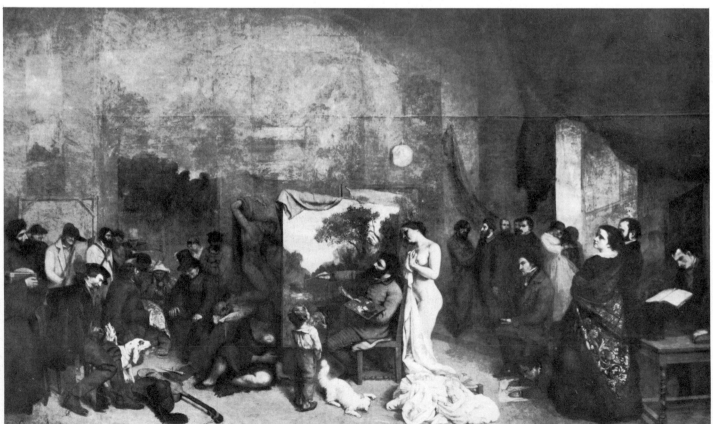

1108

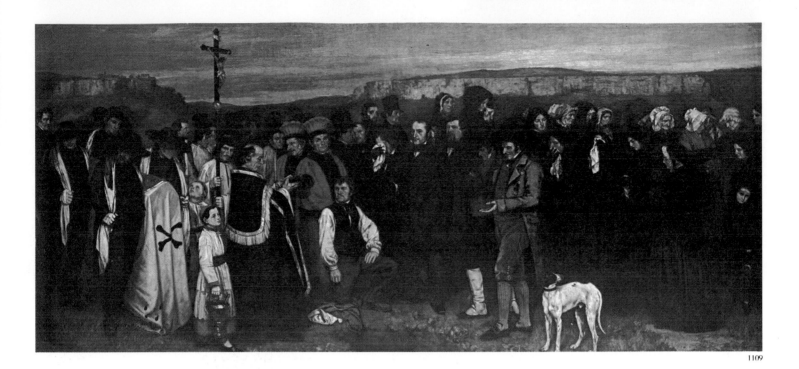

Once Courbet had won material success, however, something of the rude power of his early works vanishes from his portraits of the French aristocracy and his often provocative nudes. After the revolution of 1870 he joined the short-lived Paris Commune and took part in the commission that decreed the dismantling of the lofty Colonne Vendôme, a Napoleonic monument in central Paris. For this he was condemned under the Third Republic to six months in prison, which he spent in painting still lifes of extraordinary clarity and simplicity, and landscapes from photographs, since the real ones could not be seen from his cell. Later, he was charged a huge sum for rebuilding the monument, fled to Switzerland, and died in exile, after all his belongings had been sold by the authorities to pay the debt.

BONHEUR One of the most popular painters of the nineteenth century, by far the best of the animal artists so beloved at the time, was Rosa Bonheur (1822–99). Bonheur was too independent in life and in art to classify easily, but she is especially significant in relation to the Realist movement. She never married, lived with a female friend, smoked cigarettes (considered unladylike), cut her hair like a man, and wore trousers (for which she had to have police permission). Interested from childhood in the psychology and behavior of animals, in rendering whose fierce energy she had no rivals but the great Romantics, she had a distinct advantage over other women artists since she, at least, could study from living models. So as to gain a complete knowledge of animal anatomy she even worked in slaughterhouses, to use her own words "wading in pools of blood." Bonheur's most famous painting in America is *The Horse Fair*, of 1853–55, some thirty-three feet in length. Not only did she spend many months working with live horses, but kept photographs of Géricault's horse paintings at hand. But for her *Plowing in Nivernais* of 1849 (fig. 1110) Bonheur owed a debt to nobody. Oxen, those beasts on whose immense strength used to depend the entire rhythm of European agriculture, had never been painted with such conviction. Her two teams move diagonally forward and uphill out of the picture with a power no one

1108. GUSTAVE COURBET. *The Studio: A Real Allegory Concerning Seven Years of My Artistic Life*. 1854–55. Oil on canvas, 11'10" × 19'7¾". The Louvre, Paris

1109. GUSTAVE COURBET. *A Burial at Ornans*. 1849–50. Oil on canvas, 10'3⅜" × 21'9⅜". The Louvre, Paris

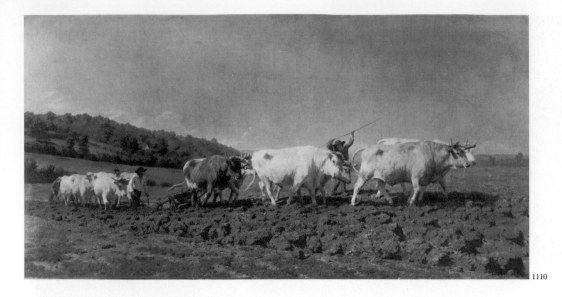

1110

who has not seen these grand animals at work can entirely appreciate. The quality of the landscape and the monumentality given to the animals and even to clods of earth relate Bonheur to Courbet and to Millet. She was made an Officer of the Legion of Honor, an award that the Empress Eugénie, then regent of France in the absence of her husband Napoleon III, came to her studio to bestow.

This is perhaps the best moment to discuss the new forms of architecture made possible by the Industrial Revolution. Metal had been used from time to time in the history of architecture as an adjunct to other materials, such as often the bronze or iron dowels in the centers of Greek columns and the iron frames used to enclose sections of stained-glass windows in Gothic cathedrals. Iron beams had even been inserted in the sixteenth century to strengthen the fragile outer walls of the Uffizi in Florence (see fig. 838). Cast iron came into use on a grand scale in England and France toward the end of the eighteenth century in bridges and for the inner structures of factories, and in the 1830s for railway stations. Almost invariably buildings using cast iron were intended for purely utilitarian purposes. A conspicuous exception was the Royal Pavilion at Brighton (see fig. 1093), whose onion domes were carried on iron frames, but when the iron was exposed in the same building in a "Chinese" staircase and in palm-tree columns in the kitchen, it was cast into shapes previously familiar from work in stone or wood. During the 1840s and 1850s, the use of cast iron became widespread, even in Gothic revival churches. The mid-nineteenth-century iron façades common in office buildings still standing in downtown New York City, and the iron dome (1850–65) of the U.S. Capitol in Washington, D.C., by Thomas U. Walter (1804–87), are outstanding examples.

An early and brilliant use of exposed iron for architectural purposes is the reading room of the Bibliothèque Sainte-Geneviève in Paris (fig. 1111), built in 1843–50 by HENRI LABROUSTE (1801–75). The exterior of the building is arched like the flanks of the Malatesta Temple (see fig. 673), but the interior is roofed by two parallel barrel vaults of iron plates, resting on iron rivets cast with a perforated vinescroll design of the greatest lightness; these are supported in the center by iron arches springing airily from slender Corinthian colonnettes, recalling the fantastic elements of pictorial architecture at Pompeii. The precast elements made it

Metal Architecture

1110. ROSA BONHEUR. *Plowing in Nivernais*. 1849. Musée National du Château de Fontainebleau

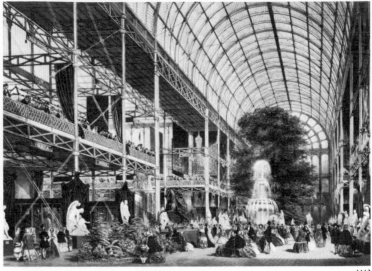

possible to assemble a large structure in comparatively short time, and seemed a great advantage to the architects of the mid-nineteenth century.

The triumph of iron architecture was the Crystal Palace (fig. 1112), built in the astonishing space of nine months in 1850–51 by Sir Joseph Paxton (1801–65), who had learned the principles of construction in iron and glass from building greenhouses. No glass-and-iron structure had ever before been put up on such a scale, however, and the airy interior with its barrel-vaulted transept and multiple galleries all of glass on an iron skeleton showing throughout was the luminous wonder of the London Great Exhibition—the first of a long procession of world's fairs. Its seemingly infinite space, pervaded by light at every point and utterly weightless, doubtless shimmering with color in a rosy glow of good weather, must have been a perfect counterpart to the paintings of Turner. A comparison with the Bibliothèque Ste.-Geneviève will show that iron has now developed an ornamental vocabulary of its own. No more colonnettes, no more vinescrolls; the elements are cast with only the lightest of surface ornament.

The rapid end of cast-iron architecture was spelled by its unsuspected vulnerability to fire. The Crystal Palace (the first of many in Dublin, New York City, and elsewhere) was reconstructed at Sydenham, south of London, in supposedly permanent shape in 1852–54, but it perished by fire in 1936. However, the utility of metal for architecture had been established, and the material was to be revived for a somewhat different constructional role, giving rise to strikingly new architectural forms after the invention of a method of making steel in 1855 by Sir Henry Bessemer.

1111. Henri Labrouste. Reading Room, Bibliothèque Ste.-Geneviève, Paris. 1843–50

1112. Sir Joseph Paxton. Interior (view of transept looking north), Crystal Palace, London. 1850–51. Cast iron and glass (Lithograph by Joseph Nash. Victoria and Albert Museum, London. Crown Copyright Reserved)

Painting in the United States

The influence of Realism spread throughout Europe. Gifted American artists arriving in France in the 1860s were deeply impressed by the work of the Barbizon painters, by Corot, and by Courbet. A formidable figure in American nineteenth-century art was Winslow Homer (1836–1910). Self-taught and active as an illustrator and documentary artist during the Civil War, he underwent the influence of Realism during a visit to France in 1866–67, at which time his early style crystallized. A typically early work is *The Croquet Game* (fig. 1113), of 1866, in which the clarity of forms and spaces and the beautiful adjustment of tones betray the influence of Corot, while the density of substance and of pigment reflects an

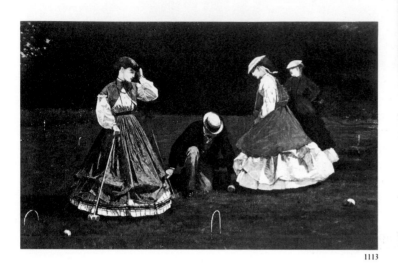

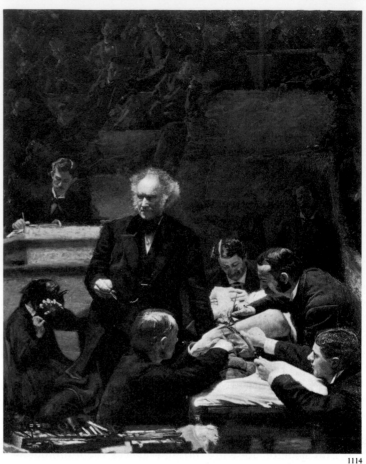

1113

1114

indebtedness to Courbet. In later life Homer developed a strongly individual style as a marine painter, in relative isolation on the Maine coast, with trips to the Caribbean.

An even more important figure, considered by many to have been America's greatest native-born artist, is THOMAS EAKINS (1844–1916). After early study at the Pennsylvania Academy, he, like Homer, visited France in 1866. He also went to Spain, where he was profoundly affected by Velázquez, and returned to America in 1870 to paint powerful works uncompromisingly founded on fact. His insistence on posing a nude male model before female students forced his resignation from the directorship of the Pennsylvania Academy, and his honest realism cost him fashionable portrait commissions. Fortunately, he enjoyed a small independent income, and was able to continue doing portraits of friends—searching psychological analyses of great depth and emotional intensity, dryly painted, without the richness of pigment in which Corot and Courbet delighted. Eakins was fascinated by the new art of photography, and used it as an aid in his researches into reality, becoming a remarkably proficient photographer himself (see Chapter Four, pages 850–51, and fig. 1128).

Eakins's masterpiece is a monumental painting called *The Gross Clinic* (fig. 1114), painted in 1875 for the Jefferson Medical College in Philadelphia, where Eakins had studied anatomy. The lifesize group represents an actual operation being performed by an eminent surgeon and his staff in an operating theater before medical students. The composition was undoubtedly influenced by Rembrandt's *Anatomy Lesson of Dr. Tulp* (see fig. 989). Like that great painting, Eakins's work deals with an inherently repulsive subject not only in a direct and analytical manner, but also with a certain reverence for the mystery of human existence. He goes far be-

1113. WINSLOW HOMER. *The Croquet Game.* 1866. Oil on canvas, 16 × 26". The Art Institute of Chicago

1114. THOMAS EAKINS. *The Gross Clinic.* 1875. Oil on canvas, 96 × 78". Jefferson Medical College, Philadelphia

1115. JOHN EVERETT MILLAIS. *Christ in the House of His Parents (The Carpenter's Shop).* 1850. Oil on canvas, 33½ × 54". The Tate Gallery, London

yond the seventeenth-century prototype in his depiction of the drama of the moment; the careful portraiture of the surgeons absorbed in their task is unforgettable, as is the compulsive gesture of the female relative of the patient, who draws her arm before her face. The noble and seemingly spontaneous grouping, enriched by strong contrasts of light and shade, is one of the most powerful pictorial compositions of the nineteenth century, worthy to be set alongside *A Burial at Ornans* (see fig. 1109).

At the same time as the Realist movement in France and the United States an independent but related revolution against official art was taking place among a group of extremely young and gifted English artists. In 1848, when the movement was founded, William Holman Hunt, its leader (1827–1910), was twenty-one years old and JOHN EVERETT MILLAIS (1829–96) only eighteen. The group included, among others, the poet-painter Dante Gabriel Rossetti and later the painter FORD MADOX BROWN (1821–93). Their title, the Pre-Raphaelite Brotherhood, was chosen because of their belief that in spite of Raphael's greatness the decline of art since his day was attributable to a misunderstanding of his principles. They did not revert to fifteenth-century Italian style but demanded a kind of precise realism in the smallest detail founded perhaps on the early Netherlandish painters but betraying inevitably the influence of the daguerreotype. Visual honesty was only the beginning; in contrast to Courbet's standpoint, the subject itself had to be important and invested with moral dignity, and the artist had to interpret it directly, as if it were happening in front of the observer, without any reference to accepted principles of composition, posing, or color. At first their name was kept secret, as in the late 1840s any "brotherhood" might suggest revolution. When made public, however, the title elicited an outcry as an insult to a universally revered master.

Millais's *Christ in the House of His Parents* (often known as *The Carpenter's Shop*; fig. 1115), exhibited at the Royal Academy in 1850, when the painter was twenty-one, was a striking example of the new style. The colors were unexpectedly bright, and the figures, based on working-class

The Pre-Raphaelites

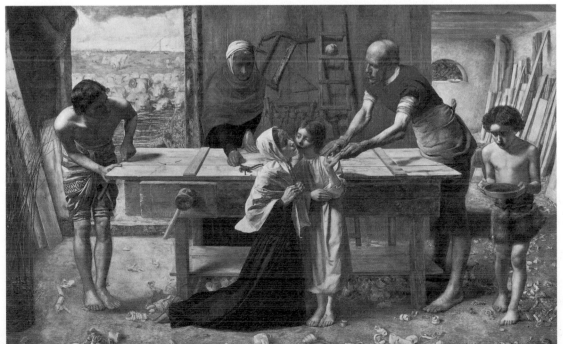
1115

models, reflected no interest in conventional beauty. The ordinary faces, particularly that of the weary Virgin Mary, brought down the denunciation of no less a figure than Charles Dickens. The work was generally regarded as blasphemous, although the intent of the artist was transparently symbolic and prophetic. Arranged in front of a foreshortened door suggesting the horizontal bar of the Cross (Christ said, "I am the door of the sheep," John 10:7), the boy Jesus, in dead center, has wounded his hand on a nail. The group of figures, despite their natural poses, is as symmetrical as any Crucifixion. A ladder, resembling the one used to take down the body from the Cross, hangs on the wall. Saint John the Baptist contemplates a bowl of water. The sheep are seen in the background. Despite all Millais's astonishing fidelity to life and to reality, one misses the deep inner knowledge of the craft of painting that ennobles the art of the great French Realists. One wonders what Courbet would have thought of this painting, or of the equally catchy *The Last of England* (fig. 1116), of 1852–55, by Ford Madox Brown. The subjects, the Pre-Raphaelite sculptor Thomas Woolner and his wife, sit at the stern of a steamer—another is seen in the background—from whose rail hangs a row of English cabbages. The young couple, whose baby is protected inside the wife's cloak so that one just sees a tiny hand, are leaving for the goldfields of Australia; their expressions appropriately solemn at the prospect of a voyage which in the days before the Suez Canal lasted months. We see them through a circle that at once suggests a favorite Renaissance form and the porthole of a vessel. By artful arrangement one of the white cliffs of the island at which the young couple gaze so mournfully is visible in the background. Their expressions contrast with the oblivion of a little girl eating an apple at the left and with the rage of a man above her, shaking his fist at an England he loves somewhat less than they. The metallic precision with which the Woolners' faces are drawn—compare them with the faces in the background—makes clear that they are based on a daguerreotype, for which presumably they posed before they sailed.

The Pre-Raphaelites' position of transcendent honesty and moral dignity was perhaps too rigid to be maintained indefinitely. Although they were all long-lived, their styles changed eventually, and not always for the better. By the 1880s the movement had been transformed into a new mixture of medievalism and aestheticism in which the original purity of purpose was lost.

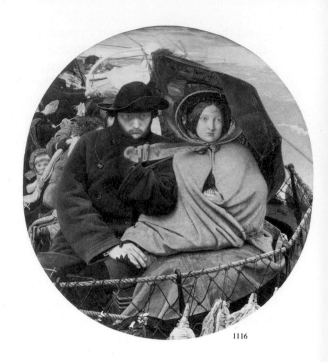

1116

The doctrines of the Realists, like those of the Neoclassicists and the Romanticists, in fact like all artistic dogmas, could not be maintained for long in their original purity. Too many aspects of natural human feeling and imagination were excluded. But the immense historic value of Realism lay in its insistence on the priority of vision over either abstract principles of form and composition or emotional and narrative content. The Realist emphasis on the here and now was essential to the formation of Impressionism, the one really crucial movement of the nineteenth century, and surely the most important for all succeeding generations. Unexpectedly, but with some force, Realism was to reappear at intervals throughout the twentieth century, as doctrinaire as ever, and at times even more fanatical.

1116. FORD MADOX BROWN. *The Last of England.* 1852–55. Oil on panel, 32½ × 29½". Birmingham Museums and Art Gallery, Birmingham, England

IMPRESSIONISM—THE ART OF PURE VISION

The new Realist movement gave rise in the mid-1860s and throughout the 1870s to the first complete artistic revolution since the Early Renaissance in the fifteenth century, and to the first universal style to originate in France since the birth of the Gothic in the twelfth century. The new style was profoundly influenced by photography—in fact, would never have existed without it—but in a totally unexpected way. The artists of the movement did not merely utilize the supposed accuracy of photography as did the Neoclassicists and the official painters, nor were they bound to its monochromatic translation of the objective world as were the Realists. They considered photography false to the psychological perception of reality in color and motion, however precisely it might fix the retinal image of shape and of tonal relations. Their goal was to beat photography at its own game, and supply the essentials that the camera missed.

The new style almost immediately became known as Impressionism, and although it lasted only about fifteen years in its purest form, it determined in one way or another nearly every artistic manifestation that has taken place since, with consequences apparent in contemporary art more than a hundred years later. "Nothing is seen without light," wrote Ghiberti (see Part Four, Chapter Two), and while that master and his Florentine contemporaries were aware, as had been the ancient Greeks before them, of the role of light in establishing the existence of objects and determining their forms and colors, it had never occurred to Renaissance artists that light might also function in the opposite way to deform, denature, or dissolve objects.

Starting on the basis of Courbet's solid Realism and the graduated light effects of Corot, the Impressionist artists, working from start to finish out-of-doors, became fascinated by the transformations wrought by light on natural objects, surfaces, and atmospheric spaces. It soon became clear to them that color, for example, is not the property of the object itself but of the moment of perception of light, and thus changes constantly with the times of day, the movement of the sun, and the density of the atmosphere. Baroque artists, especially Rubens and Vermeer (see Part Five, Chapters Two and Three), followed in the nineteenth century by Delacroix, had studied the effect colors have on each other when juxtaposed, and the reflection of one color in another, observations sternly rejected by Classical tradition from Poussin to Ingres. Much earlier, in the Renaissance, Alberti and Leonardo da Vinci had noted that if a person passed through a sunlit field both face and clothing would appear greenish. Yet neither they nor any other Renaissance artist had deemed such a scientific curiosity worthy of painting. In the twentieth century, due chiefly to the Impressionists, we take such phenomena for granted. We all know that when we drive toward the western sun the glare on a black asphalt road will turn it yellow or even white, and that many an accident has been caused by the transformation of images of form, substance, and distance by the combination of night lights and rain. We need no proof that an object can be so altered by mist or haze that neither its size nor its material composition can be grasped. And, of course, stage lighting converts

the local color of objects and persons to any desired hue just by a transparent sheet of colored gelatin interposed in front of the light source.

Nonetheless, in the 1860s and 1870s such facts, if realized at all by the general public or by most artists, were automatically discounted, and were compensated by readjustment of tones and contours in favor of the known rather than the seen qualities. This habitual compensation the Impressionists stubbornly refused to accept, and we are eternally in their debt for a brilliant new vision of the world about us. They were the first to render the full intensity of natural light and the glow of natural colors. If the general tone of a gallery hung with Realist paintings seems dark to us after experiencing the rich colors of the Romantics and the delicate tints of the Neoclassicists, that of an Impressionist gallery is keyed up to such a degree that we feel as though we had suddenly stepped from a dim interior into the full blaze of sunlight. To quote Paul Signac, a painter who helped to transform the Impressionist style in the 1880s, "the entire surface of the [Impressionist] painting glows with sunlight; the air circulates; light embraces, caresses and irradiates forms; it penetrates everywhere, even into the shadows which it illuminates." It was light, perceived in a flash too quick to permit the eye to focus on detail, judge contours, enumerate elements, and assess weights and densities, that the Impressionists tried to capture. Claude Monet, leader of the movement, called his goal "instantaneity." However, this was not the minutely detailed flash-frozen instantaneity the photographers had been able to present since 1858, but a total instantaneity of light, motion, and eventually even temperature.

It is now our task to trace how the Impressionist movement came about, how it spread, and how it became transformed into a radically different style. The well-nigh unanswerable question is why the revolution in vision occurred when and where it did. It is not enough to point out that much of what the Impressionists achieved in the perception of color in painting had already been formulated scientifically in research conducted during the 1820s, and embodied in a book published in 1839 by the French chemist Michel Eugène Chevreul (1786–1889); the Impressionists were not influenced by Chevreul's work, which was not systematically studied by painters until the days of Seurat in the 1880s (see Chapter Five). One important factor in Impressionist experience may well have been the spectacle of Baron Haussmann's Paris, which had taken shape around them, with its seemingly infinite perspectives of straight avenues and curving boulevards lined with almost identical structures. Buildings and their details, trees, carriages, pedestrians—all became particles in an endless web of color, subject to the changes of light in the soft, moisture- and smoke-laden air of Paris, in which no form is clear and all elements tend to be reduced to particles of more or less the same size (see figs. 1121, 1126). The most striking aspect of the rapid development of Impressionism is that it was in no way retarded by the defeat of France in the Franco-Prussian War of 1870–71, the devastation of Paris by Prussian shelling during the siege, and the disorders of the brutally repressed Commune of 1871. As if nothing had happened, the Impressionist friends, with few exceptions temporarily dispersed from the capital, returned to it immediately, and heightened their dazzling colors and intensified their perceptions of the light of the metropolis and its surrounding country.

Manet and Monet

The use of the name Impressionism to characterize the new style came from the first exhibition of members of the group at the recently vacated former studio of the photographer Nadar in 1874, where they had often encountered the leaders of Parisian intellectual and cultural life. Claude Monet (1840–1926) exhibited among others an extraordinary painting entitled *Impression—Sunrise, Le Havre*, painted two years earlier (fig. 1117), described by Monet himself as "sun in the mist and a few masts of boats

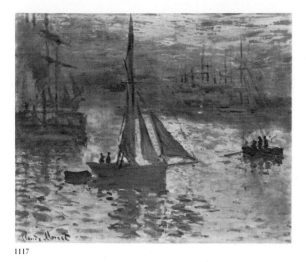

1117

sticking up in the foreground." (This picture is generally confused with another done from the same window, but with the sun clearly visible and no foreground masts.) The title gave rise to the name applied to the entire movement, one that its members soon adopted. The exhibition was greeted with public derision, the like of which had never been experienced in Paris. A newspaper story recounted solemnly how a visitor was driven mad by the paintings, and rushed out onto the Boulevard des Capucines where he started biting innocent passersby. Every tradition of European painting seemed to have been thrown aside. Not only form but also substance itself has vanished. The picture was a mere collection of colored streaks and blobs on a light blue ground. Today observers have no difficulty recognizing a sailboat and a rowboat in the foreground, masts and rigging, haze, and smoke, all reflected in the rippled surface of the water. This revolutionary painting, intended to correspond to the image the eye sees in an instantaneous glimpse of the port of Le Havre at sunrise, summed up the beliefs of the school. In retrospect, the name Impressionism seems one of the few appropriate names in the history of art.

The beginnings of the movement, from which no one, least of all the artists themselves, could have predicted its culmination, seem light-years earlier. The germs of the new perception are apparent in the art of Édouard Manet (1832–83), the similarity of whose surname to that of Monet causes confusion today and at first distressed Manet, who thought it was a bad joke. Scion of a well-to-do and elegant Parisian family, the young Manet was trained for a naval career, but then permitted to enter the studio of the conservative painter Thomas Couture, where he received thorough training. Trips to Italy, the Netherlands, Germany, and Austria in the 1850s brought him into contact with the work of the Old Masters, through careful copying. He was particularly impressed by the optical art and brilliant brushwork of Velázquez (see Part Five, Chapter Two), whose work he saw during a brief visit to Spain in 1865, and to whom he remained permanently indebted. He also admired Goya, and among the artists of his own time preferred Courbet and Daumier.

In 1863 Manet exhibited at the Salon des Refusés a canvas entitled *Luncheon on the Grass (Déjeuner sur l'herbe)* (fig. 1118), which created an uproar. The nonchalant grouping of a nude female figure and two fully clothed men in what appears to be a public park shocked the Parisians as

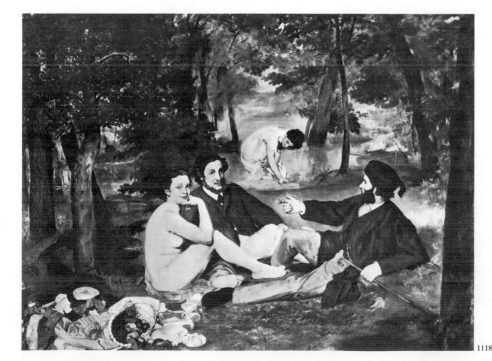

1117. CLAUDE MONET. *Impression—Sunrise, Le Havre.* 1872. Oil on canvas, 19½ × 25½". Private collection

1118. ÉDOUARD MANET. *Luncheon on the Grass (Déjeuner sur l'Herbe).* 1863. Oil on canvas, 6'9⅛" × 8'10¼". Musée du Jeu de Paume, Paris

1118

flagrant immorality. In actuality Manet had wittily adapted the composition and the poses from a sixteenth-century engraving after a design by Raphael; Giorgione also had painted a similar theme. Manet simply modernized the clothing, surroundings, and accessories. Even Courbet joined the chorus of denunciation, finding the painting formless and flat. This flatness, however, was just what Manet was striving for. He discarded Courbet's characteristic lighting from one side and strong modeling in favor of delicately modeled areas silhouetted in light and dark. Illumination seems to come from the direction of the observer, and eliminates mass. It is as though Manet were using the "indecent" subject for its shock value to point up his belief that the important thing about a picture is not what it represents but how it is painted. The erasure of form allows him to concentrate on the luminosity of the green grass and foliage, the sparkling remains of the picnic, and the glowing flesh of the nude. By posing an insoluble enigma of subject, he has, in effect, transformed a group of figures into a still life.

Manet soon went even farther; in 1867 he painted a subject from contemporary history, the *Execution of the Emperor Maximilian of Mexico* (fig. 1119), which records an event that had deeply shocked the French public and for which Napoleon III and his government, who had installed Maximilian, were generally blamed. Manet treated the incident in a totally unexpected way, almost as a reaction against such elaborately staged protest compositions as Géricault's *Raft of the Medusa* (see fig. 1078) and Goya's *Third of May, 1808* (see fig. 1072). He made a close study of newspaper accounts and composite photographs of the execution, and even of por-

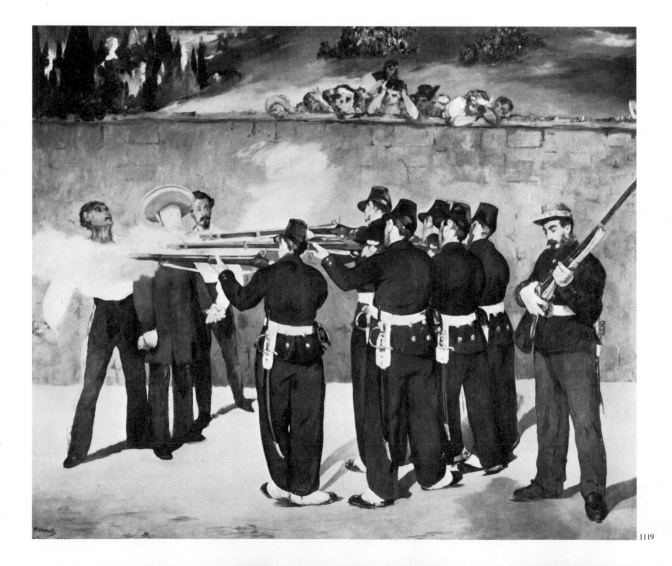

1119

trait photographs of the slain emperor, but rather than arranging the figures for maximum emotional effect seems almost to have taken a snapshot of the scene. One can scarcely make out the expressions of the doomed men. No longer the embodiment of mechanized cruelty as in Goya, the soldiers are just doing their job. If any figure receives special attention it is the officer preparing his rifle for the coup de grace. The onlookers peering over the wall are merely curious. The picture consists largely of colored uniforms, a briskly painted background, and puffs of smoke. Another traditional subject, this time a tragic one, has been modernized in terms of immediate vision.

At first Manet maintained a certain distance from the members of the Impressionist group; he went to chat with them at the Café Guerbois, but never exhibited with them. His younger contemporary, Monet, came from a different background. Although he also was born in Paris, his father was a grocer, and the family soon moved to Le Havre on the coast of Normandy, where the father became a ship chandler, and the boy could constantly observe ships and the sea. This circumstance was important for his later preoccupation with light, water, and human experience in relation to the unending stream of time. After starting as a caricaturist, the young artist was introduced to landscape painting in 1858 by a gifted outdoor painter, Eugène Boudin. In 1867 he submitted to the Salon a revolutionary work, the huge *Women in the Garden* (fig. 1120), painted the preceding year. The model for all the figures was the artist's mistress, whom he later married, Camille Doncieux. But the entire picture, more than eight feet high, was painted outdoors. Monet had already

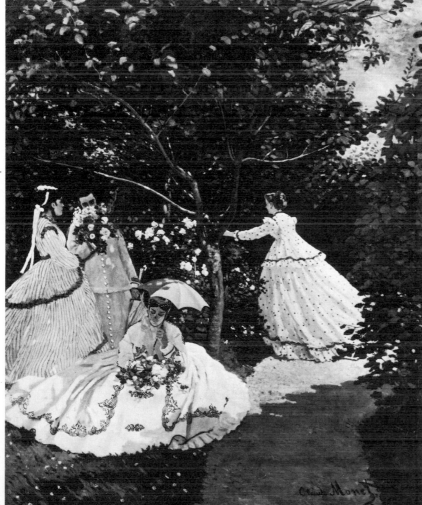

1120.

1119. ÉDOUARD MANET. *Execution of the Emperor Maximilian of Mexico*. 1867. Oil on canvas, 8'3¼" × 12'1⅛". Städtische Kunsthalle, Mannheim

1120. CLAUDE MONET. *Women in the Garden*. 1866. Oil on canvas, 8'4½" × 6'8¾". Musée du Jeu de Paume, Paris

developed in the direction of instantaneity, and the picture required him to devise new methods in order to record the immediate impression of light on the muslin dresses, the flowers, and the trees. To the astonishment of Courbet, he refused to paint at all when the sun went under a cloud. And since in order to paint the upper portions of the picture he would have had to climb a ladder, thus altering his view of the subject, he dug a trench and built a device for lowering and raising the canvas so that all parts of it could be painted from the same point of view. The feeling of sunlight is warm and rich, but the colors are still local, though soft blue and lavender shadow does reflect into the faces of the women and their flowing dresses. The leaves are colored in varying shades of green, which means that Monet had not really gone farther than Constable in his perception of the makeup of any given hue. But the general impression is far brighter than anything Manet had achieved in the *Luncheon on the Grass* of only three years before. Already Monet has begun to divide the entire surface into patches of color of roughly uniform size. Even more important, now that Manet had demolished the emotional drama as a subject, Monet in this and other pictures established the new Impressionist subject—the moment of experience in light.

However successful from an artistic and historical point of view, like most of the artist's early works the painting was a worldly failure. Not only was it rejected from the Salon of 1867, but also when it was shown in a shopwindow, Manet poked fun at it. Interestingly enough, a few years later, when he had come to understand Monet's style and adopted his brilliant coloring, Manet bought the picture for himself.

Although Manet remained in Paris during the disorders of 1870–71, Monet fled, first to London, where he experienced a different kind of light and studied the art of Constable and Turner, then to Holland and Belgium, where he was interested chiefly in landscape. On his return to France his style changed rapidly and radically. *Impression—Sunrise, Le Havre*, which we can now see in its place in the perspective of the Impressionist movement, marks very nearly the apogee of Monet's attempt to seize instantaneity. The canvas must have been already covered with a monochrome underpaint before Monet began the picture, but the actual visual impression he rendered was of such brief duration that the touches of color on the surface, indicating the water, the boats and rigging, and their reflections, could hardly have taken more than an hour. In the *Women in the Garden*, he had proclaimed the Impressionist subject as the moment of experience of light; in *Impression—Sunrise, Le Havre*, he demonstrated that color belongs not to the object but to the moment of visual experience.

This was hard for his contemporaries to accept. Monet explained his method to an American lady: "When you go out to paint, try to forget what objects you have before you, a tree, a house, a field or whatever. Merely think, here is a little square of blue, here an oblong of pink, here a streak of yellow, and paint it just as it looks to you, the exact color and shape, until it gives your own naive impression of the scene before you." What Monet achieved in the 1870s was the dissolution of the object. Substance itself becomes permeated with air and light. The difference between his approach and that of Turner (of whose art Monet never entirely approved) was that Turner began with the subjective experience of color and painted reality into it as he went, while Monet began with reality and made it entirely subservient to the objective perception of color.

As early as 1873 Monet had set up a floating studio in a boat on the Seine, an idea he borrowed from the Barbizon painter Charles-François Daubigny. If to Corot the art of painting consisted in knowing where to

1121

1121. CLAUDE MONET. *Gare Saint-Lazare in Paris.* 1877. Oil on canvas, 32½ × 39¾". Fogg Art Museum, Harvard University, Cambridge, Massachusetts. Maurice Wertheim Collection

sit down, to Monet it lay in judging where to drop anchor. The world passing before his eyes at any one spot formed a continuous stream of experience, from which he singled out moments, recorded in series. For example, at the financially disastrous third Impressionist exhibition of 1877 he showed eight canvases in which he had studied from his own objective point of view the theme of the railway. But it was neither the idea of man's victory over nature that fascinated him as it did Turner (see fig. 1091) nor sympathy with the plight of the common man trapped in his own machine as in Daumier (see fig. 1106), but the simple spectacle of a locomotive drawing cars into a station, as depicted in the *Gare Saint-Lazare in Paris*, painted in 1877 (fig. 1121).

The iron-and-glass train shed offered to him a tissue of changing light and color, dominated by blue and silver in this instance, but touched unexpectedly on the ground with tan, green, rose, and gold. The shadows and the massive black locomotive were painted in deeper shades of these hues, chiefly blue, for the Impressionists had eliminated black from their palette. Black is the absence of color, a circumstance they would not admit; their work shows what from experience we know to be true, that black absorbs and to a degree reflects colors in the surrounding atmosphere. The people in Monet's picture are spots of blue, their faces rose and gold; the puffs of steam are bubbles of blue and pearl, whose dissolution we can watch under the glass roof. The only local color remaining is the bright red of the locomotive's bumper, necessary as a foil to the myriad blues. Just as instantaneity was the basic principle of Monet's vision, accidentality produced his compositions, yet in every case they show extraordinary power and consistency.

Obviously, the fleeting effects that absorbed Monet's attention could not pause long enough for him to paint them. A picture like this one, therefore, had to be the product of several sessions. Layers of superimposed strokes can be distinguished in Monet's mature and late canvases, in contrast to the fresh and sketchy touches of *Impression—Sunrise, Le Havre*. Monet's instantaneity carried within itself the seeds of its own dissolution. The moment of experience had become a palimpsest of several similar moments isolated from the stream of experience and blended and overlaid upon each other in various stages of completion.

1122

1123

1122. CLAUDE MONET. *Rouen Cathedral in Full Sunlight*. 1892–93. Oil on canvas, 39½ × 25¾". Museum of Fine Arts, Boston. Juliana Cheney Edwards Collection. Bequest of Hannah Mary Edwards in memory of her mother, 1939

1123. ÉDOUARD MANET. *A Bar at the Folies-Bergère*. 1881–82. Oil on canvas, 37½ × 51". Courtauld Institute Galleries, University of London

There were periods when Monet could not work for lack of money to buy materials, and one moment when he slashed a number of canvases so that his creditors could not attach them. But by the 1880s his paintings were beginning to sell, and he threw himself into his work with a fierce passion as if nature were at once a friend and an enemy. He waded through ice floes in hip boots at the risk of his health to record the dazzling light effects on snow, ice, and water. He painted on a beach during a storm to ascertain the height and power of wind-driven waves, one of which swept him under (he was rescued by fishermen). He wrote to the sculptor Rodin (see page 853) that he was "fencing and wrestling with the sun. And what a sun it is. In order to paint here I would need gold and precious stones."

To achieve his effects Monet was now constrained to work systematically in series. By the 1890s, still faithful to Impressionist principles when others had long deserted them, Monet brought with him daily in a carriage, to the place chosen to paint, stacks of canvases on each of which he had begun the study of a certain light effect at a given moment of the day. He would select the canvas that corresponded most closely to the moment before him and recommence painting—not without periods of desperation when the desired light effects refused to reappear.

Monet painted series of cliffs, of haystacks, of poplars bordering a river, of the Thames at London, and the Grand Canal at Venice. But the most impressive was the series of views of Rouen Cathedral. During the winters of 1892 and 1893, when he could not easily paint outdoors, Monet, now critically accepted and financially successful, rented a second-story window in a shop opposite the façade of the Cathedral. This building, an extreme example of Flamboyant Gothic dematerialization of stone, doubtless appealed to him as an analogue of his own Impressionist insubstantiality. Systematically, he studied the effects of light and color on the lacy façade in the dimness of dawn, in the morning light, at noon, in the afternoon, at sunset. In 1895 he exhibited eighteen views of the façade and two other views of the Cathedral, an occasion that brought forth paeans of praise and torrents of condemnation. But Monet's moments had, in the very process of being painted, become the work of art, and were at once superimposed and suspended in time. Sky and ground were all but eliminated. The façade was coextensive with the canvas, covered with a tissue of spots of contrasting colors, a kind of cloth of gold embroidered in silver and studded with diamonds and sapphires, just as he had declared. The light permeating the shadows and the stone had now obviously become the object of intense emotional involvement on the part of the artist.

The painting known as *Rouen Cathedral in Full Sunlight* (fig. 1122) must represent the moment just about noon when the low winter sun is still striking the southern flanks of the masses of masonry, and has not yet entered the west portals, illuminated by reflections from the square in front. Dazzling as the cathedral paintings are, Monet himself was so discouraged by the impossibility of registering with his hand what he saw with his eyes that he thought of abandoning them. However, he took them all back to his home at Giverny, between Paris and Rouen, and worked on them, significantly enough, *away from* the object, with only his memories of light to guide him and his constantly deepening and intensifying knowledge of the poetry of color.

In 1899 Monet began a series of water landscapes that were to occupy him till his death twenty-seven years later. In some ways these late pictures are the most magical of all. He won his battle with nature by an-

1124. CLAUDE MONET. *Nymphéas (Water Lilies)*. c. 1920. Oil on canvas, 6'8½" × 19'9¼". Museum of Art, Carnegie Institute, Pittsburgh. Purchased through the generosity of Mrs. Alan M. Scaife

nexing it. At Giverny, dissatisfied with painting experiences chosen from the chaotic stream of the outside world, he constructed an environment that he could control absolutely, a water garden filled with water-loving trees and flowers, and crossed at one point by a Japanese footbridge. Here, in canvases as gigantic as any by David, Gros, or Géricault, he submerged himself in the world of changing color, a poetic fabric in which visual and emotional experience merge. Eventually abandoning the banks entirely, the aged artist gazed into the water, and these paintings (fig. 1124) show a surface in which the shimmering reflections of sky and trees blend between the floating water lilies. Two series of these canvases were designed to join, in ellipses that envelop entire rooms, without beginning or end. In Monet's last works the stream of experience has become timeless without renouncing its fluidity; despite his failing vision and his sense that he had attempted the impossible, Monet had, symbolically at least, conquered time.

In the early 1870s Manet, at the height of his career, suddenly gave up his flat style, and adopted both the brilliant palette and the broken brushwork of the Impressionists. Some of his later pictures are well-nigh indistinguishable from theirs. But the most memorable of these, *A Bar at the Folies-Bergère* (fig. 1123), painted in 1881–82, only two years before the artist's premature death at the age of fifty-one, is a brilliant restatement—in Impressionist terms—of Manet's earlier interest in the human figure.

The entire foreground is constituted by the marble bar, laden with fruit, flowers, and bottles of champagne and liqueurs. As the nearer edge of the bar is cut off by the frame, we have the illusion that its surface extends into our space, and that we as spectators are ordering a drink from the stolid barmaid who leans her hands on the inner edge. This illusion is reinforced by the reflection in the mirror, which fills the entire background of the picture. We can make out clearly a back view of the barmaid, in conversation with a top-hatted gentleman who, by elimination, must be identical with the spectator. Manet was certainly remembering Velázquez's *Las Meninas* (see fig. 970), in whose background mirror appear the king and queen. But his extension of the mirror beyond the frame at top and sides substitutes for the expected space within the picture the reflected interior of the cabaret, which is behind the spectator and, therefore, *outside* the picture. Spatially, this is the most complex image we have seen thus far in the history of art. In his early works Manet had modernized the subject. Monet in the 1870s had dissolved the object. It remained for Manet in this painting to eliminate the last vestiges of that

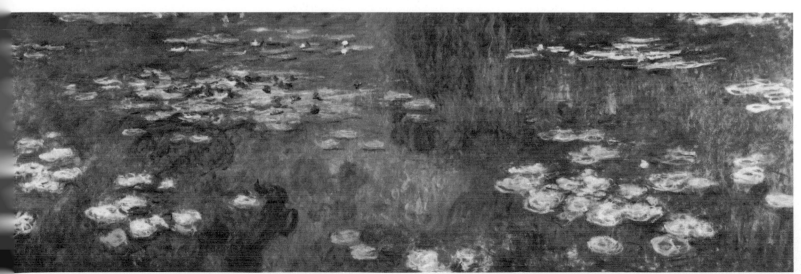

Renaissance pictorial space that Alberti (see Part Four, Chapter Two) had defined as a vertical section through the pyramid of sight. Manet's masterpiece is painted with a brushwork that combines memories of Velázquez's virtuosity with the most brilliant achievements of the Impressionists. Paradoxically, the imposing dignity of the figure and the straight lines of the bar and the crowded balcony make this work his most monumental achievement.

Morisot

The Impressionist group had one woman member, Berthe Morisot (1841–95), who exhibited with them from the start and was treated on a par with her male colleagues—the first time in the history of art since the Middle Ages that a woman artist enjoyed such a position of unquestioned equality in any artistic movement. Morisot was a grandniece of Fragonard, who died more than a generation before her birth, but contrary to the common situation in which women artists were daughters of painters, she was the only talented member of her immediate family. After a long platonic association with Manet, she married his brother Eugène, with whom she was especially happy because he understood and encouraged her in her work and assisted in planning and hanging the Impressionist exhibitions. Much of her technical excellence—for in some ways she was the most skillful member of the group—she disciplined by assiduous copying of Old Masters in the Louvre. In her youth, moreover, she profited by the guidance of Corot, whose silvery tonalities she emulated in her early landscapes. Her friendship with Manet was mutually beneficial; Morisot mastered the figure, which soon showed off her talents at their best, and Manet lightened his dark palette. Although by no means such an innovator as Monet, Manet, or Renoir, Morisot was a painter of great sensitivity of observation, insight, and touch, and above all, unrivaled lyric intimacy. Her paintings, often small, are invariably jewels. After the great burst of Impressionism in the 1870s she continued to develop; in her painting of 1886 *In the Dining Room* (fig. 1125), she has already transformed the artistic vocabulary of Impressionism into something more than purely retinal, as indeed had Monet and Renoir. The young servant looks at us with total self-possession while she works with a mortar and pestle in the midst of a controlled tempest of tiny strokes in subdued but sparkling colors. The painter has celebrated an exquisite but temporary bit of domestic disorder—the fruit is still on the table after lunch, the used tablecloth is flung over a half-open cabinet door, the white dog demands attention. This picture, as John Walker put it, "could never have been painted by a man."

1125

Pissarro and Renoir

An extremely gifted member of the Impressionist group, if less spectacular than Monet and Manet, was Camille Pissarro (1830–1903), whose father, a Portuguese Jew living in the West Indies, had become a French citizen. From the very first, Pissarro exhibited with the Impressionists. He was the most careful and craftsmanly of them all, and it was his companionship and advice that provided a much needed technical foundation for the more impetuous Cézanne (see Chapter Five), who called him (very appropriately) "humble and colossal." He is both in the scrupulously painted *Boulevard des Italiens, Paris—Morning Sunlight*, of 1897 (fig. 1126). With infinite care he recorded the innumerable spots of color constituted by people, carriages, omnibuses, trees, windows, and kiosks in this view of one of the great metropolitan thoroughfares, whose activ-

1126

ities provided the subject for so many Impressionist paintings. In fact, Impressionist artists often worked side by side painting the same view of a street, a café, or a riverbank at the same moment of light and atmosphere, and it is often only the special sensibility and personal touch of each painter that makes it possible to tell their works apart.

Although the sparkling *Les Grands Boulevards*, of 1875 (see fig. 4), by Pierre Auguste Renoir (1841–1919) was not such a collaborative venture, it shows us how much latitude remained for individuality in treating a similar subject at the height of the collective phase of the Impressionist movement. Renoir, the most sensuous and effervescent of the group, has not bothered with the detail that occupied Pissarro. Rather he has captured a moment of high excitement as we look across a roadway from the shadow of the trees to the trotting white horse pulling a carriage filled with people in blazing sun. Warmth, physical delight, and intense joy of life are the perpetual themes of Renoir; as a painter his touch is correspondingly both silkier and more spontaneous than that of Pissarro. Trained at first as a painter on porcelain, he later studied with the academic painter Charles Gabriel Gleyre, who also taught Monet, and soon made the acquaintance of the Impressionist group, with whom he exhibited until 1886.

The most exuberant image from the Impressionist heyday is Renoir's *Le Moulin de la Galette*, of 1876 (fig. 1127), depicting a Sunday afternoon in a popular outdoor *café dansant* on Montmartre. Young couples, bewitching in their freshness, are gathered at tables under the trees, or dancing happily through the changing interplay of sunlight and shadow. Characteristically, there is not a trace of black; even the coats and the shadows turn to blue, delicious as a foil to the higher tones of pearly white and soft rose. One could scarcely imagine a more complete embodiment of the fundamental theme of Impressionist painting, the enjoyment of the moment of light and air. Although he later turned toward a Post-Impressionist style (see Chapter Five), Renoir never surpassed the beauty of this picture, which sums up visually the goal he once expressed in words: "The earth as the paradise of the gods, that is what I want to paint."

1125. BERTHE MORISOT. *In the Dining Room*. 1886. Oil on canvas, 24⅛ × 19¾". National Gallery of Art, Washington, D.C. Chester Dale Collection, 1962

1126. CAMILLE PISSARRO. *Boulevard des Italiens, Paris—Morning Sunlight*. 1897. Oil on canvas, 28⅞ × 36¼". National Gallery of Art, Washington, D.C. Chester Dale Collection

There could be no more complete opposite to Renoir than Hilaire Germain Edgar Degas (1834–1917). Although Degas exhibited with the Impressionists, he did not share their interest in landscape, and his version of their cult of instantaneity concerned itself solely with people, in a detached way; as a person, Degas was apt to be remote and difficult. His apparent haughtiness concealed a profound sense of his own limitations and a continuing reverence for the Old Masters. Partly Italian by ancestry, he made several trips to Italy, and both there and in the Louvre copied Italian paintings and, particularly, Italian drawings. Taught by a disciple of Ingres, he was a deep admirer of the great Neoclassicist's linear perfection, and learned much from his analytic style. An amateur photographer himself, he studied the work of the British-American pioneer

Degas

1127. PIERRE AUGUSTE RENOIR. *Le Moulin de la Galette.* 1876. Oil on canvas, 51½ × 69". The Louvre, Paris

1128. THOMAS EAKINS. *George Reynolds, Pole Vaulting.* 1884–85. Multiple-exposure photograph. The Metropolitan Museum of Art, New York. Gift of Charles Bregler, 1941

photographer Eadweard Muybridge (1830–1904), who collaborated with Eakins in an attempt to analyze accurately the motion of human beings and horses through photographs of stages of their actions. A brilliant example is Eakins's *George Reynolds, Pole Vaulting*, of 1884–85 (fig. 1128). Nonetheless, Degas had actually drawn and painted instantaneous poses *before* the experiments of Muybridge and Eakins.

Degas defined the goal of his own style succinctly as "bewitching the truth." There could be no more apt phrase for his art, at once brilliantly real and magically beautiful. Like Monet, Degas worked in series; a subject that fascinated him, and that he explored for decades, was the dance. He had no interest in such allegorical groupings as those of Carpeaux (see fig. 1086), but in real dancers and in every facet of their activities from their grueling workouts at the bar to their rehearsals and their triumphant performances. His dancers are never idealized; they are little, sometimes scrawny women in tulle skirts, either working hard to produce an illusion of exquisite lightness and ease or merely lounging about on stage, stretching, yawning, or scratching, as in *The Rehearsal*, of 1874 (fig. 1129). The view of the stage is not that enjoyed by most of the audience, but is located far forward in a box at one side, giving an informal and diagonal aspect. Although Degas never adopted the Impressionist color fleck, this and all of his mature pictures were conceived according to the same principles of accidentality and instantaneity that govern Monet's *Gare Saint-Lazare*. Each painting is a kind of snapshot of a moment of action, with nothing edited out, not even the paunchy impresario at the right, his top hat down on his forehead and the back of the chair between his knees. The surfaces are indicated in soft, rather thin washes of tone over drawing of uncanny accuracy.

Like many artists of the last decades of the nineteenth century, Degas was fascinated by café life, including its seamier aspects. His *Glass of Absinthe*, of 1876 (fig. 1131), shows a sodden couple, beyond communication, merely tolerating each other's presence. Dominated by the central glass of milky green liqueur, the picture is a superb composition of ap-

1129. EDGAR DEGAS. *The Rehearsal*. 1874. Oil on canvas, 26 × 32¼". The Louvre, Paris

1130. EDGAR DEGAS. *Woman Bathing in a Shallow Tub*. 1885. Pastel, 32 × 22". The Metropolitan Museum of Art, New York. Bequest of Mrs. H. O. Havemeyer, 1929. The H. O. Havemeyer Collection

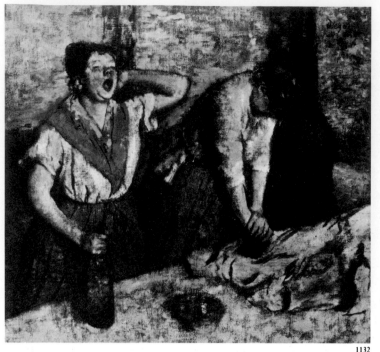

1131 1132

parently accidental diagonals in depth, composed of the tables, the bench, and even the diagonal relationship between the couple and their reflections in the mirror. The same kind of closed-in space, extending forward into that of the spectator in the manner of Manet's *A Bar at the Folies-Bergère*, is exploited in *Two Laundresses* (fig. 1132), of about 1884, one of a series. The exhausting pressure on the flatiron and the sleepiness of the workers in the steam of the stuffy interior are rendered with sovereign authority. Degas composes these figures as powerfully as had Courbet in his *The Stone Breakers* (see fig. 1107), but with a more arresting immediacy.

In later life Degas made extensive use of the medium of pastel (powdered color compressed into sticks so it can be applied almost like chalk), which had been employed for delicate effects by French portraitists of the Rococo. Degas's experiments with this medium, combining it at times with water so it could be worked into a paste, and holding it to the paper surface with a special fixative varnish, gave him at once great resonance of color and bloomlike freshness. Casting aside all allusions to Classical poses (which linger on even in Courbet's *The Studio*; see fig. 1108), he painted a strikingly original series of female nudes, seen, as he put it, "through a keyhole." To the disgust of the Parisians, whose taste in nudes had been nourished on Ingres and the Italian Renaissance tradition, he depicted "the human beast occupied with herself. Until now," he claimed, "the nude has always been represented in poses that presuppose an audience. But my women are simple, honest people, who have no other thought than their physical activity." *Woman Bathing in a Shallow Tub*, of 1885 (fig. 1130), concentrates all the forces of the composition on the simple activity of drying oneself with a towel; not even the face is shown. Unclassical though the figure may at first sight appear in its proportions and attitudes, Renoir recognized the sculptural power of Degas's nudes when he said that one of them looked like a fragment from the sculptures of the Parthenon. Tragically, like Piero della Francesca (see Part Four, Chapter Two), an earlier apostle of the poetry of sight, Degas was destined to spend his last years in near blindness and inactivity.

1131. EDGAR DEGAS. *Glass of Absinthe*. 1876. Oil on canvas, 36¼ × 26¾". The Louvre, Paris

1132. EDGAR DEGAS. *Two Laundresses*. c. 1884. Oil on canvas, 29⅞ × 32¼". The Louvre, Paris

During the eighteenth and nineteenth centuries, sculpture had lagged behind both painting and architecture as a medium of artistic expression. Among all the sculptors of this period the only one to compare with his contemporaries among the painters was Houdon. Nonetheless, public squares throughout Europe and America were populated by large-scale monuments, topped by galloping generals or frock-coated dignitaries, and loaded with allegorical figures and attributes, supplying in sheer volume what they too often lacked in aesthetic interest or even good taste. The most original sculptor of the mid-nineteenth century was the painter Daumier, whose little caricatures in clay were hardly known before his death, and only afterward evaluated and cast in bronze. Likewise, Degas produced hundreds of small sculptures of figures in action poses, few of which were known in his day. It would hardly seem likely that Impressionism, in its beginnings so strongly opposed to form—in fact dissolving it utterly in the paintings of Monet, Renoir, and Pissarro—could be accompanied by a comparable current in sculpture, by definition the art of form. Yet a backward glance at the history of sculpture, particularly during the Hellenistic period, the Early Renaissance, and the Baroque, shows that at moments sculpture could and did rival the effects of painting without sacrificing quality.

It should not, therefore, be surprising that a startlingly original sculptor, Auguste Rodin (1840–1917), would be able to parallel the basic principles of Impressionism—accidentality and immediacy—in masterpieces of a sculptural power not seen since Michelangelo. In fact, Rodin is one of the few great sculptors of Western tradition since the Middle Ages (in addition to Michelangelo, one would have to count Donatello, Claus Sluter, Bernini, and, in the twentieth century, Brancusi). Yet although Rodin had single-handedly revived sculpture as a leading art, his style was so strongly personal that he attracted no major followers. All the leading sculptors of the early twentieth century moved in directions opposed to those he had so thoroughly explored.

Sympathetic though Rodin was with the aims of Impressionism—to the point of exhibiting with Monet—Impressionist subject matter and technique were, of course, denied to sculpture. Rodin was exclusively concerned with the human figure. Like those few Impressionist painters who treated the figure, he saw it in action and in light, but unlike them in moments of great physical and emotional stress. He is, therefore, closely related to both Donatello and Michelangelo, whose works he studied with a passion, and whose expressive intensity he was the first sculptor of modern times to revive and the only one to rival. His art was always controversial. At the Salon of 1877 he exhibited *The Age of Bronze* (fig. 1133), a superb statue he had created the preceding year. Its realism, as compared to the idealized nudes then found palatable, produced a storm of indignation and the accusation that he had passed off a cast from a living figure as an original work. (Interestingly enough, this was actually done in the late twentieth century with no protest whatever; see fig. 1257).

What Rodin had in fact done, and what he was to continue to do throughout his long career, was to experiment with transient poses and accidental effects, without predetermined compositions and often without preestablished meaning, much in the manner of Monet's paintings of railway stations and Degas's studies of dancers. In this instance he was modeling in clay from a young Belgian soldier of exceptionally harmonious physique, and had posed him with a pole in his left hand as a support, according to the custom of life classes, while his right rested on his head in an attitude reminiscent of Michelangelo's *Dying Slave* (see fig. 795)

Rodin

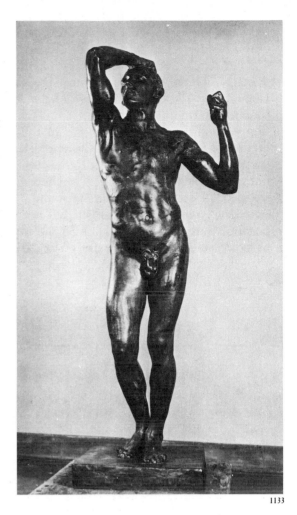

1133

1133. AUGUSTE RODIN. *The Age of Bronze*. 1876. Bronze, height 71". The Minneapolis Institute of Arts. John R. Van Derlip Fund

in reverse. He then noticed that by omitting the pole from his statue he left the figure in a state of unexplained tension, which, combined with the closed eyes and partly open mouth, seems to communicate some nameless anguish. Rodin thought up the mystifying title for the work only as it approached completion. In consequence no satisfying interpretation has ever been advanced, or can be.

The patches of clay, sometimes smoothed, sometimes left rough, produce in the final bronze a shimmer that is the sculptural counterpart of Monet's sunlight effects. Rodin found that he could similarly exploit the luminous properties of marble, as in *The Kiss*, of 1886 (fig. 1134), whose first version dates from 1880–82. In the nineteenth century the actual cutting of marble was done by stonecutters, working from plaster casts of the sculptor's original models in clay. Rodin was fascinated by the unfinished portions of many of Michelangelo's statues (see fig. 791), and stopped the stonecutter when he found a roughly carved mass that had expressive possibilities. Generally, but not always, he finished the smooth portions himself, avoiding both Michelangelo's sharp undercuttings and high polish. He preferred a softly blurred surface in the manner of Desi-

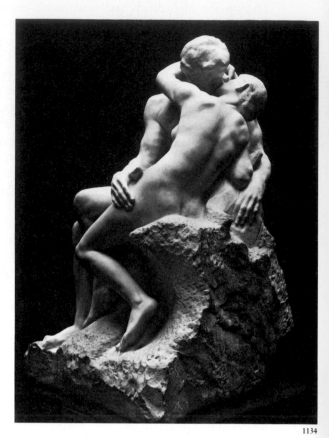

1134

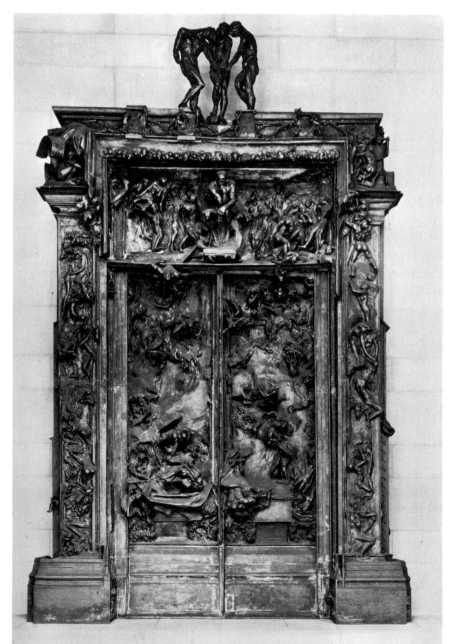

1134. AUGUSTE RODIN. *The Kiss*. 1886. Marble, over lifesize. Musée Rodin, Paris

1135. AUGUSTE RODIN. *Gates of Hell*. 1880–1917. Bronze, 18 × 12′. Rodin Museum, Philadelphia

1135

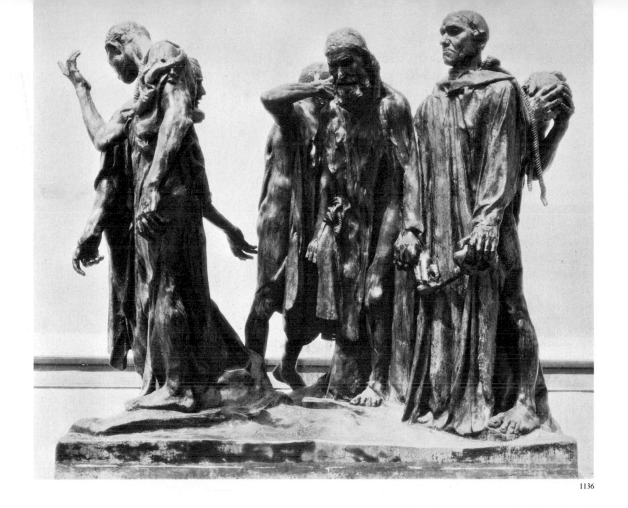

1136

derio da Settignano (see fig. 719), so that light, absorbed and reflected by the crystals of the marble, would create a glow around the figures analogous to the atmospheric effects of Impressionism. By such means the sensuous immediacy of *The Kiss* is greatly intensified.

This and many other statues in marble and bronze by Rodin originated in a large-scale commission he received in 1880 for the doors of the Museum of Decorative Arts in Paris. Still unfinished at the sculptor's death, the *Gates of Hell* (fig. 1135)—an obvious counterpart to Ghiberti's *Gates of Paradise* (see figs. 689, 690)—is the most ambitious sculptural composition of the nineteenth century, and one of the great imaginative conceptions of modern times. In its cosmic scope the work was clearly indebted to Michelangelo's *Last Judgment* (see fig. 818) and to Rubens's *Fall of the Damned* (see fig. 962). Rodin admits us to a world of flame and smoke, through whose gusts tormented spirits are propelled in poses and groups of the greatest originality and expressive power. Always intensely interested in the figure in motion, Rodin used to ask his models to move at random through his studio, running, jumping, squatting as they wished; when he spotted an unusual attitude, he would signal for an immediate freeze, and then capture the essence of the pose in a few split-second lines and touches of wash. Many of the startling poses in the *Gates of Hell* originated in this manner. He strongly objected to reliance on the poses shown by such photographs as those by Eakins and Muybridge, claiming that his method corresponded more accurately to our vision.

Revolted by the (as he saw it) hypocritical conventionality of most nineteenth-century commemorative sculpture, Rodin tried to make his monuments as arresting and immediate as possible. *The Burghers of Calais* (fig. 1136) was commissioned in 1884 as a memorial to the six heroic citizens who in 1347 came before the conquering King Edward III of

1136. AUGUSTE RODIN. *The Burghers of Calais.* 1884–86. Bronze, 82½ × 95 × 78". Hirshhorn Museum and Sculpture Garden, Smithsonian Institution, Washington, D.C.

England in sackcloth with halters around their necks, offering their own lives that the city might be spared. The work, finished two years later, after arduous labors, is a testament to Rodin's greatness as a bronze sculptor. The roughness of the drapery surfaces is masterfully exploited, in heavy folds and masses, against which the twisted gestures, taut limbs, and tragic faces communicate heroism, self-sacrifice, and the fear and inevitability of death. No sculptural figures of such rugged honesty had been created since Donatello's *Lo Zuccone* (see fig. 682). The apparent accidentality of the grouping, nonetheless, builds up to noble masses from every point of view. It is typical of the expressive intent of Rodin, as well as the immediacy of Impressionist art in general, that he wanted the monument to be placed at street level among the cobblestones so that the observer could participate as directly as possible in the emotional and physical tensions of the figures. Rodin's wishes, at first disregarded, were finally carried out in 1924.

Few of Rodin's monuments reached completion, and some were rejected by the patrons, including one of his greatest late works, the *Balzac* of 1893–97 (fig. 1137), not actually set up, at a Paris intersection, until 1939. Condemned as a menhir (Stone Age monolith), the statue is actually an attempt to convey in sculptural masses of the greatest harshness the intensity of the very moment of artistic creativity. Rodin has shown the great novelist wrapped in his bathrobe, stalking through his house as the characters of his novels have seized upon him like demons and possessed him utterly. The throes of creative emotion have never before or since been so convincingly portrayed, and the rude resulting form, with its drastic simplifications and distortions, brings Rodin to the brink of contemporary sculpture.

The reputation and eventual financial success of the Impressionist movement owed a great deal to American interest. Even today some of the most extensive and best-chosen collections of Impressionist art are in the United States. Long before Monet's death, Giverny became a kind of pilgrimage goal for American painters of all degrees of talent. But they were preceded in devotion to Impressionist ideals by three highly individual artists, one of them a woman, who spent much of their lives in Europe, yet brought American art out of isolation into the mainstream of world culture.

WHISTLER The Impressionist movement attracted quite early the partial allegiance of a young American, James Abbott McNeill Whistler (1834–1903), who had been living in Paris since 1855. Whistler admired the work of Courbet in the famous Pavilion of Realism at the Universal Exhibition in that year (see Chapter Three). For a while he worked with Courbet, and came in contact with the major figures of the Impressionist movement. He never really joined the group, although his *Portrait of Thomas Carlyle: Arrangement in Gray and Black, No. 2* (fig. 1138), painted in England in 1872 but first shown in Paris at the Salon of 1884, is still reminiscent of the flattened style of Manet. (This picture is illustrated instead of *Arrangement in Gray and Black, No. 1: The Artist's Mother*—too famous for its own good.) Whistler never emulated Manet's vigorous brushwork, however, but developed his own method of sensitive gradations and adjustments of tone. He was strongly influenced by Japanese prints, which Degas admired for their originality of viewpoint and subject, but whose

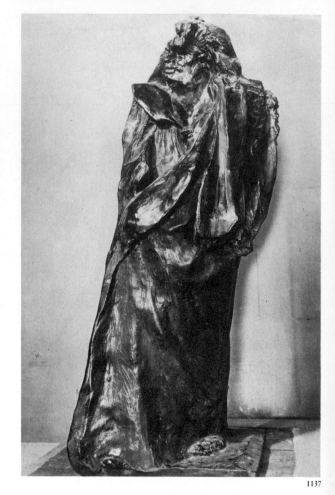

1137

Impressionism and Its Offshoots in the United States

1137. AUGUSTE RODIN. *Balzac*. 1893–97. Bronze, height 9'3". Boulevard Raspail, Paris

1138

1139

systematic silhouetting was adopted only by Whistler and his fellow-American Mary Cassatt.

In an ostensible attempt to win for art the freedom from natural resemblances always accorded to music, Whistler called his paintings harmonies, symphonies, nocturnes, or arrangements. *Nocturne in Black and Gold: Falling Rocket* (fig. 1139), painted in England about 1874 and exhibited there in 1876, was attacked in an article by the English critic John Ruskin—a supporter of "truth" in art and of craftsmanship in what he believed to be the medieval sense—as "a pot of paint [flung] in the public's face." Any apparent prophetic resemblance between this daring picture and the Abstract Expressionist works of the 1950s (see figs. 1246, 1247), especially the "drip style" of Jackson Pollock, however, is dismissed by the subtitle. In brilliant and witty testimony during a lawsuit he brought against Ruskin, Whistler claimed that his art was "divested from any outside sort of interest . . . an arrangement of line, form and color first." The last word in the sentence discloses its true substance, however, because even if Whistler felt that his pictures were arrangements *first*, there is nothing by his hand that is not at the same time thoroughly representational. He never attempted to break the tie connecting the work of art with the visual image of the object. Even the picture at issue is in fact a realistic portrayal of the clouds of sparks from a falling rocket, as much the record of an instantaneous impression as the railway stations of Monet or the ballet dancers of Degas.

1138. JAMES ABBOTT McNEILL WHISTLER. *Portrait of Thomas Carlyle: Arrangement in Gray and Black, No. 2*. 1872. Oil on canvas, 67⅜ × 56½". Glasgow Art Gallery and Museum

1139. JAMES ABBOTT McNEILL WHISTLER. *Nocturne in Black and Gold: Falling Rocket*. c. 1874. Oil on panel, 23¾ × 18⅜". The Detroit Institute of Arts

CASSATT Closer than Whistler to the Impressionist movement was Mary Cassatt (1845–1926), whose prosperous Philadelphia origins have obscured the fact that her financial well-being in later life was due wholly to the sale of her paintings. Cassatt was trained as an artist in Philadelphia, Paris, and Rome, and was for a while a regular exhibitor at the Paris Salon. There in 1875 her work attracted the enthusiastic attention of Degas, who exclaimed, "Here is someone who feels as I do!" She still remained tangential to the Impressionist circle while exhibiting with its members at the Société des Artistes Indépendants (see page 876). Although she adopted the Impressionist closed space (hers is particularly close to that of Degas), soft surface, and snapshot vision, she never accepted, as had Morisot, the brisk, divided touch that dematerialized objects and persons without distinction. She knew and respected the work of all the great Impressionists, however, and her connections with American collectors were a godsend to the struggling painters. It is largely due to Cassatt's efforts that the major private American collections of Impressionist art were formed, later the nuclei of those in American museums, so it can be fairly claimed she was responsible for the education of the American public in the new art—the first woman in history ever to exert such artistic influence.

Cassatt never married, but devoted herself entirely to her art. Yet this art was never detached and impersonal, like that of Monet. It might be said that her attitude was coolly human. Her subjects, almost exclusively female, do not smile or attempt to ingratiate themselves with the observer in any way. Often they are even homely, existing in their own right as women, girls, and children, with total dignity.

Cassatt's flesh tones are dense, her color clear and bright—sometimes sharp, sometimes blond—and always under perfect control. Her figures are so firm, her backgrounds so consistent, and her sense of structure so rigorous that one might easily place her among the Post-Impressionists, save that she, like Degas, never distorts in the interest of form.

Degas, with whom she had an intense but thorny professional relationship, proposed to Cassatt a series of studies of mothers and children, which became in some ways her major achievement. Strong in their human interest, these pictures are nonetheless free from the sentimentality that too often plagues the smiling pictures of motherhood painted by men. *The Bath*, of 1891 (fig. 1140), stands midway between Degas's *Woman Bathing* (see fig. 1130) and Cézanne's *Woman with the Coffeepot* (see fig. 1146). The intimate Impressionist point of view is strengthened by a superb sense of color and design, the three-tone stripes of the mother's dress serving as a kind of architectural enframement for the sturdy little girl, fascinated at having her feet washed. Like her mentor, Degas, for whom she cared in her generous way during his own blindness, Cassatt eventually lost her sight and passed her final years alone and embittered in the château she had bought in France, among beautiful works of art she could no longer see.

SARGENT In total contrast with Cassatt was John Singer Sargent (1856–1925). Born in Florence of American parents, he returned to the United States infrequently, only to execute commissions or to protect his American citizenship, to retain which he declined a British knighthood. He was trained in the 1870s by academic artists in France and Italy, and soon became deeply interested in Impressionism. He never joined the group, however, in spite of a brief stay at Giverny, where he painted

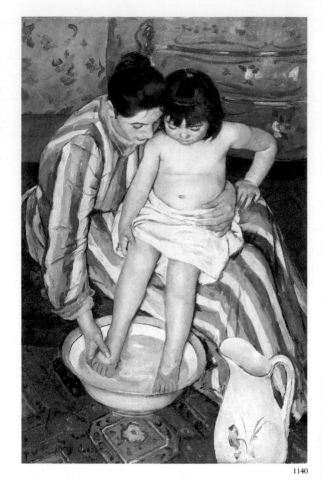

1140

1140. MARY CASSATT. *The Bath*. 1891. Oil on canvas, 39½ × 26″. The Art Institute of Chicago. Robert A. Waller Fund

alongside Monet and even painted Monet himself at work. A measure of the essential barrier that kept Sargent from the objectivity of Impressionist theory was his inability to understand how Monet could do without black. He painted portraits, landscapes, scenes of figures out-of-doors, watercolors, and—alas—murals, only the last of which are ranked today as failures. His fortunes at the critics' hands were as volatile as his style; praised one year he was attacked the next, and always for different reasons. Though eventually he was recognized as the leading painter in the English-speaking world, no one has ever called him great. Like Cassatt, he did not cross the watershed to Post-Impressionism by deserting visual reality in the interests of form or expression. *But* Sargent was beyond comparison the most brilliant master of the brush as a communicator of optical effects in any country since Velázquez, whose painting he greatly admired. His accidental groupings of figures were arresting and compelling, and even more original were his portraits, which in contrast to so many nineteenth-century artists he seems to have enjoyed painting. And not only is his virtuosity dazzling but his penetration of character is so intense that he makes Reynolds look ponderous and Gainsborough decorative. He depicted members of high society in England and America not always as they wanted to be seen (save for the brilliant externals of costume and setting) but as they were, with a psychological intensity that renders him at his best the artistic equivalent of his friend the novelist Henry James.

Sargent's portrait of Lady Agnew, wife of a Scottish nobleman (fig. 1141), painted at the height of his powers, about 1892–93, is a stunning example of his portraiture. Beginning with the pose itself, he has created a new type. There is nothing comfortable about it; the armchair is turned toward our right, the sitter to our left at the right side of the seat with knees crossed, right hand clutching a handkerchief and left hand lowered, apparently twitching with impatience. Even her mouth is a bit tense,

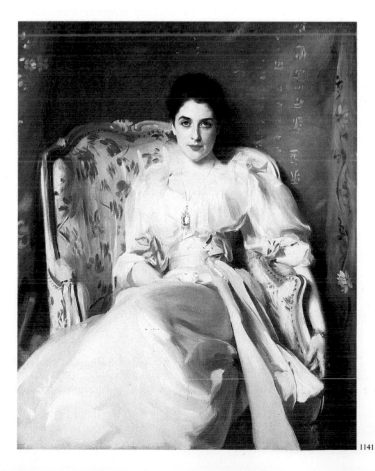

1141

1141. JOHN SINGER SARGENT. *Portrait of Lady Agnew.* c. 1892–93. Oil on canvas, 49½ × 39½". National Galleries of Scotland, Edinburgh

while her luminous, gray-green eyes calmly impale the observer from beneath their dark lashes and brows. The effect of the picture is heightened immeasurably by the fully saturated Impressionist color, set on the canvas with astonishing breadth, speed, and accuracy, yet seen as if through crystal. The background is a heavy Japanese embroidered silk curtain of the most resonant sky-blue (Monet would never have approved the black shadows deftly sketched toward the left). The white-painted chair is upholstered in white printed with red and blue flowers. The snowy satin dress with its chiffon bodice and sleeves echoes the blue of the curtain and the wonderful, soft lavender of the sash, while delicately disclosing the glow of the arms within. In contrast to Cassatt's reserved women, Lady Agnew, perhaps not conventionally beautiful, is knowingly attractive. With pictures like this Sargent was able to sail through life in the glitter of high society. Pissarro, the modest, conscientious workman on canvas, shook his head at such painting, but it is beautiful and has its place. So does Sargent.

SAINT-GAUDENS The spirit of Impressionist immediacy and insubstantiality enlivened to a degree even the seemingly intractable field of public sculpture, in the art of Augustus Saint-Gaudens (1848–1907). Unlike Rodin no original genius, Saint-Gaudens was an artist of great sensitivity, knowledge, and taste. He was born in Ireland of an Irish mother and a French father, and brought up in the United States as a naturalized citizen, remaining and working in America save for brief periods of study in Paris and Rome. Saint-Gaudens had no patience with contemporary monumental pomposity and was responsive, on the one hand, to Italian fifteenth-century sculpture, on the other, to the paintings of the Impressionists, including his friend Sargent. His *Monument to Admiral Farragut*,

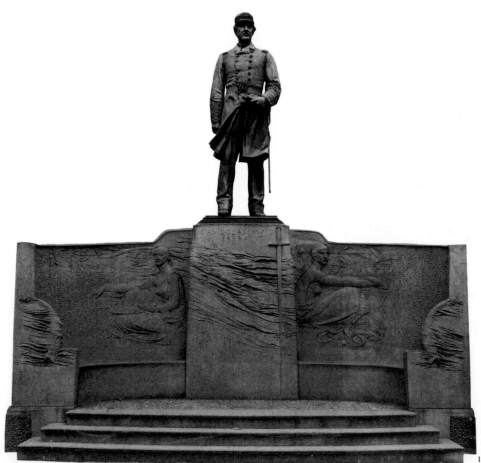

1142. AUGUSTUS SAINT-GAUDENS. *Monument to Admiral Farragut*. 1881. Bronze with stone pedestal, over lifesize. Madison Square, New York

of 1881 (fig. 1142), could hardly dispense with the conventional notion of the military hero on his pedestal flanked by allegorical figures (going all the way back to Michelangelo's Medici Chapel; see fig. 814), but he treated the latter as sculptural equivalents of the *Iliad* and *Odyssey* figures in Ingres's *Apotheosis of Homer* (see fig. 1063), executing them in the flattened relief of Donatello and Desiderio da Settignano (see figs. 681, 719). This innovation permitted him to concentrate on the subject and its environment. As if to turn the setting imaginatively into the quarterdeck of the admiral's flagship, Saint-Gaudens has allowed a sea breeze to whip the ugly lines of the nineteenth-century frock coat into interesting triangular masses of bronze. Then he dissolves the subtle shapes of the stone pedestal designed for him by Stanford White, leader of the so-called American Renaissance in architecture, transforming it into the billows of the sea, as if painted by Manet or Monet. Surging through the background of the seated figures, the limestone waves pour over the arching dolphins that form the terminals of the bench, and heave to a diagonal climax in the wave on the left of the center pedestal, to be counteracted by the clean, vertical line of the flying sword on the right. The metaphor is continued even in the plinth, whose blocks are cut to suggest the sandy, pebbly shore. Saint-Gaudens borrowed from the Renaissance the delicate, refined lettering of fifteenth-century Italian medals. The inscriptions, made full-size on sheets of tracing paper, were penciled in reverse on a plaster mold taken from the original clay model and then cut in, so as to appear lightly raised in the plaster cast turned over for execution to the stonecutter. The result was a soft shimmer rather than the harsh linearity of customary incised inscriptions. Perhaps too tasteful and derivative for true greatness, Saint-Gaudens nonetheless in a series of such monuments and in exquisite portrait reliefs, transformed the whole nature of American classic sculpture in the lull before the storm of modernism.

The Impressionists opened up a whole new world of direct optical experience of light and color, and after their brief period of triumph neither painting, nor sculpture, nor even architecture, could ever again be quite the same. Impressionism had inherited from Romanticism its belief in the supremacy of color, and from Realism its conviction of the ultimate validity of the visible world. In the work of artists peripheral to the Impressionist movement, such as Degas and Rodin, Impressionism also owed a debt to Neoclassic sureness of drawing. But its eventual effect was to substitute the moment of optical experience for the object itself, and therefore promote the dissolution of all artistic values previously accepted by the Western tradition. The question as to whether the eye really sees as the Impressionists claimed it did therefore loses weight. The artist was left to determine in private judgment or personal feeling what the object was to look like in the work of art, and eventually whether it was to appear at all. The Post-Impressionists reconstituted the object as they wished, but the effect of Impressionism was irreversible.

POST-IMPRESSIONISM—A DEEPER REALITY

During the 1880s the Impressionist movement rapidly fell apart. The exhibitions continued, but one after another the original members ceased to send their paintings to the group shows. Renoir visited Italy and found a new stylistic direction based partly on his study of Raphael. Monet himself had come to realize that what he was really creating was a prolonged moment, the palimpsest of many similar moments—a horizontal rather than a vertical section through the stream of time. One member of the original group, Cézanne, who had been considered by many a minor painter and whose works had been especially derided by the public at the Impressionist exhibitions and regularly refused at the Salons, dropped out of the Impressionist group even before the end of the 1870s—in fact, left Paris to work out a new style in isolation.

So did others. The separate tendencies, which we now group loosely together under the general title of Post-Impressionism, had little in common save their derivation from the Impressionist aesthetic. All retained the bright Impressionist palette and even to some extent the Impressionist color patches, although these acquired a new shape and a new function, in keeping with the personal artistic goal of each painter. In a negative sense, however, the Post-Impressionists were united in regarding Impressionism as too fugitive in its aspirations to achieve an art of lasting value. Each Post-Impressionist artist created a sharply individual style, which could no longer be mistaken for that of any of his contemporaries or former associates, in subject matter, content, or technique.

Among the variety of Post-Impressionist styles, we can distinguish two major tendencies. One, led by Cézanne and Seurat, sought permanence of form; the other, represented chiefly by Van Gogh and Gauguin, gave first place to emotional or sensuous expression. Both began with color. These two trends may be considered in a sense as heirs, respectively, of Neoclassicism and Romanticism, which had divided the first half of the nineteenth century into opposite and hostile camps. Among innovating artists there was no true equivalent for Realism, the third nineteenth-century tendency, which became a stylistic backwater. Instead, a new art arose here and there that owed little or nothing to Impressionism, but aimed at liberating fantasy from the shackles of realistic observation. From these three general trends, clearly distinguishable by the late 1880s, spring the principal currents of twentieth-century art.

The leading painter of the late nineteenth century in France, indeed one of the most powerful artists in the history of Western painting, was Paul Cézanne (1839–1906). Son of a prosperous banker in the southern French city of Aix-en-Provence, Cézanne experienced none of the financial difficulties that plagued Monet and Renoir during the formative period of Impressionism. He received some artistic training in Aix, and although he arrived in Paris for the first time in 1861, he never set up permanent residence there; after visits of varying duration, he always returned to his Provençal home. At first he was interested in the official art of the Salons but soon achieved an understanding of Delacroix and Courbet, and before long of Manet as well. His early works are still Romantic, thickly painted in a palette limited to black, white, tans, and grays, and an occasional touch of bright color. Not until the early 1870s, during two years spent at Pontoise and Auvers, in the Île-de-France not far from Paris, did he adopt the Impressionist palette, viewpoint, and subject matter under the tutelage of Pissarro. He showed at the first Impressionist exhibition in 1874 at Nadar's and at the third in 1877. Only in 1882 was one of his paintings exhibited at the Salon.

During most of his independent career, save for visits to Paris, its environs, and to the Mediterranean village of L'Estaque, as well as a trip to Switzerland, Cézanne remained in Aix. His isolation from other artists he considered essential for his intense concentration on the formation of a new style of painting. His great pictorial achievements date from those lonely middle and later years. His mature style is often interpreted in the light of two celebrated sayings: "I want to do Poussin over again, from nature," and "I wish to make of Impressionism something solid and durable, like the art of the museums." Less often quoted but equally important is his remark to the painter Émile Bernard: "Drawing and color are not distinct. . . . The secret of drawing and modeling lies in contrasts and relations of tones."

Among the subjects Cézanne studied repeatedly was Mont Sainte-Victoire, the rugged mass that dominates the plain of Aix. The version

Cézanne

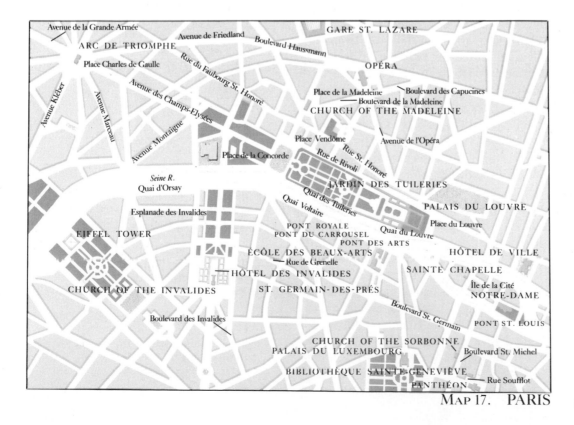

MAP 17. PARIS

illustrated (fig. 1143) was painted about 1885–87. In contrast to the momentary glimpses Monet was painting, none of Cézanne's landscapes indicate the time of day or even the season. In this he was assisted by the fact that in Provence there are many evergreens and winter wheat is green in December. It neither rains nor snows in his landscapes, and there are seldom any recognizable clouds. Time is defeated by permanence, even in the subject. In this picture Cézanne has not even informed us clearly where we stand. A bit of rock in the foreground could be near or at a little distance. We do not know where the tree is rooted. At no point in the picture are objects described even as much as in a Monet. Some objects are identifiable as houses, trees, fields, and the arches of a viaduct, but Cézanne's visual threshold is high, and below that level nothing is defined. The effect of durability and massiveness is produced by a new use of the Impressionist color spots. In his art these assume definite directions, either horizontal, vertical, or diagonal, and are grouped to form planes. The planes, in turn, are used to bound the smaller masses, even the facets of the tree trunk and the passages of white and blue in the sky. The landscape becomes a colossal rock crystal of color—a cubic cross section of the world, as it were, its foreground and background planes established by the branches and by the mountain whose rhythms they echo, its floor by the valley, its ceiling by the sky. The constituent planes embrace a great variety of subtly differentiated hues of blue, green, yellow, rose, and violet, and it is the delicate differentiation between these hues that produces the impression of three-dimensional form.

To put it simply, Cézanne has used to construct form the very color patch the Impressionists had employed ten years before to dissolve it. He has indeed achieved from nature a construction and intellectual organization much like that Poussin had derived from the organization of figures, and made of Impressionism something durable, reminding us inevitably of the stable world of Piero della Francesca (see figs. 712–15) and even of the airless backgrounds of Giotto (see figs. 2, 648). In so doing, however, he has created a world remote from human experience. A road appears for a few yards, but we cannot walk on it; there are houses, but few windows. There are in fact no people, animals, or birds in Cézanne's landscapes, nor any moving thing. The beauty of his color constructions is abstract, and it is no wonder that many artists of the early twentieth century, especially the Cubists, claimed him as the father of modern art.

Still life was to Cézanne second only to landscape, the principal subject for his analyses of form through color, for his drawing and modeling in contrasts and relationships of tones. They owe little to Dutch still lifes (see fig. 982) or to those of Chardin (see fig. 1021). *Still Life with Apples and Oranges* was painted between 1895 and 1900 (fig. 1144). His arrangements of fruits, bottles, plates, and a rumpled cloth on a tabletop never suggest the consumption of food or drink; they are spheroid or cylindrical masses, and the planes of color that build them up are solely responsible for their revolution in depth. Often the appearance of reality is neglected; the table, for example, has a tendency to disappear under the tablecloth at one level and emerge from it at another, and the two sides of a bottle or a carafe can be sharply different. Whether Cézanne did not notice such discrepancies in his search for just the right color to make a form go round in depth, or whether he decided on deformations consciously in the interests of abstract relationships of design, has never been convincingly determined. He cared for subjects as arrangements of form and color, but Meyer Schapiro has noted that they also possessed for him strong psychological significance. His procedure was so time-consuming

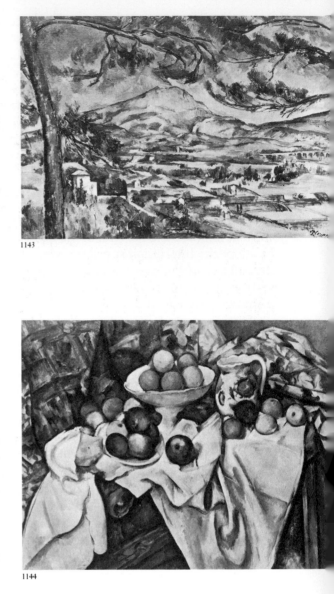

1143

1144

1143. PAUL CÉZANNE. *Mont Sainte-Victoire*. c. 1885–87. Oil on canvas, 25½ × 32″. Courtauld Institute Galleries, University of London

1144. PAUL CÉZANNE. *Still Life with Apples and Oranges*. 1895–1900. Oil on canvas, 28¾ × 36¼″. The Louvre, Paris

1145. PAUL CÉZANNE. *Card Players*. c. 1890–92. Oil on canvas, 52¾ × 71¼″. © The Barnes Foundation, 1976, Merion Station, Pennsylvania

that apples and oranges began to rot before a painting could be completed and had to be replaced by wax ones.

For his rare figure pieces, Cézanne chose during the 1890s—the great decade for his classical constructions of pure form—subjects as quiet, impersonal, and remote as his still lifes. The *Card Players*, of about 1890–92 (fig. 1145), shows three men, two of whom are clad in the blue smock of the farmer or country laborer, sitting around a table, while a fourth gazes downward, arms folded. The card game had been a favorite subject among the followers of Caravaggio, and was usually set forth dramatically with strong light-and-dark contrasts underscoring suspicious expressions; one player is often shown cheating. Nothing could be farther from Cézanne's timeless and immobile scene, which recalls in its symmetrical disposition parallel to the picture plane Rembrandt's *Supper at Emmaus* (see fig. 992). The quiet figures contemplate the cards, themselves (like Cézanne's paintings) planes of color on white surfaces. No expression can be distinguished; the downcast eyes are mere planes of color. The Giotto-like tubular folds of the smock of the man on the right echo in reverse those of the hanging curtain, locking foreground and background in a single construction. Yet the background wall fluctuates at an indeterminable distance like the sky in one of Cézanne's landscapes, and the pipes on their rack seem to float against it. These perfect constructions of Cézanne's maturity were painted very lightly as compared to the heavy pigment of his early Romantic style; the planes are indicated in veils of color so thin as to be almost transparent.

The full beauty of Cézanne's developed style is seen in his *Woman with the Coffeepot*, of about 1895 (fig. 1146). Cézanne's planes of varying hues of blue and blue-violet have built majestic cylinders from the arms and a fluted column from the body. Yet even at this most classical moment of Cézanne's career stability is something imposed by his demand for total coherence upon a fundamentally unstable arrangement. For example, the door panels in the background tilt slightly to the left, compensating for the turn of the head toward the right, and the placing of the coffeepot and cup. So exquisite are these adjustments that the removal of any ele-

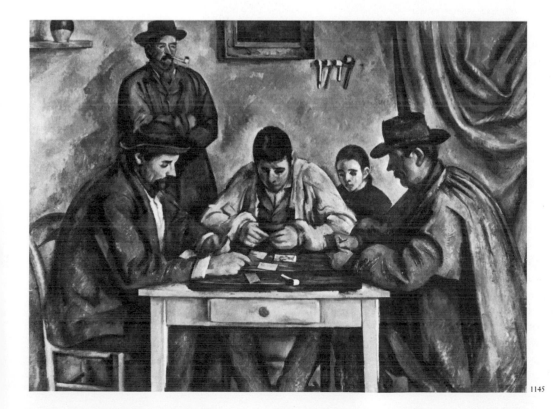

1145

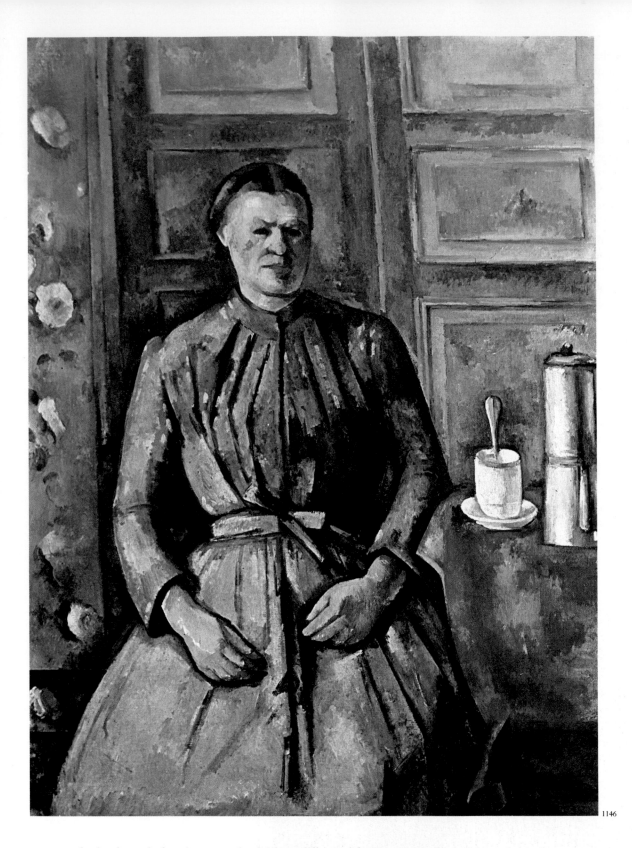

1146

ment deals the whole picture a fatal blow. The reader can experiment with this principle by covering up the coffeepot and cup, whose blue-and-white cylinders are indispensable elements in the whole, toward which the movement of all the planes is directed. Beautiful as its elements still are, the composition loses something essential. It will be noticed that any small section of the picture contains the same blues, whites, and rose tones as the painting as a whole, although in different arrangements and different gradations. The rose of the woman's cheeks, for example, turns

1146. PAUL CÉZANNE. *Woman with the Coffeepot.* c. 1895. Oil on canvas, 51¼ × 38¼". The Louvre, Paris

1147. PAUL CÉZANNE. *Bathers.* 1898–1905. Oil on canvas, 82 × 98". Philadelphia Museum of Art. The W. P. Wilstach Collection

up in her skirt and in the door, while the blue of the dress is reflected throughout the painting. Cézanne's search for the exact plane of color to fit into his structure at any given point was so demanding that at times the plane eluded him. Here and there in the hands and in the dress, for instance, some of the white priming shows through. Surprising elements are the mysteriously vertical spoon, and the cylinders of cup and pot, definitely out of drawing.

Toward the very end of his life, Cézanne's development toward abstraction became more and more evident. The large *Bathers*, of 1898–1905 (fig. 1147), is the culmination of a series of nude compositions that had occupied Cézanne's imagination again and again. These nudes were never painted from life, nor in the open air. The subject, of course, is as unlikely as that of the bubbly *Bathers* of Fragonard (see fig. 1023), of which this carefully constructed picture is the exact opposite. Women in the eighteenth and nineteenth centuries did not bathe naked in streams and sun themselves on the banks. But the fantasy gave Cézanne the materials with which to build a grand imaginary architecture, composed of strikingly simplified figures, overarching tree trunks, blue sky, and white clouds—a modern cathedral of light and color. Many areas of the figures are still in the white priming stage, because Cézanne had not yet found the right planes of color. But even if he had, the bold, sometimes multiple contour lines of the figures and heads would have remained as schematic as they now are; features are suppressed and mouths omitted entirely so as not to break the ovoid forms of the heads. Within the context of Impressionist accidentality—the women are strewn about in relaxed poses, or engaged in spreading a luncheon cloth on the ground—the figures are organized as closely as any in a composition by Poussin (compare fig. 937). The end result, perhaps as much to Cézanne's surprise as to our own, is a simplification of the human figure that had not been seen since the Middle Ages.

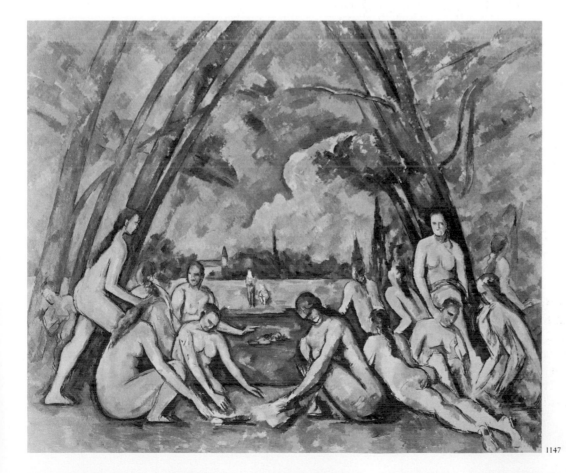

1147

While Cézanne was pursuing his lonely search for a new monumentality based on Impressionist discoveries, a younger but almost equally gifted painter, Georges Pierre Seurat (1859–91), was working toward similar goals but with radically different methods and results. During his tragically brief career (he died before reaching thirty-two), Seurat attempted to embody in a quasi-scientific style the results of his close study of Delacroix's theory and of the research of Chevreul (see pages 839, 840), as well as that of Hermann von Helmholz and Ogden N. Rood, into the physical nature of color and the chromatic structure of light.

His first major achievement in this direction was the *Bathers at Asnières*, of 1883–84 (fig. 1148), which shows still another possibility for the traditional bather composition. This is not an ideal bathing scene, like those of Cézanne, but a real one, taking place along the Seine just to the northwest of Paris, with working-class people in the foreground and boats, a bridge, and factory chimneys in the background. The picture is as completely dedicated to the enjoyment of sunlight as any of Monet. But instead of that master's instantaneity, it communicates a mood of quiet permanence, and has often been compared in this respect to the calm compositions of Piero della Francesca (see figs. 712–15), whom Seurat admired, although he could have known the originals only from photographs and copies. He prepared for this composition by careful preliminary figure drawings done in conté crayon, a rich black drawing stick that gives a luminous effect when rubbed on roughgrained white paper, and by tiny color sketches on wood panels, which look very like Impressionist paintings in their immediacy and brightness.

The final picture, however, painted in the studio in a return to traditional practice, achieves a kind of compositional grandeur absent from French painting between David and Cézanne. In contrast to the style of Monet, Renoir, and Pissarro, contours are strongly in evidence, very simple ones, outlining forms reduced to the appearance of cylinders or spheroids. These are not the drawn lines one finds in some late Cézannes, but rather hard, clear edges between darker and lighter areas. Along these

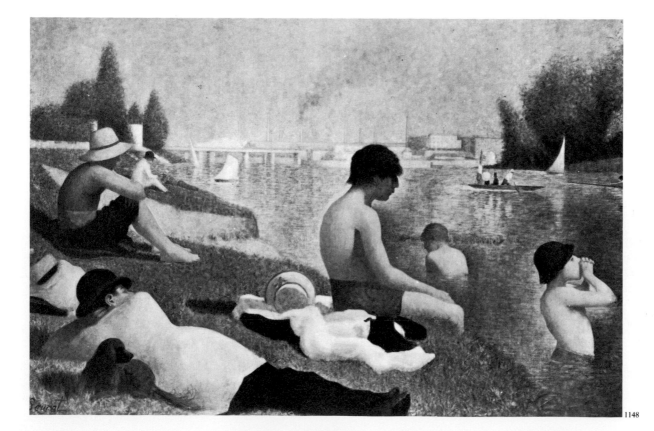

1148

edges contrasts of color and light and shade intensify abruptly, as happens in nature and can be verified in photographs. Even in the black-and-white illustration it can be seen that the water becomes lighter near the shadowed side of a figure and darker near the lighter one. In the original these are changes of hue as well as of value. Within the firm, unbroken contours, which establish a dense pattern of masses and spaces, the brushstrokes resemble a slow, methodical stippling of the surface rather than the quick strokes of the Impressionists. Also, each touch of the brush represents a separate color, set down at full intensity and contrasting with its neighbor to mix not on the palette but in the eye. This effect, drawn from the scientist's analysis of light, was called divisionism by Seurat's friend Paul Signac. The method won for Seurat and his associates the title of Neoimpressionists. It has been pointed out by Meyer Schapiro that the extraordinary sense of restful horizontality in this picture is produced partly by psychological means. The few actual horizontals in the background are reinforced by the implied horizontal gazes of the figures, although in only two cases is an eye actually indicated.

In many ways the culmination of Seurat's mature style is the huge *Sunday Afternoon on the Island of La Grande Jatte* (fig. 1149), on which Seurat worked from 1884 to 1886. About forty preliminary color studies were necessary, all done outdoors. On the basis of these accurate studies and his thorough, scientific knowledge of color, Seurat was able to paint the magically sunny picture not only in his studio but also at night, by gaslight. When it was first shown at the eighth and last Impressionist exhibition in 1886, the work was denounced by some critics and praised by others as being "Egyptian." The customary Impressionist theme is indeed treated with almost Egyptian formalism and rigidity. The foreground figures are arranged as if in a frieze, but their movement back in depth on the sunny lawn, with light and shadow coordinated with the cylindrical figures, recalls the Italian Quattrocento, especially the space of Masaccio, Uccello, and again Piero della Francesca. In his own theoretical way Seurat has done just what Cézanne was doing empirically—he has converted Impressionism into something as durable as the art of the museums.

By now, however, his divided touch has become systematized into tiny round particles, which are generally and not inaccurately compared to the tesserae of Classical and medieval mosaics. Each patch of light, each area of shadow, is composed of countless such particles, of almost identical size and shape. From close up, their colors appear absolutely pure, the quality of shading or color transition being controlled by the numerical proportion of colors of varying value or hue. Although these are intended to mix in the observer's eye, the mixture is never complete, and the little spots retain their autonomy, like the notes in music, giving the picture even at a distance a grainy texture. The mock solemnity of Seurat's composition is lightened by many touches of wit and whimsy, such as the details of costumes and accessories, and the drama between the pug-dog and the ringtail monkey at the lower right. It is amazing that a revolutionary work of such skill and brilliance could have been completed by Seurat at the age of twenty-seven. The history of modern painting might well have been different had he lived an ordinary life-span. As it was, even Pissarro, the oldest of the Impressionists, was for a while won over by the style of this twenty-nine-years-younger genius, and joined the Neoimpressionists. The art of the Fauve painters in the early twentieth century (see Chapter Six) was profoundly indebted to Seurat's discoveries.

1148. GEORGES SEURAT. *Bathers at Asnières.* 1883–84. Oil on canvas, 79⅛ × 9'10⅛". National Gallery, London

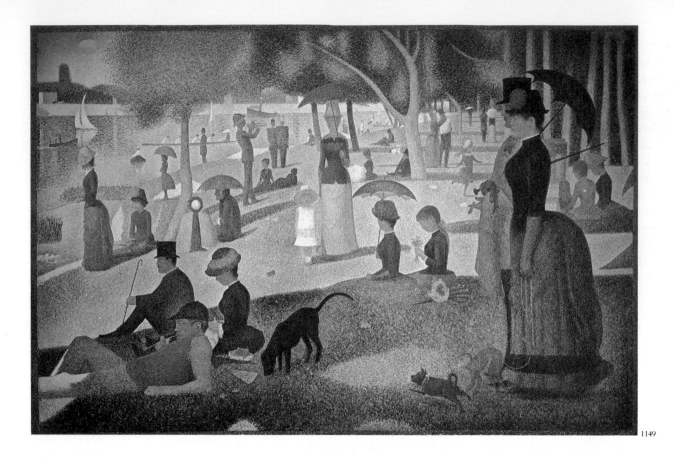

1149

A maverick on the Parisian art scene at the end of the century was Henri de Toulouse-Lautrec (1864–1901). Born to one of the oldest noble families in France, he broke both legs in early adolescence, and they never developed properly. For the rest of his brief existence he remained a dwarf, alienated from his family's fashionable life. He learned to paint, and took refuge in the night life of Paris, which he depicted with consummate

Toulouse-Lautrec

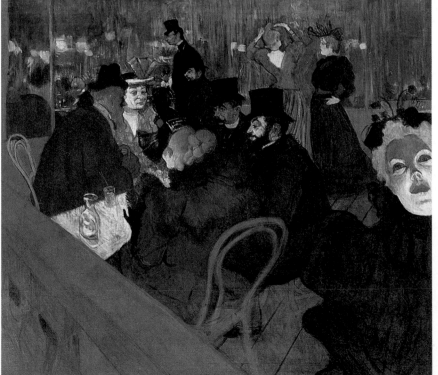

1150

1149. GEORGES SEURAT. *Sunday Afternoon on the Island of La Grande Jatte.* 1884–86. Oil on canvas, 6'9″ × 10'. The Art Institute of Chicago. The Helen Birch Bartlett Memorial Collection

1150. HENRI DE TOULOUSE-LAUTREC. *At the Moulin Rouge.* 1892. Oil on canvas, 48⅜ × 55¼″. The Art Institute of Chicago. The Helen Birch Bartlett Memorial Collection

1151. PAUL GAUGUIN. *The Day of the God.* 1894. Oil on canvas, 27⅜ × 35⅝″. The Art Institute of Chicago. The Helen Birch Bartlett Memorial Collection

skill—scenes of cafés, theaters, and cabarets, and even a witty series of bordello interiors to set against the poplars and cathedrals of Monet. All of his portrayals are prompted by the same uncritical acceptance of the facts of Parisian night life that he wished for his own deformity and found only in this shadowy world. *At the Moulin Rouge*, of 1892 (fig. 1150), was strongly influenced by Degas, whom he deeply admired (see especially fig. 1131). Toulouse-Lautrec's line was sure, almost as much so as that of his idol, but his tolerant humanity was entirely his own. The little artist can be made out toward the top of the picture in profile, just to the left of center alongside his towering cousin and constant companion. It is significant that, to reinforce the psychological impact of the picture, Toulouse-Lautrec extended it on all four sides, particularly at the bottom and at the right. The plunging perspective of a balustrade in the added section pushes the little group huddled about the table into the middle distance, while it forces toward us with startling intensity the face of a heavily powdered entertainer, so lighted from below that the shadows are green. Toulouse-Lautrec's smart and vivid drawing style, his brilliant patterning, and his surprising color contrasts were the dominant influence in Paris when in 1900, eight years after this picture was painted, the young Pablo Picasso arrived from Spain.

A more imaginative but often unequal approach to the problems of a new art was that of Paul Gauguin (1848–1903). Although without formal artistic training, this successful businessman became intensely interested in art, and began painting as an amateur. Under strong influence from Pissarro, he rapidly absorbed Impressionist ideas and techniques, and from 1879 to the last Impressionist exhibition in 1886 exhibited regularly with

Gauguin

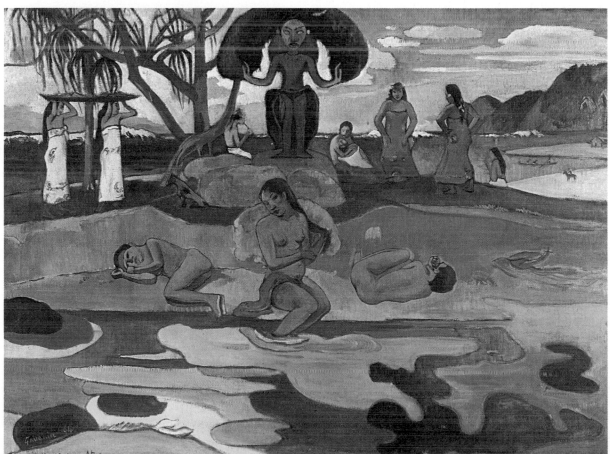

the group. In 1881 he came in contact with Cézanne, and bought some of the great painter's work. But there was a streak of the drifter in Gauguin, and rapidly, to the great gain of art but the consternation of his family, this tendency became dominant. He was partly of Peruvian (Indian) extraction, had spent four years of his childhood in Peru, six years of his youth as a sailor, and was incurably drawn to the exotic and the faraway.

Gradually, painting itself became identified with his wanderlust, and drew him away from all his daily associations. In 1883 he gave up his business career, and in 1885 he abandoned his wife, his children, and his bourgeois existence to devote his life to art. Convinced that European urban civilization and all its works were incurably sick, he spent less and less time in Paris. Henceforward, his life was nomadic; he moved back and forth between villages in Brittany (because it was the most remote and "backward" of French regions), the island of Martinique, Brittany again, Arles (where for a brief and stormy period he lived with Van Gogh), Brittany for a third time, Tahiti, Brittany for a fourth time, Tahiti again, and finally—impoverished, terminally ill, and in trouble with the law— the Marquesas Islands, where he died.

Gauguin's departure from Western artistic tradition was prompted by the same rebellious attitude that impelled his break from middle-class life. He renounced not only the instantaneity and formlessness of Impressionist vision but also Western devotion to naturalistic effects, which had been carried to its final flowering in Impressionism. Instead, he recommended a return to archaic and, for the first time in the history of art, "primitive" styles as the only refuge for art. What he sought, however, was still immediacy of experience, but intensified. "A powerful sensation," he said, "may be translated with immediacy; dream on it and seek its simplest form." This is just what Gauguin did in his brilliant *Vision After the Sermon* (fig. 1152), painted in 1888 during his second stay in Brittany. In the background Jacob is shown wrestling with the angel (Genesis 32:22–31). It has recently been demonstrated that this event forms the lesson in the Breton rite for the eighth Sunday after Trinity (August 5 in 1888). On the preceding day took place the blessing of horned beasts, followed by wrestling contests and a procession with red banners, and at night fireworks, a bonfire that turned the fields red with its glow, and an angel descending from the church tower.

Gauguin has shown in the foreground at the extreme right the head of a priest, and next to it those of praying women in Breton costume, whose vision fuses the events of the preceding day and night with the lesson on Sunday morning. The apparently arbitrary intense red of the ground is an immediate translation, in Gauguin's terms, of the powerful sensations of the folk festival. Although the figures are outlined with the clarity that Gauguin derived from his study of Oriental, medieval, and primitive arts, the contrast between the large foreground heads and the sharply smaller groups in the distance still presupposes Western perspective, and is drawn from theater subjects developed by Daumier, Degas, Renoir, and Toulouse-Lautrec.

In Oceania Gauguin was influenced only to a limited degree by the art of the natives with whom he lived. In point of fact, he took his flattened style with its emphasis on brilliant color to the South Seas with him, and fitted into it the people whose folkways and personalities attracted him. The accidental attitudes in which he drew and painted them still derive from Impressionist vision. In *The Day of the God*, for instance (fig. 1151), painted in 1894, a happy nude woman and her two children

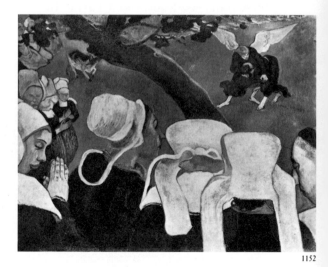

1152

1152. PAUL GAUGUIN. *Vision After the Sermon.* 1888. Oil on canvas, 28¾ × 36¼". National Gallery of Scotland, Edinburgh

relax at the water's edge, below the towering image of the god in the background. But while the poses are free in the Western tradition, the contours have been restored, as continuous and unbroken as in Egyptian or Archaic Greek art. And the contour is brilliant, arbitrary, and intense, bearing in the free-form shapes seen in the water in the foreground little or no relationship to visible reality. Just before his death, Gauguin said, "I wanted to establish the right to dare everything. . . . The public owes me nothing, since my pictorial *oeuvre* is but relatively good; but the painters who today profit from this liberty owe me something." So indeed they did, especially Matisse and the Fauves (see Chapter Six), but no more than Cubism and abstract movements since owe to the pioneer researches of Cézanne.

Van Gogh

It is with a special reverence that one approaches the art of Vincent van Gogh (1853–90), as surely the champion of those late-nineteenth-century artists who identified art with emotion as Cézanne was the leader of those who sought spiritual ultimates in form. The son of a Protestant Dutch minister, the young Van Gogh was by turns the employee of a firm of art dealers in The Hague, London, and Paris; a language teacher in Ramsgate and Isleworth, England; a student of practical evangelism in Brussels; and a missionary to the downtrodden coal miners of a village in southern Belgium. Through these fragmentary careers, and indeed through his personal relationships, including several impossible love affairs and his disastrous friendship with Gauguin, runs the same theme—a love of humanity, of life, and of things, whose inevitable corollary was a sense of failure and betrayal. This love was the theme of his art as well, and was to produce one of the most intensely personal witnesses in the spiritual history of mankind. Even Van Gogh's mental illness, severe enough to bring about his frequent hospitalization and his untimely death, did not prevent him from becoming the only Dutch painter whose stature could set him on a level with the three great Dutch masters of the seventeenth century.

Van Gogh's earliest drawings and paintings date from his association with the Belgian miners and from a later stay among the peasants of northern Holland. Only in 1881 did he embark on formal study of art, but remained in a somewhat provincial Dutch tradition, out of touch with the new coloristic discoveries of Impressionism. In 1886 he came to Paris for a two-year stay with his brother Theo, and under the joint influences of Impressionism and Japanese prints freed his palette and worked out a fresh, new sense of pattern in contour not unrelated to Seurat, but already highly original. Having shown signs of depression and emotional instability, he left the north early in 1888, hoping to find a happier and more healthful existence at Arles, in Provence (not far from Cézanne's home at Aix, although there seems to have been no contact between these two great masters of Post-Impressionism). During the next two years, which were all that remained of life to Van Gogh, he painted at white heat—often a canvas a day—his series of masterpieces in a style without precedent in European art. He showed little interest in the Roman and Romanesque antiquities of Arles, but was enraptured by the beauty of the landscape and above all by the clear southern light, utterly different from that of northern France with its mists and rain. Disturbingly, he noted that the intense sunlight could drive a man mad.

A superb example of this brief period of gladness is his *A View of La Crau* (fig. 1153), painted in June 1888, with its almost Renaissance per-

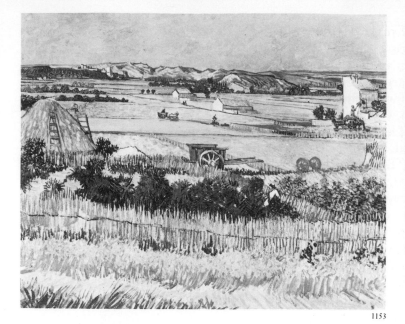

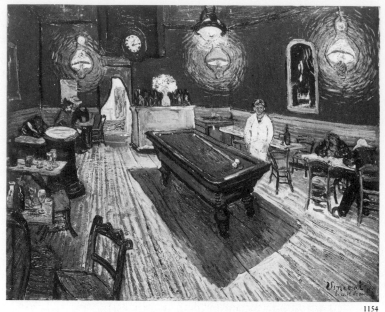

spective of fields and farms, a surprising revival of the principles that had been swept aside by the Impressionists and Gauguin. To Van Gogh, however, space construction became an expressive device, propelling the observer forcefully toward the distant mountains. The whole picture is colored in the red-gold and blue that were his own colors—hair, beard, and eyes (see fig. 1155)—and whose dominance in his work invariably betokens at least temporary mental equilibrium. The thick pigment, blazing color, and strong, straight strokes are Van Gogh's personal transformation of Impressionist technique.

Alas, the happy period did not last long. In September of the same year, a month before the eagerly awaited arrival of Gauguin to share his house, Van Gogh painted the first of his disturbing pictures, *The Night Café* (fig. 1154), which cannot be better described than in his own words:

> I have tried to express the terrible passions of humanity by means of red and green.
>
> The room is blood red and dark yellow with a green billiard table in the middle; there are four lemon yellow lamps with a glow of orange and green. Everywhere there is a clash and contrast of the most alien reds and greens in the figures of little sleeping hooligans, in the empty dreary room. . . .
>
> I have tried to express the idea that the café is a place where one can ruin one's self, run mad or commit a crime. So I have tried to express as it were the powers of darkness in a low drink shop. . . .

The harsh green ceiling completes the fierce contrasts of the picture, and the perspective, used for such a happy effect in the *View of La Crau*, is here so strongly exaggerated that it seems to catapult the observer into the end wall, in which the red-and-green contrast is insoluble. In late December of the same year Van Gogh hurled a knife at Gauguin; then he cut off one of his own ears and gave it to a prostitute; consequently, Gauguin fled Arles. Cared for at first in the hospital at Arles, then in the asylum at nearby Saint-Rémy, Van Gogh was allowed to paint, and produced some of his most beautiful and moving works. His *Self-Portrait* (fig. 1155), painted in the asylum in September 1889, betrays the period of

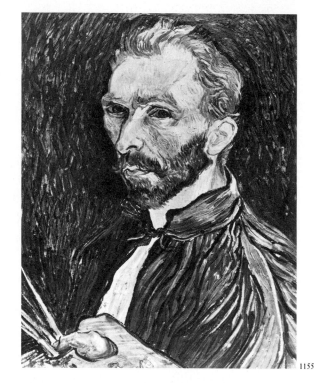

1153. VINCENT VAN GOGH. *A View of La Crau.* 1888. Oil on canvas, 28½ × 36¼". Rijksmuseum Vincent van Gogh, Amsterdam

1154. VINCENT VAN GOGH. *The Night Café.* 1888. Oil on canvas, 28½ × 36¼". Yale University Art Gallery, New Haven, Connecticut. Bequest of Stephen C. Clark

1155. VINCENT VAN GOGH. *Self-Portrait.* 1889. Oil on canvas, 22½ × 17¼". Private collection, New York

1156. VINCENT VAN GOGH. *The Starry Night.* 1889. Oil on canvas, 28¾ × 36¼". The Museum of Modern Art, New York. Acquired through the Lillie P. Bliss Bequest

desperation through which the artist had passed. The brushstrokes are now curved, and vibrate intensely throughout the picture. In a mood of renewed confidence, the artist has again endowed the painting with his own physical coloring, and his ivory face, gold hair, and red-gold beard float in tides of ever deeper and more sonorous blue, carving out a kind of haven for the soul in the sky itself, the color of the artist's piercing eyes. Only in the greatest self-portraits of Rembrandt do we find such intense self-revelation, or such a triumph over sorrow.

In the fields near the asylum, by day or even at night, Van Gogh drew and painted the wonders of the earth and sky, for which he felt a kind of pantheistic reverence, no longer explicable in terms of conventional religion. Yet these pictures communicate a mood of self-identification with the infinite, which is the mark of religious ecstasy in Van Gogh as much as in the visions of the Counter-Reformation mystics (see Part Five, Chapter One). In *The Starry Night* (fig. 1156), painted in June 1889, he shows us not the stars he observed but exploding masses of gold fire, expanding against the blue. Two of these swirl through the sky in a kind of cosmic embrace, unimagined by the denizens of the sleeping town below, but attainable through the intermediary of the dark green cypresses that swirl upward into their visionary midst.

In May 1890, Van Gogh went to Paris for a three-day stay with his brother, then to Auvers, which had sheltered many of the Impressionists and Post-Impressionists, where he placed himself under the care of Dr. Paul Gachet, friend and patron of artists. Despairing of a cure, he shot himself on July 27, and died two days later. For all the tragic circumstances of his life, Van Gogh won a spiritual victory in opening a new path for artistic vision and expression.

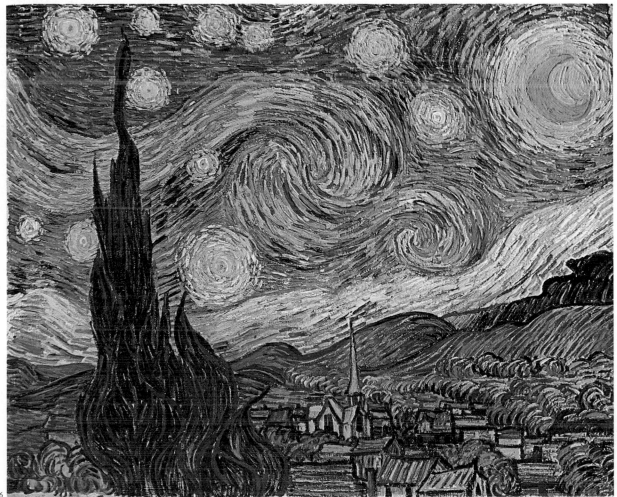

1156

The anti-Impressionist reaction of the 1880s was directed not only against the formlessness of Impressionism, which had disturbed Cézanne and Van Gogh, but also against its objectivity. A tendency to penetrate beyond the surface of visible reality into the world of folklore, mythology, fantasy, and dreams (beloved by many Romanticists) soon began to make its presence felt in the French art scene. The individual artists, and the shifting groups to which they belonged, can be loosely classified under the term *Symbolism*. A solitary apostle of this tendency—and in many ways the most gifted—was ODILON REDON (1840–1916), whose activity parallels that of Monet in time but could scarcely have been more different. After training in architecture and painting, he studied anatomy and microscopic biology. Throughout the 1870s and 1880s, calling black "the prince of colors," he turned out series after series of fantastic lithographs, often based on such poets of the imagination as Baudelaire and Poe. In the 1890s he burst forth with a steady succession of brilliantly colored works in oil and in pastel in which, according to his own words, he desired "to make improbable beings live, like human beings . . . by putting insofar as possible the logic of the visible at the service of the invisible." A striking example of his later art is *Orpheus*, of 1903 (fig. 1157). The Greek legend tells us how the great musician, after the death of his wife, Eurydice, wandered the earth, lamenting her loss in song, and refused to submit to the blandishments of the Maenads, female followers of Dionysos, who in revenge tore him to bits and threw the pieces in a stream. The frightful legend is muted by Redon into the magic of a waking dream. There is no blood. The head shines in an opalescent dusk, floating with a fragment of the singer's lyre, and sparkling flowers cluster about it. Intended to evoke the magical power of music to transfigure violence and tragedy, the picture also provides the solace of a retreat into fantasy. Redon's rich imagination and his glowing color made him the immediate precursor of a major current of twentieth-century art (see Chapter Eight) in which the private fantasy of the artist has free rein in escaping from the increasingly onerous restrictions of modern urban society.

The phenomenon of the independent exhibition, beginning with Courbet's Pavilion of Realism in 1855 and continuing with the officially sponsored Salon des Refusés of 1863, became increasingly important as the gulf between radical artists and conservative public and critics widened and deepened. The eight group exhibitions of the Impressionists from 1874 to 1886 are a case in point. In 1884 Seurat and Redon were instrumental, along with a number of other artists, in organizing the Société des Artistes Indépendants, as a counterforce to the all-powerful Salon, and it was at the exhibitions of this society that the innovators showed their work.

At various moments during the nineteenth century, veritable brotherhoods of artists were formed, fewer in France than in England and in Germany. During the last two decades of the nineteenth century, these brotherhoods began to include more and more of the most gifted artists. Van Gogh dreamed of such a brotherhood, through which he and Gauguin could lead the reform of European art. A small group of Symbolist artists, starting at Pont-Aven in Brittany around Gauguin, continued to meet in Paris. The most vocal members of the Pont-Aven group, although by no means the most talented, were Émile Bernard (1868–1941) and Maurice Denis (1870–1943). Bernard claimed more influence on Gauguin than the facts justify, and even priority in the invention of a linear, bright-colored, and flattened style. The lasting value of the Symbolist movement in its Pont-Aven phase is found less in the works of

Symbolism

1157

1158

1157. ODILON REDON. *Orpheus*. 1903. Pastel, 27½ × 22¼". The Cleveland Museum of Art. Gift of J. H. Wade

1158. ÉDOUARD VUILLARD. *Woman Sweeping in a Room*. 1892–93. Oil on composition panel, 18 × 19". The Phillips Collection, Washington, D.C.

1159. JAMES ENSOR. *The Entry of Christ into Brussels in 1889*. 1886. Oil on canvas, 8'5" × 12'5". Collection Louis Franck, London. On loan to Koninklijk Museum voor Schone Kunsten, Antwerp

these two artists than in Denis's dictum in 1890 that a picture is first of all "an arrangement of colored shapes." The Pont-Aven artists, especially Gauguin with his arbitrary forms and colors, came much closer to this principle than had Whistler to his similar pronouncement. Some of the group joined a new brotherhood of Symbolists, which met weekly for discussions in Paris, beginning in 1888, and monthly for semi-secret ceremonial dinners in costume. The group called themselves the Nabis, a name derived from a Hebrew word for "prophet," and included not only Denis but also such far more gifted artists as ÉDOUARD VUILLARD (1868–1940), and Aristide Maillol, then a painter but better known for his later work in sculpture (see Chapter Seven).

The mystical doctrines of the Nabis, allied to Rosicrucianism, included a strong devotion to home life, including the artistic decoration of domestic interiors, in spite of the group's supposed opposition to bourgeois values. The most eloquent paintings of the Nabis are those of Vuillard, who never married, lived with his mother until her death, and produced intimate paintings of interiors unrivaled in their delicacy and charm in spite of the airless and crowded nature of their subjects. In *Woman Sweeping in a Room*, of about 1892–93 (fig. 1158), every inch is packed with domestic detail, which by his own personal magic Vuillard is able to translate into exquisite pattern, relying on the juxtaposition of areas of great richness and constant variety. Sometimes his technique recalls that of Seurat and the Neoimpressionists in its use of tiny dots; at other moments parallel lines or stripes and decorative opposition of softly painted flat surfaces foretell the work of Matisse (see fig. 1166), who was deeply indebted to Vuillard's acute sensibility to the relationship of the most ordinary objects.

Forerunners of Expressionism

Toward the end of the nineteenth century, a number of artists outside of France, notably in Brussels, Oslo (then named Christiania), and Vienna, attempted the direct expression of emotion in pigment with relatively little care for the Impressionist aesthetic, considering style, color, form, and surface as subservient to the prime necessity of emotional expression. JAMES ENSOR (1860–1949), a Belgian born of an English father, absorbed

1159

Impressionist style and method, but soon turned to the most daring treatment of unexpected and shocking themes, and to the sharp, often horrifying contrast of colors and shapes. Interestingly enough, there seems to be no evidence that, at the moment of his most revolutionary works, Ensor had any knowledge of the roughly parallel development of Van Gogh. His mother kept a souvenir shop, selling among other wares the masks used at Flemish carnivals, and these obsessed Ensor as symbols of the basic evil of contemporary existence. His huge canvas entitled *The Entry of Christ into Brussels in 1889* (fig. 1159; ironically, the work was painted in 1886) so shocked his contemporaries that even The Twenty, a group of radical Belgian artists to which Ensor belonged, refused to exhibit it. Under a broad, red banner inscribed "VIVE LA SOCIALE," Christ, who can barely be distinguished at the upper center, enters the streets of Brussels, which are filled with a tide of masked figures in a cacophonous combination of brilliant reds, greens, yellows, and blues— a Christ as powerless as in a painting by Bosch (see fig. 769).

In Norway a similar tendency is seen in the art of EDVARD MUNCH (1863–1944), whose work had little in common with the academic current of Norwegian art, but showed quite early an understanding of the bright palette of the French Impressionists. Munch was associated with the great Norwegian psychological dramatist Henrik Ibsen, for whom he designed stage sets, but he went past Ibsen in his treatment of themes involving obsession with sex and death. *The Scream* (fig. 1160), painted in 1893, is a work one can hardly contemplate without horror. A person walking along a seashore promenade puts his hands to his head, bursting with anguish, while the very landscape about him heaves in waves as if vibrating along with his intolerable inner conflict, intensified by the arbitrary use of red, yellow, and green throughout the background. Munch's paintings created such an uproar when shown in Berlin in 1892 that the authorities forced the closing of a group exhibition in which he participated. Both he and Ensor were strongly influential in the development of the German Expressionist movement of the early twentieth century (see Chapter Six).

Unexpectedly enough, England in the 1890s saw the flowering of a movement that prided itself on its "decadence," centering around the controversial figure of the poet and dramatist Oscar Wilde. The short-lived and highly imaginative draftsman AUBREY BEARDSLEY (1872–98) illustrated a number of literary works, including Wilde's *Salome*, with drawings matchless in their brilliant handling of flowering line and surprising contrasts of black and white areas and scale. Such a drawing as his *John the Baptist and Salome*, of about 1894 (fig. 1161), with its strong erotic content, is also allied to the Continental current known as Art Nouveau, which found its richest expression in architecture and decoration (see Chapter Ten).

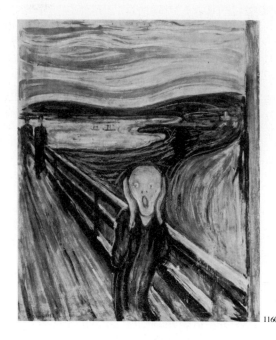

1160

1161

An utterly unexpected and delightful apparition on the Parisian art scene at the close of the nineteenth century was the self-taught painter Henri Rousseau (1844–1910). Having earned his living in the prosaic calling of toll collector, Rousseau retired early on a small pension and devoted himself entirely to painting. His combination of straight-faced whimsy, imagination, poetry, and real artistic sensitivity caused his work to be rapidly known and appreciated in the most advanced artistic circles. As early as 1886, he exhibited at the Société des Artistes Indépendants, to the universal derision of the public. Yet, although the artists of his day never took him quite as seriously as he took himself, for a quarter of a century,

Rousseau

from the days of Degas to those of Picasso, Rousseau was received everywhere. He is the first untutored, "primitive" artist to be highly valued in modern times; his naïve style is a product of imagination and visual experience rather than of visual analysis in the Western tradition that culminated in Impressionism. *The Sleeping Gypsy* (fig. 1162) shows an entirely new style in its smooth surfaces with no visible brushstrokes, its immense night sky, and its delightful air of mystery. Only recently has it been discovered that both the sleeping gypsy in her coat of many colors and the sniffing, harmless lion were modeled from children's toys on sale in Parisian shops; while painting them with utter literalness, Rousseau distilled from these toys his own delicate poetry. His art of the enigma was as important an element as the poetic fantasy of Redon in the development of the fantastic current in twentieth-century art.

Post-Impressionism was never a unified movement like its parent, Impressionism. The Post-Impressionists, many of whom had been ardent Impressionists, were either solitaries or at most formed short-lived splinter groups. Some were deeply concerned with reestablishing form; others with the analysis of pure color in light; others with the expression of feeling in color, line, and surface; still others with imagination. But whatever their direction, the Post-Impressionists traveled the road opened up for them by Impressionist immediacy, into a new artistic region where the artist alone was autonomous. Post-Impressionism established the supremacy not of visual but of creative experience. This breakthrough marked the birth of modern art in the familiar sense of the word.

1160. EDVARD MUNCH. *The Scream*. 1893. Oil on canvas, 36 × 29". Nasjonalgalleriet, Oslo

1161. AUBREY BEARDSLEY. *John the Baptist and Salome*. c. 1894. Pen and brush, black ink, and black chalk on paper. Fogg Art Museum, Harvard University, Cambridge, Massachusetts. Grenville L. Winthrop Bequest

1162. HENRI ROUSSEAU. *The Sleeping Gypsy*. 1897. Oil on canvas, 51 × 79". The Museum of Modern Art, New York. Gift of Mrs. Simon Guggenheim

TIME LINE XII

Death of Marat, by David

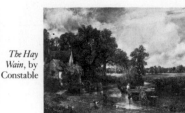

The Hay Wain, by Constable

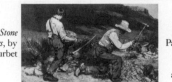

The Stone Breakers, by Courbet

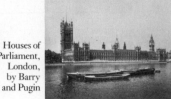

Houses of Parliament, London, by Barry and Pugin

	POLITICAL HISTORY	RELIGION, LITERATURE, MUSIC	SCIENCE, TECHNOLOGY
1780	U.S. Constitution adopted, 1789 French Revolution, 1789–97; Louis XVI beheaded, Reign of Terror, 1793 Consulate of Napoleon, 1799	*Critique of Pure Reason* by Immanuel Kant, 1781 *Lyrical Ballads* by Wordsworth and Coleridge, 1798	First aerial crossing of English Channel, 1785 Edward Jenner discovers smallpox vaccine, c. 1798
1800	Napoleon crowns himself emperor, 1804; defeated at Waterloo, banished to St. Helena, 1815 Return of Bourbon Dynasty to French throne under Louis XVIII, 1814	Ludwig van Beethoven (1770–1827) Sir Walter Scott (1771–1832) Percy Bysshe Shelley (1792–1822) Franz Peter Schubert (1797–1828) Hegel, *Phenomenology of Mind*, 1807 *Faust* (Part I) by Goethe, 1808	Alessandro Volta invents electric battery, 1800 Georges Cuvier publishes work on paleontology, 1800 First voyage of Robert Fulton's steamship *Clermont*, 1807 Michael Faraday discovers principle of electric dynamo, 1821
1825	July Revolution in France, 1830 Victoria governs England, 1837–1901 Revolutions in Paris, Berlin, Vienna, 1848	Sören Kierkegaard publishes *Either/Or*, 1843 *Communist Manifesto* by Marx and Engels, 1848 John Ruskin writes *Seven Lamps of Architecture*, 1849	First railway completed, England, 1825 Robert McCormick invents reaper, 1831 *On the Law of Simultaneous Contrast of Colors* by M. E. Chevreul, 1839
1850	Crimean War, 1853–56 German National Union founded, 1859	Giuseppe Verdi (1813–1901); Richard Wagner (1813–83) Walt Whitman publishes *Leaves of Grass*, 1855	First transatlantic cable, 1858–66 Charles Darwin publishes *On the Origin of Species*, 1859 First oil well drilled, U.S., 1859
1860	Unification of Italy, 1860–70 American Civil War, 1861–65 The First International, 1864	*Crime and Punishment* by Fyodor Dostoyevsky, 1866 First Vatican Council, 1869	Gregor Mendel publishes first experiments in genetics, 1865 Suez Canel opened, 1869
1870	Franco-Prussian War begins, 1870; France defeated, 1871 Bismarck made chancellor of German Empire, 1871	First performance of Modest Mussorgsky's *Boris Godunov*, 1874 Émile Zola (1840–1902) Stéphane Mallarmé (1842–89)	Heinrich Schliemann starts excavations at Troy, 1870 Wilhelm Wundt establishes first Institute of Experimental Psychology in Leipzig, 1875
1880	Bismarck signs "Reinsurance Treaty" with Russia, 1887 Internationalization of Suez Canal, 1889	Henry James (1843–1916) G. B. Shaw (1856–1950) W. B. Yeats (1865–1939) *Illuminations* by Arthur Rimbaud, 1886	Pasteur and Koch prove germ theory of disease, 1881 First internal combustion engines for gasoline, 1885
1890	Spanish-American War, 1898; U.S. gains Philippines, Guam, Puerto Rico; annexes Hawaii	First complete performance of Peter Tchaikovsky's *Swan Lake*, 1895	Wilhelm Roentgen discovers X-rays, 1895 Edison invents motion picture, 1896 Curies discover radium, 1898

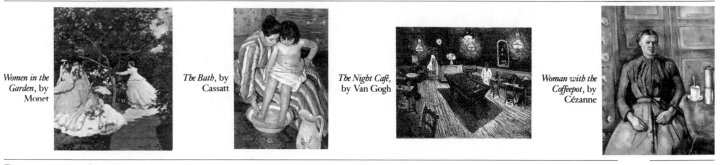

Women in the Garden, by Monet *The Bath*, by Cassatt *The Night Café*, by Van Gogh *Woman with the Coffeepot*, by Cézanne

PAINTING, SCULPTURE, ARCHITECTURE

NEOCLASSICISM	ROMANTICISM	REALISM	
David, *Oath of the Horatii; Death of Marat*	Goya, *Los Caprichos*		1780
Houdon, *George Washington*			
Jefferson, rebuilding of Monticello, Charlottesville			
David, *Coronation of Napoleon*	Goya, *Family of Charles IV*		1800
Canova, *Maria Paolina Borghese*	Gros, *Napoleon*		
Vignon, Madeleine, Paris	Nash, Royal Pavilion, Brighton		
Ingres, *Valpinçon Bather*	Friedrich, *Abbey Graveyard*		
Nash, Park Crescent, London	Géricault, *Raft of the Medusa*		
Jefferson, University of Virginia, Charlottesville	Constable, *The Hay Wain*		
	Delacroix, *Massacre at Chios*		
Ingres, *Apotheosis of Homer; Comtesse d'Haussonville*	Delacroix, *Death of Sardanapalus*	Corot, *Chartres Cathedral*	1825
	Turner, *The Slave Ship; Rain, Steam, and Speed*	Daumier, *Rue Transnonain*	
	Constable, *Stoke-by-Nayland*	Courbet, *The Stone Breakers; A Burial at Ornans*	
	Barry and Pugin, Houses of Parliament, London	Bonheur, *Plowing in Nivernais*	
		Millais, *Christ in the House of His Parents*	1850
		Millet, *Sower*	
		Courbet, *The Studio*	
IMPRESSIONISM			
Manet, *Luncheon on the Grass; Execution of Maxmilian*	Garnier, Opéra, Paris	Daumier, *Uprising; Third-Class Carriage*	1860
Monet, *Women in the Garden*		Homer, *The Croquet Game*	
Monet, *Impression, Sunrise*		Corot, *Ville d'Avray*	1870
Whistler, *Thomas Carlyle; Nocturne*		Eakins, *The Gross Clinic*	
Degas, *The Rehearsal*			
Renoir, *Le Moulin de la Galette*			
Rodin, *The Age of Bronze*			
		POST-IMPRESSIONISM	
Saint-Gaudens, *Admiral Farragut*		Seurat, *Bathers at Asnières*	1880
Manet, *A Bar at the Folies-Bergère*		Cézanne, *Mont Sainte-Victoire*	
Rodin, *The Burghers of Calais*		Gauguin, *Vision After the Sermon*	
Morisot, *In the Dining Room*		Van Gogh, *A View of La Crau; Night Café; The Starry Night*	
Degas, *Two Laundresses*			
Cassatt, *The Bath*		Vuillard, *Woman Sweeping*	1890
Sargent, *Lady Agnew*		Munch, *The Scream*	
Monet, *Rouen Cathedral*		Cézanne, *Woman with the Coffeepot; Still Life with Apples*	
Pissarro, *Boulevard des Italiens*			

THE FAUVES AND EXPRESSIONISM

SIX

In retrospect the opening decade of the twentieth century impresses us today as an era of revolution. Fundamental changes transformed the relationship between art and nature that had been traditionally accepted ever since the beginning of the Renaissance. To a great extent this impression is founded on fact; the innovators of this crucial decade did achieve often unforeseeable and strikingly new results. These amounted at times to a sharp break with the past and were largely to determine the course of twentieth-century art up to the present.

Two other considerations should be borne in mind. First, the Impressionist and Post-Impressionist movements had already deprived visual reality of its permanent properties of color, shape, and space. The artist himself now assumed the prerogative of determining these qualities, either as his eye saw them (Impressionism) or as his ideas, emotions, or fantasy might dictate (Post-Impressionism). So the path had already been prepared for even the most radical of twentieth-century artists.

Second, the vast majority of painters and sculptors at the opening of the twentieth century were working in diluted versions of styles whose basic principles had been laid down by the Neoclassicists, the Romanticists, or the Realists at least two generations earlier. These conservative artists still controlled the Salon and dictated public taste. Even Impressionism had by that time attracted wide admiration and many followers all over the globe, and was itself in the process of becoming a conservative tendency.

The innovators of the first heroic decade of the twentieth century were a hardy band. Every official, critical, and financial force was arrayed against them. But the precedent had long been established. At least since Gros called Delacroix's *Massacre at Chios* the "massacre of painting" at the Salon of 1824, every new tendency in modern art has had to establish itself as an avant-garde movement by a revolutionary exhibition or even, in the twentieth century, by provocative actions. Courbet's Pavilion of Realism and the Impressionist group exhibitions are examples of such gestures of defiance. Women artists, still in the minority, played a role in every one of the artistic movements of the twentieth century. Sometimes that role was major, sometimes truly innovative.

Artistic scandals, while hardly conducive to profitable sales, always drew public attention. Inevitably they tended to nourish the artist's courage and self-esteem. Early in the twentieth century new movements often required explanatory writings or manifestos. A rich literature of aggressive art criticism arose paralleling the provocative writings that generally attended contemporary political and social tendencies. By the early 1970s the phenomenon of the self-proclaimed avant-garde had become so generally accepted that its significance and effects were reversed. An artist could hardly hope to win critical acclaim *unless* he could demonstrate that his work truly belonged to the avant-garde. Since the possibilities available to artistic revolution are now running out, it is by no means certain whether the idea of the avant-garde still has a productive future in the few remaining years of the century.

In the early 1900s, however, the avant-garde was real enough; so indeed were the financial hardships inflicted on its members. The first unmistakable avant-garde event of the new century was the exhibition of an extraordinary roomful of pictures at the Salon d'Automne of 1905. According to a still not absolutely

verified story, the critic Louis Vauxcelles gazed about the room in horror and, seeing in the center a work of sculpture in Renaissance tradition, exclaimed, "Donatello au milieu des fauves!" ("Donatello among the wild beasts!"). The name Fauves immediately stuck to the new movement. While today its joyous productions hardly seem to show the ferocity implied by the nickname, it is not hard to understand that to an academic critic in 1905 such explosions of brilliant color, not to speak of the rough brushstrokes and anti-naturalistic drawing and perspective, seemed bestial indeed. Many of the Fauves were gifted, but only two, Matisse and Rouault, were eventually to achieve major artistic stature.

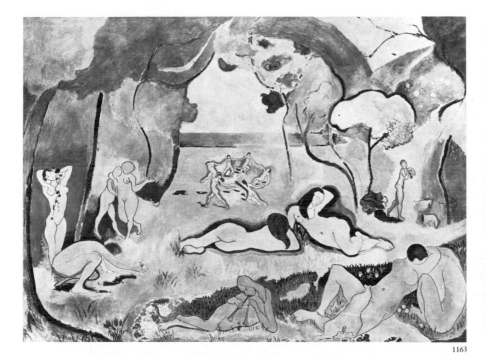

1163

1164

Matisse

When the twentieth century opened, Henri Matisse (1869–1954) was already past thirty. He was a competent painter in a modified Impressionist style, and had executed an impressive series of copies of Old Masters, some quite literal, others delicately altered to bring out those aspects that interested him the most. Yet he had shown no awareness of the innovations of the Post-Impressionists. Soon after the turn of the century, however, he began experimenting with figures so simplified that their masses could be stated in bold areas of pigment. Rapidly he turned to the divided touches of bright color introduced by the Neoimpressionists. Then in 1905 came the Fauve explosion. Matisse burst upon the art world with an astonishing series of paintings in which masses of brilliant color—reds, greens, deep blues, bright blues, roses, yellows, and lavenders—were applied in broad areas and full intensity, and juxtaposed with jarring results. His *The Green Stripe*, of 1905 (fig. 1165), exhibited in the celebrated group of Fauve pictures in the Salon d'Automne of that year, excited especial horror because this blazing bouquet of colors was applied not only to the arbitrarily divided background and the dress and collar but also, only slightly diluted by flesh tones, to the face, dominated by the intense green stripe through the center of the forehead and down the nose. Not even Gauguin had dreamed of such distortions. Nonetheless, all Matisse had really done was to intensify the differentiation of hues already analyzed by the Impressionists in order to produce a strong emotional effect.

1163. HENRI MATISSE. *Joie de Vivre (Joy of Life)*. 1905–6. Oil on canvas, 68½ × 93¾". © The Barnes Foundation, 1976, Merion Station, Pennsylvania

1164. HENRI MATISSE. *Decorative Figure Against an Ornamental Background (Nude with the Straight Back)*. 1925. Oil on canvas, 51½ × 38⅜". Musée National d'Art Moderne, Paris

The triumphant affirmation of Matisse's Fauve period is the huge *Joie de Vivre* (*Joy of Life*) of 1905–6, nearly eight feet long (fig. 1163). A forest glade, reduced to stage drops, is inhabited by a happy company of nudes, male and female, embracing, playing pipes, picking flowers, draping garlands about their bodies, or dancing in a ring, all indicated with an unbroken contour of the utmost flexibility. The sudden jumps in scale between one figure and the next can no more be explained in naturalistic terms than can the broad, thinly brushed areas of arbitrary color. Matisse's new scale and color were both in a sense prepared for by Gauguin (see figs. 1151, 1152), but Matisse has gone much farther, especially in his heightening of color to intensify the fluidity of contour. The primitivism desired by Gauguin has here been achieved without reference to exotic cultures; Matisse's figures abandon themselves to nature physically as the Impressionist painter and viewer had visually.

In 1908 Matisse published his *"Notes d'un peintre,"* in which he explained: "What I am after, above all, is expression. . . . Expression to my way of thinking does not consist of the passion mirrored upon a human face or betrayed by a violent gesture. The whole arrangement of my pictures is expressive. The place occupied by figures or objects, the empty spaces around them, the proportions, everything plays a part. . . . What I dream of is an art of balance, of purity and serenity devoid of troubling or depressing subject matter. . . ." His *Red Studio*, of 1911 (fig. 1166), sums up his art and his philosophy. Walls and floor are colored the same strong yet surprisingly airy red. As there are no shadows, the painting

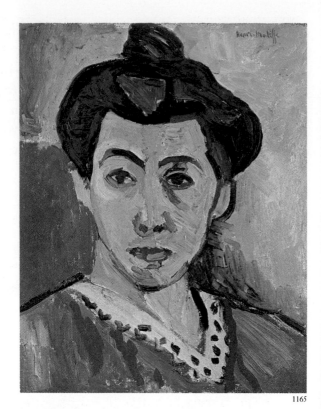

1165

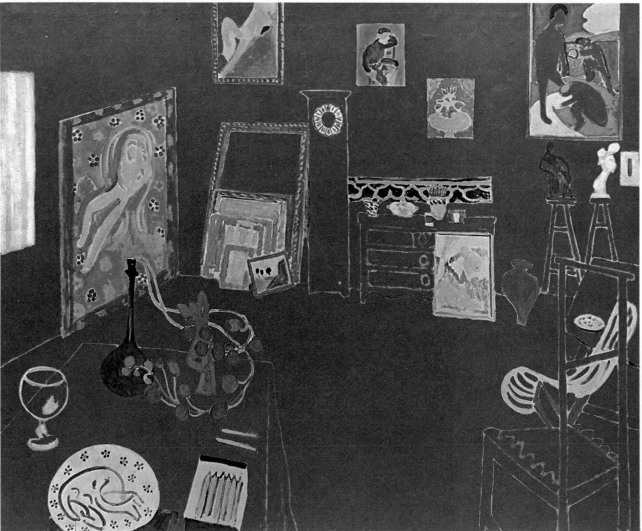

1166

1167

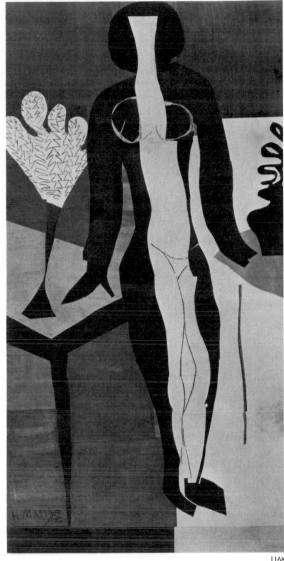

1168

looks flat at first sight, but then the beautiful, clear red begins to suggest a kind of space, in which the objects float. Against the walls hang or lean recognizable canvases by Matisse—a veritable gallery of his Fauve works of the preceding five years or so. Among the furniture contoured in wavering yellow lines are modeling stands bearing small sculptured nudes by Matisse; a figure on the table in the foreground is draped in a frond of ivy emerging from a green wine flask. Whistler's idea of the picture as an arrangement in color has been perfectly fulfilled, but in Matisse's terms of the expressive relationship between objects apparently scattered at random. His recapitulation of his artistic achievements becomes a delicate web of line and color, in which Renaissance perspective survives only as an echo.

For more than forty years longer Matisse continued to paint the relaxed themes he loved. Save for a brief flirtation with Cubism (see Chapter Seven), he never deserted his basic Fauve message of linear and coloristic freedom, calm, and beauty. In 1921 he took up residence at Nice, on the Riviera, where he turned out an unbroken series of masterpieces, large and small. Typical of his Nice period is *Decorative Figure Against an Ornamental Background*, of 1925 (fig. 1164; nicknamed *Nude with the Straight Back*). The strongly modeled, grandly simplified forms of the nude are played off against the movement of the Rococo shapes in the wallpaper and the mirror. Between the browns, rose tones, blues, and yellows of the Oriental rug and the wallpaper the richness of color is almost overwhelming.

In 1943 Matisse moved to the Riviera hill-town of Vence, where during a serious illness he was cared for by Dominican nuns. In gratitude he designed and financed a wonderful chapel for them—he created architecture, murals, stained glass, vestments, even the altar, its candlesticks, and crucifix, between 1948 and 1951 (fig. 1167). Innumerable preparatory drawings are preserved, often complex at the start, but in final definition starkly simple. The murals, surprisingly, are devoid of color, painted in Dominican black and white on ceramic tile. The color of the interior is provided entirely by the vestments and the stained glass, which bathe the interior in yellow, blue, and green light as if it were an enchanted glade.

1165. HENRI MATISSE. *The Green Stripe (Madame Matisse)*. 1905. Oil and tempera on canvas, 15⅞ × 12⅞". Statens Museum for Kunst, Copenhagen. J. Rump Collection

1166. HENRI MATISSE. *Red Studio*. 1911. Oil on canvas, 71¼ × 86¼". The Museum of Modern Art, New York. Mrs. Simon Guggenheim Fund

1167. HENRI MATISSE. Chapel of the Rosary of the Dominican Nuns, Vence, France. 1948–51 (consecrated June 25, 1951)

1168. HENRI MATISSE. *Zulma*. 1950. Gouache on cut and pasted paper, 93¾ × 52⅛". Statens Museum for Kunst, Copenhagen

Despite the fact that Matisse professed no formal religion, his labor of love is one of the few great works of religious art done in the twentieth century, and provides for the prayers and liturgies of the nuns an environment of untroubled beauty.

Although in old age Matisse was confined to his bed, the scope and freedom of his art miraculously widened. Unable to paint at an easel, he imagined lyric compositions often unexpectedly large. These were done entirely in colored papers, which he could paint and cut out while working in bed, and pinned to enormous paper surfaces on which they were later pasted. *Zulma* of 1950 (fig. 1168), dominated by blue, green, and pink, is an example of the spontaneous verve of these *gouaches découpées*, whose pulsating contours, flat surfaces, and brilliant color revive on a new scale the energy of Matisse's *Joy of Life*, painted nearly half a century before. To many critics Matisse remains, from a purely pictorial standpoint, the most sensitive painter of the twentieth century.

At the same Salon d'Automne of 1905 when the works of the Fauves first astonished Paris, there were also exhibited paintings by a companion of Matisse in student days, Georges Rouault (1871–1958). The intensely Catholic Rouault could not accept the hedonistic view of existence so delightful throughout the work of Matisse. Rouault's early paintings embody an attitude of rebellion against the life around him. His sympathies are reserved, strangely enough, for circus performers, whom he sees as tragic figures; he condemns violently a mixed population of criminals, prostitutes, and judges. In contrast to the gentle, cynical acceptance of prostitutes by Toulouse-Lautrec ten years earlier, Rouault paints them with savage fury. Expression to him is just what Matisse said it was not: "the passion mirrored upon a human face or betrayed by a violent gesture." The fierce contours of *Prostitute at Her Mirror*, of 1906 (fig. 1169), describe volumes of surprising force. This malevolent woman, exposed as an incarnation of evil, takes on a strange rhythmic beauty as if Rouault,

Rouault

1169. GEORGES ROUAULT. *Prostitute at Her Mirror*. 1906. Oil on cardboard, 27⅝ × 20⅞". Musée National d'Art Moderne, Paris

1170. GEORGES ROUAULT. *The Old King*. 1937. Oil on canvas, 30¼ × 21¼". Museum of Art, Carnegie Institute, Pittsburgh

1169

1170

like Bosch but without his fantasy (see Part Four, Chapter Three), was fascinated by what he most condemns. Like many of Rouault's early works, this one is painted in oil on cardboard, which gives a quality at once mat and translucent to the blue contours and shadows. The violence of such paintings relates Rouault less to the French Fauves than to contemporary German Expressionists, especially the Blaue Reiter (see below).

Rouault's later work shows a transformation of his early moral indignation into a gentler mysticism in some ways reminiscent of Rembrandt (see Part Five, Chapter Three). *The Old King*, of 1937 (fig. 1170), could be any monarch from the Old Testament—one thinks especially of David or Solomon—laden with a twin burden of prophecy and sorrow, which Rouault has successfully transmuted into glowing color. His early training as a stained-glass maker is doubtless influential in the way he bounds the masses of brilliant impasto with broad, black lines recalling the lead separations between the pieces of glass in medieval windows.

Expressionism

The name *Expressionism* is loosely applied to various avant-garde movements in Germany in the early twentieth century, which recall at times the emotional violence of Grünewald and other German masters in the sixteenth. Two pioneer Expressionists were women; both worked independently of any group. KAETHE KOLLWITZ (1867–1945) throughout her richly productive career as sculptor and printmaker was deeply concerned with the problems of working people, in whom she found a special nobility and beauty. For a while she exhibited with Secession, a group of Socialist artists. In her devastating etching *Outbreak*, of 1903 (fig. 1171), the direction of her interests, and to a certain extent her methods, are already clear. This was the first of a series depicting with fierce intensity events from the history of the great Peasants' War in early-sixteenth-century Germany, a revolution put down by the threatened overlords with barbaric violence. An almost legendary figure, Black Anna, stands with her back toward us and her arms upraised as if opening the floodgates for a tide of angry humanity, on which are tossed howling faces, flying hands and feet, and farm implements used as weapons. Kollwitz does not conceal her debt to Goya (see figs. 1073, 1074), but she has gone even farther in the suppression of detail and distortion of form in the interests of expression. Her harsh lines and rough light-and-dark contrasts opened the path not only for her own greatly simplified later work but for the painters of Die Brücke (see below) to follow in a year or two.

Even more original, and by contrast profoundly quiet, was the short-lived PAULA MODERSOHN-BECKER (1876–1907), whose visits to Paris brought her in contact with the work of Cézanne, Gauguin, Vuillard, and other Post-Impressionists. Since she had apparently no knowledge of the innovations of Matisse and the other Fauves, she seems to have made the transition to a completely modern style, based on arbitrary distortions, entirely on her own. Her *Self-Portrait*, of 1906 (fig. 1172), one of a series of such neo-primitive self-images, is a curious combination of harshness of mass and contour, roughness of texture, and a deep, feminine gentleness. The great, calm eyes and the gesture of self-display are typical of the poetry of the last full year of her activity, in which she rejoiced in the density and warmth of her own body. The resemblance of such pictures to Picasso's Classical women of the 1920s (see fig. 1192) seems too close to be accidental. She returned to Germany at her much older husband's insistence, became pregnant, and died three weeks after childbirth.

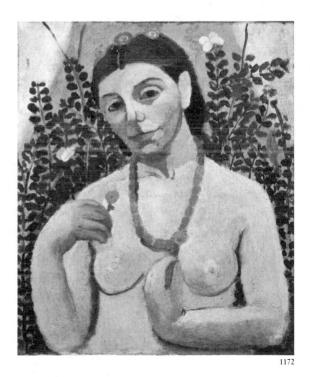

1171. KAETHE KOLLWITZ. *Outbreak*, from *Bauernkrieg (Peasants' War)*. 1903. Etching. Kupferstichkabinett, Staatliche Museen Preussischer Kulturbesitz, West Berlin

1172. PAULA MODERSOHN-BECKER. *Self-Portrait*. 1906. Oil on canvas, 24 × 19¹¹⁄₁₆″. Öffentliche Kunstsammlung, Kunstmuseum, Basel

DIE BRÜCKE A rebel group called Die Brücke ("The Bridge") was formed in Dresden in 1905, the very year the Fauves first showed in Paris. This was a brotherhood, not unlike those that had appeared in France and England at various moments in the nineteenth century, and especially close to what Van Gogh had envisioned in Arles. The most gifted member of the group was EMIL NOLDE (1867–1956), who belonged only briefly. In masses of pigment unfettered by any structural contours like those of Rouault, he expressed themes of equally fierce intensity, all the more shocking on account of the unexpected content he discovered in such traditionally Christian themes as that of the *Doubting Thomas*, painted in 1912 (fig. 1173; compare an example from the Baroque, fig. 974). The Apostles gathered around Christ in Nolde's picture seem to be engaged in some barbaric ritual; an emaciated Thomas gazes gloatingly at Christ's wounds, below a row of Apostles' heads that recall Ensor's masks (see fig. 1159). All are painted in barbarically bright color.

DER BLAUE REITER Among the constantly dissolving and recombining artist groups formed in Germany just prior to the outbreak of World War I, only Der Blaue Reiter ("The Blue Rider") surpasses Die Brücke in importance. This group did not share Die Brücke's revolutionary attitude of social protest, nor did it comprise a brotherhood; in the end Der Blaue Reiter was far more influential in the development of the most imaginative tendencies in twentieth-century art. In fact, three painters of first importance, the German Franz Marc, the Russian Wassily Kandinsky, and the Swiss Paul Klee (see Chapter Eight), were the leaders in the group of exceptional talents who exhibited together in Munich in the winter of 1911–12 (including Rousseau). FRANZ MARC (1880–1916) was a highly imaginative animal painter. His poetic art sought liberation from the conventions of human existence in the world of animals, thus—whether or not he was consciously aware of it—reviving a tradition that had played an important part in medieval art and had surfaced from time to time in such manifestations as the fantasies of Bosch. A brilliant example is Marc's *Deer in the Wood, No. I*, of 1913 (fig. 1174). Under influence from both Cubism and Futurism (see Chapter Seven), Marc crisscrosses the enchanted glade with the verticals of the trees, diagonals being derived from the slopes of the hills, and curves suggested by the flight of the hawk at the upper left; in this woodland interior nestle four deer (apparently does or fawns—certainly no antlered stags), resting or moving in poses of unconscious grace. Marc's coloring is brilliant and arbitrary, in hues generally of symbolic significance to him, and is carefully applied without the explosive roughness of the Brücke artists. The loss of Marc, killed in World War I, cut short one of the most promising careers of the twentieth century.

WASSILY KANDINSKY (1866–1944) has been credited with the first entirely abstract paintings. The truth may never be determined, but in his book *Concerning the Spiritual in Art*, written in 1910 and published in 1912, Kandinsky warned specifically against total abstraction, which might degenerate into decoration. As early as 1909 he had begun to paint his series called *Improvisations*, referring as had Whistler's titles to those of musical compositions. But Whistler implied the intervention of conscious planning in his harmonies, symphonies, arrangements, and the like. Improvisations are unplanned, and Kandinsky wrote that his were "largely unconscious, spontaneous expressions of inner character, non-material in nature." *Improvisation 30 (Cannon)*, of 1913 (fig. 1175), at first sight seems

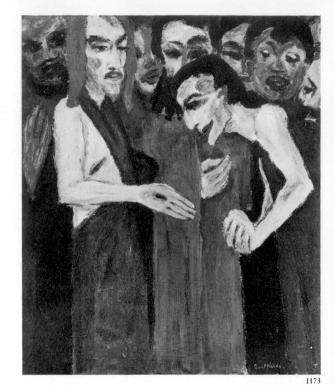

1173

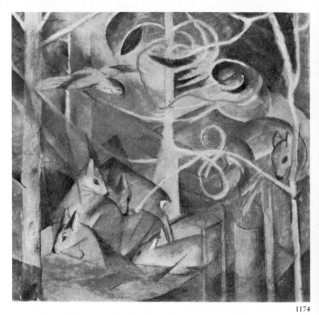

1174

1173. EMIL NOLDE. *Doubting Thomas*. 1912. Oil on canvas, 39⅜ × 33⅞". Nolde-Museum, Seebüll, Germany

1174. FRANZ MARC. *Deer in the Wood, No. I*. 1913. Oil on canvas, 39¾ × 41". The Phillips Collection, Washington, D.C.

1175. WASSILY KANDINSKY. *Improvisation 30 (Cannon)*. 1913. Oil on canvas, 43¼ × 43¼". The Art Institute of Chicago. Arthur Jerome Eddy Memorial Collection

1176. WASSILY KANDINSKY. *Composition 238: Bright Circle*. 1921. Oil on canvas, 54½ × 70⅞". Yale University Art Gallery, New Haven, Connecticut. Gift of the Société Anonyme

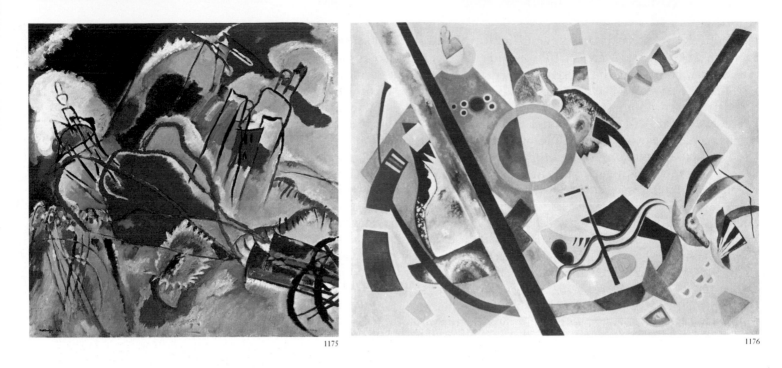

1175

1176

to be a meaningless assortment of freely brushed shapes and colors of astonishing brilliance. Then one begins to notice not only the cannons at the lower right but also what appear to be hills and houses moving at odd angles, and clouds in the sky. Kandinsky suggested that the cannons might be explained by the war talk that had been commonplace during the year, but that the name was selected by him purely for convenience and did not refer to any meaning in the picture, "painted rather subconsciously in a state of strong inner tension."

1177 OSKAR KOKOSCHKA. *Bride of the Wind (The Tempest)*. 1914. Oil on canvas, 71¼ × 86⅝". Kunstmuseum, Basel

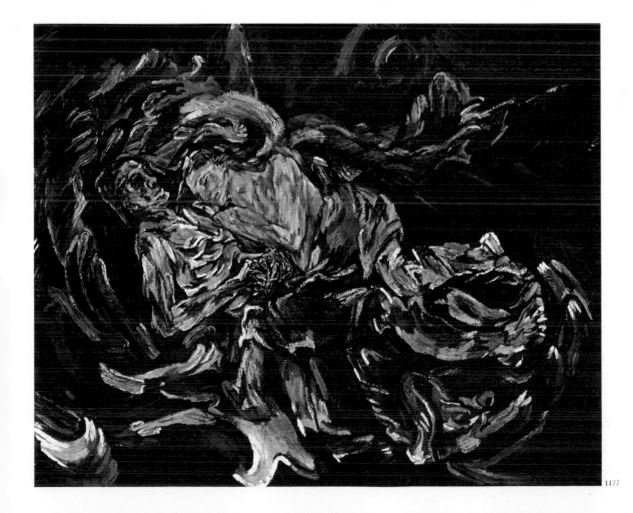

1177

The year it was painted the picture was exhibited in London, and accepted as "pure visual music" by the critic Roger Fry, who also discerned a kind of logic in the apparently spontaneous oppositions of shapes and colors. In a strange combination of Russian mysticism, theosophy, and a feeling that Impressionism had destroyed the object and atomic research had dissolved all substance, Kandinsky had, in fact, proposed a completely subjective, symbolic meaning for colors, as had Marc, and also a new theory of abstract structural relationships. At some moment during the creation of the *Improvisations*, possibly during 1910, Kandinsky happened to see one of them upside down, and was impressed by its beauty when nothing in it could any longer be recognized. But not until late in 1913 did he completely desert representation. After his return to Russia in 1914, where he was in touch with the Constructivist movement, whose members had arrived at abstraction by a different route (see Chapter Seven), Kandinsky's abstract paintings began to assume considerable dimensions. *Composition 238: Bright Circle*, painted just before his return to Germany in 1921 (fig. 1176), shows the influence of El Lissitzky in the ruled lines and geometrical shapes, but the intensity of feeling that drives the freely associated shapes is pure Kandinsky. The painting is a kind of celestial explosion in which we seem to be present at the formation of new galaxies. From 1922 to 1923 Kandinsky taught at the Bauhaus in Weimar (see page 964), and from 1933 until his death lived in the Paris suburb of Neuilly-sur-Seine. The true heirs of Kandinsky's imaginative legacy of form inflamed by emotion were the American progenitors of the Abstract Expressionist movement after World War II (see Chapter Nine).

The forces unleashed by Die Brücke were, however, by no means forgotten. The movement had exalted individual emotional experience to the plane of the ultimate determinant of moral as well as artistic values. The Austrian painter OSKAR KOKOSCHKA (1886–1980) continued the expressionist freedom of statement and technique until long after World War II without ever abandoning his loyalty to the visible world. In his early portraits Kokoschka had absorbed much from his study of Van Gogh. A haunting testament of his rebellious youth is the *Self-Portrait*, of 1913 (fig. 1178), clearly reminiscent of Van Gogh in its intense emotional avowal and heavy application of pigment, and recalling El Greco in its elongated distortion. It seems hard to believe that this "talented terror," after the production of two wildly sadistic dramas he had written and produced in 1909, was obliged to leave Vienna for a more sympathetic atmosphere in Berlin, where Expressionist artists from all over central and eastern Europe were gathering.

Kokoschka's glorious *Bride of the Wind*, of 1914 (fig. 1177), is one of the rare unabashed celebrations of romantic love in the twentieth century. The artist and his mistress, like Dante's Paolo and Francesca in Blake's illustration (see fig. 1088), are swept in a whirlwind above a blue mountain valley before glittering crags illuminated by a crescent moon, lost in their emotion like the ecstatic saints in the depths of an El Greco cloud.

MAX BECKMANN (1884–1950), a somewhat lesser figure than Kokoschka but still a powerful artist, picked up the legacy of Die Brücke after World War I and carried it to midcentury. Trained and successful as an academic painter, Beckmann was spiritually devastated by the wave of disillusionment in Germany after World War I. *The Night*, of 1918–19 (fig. 1179), is a terrifying indictment of official cruelty, difficult to connect with any specific incident save possibly the fierce repression of the Communist "Spartacus" attempt to seize power in Germany in January 1919.

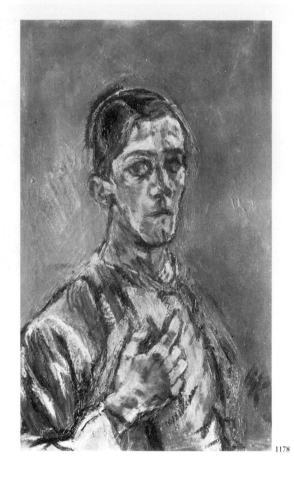

1178

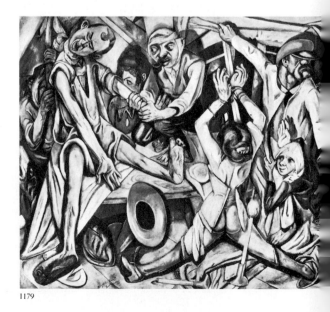

1179

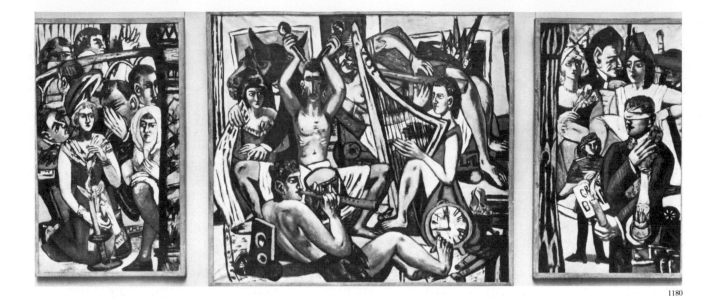

1180

The tortures and the powerful, jagged forms are reminiscent of Grüne-wald in their horror, yet the coloring is unexpectedly thin and almost monochromatic. In retrospect the picture seems prophetic of Nazism, which designated Beckmann, like all modern artists in Germany, "degen-erate." He fled to Amsterdam and, after the German occupation of the Netherlands, went into hiding. The last three years of his life Beckmann spent in the United States.

His majestic triptychs, painted during the 1930s and 1940s, preserve the angular figural composition of the earlier works, reinforced now by strong black contours reminiscent of Rouault and by brilliant coloring. Still tormented and full of enigmatic symbols insoluble by any known iconographic method, and never fully deciphered even by Beckmann himself, these paintings are as effective as if they had been planned for mural decoration. *Blindman's Buff*, painted in Amsterdam in 1945 (fig. 1180), apparently reduces life, haunted by memories of both a Classical and a barbaric past, to a terrible game.

Post-Impressionism had liberated the artist from strict conformity in either drawing, color, composition, or space to recognizable reality, and had thus established the autonomy of the artist. But even the most radical of the Post-Impressionists had no remote idea of the lengths to which the Fauves and the Expressionists would carry this new-found liberty. The first fourteen years of the twentieth century, up to, in fact, World War I, saw all the artistic revolutions of the entire nineteenth century brought to an unpredictable climax. The Fauve and Expressionist emphasis on bold brushwork, arbitrary color, harshly unreal drawing, and intense sensuous or emotional experience was to be immediately countered by an equally bold if totally different movement, transforming into abstract principles independent of observed reality the Neoclassic heritage of form and intellectual analysis.

1178. OSKAR KOKOSCHKA. *Self-Portrait*. 1913. Oil on canvas, 32⅛ × 19½". The Museum of Modern Art, New York. Purchase

1179. MAX BECKMANN. *The Night*. 1918–19. Oil on canvas, 52⅜ × 60¼". Kunstsammlung Nordrhein-Westfalen, Düsseldorf

1180. MAX BECKMANN. *Blindman's Buff* (triptych). 1945. Oil on canvas, side panels each 42½ × 71½"; center panel 90 × 80". The Minneapolis Institute of Arts. Gift of Mr. and Mrs. Donald Winston

THE SEARCH FOR FORM—CUBISM AND ABSTRACT ART

At about the same time as the Expressionist outburst of emotion, yet equally instrumental with Expressionism in eventually dissolving all ties with visual reality, came a succession of movements that attempted to explore pure form more than feeling. As the Fauves and the Expressionists derived largely from the pioneer explorations of Gauguin and Van Gogh, so the formalist movements of the early twentieth century entered the field under the banner of Cézanne. Yet Cézanne had achieved form through careful integration of color, while the formalist painters of the early twentieth century restricted the movement of color by strong contour, often reduced its intensity severely, and sometimes denied color altogether. Since sculpture is by identity the art of form, it is useful to begin our account of twentieth-century formalism with sculpture rather than painting. At one time or another Daumier, Degas, Renoir, Gauguin, and Matisse had all made use of sculpture, either as an aid to the creation of form in painting or as an end in itself. But the sculpture of the late nineteenth century had been dominated, as we have seen, by the towering genius of Rodin, who often exploited his art for what purists denounced as nonsculptural purposes.

1181. ARISTIDE MAILLOL. *Mediterranean (Crouching Woman)*. c. 1901. Bronze, height 41″. The Museum of Modern Art, New York. Gift of Stephen C. Clark

1182. WILHELM LEHMBRUCK. *Kneeling Woman*. 1911. Cast stone, height 69½″. The Museum of Modern Art, New York. Abby Aldrich Rockefeller Fund

1183. WILHELM LEHMBRUCK. *Standing Youth*. 1913. Cast stone, height 92″. The Museum of Modern Art, New York. Gift of Abby Aldrich Rockefeller

1181

The return to form begins in the early twentieth century with the sculpture of Aristide Maillol (1861–1944), who had been for a while a painter allied to the Nabis (see page 877). Not until an eye disease forced him to renounce painting did Maillol commence his career as a sculptor. His *Mediterranean*, of about 1901 (fig. 1181), then known simply as *Crouching Woman*, was exhibited at the Salon d'Automne of 1905, renowned for the Fauve scandal. Rodin had admired a slightly later work of Maillol in much the same style, saying that he knew of nothing "so absolutely beautiful, absolutely pure, absolutely a masterpiece . . . in all modern sculpture." This comment is surprising in that Maillol's style seems in every respect opposed to that of Rodin. The transformation Maillol brought about is as sudden and as far-reaching as that between the Rococo and David (see Chapter One), but without any hint of political motivation.

The accidentality, immediacy, and strong emotion of Rodin are replaced in Maillol's statue with the revived classical values of balance, repose, and restraint. The simple masses of the figure recall the nobility of the Severe Style in the sculpture of fifth-century Greece and even the simple grandeur of the sculpture of Old Kingdom Egypt, which Maillol had admired with Gauguin in the Louvre. The quiet, understated forms of the body, the limbs, and the head of Maillol's reposeful figure reveal to a greater degree than had Cézanne's own paintings the cylinder, the cone, and the sphere that the leader of Post-Impressionism sought in the natural world. Although Maillol occasionally experimented with more dynamic poses and dramatic contrasts of direction, in general he was content to the end of his long life to continue in much the same vein as this early work. He often reused an earlier figure, or removed head and limbs to reduce it to a torso fragment, thus imitating deliberately the effect produced by time and accident on works of ancient art.

The twenty-years-younger German sculptor Wilhelm Lehmbruck (1881–1919) was deeply influenced at first by Rodin and then, on his arrival in Paris in 1910, by Maillol. Although he was acquainted with the most advanced sculptors of the time, notably Brancusi (see figs. 1197, 1198), Lehmbruck remained faithful to the human figure and continued to work, as had Rodin and Maillol, in clay. Only during the last eight years of his brief and haunted life did he produce the series of masterpieces in which he combined a classicism derived from Maillol with an elongation recalling that of the Gothic figures of Chartres Cathedral's Royal Portal. Lehmbruck's strange combination of touching, bony awkwardness and Botticellian grace was influenced by the Renaissance sculpture he had seen in Italy. His almost emaciated *Kneeling Woman*, of 1911 (fig. 1182), and his *Standing Youth*, of 1913 (fig. 1183), show less concern with mass than Maillol had felt and more with space. The directions of the weary glances of these figures and the strong projections of their bony limbs extend movement, real and implied, into the surrounding atmosphere. Although he never carved directly, as other sculptors were beginning to do, Lehmbruck was interested in a stony surface. In order to produce a stone effect, he used cast stone—an amalgam of pulverized stone and cement—which gives a velvety blend with the consistency of stone and the plasticity of clay. Profoundly depressed by the tragedy of World War I, he took his own life.

Maillol and Lehmbruck

1182

1183

The long career of PABLO RUIZ Y PICASSO (1881–1973) cast across the twentieth century a shadow as long as those of Michelangelo and Titian across the sixteenth. He created, along with his associate Georges Braque, one of the most important movements of the century, participated in many others, and influenced every phase of artistic activity throughout the world in one way or another until his extreme old age. Throughout his entire life he showed an incredible range of ideas and styles, and though in later years he did not expand his imagination as Matisse did, he remains a towering figure. The best works among his prodigious output have taken their place among the masterpieces of twentieth-century art.

A fully trained painter at the age of only nineteen, the Spanish-born Picasso took up residence in France in 1900, and thereafter returned only for brief stays to his native land. In Paris he fell under the spell of Toulouse-Lautrec, an influence that he soon managed to absorb and convert into a highly original style. He became concerned with the lives of those who lived, as he did, on the periphery of society, identifying his misery with theirs. He saw prostitutes, beggars, street musicians, and blind people from within, and was able to project their moods with overpowering intensity. The woman in his *Absinthe Drinker*, of 1902 (fig. 1184; compare with Degas, fig. 1131), sits lost in the stupefying liqueur, enveloped in self-pity and helplessness, a figure of extraordinary sculptural simplicity and beauty. The entire painting is colored by an all-pervading and corrosive blue—the proverbial color of melancholy—which has given its name to this period in Picasso's evolution, lasting about four years (1901–4). For the young painter it was a period of hopeless maladjustment to the art world of Paris, punctuated by frequent, dejected returns to Barcelona.

Picasso, Braque, and the Cubist Style

1184

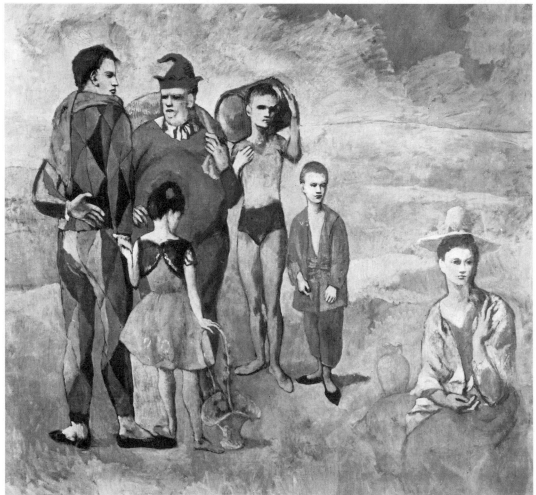

1185

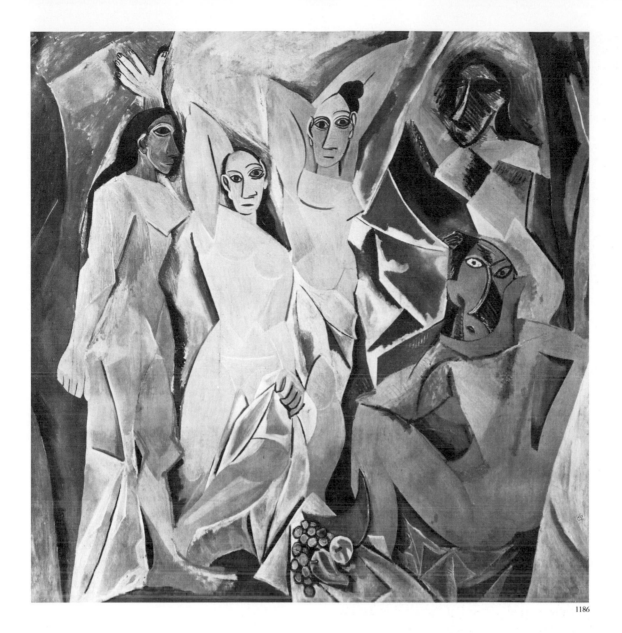

1186

For Matisse, as for the Impressionists, the frame was, with few exceptions, a finder held up to nature, which appears to extend beyond it. For Picasso, even at this early stage, form was all in all; the masses are composed with an eye to the frame, which they do not transgress or even approach; rather they are built up within it like a box within a box.

By late 1904 Picasso's mood of depression had lightened, and so also had his palette. A briefer Rose Period (1904–6) ensued, in which he was less concerned with the tragic aspects of poverty than with the nostalgic charm of itinerant circus performers and the solace of make-believe. *Saltimbanques*, of 1905 (fig. 1185), shows a family of these strolling players grouped together physically—but emotionally detached—before a mysterious desert landscape in which they appear almost to float. Figures and costumes, surely and deftly drawn and modeled, blend with the ground and the sunny haze in tones of softly grayed blue, rose, and beige, creating mother-of-pearl effects of the greatest delicacy. This, one of the loveliest pictures of the twentieth century, hardly prepares us for the outburst that followed in *Les Demoiselles d'Avignon*, in 1907 (fig. 1186), which heralds the beginning of Cubism. But these sudden oscillations between moods that verge on sentimentality and those of great violence are typical of Picasso's career.

1184. PABLO PICASSO. *Absinthe Drinker*. 1902. Oil on canvas, 31½ × 23⅝". Collection Othmar Hüber, Glarus, Switzerland

1185. PABLO PICASSO. *Saltimbanques*. 1905. Oil on canvas, 83¾ × 90⅜". National Gallery of Art, Washington, D.C. Chester Dale Collection

1186. PABLO PICASSO. *Les Demoiselles d'Avignon*. 1907. Oil on canvas, 96 × 92". The Museum of Modern Art, New York. Lillie P. Bliss Bequest

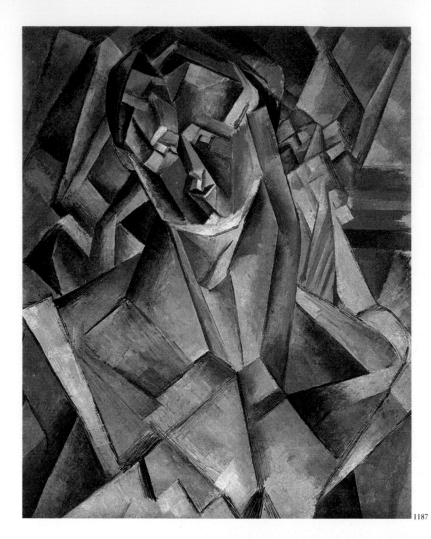

1187

The attitude and methods of the Cubists are not easy to explain. Cézanne had found planes in real objects (see Chapter Five) and had used them to establish a structure of form seen by means of color; the Cubists do the opposite, imposing their own structure of largely monochromatic planes upon the object. How and, above all, why were a small group of artists in 1908–10—comprising at first just Picasso and Braque—obsessed by such an extraordinary concern? And why did their new ideas take instant hold on the imagination of others, and spread to influence all aspects of vision and design in the twentieth century? These questions have never been satisfactorily answered, and in fact are seldom posed.

Certainly, one contributing factor was the gallery devoted to Cézanne's paintings in the Salon d'Automne of 1906, the year of the great master's death, and also the posthumous retrospective of his work at the Salon d'Automne of 1907. But such external circumstances hardly account for the transformation that took place, unrelated to Cézanne's lifelong search for form through color. Originally, to judge from the sketches, the composition of *Les Demoiselles d'Avignon* was derived from a small bather composition by Cézanne (for a monumental treatment of the same theme, see fig. 1147). The scene was at first intended to be the parlor of a brothel on the Carrer d'Avinyó (Avignon Street) in Barcelona. In the center foreground of the preliminary sketches was seated a sailor in the midst of five nude women. A student with a skull in his hand was to the left. But in the final picture, painted in the spring of 1907 before the Cézanne retrospective, the sailor and student disappear, and the women are presented to the observer in unexplained poses suggesting violent action, with faces

1187. PABLO PICASSO. *Seated Woman (Femme Assise)*. 1909. Oil on canvas, 31⅞ × 25⅝". Collection Sheldon H. Solow, New York

transfixed as if with horror at some cataclysm. Insofar as possible for a Picasso composition, constructed as always with total respect for the frame, the poses suggest a revelation of sexuality that is a demonic counterpart of El Greco's religious visions, and are traversed by sharp diagonal and twisting movements that convert the background from an interior to a kind of jungle. The intensity of the partially decomposed figures contrasts strangely with a serene little still life in the foreground (a pear, an apple, a slice of melon, a bunch of grapes). Instead of the lovely roses, blues, and greens of Cézanne, the figures are largely buff, their anatomy indicated by jagged white or black contours, but one takes on the cinnamon tone of the background at the left. A harsh blue, as if a sudden glimpse of sky, surrounds the figure at the upper right.

Strangest of all, the staring expressions of the central figures give way at the sides to faces simplified in emulation of the spoon faces and flange-like bosses in African sculpture, which Fauve painters had already started to collect as objects of aesthetic value. Since Picasso claimed that in the spring of 1907 he had not yet seen any African sculpture, these heads must have been repainted by him in the new style a few months later. But the influence of African sculpture, with its arbitrary divisions into geometrical elements, was second only to that of Cézanne in the development of Cubist style.

The final product, however, differs essentially from both Cézanne and African sculpture. Heads, busts, still lifes, and occasional landscapes form the subject matter of early Cubist painting. These are deformed by sharp separation into planes, reminding one of the torso of the Magdalene in Rosso's *Descent from the Cross* (see fig. 828), a picture probably unknown to the Cubists. These planes are often traversed by a strong vertical twist, producing a tension that threatens to burst the connection between the planes, although in such pictures as the *Seated Woman*, of 1909 (fig. 1187), the equipoise of forces produces a strikingly beautiful effect. The individual forms—the characteristic swelling and distortion of the neck muscles, for instance, or the reduction of the eyes to trapezoids—can in no way be derived from nature. And the strong, harsh coloring of *Les Demoiselles d'Avignon* has given way in early Cubist pictures to soft tans and olive tones, remarkably cool and serene.

By 1911, in the phase known to art historians as Analytical Cubism (the artists never used such terminology), the tension has burst, and so has the object. The entire foreground is filled with its component planes, floating as if in a thick mist. The planes are, moreover, no longer opaque; one seems to see through them, and a great deal of the effect of an Analytical Cubist picture is derived from the delicacy of the intersection of these planes. They are rendered with a divided touch recalling that of Impressionism. Gradually, as one watches, these planes build up a pervasive structure, often pyramidal, superseding the structure of observed reality.

The subjects, Meyer Schapiro has emphasized, are now placed close to the observer, and generally pertain to café life—a performer; his instrument; a page of music; a tabletop; glasses; letters drawn from posters, programs, or newspapers; and everywhere cigarette smoke. It is as if the subject had been disintegrated by the relaxed, nonfocused attentiveness of a café patron. The more intense the process of decomposition into planes becomes the less color remains—only occasional hints of tan, gray-blue, or olive dominated by grays and touched with black and white. To follow the simile we have used earlier, walking from an Impressionist, Post-Impressionist, or Fauve gallery into one filled with Cubist pictures

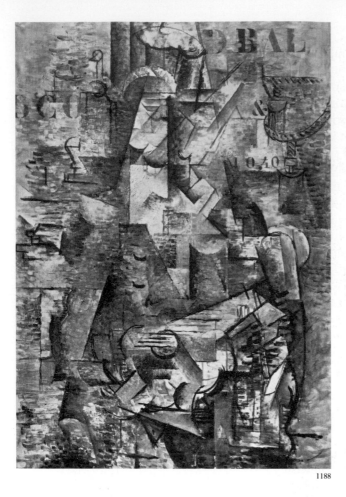

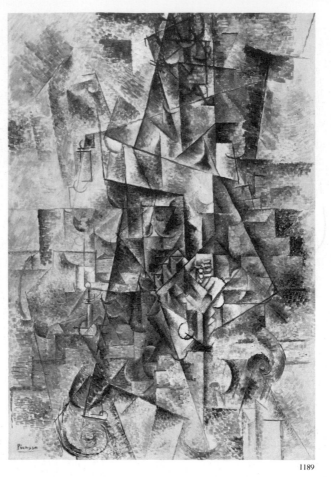

1188

1189

is like moving from brilliant sunlight into a smoke-filled, dim café. Like Impressionism, Cubism rapidly became a common style.

Working in nearby studios in 1911 and 1912, GEORGES BRAQUE (1882–1963) and Picasso turned out paintings remarkably similar in contour and even in touch. Only a hardy critic could be sure of telling the difference between the two artists in such works as *The Portuguese* by Braque (fig. 1188) and *The Accordionist* by Picasso (fig. 1189), both painted in 1911. Often the artists themselves could not. In both pictures the ostensible subjects are reduced to after images, definitely secondary to the new geometrical structures formed by the floating planes.

During 1912 the Cubist artists began to turn to a new series of interests and a new kind of experience, responsible for the phase known generally as Synthetic Cubism, since the painters no longer sought to disintegrate the object but to reassert it. In Synthetic Cubism, in fact, the barrier between reality and representation is unexpectedly broken, as it had been from time to time in earlier periods. Spanish Baroque sculptors often had supplied their plaster or wood saints with glass eyes and porcelain teeth, and Degas dressed one of his bronze ballet dancers in an actual costume. Now bits of the real object make their entrance into the picture: newspaper clippings, lengths of rope (in the paintings of Braque, simulated strips of veneering), and similar "found objects." Picasso's *The Bottle of Suze*, of 1913 (fig. 1190), is an epitome of this synthetic phase. Newspaper clippings, used as opaque equivalents of the floating planes in Analytical Cubism, are held in a structure of lines, and dominated by the bright blue label of the bottle of aperitif. Such bits, stuck to the surface of the canvas as elements in a design and echoes of the object, gave rise to the term *collage*, from the French word *coller* (to glue or paste).

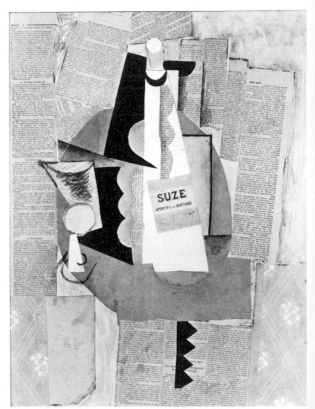

1190

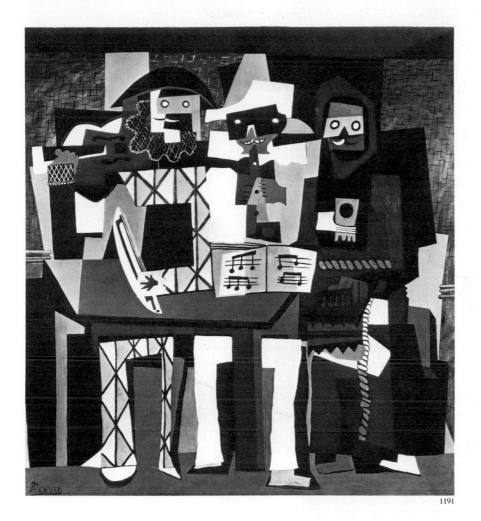

1191

Once established, the Cubist mode of vision and construction continued vital for many years. Its emphasis on the supremacy of the plane had far-reaching effects not only in painting but also in sculpture, architecture, and every aspect of commercial and industrial design. Every major current in abstract art during the period from the 1920s to the present owes a debt to Cubism; some important tendencies, such as Futurism, Constructivism, and De Stijl (see pages 905–7, 909–12), were outgrowths of Cubist theory and practice. Picasso, one of the two inventors of Cubism, continued for the rest of his life to make use of Cubist forms and ideas. They correspond to his interests at any given moment, but the presence of Cubism can be felt in the styles of all his later work.

During the years immediately after World War I, it is no longer possible to talk of "periods" in Picasso's work; two sharply different styles, superficially opposed but in reality strongly related to each other, exist side by side. The gorgeous *Three Musicians*, of 1921 (fig. 1191), is still basically a Synthetic Cubist picture in that the planes are now locked into a total design governed by the recognizable image. We have no doubt that the three incongruous musicians are there—a Pierrot and a Harlequin drawn from the tradition of the Italian strolling players of the seventeenth and eighteenth centuries, and a Franciscan monk. But the planes into which they have been divided proceed according to their own laws and not those of natural appearances. No found objects remain, but the coloring is now as brilliant as that of any Fauve painting. Its hard, clear tones (Picasso said at one time that any bright color would do), together with its astonishing size—the picture is nearly seven feet high—create a

1188. GEORGES BRAQUE. *The Portuguese*. 1911. Oil on canvas, 46⅛ × 32″. Kunstmuseum, Basel

1189. PABLO PICASSO. *The Accordionist*. 1911. Oil on canvas, 51¼ × 35¼″. The Solomon R. Guggenheim Museum, New York

1190. PABLO PICASSO. *The Bottle of Suze*. 1913. Collage and charcoal on canvas, 25¼ × 19⅝″. Washington University Gallery of Art, St. Louis

1191. PABLO PICASSO. *Three Musicians*. 1921. Oil on canvas, 80 × 74″. Philadelphia Museum of Art. The A. E. Gallatin Collection

splendid decorative effect reminding us that in 1917 Picasso had had considerable experience in stage designs. Although the figures are set on a narrow space like that of a stage, their surfaces function as subdivisions of a total surface. The background plane is as severely parallel to the pictorial surface as is that of David's *Oath of the Horatii* (see fig. 1059). The freshness, smartness, and gaiety of the *Three Musicians* are infectious, rendering it one of the few joyous large-scale compositions of the troubled twentieth century.

While Picasso was in Italy in 1917 preparing stage designs for the Ballet Russe, he had been greatly impressed by the grandeur of the Italian past, especially Roman sculpture and the mural paintings of Giotto and Piero della Francesca. Quite unexpectedly he developed, at the same time as the brilliantly colored late Cubism of the *Three Musicians*, a monumental and largely monochromatic Classical style with complete figures heavily modeled as if they were statues. He experimented with every aspect of Classical style, from imitations of Etruscan painting and Greek vases to the pencil line of Ingres, but his most imposing Classical creations are the majestic compositions involving seated giantesses seeming to derive from a legendary past. The best of them are overpowering in their cylindrical mass and stony implacability. In *Three Women at the Spring*, of 1921 (fig. 1192), Picasso has deliberately made the figures graceless, emphasizing the bulk and weight of their hands and feet, and intensifying the impersonality of their stony faces. For several years this Classical style coexisted in Picasso's production with late Cubism.

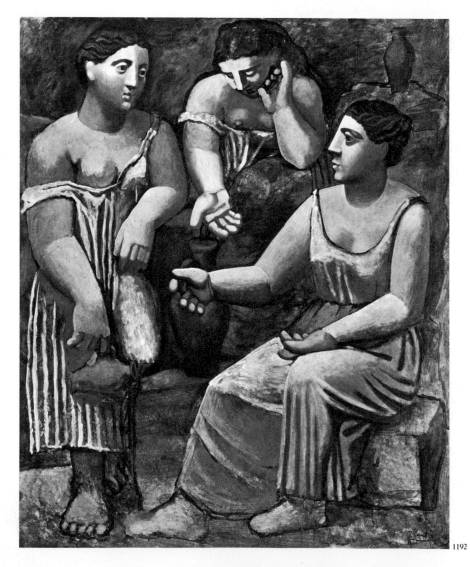

1192. PABLO PICASSO. *Three Women at the Spring.* 1921. Oil on canvas, 80¼ × 68½". The Museum of Modern Art, New York. Gift of Mr. and Mrs. Allan D. Emil

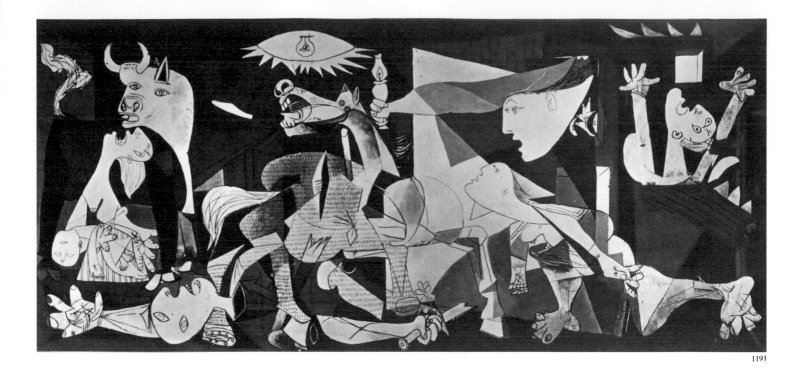

The lightning changes of style that characterize Picasso's post-Cubist work are too many to record here. Sometimes seemingly incompatible styles appear side by side in the same painting. During the 1930s Picasso took an active part in the Surrealist movement (see Chapter Eight), but his finest work of this decade, and in many ways the greatest of all social protest pictures, is *Guernica* (fig. 1193). Picasso executed this enormous painting to fulfill a commission for the pavilion of the Spanish republican government at the Paris Exposition of 1937, while the Civil War was still going on in Spain. Intended as a protest against the destruction of the little Basque town of Guernica in April, 1937, by Nazi bombers in the service of the Spanish Fascists, the picture has become in retrospect a memorial to all the crimes against humanity in the twentieth century. The painting is not a literal narration in the tradition of Goya, which would have been foreign to Picasso's nature and principles, nor even an easily legible array of symbols. As he worked, Picasso seems to have decided, perhaps subconsciously, to combine images drawn from Christian iconography, such as the Slaughter of the Innocents, with motives from Spanish folk culture, especially the bullfight, and from his own past. Actual destruction is reduced to fragmentary glimpses of walls and tiled roofs, and flames shooting from a burning house at the right. A bereft mother rushes screaming from the building, her arms thrown wide. Agonized heads and arms emerge from the wreckage. At the left a mother holding her dead child looks upward, shrieking. The implacable bull above her, the adversary in Spanish popular experience, is surely related to the dread Minotaur, adopted by the Surrealists, as an embodiment of the irrational in man, for the title of their periodical in Paris, to which Picasso had contributed designs. If the bull then signifies the forces of Fascism, the dying horse, drawn also from the bullfight ritual, suggests the torment of the Spanish people, and the oil lamp held above it the resistance of humanity against the mechanized eye, whose iris is an electric bulb. The spiritual message of combined terror and resistance is borne, unexpectedly, by the Cubist aesthetic means. An explosion of shattered planes of black, white, and gray reshapes itself as one watches into a giant pyr-

1193. PABLO PICASSO. *Guernica.* 1937. Oil on canvas, 11′5½″ × 25′5¾″. Museo del Prado, Madrid

amid, as if triumphant even in destruction. Picasso never again reached this height, and though he continued painting with great energy for thirty-six years, with occasional remarkable achievements, much of his later work is a recapitulation of motives he had invented earlier.

Although Picasso and Braque remained aloof from group exhibitions, their principles were avidly adopted by a number of lesser masters. Treatises on Cubism soon appeared, notably that by the painters Albert Gleizes and Jean Metzinger in 1912, which went through fifteen editions in less than a year and was published in English in 1913. Cubist principles influenced painters and sculptors everywhere, even for a while Matisse and certainly Kandinsky and Marc. Cubist principles also exercised a formative influence on new styles, especially that of FERNAND LÉGER (1881–1955), who applied the notion of fragmentation to his vision of an industrialized world. Léger was delighted by certain severely formal arts of the past, such as those of Egypt and Sumeria, and had little use for European painting since Giotto. His *Disks*, of 1918 (fig. 1194), shows circles and arcs suggesting dynamos dominating the grid of a city, punctuated here and there by the form of a human being. The hard, geometrical forms and mechanically inert surfaces of machinery, which were interchanged and recombined from one of Léger's pictures to the next, control the composition, just as the bright, crude colors of illuminated signs determine the color.

Whirring disks had, however, already appeared in the art of ROBERT DELAUNAY (1885–1941), who found in the industrialized world an imaginative excitement completely opposed to the stern order of Léger. Disks of brilliant color and constantly changing size and speed interlock and fuse, while never losing motion or atmospheric resonance, in Delaunay's *Homage to Blériot*, of 1914 (fig. 1195), which celebrated the first flight by a heavier-than-air craft across the English Channel in 1909. Above the

The Influence of Cubism

1194. FERNAND LÉGER. *Disks*. 1918. Oil on canvas, 94½ × 71". Musée d'Art Moderne de la Ville de Paris

1195. ROBERT DELAUNAY. *Homage to Blériot*. 1914. Tempera on canvas, 98½ × 99". Kunstmuseum, Basel

1196. MARCEL DUCHAMP. *Nude Descending a Staircase, No. 2*. 1912. Oil on canvas, 58 × 35". Philadelphia Museum of Art. Louise and Walter Arensberg Collection

1197. CONSTANTIN BRANCUSI. *Mademoiselle Pogany*. 1912. Marble, height 17½" (without base). Philadelphia Museum of Art. Gift of Mrs. Rodolphe M. de Schauensee, 1933

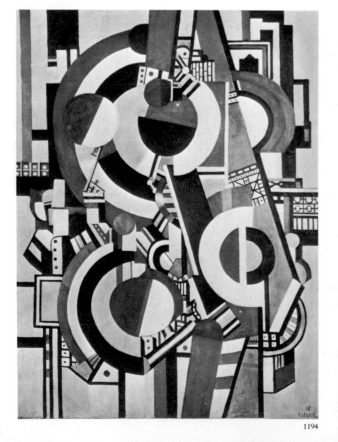

1194

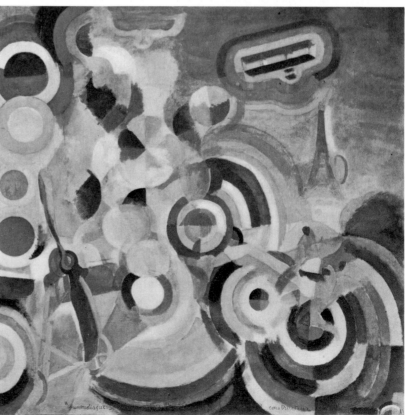

1195

tumult of form and colors a biplane and the Eiffel Tower can be seen at the upper right. Delaunay worked in constant collaboration with his equally gifted artist-wife Sonia (1885–1983), so that it is difficult to tell their paintings apart, and even more so to assess the extent of Sonia's influence on Robert's art.

The greatest French painting inspired by Cubist principles of fragmentation is the *Nude Descending a Staircase, No. 2* (fig. 1196), painted in 1912 on the basis of a study done the preceding year, by MARCEL DUCHAMP (1887–1968), a still controversial artist whose major contributions will be studied in Chapter Eight. The almost Botticellian grace of the forms seems so obvious today that it is hard to understand the uproar the picture created at the Armory Show of modern art in New York in 1913. The picture was not influenced by Futurism, of which Duchamp knew little at the time of the preparatory study, but was suggested, in part at least, by books of photographs popular at the time (descendants of the experiments of Muybridge and Eakins) that showed stages of movement succeeding each other so rapidly that one could flip the pages and obtain the effect of a motion picture. Duchamp's painting superimposes the images of such a series, so that the descending nude is seen in many successive moments simultaneously. As a result, they fuse to form a web of movement in which time is at once affirmed and denied, and thus forever suspended, just as it was at the same moment in the *Water Lilies* series (see fig. 1124) in which Monet was prolonging to infinity the instantaneity of Impressionist vision. Paradoxically, the exquisite resiliency of the figural movement is, if anything, enhanced by the apparent substitution of tubes of celluloid pierced by flexible steel rods for flesh and bones. In the course of the fluid motion all forms fuse into a magical shimmer of golden tan and brown rhythms in space.

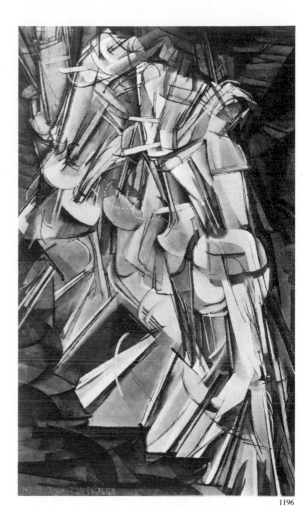

1196

Cubism and the First Abstract Sculpture

Despite the crucial importance of Cubism for many modern movements including some in sculpture, the earliest abstract sculpture was an independent development. The leading pioneer, indeed one of the two or three greatest sculptors of the twentieth century, was a Rumanian, CONSTANTIN BRANCUSI (1876–1957), who, after thorough academic training in Bucharest, arrived in Paris in 1904. He was at first strongly influenced by Rodin, and emulated the great master's atmospheric dissolution of mass. Brancusi had, however, been once apprenticed to a cabinetmaker, and his love of craftsmanship seems to have prompted him to abandon the by then universal practice of turning the actual execution of a work of sculpture over to a professional stonecarver working from the sculptor's clay model cast in plaster. As early as 1907, he began carving directly, and simplifying his shapes to elemental forms of universal beauty. "What is real," he said, "is not the external form but the essence of things," and this essence he found in subtle shapes of deceptive simplicity, approaching those of the egg, the wave-worn pebble, and the blade of grass. Some traces of African sculpture may be discerned in the bulging eyes of the bust of *Mademoiselle Pogany*, of 1912 (fig. 1197), but the spiral of the composition is derived from a delicate study of the inner rhythm of the dancer's pose. The mouth has been resorbed into the ovoid of the head, and the shapes caressing the face might be the subject's hands and wrists or the long folds of a scarf. Their exact identity no longer matters—only the delicate suggestion of movement.

The fact that a work like *Mademoiselle Pogany*, originating in marble carefully selected for its coloring and texture and lovingly smoothed by

1197

Brancusi's own hands, could be further refined in other materials and even cast in bronze or brass to take a high polish shows that the forms derived from universal ideas originating in Brancusi's mind and not in the nature of the material. The extreme of abstraction in his style is the *Bird in Space*, of 1928 (fig. 1198), which began in more representational form, but through constant refinement evolved into a marvelous symbol suggesting the shape of a bird or a feather but conveying the purity, swiftness, and solitude of flight. The beauty of Brancusi's surfaces caters irresistibly to the desire to touch, which he gratified by creating a series of so-called sculptures for the blind. Along with his exquisitely finished works in harder materials, Brancusi also carved in wood, with a certain heroic roughness, utilizing forms derived from the highly imaginative porch pillars and corbels of Rumanian peasant houses.

After a period of considerable indebtedness to the simplifications of early Cubism, RAYMOND DUCHAMP-VILLON (1876–1918) gave promise of the highest originality, but like too many others his career was cut short by World War I. His *Horse*, of 1914 (fig. 1199), is an extraordinary work. Its shapes suggest the elemental fury of a rearing horse only through their spirited curvilinear rhythms. As in the *Nude Descending a Staircase, No. 2*, by Duchamp-Villon's younger brother, Marcel Duchamp, the forms are mechanized; the elements of equine anatomy are already translated into the metal parts of turbines and pistons.

Although by no means an artist of the power of Duchamp-Villon, ALEXANDER ARCHIPENKO (1887–1964) absorbed the principles of Cubism in regard to the fragmentation of figures, and produced a series of remarkably original Cubist sculptures. Often these were painted to resemble pictures, or executed in contrasting materials to produce a pictorial effect. His *Walking Woman*, of 1912 (fig. 1200), exploits for the first time the principle of empty spaces in sculpture, which had appeared as a by-product of Baroque movement in such works as Bernini's *Apollo and Daphne* (see fig. 913). The holes are now as much a part of the composi-

1198

1199

1200

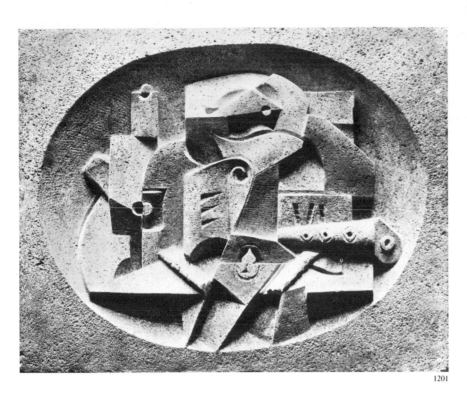

1201

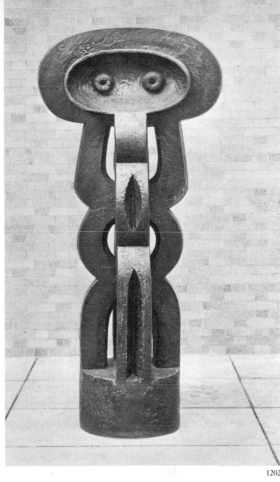

1202

tion as the solids. It remained for the Constructivists (see pages 909–10) to take the next step by substituting directly assembled flat, folded, or carved sheets of material enclosing compartments of space for the modeled or carved masses of traditional sculpture.

Another sculptor of great ingenuity was the Lithuanian-born JACQUES LIPCHITZ (1891–1973), who worked in Paris beginning in 1909, formed acquaintanceships with Cubist artists, and after 1941 lived and worked in the United States. Lipchitz declared that there was "no difference between painting and sculpture," and was for a while drawn totally into the Cubist orbit. Much of his early work, such as the *Still Life with Musical Instruments*, of 1918 (fig. 1201), is a direct sculptural counterpart of Synthetic Cubist painting. The flat planes are organized much as in Cubism in a limited foreground space, but tilted here and there so as to produce a play of light and shadow analogous to the vibrant pictorial surfaces of Picasso and Braque. Lipchitz never worked directly in hard materials as did Brancusi, and preferred to the clay used by Rodin the synthetic material plasticine, which when cast in bronze can produce a rich pictorial surface. Monumental as is the disturbing *Figure*, of 1926–30 (fig. 1202), whose eyes stare outward over a body composed of two opposed systems of links that interlock but never touch, the shimmer of light and shade still remains within the Cubist tradition.

In Italy in the first decade of the twentieth century was born a movement violently opposed to the character of that ancient land as a vast museum of the past. At first Futurism was a literary movement, conceived and championed by the writer Filippo Tommaso Marinetti as early as 1908, and proclaimed in a series of manifestos in 1906 and later. Impelled by the growing industrialization of the great cities of northern Italy, the Futurists launched an ideological program that raised the machine-Romanticism of Léger and Delaunay to the status of a religion, attacking the past, advocating the destruction of academies, museums, and monu-

1198. CONSTANTIN BRANCUSI. *Bird in Space*. 1928. Bronze, height 54". The Museum of Modern Art, New York

1199. RAYMOND DUCHAMP-VILLON. *Horse*. 1914. Bronze, 39¾ × 24". The Art Institute of Chicago. Gift of Miss Margaret Fisher

1200. ALEXANDER ARCHIPENKO. *Walking Woman*. 1912. Bronze, height 26⅜". Collection Mme Alexander Archipenko, Hollywood, California

1201. JACQUES LIPCHITZ. *Still Life with Musical Instruments*. 1918. Stone relief, 23⅝ × 29½". Estate of the artist

1202. JACQUES LIPCHITZ. *Figure*. 1926–30. Bronze, height 85¼". The Museum of Modern Art, New York. Van Gogh Purchase Fund

Futurism

mental cities as barriers to progress, extolling the glories of industrial achievement and even of modern war, and leading, alas, in the direction of Italian Fascism. The aesthetic derivation of the Futurist artists inspired by Marinetti's ideas came from a variety of sources, chiefly Neoimpressionism and Cubism. The latter is dominant in the *Funeral of the Anarchist Galli* by CARLO CARRÀ (1881–1966), a brilliant work (fig. 1203) of 1910–11. The cinematic aspects of Duchamp's *Nude Descending a Staircase, No. 2* are paralleled in a vast crowd composition, composed of a multitude of superimposed simultaneous images. The fragmented and shuffled views, stated as Cubist planes, are animated by an irresistible surge of motion, as crowds of enraged anarchists intersect with attacking police, and lifted weapons with floating banners, in a tempest of red and black planes.

The most gifted member of the Futurist group was UMBERTO BOCCIONI (1882–1916), who lost his life in World War I by a fall from a horse far from the scene of battle. His immense *The City Rises*, of 1910–11 (fig. 1204), is a panegyric to "modern" industrialism, a tidal wave of rearing draft horses and laborers hauling cables, above which rise the scaffolding and unfinished walls of a modern city in the process of building and factory chimneys belching smoke into the air. The movement is achieved by means drawn from Géricault (see fig. 1077), but the color is stated in terms of the divided palette of Seurat. Boccioni's finest achievement was in sculpture. His *Unique Forms of Continuity in Space*, of 1913 (fig. 1205), is a tour de force the like of which had not been seen since Bernini. A charging male figure is preserved in any number of superimposed views, each miraculously expressed in solid form as far as form could be carried without disappearing.

One of the last exponents of Futurism was JOSEPH STELLA (1877–1946), who came to the United States to live in 1902, but revisited his native Italy during the formative period of Futurism. Stella's cinematic vision in the *Brooklyn Bridge*, one of a series painted in 1917–18 (fig. 1206), celebrates a structure that had become for the late nineteenth and twentieth centuries a symbol of industrial and engineering triumph. Towers, cables, lights and beams of light, distant skyscrapers, tunnels, water, and night

1203. CARLO CARRÀ. *Funeral of the Anarchist Galli.* 1910–11. Oil on canvas, 6'6" × 8'6". The Museum of Modern Art, New York. Lillie P. Bliss Bequest

1204. UMBERTO BOCCIONI. *The City Rises.* 1910–11. Oil on canvas, 6'6" × 9'10". The Museum of Modern Art, New York. Mrs. Simon Guggenheim Fund

1205. UMBERTO BOCCIONI. *Unique Forms of Continuity in Space.* 1913. Bronze, height 43½". The Museum of Modern Art, New York. Lillie P. Bliss Bequest

1206. JOSEPH STELLA. *Brooklyn Bridge.* 1917–18. Oil on bedsheeting, 84 × 76". Yale University Art Gallery, New Haven, Connecticut. Collection Société Anonyme

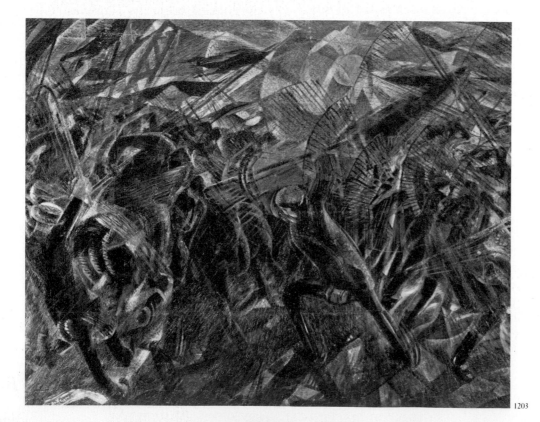

1203

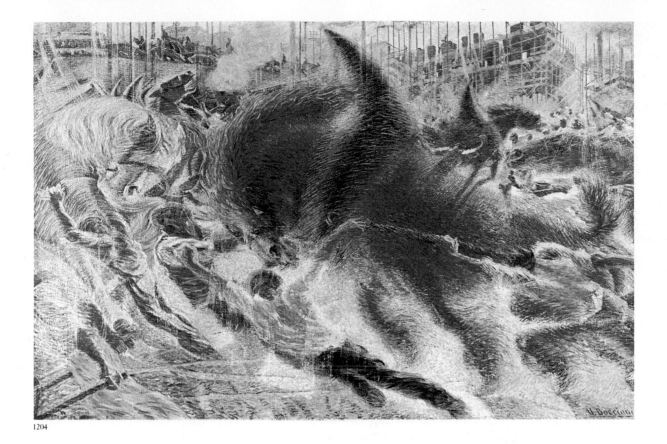

1204

are woven into a symphonic structure of interpenetrating form, space, light, and color. Exhilaration in man's engineering victories had found its first artistic expression in Turner's *Rain, Steam, and Speed* (see fig. 1091), but voices of doom had already been raised. Never again after Joseph Stella would it be possible to view in a positive sense industrial life, universally experienced in later twentieth-century art as dehumanizing.

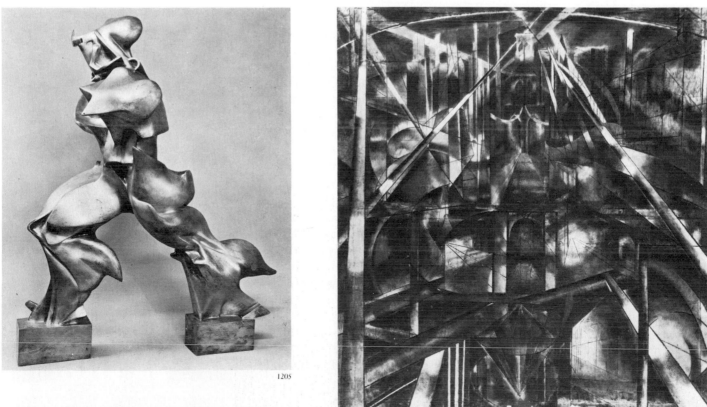

1205

1206

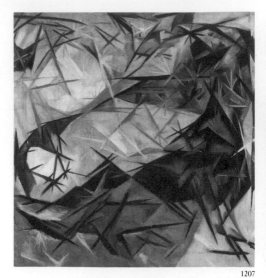

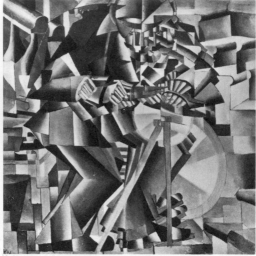

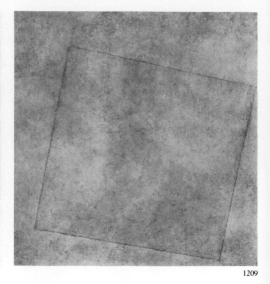

1207

1208

1209

The modern movement, in which the Russian Kandinsky played such a crucial role in Germany, enjoyed a magnificent chapter in Russia itself just before, during, and just after World War II, coming to a brief climax in the early years of the Soviet Republic. Through the influence of Russian collectors, especially Sergei Tschukine in Moscow, the new artists were thoroughly familiar with the work of the French Post-Impressionists, and were able to study the innovations of the Fauves and the Cubists at first hand, sometimes the very year they were painted. A remarkable couple, Mikhail Larionov (1881–1964) and NATALYA GONTCHAROVA (1881–1962), founded in 1911 a movement they called Rayonnism, based on a somewhat romanticized interpretation of the discoveries of twentieth-century physicists, especially Einstein. The visual field was penetrated by a host of rays, crisscrossing like searchlights, to produce exciting and ever-changing patterns. As in the case of the Delaunays, the work of the couple was at times almost indistinguishable, but that of Gontcharova was generally superior in quality. *Cats* (fig. 1207), painted in 1913, is a delightful example of the style. The animals themselves cannot be made out, as they would have been in a painting by Franz Marc, but the picture vibrates with their darting movements, not to speak of the rhythms of their tails, their plunging paws, even their ears. Rayonnism came to a sudden end in 1914, when the couple moved to Paris, where Gontcharova spent much of her productive life designing splendid sets for the Russian ballet.

In the early work of KASIMIR MALEVICH (1878–1935), especially *The Knife Grinder*, of 1912 (fig. 1208), the principles of Cubism and Futurism merge. The mechanized geometrical shapes of Léger are multiplied by the cinematic multiple vision of the Futurists; as the knife grinder sits on the balustraded steps before a town house, his left foot pumps the treadle, his hands move back and forth with the wheel and the knife, and his head bobs up and down, producing a delightful set of simplified simultaneous images in bright red, yellow, blue, and white. We are hardly prepared by such a picture for Malevich's most original invention, a style practiced by him alone, which he entitled Suprematism. At first he dealt with constellations of soaring rectangles or trapezoids, which may have influenced the later airborne visions of Kandinsky (see fig. 1176). Malevich's process of simplification culminated in the reduction, about 1918, of the whole pictorial field to a single white square floating delicately and freely on an ever so slightly different white ground (fig. 1209). The *White*

Rayonnism, Suprematism, and Constructivism

1207. NATALYA GONTCHAROVA. *Cats*. 1913. Oil on canvas, 33¼ × 33″. The Solomon R. Guggenheim Museum, New York

1208. KASIMIR MALEVICH. *The Knife Grinder*. 1912. Oil on canvas, 31⅜ × 31⅜″. Yale University Art Gallery, New Haven, Connecticut. Collection Société Anonyme

1209. KASIMIR MALEVICH. *Suprematist Composition: White on White*. c. 1918. Oil on canvas, 31¼ × 31¼″. The Museum of Modern Art, New York

1211

1210

1210. LIUBOV POPOVA. *Architectonic Painting*. 1917. Oil on canvas, 31½ × 38⅝". The Museum of Modern Art, New York. Philip Johnson Fund

1211. VLADIMIR TATLIN. *Monument to the Third International*. Model. 1919–20. Wood, iron, and glass (re-created in 1968 for the Tatlin Exhibition, Moderna Museet, Stockholm)

1212. NAUM GABO. *Space Construction C*. c. 1922. Plastic, 39 × 40". Whereabouts unknown. Photograph of the work, Yale University Art Gallery, New Haven, Connecticut. Collection Société Anonyme. Bequest of Katherine S. Dreier

1213. ANTON PEVSNER. *Portrait of Marcel Duchamp*. 1926. Celluloid on copper, 37 × 25¼". Yale University Art Gallery, New Haven, Connecticut. Collection Société Anonyme

on White series, even at this early stage of twentieth-century art, represents very nearly the ultimate in abstraction. Yet contemplating a series of these ascetic pictures hung side by side, one is astonished at the range and variety Malevich can find in so austere a theme.

Only in the past few years has the work of LIUBOV POPOVA (1889–1924) been reevaluated in the West, along with several other Russian avant-garde painters, two of them also women, through the pioneer collection of George Costakis. Popova was profoundly influenced by French Cubism, and during 1912 worked in the Paris studio of the minor Cubist Jean Metzinger. At home in Russia after the outbreak of World War I, Popova produced a series of abstractions, even preceding those of Malevich. Her *Architectonic Painting*, of 1917 (fig. 1210), has none of the floating quality of Malevich. Powerful, intersecting, opaque triangular and trapezoidal shapes parallel to the picture plane are anchored to each other and the frame in a rugged design, well on the way to the Constructivism of a few years later.

In 1913 VLADIMIR TATLIN (1895–1956) visited France, and was fascinated by the constructions Picasso was making. When he returned to Russia, Tatlin put together a series of reliefs (now destroyed and known only from photographs) from a wide range of improbable materials; these abstractions involve the principles of suspension and motion. In the early years after the revolution, Tatlin, excited by the vision of a new society, translated his abstract forms to almost inconceivable dimensions in order to praise socialism. His ambitious *Monument to the Third International*, for which only the model (fig. 1211) was ever carried out, in 1919–20, would have been about 1,300 feet in height, the tallest colossus ever imagined up to that time. As much architecture as sculpture, its three glass units inside a metal frame, housing assembly halls and meeting rooms, were intended to revolve at separate speeds, one daily, one monthly, and one yearly.

Two brilliant brothers, ANTON PEVSNER (1886–1962) and NAUM GABO (1890–1977), who changed his surname to avoid confusion with his older brother, carried Constructivism, as the new style came to be called, to a high pitch of intellectual and formal elegance. Gabo was the more inventive of the two, and was producing Constructivist sculpture based on the

1212

1213

human form but executed in sheets of metal and cardboard, thus abandoning the concept of sculpture as mass, as early as 1915 in Norway. After the 1917 revolution he returned to Moscow, where he was inspired by Tatlin's constructions, and began to create completely abstract works, some even containing motors to produce vibrations. His *Space Construction C*, of about 1922 (fig. 1212), done entirely in transparent plastic, suggests volumes without delimiting them, and produces endlessly changing relationships of spaces as the observer moves around it. Pevsner, trained as a painter, developed under his brother's influence a somewhat weightier and more static version of the volume style. The *Portrait of Marcel Duchamp* (fig. 1213), of 1926, commissioned by Katherine S. Dreier, cofounder with Duchamp and Man Ray of the Société Anonyme, suggests the brooding intellectuality of the great innovator by means of abstract volumes enclosed by translucent or opaque planes.

The achievements of the Constructivist sculptors were paralleled in painting by EL LISSITZKY (1890–1956) in a series that he called *Proun*, a fabricated word. *Proun 99*, of 1924–25 (fig. 1214), is a beautiful play on perspective lines and a cube, which float in abstract space before a slightly off-center strip anchored by semicircles at top and bottom. The freedom accorded to the ideas of the Constructivists in the early days of the revolution came to a sudden end in 1920, when the Soviet government decided that only a realistic style could enlist the adherence of the masses. The result was a veritable diaspora of Russian modernists, who brought their ideas to Germany, France, England, and the United States with results that continue in unchecked vitality to the present day.

1214

World War I was responsible for the early deaths of Marc and Duchamp-Villon and, indirectly, those of Boccioni and Lehmbruck. It also cut all contact between the groups of artists who had owed their intellectual origin to Cubism. In Holland during the war years the painters Theo van

De Stijl

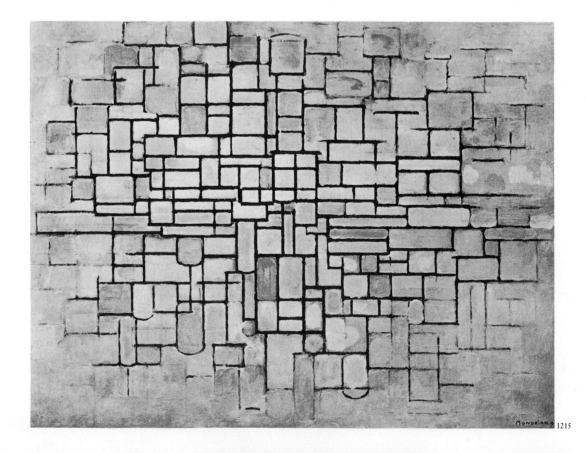

1215

Doesburg and Piet Mondrian, the Belgian sculptor Georges Vantongerloo, the architect J. J. P. Oud, and others formed a group that had certain points of similarity with Suprematism and Constructivism, although without any knowledge of their existence. The Dutch circle founded in 1917 a periodical called simply *De Stijl* (The Style), consecrated to the exaltation of mathematical simplicity in opposition to all "baroque" styles, among which they included Impressionism. Sternly, they reduced all formal elements to flat surfaces bounded by straight lines intersecting at right angles, and all colors to black, white, and gray and the three primary hues, red, yellow, and blue. Not only paintings and sculpture (which needless to say excluded all representation) but also houses, interiors, furniture, and all forms of design were subjected to this principle. The leading theorist and finest artist of the movement, indeed one of the most sensitive, imaginative, and influential painters of the twentieth century, was PIET MONDRIAN (1872–1944).

Mondrian arrived at his point of view through a rapid evolution, in which he recapitulated the various stages of Modernism we have already seen, including Realism, Impressionism, Post-Impressionism, and Cubism. His development was guided by a mystical Calvinist philosophy, according to which art helped him to attain spiritual absolutes through the balance of opposites in the Cross. He stated that "(a) in plastic art reality can be expressed only through the equilibrium of *dynamic movements* of form and color; (b) pure means afford the most effective way of attaining this [equilibrium]." In such early, still Post-Impressionist works as *The Red Tree*, of 1908 (see fig. 5), Mondrian reduced a leafless tree in

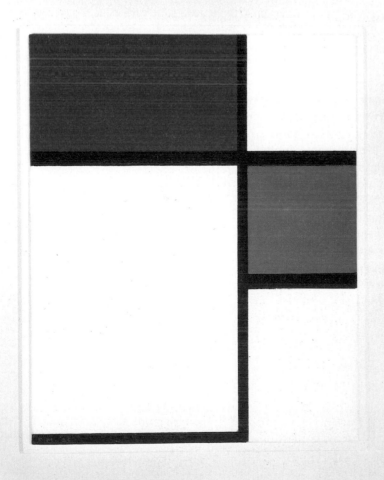

1214. EL LISSITZKY. *Proun 99*. 1924–25. Oil on canvas, 50¾ × 39″. Yale University Art Gallery, New Haven, Connecticut. Collection Société Anonyme

1215. PIET MONDRIAN. *Composition in Line and Color*. 1913. Oil on canvas, 34⅝ × 45¼″. Rijksmuseum Kröller-Müller, Otterlo, The Netherlands

1216. PIET MONDRIAN. *Composition*. 1925. Oil on canvas, 15⅞ × 12⅝″. The Museum of Modern Art, New York. Gift of Philip Johnson

SEARCH FOR FORM 911

bright winter sun to rhythms of brilliant red partly contoured in black and reflected in red touches throughout the intense blue of ground and sky. Although strongly indebted to Van Gogh, Mondrian has already negated distance and emphasized the division of the plane of the canvas into colors united by movement. The intense excitement of this early work is maintained undiminished in his apparently ascetic later creations.

In 1911 Mondrian came under the influence of Cubism in Paris, and rapidly developed on the basis of Cubist segmentation a style that reduced Cubist planes to an almost entirely rectilinear grid covering the entire surface, through which floated still rather soft colors indebted to Cubist limitations of hue. In such paintings as *Composition in Line and Color*, of 1913 (fig. 1215), Mondrian has obeyed the implications of his title, as Whistler did not, and all reference to natural appearances has vanished. It is important for the understanding of Mondrian's style that none of the scores of rectangles in the painting are identical, that each functions (as in the city views of the Impressionists) like a single individual subject to the crosscurrents of an urban conglomeration. The opening or narrowing of the intervals in the grid produces the impression of surge, flow, constriction, impulses of varying speeds.

Contending that Cubism "did not accept the consequences of its own discoveries," Mondrian by 1919 had identified the picture firmly with the foreground plane. In his *Composition*, of 1925 (fig. 1216), a system of broad black lines intersecting at right angles rules the field into rectangles of white, red, and blue. The effect is unexpectedly intense and lyrical. The white frame, designed by Mondrian himself, is set back from the canvas, and does not appear to limit the movement of colors and lines, which run to the edge and appear to continue beyond it. The color surfaces are delicately brushed, and never appear inert like those of Léger. The red and blue are exquisitely weighted so that a system of poise and counterpoise emerges. The result is, as Mondrian intended it to be, a dynamic rather than a static expression, yet it establishes a serene harmony the like of which had not been seen in art since the subtle refinements and counterpoises of the Parthenon. In all the welter of twentieth-century styles, Mondrian's is the only one to achieve such a perfect state of rest.

If imitation is the sincerest flattery, Mondrian might have been pleased by the spread of his ideas throughout all forms of twentieth-century art. He would have been less gratified by the popularization of his notions, misunderstood and caricatured, in advertising and even costume design. One reserved and sensitive artist who has always admired Mondrian, but knows how to put his principles to use in a highly original style, is the English painter-sculptor BEN NICHOLSON (1894–1982), who spent his adolescent years from 1911 to 1913 in France and Italy. Out of the planes of Cubism he produced a system of subtly projected surfaces, rectangular and strictly vertical-horizontal as in Mondrian, but sometimes interlocking, and retaining the circle to great effect. Nicholson's delicate equipoise of white or softly tinted forms, as in *White Relief*, of 1936 (fig. 1217), is more an emulation than an imitation of the great Mondrian.

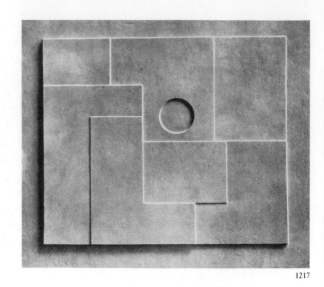

1217

1217. BEN NICHOLSON. *White Relief*. 1936. Oil on carved board, 8 × 9¼". Formerly Collection Naum Gabo, Middlebury, Connecticut

CHAPTER

FANTASTIC ART, DADA, AND SURREALISM

EIGHT

Throughout history fantasy and imagination have always underlain the most apparently rational thought processes. During the twentieth century, despite severe attempts to rationalize human behavior, even to control it by totalitarian systems, the stubbornly irrational inner life of individuals and societies, illuminated by Freud and his followers, has persisted. Throughout this superficially scientific century, the current of fantasy has been fully as productive and important as those tendencies that seek an outlet in emotional expression or exalt the ideal of pure form. The first representatives of this fantastic tendency in the twentieth century were, like their precursors in the nineteenth, isolated individuals, but soon groups arose, notably Dada and the Surrealists, at least as cohesive as the Impressionists or the Cubists and far more vocal.

CHAGALL A pioneer of twentieth-century fantastic art, and in a sense the heir of Henri Rousseau, is the Russian painter Marc Chagall (1887–). From the treasury of Russian and Jewish folklore remembered from his youth in the western Russian city of Vitebsk, he has created a personal mythology of childlike directness and intimacy. After a brief training in Vitebsk and St. Petersburg, in 1910—the year of Rousseau's death—he was drawn inevitably to Paris, artistic capital of the world. There in 1912 he painted his *Self-Portrait with Seven Fingers* (fig. 1218), in which the brilliant colors and delightful imagery of Russian-Jewish folk tradition and the fragmented forms of Cubism are combined with an overflowing richness of imagination. The artist's quite normal right hand holds his brushes and his palette dotted with bright colors as if studded with jewels, while his left, with the inexplicable seven fingers, indicates the canvas he has just painted, representing a pink cow standing by a pail, attended by a soaring milkmaid, near a little Russian church. Another vision of Russia appears in the clouds above the painting on the easel, while out the studio window searchlights comb the sky beside the Eiffel Tower. This visionary personal disclosure takes place in a studio with a yellow floor shaded here and there with red, and bright red walls curving like those in the distorting mirror in Parmigianino's *Self-Portrait* (see fig. 834). Lest we be enticed into hazardous interpretations of this and other Chagall pictures, the artist himself has said of his works, "I do not understand them at all. They are not literature. They are only pictorial arrangements of images which obsess me. . . . The theories which I make up to explain myself and those which others elaborate in connection with my work are nonsense. . . . My paintings are my reason for existence, my life, and that's all." During the exciting artistic developments after the Russian

Fantastic Art

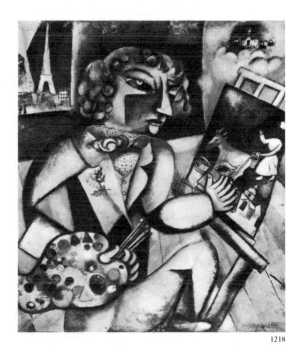

1218. MARC CHAGALL. *Self-Portrait with Seven Fingers.* 1912. Oil on canvas, 50⅛ × 42⅛". Stedelijk Museum, Amsterdam

revolution, Chagall was as active as his other great compatriots, Kandinsky and the Constructivists, and later joined them in the general exodus of modern artists from Russia after 1920. In 1923 he settled in Paris, moved to New York City during World War II, and in 1948 to Vence in southern France. For more than three-quarters of a century he has continued to pour out a prodigious series of paintings, stage designs, large-scale murals, etchings, lithographs, and the finest stained glass of the twentieth century, all in much the same personal idiom.

DE CHIRICO An even more independent figure was the Greek-born Italian Giorgio de Chirico (1888–1978), of cardinal importance to the Surrealists, who deeply admired his early work. His youthful training in Athens and his adolescent years in Munich brought him in contact with Classical antiquity and German philosophy, particularly that of Nietzsche, who had disclosed his "foreboding that underneath this reality in which we live and have our being, another and altogether different reality lies concealed." In Paris from 1911 to 1915, De Chirico had little interest in Impressionism, whose concern with sunlight seemed to him superficial, nor even in the Cubists or Fauves, then at the height of their fame. He produced a disturbing series of barren cityscapes, as monolithic as if carved from cliffs, lighted from the side so that long shadows fall across squares deserted save for occasional tiny figures. His *The Nostalgia of the Infinite* (fig. 1219), painted about 1913–14 in Paris, shows a mysterious tower at the summit of a gently rising square, flags flying triumphantly from its domed top, unapproachable and frightening. The inert surfaces deny completely the Impressionist tradition. The subconscious significance of De Chirico's paintings is often easy to interpret in Freudian terms. In this less transparent instance, the tower may be a paternal symbol. Along with Carrà, whom he met in 1917, and the painter Giorgio Morandi, De Chirico formed a short-lived group of "metaphysical artists." Soon he deserted his earlier manner in favor of a softer, pseudo-Classical style of considerably less interest and, later, imitations of Baroque painting. He even disowned some of his more psychoanalytically revealing early paintings, made copies of others, and in general played little part in the later development of contemporary art.

KLEE The most intimate, poetic, and resourceful of the independent fantastic artists was Paul Klee (1879–1940), born in Switzerland of a German father, an organist. Klee, himself a trained violinist, studied in Munich and considered himself German. Early trips to Italy and North Africa broadened his artistic horizons. In 1911 he settled in Munich, where he formed a friendship with Marc and exhibited with Der Blaue Reiter. In straitened circumstances, he had no studio, and worked on the kitchen table while preparing meals for his wife, a piano teacher. His work was of necessity on a small scale—drawings, watercolors, and etchings. From 1921 to 1931 he taught at the Bauhaus in Weimar (see Chapter Ten), where he had his first studio, and lived in a two-family house, the other half of which was occupied by Kandinsky. The two artists respected each other's work greatly, yet exerted surprisingly little influence on each other. Both wrote important theoretical works while at the Bauhaus.

Klee was deeply interested in the art of children, which he felt could reveal much about the mysteries of creativity. This insight he combined with a wholly adult sophistication of wit in a uniquely personal poetic

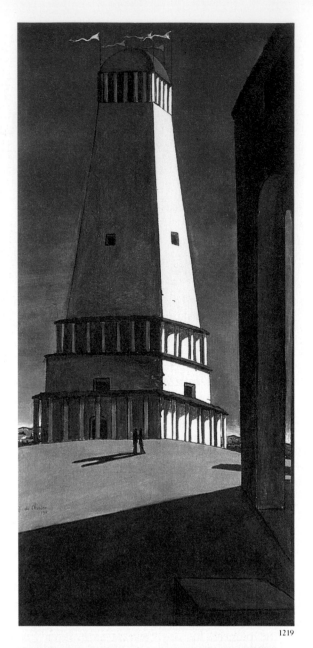

1219

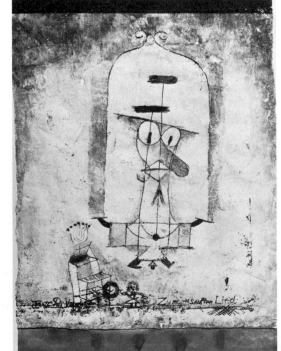

1220

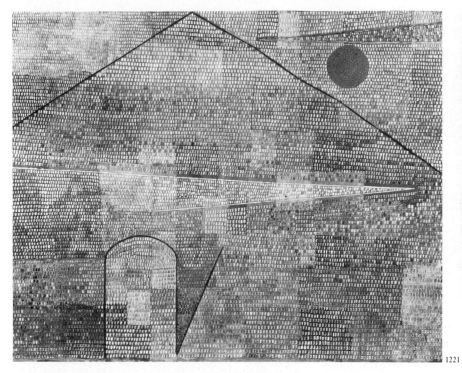

1221

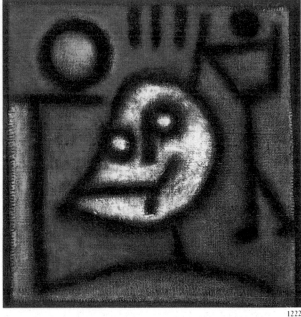

1222

way. *Dance, Monster, to My Soft Song!* (fig. 1220), of 1922, shows a tiny pianist and singer, whose music compels a floating creature, consisting largely of an inflated head with a purple nose, to dance in the air, much to its surprise. The delicacy of the apparently spontaneous scratchy line and the softness of the tone are characteristic of much of Klee's work, which has been likened to a letter or a poem to be read in the hand, rather than a picture to be hung on a wall. *Ad Parnassum*, of 1932 (fig. 1221), a painting on canvas, is apparently based on the celebrated series of piano exercises known as *Gradus ad Parnassum (Steps to Parnassus)*, whose endlessly repeated notes merge as in the mind of a patiently practicing child into a mystical mountain of musical achievement, soaring higher than the sun.

After Klee was forced into exile in Switzerland by the Nazi regime in 1933, his art grew more intense and solemn and the scale of his forms larger and more powerful. *Death and Fire* (fig. 1222), painted in 1940, the last year of the artist's life, is one of the most intense of a series dealing with messages of ultimate spiritual significance in terms of hieroglyphs. The person, the sun, the death's head in the center, the background of brown and red, the ghostly character of the entire picture may well refer to the disaster that had befallen western Europe in that dreadful year of the fall of France, the Low Countries, and much of Scandinavia before Nazi Germany's onslaught.

As early as 1915, it became apparent that the static trench warfare of World War I was unlikely to produce any result more decisive than continuing mass slaughter. A number of young intellectuals, notably the German writers Hugo Ball and Richard Huelsenbeck and the Alsatian artist Jean (Hans) Arp, sought refuge in Zurich, in neutral Switzerland, where they were soon joined by others, notably the Rumanian poet Tristan Tzara. In Zurich in 1916 Ball founded the Cabaret Voltaire, named after the great French skeptic of the eighteenth century, as a center for

1219. GIORGIO DE CHIRICO. *The Nostalgia of the Infinite*. c. 1913–14 (dated 1911). Oil on canvas, 53¼ × 25½". The Museum of Modern Art, New York. Purchase

1220. PAUL KLEE. *Dance, Monster, to My Soft Song!* 1922. Mixed mediums on gauze, mounted on paper, 17¾ × 12⅞". The Solomon R. Guggenheim Museum, New York. © Cosmopress, Geneva

1221. PAUL KLEE. *Ad Parnassum*. 1932. Casein and oil on canvas, 39⅜ × 49⅝". Kunstmuseum, Bern

1222. PAUL KLEE. *Death and Fire*. 1940. Oil and gouache on burlap, mounted on linen, 18⅛ × 17⅜". Kunstmuseum, Bern. Paul Klee Foundation. © 1984 Cosmopress, Geneva

Dada

protest against the entire fabric of European society, which could give rise to and condone the monstrous destruction of the war. At first the evenings were literary, musical, or both. "Noise-music," a phrase the group borrowed from the Futurists (with whom they had little in common) alternated with readings of poems in several languages simultaneously, or with abstract poetry composed of meaningless syllables chosen purely for their acoustic interest. Public reaction at times approached actual violence, which was just what the group wanted. They attacked every cultural standard and every form of artistic activity, including even what had been avant-garde a decade earlier. It is characteristic of the movement that there should be several contradictory explanations of how its name, *Dada*, arose, but all agree that the title was intended as nonsense, and it was accepted by acclamation.

Dada soon became international. A group was promptly organized in New York by Marcel Duchamp (see page 903), together with the Cuban artist Francis Picabia, centering around the Gallery 291, which had been founded by the eminent photographers Alfred Stieglitz and Edward Steichen (see page 925). Huelsenbeck returned to Germany in 1917 from Zurich when defeat seemed only a matter of time, and early in 1918 launched Dada in Berlin, largely as a literary movement. After the close of hostilities, Dada burst out in Cologne, instigated by the arrival of Arp, and sparked by the highly imaginative activity of Max Ernst, a local painter. Independently, Kurt Schwitters, also a painter, began his long Dada activity in Hanover. With the convergence of Tzara, Picabia, and Duchamp on Paris, Dada enjoyed a brief life there from 1919 until its dissolution in 1923.

There was always a certain mad logic about even the most perverse and apparently destructive manifestations of Dada humor, but it was hardly to be expected that new art forms would arise from it. Nonetheless, the very ferocity of the Dada offensive unleashed a remarkable amount of creativity, manifesting itself in spontaneous expressions that exalted artistic activity or chance occurrences.

JEAN ARP (1887–1966), born in Strasbourg, then a German city, was the most gifted artist of the Zurich group. According to a perhaps apocryphal story, he accidentally created a very interesting pattern by tossing on the floor the pieces of an unsatisfactory drawing he had torn up. Soon he experimented with arrangements of torn paper produced by chance, just as Tzara was at the same moment making collage-poems out of words and phrases clipped at random from newspapers.

Arp then began to experiment with pieces of wood cut out freely in curvilinear shapes with a band saw, suggesting amoebas or other primitive forms of life. Later, he used cutout cardboard, mounted and painted, in biomorphic shapes or configurations echoing nature as seen through moving water or a distorting glass. *Mountain Table Anchors Navel*, of 1925 (fig. 1223), all in white, brown, black, and sky-blue, is a particularly engaging example of Arp's whimsy. In their freedom from such restrictions as the straight lines of table legs or anchor shafts, these collapsed shapes, direct ancestors of the soft machines of Oldenburg in the 1960s (see fig. 1255), exert a special charm. After the dissolution of Dada, Arp continued to work as a sculptor in the free forms he had invented, promoting his earlier silhouettes to three-dimensional shapes melting into each other with exquisite grace. *Torso*, of 1953 (fig. 1224), swells and contracts as subtly as if the velvety marble were breathing.

The leading spirit of Dada, although at a certain distance, was Marcel Duchamp, whom we have already encountered in the wake of Cubism.

1223

1224

His greatest work, *The Bride Stripped Bare by Her Bachelors, Even*, executed between 1915 and 1923 (fig. 1225), is an immense construction, made up of two superimposed double layers of plate glass. The image is generally done on the inside of one layer and protected by the other, like the filling in a sandwich, and executed in paint, lead foil, and quicksilver by techniques generally used to apply lettering to shop windows. The work eludes final interpretation, but insofar as it can be explained it depicts erotic frustration. The "bachelors" are the nine machine molds at the lower left, united by a "bachelor-machine" to a water mill and a chocolate grinder, all rendered with the precision of an engineering diagram, and in perspective so that they seem to float. Especially delicate are the three designs of rays or concentric circles in quicksilver. The "bride" is the mechanized creature at the upper left, a descendant of the *Nude Descending a Staircase, No. 2* (see fig. 1196). She grasps a cloud (suggesting the Milky Way), pierced by windows whose quivering outlines were studied from those of squares of gauze in a crossdraft. The transparency and reflectiv-

1225

1223. JEAN (HANS) ARP. *Mountain Table Anchors Navel*. 1925. Oil on cardboard with cut-outs, 29⅝ × 23½". The Museum of Modern Art, New York. Purchase

1224. JEAN (HANS) ARP. *Torso*. 1953. White marble on polished black stone base, height (including base) 37". Smith College Museum of Art, Northampton, Massachusetts. Gift of Mr. and Mrs. Ralph F. Colin, 1956

1225. MARCEL DUCHAMP. *The Bride Stripped Bare by Her Bachelors, Even (The Large Glass)*. 1915–23. Oil, lead foil, and quicksilver on plate glass, 9'1¼" × 5'9⅛". Philadelphia Museum of Art. Louise and Walter Arensberg Collection

ity of the glass were intended to include the environment and the observer in the work of art. In 1926 the work was accidentally shattered; Duchamp was delighted, welcoming the cracks (which he meticulously repaired) as elements in his work of art. The end result of deliberate planning, mechanical draftsmanship, imagination, and accident is a work of indefinable magic. Although its fragility has prevented it from traveling, and although during the years when it was in the collection of Katherine S. Dreier it was seen only by permission, this creation has exercised an enormous influence on later art, up to and including the 1980s.

Duchamp's ingenuity produced visual machines, such as whirling blades of glass that fuse to produce floating circles, and visual gramophone records of cardboard that convert to spatial images through the revolution of the turntable. His spirit of raillery caused him to exhibit a photograph of the *Mona Lisa* supplied with a moustache and goatee and the title *L.H.O.O.Q.*, which pronounced in the French manner results in a mildly obscene pun. He exhibited such ordinary objects as a bicycle wheel, a snow shovel, a rack for drying bottles, and a urinal, to which he gave titles, calling them his "ready-mades." Whether or not these manufactured objects were in themselves beautiful (and some undoubtedly were), and although he had not in any way altered their appearance, Duchamp certainly placed a new dimension on artistic creation by limiting it to the sole act of choice. His ready-mades have provoked lively discussion among artists, critics, and historians for nearly two generations.

One of his last paintings was *Tu m'*, of 1918 (fig. 1226), long installed in the library of Katherine S. Dreier's home. Shadows of ready-mades—a bicycle wheel, a corkscrew, and a coatrack—float on the canvas, penetrated by a procession of what appear to be color cards, but which are actually painted. Seen in perspective, they seem to be rushing out of the picture, but are restrained by a *real* bolt. Duchamp hired a professional sign painter to paint the pointing hand, then *painted* a jagged rip in the canvas apparently made by the protrusion through it of a *real* bottle brush and fastened by *real* safety pins. The enigma suggested by the incomplete but probably insulting title and the interpenetration of reality, illusion, and shadows make this one of the most disturbing paintings of the twentieth century. Except for devising miniature reproductions of his glass works, Duchamp claimed to have abandoned art for chess; actually, he was producing in secret for many years an elaborate peep show of a nude woman in a vegetation-lined box, whose existence was revealed only after his death.

A kindred spirit if on a less exalted level is MAX ERNST (1891–1976), a self-taught Cologne painter. The barren world of De Chirico probably influenced Ernst's magical *The Elephant of the Celebes*, of 1921 (fig. 1227). The foreground is filled with a mechanical monster, towering above a floorlike plain, which ends in a distant range of snowcapped mountains.

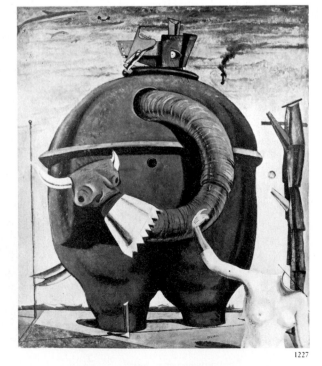

The creature is composed of a washboiler fitted with various attachments, including a hose that serves as both neck and trunk, leading to a mechanical head sprouting horns; a pair of tusks emerges from the creature's rear. In the foreground a headless female mannequin gestures with a gloved hand next to a perilous tower of coffeepots.

In Hanover, meanwhile, a lonely and sensitive spirit, KURT SCHWITTERS (1887–1948), was producing marvelous pictures out of the ordinary discards rescued from the wastebasket or the gutter—tags, wrappers, tram tickets, bits of newspapers and programs, pieces of string. In a sense they resemble Cubist collages, and are as well put together as the best of them, but they lack the unifying temporal experience of the café. Only the detritus of society interested Schwitters, a kind of poetic scavenger who could create beauty from what is ordinarily considered less than nothing—aided from time to time with a few strong touches of a color-laden brush. His *Picture with Light Center*, of 1919 (fig. 1228), is typical of what he called his *merz* pictures. This nonsense syllable was drawn from the word *Commerzbank* (bank of commerce), and he used *Merzbau* to describe the fantastic structure of junk he erected that eventually filled two stories of his house in Hanover. After the destruction of this concretion by the Nazis, Schwitters began another in Norway and yet a third in England. His *merz* pictures, often tiny and jewel-like in their delicacy and brilliance, continued some of the principles of Dada until the middle of the century.

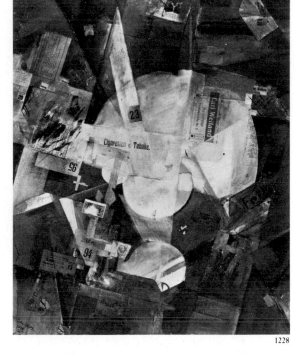

1228

By 1923 the iconoclasm and the nihilism of Dada had begun to fade, and most artists had deserted the movement. Nonetheless, Dada had performed a valiant service in liberating the creative process from logical shackles. Surrealism took the next step—that of exploring illogic on Freudian principles in an endeavor to uncover and utilize for creative purposes the "actual" (as opposed to the logical) processes of thought. In 1924 the French author André Breton launched his first Surrealist manifesto. At the outset Surrealism was a thoroughly literary movement, based on the free association of mental images through automatic writing, uncontrolled by conscious thought, thus putting in lasting form the fleeting configurations that occur ordinarily through subconscious activity only in dreams or waking reverie. Goya had already shown the way in his celebrated print *The Sleep of Reason Produces Monsters* (see fig. 1073). Methodical, even doctrinaire, as was Breton's approach, the resulting combinations of images could and often did exert a commanding power or even a poetic charm, as in a striking simile borrowed by the Surrealists from the nineteenth-century writer Lautréamont: "As beautiful as the chance encounter on a dissecting table of a sewing machine and an umbrella."

Although Breton was at first hostile to painting, artists were not slow in seeing the possibilities inherent in his emphasis on subconscious association. In 1925 the first Surrealist group exhibition took place at the Galerie Pierre in Paris; among the exhibiting artists, Arp, De Chirico, Ernst, Klee, and Picasso are already familiar to us; of these only Ernst would today be classified as a true Surrealist. A brilliant new name was that of Joan Miró. René Magritte joined the group in 1927, and in 1929 Salvador Dali became a member, although he was formally read out of the party by Breton only five years later.

Ernst at first studied the possibilities offered by recombining figures, backgrounds, and accessories cut out of nineteenth-century wood-engraved

Surrealism

1226. MARCEL DUCHAMP. *Tu m'*. 1918. Oil and graphite on canvas, with bottle brush, safety pins, and nut and bolt, 2'3½" × 10'2¾". Yale University Art Gallery, New Haven, Connecticut. Collection Société Anonyme. Bequest of Katherine S. Dreier

1227. MAX ERNST. *The Elephant of the Celebes*. 1921. Oil on canvas, 51⅛ × 43¼". Collection The Elephant Trust, London

1228. KURT SCHWITTERS. *Picture with Light Center*. 1919. Collage of paper with oil on cardboard, 33¼ × 25⅞". The Museum of Modern Art, New York. Purchase

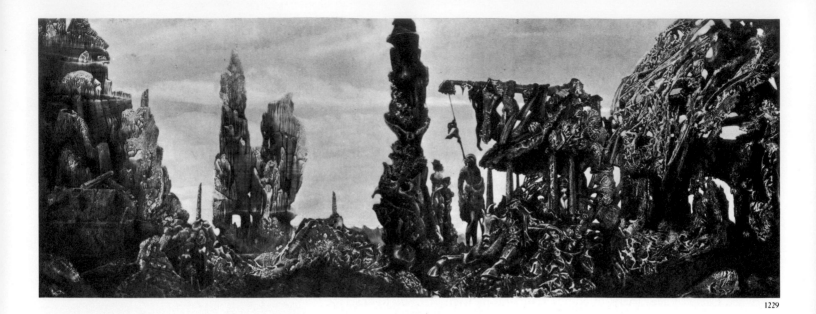

illustrations, assembling them—or so he claimed—only as dictated by free association and pasting the results into illustrations for a subconscious collage "novel." The pseudo-narrative thus produced resembles a continuous dream that at times becomes a nightmare. Ernst also discovered accidentally the effects obtainable by laying a piece of paper over a rough surface, such as wood, stone, leaves, or sackcloth, and rubbing the paper with soft pencil; in the variegated flow of tones thus produced he discovered imagery, which he then exploited in painting. He called this technique frottage (from *frotter*, meaning "to rub"). Later, he spread paint on canvas, and compressed it while still wet, forming free shapes analogous to those produced by frottage. Since conscious choice could be involved in the selection of the surfaces to be used, and in the placing of the image on canvas, it may be questioned whether the frottage technique was a true analogue of Breton's unconscious writing. Ernst used frottage in the production of his most compelling Surrealist works, a series of fantastic views suggesting jungles or underwater or lunar landscapes, among whose apparently living heaps figures can at times be discerned. A terrifying example is *Europe After the Rain*, of 1940–42 (fig. 1229), done while the artist was in hiding from the Germans during the occupation of Paris, and suggesting the desolation of a collapsed civilization.

MIRÓ In contrast to the nightmare world of Ernst, the Catalan painter Joan Miró (1893–1983) revels in a fantasy as unbridled as that of the other Surrealists, and in a wit sharper than that of any other of them. His *Harlequin's Carnival*, of 1924–25 (fig. 1230), depicts in sparkling colors a room furnished only with a table, but inhabited by a delightful menagerie of improbable beasts, some resembling cats, some insects, and others serpents. All are as flat as paper cutouts and painted black, white, red, yellow, and blue in irresponsible combinations. One serpent is headless, another terminates in a boxing glove. All are celebrating happily with the exception of an anthropoid creature at the left, whose eyes cross in a face half-red and half-blue, while a serpent winds around what appears to be a horn. A black-and-blue comet joins in the festivities, and a view out the window discloses a black pyramid, a tongue of red flame, and a black-and-blue star. Less uproarious, equally witty, and in a strange way monumental is *Painting, 1933* (fig. 1231). Biomorphic shapes reminiscent of

1229. MAX ERNST. *Europe After the Rain*. 1940–42. Oil on canvas, 21½ × 58⅛″. Wadsworth Atheneum, Hartford, Connecticut

1230. JOAN MIRÓ. *Harlequin's Carnival*. 1924–25. Oil on canvas, 26 × 36⅝″. Albright-Knox Art Gallery, Buffalo, New York. Room of Contemporary Art Fund

1231. JOAN MIRÓ. *Painting, 1933*. Oil on canvas, 68¼ × 77¼″. The Museum of Modern Art, New York. Gift of Advisory Committee

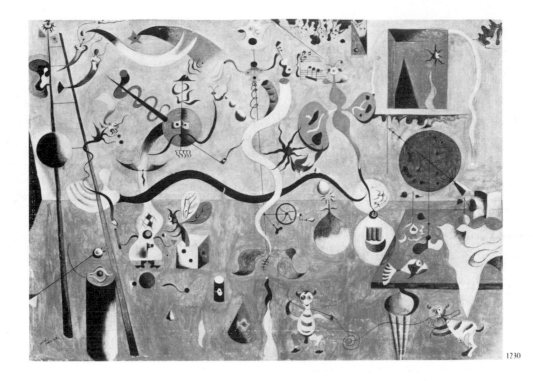

1230

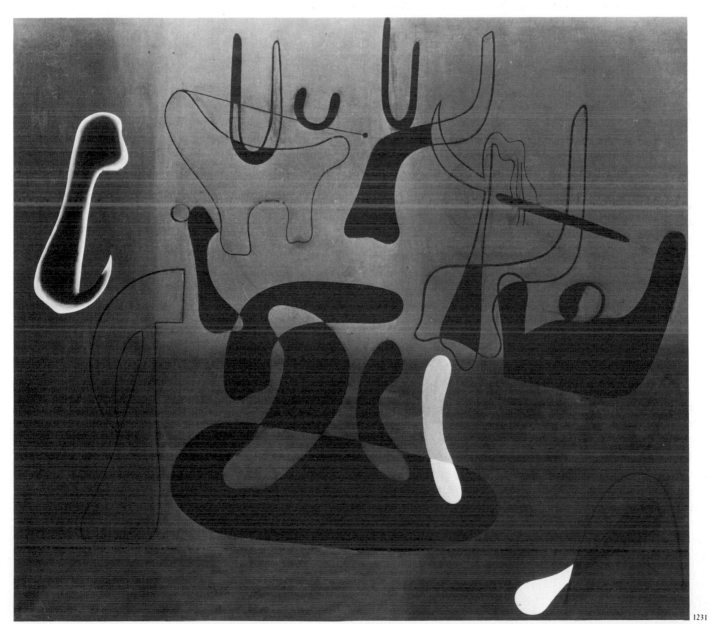

1231

Arp's are elegantly silhouetted in black, white, or red, or rendered in pure outline. They float in an atmosphere softly divided into planes of brown, tan, rose, green, and violet, dissolving into each other.

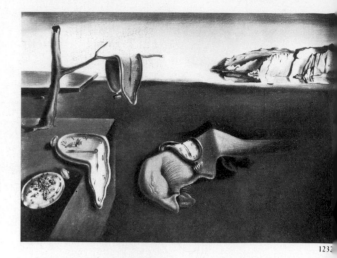

1232

DALI The flat, unmodeled shapes of Miró offer a total contrast to the work of his compatriot Salvador Dali (1904–), who in the minds of many, especially in the United States, typifies in his art, his writing, and his deliberately outrageous public behavior the Surrealist movement at its height in the 1930s. After his visit to Paris in 1928 Dali experimented briefly with semi-abstract forms, as he was then under the influence of Picasso and Miró. Soon Dali set out on his individual path, based on his study of Freud, which seemed to clarify to him his personal fantasies and obsessions. Dali began producing what he called "hand-colored photographs of the subconscious," based, as he put it, on the "three cardinal images of life: blood, excrement, and putrefaction." Needless to say, if Dali had limited his subject matter to these three substances he would have attracted only passing notice. What he called his desire to "materialize images of concrete irrationality with the utmost imperialist fury of precision" resulted in pictures of a quality and brilliance that cannot be ignored, done in bright enameled color, with an exactitude of statement that at times recalls less his idols Vermeer and Velázquez than the technique of the Netherlandish masters of the fifteenth century. Sometimes Dali's sexual symbolism is explicit enough to be classified as pornography. Usually, however, it is veiled, but the terrifying images are always brought home with tremendous force by the magical virtuosity of his draftsmanship and color.

The Persistence of Memory, of 1931 (fig. 1232), is one of Dali's most striking and best-known early Surrealist paintings. Dali said the idea for the work occurred to him while he was eating ripe Camembert cheese. Actually, the softening of hard objects had already appeared, as we have seen, in the work of Arp. Whatever their origin, the "wet watches," as they were promptly termed by the astonished, horrified, and fascinated New York public when the picture was first exhibited at the Museum of Modern Art, are disturbing in their destruction of the very idea of time. Three watches lie or hang limply, and a fourth is devoured by ants, while a severed, chinless head—its tongue hanging from its nose, its enormous eyelashes extended on its cheek—lies equally limp on a barren plain reminiscent of De Chirico or early Ernst. In the background, rendered with hallucinatory clarity, are the rocky cliffs of a Catalan bay.

A contrast to this small picture is the larger and overpowering *Soft Construction with Boiled Beans: Premonition of Civil War*, painted in 1936 (fig. 1233). Monstrous fragments of humans—arms, a breast being squeezed by a clawlike hand, a convulsed and screaming head—tower against a desolate sky partly covered with filmy clouds. The rocky terrain in the foreground pullulates with beans, while above one clenched fist a tiny bearded man gazes disconsolately at the scene. One of the most frightful images in the entire history of art, this picture is, nonetheless, endowed by Dali's astonishing skill with an unexpected and terrible beauty. After considerable activity in the fields of stage design, jewelry design, and even shop window decoration, Dali moved to Christian art. While he lost none of his technical brilliance, the evaporation of his magical fantasy is regrettable. From a religious standpoint his recent work shows neither the depth of Rouault, let us say, nor the graceful poetry of Matisse.

1232. SALVADOR DALI. *The Persistence of Memory.* 1931. Oil on canvas, 9½ × 13". The Museum of Modern Art, New York

1233. SALVADOR DALI. *Soft Construction with Boiled Beans: Premonition of Civil War.* 1936. Oil on canvas, 39½ × 39½". Philadelphia Museum of Art. The Louise and Walter Arensberg Collection

1234. MATTA. *Listen to Living (Écoutez Vivre).* 1941. Oil on canvas, 29½ × 37⅜". The Museum of Modern Art, New York. Inter-American Fund

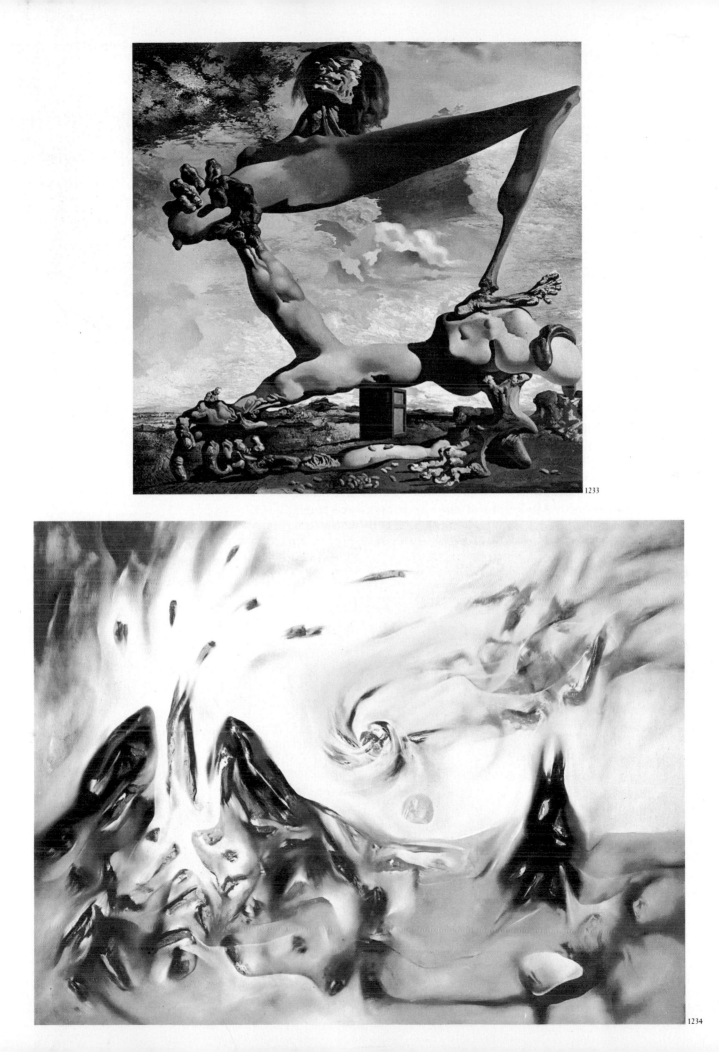

1233

1234

OTHER SURREALIST PAINTERS A delightful Surrealist, within his self-imposed limitations, is the Belgian RENÉ MAGRITTE (1898–1967), who emerged as a Surrealist in 1926. For the next forty years he continued producing his own quiet, witty versions of the Surrealist style, based on the absurd found in everyday life—double images, vanishing people, opaque objects become transparent, people and things transformed into incompatible materials. Magritte hints at nothing sinister, and his surprises offer an irresistible combination of poetry and humor. A late work, *Delusions of Grandeur*, of 1961 (fig. 1235), shows the amount of fun he can extract from nearly nothing. A cast of a Classical female torso is divided into three sections, each miraculously smaller than the one below, the last seeming to soar into a cloud-filled blue sky, itself improbably sliced into cubic sections. But we have no right to object; in the deadpan world of Magritte, anything goes.

A latecomer to the Surrealist movement, the Chilean painter Sebastian Antonio Matta Echaurren, generally known as MATTA (1912–), formed a historical link between European Surrealism and the American Abstract Expressionist movement (see Chapter Nine). But Matta's real importance is far greater than this. His work, especially during the period shortly after his arrival in the United States in 1939, is intensely beautiful in itself. Matta's ability during these exciting years lay, first of all, in his skill in rendering entirely imaginary, abstract shapes with the same convincing accuracy Dali devoted to his images based on reality, and, second, in the fierce energy that surges through his paintings. His brilliant images—opaque, transparent, translucent, pearly, sparkling, milky, in succession or all at once—seem to be driven by some unrestrainable energy, such as a fire storm or a tornado. *Listen to Living*, of 1941 (fig. 1234), with its glowing color and volcanic fury of movement, was a revelation when it was first exhibited to the New York public.

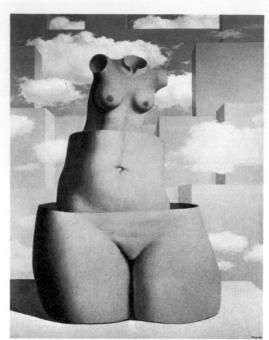

1235

1235. RENÉ MAGRITTE. *Delusions of Grandeur*. 1961. Oil on canvas, 39⅜ × 31⅞". Alexandre Iolas Gallery, New York

AMERICAN ART OF THE TWENTIETH CENTURY AND RECENT MOVEMENTS ELSEWHERE

NINE

Throughout most of its history American art remained provincial, despite the original ideas of a few gifted artists. Every current of European nineteenth-century painting continued to flow in the United States, and the most vigorous American movement of the early twentieth century, the Ash Can School (also known as The Eight), was a group of neorealists indebted largely to Courbet and the early Manet.

But in the twentieth century American art at last came into its own. Several young artists absorbed European modernism through trips to France and Germany, and returned to develop their newly acquired ideas in the United States, chiefly in New York, centering around the gallery at 291 Fifth Avenue, managed by the pioneer photographer Alfred Stieglitz, whose greatness may be assessed by contemplation of his majestic hymn to America's multinational origins entitled *The Steerage*, of 1907 (fig. 1236).

Then came the Armory Show, or to give it its full title, the International Exhibition of Modern Art, held at the New York National Guard's 69th Regiment Armory in 1913, and including all the important masters of Post-Impressionism and the Fauve movement, but relatively few works of German Expressionism and none of Italian Futurism. The works of many American pioneers were also shown. Important sections of the exhibition traveled to Chicago and to Boston. Hundreds of thousands of Americans received their first exposure to the new art through the Armory Show, and at first only a few liked what they saw. Many reactions in the press and in art schools were violent.

Nonetheless, the ice had been broken, and galleries devoted to modern art sprang up in many cities, especially New York. Katherine S. Dreier, one of the first American abstract painters, and a sensitive and foresighted collector of modern art, founded with Marcel Duchamp and Man Ray the Société Anonyme: Museum of Modern Art (as it was first called), in 1920, using rented quarters or sometimes her own apartment for exhibitions of American and European avant-garde artists. Before her death in 1952 the bulk of the Société Anonyme collection was given to Yale University. Seven works of art that she brought to the United States are illustrated in this book. In 1927 A. E. Gallatin lent his collection to New York University under the title of The Gallery of Living Art, and in 1929 the Museum of Modern Art first opened its doors in temporary quarters in New York. Stieglitz opened An American Place in 1930, and soon several other galleries were established there. The new movements could no longer be ignored or ridiculed in New York without effective reply. The collection of Dr. Albert C. Barnes, at Merion Station, Pennsylvania, was not so fortunate. Although Barnes had acquired a magnificent collection, including the finest group of Cézannes, Renoirs, and early Matisses then in public or private possession anywhere in the world, his pictures were refused by the University of Pennsylvania and held up to scorn in Philadelphia. The Barnes Foundation has, nonetheless, continued educational work on the basis of its unrivaled treasures ever since. Courses in the history of contemporary art, pioneered at Columbia University by

Meyer Schapiro, have found their way into the curriculum of well-nigh every department of the history of art in the country.

World War II resulted in the emigration of important European painters and sculptors to the United States (Ernst, Mondrian, Beckmann, Lipchitz, and for a while Léger). European art recovered only slowly from the catastrophe of the war and Nazi occupation, and although many of the leading masters resumed their activity (some, indeed, had never stopped), few new figures of importance appeared.

Astonishingly, quite the opposite took place in the United States. Some artists of European birth and training—but many more native Americans—participated in new movements, generally centering in New York, which replaced Paris in the 1950s, 1960s, and 1970s as the artistic capital of the world. Important local schools also grew up in Boston, Washington, D.C., and San Francisco.

By the second half of the twentieth century the major force in patronage, with a formative influence on art equal to that of the Church in the Middle Ages, the monarch in the Baroque, and the Salon in the early nineteenth century, had become and still remains the art dealer. The adventurous early modern galleries made little or no profit; some lost heavily. But by the 1970s and 1980s dealing in contemporary art had become big business. There are pictures originally sold by their creators for fifty or one hundred dollars which, after changing hands several times with no further payments to the artists, have come to rest in private or public collections for prices in seven figures. The dealer controls entrance to the art market, and few dealers will show works of art they do not hope to sell. After retaining a work of art for several years, a collector can recoup an original investment by selling the work at an inflated price (less capital-gains tax) or giving it to a museum and taking a deduction. The collector is then in a position to buy a more fashionable work—from a dealer.

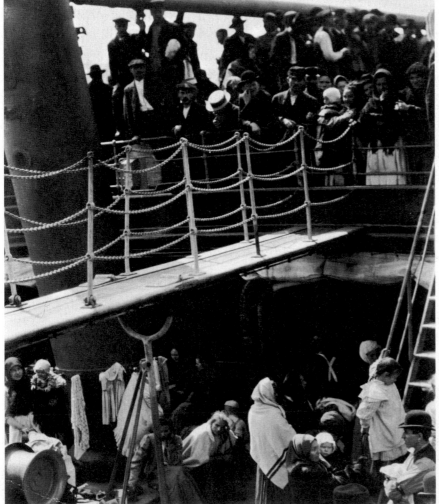

1236. ALFRED STIEGLITZ. *The Steerage*. 1907. Photograph. The Art Institute of Chicago. The Alfred Stieglitz Collection

1236

Very possibly as a result of this exclusionary procedure, most of the force of American modernism had spent itself by the mid-1980s. No new ideas of any great significance have come along for over a decade, and for a while the modern movement itself was under attack by conservatives masking as "post modern" (backed by dealers). Nonetheless, the achievements of American twentieth-century art can be rated very high. They are at least on a par with those of Germany and Russia in the first three decades of the century, and surpassed only by those of France. Choices in a period so recent are inevitably subject to individual bias. But whatever the omissions from the following account all the artists included are of real importance for the art of our own time. It is impressive to note, at last, how many of them are women now that the traditional barriers against their participation are falling in almost every profession.

1237

1238

The earliest American painter to break with naturalism was MARSDEN HARTLEY (1878–1943), who came in contact with Der Blaue Reiter group in Berlin in 1912. In the years just before World War I Hartley painted a series of pictures based on German military symbols. Although the elements of his *Iron Cross*, of 1914 (fig. 1237), are all derived from that celebrated Prussian decoration and from regimental flags, this and the other pictures in the series can certainly be termed abstractions, and are the first in American history. As masses of brilliant color arrayed against black backgrounds, they are extremely effective. This series did not, however, lead to a career in abstract art. For nearly a generation more, Hartley continued to paint Maine landscapes, whose elements are vigorously simplified for expressive purposes.

JOHN MARIN (1870–1953) spent the years 1905–11 in Europe. He was deeply impressed by the later work of Cézanne, and then by early Cubism, especially the dynamic art of Delaunay (see fig. 1195). Marin's career was spent principally in painting watercolors; among the best are those in which, like Joseph Stella (see fig. 1206), he tried to embody the energy and vitality of New York City. *Lower Manhattan (Composition Derived from Top of the Woolworth Building)*, of 1922 (fig. 1238), surveys a panorama of

The Pioneers

1237. MARSDEN HARTLEY. *Iron Cross*. 1914. Oil on canvas, 39½ × 31¾". Whitney Museum of American Art, New York. Anonymous gift

1238. JOHN MARIN. *Lower Manhattan (Composition Derived from Top of the Woolworth Building)*. 1922. Watercolor and charcoal, and paper cutout attached with thread, 21⅝ × 26⅞". The Museum of Modern Art, New York. Acquired through the Lillie P. Bliss Bequest

skyscrapers in the clashing and intersecting views typical of Cubism, yet painted with an almost Expressionist vigor of brushwork and color.

A totally original American painter, unconnected with any European movement, is GEORGIA O'KEEFFE (1887–), who married Alfred Stieglitz in 1924. Throughout her long creative life, O'Keeffe's imagery has been derived from an infinite variety of objects surrounding her, from the magnified forms of flowers to driftwood and animals' skulls. Her *Blue and Green Music*, of 1919 (fig. 1241), may be based on the aurora borealis, or is perhaps a complete invention. In either case, the free flow of rhythmic shapes against the massive diagonals moves, as the title suggests, with the quality of visual music; this kind of melodic flow is never absent from her work.

Along with these early distinguished modernists, a number of gifted American artists turned after World War I to new forms of realism, focusing on the dreariness and banality of much of American urban and rural life. One of the best of these so-called American Scene painters was EDWARD HOPPER (1882–1967). He presents a bleak world to us, made up of dreary streets, gloomy houses, comfortless rooms, and dismal restaurants—such as in *Automat*, of 1927 (fig. 1239). Yet the apparent hopelessness of his subjects, and their lack of aesthetic or spiritual rewards, is mysteriously compensated by an austere beauty of form, space, and especially of light, whether by day or night, which transforms the dullest scene into a harmonious construction of planes and spaces. By no means unaware of the formal conquests of abstract art, Hopper is a precursor of the more recent Photorealists (see pages 947–49).

The American scene appears in a different guise in the painting of STUART DAVIS (1894–1964), who was for decades the leader of American abstract painting. As a nineteen-year-old art student, Davis exhibited five

1239. EDWARD HOPPER. *Automat*. 1927. Oil on canvas, 28 × 36″. Des Moines Art Center, Iowa. Edmundson Collection

1240. STUART DAVIS. *House and Street*. 1931. Oil on canvas, 26 × 42¼″. Whitney Museum of American Art, New York. Purchase

1241. GEORGIA O'KEEFFE. *Blue and Green Music*. 1919. Oil on canvas, 23 × 19″. The Art Institute of Chicago. Gift of Georgia O'Keeffe to the Alfred Stieglitz Collection

1242. STUART DAVIS. *Owh! In San Pāo*. 1951. Oil on canvas, 52¼ × 41¾″. Whitney Museum of American Art, New York

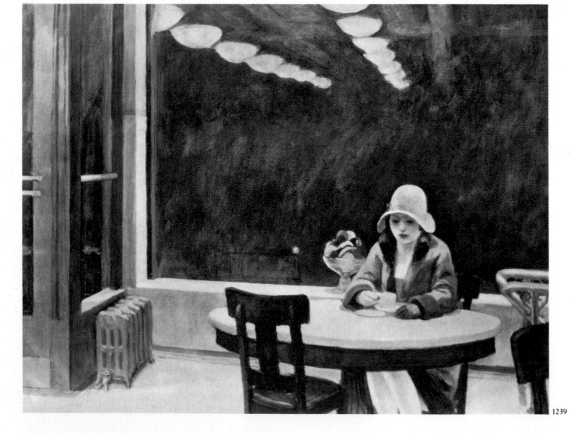

1239

1240

watercolors in the Armory Show. During the 1920s, he developed a personal manner by imposing the techniques of late Cubism on American Scene subject matter with an impudence that foretells the irreverent wit of Pop Art (see pages 938–42). His *House and Street*, of 1931 (fig. 1240), treats a subject similar to those of Hopper with a fragmented flatness recalling the impersonal paintings of Léger (see fig. 1194), but with an intensely personal smartness and decorativeness. The elements are drawn

1241

1242

from the inescapable ugliness of an American city—windows from a nineteenth-century row house, a street sign, loft buildings, the elevated railroad, even a little Bell Telephone insignia. But during and after World War II, Davis's style moved into an abstract manner in which the bits and pieces of industrial society were reduced to brilliant ornaments. *Owh! In San Pão*, of 1951 (fig. 1242), is a superb example. Disjointed words, often drawn from signs or billboards, float against a strong yellow background, among blue, violet, orange, and green rectangles, parallelograms, and trapezoids, penetrated by forms suggesting factory chimneys and rooftops, and a field of red dots surely prompted by the coarse "net" of newspaper illustrations. The grand inventions of Davis were clearly precursors of the even more austere art of Noland and Frank Stella (see figs. 1263, 1265, 1266).

The Mexicans

The decade of the 1920s saw the rise of a vigorous school of strongly Marxist mural painters in Mexico, favored by the revolutionary government with public commissions for frescoes covering vast surfaces on a scale not seen since the days of the Baroque ceiling painters. The least interesting of the leading triumvirate of Mexican muralists was Diego Rivera (1886–1957), who from 1909 to 1921 lived in Europe, and was a marginal adherent of Cubism. With limited success, Rivera attempted to create an easily understood popular style based on Mexican folk art and a study of Italian fourteenth-century fresco techniques. Far more impressive was Rivera's pupil and collaborator, José Clemente Orozco (1883–1949), who, after a massive series of mural commissions in Mexico, was invited to paint a cycle of frescoes at Dartmouth College, Hanover, New Hampshire, in 1932. *The Departure of Quetzalcoatl* (fig. 1243) from the Dartmouth frescoes, executed between 1932 and 1934, verges dangerously on bombast, and is unnecessarily crude in detail, but its strength and sincerity are, nonetheless, impressive. In the midst of his sacred serpents the god leaves his pyramid temple, while the Aztecs recoil in dismay. David Alfaro Siqueiros (1896–1974) is blatantly propagandistic in his *Portrait of the Bourgeoisie*, a mural of 1939 in the Electrical Workers'

1243

Union Building in Mexico City (fig. 1244), covering a thousand square feet with hundreds of figures and symbols. The temple of Liberté, Égalité, Fraternité (the motto of the French Revolution) is on fire. An eagle with jointed metal wings dominates the scene; factory chimneys and steel towers rise against the sky; hordes of marching soldiers are harangued by political leaders in bourgeois dress on the left, and on the right by others in Fascist uniforms, wearing helmets and gas masks, while money pours out of a huge machine. The spectator is overwhelmed, as Siqueiros intended that he should be, by the sheer volume of his descriptive rhetoric.

America's greatest single contribution to the history of modern art is the Abstract Expressionist movement, which dominated the New York scene for about fifteen years after the end of World War II. Official recognition of the movement came in a major exhibition at the Museum of Modern Art in 1951. Through the medium of modern communications, the work of the pioneers was rapidly transmitted throughout the world, and everywhere imitations of the new art grew up with far greater speed than those of Impressionism in the late nineteenth century. Abstract Expressionist exhibitions were soon organized from London to Tokyo. It is somewhat easier to explain what Abstract Expressionism is not than what it is. No consistent mode of vision or way of applying paint united the artists of the movement in the way that the Impressionists and the Cubists were united, but they were all opposed to the strict formalism that had characterized much of abstract art until that time, culminating in the painting of Mondrian, present and influential in New York from 1940 until his death in 1944.

The roots of Abstract Expressionism can be found in the early work of Kandinsky, who had been described as an "abstract expressionist" as early as 1919. But the automatism preached by the Surrealists was also important. The sharp difference between the personal styles of the Abstract Expressionist leaders is implicit in the very nature of the movement, which exalted individualism and the unfettered expression of the inner life through the free application of paint. No one before the best Abstract Expressionist painters had ever painted abstract pictures of such emotional intensity on such a scale.

Abstract Expressionism

1243. José Clemente Orozco. *The Departure of Quetzalcoatl*, detail of a fresco mural, Baker Library, Dartmouth College, Hanover, New Hampshire. 1932–34

1244. David Alfaro Siqueiros. *Portrait of the Bourgeoisie*, mural, Electrical Workers' Union Building, Mexico City. 1939

Clearly, Abstract Expressionism corresponded to the pyschological necessities of a historic moment in American, indeed world, experience. The movement, which owed its existence to a new evaluation of the individual, arose and spread immediately after the defeat of totalitarianism in World War II and the victory of the democracies, and it was strongly opposed in authoritarian Communist countries at a time when a new vision of the possibilities open to humanity was fired by the presence in New York of the United Nations, then still considered a Messianic institution. Abstract Expressionism dissolved as a movement as the Cold War intensified. Of the six Abstract Expressionist leaders considered here, only De Kooning survived to the 1980s; Gorky and Rothko ended their own lives, and Pollock perished under conditions that suggest a death wish. But it was a thrilling period while it lasted. One walked midtown Manhattan in a state of high excitement from gallery to gallery, never knowing what new marvel one would find on the walls.

GORKY The earliest painter of the American Abstract Expressionist movement is the Armenian-born Arshile Gorky (1904–48). At first a realist working in a belated Impressionist tradition, Gorky fell under the influence of Picasso, then that of Miró and Matta. By 1944 he was painting in a new style, strongly automatic, gaining an intense poetic effect from the movement of clearly contoured biomorphic shapes against freely brushed tides of color. In such works as *Golden Brown Painting*, of 1947 (fig. 1245), the regularity and surface precision of the Surrealists have vanished, and the often erotically suggestive shapes move, swell, and turn with the greatest abandon, yet with a distinct rhythmic relationship to the delicate calligraphy of the brushwork. The haunting mood of Gorky's paintings from 1944 to 1948, their disturbing combination of linear delicacy and implicit violence, and, alas, their rarity have rendered them the jewels of Abstract Expressionism.

1245. ARSHILE GORKY. *Golden Brown Painting*. 1947. Oil on canvas, 43½ × 56". Washington University Gallery of Art, St. Louis

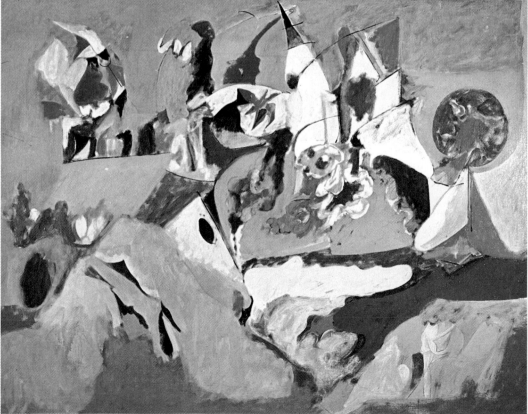

1245

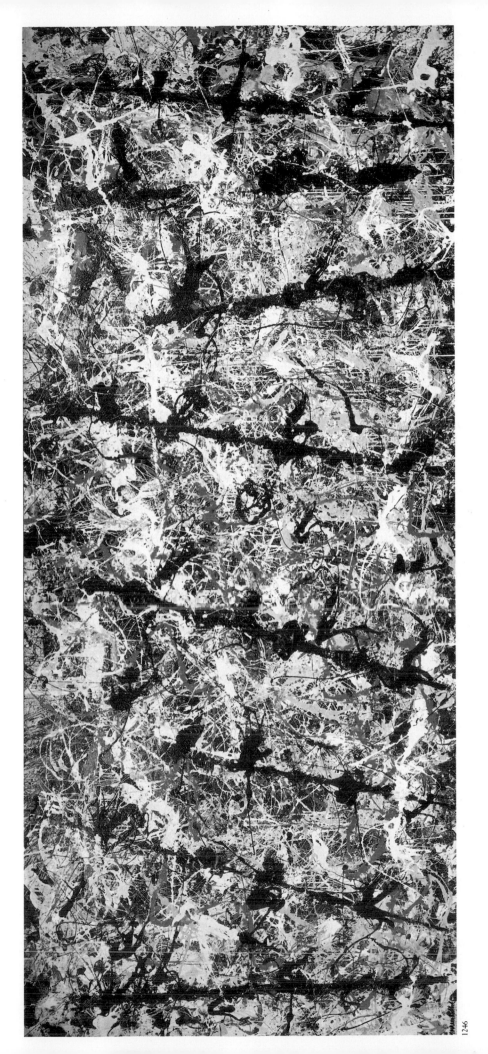

1246. JACKSON POLLOCK. *Blue Poles*. 1953. Oil, Duco, and aluminum paint on canvas, 6'11" × 16'½". Australian National Gallery, Canberra

1246

POLLOCK In the minds of most observers the hero of the Abstract Expressionist drama is Jackson Pollock (1912–56). His short and turbulent existence seems in retrospect to have been dedicated to violence, and his death in an automobile crash (he was driving) to be tragically appropriate. Born in Wyoming, Pollock passed his childhood and a rebellious and nomadic adolescence in the West, doing a stint as a surveyor—an important factor in forming his later mastery of space. At eighteen he began studying under the buoyant American Scene muralist Thomas Hart Benton at the Art Students League in New York, and made powerful drawings after Renaissance masters of action and emotion—Michelangelo, Tintoretto, and El Greco. At twenty-one he was already working in a semi-abstract manner. Although labored and uncertain, these early works show the broad curves that later became his virtual signature.

In 1944, at thirty-two, he began the free motion of the arm that characterized his mature style, and in 1946 he began to exploit the drip. Whether Pollock knew it or not, he had predecessors during the Southern Sung Period in China (1127–1279), the so-called ink-flingers, who dipped their caps in ink, struck the paper or the silk, and worked out images from the shapes thus produced. Pollock knew well and admired the sand paintings of the Southwestern Indians, which held magical significance and were executed rhythmically as part of a religious rite.

In 1946 the curving shapes began to show big gobs of color, freely dripped. In 1947 commenced the series of immense canvases, tacked to the floor unstretched, which Pollock declared made him feel "nearer, more a part of the painting, since this way I can walk round it, work from the four sides and literally be *in* the painting." At last Pollock was liberated from the obstacle of the brush and the necessity of mixing his colors. With a can of Duco or other commercial paint in his hand, he moved freely, dripping, spilling, throwing the color, apparently with total abandon as he performed a kind of pictorial dance whose choreography is recorded on the canvas. Soon dubbed "action painting," this activity Pollock allowed to be photographed, even filmed. Nonetheless, he said, "When I am painting I have a general notion as to what I am about. I *can* control the flow of the paint; there is no accident, just as there is no beginning and no end."

A completed Pollock of this period is infinitely complex. *Blue Poles*, of 1953 (fig. 1246), is one of the most monumental—sixteen feet in width—and shows layer upon layer of seething, swirling, spitting, snarling paint. White, gray, black, orange, yellow, and aluminum are intertwined in deadly conflict, resolved only by the forceful superimposition of the immense blue poles that go swaying across the scene. The religious content of the Southwestern sand paintings is answered in Pollock's turbulent psyche by a mystic and undirected intensity of feeling (he had, for a while, been interested in Oriental religions). More than any other modern painter, with the possible exception of Van Gogh, Pollock achieved in his work—rather than in his chaotic, pugnacious, alcohol-soaked life—a sense of unity with forces he conceived to be operating in the universe. Tragically enough, these were forces that eventually defeated him, as they had Van Gogh. Nevertheless, *Blue Poles* is one of the greatest paintings of the twentieth century, and one of the noblest achievements of American art.

DE KOONING An entirely different direction was taken by the Dutch-born painter Willem de Kooning (1904–), who shares with Pollock preeminence among the Abstract Expressionists. At first a realist

painter who could draw like Ingres, De Kooning painted in New York, from 1926 on, in a modern delicate, figurative manner, based partly on Picasso but with elements drawn from Gorky. Not until 1948 did he develop an Abstract Expressionist style, in pigments at first limited to black and white house paints because he could not afford colors. A superb, large-scale work of 1950 is *Excavation* (fig. 1247). At first sight there seems to be no image at all—only masses of paint randomly applied. Yet, rubbed out, scraped off, repainted, and repainted again, the surface builds up a cumulative effect like monumental sculpture, composed of many centers of implied action.

During the 1950s De Kooning's Abstract Expressionist style reached its height in a group of pictures that, for all their apparent spontaneity and freshness of surface handling, were in fact the result of intensive labor and continual reworking. In consequence of this method relatively few major works could be produced each year in spite of their limited dimensions. An intense and enigmatic series was dedicated to images of almost demonic women, terrifying in their hostility and ferocity. Even more important, however, were the paintings in which no shred of visual reality can any longer be recognized. In each picture, generally dominated by reds, greens, and yellows, but with strong passages of black and white, the eye moves from vortex to vortex, always more passionate and more intense, as if from crater to seething crater.

In *The Time of the Fire*, of 1956 (fig. 1248), the energy of any given section is not only volcanic but overflowing. De Kooning's lava is a thick pigment applied in brisk, sometimes explosive strokes, but traces of previous flows show through from below. Since many of the strokes are either vertical or horizontal, a sense of structure begins to emerge from the very opposition of directions between one passage and the next. The result is an allover compositional texture of tremendous strength, utterly different from the myriad overlapping spirals of Pollock. In later work De Kooning enlarged each vortex to embrace an entire canvas, working, therefore, with greater speed. More recently he has reverted to larger canvases with multiple vortices and accents. Although he has never revived the intensity of the 1950s, he works, now past his eightieth year, with a new serenity and openness, and an undiminished beauty of color.

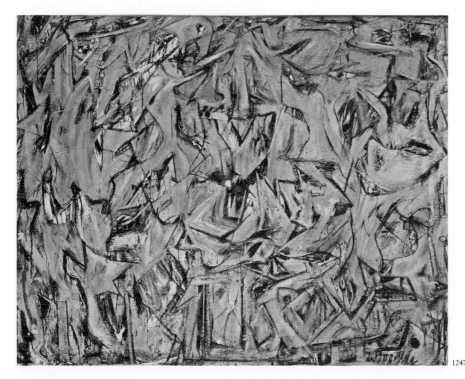

1247. WILLEM DE KOONING. *Excavation*. 1950. Oil and enamel on canvas, 80⅛ × 100⅛". The Art Institute of Chicago. Mr. and Mrs. Frank G. Logan Purchase Prize, Gift of Edgar Kaufmann, Jr., and Mr. and Mrs. Noah Goldowsky

1247

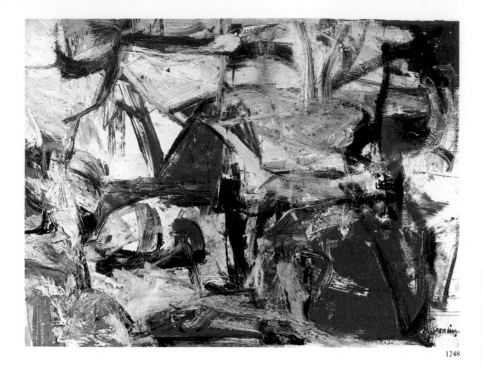

1248

HOFMANN An unexpected apparition on the New York scene was Hans Hofmann (1880–1966), who belonged to a wholly different generation than most of the Abstract Expressionists. Born in Bavaria, he lived and worked in Paris from 1903 to 1914. His surviving works from this period show the influence of Delaunay and of Matisse, but most of his early paintings perished in a studio fire. When he arrived in New York in 1932, his reputation was that of an extremely successful European teacher, and he continued to teach in the United States, exerting a great influence on younger artists. In 1940 Hofmann began experimenting with a drip technique that in a modest way prefigured some aspects of Pollock's work, but he is best known for his canvases in which areas of brilliant color assert themselves with magical intensity. Characteristic of Hofmann's Abstract Expressionist style at its height is *The Gate*, of 1960 (fig. 1249), with its great rectangles of yellow and red floating against a background whose colors change in more softly brushed rectangular areas from yellow through green to intense violet, suggesting distant space. In contradistinction to the violence that is the principal theme of de Kooning and Pollock, Hofmann's lyrical paintings achieve a serene equilibrium of mass, space, and color.

1249

KLINE Until 1949 Franz Kline (1910–62) was a representational painter with little connection with any advanced movement. His work, nonetheless, showed a highly individual sense of pigment and surface and bold brushwork. Then in 1949, while looking at enlarged projections of some of his black-and-white sketches, he discovered that small sections of them would make powerful abstract configurations. The transformation of his style was immediate. He abandoned representation and, for the moment, even color, and proceeded to work on a huge scale—*Mahoning*, of 1956 (fig. 1250), is more than eight feet wide—with powerful strokes of black laid rapidly on the white canvas with a house painter's brush. Although Chinese and Japanese calligraphy had no direct influence on Kline's style, his massive strokes, building up entirely abstract images with the greatest

1248. WILLEM DE KOONING. *The Time of the Fire.* 1956. Oil and enamel on canvas, 59¼ × 79″. Private collection

1249. HANS HOFMANN. *The Gate.* 1960. Oil on canvas, 74⅝ × 48¼″. The Solomon R. Guggenheim Museum, New York

1250. FRANZ KLINE. *Mahoning.* 1956. Oil on canvas, 80 × 100″. Whitney Museum of American Art, New York. Gift of the Friends of the Whitney

1251. MARK ROTHKO. *White and Greens in Blue.* 1957. Oil on canvas, 100 × 82″. Collection Mr. and Mrs. Paul Mellon

freedom, have often been compared to the Far Eastern freely brushed characters known as grass writing. But the fact that Kline preferred to tack his unstretched canvases to the wall for painting gives them a special hardness that is important for the often almost architectural quality of the great stripes. Before his premature death Kline was already varying his severe style by including masses of smoldering color between the black strokes. Energies have seldom been released to function as effectively as in the best of Kline's monumental paintings.

ROTHKO A deeply expressive manner of exploiting the psychic, even spiritual, effects of color was worked out slowly by Mark Rothko (1903–70). Long an abstractionist, Rothko was painting in the late 1940s in a biomorphic abstract style close to that of Gorky. Gradually, he began to eliminate contours, leaving only color areas somewhat resembling those of Hofmann, but without clear-cut edges. Through soft, blotlike borders these color areas seem to dissolve into each other as if emulating in oil the effects of watercolor allowed to spread on wet paper. Finally, in the 1950s Rothko began a majestic series of canvases in which, with a finality suggesting that of Malevich or of Mondrian, he abandoned all suggestions of form in favor of the two or three superimposed rectangular shapes with cloudy edges that constitute his dominant theme. These shapes float as if in a continual misty sunset at sea and produce a strongly meditative effect.

White and Greens in Blue, of 1957 (fig. 1251), is typical of Rothko at his greatest. Scale is extremely important in Rothko's pictures (this one is more than eight feet high). The observer seems less to be enveloped in the colors than to be enticed to float outward into them, as if in some enchanted celestial voyage. The effect of several Rothkos together in the

1250

1251

same room amounts to a mystical experience; one's voice is automatically hushed in their brooding presence. Rothko was commissioned during the 1960s to produce several murals, the most effective of which is a series of panels for a chapel at St. Thomas University in Houston, Texas, which form a unity somewhat like the *Water Lilies* series of Monet, provoking intense meditation on timeless essences and truths.

It was perhaps implicit in the intensely emotional nature of the Abstract Expressionist movement that it would soon play itself out. Furthermore, the ground swell of optimism that had given rise to the movement was no longer a real force as the disaster of the Korean War moved toward the tragedy of American involvement in Indochina. Considering the intensity and speed of twentieth-century life as compared with the more relaxed pace of the late nineteenth, it is perhaps more to be wondered at that Abstract Expressionism remained dominant as long as it did before the inevitable reaction set in—a period of about fifteen years, which corresponds more or less to the duration of the Impressionist movement prior to the emergence of the first Post-Impressionist countercurrents. Most of the greater and lesser survivors among the Abstract Expressionists continued to paint in much the same vein, although with diminished influence. But an opposing force was already being sought even in the late 1950s, with the anxious refrain, "after Abstract Expressionism, what?" The opposition was not long in coming, and with bewildering speed and multiplicity. A new movement began to appear every few years, then every year—Pop Art, Op Art, Color Field, Hard Edge, Minimal Art, Postminimal Art, Environments, Happenings, Body Art, Earth Art, Kinetic Art, Conceptual Art, and Photorealism—to name only a few. The variety and complexity of the new artistic movements of the 1960s and early 1970s can only be suggested here through their most important achievements.

POP ART Although to most observers Pop Art, in its exaltation of the most aggressively banal aspects of a plastic civilization, seems peculiarly American, it actually owes its start to a small group of artists working in London in the mid-1950s. Nevertheless, the most commanding figures among the Pop artists are all Americans, and the movement reached its height in the United States during the 1960s. Marcel Duchamp was then still active in New York, and exerted a widespread influence on the new generation. Pop owes much to Dada, born in a similar period of frustration. Pop, like Dada, functions on a basis of devastating wit, antiaestheticism, and—if one may use such a phrase—positive nihilism.

As early as 1955, one of the leading American Pop artists, ROBERT RAUSCHENBERG (1925–), was including found objects in his paintings—not fragments of an object, as in the collages of Picasso and Schwitters, but the entire object, including such diverse flotsam and jetsam as Coca-Cola bottles, old wall clocks, a quilt made up as a bed, and an entire stuffed ram with an automobile tire around its middle. Often, he incorporated silk-screen photographic prints of famous works of art, such as Rubens's *Venus with a Mirror* in *Trapeze*, of 1964 (fig. 1252). While these bits of extraneous reality suggest collage as we have seen it among the Cubists and in Dada and Surrealism, they are painted into the overall texture of a picture with a richness and abandon, at times even a splash, that derive from Abstract Expressionism. The result is invariably challenging, sometimes harrowing in its intensity.

The Reaction Against Abstract Expressionism

1252

1252. ROBERT RAUSCHENBERG. *Trapeze*. 1964. Oil on canvas with silkscreen, 10 × 4'. Private collection, Turin

Many echoes of Abstract Expressionist colorism also linger on in the work of another Pop pioneer, JASPER JOHNS (1930–), who like Rauschenberg emerged on the art scene in New York in 1955. However, Johns's imagery is entirely different. His paintings were characteristically done in encaustic, a technique, using melted wax as a vehicle, that results in a peculiarly rich surface. In contrast to this pictorial quality, often very seductive, Johns's subjects have been rigidly serialized. One series was devoted to the American flag, either identified with the actual surface of the canvas, or built up in superimposed flags of progressively diminishing scale, or painted entirely in mottled white or entirely in green. Another series consists of targets; a particularly disturbing example is the *Target with Four Faces*, of 1955 (fig. 1253), which combines the suggestion of gunfire (the bull's-eye) with that of a firing squad (the eyeless, implacable faces ranged above). In his later work Johns introduced a freedom of surface and a combination of found objects not unlike those of Rauschenberg's "combine" paintings, but with a flower-garden brilliance of color all his own.

ROY LICHTENSTEIN (1923–) founded his art exclusively on the comic strip and the mechanical technique of reproducing it; he enlarges such images to billboard size by purely mechanical means. The rich pictorial surface of Abstract Expressionism, still retained by Rauschenberg and Johns, is rejected by Lichtenstein in favor of a stenciled imitation of the hard contours and characteristic net of coarse dots used in the newspaper reproduction of comic strips. A deliberately heartless rendering of an air combat, entitled *Whaam*, of 1963 (fig. 1254), is more than thirteen feet wide, and brings the harshness of the comic-strip adventure series—needless to mention, an imitation, not an actual comic strip—to the scale of mural painting. Interestingly enough, Lichtenstein deliberately chooses all the tawdriest aspects of the comic strip to emulate—never, for example, the gentle *Peanuts*.

The wittiest of the Pop artists is assuredly the painter-sculptor CLAES OLDENBURG (1929–), who has taken ordinary mass-produced objects from American life and reproduced them in three dimensions, at first in actual size in painted plaster, later immensely enlarged in canvas, stuffed with kapok, and painted. Hamburgers oozing with catsup and onions were expanded to five feet in thickness. Then it occurred to Oldenburg that these standard objects on which we rely—lipsticks, musical instru-

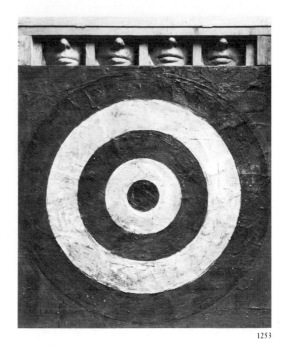

1253

1253. JASPER JOHNS. *Target with Four Faces*. 1955. Encaustic and newspaper on canvas with plaster casts, 30 × 26″. The Museum of Modern Art, New York. Gift of Mr. and Mrs. Robert C. Scull

1254. ROY LICHTENSTEIN. *Whaam* (two panels). 1963. Magna on canvas, entire work 5′8″ × 13′4″. The Tate Gallery, London

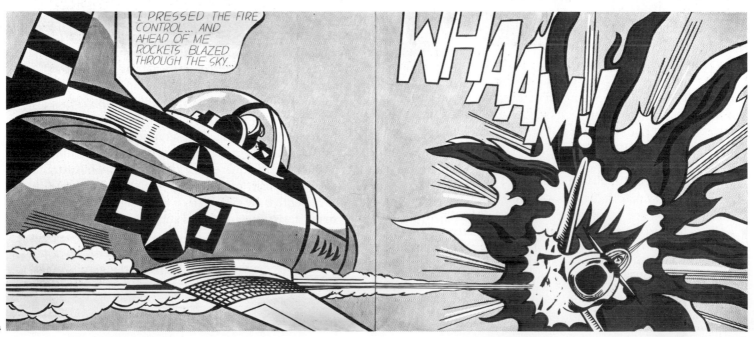

1254

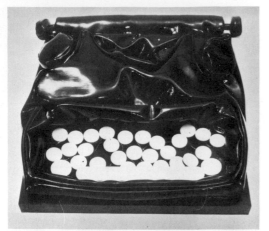

1255

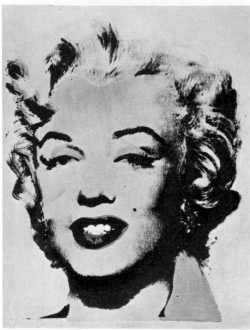

1256

1257

ments, toilets—could be made soft, as if collapsing, in a three-dimensional parody of Dali's "wet watches" (see fig. 1232). *Soft Typewriter*, of 1963 (fig. 1255), is one of the most amusing of these works, if it can really be found amusing that objects that must retain their consistency in order to function are suddenly discovered—as in a nightmare—to be soft (with all the keys unfindable). Oldenburg also projected colossally enlarged cigarette butts, peeled bananas, toilet floats, and Teddy bears with mock seriousness as monuments for the center of some hapless metropolis, such as London or New York. In the long run the power of an Oldenburg image remains after the laugh is over. His work is, in reality, a searing commentary on the triviality of modern mechanized existence, drained not only of spiritual qualities but also of genuine physical satisfactions.

Through his flamboyant personality and the films he has directed, as well as the later ones directed by others under his name, ANDY WARHOL (1930–) has become something of a household word. He specializes in the boring. One film shows nothing but the Empire State Building from one camera position and lasts for eight hours. Warhol burst upon the public consciousness with his endless arrays of Campbell's tomato soup cans and his false three-dimensional Brillo boxes, as if, on the principle of Duchamp's ready-mades, the mere finding of such objects made them works of art. (Ironically, the designer of the *actual* Brillo box was an Abstract Expressionist.) The impersonality of Warhol's mechanized sameness has its own cumulative emotional effect. He has had enormous success with his silk-screen prints in garish colors from photographs of American sex goddesses, such as *Marilyn Monroe*, of 1962 (fig. 1256), as well as those done after pictures of such horrors as automobile crashes and the electric chair, infinitely repeated like frames in a motion picture.

Among the host of sculptors affected in one way or another by the Pop movement, the most haunting is GEORGE SEGAL (1924–). Although Segal started as a painter under the tutelage of Hofmann, and demonstrated an exceptional ability to handle brilliant color, he abandoned color entirely in his sculptural treatment of the human figure. He proceeds by making direct molds of living persons with surgical plaster bandages. Reconstituted as complete figures, these images are unsettling in their ghostly white. These personages inhabit, in varying attitudes of dejection, the grisly environments Segal constructs for them out of actual rejected furniture and equipment. For his scenes Segal concentrates on the run-down and shabby periphery of modern society rather than its jazzy, aseptic mainstream exalted by Lichtenstein. In a sense, Segal's groups are three-dimensional versions of the type of subjects Hopper painted, and they are far more disturbing. In his *The Bus Riders*, of 1964 (fig. 1257), as in Daumier's *Third-Class Carriage*, people are enclosed in and subjected to a thing over which they have no control and that, at the same time, they cannot do without.

In a sense an offshoot of Pop is the work of the Bulgarian-born CHRISTO (born Christo Javachef, 1935–), who dominates his surroundings by the modern device of packaging them. He has wrapped in sheets of various kinds of plastic any number of inert objects: bicycles, machines, a skyscraper, and even one million square feet of the coast of Australia. *Wrapped Coast, Little Bay, Australia*, of 1969 (fig. 1258), shows beautiful effects of drapery movement, a by-product of the original idea. Alas, Christo's attempt to string a vast curtain across a mile-wide canyon in the Rocky Mountains must be set down as a failure. The sculpture of the Greek-born LUCAS SAMARAS (1936–) can best be considered at this point. Along with objects of furniture or boxes studded with dangerous points

1258

1259

from pins to razor blades, crawling with hair, or streaming with rope fringes, Samaras has done work of imaginative brilliance. His rooms entirely lined with squares of mirror—all four walls, ceiling, and floor—in which hangs a single electric light bulb over a single mirror-covered table, as in *Room No. 2*, of 1966 (fig. 1259), are at once dazzling and dizzying. They are, of course, exploitations of the commonplace phenomenon of multiple reflections to be seen in old-fashioned barbershops and restaurants. But as they prolong Renaissance perspective recessions to the nth power, they produce a fantastic vision of infinity that suggests cosmic implications, and lift the observer (who is inside the room and can see nothing else but its diminishing reflections in every direction) out of himself and his world.

OP ART Optical Art (Op, for short) succeeded the first outburst of Pop as a new fad in the early 1960s. It had, however, been germinating

1255. CLAES OLDENBURG. *Soft Typewriter*. 1963. Vinyl, kapok, cloth, and Plexiglas, height 27½″. Collection Alan Powers, London

1256. ANDY WARHOL. *Marilyn Monroe*. 1962. Oil, acrylic, and silkscreen enamel on canvas, 20 × 16″. Collection Jasper Johns, New York

1257. GEORGE SEGAL. *The Bus Riders*. 1964. Plaster, metal, and vinyl, 69 × 40 × 76″. Hirshhorn Museum and Sculpture Garden, Smithsonian Institution, Washington, D.C.

1258. CHRISTO. *Wrapped Coast, Little Bay, Australia*. 1969. Surface area of entire project one million square feet

1259. LUCAS SAMARAS. *Room No. 2*. 1966. Wood and mirrors, 8 × 10 × 8′. Albright-Knox Art Gallery, Buffalo, New York. Room of Contemporary Art Fund

1260. RICHARD ANUSZKIEWICZ. *Trinity*. 1970. Acrylic on canvas, 48 × 72″. Museum of Art, Carnegie Institute, Pittsburgh

1260

for many years. Op differs basically from the subject-oriented Pop in that it denies representation altogether, but it is no less firmly opposed to individual emotional expression than is Pop. Op has sought to produce by a variety of means strong optical illusions of depth, mass, and motion. Often the materials used are synthetic, and absolute regularity of production is always emphasized, so that several important Op artists have limited their own personal participation to the initial study and bequeathed the actual execution to assistants, working largely by mechanical means. The chief motive personality in the Op movement was Victor Vasarely (1908–), a Hungarian who has worked most of his life in Paris. Vasarely has characterized both painting and sculpture as anachronistic terms, and projects the observer into new worlds of experience through precalculated arrangements of line and perspective, at first in black and white, then in brilliant color. Unfortunately, his spatial illusions have been subjected to imitations that have turned up by the score in contemporary furniture shops. The British artist Bridget Riley (1931–) has been successful in similar illusionistic works limited to black, white, and gray. The most imaginative of the Op artists is the American RICHARD ANUSZ-KIEWICZ (1930–), who works by means of constantly reversing illusions of depth and mass, as in *Trinity*, of 1970 (fig. 1260), so that the same configuration may at one moment appear concave, at the next convex. His pictures are painted in colors so closely adjusted as to form sharp dissonances, or so exactly complementary as to establish contrasts of well-nigh intolerable intensity; yet in the final analysis all conflicts are resolved, and Anuszkiewicz's art is one of brilliance, harmony, poise, and beauty.

COLOR FIELD AND HARD EDGE It is less easy to label some of the other movements that arose to participate in the general assault on the Abstract Expressionist fortress. In the 1940s BARNETT NEWMAN (1905–70) was working with rectangular areas, and in the early 1950s arrived at a simple statement in terms of one or two fields of color, seldom very bright, comprising the entire canvas, usually quite large. These fields are separated from each other by one or two narrow color stripes, whose edges are purposely left a little fuzzy to suggest space. Newman was a well-read intellectual and a pioneer in insisting that the picture consist entirely of itself so that the artist's work resides solely in dividing and coloring the actual canvas. In the memorial exhibition of his work held at the Museum of Modern Art, New York, in 1973 it was evident that Newman had not always succeeded, but when he had his achievement was brilliant. His *Stations of the Cross: Twelfth Station*, of 1965 (fig. 1261), shows that he worked entirely by balancing areas against each other, with the crucial, but never central, stripe or stripes as the fulcrum. Newman was a major figure, influential in the development of a movement favoring the supremacy of the canvas itself over all illusion or expression and especially over the emotion-loaded brush, which had been all-important for the Abstract Expressionists.

By the end of the 1950s, a distinct group of painters had formed around the concept of the dominant canvas, led by MORRIS LOUIS (1912–62) and KENNETH NOLAND (1924–), both of whom worked in Washington, D.C., isolated from the New York scene. Louis based his images entirely on the physical movement of color across the raw, unprimed canvas. He poured the color on the canvas, and by means of delicate tilting let it run until it produced fluid patterns, superimposed veils of hue. Toward the end of

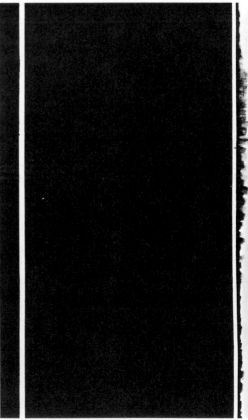
1261

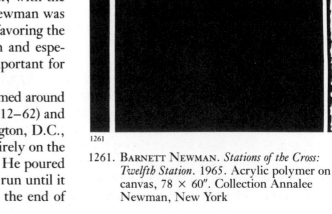
1261. BARNETT NEWMAN. *Stations of the Cross: Twelfth Station*. 1965. Acrylic polymer on canvas, 78 × 60″. Collection Annalee Newman, New York

his life, he poured from near the top of the canvas down, let each color run off the canvas, then poured the next stripe, as in *Pillar of Hope*, of 1961 (fig. 1262). These clusters of broad stripes, usually of very rich and sonorous color, move against the mat surface of the canvas with great effect.

Noland started with concentric circles of bright color painted on un-primed canvas, reminiscent of Johns's targets, and seeming to float. He then moved to immense inverted chevrons of bright color, each made up of several stripes, against the now primed canvas; at first, these were centered on the bottom edge, but later they were directed to one side or the other, as in *Bridge*, of 1964 (fig. 1263). With its powerful blues, yellow, orange, and red against white, it is a vivid example of Noland's work at its best. The execution is deliberately precise and inert. Noland painted canvases of immense length entirely in horizontal clustered stripes of brilliant color floating against a vast field of white, producing the effect of landscapes inspired by the Great Plains. Still more recently Noland has created shaped canvases dominated by colors of extraordinary subtlety and spatial allusiveness.

A still different possibility for color-field painting was explored by ELLSWORTH KELLY (1923–), whose *Red White*, of 1961 (fig. 1264), suggests remotely the free forms of Arp or the cut-paper compositions of the late Matisse. Always with great clarity of vision and execution, Kelly simplified his image so that during the early 1970s he placed large, smooth, rectangular panels, each a different and very bright color, side by side to produce color progressions with the regularity of a color chart, and with a certain loss of effect, considering the clear, rhythmic beauty of the contours in such works as *Red White*.

The name *hard edge* has been applied to such color-field paintings as those of Noland and Kelly—not without some confusion because the term could equally well designate the work of abstractionists as different from each other as Léger, Mondrian, Malevich, and Davis, to name only a few. But the phrase seems peculiarly apt as a description of the work of FRANK STELLA (1936–), the youngest of all the influential American artists of the moment. Only forty-eight in 1984, Stella was just twenty-four when his first shaped canvases appeared on the New York art scene. *Ophir*, of 1960–61 (fig. 1265), is a striking example of Stella's brilliant and implacable early style, whose hardness, coldness, and total impersonality seemed a sword aimed at the heart of the Abstract Expressionist movement. Pictures had, of course, not always been of the rectangular shape customary since the eighteenth century. A glance over the illustrations in this volume will turn up every kind of shape from the gables and pointed arches of Gothic altarpieces, to Renaissance round arches, ovals, and circles, to the irregular, pulsating areas left for paintings by Rococo architects. As early as the 1920s, some artists had experimented with new shapes. But Stella's exploitation of a total shape derived entirely from the action of the stripes within the canvas was enough to establish his place in the history of modern art.

At first, Stella's color was restricted to grays and browns—a shock after the gorgeous abandon of Abstract Expressionist color—and then he began to work in copper and aluminum paints. He restricted himself severely to a single theme—absolutely straight, parallel, monochrome stripes, separated by narrow white lines. If the stripes changed their course, so did the shape of the canvas, in forms resembling V's, W's, and horseshoes. The strange fact is that these shapes have impressed no observer as ornamental. Their very austerity and hardness have given them a to-

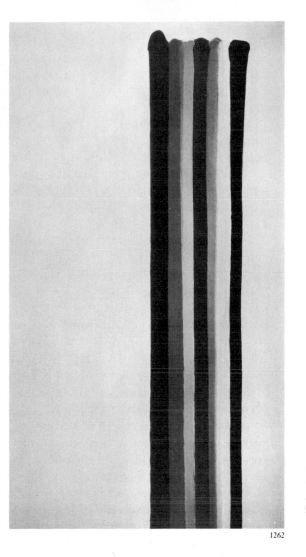

1262

1262. MORRIS LOUIS. *Pillar of Hope*. 1961. Acrylic resin on canvas, 85 × 48¼". Collection Robert H. Shoenberg, St. Louis

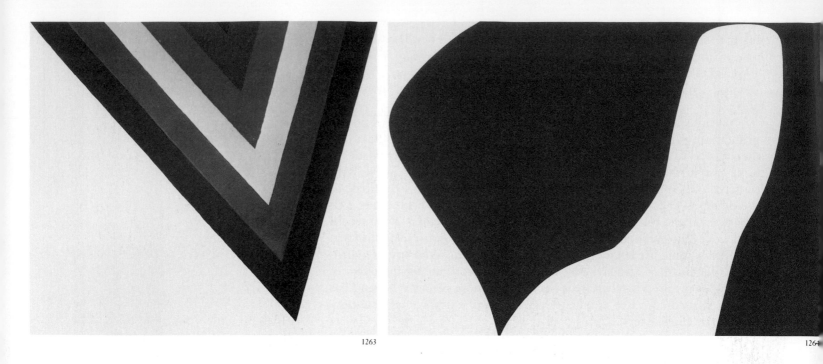

1263

1264

temic significance unsupported by either representation or expression, but residing only in the hypnotic power of the stripes and lines.

Later, Stella burst forth in canvases of tremendous size, his *Protractor* series, so called because their component forms, whose composite contours establish the shape of the picture, are systematically derived from superimposed and intersecting arcs. These are no longer restricted to the reserved, metallic tones of his early style, but painted in the teeth-jarring fluorescence of Day-glo. *Tahkt-I-Sulayman I*, of 1967 (fig. 1266), is a brilliant example of this phase, twenty feet across, and unexpectedly lyrical in its circles and half circles of yellow, two tones of red, and two tones of blue. After 1970, Stella's color calmed down considerably, and he worked out layered constructions covered with fabric and later with metal, which are as much sculpture as painting. Still more recently, these metal surfaces have been treated to resemble—unexpectedly—the free splashes of Abstract Expressionist color.

1265

1266

1267

1268

Recent sculpture is, if anything, more bewildering than recent painting in the richness of its development and the multifarious shapes of its creations. The tendency toward working directly in metal, which we have seen as early as Archipenko, Gabo, and Pevsner, found a new expression in the metal junk culled from automobile graveyards and made into assemblages by John Chamberlain and Richard Stankiewicz; these works responded in tortured surfaces and sometimes brilliant color to the pictorial richness of Abstract Expressionism. The most eloquent assemblages are those created by LOUISE NEVELSON (1900–), who ranks as one of the finest women artists of the twentieth century and the greatest living American sculptor. Nevelson works with overpowering effect by putting together found objects—boxes, pieces of wood, bits of furniture, ornamental fragments from demolished Victorian buildings. Her towering, wall-like structures share at once the echoes of haunted houses and glimmers of a new perfection. For years these assemblages were painted in a solemn, allover black; later, they gleamed in white, then in gold. Nevelson's brilliantly harmonized *An American Tribute to the British People*, of 1960–65 (fig. 1267), is a monumental, gold-painted, abstract successor to Ghiberti's *Gates of Paradise* and Rodin's *Gates of Hell*. In the late 1960s Nevelson worked with great success in such luminous materials as aluminum and Lucite without sacrificing her innate sense of structure.

One of the most impressive American sculptors of the last half century is DAVID SMITH (1906–65). Starting with welded steel constructions, Smith proceeded to put together wagons and chariots recalling those of the Bronze Age, then to make superb abstract masses built from superimposed blocks of steel. Smith did all the mechanical work himself on the basis of his experiences in an automobile plant and a locomotive factory. His triumphant period came just before his tragic death in an automobile accident. In the late 1950s and early 1960s, Smith turned out constructions of imposing grandeur and yet astonishing lightness of poise and balance in the *Cubi* series, fabricated in the studio on his farm at Bolton's Landing, New York. Three of these sculptures (*Cubi XVIII*, *Cubi XVII*, and *Cubi XIX*), with their openness, lightness, and elemental power, compete in beauty with the surrounding landscape (fig. 1268).

The constructed metal sculpture, like the glass-box skyscraper, has proved fatally easy to imitate, and has been turned out by the hundreds in the past two decades. Due to connections between architects, dealers, and sculptors, few are the glass-box skyscrapers that do not have giant welded steel constructions in front of them—often as not made of girders

Abstract Sculpture Since World War II

1263. KENNETH NOLAND. *Bridge*. 1964. Acrylic on canvas, 89 × 98″. Private collection, Toronto

1264. ELLSWORTH KELLY. *Red White*. 1961. Oil on canvas, 62¾ × 85¼″. Hirshhorn Museum and Sculpture Garden, Smithsonian Institution, Washington, D.C.

1265. FRANK STELLA. *Ophir*. 1960–61. Copper paint on canvas, 90 × 84″. Collection James Holderbaum, Smith College, Northampton, Massachusetts

1266. FRANK STELLA. *Tahkt-I-Sulayman I*. 1967. Polymer and fluorescent paint on canvas, 10′1¼″ × 20′2¼″. Pasadena Art Museum, California. Gift of Mr. and Mrs. Robert A. Rowan

1267. LOUISE NEVELSON. *An American Tribute to the British People*. 1960–65. Wood painted gold, 10′2″ × 14′3″. The Tate Gallery, London

1268. DAVID SMITH. Left: *Cubi XVIII*. 1964. Stainless steel, height 9′8″. Museum of Fine Arts, Boston. Anonymous gift. Center: *Cubi XVII*. 1963. Stainless steel, height 9′. Dallas Museum of Fine Arts. Right: *Cubi XIX*. 1964. Stainless steel, height 9′5″. The Tate Gallery, London

that look as if they had been culled from the building site, and admired by nobody.

Vastly more original are the metal constructions of Lee Bontecou (1931–), liberally peppered with bits of old canvas and zippers. Her creations are menacingly female in their suggestion of teethed vaginas, as in *Untitled*, of 1961 (fig. 1269). Bontecou is, aside from Nevelson, the only constructivist sculptor who has been able to retain a profound and compelling sense of content, as intense indeed as found in the work of any Expressionist or Surrealist.

MINIMAL ART Minimal Art came into being in the mid-1960s as the most impersonal form of all. The work of art was a simple object, shorn of all suggestions of meaning or of human receptiveness. There have been many manifestations of minimal art, ranging from simple bathroom shelves fixed to a gallery wall, to sheets of steel laid on a gallery floor, to smoothly lacquered planks leaning against anything. The most impressive of the minimalists is Donald Judd (1928–), whose art is based on pure proportion. Seven identical, quadrangular, cubic masses of galvanized iron make up his *Untitled*, of 1965 (fig. 1273). Judd also works in steel and plexiglass; his constructions are beautifully polished, and some of them are enameled. The relationship between their masses is as subtle as the coloring. Judd, unlike Smith, creates only the design, leaving the execution to skilled industrial craftsmen. The nobility of his work is a living witness to Alberti's claim (see page 523) that beauty is that quality to which nothing can be added and from which nothing can be taken away without destroying it. One also recalls Edna St. Vincent Millay's celebrated sonnet beginning, "Euclid alone has looked on Beauty bare." With forms as perfect and relationships as absolute as those Judd gives us, we can dispense with decoration.

Among the most important other directions taken by minimal art was that led by the German-born Eva Hesse (1936–70) until her brief career was ended by cancer. In contrast to the severe and self-contained perfection of Judd's polished-metal solid geometry, Hesse formed boxlike or cylindrical shapes roughly out of tan fiberglass, and either united them in series or arranged them in configurations enclosing and activating space in a completely new way, with magical and commanding effect (fig. 1270).

LIGHT SCULPTURE Some recent sculpture has renounced substance entirely, and exploited the effects of light or even light itself, in ways impossible to reproduce adequately in photographs. Gothic artists had in a sense worked with light in their stained-glass windows, and—as

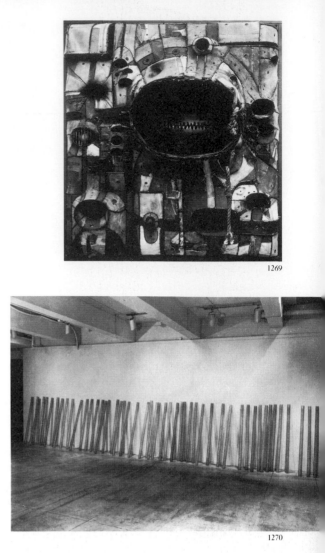
1269

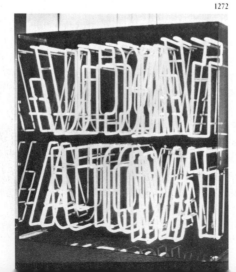

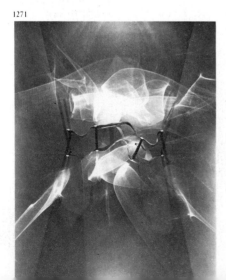
1271

1272

1269. Lee Bontecou. *Untitled*. 1961. Canvas and welded metal, height 72″. Whitney Museum of American Art, New York. Purchase

1270. Eva Hesse. *Accretion*. 1968. Fifty Fiberglas units, each 58″ long, 2½″ in diam. Rijksmuseum Kröller-Müller, Otterlo, The Netherlands

1271. Julio Le Parc. *Continuel Lumière Formes en Contorsion*. 1966. Motorized aluminum and wood, 80 × 48½ × 8″. Howard Wise Gallery, New York

1272. Chryssa. *Automat*. 1971. Neon and Plexiglas, height 68½″. The Harry N. Abrams Family Collection, New York

1273. Donald Judd. *Untitled*. 1965. Seven galvanized iron boxes, each 9 × 49 × 31″ (9″ between each box). Locksley-Shea Gallery, Minneapolis

1274. Robert Smithson. *Spiral Jetty*. 1970. Rocks, salt crystals, earth, and algae, length of coil 1,500′, width c. 15′. Great Salt Lake, Utah

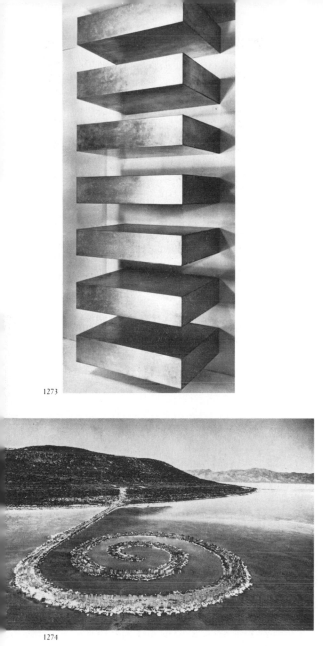

1273

1274

we have seen—Bernini was a pioneer in this respect in arranging and shaping the concealed sources of light in his *Ecstasy of Saint Theresa* and his *Cathedra Petri*, much as he had modeled water in his fountains. Thomas Wilfred (1889–1968) invented a new art, which he called Lumia; a "color organ" projects lengthy programs of constantly changing luminous forms onto a motion-picture screen. The Argentinian JULIO LE PARC (1928–), who works in Paris, contrived such wonderful structures of light and movement as *Continuel Lumière Formes en Contorsion*, of 1966 (fig. 1271), in effect not unlike some aspects of Wilfred's Lumia.

The Greek-born CHRYSSA (1933–) works with the familiar elements of the neon sign, already imitated in the paintings of Davis and Indiana, which she places in layers in depth, producing patterns of ornamental repetition in space. In *Automat*, of 1971 (fig. 1272), she has created majestic and seemingly durable forms out of these ubiquitous elements of modern urban society.

EARTH ART The latest gesture of the sculptor in space has been Earth Art, a movement led by ROBERT SMITHSON (1938–73), who met a tragic death while exploring from the air a site for one of his gigantic projects. Characteristically enough, the forms of Earth Art are extremely simple, and could certainly be greatly enriched; often, they are no more than trenches. Parenthetically, such projects demand both considerable financial expenditure and rather selfless patrons who often cannot see the works they pay for and who must content themselves with photographs and glory. Smithson's most successful work is the colossal *Spiral Jetty*, of 1970 (fig. 1274), constructed of rocks, which jut into Great Salt Lake in Utah. The whole process of earthmoving, with standard mechanical equipment, was recorded by Smithson in a film, which is in itself a work of art. Only Christo's wrappings and curtains rival Smithson's earthworks in their defiance of space, but it is worthwhile recording that Earth Art had its predecessors in the activities of the Pre-Columbian Mound Builders of North America, not to speak of the mound-shaped tombs of many ancient European and Near Eastern societies, and those of early Chinese emperors.

Photography and Its Influence

1275. RICHARD ESTES. *Downtown*. 1978. Oil on canvas, 48 × 60". Museum Moderner Kunst, Vienna. On loan from the Ludwig Collection, Aachen

1275

In the early 1970s, another strong artistic movement, Photorealism, made its appearance. Born in California, the movement struck New York in force in 1971. Its practitioners, who vary greatly among themselves in subject and in style, agree on two principles: first, that the picture should be painted, unaltered, with an airbrush from a photographic slide projected on the actual canvas; and, second, that the subject be as banal as possible. In this latter respect the Photorealists clearly derive from the tradition of such American Scene painters as Hopper, a style continued by the Pop movement of the 1960s. In the former they derive from Pop's insistence on mechanical methods, preserving even the inevitable blurry focus of snapshots enlarged to such size. The apparent impersonality of the Photorealists is belied by the fact that, after all, they take the photographs from which they work, so a considerable latitude of choice is available.

The undisputed leader of the group is RICHARD ESTES (1936–), whose dreary urban subjects are presented with stunning brilliance. But Estes proceeds in a different manner, utilizing the photograph rather than chaining himself to it. In order to create one of his townscapes, he sets forth laden with cameras of two different sizes on a Sunday morning to find as few people and as little traffic as possible, and takes many views of the same subject. He then lays out his canvas in acrylic, and proceeds to paint in oil because of its greater depth and resonance. The final picture is executed with an Eyckian precision of detail which no photographic enlargement could possibly retain. A powerful example of Estes's special quality of vision is *Downtown*, of 1978 (fig. 1275), so entitled on account of the subway sign in the center. The ugliness of the buildings and signs, and the litter on the sidewalks contrast with the brilliance of the reflections repeating the eternal miracle of light. In his strong sense of mass, depth, and coherence of design Estes displays his profound knowledge of the principles of abstract art.

Strongly related to Estes is the sculptor DUANE HANSON (1925–), who produces lifesize, colored models of human beings provided with actual accessories and painted in so lifelike a fashion that gallery-goers

1276

inevitably titter, especially when a waggish curator places an apparently real house painter complete with wet brush and full pail in the middle of a doorway through which everyone must pass. But as soon as the initial laughter dies down, such a group as the dreadful *Tourists*, of 1970 (fig. 1276), betrays its tragic content. The two fat, aging people, whose goodwill is equaled only by their lack of taste and understanding, are a devastating appraisal of Americans let loose on the world. Even less cheerful are Hanson's down-and-out characters—the dog-tired worker with a can of beer or the stoned junkie—who, as the forgotten children of civilization, can only appear the human counterpart of the rags and scraps put together by Schwitters and Rauschenberg.

Since Photorealism and its sculptural analogues reflect a mood of pessimism, it is instructive to turn to photography itself, in the work of a woman universally accepted as one of the greatest of American photographers. The art of DIANE ARBUS (1923–71) plumbs with profound empathy the existence of human beings caught in the toils of modern chaos. That some of her subjects were "freaks" (giants, dwarfs, obese persons, hermaphrodites) is only part of the story. The directness of her observation goes to the heart of every human problem she touches, and compositions of total rightness spring unrehearsed into being. *Child with Toy Hand Grenade*, of 1962 (fig. 1277), is a work so agonized that no words can compete with the power of the image.

1277

At this point it would be comforting to bring forth an array of brilliant artists still in their twenties or early thirties, from whom the future of American art will surely spring. It cannot be done. Despite the promotional efforts of the dealers, and the hundreds of exhibitions every year in New York and other metropolitan centers, the late 1970s and early 1980s have not produced a single new American artist who can command any genuine excitement on the part of either critics or public. Where are we going next? The future is in the hands of the next generation, perhaps some of the readers of this book.

In the meantime, many of the great figures of earlier decades are still producing important work. Interestingly enough, two of the most beautiful exhibitions in New York in recent years have been devoted to second-generation Abstract Expressionists, both of them women, both born in the late 1920s, both first established in the 1950s, and both continuing to paint with an energy, freshness, and grace which youth might envy—just as Monet continued his Impressionist work undeterred by fashion into the twentieth century. HELEN FRANKENTHALER (1928–) invented the staining technique, at first in oil, later in acrylic, by means of which color was poured across unprimed canvas, actually sailcloth. She thus created broad, amorphous areas of tone freely moving in space, in a way entirely her own. *Buddha* (fig. 1278), from her New York exhibition of 1983, is typical. After twenty years of attacks on Abstract Expressionism from every side, the crowds of enthralled viewers before her soaring canvases were enough to demonstrate the continuing vitality of this great American style, and of Frankenthaler's imagination.

The technique of JOAN MITCHELL (1926–) is more conservative, relying on brushwork applied in rapid strokes with some allowance for drip. She has not abandoned oil. The result is an exhilarating brilliance of color reminding one of the latest works of Monet, but which is freed from the identifiable objects of the natural world while overflowing with the energies of water, wind, forests, meadows, and above all sunlight.

Into the 1980s

1276. DUANE HANSON. *Tourists*. 1970. Fiberglas and polychromed polyester, 64 × 65 × 47″. Private collection

1277. DIANE ARBUS. *Child with Toy Hand Grenade, New York*. 1962. Photograph. The Museum of Modern Art, New York. Purchase. Copyright © The Estate of Diane Arbus 1962

1278

1279

Many of the paintings were composed of several panels so as to cover vast surfaces with gorgeous textures of color, and to enclose and yet enlarge the spaces of entire rooms. *Down the Stream*, of 1982 (fig. 1279), with its hail of singing yellow, orange, and green strokes, is typical of the response of this brilliant painter to the beauties of light.

Although a considerable number of artists of interest have made their appearance in various European countries since the close of World War II, it is safe to say from the present vantage point, a generation after the war, that none can rival such great European innovators of the first half of the twentieth century as Matisse, Picasso, Kandinsky, Mondrian, and Brancusi. A surprising number, in fact, either derive from or more or less closely parallel American contemporary artists, and they cannot really be compared in stature with such figures as Pollock, Rauschenberg, or Frank Stella. The most original personality of the postwar period in France is JEAN DUBUFFET (1901–), whose first one-man show took place only in 1944. Dubuffet's activity is prodigious and his interests, probably sparked by his study of Klee, range over every variety of what he called *art brut* ("rough" or "raw art"). He relentlessly collected and studied thousands of examples of the art of children and that of the insane—as well as the graffiti that appeared on Parisian buildings, scratched on layer over layer of posters—in a ceaseless attempt to discover how the uncensored and untutored human animal draws and paints. His own paintings could be and were made of anything from cement to ashes, and the message was generally one of profound pessimism. In the mid-1960s he emerged with a gloriously irresponsible new series, for which he coined the word *Hourloupes*. On a principle suggesting the endless relief compositions of the Aztecs, he covered many surfaces (some enormous—one painting is twenty-seven feet long) with countless tiny figures, producing a jigsaw-puzzle effect. The red and blue contours, often raised in relief, separate writhing

European Movements Since World War II

1280

1281

irregular areas of white striped with blue and occasional yellows. A small example is *Legendary Figure of a Tap*, of 1965 (fig. 1280), in which, once the eye gets used to Dubuffet's tricks, one can descry tiny figures, nude or partly clothed, locked in a continual mass embrace. The absolute uniformity of accent and the clean bright colors lend these pictures a sense of decorative gaiety belied by the licentiousness of the subjects.

Among the numerous gifted artists of the Paris School after World War II, one of the leaders was Nicolas de Staël (1914–55), born in Russia and brought up in Belgium. De Staël worked in rich masses of pigment usually laid on with the palette knife in broad areas firmly contoured and interlocking, still within a generally Cubist tradition. A relatively late work, *Le Lavandou*, of 1952 (fig. 1281), which shows the artist beginning to reassimilate visual reality into the framework of abstraction, also reveals the sensitivity of his color and the delicacy of his sense of pattern. The broad, vertical stripes of color suggest furniture, curtains, and a view out of a window. A considerable feeling of deep recession is achieved entirely by juxtaposition of color tones. In a mood of despair at having reached what he considered a blind alley in his work, de Staël committed suicide.

A delightfully outrageous figure of the Paris School was Yves Klein (1928–62), who experimented with almost anything, and seems to have been the first to exhibit the bare walls of an art gallery as his own creative work. His favorite color was ultramarine blue, with which he impregnated everything from sponges to plaster casts of his friends' nude bodies. The inventor of Body Art, Klein covered nude models with blue paint and let them roll on canvas to leave prints of their entire anatomies. He painted canvases blue, exposed them to rain, and exhibited the results. But his best works were certainly his *Fire Paintings*, such as an example of 1961–62 (fig. 1282), produced by the application of flame to painted asbestos, with a frequently gorgeous effect. Had it not been for Klein's untimely death, there is no telling what other directions this enfant terrible of modernism would have taken.

1282

In a recent monster exhibition in West Berlin, and spin-offs in galleries in New York and elsewhere, an international combine of dealers based in Italy, Germany, France, and the United States has attempted to launch a movement styled Neo-Expressionism, with lamentable aesthetic results, total critical condemnation, and—characteristically—considerable financial success.

Although the immensely successful English sculptor HENRY MOORE (1898–) was never a Cubist in the strict sense and came to international prominence only after World War II, he has continued to the present certain tendencies that found their origin in Brancusi, Archipenko, and Lipchitz. His work is uneven, but the best of it, such as *Interior-Exterior Reclining Figure*, of 1951 (fig. 1283), shows his original adaptation of the empty spaces and interlocking shapes of Cubist sculpture. The grace and smoothness of Moore's forms have perhaps caused observers to forget that his famous "holes" appeared at least as early as 1912 in the sculpture of Archipenko (see fig. 1200).

Moore's slightly younger English contemporary, BARBARA HEPWORTH (1903–1975) also came to prominence as a modernist relatively late in life, some time after her marriage in 1931 to Ben Nicholson (see page 912), which produced triplets! Although Hepworth participated in her husband's campaign to establish abstract art and modern design in Britain, her finest and most characteristic work, dating from the 1950s and later, shows no influence of Nicholson's purist relief sculpture save, perhaps, in its austerity and economy of means. She was concerned above all with her creations as objects, experiencing an almost physical self-identification with the forms of landscape, and in consequence with form in general. Her towering *Figure (Nanjizal)*, of 1958 (fig. 1284), shows the special power of Hepworth's art. Unlike Moore, who employs a team of assistants to enlarge and carry out his sculptural ideas, Hepworth worked with her own hands, chipping away wood or stone with great vigor, and used assistants only in her later years. Her rugged masses, muscular lines, and simple, unpolished surfaces might easily be described as "masculine" in comparison with the more "feminine" curves of Moore, if we had not learned to consider all such simplifications deceptive.

1284

1283

1285

The latest comet to appear in the star-studded British firmament is HOWARD HODGKIN (1932–), whose brilliance has earned him a one-man show at the British Pavilion in the Venice Biennial Exhibition of 1984. Hodgkin's work, characterized by Robert Hughes as "effortlessly superior to everything else on view by living artists," is refreshingly free from affectations, pretensions, anecdotes, or posturing of any sort. His respect for pure painting is worthy of enthusiasm, after the oscillations of the 1980s, which have already produced every conceivable technical vagary from airbrushed surfaces to gobs of pigment loaded with broken crockery. *In the Bay of Naples*, of 1980–82 (fig. 1285), is characteristic of Hodgkin's work in its contrast between massive areas set down as authoritative strokes of a broad brush, and equally wide areas enriched with diagonally superimposed rows of soft, firm dots of color. The suggestions of structure and space are enriched by dark backgrounds so that the bright colors shine like flowers in an illuminated garden at night, and the picture suddenly resolves itself into a view of the great curve of Via Caracciolo seen from a window whose frame appears at the left, with the blue-green water of the bay indicated by a single stroke. Like his American contemporaries Frankenthaler and Mitchell, Hodgkin is proving that the way to a new painting may, after all the sound and fury of recent movements, lie in the process of painting itself.

1283. HENRY MOORE. *Interior-Exterior Reclining Figure*. 1951. Bronze, height 14″. Hirshhorn Museum and Sculpture Garden, Smithsonian Institution, Washington, D.C.

1284. BARBARA HEPWORTH. *Figure (Nanjizal)*. 1958. Wood, height 98¼″. The Tate Gallery, London

1285. HOWARD HODGKIN. *In the Bay of Naples*. 1980–82. Oil on wood, 54 × 60″. Private collection

TIME LINE XIII

POLITICAL HISTORY	LITERATURE, MUSIC, ART	SCIENCE, TECHNOLOGY
1900 T. Roosevelt proclaims Open Door policy; promotes Panama Canal (opened 1914) Internal strife, reforms in Russia, 1905 Triple Entente: Great Britain, France, Russia, 1907 **1910** Revolution in China establishes republic, 1911 World War I, 1914–18 Bolshevik Revolution, 1917 Paris Peace Conference, 1919; League of Nations founded	Marcel Proust (1871–1922) Alfred Stieglitz founds Photo-Secession group, New York, 1902; opens gallery at 291 Fifth Avenue, 1905 Die Brücke formed, Dresden; Fauves' first show, Paris, 1905 Maurice Ravel (1875–1937) First Futurist manifesto, 1910 Armory Show, New York, 1913 Bauhaus founded, Weimar, 1919 Igor Stravinsky (1882–1971) T. S. Eliot (1888–1964)	Sigmund Freud publishes *Interpretation of Dreams*, 1900 Wright brothers make first flight with power-driven airplane, 1903 Albert Einstein formulates theory of relativity, 1905 Russell and Whitehead publish *Principia Mathematica*, 1910–13 Ernest Rutherford formulates theory of positively charged atomic nucleus, 1911
1920 Mussolini's Fascists seize Italian government, 1922 Stock market crash in U.S., 1929; worldwide depression **1930** Spain becomes republic, 1931 Spanish Civil War, 1936–39 World War II, 1939–45	André Breton (1898–1966); Ernest Hemingway (1898–1961); Bertolt Brecht (1898–1956) First Surrealist manifesto, 1924 Jean-Paul Sartre (1905–81) Claude Lévi-Strauss (b. 1908) Albert Camus (1913–60)	First radio station begins regularly scheduled broadcasts, 1920 First regularly scheduled TV broadcasts in U.S., 1928 Atomic fission demonstrated on laboratory scale, 1942 Penicillin discovered, 1943

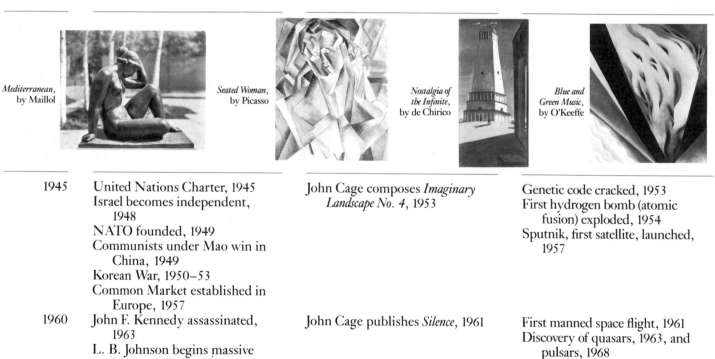

Mediterranean, by Maillol

Seated Woman, by Picasso

Nostalgia of the Infinite, by de Chirico

Blue and Green Music, by O'Keeffe

POLITICAL HISTORY	LITERATURE, MUSIC, ART	SCIENCE, TECHNOLOGY
1945 United Nations Charter, 1945 Israel becomes independent, 1948 NATO founded, 1949 Communists under Mao win in China, 1949 Korean War, 1950–53 Common Market established in Europe, 1957	John Cage composes *Imaginary Landscape No. 4*, 1953	Genetic code cracked, 1953 First hydrogen bomb (atomic fusion) exploded, 1954 Sputnik, first satellite, launched, 1957
1960 John F. Kennedy assassinated, 1963 L. B. Johnson begins massive intervention in Vietnam, 1965 Six Day War, 1967, ends in Israeli victory Russia invades Czechoslovakia, 1968	John Cage publishes *Silence*, 1961	First manned space flight, 1961 Discovery of quasars, 1963, and pulsars, 1968 First manned landing on the moon, 1969
1970 Vietnam War ends, 1974 **1980** Ronald Reagan elected president of U.S., 1980	Buckminster Fuller publishes *Synergetics*, 1975	First "test-tube" baby born, England, 1978 Home computers become widely available, 1981

PAINTING, SCULPTURE

IMPRESSIONISM *Monet, Cassatt	**POST-IMPRESSIONISM** Cézanne, *Renoir	**EXPRESSIONISM** Kollwitz, Nolde, Marc, Modersohn-Becker, Kandinsky, *Kokoschka, Beckman	**CUBISM** *Picasso, Braque, *Lipchitz, Léger, Delaunay, Brancusi, Archipenko, Duchamp Duchamp-Villon	**1900**
FAUVES *Matisse, *Rouault, Braque				
FANTASTIC ART *Chagall, *de Chirico, Klee	**RAYONNISM** Gontcharova	**SUPREMATISM** Malevich	**FUTURISM** Carrá, Boccioni, J. Stella	**1910**
	CONSTRUCTIVISM Popova, Tatlin, Gabo, Pevsner, Lissitzky			
DADA Duchamp, Arp, Ernst, Schwitters	**DE STIJL** Mondrian	**MEXICAN MODERNISM** Orozco, Siqueiros	**AMERICAN MODERNISM** Hartley, Marin, Davis, Hopper, *O'Keeffe	**1920**
SURREALISM Ernst, *Miró, *Picasso, Dali, Magritte, Matta				**1930**

*Artists whose names are starred were active for fifty years or more. Some artists are listed under more than one movement.

Ophir, by F. Stella

An American Tribute, by Nevelson

Soft Typewriter, by Oldenburg

Legendary Figure, by Dubuffet

ABSTRACT EXPRESSIONISM Gorky, †de Kooning, Pollock, Kline, Hofmann, Rothko, †Frankenthaler, †Mitchell			**1945**
	ABSTRACT SCULPTURE †Nevelson, Smith, †Bontecou, †Chryssa	**EUROPEAN MODERNISTS** Hepworth, †Moore, †Dubuffet, de Staël, Klein	
POP ART †Rauschenberg, †Lichtenstein, †Johns, †Oldenburg, †Warhol, †Segal, †Christo, †Samaras			**1960**
	OP ART †Vasarely, †Anuszkiewicz	**MINIMAL ART** Hesse, †Judd	
	HARD EDGE, COLOR FIELD Louis, †Noland, Newman, †F. Stella	**EARTH ART** Smithson	
PHOTO-REALISTS †Estes, †Hanson			**1970**
		†Hodgkin	**1980**

†Artists whose names are marked with a dagger continue active to 1985.

CHAPTER

MODERN ARCHITECTURE

TEN

Architecture has been characterized by W. R. Dalzell as the "indispensable art," and rightly so. Inevitably, the practical functions that shelters are designed to fulfill play a strong role in determining their appearance and thus, in part, their artistic character. So do the methods of construction available and practicable at any given moment. The strikingly new forms of architecture that appeared in the late nineteenth and twentieth centuries were built to meet the needs of industry and of commerce based on industry, in a society whose essential character and internal relationships had been sharply transformed by the Industrial Revolution. Few new palaces were built for the nobility or monarchies, for example; the characteristic new structures were industrial or commercial buildings, and the techniques invented to fulfill the new functions were, in turn, adopted for such traditional types as dwellings and churches.

There would seem to be no reason why women should not approach parity with men in architecture as they are already doing in painting and sculpture. The inexplicable fact remains that few women enroll in architecture schools. Architecture in the twentieth century, like all the arts in the Renaissance, remains almost exclusively a man's world.

About the middle of the nineteenth century, mechanized industrial production began to demand large, well-lighted interiors in which manufacturing could be carried on. The administration of giant industrial and commercial concerns required office buildings of unprecedented size, containing suites of offices easily accessible to employees and customers. The marketing of industrial products necessitated large-scale storage spaces, and enormous shops selling under one roof a wide variety of items. Industrial and commercial pressures drew increasing populations to urban centers, and traditional housing was no longer adequate to contain them. Mechanized transportation of industrial products and industrial and business personnel was essential. Leisure-time entertainment and cultural activities for the vast new urban populations required still a different kind of structure. Hence, the characteristic new architectural forms of the late nineteenth and twentieth centuries have been the factory, the multistory office building, the warehouse, the department store, the apartment house, the railway station (eventually superseded by the air terminal), the large theater, and the gigantic sports stadium. None of these could have been built on the desired scale by traditional constructional methods.

Unfortunately, as a glance around any modern metropolis will show, only a small fraction of these new structures could be described as artistically interesting. And many that can have nostalgically clothed their new constructional framework and methods with a veneer of columns, arches, towers, and ornament drawn from the architecture of earlier periods. Worse, the immense demand for economically "viable" new constructions has already swept out of existence considerable numbers of really fine late-nineteenth- and twentieth-century structures that were

Richardson, Sullivan, and the Chicago School

revolutionary when they were built, and completely satisfied the commercial demands of the time. The present account will be limited almost entirely to innovative structures that deliberately broke with architectural tradition in one way or another.

Since the Gothic period no truly revolutionary practical techniques of construction arose until the late eighteenth and early nineteenth centuries, when cast iron came into use for bridges, industrial structures, and temporary exhibition buildings. When used for more traditional architectural types, such as churches and libraries (see fig. 1111), cast iron was generally restricted to roofs and their internal supports, and from the exterior the building presented itself as a masonry structure. Mid-nineteenth-century commercial buildings in some American cities did, however, display cast-iron façades whose elements were imitated from the columns and arches of Italian Renaissance *palazzi*.

Cast iron had its faults as a construction material. Its tensile strength was low, and so was its melting point; hence, it was prone to collapse and to conflagration. The invention of a process for the manufacture of steel by Sir Henry Bessemer in the 1850s led to steel's first widespread use in building in response to the new necessities. Only structural steel and concrete reinforced by steel could have made possible the characteristic multistory structure of the modern city. A concomitant invention, the power elevator, made such buildings practicable by providing vertical transportation for persons and objects. Hoists of one sort or another, operated manually, have been known since antiquity, but the first power elevator, driven by steam, made its appearance only after the middle of the nineteenth century. By the 1870s steam had given way to hydraulic power as the motive force for elevators, and during the 1890s electricity took over this job. The modern city was on its way, with all its insoluble problems of space and transportation, increased manyfold by the invention of the internal-combustion engine.

RICHARDSON Early commercial structures in most nineteenth-century metropolitan centers were not essentially distinguishable from any other kind of secular building—houses or hotels, let us say—save by their extent. The development of the multistory structure, and eventually the skyscraper, was immeasurably assisted by the great fire of 1871 that virtually destroyed the center of Chicago, then largely built of wood. A number of pioneer multistory buildings were constructed during the ensuing period of chaotic rebuilding. An early attempt to face the necessities of the commercial building and express them artistically was the Marshall Field Wholesale Store (fig. 1286), built in 1885–87 by Henry Hobson Richardson (1838–86), who died before its completion. Richardson recognized that, although the ground story of a tall business building might have a real reason for being higher than the others, the needs of subsequent floors were pretty much the same. In his seven-story structure, therefore, he kept the heights of the six upper stories uniform, but treated them as if they diminished by grouping them under massive, rusticated arches imitated from those of Roman aqueducts. The first arcade embraces the second, third, and fourth stories. The second arcade, with arches half as wide as those below them, contains the fifth and sixth stories. The windows of the seventh story, above a stringcourse, are rectangular, and half the width of those of the lower floors.

Out of commercial necessity the immense number of windows was determined not by the external design of the building, as in many Ren-

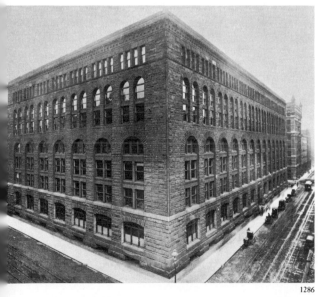

1286. HENRY HOBSON RICHARDSON. Marshall Field Wholesale Store, Chicago (demolished 1930). 1885–87. Courtesy Chicago Historical Society

aissance and Baroque structures (some of which have false windows for symmetry's sake), but by the requirements of the interior. Internally, the floors were supported by an iron skeleton, as was general at the time, but the grand exterior arches and walls did bear weight. Unfortunately, in 1930 the building was demolished to make way for a parking lot. At the moment of its construction, however, the essential characteristic of the American multistory structure, the steel frame, was already in use elsewhere in Chicago in the artistically uninteresting Home Insurance Building, built in 1883–85 by William Le Baron Jenney (1832–1907). The steel frame, composed of vertical and horizontal beams riveted together, created a structure that stood almost independent of the laws of gravity, holding together not by downward thrust but by the tensile strength of the steel. When the Home Insurance Building was demolished in 1929, the walls were found to have been supported entirely by steel shelving protruding from the frame and to have been constructionally useless.

SULLIVAN The steel-frame structure is a rectangular grid in which walls are reduced to curtains, and have in the twentieth century often been replaced entirely by glass (see fig. 1309). Hence, the impression of massiveness and of superimposed elements of constantly decreasing weight, which in the Marshall Field structure corresponded to fact, was destined to be replaced by emphasis on an allover rectangular pattern, well-nigh universal in twentieth-century multistory buildings. Post and lintel, arch and vault were reduced to anachronistic ornaments. An early building in whose design this essential fact was recognized from the start is the Wainwright Building in St. Louis, of 1890–91 (fig. 1287), a masterpiece by Louis Sullivan (1856–1924), rescued from demolition in 1975 by enlightened governmental action. Sullivan grouped the first and second stories together as a pedestal, then handled the next seven as absolutely identical. He emphasized the verticality of the structure by treating the walls between the windows as slender shafts, running up seven stories, with delicate capitals and bases, achieving the effect that the building looks much taller than it really is. For the spaces between the windows, corresponding to the floors supported by horizontal beams, and for a splendid band at the top, he used a rich system of ornamentation devised by himself. The final cornice (to hide chimneys and water tower) gives the building a blocklike effect not unlike that of a Renaissance palace (see fig. 672). But if its massive appearance recalls Renaissance tradition, for its basic design the building depends entirely on frank recognition of its steel frame.

A still more revolutionary work, remarkably prophetic of much twentieth-century architecture, is the Carson Pirie Scott Department Store, built in Chicago by Sullivan in 1899–1901 and enlarged in 1903 (fig. 1288). Here he recognized for the first time the basic identity between vertical and horizontal directions implicit in the very nature of the steel frame. In his design any reference to columns is reduced to the slender shafts running up ten stories between the windows at the rounded corner of the building. The areas between the windows on both façades are left flat and smooth, so that verticality and horizontality are perfectly balanced. Ornament is reduced to a delicate frame around each window, and to a gorgeous outburst over the corner entrance to the store. Such ornamental passages are the only aspect of Sullivan's style that ties him to the work of his European contemporaries discussed below. The crowning cornice, as compared to that of the Wainwright Building, is greatly reduced in height and projection.

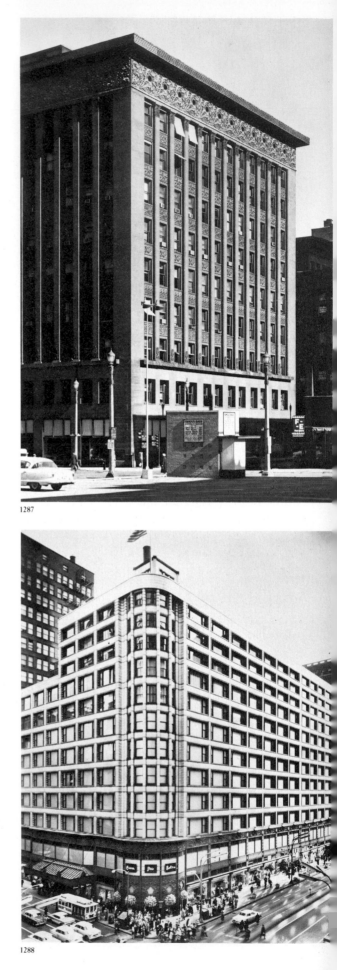

1287

1288

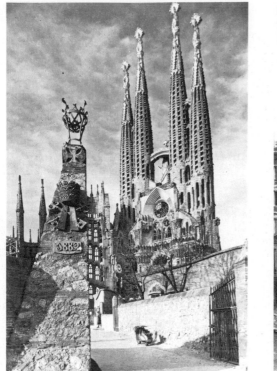

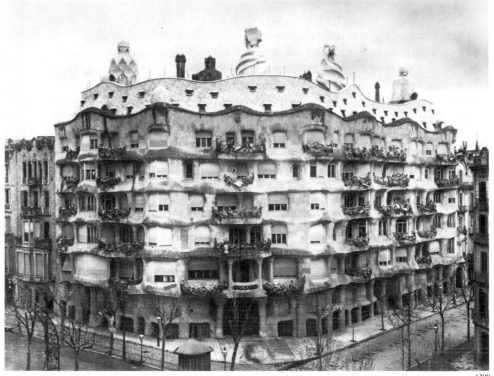

1289

1290

In sharp contrast to the rational criteria that guided the work of the architects who have come to be known as the Chicago School, a very different set of principles was evolving in Europe, related to those of the Nabis and the Symbolists (see pages 876, 877) and to the movement in interior design and the decorative arts at the turn of the century known as Art Nouveau. European designers seem to have held the straight line in horror, substituting for it wherever possible (or where not, enriching it) exuberant curves recalling those of the Rococo (see figs. 1011, 1032) but surpassing them in freedom because of their emancipation from the rules of symmetry. The fresh naturalism of Art Nouveau and its related movements was often expressed in such characteristic modern materials as metal and glass.

GAUDÍ In the last two decades of the century the new style appeared in Barcelona, and then just before the turn of the century burst forth in Paris, Brussels, Munich, Vienna, and even the traditionalist Italian cities. The greatest innovator, whose works are still astonishing in the liberty and scope of the imagination they disclose, was the Catalan architect and designer Antoni Gaudí (1852–1926). His work is limited to Barcelona, but his buildings are so richly scattered throughout the modern sections of the metropolis as to constitute one of its principal attractions.

In 1883 Gaudí took over the design and construction of the colossal Church of the Sagrada Familia in Barcelona (fig. 1289), which had previously been projected and partly built as a rigorously neo-Gothic edifice. Although Gaudí worked on the Sagrada Familia off and on until his death, the church remains a fragment; only the crypt is usable. The four bottle-shaped spires of one transept, pierced by unbelievably irregular spiral fenestration, tower above the earlier Gothic windows of the façade and the unprotected nave floor in shapes so fantastic that they seem to have grown there rather than to have been built.

Art Nouveau and Expressionist Architecture

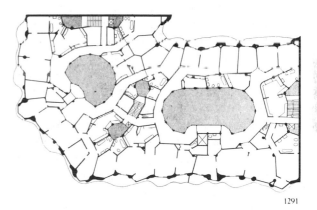

1291

1287. LOUIS SULLIVAN. Wainwright Building, St. Louis (view from the southeast). 1890–91

1288. LOUIS SULLIVAN. Carson Pirie Scott Department Store, Chicago. 1899–1901; enlarged 1903–4

1289. ANTONIO GAUDÍ. Church of the Sagrada Familia, Barcelona. 1883–1926

1290. ANTONIO GAUDÍ. Casa Milá, Barcelona. 1905–7

1291. ANTONIO GAUDÍ. Plan of a typical floor, Casa Milá, Barcelona

Gaudí's masterpiece is the Casa Milá, of 1905 (figs. 1290, 1291), an apartment house, in whose plan and design, aside from the window mullions and transoms and some inner partitions, not a straight line remains. The building is convulsed as if it were gelatin. Balconies ripple and flow, bulge and retract in a constant turmoil; windows reject vertical alignment. Rich vegetable ornament in wrought iron drips from the balconies like flowering vines or Spanish moss. The chimneys—all different, of course—are spiral or imprinted with irregular lozenge shapes or freely conoid. Inner courtyards and corridors move with the random patterns of natural caverns, and the interior walls and partitions are so arranged that few are parallel and none meet at right angles. Although one might have expected so fluid a building to have been constructed of a plastic material such as concrete, the façade is actually made of cut stone, the pulsating roof of marble slabs, and the chimneys of marble fragments. (In much of his work in houses, chapels, and parks, Gaudí included bits of broken ceramics or glass, embedded in free-form mosaics.) Could Dali have had the Casa Milá in mind when he painted his "wet watches"? Neglected and even condemned during the heyday of the International Style (see below), Gaudí has recently taken his place as one of the great creative minds of modern architecture, and his ideas have influenced immeasurably the work of such recent architects as Nervi, Eero Saarinen, and Soleri (see figs. 1314, 1315, 1321).

HORTA A less vigorous but even more refined architect of the turn of the century, the true founder of Art Nouveau, was the Belgian Victor Horta (1861–1947). Horta studied with care the principles of Baroque and Rococo architecture and the structural ideas of the French nineteenth-century neo-Gothic architect and theoretician Eugène Viollet-le-Duc (1814–79), who was responsible for the excessive restoration of many French Gothic buildings. In Horta's Salon for the Van Eetvelde House in Brussels, built in 1895 (fig. 1292), the only straight lines are the verticals of the columns and the horizontals of the floors, steps, and balustrades, although even these are curved in plan. Every line flows with the grace of natural growth, the lampstands curl like flowering vines, the light bulbs form the centers of huge flowers, and the framework that holds in place the glass of the central dome expands in natural curves like the ribs of a gigantic leaf.

EXPRESSIONIST ARCHITECTURE Parallel with the development of Expressionism in German painting, early twentieth-century German architecture took on new and freer shapes, all strongly influenced by the structural innovations and imaginative fluidity of Art Nouveau. A brilliant example, displaying daring structural techniques, is the interior of the Centenary Hall at Wroclaw, Poland (formerly Breslau, Germany), built in 1910–12 by Max Berg (1870–1948). Although the exterior is conventional and unimpressive, the vast interior space, based on an almost Leonardesque design with four apses radiating from a central circular space, is unexpectedly original (fig. 1293). The four colossal arches supporting the dome on pendentives are curved even in plan, and the vaulting of the dome and the semidomes over three of the four apses (the fourth is a stage) consists of nothing but ribs, open to views of seemingly endless tiers of windows. The thrilling effect of lightness and free space is clearly related to the inventions of Guarini (see fig. 933), which

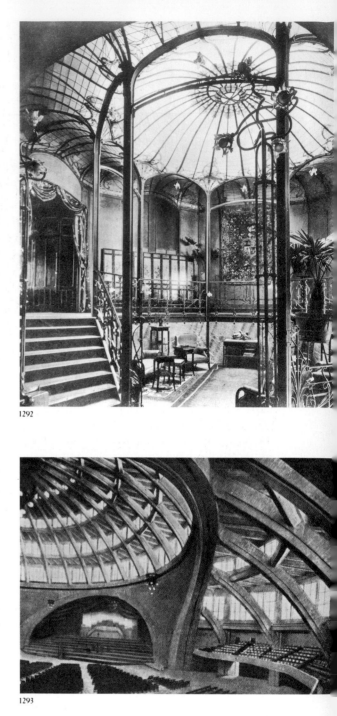

1292. VICTOR HORTA. Salon, Van Eetvelde House, Brussels. 1895

1293. MAX BERG. Interior, Centenary Hall, Wroclaw, Poland (formerly Breslau, Germany). 1912–13

1294. ERICH MENDELSOHN. Einstein Tower, Potsdam, Germany (destroyed). 1920–21

1295. FRANK LLOYD WRIGHT. Plan of the ground floor and first floor, Robie House, Chicago

1296. FRANK LLOYD WRIGHT. Robie House, Chicago. 1909

were built in masonry; Berg's new design could have been executed only in the material for which it was intended, reinforced concrete, which has been used with great advantage in Europe and adopted somewhat more reluctantly in the United States. Berg's vision was the starting point for the even more dramatic recent creations of Pier Luigi Nervi (see fig. 1314).

Another milestone in Expressionist architecture was the Einstein Tower at Potsdam, outside Berlin, built in 1919–21 by ERICH MENDELSOHN (1887–1953) and now destroyed (fig. 1294). While a soldier in the trenches during World War I, Mendelsohn occupied many dreary hours by jotting down with a heavy stub pen in tiny sketchbooks hundreds of imaginative building designs, of which the idea for the Einstein Tower was one. He designed it to be constructed of poured concrete, for which its fluid forms were obviously intended, but for technical reasons it had to be built in brick covered with stucco. All the forms, including staircase, entrance, walls, windows, and dome, flow smoothly into one another with great expressive effect, obliterating all straight lines other than, as in the Casa Milá by Gaudí, the inescapable window mullions and transoms.

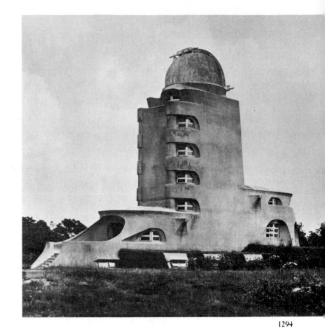

1294

Frank Lloyd Wright

A period and a law unto himself was Frank Lloyd Wright (1867–1959), one of the greatest American artists in any medium. Praise for him must be tempered by recollection of his weaknesses—his more than occasional lapses of taste, and the egoism that made it difficult for him to admit into his interiors any object he had not designed himself. This was an obvious impediment to the success of his designs for the Solomon R. Guggenheim Museum in New York City, and a torment to its staff since before the building was erected. But when all is said and done, Wright was an extraordinary man, a prophet of a new freedom and at the same time of a new discipline in architecture, a molder of form and space, and a genius who experienced the relationship between architecture and surrounding nature as has perhaps no other architect in history, so that his buildings seem literally to grow out of their environments.

Wright's first success, which brought him international recognition, was in the field of private residences, his "prairie houses," such as the revolutionary Robie House in Chicago, built in 1909 (fig. 1296). As is visible in the plan (fig. 1295), Wright has to a considerable extent departed from the Western tradition of enclosed, self-sufficient spaces opening into each other by means of doors. His rooms are partially enclosed

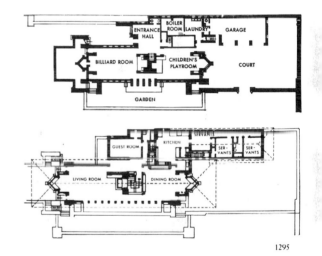

1295

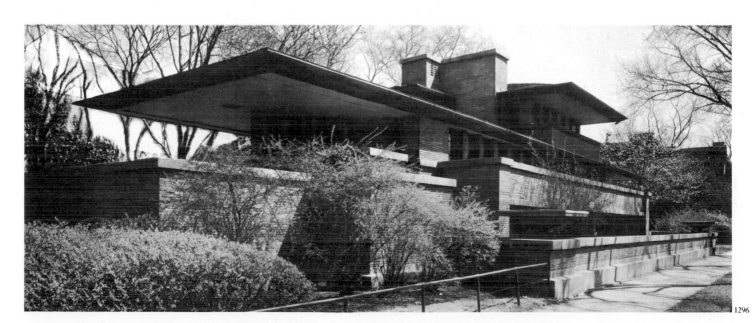

1296

subdivisions of a common space, which in itself is felt as a concentration of motives and forces outside the building. In plan and in elevation the house is at once invaded by outside space and reaches back dramatically into it. The influence on Wright of the Japanese Pavilion at the Chicago World's Fair of 1893 has often been pointed out, but it should also be recalled that as early as the 1870s American houses bristled irregularly with verandas at all levels, and interior spaces did indeed flow into one another (with room divisions often no more formidable than curtains or beaded dowel screens) off a central staircase hall utilized as the main living space. Wright's individual contribution lay in the daring of his assault on the outer world through cantilevered roofs projecting without vertical supports, seeming to float freely, and the purification of vertical and horizontal masses, as if by some sixth sense he had realized what was about to happen in Analytical Cubism in France. The Robie House combines cubic forms and projecting planes with a mastery never before seen in architecture.

More than a quarter of a century later, in 1936, Wright built one of his most original conceptions, the Kaufmann House at Bear Run, Pennsylvania, suspended over a waterfall (fig. 1297). The idea did in a sense have a prototype in the French Renaissance château of Chenonceaux, built on a bridge across the River Cher. But Wright seems to have derived the masses of "Falling Water" from the very rock ledges out of which it springs. A central mass of rough-cut stone masonry blossoms forth in cantilevered concrete terraces, colored beige so as not to disrupt the tonal harmony of their woodland environment—a house really at one with the rocks, the trees, the sky, and the rushing water.

Wright could work only with sensitive, discerning, and fairly submissive patrons, and thus was destined never to receive the great commissions to which his genius entitled him. His dream of a mile-high skyscraper for Chicago, and his Broadacre City, an imaginative combination of industrial plants with houses and gardens for factory personnel, went unbuilt.

1297. FRANK LLOYD WRIGHT. Kaufmann House ("Falling Water"), Bear Run, Pennsylvania. 1936

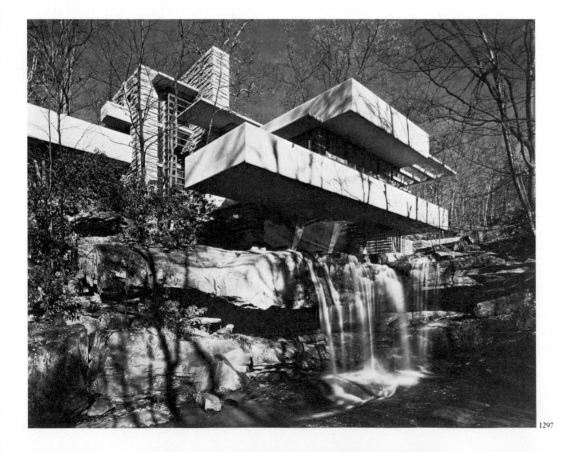

1297

After the close of World War I, a new architectural style arose almost contemporaneously in Holland, France, and Germany, and has thus received the name International Style. Its consequences, for good or ill, are still with us today. The International Style is responsible for some of the most austerely beautiful creations of twentieth-century art, and once it became apparent to patrons and builders alike that the principles of the International Style could be used for cheap construction, these principles were eventually welcomed commercially. What began in the 1920s as a revolutionary ideal for a new architecture became in the 1960s and 1970s the cliché of mass-produced building, which makes every major, unprotected city on the planet look pretty much like every other one.

The International Style rejected ornament of any sort. It also denied the traditional concept of the building as a mass. Finally, it prohibited the use of such "natural" materials as stone or wood. This was no wonder, since the open planes and spaces of the International Style could only have been created with the use of modern materials, especially steel and reinforced concrete. These were used to form flat surfaces, kept as thin as possible, and almost invariably white, alternating only with areas of glass, to enclose volumes rather than to create masses. The result is a boxlike appearance, reminding one less of architecture as it had been conceived in the West since antiquity (with the sole exception of the Gothic interlude) than of the cabin block on a steamship. Models for traditional European buildings were usually carved from wood, and some were modeled in clay and cast in plaster. A model for an International Style building could be, and often was, constructed of light cardboard and cellophane. Never in traditional architecture had there been anything so utterly weightless as the buildings of the International Style.

The principles of Cubism, with its exaltation of the plane to a position of supreme importance, played a part in the creation of the International Style. So did the new architecture of Wright, widely known in Europe after his Berlin exhibition of 1910. Especially important was the aesthetic of De Stijl (see pages 910–12 and figs. 1215, 1216), which in Holland had already reduced both the subject and the elements of art to flat planes, right angles, black, gray, white, and the three primary colors—with white predominating. One of the earliest buildings of the International Style is the Schröder House at Utrecht (figs. 1298, 1299), built in 1924 by GERRIT RIETVELD (1888–1964). In this extraordinary building the appearance of weightlessness characteristic of the International Style is first proclaimed, but in full conformity with the principles of De Stijl. The Schröder House, in fact, is the three-dimensional equivalent of a painting by Mondrian. Nothing weighs, thrusts, or rests; all planes are kept as slender as possible, as external surfaces bounding internal volumes. Some of the planes connect at the corners, some appear to slide over each other in space. The cantilevered roof and balconies, doubtless influenced by those of Wright, are restricted to concrete slabs instead of Wright's massive forms. Windows are continuous strips of glass. The only details are the mullions and the simple steel pipes used as railings. The plan of the upper floor was made completely flexible by the device of removable partitions, which could be stored for entertaining.

GROPIUS As early as 1911, the principles of the International Style had been foreshadowed in industrial architecture by Walter Gropius (1883–1969), who had used continuous glass sheathing as a substitute for walls, even at the corners of a building. The supports, entirely internal, were

The International Style

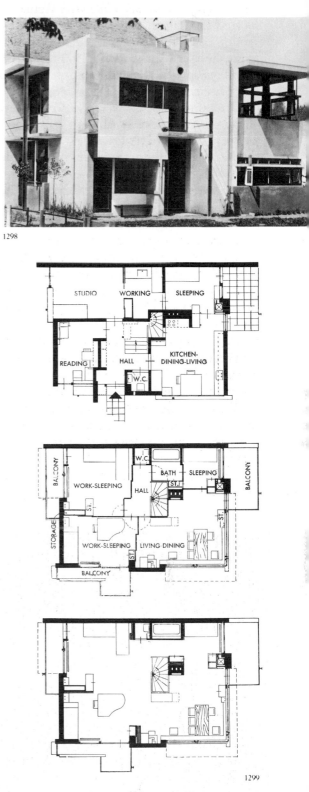

1298. GERRIT RIETVELD. Schröder House, Utrecht, The Netherlands. 1924

1299. GERRIT RIETVELD. Plans of the Schröder House, Utrecht. Top to bottom: entrance floor; upper floor; upper floor with partitions removed

not visible on the exterior. Gropius's great opportunity, however, came in the building of the famous Bauhaus, an international center for design in all its forms. Originally called the Weimar Schools of Arts and Crafts and located at Weimar, Germany, the institution in 1919 came under the direction of Gropius, who reorganized and renamed it. Bauhaus, derived from the German words for "building" (in the figurative as well as the literal sense) and "house," epitomized the purpose Gropius saw in the organization. It was to comprise instruction not only in the traditional arts of painting, sculpture, and architecture, but also in the crafts, from weaving to printing; instruction was to be directed toward industrial design and dominated by rational, up-to-date principles employing and directing mechanized techniques. As we have seen, both Klee and Kandinsky came to the Bauhaus as professors; so did a number of other artists, designers, and architects, and a large group of gifted students. From the Bauhaus the new ideas radiated to all parts of the globe.

In 1925 Gropius moved the Bauhaus to Dessau, where he was building new quarters for the school from his own designs. In the workshop wing (fig. 1300), constructed in 1925–26, Gropius carried out systematically the principles of the International Style. The building is a huge glass box, with panes as large as they could be economically manufactured held in a uniform steel grid. The four stories of the interior receive no external expression in this uninterrupted glass exterior, being separately supported on their own reinforced concrete columns. Walls are reduced to narrow, white strips at top and bottom. According to a principle of the International Style—as defiant of climate as its constructional principles are of gravity—the roof is completely flat. Such vast expanses of glass remained in fashion up to the energy crisis of the 1970s, and buildings utilizing them require enormous heating, ventilating, and cooling mechanisms, not to speak of death-defying external window-washing teams.

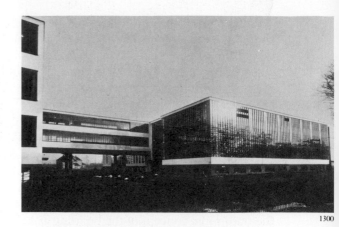

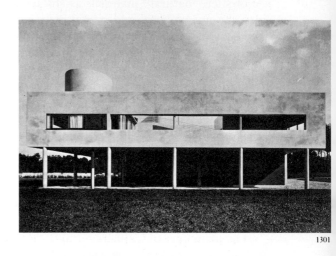

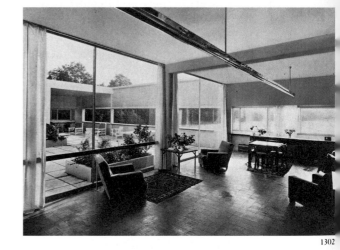

LE CORBUSIER Meanwhile, in France the principles of the International Style were being brilliantly exploited by the Swiss painter-architect Charles-Édouard Jeanneret (1887–1965), known by the pseudonym of Le Corbusier, who competes with Wright for the leadership in the formation of twentieth-century architecture. Le Corbusier had already built several International Style houses when he undertook in 1928–30 the masterpiece of his early period, the Villa Savoye at Poissy, France, even more severe and revolutionary in its appearance than the Schröder House. At first sight the building, supported on stiltlike reinforced-concrete poles, seems to have no ground story; actually, there is one, recessed deeply under the overhanging second story, and containing entrance hall, staircase, servants' quarters, and carport (fig. 1301).

Le Corbusier called his houses "machines for living in," and this one fulfills his designation to perfection. The second floor, dominated by a staircase tower that suggests the funnel of a steamship, is a box bounded by perfectly flat, continuous planes, acknowledging no possibility of overlap, and punctuated by windows reduced to unbroken horizontal strips of glass panels, sustained by slender mullions. The window strips not only light the interior rooms of the second floor, but also provide outlook for a sunny, interior terrace, open to the sky and separated from the living room only by floor-to-ceiling panels of plate glass (fig. 1302). Revolutionary in Le Corbusier's day, this method of creating a free interchange has become a commonplace of residential (and motel!) design since the 1950s.

1300. WALTER GROPIUS. Workshop wing, Bauhaus, Dessau, Germany. 1925–26

1301. LE CORBUSIER. Villa Savoye, Poissy, France. 1928–30

1302. LE CORBUSIER. Interior, Villa Savoye, Poissy (view of the living room toward the terrace)

1303. LUDWIG MIES VAN DER ROHE. German Pavilion (dismantled), Barcelona International Exposition, 1929

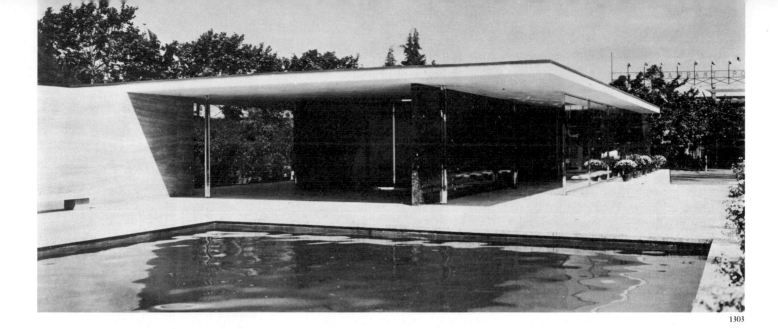

Electric lighting is confined to a long, chrome-plated fixture.

Le Corbusier did not restrict his revolutionary architectural ideas to single structures, but, as Wright had—although on a far larger scale—dreamed of urban planning as well. He envisioned, designed, and theorized about a *ville radieuse* (radial city) of three million people, with interrelated factories, office buildings, apartment blocks both high and low, and cultural and amusement centers, all connected by means of elevated highways and punctuated by green areas for recreation. As we contemplate our choked and polluted present-day urban agglomerations, we can only regret that, in spite of his designs for the administrative center of Chandigarh in India, Le Corbusier never had a chance to demonstrate the potentialities of his dream of an organic metropolis.

MIES VAN DER ROHE Under the initial influence of Gropius, the German architect Ludwig Mies Van Der Rohe (1886–1969) developed a new and purified personal version of the International Style, alongside which the work of Gropius and even of Le Corbusier seems heavy. The German Pavilion at the Barcelona International Exposition in 1929 delicately reinstated the use of such natural materials as veined marble and travertine (fig. 1303). Mies's famous dictum "less is more" is expressed here in his extraordinary refinement of space, plane, and proportion, all reduced to absolute essentials. The eye moves serenely from interior to exterior spaces, unified by the movement of planes and separated only by plate glass. Marble, concrete, chrome, water, and air are formed into a harmony as delicately adjusted as a white-on-white painting by Malevich (see fig. 1209).

The Skyscraper—Romance to Internationalism and Return

The history of the American skyscraper after Sullivan is colored by recollections of the past rather than by premonitions of the new era, of which that amazing American invention would have seemed to be the perfect herald. Skyscrapers went up apace in the first two decades of the century, and created a delightful Dolomitic skyline in downtown New York and Chicago, but each individual building, however picturesque, attempted to clothe the steel frame with elements drawn from architectural history, often grotesquely misunderstood. Generally the results were absurd, but

in 1913 the Woolworth Building in New York (fig. 1304), by Cass Gilbert (1859–1934), proved that a skyscraper could be beautiful. The essentials of the steel frame are clearly stated on the exterior of the building, sixty stories high (for seventeen years the tallest habitable construction in the world). But the shape of the tower was derived from those of Netherlandish Flamboyant Gothic bell towers, similar to those visible over the treetops in the background of the *Ghent Altarpiece* (fig. 750). At that height the rich ornamentation, in glazed white terra-cotta against green copper roofs and gilded finials, is read as a softening of the outline of the structure against the sky. (The pointed top conceals such utilities as the water-tank and chimneys). What still renders the building a delight is its elegance, lightness, and grace, surprising in so huge a mass. The romantic spire, now buried by taller and less distinguished structures, once formed the peak of New York's pyramidal skyline.

The beauty of the building was never equaled by any other traditionalist work, not even those by Cass Gilbert himself. But the tendency of advanced architects was all in the other direction. In 1922 Gropius submitted to the competition for the Chicago Tribune Tower a strongly International Style design (in association with Adolf Meyer), clearly related to the ideas of Sullivan and the Chicago School of twenty years before. His project was not selected; the choice went instead to a neo-Gothic design by Raymond Hood (1881–1934), in unsuccessful emulation of the Woolworth Building. Ironically enough, in his later buildings (see below) Hood shook off all historic ornament and began to adopt some of the principles of the International Style.

The most successful attempt to translate the language of historical forms into a twentieth-century idiom was the thrilling Chrysler Building in New York (fig. 1305) by William Van Alen (1882–1954), begun as a sort of hymn to the triumph of the American automobile in the heady atmosphere of 1928, the year before the stock market crash, and completed two years later amid universal gloom. The upward zip of the tower was increased by contrasting the three vertical columns of windows on the center of each face with the horizontal window strips at the corners. The central window columns rise higher than those on either side, and seem to explode at the top into constantly rising concentric arches, ribbed like the sunburst of the Chrysler logo, faced with stainless steel, and pierced by wedge-shaped windows. The almost Indian-looking pointed dome ends in a colossal needle. This was kept a secret, held in reserve, and then when the neighboring Chanin Building declared itself the tallest in the world, run up overnight from inside to capture the record—which the Chrysler Building lost one year later to the far less witty and imaginative Empire State Building. One wonders what the design would have been like without the gigantic winged radiator caps perched on the corners. The author will never forget his own trip up the outside of the tower as a sixteen-year-old boy in 1930, on a platform elevator without enclosures or even railings, looking out over the sea of brownstones which then characterized most of midtown Manhattan. The style of the Chrysler Building is related to the so-called Art Deco style, a name derived from the Paris Exposition des Arts Décoratifs in 1928. The building has enjoyed a revival of popularity along with Art Deco in general, and at the moment of this rewriting is proving influential upon the current procession of more romantic and imaginative shapes for skyscrapers.

Architects in New York City were bound by the conventions of the building code, including the so-called setback law, to terrace their structures progressively back from the street in order to allow sunlight to pen-

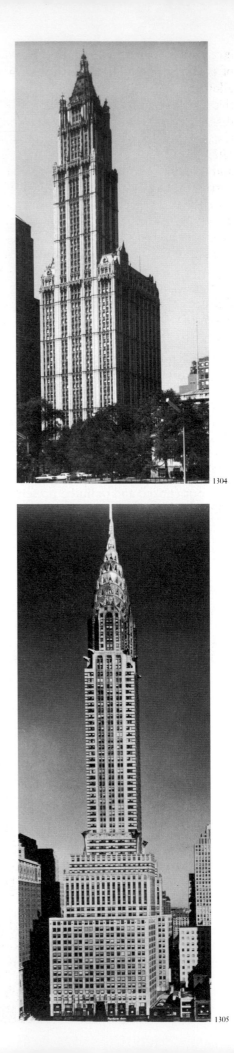

1304

1305

etrate into what were becoming dark canyons. The result was a number of commercial buildings designed so as to profit from every cubic inch allowable under the law, and promptly nicknamed "ziggurats." Imaginative architects had, nonetheless, to satisfy their materialistic clients. Hood discarded all reference to the historic past in the Daily News Building (fig. 1306), which he designed with John Mead Howells for New York in 1929; he was constrained to set the building back in steps from the street, and attempted to compensate for this enforced irregularity of contour by corresponding irregularities within planes composing the sides. Otherwise, he concentrated on unbroken strips of white masonry between the windows to accent the verticality of the steel frame. This handsome innovation, marking a considerable advance in skyscraper design, was greeted by attacks from conservative architects and derision from the general public.

A year later GEORGE HOWE (1886–1955) and WILLIAM LESCAZE (1896–1969) designed the Philadelphia Savings Fund Society Building (fig. 1307), finished in 1932, a structure that can so easily be thought of as a building designed today. The grid character of the steel frame is recognized in every aspect of the structure. Along the narrow sides of the building the windows are treated as strips of glass wrapped around the cantilevered corners. The only ornament on the exterior is the crowning PSFS.

Mies van der Rohe had made a model (now lost) for an all-glass tower as early as 1919. This was probably the earliest design to recognize that a steel or reinforced concrete frame structure is independent of principles of weight and support, and thus can be the same from bottom to top. In 1951 Mies constructed the Lake Shore Drive Apartments in Chicago (fig. 1308) as pure International Style structures whose harmony resides in their exquisite subtlety of proportion. The two buildings, placed at right angles to each other, look absolutely uniform in fenestration, until one discovers that, after every fourth window, as after every fourth beat in four-four time, comes a sort of bar line in the form of a slightly wider vertical. The next development was the all-glass Lever House, of 1951–52, in New York, one of the few really thrilling skyscraper designs in that metropolis, erected by the firm of Skidmore, Owings and Merrill, and

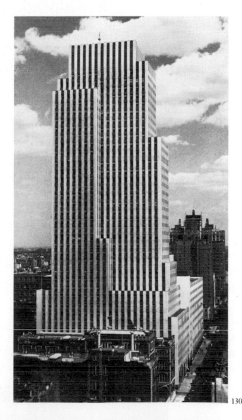

1306

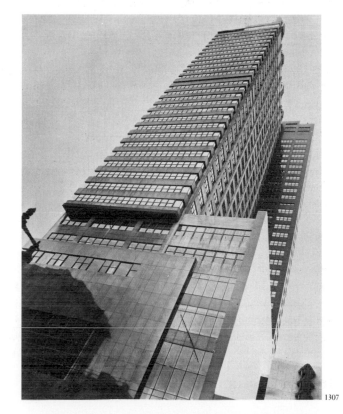

1307

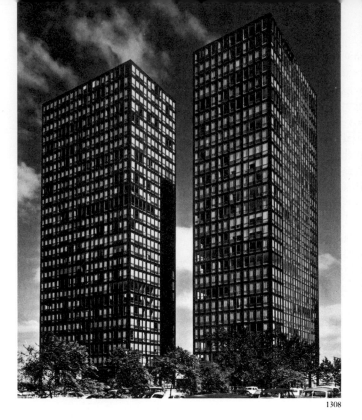

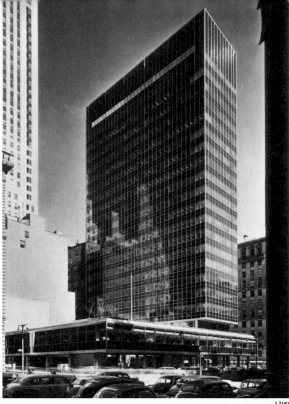

1308

1309

largely the idea of their associate GORDON BUNSHAFT (1909–). The building (fig. 1309) consists of horizontal and vertical units, both elevated on pylons above the street so that the passerby can move directly into a partially shaded and open court. The tower is a shaft of glass, totally without masonry, tinted to avoid excessive glare, and the floors are marked by panels of dark-green glass. To preserve the total unity of the building, the light fixtures, visible from the outside, are identical throughout. The result is one of the most harmonious of all modern buildings, whose beauty is only enhanced by many unsuccessful attempts to imitate it.

Alas, such imitations have continued uninterrupted, and on a world-wide scale. Glass boxes mechanically reproduced without the imagination and taste of Mies or Bunshaft have filled cities from Milan to Chicago to Tokyo to Cape Town, and disfigured even the historic beauty of London and Paris. A major New York firm recently celebrated the completion of its fiftieth such skyscraper, one of which can hardly be told from the other. For years architects and critics have rebelled against the tyranny of the glass box. Attempts have been made to model it into more interesting prismatic shapes, as in the IDS Center in Minneapolis by Philip Johnson (1906–) and John Burgee (1933–), or to reinstate traditional materials for the exterior walls, which makes sense in a period dangerously short of energy. The school that, in a reversal of logic, calls itself Post-Modern has proposed decorations ranging from Aztec to Art Nouveau, and Philip Johnson has crowned the AT&T Building in New York with a colossal broken pediment more at home on a Chippendale chest. But the most encouraging tendency has been that inspired by the romanticism of the 1920s, especially the brilliant design by German-born HELMUT JAHN (1940–) for an eighty-two-story tower in Houston, Texas (fig. 1310). His visionary concept is explicitly intended to give Houston the same recognizable image that the Eiffel Tower has long conferred on Paris. As in the Chrysler Building, the central vertical shaft of windows on each face soars against the horizontal corner windowstrips, and the tower culminates in a pinnacle, but the four crowning gables pyramidally

1310

connected at the central peak are inspired by North German Gothic church spires. The building is placed at a forty-five-degree angle to its site, and from its seven-story base, pierced by pointed one-hundred-foot-high portals, the tower of metal, stone, and glass rises in fifteen-story leaps, each emphasized by searchlights. Whether this is the style of the future is yet to be seen, but it is a welcome relief from the banality of the immediate past.

After the close of World War II, the conventions of the International Style, too easily adaptable to the multistory business building, seemed unnecessarily confining to a number of gifted architects, including even Le Corbusier, one of the pioneers of that very style. His Unité d'Habitation, built on a hilltop in Marseilles from 1947–52 (fig. 1311), treats his favorite material, reinforced concrete, in a new and monumental fashion. The building seems a gigantic piece of abstract sculpture, with the surface of the concrete left in its rough state just as it emerges from the wooden molds, and uncolored so that it turns a soft gray. The windowless end walls can scarcely be called functional, but they are an outgrowth of the concept of the building, made up of a large number of identical living units, each with a bedroom on an inner balcony above kitchen and bath, overlooking a high living room, and each having access to a continuous outer balcony, with wall breaks between units. The structure is held aloft on massive columns rather than the slender shafts of the Villa Savoye.

When Dali was asked by Le Corbusier what he thought his new architecture should look like, he replied, "soft and hairy." This is very nearly what happened in the most extraordinary of Le Corbusier's late works, the pilgrimage Chapel of Notre-Dame-du-Haut on a hilltop at Ronchamp, France, built in 1950–54 (fig. 1312). Every convention of the International Style has been abandoned. The very plan is irregular, and the forms are modeled in the most surprising way into wall and roof shapes flaring, curving, and twisting as if organic and alive. Le Corbusier had visited the island of Mykonos in the Cyclades east of mainland Greece, and had been impressed by the beauty of its simple buildings, chiefly the tiny churches and windmills. These structures have sloping, rounded walls in order to offer less resistance to the constant wind, and are whitewashed every year, so that in time they develop a kind of fur coat formed by successive layers of whitewash. Le Corbusier emulated the sloping

Countercurrents

1308. LUDWIG MIES VAN DER ROHE. Lake Shore Drive Apartments, Chicago. 1951

1309. GORDON BUNSHAFT, and Skidmore, Owings and Merrill (New York). Lever House, New York. 1951–52

1310. HELMUT JAHN. Bank of the Southwest, Houston, Texas (under construction 1984). Drawing

1311. LE CORBUSIER. Unité d'Habitation, Marseilles. 1947–52

1312. LE CORBUSIER. Notre-Dame-du-Haut, Ronchamp, France. 1950–54

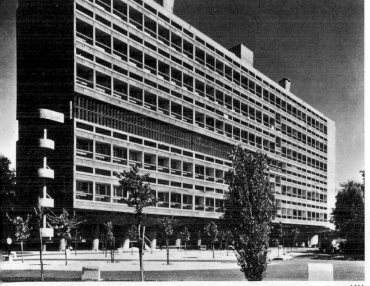

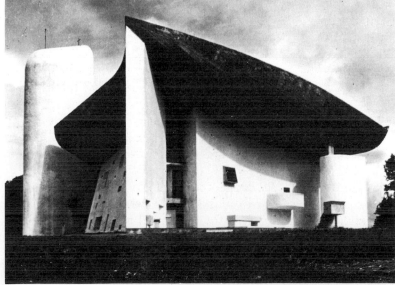

1313

walls and the softness and richness of these shapes of folk-architecture in a highly imaginative way. The dramatic cornices are based on the forms of ships, traditional symbols of the church. Even the fenestration of the chapel is irregular, openings scattered at random over the curving walls. The effect in the interior is magical (fig. 1313) because the windows are also of different sizes and proportions, their stained glass differs from window to window in color and design, and their embrasures slope at different angles, as if each corresponded to the experience of an individual worshiper approaching in his own way the mystery of the altar.

An immensely influential constructional genius, the Italian engineer-architect PIER LUIGI NERVI (1891–1979), has produced some of the most beautiful forms in modern architecture. In order to span interior spaces even greater than those by Max Berg (see fig. 1293), he abandoned traditional concepts separating walls and roof, and devised new methods of working with concrete, as in the interior of the Exhibition Hall, of 1948–49 (fig. 1314), built at Turin, the city that boasts so many triumphs of Nervi's great predecessor as a constructional innovator, Guarino Guarini (see page 708 and figs. 932, 933). The entire structure of the Exhibition Hall is formed by gigantic ribs that start from the floor in sweeping curves, united by boomerang-shaped elements, leaving countless window spaces for illumination. To facilitate rapid construction, all elements were precast and assembled on the spot. The design produces an inspiring effect of organic growth according to repeated geometrical patterns, whose soaring rhythms recall, without in any way imitating, those of High Gothic cathedrals.

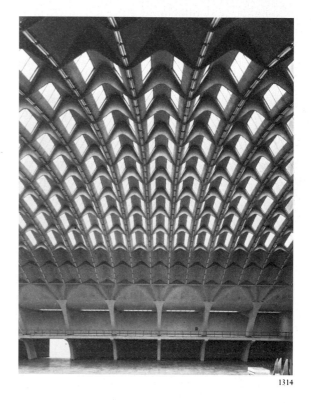

1314

1313. LE CORBUSIER. Interior, Notre-Dame-du-Haut, Ronchamp

1314. PIER LUIGI NERVI. Interior, Exhibition Hall, Turin. 1948–49

1315. EERO SAARINEN. Terminal, Dulles Airport, Chantilly, Virginia (outside of Washington, D.C.). 1961–62

1316. MARCEL BREUER. Whitney Museum of American Art, New York. Completed 1966

1317. MARCEL BREUER. Third-floor gallery, Whitney Museum of American Art, New York

1318. RENZO PIANO and RICHARD ROGERS. Pompidou Center, Paris. 1971–77

1315

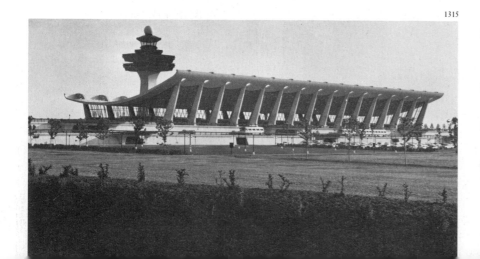

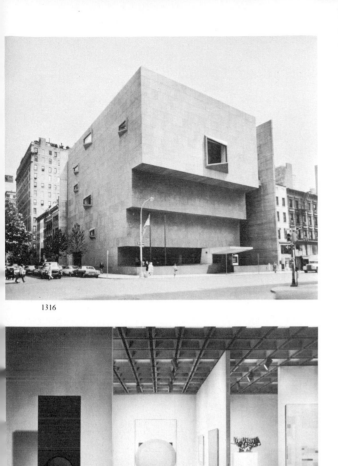

1316

1317

In countries throughout the world the problem of the air terminal has been thrust into extreme prominence by the lightning growth in air travel. How seldom it has yet been rationally faced thousands of weary air travelers can daily testify. Two of the all-too-few imaginative solutions are due to the same gifted architect, EERO SAARINEN (1910–61), son and pupil of the equally celebrated Finnish-American architect Eliel Saarinen. Eero Saarinen's untimely death prevented him from seeing either of his great air-terminal designs completed. His beautiful Trans World Airlines Terminal, finished in 1962, with its curves flowing like air currents, is the only bright spot in the hopeless confusion of New York's Kennedy Airport. And his magnificent terminal for Dulles Airport, in rural Virginia outside Washington, D.C. (fig. 1315), built in 1961–62, solves on a grand scale one of the major problems of airports—how to get passengers painlessly to and from planes, which must of necessity be widely separated on the ground—by the device of mobile lounges. At Dulles little of traditional building design is left. The sharply raking concrete columns form a kind of cradle, piercing the roof, which is concave like a colossal hammock, and is suspended from them. Even the windows are canted outward. In both his air-terminal designs, each a highly original and unique solution, Saarinen suggested the principles of aircraft construction and of aerodynamics in the lightness, buoyancy, and rounded edges of his forms.

The insistent problem of the design of the art museum has received in recent years a number of strikingly different yet effective solutions. An impressive one is the building for the Whitney Museum of American Art (fig. 1316), completed in 1966 in New York by the Hungarian-born American architect MARCEL BREUER (1902–). The immense, blank masses of the building, constructed of raw concrete blocks and granite, are cantilevered outward in three stages alongside Madison Avenue. Since the building depends on artificial illumination, there are few windows, and these are scattered and differently shaped as in Le Corbusier's chapel at Ronchamp. The vast interiors are simple and flexible; the partitions are

1318

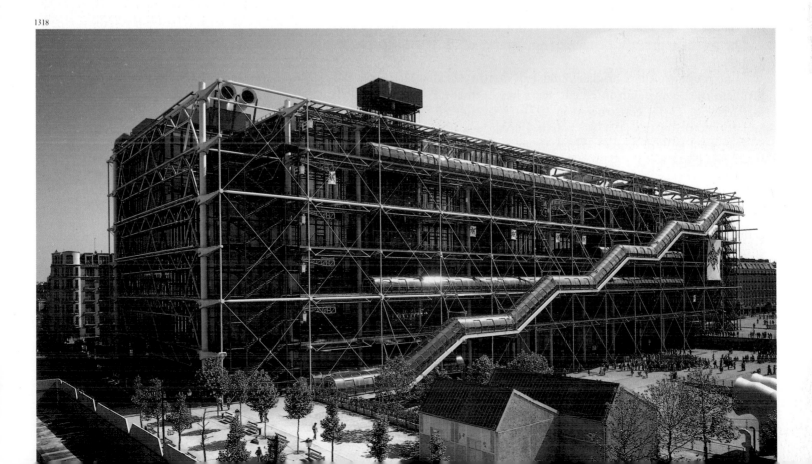

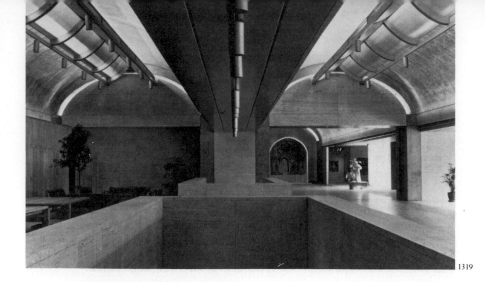

1319

movable but solid, attachable at any point under the ceiling grid, and the lighting system is extremely effective—one of the best in any New York museum (fig. 1317). Few architects of recent museum buildings have been sufficiently self-sacrificing to recognize that in a museum the work of art comes first. To his everlasting credit, Breuer has done so, and has still created a splendid building.

An architect of vast influence at midcentury was LOUIS I. KAHN (1901–74), who after thorough study of Le Corbusier turned to contemporary design problems in a highly individual and often intuitive manner, producing solutions that have been widely emulated. In his last major work, the Kimbell Art Museum in Fort Worth, Texas, completed in 1972 (fig. 1319), Kahn offered a new proposal for the museum problem. In order to utilize the abundant natural light, Kahn devised a system of semi-elliptic concrete vaults, pierced by long skylights concealed by elaborate baffles. The combination of concrete and travertine provides a sympathetic and resonant background for works of art of all periods, and the magical illumination fills the interior with a pearly radiance that brings out the paintings' colors with great accuracy, yet prevents direct glare, and belies the somewhat ponderous appearance of the interior in photographs.

The most exciting, original, and still controversial solution for the problem of the museum in recent years has been the Pompidou Center in Paris (fig. 1318), constructed in 1971–77 by RENZO PIANO (1937–) and RICHARD ROGERS (1933–). Is it a great new idea or a pretentious failure, a triumph of modern design or an insult to Paris, a vital center of intellectual and artistic activity or a supermarket of culture? The most

1320

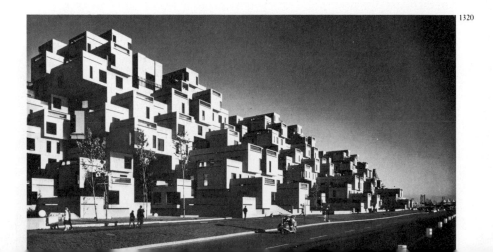

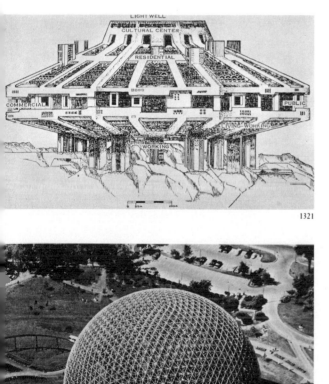

1321

1322

extraordinary aspect of the structure is that, in emulation of the Gothic cathedrals with their celebrated exoskeletons, its bones are on the outside, for all the trusses are open and visible, outside the window-walls. Even more surprisingly, so are the ducts, the ventilators, and the plexiglass escalator, the delight of tourists who sail up to ever-widening views of Paris. These utilities are, in true functionalist fashion, the only ornament, each category painted a separate bright color. Obviously such a structure would be unsuitable for Russia or for the snow and ice of the American Northeast or the Great Lakes region, but will it winter even in Paris? The Pompidou Center was not finished at the time the first edition of this book was published. At the present writing it is already cracking and peeling.

An introduction to modern architecture should consider visionary designs, some eminently practical, others that have yet to prove their merit. The first is an ingenious idea for a new kind of housing complex by the Israeli architect Moshe Safdie (1938–). In his Habitat for EXPO 67 in Montreal, Safdie devised a fresh solution for urban design, which combined ease of mass production with flexibility of plan (fig. 1320). Habitat is composed of a theoretically infinite series of precast, one-piece concrete housing units, each a complete apartment, transported to the site and set in place in a preformed frame, which can also be extended in any direction and to any height. A great amount of individuality has been allowed each tenant in the shape and size of his dwelling, in the relationships of form and space, and in the constantly changing views of the outer world and the approaches, which, on each story, include play space for children. The result is dramatic in its freedom from the uniformity of previous concepts for multiple housing, as, for example, Le Corbusier's Unité d'Habitation. Perhaps the most startling aspect of Habitat is its uncanny exterior resemblance to one of the earliest urban complexes we know, the town of Çatal Hüyük, which dates from the seventh millennium B.C. In our history of architectural development we seem to have come full circle.

Equally imaginative, but less susceptible to actual realization, are the mushroom-shaped cities (fig. 1321) envisioned by Paolo Soleri (1920–), which tower above the surrounding landscape and contain within themselves facilities for all the necessities of modern life from manufacturing to living. Finally, the uninhibited and fearless pioneer designer R. Buckminster Fuller (1895–1983) preached and practiced for nearly half a century a totally new approach to architecture in terms of prefabricated, centrally planned units. His universal solution is the geodesic dome, a spheroid structure composed of mutually sustaining polyhedral elements, which can be constructed anywhere and of any material, including opaque or transparent panels, and at extremely low cost. Previously, Fuller's domes had been realized only in greenhouses and sheds, but the American Pavilion at EXPO 67 (fig. 1322), the first large-scale realization of Fuller's eminently practical ideas, may really give us a view into the architectural future.

As we have seen in Jahn's design for the Houston Tower, the 1970s and early 1980s have been years of exciting experimentation in architectural thinking, during which many of the shibboleths of early-twentieth-century architectural theory have been swept into the discard. Controversy is the hallmark of vitality in any period, and at the time of writing these words controversy boils happily along. Out of the scores of fascinating and sometimes supremely beautiful buildings built in recent years all over Europe, the Near East, the United States, Canada, Australia, and Japan, let us choose three, recognizing from the start that any choice

among works so recent is sure to be a bit arbitrary. Two of the buildings are by Americans born in 1934, MICHAEL GRAVES and RICHARD MEIER, and one by a five-years-younger Spaniard—or, as he would probably prefer to be known, Catalan—RICARDO BOFILL.

Graves is the most gifted and prominent of the Post-Modernists, and the only one who does not deserve William Curtis's devastating assessment "cosmetic." Merely applying broken columns, plus the wrong capitals, to walls painted bright red, arches bright yellow, and spandrels bright blue does not constitute a style. Michael Graves's Portland Public Services Building, of 1980–84 (fig. 1323), functions on a higher plane. Color, both muted in single tones and strident in combinations, is essential to its formidable presence. On a slaty green podium, whose portico with its cubic piers recalls Old Kingdom Egyptian architecture, stands a butter-colored cubic mass, implacably dotted by tiny square window openings at exactly regular intervals, counting vertically and horizontally. This mass is interrupted at the center by huge horizontal pink stripes, related to smaller vertical pink stripes, breaking into an enormous sheet of mullioned glass. The utilities sit on the roof like tiny temples on an acropolis. The irrationality of the relationships, as well as the traditional adherence of the entire mass to the rectangular perimeter of the site, would have infuriated the founders of the International Style.

A few years earlier, in 1975–79, Meier had created at New Harmony, Indiana, the Atheneum (fig. 1324), a building which like all Meier's structures maintains the integrity and vitality of the very style against which Graves has pitted himself. In the exquisite adjustment of planes, the delicately integrated surfaces and spaces of both exteriors and interiors, and the stunning white, the energy of the Modernist idiom is still apparent, as it is also in the severe functional approach to all the essentials of the building (if to leave all the staircases with their iron-pipe railings open to

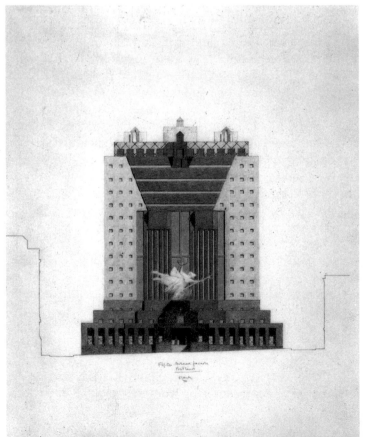

1323

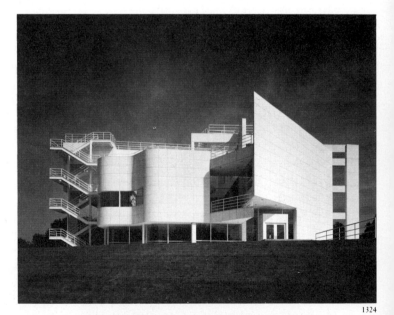

1324

1323. MICHAEL GRAVES. *Portland Public Services Building, Fifth Avenue Façade.* 1980. Pencil and prismacolor, 11 × 7½". Max Protech Gallery (courtesy Michael Graves), New York

1324. RICHARD MEIER. The Atheneum, New Harmony, Indiana. 1975–79

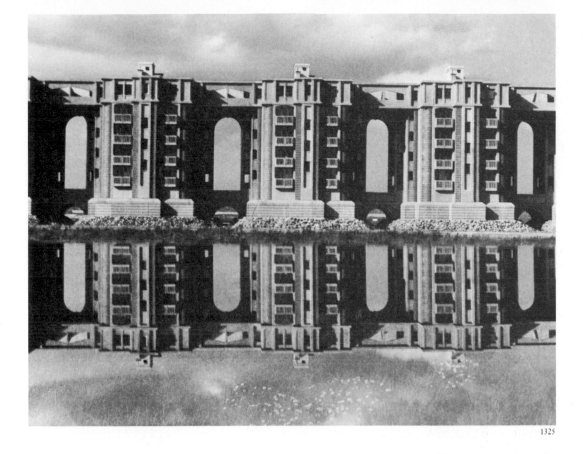

the weather is functional in an Indiana winter). The spirit of Le Corbusier is revered in this beautiful work, as is that of William Van Alen in Jahn's Bank of the Southwest in Houston. But Meier has opened up the Le Corbusier box, which now radiates at will on the green lawn. He has also interrupted the severity of its planes by new arrangements of reticulated surfaces, diagonal edges, and curving walls in a manner alien to the dogmas of the International Style. The result, as slender, elastic, and proud as an egret, stands above the lawn in perfect equipoise, its interiors filled with white light.

A still different conception of architecture, almost Gothic in the ease and the flexibility of its infinite adjustment to circumstances, is that of Ricardo Bofill and his Barcelona firm Taller de Arquitectura. In most twentieth-century offices no commission is more resented and therefore no building duller than a housing project. The Viaduct Housing at St.-Quentin-en-Yvelines in France (fig. 1325) started with an amazing opportunity, a viaduct from which apartments, filling two out of every three arches, descend almost to water level, separated only by the massive plinths of the arches—the reverse of Ponte Vecchio in Florence. The result is a spectacular structure, without ancestry in architecture, whose consistency is carefully maintained in the flatness of the balcony balustrades and upper story, and the quarter-round corners which suggest mighty columns. These are clothed in rows of narrow, vertically aligned brown-glazed tiles, contrasted in texture but not in color with the intervening masses of rough concrete stained tan, and made rougher by pebbles. The reflection of this amazing building is especially impressive, and very fortunate. But it must be remembered that a poor building is made twice as bad by its reflection. This one, like both Graves's and Meier's structures, points the way to more and constantly changing architectural developments in the future.

1325. RICARDO BOFILL and Taller de Arquitectura. Viaduct Housing, St.-Quentin-en-Yvelines, France. 1981

TIME LINE XIV: MODERN ARCHITECTURE

	EUROPE	UNITED STATES
1885	Sagrada Familia, Barcelona, by Gaudí	Marshall Field Warehouse, Chicago, by Richardson Wainwright Building, St. Louis, by Sullivan
1905	Casa Milá, Barcelona, by Gaudí Centenary Hall, Wroclaw, by Berg	Robie House, Chicago, by Wright Woolworth Building, New York, by Gilbert
1920	Einstein Tower, Potsdam, by Mendelsohn Schröder House, Utrecht, by Rietveld Bauhaus, Dessau, by Gropius Villa Savoye, Poissy, by Le Corbusier German Pavilion, Barcelona, by Mies van der Rohe	Chrysler Building, New York, by Van Alen
1930		Daily News Building, New York, by Hood and Howells Philadelphia Savings Building, by Howe and Lescaze Kaufmann House, Bear Run, by Wright
1940	Unité d'Habitation, Marseilles, by Le Corbusier Exhibition Hall, Turin, by Nervi	

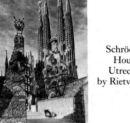

Sagrada Familia, Barcelona, by Gaudí

Schröder House, Utrecht, by Rietveld

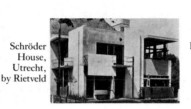

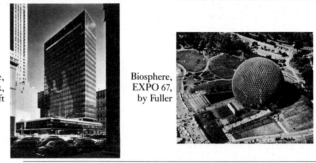

Lever House, New York, by Bunshaft

Biosphere, EXPO 67, by Fuller

	EUROPE	UNITED STATES
1950	Notre-Dame, Ronchamp, by Le Corbusier	Lever House, New York, by Bunshaft Lake Shore Apts., Chicago, by Mies van der Rohe
1960		Dulles Airport Terminal, by E. Saarinen Whitney Museum, New York, by Breuer Habitat, EXPO 67, by Safdie Biosphere, EXPO 67, by Fuller
1970	Pompidou Center, Paris, by Piano and Rogers	Kimbell Museum, Fort Worth, by Kahn Atheneum, New Harmony, by Meier
1980	Viaduct Housing, St.-Quentin-en-Yvelines, by Bofill	Portland Public Services Building, by Graves Houston Building, by Jahn

GLOSSARY

ABACUS (pl. ABACI). In architecture, the slab that forms the uppermost member of a CAPITAL and supports the ARCHITRAVE.

ABBEY. The religious body governed by an abbot or an abbess, or the monastic buildings themselves. The abbey church frequently has special features such as a particularly large CHOIR to accommodate the monks or nuns.

ACADEMY. The word, meaning a *place of study* or a *learned society*, is derived from the name of the grove near Athens where Plato and his followers held their philosophical conferences during the fifth and fourth centuries B.C. Modern academies of fine arts have as their purpose the fostering of the arts through instruction, financial assistance, and exhibitions; the first was the Accademia di Disegno founded by Giorgio Vasari in Florence in 1563; the two most influential have been the Académie Royale de Peinture et de Sculpture founded in 1648 in Paris by Louis XIV and the Royal Academy of Arts founded in London in 1768.

ACANTHUS. A plant having large toothed and scalloped leaves whose forms were imitated on CAPITALS and used to ornament MOULDINGS, BRACKETS, and FRIEZES.

ACOLYTE. In the Roman Catholic Church, an altar attendant of a minor rank.

ACROTERIUM (pl. ACROTERIA). A sculpture or other ornament placed at the lower angles and the apex of a PEDIMENT, or the PEDESTAL, often without a BASE, on which it stands.

ADOBE. A sun-dried brick used by the Indians of the western United States and Central America. A structure made of the same.

AEDICULA (pl. AEDICULAE). Latin word for *niche* or *small shrine*.

AERIAL PERSPECTIVE. See PERSPECTIVE.

AGORA. Greek word for *assembly*, thus denoting the square or marketplace that was the center of public life in every Greek city.

AISLE. See SIDE AISLE.

ALABASTER. A fine-grained gypsum or calcite, often white and translucent, though sometimes delicately tinted.

ALTARPIECE. A painted and/or sculptured work of art that stands as a religious image upon and at the back of an altar, either representing in visual symbols the underlying doctrine of the MASS, or depicting the saint to whom a particular church or chapel is dedicated, together with scenes from his life. Examples from certain periods include decorated GABLES and PINNACLES, as well as a PREDELLA. See MAESTÀ.

AMBULATORY. A place for walking, usually covered, as in an ARCADE around a cloister, or a semicircular passageway around the APSE behind the main altar. In a church or mosque with a centralized PLAN, it is the passageway around the central space that corresponds to a SIDE AISLE and that is used for ceremonial processions.

AMPHIPROSTYLE. Having a PORTICO in the rear as well as in the front, but not on the sides.

AMPHITHEATER. A double THEATER. A building of elliptical shape with tiers of seats rising one behind another about a central open space or arena.

AMPHORA (pl. AMPHORAE). A storage jar used in ancient Greece having an egg-shaped body, a foot, and two handles, each attached at the neck and shoulder of the jar.

APOCALYPSE. The Book of Revelation, the last book of the New Testament, in which are narrated the visions of the future experienced by Saint John the Evangelist on the island of Patmos.

APOCRYPHA. A group of books included at one time in authorized Christian versions of the BIBLE (now generally omitted from Protestant versions).

APOSTLES. In Christian usage the word commonly denotes the twelve followers or disciples chosen by Christ to preach his GOSPEL, though the term is sometimes used loosely. Those listed in the Gospels are: Andrew; James, the son of Zebedee, called James the Major; James, the son of Alphaeus, called James the Minor; Bartholomew; John; Judas Iscariot; Matthew; Philip; Peter; Simon the Canaanite; Thaddeus; and Thomas (Matthew 10:1–4; Mark 3:13–19).

APSE. A large semicircular or polygonal niche. In a Roman BASILICA it was frequently found at both ends of the NAVE; in a Christian church it is usually placed at one end of the nave after the CHOIR; it may also appear at the ends of the TRANSEPT and at the ends of chapels.

AQUATINT. A PRINT produced by the same technique as an ETCHING except that the areas between the etched lines are covered with a powdered resin that protects the surface from the biting process of the acid bath. The granular appearance that results in the print aims at approximating the effects and gray tonalities of a WATERCOLOR drawing.

AQUEDUCT. From the Latin for *duct of water*. An artificial channel for conducting water from a distance, which, in Roman times, was usually built overground and supported on ARCHES.

ARCADE. A series of ARCHES and their supports. Called a *blind arcade* when placed against a wall and used primarily as surface decoration.

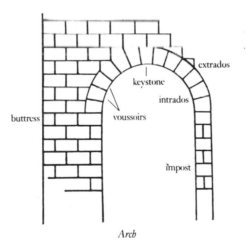

Arch

ARCH. An architectural construction, often semicircular, built of wedge-shaped blocks (called *voussoirs*) to span an opening. The center stone is called the *keystone*. The weight of this structure requires support from walls, PIERS, or COLUMNS, and the THRUST requires BUTTRESSING at the sides. When an arch is made of overlapping courses of stone, each block projecting slightly farther over the opening than the block beneath it, it is called a CORBEL ARCH.

ARCHBISHOP. The chief BISHOP of an ecclesiastical province or archbishopric.

ARCHITRAVE. The main horizontal beam and the lowest member of an ENTABLATURE; it may be a series of LINTELS, each spanning the space from the top of one support to the next.

ARCHIVOLT. The molding or moldings above an arched opening; in Romanesque and Gothic churches, frequently decorated with sculpture.

ARK OF THE COVENANT. The wooden chest containing a handwritten scroll of the TORAH. It is kept in the holiest place in the TABERNACLE, which, in Western countries, is usually against the east wall, the direction of the Holy Land.

ARRICCIO, ARRICCIATO. The rough coat of coarse plaster that is the first layer to be spread on a wall when making a FRESCO.

ARTE (pl. ARTI). See GUILDS.

A SECCO. See FRESCO.

ATMOSPHERIC PERSPECTIVE. See PERSPECTIVE.

ATRIUM. The open entrance hall or central hall of an ancient Roman house. A court in front of the principal doors of a church.

ATTIC. The upper story, usually low in height, placed above an ENTABLATURE or main CORNICE of a building, and frequently decorated with PILASTERS.

BACCHANTE (pl. BACCHAE). See MAENAD.

BALDACHIN. From Italian *baldacchino*, a rich silk fabric from Baghdad. A canopy of such material, or of wood, stone, etc., either permanently installed over an altar, throne, or doorway, or constructed in portable form to be carried in religious processions.

BALUSTRADE. A row of short pillars, called *balusters*, surmounted by a railing.

BAPTISTERY. Either a separate building or a part of a church in which the SACRAMENT of Baptism is administered.

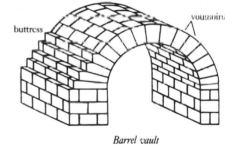

Barrel vault

BARREL VAULT. A semicylindrical VAULT that normally requires continuous support and BUTTRESSING.

BAR TRACERY. See TRACERY.

BASALT. A fine-grained volcanic rock of high density and dark color.

BASE. The lowest element of a COLUMN, PIER, PILASTER, temple, wall, or DOME, and, occasionally, of a statue.

BASILICA. In ancient Roman architecture, a rectangular building whose ground PLAN was generally divided into NAVE, SIDE AISLES, and one or more APSES, and whose elevation sometimes included a CLERESTORY and GALLERIES, though there was no strict uniformity. It was used as a hall of justice and as a public meeting place. In Christian architecture, the term is applied to any church that has a longitudinal nave terminated by an apse and flanked by lower side aisles.

BAY. A compartment into which a building may be subdivided, usually formed by the space bounded by consecutive architectural supports.

BEATO (fem. **BEATA**). Italian word meaning *blessed*. Specifically, beatification is a papal decree that declares a deceased person to be in the enjoyment of heavenly bliss (*beatus*) and grants a form of veneration to him. It is usually a step toward canonization.

BEMA. The SANCTUARY of an Early Christian or modern Eastern Orthodox church.

BENEDICTINE ORDER. Founded in 529 by Saint Benedict of Nursus (c. 480–543), at Subiaco, near Rome, the Benedictine ORDER spread to England and much of western Europe in the next two centuries. Less austere than other early orders, the Benedictines divided their time into periods of religious worship, reading, and work, the last generally either educational or agricultural.

BIBLE. The collection of sacred writings of the Christian religion that includes the Old and the New Testaments, or that of the Jewish religion, which includes the Old Testament only. The versions commonly used in the Roman Catholic Church are based on the Vulgate, a Latin translation made by Saint Jerome in the fourth century A.D. An English translation, made by members of the English College at Douai, France, between 1582 and 1610, is called the Douai. Widely used Protestant translations include Martin Luther's German translation from the first half of the sixteenth century and the English King James Version, first published in 1611.

BISHOP. A spiritual overseer of a number of churches or a *diocese*; in the Greek, Roman Catholic, Anglican, and other churches, a member of the highest order in the ministry. See CATHEDRAL.

BLESSED. See BEATO.

BLIND ARCADE. See ARCADE.

BOOK OF HOURS. See HOURS, BOOK OF.

BOTTEGA (pl. **BOTTEGHE**). Italian word for *shop*, used to describe an artist's atelier in which assistants and apprentices worked with an artist on his commissions, and in which works were displayed and offered for sale.

BRACKET. A piece of stone, wood, or metal projecting from a wall and having a flat upper surface that serves to support a statue, beam, or other weight.

BREVIARY. A book containing the daily offices or prayers and the necessary psalms and hymns for daily devotions. Frequently illustrated and generally intended for use by the clergy.

BROKEN PEDIMENT. See PEDIMENT.

BRONZE and IRON AGES. The period from approximately 3000 B.C. to the first century B.C., characterized in general by the use of metal and the smelting of metal. Farming communities were settled, and the making and use of pottery became widespread.

BURIN. See ENGRAVING.

BUTTRESS. A masonry support that counteracts the

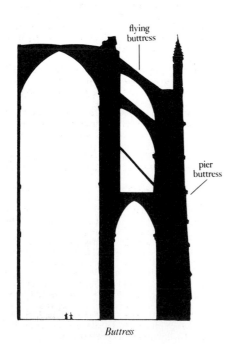

Buttress

lateral pressure, or THRUST, exerted by an ARCH or VAULT. See FLYING BUTTRESS and PIER BUTTRESS.

CALIPH. A leader of Muslims in both a spiritual and political sense; in theory, there should be only one, but in fact, after the loss of power by the Abbasid caliph in the tenth century, a Sunni caliphate was established at Córdoba (925–1030) and a Shia caliphate was established by the Fatimids (915–1171). With the murder of the last Abbasid caliph at Baghdad in 1258, a shadow caliphate survived in Egypt until the Turkish conquest of 1517. The claim of the later Turkish sultans to the caliphate was not legitimate.

CALLIGRAPHY. In a loose sense, handwriting, but usually refers to beautiful handwriting or fine penmanship.

CALVARY. See GOLGOTHA.

CAMEO. A carving in RELIEF upon a gem, stone, or shell, especially when differently colored layers of the material are revealed to produce a design of lighter color against a darker background. A gem, stone, or shell so carved.

CAMERA. Italian word for *room* or *chamber*.

CAMPAGNA. Italian word for *countryside*. When capitalized it generally refers to the area outside Rome.

CAMPANILE. From the Italian word for *bell (campana)*. A bell tower, either attached to a church or freestanding nearby.

CAMPO. Italian word for *field*; used in Siena, Venice, and other Italian cities to denote certain public squares. See PIAZZA.

CAMPO SANTO. Italian phrase for *holy field*; thus, a cemetery.

CANON. A clergyman who serves in a CATHEDRAL or a collegiate church.

CANONICAL HOURS. In the Roman Catholic Church, certain hours of each day set aside for prayer and devotion; the seven periods are: matins, prime, tierce, sext, nones, vespers, and compline. These are strictly observed only in monastic establishments.

CANON OF THE MASS. The part of the Christian MASS between the Sanctus, a hymn, and the Lord's Prayer; the actual EUCHARIST, or sacrifice of bread and wine, to which only the baptized were admitted.

CANOPY. An ornamental rooflike projection or covering placed over a niche, statue, tomb, altar, or the like.

CANTILEVER. A projecting BRACKET that supports a balcony, CORNICE, or the like, or a projecting beam or slab of great length attached at one end only.

CAPITAL. The crowning member of a COLUMN, PIER, or PILASTER on which rests the lowest element of the ENTABLATURE. See ORDER.

CARDINAL. A member of the ecclesiastical body known as the Sacred College of Cardinals, which elects the pope and constitutes his chief advisory council.

CARDINAL VIRTUES. See VIRTUES.

CARTHUSIAN ORDER. An eremitic ORDER founded by Saint Bruno (c. 1030–1101) at Chartreuse, near Grenoble, in 1084. The life of the monks was, and still is, one of prayer, silence, and extreme austerity.

CARTOON. From the Italian word *cartone*. A full-scale preparatory drawing for a painting.

CARTOUCHE. An ornamental SCROLL-shaped tablet with an inscription or decoration, either sculptured or drawn.

CARVING. The shaping of an image by cutting or chiseling it out from a hard substance such as stone or wood, in contrast to the additive process of MODELING.

CARYATID. A figure, usually female, used as a COLUMN.

CASSOCK. A long, close-fitting garment with sleeves and a high neck worn under the SURPLICE by clergymen, choristers, etc., at church services or as ordinary clerical costume.

CASTING. A method of reproducing a three-dimensional object or RELIEF by pouring a hardening liquid or molten metal into a mold bearing its impression.

CATACOMBS. Subterranean burial places consisting of GALLERIES with niches for SARCOPHAGI and small chapels for funeral feasts and commemorative services.

CATECHUMEN. One under instruction in the rudiments of Christian doctrine, usually a new convert.

CATHEDRAL. The principal church of a *diocese*, containing the BISHOP's throne, or cathedra.

CATWALK. A narrow footway at the side of a bridge or near the ceiling of a building.

CELLA. The body of a temple as distinct from the PORTICO and other external elements, or an interior structure built to house an image.

CENOTAPH. An empty tomb; a commemorative sepulchral monument not intended for burial.

CENTAUR. In Greek mythology, a creature with the head and torso of a man and the body and legs of a horse.

CENTERING. A wooden framework used as support during the construction of a stone ARCH or VAULT.

CERTOSA. Italian word for *Carthusian monastery* (*Chartreuse* in French). Adopted from the name of the town Chartreuse, where Saint Bruno founded a monastery in 1084. See also CARTHUSIAN ORDER.

CHALICE. Generally, a drinking cup, but specifically, the cup used to hold the consecrated wine of the EUCHARIST.

CHANCEL. In a church, the space reserved for the clergy and the CHOIR, between the APSE and the NAVE and TRANSEPT, usually separated from the latter two by steps and a railing or a screen.

CHARTREUSE. See CARTHUSIAN ORDER and CERTOSA.

CHASUBLE. A long, oval, sleeveless mantle with an opening for the head; it is worn over all other vestments by a priest when celebrating MASS, and it is used in commemoration of Christ's seamless robe.

CHÂTEAU (pl. **CHÂTEAUX**). A French castle or large country house.

CHERUB (pl. **CHERUBIM**). One of an order of angelic beings ranking second to the SERAPH in the celestial hierarchy, often represented as a winged child or as the winged head of a child.

CHEVET. The eastern end of a church or CATHEDRAL consisting of the AMBULATORY and a main APSE with secondary apses or chapels radiating from it.

CHEVRON. A zigzag or V-shaped pattern used decoratively, especially in Romanesque architecture.

CHIAROSCURO. From the Italian *chiaro (light)* and *oscuro (dark)*. Used to describe the opposition of light and shade.

CHITON. A sleeveless Greek TUNIC, the basic garment worn by both men and women in ancient times.

CHOIR. A body of trained singers, or that part of a church occupied by them. See CHANCEL.

CHOIR SCREEN. A partition of wood or stone, often elaborately carved, that separates the CHOIR from the NAVE and TRANSEPT of a church. In Byzantine churches, the choir screen, decorated with ICONS, is called an ICONOSTASIS.

CHRISTUS MORTUUS. Latin phrase for *dead Christ*.

CHRISTUS PATIENS. Latin phrase for *suffering Christ*. A cross with a representation of the dead Christ, which in general superseded representations of the CHRISTUS TRIUMPHANS type.

CHRISTUS TRIUMPHANS. Latin phrase for *triumphant Christ*. A cross with a representation of the living Christ, eyes open and triumphant over death. Scenes of the PASSION are usually depicted at the sides of the cross, below the crossarms.

CISTERCIAN ORDER. A reform movement in the BENEDICTINE ORDER started in France in 1098 by Saint Robert of Molesme for the purpose of reasserting the original Benedictine ideals of field work and a life of severe simplicity.

CLAUSURA. Latin word for *closure*. In the Roman Catholic Church, the word is used to signify the restriction of certain classes of nuns and monks prohibited from communication with outsiders to sections of their convents or monasteries. Those living within these restrictions are said to be *in clausura* or CLOISTERED.

CLERESTORY. The section of an interior wall that rises above adjacent rooftops, having a row of windows that admit daylight. Used in Egyptian temples, Roman BASILICAS, and Christian basilican churches; in Christian churches, the wall that rises above the nave ARCADE or the TRIFORIUM to the VAULTING or roof.

CLOISTER. Generally, a place of religious seclusion; a monastery, nunnery, or convent. Specifically, a covered walk or AMBULATORY around an open court having a plain wall on one side and an open ARCADE or COLONNADE on the other. It is commonly connected with a church, monastery, or other building, and is used for exercise and study. See CLAUSURA.

CLOSED DOOR or CLOSED GATE. Ezekiel's vision of the door or gate of the SANCTUARY in the temple that was

closed because only the Lord could enter it (Ezekiel 44:1–4). Interpreted as a prophecy and used as a symbol of Mary's virginity.

CLOSED GARDEN. "A garden enclosed is my sister, my spouse; a spring shut up, a fountain sealed" (Song of Solomon 4:12). Like CLOSED DOOR, used as a symbol of Mary's virginity.

CLUNIAC ORDER. A reformed ORDER of BENEDICTINE monks founded in 910 by William I the Pious at the monastery of Cluny in eastern France. For about 250 years it was headed by a succession of remarkable abbots who extended its rule over hundreds of monasteries in western Europe and exerted great influence in ecclesiastical and temporal affairs. With the rise of the CISTERCIAN and the mendicant ORDERS, its strength declined, and it became merely a group of French houses. The order was dissolved in 1790.

CODEX (pl. CODICES). A manuscript in book form as distinguished from a SCROLL. From the first to the fourth century A.D., the codex gradually replaced the scroll.

COFFER. A casket or box. In architecture, a recessed panel in a ceiling.

COLLAGE. From the French verb *coller*, meaning *to glue*. A composition made by pasting various scraps of materials (such as newspaper, cloth, or photographs) onto a flat surface.

COLONNADE. A series of COLUMNS spanned by LINTELS.

COLONNETTE. A small COLUMN.

COLOR. See HUE, SATURATION, and VALUE.

COLUMN. A vertical architectural support, usually consisting of a BASE, a rounded SHAFT, and a CAPITAL. When half or more of it is attached to a wall, it is called an *engaged column*. Columns are occasionally used singly for a decorative or commemorative reason. See also ORDER.

COMPANY. See SCUOLA.

COMPOUND PIER. A PIER with COLUMNS, PILASTERS, or SHAFTS attached to it, which members usually support or respond to ARCHES or RIBS above them.

CONFRATERNITY. See SCUOLA.

CONSOLE. A BRACKET, usually formed of S-shaped SCROLLS, projecting from a wall to support a LINTEL or other member.

CONTÉ CRAYON. A rich black drawing stick.

CONTRAPPOSTO. Italian word for *set against*. A device introduced in late Greek art that freed representations of the figure from the rigidity present in Egyptian and Archaic Greek painting and sculpture; used to express the shift in axes when contrasting actions set parts of the body in opposition to each other around a central vertical axis.

COPE. A semicircular cloak or cape worn by ecclesiastics in procession and on other ceremonial occasions.

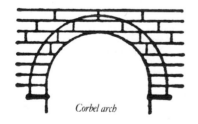

Corbel arch

CORBEL. An overlapping arrangement of stones, each course projecting beyond the one below, used to construct a VAULT or ARCH, or as a support projecting from the face of a wall.

CORBEL TABLE. A horizontal piece of masonry used as a CORNICE or part of a wall and supported by CORBELS.

CORBEL VAULT. An arched roof constructed of corbeled masonry.

CORNICE. The crowning, projecting architectural feature, especially the uppermost part of an ENTABLATURE. It is frequently decorated. When it is not horizontal, as above a PEDIMENT, it is called a *raking cornice*.

COURSED MASONRY. Masonry in which stones or bricks of equal height are placed in continuous horizontal layers.

CRENELLATED. Fortified or decorated with battlements (notched or indented parapets).

CRO-MAGNON. A species of PALEOLITHIC man, the ancestor of modern European man, whose remains were discovered in the Cro-Magnon cave in the Dordogne region of France.

CROMLECH. A circle of standing unhewn stones; the term is sometimes used interchangeably with DOLMEN.

CROSSHATCHING. See HATCHING.

CROSSING. That part of a church where the TRANSEPT crosses the NAVE; it is sometimes emphasized by a DOME or by a tower over the crossing.

CROSS SECTION. See SECTION.

CRUCIFIX. From the Latin word *crucifixus*. A representation of a cross with the figure of Christ crucified on it. See CHRISTUS MORTUUS, CHRISTUS PATIENS, and CHRISTUS TRIUMPHANS.

CRYPT. A VAULTED chamber, usually beneath the raised CHOIR of a church, housing a tomb and/or a chapel. Also, a vaulted underground chamber used for burial as in the CATACOMBS.

CUFIC. See KUFIC.

CUNEIFORM. From the Latin for *wedge-shaped*. Used to describe Mesopotamian scripts, which were written in soft clay with the wedge-shaped end of a reed.

CUPOLA. A rounded, convex roof or VAULTED ceiling on a circular BASE, requiring BUTTRESSING. See DOME.

CUSP. The pointed projection where two curves meet.

CYCLOPEAN MASONRY. Walls constructed with massive stones more or less irregular in shape, once thought to be the work of the mythical race of giants called CYCLOPES.

CYCLOPS. A member of a mythological race of giants with one round eye in the center of the forehead. The Cyclopes were believed to have forged Zeus' thunderbolts and to have built massive prehistoric walls.

DALMATIC. An ecclesiastical vestment with wide sleeves and two stripes, worn in the Western church by DEACONS and BISHOPS on certain occasions.

DEACON. A lay church officer or a subordinate minister. In the Roman Catholic, Anglican, and Episcopal churches, the cleric ranking next after the priest.

DEËSIS. The Greek word for *supplication*. A representation of Christ Enthroned between the Virgin Mary and Saint John the Baptist, who act as intercessors for mankind; it appears frequently in Byzantine MOSAICS and in later depictions of the Last Judgment.

DENTILS. A series of small, ornamental, projecting, teethlike blocks found on Ionic and Corinthian CORNICES.

DIAKONICON. See VESTRY.

DIOCESE. See BISHOP.

DIPTERAL. Having a double COLONNADE or PERISTYLE.

DIPTYCH. A pair of wood, ivory, or metal plaques usually hinged together, with the interior surfaces either painted or CARVED with a religious or memorial subject, or covered with wax for writing.

DOGE. Italian word for the *chief magistrate* in the former republics of Venice and Genoa.

DOLMEN. A structure of large unhewn stones set on end and covered with a single stone or several stones.

DOME. A large CUPOLA supported by a circular wall or DRUM, or, over a noncircular space, by corner structures. See PENDENTIVE.

DOMINICAN ORDER. A preaching ORDER of the Roman Catholic Church founded by Saint Dominic in 1216 in Toulouse. The Dominicans live austerely, believe in having no possessions, and subsist on charity. It is the second great mendicant order, after the FRANCISCAN.

DONOR. The patron or commissioner of a work of art, often represented in the work.

DORMER. A vertical window projecting from a sloping roof and having vertical sides and a flat or sloping roof.

DOUAY VERSION. See BIBLE.

DRÔLERIES. French word for *jests*. In art, designs interlaced with animals and small fanciful figures; found primarily in the margins of Gothic manuscripts, but also occasionally in decorative wood CARVINGS of the same period.

DRUM. One of several sections composing the SHAFT of a COLUMN. Also, a cylindrical wall supporting a DOME.

ECHINUS. In architecture, the rounded cushion-shaped molding below the ABACUS of a Doric CAPITAL.

ELEVATION. One side of a building, or a drawing of the same.

EMBRASURE. A door or window frame enlarged at the interior wall by beveling or splaying the sides of the frame.

ENAMEL. Powdered colored glass thermally fused to a metal ground. *Champlevé* is a method by which the areas to be filled with enamel are dug out of the ground with a cutting tool. *Cloisonné* is a method in which the surface to be decorated is divided into compartments or *cloisons* by strips of metal attached to the ground. The compartments are filled with enamel powder and the piece is fused.

ENCAUSTIC. A method of painting on wood panels and walls with colors dissolved in hot wax.

ENGAGED COLUMN. See COLUMN.

ENGRAVING. A means of ornamenting metal objects, such as suits of armor or stones, by incising a design on the surface. In pictorial arts, the technique of reproducing a design by incising it on a copper plate with a steel instrument called a *burin*, which digs up a continuous shaving of the metal, leaving a groove. The plate is inked and the ink wiped off except for that remaining in the groove. Then, by subjecting the plate to great pressure on a moistened piece of paper, the image is reproduced and the resulting PRINT is called an *engraving*.

ENTABLATURE. The upper part of an architectural ORDER, usually divided into three major parts: the ARCHITRAVE, FRIEZE, and CORNICE.

ENTASIS. The subtle convex curvature swelling along the line of taper of classical COLUMNS.

EPISTLE. In Christian usage, one of the apostolic letters that constitute twenty-one books of the New Testament. See also MASS.

ETCHING. The technique of reproducing a design by coating a metal plate with wax and drawing with a sharp instrument called a STYLUS through the wax down to the metal. The plate is put in an acid bath, which eats away the incised lines; it is then heated to dissolve the wax and finally inked and printed on paper. The resulting PRINT is called an *etching*. The plate may be altered between printings, and the prints are then differentiated as *first state, second state*, etc.

EUCHARIST. From the Greek word for *thanksgiving*. The SACRAMENT of the Lord's Supper, the consecrated bread and wine used in the rite of Communion, or the rite itself.

EVANGELISTS, FOUR. Matthew, Mark, Luke, and John, generally assumed to be the authors of the GOSPELS in the New Testament. They are usually represented with their symbols, which are derived either from the four mysterious creatures in the vision of Ezekiel (1:5) or from the four beasts surrounding the throne of the Lamb in Revelation (4:7). Frequently, they are referred to by the symbols alone: an angel for Matthew, a lion for Mark, a bull for Luke, and an eagle for John, or by a representation of the four rivers of Paradise.

EXARCHATE. A province of the Byzantine Empire ruled by a provincial governor called an *exarch*.

EXEDRA (pl. EXEDRAE). A semicircular PORCH, chapel, or recession in a wall.

EXOSKELETON. By extension from zoology, the system of supports in a French Gothic church, including the RIBBED VAULTS, FLYING BUTTRESSES, and PIER BUTTRESSES.

FAÇADE. The front or principal face of a building; sometimes loosely used to indicate the entire outer surface of any side.

FAIENCE. Glazed earthenware or pottery used for sculpture, tiles, and decorative objects.

FAN VAULT. A complex VAULT, characteristic of late English Gothic architecture, in which radiating RIBS form a fanlike pattern.

FASCES. Latin plural of *fascis* (*bundle*). A bundle of rods containing an ax with the blade projecting, borne before Roman magistrates as a symbol of power.

FASCIA (pl. FASCIAE). Any long, flat surface of wood or stone. In the Ionic and Corinthian ORDERS, the three surfaces, the top two of which project slightly over the one below, that make up the ARCHITRAVE.

FATES, THREE. In Greek and Roman mythology, the goddesses Clotho, Lachesis, and Atropos, who were believed to determine the course of human life.

FATHERS OF THE CHURCH. Early teachers and defenders of Christianity from the third to the sixth century A.D. Eight in number, they include the four Latin Fathers: Saint Jerome, Saint Ambrose, Saint Augustine, and Saint Gregory; and the four Greek Fathers: Saint John Chrysostom, Saint Basil the Great, Saint Athanasius, and Saint Gregory Nazianzen. See BIBLE.

FERROCONCRETE. See REINFORCED CONCRETE.

FINIAL. An ornament terminating a spire, PINNACLE, GABLE, etc.

FLUTING. The shallow vertical grooves in the SHAFT of a COLUMN that either meet in a sharp edge as in Doric columns, or are separated by a narrow strip as in Ionic columns.

FLYING BUTTRESS. An ARCH that springs from the upper part of the PIER BUTTRESS of a Gothic church, spans the SIDE AISLE roof, and abuts the upper NAVE wall to receive the THRUST from the nave VAULTS; it transmits this thrust to the solid pier buttress.

FONT. A receptacle in a BAPTISTERY or church for the water used in Baptism; it is usually of stone and frequently decorated with sculpture.

FORESHORTENING. In drawing, painting, etc., a method of reproducing the forms of an object not parallel to the PICTURE PLANE so that the object seems to recede in space and to convey the illusion of three dimensions as perceived by the human eye.

FORUM (pl. FORA). In ancient Rome, the center of assembly for judicial and other public business, and a gathering place for the people.

FOUR RIVERS OF PARADISE. See EVANGELISTS, FOUR.

FRANCISCAN ORDER. The first great mendicant ORDER. Founded by Saint Francis of Assisi (Giovanni de Bernardone, 1182?-1226) for the purpose of ministering to the spiritual needs of the poor and imitating as closely as possible the life of Christ, especially in its poverty; the monks depended only on alms for subsistence.

FRESCO. Italian word for *fresh*. A painting executed on wet plaster with pigments suspended in water so that the plaster absorbs the colors and the painting becomes part of the wall. *Fresco a secco*, or painting on dry plaster (*secco* is the Italian word for *dry*), is a much less durable technique; the paint tends to flake off with time. The *secco su fresco* method involves the application of color in a vehicle containing some organic binding material (such as oil, egg, or wax) over the still damp plaster.

FRIEZE. The architectural element that rests upon the ARCHITRAVE and is immediately below the CORNICE; also, any horizontal band decorated with MOLDINGS, RELIEF sculpture, or painting.

GABLE. The vertical, triangular piece of wall at the end of a ridged roof, from the level of the eaves or CORNICE to the summit; called a PEDIMENT in Classical architecture. It is sometimes used with no roof, as over the PORTALS of Gothic cathedrals, and as a decorative element on ALTARPIECES.

GALLERY. An elevated floor projecting from the interior wall of a building. In a BASILICAN church it is placed over the SIDE AISLES and supported by the COLUMNS or PIERS that separate the NAVE and the side aisles; in a church with a central PLAN, it is placed over the AMBULATORY; in an ancient Roman basilica, it was generally built over each end as well as over the side aisles.

GARDEN. See CLOSED GARDEN.

GENIUS (pl. GENII). In Classical and Renaissance art, usually the guardian spirit of a person, place, thing, or concept; often purely decorative, genii are represented in human form, frequently seminude and winged.

GENRE PAINTING. The representation of scenes from everyday life for their own sake, usually with no religious or symbolic significance.

GESSO. A mixture of finely ground plaster and glue spread on a surface in preparation for painting.

GILDING. Coating paintings, sculptures, and architectural ornament with gold, gold leaf, or some gold-colored substance, either by mechanical or chemical means. In panel painting and wood sculpture, the gold leaf is attached with a glue sizing that is usually a dull red in color.

GLAZE. In pottery, superficial layer of molten material used to coat a finished piece before it is fired in a kiln. In OIL PAINTING, a transparent film of the vehicle, customarily linseed oil mixed with turpentine, in which a small amount of pigment is dissolved, so as to change the appearance of the color beneath.

GLORY. The circle of light represented around the head or figure of the Savior, the Virgin Mary, or a saint. When it surrounds the head only, it is called a *halo*. See MANDORLA.

GOLGOTHA. From the Aramaic word for *skull*; thus, *the Place of the Skull*. The name of the place outside Jerusalem where Christ was crucified (Matthew 27:33). *Calvary*, from *calvaria*, meaning *skull* (Luke 23:33), is the Latin translation of the Aramaic word.

GORGON. In ancient Greece, one of three mythological sisters, having snakes for hair, whose hideous appearance turned every beholder to stone. Of the three, Medusa is represented most frequently.

GOSPEL. In Christian usage, the story of Christ's life and teaching, as related in the first four books of the New Testament, traditionally ascribed to the EVANGELISTS Matthew, Mark, Luke, and John. Also used to designate an ILLUMINATED copy of the same; sometimes called a Gospel lectionary. See MASS.

GREEK CROSS. A cross with four equal arms.

GRIFFIN. A fabulous animal usually having the head and wings of an eagle and the body of a lion.

GROIN. The sharp edge formed by two intersecting VAULTS.

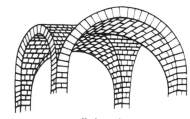

Groin vault

GROIN VAULT. A VAULT formed by the intersection at right angles of two BARREL VAULTS of equal height and diameter so that the GROINS form a diagonal cross.

GROUND PLAN. See PLAN.

GUILDS. *Arti* (sing. *Arte*) in Italian. Independent associations of bankers and of artisan-manufacturers. The seven major guilds in Florence were: *Arte della Calimala*—refiners of imported wool; *Arte della Lana*—wool merchants who manufactured their own cloth; *Arte dei Giudici e Notai*—judges and notaries; *Arte del Cambio*—bankers and money changers; *Arte della Seta*—silk weavers, to which the sculptors in metal belonged; *Arte dei Medici e Speziali*—doctors and pharmacists, to which painters belonged; *Arte dei Vaiai e Pellicciai*—furriers. Other important guilds were: *Arte di Pietra e Legname*—workers in stone and wood; *Arte dei Corazzai e Spadai*—armorers and sword makers; *Arte de Linaioli e Rigattieri*—linen drapers and peddlers.

HALL CHURCH. See HALLENKIRCHE.

HALLENKIRCHE. German word for *hall church*. A church in which the SIDE AISLES are as high, or almost as high, as the NAVE; especially popular in the German Gothic style.

HALO. See GLORY.

HARPY (pl. HARPIES). From the Greek word for *snatcher*. A female monster that carries souls to Hell; often represented with a woman's head and body, and a bird's wings, legs, claws, and tail. She occasionally appears as a more benign spirit that carries souls to another world.

HATCHING. In drawing or engraving, the use of parallel lines to produce the effect of shading. When crossing sets of parallel lines are used the technique is called *crosshatching*.

HIEROGLYPHS. Characters (pictures or symbols representing or standing for sounds, words, ideas, etc.) in the picture-writing system of the ancient Egyptians.

HIMATION. A mantle worn in ancient times by Greek men and women and draped in a variety of styles over the CHITON.

HORTUS CONCLUSUS. Latin phrase for CLOSED GARDEN.

HOST. From the Latin word for *sacrificial victim* (*hostia*). In the Roman Catholic Church it is used to designate the bread or wafer, regarded as the body of Christ, consecrated in the EUCHARIST.

HÔTEL. In French, a large private town residence.

HOURS, BOOK OF. A book for private devotions containing the prayers for the seven CANONICAL HOURS of the Roman Catholic Church. It sometimes contains a calendar, and often elaborate ILLUMINATION. The most famous examples are now known by the names of their original owners.

HUE. That attribute of a color that gives it its name. The spectrum is usually divided into six basic hues: the three primary colors of red, yellow, and blue, and the secondary colors of green, orange, and violet.

HYPOSTYLE HALL. A building whose roof is supported on COLUMNS.

ICON. Literally, any image or likeness, but commonly used to designate a panel representing Christ, the Virgin Mary, or a saint venerated by Orthodox (Eastern) Catholics.

ICONOCLASM. Breaking or destroying of images, particularly those set up for religious veneration. Many paintings and statues were destroyed in the Eastern Church in the eighth and ninth centuries as a result of the Iconoclastic Controversy. In the sixteenth and seventeenth centuries, especially in the Netherlands, the Protestants also destroyed many religious images.

ICONOSTASIS. In Eastern Christian churches, a screen separating the main body of the church from the SANCTUARY; it is usually decorated with ICONS whose subject matter and order were largely predetermined.

ILLUMINATED MANUSCRIPTS. CODICES or SCROLLS decorated with illustrations or designs in gold, silver, and bright colors.

IMAM. Muslim teacher who, serving as a priest in a mosque, recites the prayers and leads the devotions of the faithful.

IMPASTO (pl. IMPASTOS). Pigment applied very thickly to a panel or canvas.

IMPERATOR. Freely translated from the Latin as *emperor*, but in Roman times it literally meant *army commander*.

IMPOST BLOCK. A block placed between the CAPITAL of a COLUMN and the ARCHES or VAULTS it supports.

INSULA (pl. INSULAE). Latin word for *island*. In Roman antiquity, a mapped-out space or a city block. Also, a group of buildings or a large building similar to a modern apartment house.

IRON AGE. See BRONZE and IRON AGES.

JAMB. The vertical piece or pieces forming the side of a doorway or window. In Romanesque and Gothic churches, these supports were slanted or splayed outward to increase the impression of thickness in the walls and to provide space for sculptural decoration.

JESUIT ORDER. Founded as the Society of Jesus in 1540 by Saint Ignatius Loyola (1491-1556) for the purpose of achieving the spiritual perfection not only of its members but also of all men. It became a leading factor in the struggle of the Counter-Reformation to support the Catholic faith against the Protestant Reformation. It also became a teaching ORDER that was responsible for the propagation of the faith in Africa, Asia, and the Americas, as well as in Europe.

KA'BAH. The most sacred shrine of the Muslims. A small cube-shaped building in the great mosque at Mecca toward which Muslims face when praying. It contains a sacred stone said to have been turned black by the tears of repentant pilgrims or, according to another tradition, by the sins of those who have touched it.

KEEP. The innermost central tower of a medieval castle, which served both as a last defense and as a dungeon and contained living quarters, a prison, and sometimes a chapel; or a tower-like fortress, square, polygonal, or round, generally built on a mound as a military outpost.

KEYSTONE. See ARCH.

KING JAMES VERSION. See BIBLE.

KORAN. The sacred Muslim writings as revealed by Allah to Mohammed and taken down by him or his companions.

KORE (pl. KORAI). Greek for *maiden*. An archaic Greek statue of a standing clothed female.

KOUROS (pl. KOUROI). Greek for *youth*. An archaic Greek statue of a standing nude young man.

KRATER. A Greek or Roman bowl with a wide neck, used for mixing wine and water. The body has two handles projecting vertically from the juncture of the neck and body.

KUFIC or CUFIC. The earliest Arabic script used on CARVINGS and manuscripts, and, in the West, sometimes as pure ornament.

KYLIX. In Greek and Roman antiquity, a drinking vessel shaped like a shallow bowl and having two horizontal handles projecting from the sides; often set upon a stem with a foot.

LABORS OF THE MONTHS. Representations of occupations suitable to the twelve months of the year; frequently CARVED around the PORTALS of Romanesque and Gothic churches together with the signs of the ZODIAC, or represented in the calendar scenes of ILLUMINATED MANUSCRIPTS.

LANCET WINDOW. A high, narrow window with a pointed ARCH at the top.

LANTERN. In architecture, a tall, more or less open structure crowning a roof, DOME, tower, etc., and admitting light to an enclosed area below.

LAPIS LAZULI. A deep blue stone or complex mixture of minerals used for ornamentation and in the making of pigments.

LA TÈNE. An IRON AGE culture named after its site on Lake Neuchâtel in Switzerland.

LATIN CROSS. A cross whose vertical member is longer than its horizontal one.

LECTIONARY. A book containing portions of the Scriptures arranged in the order in which they are read at Christian services.

LEKYTHOS. In ancient Greece, a tall vase with an ellipsoidal body, a narrow neck, and a flanged mouth. The curved handle extends from below the lip to the shoulder, and the narrow base ends in a foot. It was used to contain oil or perfumes.

LIBERAL ARTS, SEVEN. Derived from the standard medieval prephilosophical education, they consisted of the trivium of Grammar, Rhetoric, and Logic, and the quadrivium of Arithmetic, Music, Geometry, and Astronomy. During the Middle Ages and the Renaissance, they were frequently represented allegorically.

LIGHT. A pane, or compartment of a window.

LINEAR PERSPECTIVE. See PERSPECTIVE.

LINTEL. See POST AND LINTEL.

LITANY. A form of group prayer consisting of a series of supplications by the clergy with responses from the congregation.

LITHOGRAPH. A PRINT made by drawing with a fatty crayon or other oily substance on a porous stone or a metal plate. Greasy printing ink applied to the moistened stone adheres only to the lines of the drawing; the design can be transferred easily to a damp sheet of paper.

LITURGY. A collection of prescribed prayers and ceremonies for public worship; specifically, in the Roman Catholic, Orthodox, and Anglican churches, those used in the celebration of the MASS.

LOGGIA (pl. LOGGIE). A GALLERY or ARCADE open on at least one side.

LUNETTE. A semicircular opening or surface, as on the wall of a VAULTED room or over a door, niche, or window. When it is over the PORTAL of a church, it is called a TYMPANUM.

LUTHER, MARTIN. See BIBLE.

MADRASAH. Arabic word meaning *place of study*. An Islamic theological college providing student lodgings, a prayer hall, lecture halls, and a library. Perhaps first established in the tenth century by the Ghaznavids to combat the influence of dissenting sects, such as the Shiites; by the fourteenth century madrasahs were located in all great cities of the Muslim world. Usually consists of an open quadrangle bordered by VAULTED CLOISTERS called *iwans*.

MAENAD. An ecstatic female follower of the wine god Dionysos (Greek) or Bacchus (Roman); hence, also called a *bacchante* (pl. *bacchae*).

MAESTÀ. Italian word for *majesty*, and in religion signifying the Virgin in Majesty. A large ALTARPIECE with a central panel representing the Virgin Enthroned, adored by saints and angels.

MAGUS (pl. MAGI). A member of the priestly caste in ancient Media and Persia traditionally reputed to have practiced supernatural arts. In Christian art, the Three Wise Men who came from the East to pay homage to the Infant Jesus are called the *Magi*.

MAJOLICA. A kind of Italian pottery, heavily glazed and usually decorated in rich colors.

MANDORLA. The Italian word for *almond*. A large oval surrounding the figure of God, Christ, the Virgin Mary, or occasionally a saint, indicating divinity or holiness.

MANSARD ROOF. A roof with two slopes, the lower steeper than the upper; named after the French architect François Mansart (1598-1666).

MARTYRIUM. A shrine or chapel erected in honor of or over the grave of a martyr.

MASS. The celebration of the EUCHARIST to perpetuate the sacrifice of Christ upon the Cross, plus readings from one of the GOSPELS and an EPISTLE; also, the form of LITURGY used in this celebration. See CANON OF THE MASS.

MASTABA. Arabic for *bench*. In Egyptian times, a tomb constructed of masonry and mud brick, rectangular in plan, with sloping sides and a flat roof. It covered a burial chamber and a chapel for offerings.

MAUSOLEUM. The magnificent tomb of Mausolus, erected by his wife at Halikarnassos in the middle of the fourth century B.C. Hence, any stately building erected as a burial place.

MAZZOCCHIO. A wire or wicker frame around which a hood or *cappuccio* was wrapped to form the turban-like headdress commonly worn by Florentine men in the fifteenth century.

MEANDER. From the name of a winding river in Asia Minor. In Greek decoration, an ornamental pattern of lines that wind in and out or cross one another.

MEGARON. Principal hall in the Mycenaean palace or house.

MENDICANT ORDERS. See DOMINICAN and FRANCISCAN ORDERS.

MENHIR. A prehistoric monument consisting of an upright monumental stone, left rough or sometimes partly shaped, and either standing alone or grouped with others.

MESOLITHIC ERA. Middle Stone Age, approximately 19,000-18,000 to 9000-8000 B.C. An intermediate period characterized by food-gathering activities and the beginnings of agriculture.

METOPE. A square slab, sometimes decorated, between the TRIGLYPHS in the FRIEZE of the ENTABLATURE of the Doric ORDER. Originally, the openings left by Greek builders between the ends of ceiling beams.

MIHRAB. Arabic word for a niche in the QIBLA wall of a mosque, pointing in the direction of Mecca. Perhaps of Egypto-Christian origin, it was first installed in the early eighth-century rebuilding of the mosque at Medina.

MINARET. A tall slender tower attached to a mosque and surrounded by one or more balconies from which the MUEZZIN calls the people to prayer.

MINBAR. Arabic word initially referring to the pulpit used in Medina by Mohammed, and later referring to the pulpit installed in each mosque to the right of the MIHRAB for the reading of the KORAN and prayers by the IMAM.

MINOTAUR. In Greek mythology, a monster with the body of a man and the head of a bull, who, confined in the labyrinth built for Minos, king of Crete, in his palace at Knossos, fed on human flesh and who was finally killed by the Athenian hero Theseus.

MITER. A tall cap terminating in two peaks, one in front and one in back, that is the distinctive headdress of BISHOPS (including the pope as bishop of Rome) and abbots of the Western Church.

MOAT. A deep defensive ditch that surrounds the wall of a fortified town or castle and is usually filled with water.

MODELING. The building up of three-dimensional form in a soft substance, such as clay or wax; the CARVING of surfaces into proper RELIEF; the rendering of the appearance of three-dimensional form in painting.

MOLDING. An ornamental strip, either depressed or projecting, that gives variety to the surface of a building by creating contrasts of light and shadow.

MONSTRANCE. An open or transparent receptacle of gold or silver in which the consecrated HOST is exposed for adoration.

MOSAIC. A type of surface decoration (used on pavements, walls, and VAULTS) in which bits of colored stone or glass (*tesserae*) are laid in cement in a figurative design or decorative pattern. In Roman examples, colored stones, set regularly, are most frequently used; in Byzantine work, bits of glass, many with gold baked into them, are set irregularly.

MUEZZIN. In Muslim countries, a crier who calls the people to prayer at stated hours, either from a MINARET or from another part of a mosque or high building.

MULLION. A vertical element that divides a window or a screen into partitions.

MURAL. A painting executed directly on a wall or done separately for a specific wall and attached to it.

MUSES. The nine sister goddesses of Classical mythology who presided over learning and the arts. They came to be known as Calliope, muse of epic poetry; Clio, muse of history; Erato, muse of love poetry; Euterpe, muse of music; Melpomene, muse of tragedy; Polyhymnia, muse of sacred song; Terpsichore, muse of dancing; Thalia, muse of comedy; and Urania, muse of astronomy.

NARTHEX. A PORCH or vestibule, sometimes enclosed, preceding the main entrance of a church; frequently, in churches preceded by an ATRIUM, the narthex is one side of the open AMBULATORY.

NAVE. From the Latin word for *ship*. The central aisle of an ancient Roman BASILICA or a Christian basilican church, as distinguished from the SIDE AISLES; the part of the church, between the main entrance and the CHANCEL, used by the congregation.

NEANDERTHAL MAN. A species of Middle PALEOLITHIC man.

NEOLITHIC ERA. New Stone Age, approximately 9000-8000 to 3000 B.C. Characterized by fixed settlements and farming, and the beginnings of architecture and religion.

NEOPLATONISM. A philosophy, developed by Plotinus of Alexandria in the third century A.D., founded mainly on Platonic doctrine, Oriental mysticism, and Christian beliefs, in an effort to construct an all-inclusive, philosophical system. Neoplatonism was of special interest to Italian humanists of the fifteenth century.

NIKE. See VICTORY.

OBELISK. A tapering four-sided SHAFT of stone, usually monolithic, with a pyramidal apex, used as a freestanding monument (as in ancient Egypt) or as an architectural decoration.

OCULUS (pl. OCULI). Latin word for *eye*. A circular opening in a wall or at the apex of a DOME.

OFFICE OF THE DEAD. The burial service of the Christian Church.

OIL PAINT. Pigments mixed with oil; usually applied to a panel covered with GESSO, or to a stretched canvas that has been PRIMED with a mixture of glue and white pigment.

OINOCHOE. A Greek pitcher with a three-lobed rim for dipping wine from a bowl and pouring it into wine cups.

ORANT. From the Latin word for *praying*. Used to describe figures standing with arms outstretched in an attitude of prayer.

ORATORY. In the Roman Catholic Church, a religious society of priests who live in a community, but are not bound by vows (as are monks). In architecture, a place of prayer, more specifically, a chapel or separate structure for meditation and prayer by a small group of people.

ORATORY OF DIVINE LOVE. A confraternity, founded in Rome, which by 1517 had the grudging approval of Pope Leo X. Its goals were the reform of the Church from within, the cultivation of the spiritual life of its members by prayer and frequent Communion, and the performance of charitable work. When it was dissolved in 1524, its members expanded their original work into the Theatine ORDER, which was founded in 1524 by Saint Cajetan. See SCUOLA.

ORDER (architectural). An architectural system based on the COLUMN (including BASE, SHAFT, and CAPITAL) and its ENTABLATURE (including ARCHITRAVE, FRIEZE, and CORNICE). The five classical orders are the Doric, Ionic, Corinthian, Tuscan, and Composite.

ORDER (monastic). A religious society or confraternity whose members live under a strict set of rules and regulations, such as the BENEDICTINE, CISTERCIAN, DOMINICAN, FRANCISCAN, CARTHUSIAN, CLUNIAC, JESUIT, and Theatine.

ORDINARY AND PROPER OF THE MASS. The service of the MASS exclusive of the CANON. It includes prayers, hymns, and readings from the EPISTLES and the GOSPELS.

ORTHOGONALS. Lines that are at right angles to the plane of the picture surface, but that, in a representation using one-point PERSPECTIVE, converge toward

a common vanishing point in the distance.

PAGODA. In the Far East, a sacred tower or temple usually pyramidal in shape and profusely decorated. Also, a small, ornamental structure built to imitate such a temple.

PALAZZO (pl. PALAZZI). Italian word for a *large town house;* used freely to refer to large civic or religious buildings as well as to relatively modest town houses.

PALEOLITHIC ERA. Old Stone Age, approximately 30,000 to 19,000 B.C. Populated by a society of nomadic hunters who used stone weapons and implements, and who lived largely in caves that they decorated with paintings.

PALESTRA (pl. PALESTRAE). In Greek antiquity, a public place for training in wrestling or athletics. A gymnasium.

PALETTE. A thin, usually oval or oblong tablet, with a hole for the thumb, upon which painters place and mix their colors.

PALETTE KNIFE. A small knife with a thin flexible blade, used for mixing painters' colors and sometimes for applying the paint directly to the picture surface.

PANTHEON. From the Greek words meaning *all the gods;* hence, a temple dedicated to all the gods. Specifically, the temple built about 25 B.C. in Rome and so dedicated.

PANTOCRATOR. A representation of Christ as the Almighty Ruler of the Universe (from the Greek) in which the attributes of God the Father are combined with those of the Son; an image frequently found in the apse or dome MOSAICS of Byzantine churches.

PAPYRUS. A tall aquatic plant formerly very abundant in Egypt. Also, the material used for writing or painting upon by the ancient Egyptians, Greeks, and Romans. It was made by soaking, pressing, and drying thin strips of the pith of the plant laid together. Also, a manuscript or document of this material.

PARAPET. A low protective wall or barrier at the edge of a balcony, roof, bridge, or the like.

PARCHMENT. A paper-like material made from animal skins that have been carefully scraped, stretched, and dried to whiteness. The name is a corruption of *Pergamon,* the city in Asia Minor where parchment was invented in the second century B.C. Also, a manuscript or document of such material.

PARECCLESION. A funeral chapel.

PARNASSUS. A mountain in Greece, anciently sacred to Apollo and the MUSES; hence, used allusively in both painting and poetry.

PASSION. In the Christian Church, used specifically to describe the sufferings of Christ during his last week of earthly life; also, the representation of his sufferings in narrative or pictorial form.

PASTEL. A crayon made of ground pigments mixed with gum water, or a picture drawn with such crayons.

PAVILION. A projecting subdivision of a building, usually distinguished from the main structure by greater height or more elaborate decoration. Also, a light, ornamental building or pleasure house.

PEDESTAL. An architectural support for a COLUMN, statue, vase, etc.; also a foundation or BASE.

PEDIMENT. A low-pitched triangular area, resembling a GABLE, formed by the two slopes of a roof of a building (over a PORTICO, door, niche, or window), framed by a raking CORNICE, and frequently decorated with sculpture. When pieces of the cornice are either omitted or jut out from the main axis, as in some late Roman and Baroque buildings, it is called a *broken pediment.* See TYMPANUM.

PENDENTIVE. An architectural feature, having the shape of a spherical triangle, used as a transition from a square ground PLAN to a circular plan that will support a DOME. The dome may rest directly on the pendentives or on an intermediate DRUM.

PENTATEUCH. See TORAH.

PEPLOS. A simple, loose outer garment worn by women in ancient Greece.

PERICOPE. Extracts or passages from the BIBLE selected for use in public worship.

PERIPTERAL. Having a COLONNADE or PERISTYLE on all four sides.

PERISTYLE. A COLONNADE or ARCADE around a building or open court.

PERSPECTIVE. The representation of three-dimensional objects on a flat surface so as to produce the same impression of distance and relative size as that received by the human eye. In one-point *linear per-* *spective,* developed during the fifteenth century, all parallel lines in a given visual field converge at a single vanishing point on the horizon. In *aerial* or *atmospheric perspective* the relative distance of objects is indicated by gradations of tone and color, and by variations in the clarity of outlines. See ORTHOGONALS and TRANSVERSALS.

PHARAOH. From the Egyptian word meaning *great house.* A title of the sovereigns of ancient Egypt; used in the Old Testament as a proper name.

PIAZZA (pl. PIAZZE). Italian word for *public square.* See CAMPO.

PICTURE PLANE. The actual surface on which a picture is painted.

PIER. An independent architectural element, usually rectangular in section, used to support a vertical load; if used with an ORDER, it often has a BASE and CAPITAL of the same design. See COMPOUND PIER.

PIER BUTTRESS. An exterior PIER in Romanesque and Gothic architecture, BUTTRESSING the THRUST of the VAULTS within.

PIETÀ. Italian word meaning both *pity* and *piety.* Used to designate a representation of the dead Christ mourned by the Virgin, with or without saints and angels. When the representation is intended to show a specific event prior to Christ's burial, it is usually called a *Lamentation.*

PIETRA SERENA. Italian for *clear stone.* A clear gray Tuscan limestone used for building chiefly in Florence and its environs.

PILASTER. A flat vertical element, having a CAPITAL and BASE, engaged in a wall from which it projects. It has a decorative rather than a structural purpose.

PINNACLE. A small ornamental turret on top of BUTTRESSES, PIERS, or elsewhere; mainly decorative, it may also have a structural purpose, as in Reims Cathedral.

PLAN. The general arrangement of the parts of a building or group of buildings, or a drawing of these as they would appear on a plane cut horizontally above the ground or floor.

PLATE TRACERY. See TRACERY.

PODIUM (pl. PODIA). In architecture, a continuous projecting BASE or PEDESTAL used to support COLUMNS, sculptures, or a wall. Also, the raised platform surrounding the arena of an ancient AMPHITHEATER.

POLYPTYCH. ALTARPIECE or devotional picture consisting of more than three wooden panels joined together.

PORCH. An exterior structure forming a covered approach to the entrance of a building.

PORPHYRY. A very hard rock having a dark purplish-red base. The room in the Imperial Palace in Constantinople reserved for the confinement of the reigning empress was decorated with porphyry so that the child would be "born to the purple," or "Porphyrogenitus."

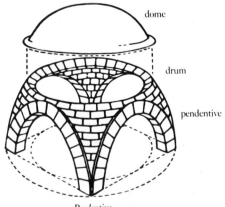

Pendentive

PORTA. Italian word for *gate.*

PORTA CLAUSA. Latin phrase for CLOSED DOOR or CLOSED GATE.

PORTAL. A door or gate, especially one of imposing appearance, as in the entrances and PORCHES of a large church or other building. In Gothic churches the FAÇADES frequently include three large portals with elaborate sculptural decoration.

PORTICO. A structure consisting of a roof, or an ENTABLATURE and PEDIMENT, supported by COLUMNS, sometimes attached to a building as a PORCH.

POST AND LINTEL. The ancient but still widely used system of construction in which the basic unit consists of two or more upright posts supporting a horizontal beam, or *lintel,* which spans the opening between them.

POTSHERD. A fragment or broken piece of earthenware.

PREDELLA. PEDESTAL of an ALTARPIECE, usually decorated with small narrative scenes that expand the theme of the major work above it.

PRIMING. A preparatory layer of paint, size, or the like applied to the surface, such as canvas or wood, that is to be painted.

PRINT. A picture, design, or the like reproduced from an engraved or otherwise prepared block or plate from which more than one copy can be made. See ENGRAVING, ETCHING, AQUATINT, WOODCUT, and LITHOGRAPH.

PRIORI. Italian word for *priors.* The council or principal governing body of a town.

PRIORY. A monastic house presided over by a prior or prioress; a dependency of an ABBEY.

PRONAOS. The vestibule in front of the doorway to the SANCTUARY in a Greek or Roman PERIPTERAL temple.

PROPYLAION (pl. PROPYLIA). Generally, the entrance to a temple or other sacred enclosure. Specifically, the entrance gate to the Acropolis in Athens.

PROSTYLE. Used to describe a temple having a PORTICO across the entire front.

PROTHESIS. In an Early Christian or modern Eastern Orthodox church, a space or chamber next to the SANCTUARY for the preparation and safekeeping of the EUCHARIST. See BEMA.

PSALTER. The Book of Psalms in the Old Testament, or a copy of it, used for liturgical or devotional purposes; many psalters illuminated in the Middle Ages have survived. See ILLUMINATED MANUSCRIPTS.

PUEBLO. Communal houses or groups of houses built of stone or ADOBE by the Indians of the southwestern United States.

PYLON. Greek word for *gateway.* In Egyptian architecture, the monumental entrance to a temple or other large edifice, consisting of two truncated pyramidal towers flanking a central gateway. Also, applied to either of the flanking towers.

QUATREFOIL A four-lobed form used as ornamentation.

QUATTROCENTO. Italian term for *four hundred,* meaning the fourteen hundreds or the fifteenth century.

QIBLA. The direction of Mecca, which Muslims face when praying, indicated by the MIHRAB in the qibla wall of a mosque.

RAKING CORNICE. See CORNICE.

REFECTORY. From the Latin verb meaning *to renew* or *restore.* A room for eating; in particular, the dining hall in a monastery, college, or other institution.

REGISTER. One of a series of horizontal bands used to differentiate areas of decoration when the bands are placed one above the other as in Egyptian tombs, medieval church sculpture, and the pages of a manuscript.

REINFORCED CONCRETE. Poured concrete with iron or steel mesh or bars imbedded in it to increase its tensile strength.

RELIEF. Sculpture that is not freestanding but projects from the background of which it is a part. *High relief* or *low relief* describes the amount of projection; when the background is not cut out, as in some Egyptian sculpture, the work is called *incised relief.*

RELIQUARY. A casket, COFFER, or other small receptacle for a sacred relic, usually made of precious materials and richly decorated.

REPOUSSOIR. From the French verb meaning *to push back.* A means of achieving PERSPECTIVE or spatial contrasts by the use of illusionistic devices such as the placement of a large figure or object in the immediate foreground of a painting to increase the illusion of depth in the rest of the picture.

RETARDATAIRE. From the French meaning *to be slow* or *behind time.* Said of an artist (or work) whose style reflects that of the past rather than that of the present.

RHYTON. An ancient Greek drinking vessel having one handle and, frequently, the shape of an animal.

RIB. A slender projecting ARCH used primarily as support in Romanesque and Gothic VAULTS; in late Gothic architecture, the ribs are frequently ornamental as well as structural.

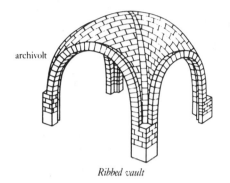

archivolt

Ribbed vault

RIBBED VAULT. A compound masonry VAULT, the GROINS of which are marked by projecting stone RIBS.

ROSARY. A series of prayers primarily to the Virgin Mary, or a string of beads invented by the DOMINICANS as an aid to memory in the recitation of these prayers. During the recitation the worshipper meditates on the five Joyful, the five Glorious, or the five Sorrowful Mysteries of the Virgin.

ROSE WINDOW. A circular window with stone TRACERY radiating from the center; a feature characteristic of Gothic church architecture.

ROSTRUM (pl. ROSTRA). A pulpit or platform for public speakers. In the Roman FORUM, the orator's platform that was decorated with the beaks of warships captured in 338 B.C.

ROTULUS (pl. ROTULI). Latin word for SCROLL.

ROTUNDA. A circular building or interior hall usually surmounted by a DOME.

RUSTICATION. Masonry having indented joinings and, frequently, a roughened surface.

SACRAMENT. A rite regarded as an outward and visible sign of an inward and spiritual grace. Specifically, in the Roman Catholic Church, any one of the seven rites recognized as having been instituted by Christ: Baptism, confirmation, the EUCHARIST, penance, matrimony, holy orders, and extreme unction.

SACRISTY. See VESTRY.

SAHN. Arabic name for the open interior courtyard of a mosque; it usually has a pool in the center.

SALON. A reception room or drawing room in a large house. Also, the exhibition of work by living painters, held in Paris at first biennially and since the mid-eighteenth century annually; so called because it was formerly held in the Salon Carré of the Louvre.

SANCTUARY. A sacred or holy place. In architecture, the term is generally used to designate the most sacred part of a building.

SARCOPHAGUS. From the Greek words meaning *flesh-eating*. In ancient Greece, a kind of limestone said to reduce flesh to dust; thus, the term was used for coffins. A general term for a stone coffin often decorated with sculpture or bearing inscriptions.

SATURATION. The degree of intensity of a HUE and its relative freedom from an admixture with white.

SATYR. One of the woodland creatures thought to be the companions of Dionysos and noted for lasciviousness; represented with the body of a man, pointed ears, two horns, a tail, and the legs of a goat.

SCRIPTURE. See BIBLE.

SCROLL. A roll of paper, parchment, or the like, intended for writing upon. In architecture, an ornament resembling a partly unrolled sheet of paper or having a spiral or coiled form, as in the VOLUTES of Ionic and Corinthian COLUMNS.

SCUOLA (pl. SCUOLE). Italian word for *school*. In Venetian Renaissance terms, a fraternal organization under ecclesiastical auspices, dedicated to good works, but with no educational function. Called a *company* elsewhere in Italy, except in Tuscany, where it was sometimes called a *confraternity*.

SECCO SU FRESCO. See FRESCO.

SECTION. A drawing or diagram of a building showing its various parts as they would appear if the building were cut on a vertical plane.

SERAPH (pl. SERAPHIM). A celestial being or angel of the highest order, usually represented with six wings.

SHAFT. A cylindrical form; in architecture, the part of a COLUMN or PIER between the BASE and the CAPITAL.

SHOP. See BOTTEGA.

SIBYL. Any of various women of Greek and Roman mythology who were reputed to possess powers of prophecy and divination. In time, as many as twelve came to be recognized, some of whom Michelangelo painted in the frescoes adorning the Sistine Chapel ceiling because they were believed to have foretold the first coming of Christ.

SIDE AISLE. One of the corridors parallel to the NAVE of a church or BASILICA, separated from it by an ARCADE or COLONNADE.

SILKSCREEN. A printmaking technique in which a design is blocked out on a piece of stretched silk gauze by means of a stencil, glue sizing, etc. Paint is then forced through the untreated spaces in the silk onto a piece of paper.

SINOPIA (pl. SINOPIE). An Italian term taken from *Sinope*, the name of a city in Asia Minor famous for its red earth. Used to designate the preliminary brush drawing, executed in red earth mixed with water, for a painting in FRESCO; usually done on the ARRICCIO.

SINS, SEVEN DEADLY. See VICES.

SIREN. In Classical mythology, one of several fabulous creatures, half woman and half bird, who were reputed to lure sailors to destruction by their seductive singing.

SLIP. Potter's clay reduced with water to a semi-liquid state and used for coating or decorating pottery, cementing handles, etc.

SOCLE. A square block supporting a COLUMN, statue, vase, or other work of art, or a low BASE supporting a wall.

SPANDREL. An area between the exterior curves of two adjoining ARCHES, or, enclosed by the exterior curve of an arch, a perpendicular from its springing and a horizontal through its apex.

SPHINX. In Egyptian mythology, a creature with the body of a lion and the head of a man, a bird, or a beast; the monumental sculpture of the same. In Greek mythology, a monster usually having the winged body of a lion and the head of a woman.

SQUINCH. An architectural device that uses ARCHES, LINTELS, or CORBELS on the corners of a square space to support a DOME and to make the transition from the square space to a polygonal or round one.

STANZA (pl. STANZE). Italian word for *room*.

STATE. See ETCHING.

STEATITE. A variety of talc or soapstone.

STELE (pl. STELAE). A greek word meaning *standing block*. An upright slab bearing sculptured or painted designs or inscriptions.

STIPPLING. In painting, drawing, and ENGRAVING, a method of representing light and shade by the use of dots.

STOA. In Greek architecture, a PORTICO or covered COLONNADE, usually of considerable length, used as a promenade or meeting place.

STONE AGE. See MESOLITHIC, NEOLITHIC, and PALEOLITHIC.

STRINGCOURSE. A horizontal MOLDING or band of stone, usually projecting and sometimes richly carved, that runs across the face of a building.

STUCCO. Any of various plasters used for CORNICES, MOLDINGS, and other wall decorations. A cement or concrete for coating exterior walls in imitation of stone.

STYLOBATE. The top step of a stepped BASE of a Greek temple, on which COLUMNS rest.

STYLUS. A pointed instrument used in ancient times for writing on tablets of a soft material, such as clay. Also, an etcher's tool. See ETCHING.

SUPERIMPOSED ORDERS. One ORDER on top of another on the face of a building of more than one story. The upper order is usually lighter in form than the lower.

SURPLICE. A loose, broad-sleeved white vestment, properly of linen, worn over the CASSOCK by clergymen, choristers, and others taking part in church services.

TABERNACLE. The portable SANCTUARY used by the Israelites in the wilderness before the building of the Temple. Generally, any place or house of worship. In architecture, a canopied niche or recess, in a wall or a pillar, built to contain an image.

TABLES OF THE LAW. The stone slabs on which the Ten Commandments were inscribed.

TEMPERA. Ground colors mixed with yolk of egg, instead of oil, as a vehicle; a medium widely used for Italian panel painting before the sixteenth century.

TENEBROSI. Italian word for *shadowy ones*. A group of Neapolitan followers of Caravaggio who adopted and exaggerated his strong contrasts of light and dark.

TERRA-COTTA. Italian words for *baked earth*. A hard glazed or unglazed earthenware used for sculpture and pottery or as a building material. The word can also mean something made of this material or its color, a dull brownish red.

TERRA VERDE. Italian words for *green earth*. The color used for the underpaint of flesh tones in TEMPERA painting.

TESSERA (pl. TESSERAE). See MOSAIC.

THEATER. In ancient Greece and Rome, an open-air structure in the form of a segment of a circle, frequently excavated from a hillside, with the seats arranged in tiers behind and above one another.

THEATINE ORDER. See ORATORY OF DIVINE LOVE.

THEOLOGICAL VIRTUES. See VIRTUES.

THOLOS. In Greek and Roman architecture, a circular building derived from early Greek tombs and used for a variety of purposes.

THRUST. The outward force exerted by an ARCH or VAULT that must be counterbalanced by BUTTRESSING.

TIARA (papal). The pope's triple crown, surmounted by the orb and cross. It is the emblem of sovereign power, but has no sacred character; at LITURGICAL functions the pope always wears a MITER.

TIE ROD. An iron rod used as a structural element to keep the lower ends of a roof or ARCH from spreading.

TOGA. A loose garment consisting of a single piece of material, without sleeves or armholes, which covered nearly the whole body, worn by the citizens of ancient Rome when appearing in public in times of peace.

TONDO. Italian term for a *circular work of art*: painting, RELIEF sculpture, or the like.

TORAH. The Jewish books of the law or the first five books of the Old Testament. Also called the *Pentateuch* in both Jewish and Christian usage.

TOTEM POLE. A wooden post carved and painted with the emblem (totem) of a clan or family, and erected in front of the homes of the Indians of northwestern America.

TRACERY. Ornamental stonework in geometric patterns used primarily in Gothic windows as support and decoration, but also used on panels, screens, etc. When the window appears to be cut through the solid stone, the style is called *plate tracery*; when slender pieces of stone are erected within the window opening, the style is called *bar tracery*.

TRANSEPT. In a BASILICAN church, the crossarm, placed at right angles to the NAVE, usually separating the latter from the CHANCEL or the APSE.

TRANSVERSALS. Horizontal lines running parallel to the PICTURE PLANE and intersecting the ORTHOGONALS.

TRAVERTINE. A tan or light-colored limestone used in Italy, and elsewhere, for building. The surface is characterized by alternating smooth and porous areas.

TREE OF LIFE. A tree in the Garden of Eden whose fruit gave everlasting life and was thus equated with Christ in medieval theology (Genesis 2:9; 3:22). Also, according to a vision of St. John the Evangelist, a tree in the heavenly city of Jerusalem with leaves for the healing of nations (Revelation 22:2).

TREE OF THE KNOWLEDGE OF GOOD AND EVIL. A tree in the Garden of Eden bearing the forbidden fruit, the eating of which destroyed Adam's and Eve's innocence (Genesis 2:9; 3:17).

TREFOIL. A three-lobed form used as ornamentation or as the basis for a ground PLAN.

TRICLINIUM. The dining room in a Roman house.

TRIFORIUM. The section of the wall in the NAVE, CHOIR, and sometimes in the TRANSEPT above the ARCHES and below the CLERESTORY. It usually consists of a blind ARCADE or a GALLERY.

TRIGLYPH. From the Greek for *three grooves*. An ornamental member of a Doric FRIEZE, placed between

two METOPES and consisting of a rectangular slab with two complete grooves in the center and a half groove at either side. Originally the end of a ceiling beam.

TRILITHON. Greek for *three stones*. A structure consisting of large unhewn stones, two upright and one resting on them like a LINTEL.

TRIPTYCH. ALTARPIECE or devotional picture consisting of three panels joined together. It is frequently hinged so that the center panel is covered when the side panels are closed.

TRITON. In Classical mythology, a son of Poseidon and Amphitrite, represented as having the head and trunk of a man and the tail of a fish, and carrying a conch shell that he blows to raise or calm the waves. Later, one of a race of subordinate sea gods.

TRIUMPHAL ARCH. In ancient Rome, a freestanding monumental ARCH or series of three arches erected to commemorate a military victory, usually decorated with sculptured scenes of a war and its subsequent triumphal procession. In a Christian church, the transverse wall with a large arched opening that separates the CHANCEL and the APSE from the main body of the church, and that is frequently decorated with religious scenes executed in MOSAIC or FRESCO.

TROPHY. A memorial erected by the ancient Greeks and Romans in commemoration of a victory. It usually consisted of arms and spoils taken from the enemy and hung on a tree or pillar. Also, the representation of such a memorial as an allegory or simply as decoration.

TRUMEAU (pl. TRUMEAUX). A central PIER dividing a wide doorway, used to support the LINTEL; in medieval churches, trumeaux were frequently decorated with sculpture.

TUFA. Any of various porous rocks composed of calcium deposited by springs or streams; or a volcanic stone.

TUMULUS (pl. TUMULI). An artificially constructed mound of earth raised over a tomb or sepulchral chamber.

TUNIC. In ancient Greece and Rome, a knee-length garment with or without sleeves, usually worn without a girdle by both sexes.

TYMPANUM (pl. TYMPANA). In Classical architecture, the vertical recessed face of a PEDIMENT; in medieval architecture, the space between an ARCH and the LINTEL over a door or window, which was often decorated with sculpture.

VALUE. The degree of lightness or darkness of a HUE.

VAULT. An ARCHED roof or covering made of brick, stone, or concrete. See BARREL VAULT, GROIN VAULT, RIBBED VAULT, CORBEL VAULT.

VELLUM. A fine kind of parchment made from calfskin and used for the writing, ILLUMINATING, and binding of medieval manuscripts.

VESTRY. A room in or a building attached to a church where the vestments and sacred vessels are kept; also called a *sacristy*. Used, in some churches, as a chapel or a meeting room.

VICAR. An ecclesiastic of the Roman Catholic Church who represents a pope or BISHOP; the pope himself as the vicar of Christ.

VICES. Coming from the same tradition as the VIRTUES, and frequently paired with them, they are more variable, but usually include Pride, Avarice, Wrath, Gluttony, and Unchastity. Others such as Folly, Inconstancy, and Injustice may be selected to make a total of seven.

VICTORY. A female deity of the ancient Romans, or the corresponding deity the ancient Greeks called *Nike*. Also, the representation of this deity, usually as a winged woman in windblown draperies and holding a laurel wreath, palm branch, or other symbolic object.

VILLA. From the Latin and Italian *villa*. Originally a country house of some size and pretension, but now also used to designate a rural or suburban residence or a detached house in a residential area.

VIRGIN IN MAJESTY. See MAESTÀ.

VIRTUES. Divided into the three Theological Virtues of Faith, Hope, and Charity, and the four Cardinal Virtues of Prudence, Justice, Fortitude, and Temperance. As with the VICES, the allegorical representation of the Virtues derives from a long medieval tradition in manuscripts and sculpture, and from such literary sources as the *Psychomachia* of Prudentius and the writings of Saint Augustine.

VOLUTE. An ornament resembling a rolled SCROLL. Especially prominent on CAPITALS of the Ionic and Composite ORDERS.

VOUSSOIR. See ARCH.

VULGATE. See BIBLE.

WASH. Used in WATERCOLOR painting, brush drawing, and occasionally in OIL PAINTING to describe a broad thin layer of diluted pigment or ink. Also refers to a drawing made in this technique.

WATERCOLOR. Paint in which the pigment is mixed with water as a solvent, or a design executed with this paint.

WESTWORK. The multistoried, towered western end of a Carolingian church that usually included a second TRANSEPT below and a chapel and GALLERIES above.

WOODCUT. A PRINT made by cutting a design in RELIEF on a block of wood and printing only the raised surfaces.

ZIGGURAT. From the Assyrian-Babylonian word *ziqquratu (mountaintop)*. A tiered, truncated pyramid of mud brick, built by the Sumerians and later by the Assyrians as a support for a shrine.

ZODIAC. An imaginary belt encircling the heavens within which lie the paths of the sun, moon, and principal planets. It is divided into twelve equal parts called *signs*, which are named after twelve constellations: Aries, the ram; Taurus, the bull; Gemini, the twins; Cancer, the crab; Leo, the lion; Virgo, the virgin; Libra, the balance; Scorpio, the scorpion; Sagittarius, the archer; Capricorn, the goat; Aquarius, the waterbearer; and Pisces, the fishes. Also, a circular or elliptical diagram representing this belt with pictures of the symbols associated with the constellations.

BOOKS FOR FURTHER READING

The author's warm thanks to Paul Barolsky and Lawrence Goedde for their assistance in compiling, respectively, the Renaissance and Baroque sections of this bibliography.

INTRODUCTION

BACHMANN, DONNA G., and PILAND, SHERRY, *Women Artists: An Historical, Contemporary and Feminist Bibliography*, Scarecrow Press, Metuchen, N.J., 1978

BERNHEIMER, RICHARD, *The Nature of Representation*, New York University Press, 1961

COLLIER, GRAHAM, *Art and the Creative Consciousness*, Prentice-Hall, Englewood Cliffs, N.J., 1972

Female Artists Past and Present, 2d ed., Women's History Research Center, Berkeley, Calif., 1974; supplement 1975

FINE, ELSA HONIG, *Women and Art, A History of Women Painters and Sculptors from the Renaissance to the Twentieth Century*, Allanheld & Schram, Montclair, N.J., 1978

FOCILLON, HENRI, *The Life of Forms in Art*, 2d ed., Wittenborn, New York, 1958

GIBSON, ÉTIENNE, *Painting and Reality*, Pantheon, New York, 1957

GOMBRICH, ERNST H., *Art and Illusion*, 2d ed., Princeton University Press, 1961; 4th ed., Phaidon, London, 1972

————, *Art, Perception and Reality*, Johns Hopkins University Press, Baltimore, 1972

HAUSER, ARNOLD, *The Social History of Art* (tr. S. Goodman, in collaboration with the author), Knopf, New York, 1951

HOLT, ELIZABETH B., *A Documentary History of Art*, 2d ed., 2 vols., Doubleday, Garden City, N.Y., 1981–

KRAUSE, JOSEPH G., *The Nature of Art*, Prentice Hall, Englewood Cliffs, N.J., 1969

MALRAUX, ANDRÉ, *TVS*, Doubleday, New York, 1953

PETERSEN, KAREN, and WILSON, J. J., *Women Artists: Recognition and Reappraisal from the Early Middle Ages to the Twentieth Century*, New York University Press, 1976

PART ONE
MAGIC, FORM, AND FANTASY

MARSHACK, ALEXANDER, *The Roots of Civilization: The Cognitive Beginnings of Man's First Art, Symbol and Notation*, McGraw-Hill, New York, 1971

CHAPTER ONE
ART BEFORE WRITING

Paleolithic Art

BANDI, HANS GEORG, et al., *The Art of the Stone Age*, Crown, New York, 1961

BREUIL, HENRI, *Four Hundred Centuries of Cave Art*, Centre d'études et de documentation préhistorique, Montignac, France, 1952

————, and LANTIER, R., *The Men of the Old Stone Age*, 2d ed., St. Martin's Press, New York, 1965

LEROI-GOURHAN, ANDRÉ, *Treasures of Prehistoric Art*, Abrams, New York, 1967

LOMMEL, ANDREAS, *Shamanism, The Beginnings of Art*, McGraw-Hill, New York, 1967

POWELL, T. G., *Prehistoric Art*, Praeger, New York, 1966

UCKO, PETER J., and ROSENFELD, A., *Palaeolithic Cave Art*, Weidenfeld & Nicholson, London, 1967

Neolithic Art

ARRIBAS, ANTONIO, *The Iberians*, Praeger, New York, 1963

DANIEL, GLYN E., *The Megalith Builders of Western Europe*, Praeger, New York, 1959

MELLAART, JAMES, *The Neolithic of the Near East*, Scribner, New York, 1975

PIGGOTT, STUART, *Ancient Europe*, Aldine, Chicago, 1966

CHAPTER TWO
THE ART OF LATER ETHNIC GROUPS

Black African Art

BASCOM, WILLIAM R., *African Art in Cultural Perspective: An Introduction*, Norton, New York, 1973

LAUDE, JEAN, *The Arts of Black Africa*, University of California Press, Berkeley, 1971

LEIRIS, MICHEL, and DULANGE, J., *African Art*, Thames & Hudson, London, 1968

LEUZINGER, ELSY, *The Art of Black Africa*, New York Graphic Society, Greenwich, Conn., 1972

WASSING, RENÉ S., *African Art: Its Background and Traditions*, Abrams, New York, 1968

WILLETT, FRANK, *African Art: An Introduction*, Praeger, New York, 1971

Oceanic Art

BÜHLER, ALFRED; BARROW, T.; and MOUNTFORD, C. T., *The Art of the South Sea Islands*, Crown, New York, 1962

SCHMITZ, CARL A., *Oceanic Art: Myth, Man, and Image in the South Seas*, Abrams, New York, 1971

North American Indian Art

ADAMS, RICHARD E. W., *Prehistoric Mesoamerica*, Little, Brown, Boston, 1977

COVARRUBIAS, MIGUEL, *The Eagle, the Jaguar and the Serpent: Indian Art of the Americas*, Knopf, New York, 1954

HIGHWATER, JAMAKE, *Arts of the Indian Americas: Leaves from the Sacred Tree*, Harper & Row, New York, 1983

Pre-Columbian Art

CORDY-COLLINS, ALANA, and STERN, JEAN, eds., *Pre-Columbian Art History: Selected Readings*, 2d ed., Peek Publications, Palo Alto, Calif., 1982

HEMMING, JOHN, and RANNEY, EDWARD, *Monuments of the Incas*, Little, Brown, Boston, 1982

HUNTER, C. BRUCE, *A Guide to Ancient Mexican Ruins*, University of Oklahoma Press, Norman, 1977

KUBLER, GEORGE, *The Art and Architecture of Ancient America*, rev. ed., Penguin, Harmondsworth and Baltimore, 1975

LAPINER, ALAN C., *Pre-Columbian Art of South America*, Abrams, New York, 1976

SOUSTELLE, JACQUES, *Mexico*, Barrie & Rockliff, Cresset Press, London, 1969

WINNING, HASSO VON, *Pre-Columbian Art of Mexico and Central America*, Abrams, New York, 1968

PART TWO
THE ANCIENT WORLD

AMIET, PIERRE, *Art in the Ancient World: A Handbook of Styles and Forms*, Rizzoli, New York, 1981

GROENEWEGEN-FRANKFORT, HENRIETTE A., and ASHMOLE, BERNARD, *Art of the Ancient World*, Abrams, New York, and Prentice-Hall, Englewood Cliffs, N.J., 1971

HAWKES, JACQUETTA H., *Atlas of Ancient Archaeology*, McGraw-Hill, New York, 1974

LLOYD, SETON, et al., *Ancient Architecture*, Abrams, New York, 1974

CHAPTER ONE
EGYPTIAN ART

ALDRED, CYRIL, *The Development of Ancient Egyptian Art from 3200 to 1315 B.C.*, 3 vols., Academy Editions, London, 1973

BADAWY, ALEXANDER, *A History of Egyptian Architecture*, 3 vols., Sh. Studio Misr, Giza (I), University of California Press, Berkeley (II, III), 1954–68

EMERY, WALTER B., *Archaic Egypt*, Penguin, Baltimore, 1962

LANGE, KURT, and HIRMER, MAX, *Egypt: Architecture, Sculpture, and Painting in Three Thousand Years*, 4th ed., Phaidon, New York and London, 1968

MICHALOWSKI, KAZIMIERZ, *Art of Ancient Egypt*, Abrams, New York, 1969

SMITH, WILLIAM STEVENSON, *The Art and Architecture of Ancient Egypt*, rev. ed., Penguin, New York, 1981

CHAPTER TWO
MESOPOTAMIAN ART

AKURGAL, EKREM, *Art of the Hittites*, Abrams, New York, 1962

AMIET, PIERRE, *Art of the Ancient Near East*, Abrams, New York, 1980

FRANKFORT, HENRI, *The Art and Architecture of the Ancient Orient*, 4th ed., Penguin, Baltimore, 1969

GHIRSHMAN, ROMAN, *Iran from the Earliest Times to the Islamic Conquest*, Penguin, Harmondsworth and New York, 1978

GOFF, BEATRICE L., *Symbols of Prehistoric Mesopotamia*, Yale University Press, New Haven, 1963

KRAMER, SAMUEL N., *The Sumerians: Their History, Culture, and Character*, University of Chicago Press, 1963

LLOYD, SETON, *The Archaeology of Mesopotamia: From the Old Stone Age to the Persian Conquest*, Thames & Hudson, London, 1978

————, *The Art of the Ancient Near East*, Thames & Hudson, London, and Praeger, New York, 1961

MELLAART, JAMES, *Earliest Civilizations of the Near East*, McGraw-Hill, New York, 1965

MOOREY, P.R.S., *Ancient Iraq: Assyria and Babylonia*, Ashmolean Museum, Oxford, 1976

PARROT, ANDRÉ, *The Arts of Assyria*, Golden Press, New York, 1961

————, *Nineveh and Babylon*, Thames & Hudson, London, 1960

————, *Sumer: The Dawn of Art*, Golden Press, New York, 1961

PORADA, EDITH, *The Art of Ancient Iran: Pre-Islamic Cultures*, Crown, New York, 1965

SMITH, WILLIAM STEVENSON, *Interconnections in the Ancient Near East*, Yale University Press, New Haven, 1965

STROMMENGER, EVA, and HIRMER, MAX, *5000 Years of the Art of Mesopotamia*, Abrams, New York, 1964

WOOLLEY, SIR CHARLES LEONARD, *Mesopotamia and the Middle East*, Methuen, London, 1961

————, *Ur of the Chaldees*, rev. ed., Norton, New York, 1965

CHAPTER THREE
AEGEAN ART

BOARDMAN, JOHN, *Pre-Classical: From Crete to Archaic Greece*, Penguin, Harmondsworth, 1967

BRANIGAN, KEITH, *Aegean Metalwork of the Early and Middle Bronze Age*, Clarendon Press, Oxford, 1974

DEMARGNE, PIERRE, *Aegean Art: The Origins of Greek Art*, Golden Press, New York, and Thames & Hudson, London, 1964

EVANS, SIR ARTHUR JOHN, *The Palace of Minos*, 4 vols., Macmillan, New York, 1921–35; repr. ed., Biblo and Tannen, New York, 1964

GRAHAM, JAMES WALTER, *The Palaces of Crete*, Princeton University Press, 1962

HAMPE, ROLAND, and SIMON, ERIKA, *The Birth of Greek Art, From the Mycenaeans to the Archaic Period*, Oxford University Press, New York, 1981

HIGGINS, REYNOLD, *Minoan and Mycenaean Art*, rev. ed., Oxford University Press, New York, 1981

HOOD, SINCLAIR, *The Arts in Prehistoric Greece*, Penguin, Harmondsworth and New York, 1978

HUTCHINSON, ROBERT W., *Prehistoric Crete*, Penguin, Baltimore, 1962

MARINATOS, SPYRIDON, and HIRMER, MAX, *Crete and Mycenae*, Abrams, New York, and Thames & Hudson, London, 1960

MATZ, FRIEDRICH, *The Art of Crete and Early Greece*, Crown, New York, 1962

PENDLEBURY, JOHN D. S., *Archaeology of Crete*, Norton, New York, 1965

VERMEULE, EMILY, *Greece in the Bronze Age*, University of Chicago Press, 1964

WACE, ALAN J. B., *Mycenae: An Archaeological History and Guide*, Princeton University Press, 1949; repr. ed., Biblo and Tannen, New York, 1964

CHAPTER FOUR
GREEK ART

ARIAS, PAOLO E., and HIRMER, M., *A History of 1000 Years of Greek Vase Painting*, Abrams, New York, 1963

ASHMOLE, BERNARD, *Architect and Sculptor in Classical Greece*, New York University Press, 1972

———, and YALOURIS, N., *Olympia: The Sculptures of the Temple of Zeus*, Phaidon, London, 1967

BEAZLEY, JOHN D., *Attic Black-Figure Vase-Painters*, Clarendon Press, Oxford, 1956

———, *Attic Red-Figure Vase-Painters*, 2d ed., 3 vols., Clarendon Press, Oxford, 1963

———, and ASHMOLE, B., *Greek Sculpture and Painting to the End of the Hellenistic Period*, Cambridge University Press, 1966

BECATTI, GIOVANNI, *The Art of Ancient Greece and Rome*, Abrams, New York, 1967

BERVE, HELMUT; GRUBEN, G.; and HIRMER, M., *Greek Temples, Theatres and Shrines*, Abrams, New York, 1963

BIEBER, MARGARETE, *The Sculpture of the Hellenistic Age*, 2d ed., Columbia University Press, New York, 1961

BOARDMAN, JOHN, *Athenian Black Figure Vases*, Oxford University Press, New York, 1975

———, *Athenian Red Figure Vases*, Oxford University Press, New York, 1979

———, *Greek Sculpture: The Archaic Period*, Oxford University Press, New York, 1978

———, et al., *Greek Art and Architecture*, Abrams, New York, 1967

CARPENTER, RHYS, *Aesthetic Basis of Greek Art of the Fifth and Fourth Centuries, B.C.*, 2d ed., Indiana University Press, Bloomington, 1965

———, *Greek Sculpture: A Critical Review*, University of Chicago Press, 1960

CHARBONNEAUX, JEAN, *Classical Greek Art*, Braziller, New York, 1972

———, *Greek Bronzes*, Viking, New York, 1962

———, *Hellenistic Greek Art*, Braziller, New York, 1973

———, et al., *Archaic Greek Art*, Braziller, New York, 1971

COOK, ROBERT M., *Greek Art: Its Development, Character, and Influence*, Farrar, Straus & Giroux, New York, 1973

———, *Greek Painted Pottery*, 2d ed., Methuen, London, 1966

HIGGINS, REYNOLD A., *Greek Terracottas*, Methuen, London, 1967

KRAAY, COLIN M., and HIRMER, M., *Greek Coins*, Abrams, New York, and Thames & Hudson, London, 1966

LANE, ARTHUR, *Greek Pottery*, 3d ed., Faber & Faber, London, 1971

LANGLOTZ, ERNST, and HIRMER, M., *The Art of Magna Graecia: Greek Art in Southern Italy and Sicily*, Thames & Hudson, London, 1965

LAWRENCE, ARNOLD W., *Greek Architecture*, 2d ed., Penguin, Baltimore, 1967

LULLIES, REINHARD, and HIRMER, M., *Greek Sculpture*, Abrams, New York, 1960

POLLITT, J. J., *The Ancient View of Greek Art*, Yale University Press, New Haven, 1974

———, *Art and Experience in Classical Greece*, Cambridge University Press, 1972

———, *The Art of Greece (1400–31 B.C.): Sources and Documents in the History of Art*, Prentice-Hall, Englewood Cliffs, N.J., 1965

RICHTER, GISELA M. A., *A Handbook of Greek Art*, 6th ed., Phaidon, New York, 1969

———, *Perspective in Greek and Roman Art*, Phaidon, London and New York, 1970

———, *The Portraits of the Greeks*, 3 vols., Phaidon, London, 1965

———, *The Sculpture and Sculptors of the Greeks*, 4th ed., Yale University Press, New Haven, 1970

RIDGWAY, B. S., *The Archaic Style in Greek Sculpture*, Princeton University Press, 1977

———, *Fifth Century Styles in Greek Sculpture*, Princeton University Press, 1981

———, *The Severe Style in Greek Sculpture*, Princeton University Press, 1970

ROBERTSON, DONALD S., *Greek and Roman Architecture*, 2d ed., Cambridge University Press, 1969

ROBERTSON, MARTIN, *Greek Painting*, Skira, Geneva, 1959

———, *A History of Greek Art*, 2 vols., Cambridge University Press, London and New York, 1975

SCRANTON, ROBERT L., *Greek Architecture*, Braziller, New York, 1962

WARD PERKINS, JOHN B., *The Cities of Ancient Greece and Italy: Planning in Classical Antiquity*, Braziller, New York, 1974

WEBSTER, THOMAS B. L., *Art and Literature in Fourth-Century Athens*, Greenwood Press, New York, 1969

CHAPTER FIVE
ETRUSCAN ART

BANTI, LUISA, *Etruscan Cities and Their Culture*, University of California Press, Berkeley, 1973

BOETHIUS, AXEL, and WARD PERKINS, J. B., *Etruscan and Early Roman Architecture*, 2d integrated ed., rev., Penguin, Harmondsworth and New York, 1978

MANSUELLI, G. A., *The Art of Etruria and Early Rome*, Crown, New York, 1965

PALLOTTINO, MASSIMO, *Etruscan Painting*, Skira, New York, 1953

RICHARDSON, EMELINE, *The Etruscans: Their Art and Civilization*, University of Chicago Press, 1976

RIIS, P. J., *An Introduction to Etruscan Art*, Munksgaard, Copenhagen, 1953

CHAPTER SIX
ROMAN ART

ANDREAE, BERNARD, *The Art of Rome*, Abrams, 1977

BLAKE, MARION E., *Roman Construction in Italy from Nerva Through the Antonines*, American Philosophical Society, Philadelphia, 1973

BRENDEL, OTTO, *Prolegomena to the Study of Roman Art*, Yale University Press, New Haven, 1979

BRILLIANT, RICHARD, *Roman Art from the Republic to Constantine*, Phaidon, New York, 1974

HANFMANN, GEORGE M. A., *Roman Art*, New York Graphic Society, Greenwich, Conn., 1964

HODDINOTT, RALPH F., *The Thracians*, Thames & Hudson, London, 1981

LEHMANN, PHYLLIS W., *Roman Wall Paintings from Boscoreale in The Metropolitan Museum of Art*, Metropolitan Museum of Art, New York, 1953

L'ORANGE, HANS PETER, *Art Forms and Civic Life in the Later Roman Empire*, Princeton University Press, 1965

MACCORMACK, SABINE, *Art and Ceremony in Late Antiquity*, University of California Press, Berkeley, 1981

MACDONALD, WILLIAM L., *The Architecture of the Roman Empire*, Vol. I, rev. ed., Yale University Press, New Haven, 1982

———, *The Pantheon: Design, Meaning and Progeny*, Harvard University Press, Cambridge, Mass., 1976

McKAY, ALEXANDER, G., *Houses, Villas and Palaces in the Roman World*, Cornell University Press, Ithaca, N.Y., 1975

MAIURI, AMEDEO, *Roman Painting*, Skira, New York, 1953

MANSUELLI, GUIDO A., *The Art of Etruria and Early Rome*, Crown, New York, 1965

NASH, ERNEST, *Pictorial Dictionary of Ancient Rome*, 2d ed., 2 vols., Praeger, New York, 1968

PERCIVAL, JOHN, *The Roman Villa: An Historical Introduction*, University of California Press, Berkeley, 1976

PERKINS, ANN, *The Art of Dura-Europos*, Clarendon Press, Oxford, 1963

POLLITT, J. J., *The Art of Rome and Late Antiquity: Sources and Documents in the History of Art*, Prentice-Hall, Englewood Cliffs, N.J., 1966

ROBERTSON, DONALD S., *Greek and Roman Architecture*, 2d ed., Cambridge University Press, 1969

STRONG, DONALD E., *Roman Art*, Penguin, Harmondsworth and Baltimore, 1976

———, *Roman Imperial Sculpture: An Introduction to the Commemorative and Decorative Sculpture of the Roman Empire Down to the Death of Constantine*, Tiranti, London, 1961

TOYNBEE, JOCELYN M. C., *Roman Historical Portraits*, Thames & Hudson, London, 1978

VERMEULE III, CORNELIUS C., *Roman Imperial Art in Greece and Asia Minor*, Belknap Press, Cambridge, Mass., 1968

WARD PERKINS, JOHN B., *Roman Architecture*, Abrams, New York, 1977

———, *Roman Imperial Architecture*, Penguin, Harmondsworth and New York, 1981

———, and BOETHIUS, AXEL, *Etruscan and Roman Architecture*, Penguin, Harmondsworth, 1970

PART THREE
THE MIDDLE AGES

DAVIS WEYER, CAECILIA, *Early Medieval Art, 300–1150: Sources and Documents in the History of Art*, Prentice-Hall, Englewood Cliffs, N.J., 1971

KIDSON, PETER, *The Medieval World*, McGraw-Hill, New York, 1967

KLINGENDER, FRANCIS D., *Animals in Art and Thought to the End of the Middle Ages*, MIT Press, Cambridge, Mass., 1971

MARTINDALE, ANDREW, *The Rise of the Artist in the Middle Ages and Early Renaissance*, McGraw-Hill, New York, 1972

OAKESHOTT, WALTER F., *Classical Inspiration in Medieval Art*, Chapman & Hall, London, 1959

SAALMAN, HOWARD, *Medieval Architecture: European Architecture, 600–1200*, Braziller, New York, 1962

SMITH, EARL BALDWIN, *Architectural Symbolism of Imperial Rome and the Middle Ages*, Princeton University Press, 1956

ZARNECKI, GEORGE, *Art of the Medieval World*, Abrams, New York, and Prentice-Hall, Englewood Cliffs, N.J., 1975

CHAPTER ONE
EARLY CHRISTIAN AND
BYZANTINE ART

BECKWITH, JOHN, *The Art of Constantinople: An Introduction to Byzantine Art (330–1453)*, 2d ed., Phaidon, New York, 1968

———, *Early Christian and Byzantine Art*, 2d integrated ed., Penguin, Baltimore, 1979

BEZA, MARCU, *Byzantine Art in Roumania*, Batsford, London, 1940

BIHALJI-MERIN, OTO, *Byzantine Frescoes and Icons in Yugoslavia*, Abrams, New York, 1960

BOVINI, GIUSEPPE, and VON MATT, L., *Ravenna*, Abrams, New York, 1972

CHATZIDAKIS, MANOLIS, *Byzantine and Early Medieval Painting*, Viking, New York, 1965

DEMUS, OTTO, *Byzantine Art and the West*, New York University Press, 1970

———, *Byzantine Mosaic Decoration*, Routledge & Kegan Paul, London, 1953

———, *The Mosaics of Norman Sicily*, Routledge & Kegan Paul, London, 1950

DER NERSESSIAN, SIRARPIE, *Armenia and the Byzantine Empire*, Harvard University Press, Cambridge, Mass., 1945

FORSYTH, GEORGE H., and WEITZMANN, K., *The Church and Fortress of Justinian*, University of Michigan Press, Ann Arbor, 1973

FRAZER, MARGARET E., *Age of Spirituality: Late Antique and Early Christian Art, Third to Seventh Century*, Metropolitan Museum of Art, New York, 1977

GALAVARIS, GEORGE, *The Icon in the Life of the Church: Doctrine, Liturgy, Devotion*, Brill, Leiden, 1981

GRABAR, ANDRÉ, *The Art of the Byzantine Empire: Byzantine Art in the Middle Ages*, Crown, New York, 1966

———, *The Beginnings of Christian Art, 200–395*, Thames & Hudson, London, 1967

———, *Byzantine Painting*, Skira, Geneva, 1953

———, *The Golden Age of Justinian: From the Death of Theodosius to the Rise of Islam*, Odyssey Press, New York, 1967

HAMILTON, GEORGE H., *Art and Architecture of Russia*, 2d ed., Viking, New York, 1975

HAMILTON, JOHN A., *Byzantine Architecture and Decoration*, 2d ed., Batsford, London, 1956: reprint, Books for Libraries/Arno, Freeport, N.Y., 1972

KITZINGER, ERNST, *The Art of Byzantium and the Medieval West: Selected Studies*, Indiana University Press, Bloomington, 1976

KOSTOF, SPIRO K., *The Orthodox Baptistery of Ravenna*, Yale University Press, New Haven, Conn., 1965

KRAUTHEIMER, RICHARD, *Early Christian and Byzantine Architecture*, Penguin, Baltimore, 1965

———, *Studies in Early Christian, Medieval and Renaissance Art*, New York University Press, 1969

MACDONALD, WILLIAM L., *Early Christian and Byzantine Architecture*, Braziller, New York, 1962

MAGUIRE, HENRY, *Art and Eloquence in Byzantium*, Princeton University Press, 1981

MANGO, CYRIL, *The Art of the Byzantine Empire, 312–1453: Sources and Documents in the History of Art*, Prentice-Hall, Englewood Cliffs, N.J., 1972

———, *Byzantine Architecture*, Abrams, New York, 1976

MATHEWS, THOMAS S., *The Byzantine Churches of Istanbul: A Photographic Survey*, Pennsylvania State University Press, University Park, 1976

PALOL SALELLAS, PEDRO DE, and HIRMER, M., *Early Medieval Art in Spain*, Thames & Hudson, London, and Abrams, New York, 1967

RICE, DAVID TALBOT, *The Appreciation of Byzantine Art*, Oxford University Press, London, 1972

———, *Art of the Byzantine Era*, Praeger, New York, and Thames & Hudson, London, 1963

———, *Byzantine Art*, rev. ed., Penguin, Harmondsworth and Baltimore, 1962

ROSTOVTSEV, MIKHAIL I., *Dura-Europos and Its Art*, Clarendon Press, Oxford, 1953

RUNCIMAN, STEVEN, *Byzantine Style and Civilization*, Penguin, Harmondsworth and Baltimore, 1975

SHUG-WILLE, CHRISTA, *Art of the Byzantine World*, Abrams, New York, 1969

SIMSON, OTTO VON, *The Sacred Fortress*, University of Chicago Press, 1948; repr. 1976

SWIFT, EMERSON H., *Hagia Sophia*, Columbia University Press, New York, 1940

UNDERWOOD, PAUL A., *The Kariye Djami*, 4 vols., Bollingen Foundation, New York, 1966–75

VOLBACH, WOLFGANG F., and HIRMER, M., *Early Christian Art*, Abrams, New York, and Thames & Hudson, London, 1962

VOYCE, ARTHUR, *The Art and Architecture of Medieval Russia*, University of Oklahoma Press, Norman, 1967

WALTER, CHRISTOPHER, *Art and Ritual of the Byzantine Church*, Variorum Reprints, London, 1982

———, *Studies in Byzantine Iconography*, Variorum Reprints, London, 1977

WEITZMANN, KURT, *Byzantine Book Illumination and Ivories*, Variorum Reprints, London, 1980

———, *Late Antique and Early Christian Book Illumination*, Braziller, New York, 1977

———, *The Monastery of Saint Catherine at Mount Sinai: The Icons*, Princeton University Press, 1976

———, *A Treasury of Icons: Sixth to Seventeenth Centuries*, Abrams, New York, 1967

———, et al., *The Icon*, Knopf, New York, 1982

CHAPTER TWO
ISLAMIC ART

ASLANAPA, OKTAY, *Turkish Art and Architecture*, Praeger, New York, and Faber & Faber, London, 1971

BINYON, LAWRENCE; WILKINSON, J.V.S.; and GRAY, B., *Persian Miniature Painting*, Oxford University Press, New York and London, 1933

BRICE, WILLIAM C., ed., *An Historical Atlas of Islam*, Brill, Leiden, 1981

CRESWELL, K.A.C., *Early Muslim Architecture*, 2 vols., Clarendon Press, Oxford, 1932–40; 2d ed. with van Berchem, Marguerite, Clarendon Press, Oxford, 1969

———, *The Muslim Architecture of Egypt*, 2 vols., Clarendon Press, Oxford, 1952–59

ETTINGHAUSEN, RICHARD, *Arab Painting*, Skira, New York, 1962

GRABAR, OLEG, *The Formation of Islamic Art*, Yale University Press, New Haven, 1973

HILL, DEREK, *Islamic Architecture and Its Decoration: A.D. 800–1500*, University of Chicago Press, 1964

HOAG, JOHN D., *Islamic Architecture*, Abrams, New York, 1977

LANE, ARTHUR, *Islamic Pottery from the Ninth to the Fourteenth Centuries, A.D.*, Faber & Faber, London, 1956

POPE, ARTHUR UPHAM, and ACKERMAN, P., eds., *A Survey of Persian Art from Prehistoric Times to the Present*, 7 vols., Oxford University Press, New York and London, 1977

RICE, DAVID TALBOT, *Islamic Art*, Thames & Hudson, London, 1975

ROBINSON, B.W., et al., *Islamic Painting and the Arts of the Book*, Faber & Faber, London, 1976

CHAPTER THREE
BARBARIAN AND CHRISTIAN ART IN NORTHERN EUROPE

Barbarian Art

FOX, CYRIL F., *Life and Death in the Bronze Age*, Routledge & Kegan Paul, London, 1959

HUBERT, JEAN; PORCHER, J.; and VOLBACH, W. F., *Europe of the Invasions*, Braziller, New York, 1969

JETTMAR, KARL, *Art of the Steppes: The Eurasian Animal Style*, Methuen, London, 1967

KNOBLOCH, EDGAR, *Beyond the Oxus: Archaeology, Art and Architecture of Central Asia*, Benn, London, 1972

MEGAW, J.V.S., *Art of the European Iron Age*, Harper & Row, New York, 1970

MELLAART, JAMES, *The Chalcolithic and Early Bronze Age in the Near East and Anatolia*, Khayats, Beirut, 1966

SANDARS, NANCY K., *Bronze Age Cultures in France*, Cambridge University Press, 1957

Christian (Hiberno-Saxon) Art

ARNOLD, BRUCE, *A Concise History of Irish Art*, Praeger, New York, 1968; rev. ed., Thames & Hudson, London, 1977

BECKWITH, JOHN, *Early Medieval Art: Carolingian, Ottonian, Romanesque*, Thames & Hudson, London, 1964; Oxford University Press, New York, 1974

———, *Ivory Carvings in Early Medieval England*, New York Graphic Society, Greenwich, Conn., 1972

FINLAY, IAN, *Celtic Art: An Introduction*, Faber & Faber, London, 1973

HARBISON, PETER, et al., *Irish Art and Architecture from Prehistory to the Present*, Thames & Hudson, London, 1978

HENRY, FRANÇOISE, ed., *The Book of Kells*, Knopf, New York, 1974

———, *Irish Art in the Early Christian Period, to 800 A.D.*, Methuen, London, and Cornell University Press, Ithaca, N.Y., 1965

LUCAS, A. T., *Treasures of Ireland*, Gill & Macmillan, Dublin, 1973

STROLL, ROBERT, *Architecture and Sculpture in Early Britain*, Thames & Hudson, London, 1967

CHAPTER FOUR
THE ART OF THE HOLY ROMAN EMPIRE

BACKES, MAGNUS, and DÖLLING, R., *Art of the Dark Ages*, Abrams, New York, 1971

BECKWITH, JOHN, *Early Medieval Art: Carolingian, Ottonian, Romanesque*, Thames & Hudson, London, 1964; Oxford University Press, New York, 1974

CONANT, KENNETH J., *Carolingian and Romanesque Architecture, 800–1200*, 4th, rev. ed., Penguin, New York, 1978

DODWELL, C. R., *Painting in Europe, 800–1200*, Penguin, Baltimore, 1971

GRABAR, ANDRÉ, and NORDENFALK, C., *Early Medieval Painting*, Skira, New York, 1957

HENDERSON, GEORGE, *Early Medieval*, Penguin, Baltimore, 1972

HENRY, FRANÇOISE, *Irish Art During the Viking Invasions, 800–1200 A.D.*, Cornell University Press, Ithaca, N.Y., 1967

METROPOLITAN MUSEUM OF ART, *The Secular Spirit: Life and Art at the End of the Middle Ages*, Dutton, New York, 1975

MUTHERICH, FLORENTINE, and GAEHDE, J. E., *Carolingian Painting*, Braziller, New York, 1976

RICE, DAVID TALBOT, *The Dawn of European Civilization: The Dark Ages*, McGraw-Hill, New York, 1965

CHAPTER FIVE
ROMANESQUE ART

ALLSOPP, BRUCE, *Romanesque Architecture: The Romanesque Achievement*, John Day Co., New York, 1971

ANTHONY, EDGAR W., *Romanesque Frescoes*, Princeton University Press, 1951; distributed by Oxford University Press, London

AUBERT, MARCEL, *Romanesque Cathedrals and Abbeys of France*, N. Vane, London, 1966

BOASE, T. S. R., *English Art 1100–1216*, 2d ed., Clarendon Press, Oxford, 1968

BOLOGNA, FERDINANDO, *Early Italian Painting*, Van Nostrand, Princeton, N.J., 1964

BRAUN, HUGH, *English Abbeys*, Faber & Faber, London, 1971

———, *An Introduction to English Medieval Architecture*, 2d ed., Faber & Faber, London, 1968

CAHN, WALTER, *Romanesque Bible Illumination*, Cornell University Press, Ithaca, N.Y., 1982

CLAPHAM, ALFRED WILLIAM, *English Romanesque Architecture*, 2 vols., Clarendon Press, Oxford, 1964

CONANT, KENNETH J., *Carolingian and Romanesque Architecture, 800–1200*, 4th, rev. ed., Penguin, New York, 1978

COURTENS, ANDRÉ, *Romanesque Art in Belgium*, M. Vokaer, Brussels, 1969

CRICHTON, GEORGE H., *Romanesque Sculpture in Italy*, Routledge & Kegan Paul, London, 1954

DECKER, HEINRICH, *Romanesque Art in Italy*, Abrams, New York, 1959

DEMUS, OTTO, *Romanesque Mural Painting*, Abrams, New York, 1970

DUBY, GEORGES, *The Age of the Cathedrals: Art and Society 980–1420*, University of Chicago Press, 1981

EVANS, JOAN, *Art in Medieval France 987–1498*, Clarendon Press, Oxford, 1969

———, *The Romanesque Architecture of the Order of Cluny*, 2d ed., AMS Press, New York, 1972

FOCILLON, HENRI, *The Art of the West in the Middle Ages*, 2d ed., Phaidon, London, New York, 1969

GRABAR, ANDRÉ, and NORDENFALK, C., *Romanesque Painting*, Skira, New York, and Zwemmer, London, 1958

GRIVOT, DENIS, and ZARNECKI, GEORGE, *Gislebertus: Sculptor of Autun*, Orion, New York, 1961

HAZARD, HENRY, ed., *The Art and Architecture of the Crusader States*, University of Wisconsin Press, Madison, 1977

HELL, VERA and HELLMUT, *The Great Pilgrimage of the Middle Ages*, Barrie & Rockliff, London, 1966

KIDSON, PETER, *The Medieval World*, McGraw-Hill, New York, 1967

KRAUS, HENRY, *The Living Theatre of Medieval Art*, Indiana University Press, Bloomington, 1967

KUBACH, HANS E., *Romanesque Architecture*, Abrams, New York, 1975

KUNSTLER, GUSTAV, comp., *Romanesque Art in Europe*, Norton, New York, 1973

MICHEL, PAUL H., *Romanesque Wall Paintings in France*, Éditions du Chêne, Paris, 1949

MORRIS, RICHARD, *Cathedrals and Abbeys of England and Wales: The Building Church, 600–1540*, Dent, London, 1979

PALOL SALELLAS, PEDRO DE, and HIRMER, MAX, *Early Medieval Art in Spain*, Abrams, New York, 1967

PLATT, COLIN, *The English Medieval Town*, Secker & Warburg, London, 1976

PORTER, ARTHUR KINGSLEY, *Lombard Architecture*, 4 vols., Yale University Press, New Haven, 1915–17

———, *Romanesque Sculpture of the Pilgrimage Roads*, 10 vols., Marshall Jones, Boston, 1923

SAALMAN, HOWARD, *Medieval Cities*, Braziller, New York, 1968

SAXL, FRITZ, *English Sculptures of the Twelfth Century*, Faber & Faber, London, 1954

SCHAPIRO, MEYER, *Romanesque Art*, Braziller, New York, and Chatto & Windus, London, 1977

SMITH, J. T.; FAULKNER, P. A.; and EMERY, A., *Studies in Medieval Domestic Architecture*, Royal Archaeological Institute, London, 1975

STODDARD, WHITNEY S., *Art and Architecture in Medieval France*, Harper & Row, New York, 1972

STONE, LAWRENCE, *Sculpture in Britain in the Middle Ages*, Penguin, Harmondsworth and Baltimore, 1955

SWARZENSKI, HANNS, *Monuments of Romanesque Art*, Faber & Faber, London, 1955; 2d ed., University of Chicago Press, 1974

WEBB, GEOFFREY, *Architecture in Britain: The Middle Ages*, Penguin, Harmondsworth, 1956; 2d ed., Penguin, Baltimore, 1965

WHITEHILL, WALTER M., *Spanish Romanesque Architecture of the Eleventh Century*, repr. ed., Oxford University Press, London, 1968

ZARNECKI, GEORGE, *Romanesque Art*, Universe Books, New York, 1971

———, *Studies in Romanesque Sculpture*, Dorian Press, London, 1979

CHAPTER SIX
GOTHIC ART

ACLAND, JAMES H., *Medieval Structure: The Gothic Vault*, University of Toronto Press, 1972

ARNOLD, HUGH, *Stained Glass of the Middle Ages in England and France*, 2d ed., Macmillan, New York, 1940

AUBERT, MARCEL, *The Art of the High Gothic Era*, Crown, New York, 1965

AVRIL, FRANÇOIS, *Manuscript Painting at the Court of France: The Fourteenth Century, 1310–1380*, Braziller, New York, 1978

BONY, JEAN, *French Gothic Architecture of the 12th and 13th Centuries*, University of California Press, Berkeley, 1983

BRANNER, ROBERT, *Chartres Cathedral*, Norton, New York, 1969

———, *Gothic Architecture*, Braziller, New York, 1961

———, *St. Louis and the Court Style in Gothic Architecture*, Zwemmer, London, 1965

BRIEGER, PETER, *English Art 1216–1307*, Clarendon Press, Oxford, 1957

BUSCH, HARALD, and LOHSE, B., *Gothic Sculpture*, Macmillan, New York, 1963

DEUCHLER, FLORENS, *Gothic Art*, Universe Books, New York, 1973

DUBY, GEORGES, *The Europe of the Cathedrals, 1140–1280*, Skira, Geneva, 1966

———, *Foundations of a New Humanism, 1280–1440*, Skira, Geneva, 1966

DUPONT, J., *Gothic Painting*, Skira, New York, 1954

FOCILLON, HENRI, *The Art of the West in the Middle Ages*, II, Cornell University, Ithaca, N.Y., 1980

FRANKL, PAUL, *Gothic Architecture*, Penguin, Baltimore, 1963

FRISCH, TERESA GRACE, *Gothic Art 1140–c. 1450: Sources and Documents in the History of Art*, Prentice-Hall, Englewood Cliffs, N.J., 1971

GIMPEL, JEAN, *The Cathedral Builders*, Grove Press, New York, 1961

GRODECKI, LOUIS, et al., *Gothic Architecture*, Abrams, New York, 1977

HARVEY, JOHN H., *The Gothic World*, Batsford, London, 1950

———, *The Master Builders: Architecture in the Middle Ages*, McGraw-Hill, New York, 1971

———, *Medieval Craftsmen*, Batsford, London, 1975

JANTZEN, HANS, *The High Gothic: The Classic Cathedrals of Chartres, Reims, and Amiens*, Pantheon, New York, 1962

KATZENELLENBOGEN, ADOLF, *The Sculptural Programs of Chartres Cathedral*, John Hopkins University Press, Baltimore, 1959

MACAULAY, DAVID, *Cathedral: The Story of Its Construction*, Houghton, Mifflin, Boston, 1973

MÂLE, ÉMILE, *The Gothic Image: Religious Art in France of the Thirteenth Century*, Harper & Row, New York, 1958

PANOFSKY, ERWIN, *Abbot Suger on the Abbey Church of St.-Denis and Its Art Treasures*, 2d ed., Princeton University Press, 1979

———, *Gothic Architecture and Scholasticism*, Meridian Books, New York, 1963

PORCHER, JEAN, *Medieval French Miniatures*, Abrams, New York, 1960

SAUERLÄNDER, WILLIBALD, and HIRMER, M., *Gothic Sculptures in France 1140–1270*, Abrams, New York, 1973

SIMSON, OTTO G., VON, *The Gothic Cathedral*, Princeton University Press, 1973

PART FOUR
THE RENAISSANCE

ALBERTI, LEONE BATTISTA, *On Painting and On Sculpture* (tr. C. Grayson), Phaidon, New York, 1972

———, *Ten Books on Architecture* (ed. J. Rykwert, tr. J. Leoni), Tiranti, London, 1955

AMES-LEWIS, FRANCIS, *Drawing in Early Renaissance Italy*, Yale University Press, New Haven, 1981

BERENSON, BERNARD, *The Drawings of the Florentine Painters*, 2d ed., 3 vols., University of Chicago Press, 1970

———, *Italian Painters of the Renaissance*, rev. ed., Phaidon, London, 1967

———, *Italian Pictures of the Renaissance*, 7 vols., Phaidon, London, 1957–68

BLUNT, ANTHONY, *Artistic Theory in Italy 1450–1600*, Oxford University Press, New York, 1956

BORSOOK, EVE, *The Mural Painters of Tuscany from Cimabue to Andrea del Sarto*, Oxford University Press, New York, 1981

BURCKHARDT, JAKOB C., *The Civilization of the Renaissance in Italy* (tr. S.G.C. Middlemore), 4th ed., Phaidon, London, 1960

CENNINI, CENNINO, *The Craftsman's Handbook* (tr. D. V. Thompson, Jr.), Dover, New York, 1954

CHASTEL, ANDRÉ, *The Age of Humanism: Europe 1480–1539* (tr. K. M. Delavenay and E. M. Gwyer), McGraw-Hill, New York, 1964

———, *Studios and Styles of the Italian Renaissance* (tr. J. Griffin), Braziller, New York, 1966

GOMBRICH, E. H., *The Heritage of Apelles*, Cornell University Press, Ithaca, N.Y., 1976

———, *Norm and Form: Studies in the Art of the Renaissance*, Phaidon, London, 1966

———, *Symbolic Images: Studies in the Art of the Renaissance*, Phaidon, London, 1972

HARTT, FREDERICK, *History of Italian Renaissance Art*, 2d ed., Abrams, New York, 1979

HEYDENREICH, LUDWIG H., and LOTZ, WOLFGANG, *Architecture in Italy 1400–1600* (tr. Mary Hottinger), Penguin, Harmondsworth and Baltimore, 1974

LEONARDO DA VINCI, *Treatise on Painting* (tr. A. P. McMahon), 2 vols., Princeton University Press, 1956

LIEBERMAN, RALPH, *Renaissance Architecture in Venice*, Abbeville, New York, 1982

MARLE, RAIMOND VAN, *The Development of the Italian Schools of Painting*, vols. X–XIX, Hacker, New York, 1970

MARTINEAU, JANE, and HOPE, CHARLES, eds., *The Genius of Venice*, Abrams, New York, 1984

PANOFSKY, ERWIN, *Meaning in the Visual Arts*, Doubleday, Garden City, N.Y., 1955

———, *Renaissance and Renascences in Western Art*, Harper & Row, New York, 1969

———, *Studies in Iconology: Humanistic Themes in the Art of the Renaissance*, Oxford University Press, New York, 1939

PATER, WALTER, *The Renaissance: Studies in Art and Poetry* (ed. Donald L. Hill), University of California Press, Berkeley, 1980

POPE-HENNESSY, JOHN, *The Portrait in the Renaissance*, Pantheon, New York, 1966

SIMPSON, LUCIE, *The Greek Spirit of Renaissance Art*, Ettrick Press, Edinburgh, 1953

VASARI, GIORGIO, *The Lives of the Painters* (ed. Kenneth Clark), 3 vols., Abrams, New York, 1979

WITTKOWER, RUDOLF, *Architectural Principles in the Age of Humanism*, Random House, New York, 1965

CHAPTER ONE
THE DAWN OF INDIVIDUALISM IN ITALIAN ART—THE THIRTEENTH AND FOURTEENTH CENTURIES

BATTISTI, EUGENIO, *Cimabue*, Pennsylvania State University Press, University Park, 1967

BAXANDALL, MICHAEL, *Giotto and the Orators (1350–1450)*, Clarendon Press, Oxford, 1971

COLE, BRUCE, *Sienese Painting: From Its Origin to the Fifteenth Century*, Harper & Row, New York, 1980

CRICHTON, GEORGE H., and CRICHTON, SYLVIA R., *Nicola Pisano and the Revival of Sculpture in Italy*, Cambridge University Press, 1938

DE WALD, ERNEST, *Pietro Lorenzetti*, Harvard University Press, Cambridge, Mass., 1930

FREMANTLE, RICHARD, *Florentine Gothic Painters from Giotto to Masaccio: A Guide to Painting in and near Florence*, Secker & Warburg, London, 1975

LARNER, JOHN, *Culture and Society in Italy, 1290–1420*, Scribner, New York, 1971

MEISS, MILLARD, *Painting in Florence and Siena After the Black Death*, Princeton University Press, 1951

POPE-HENNESSY, JOHN, *Italian Gothic Sculpture*, Phaidon, London, 1955

STUBBLEBINE, JAMES H., ed., *Giotto: The Arena Chapel Frescoes*, Norton, New York, 1969

CHAPTER TWO
THE EARLY RENAISSANCE IN ITALY— THE FIFTEENTH CENTURY

ARGAN, GIULIO C., *Fra Angelico: Biographical and Critical Study* (tr. J. Emmons), Skira, Cleveland, 1955

BATTISTI, EUGENIO, *Filippo Brunelleschi: The Complete Work*, Rizzoli, New York, 1981

BAXANDALL, MICHAEL, *Painting and Experience in Fifteenth Century Italy*, Oxford University Press, New York, 1974

BERTI, LUCIANO, *Masaccio*, Pennsylvania State University Press, University Park, 1967

CHRISTIANSEN, KEITH, *Gentile da Fabriano*, Cornell University Press, Ithaca, N.Y., 1982

CLARK, KENNETH M., *Piero della Francesca*, 2d ed., Phaidon, London, 1969

COLE, BRUCE, *Masaccio and the Art of Early Renaissance Florence*, Indiana University Press, Bloomington, c. 1980

EDGERTON, SAMUEL Y., JR., *The Renaissance Rediscovery of Linear Perspective*, Harper & Row, New York, 1976

GILBERT, CREIGHTON, *Italian Art 1400–1500: Sources and Documents in the History of Art*, Prentice-Hall, Englewood Cliffs, N.J., 1979

HALE, JOHN R., *Italian Renaissance Painting from Masaccio to Titian*, Dutton, New York, 1977

HARTT, FREDERICK, and FINN, D., *Donatello: Prophet of Modern Vision*, Abrams, New York, 1973

HENDY, PHILIP, *Piero della Francesca and the Early Renaissance*, Macmillan, New York, 1968

HORNE, HERBERT, *Botticelli: Painter of Florence*, Princeton University Press, 1980

HORSTER, MARITA, *Andrea del Castagno*, Cornell University Press, Ithaca, N.Y., 1980

JANSON, H. W., *The Sculpture of Donatello*, 2 vols., Princeton University Press, 1957

KRAUTHEIMER, RICHARD, and KRAUTHEIMER-HESS,

T., *Lorenzo Ghiberti*, 2d ed., 2 vols., Princeton University Press, 1970

LADIS, ANDREW T., *Taddeo Gaddi*, University of Missouri Press, Columbia, 1982

LAUTS, JAN, ed., *Carpaccio*, Phaidon, New York, 1962

LIGHTBOWN, RONALD, *Sandro Botticelli*, 2 vols., University of California Press, Berkeley, 1978

MANETTI, ANTONIO DI TUCCIO, *The Life of Brunelleschi*, Howard Saalman, ed., Pennsylvania State University Press, University Park, 1970

MARTINDALE, ANDREW, ed., *The Complete Paintings of Mantegna*, Abrams, New York, 1967

MURRAY, PETER, and MURRAY, LINDA, *The Art of the Renaissance*, Thames & Hudson, London, 1974

PASSAVANT, GÜNTER, *Verrocchio* (tr. K. Watson), Phaidon, London, 1969

POPE-HENNESSY, JOHN, *The Complete Work of Paolo Uccello*, 2d ed., 2 vols., Phaidon, London, 1969

———, *Fra Angelico*, Phaidon, London, 1952

———, *Sienese Quattrocento Painting*, Oxford University Press, New York, 1947

ROBERTSON, GILES, *Giovanni Bellini*, Clarendon Press, Oxford, 1968

SEYMOUR, CHARLES, JR., *Jacopo della Quercia: Sculptor*, Yale University Press, New Haven, 1973

———, *Sculpture in Italy, 1400–1500*, Penguin, Baltimore, 1966

———, *The Sculpture of Verrocchio*, New York Graphic Society, Greenwich, Conn., 1971

TIETZE-CONRAT, ERICA, *Mantegna: Paintings, Drawings, Engravings*, Phaidon, New York, 1955

CHAPTER THREE
THE EARLY RENAISSANCE IN NORTHERN EUROPE

BLUM, SHIRLEY N., *Early Netherlandish Triptychs*, University of California Press, Berkeley, 1969

CHATELET, ALBERT, *Early Dutch Painting*, Rizzoli, New York, 1981

CHRISTENSEN, C., *Art and the Reformation in Germany*, Ohio University Press, Athens, and Wayne State University Press, Detroit, 1979

CONWAY, WILLIAM M., *The Van Eycks and Their Followers*, AMS Press, New York, 1979

COREMANS, PAUL, ed., *Flanders in the Fifteenth Century: Art and Civilization*, Detroit Institute of Arts, 1960

DAVIES, MARTIN, *Rogier van der Weyden*, Phaidon, London, 1972

DE TOLNAY, CHARLES, *Hieronymus Bosch* (tr. M. Bullock and H. Mins), Reynal, New York, 1966

FRIEDLANDER, MAX J., *Early Netherlandish Painting* (tr. H. Norden), 14 vols., Praeger, New York, and Phaidon, London, 1967–76

———, *From Van Eyck to Bruegel*, Cornell University Press, Ithaca, N.Y., 1981

GIBSON, WALTER S., *Hieronymus Bosch*, Oxford University Press, New York, 1973

HIND, ARTHUR M., *History of Engraving and Etching*, 3d ed., Dover, New York, 1963

———, *An Introduction to a History of Woodcut*, 2 vols., Dover, New York, 1963

HOLLSTEIN, F.W.H., *Dutch and Flemish Etchings, Engravings, and Woodcuts*, 19 vols., Menno Hertzberger, Amsterdam, 1949–74

HUIZINGA, JOHAN, *The Waning of the Middle Ages*, Doubleday/Anchor, New York, 1970

LASSAIGNE, JACQUES, *Flemish Painting* (tr. S. Gilbert), Vol. II (*Bosch to Rubens*), Skira, Geneva, 1958

MEISS, MILLARD, *French Painting in the Time of Jean de Berry: The Boucicaut Master*, Braziller, New York, 1974

———, *French Painting in the Time of Jean de Berry: The Late Fourteenth Century and the Patronage of the Duke*, 2 vols., Phaidon, London, 1967

———, *French Painting in the Time of Jean de Berry: The Limbourgs and Their Contemporaries*, 2 vols., Braziller, New York, 1974

———, ed., *The Belles Heures of Jean, Duke of Berry*, Braziller, New York, 1974

MÜLLER, THEODOR, *Sculpture in the Netherlands, France, Germany and Spain: 1400 to 1500*, Penguin, Baltimore, 1966

PANOFSKY, ERWIN, *Early Netherlandish Painting*, 2 vols., Harvard University Press, Cambridge, Mass., 1953

PHILIP, LOTTE BRAND, *The Ghent Altarpiece and the Art of Jan van Eyck*, Princeton University Press, 1971

PORCHER, JEAN, *Medieval French Miniatures*, Abrams, New York, 1960

SNYDER, JAMES, *Northern Renaissance Art*, Abrams, New York, and Prentice-Hall, Englewood Cliffs, N.J., 1985

STECHOW, WOLFGANG, *Northern Renaissance Art 1400–1600: Sources and Documents in the History of Art*, Prentice-Hall, Englewood Cliffs, N.J., 1966

STERLING, CHARLES, ed., *The Hours of Étienne Chevalier by Jean Fouquet*, Braziller, New York, 1971

CHAPTER FOUR
THE HIGH RENAISSANCE IN CENTRAL ITALY

ACKERMAN, JAMES S., *The Architecture of Michelangelo*, 2 vols., Viking, New York, 1961-64
CHIERICI, GINO, *Donato Bramante* (tr. P. Simmons), Universe Books, New York, 1960
CLARK, KENNETH M., *Leonardo da Vinci*, 2d ed., Penguin, Baltimore, 1967
DE TOLNAY, CHARLES, *Michelangelo*, 2d ed., 5 vols., Princeton University Press, 1969-71
DUSSLER, LUITPOLD, *Raphael: A Critical Catalogue*, Phaidon, New York, 1971
FISCHEL, OSKAR, *Raphael* (tr. B. Rackham), Spring Books, London, 1964
FREEDBERG, SYDNEY J., *Painting in Italy: 1500–1600*, Penguin, Harmondsworth, 1975
―――, *Painting of the High Renaissance in Rome and Florence*, Harper & Row, New York, 1971
GOLDSCHIEDER, LUDWIG, *Leonardo da Vinci*, 8th ed., Phaidon, London, 1967
―――, *Michelangelo: Paintings, Sculpture, and Architecture*, 4th ed., Phaidon, London, 1964
HARTT, FREDERICK, *Michelangelo*, 3 vols., Abrams, New York, 1965-76
HIBBARD, HOWARD, *Michelangelo*, Harper & Row, New York, 1975
JONES, ROGER, and PENNY, NICHOLAS, *Raphael*, Yale University Press, New Haven, 1983
KLEIN, ROBERT, and ZERNER, H., *Italian Art 1500–1600: Sources and Documents in the History of Art*, Prentice-Hall, Englewood Cliffs, N.J., 1966
POPE-HENNESSY, JOHN, *Italian High Renaissance and Baroque Sculpture*, 3 vols., Phaidon, London, 1963
SUMMERS, DAVID, *Michelangelo and the Language of Art*, Princeton University Press, 1981
WASSERMAN, JACK, *Leonardo*, Abrams, New York, 1975
WÖLFFLIN, HEINRICH, *Classic Art*, 2d ed., Phaidon, London, 1953

CHAPTER FIVE
MICHELANGELO AND MANNERISM

CHASTEL, ANDRÉ, *The Sack of Rome*, Princeton University Press, 1983
FREEDBERG, SYDNEY J., *Andrea del Sarto*, 2 vols., Belknap Press, Cambridge, Mass., 1963
―――, *Parmigianino: His Works in Painting*, Harvard University Press, Cambridge, Mass., 1950
FRIEDLÄNDER, WALTER F., *Mannerism and Anti Mannerism in Italian Painting*, Schocken, New York, 1965
GOULD, CECIL, *The Paintings of Correggio*, Cornell University Press, Ithaca, N.Y., 1976
McCORQUODALE, CHARLES, *Bronzino*, Harper & Row, New York, 1981
PANOFSKY, ERWIN, *The Iconography of Correggio's Camera di San Paolo*, Warburg Institute, London, 1961
POPHAM, ARTHUR E., *Correggio's Drawings*, Oxford University Press, London, 1957
―――, *The Drawings of Parmigianino*, 3 vols., Yale University Press, New Haven, 1971
SHEARMAN, JOHN, *Andrea del Sarto*, Clarendon Press, Oxford, 1965
―――, *Mannerism*, Penguin, Baltimore, 1978
SMYTH, CRAIG H., *Mannerism and Maniera*, J. J. Augustin, Locust Valley, N.Y., 1963

CHAPTER SIX
THE HIGH AND LATE RENAISSANCE IN VENICE

ACKERMAN, JAMES S., *Palladio*, Penguin, New York, 1978
BALDASS, LUDWIG VON, *Giorgione* (tr. J. M. Brownjohn), Abrams, New York, 1965
HOWARD, DEBORAH, *Jacopo Sansovino: Architecture and Patronage in Renaissance Venice*, Yale University Press, New Haven, 1975
NEWTON, ERIC, *Tintoretto*, Greenwood Press, Westport, Conn., 1972
PANOFSKY, ERWIN, *Problems in Titian*, New York University Press, 1969
PIGNATTI, TERISIO, *Giorgione*, Phaidon, London, 1971
ROSAND, DAVID, *Titian*, Abrams, New York, 1978
TIETZE, HANS, *Tintoretto: The Paintings and Drawings*, Phaidon, London, 1948
―――, *Titian: Paintings and Drawings*, 2d ed., Oxford University Press, New York, 1950
WILDE, JOHANNES, *Venetian Art from Bellini to Titian*, Oxford University Press, New York, 1974

CHAPTER SEVEN
THE HIGH AND LATE RENAISSANCE OUTSIDE ITALY

BENESCH, OTTO, *The Art of the Renaissance in Northern Europe*, 2d ed., Phaidon, London, 1965
―――, *German Painting from Dürer to Holbein* (tr. H.S.B. Harrison), Skira, Geneva, 1966
BLUNT, ANTHONY, *Art and Architecture in France: 1500 to 1700*, 2d ed., Penguin, Baltimore, 1970
GANZ, PAUL, *The Paintings of Hans Holbein the Younger*, Phaidon, London, 1956
GIBSON, WALTER S., *Bruegel*, Oxford University Press, New York, 1977
GUDIOL I RICART, JOSIP, *Domenikos Theotokopoulos, El Greco, 1541–1614* (tr. K. Lyons), Viking, New York, 1973
KUBLER, GEORGE, and SORIA, M., *Art and Architecture in Spain and Portugal...1500–1800*, Penguin, Baltimore, 1959
LAVALLEYE, JACQUES, *Pieter Brueghel the Elder and Lucas van Leyden: The Complete Engravings, Etchings and Woodcuts*, Abrams, New York, 1967
OSTEN, GERT VON DER, and VEY, H., *Paintings and Sculpture in Germany and the Netherlands: 1500–1600*, Penguin, Baltimore, 1969
PANOFSKY, ERWIN, *The Life and Art of Albrecht Dürer*, 4th ed., Princeton University Press, 1955
PEVSNER, NIKOLAUS, and MEIER, M., *Grünewald*, Abrams, New York, 1958
POST, CHANDLER R., *History of Spanish Painting*, 14 vols., Harvard University Press, Cambridge, Mass., 1930-66
RÜHMER, EBERHARD, *Cranach* (tr. J. Spencer), Phaidon, London, 1963
SMITH, ALLISON, *The Complete Paintings of Dürer*, Abrams, New York, 1968
STECHOW, WOLFGANG, *Pieter Brueghel the Elder*, Abrams, New York, 1969
STRAUSS, WALTER L., *The Complete Drawings of Albrecht Dürer*, 6 vols., Abaris, New York, 1974
WAETZOLDT, WILHELM, *Dürer and His Times*, Phaidon, New York, 1950

PART FIVE
THE BAROQUE

BAZIN, GERMAIN, *The Baroque* (tr. P. Wardroper), New York Graphic Society, Greenwich, Conn., 1968
BLUNT, ANTHONY, ed., *Baroque and Rococo: Architecture and Decoration*, Harper & Row, New York, 1978
HARTT, FREDERICK, *Love in Baroque Art*, J. J. Augustin, Locust Valley, N.Y., 1964
HELD, JULIUS S., and POSNER, D., *17th and 18th Century Art*, Abrams, New York, 1971
KITSON, MICHAEL, *The Age of Baroque*, McGraw-Hill, New York, 1966
LEVEY, MICHAEL, *Rococo to Revolution*, Praeger, New York, 1966
MARTIN, JOHN RUPERT, *Baroque*, Harper & Row, New York, 1977
MILLON, HENRY A., *Baroque and Rococo Architecture*, Braziller, New York, 1961
NORBERG-SCHULZ, CHRISTIAN, *Baroque Architecture*, Abrams, New York, 1972
―――, *Late Baroque and Rococo Architecture*, Abrams, New York, 1974
PEVSNER, NIKOLAUS, *An Outline of European Architecture*, 6th ed., Penguin, Baltimore, 1960
PIGNATTI, TERISIO, *The Age of Rococo* (tr. L. Andrade), Hamlyn, New York, 1969
THORNTON, PETER, *Seventeenth Century Interior Decoration in England, France and Holland*, Yale University Press, New Haven, 1978
WÖLFFLIN, HEINRICH, *Principles of Art History*, Dover, New York, 1950

CHAPTER ONE
THE SEVENTEENTH CENTURY IN ITALY

BLUNT, ANTHONY, and CROFT-MURRAY, E., *Venetian Drawings of the XVII and XVIII Centuries...at Windsor Castle*, Phaidon, London, 1957
ENGGASS, ROBERT, and BROWN, JONATHAN, *Italy and Spain, 1600–1750: Sources and Documents in the History of Art*, Prentice-Hall, Englewood Cliffs, N.J., 1970
FRIEDLÄNDER, WALTER F., *Caravaggio Studies*, Princeton University Press, 1955
―――, *Mannerism and Anti-Mannerism in Italian Painting*, Schocken, New York, 1965
HASKELL, FRANCIS, *Patrons and Painters: A Study in the Relations Between Italian Art and Society in the Age of the Baroque*, Knopf, New York, 1963
HIBBARD, HOWARD, *Bernini*, Penguin, Baltimore, 1965
―――, *Caravaggio*, Harper & Row, New York, 1983

―――, *Carlo Maderno and Roman Architecture, 1580–1630*, Pennsylvania State University Press, University Park, 1971
MAHON, DENIS, *Studies in Seicento Art and Theory*, Warburg Institute, London, 1947
MOIR, ALFRED, *Caravaggio*, Abrams, New York, 1982
Painting in Naples, 1606–1705, National Gallery of Art, Washington, D.C., 1983
PORTOGHESI, PAOLO, *Roma Barocca: The History of an Architectonic Culture*, MIT Press, Cambridge, Mass., 1970
POSNER, DONALD, *Annibale Carracci*, 2 vols., Phaidon, London, 1971
SPEAR, RICHARD, *Caravaggio and His Followers*, Cleveland Museum of Art, 1972
WATERHOUSE, ELLIS K., *Italian Baroque Painting*, 2d ed., Phaidon, London, 1969
WITTKOWER, RUDOLF, *Art and Architecture in Italy: 1600 to 1750*, 3d ed., Penguin, Baltimore, 1973
―――, *Gian Lorenzo Bernini: The Sculptor of the Roman Baroque*, 2d ed., Cornell University Press, Ithaca, N.Y., 1981
―――, *Gothic v. Classic: Architectural Projects in Seventeenth-Century Italy*, Braziller, New York, 1974
―――, *Studies in Italian Baroque*, Thames & Hudson, London, 1975
―――, and JAFFE, IRMA B., eds., *Baroque Art: The Jesuit Contribution*, Fordham University Press, New York, 1972

CHAPTER TWO
THE SEVENTEENTH CENTURY IN CATHOLIC EUROPE OUTSIDE ITALY

BLUNT, ANTHONY, *Art and Architecture in France: 1500 to 1700*, 2d ed., Penguin, Baltimore, 1970
―――, *Nicolas Poussin*, 2 vols., Pantheon, New York, 1967
BROWN, CHRISTOPHER, *Van Dyck*, Cornell University Press, Ithaca, N.Y., 1983
BROWN, JONATHAN, *Images and Ideas in Seventeenth-Century Spanish Painting*, Princeton University Press, 1978
―――, *Zurbarán*, Abrams, New York, 1973
FELTON, CRAIG, and JORDAN, WILLIAM B., eds., *Jusepe de Ribera io Spagnoletto*, Kimbell Art Museum, Fort Worth, 1982; distributed by University of Washington Press, Seattle
FOX, HELEN M., *André Le Nôtre*, Crown, New York, 1962
FRIEDLÄNDER, WALTER F., *Nicolas Poussin: A New Approach*, Abrams, New York, 1965
FROMENTIN, EUGÈNE, *The Old Masters of Belgium and Holland* (tr. Mary C. Robbins, intro. Meyer Schapiro), Schocken, New York, 1963
FURNESS, S.M.M., *Georges de la Tour of Lorraine, 1593–1652*, Routledge & Kegan Paul, London, 1949
GERSON, HORST, and TER KUILE, E.H., *Art and Architecture in Belgium, 1600–1800*, Penguin, Baltimore, 1960
HELD, JULIUS S., *Rubens: Selected Drawings*, 2 vols., Phaidon, London, 1959
―――, *Rubens and His Circle*, Princeton University Press, 1981
HEMPEL, EBERHARD, *Baroque Art and Architecture in Central Europe*, Penguin, Baltimore, 1965
KUBLER, GEORGE, and SORIA, M., *Art and Architecture in Spain and Portugal...1500 to 1800*, Penguin, Baltimore, 1959
LEES-MILNE, JAMES, *Baroque in Spain and Portugal, and Its Antecedents*, Batsford, London, 1960
LÓPEZ-REY, JOSÉ, *Velázquez: A Catalogue Raisonné of His Oeuvre*, Faber & Faber, London, 1963
MAGURN, RUTH S., ed., *The Letters of Peter Paul Rubens*, Harvard University Press, Cambridge, Mass., 1955
ROSENBERG, PIERRE, *France in the Golden Age*, Metropolitan Museum of Art, New York, 1982
RUSSELL, H. DIANE, *Claude Lorrain*, National Gallery of Art, Washington, D.C., 1982
SAVAGE, GEORGE, *French Decorative Art, 1638-1793*, Praeger, New York, 1969
SÉRULLAZ, MAURICE, *Velázquez*, Abrams, New York, 1981
SMITH, P., and GRAHAM, A., *François Mansart*, London, 1972
The Splendid Century: French Art, 1600-1715, Metropolitan Museum of Art, New York, 1960
STECHOW, WOLFGANG, *Rubens and the Classical Tradition*, Harvard University Press, Cambridge, Mass., 1968
THUILLIER, JACQUES, and CHÂTELET, A., *French Painting from Le Nain to Fragonard* (tr. S. Gilbert), Skira, Geneva, 1964

VAN PUYVELDE, LEO, and VAN PUYVELDE, THIERRY, *Flemish Painting: The Age of Rubens and Van Dyck* (tr. A. Kendall), McGraw-Hill, New York, 1971

CHAPTER THREE
THE SEVENTEENTH CENTURY IN PROTESTANT COUNTRIES

ALPERS, SVETLANA, *The Art of Describing: Dutch Art in the Seventeenth Century*, University of Chicago Press, 1983

BERGSTRÖM, INGVAR, *Dutch Still Life Painting in the Seventeenth Century* (tr. C. Hedström and G. Taylor), Yoseloff, New York, 1956

BLANKERT, ALBERT, *Vermeer of Delft*, Phaidon, New York, 1978

DOWNES, KERRY, *English Baroque Architecture*, Zwemmer, London, 1966

FROMENTIN, EUGÈNE, *The Old Masters of Belgium and Holland* (tr. Mary C. Robbins, intro. Meyer Schapiro), Schocken, New York, 1963

FUCHS, R. H., *Dutch Painting*, Oxford University Press, New York, 1978

GERSON, HORST, *Rembrandt Paintings*, Reynal, New York, 1968

GOWING, LAWRENCE, *Vermeer*, Harper & Row, New York, 1970

HAAK, BOB, *The Golden Age: Dutch Painters of the Seventeenth Century* (tr. E. Willems-Treeman), Abrams, New York, 1984

————, *Rembrandt: His Life, His Work, His Time*, Abrams, New York, 1969

HAVERKAMP-BEGEMANN, E., *Rembrandt: The Night Watch*, Princeton University Press, 1982

Masters of Seventeenth-Century Dutch Genre Painting, Philadelphia Museum of Art, 1984

MÜNZ, LUDWIG, and HAAK, BOB, *Rembrandt*, Abrams, New York, 1967

NICOLSON, BENEDICT, *Hendrick Terbrugghen*, Lund Humphries, London, 1958

ROSENBERG, JAKOB, *Rembrandt*, 2d ed., Phaidon, London, 1964

————, SLIVE, S., and TER KUILE, E. H., *Dutch Art and Architecture, 1600–1800*, 2d ed., Penguin, Baltimore, 1972

SLIVE, SEYMOUR, *Frans Hals*, 2 vols., Phaidon, London, 1970

STECHOW, WOLFGANG, *Dutch Landscape Painting of the Seventeenth Century*, Phaidon, London, 1966

SUMMERSON, JOHN, *Architecture in Britain: 1530–1830*, 4th ed., Penguin, Baltimore, 1963

————, *Inigo Jones*, Penguin, Harmondsworth, 1966

WHEELOCK, ARTHUR K., JR., *Vermeer*, Abrams, New York, 1981

WHINNEY, MARGARET D., *Christopher Wren*, Praeger, New York, 1971

————, and MILLAR, O., *English Art 1625–1714*, Clarendon Press, Oxford, 1957

WHITE, CHRISTOPHER, *Rembrandt as an Etcher*, 2 vols., Pennsylvania State University Press, University Park, 1969

WRIGHT, CHRISTOPHER, *The Dutch Painters: One Hundred Seventeenth Century Masters*, Barron, Woodbury, N.Y., 1978

CHAPTER FOUR
THE EIGHTEENTH CENTURY

ALBERTS, ROBERT C., *Benjamin West: A Biography*, Houghton, Mifflin, Boston, 1978

ANTAL, FREDERICK, *Hogarth*, Routledge & Kegan Paul, London, 1962

BOURKE, JOHN, *Baroque Churches of Central Europe*, 2d ed., Faber & Faber, London, 1962

BROWN, MILTON, *American Art to 1900*, Abrams, New York, 1977

CONSTABLE, WILLIAM G., *Canaletto*, 2 vols., Oxford University Press, London, 1962

GRASELLI, MARGARET MORGAN, and ROSENBERG, PIERRE, *Watteau: 1684–1721*, National Gallery of Art, Washington, D.C., 1984

HITCHCOCK, HENRY-RUSSELL, *Rococo Architecture in Southern Germany*, Phaidon, London, 1968

HUDSON, DEREK, *Sir Joshua Reynolds: A Personal Study*, G. Bles, London, 1958

KALNEIN, WEND GRAF, and LEVEY, M., *Art and Architecture of the Eighteenth Century in France*, Penguin, Baltimore, 1972

KIMBALL, SIDNEY FISKE, *The Creation of the Rococo*, Philadelphia Museum of Art, 1943

LEVEY, MICHAEL, *Painting in XVIII Century Venice*, Phaidon, London, 1959

MCINNES, IAN, *Painter, King and Pompadour: François Boucher at the Court of Louis XV*, F. Muller, London, 1965

MAXON, JOHN, ed., *Painting in Italy in the Eighteenth Century: Rococo to Romanticism*, Art Institute of Chicago, 1970

MAYOR, A. HYATT, *Giovanni Battista Piranesi*, H. Bittner, New York, 1952

MONTAGNI, E. C., *The Complete Paintings of Watteau*, Abrams, New York, 1971

MORASSI, ANTONIO, *G. B. Tiepolo*, Phaidon, New York, 1955

PAULSON, RONALD, *Hogarth: His Life, Art and Times*, 2 vols., Yale University Press, New Haven, 1971

POSNER, DONALD, *Antoine Watteau*, Cornell University Press, Ithaca, N.Y., 1983

POWELL, NICOLAS, *From Baroque to Rococo*, Faber & Faber, London, 1959

PROWN, JULES D., *John Singleton Copley*, 2 vols., Harvard University Press, Cambridge, Mass., 1966

ROSENBERG, PIERRE, *Chardin*, Cleveland Museum of Art, 1979

SUTTON, DENYS, *France in the Eighteenth Century*, Royal Academy, London, 1968

THUILLIER, JACQUES, *Fragonard* (tr. R. Allen), Skira, Geneva, 1967

WATERHOUSE, ELLIS K., *Gainsborough*, 2d ed., Spring Books, London, 1966

————, *Painting in Britain: 1530 to 1790*, 2d ed., Penguin, Baltimore, 1962

WILDENSTEIN, GEORGES, *Chardin* (tr. D. Wildenstein), New York Graphic Society, Greenwich, Conn., 1969

————, *The Paintings of Fragonard* (tr. C. W. Chilton and A. L. Kitson), Phaidon, London, 1960

PART SIX
THE MODERN WORLD

ARMSTRONG, TOM, et al., *200 Years of American Sculpture*, Whitney Museum of American Art, New York, 1976

ARNASON, H. H., *History of Modern Art*, rev. ed., Abrams, New York, 1977

BARKER, VIRGIL, *American Painting: History and Interpretation*, Bonanza, New York, 1960

BOWNESS, ALAN, *Modern European Art*, Harcourt Brace Jovanovich, New York, 1972

BROWN, MILTON; HUNTER, SAM; and JACOBUS, JOHN, *American Art: Painting, Sculpture, Architecture, Decorative Arts, Photography*, Abrams, New York, 1979

CANADAY, JOHN, *Mainstreams of Modern Art*, 2d ed., Holt, Rinehart & Winston, New York, 1981

CHIPP, HERSCHEL B., *Theories of Modern Art*, University of California Press, Berkeley, 1968

GERNSHEIM, HELMUT, and GERNSHEIM, ALISON, *The History of Photography from the Camera Obscura to the Beginning of the Modern Era*, Thames & Hudson, London, 1969

HAFTMANN, WERNER, *Painting in the Twentieth Century* (tr. R. Manheim), 2d ed., 2 vols., Praeger, New York, 1965

HAMILTON, GEORGE H., *19th and 20th Century Art: Painting, Sculpture, Architecture*, Abrams, New York, 1970

————, *Painting and Sculpture in Europe, 1880–1940*, Penguin, Baltimore, 1967

HARRIS, NEIL, *The Artist in American Society: The Formative Years, 1790–1860*, Braziller, New York, 1966

HATJE, GERD, ed., *Encyclopedia of 20th-Century Architecture*, 3d ed., Abrams, New York, 1985

HERBERT, ROBERT L., ed., *Modern Artists on Art*, Prentice-Hall, Englewood Cliffs, N.J., 1964

HUNTER, SAM, and JACOBUS, JOHN, *Modern Art*, 2d ed., Abrams, New York, and Prentice-Hall, Englewood Cliffs, N.J., 1985

JANSON, H. W., *19th-Century Sculpture*, Abrams, New York, 1985

LYNES, RUSSELL, *The Art-Makers of Nineteenth Century America*, Atheneum, New York, 1970

MCCOUBREY, JOHN, *American Art, 1700–1960: Sources and Documents in the History of Art*, Prentice-Hall, Englewood Cliffs, N.J., 1965

MARCHIORI, GIUSEPPE, *Modern French Sculpture* (tr. J. Ross), Abrams, New York, 1963

MYERS, BERNARD S., *Mexican Painting In Our Time*, Oxford University Press, New York, 1956

NEWHALL, BEAUMONT, *The History of Photography, from 1839 to the Present*, rev. ed., Museum of Modern Art, New York, 1982

NOVOTNY, FRITZ, *Painting and Sculpture in Europe, 1780–1880*, 2d ed., Penguin, Harmondsworth, 1971

RHEIMS, MAURICE, *Nineteenth-Century Sculpture*, Abrams, New York, 1977

ROH, FRANZ, *German Art in the 20th Century*, New York Graphic Society, Greenwich, Conn., 1968

ROSENBLUM, ROBERT, and JANSON, H. W., *19th-Century Art*, Abrams, New York, 1984

ROTHEL, HANS K., *Modern German Painting*, Reynal, New York, 1957

RUSSELL, JOHN, *The Meanings of Modern Art*, Museum of Modern Art and Harper & Row, New York, 1981

SCHAPIRO, MEYER, *Modern Art: 19th and 20th Centuries*, Braziller, New York, 1980

SELZ, PETER, *Art in Our Times: A Pictorial History: 1890–1980*, Harcourt Brace Jovanovich and Abrams, New York, 1981

SEMBACH, KLAUS-JÜRGEN, *Into the Thirties* (tr. J. Filson), Thames & Hudson, London, 1972

WILMERDING, JOHN, *American Art*, Viking, New York, 1976

CHAPTER ONE
NEOCLASSICISM

ARNASON, H. HARVARD, *The Sculptures of Houdon*, Oxford University Press, New York, 1975

BROOKNER, ANITA, *Jacques-Louis David*, Chatto & Windus, London, 1980

EITNER, LORENZ, *Neoclassicism and Romanticism, 1750–1850: Sources and Documents in the History of Art*, 2 vols., Prentice-Hall, Englewood Cliffs, N.J., 1970

FRIEDLÄNDER, WALTER F., *From David to Delacroix*, Schocken, New York, 1968

HONOUR, HUGH, *Neo-Classicism*, Penguin, Harmondsworth, 1968

PICON, GAËTON, *Ingres*, Rizzoli, New York, 1980

ROSENBLUM, ROBERT, *Jean-Auguste-Dominique Ingres*, Abrams, New York, 1967

————, *Transformations in Late Eighteenth Century Art*, Princeton University Press, 1967

CHAPTER TWO
ROMANTICISM

BERGER, KLAUS, *Géricault and His Work* (tr. W. Ames), University of Kansas Press, Lawrence, 1955

BINDMAN, DAVID, *William Blake: His Art and Times*, Yale Center for British Art, New Haven, 1982

BRION, MARCEL, *Art of the Romantic Era*, Praeger, New York, 1966

BUTLIN, MARTIN, and JOLL, EVELYN, *The Paintings of J.M.W. Turner*, 2 vols., Yale University Press, New Haven, 1977

CLAY, JEAN, *Romanticism*, Vendome, New York, 1981

COURTHION, PIERRE, *Romanticism*, (tr. S. Gilbert), Skira, Geneva, 1962

EITNER, LORENZ, *Géricault: His Life and Work*, Cornell University Press, Ithaca, N.Y., 1982

————, *Géricault's Raft of the Medusa*, Phaidon, London, 1972

————, *Neoclassicism and Romanticism, 1750–1850: Sources and Documents in the History of Art*, 2 vols., Prentice-Hall, Englewood Cliffs, N.J., 1970

FINBERG, ALEXANDER J., *The Life of J.M.W. Turner, R.A.*, 2d rev. ed., Clarendon Press, Oxford, 1961

GUDIOL I RICART, JOSÉ, *Goya*, Abrams, New York, 1965

HITCHCOCK, HENRY-RUSSELL, *Architecture: Nineteenth and Twentieth Centuries*, 2d ed., Penguin, Baltimore, 1971

HUYGHE, RENÉ, *Delacroix* (tr. M. Griffin), Abrams, New York, 1963

JOHNSON, LEE, *The Paintings of Eugène Delacroix, a Critical Catalogue: 1816–1831*, 2 vols., Oxford University Press, New York, 1981

LEYMARIE, JEAN, *French Painting in the Nineteenth Century*, Skira, Geneva, 1962

LICHT, FRED, *Goya: The Origins of the Modern Temper in Art*, Universe Books, New York, 1979

RAINE, KATHLEEN, *William Blake*, Praeger, New York, 1971

ROSENBLUM, ROBERT, *Modern Painting and the Northern Romantic Tradition: Friedrich to Rothko*, Harper & Row, New York, 1975

ROSENTHAL, MICHAEL, *Constable: The East Painter and His Landscape*, Yale University Press, New Haven, 1983

SCHIFF, GERT, *German Masters of the Nineteenth Century*, Abrams, New York, 1981

SULLIVAN, EDWARD, *Goya and the Art of His Times*, Meadows Museum, S. Methodist University, Dallas, 1982

WALKER, JOHN, *Constable*, Abrams, New York, 1978

————, *Turner*, Abrams, New York, 1976

CHAPTER THREE
REALISM

ADHÉMAR, JEAN, *Honoré Daumier* (English ed.), P. Tisné, New York and Basel, 1954

CHU, PETRA TEN DOESSCHATE, ed., *Courbet in Perspective*, Prentice-Hall, Englewood Cliffs, N.J., 1977

GOODRICH, LLOYD, *Thomas Eakins*, 2 vols., Harvard University Press, Cambridge, Mass., 1982

———, *Winslow Homer*, Macmillan for Whitney Museum of American Art, New York, 1944

HENDRICKS, GORDON, *The Life and Work of Winslow Homer*, Abrams, New York, 1979

HERBERT, ROBERT L., *Jean-François Millet*, Hayward Gallery, London, 1976

HOURS, MADELEINE, *Jean-Baptiste-Camille Corot*, Abrams, New York, 1979

MARKOWSKI, GENE, *The Art of Photography: Image and Illusion*, Prentice-Hall, Englewood Cliffs, N.J., 1984

NICOLSON, BENEDICT, *Courbet: The Studio of the Painter*, Allen Lane, London, 1973

NOCHLIN, LINDA, *Gustave Courbet: A Study of Style and Society*, Garland, New York, 1976

———, *Realism*, Penguin, Harmondsworth, 1971

———, *Realism and Tradition in Art, 1848–1900: Sources and Documents in the History of Art*, Prentice-Hall, Englewood Cliffs, N.J., 1966

SEWELL, DARREL, *Thomas Eakins: Artist of Philadelphia*, Philadelphia Museum of Art, 1982

WEISBERG, GABRIEL, *The Realist Tradition: French Painting and Drawing, 1830–1900*, Cleveland Museum of Art, 1980

WOOD, CHRISTOPHER, *The Pre-Raphaelites*, Abrams, New York, 1981

CHAPTER FOUR
IMPRESSIONISM—THE ART OF PURE VISION

BREESKIN, ADELYN DOHME, *Mary Cassatt: A Catalogue Raisonné of the Oils, Pastels, Watercolors, and Drawings*, Smithsonian Press, Washington, D.C., 1970

BRETTELL, RICHARD R., et al., *A Day in the Country: Impressionism and the French Landscape*, Abrams, New York, and Los Angeles County Museum, 1984

BUTLER, RUTH, ed., *Rodin in Perspective*, Prentice-Hall, Englewood Cliffs, N.J., 1980

CHAMPIGNEULLE, BERNARD, *Rodin: His Sculpture, Drawings and Watercolors* (tr. J. M. Brownjohn), Abrams, New York, 1967

ELSEN, ALBERT EDWARD, *Rodin*, Doubleday, Garden City, for Museum of Modern Art, New York, 1963

———, ed., *Auguste Rodin: Readings on His Life and Work*, Prentice-Hall, Englewood Cliffs, N.J., 1965

ELSEN, ALBERT, and VARNEDOE, J.K.T., *The Drawings of Rodin*, Praeger, New York, 1973

GORDON, ROBERT, and FORGE, ANDREW, *Monet*, Abrams, New York, 1983

HANSON, ANNE COFFIN, *Manet and the Modern Tradition*, Yale University Press, New Haven, 1977

ISAACSON, JOEL, *The Crisis of Impressionism: 1878–1882*, University of Michigan Museum of Art, Ann Arbor, 1979

Manet: 1832–1883, Abrams and Metropolitan Museum of Art, New York, 1983

PACH, WALTER, *Pierre Auguste Renoir*, Abrams, New York, 1950

RATCLIFF, CARTER, *John Singer Sargent*, Abbeville, New York, 1982

REFF, THEODORE, *Degas: The Artist's Mind*, Harper & Row, New York, 1976

REWALD, JOHN, *Camille Pissarro*, Abrams, New York, 1963

———, *The History of Impressionism*, 4th rev. ed., New York Graphic Society, Greenwich, Conn., for Museum of Modern Art, New York, 1973

———, and MATT, L. VON, *Degas, Sculpture: The Complete Works*, Abrams, New York, 1956

SEITZ, WILLIAM C., *Claude Monet*, Abrams, New York, 1960

WHITE, BARBARA EHRLICH, *Renoir*, Abrams, New York, 1984

———, ed., *Impressionism in Perspective*, Prentice-Hall, Englewood Cliffs, N.J., 1978

YOUNG, ANDREW MCLAREN; MACDONALD, MARGARET; and SPENCER, ROBIN, *The Paintings of James McNeill Whistler*, 2 vols., Yale University Press, New Haven, 1980

CHAPTER FIVE
POST-IMPRESSIONISM—A DEEPER REALITY

ANDERSEN, WAYNE, *Gauguin's Paradise Lost*, Viking, New York, 1971

BROUDE, NORMA, ed., *Seurat in Perspective*, Prentice-Hall, Englewood Cliffs, N.J., 1978

CHAPPUIS, ADRIEN, *The Drawings of Paul Cézanne*, 2 vols., Thames & Hudson, London, 1973

CHASSÉ, CHARLES, *The Nabis and Their Period* (tr. M. Bullock), Praeger, New York, 1969

COURTHION, PIERRE, *Georges Seurat* (tr. N. Guterman), Abrams, New York, 1968

GERHARDUS, MALY, and GERHARDUS, DIETFRIED, *Symbolism and Art Nouveau*, Phaidon, Oxford, 1979

GOGH, VINCENT VAN, *The Complete Letters of Vincent Van Gogh* (tr. J. Van Gogh-Bonger and C. de Dood), 3 vols., New York Graphic Society, Greenwich, Conn., 1958

GOLDWATER, ROBERT, *Symbolism*, Harper & Row, New York, 1979

HOBBS, RICHARD, *Odilon Redon*, New York Graphic Society, Boston, 1977

HULSKER, JAN, *The Complete Van Gogh: Paintings, Drawings, Sketches*, Abrams, New York, 1980

LÖVGREN, SVEN, *The Genesis of Modernism: Seurat, Gauguin, Van Gogh and French Symbolism in the 1880s*, 2d ed., Indiana University Press, Bloomington, 1971

MESSER, THOMAS W., *Edvard Munch*, Abrams, New York, 1971

NOCHLIN, LINDA, *Impressionism and Post-Impressionism, 1874–1904: Sources and Documents in the History of Art*, Prentice-Hall, Englewood Cliffs, N.J., 1966

PICKVANCE, RONALD, *Van Gogh at Arles*, Abrams and Metropolitan Museum of Art, New York, 1984

Post-Impressionism: Cross-Currents in European and American Painting, 1880–1906, National Gallery of Art, Washington, D.C., 1980

READE, BRIAN, *Aubrey Beardsley*, Viking, New York, 1967

REWALD, JOHN, *Paul Cézanne: A Biography* (tr. M. H. Liebman), Schocken, New York, 1968

———, *Post-Impressionism from Van Gogh to Gauguin*, 2d ed., Museum of Modern Art, New York, 1962

ROOKMAAKER, HENDRIK R., *Gauguin and 19th Century Art Theory*, Swets & Zeitlinger, Amsterdam, 1972

———, *Synthetist Art Theories: Genesis and Nature of the Ideas on Art of Gauguin and His Circle*, Swets & Zeitlinger, Amsterdam, 1959

ROSKILL, MARK W., *Van Gogh, Gauguin, and the Impressionist Circle*, New York Graphic Society, Greenwich, Conn., 1970

RUBIN, WILLIAM, ed., *Cézanne: The Late Work*, Museum of Modern Art, New York, 1977

RUSSELL, JOHN, *Seurat*, Praeger, New York, 1965

———, ed., *Vuillard*, New York Graphic Society, Greenwich, Conn., 1971

SCHAPIRO, MEYER, *Paul Cézanne*, 3d ed., Abrams, New York, 1965

———, *Vincent van Gogh*, Abrams, New York, 1950

SCHMUTZLER, ROBERT, *Art Nouveau* (tr. E. Roditi), Abrams, New York, 1962

SHIFF, RICHARD, *Cézanne and the End of Impressionism*, University of Chicago Press, 1984

SUTTON, DENYS, *The Complete Paintings of Toulouse-Lautrec* (tr. G. M. Sugana), Weidenfeld & Nicholson, London, 1973

VALLIER, DORA, *Henri Rousseau*, Abrams, New York, 1964

WECHSLER, JUDITH, ed., *Cézanne in Perspective*, Prentice-Hall, Englewood Cliffs, N.J., 1975

CHAPTER SIX
THE FAUVES AND EXPRESSIONISM

BARR, ALFRED H., JR., *Matisse, His Art and His Public*, Arno Press, New York, 1966

COURTHION, PIERRE, *Georges Rouault*, Abrams, New York, 1962

COWART, JACK, et al., *Henri Matisse: Paper Cut-Outs*, Abrams, New York, and Detroit Institute of Art, 1978

CRESPELLE, JEAN PAUL, *The Fauves* (tr. A. Brookner), New York Graphic Society, Greenwich, Conn., 1962

ELSEN, ALBERT E., *The Sculpture of Henri Matisse*, Abrams, New York, 1972

GROHMANN, WILL, *Wassily Kandinsky: Life and Work* (tr. N. Guterman), Abrams, New York, 1958

HODIN, JOSEF PAUL, *Oskar Kokoschka: The Artist and His Time*, New York Graphic Society, Greenwich, Conn., 1966

JACOBUS, JOHN, *Henri Matisse*, Abrams, New York, 1973

KUHN, CHARLES L., *German Expressionism and Abstract Art: The Harvard Collections*, Harvard University Press, Cambridge, Mass., 1957

MULLER, JOSEPH-ÉMILE, *Fauvism* (tr. S. E. Jones), Praeger, New York, 1967

NAGEL, OTTO, *Käthe Kollwitz*, New York Graphic Society, Greenwich, Conn., 1971

POLING, CLARK V., ed., *Kandinsky: Russian and Bauhaus Years*, Solomon R. Guggenheim Museum, New York, 1983

ROETHEL, HANS K., and BENJAMIN, JEAN K., *Kandinsky: Catalogue Raisonné of the Oil Paintings*, 2 vols., Cornell University Press, Ithaca, N.Y., 1982, 1984

SCHNEIDER, PIERRE, *Matisse*, Rizzoli, New York, 1984

SELZ, PETER, *German Expressionist Painting*, University of California Press, Berkeley, 1957

VOGT, PAUL, *Expressionism: German Painting 1905–1920*, Abrams, New York, 1980

WEISS, PEG, ed., *Kandinsky in Munich: 1896–1916*, Solomon R. Guggenheim Museum, New York, 1982

CHAPTER SEVEN
THE SEARCH FOR FORM—CUBISM AND ABSTRACT ART

APOLLINAIRE, GUILLAUME, *The Cubist Painters* (tr. L. Abel), Wittenborn, Schultz, New York, 1970

BLUNT, ANTHONY, and POOL, P., *Picasso, The Formative Years: A Study of His Sources*, New York Graphic Society, Greenwich, Conn., 1962

BOECK, WILHELM, and SABARTÉS, J., *Picasso*, Abrams, New York, 1955

COGNIAT, RAYMOND, *Georges Braque*, Abrams, New York, 1980

COOPER, DOUGLASS, *The Cubist Epoch*, Phaidon, New York, 1971

DAIX, PIERRE, and BOUDAILLE, G., *Picasso: The Blue and Rose Periods* (tr. P. Pool), New York Graphic Society, Greenwich, Conn., 1967

———, and ROSSELET, JOAN, *Picasso: The Cubist Years: 1907–16*, New York Graphic Society, Boston, 1980

DE FRANCIA, PETER, *Fernand Léger*, Yale University Press, New Haven, 1983

D'HARNONCOURT, ANNE, *Futurism and the International Avant-Garde*, Philadelphia Museum of Art, 1982

DOESBURG, THEO VAN, *Principles of Neo-Plastic Art*, New York Graphic Society, Greenwich, Conn., 1968

GEIST, SIDNEY, *Brancusi: The Sculpture and Drawings*, Abrams, New York, 1975

GOLDING, JOHN, *Cubism: A History and an Analysis, 1907–1914*, rev. ed., Boston Book and Art Shop, 1968

———, and PENROSE, ROLAND, eds., *Picasso in Retrospective*, Harper & Row, New York, 1980

GRAY, CAMILLA, *The Great Experiment: Russian Art 1863–1922*, Abrams, New York, 1962

HAMMACHER, A. M., *Jacques Lipchitz: His Sculpture*, 2d ed., Abrams, New York, 1975

HANSON, ANNE COFFIN, ed., *The Futurist Imagination: Word and Image*, Yale University Art Gallery, New Haven, 1983

JAFFÉ, HANS L. C., *De Stijl, 1917–1931: The Dutch Contribution to Modern Art*, Meulenhoff, Amsterdam, 1956

———, *Pablo Picasso*, Doubleday, Garden City, N.Y., 1980

———, et al., *De Stijl, 1917–1931: Visions of Utopia*, Walker Art Center, Minneapolis, and Abbeville, New York, 1982

MARTIN, MARIANNE W., *Futurist Art and Theory, 1909–1915*, Clarendon Press, Oxford, 1968

RICKEY, GEORGE, *Constructivism: Origins and Evolution*, Braziller, New York, 1967

ROSENBLUM, ROBERT, *Cubism and Twentieth-Century Art*, rev. ed., Abrams, New York, 1976

RUBIN, WILLIAM, ed., *Pablo Picasso: A Retrospective*, Museum of Modern Art, New York, 1980

RUDENSTINE, ANGELIKA ZANDER, gen. ed., *Russian Avant-Garde Art: The George Costakis Collection*, Solomon R. Guggenheim Museum and Abrams, New York, 1981

SCHIFF, GERT, *Picasso: The Last Years: 1963–73*, Solomon R. Guggenheim Museum and Braziller, New York, 1984

———, ed., *Picasso in Perspective*, Prentice-Hall, Englewood Cliffs, N.J., 1976

SCHMALENBACH, WERNER, *Fernand Léger*, Abrams, New York, 1976

SPIES, WERNER, *Sculpture by Picasso* (tr. J. M. Brownjohn), Abrams, New York, 1971

CHAPTER EIGHT
FANTASTIC ART, DADA, AND SURREALISM

BRETON, ANDRÉ, *Surrealism and Painting* (tr. S. W. Taylor), Harper & Row, New York, 1972

DESCHARNES, ROBERT, *Dali: The Work, The Man*, Abrams, New York, 1984

D'HARNONCOURT, ANNE, and MCSHINE, KYNASTON, *Marcel Duchamp*, New York Graphic Society, Greenwich, Conn., 1973

DUPIN, JACQUES, *Miró* (tr. N. Guterman), Abrams, New York, 1962

GROHMANN, WILL, *Paul Klee*, Abrams, New York, 1967

HAFTMANN, WERNER, *Marc Chagall* (tr. Heinrich Baumann and Alexis Brown), Abrams, New York, 1973

HAMMACHER, A. M., *René Magritte* (tr. James Brockway), Abrams, New York, 1973

JORDAN, JIM M., *Paul Klee and Cubism*, Princeton University Press, 1984

MASCHEK, JOSEPH, ed., *Marcel Duchamp in Perspective*, Prentice-Hall, Englewood Cliffs, N.J., 1974

MOTHERWELL, ROBERT, ed., *The Dada Painters and Poets: An Anthology*, Wittenborn, Schultz, New York, 1951

PLANT, MARGARET, *Paul Klee: Figures and Marks*, Thames & Hudson, London, 1978

READ, SIR HERBERT, *The Art of Jean Arp*, Abrams, New York, 1968

RICHTER, HANS, *Dada: Art and Anti-Art*, Oxford University Press, New York, 1978

RUBIN, WILLIAM S., *Dada and Surrealist Art*, Abrams, New York, 1968

———, ed., *De Chirico*, Museum of Modern Art, New York, 1982

RUSSELL, JOHN, *Max Ernst: Life and Work*, Abrams, New York, 1967

SCHMALENBACH, WERNER, *Kurt Schwitters*, Abrams, New York, 1967

SCHWARTZ, ARTURO, *Marcel Duchamp*, Abrams, New York, 1975

SOBY, JAMES THRALL, *Giorgio de Chirico*, Museum of Modern Art, New York, 1955

TORCZYNER, HARRY, ed., *Magritte: Ideas and Images*, Abrams, New York, 1980

CHAPTER NINE
AMERICAN ART OF THE TWENTIETH CENTURY AND RECENT MOVEMENTS ELSEWHERE

ASHTON, DORE, *American Art Since 1945*, rev. ed., Oxford University Press, New York, 1982

BATTCOCK, GREGORY, *The New Art: A Critical Anthology*, rev. ed., Dutton, New York, 1968

———, *New Artists Video: A Critical Anthology*, Dutton, New York, 1978

———, ed., *Minimal Art: A Critical Anthology*, Dutton, New York, 1968

BROWN, MILTON W., *American Painting from the Armory Show to the Depression*, Princeton University Press, 1955

COPLANS, JOHN, *Ellsworth Kelly*, Abrams, New York, 1971

COWART, JACK, *Roy Lichtenstein: 1970–1980*, Hudson Hills Press, New York, and St. Louis Art Museum, 1981

———, ed., *Expressions: New Art from Germany*, St. Louis Art Museum, 1983

CRICHTON, MICHAEL, *Jasper Johns*, Whitney Museum of American Art, New York, 1977

FINCH, CHRISTOPHER, *Pop Art: The Object and the Image*, Dutton, New York, 1968

FINN, DAVID, *Henry Moore: Sculpture and Environment*, Abrams, New York, 1976

FORGE, ANDREW, *Rauschenberg*, Abrams, New York, 1969

FRANK, ELIZABETH, *Jackson Pollock*, Abbeville, New York, 1983

FRANZKE, ANDREAS, *Dubuffet*, Abrams, New York, 1981

FRY, EDWARD F., *David Smith*, Solomon R. Guggenheim Museum, New York, 1969

Georgia O'Keeffe, Viking, New York, 1976

GLIMCHER, ARNOLD B., *Louise Nevelson*, Praeger, New York, 1972

GOODYEAR, FRANK H., JR., *Contemporary American Realism Since 1960*, New York Graphic Society, Boston, 1981

GOTTLIEB, CARLA, *Beyond Modern Art*, Dutton, New York, 1976

GUILBAUT, SERGE, *How New York Stole the Idea of Modern Art*, University of Chicago Press, 1983

HAMMACHER, A. M., *The Sculpture of Barbara Hepworth* (tr. J. Brockway), Abrams, New York, 1968

HERBERT, ROBERT L., ed., *Modern Artists on Art*, Prentice-Hall, Englewood Cliffs, N.J., 1965

HOBBS, ROBERT, *Robert Smithson: Sculpture*, Cornell University Press, Ithaca, N.Y., 1981

———, and LEVIN, GAIL, *Abstract Expressionism: The Formative Years*, Whitney Museum of American Art, New York, 1981

HUGHES, ROBERT, *The Shock of the New*, Knopf, New York, 1981

HUNTER, SAM, and JACOBUS, JOHN, *American Art of the 20th Century: Painting, Sculpture, Architecture*, Abrams, New York, 1973

JORDAN, JIM, and GOLDWATER, ROBERT, *The Paintings of Arshile Gorky: A Critical Catalogue*, New York University Press, 1982

JUDD, DONALD, *Complete Writings: 1959–1975*, New York University Press, 1975

LEIDER, PHILIP, *Stella Since 1970*, Fort Worth Art Museum, 1978

LIPPARD, LUCY R., *Overlay: Contemporary Art and the Art of Prehistory*, Pantheon, New York, 1983

———, *Pop Art*, Praeger, New York, 1966

LUCIE-SMITH, EDWARD, *Art in the Seventies*, Cornell University Press, Ithaca, N.Y., 1980

McSHINE, KYNASTON, *An International Survey of Recent Painting and Sculpture*, Museum of Modern Art, New York, 1984

MEISEL, LOUIS, *Photo-Realism*, Abrams, New York, 1980

MERKERT, JÖRN, *Willem de Kooning Retrospective Exhibition*, Whitney Museum of American Art, New York, 1984

MOFFETT, KENWORTH, *Kenneth Noland*, Abrams, New York, 1977

O'CONNOR, FRANCIS V., and THAW, EUGENE V., *Jackson Pollock: A Catalogue Raisonné of Paintings, Drawings, and Other Works*, Yale University Press, New Haven, 1978

O'DOHERTY, BRIAN, *American Masters: The Voice and the Myth in Modern Art*, Dutton, New York, 1982

RATCLIFF, CARTER, *Andy Warhol*, Abbeville, New York, 1983

ROSE, BARBARA, *American Art Since 1900*, rev. and expanded ed., Praeger, New York, 1975

ROSENBERG, HAROLD, *Barnett Newman*, Abrams, New York, 1978

SANDLER, IRVING, *The New York School: The Painters and Sculptors of the Fifties*, Harper & Row, New York, 1978

———, *The Triumph of American Painting: A History of Abstract Expressionism*, Praeger, New York, 1970

SHAPIRO, DAVID, *Jasper Johns Drawings 1954–1984*, Abrams, New York, 1984

WALDMAN, DIANE, *Arshile Gorky, 1904–1948: A Retrospective*, Solomon R. Guggenheim Museum, New York, 1981

———, *Mark Rothko, 1903–1970: A Retrospective*, Solomon R. Guggenheim Museum, New York, 1978

WOODS, GERALD, et al., eds., *Art Without Boundaries 1950–70*, Thames & Hudson, London, 1972

CHAPTER TEN
MODERN ARCHITECTURE

ARNHEIM, RUDOLF, *The Dynamics of Architectural Form*, University of California Press, Berkeley and Los Angeles, 1977

BAKER, GEOFFREY, *Le Corbusier: An Analyst of Form*, Van Nostrand, New York, 1984

BANHAM, REYNER, *The New Brutalism: Ethic or Aesthetics*, Reinhold, New York, 1966

BAYER, HERBERT, *Bauhaus 1919–1928*, New York Graphic Society, Greenwich, Conn., for Museum of Modern Art, New York, 1976

BENEVOLO, LEONARDO, *History of Modern Architecture*, 2 vols., MIT Press, Cambridge, Mass., 1977

BLAKE, PETER, *The Master Builder*, Norton, New York, 1976

BLASER, WERNER, *Mies van der Rohe: The Art of Structure* (tr. D. Q. Stephenson), rev. ed., Praeger, New York, 1972

BOESIGER, WILLY, ed., *Le Corbusier*, Praeger, New York, 1972

———, and GIRSBERGER, H., *Le Corbusier, 1910–65*, Thames & Hudson, New York, 1967

BROOKS, H. ALLEN, ed., *Writings on Wright: Selected Comments on Frank Lloyd Wright*, MIT Press, Cambridge, Mass., 1981

CARTER, PETER, *Mies van der Rohe at Work*, Pall Mall Press, London, 1974

CHOAY, FRANÇOISE, *Le Corbusier*, Braziller, New York, 1960

CHRIST-JENNER, ALBERT, *Eliel Saarinen*, rev. ed., University of Chicago Press, 1979

COLLINS, GEORGE R., *Antoni Gaudí*, Braziller, New York, 1960

COLLINS, PETER, *Changing Ideas in Modern Architecture, 1750–1950*, Faber & Faber, London, 1971

CURTIS, WILLIAM J. R., *Modern Architecture Since 1900*, Prentice-Hall, Englewood Cliffs, N.J., 1982

DREXLER, ARTHUR L., *Ludwig Mies van der Rohe*, Braziller, New York, 1960

———, *Transformations in Modern Architecture*, Museum of Modern Art, New York, 1979

FITCH, JAMES MADISON, *Walter Gropius*, Braziller, New York, 1960

FRAMPTON, KENNETH, *Modern Architecture*, Rizzoli, New York, 1980

———, *Modern Architecture, 1851–1945*, 2 vols., Rizzoli, New York, 1983

FRANCISCONO, MARCEL, *Walter Gropius and the Creation of the Bauhaus in Weimar*, University of Illinois Press, Urbana, 1971

GIEDION, SIGFRIED, *Space, Time and Architecture*, 5th ed., Harvard University Press, Cambridge, Mass., 1967

GOLDBERGER, PAUL, *On the Rise: Architecture and Design in a Post Modern Age*, Times Books, New York, 1983

———, *The Skyscraper*, Knopf, New York, 1981

GUITON, JACQUES, ed., *The Ideas of Le Corbusier: On Architecture and Urban Planning*, Braziller, New York, 1981

HAMLIN, TALBOT, F., ed., *Forms and Functions of Twentieth-Century Architecture*, 4 vols., Columbia University Press, New York, 1952

HATJE, GERD, ed., *Encyclopedia of 20th-Century Architecture*, 3d ed., Abrams, New York, 1985

HINES, THOMAS, *Richard Neutra and the Search for Modern Architecture*, Oxford University Press, New York, 1982

HITCHCOCK, HENRY-RUSSELL, *Architecture: Nineteenth and Twentieth Centuries*, 2d ed., Penguin, Baltimore, 1971

———, *The Architecture of H. H. Richardson and His Times*, rev. ed., MIT Press, Cambridge, Mass., 1966

———, *In the Nature of Materials: The Buildings of Frank Lloyd Wright, 1887–1941*, Da Capo Press, New York, 1973

———, and JOHNSON, PHILIP, *The International Style*, Norton, New York, 1966

JENCKS, CHARLES, *Architecture Today*, Abrams, New York, 1981

———, *Le Corbusier and the Tragic View of Architecture*, Harvard University Press, Cambridge, Mass., 1973

LOBELL, JOHN, *Between Silence and Light: Spirit in the Architecture of Louis I. Kahn*, Shambhala, Boulder, Colo., 1979

MORRISON, HUGH, *Louis Sullivan*, 2d ed., Norton, New York, 1962

PEHNT, WOLFGANG, *Expressionist Architecture*, Praeger, New York, 1973

PEVSNER, NIKOLAUS, *Pioneers of Modern Design*, Penguin, Baltimore, 1965

ROBINSON, CERVIN, and HAAG BLETTER, ROSEMARIE, *Skyscraper Style: Art Deco New York*, Oxford University Press, New York, 1975

ROTH, LELAND M., *A Concise History of American Architecture*, Harper & Row, New York, 1979

SAARINEN, ALINE B., ed., *Eero Saarinen on His Work*, 2d ed., Yale University Press, New Haven, 1968

SWEENEY, JAMES J., and SERT, J. L., *Antoni Gaudí*, 2d ed., Praeger, New York, 1970

WHIFFEN, MARCUS, and KOEPER, FREDERICK, *American Architecture*, MIT Press, Cambridge, Mass., 1983

PHOTOGRAPH CREDITS

© A.C.L., Brussels, 3, 539, 750, 751, 752, 753, 761, 764, 765, 766, 767, 960, 1060, 1159; Adant, Hélène, Paris, 1167; Agarwal, Jagdish, Uniphoto Picture Agency, Washington, D.C., 478; Agraci, Paris, 1132, 1144; Alinari, Florence, 2, 91, 214, 216, 223, 283, 296, 299, 304, 312, 318, 323, 327, 336, 338, 342, 343, 346, 352, 355, 356, 357, 360, 363, 370, 375, 376, 378, 385, 399, 400, 403, 410, 413, 417, 418, 421, 424, 435, 447, 448, 449, 450, 541, 543, 545, 546, 547, 552, 554, 560, 629, 630, 632, 633, 634, 635, 637, 638, 639, 640, 641, 642, 643, 644, 645, 647, 648, 649, 650, 655, 656, 658, 660, 661, 662, 663, 664, 668, 669, 671, 672, 677, 678, 680, 681, 682, 683, 685, 686, 687, 688, 689, 690, 691, 693, 694, 696, 699, 703, 704, 705, 710, 712, 716, 717, 722, 724, 728, 729, 730, 731, 733, 735, 763, 770, 773, 787, 793, 794, 797, 798, 799, 804, 807, 809, 810, 812, 813, 814, 815, 816, 817, 818, 819, 825, 828, 830, 831, 836, 837, 838, 839, 842, 847, 848, 849, 850, 853, 855, 857, 861, 876, 887, 901, 902, 903, 904, 905, 906, 909, 910, 911, 913, 915, 917, 920, 922, 925, 929, 932, 949, 959, 965, 972, 973, 1005, 1006, 1007, 1008, 1068, 1134; American School of Classical Studies, Athens, 228; Anders, Jörg P., 1171; Andrews, Wayne, Chicago, 1011, 1051, 1304; Anker, Peter, Oslo, 493; Annan, T. R., Glasgow, 1152; Antiken-Sammlung, Staatliche Museen zu Berlin, Haupstadt der DDR, 284; Archivio Fotografico dei Musei e Gallerie Pontificie, Vatican City, Rome, 361, 407, 408; Arnold, Dieter, *Der Tempel des Koënigs Mentuhotep von Deir el Bahari*, Band I, Architektur und Deutung, Mainz am Rhein, Verlag Philipp von Zabern, 98; Artothek, Munich, 852, 873; The Athlone Press, University of London, 34, 35; Audinet, Jack, Boulogne, 564; Aufsberg, Lala, Sonthofen im Allgau, Switz., 1034; Austin, James, Cambridge, Eng., 532, 1014; Avery Library, Columbia University, New York, 351; Babey, Maurice, Basel, 97, 122; Balestrini, Bruno, Electa Editrice, Milan, 120; Bell-Scott, Donald, 285; Biblioteca Apostolica Vaticana, Rome, 508; Bibliothèque Nationale, Paris, 518, 742, 744, 779, 784; Bildarchiv Foto Marburg, Marburg/Lahn, Ger., 90, 99, 254, 275, 308, 501, 512, 549, 558, 559, 574, 575, 586, 590, 591, 595, 599, 603, 608, 609, 611, 612, 613, 619, 924, 938, 1029; Böhm, Erwin, Mainz, 544, 550, Bohm, Osvaldo, Venice, 846, 1010; Boltin, Lee, 118, 292; Bruckmann, F., Munich, 834; Buch- und Kunstsammlung St. Hildegarde, Rhein-Eibingen, 569; Bulloz, Paris, 183, 882, 883, 884, 885, 886, 1021, 1085, 1097; Bundesdenkmalamt, Vienna, 614; Burckhardt, Rudolph, New York, 1265, 1269; Caisse Nationale des Monuments Historiques, Paris, 17, 21, 22, 153, 523, 524, 529, 530, 531, 533, 534, 535, 537, 538, 571, 573, 576, 579, 581, 589, 592, 593, 605, 617, 737, 738, 739, 946, 947, 950, 952, 957, 1015, 1077, 1080, 1083, 1086, 1108, 1111, 1118; Calzolari, Mantua, 676; Camponogara, J., Lyons, 1079; Canadian Consulate General, New York, 1322; Canali, Ludovico, Rome, 298, 325, 412, 422, 684, 697, 708, 715, 725, 726, 808, 811, 827, 833, 844, 854, 907; Chambi, Victor, Cuzco, Peru, 69; Chicago Historical Society, 1286; Cine Grassi, Siena, 651; Clements, Geoffrey, New York, 431 (from a color proof supplied by Kurt Weitzmann, Princeton), 1240, 1246, 1250, 1264; Compania Mexicana Aerofoto, Mexico City, 58; Conant, Kenneth John, Wellesley, 527, 528; Copyright *Country Life*, London, 944, 1041, 1042; © Cosmopress, ADAGP, 1222; Courtauld Institute, London, © Mrs. J. P. Summer, Essex, Eng., 628; De Antonis Fotografo, Rome, 165, 384; De Menil, Adelaide, New York, 1235; Department of Antiquities, Algeria, 365; Department of the Environment, Edinburgh (British Crown Copyright), 36; Department of the Environment, London, 1038; Deutsche Fotothek, Dresden, 457, 1107; Deutscher Kunstverlag, Munich, 497, 618 (Walter Hegge), 1057; Deutsches Archäologisches Institut, Athens, 174, 196, 212; Deutsches Archäologisches Institut, Cairo, 96; Deutsches Archäologisches Institut, Istanbul, 267; Deutsches Archäologisches Institut, Rome, 261, 288, 301, 328, 335, 344, 345, 349, 372, 373, 383; Dieuzaide, Jean, Toulouse (YAN), 23, 24; Dingjan, A., The Hague, 984, 987, 989, 999; Directorate General of Antiquities and Museums, Damascus, 377; Dumbarton Oaks Center for Byzantine Studies, Washington, D.C., 438; George Eastman House, Rochester, 1098, 1099; École Française d'Athènes, 292; Edelmann, U., Frankfurt, 748, 975; Éditions Cercle d'Art, Paris, 456; Éditions d'Art Skira, Geneva, 465; Andre Emmerich Gallery, New York, 1262; Enciclopedica Romana, Bucharest, courtesy the Romanian Library, New York, 485; Esser, Lotte, Darmstadt, 877; Rev. Fabbrica di S. Pietro, Rome, 415; Felton, Herbert, London, 626; Fondazione Giorgio Cini, Venice, 860; Foto Rosso, Turin, 142, 933; Foto Schönwetter, Glarus,

1184; Foto Vaghi, Parma, 548; Fotocielo, Rome, 542; Fotomas, London, 985; Fototeca Unione, Rome, 287, 295, 311, 313, 314, 315, 329, 330, 337, 339, 340, 350, 354, 358, 364, 367, 380, 381, 388, 503, 822; Fourcade, Xavier, New York, 1270, 1279; Frantz, Alison, Princeton, 169, 181, 210, 229, 242, 244, 252, 441, 442; Fraser, 402; French Government Tourist Office, New York, 1056, 1095; French Tourist Service, Paris, 953; Fürböck, Graz, 484; Gabinetto Fotografico, Galleria degli Uffizi, Florence, 300, 692, 698, 701, 706, 713, 723, 727, 785; Gabinetto Fotografico Nazionale, Rome, 297, 437, 823, 840, 912, 923, 927, 940; GAI, Baghdad, 123; Gardner, *Art Through the Ages*, Fifth Edition, Revised by Horst de la Croix and Richard G. Tanney, copyright © 1970 by Harcourt Brace Jovanovich, 500; Gendreau, Philip, New York, 1306; Giraudon, Paris, 463, 583, 588, 604, 743, 780, 781, 786, 788, 790, 878, 879, 935, 1022, 1078, 1131, 1146; Graves, Michael, Max Protetch Gallery, New York, 1323; The Green Studio, Ltd., Dublin, 496; Hammarskjold/Tio, Stockholm, 1211; Harris, Ann Sutherland, 835; Hedrich-Blessing, Chicago, 1296, 1297, 1308; Held, André, Ecublens, 93, 290, 455; Hell, Dr. Helmut, Reutlingen, 406; Henrot, Paris, 951; Hervé, Lucien, Paris, 1301, 1302, 1312, 1313; Hinz, Hans, Basel, 44, 45, 1177; Hirmer Fotoarchiv, Munich, 71, 77, 81, 82, 85, 86, 87, 88, 95, 102, 104, 106, 107, 112, 115, 119, 125, 126, 131, 133, 143, 156, 157, 159, 160, 161, 164, 166, 171, 176, 178, 179, 182, 185, 186, 187, 188, 189, 190, 194, 197, 199, 204, 206, 209, 211, 213, 217, 220, 221, 224, 226, 232, 233, 234, 235, 237, 240, 241, 243, 246, 247, 248, 250, 256, 259, 260, 263, 273, 276, 278, 279, 282, 411, 425, 426, 427, 430, 453, 454, 561, 562, 601; Holton, George, New York, 50; Hornung Professor Erik, Basel, 94; Hurlimann, Martin, Zurich, 458; Istituto Centrale del Restauro, Rome, 653, 654; Istituto per la Collaborazione Culturale, Rome, 148; Istituto di Etruscologia e Antichità Italiche, Università di Roma, 294; Jencks, Charles, London, 1325; Josse, H., Paris, 789, 945, 1127; Juley, Peter A., New York, 1239; Kaster, Gert, 245; Keleman, Pal, 67; Kersting, A. F., London, 469, 476, 555, 585, 1000, 1003, 1012, 1030, 1035, 1039, 1040, 1043, 1058; Kessel, Dmitri, Paris, 1, 162; Klein, Walter, Düsseldorf, 1179; Kleinhempel, Hamburg, 1173; M. Knoedler & Co., Inc., New York, 1285; Lampl, 394 (adapted from J. W. Crowfoot), 395 (adapted from J. C. M. Toynbee and J. B. Ward Perkins); Loose, Louis, Brussels, 890; McKenna, Rollie, Stonington, Conn., 666, 674, 859; Mannino, Giovanni, Rome, 26; Mariani, Enrico, Como, 477; Markowski, Eugene D., 368; Marlborough Gallery, Inc., New York, 1260; Marzari, P., Milan, 348; MAS, Barcelona, 10, 473, 479, 536, 564, 565, 621, 759, 771, 772, 845, 895, 896, 897, 967, 968, 970, 971, 1070, 1071, 1072, 1075, 1289, 1290; Mates, Robert E., New York, 1207; Matt, Leonard von, Buochs, Switz., 167, 320, 914, 918, 919; Mellaart, James, London, 29, 30, 31, 32, 33; Metropolitan Museum of Art, New York, Egyptian Expedition, 113; Meyer, Erwin, Vienna, 331, 868, 998; Mills, Charles, Philadelphia, 129; Ministry of Public Building and Works, London, 37, 38; Muller, Erich, Kassel, 1031; Murphy/Jahn, Chicago, 1310; Musées de la Ville de Strasbourg, France, 620; Museum of Fine Arts, Boston, Harvard-Boston Expedition, 100; Museum of Modern Art, New York, 1201, 1292, 1298, 1300, 1303; Museum of the American Indian, Heye Foundation, New York, 51; Museum voor Land- en Volkenkunde de Rotterdam, courtesy Mr. René Wassing, 46; Mylonas, Professor G. E., Athens, 177; National Monuments Record, London, 623, 624, 625, 1004, 1094; New York Public Library, 956; Nickel, Richard, Chicago, 1287; Ohio Historical Society, Marietta, 52; Oriental Institute, University of Chicago, 128, 138, 139, 141, 149, 150; Peabody Museum, Harvard University, Cambridge, Mass., 61, 65; Pedecini, Naples, 736; Percheron, René, Puteaux, France, 475; Pericot-Garcia, Galloway, and Lommel, *Prehistoric and Primitive Art*, © 1967 by Sansoni Editore, Florence, 18; Perkins, J. B. Ward, 316, 319, 334, 379; Philadelphia Museum of Art, 1114; Pickard, *Theatre of Dionysus in Athens*, Cambridge, 257; Pontificia Commissione di Architettura Sacra, Vatican City, Rome, 396, 397; Powell, Josephine, Rome, 225, 227, 317, 443, 444, 445, 451; Proskouriakoff, Tatiana, *An Album of Maya Architecture* (1946), The Carnegie Institution of Washington, D.C., 60; Remy, Dijon, 567, 746; Renger-Patzsch, A., Wamel-Dorf Uber Soest, Ger., 1033; Rheinisches Bildarchiv, Cologne, 509, 516, 615; Rheinisches Landesmuseum, Trier, 391, 392; Roos, George, New York, 393; Roubier, Jean, Paris, 954; Royal Pavilion, Brighton, 1093; Sansoni Editore, Florence, 25; Sansoni, R., Rome, 792; Scala, Florence, 725; Scala Fine Art Publishers, Inc., New York, 80, 423, 540, 646, 732, 900, 928; Schaeffer, J. H., Baltimore, 1053; Schmidt-Glassner, Helga, Stuttgart, 332, 1028, 1032; Schneider-Lengyel, Paris, 1137; Service Photographique des Musées Nationaux, Paris, 134, 719, 754, 755, 936, 942, 952, 963, 966, 990, 992, 1017, 1023, 1025, 1059, 1061, 1062, 1063, 1064, 1076, 1082, 1084, 1109, 1110, 1120, 1129, 1164, 1169, 1281; Shunk-Kender, New York, 1258; Sloman, Steve,